ART
THROUGH
THE AGES

SIXTH EDITION

REVISED BY

Horst de la Croix

SAN JOSE STATE UNIVERSITY

&

Richard G. Tansey

SAN JOSE STATE UNIVERSITY

GARDNER'S

ART
THROUGH
THE AGES

SIXTH EDITION

HARCOURT BRACE JOVANOVICH, INC.
New York / Chicago / San Francisco / Atlanta

Chapter-opening illustrations by Viet-Martin Associates and Martin Eichtersheimer
Architectural drawings by Felix Cooper and others

ISBN: 0-15-503753-6
Library of Congress Catalog Card Number: 74-22995

PREFACE

Since publication of the first edition in 1926, Helen Gardner's *Art Through the Ages* has been a favorite with generations of students and general readers, who have found it an exciting and informative survey. Miss Gardner's enthusiasm, knowledge, and humanity have made it possible for the beginner to learn how to see and thereby to penetrate the seeming mysteries of even the most complex artistic achievements. Every effort has been made in this volume to preserve her freshness and simplicity of style and, above all, her sympathetic approach to individual works of art and to the styles of which they are a part.

Miss Gardner completed the third edition shortly before her death in 1946. The fourth was prepared in 1959 by Professor Sumner Crosby and his colleagues at Yale University, and our fifth edition was published in 1970. The popularity of that edition and suggestions for further improvement led us to prepare this sixth edition.

In addition to a revised but undiminished treatment of Western art this edition offers surveys of the arts of Islam, Asia, pre-Columbian America, the North American Indian, Africa, and Oceania. The chapter on the art of the twentieth century has been enlarged to accommodate revisions necessitated by the rapid development and changing interpretations of its subject, and the general introduction to the book now includes a discussion of the formal aspects of art, dealing with fundamental concepts in some detail. There are, of course, corresponding increases in illustrations, in those student aids introduced in the fifth edition, and

in the glossary, essay-style bibliography, and index. The book now constitutes a balanced introduction to the art of the world.

Although in some cases, like that of North American Indian art, a sure chronology is impossible, it remains our conviction that a chronological presentation is still the best for introducing the history of art, and this bias is reflected in our use of a linear chronology to open most chapters and in our use of time-lines—short elaborated sections of a chapter chronology that are keyed into the text at the points or periods on which they focus. Most chapters also open with a map that is related to the accompanying chronology; small drawings of key monuments, shown on the chronology, also appear on the map, thus orienting the various works in space as well as time.

Hardest of all aspects of making a book of this nature is selection—in effect, limitation—of the monuments to be discussed and illustrated. Though a corpus of monuments essential to the art-history survey course has long been forming, and though there seems to be considerable agreement as to what constitutes it, there will naturally be differences of choice deriving from differences of emphasis. While this is as it should be, radical departure from the corpus might well obliterate the outlines of the study. To avoid the random, systemless distribution of material that might result we have generally adhered to the corpus, occasionally introducing monuments not well known or not customarily treated in a survey. Our aim throughout has been to present and interpret works as reflections of an intelligible development rather than merely as items of a catalogue or miscellany. We have tried particularly to give coherence to the vast assortment of materials by stressing—in the descriptions of sculpture and painting—the theme of representation as it passes through the many historical variations behind which operate the crucial transformations of humankind's view of itself and the world.

A work as extensive as a history of world art could not be undertaken or completed without the counsel and active participation of experts in fields other than our own. The chapters dealing with Indian, Chinese, and Japanese art were prepared by Professor J. Leroy Davidson of the University of California, Los Angeles; Professor Herbert Cole of the University of California, Santa Barbara, prepared the chapter on the arts of the North American Indian, Africa, and Oceania; and Professor Raphael Reichert of California State University, Fresno, prepared the chapter on pre-Columbian art. They have our sincere thanks, as does Bruce Radde of San José State University, who guided us through the all-important revision of the chapter dealing with the art of the twentieth century. Many valuable comments and suggestions were received from specialists who reviewed portions of the work in progress; among these are: Dr. Richard Ettinghausen, Consultative Chairman, Department of Islamic Art, Metropolitan Museum of Art, and Hagop Kevorkian Professor of Islamic Art, Institute of Fine Arts, New York University; Julie Jones, Curator, Museum of Primitive Art, New York; Dr. Martin Lerner, Metropolitan Museum of Art, New York; Dr. Roy Sieber, Rudy Professor of Fine Arts, Indiana University, Bloomington. Richard McLanathan reviewed all color plates and suggested adjustments necessary to achieve high

color fidelity. Patricia Pinkerton and Marguerite Agramonte gave us most valuable bibliographical assistance, and Luraine Tansey of San José City College read proof and offered many useful suggestions.

Philip Ressner, at Harcourt Brace Jovanovich, has now been our editor for two editions of this book; he has done his task with a skill, diligence, and good humor that honor his profession and his house.

We should like, as we thank all those who have helped immeasurably in the production of this book, to affirm that we alone are responsible for whatever may be its deficiencies.

HORST DE LA CROIX
RICHARD G. TANSEY

CONTENTS

72 The Art of Egypt *Chapter Three*

102 The Art of the Aegean *Chapter Four*

122 The Art of Greece *Chapter Five*

184 Etruscan and Roman Art *Chapter Six*

ART
THROUGH
THE AGES

SIXTH EDITION

INTRODUCTION

The goal of art history, the subject of this book, is the discerning appreciation and enjoyment of art, from whatever time and place it may have come, by whatever hands made. Outside the academic world the terms *art* and *history* are not often so juxtaposed. People tend to think of history as the record and interpretation of past (particularly political) human actions, and of art—quite correctly—as something *present* to the eye and touch, which, of course, the vanished human events that make up history are not. The fact is that a work of art, visible and tangible as it is, is a kind of *persisting event*. It was made at a particular time and place by particular persons, even if we do not always know just when, where, and by whom. Though it is the creation of the past, it continues to exist in the present, long surviving its times; Charlemagne has been dead for a thousand years, but his chapel still stands at Aachen.

THE BASES OF ART HISTORY

Style

The time a work of art was made has everything to do with the way it looks—with, in one key term, its *style*. In other words, the style of a work of art is a function of its historical *period*. The historiography of art proceeds by sorting works of architecture,

sculpture, and painting into stylistic classes on the bases of their likenesses and the times or periods when they were produced. It is a fundamental working hypothesis of art history that works produced at the same time (and, of course, the same place) will generally have common stylistic traits. Of course all historiography assumes that events derive their character from the time in which they happen (and perhaps from their "great men," also products of their time); thus we can speak of the Periclean Age, the Age of Reason, even—as with the title of a recent historical work—the Age of Roosevelt. We must also know the time of a work if we are to know its meaning, to know it for what it is. Yet if the work of art still stands before us, persisting from the past, is this not sufficient? By virtue of its survival, is not the work in a sense *independent* of time? May not a work of art speak to men of all times as long as it survives? The key to the question is the word "speak." Indeed, it may speak, but what is its language? What does it say to us? Art may be more than a form of communication, yet it is certainly that; and it is the business of art history to learn the "languages" of the art of many different periods as they are embodied in the monuments from their respective times. We can assume that artists in every age expressed in their works a meaning of some sort intelligible to themselves and others. One can get at that meaning only by setting a particular work in relation to others like it that were made about the same time. To works grouped in this way we can infer a community of meaning as well as of form; we will have outlined, then, a style. In a chronological series of works having common stylistic features, one may find that the later and the earlier works show stylistic *differences* as well. The art historian tends to think of this phenomenon as reflecting an evolution, a *development*.

It is obvious that before one can infer stylistic development it is necessary to be sure that the chronological sequence is correct, that each monument is correctly dated; without this certainty art-historical order and intelligibility are impossible. Thus an indispensable tool of the historian is *chronology*, the measuring scale of historical time; without it there could be no history of style, only a confusion of unclassifiable monuments impossible to describe in any sequence of change.

The table of contents of this book reflects what is essentially a series of periods and subperiods arranged in chronological order, the historical sequence that embraces the sequence of art styles. Until the later eighteenth century the history of art was really a disconnected account of the lives and works of individual artists. Now we regard it as a record of the dynamic change of styles in

time, the art of individual masters being substyles of the overall period styles. Although one speaks of "change" in the history of art, the objects themselves obviously do not change; as we have said, they persist, although each will of course suffer some material wear and tear with time. But the fact that works of art from one period look different from those of other periods leads us to infer that *something* changes. This something can only be the points of view of the human makers of works of art with respect to the meaning of life and of art. Modern historiography is much influenced by modern philosophies of change and evolution and, from the terms and data of biological science, our modern history of art was bound to borrow a sense of continuous process to help explain art-historical change.

In art history, as in the sciences and in other historical disciplines, we have gone far in knowing a thing once we have classified it. Art historians, having done this, resemble experienced travelers who learn to discriminate the different "styles" peculiar to different places. The latter know that one must not expect the same style of life in the Maine woods as on the Riviera, and when they have seen a great many places and peoples—like art historians who are familiar with a great many monuments—they are not only at ease with them, but can be said to know and appreciate them for what they are. As their experience broadens so does their discrimination, their perception of distinctive differences. As world travelers come to see that the location contributes to the unique quality and charm of a town, so students of art, viewing it in the historical dimension, become convinced that a work's peculiar significance, quality, and charm are a function of the time of its making.

But is not the historical "placing" of a work of art, so visibly and tangibly present, irrelevant to the *appreciation* of it? After all, is not art-historical knowledge *about* a work of art something different from direct experience of it? The answers lie in the fact that uninstructed appreciators, no matter how sincere, will still approach a work with the esthetic presuppositions of their own time rather than those of the time of the work itself. Hence, their presuppositions can be tantamount to prejudices, so that their appreciation, even if genuine, may well be for the wrong reasons; it will, in fact, be undiscerning and indiscriminate, so that dozens of works of art may be viewed in the same way, without any savor of the individual significance and quality of each. Thus, as a work of art is intended for a particular audience at a particular time and place, so may its *purpose* be quite particular, and its purpose necessarily enters into its meaning. For example, the famous *Vladimir Madonna* (FIG. 7-48, p. 285) is a Byzantine-Russian icon, a species of art produced not as a work

of "fine art" so much as a sacred object endowed with religio-magical power. It was considered, moreover, the especially holy picture of Russia that miraculously saved the city of Vladimir from the hosts of Tamerlane, the city of Kazan from the later Tartar invasions, and all of Russia from the Poles in the seventeenth century. We may admire it for its innate beauty of line, shape, and color, its expressiveness, and its craftsmanship, but unless we are aware of its special historical function as a wonder-working image we miss the point. We can admire many works of art for their form, content, and quality, but we need a further characterizing experience; otherwise we are admiring very different works without discriminating their decisive differences. We shall be confused and our judgment faulty.

While our most fundamental way of classifying works of art is by the time of their making, classification by *place of origin* is also crucial. In many periods a general style, Gothic for example, will have a great many regional variations: French Gothic architecture is strikingly different from both English and Italian Gothic. Differences of climate helped to make French Gothic an architecture without bearing walls (and with great spaces for stained-glass windows) and Italian Gothic an architecture with large expanses of wall wonderfully suited to mural painting. Art history, then, is also concerned with the spread of a style from its place of origin. Supplementing time of origin with place of origin thus adds another dimension to the picture of art monuments in the process of stylistic development.

The *artist*, of course, provides a third dimension in the history of art. As we have noted, early "histories" of art, written before the advent of modern concepts of style and stylistic development, were simply biographies of artists. Biography as one dimension is still important, for through it we can trace stylistic development within the artists' careers. We can learn much from contemporaneous historical accounts, from documents such as commission contracts, and from the artists' own theoretical writings and literary remains. All of this is of use in "explaining" their works, though of course no complete "explanation" exhausts the meaning of them. Relationships to their predecessors, contemporaries, and followers are describable in terms of the concepts *influence* and *school*: Artists are likely to have been influenced by their masters, and then to have influenced or been influenced by their fellows working somewhat in the same style at the same time and place. We designate a group of such artists as a school, by which we mean not an academy, but a time-place-style classification. Thus we may speak of the Dutch School of the seventeenth century and, within it, of subschools like those of Haarlem, Utrecht, and Leyden.

Iconography

Thus the categories of time and place, the record of the artist, influences, and schools—all are used in composition of the picture of stylistic development. Another kind of classification, another key to works of art, is *iconography*—the study of the subject matter of and symbolism in works of art. By this approach paintings and sculptures are grouped in terms of their themes rather than their styles, and the development of subject matter becomes a major focus. Iconographical studies have an ancillary function in stylistic analysis since they are often valuable in tracing influences and in assigning dates and places of origin.

Historical Context

Another, very broad, source of knowledge of a work of art lies outside the artistic region itself, yet encloses it and is in transaction with it. This is the *general historical context*—the political, social, economic, scientific, technological, and intellectual background that accompanies and influences the specifically art-historical events. The fall of Rome, the coming of Christianity, and the barbarian invasions all had much to do with stylistic changes in architecture, sculpture, and painting in the early centuries of our era. The triumph of science and technology has everything to do with the great transformation of the Renaissance tradition that takes place in what we call modern art, the art of our own time. The work of art, the persisting event, is after all a historical document.

THE WORK OF ART

The work of art is an object as well as an historical event. To describe and analyze it we use categories and vocabularies that have become more or less standard and that are indispensable for understanding this book.

General Concepts

Form, for the purposes of art history, refers to the shape of whatever is the "object" of art; in the made object it is the shape that the expression of content takes. To create forms, to make a work of art, artists must of course shape materials with tools. Of the many materials, tools, and processes available, each has

its own potentialities and limitations, and it is part of the artists' creative activity to select the ones most suitable to their purpose. The technical processes they employ as well as the distinctive, personal way they handle them, we call their *technique*. If the material artists use is the substance of art, technique is their individual manner of giving that substance form. Form, technique, and material are interrelated, as can be readily seen in a comparison of the marble statue of Apollo from Olympia (FIG. 5-35, p. 150) with the bronze *Charioteer of Delphi* (FIG. 5-32, p. 148). The *Apollo* is firmly modeled in broad, generalized planes reflecting the ways of shaping stone that are more or less dictated by the character of that material and by the tool used—the chisel. On the other hand, the *Charioteer's* fineness of detail, the crisp, sharp folds of the drapery, reflect the qualities inherent in cast metal. However, a given medium (the material used) can lend itself to more than one kind of manipulation. The technique of Lehmbruck's bronze *Seated Youth* (FIG. 1), for example, contrasts strikingly with Rodin's *The Thinker* (FIG. 2), also bronze. The surfaces of Lehmbruck's figure are smooth, flowing, quiet, while those of Rodin's are rough, broken, and tortuous. Here it is not so much the bronze that determines the form as it is the sculptor's difference of purpose and of personal technique.

Space, in our common-sense experience, is the bounded or boundless "container" of masses or objects. For the analysis of works of art we regard it as bounded and susceptible of esthetic and expressive organization. Architecture provides our commonest experience of the actual manipulation of space, while the art of painting frequently has had the purpose of projecting upon a two-dimensional surface an image (or illusion) of the three-dimensional spatial world we move in.

Area and *plane*, terms that describe limited, two-dimensional space, generally refer to surface. A plane is flat, two-dimensional —like this page and like elements dealt with in plane geometry, such as a circle, square, triangle. An area, also describable in terms of plane geometry, is often a plane or flat surface that is enclosed or bounded. Bernini, when he defined the essentially plane surface in front of St. Peter's by means of his curving colonnades, created an area (FIG. 15-3, p. 582).

Mass and *volume*, in contradistinction to plane and area, describe three-dimensional space. In both architecture and sculpture, mass is the bulk, density, and weight of matter in space. Yet the mass need not be solid; it can be the exterior form of enclosed space. For example, "mass" can apply to a pyramid (FIG. 3-7, p. 80), which is essentially solid, or to the exterior of the Hagia

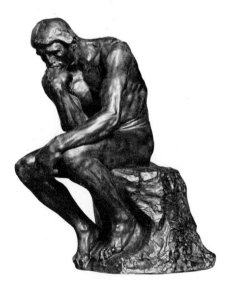

1 WILHELM LEHMBRUCK, *Seated Youth*, 1918. Bronze. Wilhelm-Lehmbruck-Museum.

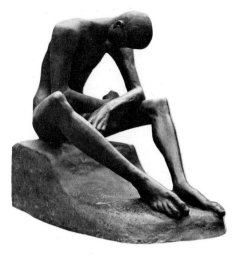

2 AUGUSTE RODIN, *The Thinker*, 1880. Bronze. Metropolitan Museum of Art, New York (gift of Thomas F. Ryan, 1910).

Sophia (FIG. 7-32, p. 273), which is essentially a shell enclosing vast spaces. Volume is the space that is organized, divided, or enclosed by mass. It may be the spaces of the interior of a building or the intervals between the masses of a building or between those of a piece of sculpture, ceramics, or furniture. Volume and mass describe the exterior as well as the interior forms of a work of art—the forms of the matter of which it is composed *and* the forms of the spaces that exist immediately around that matter and interact with it. For example, in the Lehmbruck statue (FIG. 1), referred to above, the expressive volumes enclosed by the attenuated masses of the torso and legs play an important part in the open design of the piece. The absence of enclosed volumes in the Rodin figure—equally expressive—closes the design, making it compact, heavy, and locked-in. (Yet both works convey the same mood—one of brooding introversion.) These forms—the closed and the open—manifest through the history of art, demonstrate the intimate connection between mass and the space that surrounds and penetrates it.

In the definition of mass and volume, *line* is one of the most important yet most difficult terms to comprehend fully. In both science and art line can be understood as the path of a point moving in space, the track of a motion. Because the directions of motions can be almost infinite, the quality of line can be incredibly various and subtle. It is well known that psychological responses attach to the direction of a line—a vertical line being positive, a horizontal one passive, a diagonal suggestive of movement, energy, or unbalance, and so on. Hogarth regarded the serpentine or S-curve line as the "line of beauty." Our psychological response to line is also bound up with our esthetic sense of its quality. A line may be very thin, wirelike and delicate, giving a sense of fragility, as in Klee's *Twittering Machine* (FIG. 17-20, p. 742). Or it may alternate quickly from thick to thin, the strokes jagged, the outline broken, as in a 600-year-old Chinese painting (FIG. 19-16, p. 841); the effect is of vigorous action and angry agitation. A gentle, undulating but firm line, like that in Picasso's *Bathers* (FIG. 3), defines a *contour* that is restful and quietly sensuous. A contour continuously and subtly contains and suggests mass and volume. In the Picasso drawing the line is distinct, dark against the white of the paper. But line can be felt as a controlling presence in a hard edge, profile, or boundary created by a contrasting area even when its tone differs only slightly from that of the area it bounds. A good example of this is to be seen in the central figure of the goddess in Botticelli's *Birth of Venus* (FIG. 12-56, p. 468).

When a line serves as an element along which forms are organized, it is known as an *axis*. The axis line itself need not be

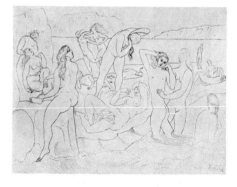

3 PABLO PICASSO, detail of *Bathers*, 1918. Pencil drawing. Fogg Art Museum, Harvard University (bequest of Paul J. Sachs).

evident, and there may be several (usually with one dominant), as in the layout of a city. Though we are most familiar with directional axes in urban complexes, they occur in all the arts. A fine example of the use of axis in large-scale architecture is the plan of the Palace of Versailles and its magnificent gardens (FIG. 15-52, p. 624). Axis—vertical, horizontal, or diagonal—is also an important compositional element in painting.

Perspective, no less than axis, is a method of organizing forms in space, yet we use perspective mainly in creating an illusion of depth or space on a two-dimensional surface. Conditioned by exposure to Western single-point perspective, an invention of the Italian Renaissance (see pp. 476–510), we tend to see perspective as a systematic ordering of pictorial space in terms of a single point—a point where those lines converge that mark the diminishing size of forms as they recede into the distance (FIG. 13-16, p. 490). Renaissance and Baroque artists created masterpieces of perspective illusionism. In Leonardo's *Last Supper* (FIG. 4), for example, the lines of perspective (dashed lines) are handled so that they converge on Christ and, in the foreground, project the picture space into the room on whose wall the painting appears, creating the illusion that the space of the picture and of the room are continuous. Yet we must remember that Renaissance perspective is only one of several systems for depicting depth. Others were used in ancient Greece and Rome, and still others,

4 LEONARDO DA VINCI, *The Last Supper*, c. 1495–98. Fresco. Santa Maria delle Grazie, Milan. Perspective lines are dashed; lines indicating proportions are solid white or black.

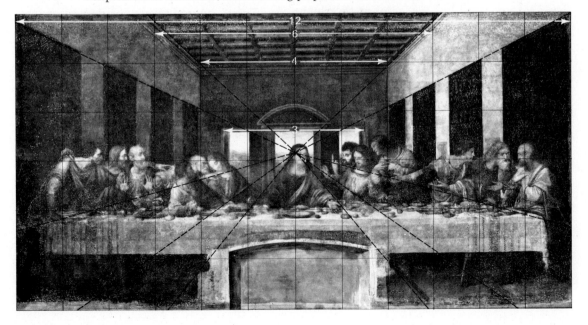

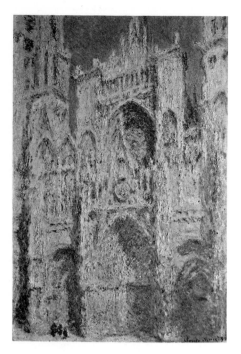

5 CLAUDE MONET, Façade of Rouen Cathedral, *c.* 1880. Above, National Gallery of Art, Washington, D.C. (Chester Dale Collection); below, Museum of Fine Arts, Boston (bequest of Hanna Marcy Edwards).

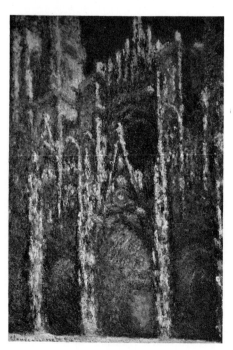

in the East. Some of these other systems, as well as Renaissance perspective, continue to be used. There is no final or absolutely correct projection of what we "in fact" see.

Proportion deals with the relationships (in terms of size) of the parts of a work. The experience of proportion is common to all of us: We seem to recognize at once when the features, say, of the human face or body are "out of proportion," if the nose or ears are too large for the face or the legs too short for the body. An instinctive or conventional sense of proportion leads us at once to regard the disproportionate as ludicrous or ugly. Proportion, formalized, is the mathematical relationship in size of one part of a work of art to the others within the work, as well as to the totality of the parts; it implies the use of a denominator common to the various parts. Recently it has been shown that the major elements of Leonardo's *Last Supper* show proportions found in harmonic ratios in music—12:6:4:3 (FIG. 4). These figures (with the greatest width of a ceiling panel taken as one unit) are the widths, respectively, of the painting, the ceiling (at the front), the rear wall, and the three windows (taken together and including interstices); they apply as well to the vertical organization of the painting. Leonardo found proportion everywhere, "not only in numbers and measures, but also in sounds, weights, intervals of time, and in every active force in existence."[1] The ancient Greeks, who thought beauty to be "correct" proportion, sought a canon (or rule) of proportion, not only in music, but also for the human figure. The famous canon of Polycleitos (p. 164), expressed in his statue of Doryphoros (FIG. 5-53, p. 163), long provided an exemplar of correct proportion. But it should be noted that canons of proportion differ from time to time and culture to culture and that, occasionally, artists have deliberately used disproportion. Part of the task of the students of art history is to perceive and adjust to these differences as they try to understand the wide universe of art forms. Proportional relationships are often based on a *module*, a dimension of which the various parts of a building or other work are fractions or multiples. It might be the diameter of a column, the height of the human body, an abstract unit of measurement. For example, the famous "ideal" plan of the ninth-century monastery of St. Gall (FIG. 8-11, p. 317) has a modular base of $2\frac{1}{2}$ feet, with all parts of the structure multiples or fractions of this dimension.

Scale (like proportion) refers to the dimensional relations of the parts of a work to its totality (or of a work to its setting) but

[1] In Thomas Brachert, "A Musical Canon of Proportion in Leonardo da Vinci's *Last Supper*," *Art Bulletin*, N.Y. December 1971, LIII, 4, pp. 461–66.

usually in terms of appropriateness to use or function. We do not think a private home need be high as an office building, nor an elephant's house at the zoo the size of a hencoop—or vice versa. This sense of scale is necessary for the construction of form in all the arts. Most often, but not necessarily, it is the human figure that gives the scale to form.

Form, with which we began this list of fundamental concepts, is mediated primarily by *light*. The function of light in the world of nature is so pervasive that we often take it for granted, and there are few who realize the extraordinary variations wrought by light alone—whether natural or artificial—on our most familiar surroundings, as daylight, for example, changes with the hour or season. Few realize fully the extent to which light affects and reveals form. One who did was the French artist Monet (pp. 694–96), who painted the reflections in a waterlily pond according to their seasonal variations, and in a series of more than twenty canvases of the façade of the cathedral of Rouen revealed its changing aspect from dawn until twilight in different seasons (PLATE 16-5 and FIG. 5). Light is as important for the perception of form as is the matter of which form is made.

One function of light is *value*. In painting, and in the graphic arts generally, value refers to lightness, or the amount of light that is (or appears to be) reflected from a surface. Value is a subjective experience, as FIGURE 6 shows. In absolute terms—if measured, say, by a photoelectric device—the center bar in this diagram is uniform in value. Yet, where the bar is adjacent to a dark area, it *looks* lighter, and where adjacent to a lighter area, darker. Value is the basis of the quality called *chiaroscuro*— *chiaro* (light), *scuro* (dark)—which refers to gradations between light and dark that produce the effect of *modeling*, or of light reflected from three-dimensional surfaces, as exemplified in Leonardo's superb rendering of *The Virgin and St. Anne* (FIG. 13-2, p. 478).

In the analysis of light an important distinction must be made for the realm of art: natural light, or sunlight, is whole or additive light, whereas the painter's light in art—the light reflected from pigments and objects—is subtractive light. Natural light is the sum of all the wavelengths composing the visible spectrum, which may be disassembled or fragmented into the individual colors of the spectral band. (Recent experiments with lasers—*l*ight *a*mplification by *s*timulated *e*mission of *r*adiation— have produced color of incredible brilliance and intensity, opening possibilities of color composition until now not suspected. The range and strength of color produced in this way approach, though at considerable distance, those of the sun.) Although the

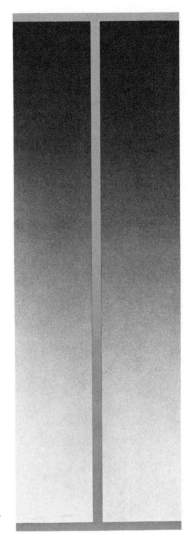

6 Effect of adjacent value on apparent value. Actual value of center bar is constant.

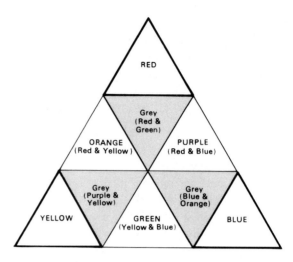

7 Color triangle prepared by Josef Albers and Sewell Sillman, Yale University.

esthetics of color is largely the province of the artist and can usually be genuinely experienced and understood only through intense practice and experimentation, some aspects are susceptible of analysis and systematization. Paint pigments (as well as those of the human body) produce their individual colors by reflecting a segment of the spectrum while absorbing all the rest. A "green" pigment, for example, subtracts or absorbs all the light in the spectrum except that seen by us as green, which it reflects to the eye. (In the case of transmitted rather than reflected light, the coloring matter—as in stained glass—blocks or screens out all wavelengths of the spectrum but those of the color one sees.) Thus, theoretically, a mixture of pigments that embraced all the colors of the spectrum would subtract all light—that is, it would be black; actually, such a mixture of pigments never produces more than a dark gray. (See below, p. 13, the discussion of complementary colors.)

The name of a color is its *hue*—red, blue, yellow. Although the colors of the spectrum merge into each other, artists usually conceive of their hues as distinct from each other, and this gives rise to many different devices for representing color relationships. There are basically two variables in color—the apparent amount of light reflected and the apparent purity, and a change in one must produce a change in the other. Some terms for these variables are (for lightness) *value* (see above) and *tonality*, and (for purity) *chroma*, *saturation*, and *intensity*.

One of the more noteworthy diagrams of the relationships of colors is the triangle (Fig. 7), once attributed to Goethe, in

which red, yellow, and blue (the *primary colors*) are the vertexes of the triangle, and orange, green, and purple (the *secondary colors*, which result from mixing pairs of primaries) lie between them. Colors that lie opposite each other (such as red and green) are called *complementary*, since they complement, or complete, one another, each absorbing those colors that the other reflects, leaving a neutral, or gray (theoretically, black), when mixed in the right proportions. The inner triangles are products of such mixing.

Color also has a psychological dimension, red and yellow, quite naturally, having connotations of warmth, and blue and green, coolness. Generally, *warm colors* seem to advance, and *cool colors*, to recede.

The quality of a surface—rough, smooth, hard, soft, shiny, dull—as revealed by light is *texture*. The many painting media and techniques permit creation of a variety of textures. The artist may simulate the texture of materials represented, as in Kalf's *Still Life* (PLATE 15-9), or create arbitrary surface differences, even using materials other than canvas, as in Picasso's *Still Life with Chair-caning* (FIG. 17-8, p. 731).

Specialized Concepts

The terms we have been discussing have connotations for all the visual arts. Certain observations, however, are relevant to only one category of artistic endeavor—to architecture only, or to painting, or to sculpture.

IN ARCHITECTURE

Works of architecture are so much a part of our environment that we accept them as given, scarcely noticing them until our attention is summoned. People have long known how to enclose space for the many purposes of life. Of all the arts it is in architecture that the spatial aspect is most obvious. The architect makes groupings of enclosed spaces and enclosing masses, keeping always in mind the function of the structure, its construction and materials, and of course its design, the correlative of the other two. We experience architecture both visually and by motion through and around it, so that architectural space and mass are given to our perception together. The articulation of space and mass in building is expressed graphically in several ways; the principal ones follow.

A *plan* is essentially a map of a floor, showing the placement

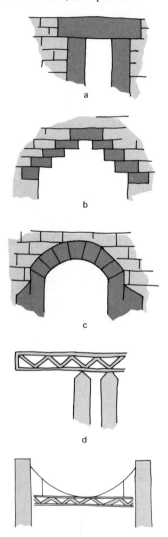

8 Basic structural devices: *a*, post and lintel; *b*, corbeled arch; *c*, arch; *d*, cantilever; *e*, suspension.

of a structure's masses and, therefore, the spaces they bound and enclose (FIG. 7-35, p. 277). A *section*, like a vertical plan, shows placement of the masses as if the building were cut through along a plane (often one that is a major axis of the building). An *elevation* is a head-on view of an external or internal wall, showing its features and often other elements that would be visible beyond or before the wall. (For details, see p. 930, "Plan and Section Conventions."

Our response to a building can range from simple comfort to astonishment and awe, and such reactions are products of our experience of a building's function, construction, and design. We react differently to a church, a gymnasium, and an office building. For one thing, the very movements required of us in order to experience one building will differ widely and profoundly from those required to experience another. These movements will be controlled by the continuity—or discontinuity—of the plan, or by the placement of its axes. For example, in a central plan—one that radiates from a central point, as in the Pantheon in Rome (FIG. 6-42, p. 223)—we perceive the whole spatial entity at once, while in the long axial plan of a Christian basilica (FIG. 7-24, p. 266) or a Gothic cathedral (FIG. 10-17, p. 367) our attention tends to focus on a given point—the altar at the eastern end of the nave. Mass and space can be so interrelated as to produce effects of great complexity, as, for example, in the Byzantine church of the Katholikon (FIG. 7-39, p. 279) or Le Corbusier's church at Ronchamp (FIG. 17-82, p. 790). Thus, our experience of architecture will be the consequence of a great number of material and formal factors, including training and knowledge and our perceptual and psychological makeup, which function in our experience of any work of art.

The architect must have the sensibilities of a sculptor and of a painter and in establishing the plan of a building must be able, as well, to use the instruments of a mathematician. As architects resolve structural problems they act as—or with—engineers cognizant of the structural principles underlying all architecture (FIG. 8). Their major responsibilities, however, lie in the manner in which they interpret the *program* of the building. We are not talking in architectural terms when we describe a structure simply as a church, a hospital, an airport concourse, a house. Any proposed building presents an architect with problems peculiar to it alone—problems related to the site and its surroundings, the requirements of the client, and the materials available—as well as the function of the building. A program, then, deals with more than function; it addresses itself to all the problems embodied in a specific building.

Like architecture, sculpture exists in the three-dimensional space of our physical world. But sculpture as image is closer to painting than is architecture. Until recently, sculpture has been primarily concerned with the representation of human and of natural forms in tangible materials, which exist in the same space as the forms they represent. Sculpture may also embody visions and ideals and has consistently presented images of deities and of people in their most heroic as well as most human aspects (FIG. 13-18, p. 494, and 5-64, p. 172). Today sculpture often dispenses with the figure as image, and even with the image itself, producing new forms in new materials and with new techniques (FIGS. 17-66 to 17-76, pp. 778–84).

Sculpture may be intimately associated with architecture, often to such a degree that it is impossible to disassociate them (FIG. 10-14, p. 365). Sculpture is called *relief* sculpture (FIG. 3-35, p. 101) when it is attached to a back-slab or back plate; *high relief* if the figures or design project boldly (FIG. 5-66, p. 173); *low relief*, or *bas-relief*, if they project slightly (FIG. 3-35, p. 101).

Sculpture that exists in its own right, independent of any architectural frame or setting (FIG. 13-41, p. 515), is usually referred to as *free-standing* or "sculpture in the round," although there are many occasions in the art of Greece and of the Renaissance when free-standing sculpture is closely allied to architecture. Indeed, sculpture is such a powerful agent in creating a spatial as well as an intellectual environment that its presence in city squares or in parks and gardens is usually the controlling factor in their "atmosphere" or general effect (FIG. 15-57, p. 629).

Some statues are meant to be seen as a whole—to be walked around (FIG. 13-41, p. 515). Others have been created to be viewed only from a restricted angle. How a sculpture is meant to be seen of course has to be taken into account by the sculptor, and by those who exhibit the work. Figure 9 illustrates the effect of ignoring this. The upper photograph is taken directly from the front, as the piece is now seen in the museum, whereas the lower one is taken from below, at approximately the same angle from which the statue was originally meant to be seen in its niche on the façade of the cathedral of Florence.

In sculpture, perhaps more than in any other medium, textures, or tactile values, are important. One's first impulse is almost always to handle a piece of sculpture, to run one's finger over its surfaces. The sculptor plans for this, using a great variety of surfaces from rugged coarseness to polished smoothness (FIGS. 10-43, p. 387, and 12-48, p. 461). Textures, of course, are

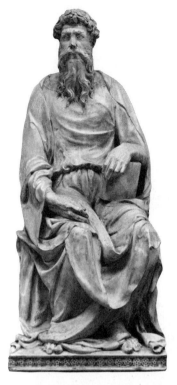

9 DONATELLO, *St. John the Evangelist*, 1412–15. Marble. Museo del Duomo, Florence. Above, as seen in museum; below, as intended to be seen on façade of the cathedral of Florence.

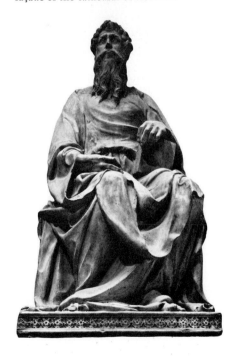

often intrinsic to a material, and this influences the type of stone, wood, plastic, clay, or metal that the sculptor selects. There are two basic categories of sculptural technique—*subtractive* and *additive*. Carving, for instance, is a subtractive technique, in that the final form is a reduction of the original mass (FIG. 10). Additive sculpture, however, is built up, usually in clay around an armature. The piece so made is fired and used to make a mold in which the final work is cast in a material such as bronze (FIG. 12-49, p. 462). Casting is a popular technique today, as is direct construction of forms by the welding of shaped metals (FIG. 17-67, p. 778), also an additive technique.

Within the sculptural family must be included ceramics and metalwork, and numerous smaller, related arts, all of which employ very specialized techniques with their own distinct vocabularies. These will be considered as they arise in the text.

IN THE GRAPHIC ARTS

While the forms of architecture and sculpture exist in the actual, three-dimensional space, the forms of painting (and of its relatives, drawing, engraving, etc.) exist almost wholly on a two-dimensional surface on which the artist creates an illusion—something that replicates what we see around us or something that is unique to the artist's imagination and that has little correspondence to anything seen in the optical world. Human discovery of the power to project illusions of the three-dimensional world upon two-dimensional surfaces goes back thousands of years and marks an enormous step in the control and manipulation of things perceived. To achieve this illusion the artist configures images or representations drawn from the world of common visual experience. Throughout the history of art this has been interpreted in almost infinite variety; yet doubtless there is much that all people *see* in common and can agree on: the moon at night, a flying bird, an obstacle in one's path. They may differ, though, in their interpretation of the seen; for seeing, and then representing what is seen, are very different matters. The difference between seeing and representing determines the variability of artistic styles, both cultural and personal. For what we *actually* see—that is, the optical "fact"—is not necessarily reported in what we represent. In other words, for art there is and need be but little agreement about the likeness of things to the representations of them. This makes a persisting problem in the history of art: How are we to interpret or "read" images or replicas of the seen? Is there a "correct" vision of the "real" world?

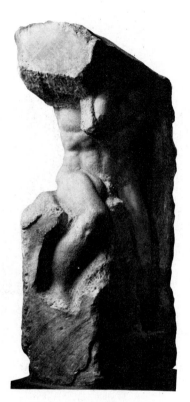

10 MICHELANGELO, *Unfinished Bound Slave*, 1519. Marble. Accademia, Florence.

THE PROBLEM OF REPRESENTATION

The conundrum of seeing something and making a representation of it is artfully illustrated in FIGURE 11, a cartoon of an ancient Egyptian life-drawing class that Gombrich uses to introduce his invaluable work *Art and Illusion*. The cartoon and the actual representation of an Egyptian queen (FIG. 12) raise many questions: Did Egyptian artists copy models exactly as they saw them? (That is, did Egyptians actually *see* each other in this way?) Or did they translate what they saw according to some formula dictated by conventions of representation peculiar to their cul-

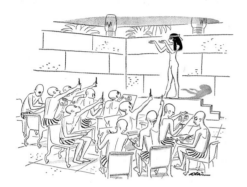

11 ALAIN, drawing. Copyright 1955 by The New Yorker Magazine, Inc.

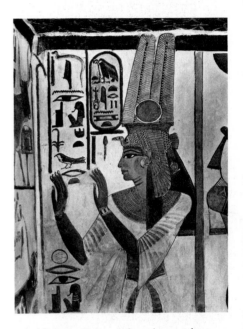

12 *Queen Nofretari*, from her tomb at Thebes, *c.* 1250 B.C. Detail of a painted bas-relief.

ture? Would we have to say—if what was seen and what was recorded were optically the same—that this is the way Egyptians must have looked? Or wished to look? Beginning students usually have questions somewhat like these in mind when they perceive deviation, in historical styles, from the recent Western realism to which they have been conditioned. They will ask whether the Egyptians or others were simply unskilled at matching eye and hand, so to speak, and could not draw from what they saw. But this would be to presuppose that the objective of the artist has always been to match appearances with cameralike exactitude. This is not the case, nor is it the case that artists of one period "see" more "correctly" and render more "skillfully" than those of another. It seems rather to be the case that artists represent what they *conceive* to be real rather than what they *perceive*. They bring to the making of images conceptions that have been instilled in them by their cultures. They understand the visible world in certain unconscious, culturally agreed-upon ways, and thus bring to the artistic process ideas and meanings out of a common stock. They record not so much what they *see* as what they *know* or *mean*. Even in the period of dominant realism in recent Western European art, great deviations from camera realism have set in. Moreover, in our everyday life there are images familiar to all of us, that distort optical

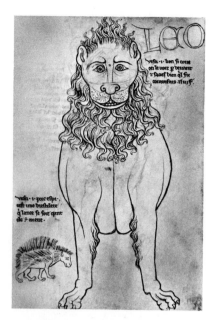

13 VILLARD DE HONNECOURT, *Lion Portrayed from Life*, c. 1230–35. Drawing. Cabinet des Manuscrits, Bibliothèque Nationale, Paris.

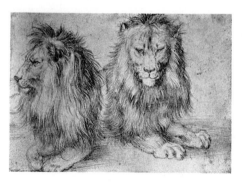

14 ALBRECHT DÜRER, *Two Lions*, c. 1521. Drawing. Staatliche Museen Preußischer Kulturbesitz, Kupferstichkabinet Berlin.

"reality" quite radically: consider, for one example, those of the ubiquitous comic strip.

Solutions to the problem of representation compose the history of artistic style. It is useful to examine some specimens of sharp divergence in representational approach. Compare, for example, the lion drawn by the medieval artist Villard de Honnecourt (FIG. 13) and lions drawn by the Renaissance artist Albrecht Dürer (FIG. 14). In the de Honnecourt lion, which, it is important to notice, the artist asserts was drawn from life, we have a figure entirely adequate for identification, yet preconceived in the formulas of its time and constructed accordingly. Dürer's lions, drawn some three centuries later, obviously make a much different report of what the artist is seeing or has seen. So do the Assyrian lions of the hunting reliefs (FIG. 2-27, p. 65), the lion of the Ishtar Gate processional way (FIG. 2-28, p. 65), the lion in Rousseau le Douanier's *Sleeping Gypsy* (FIG. 16-61, p. 708), or (in a slight shift of genus) Barye's sculpture of a jaguar in his *Jaguar Devouring a Hare* (FIG. 16-14, p. 663). In each case personal vision joins with the artistic conventions of time and place to decide the manner and effect of the representation. Yet even at the same time and place—for example, nineteenth-century Paris—we can find sharp differences in representation where opposing personal styles, those of Ingres and Delacroix, are recording the same subject (FIGS. 16-35 and 16-36, p. 681).

A final example will underscore the relativity of vision and representation that differences in human cultures produce. We recognize, moreover, that close matching of appearances has mattered only in a few times and places. Although both portraits (FIG. 15) of a Maori chieftain, one by a European, the other by the chieftain himself, reproduce his facial tatooing, the first portrait is a simple commonplace likeness that underplays the tatooing. The latter is a statement by the chieftain of the supreme importance of the design that symbolizes his rank among his people. It is the splendidly composed insignia that is his image of himself, the European likeness being superficial and irrelevant to him.

Students of the history of art, then, learn to distinguish the works before them by scrutinizing them closely in the context of their time and place of origin. But this is only the beginning. The causes of stylistic change in time are mysterious and innumerable; and it is only through the continuing process of art-historical research that we can hope to make the picture even fragmentarily recognizable, never complete. Incomplete though the picture is, the panorama of art, changing in time, lies before the students; and, as their art-historical perspective

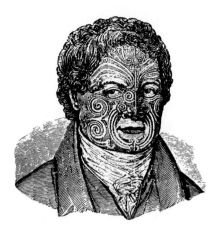

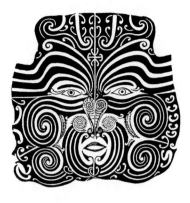

gains depth and focus, they will come to perceive the continuity of the art of the past with that of the present. It will become clear that one cannot be understood without the other, and that our understanding of the one will constantly change with changes in our understanding of the other. The great American poet and critic T. S. Eliot has cogently expressed this truth for all of art in a passage that suggests the philosophy and method of this book:

> ... what happens when a new work of art is created is something that happens simultaneously to all the works of art which preceded it. The existing monuments form an ideal order among themselves, which is modified by the introduction of the new (the really new) work of art among them.... Whoever has approved this idea of order ... will not find it preposterous that the past should be altered by the present as much as the present is directed by the past.[2]

[2] "Tradition and the Individual Talent" in *Selected Essays 1917–1932*, by T. S. Eliot (New York: Harcourt Brace Jovanovich, Inc., 1932), p. 5.

15 *The Maori Chief Tupai Kupa, c.* 1800. Left, after a drawing by John Sylvester; right, a self-portrait. From *The Childhood of Man* by Leo Frobenius, 1909. Reproduced by permission of J. B. Lippincott Company.

PART ONE

THE ANCIENT WORLD

The Christian civilizations of the Western world early distinguished an ancient past from a new age—the times, respectively, before and after Christ. For them the ancient world—the world of the Old Testament—had the character of a preparation; it was related to the new era as promise to fulfillment. This slightly condescending view toward antiquity changed during the Renaissance, when scholars and artists deeply admired especially the Greek and Roman past and often debated the question of which was superior, the "ancient" or the "modern." Interest in Greco-Roman antiquity was broadened later to take in the great civilizations that had preceded it—those of the pre-Greek Mediterranean, Egypt, the Near East, and the very remote, prehistoric cave cultures of western Europe. From the end of the eighteenth century to the present, archeologists and art historians, with ever improving methods of investigation, have recovered great tracts of forgotten history to fill out with increasing accuracy our picture of the distant past. Within the past two decades evidence has been brought forward of the existence of civilizations that flourished as early as 7000 B.C., and the sequence of development that viewed early Egypt and Mesopotamia as concurrent has been shown to be incorrect, Mesopotamia, in fact, preceding Egypt by many centuries.

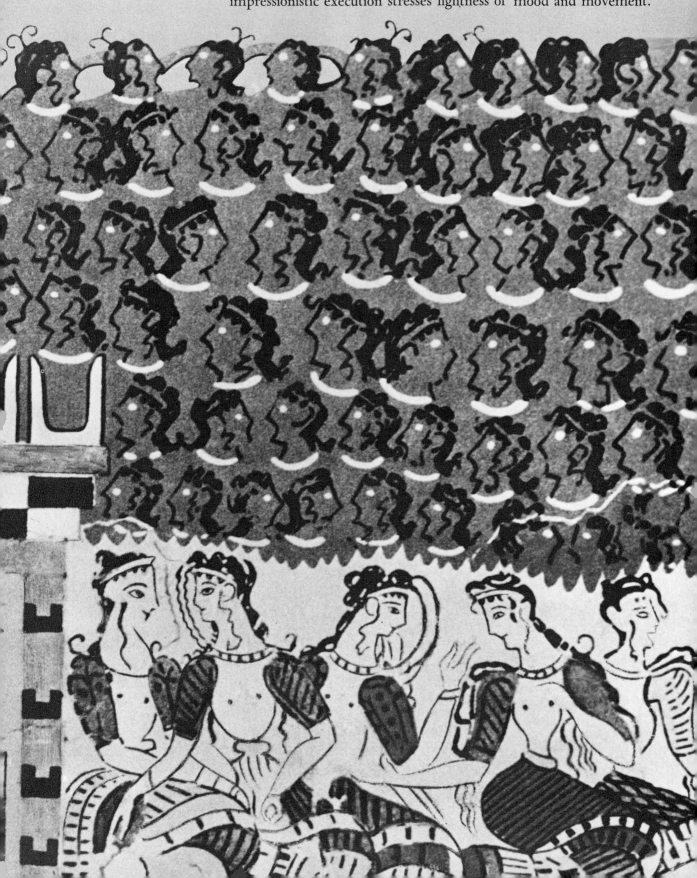

Cretan fresco of court ladies at a festival, from the palace at Knossos, c. 1600–1400 B.C. Though similar to Egyptian painting in concept, its impressionistic execution stresses lightness of mood and movement.

Historical perspective is likely to produce a distortion of view akin to that of the early Christian depreciation of the pre-Christian world. Until we have become familiar with the ancient world, it seems to us simply *that*—ancient, exceedingly old—and we imagine it in terms and images of faded inscriptions, dusty ruins, fallen idols, and long-outdated institutions. More properly we should see *ourselves* as ancient—that is, as living in the later eras of a great epoch at whose beginning, thousands of years ago, some of our most fundamental beliefs, institutions, folkways, and art and science had their inception.

The precarious, furtive life of the cave-dwelling hunter was, with the development of agriculture and the domestication of animals, succeeded by the more sedentary, predictable, and ordered life of village farmers. Aside from the technological revolutions of our times, this leap from food-gathering to food production brought perhaps the most significant transformation of the human condition and made possible all that has followed. In Mesopotamia, Asia Minor, and Egypt more complex forms of human community were created—cities, city-states, and kingdoms. Formal religion and codes of law were developed to regulate the relationships of gods and men. Writing was invented, as well as numbers and the art of calculation. The courses of the stars were plotted to predict the seasons and the times for planting and harvesting. Architecture, sculpture, and painting flourished in the service of kingly magnificence. The sacred books of Judaism and Christianity were produced in the shadow of mighty and hostile empires, and the legacy of Israel, which has contributed so much to the formation of the Western spirit, was preserved through all the vicissitudes of a remarkable people.

It was with the Greeks that there emerged what might be called the specifically Western intelligence, with its respect for reason, scientific inquiry, the physical concept of nature, and the humanistic view of man. The city-states of Greece were more than seats of commerce and government, and the loyalties of the citizens of each had social, educative, and local religious bases as well. It was in some of these city-states—Athens in particular—that democracy, though in a limited form, first evolved. With the repulse of the Persian invaders in the fifth century B.C., the Greeks inaugurated the first authentic phase of European culture, the content and spirit of which, commingled with Hebraism, is still largely with us in our patterns of life and thought.

Rome, never matching the Greek achievement in intellectual and artistic culture, yet produced the greatest empire of the ancient world. In eight hundred years it passed from its beginnings as a trading center under Etruscan kings to the zenith of its empire, when it extended from what are now the borders of Scotland to Jordan, asserting its hegemony over a multitude of peoples and lands. The dynamic and aggressive Roman spirit was reflected in and supported by an astonishing military

machine and technology, although Roman control over diverse peoples was exercised as much by the encouragement of their participation in the empire as in the naked assertion of Roman power. The Romanization of western Europe—through the Roman genius for government and the "Roman Peace"—has still much to do with its character, and the Roman ideal of a single, peaceful community of all mankind is very much in our view today.

Chapter One

The Birth
of Art

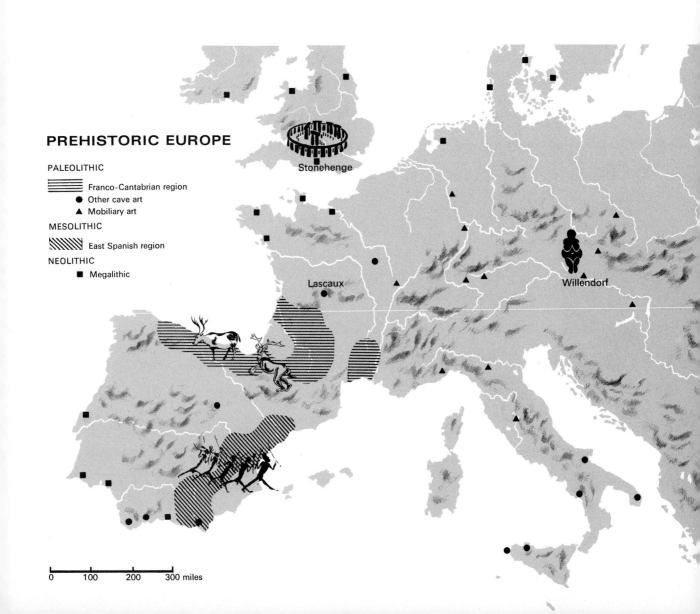

PREHISTORIC EUROPE

PALEOLITHIC

Franco-Cantabrian region

● Other cave art

▲ Mobiliary art

MESOLITHIC

East Spanish region

NEOLITHIC

■ Megalithic

Stonehenge

Lascaux

Willendorf

0 100 200 300 miles

W^HAT GENESIS is to the biblical account of the fall and redemption of man, early cave art is to the history of his intelligence, imagination, and creative power. In the caves of southern France and northern Spain, discovered only about a century ago and still being explored, we may witness the birth of that characteristically human capability that has made man master of his environment—the making of images and symbols. By this original and tremendous feat of abstraction Aurignacian and Magdalenian men were able to fix the world of their experience, rendering the continuous processes of life in discrete and unmoving shapes that had identity and meaning as the living animals that were their prey. Like Adam, Paleolithic man gathered and named the animals, and the faculty of imagination came into being along with the concepts of identity and meaning.

In that remote time during the last advance and retreat of the great glaciers man made the critical breakthrough and became wholly human. Our intellectual and imaginative processes function through the recognition and construction of

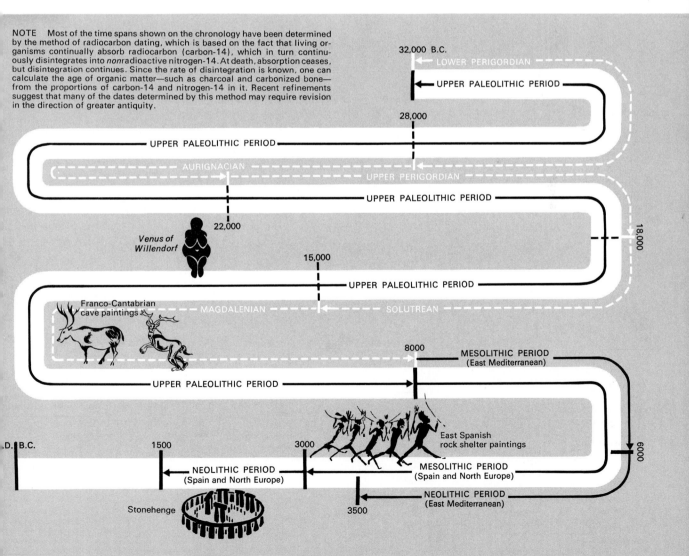

NOTE Most of the time spans shown on the chronology have been determined by the method of radiocarbon dating, which is based on the fact that living organisms continually absorb radiocarbon (carbon-14), which in turn continuously disintegrates into *non*radioactive nitrogen-14. At death, absorption ceases, but disintegration continues. Since the rate of disintegration is known, one can calculate the age of organic matter—such as charcoal and carbonized bone—from the proportions of carbon-14 and nitrogen-14 in it. Recent refinements suggest that many of the dates determined by this method may require revision in the direction of greater antiquity.

32,000 B.C.
LOWER PERIGORDIAN
UPPER PALEOLITHIC PERIOD
28,000
UPPER PALEOLITHIC PERIOD
AURIGNACIAN
UPPER PERIGORDIAN
UPPER PALEOLITHIC PERIOD
18,000
Venus of Willendorf
22,000
15,000
UPPER PALEOLITHIC PERIOD
Franco-Cantabrian cave paintings
MAGDALENIAN
SOLUTREAN
8000
MESOLITHIC PERIOD (East Mediterranean)
UPPER PALEOLITHIC PERIOD
East Spanish rock shelter paintings
6000
A.D. B.C.
1500
3000
NEOLITHIC PERIOD (Spain and North Europe)
MESOLITHIC PERIOD (Spain and North Europe)
Stonehenge
NEOLITHIC PERIOD (East Mediterranean)
3500

images and symbols; we see and understand the world pretty much as we are taught to by the representations of it familiar to our time and place. The immense achievement of Stone Age man, the invention of representation, cannot be exaggerated.

THE LATER OLD STONE AGE (UPPER PALEOLITHIC)

The physical environment of the cave peoples during the long thousands of years would not, one imagines, be favorable to the creation of an art of quality and sophistication since survival alone would seem to have required most of their energies. Though the Aurignacian period began

between the early and main advances of the last glacier and for a while was temperate, it grew cold toward its end. The Solutrean period saw the reign of arctic weather. The great ice sheet advanced south from Scandinavia over the plains of north central Europe, and glaciers spread down from the Alps and other mountain ranges to produce climatic conditions very much like those of Greenland today. With the Magdalenian period began the final recession of the ice and the onset of temperate weather. (Climatically, we are still in the postglacial or, according to some, an interglacial period.) In the cold periods, man, the hunter and food-gatherer, took refuge in caves, and it was here that Cro-Magnon man, who first appeared during the Aurignacian period, replacing Neanderthal man, took the remarkable turn that made him not simply a fabricator of rudimentary stone tools but an artist.

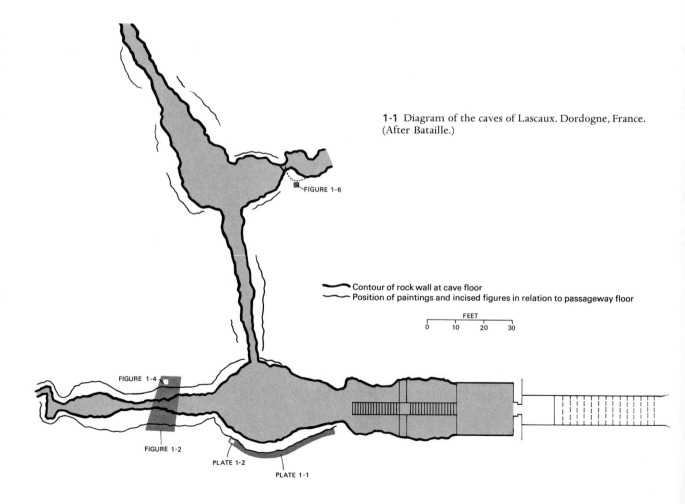

1-1 Diagram of the caves of Lascaux. Dordogne, France. (After Bataille.)

Contour of rock wall at cave floor
Position of paintings and incised figures in relation to passageway floor

FEET
0 10 20 30

FIGURE 1-6

FIGURE 1-4

FIGURE 1-2

PLATE 1-2

PLATE 1-1

Cave Art

This most ancient of all human cultures was the most recently discovered—by amateurs and by accident. In 1879, near Santander in northern Spain, Marcelino de Sautuola, a local resident interested in the antiquity of man, was exploring the Altamira Caves on his estate, in which he had already found specimens of flint and carved bone. With him was his little daughter. Since the ceiling of the debris-filled cavern was only a few inches above the father's head, it was the child who was first able to discern, from her lower vantage point, the shadowy forms of painted beasts on the cave roof. De Sautuola was the first modern man to explore this cave and he was certain that these paintings dated back to prehistoric times. Archeologists, however, were highly dubious of their authenticity, and at the Lisbon Congress on Prehistoric Archeology in 1880 the Altamira paintings were officially dismissed as forgeries. But in 1896, at Pair-non-Pair in the Gironde district of France, paintings were discovered partially covered by calcareous deposits that would have taken thousands of years to accumulate; these paintings were the first to be recognized as authentic by experts. The conviction grew that these remarkable works were of an antiquity far greater than man had ever dreamed. In 1901 Abbé Breuil, dean of archeologists of the prehistoric, discovered and verified the cave art of Font-de-Gaume in Dordogne, France. The skeptics were finally convinced.

The caves at Lascaux, near Montignac, also in the Dordogne region of France, were discovered accidentally in 1941 by two young boys who were playing in a field. Their dog, following a ball, disappeared into a hole, and the boys, hearing barking from below, followed the animal down into the caves. Their lighted matches revealed magnificent drawings of animals, now generally regarded as the most outstanding of all prehistoric art (PLATES 1-1 and 1-2).

While these paintings survived more than ten thousand years in the sealed and dry subterranean chambers, many have deteriorated rapidly since the caves were opened to the public in recent decades. At Lascaux, for example, it was found that moisture (carried into the caves by hordes of visitors) settled on the walls and calcified, creating a film that dims the paintings. To avoid further damage, the cave has been closed to the public.

The Lascaux caverns (FIG. 1-1), like the others, had been subterranean water channels, a few hundred to some four thousand feet long. They are often choked, sometimes almost impassably, by faults or by deposits such as stalactites and stalagmites. Far inside these caverns, well removed from the cave mouths that he chose for habitation, the hunter-artist engraved and painted on the walls pictures of animals—mammoth, bison, reindeer, horse, boar, wolf. For light he must have used tiny stone lamps filled with marrow or fat, with a wick, perhaps of moss. For drawing he used chunks of red and yellow ocher, and for painting he ground these same ochers into powder that he blew onto the walls or mixed with some medium, perhaps animal fat, before applying. A large flat bone may have served him as a palette; he could make brushes from reeds or bristles; he could use a blowpipe of reeds to trace outlines of figures and to put pigments on out-of-reach surfaces; and he had stone scrapers for smoothing the wall and sharp flint points for engraving. Such were the artist's tools. Rudimentary as they were, they were sufficient to produce the art that astonishes us today.

The artist's approach to the figures, as seen at Lascaux and at other sites, is naturalistic; he attempts to represent as convincing a pose and action as possible. Each painting reflects the keen observation and extraordinary memory of the hunter-artist, whose accuracy in capturing fleeting poses is hardly surpassed by today's camera (PLATES 1-1 and 1-2, FIG. 1-10). Yet this observation was selective, the artist seeing and recording only those aspects essential in interpreting the appearance and the character of the animal—its grace or awkwardness, its cunning, dignity, or ferocity. It is almost as if the artist were constructing a pictorial definition of the animal, capturing its very essence.

Any modern interpretation of this cave art must, of course, remain pure speculation. Properties common to all these paintings, how-

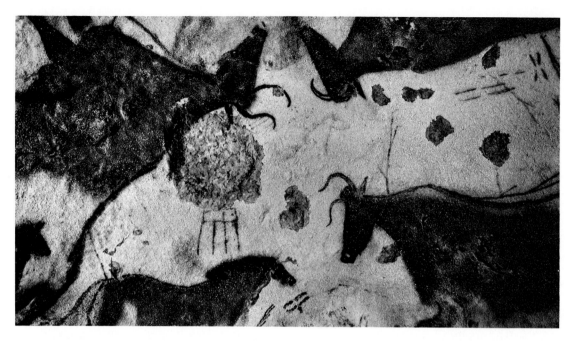

1-2 *Three Cows and One Horse*, ceiling of the Axial Gallery, Lascaux, *c.* 15,000–10,000 B.C. Approx. life-size. Dordogne, France.

ever, provide researchers with some fairly definite clues to what they meant to their creators. For instance, the fact that the paintings are never found in those parts of the caves that were inhabited or near daylight rules out any purely decorative purpose. At Font-de-Gaume the first paintings were encountered about seventy yards behind the cave mouth, and in the cave at Niaux the painted animals in the "Salon Noir" are found some 850 tortuous yards from the entrance. The remoteness and difficulty of access of many of these sites and the fact that they appear to have been used for centuries strongly suggest that the prehistoric hunter attributed magical properties to them. And so the paintings themselves most likely had magical meaning to their creators. As Abbé Breuil has suggested, "by confining the animal within the limits of a painting, one subjected it to one's power in the hunting grounds." And, within this context, the artist's aim to be realistic may be explained by his probable conviction that the painting's magical power was directly related to its lifelikeness.

The naturalistic pictures of animals are often accompanied by geometric signs, some of which seem to represent man-made structures, or *tectiforms* (FIG. 1-2), while others consist of checkers, dots, squares, or other arrangements of lines. Several observers have seen a primitive form of writing in these representations of non-living things, but more likely they, too, had only magical significance. The ones that look like traps or snares, for example, may have been drawn to ensure success in hunting with these devices. In many places there appear representations of human hands, most of them "negative," where the hunter placed his hand against the wall and then painted or blew pigment around it (FIG. 1-3). Occasionally he would dip his hand in paint and then press it against the wall, leaving a "positive" imprint. These, too, may have had magical significance, or may simply have been the "signatures" left by whole generations of visitors to these sacred places, much as the modern tourist leaves some memento of his presence.

Though the figures are in themselves marvelous approximations of optical fact, their arrangement upon the cave walls shows little concern for any consistency of placement in

relationship to each other or to the wall space; certainly we find no compositional adjustment to suggest the perspective effect and no notion of separation and enframement. Figures, far from being proportionally related, are often superimposed at random and are of quite different sizes (PLATES 1-1 and 1-2). Generations of artists, working in the same sanctuaries, covered and recovered the crowded walls, though often pains seem to have been taken not to break through the outlines of an earlier figure. It seems that attention to a single figure, the rendering of a single image, in itself fulfilled the purpose of the artist.

The hunter-artist made frequent and skillful use of the naturally irregular surfaces of the walls, of their projections, recessions, fissures, and ridges, to help give the illusion of real presence to his forms. A swelling outward of the wall could be used within the outline of a charging bison to suggest the bulging volume of the beast's body. The spotted horse at Pech-Merle (FIG. 1-3) may

have been inspired by a rock formation that resembles a horse's head and neck (on the right of the figure), although the artist's eventual version of the head is much smaller than the formation and highly abstract. Natural forms like those of foliage or clouds, the profile of a mountain, or the shapes of eroded earth and rock can represent for any of us—sometimes quite startlingly—the features of men, animals, or objects. Thus man's first representations may have followed some primal experience of resemblance between a chance configuration of cave wall and the animal he had just been hunting. This might have had for him the effect of an awesome apparition of the very animal, a miraculous and magical reappearance of its vanished life. With the impulse to give the apparition even more presence he could have "finished" the form by cutting an outline around the relief and continuing it until a silhouette more or less complete and familiar had emerged. The addition of color would enhance the reality of the image.

1-3 *Spotted Horses and Negative Hand Imprints*, Pech-Merle, c. 15,000–10,000 B.C. 11′ 2″ long. Lot, France.

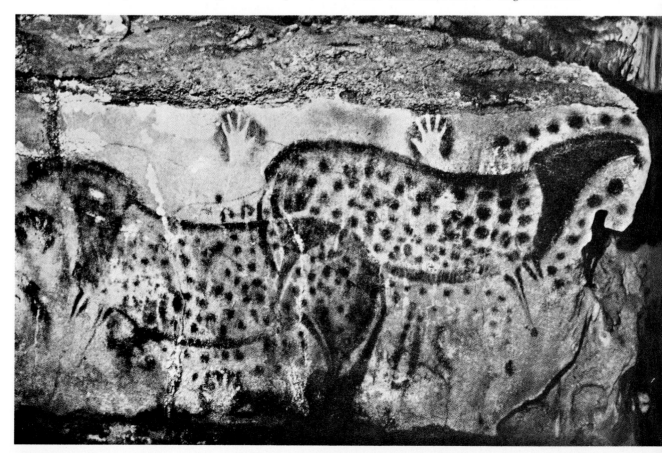

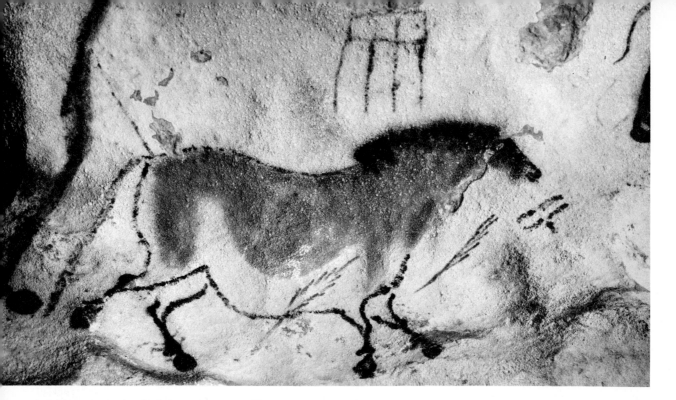

1-4 *Chinese Horse*, detail of FIG. 1-2. Approx. 56″ long.

1-5 *Bison with Superposed Arrows*, Niaux, *c.* 15,000–10,009 B.C. 4′ 2″ long. Ariège, France.

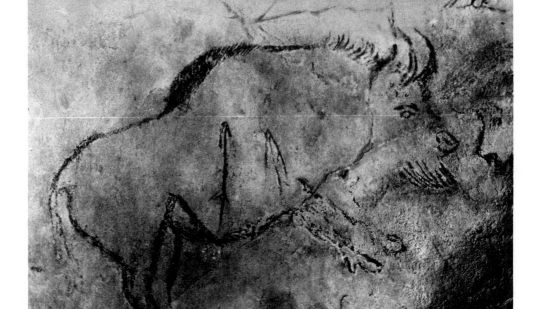

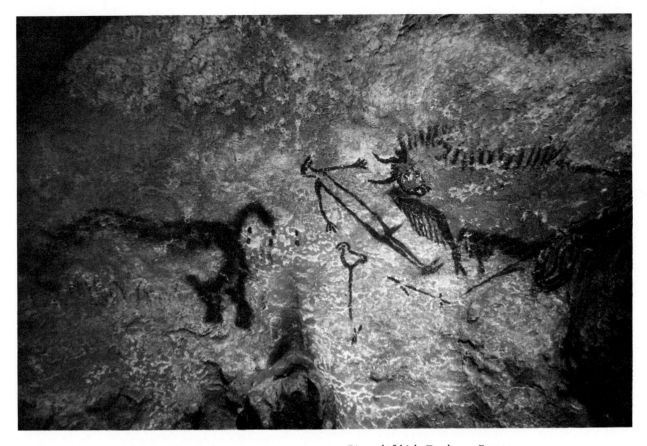

1-6 *Well Scene*, Lascaux, *c.* 15,000–10,000 B.C. Bison 4′ 7″ high. Dordogne, France.

THE MAGICAL FUNCTION

It is likely that the cave painter did not carefully distinguish between illusion and reality and that for him the bison recreated on the wall was different from the bison he hunted only in its state of being. We have evidence enough that the hunters in the caves, perhaps in a frenzy stimulated by magical rites and dances, treated the painted animals as if they were indeed alive. Not only was the quarry painted as pierced by arrows, as in the *Chinese Horse* at Lascaux (FIG. 1-4), but hunters may have thrown spears at the images— as sharp gouges in the side of the bison at Niaux (FIG. 1-5) suggest—predestinating and magically commanding the death of the animals. This practice would be analogous to that kind of homeopathic magic, still cultivated in parts of the world today, that has as a basis the belief that harm can be done to an enemy by abusing an image of him.

This art produced in dark caverns deep in the earth must have had, as most scholars are now convinced, some profound magical functions. Familiar in religious architecture, which had its beginning thousands of years after the era of the caves, are the cavelike spaces of the sanctuary where the most sacred and hidden mysteries are kept and where the god dwells in silence. The sacred has meant the mysterious, and this means in many cases a place of darkness, lit only by fitful light, where, at the culmination of rituals, absolute silence reigns. These features of the sacred environment were already present in the "architecture" of the caves, and the central theme has never been lost despite its myriad variations.

It is significant that the miracle of abstraction— the creation of image and symbol—should have taken place in just such secret and magical caverns. For abstraction is representation, a human device of fundamental power, by which not only art but ultimately science comes into existence,

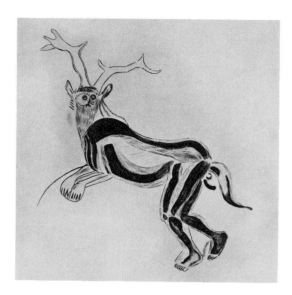

1-7 *Sorcerer*, Trois-Frères, *c.* 15,000–10,000 B.C.
2′ high. Ariège, France.

and both art and science are methods for the control of human experience and the mastery of the environment. And that too was the end purpose of the hunter-magician—to control the world of the beasts he hunted. The making of the image was, by itself, a form of magic; by painting an animal, the hunter fixed and controlled its soul within the prison of an outline, and from this initial magic all the rest must follow. Rites before

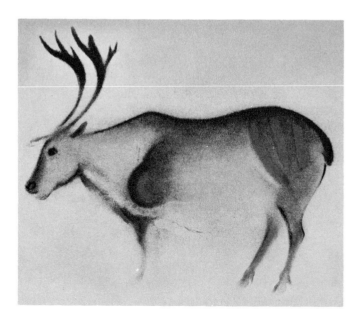

the paintings may have served to improve the hunter's luck. At the same time, prehistoric man must have been anxious to preserve his food supply, and the many representations of pregnant animals (FIG. 1-4) suggest that these cavalcades of painted beasts may also have served magically to assure the survival of the actual herds.

THE REPRESENTATION OF MAN

The figure of man is almost completely excluded from representation among the vivid troops of painted animals. There are at least two notable exceptions. A very puzzling picture at Lascaux (FIG. 1-6) shows a stick-figure man, falling or fallen, before a huge bison that has been disemboweled, probably by the rhinoceros at the left, which slouches away from the scene. The two animals are rendered with all that skilled attention to animal detail we are accustomed to in cave art; the rhinoceros heavy and lumbering, the buffalo tense and bristling with rage, its bowels hanging from it in a heavy coil. But the bird-faced (masked?) man is rendered with the crude and clumsy touch of the unskilled at any time or place. His position is ambiguous. Is he dead or in an ecstatic trance? The meaning of the bird on the staff and of the spear and throw stick is no more obvious. We shall not add here to the already abundant speculation on the meaning of this picture. More important is the question, Why the difference in treatment of the man and the animal figures? Does man in this dawn of magic distinguish himself so much from the beast that he can find no image suitable to self-depiction? Or is he afraid to cast a spell on himself, as he casts it upon the animals, by rendering his image visible?

At Trois Frères in the Pyrenees there is a very strange humanoid creature, masked and wearing the antlers of a reindeer (FIG. 1-7)—the so-called *Sorcerer.* Is this the memory sketch of a chief shaman or witch-doctor? If so, one can imagine how the fearsome composite apparition—the paws of a bear, tail of a wolf, beard of a man,

1-8 *Reindeer*, Font-de-Gaume, *c.* 15,000–10,000 B.C.
Dordogne, France. (After a copy by Abbé Breuil.)

corporal parts of a lion—could have struck terror into the heart of its audience. The chamber in which the figure appears is crowded with beasts, and Breuil has suggested that the figure may be their god, who has descended into the witch-doctor and filled him with his bestial power. It has also been suggested that this is only a hunter camouflaged to stalk deer, but it would again appear that, for Paleolithic man, mankind simply is not to be counted among the animals; at least his figure must be so disguised—perhaps to avoid magical self-involvement—as to be un-recognizable as a man.

QUALITY

In explaining the great accomplishment of Stone Age man—who pictured the world in order to magically control it—we must not forget that his art is *art*. It is not simply that he made images but that he made them skillfully and beautifully. Ancient and modern art have produced, along with masterpieces, images that are dull, prosaic, and of indifferent quality. The art of the caves is of an extraordinary level of quality. The splendid horse in the Axial Gallery at Lascaux (FIG. 1-4) has been called the *Chinese Horse* because its style strangely resembles that of Chinese painting of the best period. Not only do the outlines have the elastic strength and fluency that we find in Chinese calligraphy and brushwork, but the tone is so managed as to suggest both the turning under of the belly of the pregnant animal and the change of the color of the coat. At Font-de-Gaume there is a painted reindeer (FIG. 1-8) executed with deft elegance in the contours and remarkable subtlety in the modeling tones. The grace of the antlers is effortlessly translated into an upward-sweeping line that renders the natural shapes with both strength and delicacy. Breuil, while copying the originals, discerned some highly sophisticated pictorial devices that one expects to find only in the art of far later times; for example, the dark-ening of the forward contour of the left hind leg so as to bring it nearer to the observer than the right leg.

The pictures of cattle at Lascaux and elsewhere (PLATE 1-2, FIG. 1-2) show a convention of representation of the horns that has been called *twisted perspective*, since we see the heads in profile but the horns from a different angle. Thus, the approach of the artist is not strictly or consistently optical—that is, organized from a fixed-view-point perspective. Rather, the approach is de-scriptive of the fact that cattle have two horns. Two horns would be part of the concepts "cow" and "bull." In strict optical-perspective profile only one horn would be visible, but to paint the animal in such a way would, as it were, amount to an incomplete definition of it. And for the cave artist this would have been a defective image, without magic. When we discuss the art of the ancient Near East and Egypt, we shall note again this peculiarity and its significance.

Engravings and Sculpture

The principal bequests of the hunter-artists that can be regarded as fine art are their paintings. However, they have also left us splendid engrav-ings—on stone, ivory, and horn, on both flat and curving surfaces—and sculpture. In the *Bison with Turned Head* (FIG. 1-9) we are impressed by the striking vitality and the simplicity with which the formal beauty is expressed—a sim-plicity and economy of means that distinguishes the great paintings. The head is so turned that it is entirely framed by the massive bulk of the

1-9 *Bison with Turned Head*, La Madeleine, *c.* 15,000–10,000 B.C. Reindeer horn, 4⅛″ high. Dordogne, France. Musée des Antiquités Nationales, St. Germain-en-Laye.

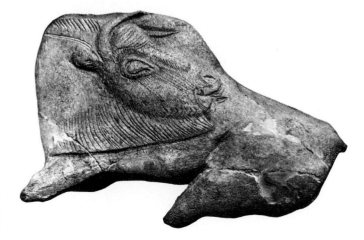

1-10 *Relief Horse,* Cap Blanc, *c.* 15,000–10,000 B.C. 7′ long. Dordogne, France.

1-11 *Venus of Willendorf,* original *c.* 15,000–10,000 B.C. Stone, 4⅜″ high. Naturhistorisches Museum, Vienna. (Cast of original.)

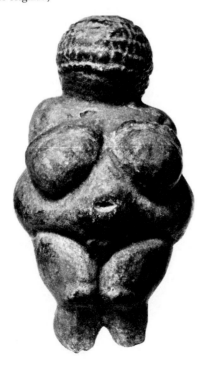

body, and there is a vivid play of curve and countercurve and a surface contrast obtained by the use of decorative hatching to indicate the mane. The artist would have been perfectly familiar with the method of incision of surfaces; incising the outlines of a figure before the tones were introduced was the usual procedure for painting. But the artists of the caves went farther than incision and produced sculpture in deep relief and in the full round. An example of the first is a horse in deep relief (FIG. 1-10) found in the rock shelter of Cap Blanc, not far from Lascaux. The figure is part of a frieze of sculptured horses and bison, some of the figures almost a foot in depth and masterpieces of relief modeling. Though the figures are eroded by weather, we can perceive their characteristics well enough. They are not simply "filled-out" natural rock contours but in parts strongly modeled. The eyes are sharply incised, and, as in the case of the bison incised in reindeer horn (FIG. 1-9), the manes, forelocks, and portions of the head and muzzle have been carefully indicated by hatching.

The Birth of Art

There are small sculptures in the full round representing the female figure (called Venus figures by archeologists), an exception to the rule of exclusion of the human figure from the cave artist's vocabulary of forms. Perhaps the most famous of these is the *Venus of Willendorf* (FIG. I-II), a figurine of a woman that is composed of a cluster of almost ball-like shapes. The anatomical exaggeration suggests that this and similar statuettes served as fertility fetishes; the needs for game and human offspring were one in the dangerous life of the hunter. But again the artist's approach to the human figure differs from that to animals. He obviously does not aim for that heightened realism so characteristic of his animal representations; facial features, for instance, are seldom indicated in these statuettes, and in some specimens not even the heads are shown. Evidently the artist's aim was not to show the female of his kind but rather the idea of female fecundity; he depicted not woman but fertility.

THE MIDDLE STONE AGE (MESOLITHIC)

Rock-shelter Paintings

As the ice of the Paleolithic period melted in the increasing warmth, the reindeer migrated north, the wooly mammoth and rhinoceros disappeared, and the hunters left their caves. The Ice Age gave way to a transition period known as the Mesolithic, when Europe became climatically, geographically, and biologically much as it is today. During this time there flourished a culture whose art complements that of the caves, from which, indeed, it may partially have originated. Since 1903, diminutive, extraordinarily lively paintings of animals and men in scenes of the hunt, battle, ritual dance, and harvest have been discovered on the stone walls of shallow rock shelters among the barren hills of the eastern coast of Spain (the Spanish Levant). The artists show the same masterful skill in depicting the animal figure as their predecessors of the caves, and it may be that we have here specimens of a

lingering tradition or long-persisting habit of vision and representation of animals. But what is strikingly new is the appearance of the human figure, not only singly, but in large, coherent groups, with wide variety of pose, subject, and setting. We have seen that in cave art the human figure almost never appears; the falling or fallen man of the well scene (FIG. 1-6) at Lascaux is quite exceptional. In the rock-shelter paintings the new sentiment for human themes and concerns and the emphasis on action in which man dominates the animal are central. The new vocabulary of forms may have migrated across the Mediterranean from North Africa, where many paintings similar to those in the Spanish Levant have been found. There has been much learned debate about the dating of the whole development, and there is now some agreement that its beginnings were around 8000 B.C. and that the style may have lasted (with many variations) until about 3000 B.C.

Some characteristic features of the rock paintings appear in an energetic group of five warriors (FIG. 1-12) found in the Gasulla gorge. The group, only about nine inches in width, shows a customary tense exaggeration of movement, a rhythmic repetition of basic shape, and in general a sacrifice of naturalistic appearance to narrative and to unity of action. Even so, we can distinguish details that are economically descriptive—bows, arrows, and the feathered headdress of the leader. The widely splayed legs read as a leaping stride, perhaps a march to battle or a ritual dance.

Other such paintings show an even greater uniformity of basic shape, and a nervous, sharp angularity, which suggest the pictograph or—as we have proposed—even the phonetic hieroglyph. And over the millennia the rock painting styles do indeed become more abstract and schematic, more symbol than picture, and it is likely that they record a step in the evolution of the symbolic from the pictorial, an evolution that, in the Near East, culminates in the invention of writing. Later on the liveliness and spontaneity of the rock paintings is lost in the rigid uniformities of almost letterlike shapes repeated as if from a limited stock of signs.

The significance of the rock paintings was probably magical-religious, like the paintings of the caves, though some observers believe them

		c. **8000**		c. **6000**		c. 3500 B.C.
← to c. 32,000 B.C.						

UPPER PALEOLITHIC PERIOD	EAST MEDITERRANEAN MESOLITHIC PERIOD	EAST MEDITERRANEAN NEOLITHIC PERIOD
Franco-Cantabrian cave painting	SPAIN AND NORTHERN EUROPE M E S O L I T H I C P E R I O D	
	East Spanish rock-shelter painting	to c. **3000** B.C. →

to be no more than pictorial records of memorable events. The paintings are concentrated at particular sites that were used for long periods, while nearby places, better suited for painting, were not used. This suggests that the sites were held sacred, not only by the Mesolithic painters, but by those working well into the historical period. Iberian and Latin inscriptions indicate that supernatural powers were ascribed to some of these holy places as late as the Roman era.

THE NEW STONE AGE (NEOLITHIC)

In Paleolithic art, man, in a supreme feat of intellection, learned to abstract his world by making a picture of it. Thus he sought to control it by capturing and holding its image. In the Neolithic period he made the giant stride toward the actual, concrete control of his environment by

1-12 *Marching Warriors* (ritual dance?), Gasulla gorge, *c.* 8000–3000 B.C. Approx. *9″* wide. Castellón, Spain.

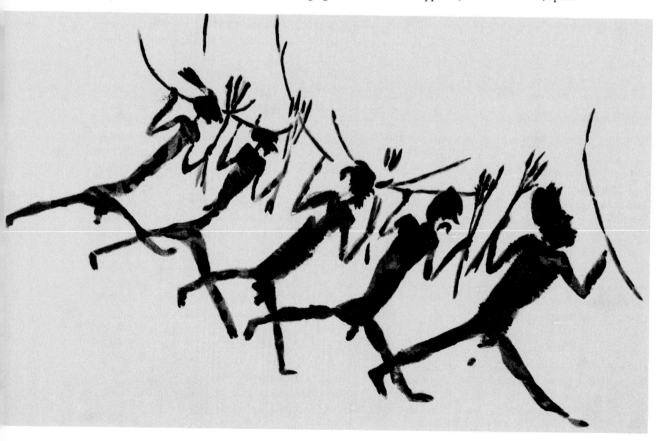

inventing agriculture and domesticating animals. His food supply assured, he changed from hunter to herdsman, to farmer, and, perhaps as early as 7000 B.C., to townsman. The wandering hunter settled down to organized community living in villages surrounded by cultivated fields. Then began the long evolution toward the incredible technological command of the physical environment that exists today. Before the Stone Age had come to a close, as late as 1150 B.C. in parts of Europe, man had invented writing and techniques of measurement, the indispensable intellectual tools with which he could communicate and record his experience and with which he could calculate and predict changes in space and time.

We shall see in the following chapter that it is very likely that these achievements, so enormously important for the making of civilization, were gradually produced in the Near East (western Asia). Slowly, through commerce, colonization, and the quickening migration of ideas, the relatively advanced Near Eastern culture made its influence felt in the comparatively backward region of western Europe, which was still in the Mesolithic and Neolithic stages of its development.

The Megaliths

That influence was exercised not so much through new arts, however, as through new religious and burial customs and a mode of marking sacred and sepulchral places with monumental stone. In the extreme west of Europe—in Brittany, Ireland, and England—there stand monuments of massive, rough-hewn stones that have puzzled and fascinated men for centuries. The very dimensions of the stones, some as high as seventy feet and weighing tons, have prompted the historian to call them *megaliths* (great stones), and the culture that produced them *megalithic*. Megalithic structures appear in western Europe around 3000 B.C. The earliest examples are found in southern Spain and Portugal in association with the first settled and fortified villages in that part of the continent. These villages may have been colonial settlements, perhaps the result of imperial or economic expansion from the Near

East, which was the only city-dwelling culture in the western world at that time. Thus the megaliths appear to be manifestations of the arrival of foreign cultural and religious influences, which were adopted by the native populations of Spain and Portugal. From there the culture spread northward along the Atlantic coast, to reach the peoples of the British islands sometime before 2000 B.C.

There are several types of megalithic structures. The *dolmen* consists of several great stones set on end, with a large covering slab. Dolmens may be the remains of passage graves from which a covering earth mound has been washed away. The passage grave, the dominant megalithic tomb type—literally thousands exist in France and England—has a corridor lined with large stone slabs leading to a circular chamber often having a *corbeled* vault, in which each of numerous rings of stones projects inward beyond the underlying course, until the rings close at the top. They were frequently built into a hill slope or covered by mounds of earth, and they may be related to the well-preserved Mycenaean "beehive" tombs (see below and FIG. 4-21). At Carnac in Brittany, great single stones, called *menhirs*, set on end, were arranged in parallel rows, some of which run for several miles and consist of thousands of stones. Their purpose was evidently religious and may have had to do with the cult of the dead or the worship of the sun. Sometimes these huge stones were arranged in a circle known as a *cromlech*; among the most imposing cromlechs are those at Avebury and at Stonehenge, in England (FIGS. 1-13 and 1-14). The structure at Avebury is surrounded by a stone bank about four-fifths of a mile in diameter. The remains at Stonehenge are of a complex of rough-cut sarsen stones and smaller "bluestones." Outermost was a ring of large monoliths of sarsen stones capped by lintels. Next was a ring of bluestones, which, in turn, encircled a horseshoe (open end facing east) of trilithons—five lintel-topped pairs of the largest sarsens, each of which weighs 45 to 50 tons. Standing apart and to the east is the "heel-stone," which, for a person looking outward from the centre of the complex, would have marked the point at which the sun rose at the midsummer solstice.

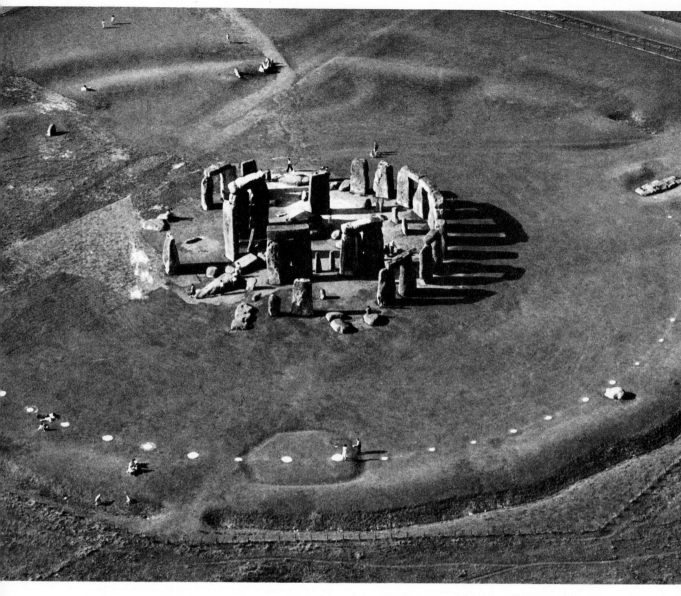

1-13 Stonehenge, *c.* 1650 B.C. 97′ in diameter. Salisbury Plain, Wiltshire, England.

If this stone was raised to mark exactly the line of sunrise at the summer solstice of the year it was erected, it would naturally follow—owing to astronomical factors—that in the course of time the direction of this line would have slowly changed. The amount of deviation would be commensurate with the time elapsed since erection of the stones, thus supplying the age of the structure. A calculation made early in this century

had it that on Midsummer Day, 1680 B.C., the sun rose exactly over the mark-stone and in a direct line with the axis of the temple and avenue of approach. Carbon-14 dating confirmed this, though recent refinements in that method may shift the date back in time considerably.

At the present time, computer-based calculations are raising something of a controversy once again, not so much over the date as over the

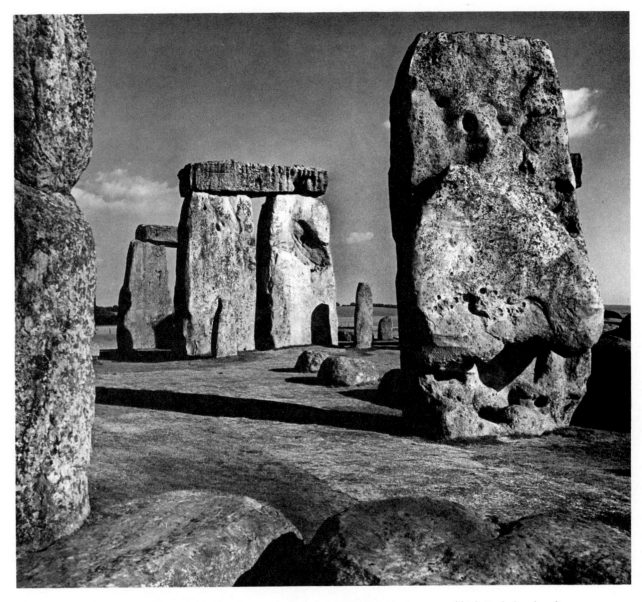

1-14 Stonehenge trilithons (lintel-topped pairs of stones at center). Approx. 24′ high (including lintel).

purpose of Stonehenge. The mysterious structure, believed in the Middle Ages to have been the work of the magician Merlin, who spirited it from Ireland, or the work of a race of giants, comes in our own time to be thought of as a remarkably accurate calendar, a testimony to the rapidly developing intellectual powers of man. Even in their ruined condition the monoliths of Stonehenge possess a solemn majesty, created by heroic human effort, physical and intellectual. At Avebury, as at Stonehenge, there is, in the series of concentric circles with connecting curvilinear pathways or avenues, a feeling for order, symmetry, and rhythm that is evidence not only of well-developed and systematized ceremonial rituals, but perhaps also of a maturing geometrical sense born of observation of the apparent movement of the sun and moon.

Chapter Two

The Ancient Near East

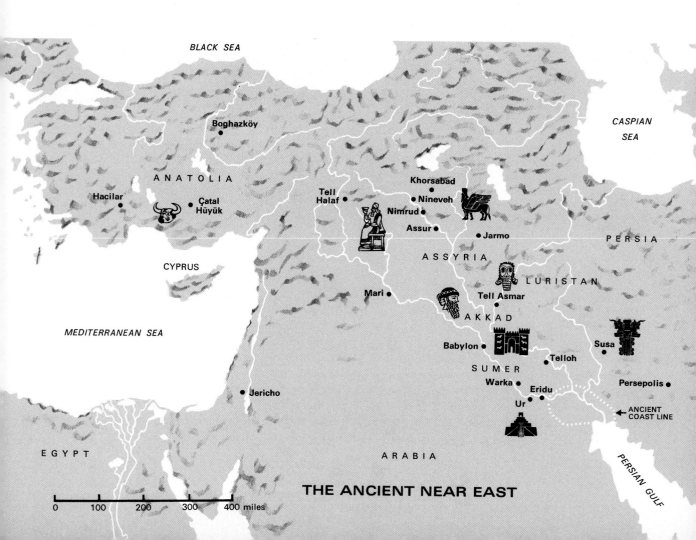

THE ANCIENT NEAR EAST

BLACK SEA

CASPIAN SEA

Boghazköy

ANATOLIA

Hacilar

Çatal Hüyük

Tell Halaf

Khorsabad

Nineveh

Nimrud

Assur

Jarmo

PERSIA

ASSYRIA

LURISTAN

CYPRUS

Mari

Tell Asmar

AKKAD

MEDITERRANEAN SEA

Babylon

Telloh

Susa

SUMER

Warka

Eridu

Persepolis

Ur

ANCIENT COAST LINE

Jericho

EGYPT

ARABIA

PERSIAN GULF

0 100 200 300 400 miles

JUST HOW AND WHY the state of human society we call civilization began we are not certain; we are more certain where and when it began. Since World War II archeologists have been uncovering the sites in the Near East where the immense transformation began and have pushed back its date as far as 8000 B.C. The onset of civilized life is marked off from all that went before by the development of agriculture. The conventional three-part division of the time preceding recorded history—the Paleolithic, Mesolithic, and Neolithic periods—based on the development of stone implements, is not so basic and decisive as the simpler distinction between an

age of food-gathering and an age of food production. In this scheme the Paleolithic period would correspond roughly to the age of food-gathering, with the Mesolithic period, the last phase of that age, marked by intensified food-gathering and the domestication of the dog. The proto-Neolithic would be the period of incipient food production and greater domestication of animals preceding the Neolithic, the period when agriculture and stock-raising become man's major food sources.

According to one view, the area we know today as the Near East—Egypt, Israel, Syria, Iraq, Iran, and Turkey—dried out into desert and semidesert after the last retreat of the glaciers,

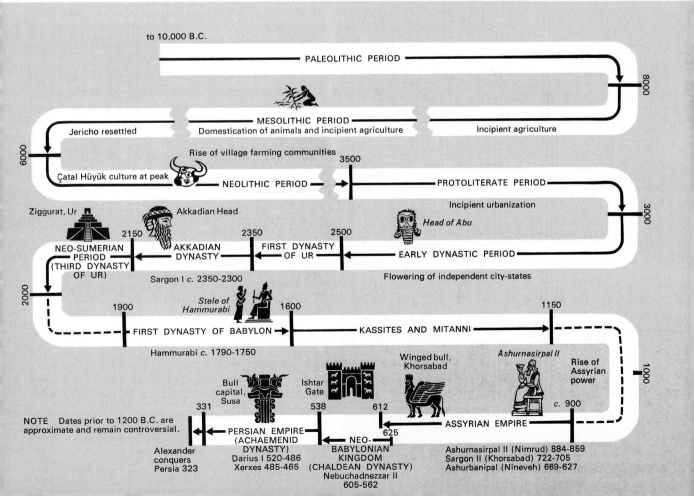

compelling the inhabitants to move to the fertile alluvial valleys of the Nile in Egypt and the Tigris and Euphrates in Mesopotamia (parts of modern Syria and Iraq). But this view is perhaps too simple and may no longer be tenable in light of recent archeological findings. The oldest settled communities are found not in the river valleys but in the grassy uplands bordering them. These regions provided the necessary preconditions for the development of agriculture. Species of native plants like wild wheat and barley were plentiful, as were herds of animals—like goats, sheep, and pigs—that could be domesticated; there was also sufficient rain for the raising of crops. It was only after village-farming life was well developed that settlers, attracted by the greater fertility of the soil, moved into the river valleys and deltas.

There it was that civilized societies originated—in addition to systematic agriculture—government, law, and formal religion, with such instrumentalities and techniques as writing, measurement and calculation, weaving, metalcraft, and pottery.

For a long time it was thought that these developments occurred concurrently in Egypt and Mesopotamia. But again archeology is forcing a revision of our views. It is becoming clear that Mesopotamia and its environs were far ahead of Egypt temporally. Village-farming communities like Jarmo in Iraq and Çatal Hüyük in southern Anatolia (Turkey) date back to the mid-seventh millennium B.C., and the remarkable fortified town of Jericho, before whose walls Joshua appeared thousands of years later, is even older. In Egypt the oldest villages, in the Faiyum district near the Delta, do not seem to have been founded before 4500 B.C., and, furthermore, an urban society like that of Mesopotamia seems never to have developed there. The invention of writing in Mesopotamia preceded that in Egypt by several hundred years, and it may be that the whole development of Egyptian civilization was the result of Mesopotamian influence. Traditionally the history of art in the ancient world begins with Egypt and then passes to Mesopotamia. Archeological studies of Egypt are older, scientific archeology having begun there at the end of the eighteenth century. In addition, the chronology of Egypt is more firmly established, and the general cultural picture is more complete. Nevertheless, in view of the array of new facts presented by the latest archeological investigations, the traditional sequence should be reversed: Mesopotamia should be placed at the beginning of the study of ancient art.

THE BEGINNINGS

Jericho

By 7000 B.C. agriculture was well established in at least three Near Eastern regions: Jordan, Iran, and Anatolia (Turkey). Although no remains of

2-1 Proto-Neolithic fortifications, Jericho, 8000–7000 B.C.

2-2 Human skull, Jericho, 7000–6000 B.C. Features molded in plaster.

this, built with the aid of only the most primitive kinds of stone tools, was certainly a tremendous technical achievement.

Around 7000 B.C. the site was abandoned by its original inhabitants, but new settlers arrived in the early seventh millennium. They built rectangular mudbrick houses on stone foundations and carefully plastered and painted their floors and walls. Several of the excavated buildings seem to have served as shrines, the plan of one of them being remarkably similar to that of the later Greek megaron (see Chapter Five). These settlers fashioned statuettes of a mother goddess and of animals associated with a fertility cult. Most striking is a group of human skulls on which the features have been "reconstructed" in plaster (FIG. 2-2). Subtly modeled, the eyes inlaid sea shells, and the hair painted (a painted mustache has been preserved on one specimen), they present a strikingly lifelike appearance. Since the skulls were detached from the bodies before burial and displayed above ground, they may have been regarded as "spirit traps," implying a well-developed belief in survival after the death of the body.

domestic cereal grains have been found that can be dated before 7000 B.C., the advanced state of agriculture at that time presupposes a long development; indeed, the very existence of a town like Jericho gives strong support to this assumption. The site of Jericho, a plateau in the Jordan river valley with an unfailing spring, was occupied by a small village as early as the ninth millennium B.C. This proto-Neolithic village underwent a spectacular development around 8000 B.C., when a new town was built with houses of mudbrick on round or oval stone foundations. As the town's wealth grew and powerful neighbors established themselves, the need for protection resulted in the first known permanent stone fortifications. By the middle of the eighth millennium B.C. the town, estimated to have had a population of over 2000, had a wide, rock-cut ditch and a five-foot-thick wall surrounding it. Into this wall, which has been preserved to a height of twelve feet, was built a great circular stone tower, thirty feet in height and diameter (FIG. 2-1). Not enough of the site has been excavated to determine whether this tower was solitary, like the keeps in Medieval castles, or one of several similar towers that formed a complete defense system. In either case, a structure like

Çatal Hüyük

Perhaps even more remarkable than the Jericho finds are recent discoveries in Anatolia. Excavations at Hacilar and Çatal Hüyük have shown not only that the central Anatolian plateau was the site of a flourishing Neolithic culture between 7000 and 5000 B.C., but that it may well have been the culturally most advanced region of its time. Twelve successive building levels excavated at Çatal Hüyük between 1961 and 1963 have been dated between 6500 and 5700 B.C. On a single site of thirty-two acres (of which only one acre has been explored) it has become possible to retrace, in an unbroken sequence, the evolution of a Neolithic culture over a period of 800 years, an evolution that led from a predominantly hunting and food-gathering economy to a fully agrarian one.

Along with Jericho, Çatal Hüyük has been called "one of man's first essays in the development of town life." The regularity of the town plan sug-

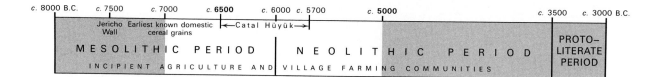

c. 8000 B.C. c. 7500 c. 7000 c. 6500 c. 6000 c. 5700 c. 5000 c. 3500 c. 3000 B.C.

Jericho Earliest known domestic ←Catal Hüyük→
Wall cereal grains

M E S O L I T H I C P E R I O D N E O L I T H I C P E R I O D PROTO–
 LITERATE
INCIPIENT AGRICULTURE AND VILLAGE FARMING COMMUNITIES PERIOD

gests that it was built according to some *a priori* plan. A peculiarity of the town is its complete lack of streets, the houses adjoining each other and having access through their roofs (FIG. 2-3). Impractical as such an arrangement may appear today (although it survived in parts of central Anatolia and western Iran), it did offer some advantages: The buildings, braced against each other, had greater stability than free-standing structures, and defense was easier because the town site was surrounded by an unbroken ring of buildings with blank walls facing the countryside. Thus, if an enemy managed to breach the exterior wall, he would find himself not inside the town but inside a single room, with the defenders waiting for him on the roof—a dismal prospect at best.

Here and there the dense building mass is interrupted by an open court, which served as a garbage dump. Liberal amounts of ashes mixed in with the refuse acted as sterilizers, although probably not as deodorants. The houses, varying in size, were of a standard plan and constructed of mudbrick walls strengthened by sturdy timber frames. Walls and floors were plastered and painted, and platforms along walls served for sleep, work, and eating. A great number of shrines have been found intermingled with standard houses. Varying with the different levels, the average ratio is about one shrine for every four houses. This may not hold true for the whole town, only about one thirtieth of which has been excavated.

The shrines (FIG. 2-4) are distinguished from other houses by the greater richness of their interior decoration, which consisted of wall paintings, plaster reliefs, animal heads, bucrania (bovine skulls), and cult statuettes. Bulls' horns, which adorn most shrines, sometimes in considerable numbers, were set into stylized, remodeled heads of bulls or into benches and pillars and may have been thought to protect the inhabitants and ward off evil. Nothing, however, suggests that the bull, or any other animal, was

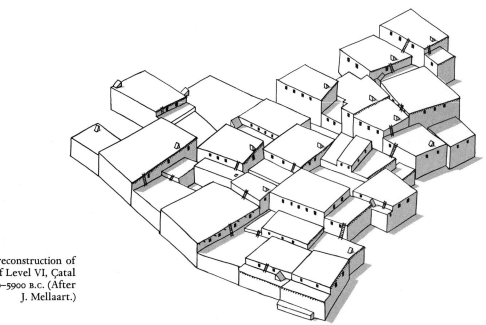

2-3 Schematic reconstruction of a section of Level VI, Çatal Hüyük, *c.* 6000–5900 B.C. (After J. Mellaart.)

regarded as a deity. Cult statuettes found at Çatal Hüyük indicate that the people believed their gods to have human form, both male and female. When represented in association with animals—the female deity usually with leopards, the male with a bull—the animals are always shown as subservient.

The statuettes are of stone or baked clay and are quite small, most between two and eight inches high and a few reaching twelve inches. All the female figures, which predominate, seem to represent a mother goddess but in a great variety of aspects: young, old, in ritual marriage, in pregnancy, giving birth, and as ruler of wild animals. These are described explicitly, and, while the bulbous forms of the headless *Seated Goddess* (FIG. 2-5) may remind us of the *Venus of Willendorf* (from which she may indeed have descended), the artist's approach toward his subject is quite realistic. Unlike the Paleolithic artist, who tried to represent the abstract concept of fertility, the Neolithic sculptor converts an abstract being (a goddess) into a human figure. The breasts are sensitively modeled, the small hands carefully rendered, and, judging from other examples, it may be safely assumed that the lost head had fairly well described facial features. The figure is painted with crosslike floral patterns, known also from wall paintings as symbols of agriculture, which here endow the goddess with the specific function of agrarian deity.

Fertility and agricultural symbolism dominate the art of the upper (later) levels of Çatal Hüyük. But hunting also played an important part in the early Neolithic economy, and Paleolithic hunting rituals survived far into the Neolithic period. Numerous crude animal figurines, intentionally broken and damaged, some pitted with arrow marks, have been found at Çatal Hüyük; they evidently served as animal substitutes during hunting rites and were buried in pits after having served their purpose. The importance of hunting as a food source (until about 5700 B.C.) is reflected also in wall paintings, in which, in the older shrines, hunting scenes predominate. In style and concept, the *Deer Hunt* (FIG. 2-6) recalls the rock-shelter paintings of the Spanish Levant, but these figures are more full-bodied and rendered with greater realism. The

2-5 *Seated Goddess*, Çatal Hüyük, c. 5900 B.C. Baked clay.

artist used a full range of pigments, mostly derived from minerals, which he applied with a brush to the white background of dry plaster. A fragment from this hunting scene shows a dancing hunter (PLATE 2-1) dressed in a white loincloth and a leopard skin, holding a bow in one hand, the speed of his movement effectively emphasized by the manner in which the leopard skin whirls around his waist. Once the apparently ritual function of these paintings had been fulfilled, they were covered with a layer of white plaster and later replaced with a new painting of either a similar or a different subject.

In one of the older shrines a painting was uncovered that was to be unique for thousands of years to come. It is a pure landscape and, according to carbon-14 dating, was painted soon after 6200 B.C. (FIG. 2-7). In the foreground is shown a town with rectangular houses neatly laid out side by side, probably representing Çatal Hüyük; behind it, on a smaller scale, as though far away, appears a mountain with two peaks; dots and lines issuing from the higher of the two cones clearly represent a volcanic eruption. The mountain has been identified as the 10,600-foot Hasan Daǧ, located within view of Çatal Hüyük, and the only twin-peaked volcano (now extinct) in central Anatolia. Since the painting appears on the walls of a shrine, the recorded volcanic eruption must have had some religious meaning. While the artist may have linked the event with the underworld and witnessed it with fearful awe, his dread may have been mingled with gratitude to a bountiful Mother Earth, for it is believed that Çatal Hüyük derived much of its wealth from trade in obsidian, a vitreous volcanic

stone easily chipped into fine cutting edges and highly valued by Neolithic tool- and weapon-makers.

The rich finds at Çatal Hüyük give the impression of a prosperous and well-ordered society that practiced a great variety of arts and crafts. In addition to painting and sculpture, weaving and pottery were well established, and even the art of smelting copper and lead in small quantities was known before 6000 B.C. The society seems conservative in its long retention of Paleolithic traditions and practices, but it was also progressive in effecting, slowly but relentlessly, the revolutionary shift from a food-gathering to a food-producing economy. In the arts this shift is mirrored in a de-emphasis of realism in favor of a more abstract symbolism, in the disappearance of hunting scenes, and in a gradual decline in production of statuettes representing male deities. At the same time representations of the mother goddess increase in number, reflecting perhaps a corresponding change in the importance, if not the social position, of woman. As agriculture took precedence over hunting, female occupations, like the milling of grain, baking, weaving, and the care and feeding of domestic animals, became ever more important. At Çatal Hüyük the change to a fully agrarian economy appears to have been completed by about 5700 B.C. Less than a century later the site was abandoned. A probably related culture at Hacilar, some 200 miles to the west, provides an afterglow. But by about 5000 B.C. the Anatolian Neolithic culture had ceased to exist, and the limelight shifts eastward toward the Mesopotamian valley.

2-6 *Deer Hunt*, detail of a copy of a wall painting from Level III, Çatal Hüyük, *c.* 5750 B.C.

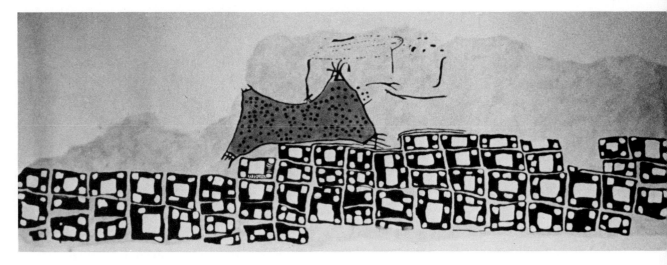

2-7 *Landscape with Volcanic Eruption*, detail of a copy of a wall painting from Level VII, Çatal Hüyük, *c.* 6150 B.C.

SUMER

Some time in the early fourth millennium B.C. in Mesopotamia a critical event took place—the settlement of the great river valleys. It was after this that writing, art, monumental architecture, and new political forms were introduced in Mesopotamia and Egypt, but with striking differences in function. As Henri Frankfort describes it:

> The earliest written documents of Mesopotamia . . . facilitated the administration of large economic units, the temple communities. The earliest Egyptian inscriptions were legends on royal monuments or seal engravings identifying the king's officials. The earliest representations in Mesopotamian art are preponderantly religious; in Egyptian art they celebrate royal achievements and consist of historical subjects. Monumental architecture consists, in Mesopotamia, of temples, in Egypt of royal tombs. The earliest civilized society of Mesopotamia crystallized in separate nuclei, a number of distinct, autonomous cities— clear-cut, self-assertive polities—with the surrounding lands to sustain each one. Egyptian society assumed the form of the single, united, but rural, domain of an absolute monarch.

Thus, not one, but *two* civilizations emerged, each having its own special character. From this time forward world history will be the record of the birth, development, and disappearance of civilizations and the rise and decline within them of peoples, states, and nations. It is with these two mighty, contrasting civilizations bordering the eastern Mediterranean region that the drama of Western mankind truly begins.

In the fertile lower valley of the Tigris and Euphrates man may have found the equivalent of the Garden of Eden celebrated in Genesis and long a part of Mesopotamian tradition. Once he had learned the arts of irrigation and, to a degree, the control of floods, the possibility of creating a great oasis was before him, and he realized it. The turbulence of its history strongly suggests that this land, with its promise of a hitherto unknown life of abundance, was enormously attractive to man.

At the dawn of recorded history the lower Mesopotamian valley was occupied by the Sumerians, whose origin is still one of the great puzzles of ancient history. They were an agricultural people who learned to control floods and built strong-walled towns, such as Uruk, the biblical Erech and the modern Warka, and Lagash, the modern Telloh. After several centuries, Semitic nomad shepherds came from the western desert; they adopted agriculture, absorbed much from Sumerian culture, and built their own cities farther north—Kish, Akkad, Mari, and Babylon. Over the centuries, dominion oscillated between the two peoples, but the Semites produced two of the mightiest kings, Sargon and Hammurabi.

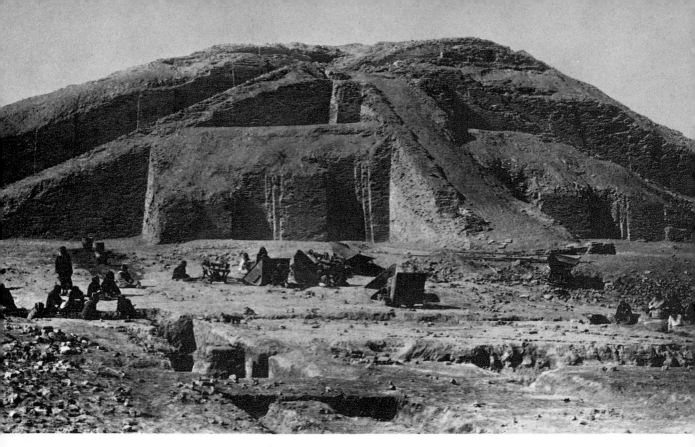

2-8 Ziggurat at Ur, *c.* 2100 B.C.

From as early as the Paleolithic caves we have evidence of man's effort to control his environment by picture magic. With the appearance of the Sumerians and the beginning of recorded history the older magic was replaced by a religion of gods, benevolent or malevolent, who personified the forces of nature that often contended destructively with man's hopes and designs. In the fertile valley the fiery heat of summer and the catastrophic floods, droughts, blights, and locusts easily persuaded man that there were powers above and beyond his control, powers that he must somehow placate and win over. Formal religion, a kind of system of transactions between gods and men, may have begun with the Sumerians; and no matter how it has been systematized and diversified since then, religion has retained its original propitiatory devices of prayer, sacrifice, and ritual, as well as a view of man as imperfect by nature and dependent upon and obligated to some higher being. The religion of the Sumerians and of those who followed them centered about nature gods: Anu, god of the sky;

Enlil (Bel), a creator and ruler of earth and "lord of the storm"; Ea (or Enki), lord of the waters (a healing, benevolent god); Nannar (Sin), the moon god; Utu (Shamash), the sun god; and Inanna (associated with the planet Venus), goddess of love and fertility, who, as Ishtar, is later also endowed with the functions of battle goddess.[1]

The City-State and the Ziggurat

Religion, dominating life and investing it with meaning, determined the form of society as well as its expression in architecture and art. The Mesopotamian city-state was under the protection of the god of the city; the king was his representative on earth and the steward of his earthly treasure. The relation of the king to the

[1] Bel and Shamash are Akkadian names; Sin is Babylonian.

gods above and to his subjects below may be read in the prayer of an early Sumerian king to the god Enlil of the city of Nippur:

O En-lil, the king of the lands, may Anu to his beloved father speak my prayer; to my life may he add life, and cause the lands to dwell in security; may he give me warriors as many as the grass; the herds of heaven may he watch over; the land with prosperity endow; the good fortune which the gods have given me, may he not change; and may I ever remain the shepherd, who standeth at the head.

The plan of the city reflected this centrality of the god in its life, his temple being its monumental nucleus. The temple was the focus not only of the religion of the city but of its administrative and economic process. It was indeed the domain of the god, who was regarded as a great and rich holder of lands and herds as well as the protector of the city. The whole function of the city was to serve the god as a master, as the function of all men in general was to serve the gods. The vast temple complex, a kind of city within a city, had a multitude of functions. A temple staff of priests and scribes carried on the business of the city, looking after the possessions of the god and of the king. It must have been in such a setting that writing developed into an instrument of precision; the very earliest examples of it have to do with the keeping of accounts and the description of simple transactions, stores, and supplies.

The most prominent part of a temple compound, and indeed the most characteristic structure of the Mesopotamian valley, was the *ziggurat*. Neither the origin nor the purpose of these huge, multistoried brick structures are known. They have been interpreted as "stairways from heaven" or as artificial mountains and have been linked with the widespread ancient belief that lofty mountain peaks were the homes of the gods (compare Mount Olympus in Greek religion). The shrines atop these ziggurats were called "waiting rooms" or "rooms one passes through," and they may have been thought of as halls in which the faithful might await the manifestation of their deity.

Most of the ruined cities of Sumer—Ur, Warka, Nippur, Larsa, Eridu—are still dominated by their eroded ziggurats. The ziggurat at Ur is a good example, dating from the period called Neo-Sumerian—from the twenty-second to the twenty-first century B.C.—when the builders were pushing for the greatest heights possible (FIGS. 2-8 and 2-9). In one view we see the huge mound of sun-dried brick worn almost into shapelessness by time, weather, and depredation; in the other a conjectural reconstruction. On a massive base, fifty feet high, stand two successively smaller stages, of which presumably the uppermost served as a pedestal for the shrine. Three ramplike stairways of 100 steps each converge toward a tower-flanked gateway from which another flight of steps probably led to the shrine, the focal point of ceremonial pageantry.

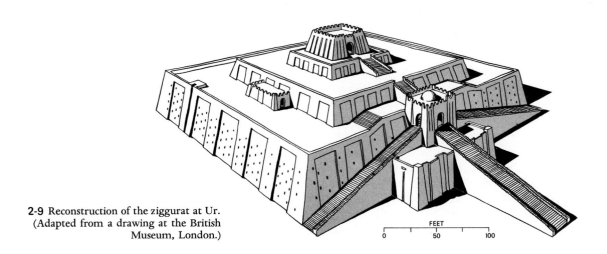

2-9 Reconstruction of the ziggurat at Ur. (Adapted from a drawing at the British Museum, London.)

FEET
0 50 100

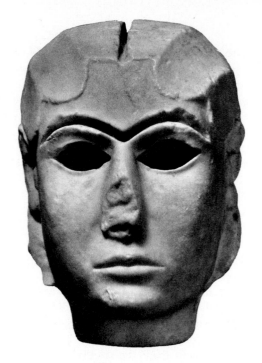

2-10 *Female Head*, Warka, c. 3500–3000 B.C. Alabaster, approx. 8″ high. The Iraq Museum, Baghdad.

The structure is a solid mass of mudbrick with a thick facing of baked brick laid in bitumen, the latter designed to withstand floods and weathering. Originally the stages may have been of different colors, used symbolically, and trees and gardens may have been planted on the terraces. The very height of the structure and the arduous climb toward its summit shrine may have symbolized, as in other religions, a kind of hard preparation of the spirit for the experience of divine enlightenment. Certainly the loftiness of the great ziggurats, which seemed to reach into the heavens, made a profound impression on the ancient Hebrews, who memorialized the one in Babylon as the Tower of Babel, a monument to the insolent pride of man.

The three great inventions of the Sumerians— a system of gods and god-man relations, the city-state itself, and the art of writing—provided the basis for a new order of human society. In the city-state, consecrated by the presence of the civic deity, men experienced new interrelations with the god and with each other, and these interrelations were formalized and given permanence by being recorded in writing. Life became regularized, and the community as-

sumed functions formerly the individual's, such as defense against man and the caprices of nature. This and the division of labor (specialization), which is encouraged where large numbers of people are concentrated in a coherent community, emancipated the inhabitants from the consuming necessities of daily life so that they could develop and apply skills and talents unthinkable in fluid and unintegrated societies. The relatively fixed character of the city-state also conferred on the community a permanent identity as a city whose king and god were known and present. This sense of identity extended to the individual inhabitant as well, who received his identity from his membership in the community, discovering himself in his interrelations with the city, god, king, and citizens. The new written language may also have contributed to this growing identification, the individual perceiving himself as a name among the names for other things and actions. Thus from the Sumerian creation of stable patterns of life begins that sense of identity, that self-awareness of historical man that will mature and reach its highest development in the civilization of Greece.

Sculpture

We have seen that in the animal paintings of the caves the figure of man almost never appears; he has not come into the field of self-awareness. Though the rock paintings of the Spanish Levant do indeed represent the human figure, they do so only schematically and almost as a kind of picture-writing. Thus we are not prepared for the beautiful female head from Warka (FIG. 2-10). Its ancestry is unknown. Dating from the so-called protoliterate period, when writing first appeared, it is not a complete head but a marble face meant to be attached to a wood backing and wigged, perhaps, in gold. The deep recesses for the eyebrows were filled with colored shell or stone, as were the large eyes. The subject is unknown (goddess, priestess, queen?), but our ignorance of it and of the history of the head does not diminish our appreciation of its exquisite refinement of feature and expression, despite the mutilations of time and accident. The soft modeling of the

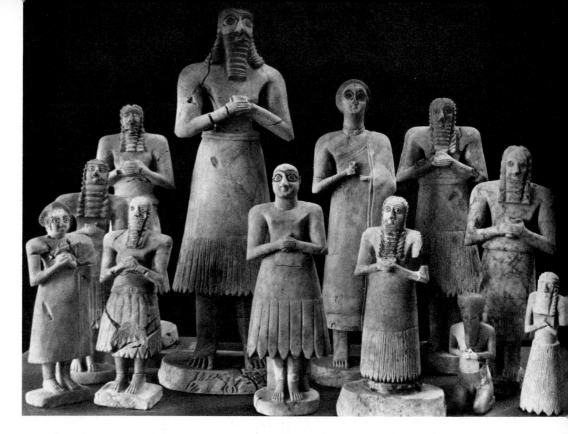

2-11 Statuettes from the Abu Temple, Tell Asmar, c. 2700–2500 B.C. Marble, tallest figure approx. 30″ high. The Iraq Museum, Baghdad, and the Oriental Institute, University of Chicago.

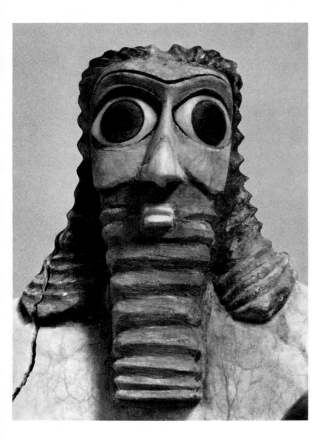

cheeks, the sensitivity of the mouth, the hesitancy of the expression between the sweet and the somber not only render for us a person in herself beguiling and mysterious but suggest a sophistication in the artist beyond our expectation of his time.

One notices at once in the Warka head how disproportionately large the eyes are. This is a trait of a whole group of figures from Tell Asmar (FIGS. 2-11 and 2-12). The reason for this convention, which is not only Sumerian but appears throughout ancient art, can only be guessed. Long before Aristotle asserted that man is distinguished from the animals by being rational and that sight is the most "rational" of the organs of sense, men must have perceived and feared the power of the eye to hold, charm, and hypnotize for ends good or ill. The "evil eye" was feared in the ancient world, as it still is feared. It is a popular belief and a part of folklore that one can learn much about another's intentions and character by "looking him straight in the eye";

2-12 *Head of the God Abu*, Tell Asmar, c. 2700–2500 B.C. Marble. The Iraq Museum, Baghdad.

and the modern affectation of dark glasses (curiously Sumerian when oversized!) may be both a defense and a badge of attractive mystery. To the ancient artist, the eyes, the "windows of the soul," could have had several associations: Large eyes fixed in unflagging gaze see all, and frontal, binocular vision, distinguishing human from mere animal seeing, represents the all-seeing vigilance and omniscience of the gods and the guarantee of justice. In the conventionalization of the human image, vision understandably becomes a peculiarly human trait—in its lesser physical sense as well as in its greater intellectual, spiritual, and theistic sense. Godlike vision as the foundation of law and justice is evident in the stories of great law-givers of the ancient world like Hammurabi of Babylon, Moses, Lycurgus of Sparta, and Solon of Athens.

Although it may be that none of our speculations entered the mind of the artist of the Tell Asmar figures, some association of vision with supernatural powers seems to be indicated by the fact that the two largest figures, identified as deities by emblems on their bases, also have the largest eyes in relation to their heads. The other statuettes represent worshipers, the larger ones priests, the smaller laymen; with their hands tightly clasped across their chests in the attitude of prayer, their large eyes seem to express reverent awe in the presence of their gods. The purpose of these votive figures was to offer constant prayers to the gods in behalf of their donors, and thus their open-eyed stares may symbolize the eternal wakefulness necessary if they are to fulfill their duty.

CONVENTIONALIZATION

Just as through formal religion and civic life the Sumerians, at the dawn of recorded history, created a new kind of human experience, so through writing and figurative art they found a new way to represent that experience. Writing had been invented by the simplifying of pictures into signs, wedge-shaped (cuneiform) strokes in numerous combinations pressed by a stylus into wet clay tablets. In figurative art, by an analogous process of simplification, the multitude of appearances of things in the optical world was reduced to a few telling traits sufficient to present the human figure and human action. This process of simplification is variously named schematization, stylization, conventionalization, generalization, and formalization. Conventional simplifications of the human figure are universal and not characteristic of ancient art only. Indeed, all artistic styles are conventional in that, in societies in which they prevail, they are tacitly agreed upon as a comprehensible means of representation. The conventions may be broad or narrow, slow to change or under continual revision, as in our times. In any case, criteria such as fidelity to optical "fact" should not be used in evaluating a style. Although since the 1880's the main trends in modern art have been away from optical "fact," and although today's artists often deliberately disregard photographic "truth," the images they make—such as those seen in comic strips and in commercial art and advertising—are perfectly recognizable to us.

The Sumerians, working out patterns and conventions that regulated the new life that they had in effect devised, also established conventions for the making of the human image. The large eyes of the Warka and Tell Asmar figures are not the only conventionalized details. In the small figures of a shell-inlaid box, the so-called *Standard of Ur* (PLATE 2-2), we find several devices of representation that simplify the narrative, explain the action, and even convey the impression of motion. The panel depicts a Sumerian military victory and its aftermath—the advance of the foot soldiers, the charge of the chariots, lines of prisoners and servants bringing in booty, and finally the king relaxing after the battle, when he drinks with his nobles and listens to harp and song. The figures are carefully arranged in superimposed strips, each strikingly suggestive of a film or comic strip; and doubtless the purpose is the same—to achieve a continuous narrative effect. They are carefully spaced, with no overlapping. (Compare this regularized, formal presentation with the casual and haphazard placements of the figure in Paleolithic and Mesolithic art.) Poses are repeated, as in the line of foot soldiers, to suggest large numbers. The horses of the war chariots,

the lines of the legs repeated to suggest the other horses of the team and their alignment in space, change from a walk to a gallop as they attack. The figures are essentially in profile, but it is a convention almost universal in the ancient Near East that the eyes—again, very large—are in front view, as are the torsos. The artist indicates the parts of the human body that enter into our concept of what it looks like, and he avoids positions, attitudes, or views that would conceal or obscure the characterizing parts. For example, were the figures in strict profile, an arm and perhaps a leg would be concealed, the body would appear to have only half its breadth, and the eye would not "read" as an eye at all, since it would not have its distinctive flat oval shape, and the pupil, so important in the Tell Asmar figures, would not appear. We could call this approach "conceptual" rather than "optical," since the artist records not the immediate, fleeting aspect of things but rather his concept of the distinguishing and abiding properties of the human body. It is the fundamental forms of things and his knowledge of them, not their accidental appearance, that direct his hand. But this is simply a reflection of the general *formalism* that was imposed at the beginning of the historical period in an effort to create an enduring order. This formalism continued to rule human conduct through history in thousands of customs, conventions, and ceremonies regarded as sacred and above change. In Greece, many centuries later, Plato conceived the famous philosophy of Forms, claiming that the world of pure form, in which exist the ultimate and unchanging truths of mathematical figures and relationships, is the real world, whereas the world we see, the world of mere appearance, is the realm of the unreal, of illusion, of change, and of death.

THE UNION OF THE FORMAL AND NATURAL

On the inlaid soundbox of a harp from Ur (FIG. 2-13) there are figures representing, in the top register, a Sumerian hero wrestling with two man-headed bulls and, in the lower registers, real and fantastic animals preparing a banquet.

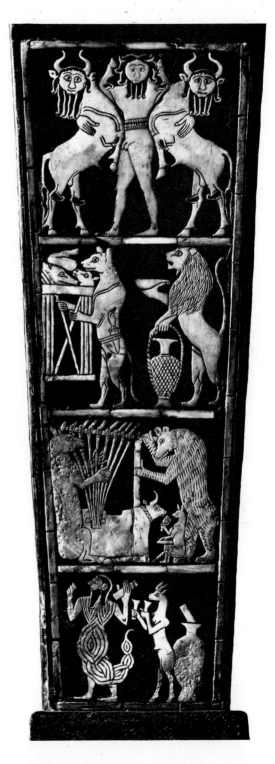

2-13 Soundbox of a harp, Ur, c. 2600 B.C. Shell inlay, approx. 9″ high. University Museum, Philadelphia.

The topmost register of the panel presents the figures in heraldic symmetry, and, except that the heads are in front view, they exhibit the conventional formalized pose of the *Standard of Ur*. On the other hand, the figures of the animals in the other registers show the formalism markedly relaxed. The dagger-wearing dog bringing in a laden table, the lion bringing in the wine service, the ass playing the harp, the jackal playing the zither, the bear steadying the harp (or is he dancing?), and the gazelle offering goblets of wine to the scorpion-man—all are seen in more or less true profile. Torsos naturally cut off the view of the far arms, and the near legs obstruct the far legs. Shoulders are properly placed, and features are carefully noted and designated. The heroic human figures have the formality we find in the stylized animals on a coat of arms, but the banquet animals are at ease or seem almost to be burlesquing a stately parade of servants and musicians. Long before the figure of man appears in art we have the naturalistic animal figures of the Paleolithic caves. And for a long time, as if by rule, man is represented with rigid formality, while the animal figure looks and moves much as it would appear to the eye. Our panel shows a delightful Aesop-like scene (the comedy of which may not have been intended) in what is probably a representation of ancient myths. Surely it is a very early specimen of that theme in both literature and art in which animals act as people; thus we pass from the artist of this panel to Aesop's fables, to the Medieval bestiaries, to the zoological creations of Walt Disney.

On the same harp is a splendid bull's head finished in gold leaf and with beard and details in lapis lazuli (FIG. 2-14). (Note where the head is attached to the harp, as it is shown on the third register from the top in FIG. 2-13.) The bull, an

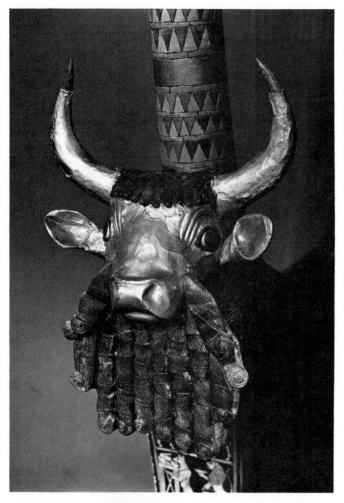

2-14 Bull's head from the soundbox. Gold leaf and lapis lazuli with inlaid eyes, approx. 17″ high. University Museum, Philadelphia.

2-15 Cylinder seal and its impression, Ur, *c.* 2700 B.C. Stone, approx. 1½″ high. The Oriental Institute, University of Chicago.

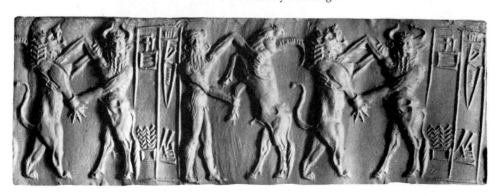

exemplification of fertility and strength, would naturally become the animal worshiped by early herdsmen, its power invoked against the natural enemies of cattle—drought and predatory beasts. The archaic artist shares with his prehistoric predecessor the genius for rendering with sharp perception the features, almost the personality, of animals. Throughout the ancient Near East and the Mediterranean the bull was revered. In this example, the beard may represent some supernatural amplification of the bull's power. The beard and such humanizing features as the man-heads added to the bulls in the top panel of the soundbox foreshadow the man-headed bulls and lions that appeared much later in Assyria.

The contest of forces natural and supernatural in the Mesopotamians' world is expressed as a struggle between animals and monsters. Such a struggle we find represented in miniature upon a cylinder seal only an inch and a half high (FIG. 2-15), the design cut with exquisite refinement. A seal consisted of a cylindrical piece of stone, usually about an inch or so in height and pierced for the attachment of a cord. Made of various colored stones, both hard and soft, such as rock crystal, agate, carnelian and jasper, lapis lazuli, marble, and alabaster, the seal was decorated with a design in intaglio (incised) so that when it was rolled over soft clay a raised pattern was left. With this device the Sumerian sealed, signed, and identified his letters and documents, which were written on clay tablets. Our illustration shows both the seal and the relief design made from it. A hero fights a bull, and a being—half-man and half-bull—fights a lion. The heraldic attitudes and groupings reflect the formal method of representation, but even in the small area of the seal the skillful artist shows such mastery of animal form that one almost hears the roaring and bellowing of the struggle.

AKKAD

At about 2300 B.C. that loose group of cities we know as Sumer (where the tremendous change from prehistory to civilization had begun) came under the domination of a great ruler, Sargon of Akkad. The Akkadians, though Semitic in origin and speaking a language entirely different from that of Sumer, had assimilated Sumerian culture and under Sargon and his followers introduced a new concept of royal power, its basis unswerving loyalty to the king rather than to the city-state. During the rule of Sargon's grandson, Naram-Sin, governors of cities were called slaves of the king, who, in turn, called himself King of the Four Quarters (of the universe)—in effect, ruler of the earth. A magnificent bronze head of a king from Nineveh (a portrait of Naram-Sin?) embodies this new concept of absolute monarchy (FIG. 2-16). The elaborate coiffure, Sumerian in style, attests the persistence of the tradition of Sumer and serves as crown to the unforgettable face with its expression of majestic serenity. The large eyes, made even larger by the absence of the precious stones once embedded in the sockets, and the emphatic ridgelike brows would seem

2-16 *Head of an Akkadian Ruler,* Nineveh, *c.* 2300–2200 B.C. Bronze, approx. 12″ high. The Iraq Museum, Baghdad.

2-17 *Victory Stele of Naram-Sin,* c. 2300–2200 B.C. Pink sandstone, approx. 6′ 6″ high. Louvre, Paris.

minded and commanding one, yet in a pensive and composed mood, with perhaps just a trace of irony. The age of metals has come, and the piece demonstrates the craftsman's sophisticated skill in casting and in the engraving of details.

The godlike sovereignty claimed by the kings of Akkad may be seen proclaimed in another masterpiece of Akkadian art, the great *Victory Stele of Naram-Sin* (FIG. 2-17). On the stele the war-like grandson of Sargon is represented leading his victorious armies up the slopes of a wooded mountain and through the routed enemy, who are crushed underfoot, fall, flee, die, or beg for mercy. The king stands alone, far taller than his men, treading upon the bodies of two of the fallen enemy. He wears the horned helmet that signifies his deification, and two auspicious astral bodies, representing Shamash and Ishtar, shine upon his triumph. The artist shows an almost startling originality, not only in his ingenious management of the theme, but in the variety of poses and in the setting. The king's troops, a whole army suggested by eight figures marching in two orderly files, carry spears and flying banners as they encounter the shattered enemy (seven figures), one of whom falls headlong down the mountain side. In comparison with the stele figures, those of the *Standard of Ur* seem rather static and formal. The Naram-Sin artist is a daring inventor, and though he adheres to older conventions, especially in the figures of the king and his soldiers (in simultaneous profile and front view), he nevertheless relies upon his own perception to create the first landscape in Near Eastern art since Çatal Hüyük (FIG. 2-7).

The achievements of Akkad were brought to an end by an incursion of barbarous mountaineers, the Guti, who dominated life in central and lower Mesopotamia for about sixty years, when the cities of Sumer, responding to the alien presence, reasserted themselves and established a Neo-Sumerian polity under the kings of Ur. During this age the most conspicuous contribution came from the city of Lagash under its ruler, Gudea. There are about twenty statues of Gudea, and they show him seated or standing, hands tightly clasped, and sometimes wearing a woolen cap; the statue illustrated is characteristic (FIG. 2-18). Gudea, who attributed his good fortune and that of his city to the favor of the gods,

to go back a long way in tradition, even to the Warka head; the sensitive mouth also recalls that of the earlier work. Here we see to particular advantage that union of the formal with the natural so common in Mesopotamian art. The symmetry of the head and the stylized motifs of the curly locks of hair manage to be consistent with the projection of personality—a strong-

zealously looked after the performance of their rites; his statues were numerous so that he could take his (symbolic) place in the temples and there render perpetual service to the benevolent deities. The standing Gudea shown is, like the others, of dolerite, an extremely hard stone that the sculptor works with consummate skill, making an opportunity out of difficulty. The capped figure stands in the formal frontal pose that descends from the age of Tell Asmar; the great eyes and eyebrow ridges are in the Mesopotamian tradition. One shoulder and arm are bare; the drapery pulls about the torso and under the arm and falls almost vertically from the other arm. The overall contour is simple in the extreme, with no irregular or complex relief. There is a singular unity and compactness to the figure that arises from the artist's conceiving of it as a cylindrical or conical form that resides in the mass of the finely textured stone. The smooth sweep of its contours, the elegance of the profile, and the richness of the polished dolerite all complement each other.

BABYLONIA

Lagash, which had retained its independence during the Guti invasion, became a dependency of Ur during that city's brief resurgence in the late third millennium B.C. For a little over a century the Third Dynasty of Ur ruled over a once-more united realm. Its last king fell before the attacks of foreign invaders, and the following two centuries saw the return of the traditional Mesopotamian political pattern in which several independent city-states existed side by side. One of these was Babylon, until its most powerful king, Hammurabi, was able to reestablish a centralized government that ruled the whole country. Perhaps the most renowned king in Mesopotamian history, Hammurabi was famous for his codification of the confused, conflicting, and often unwritten laws of the Mesopotamian towns. Though Hammurabi was not the first to try to bring order out of the chaos, he was the first to succeed; echoes of his code can be found in the Law of Moses.

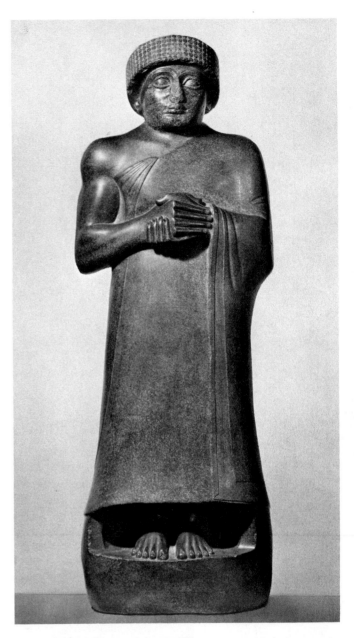

2-18 *Gudea Worshiping*, Telloh, c. 2100 B.C. Dolerite, approx. 42″ high. Louvre, Paris.

The code, beautifully inscribed on a tall, irregularly surfaced black basalt stele, is capped by a relief sculpture of Hammurabi receiving the inspiration for it from the flame-shouldered sun god, Shamash (FIG. 2-19). The event takes place on a mountain, indicated by toothlike devices beneath the god's feet. Shamash holds the re-

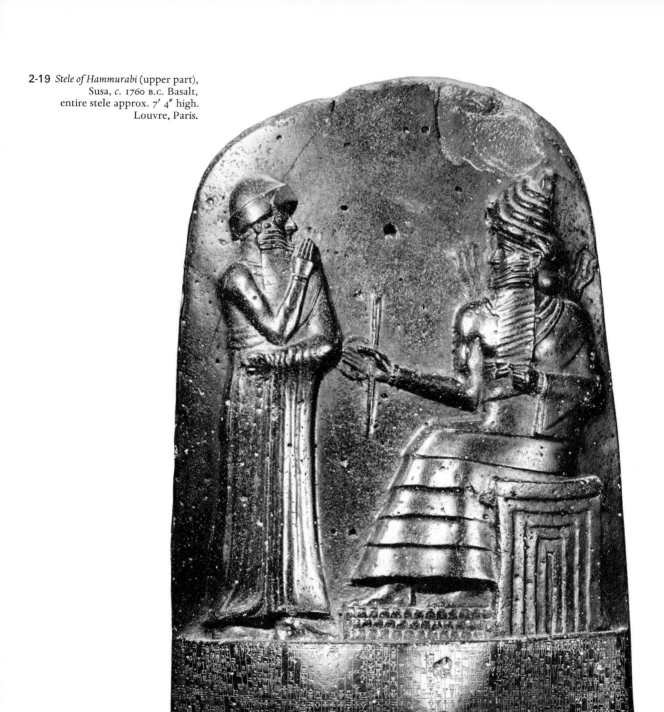

2-19 *Stele of Hammurabi* (upper part), Susa, *c.* 1760 B.C. Basalt, entire stele approx. 7′ 4″ high. Louvre, Paris.

galia of divine power, a baton and a ring, while he dictates the law to Hammurabi, represented in a gesture of reverent attention. We find here again the Mesopotamian artist's instinct for cylindrical volume. Shamash is represented in the familiar convention of combined front and side views, while Hammurabi, his servant, is shown in a position closer to profile. This confrontation between god and man expresses the increasing humanization of natural and supernatural forces, as man, increasingly self-aware, begins (in Babylon) to attribute human form to the gods.

| Sargon I | Gudea | | | | Code of Hammurabi | |
| AKKADIAN DYNASTY | THIRD DYNASTY OF UR | | | | FIRST DYNASTY OF BABYLON | |

Hammurabi's Babylonian empire was brought down by the Hittites, who, after sacking Babylon around 1595 B.C., retired to Anatolia, the seat of Hittite power, leaving Babylonia in the hands of marauding mountaineers, the Kassites. The Hittites, who spoke an Indo-European tongue, developed an art of great power and originality. Their strongly fortified capital, near the modern Turkish village of Boghazköy, was fronted with massive stone gates set between towers (FIG. 2-20). Projecting from the cyclopean stones—so different from the brick of Mesopotamian architecture!—are rugged figures of lions, blunt and brutal in aspect. Whatever the source for the concept of guardian beasts—Mesopotamia, Syria, or Egypt—the Hittite realization of it is original, the figures being strongly bound to and dominated by the architecture, rather than freestanding and in the round.

ASSYRIA

For centuries the Assyrians, the people of northern Mesopotamia, were frustrated in their impulse to power by the kingdoms of the south—Sumer, Akkad, and Babylon—and, on the northwest, by the Mitanni, to whom for a while they were subject. Their opportunity came when their Mitannian overlords were broken by the Hittites and when the weak Kassite kingdom that had succeeded the Babylonian dynasty proved incapable of effective resistance. By about 900 B.C. the Assyrian destiny was already becoming an actuality and for the next three centuries Assyria was the dominant power in the Near East. Assyrian kings became military commanders, and Assyria itself, with its center successively at Calah (the modern Nimrud), Dur-Sharrukin (the modern Khorsabad), and Nineveh,

2-20 *Lion Gate*, Boghazköy, Anatolia, *c.* 1400 B.C. Lions approx. 7′ high.

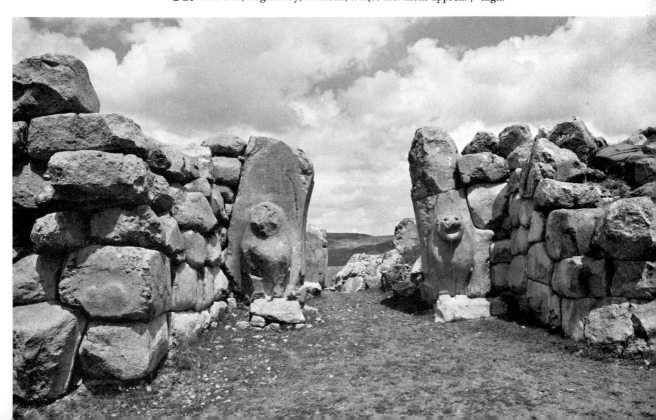

became a garrison state with an imperial structure that extended from the Tigris to the Nile and from the Persian Gulf to Asia Minor. Centuries of unremitting warfare against their neighbors and often rebellious subjects hardened the Assyrians into a cruel and merciless people whose atrocities in warfare were bitterly decried throughout the ancient world. Although they held the restless Babylonian south in thrall, the Assyrians respected the religion and the culture of Sumer-Babylon and were, in fact, dependent on its advanced civilization—as the large library of Ashurbanipal attests. (Discovery of this library in the nineteenth century opened an immense field of knowledge about Assyria.)

Architecture

The unfinished royal citadel of Sargon II of Assyria, built at Khorsabad, reveals in its ambitious plan the confidence of the "great kings" in their all-conquering might (FIG. 2-21). The palace covered some twenty-five acres and had over 200 courtyards and rooms. The city, above which the citadel-palace stood on a mound fifty feet high, is itself about a square mile in area. The palace may have been elevated solely to raise it above flood level, but its elevation also served to put the king's residence above those of his subjects and midway between them and the gods. Though the builders probably aimed at symmetry, the plan is rambling, embracing an aggregation of rectangular rooms and halls grouped around square courts (FIG. 2-22). The shape of the long, narrow rooms and the massiveness of the side walls suggest that the rooms were covered by brick barrel vaults (see Chapter Six), the most practical roofing method in a region that lacks both timber and good building stone. Behind the main courtyard, each side of which measures 300 feet, were the residential quarters of the king, who received foreign emissaries in

2-21 Reconstruction drawing of the citadel of Sargon II, Khorsabad, *c.* 720 B.C.

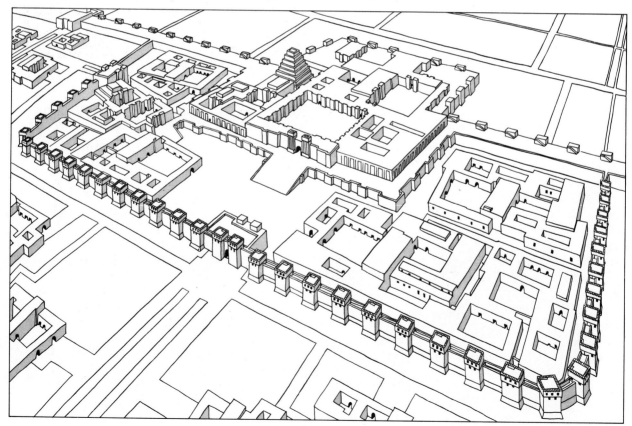

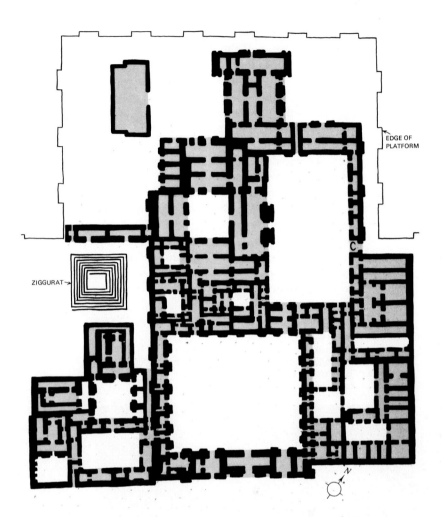

EDGE OF PLATFORM

ZIGGURAT→

C

N

▭ Probable roofed areas

FEET

0	100	200	300

2-22 Plan of the inner precincts of the citadel of Sargon II.

state in the long, high, brilliantly painted throne room. Such visitors entered from another large courtyard, passing through the central entrance between huge guardian demons, some thirteen feet in height, and into the presence of enthroned power. Waiting in the court for the audience, visitors had time to meditate upon their own insignificance in comparison with the awesome strength of the king, for the walls of the court were lined with giant figures of the king and his courtiers.

Sargon II regarded his city and palace as an expression of his grandeur, which he viewed as founded upon the submission and enslavement of his enemies. He writes in an inscription: "I built a city with [the labors of] the peoples subdued by my hand, whom Assur, Nabu and Marduk had caused to lay themselves at my feet and bear my yoke at the foot of Mount Musri,

above Nineveh." And in another text he proclaims: "Sargon, King of the World, has built a city. Dur Sharrukin he has named it. A peerless palace he has built within it."

In addition to the complex of courtyards, throne room, state chambers, harem, service quarters, and guard rooms making up the palace were the essential temple and ziggurat. The ziggurat at Khorsabad may have had as many as seven stages, of which four have been preserved, each eighteen feet high and each painted a different color. The ascent was made by a continuous ramp spiraling around the building from its base to its summit.

The palace façade consisted of a massive crenelated wall broken by huge rectangular towers flanking an arched doorway. Around the arch and on the towers were friezes of brilliantly colored glazed tiles, the whole effect being sump-

tuous and grand. Dazzling brilliance seems also to have been part of the royal Assyrian plan to overwhelm the visitor. The doorway was guarded by colossal winged bulls with human heads (FIG. 2-23). These man-headed bulls may be derived from the animal figures at Hittite Boghazköy. Both sets of animals served to ward off enemies, visible and invisible, and to invest the palace façade with an imposing and dramatic aspect. They are partly in the round and partly in high relief, and they combine the front view at rest with the side view in movement, contriving this combination by the addition of fifth legs. The gigantic size; the bold vigorous carving, the fine sweep of wings, and the patterning of the surface by the conventional treatment of details produce together a splendor and a stupendous strength that are awesome even today. But we may think of them in all their majesty not so much as guardians of the king as augmentations of his regality. They wear the horned crowns of the god-kings of Akkad and the large-eyed, bearded masks familiar ever since Sumer, and they evidence in their bull and lion bodies the superhuman strength and fierceness of the king and, with their eagles' wings, his swiftness to bring justice or vengeance. The virtues of Assyrian kingship are written large in these hybrid beasts. Ancient art repeatedly testifies to man's persisting fear and admiration of the great beasts that serve as his metaphors for the powers of nature and for the gods themselves.

Relief Sculpture

Although the kings of Assyria had their power depicted in nonhuman forms, they were very much of the world and expected their greatness in their favorite pursuits—war and hunting—to be recorded in unmistakably exact and concrete terms. The chronicle revealed in inscriptions is surprisingly complete, yet we learn of the character of Assyrian royal life quite as much from the numerous relief carvings found in the ruins of Nimrud and Nineveh, those magnificent capitals of Assyria in its prime. The history of Assyrian art is mainly the history of relief carving; very little sculpture in the round survives. Even the great winged beasts are thought of as relief sculpture and are locked into their stone slabs, presenting three relief surfaces. To narrate the royal feasts pictorially required flat, continuous surfaces upon which could be repeated almost without end the campaigns, sieges, conquests and slaughters, and never ending massacres of wild animals that occupied the waking hours of the kings. The artists, working within the limitations of a rectangular surface, devised a vocabulary of forms which, though conventional, was sharply descriptive. The Assyrian reliefs constitute a narrative whose continuity is broken only by the edges of the fitted blocks. What began long before in the *Standard of Ur* here reaches its perfection.

The astonishing multiplicity of a relief of Ashurnasirpal II at war (FIG. 2-24) compels careful study of the composition if one is to discriminate its details. The king stands in his chariot drawing his bow. He is accompanied by officers, and, in

2-23 Winged human-headed bull, Khorsabad, *c.* 720 B.C. Limestone, approx. 13′ 10″ high. Louvre, Paris.

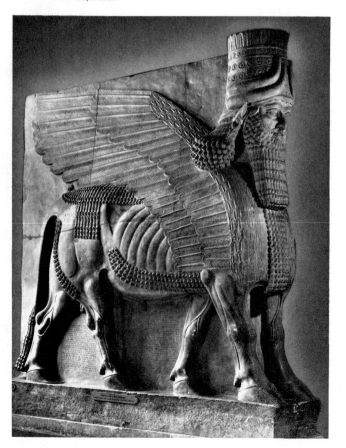

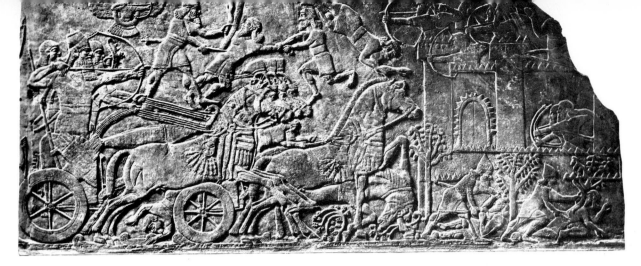

2-24 *Ashurnasirpal II at War*, Nimrud, *c.* 875 B.C. Limestone, approx. 39″ high. British Museum, London.

the sky above him, the winged god of Assyria, Ashur, draws his bow and leads him on. The king's team, the reins tight, is passing an enemy chariot already breaking up, its driver thrown down and one horse fallen. Assyrian foot soldiers cut the throats of the enemy wounded. At upper center an Assyrian soldier slays a foe while his comrade tries to save him. Behind them a soldier is lying dead; and, in the upper right, enemy bowmen desperately defend the towers of their city. What is remarkable is the ease with which we read the incidents, though they are not depicted in perspective or in logical sequence. The artist uses the space of his block for a field to be divided as narrative convenience and his own

sense of both the factual and the dramatic dictate. The liveliness of individual poses and movements is exceptionally fine and convincing, and despite the formality that exists in Mesopotamian art side by side with naturalistic details, sophisticated spatial devices appear throughout. One such is the overlapping of figures to suggest greater or lesser distance from the observer; the king's overlapping of his officers is a good example.

The formality of Assyrian art at its most rigid can be seen in another relief of Ashurnasirpal II (FIG. 2-25), in which the king, seated right of center, solemnly raises a ceremonial cup, while the presence of an august personage—at the far

2-25 *Ashurnasirpal II Drinking*, Nimrud, *c.* 875 B.C. Limestone, approx. 92″ high. British Museum, London.

left a winged genius who sprinkles holy water—makes the king's act part of a sacred ritual. The slow gestures and stately mien are what we expect of some grave liturgy; we recognize them in religious services today. The cuneiform inscriptions on the flat, thin slabs of relief continue across shallow recesses between the slabs, accentuating the neutrality of the planes and suggesting that the carving is meant to be not so much a three-dimensional form (that throws shadows) as a report of an event in pictures as well as writing. An interesting Assyrian convention nevertheless makes itself felt—the representation of the human body as thick-set and weighty and the limbs as bulging with muscle, as witness the advanced left leg of the genius and the arms of the king. The calf and forearm muscles are exaggerated, and the veins are like cables, an example of realistic observation converted to a kind of symbol of brute human strength. Also noteworthy is the way in which the profile view of the arms comprises, with the front-view torso, a kind of three-quarter view. The artist, though subject to the conventions of his time, is experimenting with the problems of representing what his eye sees.

Two centuries later, in a relief from Nineveh showing Ashurbanipal hunting lions (FIG. 2-26),

the conventions of the time of Ashurnasirpal II persist, although more realistic elements are introduced. In this relief, lions released from cages in some large, enclosed arena charge the king, who, in his chariot and with his servants protecting his blind sides, shoots down the enraged animals. The king, menaced by the savage spring of a lion at his back, is saved by the quick action of two of his spearmen. Behind his chariot lies a pathetic trail of dead and dying animals pierced by what would appear to be far more arrows than are needed to kill them. A wounded lioness (FIG. 2-27) drags her hindquarters, paralyzed by arrows that pierce her spine. Blood streams from her wounds—a detail recurring in Assyrian art and revealing the savage character of its patrons. The artist gives a ruthless reading of the straining muscles, the swelling veins, the corrugations of the muzzle, the flattened ears— once more a hard realism under control of the formality of silhouette in low relief. Modern sympathies make of the scene of carnage a kind of heroic tragedy, with the lions as protagonists; but it is unlikely that the artists of the king had any intention other than to aggrandize his image by piling up his kills, by showing the king of men pitting himself against the king of beasts and conquering him.

2-26 *Ashurbanipal Hunting Lions*, Nineveh, *c.* 650 B.C. Alabaster, approx. 5′ high. British Museum, London.

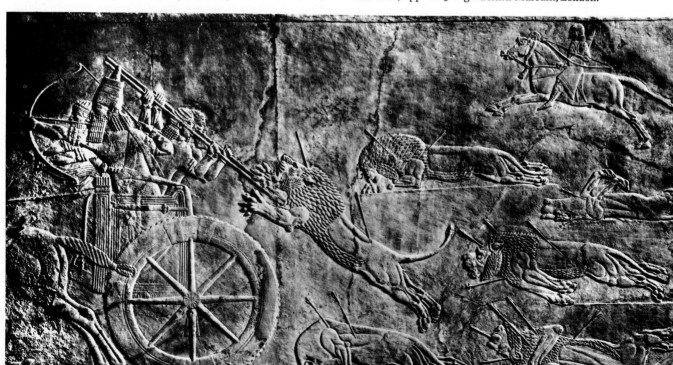

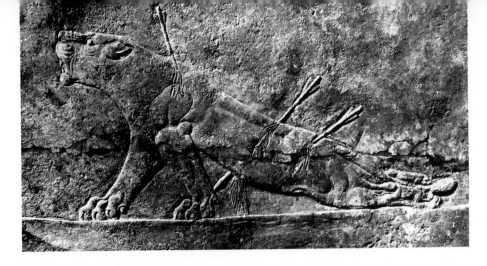

NEO-BABYLONIA

The Assyrian empire was never very secure, and most of its kings had to fight revolts in large sections of the Near East. The seventh century B.C. saw a steady rise of opposition to Assyrian rule, and, during the last years of Ashurbanipal's reign, the empire began to disintegrate. Under his son and successor it collapsed before the simultaneous onslaught of the Medes from the east and the resurgent Babylonians from the south. Babylon rose once again, and, in a brief renewal (612–538 B.C.), the old southern Mesopotamian culture flourished, especially under the storied King Nebuchadnezzar, whose exploits we read of in the Book of Daniel. Nebuchadnezzar made Babylon a fabulous city once again and its famous "hanging gardens" one of the seven wonders of the an-

cient world. Of its temple to Bel—the Hebrews' Tower of Babel—only a little of the great ziggurat remains. But Herodotus, the ancient Greek traveler and "father of history," has left us a brief account of his visit to the temple complex during the fifth century B.C.:

> In the one [division of the city] stood the palace of the kings, surrounded by a wall of great strength and size: in the other was the sacred precinct of Zeus-Bel, an enclosure a quarter of a mile square, with gates of solid brass, which was also remaining in my time. In the middle of the precinct there was a tower of solid masonry, a furlong in length and breadth, upon which was raised a second tower, and on that a third, and so on up to eight. The ascent to the top is on the outside, by a path which winds round all the towers. When one is about halfway up, one finds a resting-place and

2-28 *Lion from the Processional Way*, Babylon, *c.* 575 B.C. Glazed brick, approx. 3′ 5″ high. Louvre, Paris.

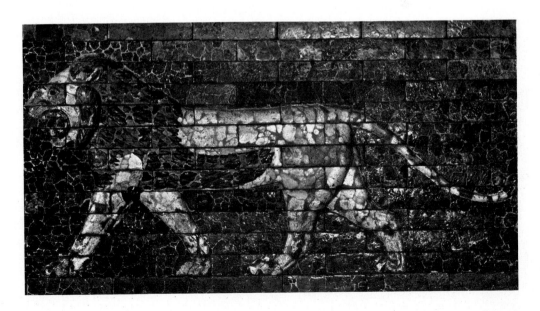

2-29 Stairway to the Royal Audience Hall, Persepolis, *c.* 500 B.C.

seats, where persons are wont to sit some time on their way to the summit. On the top-most tower there is a spacious temple, and inside the temple stands a couch of unusual size, richly adorned, with a golden table by its side.... They also declare that the god comes down in person into this chamber, and sleeps upon the couch, but I do not believe it.

A grand approach to the temple complex led down a walled processional way lined with sixty stately figures of lions done in brightly colored glazed bricks (FIG. 2-28). These remarkable beasts, sacred to the goddess Ishtar, are molded in relief and glazed in yellow-brown and red against a ground of turquoise or dark blue. The Babylonian glazes are opaque and hard; possibly each brick was molded and enameled separately. Also, it may be that as a result of this technique these animals, whose vigor is suggested by snarling muzzles, long, nervous tails, and carefully depicted muscles, are more stylized than those of the Assyrian hunting reliefs.

The processional way passed through the monumental, brilliantly glazed Ishtar Gate (PLATE 2-3), the design of which, with its flanking crenelated towers, conforms to the type of gate found in earlier Babylonian and Assyrian architecture. Glazed tiles had been used much earlier, but the surface of the bricks, even of those on which figures appeared, was flat. On the surfaces of the Ishtar Gate, laboriously reassembled, are superposed tiers of figures in profile, the dragon of Marduk and the bull of Adad alternating. Here is the characteristic Mesopotamian formality at its best. The figures make a stately heraldry proclaiming the gods of the temples toward which the Sacred Way leads. The lessons of architectural sculpture from Boghazköy and Khorsabad have been well learned, and the perfect adjustment of figure to wall found in the Ishtar animals has rarely been surpassed; certainly in the history of architecture few more colorful and durable surface ornaments are known.

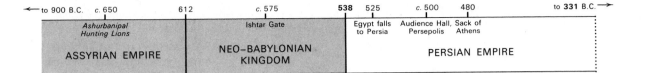

← to 900 B.C.	c. 650	612	c. 575	**538**	525	c. 500	480	to **331** B.C. →

Ashurbanipal Hunting Lions	Ishtar Gate	Egypt falls to Persia	Audience Hall, Persepolis	Sack of Athens	

ASSYRIAN EMPIRE	NEO–BABYLONIAN KINGDOM	PERSIAN EMPIRE

PERSIA

Nebuchadnezzar, Daniel's "King of Kings," boasted: "I caused a mighty wall to circumscribe Babylon . . . so that the enemy who would do evil would not threaten [and] of the city of Babylon [I] made a fortress." Nevertheless, the handwriting on the wall appeared, the city was taken by Cyrus of Persia, and the line of Nebuchadnezzar came to an end. The impetus of the Persians' expansion carried them far beyond Babylon. Egypt fell to them in 525 B.C. By 480 B.C. the Persian empire extended from the Indus to the Danube, and only the successful resistance of the Greeks in the fifth century prevented it from embracing southeastern Europe as well.

Architecture

The most important source of our knowledge of Persian building is the palace at Persepolis (FIG. 2-29), built between 520 and 460 B.C. by Darius and Xerxes, successors of Cyrus. Situated on the high plateau to the east of the Mesopotamian river valley, the heavily fortified palace stood on a wide platform overlooking the plain toward the sunset. Although destroyed by Alexander the Great in a gesture symbolizing the destruc-

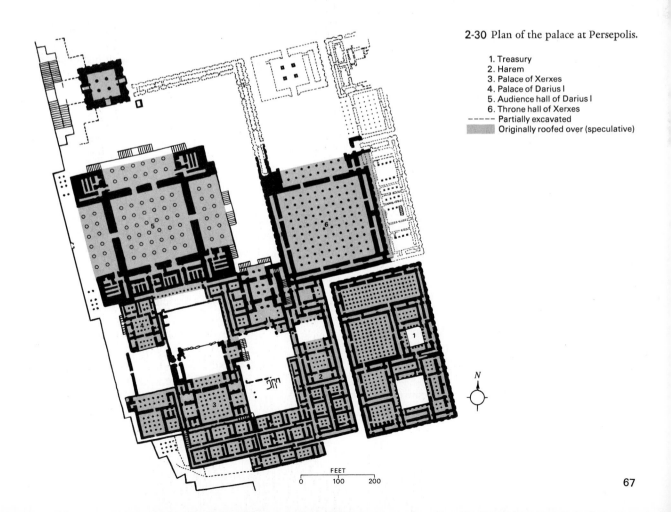

2-30 Plan of the palace at Persepolis.

1. Treasury
2. Harem
3. Palace of Xerxes
4. Palace of Darius I
5. Audience hall of Darius I
6. Throne hall of Xerxes
- - - - - Partially excavated
▧ Originally roofed over (speculative)

FEET
0 100 200

N

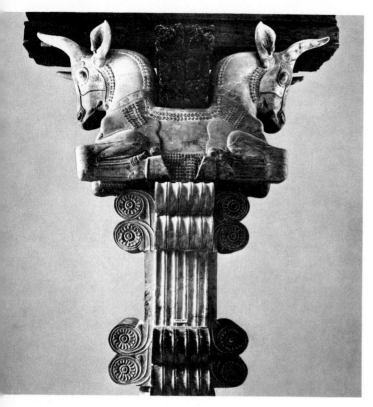

2-31 Bull capital from the Royal Audience Hall of the palace of Artaxerxes II, Susa, *c.* 375 B.C. Gray marble. Louvre, Paris.

descendants. Unknown also remains the genesis of the square, many-columned hall so characteristic of the Persepolis palace. It has been suggested that it may have been derived from Median architecture, which has remained a blank page in archeologists' books. The Medes were the northern allies, later subjects, of the Persians and are believed to have been the intermediaries through whom Persian art received a variety of Iranian stylistic elements.

Stone, easily available at the site, was used liberally at Persepolis for platforms, gateways, stairs, and columns; brick was used for the walls, however, and wood for the smaller columns and the roofs. The ruins of the palace at Persepolis (FIG. 2-32) show that stone was used also for door and window frames. The forms are derived from Egyptian architecture, which had impressed Darius, but here the frames are not composed structurally of posts, lintels, and sills but are cut in an arbitrary manner and used as sculptural ornaments. In fact, the entire complex of buildings, and particularly the apadana, seems to have been designed primarily for visual effect; it is a gigantic stage setting for magnificent ceremonials celebrating not only traditional festivals but the greatness of the Persian empire and the power of its king.

Sculpture

The approach to the apadana leads through a monumental gateway flanked by colossal man-headed bulls and thence at right angles toward the elevated great hall, ascent to which is by broad, ceremonial stairways, designed as though for a stage. The walls of the terrace and staircases are decorated with reliefs representing processions of royal guards, Persian and Median nobles and dignitaries, and representatives from the subjected nations bringing tribute and gifts to the king (FIG. 2-33). These reliefs are thought to represent, in a shorthand version, the actual ceremonies that took place at Persepolis during the great New Year festivals. Traces of color found on similar monuments at other Persian sites suggest that, at least in part, these reliefs were colored. Their original effect must have been

tion of Persian imperial power, its still impressive ruins permit a fairly complete reconstruction of its original appearance.

Unlike the Assyrian palace, which was tightly enfolded around courts (FIG. 2-22), the Persepolis buildings were loosely grouped and separated from each other by streets and irregular open spaces (FIG. 2-30). The dominant structure was a vast columned hall, sixty feet high and over 200 feet square. Standing on its own rock-cut podium, which is about ten feet high, this huge audience hall (*apadana*) has been called "one of the noblest structures of the ancient world." It contained thirty-six forty-foot columns with slender, fluted shafts and capitals composed of the foreparts of bulls or lions arranged to provide a firm cradle for the roof timbers. FIG. 2-31 shows a well-preserved example from the somewhat later palace of Artaxerxes at Susa. These unique capitals are an impressive and decorative Persian invention with no known antecedents or

even greater than it is today as the rows of figures sparkled in a blaze of colors rivaling that presented by the court during the festivals. On the other hand, the present denuded state of the reliefs makes it easier for us to appreciate their highly refined sculptural style. The cutting of the stone, both in the subtly modeled surfaces and the crisply chiseled details, is technically superb. Although they may have been inspired by Assyrian reliefs (FIGS. 2-24, 2-25, and 2-26), these Persian reliefs are strikingly different in style. The forms are more rounded and their projection from the background greater; there is less emphasis on such details as straining sinews and bulging muscles; and, most important perhaps, the figures seem organically more unified, as the torsos are now shown in natural side view and are thus more convincingly related to heads and legs. The supposition that most of these modifications of traditional formal elements are the result of Greek (Ionian) influence becomes almost a certainty when we note how the garments worn by the figures have been stylized in accordance with Greek Archaic practice (see Chapter Five). Despite the modifications, the Persepolis reliefs represent a triumph of Near Eastern formality in art. Their purpose and function, to glorify the king in a manner both decorative and monumental, is fulfilled most successfully.

Craft Art

Love for well-ordered forms enabled the designers to create, on a vast scale, a rich and unified setting for official ceremonials. But the Persians could also work successfully on a much smaller scale. They were excellent goldsmiths and silversmiths; the example shown, a jar handle in the form of a winged ibex (FIG. 2-34), typifies their exquisite and enduring art. Made of silver inlaid with gold, the ibex rears up on a palmette growing from the head of a satyr. The leap of the lithe body rises into the higher leap of the horns, and the suave curves of the wings smooth the motion. All that is needed of truth to nature is here, and none of it intrudes upon the effortless play of fancy.

As with most elements of Persian art, it is not difficult to trace the genesis of this winged ibex. Although the animal's body has regained its organic unity, probably through Mesopotamian influence, its original source of inspiration is to be found among the Luristan bronzes. Luristan, a mountainous region to the east of the Mesopotamian valley, inhabited at different times by Kassites, Medes, and other seminomadic tribes, was the home of a flourishing bronze industry that reached its peak during the eighth and seventh centuries B.C. It produced a variety of

2-32 Palace of Darius, Persepolis, *c.* 500 B.C.

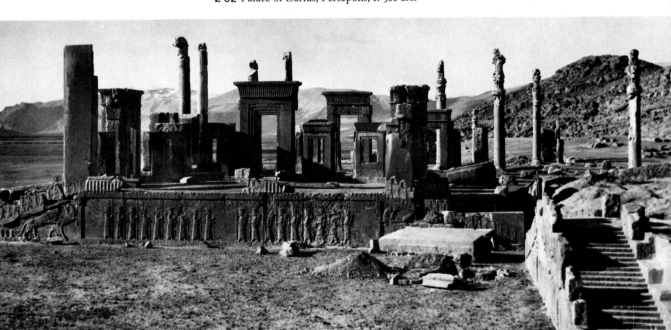

portable objects, such as cups, bowls, weapons, bridles, and articles of personal adornment that, collectively, are referred to as nomad's gear. While we do not know by and for whom these objects were made, they form a homogeneous group that is rooted in an old and widespread tradition whose exponents delighted in working with animal forms. This so-called animal style may have originated in the Luristan region; at any rate it spread over much of the ancient world, from the Asiatic steppes to central and western Europe. The Luristan bronzes are characterized by a high degree of abstraction that converts the representations of animals into purely decorative devices. In the handle of the ceremonial cauldron illustrated (FIG. 2-35), the two rearing ibexes make interlocking arcs that echo in linear form

the three-dimensional shape of the vessel to which they are attached. Although wingless, their pose, attitude, and purpose leave little room for doubt that they are the forerunners of the Persian ibex. And, incidentally, the source of inspiration for the Persian animal's wings seems to appear in the embossed decoration of the bowl, where the Luristan artist has boldly copied Assyrian winged bulls and sacred emblems (in Assyrian style and technique).

Eclecticism of Persian Art

Persian art borrowed from so many sources besides Assyria and Luristan that it has been criticized as overly eclectic—that is, as being derivative and lacking originality. A superficial

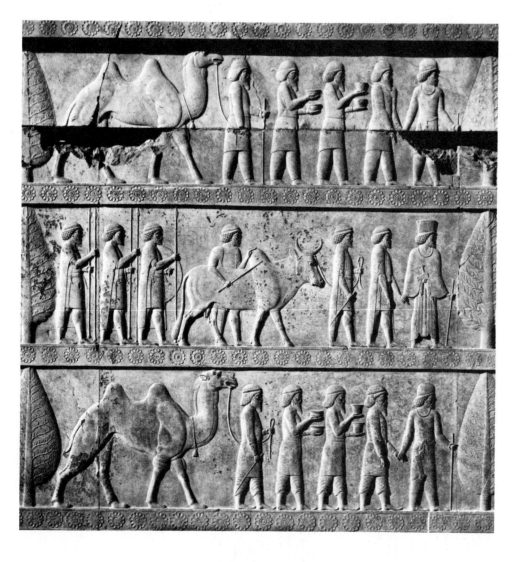

2-33 *Subjects Bringing Gifts to the King*, detail from the stairway to the Royal Audience Hall, Persepolis, *c.* 500 B.C. Limestone.

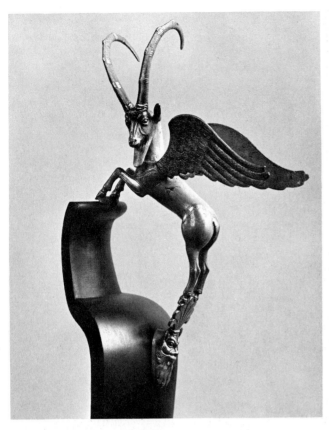

2-34 Jar handle in the form of a winged ibex, Persia, fifth to fourth centuries B.C. Silver inlaid with gold, approx. 10½" high. Louvre, Paris.

2-35 Ritual cauldron, Luristan, eighth century B.C. Bronze, approx. 9" high. Cincinnati Art Museum, The Mary Hanna Fund.

survey of Persian art might indeed leave such an impression. [The platforms of Persian palaces are of Mesopotamian, the guardian figures of Assyrian origin, the machinelike precision in the carving of details is reminiscent of Assyrian relief sculpture, the columned halls may have been influenced by Egyptian or Median models, and the fluting of columns is derived from Greek (Ionian) practice.] And yet, the manner in which these various elements have been combined produces an ensemble that is quite new and different from the art of those nations from which they may derive. A Persian column cannot be mistaken for either an Egyptian or a Greek one, and nothing like the Persian apadana has been found in earlier architecture.

Prior to their conquest of the Near East, the Persians' art had consisted mainly of the small-scale nomad's gear. Their monumental art was created "on the spur of the moment," one might say, when they found themselves masters of the Near East and heirs to its rich culture. To glorify and eternalize their military and political achievements the Persians not only adopted those features of foreign and conquered cultures that seemed to serve this purpose but also brought into the country the artisans who could best realize their ambitious projects. A building inscription at Susa names Ionians, Sardians, Medes, Egyptians, and Babylonians among the workmen who built and decorated the palace. But under the single-minded direction of its Persian masters this mixed crowd with a widely varied cultural and artistic background created a new and coherent style that was perfectly suited to express Persian imperial ambitions. A court style, like that of Louis XIV over two millennia later, it compelled its contributors into a synthesis that was to remain remarkably uniform during the 200-year reign of the Achaemenid dynasty.

The Art of Egypt

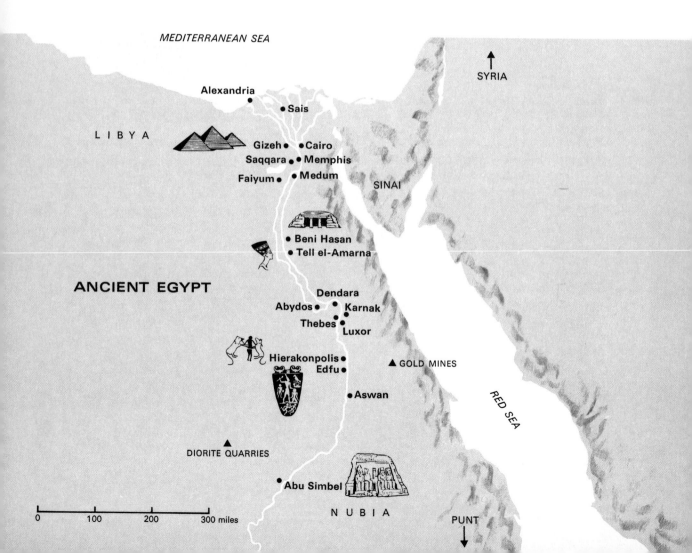

MEDITERRANEAN SEA

SYRIA

Alexandria

Sais

LIBYA

Gizeh • Cairo
Saqqara • Memphis
Faiyum • Medum

SINAI

• Beni Hasan
• Tell el-Amarna

ANCIENT EGYPT

Dendara
Abydos • • Karnak
Thebes • • Luxor

Hierakonpolis •
Edfu •

▲ GOLD MINES

• Aswan

RED SEA

▲
DIORITE QUARRIES

• Abu Simbel

N U B I A

PUNT

0 100 200 300 miles

OVER 2000 YEARS AGO the admiring Herodotus wrote: "Concerning Egypt itself I shall extend my remarks to a great length, because there is no country that possesses so many wonders, nor any that has such a number of works which defy description." He added a little later: "They [the Egyptians] are religious to excess, far beyond any other race of men." Men of discernment, aware of the profusion of monuments left to the world by the ancient Egyptians, have long been in agreement with these observations. While the Egyptians built their dwellings of impermanent materials, they made their tombs (which they believed would preserve their bodies forever), their temples to the immortal gods, and the statues of their equally immortal god-king of imperishable stone. The cliffs of the Libyan and Arabian deserts and the Nile flowing between them could represent, respectively, the timelessness of the Egyptian world and the endless cycles of natural process. Religion and permanence—these are the elements that characterize their solemn and ageless art and express the unchanging order that for the ancient Egyptians was divinely ordained.

Even more than the Tigris and Euphrates, the Nile defined the cultures that lived by virtue of its presence. Originating deep in Africa, the

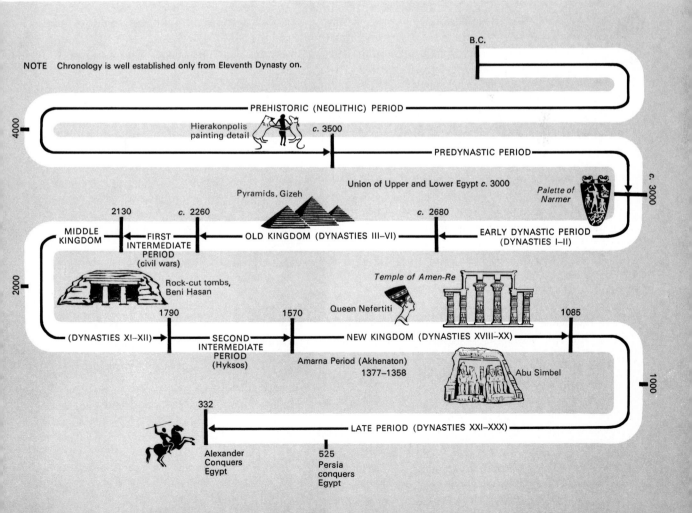

NOTE Chronology is well established only from Eleventh Dynasty on.

B.C.

PREHISTORIC (NEOLITHIC) PERIOD

4000

Hierakonpolis painting detail c. 3500

PREDYNASTIC PERIOD

Union of Upper and Lower Egypt c. 3000

c. 3000

Palette of Narmer

Pyramids, Gizeh

2130 c. 2260 c. 2680

MIDDLE KINGDOM FIRST INTERMEDIATE PERIOD (civil wars) OLD KINGDOM (DYNASTIES III–VI) EARLY DYNASTIC PERIOD (DYNASTIES I–II)

2000

Rock-cut tombs, Beni Hasan

Temple of Amen-Re

Queen Nefertiti

1790 1570 1085

(DYNASTIES XI–XII) SECOND INTERMEDIATE PERIOD (Hyksos) NEW KINGDOM (DYNASTIES XVIII–XX)

Amarna Period (Akhenaton) 1377–1358

Abu Simbel

1000

332

Alexander Conquers Egypt

525 Persia conquers Egypt

LATE PERIOD (DYNASTIES XXI–XXX)

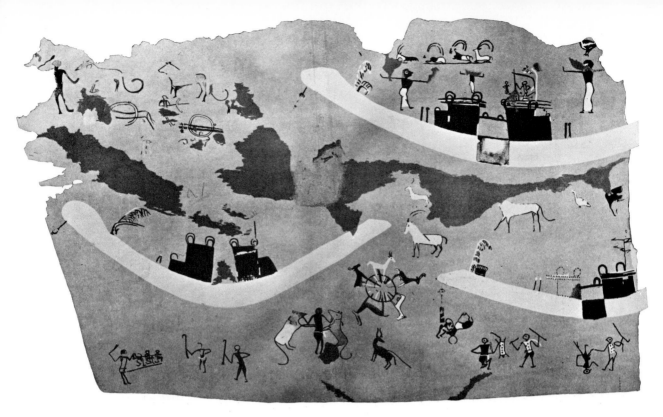

3-1 *Men, Boats, and Animals*, wall painting from a shrine at Hierakonpolis, *c.* 3500 B.C. (After Quibel.)

world's longest river descended through many cataracts to sea level in Egypt, where, in annual flood, it deposited rich soil brought thousands of miles from the African hills. Hemmed in by the narrow valley, which even in its widest parts reaches a width of only about twelve miles, the Nile flows through regions that may not have a single drop of rainfall in a decade. Yet, crops grow luxuriantly from the fertilizing silt, as they did in ancient times. Game also abounded then, and the great river that made life possible entered the consciousness of the Egyptians as a god and as a symbol of life.

In predynastic, or prehistoric, and pharaonic times the river held wider sway than it does today. Egypt was a land of marshes dotted with island ridges, and what is now arid desert valley was grassy parkland well suited for grazing cattle and hunting. Amphibious animals swarmed in the marshes and were hunted through tall forests of papyrus and rushes. The fertility of Egypt was proverbial, and, at the end of its history, when Egypt had become a province of the Roman empire, it was the granary of the Mediterranean world.

Before settled communities could be built along the Nile's banks, however, it was necessary to control the annual floods. This was done with dams, and the communal effort needed for construction of them provided the basis for the growth of an Egyptian civilization, just as the irrigation projects in the Mesopotamian valley had furnished the civilizing impetus for that region a few centuries earlier.

In the Middle Ages, when the history of Egypt was thought of as part of the history of Islam, its ancient reputation as a land of wonders and mystery lived on in more or less fabulous report. Until the later eighteenth century, its undeciphered writing and its exotic monuments were regarded as treasures of occult wisdom locked away from any but those initiated in the mystic arts. Scholars knew something of the history of Egypt from references in the Old Testament, from the unreliable reports of travelers ancient and modern, and from a history of Egypt written in Greek by an Egyptian named Manetho in the second century B.C. Manetho described the succession of pharaohs, dividing them into the still useful groups we

call dynasties; but his chronology is very inaccurate and his account untrustworthy.

Scientific history, or at least scientific archeology, had its start when, at the end of the eighteenth century, modern Europe rediscovered Egypt; Egypt became the first subject of archeological exploration, and was followed by the uncovering of the ancient civilizations of the Tigris and the Euphrates. In 1799, Napoleon Bonaparte, on a military expedition to Egypt, took with him a small troop of scholars, linguists, antiquarians, and artists. The chance discovery of the famed Rosetta Stone gave the eager scholars what they wanted, a key to the till then undeciphered Egyptian hieroglyphic writing. The stone bears an inscription in three sections, one in Greek, which was easily read, one in *demotic* (people's) Egyptian, and one in priestly hieroglyphic. It was at once suspected that the inscription was the same in all three sections and that with the Greek as a key the other two could be deciphered. More than twenty years later, after many false starts, a young linguist, Jean François Champollion, deduced that the hieroglyphs were not simply pictographs but the signs of a once-spoken language—vestiges of which survived in Coptic—that had relatively recently been written in Greek characters. Champollion's feat made him a kind of Columbus of the new science of archeology, as well as of that special branch within it, Egyptology. Those who followed Champollion, like Auguste Mariette and Gaston Maspero, sought to build classified collections and to protect Egyptian art from the unscrupulous. Men like Flinders Petrie introduced techniques of excavation, preparing the ground for the development of sound methods for validating knowledge of Egyptian civilization.

Ideally the foundation of archeological knowledge is a reliable chronology. Yet, as the body of archeological evidence enlarges and new scientific methods of dating are developed, the chronology must change to accommodate them. Sometimes what was thought close to certain turns problematical; sometimes what was guesswork or speculation suddenly becomes probable. Because this is more often the case the further back one goes in time, the predynastic beginnings of Egyptian civilization are chronologically vague, as are those of Mesopotamia. Some time around 3500 B.C. a people of native African stock may have been exposed to influences from Mesopotamia, or it is possible that, as in Sumer, the sudden cultural development may have been due to an actual incursion of a new people. A wall painting from the late predynastic period, found in a shrine at Hierakonpolis in Upper Egypt (FIG. 3-1), represents men, animals, and boats in a lively, helter-skelter fashion. The boats, symbolic of the journey across the Nile of life and death, are painted white and seem to carry a cargo of tombs mourned over by women. Also shown are a heraldic grouping of two animals (lions?) on either side of a human figure, many figures of gazelles, and, in the lower right corner, men fighting. The heraldic group, a compositional type usually associated with Mesopotamian art, suggests that by this time influences from Mesopotamia not only had reached Egypt but had already made the thousand-mile journey upstream. The stick-figures and their apparently random arrangement remind one of the Mesolithic rock paintings from the Spanish Levant and North Africa, the style of which flourished also in the central Sahara and may have been another impetus to the development of Egyptian art.

The Hierakonpolis mural is the earliest known representative of that millennia-long tradition of painting that reveals to us the funerary customs of Egypt, so much at the center of Egyptian life. Most paintings are found in tombs and provide the principal archeological evidence for the historical reconstruction of Egyptian civilization. Religion pervaded that civilization. In Herodotus' words, the Egyptian was "religious to excess," and his concern for immortality amounted to near-obsession; his overall preoccupation in this life was to ensure his safety and happiness in the next. To this preoccupation we owe the major part of the monuments the Egyptians left behind them.

The sharp distinction between body and soul, long familiar to Christianity and other later religions, was not made in the religion of the Egyptians. Rather they believed that from birth one was accompanied by a kind of other self, the *ka*, which, upon the death of the fleshly body,

could inhabit the corpse and live on. For the ka to live securely, however, the dead body must remain as nearly intact as possible; to see that it did, the Egyptians developed to a high art the technique of embalming, their success in which is made evident by numerous well-preserved mummies of kings (like Rameses II), princes, and nobles, as well as of some common persons. The first requirement for immortality, mummification, was followed by others: Food and drink had to be provided, as well as clothing, utensils, and all the apparatus of life, so that nothing would be lacking that had been enjoyed on earth. Images of the deceased, sculptured in the round and placed in shallow recesses, guaranteed the permanence of his identity by providing substitute dwelling places for the ka in case the mummy disintegrated. Wall paintings (for the use and delectation of the ka) recorded with great animation and detail the recurring round of human activities, a cycle of "works and days" that changed with the calendar and the seasons. The Egyptians hoped and expected that the images and inventory of life, set up and collected within the protecting, massive stone walls of the tomb, would ensure immortality; but almost from the beginning of the elaborate interments, the thorough plundering of tombs became a profitable occupation. Only one royal burial place remained intact, that of King Tutankhamen of the Eighteenth Dynasty; its discovery, in 1924, revealed to a fascinated world the full splendor of a pharaoh's funerary assemblage.

THE EARLY DYNASTIC PERIOD AND THE OLD KINGDOM

Egypt has been known as the Kingdom of the Two Lands, a reference to its very early physical and political division into Upper Egypt and Lower Egypt. The upper land was dry and rocky and rustic in culture; the lower land, opulent, urban, and populous. Even in predynastic times there must have been conflict between the two, for the ancient Egyptians began the history of Egypt, as we do, with the forcible unification of the two lands by a certain Menes.

The "Palette of Narmer"

Menes is thought to be King Narmer, whose image we find on a slate slab from Hierakonpolis (FIG. 3-2). The slab, or palette as it is called, was

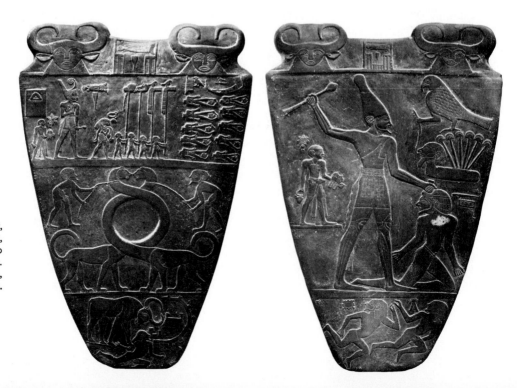

3-2 *Palette of Narmer*, front and back, Hierakonpolis, c. 3000 B.C. Slate, 25" high. Egyptian Museum, Cairo.

originally used as a tablet on which eye makeup (to protect the eyes against sun-glare and irritation) was prepared. The *Palette of Narmer* is an elaborate, formalized version of a utilitarian object common in the predynastic period. Its importance is great, not only as a historical document that records the unification of the two Egypts and the beginning of the dynastic period, but as a kind of early blueprint of the formula of figure representation that was to rule Egyptian art for some 3000 years. On the palette's back, the king, wearing the high, bowling-pin-shaped crown of Upper Egypt, is about to slay an enemy as a sacrifice. Before him a hawk, symbol of the sky god, Horus, protector of the king, takes into captivity a man-headed land from which papyrus grows (a symbol for Lower Egypt). Below the king are two fallen enemies and, above, two heads of Hathor, a goddess favorably disposed to Narmer. The other side of the palette shows Narmer wearing the cobra crown of Lower Egypt and reviewing a pile of the beheaded enemy. In both cases it is significant that the king, towering over his own men and the enemy—by virtue of his superior rank—performs his ritual task alone. Historical narrative as we find it in Mesopotamian reliefs (see the *Victory Stele of Naram-Sin*, FIG. 2-17) is not of primary importance in this work; what is important is the concentration upon the king as a deified figure, isolated from all ordinary men and far above them and alone responsible for his triumph. As early as the Narmer palette (about 3000 B.C.) we see evidence of this Egyptian convention of thought, of art, and of state policy—namely, that the kingship is divine, that its prestige is one with the prestige of the gods.

If what belongs to the gods and to nature is unchanging and if the king is divine then his attributes must be eternal. We have already seen that, in Mesopotamian art, the ever changing natural shapes are formalized into simple poses, attitudes, and actions. The same thing happens in Egypt, even though the instinct for convention leads to a somewhat different style. In the figure of Narmer we find the stereotype of kingly transcendence that, through several slight variations, will be repeated in subsequent representation of all Egyptian dynasts but Akhenaton (see below) in the fourteenth century. The king is seen in a perspective that combines the profile views of head, legs, and arms with the front views of eyes and torso. While the proportions of the figure will change, the method of its representation will become a standard for all later Egyptian art. Like a set of primordial commandments, the *Palette of Narmer* sets forth the basic laws that will govern art along the Nile for thousands of years. In the Hierakonpolis painting (FIG. 3-1) figures had been scattered across the wall more or less haphazardly; here a surface has been subdivided into a number of bands, and the pictorial elements have been inserted in a neat and orderly way into their organized setting. The horizontal lines that separate the bands also define the ground that supports the figures—a mode that will persist in hundreds of acres of Egyptian wall paintings and reliefs.

Three centuries later we find the basic conventions of Egyptian figure representation that were fixed in the *Palette of Narmer* refined and systematized on a carved wooden panel representing Hesire, a high official from the court of King Zoser (FIG. 3-3). The figure's swelling forms have been modeled with greater subtlety and its proportions have been changed to a broad-shouldered, narrow-hipped, heroic ideal; the artist uses the conceptual approach (see Chapter Two, p. 41) rather than the optical, representing what he knows to be true of the object instead of some random view of it and showing its most characteristic parts at right angles to the line of vision. This conceptual approach expresses a feeling for the constant and changeless aspect of things and lends itself to systematic methods of figure construction (FIG. 3-4). Although perhaps not quite so simple as his description of it, the system has been explained by Erwin Panofsky as follows:

With its more significant lines permanently fixed on specific points of the human body, the Egyptian network [of equal squares] immediately indicates to the painter or sculptor how to organize his figure: he will know from the outset that he must place the ankle on the first horizontal line, the knee on the sixth . . . and so on. . . . It was, for instance, agreed that in a [lunging] figure . . . the length of pace . . . should amount

3-3 *Panel of Hesire*, Saqqara, *c.* 2750 B.C. Wood, 45″ high. Egyptian Museum, Cairo.

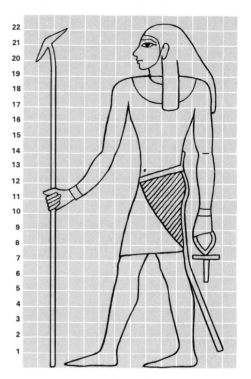

3-4 The "Later Canon" of Egyptian Art. (After Panofsky.)

to 10½ units, while this distance in a figure quietly standing was set at 4½ or 5½ units. Without too much exaggeration one could maintain that, when an Egyptian artist familiar with this system of proportion was set the task of representing a standing, sitting, or striding figure, the result was a foregone conclusion once the figure's absolute size was determined.[1]

[1] Erwin Panofsky, *Meaning in the Visual Arts* (Garden City, N.Y.: Doubleday, 1955), pp. 58–61.

In addition to recording an important historical event and to laying down ground rules for the pictorial arts, the *Palette of Narmer* also illustrates several stages in the development of Egyptian writing. The story of Narmer's victories is represented in the different registers with varying degrees of symbolism. Straight pictorial narrative is used to show the king following his standard-bearers in triumphal procession and inspecting the bodies of his slain enemies. This simple picture-writing becomes symbolic when, in a bottom register, the king is shown as a bull breaking down the walls of an enemy fortress. The symbolism becomes more abstract in the pile of decapitated foes: Here each body, its severed head neatly placed between its legs, probably is a numerical symbol representing a specific number of fallen enemies. Finally, in the signs appearing near the heads of the more important figures, pictographs take on phonetic values, as the names of the respective individuals have been written in true hieroglyphs.

Architecture

Similar principles of permanence and regularity appear in the design of the Egyptian tomb, that symbol of the timeless, the silent house of the dead. We find its standard shape in the *mastaba* (FIG. 3-5). The mastaba (Arabic for "bench") is a rectangular brick or stone structure with battered (sloping) sides erected over a subterranean tomb chamber that was connected with the outside by a shaft. The form was probably developed from mounds of earth or stone that covered earlier tombs. It is significant that in Mesopotamia there was relative indifference to the cult of burial and to the permanence of the tomb, while in Egypt such matters are considered to be of the first importance.

About 2750 B.C. the Stepped Pyramid of King

1. Chapel
2. False door
3. Shaft into burial chamber
4. Serdab (chamber for statue of deceased)
5. Burial chamber

3-5 Plan and section of a mastaba.

Zoser of the Third Dynasty (FIG. 3-6) was raised at Saqqara, the ancient necropolis (city of the dead) of Memphis. Possibly Egypt's oldest stone building, it was the first monumental royal tomb. In form a kind of compromise between the mastaba and the later "true" pyramids at Gizeh, it is in fact a piling of mastabas of diminishing size one upon another, forming a structure resembling the great ziggurats of Mesopotamia. Unlike them, Zoser's pyramid is a tomb, not a temple, and is elevated above the funerary city arranged around it.

A tomb such as Zoser's had a dual function: to protect the mummified king and his possessions and to symbolize by its gigantic presence his absolute, godlike power. This structure, with its temples (now thought to be a medical shrine), complex of chambered terraces, and great courtyard, was the work of Imhotep, the first artist of recorded history. Grand vizier to King Zoser and a man of legendary powers, he was celebrated in the ancient world not only as an architect but as a wise man, wizard, physician ("the father of medicine"), priest, and scribe—a kind of universal genius who later came to be worshiped as a deity.

At Gizeh, across the Nile from modern Cairo, are three pyramids (FIG. 3-7) of pharaohs of the Fourth Dynasty—Khufu (the Greek Cheops), Khafre (Chephren), and Menkure (Mykerinus). Built after 2700 B.C., they have been associated with mystery and with "hidden" knowledge and have served as symbols for many things—primeval wisdom, Egypt itself, eternal stability, and the arts of magic. The pyramids of Gizeh represent the culmination of an architectural evolution that began with the mastaba. They did not evolve out of necessity; kings could have gone on indefinitely piling mastabas one upon another to make their weighty tombs. Rather, it has been suggested that when the kings of the Third Dynasty moved their permanent residence to Memphis they came under the influence of nearby Heliopolis. This city was the seat of the powerful cult of Re, the sun god, whose fetish was a pyramidal stone, the *ben-ben*. By the Fourth Dynasty the pharaohs considered themselves the sons of Re and, hence, his incarnation on earth. For the pharaohs, then, it would have been only

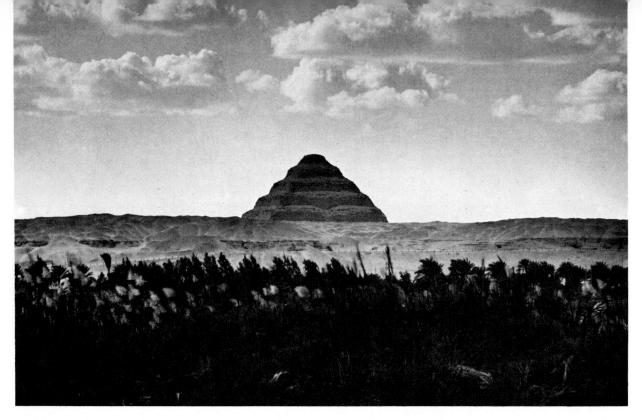

3-6 Stepped Pyramid of King Zoser, Saqqara, *c.* 2750 B.C.

3-7 Great Pyramids of Gizeh: Menkure, *c.* 2575 B.C.; Khafre, *c.* 2600 B.C.; Khufu, *c.* 2650 B.C.

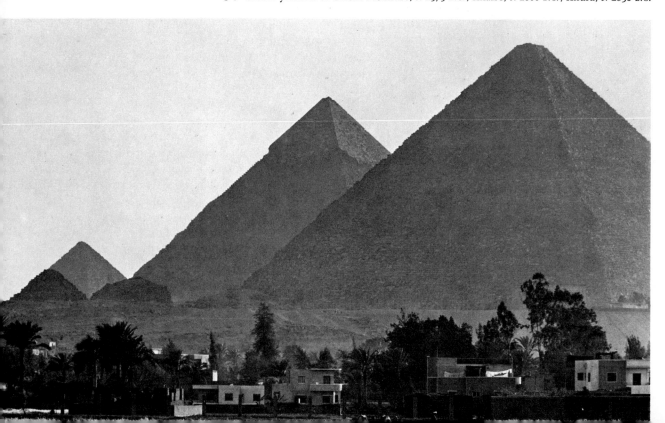

c. 3000 B.C.		c. **2680**	c. 2600	c. 2500		c. **2260**	2130		1790 B.C.
Palette of Narmer		Great Pyramids of Gizeh	Tomb of Ti						Rock-cut tombs, Beni Hasan
EARLY DYNASTIC PERIOD			OLD KINGDOM			CIVIL WARS	MIDDLE KINGDOM		
DYNASTIES I–II			DYNASTIES III–VI				DYNASTIES XI–XII		

a step from the belief that the spirit and power of Re resided in the pyramidal *ben-ben* to the belief that their divine spirits and bodies would be similarly preserved within pyramidal tombs.

Is the pyramid form, then, an invention inspired by a religious demand rather than the result of a formal evolution? We need not decide here. Our concern is rather with the remarkable features of the Fourth Dynasty pyramid. Of the three at Gizeh, that of Khufu is the oldest and largest. Except for the galleries and burial chamber it is an almost solid mass of limestone masonry, a stone mountain built on the same principle as the Stepped Pyramid of Zoser, the interior spaces in plan and elevation being relatively tiny, as if crushed out of the scheme by the sheer weight of stone (FIG. 3-8). The limestone was quarried in the eastern Nile cliffs and floated across the river during the seasonal floods. After the masons finished cutting the stones, they marked them with red ink to indicate the place of each in the structure. Then great gangs of laborers dragged them (the wheel was not yet known) up temporary ramps and laid them course upon course. Finally the pyramid was surfaced with a casing of pearly white limestone, cut with such nicety that the eye could scarcely detect the joints. A few casing stones can still be seen in the cap that covers the Pyramid of Khafre, all that remain after many centuries during which the pyramids were stripped to supply limestone for the Islamic builders of Cairo. The immensity of the Pyramid of Khufu is indicated by some dimensions in round numbers: At the base the length of one side is 775 feet and its area some 13 acres; its present height is 450 feet (originally 480 feet). According to Petrie, the structure contains about 2,300,000 blocks of stone, each of which averages $2\frac{1}{2}$ tons in weight; it has been calculated that this enormous number of blocks would be enough to build a low wall along the perimeter of modern France. Yet it is not alone huge size and successful engineering that consti-

tute the art of this structure but its formal design —the proportions and immense dignity so consistent with its funerary and religious function and so well adapted to its geographical setting: The four corners are oriented to the four points of the compass, and the grave and simple mass dominates the flat landscape to the horizon. The ironic outcome of the stupendous effort may be read from the cross section (FIG. 3-8). The dotted lines at the base of the structure indicate the path cut into the pyramid by ancient grave robbers. Unable to locate the carefully sealed and hidden entrance, they started some forty feet above the the base and tunneled into the structure until they intercepted the ascending corridor. Many royal tombs were plundered almost as soon as the funeral ceremonies had ended; the very conspicuousness of the pyramid was an invitation to despoilment. The hard lesson was learned by the successors of the Old Kingdom pyramid-builders; they built few pyramids, and those were relatively small and inconspicuous.

3-8 Section of the Pyramid of Khufu. (After Hoelscher.)

1. Silhouette with original facing stone
2. Thieves' tunnels
3. Entrance
4. Grand gallery
5. King's chamber
6. So-called queen's chamber
7. False tomb chamber
8. Relieving blocks
9. Airshafts

The Early Dynastic Period and the Old Kingdom　　81

1. Pyramid of Khafre
2. Mortuary temple
3. Covered causeway
4. Valley temple
5. Great Sphinx
6. Pyramid of Khufu
7. Pyramids of the royal family and mastabas of nobles

3-9 Reconstruction of the Pyramids of Khufu and Khafre. (After Hoelscher.)

From the remains around the middle pyramid at Gizeh, that of Khafre, we can reconstruct an entire pyramid complex (FIG. 3-9). This consisted of the pyramid itself, within or below which was the burial chamber; the chapel, adjoining the pyramid on the east side, where offerings were made and ceremonies performed and where were stored cloth, food, and ceremonial vessels; the covered causeway leading down to the valley; and the valley temple, or vestibule of the causeway. Beside the causeway and dominating the temple of Khafre rose the Great Sphinx, carved from a spur of rock to commemorate the pharaoh. The head is often referred to as a portrait of Khafre, although the features are so generalized that little individuality can be discerned. In size it is unique in ancient sculpture.

The valley temple of the Pyramid of Khafre (FIG. 3-10) was built on the post-and-lintel system —upright supports, or posts, with horizontal beams, or lintels, resting on them. Both posts and lintels were huge, rectangular, red-granite monoliths, finely proportioned, skillfully cut and

polished, and devoid of decoration. Alabaster slabs covered the floor, and seated statues, the only embellishment of the temple, were ranged along the wall. The interior was lighted by a few slanting rays filtering in from above. Although the Egyptians knew the arch and the vault and had used them occasionally in predynastic tombs, they rarely used them again after about 3000 B.C., the beginning of the dynastic period. Egyptian architects preferred the static forms of the post-and-lintel system, which, if cast into the heavy, massive shapes of the Khafre temple, express perhaps better than any other architectural style the changeless and eternal.

Sculpture

We have already noted that in the tombs sculpture in the round served the important function of creating an image of the deceased that could serve as an abode for the ka should the mummy be destroyed. For this reason an interest in portrait likenesses developed early in Egypt.

Hence, too, permanence of style and material were essential. Though wood, clay, and bronze were used, mostly for images of those not of the royal or noble classes, stone was the primary material: limestone and sandstone from the Nile cliffs, granite from the cataracts of the Upper Nile, and diorite from the desert.

A seated statue of Khafre (FIG. 3-11) was one of a series of similar statues carved for Khafre's temple of the Sphinx. These statues, the only organic forms in the geometric severity of the temple structure, with its flat-planed posts and lintels, must have created a striking atmosphere of solemn majesty. Khafre is seated on a throne on the base of which is carved the intertwined lotus and papyrus, symbol of united Egypt. Sheltering his head are the protecting wings of the hawk, symbol of the sun, indicating Khafre's divine status as son of Re. He wears the simple kilt of the Old Kingdom and a linen headdress that covers his forehead and falls in pleated folds over his shoulders. The portrait of the king is strongly individualized yet permeated with an imperturbable calm, reflecting the enduring power of the pharaoh and of kingship in general. This effect, common to royal statues of the ka, is achieved by devices of form and technique that we can still admire. The figure has great compactness and solidity, with few projecting, breakable parts; the form manifests the purpose—to last for eternity. The body is attached to a back slab, the arms are held close to the torso and thighs, the legs are close together and attached to the throne by stone webs. Like Mesopotamian statues, the pose is frontal, rigid, and bisymmetrical. This repeatable scheme arranges the parts of the body so that they are presented in a totally frontal projection or entirely in profile. As Panofsky remarked:

> . . . we can recognize from many unfinished pieces that even in sculpture the final form is always

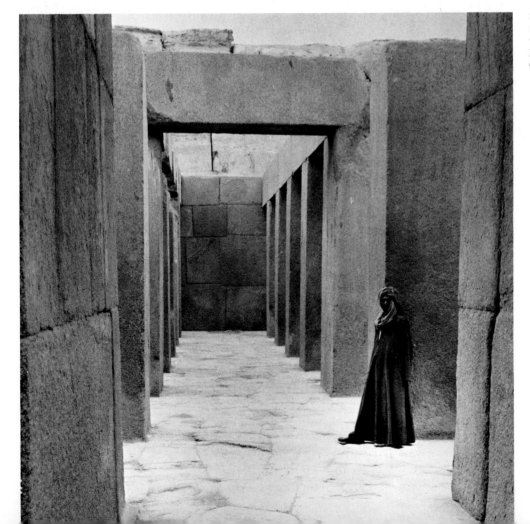

3-10 Middle aisle of the hall of pillars, valley temple of the Pyramid of Khafre, Gizeh, c. 2600 B.C.

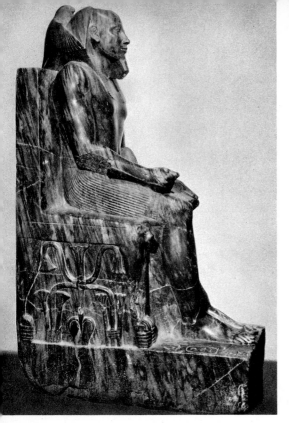
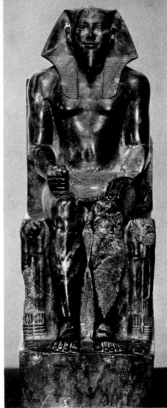

3-11 *Khafre*, side and front, Gizeh, c. 2600 B.C. Diorite, 66″ high. Egyptian Museum, Cairo.

determined by an underlying geometrical plan originally sketched on the surfaces of the block. It is evident that the artist drew four separate designs on the vertical surfaces of the block ... that he then evolved the figure by working away the surplus mass of stone so that the form was bounded by a system of planes meeting at right angles and connected by slopes.... there is a sculptor's working drawing ... that illustrates the mason-like method of these sculptors even more clearly: as if he were constructing a house, the sculptor drew up plans for his sphinx in frontal elevation, ground plan and profile elevation ... so that even today the figure could be executed according to plan.[2]

This subtractive method of "working away the surplus ... stone" accounts for the blocklike look of the standard Egyptian statue, which strongly differs from the Mesopotamian cylindrical or conical shape seen, for example, in the Gudea statues (FIG. 2-18). The hardest stone was used to ensure the permanence of the image—and Egypt, again unlike Mesopotamia, is rich in

[2] Panofsky, *op. cit.*, pp. 58–59.

stone. Even so, the difficulty of working granite and diorite with bronze tools (much of the finishing had to be done by abrasion) made production too expensive for all but the wealthiest. The hard and costly stones were rarely painted, especially if the stone had a grain that could be brought out by polishing.

As the figure was cut to plan, so were its proportions determined beforehand. A canon of ideal proportions, designated as appropriate for the representation of imposing majesty, was accepted and applied quite independently of optical fact. The generalized anatomy persisted in Egyptian statuary even into the Ptolemaic age, when Greek influence might have been expected to shift it toward realism. The Egyptian sculptor seems to have been indifferent to realistic representation of the body, preferring to strive for fidelity to nature in the art of portraiture, at which Egyptians have not been surpassed.

An example of their skill is a so-called reserve (duplicate, or spare) head of a prince of the family of Khufu (FIG. 3-12). Attention is given only to the execution of the face, which shows the union of the formal with the realistic that gives distinc-

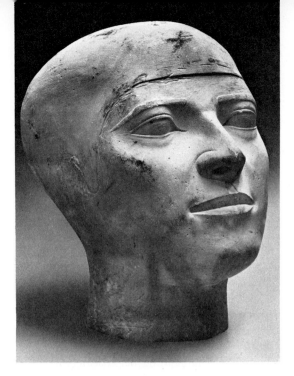

3-12 Reserve head of a prince, Gizeh, *c.* 2600 B.C. Limestone, life-size. Egyptian Museum, Cairo.

covered with painted canvas or plaster, a common procedure when soft or unattractive woods were used. Sensitive to the intrinsic beauty of the material with which he worked, the Egyptian sculptor treated hard woods like hard stones: He polished but did not paint them.

Painting and Relief

The scenes in painted limestone relief that decorate the walls of the tomb of an Old Kingdom official, Ti, typify the subjects favored by the patrons; most often they are of agriculture and hunting (FIG. 3-14), activities that represent the fundamental human concern with nature and that are associated with the provisioning of the ka in the hereafter. Ti, his men, and his boats

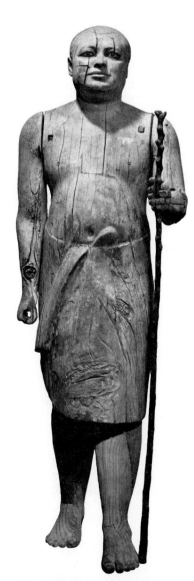

3-13 *Sheikh el Beled*, from his tomb at Saqqara, *c.* 2500 B.C. Wood, approx. 43″ high. Egyptian Museum, Cairo. (Partially restored.)

tion to so many portrait busts of its type. Reserve heads were not placed in the chamber of the ka, and their purpose is not understood. This head displays the extraordinary sensitivity of Old Kingdom portraiture. The personality—sharply intelligent, vivacious, and alert—is read by the sculptor with a penetration and sympathy seldom achieved in the history of sculpture.

In the history of art, especially portraiture, it is almost a rule that formality is relaxed and realism increased where the subject is a person of lesser importance. The famous wood statue of Ka-Aper (or Sheikh el Beled) is a case in point (FIG. 3-13). The work is a lively representation of a man whose function was to serve the king in the spirit world as he had in life. The face is startlingly alive, an effect that is heightened by eyes of rock crystal. The sheikh stands erect in conventional frontal pose, left leg advanced. His paunchy physique lacks the heroic and idealized proportions one finds in representations of royalty and nobility; he was, after all, only a minor official. The wood medium permitted the artist to omit the backslab and try a freer pose. Actually, what we see is the wood core that was originally

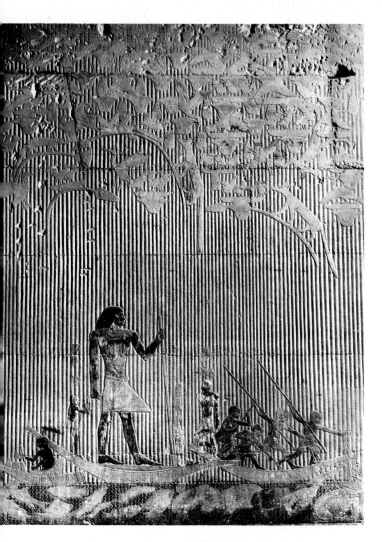

move slowly through the marshes, hunting hippopotamuses, in a dense growth of towering papyrus. The slender, reedy stems of the plants are delineated with repeated fine grooves that fan out gracefully at the top into a commotion of frightened birds and stalking beasts. Beneath the boats, the water, signified by a pattern of wavy lines, is crowded with hippopotamuses and other aquatic fauna. Ti's men seem frantically busy with their spears, while Ti himself, looming twice their size, stands impassive and aloof in the formal stance that we have seen in the figure of Hesire (FIG. 3-3). The outsize and ideal proportions bespeak Ti's rank, as does the conventional pose, which contrasts with the realistically rendered activity of his diminutive servants and particularly with the precisely observed figures of the birds and animals among the papyrus buds.

A rare and fine example of Old Kingdom painting is the frieze called the *Geese of Medum* (FIG. 3-15). In the prehistoric art of the caves, the rock paintings, and the art of Mesopotamia, we admired the peculiar sensitivity of early artists to the animal figure. They seem to have had empathy with the nonhuman creature, what Keats called negative capability—the power almost to share the being of the animal and to feel as it feels.

The *fresco secco* technique used, in which the artist lets the plaster dry before he paints on it, lends itself to slow and meticulous work, encouraging the trained professional to take pains in rendering the image and expressing his exact knowledge of its subject. The delicate, prehensile necks of the geese, the beaks, the suppleness of

3-14 *Hippopotamus Hunt*, tomb of Ti, Saqqara, *c.* 2500 B.C. Painted limestone relief, approx. 48″ high.

3-15 *Geese of Medum*, *c.* 2600 B.C. Dry fresco, approx. 18″ high. Egyptian Museum, Cairo.

the bodies, and the animals' characteristic step and carriage are rendered with an exactitude and discernment that would elicit the admiration of an Audubon. The firm, strong execution of the figures is the work of an expert, with superbly trained eye and hand, probably conscious of his power and proud of it. It is probable, too, that religious motives mingled here with esthetic ones, for, after all, once a tomb was sealed no mortal eyes could ever be expected to see the paintings again. It must have been thought that in the darkness and silence the pictures worked their own spell, creating a force that would serve the ka eternally; something of the magic-working of the cave paintings seems to persist here.

The art of the Old Kingdom is the classic art of Egypt. Its conventions, definitively established, survived three millennia without major change. And the quality of Old Kingdom art at its best, though sometimes equaled, was never surpassed in later periods of Egyptian history.

THE MIDDLE KINGDOM

About 2300 B.C. the power of the pharaohs was challenged by ambitious feudal lords, and for about a century the land was in a state of civil unrest and near-anarchy. Eventually a Theban prince, Mentuhotep I, managed to unite Egypt again under the rule of a single king. In the Eleventh and Twelfth dynasties that followed (called the Middle Kingdom), art was revived, and a rich and varied literature appeared.

Rock-cut Tombs

Among the most characteristic remains of the Middle Kingdom are the rock-cut tombs at Beni Hasan (FIG. 3-16). One of the best preserved is the tomb of Khnumhotep, who boasted in an inscription of its elaborateness, saying that its doors were of cedar, seven cubits (about twenty feet) high. Expressing the characteristic Egyptian attitude toward the last resting place, he added:

> My chief nobility was: I executed a cliff-tomb, for a man should imitate that which his father does. My father made for himself a house of the *ka* in the town of Mernofret, of good stone of Ayan, in order to prepetuate his name forever and establish it eternally.

The rock-cut tombs of the Middle Kingdom largely replaced the Old Kingdom pyramid tombs. The immense cost and the futile effort to protect the king's mummy under a conspicuous and penetrable pyramid led to this new burial custom, in which tombs were hollowed out of the living rock at remote sites. Fronted by a shallow columned portico, the tombs contained the fundamental units of Egyptian architecture—portico or vestibule, columned hall, and sacred chamber (FIG. 3-17). The interior of the rock-cut

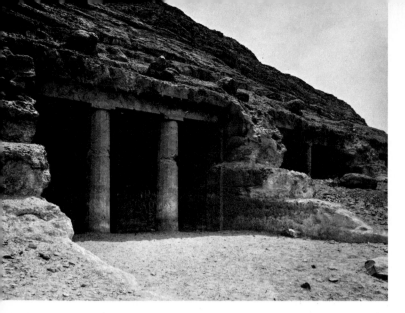

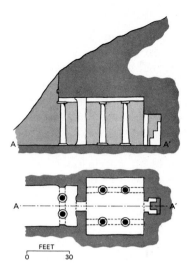

3-16 Rock-cut tombs, Beni Hasan, *c.* 1800 B.C.

3-17 Plan and section of a rock-cut tomb. (After Sir Banister Fletcher.)

tomb of Amenemhet I (FIG. 3-18) shows the hall, the columns of which serve no supporting function, being, like the portico columns, continuous parts of the rock fabric. (Note the broken column in the rear, suspended from the ceiling like a stalactite.) Tomb walls were decorated with paintings and painted reliefs as in former times, and the subjects were much the same.

Painting and Sculpture

A painting from the tomb of Khnumhotep (FIG. 3-19) shows servants feeding oryxes (antelopes), the domesticated pets of the Egyptian gentry. The artist here has made a daring attempt to present the shoulders and backs of both human figures in foreshortening. However, working within the rigid framework of convention, he simply joined their front and side views in an unusual combination. As a result the action reads convincingly enough, but the figures fall short of optical consistency.

In portrait sculpture of the Middle Kingdom a somewhat deepened perception of personality and mood can be noted, as shown in a partially damaged head thought to be of Amenemhet III or Sesostris III (FIG. 3-20). Although the head is small—only five inches high—and can be held in the palm of one's hand, it has the effect of a

life-sized representation. It is carved in obsidian, a hard stone that required great skill in cutting, grinding, and polishing. The stylized headdress, the strong modeling, and the accent on clearly defined planes identify it as Egyptian. The strong mouth, the drooping lines about the nose and eyes, and the shadowy brows show a determined ruler, who had also shared in the cares of the world, sunk in brooding meditation. The portrait is strangely different from the typical realistic and "public" Old Kingdom face, being personal, almost intimate, in its revelation of the mark of anxiety a troubled age might leave on the soul of a king.

THE HYKSOS AND THE NEW KINGDOM

This anxiety may have reflected premonitions of disaster. The Middle Kingdom, like that which had preceded it, disintegrated, and power passed to a line of migrant Semitic Asiatics from the Syrian and Mesopotamian uplands, called the Hyksos, or Shepherd Kings, who brought with them a new and influential culture and that practical instrument, the horse. The invasion and domination of the Hyksos, traditionally thought to have been a disaster, was latterly reassessed

as a seminal influence that kept Egypt in the mainstream of the Bronze Age culture in the eastern Mediterranean. In any event, the innovations introduced by the Hyksos, especially in weapons and the techniques of war, contributed to their own overthrow by native Egyptian kings of the Seventeenth Dynasty. Ahmose I, final conqueror of the Hyksos and first king of the Eighteenth Dynasty, ushered in the New Kingdom (the Empire), the most brilliant period of Egypt's long history. At this time Egypt extended her borders by conquest from the Euphrates in the east deep into Nubia (the Sudan) to the south. Wider foreign contact was afforded by visiting embassies and by new and profitable trade with Asia and the Aegean islands. The booty taken in wars and the tribute exacted from subjected peoples made possible the development of a new capital, Thebes, which became a great and luxurious metropolis with magnificent palaces,

3-18 Interior of the tomb of Amenemhet I, Beni Hasan, *c.* 1975 B.C.

3-19 *Feeding of Oryxes*, fresco from the tomb of Khnumhotep, Beni Hasan, *c.* 1900 B.C.

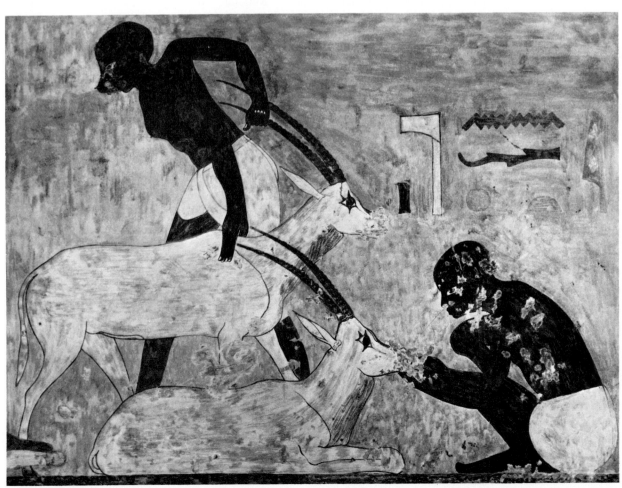

tombs, and temples along both banks of the Nile. Thutmose III, who died in the fifty-fourth year of his reign, in the first half of the fifteenth century B.C., was the greatest pharaoh of the New Kingdom, if not of all Egyptian history, and his successors continued the grand traditions he established. The optimistic mood of the new era is recorded in an inscription above the heads of revelers in a painting now in the British Museum:

> The Earth-god has implanted his beauty in every body.
> The Creator has done this with his two hands as balm to his heart.
> The channels are filled with waters anew
> And the land is flooded with his love.

3-20 *Head of Amenemhet III (?), c.* 1850 B.C. Obsidian, approx. 5″ high. National Gallery of Art, Washington, D.C. (C. S. Gulbenkian Collection).

3-21 Mortuary Temple of Queen Hatshepsut, Deir el-Bahari, *c.* 1500 B.C.

Architecture

If the most impressive monuments of the Old Kingdom are its pyramids, those of the New Kingdom are its grandiose temples. Burial still

The Art of Egypt

demanded the elaborate care shown earlier, and, following the tradition of the Middle Kingdom, nobles and kings hollowed their burial chambers deep in the cliffs west of the Nile. In the Valley of the Kings, the tombs are rock cut, approached by long corridors extending as deep as 500 feet into the hillside. The entrances to these burial chambers were carefully concealed, and the mortuary temples were built along the banks of the river at some distance from the tombs. The temple, which provided the king with a place for worshiping his patron god and then served as a mortuary chapel after his death, became elaborate and sumptuous, befitting both the king and the god.

The noblest of these royal mortuary temples, at Deir el-Bahari, was that of Queen Hatshepsut (FIG. 3-21), who preceded the conquering pharaoh Thutmose III. A princess who became queen when there were no legitimate male heirs, she boasted of having made the "Two Lands to labour with bowed back for her." Built about 1500 B.C. along the lines of the neighboring Middle Kingdom temple of Mentuhotep I, but without

the original pyramid in the forecourt, the structure rises from the valley floor in three colonnaded terraces connected by ramps. It is remarkable how visually well suited the structure is to its natural setting. The long horizontals and verticals of the colonnades and their rhythm of light and dark repeat, in man-made symmetry, the pattern of the rocky cliffs above. The pillars of the colonnades, which are either simply rectangular or chamfered (beveled, or flattened at the edges) into sixteen sides, are esthetically proportioned and spaced. Statues in the round, perhaps 200, were intimately associated with the temple architecture. So also were the brightly painted low reliefs that covered the walls and whose remnants may still be seen. These reliefs represented Hatshepsut's birth, coronation, and great deeds. In her day the terraces were not the barren places they are now but gardens with frankincense trees and rare plants brought by the queen from an expedition to the faraway "land of Punt" on the Red Sea, an event that figures prominently in the temple's figural decorations.

The immense rock-cut temple of Rameses II,

3-22 Temple of Rameses II, Abu Simbel, 1257 B.C. Colossi approx. 60' high.

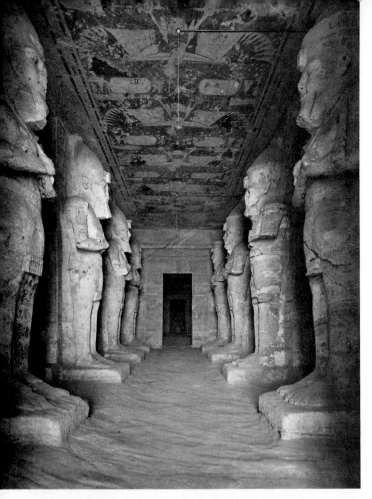

3-23 Interior of the Temple of Rameses II.

face each other across the narrow corridor, their exaggerated mass seeming to appropriate the architectural space. The columns are *reserved*—that is, hewn from the living rock—and have no bearing function, in this respect resembling the columns in the tombs at Beni Hasan. The figure-as-column, the *caryatid* form, will appear later in Greek architecture, and its presence at Abu Simbel may be its earliest use.

Distinct from the mortuary temples were the edifices built to honor one or more of the gods and often added to by successive kings until they reached gigantic size as in the temples at Karnak and Luxor (FIGS. 3-27 and 3-28). These temples all had similar plans. A typical pylon temple plan (FIG. 3-24) is bilaterally symmetrical along a single axis that runs from an approaching avenue through a colonnaded court and hall to a dimly lighted sanctuary. The dominating feature of the statuary-lined approach is the façade of the pylon, simple and massive, with sloping walls. The close-up example of a pylon shown in FIG. 3-25 is from the Temple of Horus at Edfu, which was built during the Ptolemaic period and is a striking monument to the persistence of Egyptian artistic traditions. Its broad surface is broken by the doorway with its overshadowing cornice, by deep channels to hold great flag-staffs, and by low reliefs. Moldings finish its top and sides. Within is an open court colonnaded on three sides, followed by a hall between court and sanctuary, its long axis placed at right angles to that of the entire building complex. This "broad" or hypostyle hall (that is, having a roof supported by columns) is crowded with massive columns and roofed by stone slabs carried on lintels that rest in turn on impost blocks supported by the great capitals. In the hypostyle hall of the Temple of Amen-Re at Karnak (FIGS. 3-26 and 3-27) the columns are sixty-six feet high, and the capitals, twenty-two feet in diameter at the top, large enough to hold 100 men. The Egyptians, who did not use cement, depended on the weight of the huge stones to hold the columns in place. In many such hypostyle halls the central rows of columns were higher than those at the sides, raising the roof of the central section and creating a clerestory. Openings in this clerestory permitted light to filter into the interior. This method of construction appears in primitive

Egypt's last great warrior-pharaoh, who lived a little before the exodus from Egypt under Moses, was built far up the Nile at Abu Simbel. Rameses, proud of his many campaigns to restore the empire, aggrandized his greatness by placing four colossal images of himself in the temple façade (FIG. 3-22). The whole monument was moved in 1968 to save it from submersion in the new Aswan Dam reservoir. In later times, the glories of kings and emperors in periods of conquest and imperial grandeur were also celebrated in huge monuments; gigantism seems characteristic of much of the art of empires that have reached their peaks. Here, Rameses' artists use the principle of augmentation both by size and by repetition. The massive statues lack the refinement of earlier periods, since much is sacrificed to overwhelming size. The grand scale is carried out in the interior also (FIG. 3-23). The giant figures of the king, formed as columns,

3-24 Plan of a typical pylon temple.

1. Pylon
2. Court
3. Hypostyle hall
4. Sanctuary
5. Girdle wall
6. Colossal statues of the pharaoh
7. Obelisks
8. Avenue of recumbent animals

 Probable roofed areas

3-25 Pylon Temple of Horus, Edfu, c. 237–212 B.C.

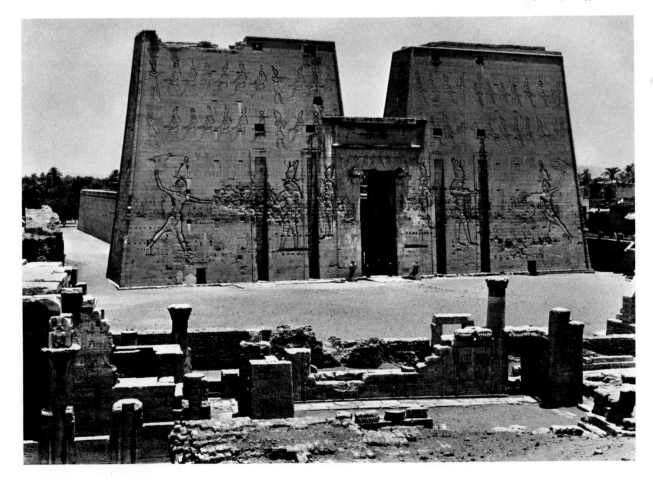

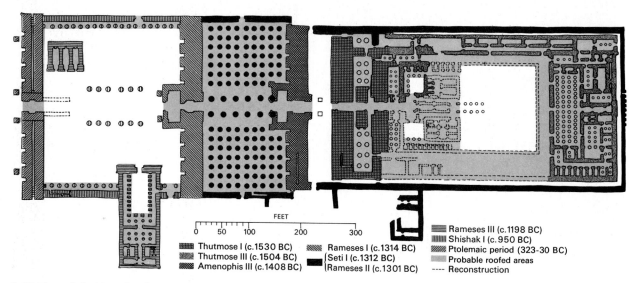

3-26 Plan of the Temple of Amen-Re, Karnak. Dates in parentheses indicate time of construction. (After Sir Banister Fletcher.)

FEET

Thutmose I (c.1530 BC)	Rameses I (c.1314 BC)
Thutmose III (c.1504 BC)	Seti I (c.1312 BC)
Amenophis III (c.1408 BC)	Rameses II (c.1301 BC)

Rameses III (c.1198 BC)
Shishak I (c.950 BC)
Ptolemaic period (323-30 BC)
Probable roofed areas
---- Reconstruction

3-27 Model of hypostyle hall, Temple of Amen-Re, Karnak, *c.* 1300 B.C. Metropolitan Museum of Art, New York (bequest of Levi Hale Willard).

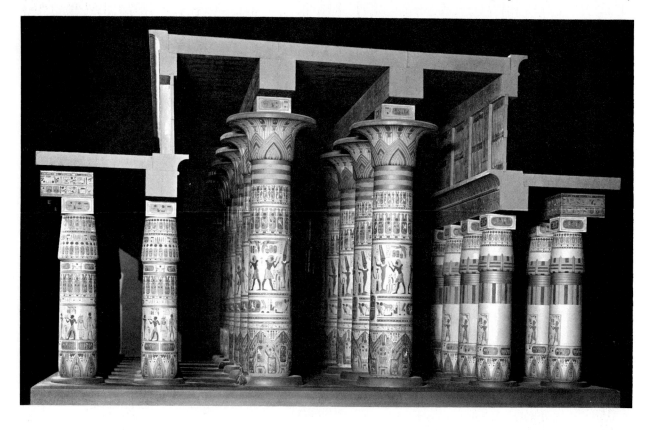

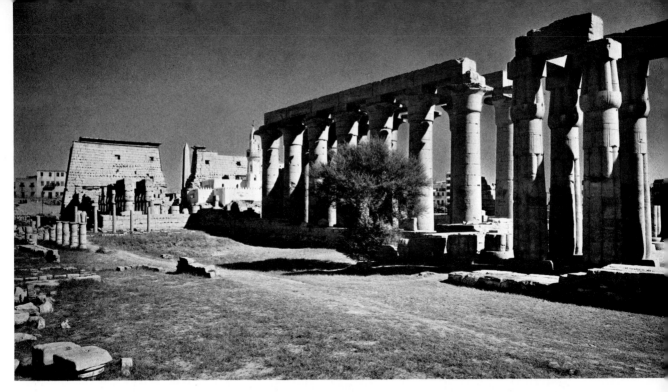

3-28 Court and pylon of Rameses II, *c.* 1290 B.C., and court and colonnade of Amenhotep III, *c.* 1390 B.C., Temple of Amen-Mut-Khonsu, Luxor.

form as early as the Old Kingdom in the valley temple of the Pyramid of Khafre. Evidently an Egyptian invention, it has remained an important architectural feature down to our times and was particularly important in the design of Medieval cathedrals.

The Egyptian temple plan evolved from ritualistic requirements. Only the pharaoh and the priest could enter the sanctuary; a chosen few were admitted to the hypostyle hall; the mass of the people was allowed only as far as the open court, and a high wall shut off the site from the outside world. The conservative Egyptians did not deviate from this basic plan for hundreds of years. The corridor axis, which dominates the plan, makes the temple not so much a building as, in Oswald Spengler's phrase, "a path enclosed by mighty masonry." Like the Nile that it almost symbolizes, the corridor may have been an expression of the Egyptian concept of life. Spengler suggests that the Egyptian saw himself moving down a narrow, predestined life-path that ended before the judges of the dead. The whole of Egyptian culture can be regarded as illustrating this theme.

The hypostyle hall at Karnak (FIG. 3-27) shows the smooth-shafted (as opposed to fluted) Egyptian columns with the two basic types of capitals: the bud-shaped and the campaniform, or bell-shaped. Though the columns are structural members, unlike the reserve "columns" of the Middle Kingdom tombs at Beni Hasan and the figure-columns at Abu Simbel, their function as carriers of vertical stress is almost hidden by horizontal bands of relief sculpture and painting, suggesting that the intention of the architects was not to emphasize the functional role of the columns so much as to utilize them as surface for decoration. This contrasts sharply with later Greek practice, which keeps the vertical lines of the column emphatic and its function clear by freeing the surfaces of the shaft from all ornament.

The courts and colonnades of the Temple of Amen-Mut-Khonsu at Luxor (FIG. 3-28) exhibit the columnar style especially well. The post-and-lintel structure of the temples appears to have had its origin in an early building technique that used firmly bound sheaves of reeds and swamp plants as roof supports in adobe struc-

2130 B.C.	c. 1975	1790	1570		1085	332 B.C.
	Tomb of Amenemhet I			Akhenaton (1377–1358)		
MIDDLE KINGDOM		HYKSOS DOMINATION	NEW KINGDOM		LATE PERIOD	
DYNASTIES XI–XII			DYNASTIES XVIII–XX		DYNASTIES XXI–XXV	

tures. Evidence of this origin is seen in the columns themselves, which are carved to resemble sheaves of papyrus or lotus reeds, with the bud-cluster or bell-shaped capitals. Painted decorations, traces of which can still be seen on the surfaces of the shafts and capitals, emphasized these natural details. In fact, the flora of the Nile valley supplied the basic decorative motifs in all Egyptian art. With respect to a possible Mesopotamian influence, it is important to note that, until the time of Persia, Mesopotamian architecture seldom employed the post-and-lintel system; the column was rarely seen. Moreover, the formalization of plant forms into the rigid

3-29 *Senmut with Princess Nefrua*, Thebes, c. 1480 B.C. Black stone, approx. 40″ high. Staatliche Museen, Berlin.

profiles of architecture is precisely the same thing as the formalization of human bodies and action that the Egyptians achieved so skillfully in tomb painting and sculpture.

Sculpture and Painting

This radical simplification of form, which preserves in the ka figures the cubic essence of the block, can be seen to advantage in the statue showing Senmut (Queen Hatshepsut's chancellor and the architect of her temple at Deir el-Bahari) with Princess Nefrua (FIG. 3-29). This curious design, evidently popular in the New Kingdom, concentrates attention upon the portrait head, leaving the "bodies" a cubic block, which is given over to inscriptions. With surfaces turning subtly about smoothly rounded corners, it seems another expression of the Egyptian fondness for volume enclosed by flat, unambiguous planes. The polished stone shape has its own simple beauty.

The persistence of the formulas for projection of an image onto a flat surface can be seen in wall paintings in the tomb of Amenemheb at Thebes, which dates from the Eighteenth Dynasty (PLATE 3-1). The deceased nobleman is standing in his boat and driving the birds from a papyrus swamp with his throw-stick. In his right hand he holds three birds he has caught; his hunting cat, on a papyrus stem just in front of him, has caught two more in her claws and is holding the wings of a third in her teeth. His two companions, perhaps his wife and daughter, their figures scaled down in proportion to their rank, are enjoying the lotuses they have gathered. Although the water and the figures are represented by the usual conventions, cat, fish, and birds show a naturalism based upon visual perception like that which we have seen in the *Geese of Medum* (FIG. 3-15).

The tomb chamber, as we see it in the well-

preserved New Kingdom tomb of Nakht, at Thebes (FIG. 3-30), is similar to the tomb chambers of the Old Kingdom; in the mural the system of registers still preserves the rigid separation of the zones of action. But some innovations of detail appear: here and there a new liveliness and a closer inspection of life. A fresco fragment from another New Kingdom tomb (FIG. 3-31) shows four ladies watching and apparently participating in a musicale and dance in which two nimble little nude dancing girls perform. The overlapping of the girls' figures, facing in opposite directions, and the rather complicated gyrations of the dance are carefully and accurately observed and executed. Of the four ladies of the audience, two at the left are represented conventionally, but the other two face us in what is a most unusual and very rarely attempted frontal pose. They seem to beat time to the dance; one of them plays the pipes, and the artist takes careful note of the soles of their feet as they sit cross-legged. This informality may mean a relaxation not only of the stiff rules of representation but of the set themes thought appropriate for tomb painting. We may also have here the reflection of a more luxurious mode of life in the New Kingdom, and it may have been that the ka now required not only necessities and comforts in the hereafter but formal entertainment as well.

AKHENATON AND THE AMARNA PERIOD

These small variations of age-old formulas heralded a short but violent upheaval in Egyptian art, the only major break in the continuity of its long tradition. In the fourteenth century B.C. the emperor Amenophis IV (Amenhotep IV), later known as Akhenaton (or Ikhnaton), proclaimed the religion of Aton, the universal and only god of the sun. He thus contested and abolished the native cult of Amen, sacred to Thebes and professed by the mighty priests of such temples as Karnak and Luxor, as well as by the people of Egypt. He blotted out the name of Amen from all inscriptions, and even from his

own name and that of his father, Amenophis III. He emptied the great temples, embittered the priests and people, and moved his capital downriver from Thebes to a site now called Tell el-Amarna, where he built his own city and shrines to the religion of Aton.

This action by Amenophis IV—now Akhenaton—though it might savor of the psychotic or of the fanaticism of sudden conversion, was portended by events in the formation and expansion of the power of the great Eighteenth Dynasty. Egyptian might had formed the first world empire. Ruling over Syria and Nubia, bordered by the Hittites, and checking the penetration of the Mitanni, the conquering, imperialist pharaohs had gradually enlarged the powers of their old

3-30 Tomb of Nakht, Thebes, c. 1450 B.C. Rear wall 55″ × 60″.

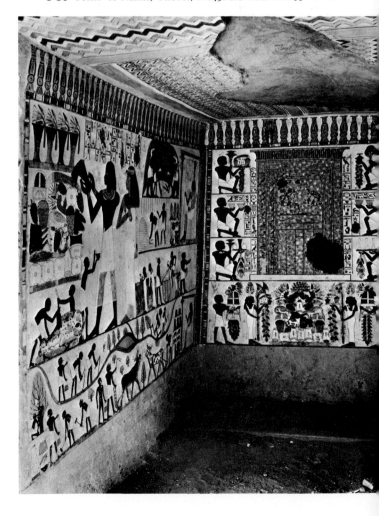

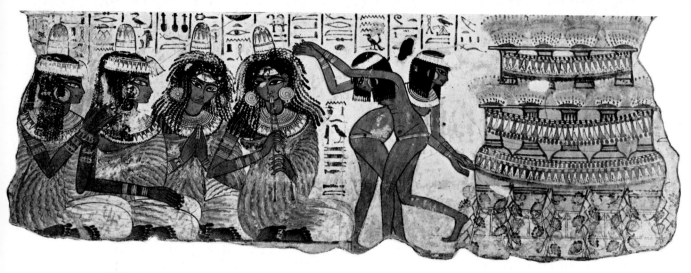

3-31 *Musicians and Dancers*, detail of a wall painting from a tomb in the necropolis at Thebes, *c*.1400 B.C. British Museum, London.

sun god, Amen, to make him not simply god of the Egyptians, but of all men. Even before Egypt had become the main force in the Mediterranean world—before, as James Breasted describes it, "the Egyptian supremacy [was] undisputed from the Greek islands, the coasts of Asia Minor, and the highlands of the Upper Euphrates on the north to the Fourth Cataract of the Nile on the south"—Thutmose I, a founder of the fortunes of the dynasty, could say of the sun god that his kingdom extended as far as "the circuit of the sun." And the military pharaoh, Thutmose III, said of this aggrandized god: "He seeth the whole earth hourly." Thus, Akhenaton was exploiting forces already gathering when he raised the imperialized god of the sun to be the only god of all the earth and proscribed any rival as blasphemous. He appropriated to himself the new and universal god, making himself both the son and prophet, even the sole experient, of Aton. To him alone could the god make revelation. His hymn to Aton survives:

> Thou art in my heart
> There is no other that knoweth thee
> Save thy son Ikhnaton.
> Thou hast made him wise.
> In thy designs and might.
> The world is in thy hand,
> Even as thou hast made them . . .
> Thou didst establish the world,

> And raise them up for thy son,
> Who came forth from thy limbs,
> The king of Upper and Lower Egypt,
> Living in Truth, Lord of Two Lands . . .

Egypt has left us the ingredients, as it were, of the later monotheisms so influential in the world. Akhenaton's brief theocracy seems to have embodied the seeds of later concepts of one god, of an eternal son who is also a king, of a world created by that one god, and of the intimate revelation of that god's spirit to a chosen one.

One of the effects of the new religious philosophy seems to have been a temporary relaxation of the Egyptians' preoccupation with death and the hereafter and a correspondingly greater concern with life on this earth. In art this change is reflected in a different attitude toward the representation of the human figure. Artists aim for a new sense of life and movement, expressed in swelling, curvilinear forms; and their long-fostered naturalistic tendencies, so far confined largely to the representation of animals, are now extended not only to the human figure of the lowly but significantly to royalty also. A colossal statue of Akhenaton (FIG. 3-32), from his capital at Tell el-Amarna, retains the standard frontal pose; but the strange, epicene body with its curving contours and the long, full-lipped face, heavy-lidded eyes, and dreaming expression, show that the artist has studied his subject

with care and rendered it with all the physiognomical and physical irregularities that were part of the king's actual appearance. The predilection for curved lines stresses the softness of the slack, big-hipped body that is a far cry indeed from the heroically proportioned figures of Akhenaton's predecessors. In a daring mixture of naturalism and stylization, the artist has given us an informal and uncompromising portrayal of the king that is charged with both vitality and a psychological complexity that has been called expressionistic.

The famous painted limestone bust of Akhenaton's queen, Nefertiti (PLATE 3-2), exhibits a similar expression of entranced musing and an almost mannered sensitivity and delicacy of curving contour. It may be that the sculptor deliberately alludes to a heavy flower on its slender stalk when he exaggerates the weight of the crowned head and the length of the almost serpentine neck. One thinks of those modern descendants of Queen Nefertiti—the models in the fashion magazines, with their gaunt, swaying frames, masklike, pallid faces, and enormous, shadowed eyes. As the modern mannerism shapes the living model to its dictates, so the sculptors of Tell el-Amarna may have had some standard of spiritual beauty to which they adjusted the actual likeness of their subjects. Even so, one is made very much aware of the reality of the queen through her contrived mask of beauty, a masterpiece of cosmetic art. The Nefertiti bust is one more example of that elegant blending of the real and the formal that we have noticed so often in the art of the ancient Near East.

During the last three years of his reign Akhenaton's coregent was his half-brother, Smenkhkare. A relief from Tell el-Amarna shows Smenkhkare and his wife Meritaten (FIG. 3-33) in an informal, even intimate, pose that contrasts strongly with the traditional formality in representation of exalted persons. Once-rigid lines have become undulating curves, and the pose of Smenkhkare has no known precedent. The prince leans casually on his staff, one leg at ease, an attitude that presumes knowledge on the sculptor's part of the flexible shift of body masses, a principle not really grasped until Classical times in Greece. This quite realistic detail accompanies others that are the result of a freer expression of what is observed:

details of costume and the departures from the traditional formality, such as the elongated and bulging head of Meritaten and the prominent bellies that characterize figures of the Amarna school. Proportions of figures no longer depend on rank; the princess is depicted in the same scale as her husband on the basis of their natural proportions.

We have seen that there was some slight loosening of the conventions of sculpture and painting even before Akhenaton. But the Amarna style (and a subsequent return to the earlier tradition) marks breaks too abrupt and emphatic to let us conclude that the style was simply a local, native flowering. It is at least possible that there was some influence from the Mediterranean world. We know that Egypt had commercial relations with Crete beginning in the predynastic

3-32 *Akhenaton,* from a pillar statue in the Temple of Aton, Tell el-Amarna, *c.* 1375 B.C. Sandstone, approx. 13′ high. Egyptian Museum, Cairo.

3-33 *King Smenkhkare and Meritaten* (?), Tell el-Amarna, *c.* 1360 B.C. Painted limestone relief, approx. 69″ high. Staatliche Museen, Berlin.

period, and the livelier, less convention-bound art of the Minoans could have proved suggestive and stimulating to the Amarna artists. Although the Cretan palace culture came to an end around 1400 B.C. (see Chapter Four) and Akhenaton did not ascend the Egyptian throne until 1377 (first as coruler with his father), the time lag does not seem too great to preclude such an influence. It may be that some Cretan artists, finding refuge in Egypt, and a sympathetic artistic climate under Akhenaton's rule, fertilized the Amarna style.

The survival of the Amarna style is seen in a painted panel from a chest of Tutankhamen, the successor to Akhenaton (FIG. 3-34). The panel represents the king hunting droves of fleeing animals in the desert. The theme is traditional, but the fluid, curvilinear forms, the dynamic composition—with its emphasis on movement and action—and the disposition of the hunted animals who, freed of the conventional ground lines, race wildly across the panel, are features reminiscent not only of the Amarna style but of the lively naturalism of Cretan art.

The pharaohs who followed Akhenaton re-established the cult and priesthood of Amen,

3-34 Painted panel from a chest, tomb of Tutankhamen, Thebes, *c.* 1350 B.C. Approx. 20″ long. Egyptian Museum, Cairo.

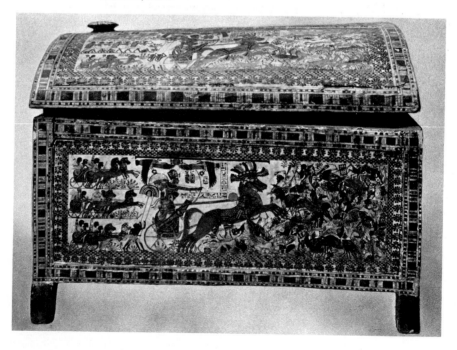

restored the temples and the inscriptions, and returned to the old manner in art. Akhenaton's monuments were wiped out, his heresy anathematized, and his city abandoned. The conservative reaction can be seen in a relief of the pharaoh Seti I (FIG. 3-35). The rigid, flattened shapes repeat the formula of the *Palette of Narmer* (FIG. 3-2) and the static formality of Old Kingdom art. It is as if some fifteen centuries had not passed into history.

Though art by no means died out after the New Kingdom, its lingering life over some thousand years, when Egypt became a backwater of Mediterranean civilization, was feeble indeed—at least in comparison to what it had been. Summing up the New Kingdom and the later decline, Maspero wrote:

Seeing things on a great scale, they sought to create greatness, no longer after the manner of their ancestors, the Pyramid-builders, by the exaggerated bulk of their material, but by the reasoned immensity of their conceptions; thus architects had arrived at the gigantic colonnades of Luxor and Karnak, and sculptors at the colossi of the Theban plain and Abu-Simbel. When they had reached this point, which they could not surpass, they did not long maintain themselves at its level....[3]

The prodigiousness of the effort seemed to have sapped Egypt's creative energies, and her military decline after Rameses III had its parallel in the waning of her artistic vigor.

[3] G. Maspero, *Art in Egypt* (New York: Scribner's, 1922), pp. 207–08.

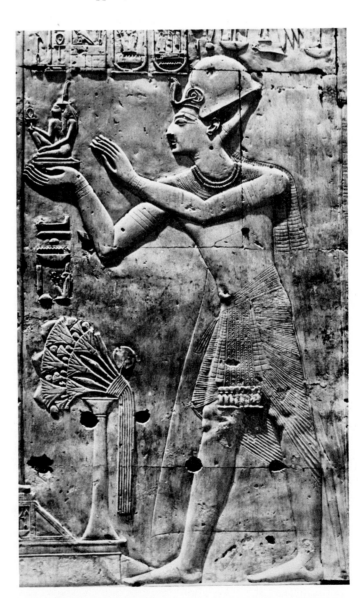

3-35 *Seti I Offering*, Temple of Seti I, Abydos, *c.* 1300 B.C. Painted limestone, Louvre, Paris.

Chapter Four

The Art of
the Aegean

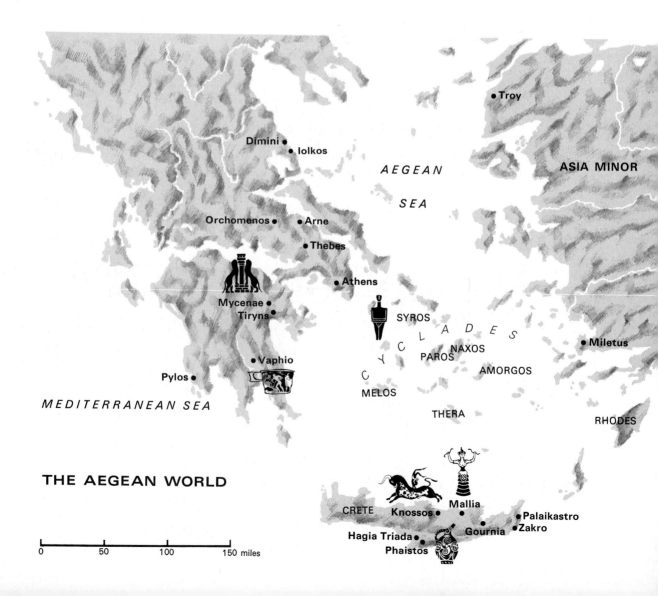

THE AEGEAN WORLD

Troy

Dimini • Iolkos

AEGEAN
SEA

ASIA MINOR

Orchomenos • Arne

• Thebes

• Athens

Mycenae •
Tiryns •

SYROS

Miletus

NAXOS
PAROS

C
Y
C
L
A
D
E
S

AMORGOS

Pylos •

• Vaphio

MEDITERRANEAN SEA

MELOS

THERA

RHODES

CRETE Knossos • Mallia
•

Palaikastro
•
Gournia • Zakro
•

Hagia Triada •

Phaistos

0 50 100 150 miles

HOMER WROTE of the might and splendor of the Achaean host deployed for war against Troy:

So clan after clan poured out from the ships and huts onto the plain of Scamander, and . . . found their places in the flowery meadows by the river, innumerable as the leaves and blossoms in their season . . . the Locrians . . . the Athenians . . . the citizens of Argos and Tiryns of the Great Walls . . . troops from the great stronghold of Mycenae, from wealthy Corinth . . . from Lacedaemon . . . from Pylos . . . Knossos in Crete, Phaistos . . . and the other troops that had their homes in Crete of the Hundred Towns. . . .

The list goes on and on, outlining the peoples and the geography of the Aegean world in intimate detail. Until about 1870, historians of ancient Greece, though they acknowledged Homer's superb art, discounted him as a historian, attributing the profusion of his names and places to the rich abundance of his imagination. The pre-history of classical Greece remained shadowy and lost—as the historians believed—in an impenetrable world of myth. That they had done

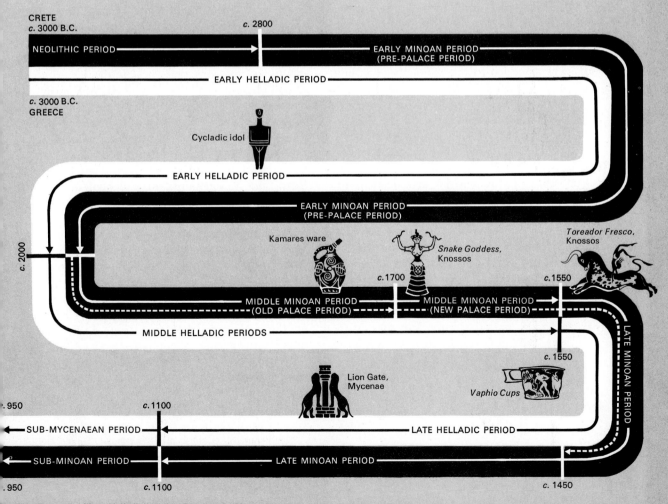

CRETE
c. 3000 B.C. *c.* 2800

NEOLITHIC PERIOD → EARLY MINOAN PERIOD (PRE-PALACE PERIOD)

EARLY HELLADIC PERIOD

c. 3000 B.C.
GREECE

Cycladic idol

EARLY HELLADIC PERIOD

EARLY MINOAN PERIOD (PRE-PALACE PERIOD)

c. 2000

Kamares ware Snake Goddess, Knossos *Toreador Fresco,* Knossos

c. 1700 *c.* 1550

MIDDLE MINOAN PERIOD (OLD PALACE PERIOD) MIDDLE MINOAN PERIOD (NEW PALACE PERIOD)

MIDDLE HELLADIC PERIODS

c. 1550

Lion Gate, Mycenae *Vaphio Cups*

LATE MINOAN PERIOD

c. 950 *c.* 1100

SUB-MYCENAEAN PERIOD ← LATE HELLADIC PERIOD

SUB-MINOAN PERIOD ← LATE MINOAN PERIOD

c. 950 *c.* 1100 *c.* 1450

NOTE The period "Late Helladic" is also designated "Mycenaean."

less than justice to the truth of Homer's account or, for that matter, to ancient Greek literary sources in general, was proved by a German amateur archeologist, Heinrich Schliemann, who, between 1870 and his death twenty years later, uncovered some of the very cities of the Trojan and Achaean heroes whom Homer celebrates: Troy, Mycenae, Orchomenos, Tiryns. In 1870, at Hissarlik in the northwest corner of Asia Minor, which his knowledge of the *Iliad* had led him to believe was the site of Homer's Troy, he dug into a vast *tell*, or mound, and found there a number of fortified cities built one upon the remains of another, together with the evidence of their destruction by fire. Schliemann continued his excavations at Mycenae on the Greek mainland, whence he believed Agamemnon and Achilles had sailed to avenge the capture of Helen, and here his finds were even more startling. Massive fortress-palaces, elaborate tombs, quantities of gold jewelry and ornaments, cups, and inlaid weapons revealed a magnificent preclassical civilization.

But further discoveries were to prove that Mycenae had not been its center. An important Greek legend told of Minos, king of Crete, who had exacted from Athens a tribute of youths and maidens to be fed to the Minotaur—half-bull, half-man—which was housed in a vast labyrinth. Might this legend too be based on historical fact? The lesson of Schliemann's success in pursuing hunches based on careful reading of ancient legends was not lost on his successors. An Englishman, Arthur Evans, had long considered Crete a potentially fertile field for investigation, and Schliemann himself, shortly before his death, had wanted to explore the site of Knossos. In 1900, Evans began work on Crete and a short time later uncovered extensive unfortified palaces of the old sea-kings of Crete, which indeed did resemble labyrinths (FIG. 4-6). His findings, primarily at Knossos, were augmented by additional excavations there and at Phaistos, Hagia Triada, and other important sites on the southern coast of Crete. In 1962, excavation of another palace was begun on the eastern tip of Crete at Kato Zakro; more recently, in 1966, a queen's burial chamber judged to be about 3400 years old was discovered near Knossos.

MINOAN AND CYCLADIC ART

The civilization of the coasts and islands of the Aegean emerged about the same time as the river-valley civilizations of Egypt and Mesopotamia. Though there was close contact at various times and active exchange of influences, each civilization manifested a brilliant originality of its own; the Aegean civilization, however, has a special significance as the forerunner of the first truly European civilization—that of Greece. The sea-dominated geography of the Aegean contrasts sharply with that of the Near East, as does its temperate climate. In the ancient world this made for a busy, commercial seafaring culture, with decentralized authority and a way of life vigorous, vivacious, and pleasure-loving. This is especially true of Crete, the ancient center of Aegean civilization from which radiated its creative forces. As a commercial crossroads for the ancient world, Crete was strategically placed in the east Mediterranean, and her remarkable variety of products, both of agriculture and manufacture, was exported widely. The sea provided a natural defense against the frequent and often disruptive invasions that checker the histories of land-bound civilizations like Mesopotamia, and the navies of the sea-kings maintained a prosperous, far-flung maritime empire that served for the transmission of ideas and influences as well as goods. The controlled accessibility to Crete of impulses from abroad, especially from Egypt and Mesopotamia, may account for the initiation of a great culture there. Cretan culture influenced all of the Aegean area, and the particular modifications of it on the Greek mainland and in the islands of the Cyclades north of Crete have been identified. Thus, the art of Crete itself is called Minoan, after King Minos; that of the mainland, Helladic; and that of the islands, Cycladic. The culture associated with Mycenae on the mainland—the Mycenaean—is classed under Late Helladic (about 1550–1100 B.C.).

The archeological problems confronting investigators of Near Eastern civilizations were much less difficult than those of archeologists working in the Aegean area. Here there survived

very few documents like the chronicles and inscriptions of Egypt and Mesopotamia with which to correlate the archeological findings, and there were no "absolute" dates expressible numerically. Evans had to construct a "relative" dating in terms of different periods of ceramic and decorative style from various sites on Crete, in the Cyclades, and at Mycenae. Evans' tripartite division of Minoan art into Early, Middle, and Late Minoan and the further division of each large period into three subperiods are a classic example of a relative chronology, used by the archeologist-historian when he lacks absolute dates. A greater firmness was given the Minoan chronology when points of contact with the chronology of Egyptian art were established. Imported objects of a certain style from the one country were uncovered in datable contexts in the other; in this way, for example, the Middle Minoan period was found to be roughly contemporary with the Middle Kingdom in Egypt.

The two earliest of several scripts found on Crete seem to have been inspired by Egyptian hieroglyphs. Of the later scripts, Linear A and Linear B, only the latter has been deciphered (as late as 1953); it is a pre-Homeric form of Greek. But the tablets inscribed with it represent almost exclusively inventories and tallies of objects and are of little aid in delineating the Minoan culture. For Minoan history, pottery remains have been by far the greatest evidence, since figurative art is relatively scarce and often so fragmentary and diminutive as to preclude building a stylistic continuity upon it. Potsherds are one of the mainstays of archeology when documentary and monumental evidence is sparse or missing. Pots (kitchenware, for example) were thrown on the garbage heap when broken. Over the years perishable materials decayed and disappeared leaving only pottery sherds, which settled into firmly stratified mounds. Careful excavation of such mounds can produce relative chronologies. Although the sequence of Cretan pottery styles was well established by Evans, some archeologists now feel that his method of dating has become inadequate in view of increased knowledge of the Minoan civilization. A new chronology has been suggested that is based on the construction of the great Cretan palaces. Its

relation to the traditional chronology is shown on p. 103.

Nevertheless, absolute dates are few, and our knowledge of Minoan history remains vague and provisional. Even the origin of the Cretans is problematical. Some believe that they may have come from Anatolia as early as 6000 B.C., bringing with them a well-developed Neolithic culture, complete with pottery, and that the Bronze Age may have been ushered in by a new wave of immigrants (also from Anatolia?) around the year 2800 B.C.

The Early Minoan Period

The Early Minoan (pre-Palace) period is known to us primarily through pottery and a few scattered pieces of minor sculpture. There is the Mochlos stoneware (named after the site where

4-1 Cycladic idol, Syros, c. 2500–2000 B.C. Marble, $8\frac{1}{2}$″ high.

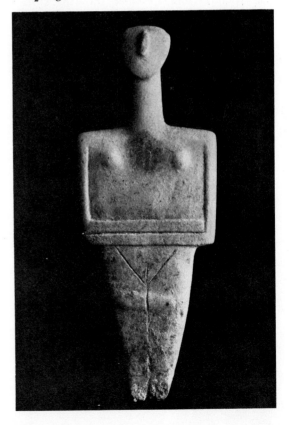

it was found and apparently copied from Egyptian pieces of the First to Fourth Dynasties), and there are hand-made clay pots decorated with incised geometric patterns.

The most striking and perhaps the most appealing Aegean products of the Early Bronze Age are the numerous marble statuettes from the Cycladic islands. Most of them are representations of nude females with their arms folded across their abdomens. Varying greatly in size (from a few inches in height to life-size), these flat "plank idols" are highly schematized descendants of the Neolithic mother goddess. Their styles are as varied as their sizes and range from figures of almost normal proportions to shapes that resemble violins rather than human figures. The example shown (FIG. 4-1) occupies a middle ground: The organic forms have been converted into near-geometric shapes (triangles, rectangles, ovals, and cylinders), but the reference to the female figure remains clear, and the manner in which the various stylized parts have been combined has considerable esthetic appeal. Traces of paint found on some specimens show that at least

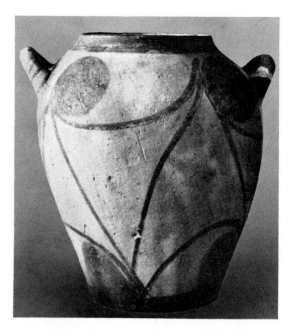

4-3 Small storage jar, Psyra, c. 2000–1850 B.C. 11″ high.

parts of these figures were colored. The eyes were usually painted, and additional color touches were provided by painted necklaces and bracelets.

Occasionally male figures also occur in the Cycladic repertoire. They usually appear as musicians, like the *Lyre Player* (FIG. 4-2), who, wedged between the echoing shapes of chair and lyre, dutifully performs a task that seems to have been part of funerary rituals. In the rendering of the figure, the disk-shaped head and the long, tubular neck are in the same style as the plank figures, but the body has gained mass and volume, and the composition has a three-dimensional quality lacking in the plank idols. Although it has not been possible to establish a chronological sequence for these Cycladic figurines, most seem to date from the second half of the third millennium B.C.; the *Lyre Player* is believed to belong to the end of the line and may have been contemporary with the Cretan palaces.

The Middle Minoan Period

The Middle Minoan period is marked by the founding of the "old" palaces around the year

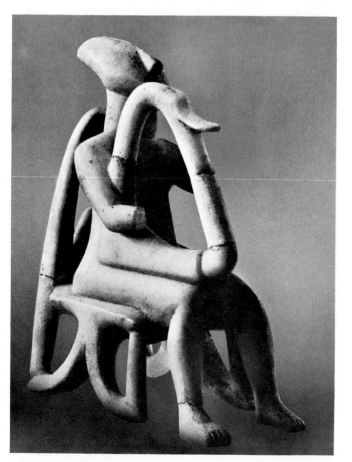

4-2 *Lyre Player*, Keros, c. 2000 B.C. Marble, 9″ high.

2000 B.C. Building in Crete emphasized neither tombs, temples, nor fortresses but, instead, palaces for the king and his retainers, around which grew up royal towns. The absence of fortification on Crete is conspicuous in the Aegean world, since fortified sites appear everywhere in the Helladic and Cycladic areas. It attests either to the power of the Cretan navies, to a long-enduring insular peace (a kind of *Pax Minoica*), or to both. But after only about three centuries, around 1700 B.C., these early palaces were destroyed, probably by one of the frequent earthquakes that ravage this part of the Mediterranean region.

An important technological advance of the beginning of the Old Palace period was the introduction of the potter's wheel, which permitted the throwing of vessels with thinner walls and subtler shapes and led to the development of a thriving industry. In the so-called eggshell ware, the Minoan potter's art reached a degree of excellence that deserves our highest admiration, if for the delicacy of the ceramic technique alone. But the Cretan artist also developed a style of decoration that complemented the delicate fabric and sophisticated shapes of his pottery. Beginning with relatively simple, curvilinear patterns painted dark on light (FIG. 4-3), he moved toward a fully polychrome style of decoration that found its culmination in the splendid pottery (FIG. 4-4) discovered in the cave at Kamares on the slope of Mount Ida. On a surface swelling robustly with the peculiarly Minoan "feel" for the vigor and buoyancy of active life we find a lustrous black ground on which is a quasi-geometric pattern of creamy white interspersed with yellow and red, forming a colorful and harmonious decoration. As in Egypt, the motifs derive from natural forms; here they are simplified into a play of spirals that are beautifully adjusted to and integrated with the shape of the vessel.

The Late Minoan Period

Somewhere between 1600 and 1500 B.C. began the period of the "new" palaces, when the destroyed palaces were rebuilt and the Golden

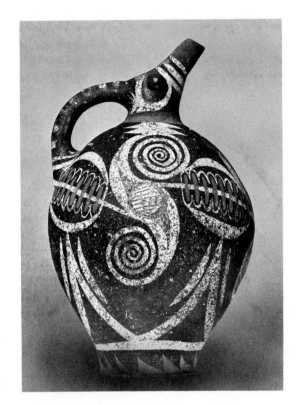

4-4 Kamares pitcher, Phaistos, *c.* 1800–1700 B.C. Approx. 10″ high. Archeological Museum, Herakleion.

Age of Crete produced the first great Western civilization. The bulk of the surviving archeological material—the evidence of an age of unsurpassed creative energy and precocious artistic achievement—dates from this era, which ended about 1400 B.C.

THE PALACES

The palaces rebuilt for the kings and their retainers were large, comfortable, and handsome, with ample staircases and courtyards for pageants, ceremonies, and games. The largest of them, the palace at Knossos (FIGS. 4-5 and 4-6), was a rambling structure built against the upper slopes and across the top of a low hill rising from a fertile plain. The great rectangular court around which the units of the palace are grouped had been leveled in the time of the old palace, and the manner of the grouping of buildings suggests

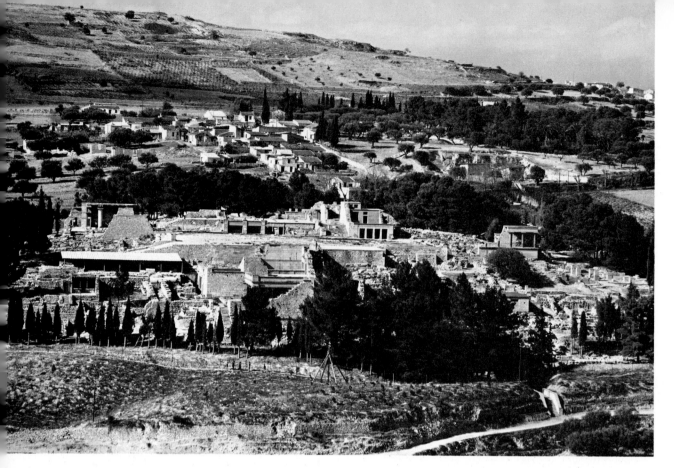

4-5 Palace at Knossos, c. 1600–1400 B.C. (view from the east).

that it was not preplanned but that several building nuclei grew together, with the court as the major organizing element. A secondary organization of the plan is provided by two long corridors. On the west side of the court a north-south corridor separates official and ceremonial rooms from the magazines, where wine, grain, oil, and honey were stored in large jars (*pithoi*). On the east side of the court, an east-west corridor separates the king's and queen's quarters and reception rooms (south) from the workmen's and servant's quarters (north). At the northwest corner of the entire building complex is the "arena," or "theater area," with steps (seats?) on two sides—a possible forerunner of the later Greek theater. Its purpose is unknown, but it is a feature that, like the central court, appears in other Cretan palaces. The complexity of the palace's plan came to be associated for the Greeks with the cult of the double axe (*labrys*), celebrated here; thus, perhaps, the Greek myth of the Cretan *labyrinth*. Certainly it was the product

of wealth and luxurious tastes and of a love for the convenient. Beneath the palace is a remarkably efficient drainage system of terra-cotta pipes that must have made Knossos one of the most sanitary cities existing before the twentieth century.

The practical storage system is exhibited in the magazines of the west wing (FIG. 4-7), where some of the pithoi are still in place. Some of the rooms had flat floors; others, like those shown here, had stone-lined pits. The walls were quite thick, as must have been the roofing over these magazines; the masonry may have been covered with earth to keep the interior cool. In most parts of the palace the masonry composing the walls was rough, consisting of unshaped field stones imbedded in mortar; ashlar masonry, made of shaped blocks of stone, was used at building corners and around door and window openings.

The palace had as many as three stories with interior staircases built around light and air wells

(FIG. 4-8), which provided necessary illumination and ventilation. Distinguishing features of the Minoan columns, which were originally fashioned of wood but were restored in stone (with, it is now thought, mistakenly bulky proportions), are their bulbous, cushionlike capitals and the manner in which the column shafts taper toward the base, being widest at the top. Strong evidence that the column had religious significance for the Cretans is its central position in the Lion Gate at Mycenae (FIG. 4-20) and the fact that the base of a column in one of the lower stories of the palace at Knossos is surrounded by a trough that was used for libations.

PAINTING

A view into the Queen's Megaron, with its pillared hall and light well (FIG. 4-9), shows the typically elaborate wall decoration of the more important rooms at Knossos. Here plastered walls were painted with frescoes, which, together with the red- or blue-shafted columns, must have

4-6 Plan of the palace at Knossos.

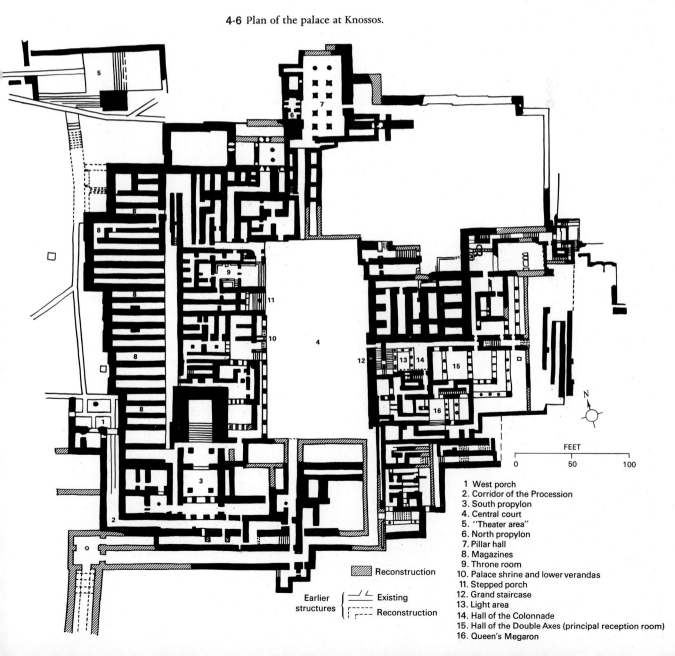

Reconstruction

Earlier structures { Existing — Reconstruction ---

1. West porch
2. Corridor of the Procession
3. South propylon
4. Central court
5. "Theater area"
6. North propylon
7. Pillar hall
8. Magazines
9. Throne room
10. Palace shrine and lower verandas
11. Stepped porch
12. Grand staircase
13. Light area
14. Hall of the Colonnade
15. Hall of the Double Axes (principal reception room)
16. Queen's Megaron

FEET
0 50 100

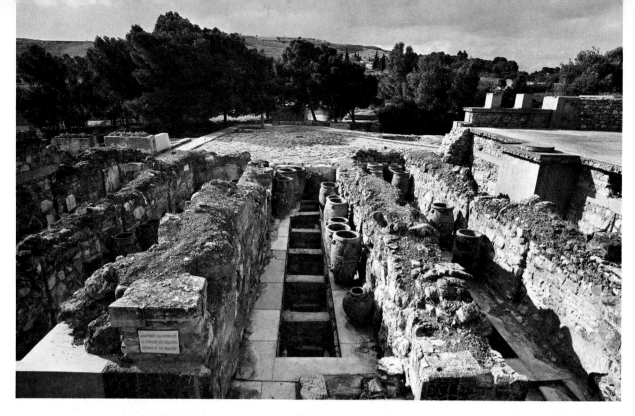

4-7 View of the west magazine, palace at Knossos, with large pithoi *in situ*.

4-8 Reconstruction of a stairwell, palace at Knossos.

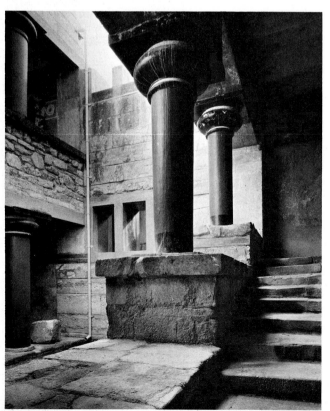

provided an extraordinarily rich effect. The frescoes depicted many aspects of Cretan life (bullfights, processions, and ceremonies) and of nature (birds, animals, flowers and—as here—marine life with dolphins frolicking among other fauna of the sea).

One of the most memorable figures from the art of Crete is the *Cupbearer* from the procession fresco of the South Propylon at Knossos (FIG. 4-10). It is the only one preserved from a sequence, shown in two registers, that may have contained over 500 figures—if those from the Corridor of the Procession are included. The ceremonial *rhyton* (vessel for pouring ritual libations) carried by the youth has a typically Minoan shape, found nowhere else except as a Minoan import. And the figure itself is unmistakably Minoan. The youth has long curly hair, wears an elaborately embroidered loincloth with a silver-mounted girdle, and has ornaments on his arms, neck, ankles, and wrist. Although the profile pose with the full-view eye was a familiar convention in Egypt and Mesopotamia, the elegance of the Cretan figure, with its pinched waist, proud, self-confident bearing, and free movement,

distinguishes it from all other early figure styles. The angularity of the older styles is typically modified in the curving line that suggests the elasticity of the living and moving being.

Vivacity and spontaneity characterize the *Toreador Fresco* (FIG. 4-11). Although only fragments of it have been recovered, they are extraordinary in their depiction of vigorous movements of the girls and the young man, who is shown in the air, having, perhaps, grasped the bull's horns and somersaulted over its back. We have seen how important the bull is in the Near East, especially in Mesopotamian art. The difference in the Minoan paintings is in the relationship of the bull—it may be that here he is even a god—to human beings. In this fresco, man and beast contest with each other in a dangerous game that takes place in the here and now, the human beings as conspicuous in the action as the bull. In a powerful characterization of the natures of both man and beast, the poise and agility of the toreadors play off against the exploding energy

4-10 *The Cupbearer,* Knossos, *c.* 1500 B.C. Fresco, approx. 5′ high. Archeological Museum, Herakleion.

4-9 Reconstruction of the Queen's Megaron, palace at Knossos.

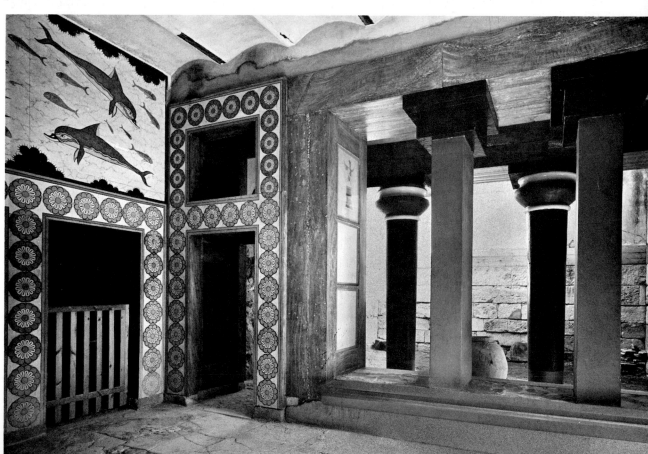

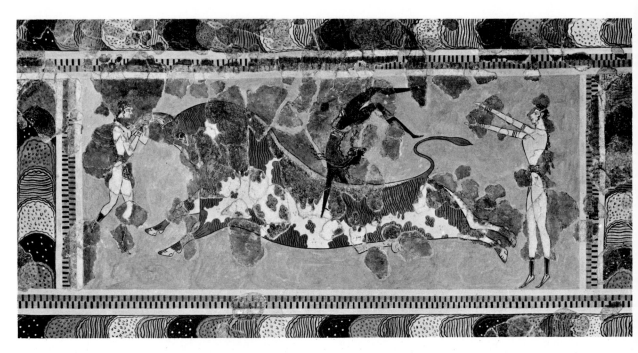

4-11 *The Toreador Fresco*, Knossos, *c.* 1500 B.C. Approx. 32″ high including border. Archeological Museum, Herakleion.

of the bull. (One thinks back to the charging bisons of the Paleolithic caves.) Everywhere within the frame are curving lines, the directional lines of action, and nowhere more conspicuously and vitally than in the electric energy of the line that sweeps from the head of the bull to the whip of his tail.

Because of her cosmetic prettiness—like that of a sophisticated, modern type of womanhood—a girl represented in a fragment of another fresco has been labeled *La Parisienne* (PLATE 4-1). With her conventionally enlarged and front-view eye, her turned-up nose, full red lips, and elaborate coiffure, she is almost disturbingly of our own times, especially as we conventionalize her type in popular art. Surely there is nothing quite like this sprightly charm, freshness, and *joie de vivre* in the art of the ancient Near East. The painting method used is appropriate to the lively spirit of the Minoans. Unlike the Egyptians, who painted in the dry fresco technique, the Minoans used a true, or wet, fresco method, which required rapid execution and a skill in getting quick, almost "impressionistic" effects. If one is to catch an interesting but fugitive aspect of an object or a scene, one must work quickly, even

spontaneously, allowing for happy accidents. Thus, because the wet-fresco technique compelled the artist to work rapidly, the spirit of *La Parisienne* is also a product of the resultant verve of his hand, and the simple, light delicacy of the technique matches exactly the vivacity of the subject. It is the Minoan sense of immediate life and the Minoan skill in catching it that strike us as novel in the ancient world and prophetic of great changes in man's outlook on nature.

POTTERY

The Minoan feeling for the dynamics of living nature, revealed in their figurative fresco art, is no less visible in their pottery, among the finest in history. In the Kamares ware this interest in animate nature does not at once appear; the taste is for abstract spiral forms, scrolls, whorls, and the like. As time went on, the tendency toward naturalism in decoration increased. Motifs were derived from sea life, such as dolphins, seaweed, and octopuses. The tentacles reaching out over the curving surfaces of the *Octopus Jar* from Gournia (FIG. 4-12) embrace the piece and em-

phasize its elastic volume. This is a masterful realization of the relation between the decoration of the vessel and its shape, always a problem for the ceramist. From the Kamares silhouetting of light abstract forms upon a dark ground, we go, in the *Octopus Jar*, to a silhouetting of dark naturalistic forms upon a light ground. This manner lasts from about 1600 to 1500 B.C., when the fluid, open, and lively naturalistic style becomes increasingly stiff and abstract. This late style can be seen in a three-handled jar of about 1425 B.C. from Knossos (FIG. 4-13). The stalks of its papyrus decoration grow symmetrically, and the flowers turn into stylized scrolls and fans, symmetrically balanced. Wavy bands, simple concentric circles with crosses, and other rudimentary space-fillers occupy the surface rather than adjust to it and embrace it. Such devolution from naturalism to formalism and abstraction can be observed frequently in the history of world art.

An increasing self-awareness, which we have watched slowly evolving in ancient art, requires that man represent himself ever more as he is, in more conditions and situations, with fewer restrictions imposed by tradition. The *Harvester Vase* (FIGS. 4-14 and 4-15), made of steatite (soapstone), gives a sharp new glimpse of man as he is in his usual physical context. The egg-shaped rhyton, its lower half missing, shows a riotous crowd of olive-harvesters, singing and shouting. Their forward movement and lusty exuberance are most vividly expressed. The pattern of pitchforks fills the upper part of the band, while the figures below, in higher relief, create a variation in surface. The entire design, like the octopus of the Gournia vase, hugs the shape so tightly that it seems to be an integral part of the wall of the vase. But the figures themselves are depicted with a gusto that matches their mood. They are led by a man who carries a *sistrum*, or rattle, and beats time, while his lungs are so inflated with air that his ribs show. The harvesters' facial expressions are rendered with astonishing exactitude; there are degrees of hilarity and degrees of vocal effort, all marked in the tension or relaxation of facial muscles.

4-12 *The Octopus Jar* (amphora), Gournia, *c.* 1600 B.C. Approx. 8″ high. Archeological Museum, Herakleion.

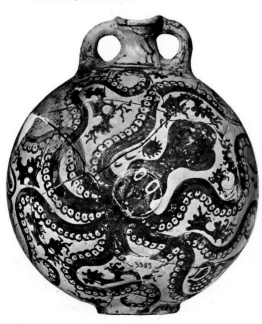

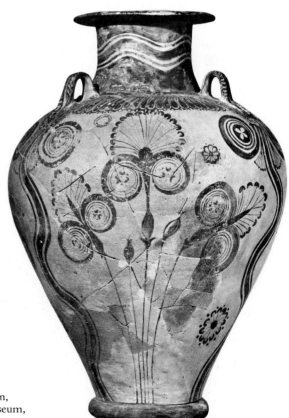

4-13 Right: Three-handled jar with papyrus decoration, Knossos, *c.* 1500 B.C. Approx. 53″ high. Archeological Museum, Herakleion.

This reading of the human face as a vehicle of emotional states is without precedent in ancient art before the Minoans.

SCULPTURE

There is little sculpture in the round in Minoan art, and what there is is diminutive; there is no monumental sculpture of gods, kings, and monsters, such as we find in Mesopotamia and Egypt—at least, none has been found. This absence of large-scale sculpture may reflect an absence of a systematic and formal religion—though this is entirely speculation because of our ignorance of Minoan religion. The small figures of "snake goddesses" like the one shown from Knossos (FIG. 4-16) are hardly more than of talisman or fetish size. They exhibit most of the rigid conventions, including the frontal pose, that we have met in Egypt and Mesopotamia, but their snake-entwined arms have been released from the core of the block and are held forward or aloft. Thus, they are shown to be active and, somehow, seem more alive than their Near-Eastern or Egyptian cousins. The Cretans seem to have worshiped a mother goddess sacred to many places and manifest in many forms. Whether or not these miniature figures brandishing snakes are images of her is not certain, but they are clearly identified as Minoan by their costume—the open bodice and flounced skirt worn by Minoan women as we find them depicted many times over. This touch of the real may be another example of man fashioning his gods in his own image.

The circumstances under which the Minoan civilization came to an end are still hotly disputed. One theory, which seems to be gaining adherents, has it that the Cretan palaces were destroyed around 1450 B.C. as the result of a cataclysmic volcanic eruption on the island of Thera, which lies some eighty miles north of Crete. The seismic catastrophe may have caused such a loss of population that the Mycenaeans could move into the island and establish themselves at Knossos without meeting major resistance. From the repaired palace at Knossos they seem to have ruled the island for at least half a century, perhaps much longer. Parts of the palace continued to be occupied until its final destruction around 1200 B.C., this time by the Dorians, but its importance as a cultural center faded soon after 1400, as the focus of Aegean civilization shifted to the Greek mainland.

4-14 *The Harvester Vase* (rhyton), Hagia Triada, c. 1500 B.C. Steatite, approx. 5″ wide. Archeological Museum, Herakleion. (Lower part is lost.)

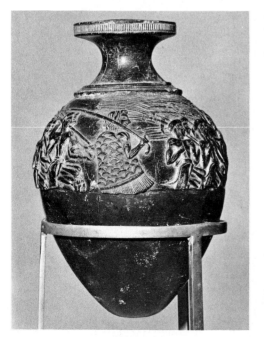

4-15 *The Harvester Vase*, detail.

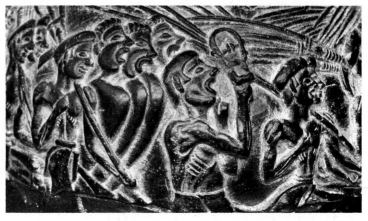

EARLY MINOAN (PRE–PALACE) PERIOD	MIDDLE MINOAN PERIOD	Destruction of Old Palaces	Toreador Fresco	LATE MINOAN PERIOD	Lion Gate
	←—— OLD PALACES ——→ Kamares Style	←— NEW PALACES —→		←——— MYCENAEAN PERIOD ———→	

MYCENAEAN ART

Just as the end of the Minoan, so the origins of Mycenaean culture are still being debated. The primitive Greeks may have moved into the mainland about the time the old palaces were being built in Crete—that is, about the beginning of the second millennium B.C. Doubtless they were influenced by Crete even then, and some believe that for a long time the mainland was a Minoan colony, though the mainlanders developed and held to many cultural features of their own. At any rate, Mycenaean power rose on the mainland in the palmy days of the new palaces on Crete, and by 1500 B.C. a new and splendid culture was flourishing in Greece to which, 700 years later, Homer was to give the epithet "rich in gold." It is possible that the Mycenaeans made close contact in this new era not only with Crete but with Egypt, with which they may have been allied against the Hittites in the early part of the New Kingdom; and the Mycenaeans' taste for gold, as well as their actual treasure, may have been acquired in the mercenary service of Egypt, which was known in the ancient world for its lavish use of the metal. Thus, the awakening of the Mycenaean world may have been the consequence of a kind of three-way route of influence connecting the mainland, Crete, and Egypt. The destruction of the Cretan palaces left the Mycenaean (mainland) culture supreme, but new waves of migrating proto-Greek peoples, the Dorians, finally submerged the Mycenaean civilization. The steady infiltration of these peoples had already made a fortress architecture necessary (unlike the case in Crete) and by about 1200 B.C. the fortified citadels of the mainland were overwhelmed by the invaders. The heroes and battles of these last centuries of Aegean civilization must have provided the tradition that, hundreds of years later, Homer would immortalize in the first great European epics, the *Iliad* and the *Odyssey*.

Though Mycenae appears to have been the cultural center of the mainland development, the remains of other large palaces have been found at Vaphio, Pylos, Orchomenos, Arne, and (most recently) at Iolkos. The best preserved and most impressive Mycenaean remains are those of the fortified palaces at Tiryns and Mycenae, both built at the beginning of the Late Mycenaean period, about 1400 B.C., and razed (along with the others) between 1250 and 1200 B.C.

4-16 *Snake Goddess*, Knossos, c. 1600 B.C. Faïence, approx. 13½" high. Archeological Museum, Herakleion.

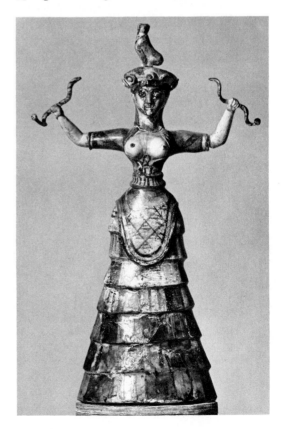

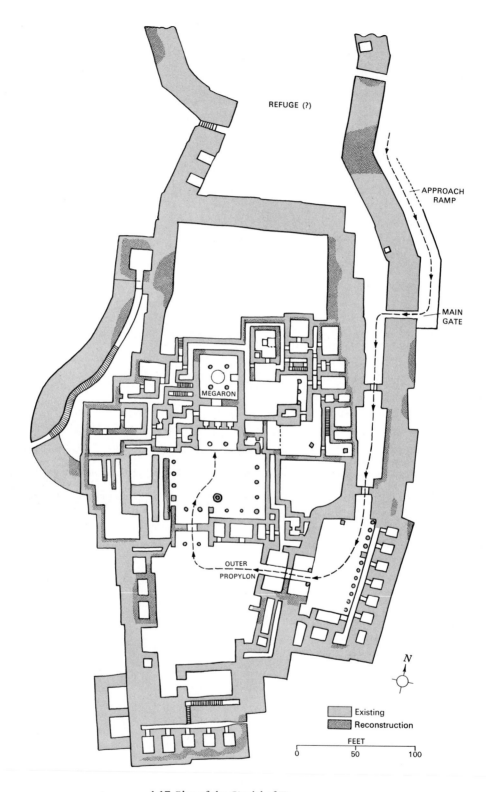

REFUGE (?)

APPROACH
RAMP

MAIN
GATE

MEGARON

OUTER
PROPYLON

N

Existing

Reconstruction

FEET
0 50 100

4-17 Plan of the Citadel of Tiryns, *c.* 1400–1200 B.C.

4-18 Plan of the megaron, Tiryns.

Architecture

The Citadel of Tiryns (FIG. 4-17), only ten miles from Mycenae, so that at times they may have been under the same lord, was known by Homer as Tiryns of the Great Walls and by the ancient world as the birthplace of Herakles, the mythic hero of great strength. The ancient sightseer and guidebook-writer, Pausanias, thought the walls of Tiryns quite as spectacular as the pyramids of Egypt. The heavy walls are in sharp contrast with the "open" Cretan palaces and clearly reveal their defensive character. The buildings within the twenty-foot-thick walls are aligned axially and seem to have been laid out according to a predetermined plan. Unlike the rambling and often confusing layout of the Cretan palaces, the Mycenaean plan is an example of a clear and simple arrangement of the units. The megaron (FIG. 4-18), the three-chambered structure at the heart of the design and the center of the life of the citadel, embodies the germ of the classical temples of Greece. This fundamental building type does not appear in the palaces of Crete but does appear, surprisingly, at Troy as early as 2000 B.C. A hall of state, the megaron was rectangular, with a central hearth and four columns supporting the roof.

The massive fortification walls at Tiryns and other Mycenaean sites, built of unhewn or

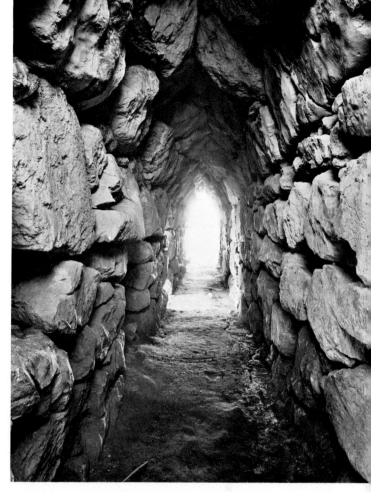

4-19 Corbeled gallery, Tiryns.

roughly dressed stone, were called cyclopean by later Greeks, who imagined them to have been built by that mythical race of giants. Through the walls at intervals run corbeled galleries (FIG. 4-19), which may have been used as part of the defensive structure or as part of a complicated and dramatic ceremonial path leading, through a porch and vestibule, to the chief room of the palace—the megaron. The corbeled gallery pictured makes use, as its name indicates, of the primitive corbeled arch. The rough appearance of these cyclopean structures is most impressive in its crude monumentality; it possesses an earthy dynamism not found in other, more sophisticated ancient architectural styles.

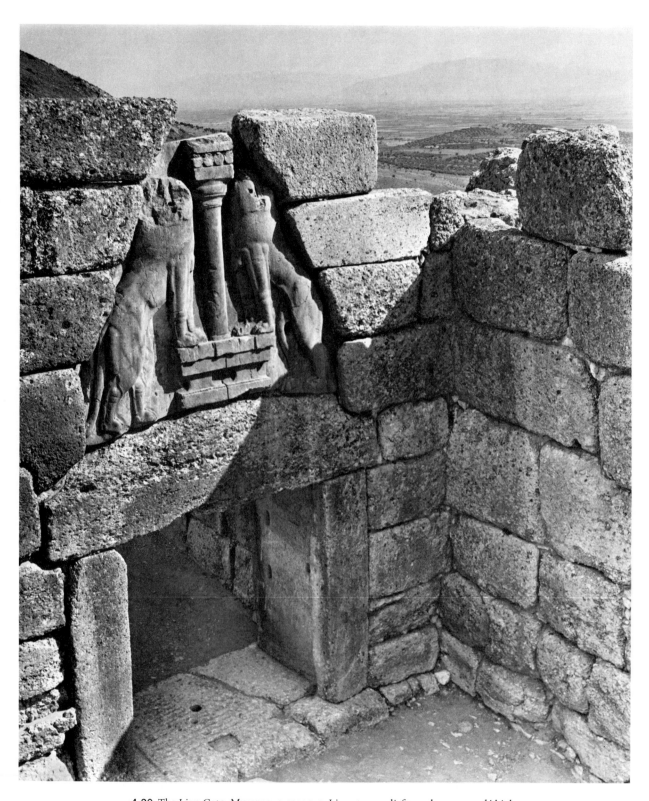

4-20 The Lion Gate, Mycenae, *c.* 1300 B.C. Limestone relief panel, approx. 9½′ high.

The Art of the Aegean

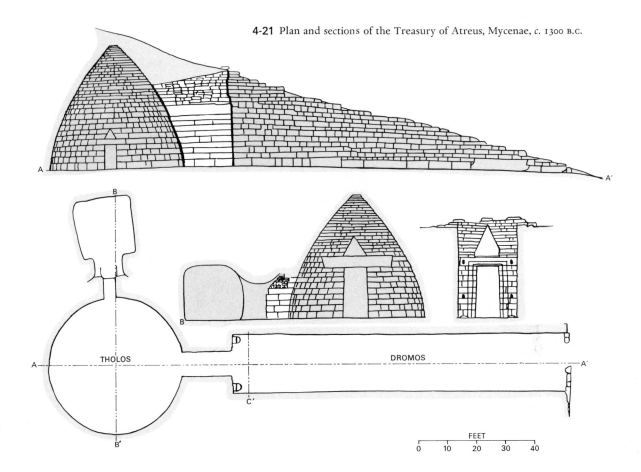

THOLOS

DROMOS

A

A'

B

B

B'

D

D

C'

FEET

0 10 20 30 40

The sternness of these fortress-palaces was relieved by frescoes, by carvings, and, at Mycenae at least, by monumental architectural sculpture—the Lion Gate (FIG. 4-20). This outer gateway of the stronghold, protected on the left by a wall and on the right by a projecting bastion, is formed of two great monoliths capped with a huge lintel above which the layers of stone form a corbeled arch, leaving a triangular opening that serves to lighten the weight to be carried by the lintel. The arched space is filled with a slab on which two lions carved in high relief confront each other on either side of a column of the probably sacred Minoan type, resting their forepaws on its base. (This column of the Lion Gate supplies evidence of what the vanished wooden Minoan columns looked like.) Holes near the top of the animals indicate that the heads, now lost, were made of separate pieces of stone or metal. The lions are carved with breadth and vigor, and the

whole design admirably fills its triangular space, harmonizing in dignity, strength, and scale with the massive stones that form the walls and gate. We find similar groups in miniature on Cretan seals, and one senses that these lions are not too distant from Mesopotamian heraldic composition.

Within the gate and to the right lies the grave circle, an enclosure containing a number of simple shaft graves, stone-lined pits serving as tombs for kings and their families, covered and marked by a stele. Another similar grave circle was recently discovered outside the walls of Mycenae. Both grave circles date from about 1600–1500 B.C. But at this time shaft graves were gradually being replaced by the so-called beehive tombs, of which the best preserved is the remarkable Treasury of Atreus (FIGS. 4-21 and 4-22), misnamed that by Schliemann, who thought it—the most imposing of a group—to be the storehouse for the treasure of Atreus,

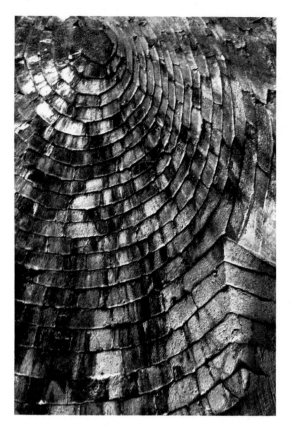

4-22 Interior of the tholos, Treasury of Atreus Vault approx. 45′ high.

reveal the influence of the Minoan figure style (PLATE 4-2). On the longest of the three blades illustrated, three hunters with spears, bows, and shields attack a lion that has struck down a fourth hunter, while two other lions flee. The subject is of Mesopotamian derivation, but the costumes are Cretan, and the vigorous, spirited movements of the hunters, the lithe strength and spring of the lions, are of the Minoan taste.

Beaten gold (*repoussé*) masks were found in the shaft graves, attached to the faces of the mummified Mycenaean princes (FIG. 4-23). Powerfully realistic in their record of the features of the deceased, they also testify to the influx of gold from Egypt. This and the elaboration of funeral practices lend strong support to the supposition that the impulse that started this high phase of Mycenaean civilization originated partly in Egypt, partly in Crete.

The golden culture of Mycenae produced such masterpieces as the famous cups from Vaphio (FIG. 4-24). Found in a beehive tomb, these beautiful vessels are still the subject of warm debate among experts who see them as originating in Crete and those who insist that, despite their undoubted resemblance to Minoan figure style, they are Mycenaean. The cups are a pair, each made of two plates of gold, one of which was worked in *repoussé* for the outside, the other left plain to make a smooth surface for the inside.

father of Agamemnon and Menelaus. Built into a hill and approached by a long passage, or *dromos*, the beehive shape of the round tomb chamber, or *tholos*, was achieved by use of corbeled courses of stone laid on a circular base, splendidly fitted to the curve of the wall, and ending in a lofty dome, which in this fine example is about forty feet high. This was the largest vaulted structure without interior supports in all antiquity until the Roman Pantheon was built 1500 years later.

Pottery, Relief, and Craft Art

Most of the beehive tombs had been thoroughly looted long before their modern rediscovery. On the other hand, rich finds were made in shaft graves at Mycenae. Some bronze daggers, inlaid with gold and silver, found in these graves

4-23 Funeral mask from the royal tombs of Mycenae, *c.* 1500 B.C. Beaten gold, approx. 12″ high. National Museum, Athens.

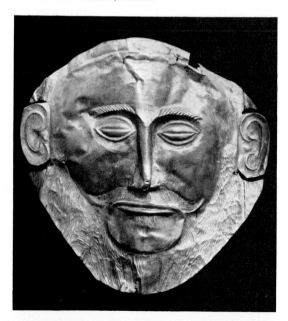

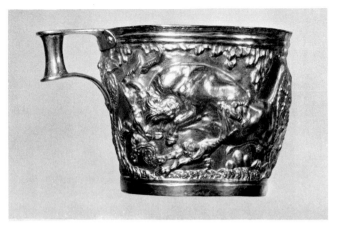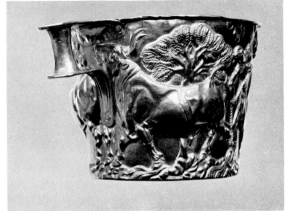

4-24 *The Vaphio Cups, c.* 1500 B.C. Gold with *repoussé* decoration, approx. 3½″ high. National Museum, Athens.

The plates were fastened together, the handles riveted on, and some of the details then engraved. The subject seems to be Minoan (the men are costumed in the Minoan manner) and related to the bull-leaping ritual; bulls are being trapped and snared, with a cow used as a lure in one case. One cup shows a bull caught in a net. A second bull, charging furiously, impales with its horns a man whose companion falls to one side. A third bull dashes madly from the fracas. The other cup presents a quieter scene. At the right the bull moves toward the cow; in the center he stands beside her; at the left, captured and hobbled, he is bellowing. The three scenes are integrated by the trees and the man, and the whole design is admirably composed to fit the space. In both cups, areas not filled by the animal and human figures contain landscape motifs of trees, rocks, and clouds similar to those in painting. The shallowness of the relief and the conventional treatment of the trees produce a rich play of light and shade together with a variety of textures.

The *Warrior Vase* (FIG. 4-25) represents a file of Mycenaean soldiers strikingly different in costume, physiognomy, and beards from the Cretan types we have seen in Minoan art. This would seem to strengthen the argument of those who regard the Mycenaeans as being of entirely different racial stock from the Minoans and as the indigenous builders of their own civilization. It may be, too, that we are looking here at the last Mycenaean warriors who marched forth to meet the Dorian invaders, under whose onslaught the Mycenaean civilization collapsed after 1200 B.C. The Dorians carried iron weapons, superior to the softer bronze of the Mycenaeans, and their success illustrates the historical commonplace that a superior technology can overcome an otherwise more highly developed civilization. The centuries-long "dark age" that followed the obliteration of Aegean culture, though little survives from it, cannot be considered merely a historical void. New energies were gathering that would form one of the greatest civilizations the world has known, a civilization new, bold, self-confident, and "modern."

4-25 *The Warrior Vase,* Mycenae, *c.* 1200 B.C. Approx. 14″ high. National Museum, Athens.

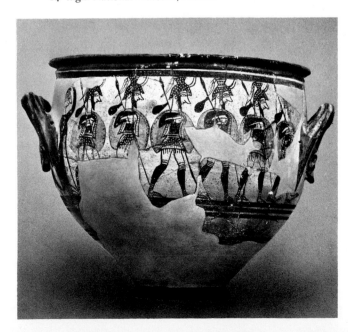

Chapter Five

The Art of Greece

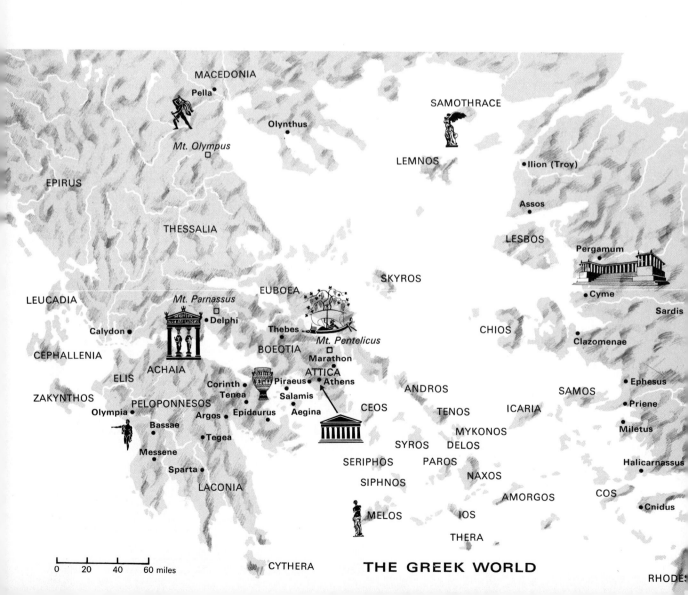

MACEDONIA

Pella

Olynthus

SAMOTHRACE

LEMNOS

Mt. Olympus

EPIRUS

Ilion (Troy)

Assos

THESSALIA

LESBOS

Pergamum

LEUCADIA

Mt. Parnassus

EUBOEA

SKYROS

Cyme

Sardis

Calydon

Delphi

Thebes

CHIOS

Clazomenae

Mt. Pentelicus

CEPHALLENIA

BOEOTIA

Marathon

ACHAIA

ATTICA

Ephesus

ELIS

Corinth

Piraeus

Athens

ANDROS

SAMOS

ZAKYNTHOS

Tenea

Salamis

Priene

Olympia

PELOPONNESOS

Argos

Epidaurus

Aegina

CEOS

TENOS

ICARIA

Miletus

Bassae

Tegea

MYKONOS

Messene

SYROS

DELOS

Sparta

SERIPHOS

PAROS

Halicarnassus

LACONIA

SIPHNOS

NAXOS

COS

AMORGOS

MELOS

IOS

Cnidus

THERA

0 20 40 60 miles

CYTHERA

THE GREEK WORLD

RHODES

"OR WE ARE LOVERS of the beautiful, yet with simplicity, and we cultivate the mind without loss of manliness. . . . We are the school of Greece." In the fifth century B.C., the Golden Age of Athens, Thucydides has Pericles make this assertion in praise of the Athenians, comparing their open, democratic society with the closed, barracks state of their rivals, the Spartans. But he might be speaking in general of Greek culture as we have received it and of the ideal of humanistic education and life created by that culture. In the "humanistic" view, man is what matters, and he is, in the words of Protagoras, the "measure of all things."

For the Greeks, what sets man apart is his intelligence, and human intelligence, trained in reasoning, is the highest function nature has created. Moreover, Aristotle assures us that "all men by nature desire to know." And what we know is the order of nature, which is one with the order of human reason.

The order of both nature and reason, said the Greeks, is beautiful and simple, and the beauty of things is one with our knowledge of them;

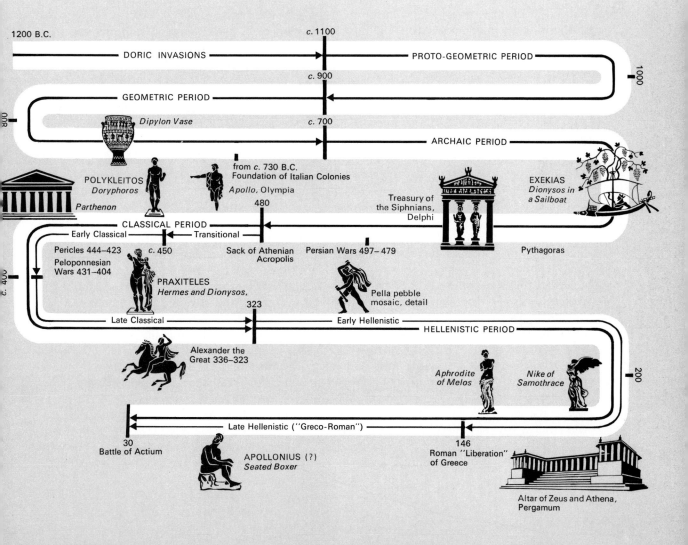

thus, the good life, the achievement of the "beautiful soul," follows upon compliance with that typically Greek command, "Know thyself!" One achieves the good life, then, through an intellectual process; one lives "according to nature"—that is, according to the natural laws of life discoverable by rational man. The self now becomes of first importance, and as man comes to full self-awareness he necessarily becomes aware of nature as well.

Man is regarded as the highest creation of and value in nature, and it was the Greeks who created democracy as well as the natural image of man in art. The late great scholar of Classical Greece, Werner Jaeger, wrote of their exaltation of man: "As against the Oriental exaltation of one God-king . . . and the . . . suppression of the great mass of the people . . . the beginning of Greek history appears to be the beginning of a new conception of the individual the history of personality in Europe must start with them [the Greeks]."[1]

This honoring of the individual—and through the individual, the laws of human nature—is so completely part of our habit of mind that we are scarcely aware of it and of its origin in the minds of the Greeks.

From the Paleolithic age we have been surveying man in a world dominated by the great beasts—threatened by them, fighting them, dependent upon them (or their embodiment), worshiping them, conceding their might and his own weakness. Now, in Greece, he asserts that his own peculiar power—the power of intelligence—puts him far above the beasts. But the Greek mind is not dryly or pallidly rationalistic; it knows well the forces of the irrational against which reason must struggle constantly. In fact, Greek art constitutes with Greek culture a compact synthesis of opposites, a harmony between profound passion and rational order. Its clarity and symmetry are not cold but blazing; its forms can be rigorous and mathematical, yet full of life.

In marked contrast to Egypt, with its long horizontals of alluvial plain between desert plateaus and seemingly invariable sunshine, Greece is a country of diversified geography and climate. The bays of its deeply indented, rugged

[1] Werner Jaeger, *Paideia: The Ideals of Greek Culture* (New York: Oxford Univ. Press), Vol. I, p. xix.

coastline make the country half land and half sea; mountain ridges divide it into many small units. The climate is vigorous—cold in the winter, dry and hot in the summer. There is almost always a breeze from the sea. The unusually clear, almost crystalline atmosphere is often softened by a haze. Both sky and sea are brilliant in color. It is little wonder that the Greeks, with their joy in nature, should people mountains, woods, streams, sky, and sea with divinities; that they should picture Zeus, the king of this realm of gods, as reigning from their loftiest peak, Olympus; the Muses as dwelling in the deep, cool groves on the long slopes of Parnassus and Cithaeron; and Apollo as speaking from the awe-inspiring rocky clefts of Delphi.

Nature worship evolved into personification. The gods assumed human forms whose grandeur and nobility were not free from human frailty; indeed, unlike the gods of Egypt and Mesopotamia, their only real difference from men was that they were immortal. There is a saying that the Greeks made their gods into men and their men into gods. Man, becoming the measure of all things, must become, if all things in their perfection are beautiful, the unchanging standard of the best; to create the perfect individual became the Greek ideal.

The Greeks, or Hellenes, as they called themselves, appear to have been the product of an intermingling of Aegean peoples and of Indo-European invaders. This intermingling may have been a vitalizing factor that should be considered, together with the climate and the strongly diversified mountain-valley terrain of the Greek peninsula, in hypothesizing the causes of the peculiarly high competitive and creative energy of the Greek peoples.

The first of the invaders began to drift into the area about 2000 B.C., and after 1600 B.C., as we have seen, they formed the Mycenaean civilization on the Greek peninsula. After about 1200 B.C. the Mycenaeans were apparently overwhelmed in turn by new invaders from the north—the Dorians and perhaps the Ionians. The Dorians made the Peloponnesos the center of their power and may have forced the Ionians eastward across the Aegean to the coast of Asia Minor. The origin of the Ionians is still a matter of dispute. Some scholars feel that proto-Ionians

lived at Athens during Mycenaean times and that they were displaced during the Doric invasions. Others hold that they developed on the coast of Asia Minor between the eleventh and eighth century B.C. out of a mixed stock of settlers. In either case, the Ionians seem to have been more individualistic than the tribally ordered Dorians, whose most characteristic city became conservative Sparta.

In Ionia, on the east coast of Asia Minor, epics of individual greatness had come to be celebrated by the eighth century B.C., and by the seventh century, the rational philosophers of Miletus had begun to interpret the world in terms of reason rather than religion, beginning that immense transformation of the worship of nature into the science of nature, the science that is still expanding today. Between Ionia and the Peloponnesos lay Attica, and there, in Athens, a conservative tribal order and individualistic striving combined to produce the most fruitful of all the *poleis*, or city-states, of Greece, the one that Thucydides could boast was the "school of Greece."

By the eighth century B.C. the separate Greek-speaking states had held their first ceremonial games in common: the Olympiad of 776 B.C., from which time the historical Greeks calculated their chronology. From then on, despite their chronic rivalries and wars, they regarded themselves as Hellenes, distinct from the surrounding "barbarians," who did not speak Greek. The enterprising Hellenes, greatly aided by their indented coasts and island stepping-stones, became a trading and a colonizing people who enlarged the geographic and cultural boundaries of Hellas. Tribal organizations had evolved into city-states, each an individual unit. Political development differed from state to state, but a kind of pattern emerged in which rule was first by kings, then by nobles, then by "tyrants" who seized personal power. At last, in Athens, appeared the dynamic balance that was called democracy.

Athens has in many ways become the symbol of Greek culture; many of the finest products of Greek civilization were created by Athenians or by men who were closely associated with Athens and its traditions. Athens, at the time of its brief flowering after the Persian Wars, was an active business city of about 100,000 people. Above its

olive groves and rooftops towered the Acropolis, or higher city, formerly a Mycenaean fortress but in this age crowned with temples rising in bright colors against an intensely blue sky. Under the covered colonnades (*stoas*) that surrounded the city's central marketplace (*agora*), the citizens congregated to discuss the latest political development or a new philosophical idea. Among the Athenians, philosophical argument was both a public and a private exercise that went on wherever a few disputants could be assembled. This love of intellectual contest, the vigorous forerunner of science itself, was astonishingly popular, and whether in the house of a rich man or in the marketplace, in the gymnasium, or on the street corner, such discussion was the key to the intense political and intellectual life that developed in the Greek city-state. Bodily exercise also played a large part in education and daily life, and the Athenian aim of a balance of intellectual and physical discipline, an ideal of humanistic education, is expressed in the Latin, *mens sana in corpore sano*, "a sound mind in a sound body."

The tragedies of Aeschylus and Sophocles, played before the eager citizens, presented the individual as having an obligation to the gods, and the rise and fall of his fortunes as a reflection of the contest between blind fate and the new-found power of reason.

The constants of Greek culture were man, nature, and reason, and the Greeks understood goodness to be the harmony of all three. Upon this elementary conviction, new to the world, they built their grand achievements in art, poetry, mathematics, philosophy, logic, history, and science—the heritage upon which the modern Western world was in turn constructed. In discovering man the Greeks discovered and confronted the problem of persistence and change; men pass away, but mankind remains. And although they aspired toward the timeless ideal, the Greeks recognized the changes that produce growth and development.

The remains of Greek civilization enable us to reconstruct the development of the Greek style in art. That the Greek style should in fact have "developed," is in itself significant. Development in the art of Egypt, for example, was minimal; the pattern of ritual and of form was not to be broken. Change in Egypt occurred, when it did,

despite the pattern of the culture as a whole. Of course we must remember that an important factor in the sudden appearance of Greece on the summit of historical eminence was the base on which it rose—the civilizations of Egypt and the Near East, the quality and matter of which the Greeks quite honestly acknowledged borrowing. From these older civilizations they acquired ideas, motifs, conventions, and skills. But from the beginning, the Greeks embraced experiment, even while adopting and holding to the older forms. Development and change were inherent in Greek culture, as conservatism was in Egyptian, and change has recognizable forms, as in the recurring stages of human life from infancy to old age. Greek art displays much more readily discernible stages than the relatively unchanging art of the ancient Near East.

THE GEOMETRIC AND ARCHAIC PERIODS

Pottery serves, as no other artistic medium can, to link the very late Mycenaean (sub-Mycenaean) age with that of historical Greece. For one thing, it has survived. We can trace a continuity from the sub-Mycenaean period into the Classical fifth century B.C. entirely in terms of the figurative decoration of Greek ceramic ware, showing the artist's confrontation with radically new ideas and problems and his equally radical interpretations and solutions. It is appropriate, then, given this continuity and the Greek notion of the development of forms, to begin the study of Greek art with vase paintings that illuminate changes that were profoundly influential in human history and that take place in a curiously logical order. We have already seen numerous examples of how man represents himself, from the strange, falling stick-figure in the well at Lascaux to the agile Minoans of the Vaphio cups. Now we can review changes in the representation of the human body that are the result not of accidental differences of convention but of carefully accumulated increments of knowledge. These were firmed into a tradition of technical

procedure that did not backslide—as was the case in the Egyptian return to old forms after the death of the innovating Akhenaton (see Chapter Three). We can see in the Archaic Greek vases that man for the first time has become the subject of intense analytical study. As the philosopher questions man's nature and purpose, the artist begins to inquire how man looks to others of his kind in the world of optical experience. The old conceptual way of placing him and enumerating his features, which we have seen in the older civilizations, gradually is given up and is replaced by a method of painstaking observation of the pose and motion of the body in life. This did not happen all at once; centuries were involved in the great transformation, and the dated sequence of vases reveals the ordered phases of the change. It is useful to describe these changes at the outset, for, from its earliest appearances on vases, the human figure remains the principal motif of Greek art, as man is central to its thought and interest.

Vase Painting

An *amphora* (FIG. 5-1), a tall, two-handled jar for wine or oil, from about the tenth century B.C. shows us the formative phase of what is called the Geometric style. Though it borrows the decorative devices of the earlier sub-Mycenaean style, its execution is neater and more painstaking. As the Geometric style develops, the Minoan stock of curvilinear forms is gradually replaced by

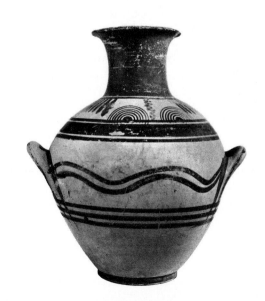

5-1 Proto-Geometric amphora, Dipylon cemetery, tenth century B.C. Approx. 16¼″ high. Keramikos Museum, Athens.

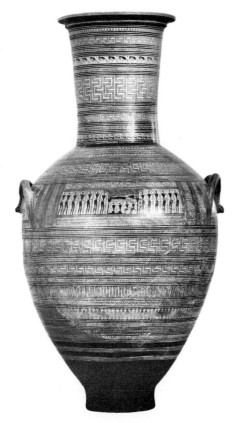

5-2 *Dipylon Vase* (Geometric amphora), eighth century B.C. Approx. 4′ 11″ high. National Museum, Athens.

possibly of the same date as the Dipylon vase of FIG. 5-2 or somewhat later, shows a certain loss of refinement as the geometric ornament becomes secondary. The figures represent a funeral procession, with horse-drawn chariots occupied by warriors carrying shields; in the conceptual manner both wheels of each chariot are represented, the horses carefully distinguished, and their legs correct in number. The warriors are standing behind their shields, which are shown in front view. The number of represented figures has increased markedly over that of FIG. 5-2, suggesting that the artist was intrigued with the rediscovery of a subject—the human figure—that had been absent from mainland pottery decoration for over 400 years.

The Geometric period was succeeded by the Orientalizing phase of the Archaic period, a time of marked commercial and colonial expansion that brought the Greeks into closer contact with ancient Eastern civilizations. A consequence of these new relationships was the frequent appearance of Oriental animals and composite monsters on Greek vases, motifs familiar to us from Mesopotamian and Egyptian art: lions, sphinxes, griffins, and centaurs. Stylistically, a vase from Eleusis (FIG. 5-4), typical of the Orientalizing

rectilinear shapes arranged in tight bands that cover more and more of the vessel.

The human figure reappears in the decorative scheme in the period of the culminating Geometric style, specifically in the so-called *Dipylon Vase* (FIG. 5-2), from the eighth century B.C. and named after the Dipylon cemetery in Athens, where it was found. The figures are hardly more than symbols, fashioned of diamond and wedge shapes that fit the severe, regular, geometric characteristics of the banded shapes. The extremely abstract figures are arranged on the shoulders of the vessel, toward which the design builds up from below, the decorative bands generally wider the higher their placement on the body of the vase.

Another type of Greek vase, the *krater*, had a larger body and wider mouth than the amphora. A krater from the Dipylon cemetery (FIG. 5-3),

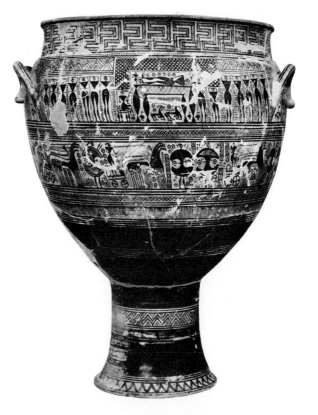

5-3 Geometric Dipylon krater (with prothesis), Dipylon cemetery, eighth century B.C. Approx. 40½″ high. Metropolitan Museum of Art, New York (Rogers Fund).

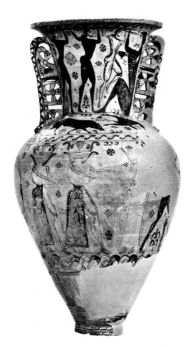

5-4 *The Blinding of Polyphemos* and *Gorgons* (proto-Attic amphora), Eleusis, *c.* 675–650 B.C. Approx. 56″ high. Museum, Eleusis.

phase, represents a complete and radical break with the orderly Geometric manner. The figurative decor occupies most of the vessel; the arrangement of the motifs is loose, almost casual, and the shapes are mostly curvilinear. It is almost as if the artist were intentionally throwing off the Geometric strait jacket as an awkward restraint upon a new interest—the representation of narrative scenes, some from Homeric legend. On the amphora in FIG. 5-4 where Polyphemos, the one-eyed giant, is being blinded by Odysseus, the human figure—resembling those of the Geometric period, but much more filled out, rounded, and active—now occupies the largest

areas of the vessel, and the ornament retreats to the smaller areas in the neck, shoulder, and base. It was in the Geometric period that the Homeric themes were collected in the great epics; the Orientalizing phase marks their diffusion and their achievement of universal popularity in Greece. The illustration of the epics will occupy the surfaces of vases for centuries to come; it might almost seem that this first great reflection of man and his actions, in Greek epic, launched the enterprise of representing him in art.

During the Geometric and Archaic periods, numerous pottery centers developed throughout the Aegean world. They have been divided into two main groups—those of the mainland and those of eastern Greece (the regions east of the mainland). On the mainland the most important centers were Athens in Attica and Corinth in the Peloponnesos, and after 550 B.C. Athens became the principal ceramic center and the largest exporter of vases in the Mediterranean basin. In this brief survey we shall confine ourselves to Athenian wares.

The number of basic Attic vase shapes was limited to six or seven, each subject to four or five variations. The shapes developed out of specific usages and were entirely functional (FIG. 5-5).

The *François Vase* (FIG. 5-6), which was named after its discoverer and is perhaps the finest existent example of an early Archaic krater, with its volute handles and extraordinarily vigorous shape, was found in an Etruscan necropolis. (We are indebted to the Etruscans for their avid collecting of Greek vases, as many of the best-preserved have been found in Etruscan tombs.) It is especially important, not only for its high quality but for the fact that it is signed by both

5-5 Greek vase shapes: (a) the *hydria* (from the Greek for "water"), a water jar with three handles, two for lifting and one for carrying; (b) the *lekythos*, an oil flask with a long narrow neck adapted for pouring oil slowly, used chiefly in funeral rites; (c) the *krater* (from the Greek "to mix"), a bowl for mixing wine and water, the usual beverage of the Greeks; (d) the *amphora* (meaning "to carry on both sides," referring to the two handles), a vessel for storing provisions (wine, corn, oil, honey), with an opening large enough to admit a ladle and usually fitted with a cover; (e) the *kylix* (from the Greek "to roll," referring to the vases' being turned on the potter's wheel), chief form of the drinking cup; (f) the *oenochoe* (from the Greek "to pour out wine"), a wine jug, the lip pinched into a trefoil shape to facilitate pouring.

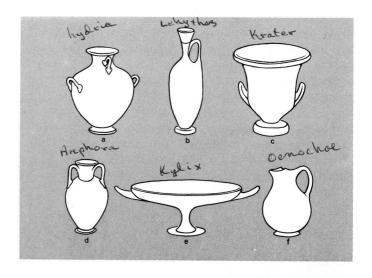

the potter ("Ergotimos epoiesen") and the painter ("Kleitias egraphsen"). Signed vases appear for the first time in the early seventh century B.C. and suggest that their makers had pride in their profession and that their art had at least as much prestige, say, as that of the sculptor or wall painter.

The *François Vase* is ornamented with over 200 figures distributed in bands around the vessel. Representing almost the entire Greek pantheon, the figures provide us with one of our first pictorial glimpses of the forms and personages of Greek religion: The subject is the wedding of Peleus, with the gods in attendance. In addition to the scene of the gods and Peleus, father of Achilles, are depictions of the Calydonian boar hunt and the funeral games for Patroklos. On the foot of the vase is an account of an animated battle between cranes and pygmies, above which rays felicitously augment the swelling surface of the krater. The lively scenes are rigidly organized in six bands of varying widths, the widest placed on the vessel's shoulders, a return to the discipline and formality of the Geometric style after the casual and permissive Orientalizing style of the vase from Eleusis (FIG. 5-4).

The François Vase is decorated in an early form of the so-called *black-figure* technique, which is shown fully developed and at its best in a *kylix* (drinking cup) by the potter-painter EXEKIAS (FIG. 5-7). Dark figures are silhouetted against the light background of the natural reddish clay. Details are incised into the silhouettes with a sharp, pointed instrument to expose the red beneath; touches of white and purple, particularly on the earlier wares, add color to the dominantly monochrome decoration. Although the black areas are customarily referred to as glazes, it should be pointed out that the black on these Greek pots is neither a pigment nor a glaze but *engobe*, a slip of finely sifted clay that originally is of the same color as the clay of the pot. In the three-phase firing process used by Greek potters, the first (oxidizing) phase turns both pot and slip red; during the second (reducing) phase the oxygen supply into the kiln is shut off and both pot and slip turn black; in the final (reoxidizing) phase the coarser material of the pot reabsorbs oxygen and becomes red again, while the smooth-

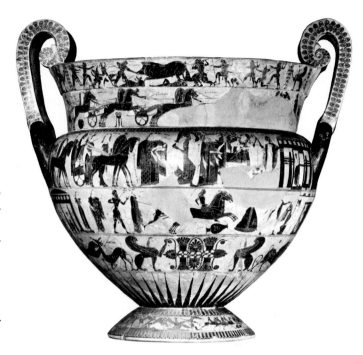

5-6 *The François Vase* (Attic black-figure krater), Chiusi, *c.* 575 B.C. Approx. 26″ high. Museo Archeologico, Florence.

er, silica-laden slip does not and remains black. After long experiment, Greek potters developed a velvety, jet-black "glaze" of this kind. The touches of white and purple were used more sparingly, with the result that the figures stood in even stronger contrast against their reddish

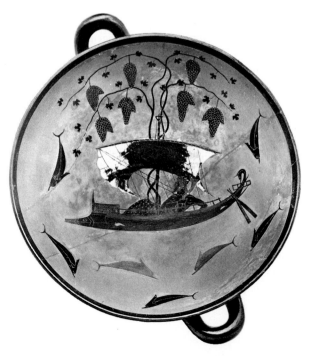

5-7 EXEKIAS, *Dionysos in a Sailboat*, interior of an Attic black-figure kylix, Vulci, *c.* 550–525 B.C. 12″ in diameter. Staatliche Antikensammlungen, Munich.

backgrounds. This superb formal control provides the framework for a wealth of naturalistic detail, some of it strikingly novel.

Exekias' kylix, with a representation of Dionysos sailing over the sea carrying his gifts to mankind and accompanied by sporting dolphins, his boat's mast entwined by a joyful grapevine, introduces a still more spectacular innovation, one that heralds the beginning of a revolution in world art. In his drawing of the boat's sail, Exekias does not show a traditional and conventional symbol that "reads" as a "sail" but a sail as a sail would actually look, bellying out and filled with wind. It is an image of the action of wind itself, the wind made palpable as a force, and it must have come from a new awareness of the *physical* presence of nature. This awareness was abroad; it is in the Ionian speculations about the physical constitution of the world, and in the reality-charged poetry of Homer: "But soon an off-shore breeze blew to our liking— a canvas-bellying breeze. . . . The bows went plunging . . . sails cracked and lashed out"

Though in Homer the gods are still the manipulators of the elements, it is men who feel their effects, who hear the howl of the great winds, smell the brine, and feel the harsh ropes and drenching rain. Man's experience of the world, as well as the world itself, begins to be understood by him in physical terms. Such a profound change in man's awareness of his relation to nature and, in consequence, of his own nature, is one that is bound to make itself felt in art. From Exekias' sail on, Greek art will manifest an increasing comprehension of physical nature as it is apprehended by vision.

Exekias' skill and subtlety also solve to perfection a difficult compositional problem: how to fix the ship within its circular frame. Part of his solution lies in the down-branching weight of the loaded vines, part in the reverse hooklike dolphins, which seem to stitch the composition to its frame.

Around 530 B.C. a new painting technique was invented that reversed the black-figure style by making the background black and leaving the figures reserved in red. The figures of men and animals no longer are dark and earthy, massive against a light ground, but instead are luminous, like light and air, shining forth from the black background. In this new *red-figure* technique the major interior markings were rendered with relief lines applied with a syringelike instrument that squeezed out the black "glaze" matter evenly and smoothly. Secondary markings, such as those representing hair, muscles, and sometimes even shading, were painted in "dilute glaze" (engobe diluted with water), which could be applied with a fine brush. The style is freer and more facile than the earlier black-figure style, which it largely replaced within twenty years. The artist felt no need to enlarge his limited color scheme, for the polished coppery red against a velvety black created an effect that was rich and of reserved elegance. The artist usually credited with the invention of the red-figure technique is the ANDOKIDES PAINTER, who is named for the potter Andokides, several of whose signed vases he decorated. Sometimes called a student of Exekias, the Andokides Painter uses pictorial devices that are rooted in the style of the older master. On an amphora that shows Herakles and Apollo struggling for the tripod (FIG. 5-8) he shows an interest in rich drapery ornaments and textural effects such as are found in the work of his presumed master. His work lacks some of the warmth and sympathy of Exekias' as he is more concerned with exploiting the possi-

5-8 ANDOKIDES PAINTER, *Herakles and Apollo Struggling for the Tripod*, detail from amphora, *c.* 350 B.C. Outline drawing at right indicates relation to whole vessel. Portion shown approx. 11″ high; whole vessel approx. 23″ high.

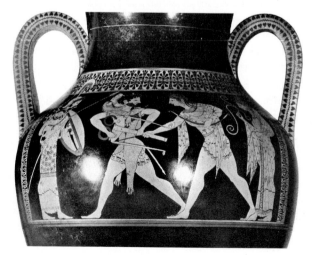

bilities of his newly discovered technique. And there he breaks new ground, experimenting with novel and varied effects of color (he liked to use both purple and white) and, in a technique that dispenses with the laborious process of incision, creating new decorative schemes of great elegance.

A krater painted by EUPHRONIOS, one of the most forceful red-figure painters working near the end of the sixth century B.C., shows Herakles strangling the giant Antaios (FIG. 5-9). Euphronios was among the first to devote himself seriously to the study of anatomy and was famous for this in his time. Here he shows two male figures in a complicated wrestling pose, one figure from the side, the other from the front. He attempts such radical experiments as the doubled-under leg of Antaios and the rendering of Antaios' face in white to suggest the pallor of impending death. He makes an effort to describe Herakles' and Antaios' straining, powerful bodies with painstaking attention to the musculature, and though he does not entirely succeed in producing a correct representation, his attempt to apply knowledge gained through observation of bodily action is most significant.

EUTHYMIDES was a contemporary and competitor of Euphronios and, like him, an experimenter. As we can see from his picture of revelers done on an amphora (FIG. 5-10), Euthymides is less concerned with anatomical description than with the problems of foreshortening in the figures and of showing them from different viewpoints. The fairly tipsy dancers, mightily enjoying themselves, are a rather popular subject on late Archaic and early Classical vases, and celebrate the Hellenic sense of the comic that served as counterpoise to its genius for tragic art in the drama. In this case it gives Euthymides an opportunity to present the figures in informal motion and in fairly successful three-quarter back and front views. The turning and twisting of the figures indicate that the artist is beginning to think of them as three-dimensional volumes that have free mobility in a space deeper than the flat, two-dimensional surface of the picture plane—a significant departure from pre-Greek tradition. The maturing self-consciousness of the Greeks is shown not only in their concern for the figures of man but also, of course, in their consciousness of themselves as artists. They sign their names to

their work and they are aware that they are doing new and revolutionary things as collaborators and rivals in a common professional enterprise. Euthymides, in an inscription on this amphora

5-9 EUPHRONIOS, *Herakles Strangling Antaios*, detail from krater, Cerveteri, *c*. 510–500 B.C. Outline drawing at right indicates relation to whole vessel. Portion shown approx. 12″ high; whole vessel approx. 19″ high.

5-10 EUTHYMIDES, *Revelers*, detail from amphora, Vulci, *c*. 510–500 B.C. Outline drawing at right indicates relation to whole vessel. Portion shown approx. 12″ high; whole vessel approx. 24″ high.

The Geometric and Archaic Periods 131

(FIG. 5-10), proclaims with naive pride: "Euphronios never did anything like it."

As revolutionary as Euphronios and Euthymides had been, the BRYGOS PAINTER (an anonymous artist who is named after the potter whose vases he decorated) takes a significant step beyond them, around the year 490 B.C. Again the revelers theme, with its gaily swinging movement, gives the experimenting artist his opportunity (FIG. 5-11). For some 2500 years, since the *Palette of Narmer* (FIG. 3-2), painted figures and figures in relief had advanced the *far* leg to show a stride—which, after all, is the best way if the torso is to be shown in front view with minimum distortion of the figure. Euthymides had broken this rule, advancing the near leg of a figure to show it in a three-quarter rear view (FIG. 5-10). But the Brygos Painter, for the first time, presents a striding figure with the near leg advanced and its shoulder turned diagonally toward the observer. (See the two central figures.) The result is the first true *contrapposto* stance in the history of painting. The figure is now understood as an acting unit, not merely an assemblage of parts; the problem of its engineering has been solved to the extent that it can be represented in convincing movement. This may at first seem to be a small matter, but an apparently superficial detail may be the manifestation of an epoch-making change in the concept of what human beings perceive.

5-11 BRYGOS PAINTER, *Revelers*, detail from kylix, Vulci, *c.* 490 B.C. Outline drawing at right indicates relation to whole vessel. Portion shown approx. 10″ wide; whole vessel approx. 13″ wide. Martin V. Wagner Museen der Universität, Wurzburg.

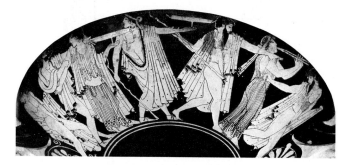

Sculpture

Trends in the development of sculpture in Greece are just as visible and describable as those we have traced in vase painting, though much less sculpture survives. The earliest pieces go back to the beginning of the ninth century B.C. and consist of small-scale representations of animals (horses, oxen, deer, birds) and of human figures in various materials: copper, bronze, lead, ivory, and terra-cotta. Some of these were ornaments on larger objects like vases and bronze tripods; others were separate votive offerings that have been found near ancient sanctuaries. At Olympia they seem to have been manufactured on the spot for sale to visitors to the shrines.

A bronze warrior from the Acropolis of Athens, from the late eighth century B.C. (FIG. 5-12), shows all the clear simplifications of the Geometric period. The figure, a favorite type in Geometric art, is solid cast. (Given the figure's diminutive size, this would be the reasonable casting method, as hollow casting, which was understood, would not have saved much bronze.) The warrior originally held a spear in one raised arm, and a shield in the other, though both shield and spear are missing in most surviving examples. The rather carefully rendered head and face, with the large eyes and broad grimace, later to become known as the standard "Archaic smile," attest to the fact that this figure is a late specimen of a type whose earlier examples had heads and faces that were little more than shapeless lumps. Moreover, the body forms have become smoother, losing some of their former angularity, as if the artist were trying to rid himself of centuries-old conventions of Geometric figure representation before the new approach—the visual one—could be tried. It is believed that these warrior statuettes were Syrian in inspiration, but a difference important in the evolution of Greek sculpture should be noted: The Greek figures are represented nude, while the Syrian prototypes wear loincloths. As early as this, the Greek instinct for the natural beauty of the human figure, which peculiarly and permanently distinguishes Greek art, is set in contrast with the Near Eastern traditional prejudice against the representation of the nude in sculpture in the round.

5-12 Geometric bronze warrior, front and back views, Acropolis, Athens, late eighth century B.C. Bronze, approx. 8″ high. National Museum, Athens.

Kouros and Kore

A bronze figure of a youth from around 680 B.C. (FIG. 5-13) stands at the beginning of the Archaic period; it is a small forerunner of the later *Kouros* figures (see FIGS. 5-15 and 5-16). The silhouette remains essentially geometric, with a triangular torso, a narrow waist, and bulging thighs; but the forms have gained volume, and the modeling of the pectoral muscles and the description of other anatomical details by means of incised lines show an incipient interest in the structure of the body.

Monumental, freestanding sculpture (life-size or larger) first appeared about 600 B.C., in the earlier stages of the Archaic period. Its rise is contemporary with the Orientalizing phase in vase painting and was probably inspired by foreign sources, most likely Egypt and Mesopotamia, which were in fact the only areas at that time that could show monumental sculpture in abundance. An early example of this monumental, freestanding sculpture is the *Hera of Samos* (FIG. 5-14), which is over six feet tall and has a cylindrical shape that could have been derived only from Mesopotamia (compare FIGS. 2-18 and 2-19). The goddess stands in a frontal pose, feet together, the right arm held tightly to the side, the left bent to the breast and probably originally holding some attribute, or symbol, of authority. She is the goddess as a sheathed column (in origin a tree?), as were the deities of Crete and Mycenae, but here the Greek artist displays his extraordinary sensitivity for surface ornamentation. The stability of the lower portions—where the striations of the *chiton*, or tunic, are placed against the plain surface of the *himation*, a kind of cape—contrasts with the movement in the upper portions, where the himation is drawn in gracefully curving folds around the delicate modeling of the swelling bosom.

We are reminded of Egyptian statues by the early Kouros figures (FIGS. 5-15 and 5-16). Some of these figures are of youths who are dedicated to a god and are apparently advancing into his

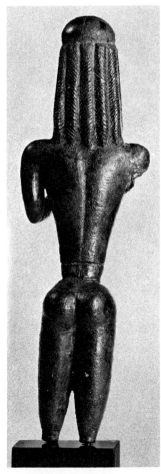

5-13 *Mantiklos "Apollo,"* front and back views, Thebes, c. 680 B.C. Bronze, approx. 8″ high. Museum of Fine Arts, Boston (Francis Bartlett Fund).

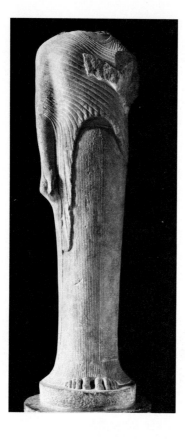

of the figure from the original block of stone. On the broad planes of the figure anatomical details are carefully modeled, as in the chest and knee joints. The head is geometrically simplified into flat planes, the eyes large and protruding, and the nose, mouth, ears, and wig all highly stylized attributes of the almost cubic mass of the head. Though still almost provincial Egyptian, the Tenea Kouros is quite un-Egyptian in its nudity and in its more dynamic, half-striding stance. Moreover, this figure is slender and elegant, with the alert, elastic physique of a sprinter. Description of the anatomy by incised line, typical of the earlier models, has been given up, and the torso, thighs, and calves are modeled in the full round with ever closer approximation of anatomical truth.

With the *Kroisos* from Anavysos (FIG. 5-16), we come to the verge of a breakthrough similar to that which we have seen in vase painting. The statue is, according to an inscription on its base, a funerary monument of a youth, Kroisos, who had died a hero's death in battle. Where the anatomy of the Tenea figure is still somewhat generalized, it here becomes specific and accurate. The artist not only understands the structural parts of the figure and their natural relation and how to represent their surfaces by modeling the stone, but he is able to give us what amounts to a *portrait* of the body, a likeness of a particular physique—in this case, that of a muscular wrestler, strikingly in contrast with the taut, spare Tenea figure. It is noteworthy that the Greeks begin their monumental sculpture with portraits not of the head but of the body. This "bodiliness" of Greek sculpture persisted for centuries until it became lost in a realism that compelled the sculptor to use illusional devices more appropriate to painting.

What we might think of as companion figures to the Kouroi (youths) are the draped *Korai* (maidens), contemporaneous with the former and manifesting in their own style similar features of concept and design. The *Peplos Kore* (PLATE 5-1), contemporary with the *Kroisos*, is one of numerous figures found on the Acropolis of Athens, where they had been thrown down by the Persians after their sack of the city in 480 B.C. Their purpose is obscure, but they may have been

presence; others are memorial statues that stand over graves of noblemen. Thus, they are men, not gods (not, as once thought, "Apollos"), and this is significant, this glorification of men in monumental statues that commemorate their triumph and give them a godlike scale and presence. The Kouroi recall Egyptian statues in the pose (the left foot advanced), in the broad, square shoulders, and in the rigidly frontal and symmetrical design. The Egyptian and Mesopotamian thought of the sculptured human body as a smooth envelope of stone, but the Greek was interested in the structural parts and how they fitted together. The *Kouros from Tenea* (FIG. 5-15) shows us characteristic traits of the type, though the Kouroi differ markedly from each other. Because the figures were freestanding, without the Egyptian stone slab for support, most Kouroi have been found broken at the ankles. Obviously, the Greek sculptor was not aiming for Egyptian permanence so much as for fidelity to appearance, and one of his first steps toward that goal was the liberation

votive figures attending the deities in a kind of permanent and perpetual ritual. In contrast with those of earlier types, the face of this Kore has become more expressively modeled; the chin, cheeks, and corners of the mouth subtly planed. The great eyes, originally with painted lids, may have been intended to have a hypnotic power: One thinks back to the ancient head from Warka (FIG. 2-10). The missing left arm was extended, a break from the frontal compression of the arms at the sides in Egyptian statues. The body itself is modeled with a soft smoothness that takes account of the figure beneath the drapery much

like the earlier *Hera of Samos*, yet with a great deal more of the anatomically real. Traces of paint may be seen on parts of the figure, for all Greek stone statues were painted, the powder-white of Classical statues being an error of modern interpretation. But the Greeks did not smear their statues garishly with bright colors, indifferent to their place and effect; only the decisive parts, such as eyes, lips, hair, and the edges of drapery, were painted, to provide accents and contrast to the color of the soft marble itself, the latter being waxed and polished. The whole purpose of coloring was to

5-15 *Kouros from Tenea, c.* 570 B.C. Marble, approx. 5′ high. Staatliche Antikensammlungen, Munich.

5-16 *Kroisos* (Kouros from Anavysos), *c.* 540–515 B.C. Marble, approx. 6′ 4″ high. National Museum, Athens.

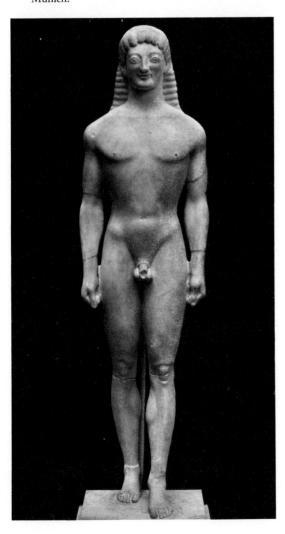

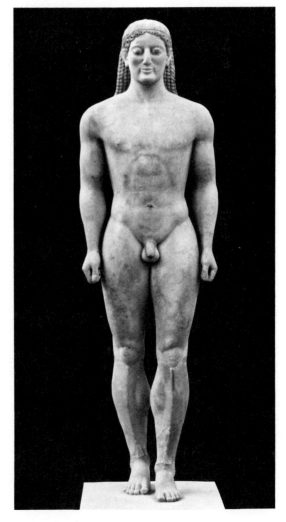

make the statue more lifelike, more convincing as a kind of person confronting the visitor to the shrines of the Acropolis. The remarkable permanence of the color is partly ascribable to the technique of *encaustic,* in which pigment is mixed with wax and applied to the surface while hot. This method was widely used in ancient wall painting as well as in the embellishment of statues.

The preservation of the color of many of the Kore statues is also a result of the Athenians' use of fragments of broken statues and temples as rubble fill in rebuilding the temples and retaining the walls of the Acropolis after the Persian destruction. Found in this material by modern archeologists have been works such as the *Kore from Chios* (FIG. 5-17). The figures' luxurious gowns may be evidence that they were made in Ionia, where the wealthy Greek states cultivated the Oriental taste for rich ornamentation in both life and art. Ionian influence was strong in Athens during the Archaic period, and Ionian fashions, featuring the intricately folded, chic chiton, interested not only women, but sculptors, who found in the representation of delicate texture and fold a peculiarly difficult challenge. For some time they seemed to take delight in working out the complexities of the pleats and folds made by the thin, soft material and were content to let the matter remain one of decoration rather than structure. Though much must have been learned of the movement of a surface independent of the body beneath it, the Kore figures remain frontal and basically unchanged through a considerable period. Although there are slight changes, the scheme of this example is repeated over and over until the end of the Archaic period. The attractive problem of surface texture appears to have deflected the sculptors of the Kore figures from larger issues.

The larger issues involve not the draped female figure but the nude Kouros type we have been describing; at least, it is there that the break with age-old sculptural traditions takes place. The female nude does not appear in ancient sculpture—with some minor exceptions—until the fourth century B.C. We will see that its appearance in Greek art accompanies changes of a fundamental kind in Greek culture and morals. Why the

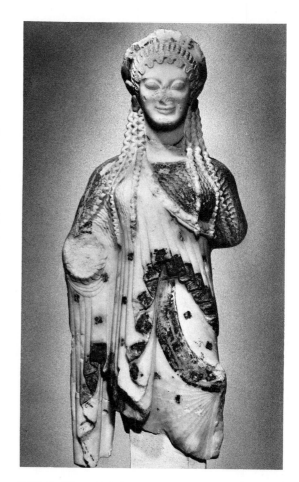

5-17 *Kore from Chios* (?), *c.* 510 B.C. Marble, approx. 21½″ high. Acropolis Museum, Athens.

Greek artist should have represented the male figure nude some 300 years before he represented the female so is not known. He may have found, as any student of the living model in art has found, that the male figure is much more revealing of human structure. He may have had available for observation male models in exercises and at the games; we know that in the Dorian world, of which Sparta was the capital, he would also have been able to observe female models, yet the male figure had priority. By the time of Plato, nudity in the context of athletics was commonplace in the Greek world, and the prejudice against it could be regarded as barbarous—that is, merely a prejudice of the non-Hellenic Near East. In Plato's *Republic* Socrates remarks:

Not long ago . . . the Hellenes were of the opinion, which is still generally received among the barbarians, that the sight of a naked man was ridiculous and improper. . . . But experience showed that to let all things be uncovered was far better than to cover them up . . .

Certainly by about 520 B.C. the male nude must have been familiar enough for the artist to construct from the observation of it a convincingly real image. The establishment of a new convention, the propriety of the nude, implied the setting aside of the 3000-year-old convention of the pre-Greek world that inhibited—probably because nudity was the badge of slavery—the study of the structure of the human body as given to the eye.

In the *Kroisos* figure the independent elements of the body have been sufficiently described. The question must now be: How do the elements work together? From the time of King Narmer, there have been more or less successful approximations of the human figure, the parts enumerated, and the attitudes universally stiff and immobile. What can put these parts into motion? The answer appears in a late Kouros—if we can still call it that—found in the Acropolis rubble and dating from just before the Persian destruction. The statue, which must have been the consequence of a mind deliberating upon what had already been done, is called the *Kritios Boy* (FIG. 5-18), from the name of its presumed sculptor. It is not in action but stands at rest; that is to say, it *really* stands at rest and not merely in a stiff-legged pose or a pose bound to a block. The secret of its new and radical naturalness lies in its artist's knowledge of the principle of *weight-shift*, the shifting of position of the main parts of the body around the vertical but flexible axis of the spine. The shifting of the human body in life never takes place in a rigid, stiff-legged manner; indeed we laugh at, or are in terror of, the science-fiction monster that moves in this ponderous, mechanical way. Rather, when we change place and move, the elastic musculoskeletal structure of our bodies dictates a harmonious, smooth motion of all the elements of the body. Greek artists were the first to grasp this fact, and the artist of the *Kritios Boy* was the first to represent it. The youth turns his head

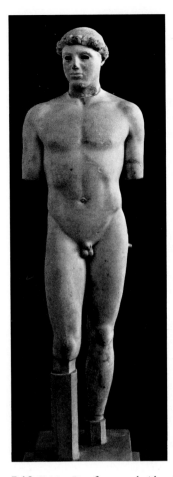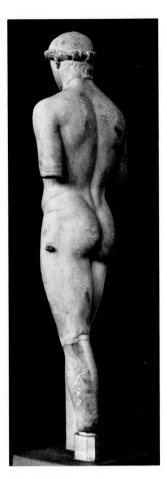

5-18 *Kritios Boy*, front and side views, Acropolis, Athens, c. 480 B.C. Marble, approx. 34″ high. Acropolis Museum, Athens.

away from the central axis—only very slightly. There is the slightest dip to the shoulders and to the hips, indicating the shift of weight onto the left leg; the right leg is at ease. (One can easily assume this pose and the contrasting flat-footed poses of the Kouros statues.) Once the principle of weight-shift has been realized, all motion of the human figure is possible in the world of representation; not simply in terms of the signs of motion—simple gesture—but in terms of motion of the whole body as we see *and* experience it. After the *Kritios Boy* Greek sculpture rapidly passes through the possibilities of the figure understood as having its own physical principle of motion, a principle revealed to the eye in ordinary optical experience and confirmed by the observer's own physical sense of motion.

So far we have been considering sculpture apart from architecture. But the decoration of buildings, especially temples, with sculpture, both in relief and in the round, offered the Greek sculptor a major opportunity. Since sculpture was applied only to very specific and limited areas of temples, it is necessary first to become acquainted with the basic structure of the various buildings that it adorned.

Architecture

Greek architecture is more familiar to us perhaps than any but "modern" architecture. The "revival" of it by European architects in the late eighteenth century brought about a wide diffusion of its style, and especially official public buildings—court houses, banks, city halls, legislative chambers—designed for impressive

5-19 Six representative plans of the Greek temple: (a) Treasury of the Athenians at Delphi, a temple *in antis*, in which the portico is formed by the projecting side walls with two columns set between their ends (*antae*); (b) Temple B at Selinus, Sicily, a *prostyle* temple, in which the columns stand in front of the cella and extend to its width; (c) Temple of Athena Nike on the Acropolis at Athens, an *amphiprostyle* temple, in which the prostyle plan has a porch added at the rear; (d) Temple of Hera at Olympia and (e) Temple of Aphaia at Aegina, *peripteral* temples in which a single colonnade surrounds the cella; and (f) Temple of Apollo at Didyma, near Miletus, a *dipteral* temple, in which two colonnades surround the cella. (Drawings are not to scale.)

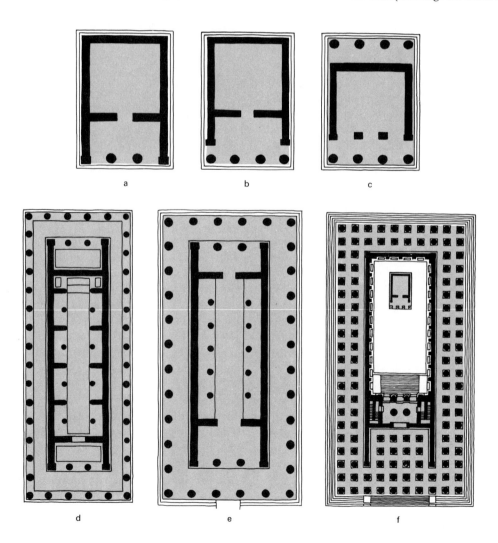

a b c

d e f

to *c.* 900 B.C.	*c.* 750		*c.* **700**	*c.* 680		*c.* 575	*c.* 550	*c.* 530	490 **480**		to 323 B.C. →

Dipylon vases		Mantiklos "Apollo"			François Vase	EXEKIAS Dionysos in a Sailboat	Peplos Kore	Battle of Marathon	Kritios Boy	
GEOMETRIC PERIOD		A R C H A I C P E R I O D							CLASSICAL PERIOD	

formality, imitated the architecture of Classicism, which was fundamentally Greek in inspiration. Although their homes were unpretentious places, they had no monarchs to house royally, and they performed religious rites in the open, the ancient Greeks were industrious builders. Their significant buildings began primarily as simple shrines to protect the statues to their gods. More and more attention was lavished on these until possibly the qualities of the god became embodied in the structures themselves. Figure sculpture played its part in this program, partly to embellish the protective building, partly to tell something of the deity symbolized within, and partly as a votive offering. But the building was itself also conceived as sculpture, abstract in form and possessing the power of sculpture to evoke human qualities. The commanding importance of the sculptured temple, its inspiring function in public life, was emphasized in its elevated site, often on a hill above the city (the *acropolis*). As Aristotle stipulated: "the site should be a spot seen far and wide, which gives due elevation to virtue and towers over the neighborhood." And the reverent awe that must have been attached to the temple and to the genius of its founders echoes in Plato: "Gods and temples are not easily instituted, and to establish them rightly is the work of a mighty intellect."

The earliest temples were of wood, and these wooden forms were in time translated into the more permanent materials of limestone and sometimes marble. Marble was expensive, but mountains of it were available: from Hymettos, just east of Athens, with its bluish-white stone; from Pentelicus, northeast of the city, its glittering white stone particularly adapted for carving; and from the islands of the Aegean, Paros in particular, which supplied marble of varying quantities and qualities.

In its plan the Greek temple discloses a close affinity with the Mycenaean megaron and even in its most elaborate form retains the latter structure's basic simplicity (FIG. 5-19): a single or double room (the *cella*) with no windows and one door (two for a double cella) and with (a) a portico with two columns between the extended walls (columns *in antis*), or (b) a colonnade across the front (*prostyle*), or (c) a colonnade across both front and back (*amphiprostyle*), or any of these plans surrounded by (d and e) a single (*peripteral*) or (f) a double (*dipteral*) colonnade. What strikes the eye first in the Greek scheme, after what has been seen of the architecture of the ancient Near East, is its remarkable order, compactness, and symmetry, in contrast, say, to the rambling groupings of the Egyptian temples. The difference lies in the Greeks' sense of proportion and in their effort to achieve ideal forms in terms of regular numerical relations and the rules of geometry.

We can discern in the plans a kind of development from quite simple units to more complex, without, however, any fundamental change in the nature of the units or of their grouping. For Greek architecture, like classical music, has a simple core theme from which is developed a series of complex, but always quite intelligible, variations. And, to change the analogy, the development of the temple scheme is like that other great invention of the Greeks, geometry, where theorems, propositions, and their corollaries are deduced from a simple original set of axioms. The insistence of the Greeks on mathematical order guided the experiments with the proportions of temple plans. The earlier, Archaic temples tended to be long and narrow (FIG. 5-19d), with a proportion of the ends to the sides roughly expressible as 1:3. Late Classical and Hellenistic (see below) plans approached, but rarely had a proportion of exactly 1:2, with Classical temples tending to be a little longer than twice the width (FIG. 5-19e) and Hellenistic a little shorter (FIG. 5-19f). Proportion in architecture and sculpture, and harmony in music, were much the same to the Greek mind and indeed reflected and embodied the cosmic order just as did the rationally pursued "good life."

The description of the elevation of a Greek

The Geometric and Archaic Periods 139

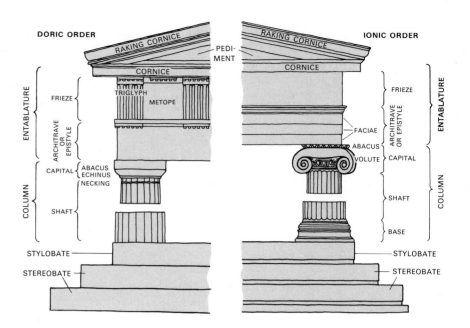

DORIC ORDER

RAKING CORNICE

ENTABLATURE

FRIEZE

CORNICE

PEDI-
MENT

TRIGLYPH

METOPE

ARCHITRAVE
OR
EPISTYLE

CAPITAL

ABACUS
ECHINUS
NECKING

COLUMN

SHAFT

STYLOBATE

STEREOBATE

IONIC ORDER

RAKING CORNICE

CORNICE

FRIEZE

ARCHITRAVE
OR EPISTYLE

ENTABLATURE

FACIAE

ABACUS

VOLUTE

CAPITAL

SHAFT

COLUMN

BASE

STYLOBATE

STEREOBATE

5-20 Doric and Ionic orders. (After Grinnell.)

building is in terms of the column, platform, and superstructure, or *entablature*; this combination and relationship of three units is called an order. The three orders developed by Greek builders are differentiated partly by details but chiefly by the relative proportions of the parts. Each order served different purposes and embodied different meanings. The earliest of the Greek architectural orders to be formulated were the *Doric*, of mainland Greece, and the *Ionic*, of Asia Minor and the Aegean islands (FIG. 5-20). The *Corinthian* order followed much later.

The columns, which rest on a platform (*stylobate*), have two or three parts, depending on the order: the *shaft*, which is marked with vertical channels (*fluting*); the *capital*; and (in the Ionic and Corinthian) the *base*. As the shaft rises, its diameter decreases gradually, giving the profile a subtle curve (*entasis*); the top (in the Doric) is marked with one or several horizontal lines (*necking*) that furnish the transition to the capital. The capital has two elements, the lower of which (the *echinus*) varies with the order: In the Doric it is convex and cushionlike; in the Ionic it is small and supports a bolster ending in scroll-like spirals (the *volute*); and in the Corinthian, a relatively elongated element principally of stylized acanthus leaves that form an inverted-bell shape. The upper element, present in all orders, is

a flat, square block (the *abacus*) that provides the immediate support for the entablature. The entablature has three parts: the *architrave*, the main weight-bearing and weight-distributing element; the *frieze*; and the *cornice*, a molded horizontal projection that, with two sloping (*raking*) cornices, forms a triangle that enframes the *pediment*. The architrave is usually subdivided into three horizontal bands (*fasciae*) in the Ionic and Corinthian orders. The frieze is subdivided into *triglyphs* and *metopes* in the Doric order and left open in the Ionic to provide a continuous field for reliefs.

The Doric order is massive in appearance, its sturdy columns firmly planted on the stylobate. Compared with the weighty and severe Doric, the Ionic seems light, airy, and much more decorative. Its columns are slenderer and rise from molded bases. While the Doric flutings meet in sharp ridges (*arrises*), the Ionic ones are flat. The most obvious differences among the three orders are, of course, in the capitals, the Doric severely plain, the Ionic and Corinthian highly ornamental.

In ancient times the Doric and Ionic orders were contrasted as masculine and feminine. The Corinthian order was not developed until the fifth century B.C., when it appeared inside the temple, like a natural form growing in the dark-

ness of the interior. It was not widely used, however, until Roman times. Since the Renaissance, and until about two generations ago, architecture in the Western world was considered to be in essence the display of the refined beauty of these architectural orders.

The functional placement of the architectural units may have been set by a tradition of building going back to the use of wooden structural members. Thus, many of the parts of the Doric order seem to be translations into stone of an earlier timber architecture. Pausanias, writing in the second century A.D., noted that in the even then ancient Temple of Hera at Olympia (FIG. 5-19d) there was still a wooden column in place; the rest had been replaced by stone columns. It has been inferred, from the varying proportions of these columns, that the wooden columns were replaced at different times, probably as the wood of the original columns rotted. One feature of the Doric order can be explained only as a translation from the wooden original into stone: the organization of the frieze into triglyphs and metopes. The triglyphs most likely derived from the ends of cross beams that rested on the main horizontal support, the architrave. The metopes would then correspond to the voids between the beam-ends in the original wooden structure.

Sculptural ornamentation, which played an important part in the design of the temple, was concentrated on the upper part of the building—in the frieze and pediments. It was basically sculpture that was gaily painted in red and blue, with touches of green, yellow, black, and perhaps a little gold, and was applied only to those parts of the building that had no structural function or that suggested a former structural function. This is true particularly of the Doric style, in which decorative sculpture was applied only to the "voids" of the metopes and of the pediment. Ionic builders were less severe in this respect and were willing to decorate the entire frieze and sometimes even the lower drums of columns. Occasionally they replaced their columns with female figures (caryatids), something the Doric builder would probably not have done. Using color, the designer could bring out more clearly the relationships of the structural parts, soften the glitter of the stone at specific points, and provide a background to set off the figures. Although it is true that color was used for emphasis and to mitigate what might have seemed too bare a simplicity (in Doric buildings as well as in Ionic), the primary dependence in Greek architecture—as in Greek mathematics, science, and philosophy—was on the setting of clear limits. This thesis had to begin with the axiom that the limits themselves must never be encroached upon, must always contain, and must never be vague. The architectural orders described above were embodiments of codified limits, given plainly to the eye as functioning realities. To the Greek it was unthinkable to use surfaces in the way that the Egyptian used his gigantic columns—as fields for complicated ornamentation. The very building itself, the Greek temple as given to the eye, must have the clarity of a Euclidean demonstration. This is borne out not only by its plan, elevation, and function-enhancing ornament but also by its "dry-jointed" construction (that is, construction without mortar), which seems evidence that Greek architects looked upon their temples not as "buildings" but as monumental pieces of sculpture.

The placement of the building strengthened its sculptural aspect. Unlike Egyptian temples, Greek temples faced outward. Rites were performed at altars in front of the temple, and the building itself served to house the cult statue and perhaps trophies and treasure. Private cults were frowned upon and public ritual prevailed. Thus it was on the exterior of the building and its surfaces that the architect generally concentrated his efforts to make the temple a suitable monument to the deity. The studied visual relationships of solids and voids, of light and shade in the colonnades, and the lighter accents of the entablature make a sculptural form out of the rectangular mass of the temple. The history of Greek architecture is the history of the artists' unflagging efforts to express the form of the temple in its most satisfactory—that is to say, perfect—proportions.

The experiment in proportions can be followed rather easily if we begin with the Archaic Doric architecture of the Greek colonies—especially that in Sicily and southern Italy—for it is here that the best-preserved examples of Archaic temples are found. (In examining Greek architecture it is useful to keep in mind the develop-

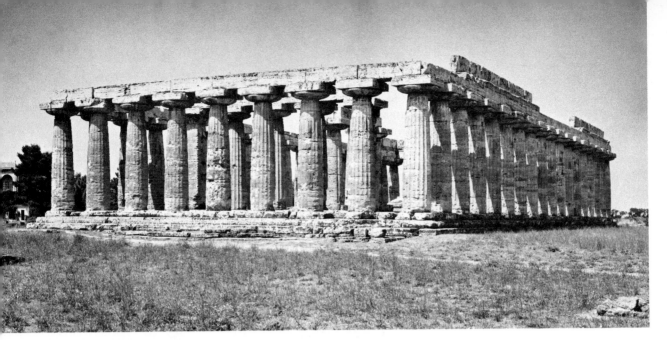

5-21 "Basilica," *c.* 550 B.C. Paestum, Italy.

5-22 Corner of the "Basilica" colonnade with view of the Temple of Hera beyond.

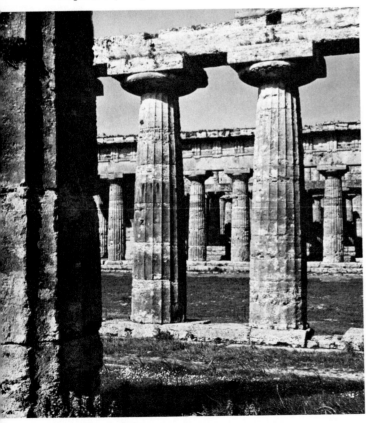

ment of the human figure in Greek painting and in sculpture, for the architectural events are not only contemporaneous but reflect a similar concern with "true" proportions.) The "Basilica" at Paestum, south of Naples, dates from about 550 B.C., and is a quite typical example of Archaic Doric style (FIG. 5-21). Called "the Basilica" after a Roman building type that early investigators felt it resembled, it is a peripteral temple with heavy columns of pronounced entasis, closely spaced, with large, bulky, pillowlike capitals, supporting a high and massive entablature that makes the columns seem proportionately squat. These parts of the order will be gradually adjusted until a lighter, taller, and more graceful combination is achieved. There is a structural reason, perhaps, for the heaviness of the design and the narrowness of the spans between the columns. The architects at this time may not have been certain of the strength of their materials and may have wisely operated within a broad margin of safety. A corner of the "Basilica" colonnade (FIG. 5-22) shows extreme spread of the cushion capitals and exaggeration of the supporting surface in relation to the spans bridged by the architrave. The columns are built up of separate dry-jointed "drums," fitted with square metal plugs to prevent turning as well as shifting.

The whole temple was of this typically Greek construction, the blocks of stone in a horizontal course being held together by metal cramps, while those of different courses, one above the other, were joined vertically by metal dowels. Through the "Basilica" colonnade one can see the nearby Temple of Hera, which was built eighty to ninety years later and whose columns have proportions strikingly different from those of the "Basilica."

The diagram (FIG. 5-23) showing the evolution in the proportions of the Doric order from Archaic to Classical points up the thesis that Greek art evolves with a certain logic, whether in its figurative forms or its architectural, moving toward a conclusion that is as satisfactory as it is true. Plato, in speaking of the imitative arts, declared that the degree of their truth or rightness is determined by the proportionality of their elements and that if they are to be judged at all they must be judged by the "standard of truth, and by no other whatever." In this diagram we see the architects working toward proportions that could be thought of as "true" and final. Some of the earliest columns (not shown) were extremely slender, under massive capitals. The shafts soon thickened to the shape of the "Basilica" type, as the builders searched for a better relationship between the shaft and the capital. From then on, the forms were constantly refined, the shafts becoming more slender, the entasis subtler, the capitals smaller, and the entablature lighter. The final Classical proportions were considered to be ideal ones beyond which further refinement was impossible.

The Temple of Hera at Paestum (FIG. 5-24) dates from about 460 B.C.; although the forms have been refined, the columns are still massive and closely spaced. This was erected at a time when, on the Greek mainland, the Doric order had already achieved its Classical proportions— as early as 490 B.C.—in the Temple of Aphaia at Aegina. There was a considerable time lag between developments on the mainland and their adoption by the colonies in Italy and Sicily, so that the colonial architecture exhibits the usual provincial conservatism characteristic of styles distant from their source of inspiration in the cultural capital. The plan and section of the

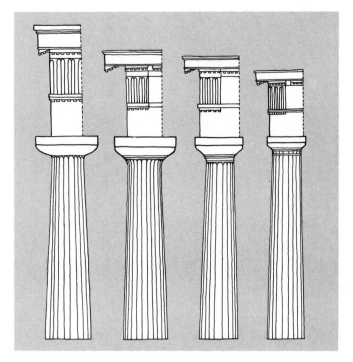

5-23 Changes in Doric-order proportions, Archaic to Classical. Examples are not drawn to same scale.

Temple of Hera (FIG. 5-25) show a noteworthy peculiarity in the support structure of the interior, the columns of which rise higher than the outer, peripteral columns. Each of the two rows of small Doric columns that support the roof is made up of two sets of columns, one resting on a stone course that rests on the set of columns below. This was a standard form where Doric columns were used to support the roof, the reason being, apparently, that a single row of large columns, as in the "Basilica," would produce a distortion of scale and look out of proportion and oppressive inside the relatively small cellas. Later, the support problem was solved by using Ionic or Corinthian columns in the interior, since they were taller in relation to their diameters than were the Doric ones.

One of the earliest Ionic buildings in Greece is the Treasury of the Siphnians at Delphi, constructed about 530 B.C. (FIG. 5-26). Although it has no Ionic columns, the supporting function being assumed by luxuriously carved caryatids, it has the identifying Ionic feature—the con-

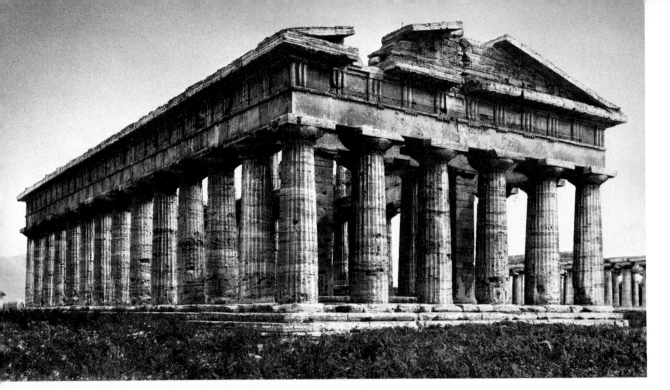

5-24 Temple of Hera at Paestum, *c.* 460 B.C.

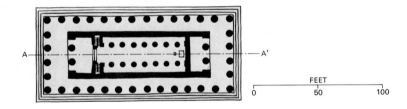

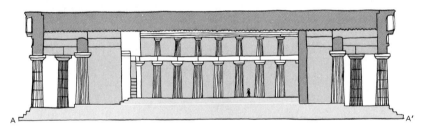

5-25 Reconstruction of the plan and section
of the Temple of Hera at Paestum.
(After Sir Banister Fletcher.)

FEET
0 50 100

tinuous frieze—which here appears as part of a heavy Archaic entablature. The caryatids, with their elaborate costume and very irregular silhouettes, could never fit into a context of Doric architecture, with its severity of line and disdain of ornament. Yet as the Athenian Erechtheum (FIG. 5-48) shows, the demands of architecture can quiet the profiles of the caryatids, and architect and sculptor can collaborate in producing a most convincing columnar effect in the motif of the human body as a supporting vertical element.

Architectural Sculpture

We have noted already that decorative sculpture was applied only to those parts of a temple that had no evident structural function—that is, the frieze and the pediment. The caryatids are exceptional, but their use is rare. Ordinarily the weight-carrying columns and the weight-distributing architraves were not decorated, though it may be that war trophies were hung upon the blank Doric architrave. In the Doric order only

the metopes bore relief sculpture. It might be argued that the fluting of columns is a form of decoration, but in fact the fluting simply explains and emphasizes the form and function of the column, stressing its verticality—the only vertical in the temple design. It also exhibits the column's rotundity, for when the sunlight strikes sharply upon the shaft (FIG. 5-22) the flutings throw numerous shadows of graduated width and darkness that lead the eye around the shaft in a series of graded steps, making the effect of roundness more evident than in the nonfluted column, in which the sunlight creates a single, indistinct line separating the light and dark sides.

The architectural sculptor had a problem similar to that of the vase painter: how to adjust the image to the surface on which it is placed. This is not apparent in the frieze from the Treasury of the Siphnians (FIG. 5-27), for here the sculptor has merely a continuous blank zone to manage and can arrange his figures in a simple file, their heads on the same level, each filling a unit of space of approximately the same dimension. This is a good example of the formalizing effect of architectural line on figurative composition, just as the surface of the ceramic vessel imposed its necessities on the vase painter, making for simplicity and elegance of style. In fact, in the case of the Siphnian figures there is a resemblance stylistically between them and contemporary painting like that of the Andokides Painter (FIG. 5-8). But an awkward space like that of the triangular pediment of the Archaic Temple of Artemis (early sixth century B.C.) on the island of Corfu (FIG. 5-28) is more troublesome to manage. The figures are heraldically arranged and bring to mind compositions that go back beyond the Lion Gate at Mycenae to the symmetrical man-beast compositions of Mesopotamia. On the thin panel of stone that fills the space between the cornices of the pediment, the sculptor presents a Gorgon flanked by spotted panthers. The Gorgon, a guardian monster, grimaces hideously, exposing her boar's teeth (her look could turn men to stone) and fulfilling her function as a winged demon to repulse all enemies from the sanctuary of the goddess. To the left and the right of the central Gorgon appear, on a smaller scale, the figures of Chrysoar and Pegasus, those mythological creatures that,

according to legend, sprang from the Gorgon's head when she was struck by the sword of Perseus. Still smaller are two groups of figures beyond the panthers: Zeus slaying a giant (on the observer's right) and one of the climactic events of the Trojan War, Neoptolemos killing

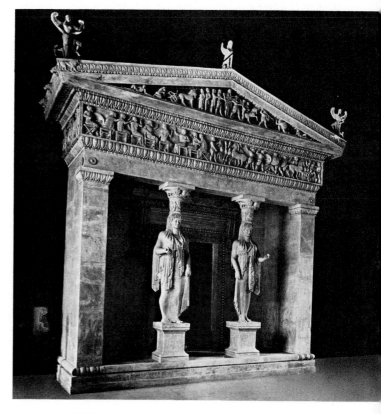

5-26 Reconstruction of the façade of the Treasury of the Siphnians in the Sanctuary of Apollo at Delphi, c. 530 B.C. Museum, Delphi.

5-27 *Battle of the Gods and Giants*, from the north frieze of the Treasury of the Siphnians. Marble, approx. 26″ high. Museum, Delphi.

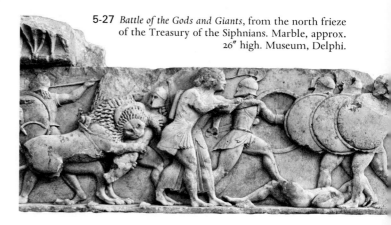

Priam. In the outer ends of the pediment, recumbent figures represent a fallen Trojan and a dead giant. As pieced together from the surviving fragments, the artist's narrative intention is clear enough, but the odd shape of the surface on which he worked compelled him to distribute his figures somewhat haphazardly around the central ones and to show them on different scales. As time progresses, the Greek artist attempts to fill the space more organically, with figures so grouped that they appear to be of the same size and participating in a unified way in a single event.

Toward the end of the Archaic period Greek sculptors were arriving at a solution to the problem of pedimental composition. In the pedimental sculptures of the Temple of Aphaia at Aegina (FIGS. 5-29 to 5-31) we find that the figures in different poses, but of the same scale, have been fitted into the difficult triangular space. The figures, heavily cleaned and over-restored in the nineteenth century, probably represent some episode of the Trojan War. Athena, with aegis and spear, stands in the center, with fighting groups on either side. We notice most the freedom of movement and variety of pose. The figures are modeled with great vigor and an understanding of the human physique that, as we have seen in the contemporary vase paintings, reflect a careful observation of nature. The figure of the fallen warrior from the left angle of the pediment

(FIG. 5-30) exhibits the daring with which the sculptor tackles the challenging problem of a difficult twisted pose. The bold composition of the turning masses of the body manifests his new confidence in his mastery of the science of representation. The dynamics of muscular tension and relaxation are appreciated and are close to life in their rendering. Mistakes are still made, and the transition from chest to pelvis has not been fully solved in this complex pose. (Note the misplaced navel.) These rather technical considerations should not blind us to the marvelously expressive power of this figure. The *Fallen Warrior* brings to mind the spare and monumental nobility of Homer's heroes, and particularly the Homeric simile, "darkness came down upon his eyes, and he crashed in the battle like a falling tower."

The figure of the archer Herakles (FIG. 5-31) from the same pediment is another instance of the Greek sculptor's triumph over age-old taboos and difficulties of representation. It is thought that this nimble archer is executing a maneuver hard to perform without long practice but required in the Greek war games and in actual combat. Running forward, he has dropped suddenly almost to one knee, and from this tense position takes aim and fires a flight of arrows in a matter of seconds. Soon he will spring to his feet to run forward again. The practiced strength

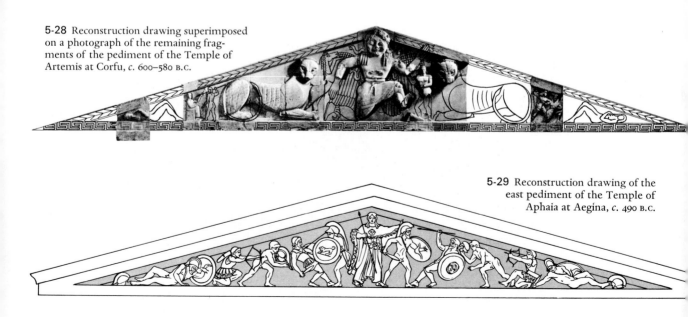

5-28 Reconstruction drawing superimposed on a photograph of the remaining fragments of the pediment of the Temple of Artemis at Corfu, c. 600–580 B.C.

5-29 Reconstruction drawing of the east pediment of the Temple of Aphaia at Aegina, c. 490 B.C.

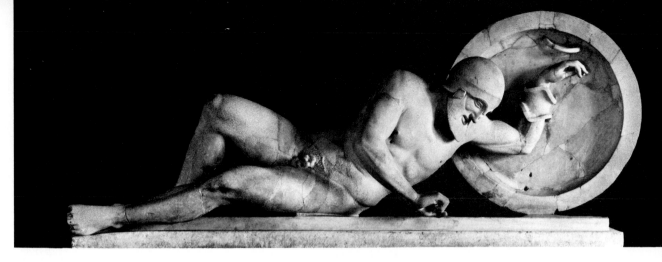

5-30 *Fallen Warrior*, from the east pediment of the Temple of Aphaia at Aegina. Marble, 72″ long. Staatliche Antikensammlungen, Munich.

and poise demanded by such a feat is beautifully caught in the elastic, though momentarily rigid, pose. One might read here the expression of a new spirit in Greek life and art, a spirit buoyant and optimistic as it meets the great challenge of the Persians at Marathon and looks to a future that the old Near Eastern world could never envision and never encompass.

THE FIFTH CENTURY

The Transitional Period

The thirty years or so of the Transitional period constitute the heroic age of the Athenians and of all the Hellenes who joined forces against the invasion of Greece by the Persians. Just as we look back to the age of the American Revolution and of the founding fathers of the republic for our models of heroism and of civic wisdom and virtue, so did the Greeks of the later fifth century revere the men of Marathon, Thermopylae, and Salamis, the battles that daunted and finally turned back the mighty hosts of Asia led by Xerxes. The new world of the Greeks—attributed by them to the Homeric feats of their heroes—turned away from Asia, barbarism, tyranny, and ignorance (it was all the same to the Greeks) to build a Hellenic civilization productive of a new species of mankind. Typical of the time were the views of the great dramatist Aeschylus, who celebrated, in his *Oresteia*, the triumph of reason and law over barbarous crime, blood feud, and

mad vengeance. Himself a veteran of Marathon, Aeschylus repudiated in majestic verse all the slavish and inhuman traits of nature that the Greeks at that time of crisis tended to associate with the Persians.

Shortly after Athens was occupied and sacked in 480 B.C., the Greeks won a great naval victory over the Persians at Salamis. This resilient toughness of the Athenians signified a new pride that was to mature into a sense of Hellenic identity so strong that thenceforth the history of European civilization would be distinct from—even though in interaction with—the civilization of Asia. The period of struggle with the Persians, calling repeatedly for courage and endurance, produced in the Hellenes a kind of austere grandeur that is manifested in the art of that period. This quality is rendered in the fine bronze,

5-31 *Herakles*, from the east pediment of the Temple of Aphaia at Aegina. Marble, approx. 31″ high. Staatliche Antikensammlungen, Munich.

5-32 *Charioteer*, from the Sanctuary of Apollo at Delphi, *c.* 470 B.C. Bronze, approx. 71″ high. Museum, Delphi.

and in the conventional way in which the hair is worked. But we notice also the skillful modeling of the hand and the feet, the toes of which cling to the chariot floor, and the slight twist of the torso, giving the feeling of an organic structure beneath the drapery. These subtleties are not seen at first and one might mistake the statue for another example of the Archaic formulas of rigid frontality. But it is only the formality of the pose, not ignorance of the principle of weight distribution, that determines the tight composure of the figure; it is as "alive" as the pose of a soldier at parade rest. The statue is probably a portrait, yet there are few individualized traits. This is typical of most works of the Greek Classical period and distinguishes Greek from Egyptian portrait statues, which had a religious function— the preservation of the deceased's likeness meaning the preservation of the ka. Although with the Greeks, man comes to complete self-consciousness ("Know thyself!") and although the *figure* of man is idealized, he himself, as an individual, is not regarded as being true or perfect nor, consequently, an appropriate subject for representation. In the words of Bruno Snell:

> If we want to describe the statues of the fifth century in the words of their age, we should say that they represent beautiful or perfect men, or, to use a phrase employed in the early lyrics for purposes of eulogy: "god-like" men. Even for Plato the norm of judgment still rests with the gods, and not with men.[2]

Thus, the observations made at the beginning of the chapter must be modified: Though with Protagoras "man is the measure," for art the gods are the measure of man, and to achieve the ideal is to achieve the "godlike."

The rapid process of liberation from Archaic limits continues in the renowned *Discobolos* of the sculptor MYRON (FIG. 5-33), from about 450 B.C. As have most freestanding statues by the "Great Masters" of Greek sculpture, this has survived only in Roman marble copies after the bronze original (see pp. 151–52). Myron's representation of an athlete engaged in the discus throw,

the *Charioteer of Delphi* (FIG. 5-32). The Greek search for ideal beauty is also fully shown here, as well as the culmination of the long-evolving mastery of the structure of the human figure. The statue belonged to a group with chariot and horses, probably erected to commemorate the victory of King Polyzalos of Gela at the races in 478 B.C. It represents a youthful aristocrat who stands firmly on both feet, holding the reins in his outstretched hand. He is dressed in the customary garment of a driver, girdled high and held in at the shoulders and the back to keep it from flapping. The hair is confined by a band tied behind the head. The eyes are made of glass paste and shaded by lashes of hairlike pieces of bronze. We feel the sharp clarity of Archaic work in the figure, especially in the lower part, where the folds of the dress have almost the quality of a fluted column, in the sharp lines of the brow,

[2] Bruno Snell, *The Discovery of the Mind: The Greek Origins of European Thought* (New York: Harper & Row, 1960), p. 247.

expression of concentrated force. The composition is in terms of two intersecting arcs, creating the impression of a tightly stretched bow a moment before the string's release.

The "severe" early style of the transition finds clearest and most representative expression in the pedimental sculptures of the Temple of Zeus at Olympia (FIG. 5-34). On the west pediment is represented the combat of centaurs and Lapiths at the wedding feast of Peirithous. The centaurs, half beast, had been invited to the celebration but became drunk and attempted to abduct the bride and her maidens. They were prevented from doing so by Peirithous and Theseus, and Apollo, appearing above the combat, approves the heroes' chastisement of this breach of hospitality. The scene symbolizes three things: the Greek victories over the Persians; the sacred truce of Olympia (which outlawed strife within or on the approaches of the consecrated precincts of the temple); and the responsibility of men, who, unlike animals, acknowledge the rule of law.

The grouping of the figures in the Olympia pediments shows considerable improvement over the older Aegina grouping (FIG. 5-29) in the adjustment of the poses to fit the triangular pediment. In the center, Apollo thrusts out his arm amid the tumult (FIG. 5-35). The figure should be compared with the Archaic Kouroi (FIGS. 5-15 and 5-16): From its formality and such lingering archaisms as the tight, decorative treatment of the hair, it seems the last of that great line, although the new understanding of bodily structure shows in the splendid and exact modeling of the athletic physique. The musculature is no longer schematic but swelling with life and power. The

still an athletic event in the Olympic games, was revolutionary because of its vigorous and convincing movement; it has been widely reproduced in both the ancient and modern worlds. However, the motion of the *Discobolos* has clearly been restricted to one plane, which means that only two distinct views are possible. The figure, represented at the point between the backward swing and the forward thrust of the arm, becomes by means of certain formal devices an

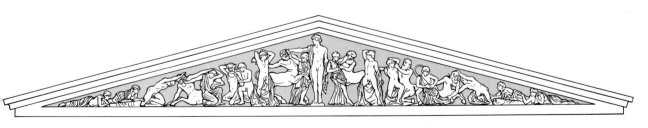

5-34 Reconstruction drawing of the west pediment of the Temple of Zeus at Olympia, 468–460 B.C. Approx. 91' wide.

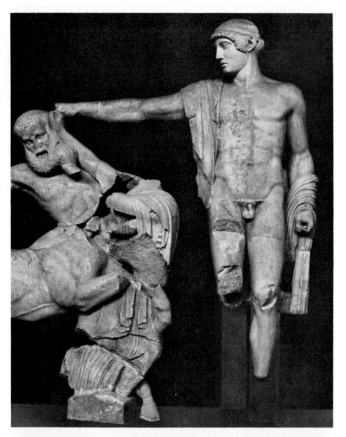

transitions from one group of muscles to another are smoothly and subtly made, and this soft flow of planes and contours belies the formal rigidity of the pose. The face of the *Apollo*, like those of the *Charioteer of Delphi* and the *Discobolos*, is composed in the expressionless mask of regular beauty deemed appropriate to gods and godlike men, despite their action or potential for action. This ideal mask, expressing the conviction of Greek philosophy that reason must be above and in control of the passions, precludes the distortion of the face by any strain of emotion, even in scenes of the most violent action. In the twisted complication of the group of *Hippodameia and the Centaur* (FIG. 5-36), where the bride of Peirithous tries to wrench from her breast the centaur's clutching hand, the girl's face remains serenely neutral. Her predicament is dire, as the artful sculptor dramatically describes it; yet, and significantly, it is only the centaur's face that is distorted, as befits the low creature that it is, surrendering to drunkenness and lust. This distinction between the calm of noble men and the frenzy of the creature abandoned to impulse prevails for centuries in Greek art. The Greeks were convinced that overwhelming disaster awaited the man who yielded to the spell cast by the dark god of intoxication and madness, Dionysos; this conviction is reflected in their drama and in their persistent appeal to reason and order, both in art and life. Against Dionysos they attempted to raise the shining figure of Apollo, god of light, beauty, and wisdom. Thus, it was with the pediments of Olympia that the visual arts moved into the realm of philosophy and drama, and it was in the presence of these sculptures that the Greek athletes took their oath at the altar of Zeus before the Olympic games.

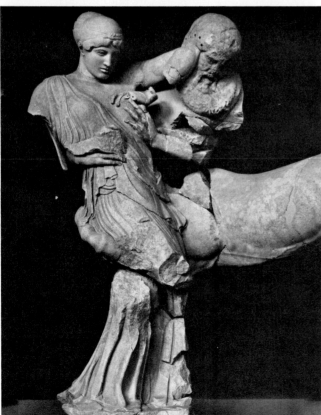

5-36 *Hippodameia and the Centaur*, from the west pediment of the Temple of Zeus at Olympia. Marble, slightly over life-size. Museum, Olympia.

The Early Classical Period

The prestige that the Athenians won by their leading role in the repulse of the Persians and by virtue of the powerful fleet they had built in the process made them the dominant political force in the Greek world. They acquired a sea empire disguised as a more or less democratic alliance of city and island states throughout the Aegean. Members of the alliance, which was called the Delian League, had cause enough to complain bitterly that they were more the subjects of Athens than her allies and that she siphoned off a large part of the common treasury (raised as a fund for defense against Persia), for her own uses. Despite chronic warfare within the "alliance" (and between it and the rival league led by Sparta), Athens, under the leadership of its adroit statesman, Pericles, became an immensely prosperous and proud community. The brief period of her glory under Pericles saw a concentration of human creative energy and a triumph of drama, philosophy, and art such as has been known in no other place or time in all of the Western world.

Disdaining to reassemble the desecrated stones of the Athenian Acropolis after the sack of the city in 480 B.C., the Athenians, led by Pericles, signalized their new power and independence by completely rebuilding the Acropolis, an undertaking that was one of the greatest building projects of antiquity before Roman times. Their success stands as a rare human achievement against the larger history of human failure. The beauty of the buildings, set upon a towering platform of rock with difficult access (FIGS. 5-37 and 5-38), was recognized and celebrated in ancient times as it is today. Plutarch, writing some 500 years after the rebuilding of the Acropolis, commented:

> Pericles' works are especially admired, as having been made quickly, to last long. For every particular piece of his work was immediately, even at that time when it was new, recognized as ancient, because of its beauty and elegance; and yet in its vigor and freshness it looks to this day as if it had just been done. There is a sort of bloom and newness upon those works of his, preserving them from the touch of time

The late architect Eric Mendelssohn (1887–1953) made almost the same observation when he first visited Athens. Expecting to be depressed by the view of that original source of the academic classicism from which his generation was fighting to free itself, he found himself exclaiming that the Parthenon is "modern," meaning that good architecture is always good, and so, always "modern."

THE PARTHENON

Of the buildings on the Acropolis, the Parthenon (the temple sacred to Athena Parthenos) was the first and the largest to be constructed (FIG. 5-39). Its architects were ICTINOS and CALLICRATES, and its sculptural ornament was produced under the direction of PHIDIAS, friend of Pericles and one of the great sculptors of all time. In plan (FIG. 5-38) the Parthenon is a peripteral temple, its short side slightly less than half the length of its long. Its cella is subdivided into two parts; the larger contained the cult statue of Athena Parthenos in ivory and gold, some forty feet in height, the work of Phidias; the smaller had been designed to serve as treasury of the Delian League, but most of the revenues contributed by the Aegean members were expended upon Pericles' ambitious building projects. The interiors of the two rooms are organized differently. The cella proper has two double rows of small columns for roof support; although long disputed, the purpose of the rows was, according to some, to provide a second-story gallery from which visitors could view the statue, the foundation of which is still visible. The treasury had four single Ionic columns—one of several Ionic features in the otherwise Doric building, another being the continuous frieze of sculpture that runs around the top of the cella wall on the exterior. Except for these Ionic elements, the Parthenon is the epitome of the classical Doric temple, exhibiting the order at the peak of its refinement.

The building seen today is a restoration. Through the centuries the Parthenon has undergone many transformations, having been at one time a Greek temple, at another a Christian church, and then a Turkish mosque. In 1687

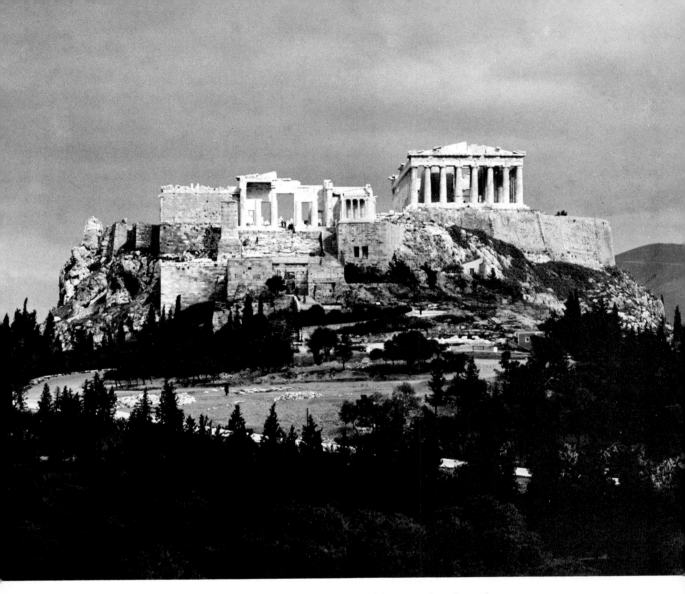

5-37 View (from the west) of the Acropolis today, Athens.

the cella was being used as an ammunition dump by the Turks, who were then at war with the Venetians. A Venetian rocket scored a direct hit, and the resultant explosion blew out the center of the building. During the past century the colonnades have been reassembled, but the core of the structure remains a ruin.

Despite its dilapidated condition, the Parthenon is probably the most carefully surveyed and measured building in the world. The consequence of this searching study is the revelation that the builders aimed for unsurpassable ex-

cellence in every detail; the "refinements" of the structure have become almost a subtopic in the history of Greek architecture. If there is anything we are led to expect from the severe Doric order, it is that its lines must be rigidly and consistently straight and plumb; yet there are few straight structural lines in the Parthenon. The stylobate is convex, so subtly as to be almost imperceptible as a curve; only if one sights along it from one end does the curvature, which is repeated in the entablature, become visible. The columns tilt slightly inward and are not

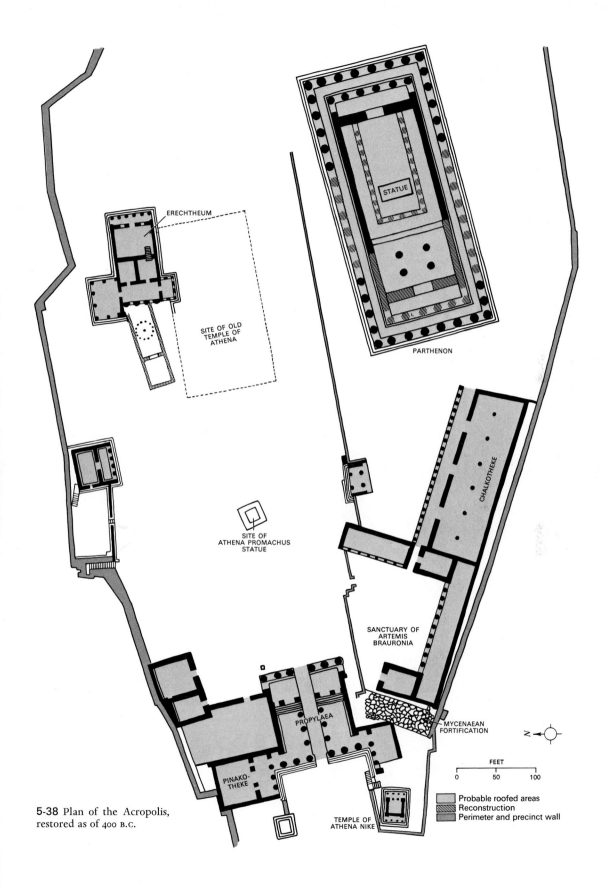

ERECHTHEUM

SITE OF OLD
TEMPLE OF
ATHENA

PARTHENON

STATUE

CHALKOTHEKE

SITE OF
ATHENA PROMACHUS
STATUE

SANCTUARY OF
ARTEMIS
BRAURONIA

N

PROPYLAEA

MYCENAEAN
FORTIFICATION

FEET

0 50 100

Probable roofed areas
Reconstruction
Perimeter and precinct wall

PINAKO-
THEKE

5-38 Plan of the Acropolis,
restored as of 400 B.C.

TEMPLE OF
ATHENA NIKE

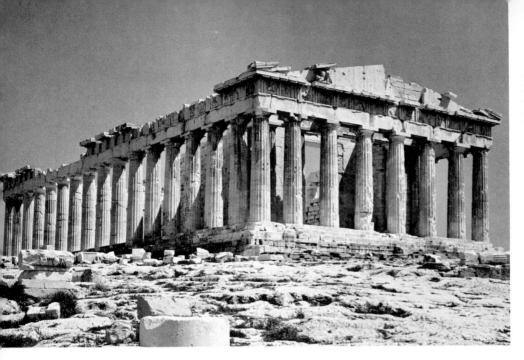

5-39 Ictinos and Callicrates, the Parthenon, Acropolis, Athens, 448–432 B.C. (view from the west).

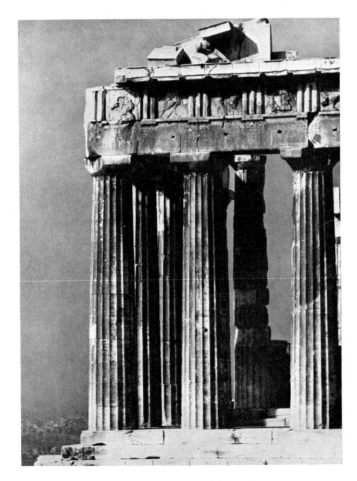

5-40 Southeast corner of the Parthenon.

uniformly spaced, standing closer to each other at the corners of the buildings. Moreover, not all the columns are of the same diameter, those at the corners having somewhat greater girth than the rest. The entasis, which gives a kind of muscle-tense elasticity and buoyancy to the profile of the column, has the same subtlety seen in the curvature of the stylobate and the entablature.

These deviations from the mechanical, plumbline, straight-edged norm are plainly intentional; most have been found in other temples. But interpretations of these refinements do not agree; some feel that they are purely functional, the curvature of the stylobate, for example, facilitating drainage or perhaps anticipating settling of the central part of the building. Others believe that the deviations were intended to offset marginal distortions in the human visual field— optical illusions that might make columns with exactly vertical profiles look pinched and weak. Still other speculation sees the refinements as required by Greek instinct for completeness in the look of the building and for integrity with its surroundings; for example, the downward-tending curve of the stylobate would find its limit in the earth, making a visually stable and strong base for the building's aspect. A reasonable conjecture would be that the Parthenon was intended to be more than a product of engineering logic, that it was to be viewed and appreciated

as a great work of sculpture, having the elasticity, resilience, and life of the human figure in statuary. Thus, the particulars would be designed to work in smooth relation to each other and to the whole structure in an organic way that, of course, means predominance of the curved line over the straight. The Parthenon columns especially display this in their entasis, appearing to respond to the burden they bear by the seeming swell of their compressed contours, expressing their function not mechanically but organically.

Parts of the building were painted. This painting provided background against which sculpture could be seen clearly and, perhaps more important, delineated the upper parts of the building against the bright sky, so that the temple's basic proportions were crisply shown and could not be misread. Color also ensured that the visible parts of the building would be clearly defined and distinguished one from another.

The insistence upon clarity in argument, which led to the invention of logic by the Greeks, operates just as strongly in the "arguments" of their architectural design. Unfortunately, that early triumph of Greek thought, the syllogism, with its three propositions ending in a logically correct conclusion, cannot quite be matched in the Doric order. As examination of a corner of the Parthenon (FIG. 5-40) will show, Greek architecture was not as "rational" as Greek logic. The Doric frieze was organized according to three inflexible rules: (1) a triglyph must be exactly over the center of each column; (2) a triglyph must be over the center of each intercolumniation; and (3) triglyphs at the corners of the frieze must meet, so that no space is left over. But the architectural "argument" does not work out; the logical syllogism is faulty, for Rule 3, the "conclusion," cannot be harmonized with Rule 1: If the corner triglyphs must meet, they cannot be placed over the center of the corner column. Though irremediable, this might seem to us a minor flaw, even in a building that aimed at perfection in all details. The Greeks wanted to be sure, and they worked out, in logic, a method for making series of statements conform to a rule for validity. But in Doric architecture, there was something left over, something that did not fit. To the Greeks it must have appeared like the in-commensurable, "irrational" numbers (such as the square root of two)—a disturbing thing, since it has no limit or definition. (According to a singular and significant Greek legend, the man who first revealed the mystery of the irrationals perished by shipwreck, "for the unspeakable and the formless must be left hidden forever!") In much the same manner as mathematicians and logicians faced with some disturbing contradiction in their results, the architects and artists who aimed at perfection must have found this problem of the corner triglyph a constant irritation and embarrassment. Indeed, it may have contributed to the eventual decline of the Doric order, which began in the fourth century B.C., and to the rise of the Ionic and Corinthian orders, whose continuous friezes eliminate the problem.

The main purpose of the Parthenon, as already noted, was to house the cult statue of Athena Parthenos. Since the image of Athena—for whom the city of Athens was named—was made of ivory and gold, it did not survive centuries of depredation, although it seems to have been in existence as late as the second century A.D. We know the look of it only from accounts by Pausanias and others and from a few small replicas that differ in detail. Plutarch, in his *Life of Pericles*, tells us that its artist, Phidias, probably the scapegoat in an anti-Pericles plot, was convicted of stealing some of the gold intended for the statue and died in prison (though we know from other sources and recent excavations that he was working on a statue of Zeus at Olympia after he left Athens and that he died in exile). Because work on the colossal cult statue for the cella of the Parthenon must have taken up most of Phidias' time, it is quite likely that he planned and designed the pedimental groups and friezes but left the carving of these architectural sculptures to his students and assistants. Nevertheless, they undoubtedly reflect his style and they are among the most marvelous of all surviving Greek works of sculpture and among the supreme masterworks of all time. The east pedimental group depicted the birth of Athena; the west, her contest with Poseidon for the city of Athens.

Most of these sculptures are now in the British Museum in London, where they are popularly

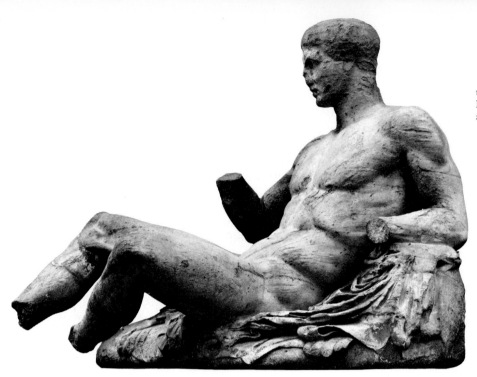

5-41 *Dionysos* (*Herakles*?), from the east pediment of the Parthenon. Marble, over life-size. British Museum, London.

known as the Elgin marbles. Between 1801 and 1803, while Greece was still under Turkish rule, Lord Elgin, the British ambassador to the Ottoman court at Constantinople, was permitted to dismantle the Parthenon sculptures and to ship the best-preserved ones to England. He eventually sold them to the British government, although at a great financial loss to himself. Although he was severely criticized for having "stolen" the treasures of Athens, Lord Elgin's quite civilized motives in saving the statues from almost certain ruin are no longer doubted. During his time there seemed to be no prospect that the statues, surrounded by rubble and neglected for centuries, might one day be salvaged and protected against further damage and decay.

The figure of Dionysos (recently identified as Herakles) from the Parthenon shows the final relaxing of all the limitations of Archaic figurative art. Phidias and his assistants are in full possession of the knowledge of the organic, coordinated human body and render it effortlessly and with entirely convincing consistency in all its parts. This fidelity to nature was a revelation even in an age (the nineteenth century) that was at the end of a long tradition of respect for nature in art. The artist Benjamin Robert Haydon, writing in that time, described his reaction to the reclining figure of Dionysos (Herakles?) (FIG. 5-41), which he called Theseus:

But when I turned to the Theseus, and saw that every form was altered by action or repose— when I saw that the two sides of his back varied, one side stretched from the shoulder blade being pulled forward, and the other being compressed from the shoulder blade being pushed close to the spine, as he rested on his elbow, with the belly flat because the bowels fell into the pelvis as he sat—when I saw in fact the most heroic style of art, combined with all the essential detail of actual life, the thing was done at once and forever . . . Here were principles which the great Greeks in their finest time established . . .[3]

These principles seem indeed to be the monumental or heroic style "combined," as Haydon wrote, "with all the essential detail of actual life," the calm grandeur and simplicity of the one being in no way weakened by the precise, dynamic anatomical logic of the other.

The three goddesses from the east pediment of the Parthenon (FIG. 5-42), show even more than the *Dionysos* (*Herakles*?) the reinforcing and complementary actions of the principles of monumentality of scale and simplicity of pose with the "essential detail of actual life." The statues are typically Phidian in style, at once majestic and utterly "real" in the reading of the relaxed forms.

[3] In F. H. Taylor, *The Taste of Angels* (Boston: Little, Brown, 1948), p. 502.

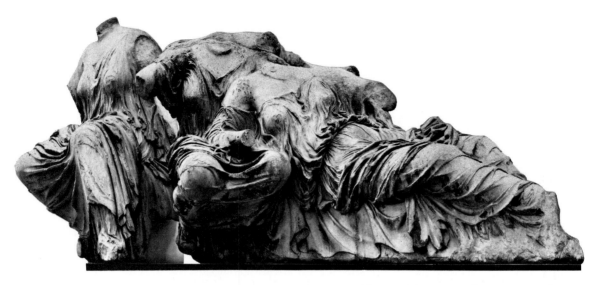

5-42 *Three Goddesses*, from the east pediment of the Parthenon. Marble, over life-size. British Museum, London.

In thin and heavy folds, the drapery alternately reveals and conceals the main and the lesser masses of the bodies, at the same time swirling in a compositional tide that subtly unifies the group, the articulation and integration of the bodies producing a wonderful variation of surface and play of light and shade. Not only are the bodies fluidly related to each other, but they are related as well to the draperies, though the latter remain distinct from the bodies materially. The treatment of body and drapery as obviously different stuffs, yet in functional relation to each other, illustrates the thoroughly reasoned laws of appearance that Phidias and his generation had come to know and respect.

The sculptural decorations of the Parthenon are in the pediments (some of the figures of which were just described), on the metopes, and on a continuous Ionic frieze at the top of the external cella wall. Those on the metopes provide an accent of movement, notably by the use of diagonal forms in successive compositions of pairs of struggling interlocking figures done in high relief—centaurs and Lapiths, gods and giants, Greeks and Amazons. The metope illustrated (FIG. 5-43), shows a battle between a Lapith and a centaur, the theme of the Apollo pediment at Olympia (FIG. 5-34). The figures are accommodated with great adroitness to the square spaces offered by the metopes, and the whole series

displays the ingenuity of the Phidian school in varying the poses and attitudes of the figures and avoiding the monotony that a regularly repeated space could impose. It is interesting also that the fortunes of the contestants are about equally balanced, the Greeks seeming to win or lose as often as their opponents.

The inner Ionic frieze of figures (FIGS. 5-44 and 5-45) was seen from below in reflected light against a colored ground. It enriched the plain wall and directed attention toward the entrance to the temple. It may represent the Panathenaic

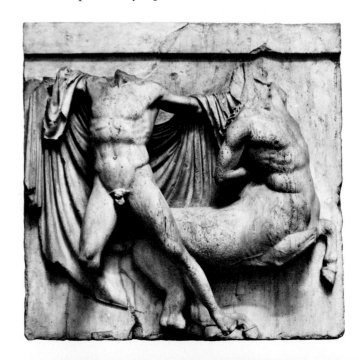

5-43 *Lapith and Centaur*, metope from the Parthenon. Marble, 4′ 8″ high. British Museum, London.

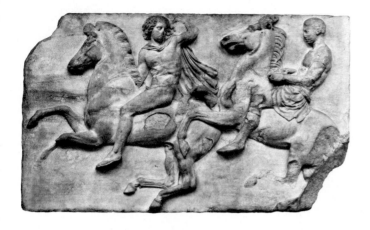

5-44 *Horsemen*, from the west frieze of the Parthenon. Marble, approx. 43″ high. British Museum, London.

procession, which took place every four years, when the citizens of Athens gathered in the marketplace and carried to the Parthenon the *peplos*, or robe, for the statue of Athena. If so, this is the first known representation of a non-mythological subject in Greek temple reliefs.

The Panathenaic frieze is unique in the ancient world for its careful creation of the impression of the passage of time, albeit a brief fragment of it. The effect is achieved by use of a sequence of figures so posed as to present a gradation of motion—a rudimentary picture of time as an acceleration or deceleration. In order to experience the illusion, the observer must himself be in motion, following the frieze around the colonnade of the temple. In the part of the frieze that

decorated the western side of the cella the viewer can see the procession forming: Youths are lacing their sandals and holding or mounting their horses; they are guided by marshals who stand at intervals, and particularly at the corners, to slow movement and guide the horsemen at the turn. In the friezes of the two long sides of the cella the procession moves in parallel lines, a cavalcade of spirited youths, chariots, elders, jar-carriers, and animals for sacrifice. Seen throughout the procession is that balance of the monumental-simple and the actual, of the tactile and the optical, of the "ideal" and the "real," of the permanent and the momentary that, again, is characteristically Greek and the perfect exemplification of the "inner concord of opposites" that Herakleitos, the philosopher, wrote of in the sixth century B.C. The eye follows the movement of light and shade in the drapery, pausing at any point by shifting focus to the broad areas of planes, with their sharply linear outlines. The movement of the procession becomes slower and more solemn as it nears the eastern side of the cella, when, after turning the corner, it approaches the seated divinities, who appear to be guests of Athena at her great festival. Standing

5-45 *Head of the Procession*, from the east frieze of the Parthenon. Marble, approx. 43″ high. Louvre, Paris.

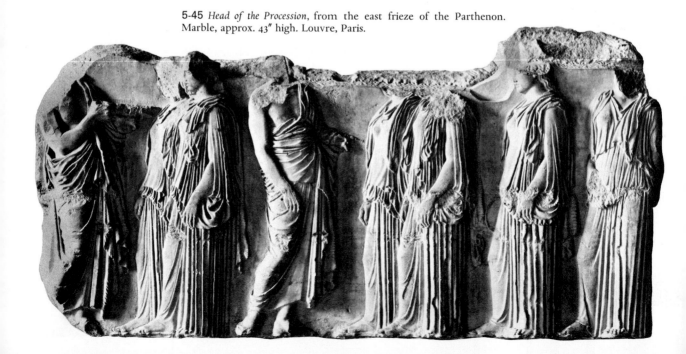

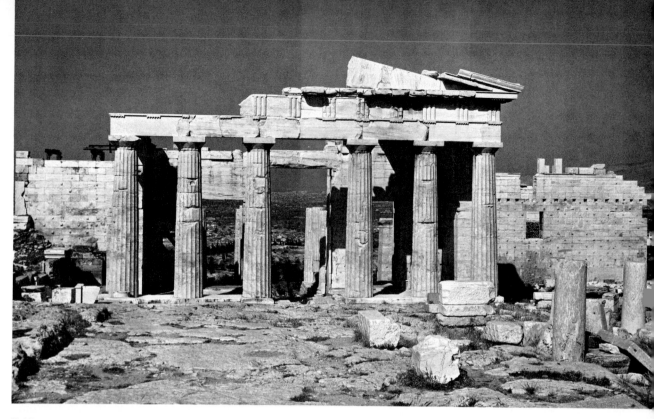

5-46 MNESICLES, the Propylaea, Acropolis, Athens, *c.* 437–432 B.C. (view from the east).

5-47 Temple of Athena Nike, Acropolis, Athens, 427–424 B.C.

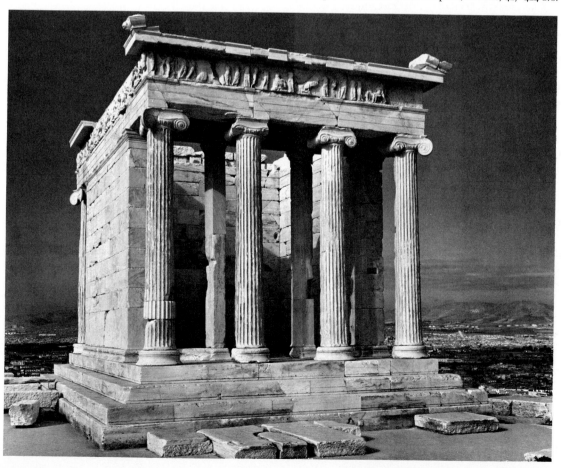

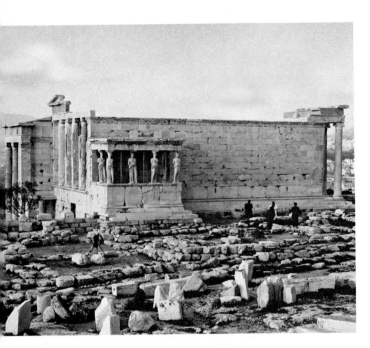

5-48 The Erechtheum, Acropolis, Athens, 421–405 B.C. (view from the south).

5-49 Reconstructed elevations of the east and west façades of the Erechtheum.

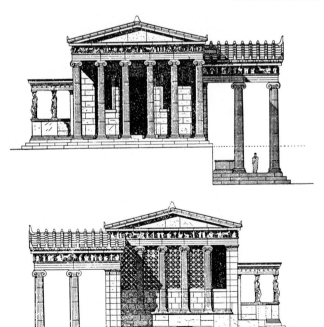

figures—to note one device of the artists—face against the general movement at ever closer intervals, slowing the forward motion of the procession (FIG. 5-45).

OTHER BUILDINGS OF THE ACROPOLIS

To reach the Parthenon, the Panathenaic procession would have wound its way from the lower level of the city of Athens, up the steep slope of the Acropolis, and through the gate called the Propylaea (FIGS. 5-38 and 5-46), another structure of the Periclean project. Built by MNESICLES between 437 and 432 B.C., it was begun immediately upon the completion of the Parthenon but was never finished, partly because of the financial drain of the Peloponnesian War and partly, it is believed, because one of its wings would have trespassed on the sanctuary of Artemis Brauronia. The design is a monumental and subtle elaboration of a gate unit leading through a city wall, the gate hall itself being flanked by buildings containing a library and perhaps the first picture gallery (*pinakotheke*) in history. Here persons could rest in beautiful surroundings after the steep climb and before they passed on to the sacred buildings on the summit. The Propylaea shows modifications of Doric regularity in the broadening of the space between the central columns to make the passageway more commodious, and, like the Parthenon, it includes Ionic elements such as the columns lining the corridor and giving greater height where it is needed for the support of the central roof structure.

The beautiful little Ionic Temple of Athena Nike (Athena Victorious), built under the direction of Callicrates between 427 and 424 B.C. (FIGS. 5-19C, 5-38, and 5-47), is the earliest completely Ionic building extant on the Acropolis. Before this time the Ionic order had been used for a whole building in a few treasuries at Olympia and Delphi on the Greek mainland (for example, the Treasury of the Siphnians, FIG. 5-26), and these had been constructed by Aegean islanders, not by Greeks of the mainland. It was through Athens' rule of the islands that it became open to eastern Greek and Ionian influences.

←to c. 700 B.C. 480 c. **450** 448 421 c. **400** 399 c. 340 323 B.C.

| AR-CHAIC PERIOD | *Kritios Boy* | Parthenon begun | Erechtheum begun | Socrates dies | PRAXITELES *Hermes and Dionysos* | Alexander dies |

←TRANSITIONAL→ C L A S S I C A L ←EARLY→ P E R I O D ←LATE→

The little amphiprostyle temple stands on what used to be a Mycenaean bastion near the Propylaea, to the Doric severity of which this slender, exquisitely proportioned building offers a striking contrast, heightening the effect of both.

Another Ionic building situated on the Acropolis is the Erechtheum (FIGS. 5-38 and 5-48), the last of the Periclean program. Constructed between 421 and 405 B.C., the Erechtheum is most unusual in plan and quite unlike any other Greek temple. It was named after the mythic Athenian hero, Erechtheus, to whom it was in part dedicated. Its many unusual features are due partly to the irregularity of its site and partly to the number of shrines included within it. According to the above-mentioned Pausanias, the Greek geographer and historian of the second century A.D., the Erechtheum stood on the traditional site of the contest between Poseidon and Athena for dominion over Athens, the theme of the sculpture group in the west pediment of the Parthenon. Also at the site were a rock supposed to be at the imprint of Poseidon's trident, the spring of salt water that the stroke of the trident produced, and Athena's olive tree. The asymmetrical arrangement of the building, which probably was not intended in the original plan, may also reflect an interruption and a "making-do" caused by the impending and final defeat of Athens in the Peloponnesian War, in 404 B.C. Thus, the Erechtheum was not completed as planned, and it can be assumed that the original plan provided for the west face to extend so that the north and south porches would have had their positions in the centers of the long blank walls. In the reconstructed elevations of the east and the west sides (FIG. 5-49) we can observe that on the east the different levels of the friezes are smoothly adjusted, while the west side appears to have been finished hurriedly with a wall to which are attached half-columns, the spaces between which are closed with bronze grilles. These *engaged* columns are rarely used in Classical Greek architecture, though the device is very popular later in Roman architecture. If one approaches the building with some rigid preconception of Greek architectural order, its overall effect may be disappointing; however, the asymmetry of the Erechtheum is extremely effective as a complement to the symmetrical unity of the Parthenon, just as the Korai of its Porch of the Maidens complement the Parthenon's Doric columns. Moreover, the carved details of the Erechtheum are without rival in their refined beauty.

SCULPTURE

The Porch of the Maidens, the south porch of the Erechtheum, is so called because its caryatids are its dominating feature (FIG. 5-50). It brings

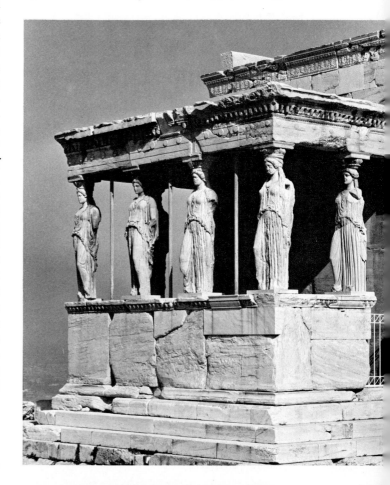

5-50 Porch of the Maidens, the Erechtheum.

5-51 *Grave Stele of Hegeso*, Dipylon cemetery, c. 410–400 B.C. Marble, 59″ high. National Museum, Athens.

sumed to be supporting. There are technical as well as esthetic reasons for the Erechtheum adjustment: Although the weight of a full entablature was borne by the Siphnian caryatids, in this case the load could have been too great for the necks of the figures, their weakest point; however, esthetic considerations were probably the more persuasive. Thus, again, we find the Classical architect-sculptor balancing in his wonderfully trained judgment the realities of structure with the necessities of ideal beauty. The figures have enough rigidity to suggest the structural columnar and just the degree of flexibility necessary to suggest the living body. The compromise is quite superbly brought off. The corner figures determine the stance by representing the weight as falling on the outer leg. The inner figures repeat this pose so that the legs not carrying the weight, and bent at the knee, do not determine the architectural verticals, nor disturb their natural plumb-line straightness. These figures have all the monumental majesty of Phidias' on the Parthenon pediments; the pleats and folds of their draperies reveal the quiet power of their bodies, and the very obligation imposed upon them by the architecture serves only to strengthen their noble poise.

The Phidian style dominated Athenian sculpture until the end of the fifth century B.C. Because of the Peloponnesian War fewer large-scale sculptural enterprises were launched, although the style lingered on in smaller works such as the popular grave steles produced in considerable numbers for both local use and export. One of the most harmoniously designed of these is the *Grave Stele of Hegeso* (FIG. 5-51), which was found in the Dipylon cemetery. As was often the case in grave reliefs of the Classical period, the figures are placed in an architectural framework. The deceased is seated on a chair with sweepingly curved back and legs that provides an effective transition from the frozen forms of the architecture to the organic ones of the figures. Hegeso is contemplating a necklace (originally rendered in paint) that she has taken from the box held by her girl servant. The quiet glances of mistress and servant meet at Hegeso's right hand, which, placed exactly in the center of the panel, is the compositional focal point. Although the

to mind that earlier Ionic caryatid design, the Treasury of the Siphnians (FIG. 5-26), and comparison of the two is useful. Unlike the Siphnian caryatids, those of the south porch of the Erechtheum do not carry a full entablature but one that consists of architrave and cornice only, the topmost fascia of the architrave being decorated with medallions to simulate the missing frieze. This seems to be a deliberate proportional adjustment undertaken by the sculptors of the Erechtheum figures to avoid the effect seen in the Siphnian caryatids, which look overloaded by the entablature; the sculptors must have been aware that figures graceful in attitude and dimension could scarcely harmonize with a massive architectural superstructure they would be pre-

5-52 *Nike Fastening her Sandal*, from the parapet of the Temple of Athena Nike, Acropolis, Athens, c. 410 B.C. Marble, approx. 42″ high. Acropolis Museum, Athens.

stele was carved toward the end of the century, it is devoid of the sentimentality found in many other works of its day; the solemn pathos of the scene links the stele with the grandiose conception of the Parthenon sculptures.

The relief of a Nike fastening her sandal (FIG. 5-52) from a parapet that was constructed around the Temple of Athena Nike about 410 B.C. shows how sculptors, having achieved the Classical perfection of the human form, now exhibit their virtuosity. The function of the concentrically arranged draperies, heavy and clinging to the form as if drenched with water, is to reveal the supple beauty of the young body. The interplay of the intricately moving drapery and the smooth volumes of the body seen in the *Three Goddesses* of the Parthenon (FIG. 5-42) is here refined to make a deliberately transparent veil for the female figure, which now fully emerges from the elaborate costume of the Kore tradition.

In contrast with the Ionian sumptuousness of the Phidian style is a work of the Argive school of southern Greece, the *Doryphoros* (FIG. 5-53) of POLYKLEITOS, a sculptor whose fame rivaled that of Phidias in the ancient world. The work shown here, the original of which is dated 450–440 B.C., is a Roman copy made much later.

Almost all extant works of the so-called Great Masters of Greek sculpture are replicas, the originals having disappeared. Originals of Roman copies can be identified through descriptions by ancient authors, especially Pausanias and Pliny the Elder, and occasionally through representations on ancient coins. There are a number of reasons for the disappearance of the originals: In war, statues made of precious materials were often pillaged and bronze statues melted to make weapons or utensils; during the barbarian invasions in the time of the fall of the Roman empire marble statues were used to make lime for mortar. After the Romans conquered Greece, in the second century B.C., they took Greek works of art to Rome to adorn the imperial palaces and the villas of the rich. Numerous copies were

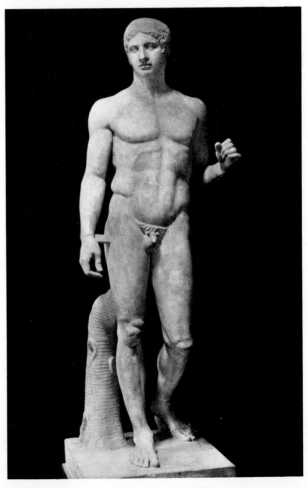

5-53 POLYKLEITOS, *Doryphoros*, original c. 450–440 B.C. Roman copy, marble, 6′ 6″ high. Museo Nazionale, Naples.

made of some statues, reflecting their popularity and fame. Many of the copyists took liberties with the originals; changes were made to conform with popular taste, and very few of the copies even approach the quality and refinement that the originals must have had. When the Romans were copying bronze in marble, they used awkward devices to strengthen weak points —such as a tree trunk placed next to a statue's leg and braces and struts to prevent breakage of the arms, as can be seen in the *Doryphoros*. Nevertheless, the copy of the *Doryphoros* does give evidence of the appearance of the original, and we can compare its blocky solidity and strength with the subtle grace of the Phidian style. Although the unity and equilibrium that pervade the works of Phidias are also in the Polykleitan statue, the origins differ, for while the artists at work on the Parthenon seem to have achieved their results with a deft, spontaneous translation of natural appearances, Polykleitos worked according to a canon of proportions in which he formulated the principles that give rise to unity. Although Polykleitos' own treatise enunciating his canon is lost, Galen, the second century A.D. physician, interprets it as follows in his *Placita Hippocratis et Platonis*:

> beauty consists in the proportions, not of the elements, but of the parts, that is to say, of finger to finger, and of all the fingers to the palm and the wrist, and of these to the forearm, and of the forearm to the upper arm, and of all the other parts to each other, as they are set forth in the Canon of Polycleitos.

It was said that in the *Doryphoros* Polykleitos had not simply made a statue but had manifested sculpture itself, and Aristotle uses "sculptor" and "Polykleitos" interchangeably. As the Greeks saw proportion as the central problem in architecture, so did they in sculpture, and they viewed Polykleitos' canon as the embodiment of proportional rationality for sculpture.

In the *Doryphoros*, movement, which began to be expressed successfully in the early fifth century B.C., is disciplined through the use of an imposed system of proportions. The mighty body, with its broad shoulders. thick torso, and muscular limbs, strikes us as the embodiment of the Spartan ideal of the warrior physique, the human equivalent of the Doric order. And, like the Doric order, the figure appeals to the intellect and must be studied long and carefully before it fully reveals itself to the observer. The slow forward walk, the standard Polykleitan pose, stresses the principle of weight-shift—the maneuver that must be made before we can move at all and with which the whole development of the representation of the moving human figure begins. What appears to be a casually natural pose is, in fact, the result of an extremely complex and subtle organization of the various parts of the figure. Note, for instance, how the function of the supporting leg is echoed by the straight-hanging arm to provide the right side of the figure with the columnar stability needed to anchor the dynamically flexed limbs of the left side. If read anatomically, on the other hand, the tensed and relaxed limbs may be seen to oppose each other diagonally (that is, the right arm and the left leg are relaxed, and the tensed supporting leg is opposed by the flexed right arm, which held a spear). Thus, all parts of the figure have been carefully composed to achieve the utmost variety within a compact and stable whole. A most circumspect and subtle artist has combined realism, monumentality, and diversity in a unified design that seems to be beyond the reproach of even the most discriminating critic.

PAINTING

The mural painter POLYGNOTOS enjoyed almost as much fame in antiquity as his contemporaries, Phidias and Polykleitos. Unfortunately, none of his works survive. On the basis of ancient literary sources, it is believed that his style is reflected in the vase decoration of the NIOBID PAINTER, whose *Argonaut Krater* (FIG. 5-54) illustrates a radical break with the traditional decorative style. For over two centuries figures had been arranged isocephalically—that is, with all the heads at one level—in horizontal bands, not only in Greek vase decoration, but also in monumental painting. Evidence for the latter seems to be provided by surviving Etruscan frescoes, which presumably reflect contemporary, or slightly earlier, Greek mural styles (see

Chapter Six). On the *Argonaut Krater* the figures have been placed on different levels, and ground lines on which they stand or recline attempt to introduce into painting the illusion of depth, an effect that is thwarted, however, by the uniform size of the figures. We also read that Polygnotos modeled his figures in dark and light, aiming for three-dimensional and sculptural effects. This last feature was not adopted by the Niobid Painter, whose style remains linear and does not reveal what must have been an impressive statuesque quality of Polygnotan figures. Though important as reflecting—dimly, to be sure—the monumental manner of Polygnotos, the Niobid Painter's works also represent the decline of vase painting as the figurative decoration loses contact with the body of the vessel, the earlier cohesion of figure and surface becoming mere adhesion.

Although the work of the Niobid Painter may give some notion of the general compositional schemes of Polygnotos, it tells nothing of his use of color. A pale reflection of it may be found in the so-called white-ground vases of the fifth century B.C. Experiments with the white-ground technique go back to the Andokides Painter, but the method became popular only toward the middle of the fifth century. It is essentially a variation of the red-figure technique, the pot first being covered with a slip of very fine white clay that, when burnished, provided a glossy or matte white surface for drawing in black glaze or dilute brown wash. The range of colors remained severely limited—purple, brown, and several kinds of red—as few colors known to the Greeks could survive the heat of the kiln. Also, the white slip, although highly effective as background for drawing and coloring, was not durable, tending to flake off. Crucial for wares that saw daily use, such as cups and kraters, this impermanence was less so in vessels that had a more limited use, such as funerary *lekythoi* (oil flasks), which were not handled after they had been deposited in the tomb. After mid-century, the white-ground technique was reserved almost exclusively for funerary vases of this type, some of which were even painted in full polychrome *after* the vase had been fired—naturally at an even greater cost in durability.

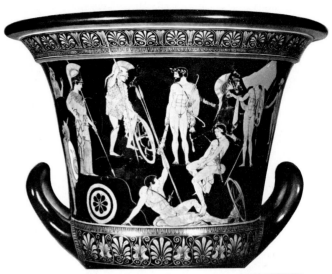

5-54 NIOBID PAINTER, *Argonaut Krater*, Orvieto, Italy, *c.* 455–450 B.C. Outline drawing at right indicates relation to whole vessel. Portion shown approx. 15″ high; whole vessel approx. 21″ high. Louvre, Paris.

The example shown in PLATE 5-2 uses the conservative colors that could withstand firing. It shows Hermes handing the infant Dionysos to Papposilenos ("granddad-satyr") and the nymphs in the shady glens of Nysa, where Zeus had sent Dionysos, one of his illegitimate sons, to be raised, safe from the possible wrath of his wife, Hera. The artist has used reds, brown, purple, and a special snowy white, the last for the flesh of the nymphs and for such details as the hair, beard, and shaggy body of Papposilenos. Despite this rather limited color scheme, the painting's effect is warm and rich; in combination with the compositional devices of the Niobid Painter, it may provide a shadowy idea of the appearance of the famed Polygnotan murals, which had so impressed ancient viewers.

The grandeur of the age of Phidias and Polykleitos, when their styles briefly dominated Greek art, passed with them. What followed, though exquisite and virtuoso, constituted a descent from their heights, becoming elegant, slight, more and more naturalistic, less concerned with the lofty themes and majestic forms. The statues of "godlike" men became statues of men of this world.

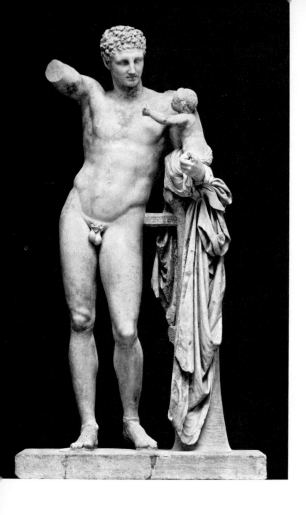

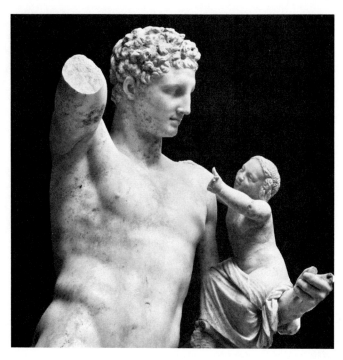

5-56 PRAXITELES, *Head of Hermes*, detail of FIG. 5-55.

5-55 PRAXITELES, *Hermes and Dionysos*, c. 340 B.C. Marble, approx. 7′ high. Museum, Olympia.

THE FOURTH CENTURY AND THE HELLENISTIC PERIOD

The Late Classical Period

The disastrous Peloponnesian War, which ended in 404 B.C. with the complete defeat of Athens, left Greece drained of its strength. Sparta and then Thebes took the leadership of Greece, both unsuccessfully. In the latter half of the fourth century B.C., the Greek states lost their liberty to Philip of Macedon. Athens lost its precedence. The whole structure of life changed; the traditional balance between the city-state and the individual was lost. The serene idealism of the fifth century, born of a simple, robust concept of mind and matter, of man and the state, gave way to chronic civil wars, social and political unrest, skepticism, and cynicism.

The Apollonian command "Know thyself," which Socrates taught as he spoke with the people in their daily gathering places, inevitably changed the Greek point of view to a more individualistic one. Euripides, too, seems to regard the individual as paramount, and his dramas depict a whole spectrum of human passions and crises. Aristophanes, however, ridiculed both Socrates and Euripides for their apparent departures from the good old Classical ways and customs and especially for their emphasis upon the role and value of the individual. During the fourth century B.C. man's intellectual independence was firmly established by Plato—however much he himself regretted the passing of the old ways—whose doctrine of eternal forms such as "virtue," "justice," and "courage" could serve as the rational models upon which the individual could construct his life. Aristotle, perhaps the most versatile of all thinkers, formulated the operations of reason in the science we call logic, converting reason into an instrument applicable to all human experience. Aristotle turned his attention systematically on just about everything that could be of interest to man, and among his

fundamental contributions is the outline of the sciences of nature.

Thus, gradually separating himself from the old assurances—the gods, their oracles, and time-honored custom—as prime interpreters of the meaning of life, the Greek carried on his search to know himself and to achieve knowledge of the world and life through observant experience. His dependence upon the city-state lessened, until he boasted with Diogenes: "I am a citizen of the world." Knowing the real, for whatever purpose, becomes the conspicuously Greek faculty and value. In the midst of political disaster, Greece, in the fourth century, enacted a daring drama of human discovery.

SCULPTURE

The humanizing tendency that had been gathering force throughout the fifth century achieved characteristic expression in the sculpture of the fourth century; though themes lose something of the earlier, solemn grandeur and representations of the greater gods give place to those of the lesser, the naturalistic view of the human figure is fully focused. The *Hermes and Dionysos* attributed to Praxiteles (FIGS. 5-55 and 5-56) is a work of such high quality that some authorities insist it must be by Praxiteles himself and not a mere Roman copy. The god is represented standing, with a shift in weight from the left arm (supporting the upper body) to the right leg, so that there is a double distribution of the weight, giving the pose, with its fluid axis, the form of a sinuous, shallow S-curve that becomes a manner with Praxiteles. On his arm Hermes holds the infant Dionysos, who reaches for something (probably a bunch of grapes) Hermes held in his right hand. Hermes is looking off into space with a dreamy expression, half smiling. The whole figure, particularly the head, seems in deep reverie, the god withdrawn in self-admiration. The modeling is deliberately smooth and subtle, producing soft shadows that follow the planes as they flow almost imperceptibly one into another. The delicacy of the features is enhanced by the rough, impressionistic way in which the hair is indicated, and the deep folds of the realistic drapery are sharply contrasted with the flow and

gloss of the languidly graceful figure. It needs but a comparative glance at Polykleitos' *Doryphoros* to see how broad a change in artistic attitude and intent took place from the mid-fifth to the mid-fourth century. Majestic strength and rationalizing design are replaced by sensuous languor and an order of beauty appealing more to the eye than the mind. Praxiteles' esthetic of the human nude, with its emphasis on the exquisitely smooth modeling that reproduces the tones of resilient flesh, naturally led him to become the inventor of the nude female statue. His *Aphrodite*

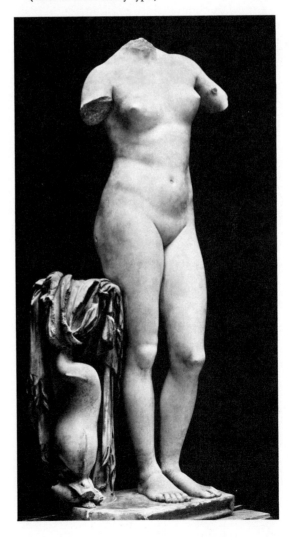

5-57 *Aphrodite of Cyrene*, North Africa, c. 100 B.C. Marble. Museo Nazionale Romano, Rome. (After fourth-century type.)

5-58 *Warrior's Head,* from the Temple of Athena Alea at Tegea, *c.* 350 B.C. Marble. National Museum, Athens.

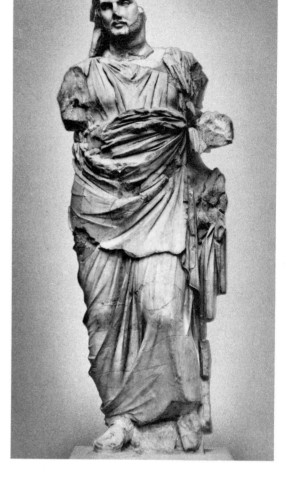

5-59 *Mausolus,* from the mausoleum at Halicarnassus, *c.* 355 B.C. Marble, approx. 9′ 10″ high. British Museum, London.

of Cnidus was widely regarded in antiquity as the most beautiful of all statues, the pride of Cnidus, the city that owned it. Its charm can best be understood, not from the inferior Roman copy of it, but from a much later, Hellenistic work, the *Aphrodite of Cyrene* (FIG. 5-57), which at two centuries remove conveys a Praxitelean poetry of sensual beauty. For both the male and female nude, Praxiteles set a new, more personal and naturalistic ideal of physical beauty.

Though Praxiteles' style was greatly admired, and though his theme of the bathing Aphrodite was taken up again and again long after his time, he was not the only influential sculptor in the late Classical period. A fellow Athenian, SCOPAS, is known for a robust and vigorous style more suited to the representation of action and perhaps

derived from Polykleitos. A fragmentary head from Tegea in Greece (FIG. 5-58) illustrates Scopas' style and shows a hitherto undepicted tension of facial expression, the features broad and strong, the eyes large, round, and set deeply under knitted brows. As a reflection of inner states through varied facial expressions, this work breaks with the Classical tradition of benign, neutral features and prefigures later Hellenistic art, when the depiction of emotion becomes more important to sculpture.

The monumental Tomb of Mausolus, another of the seven wonders of the ancient world, was built for King Mausolus and his Queen Artemisia. Mausolus was king of Caria, a non-Greek state in southwest Asia Minor, and was in the service of the king of Persia. The colossal portrait-statues of

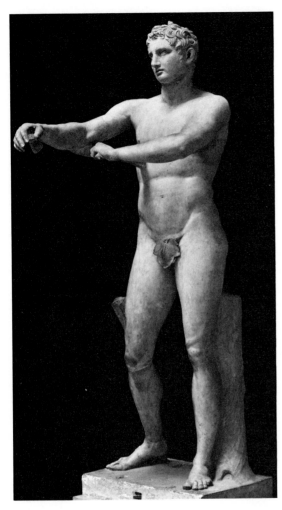

5-60 Lysippos, *Apoxyomenos*, bronze original *c.* 330 B.C. Roman copy, marble, approx. 6′ 9″ high. Vatican Museums, Rome.

pos was very prolific, his work is extant in copies only, including, notably, the *Apoxyomenos* (FIG. 5-60), which represents a young athlete scraping oil and mud from his body before taking his bath. The figure embodies two important innovations of the time, which may be creditable to Lysippos. One was a new canon of proportions, replacing the Polykleitan canon and reflecting a change in taste noticeable in all the arts. The new canon required a more slender, supple, and tall figure, a conception toward which we have already seen Praxiteles moving. This innovation may indeed have been influenced by the second (also foreshadowed in earlier works)—the full realization of the figure moving in space, not in the two dimensions of the figures hitherto examined (whether Phidian, Polykleitan, or Praxitelean), but in *three* dimensions. Thus, the figure now moves in a kind of free spiral through the space around it; it is made to be seen from a variety of angles, and it is related to things in its environment other than itself. The earliest Greek figures had been in a stiff frontal position, with the planes closely related to the stone block from which they had been carved; they were best seen from only one or two positions. The form was enclosed in space; space was its limit. Even when the figure was treated less rigidly, so that the torso as well as the arms and legs moved in a curve, it was still seen satisfactorily only from one or two points of view. In this respect an Archaic Kouros (FIG. 5-16) and the *Hermes and Dionysos* of Praxiteles (FIG. 5-55) are more nearly alike than are the *Hermes* and the *Apoxyomenos* of Lysippos. In the latter the arms curve forward, the figure enclosing space in its reach and twisting in it; the small head is thrown into stronger perspective by the large hand interposed between it and the viewer. Lysippos said that he wished to make men the way the eye sees them, allowing thus for accidents of perspective.

the king (FIG. 5-59) and queen date from about 355 B.C. Presumably they are intended as likenesses; the sculptor, who is unknown, is particular about the hair—curiously reminiscent of the Archaic—and the dynamics of the drapery. He continues that study of the drapery masses begun in the previous century and is at pains to read them so closely and realistically that he differentiates folds and pleats from the minute creases thin drapery would acquire in use. The colossal monument and the large figures reflect Eastern influence, and already we sense that mingling of East and West that is to compose the Hellenistic styles of the last centuries before Christ.

The most renowned sculptor of the second half of the fourth century B.C. was Lysippos, court sculptor to Alexander the Great. Although Lysip-

As Praxiteles prepared the way for developing optical realism in his subtle surface effects, so Scopas and Lysippos foreshadow Hellenistic themes (see below) demanding force, action, and dramatic emotion. Before the new drama could develop in sculpture, space had to be understood

The Fourth Century and the Hellenistic Period 169

in a new way, not as merely the limit of the body, but as an environment in which the body could act freely, as in nature.

ARCHITECTURE

It is noteworthy that, in its full development of the Corinthian order, the architecture of the fourth century also produced a "body" that offered a complete aspect from any angle. The first Corinthian capital—the order differs from the Ionic only in its capital—had appeared on the inside of the cella of the Temple of Apollo at Bassae, around 450 B.C. It crowned a column that, because it stood as a divider between two parts of the cella, could be seen from all sides. Presumably it was designed for that purpose and provided a much more satisfactory solution than the Ionic capital, which is designed to be seen effectively from two sides only. For Ionic colonnades that turn corners, like those of peripteral structures, special "corner capitals" had to be designed that would look the same on the two sides facing outward. The sharply projecting edge formed by the two meeting volutes never quite satisfied Classical architects, who may also have felt that this solution was achieved only at the expense of

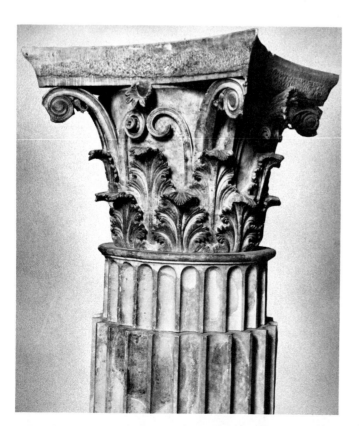

the structural logic of the Ionic capital and by a distortion of its functional parts. The problem was solved by the Corinthian capital, which can be seen to equal advantage from all sides. Its original design has been associated with the relief sculptor and metal-worker Callimachos, who may have been at Bassae when the Temple of Apollo was built and of whom the sentimental story was told in antiquity that he was inspired to design the capital when he saw acanthus leaves growing up around a slab-weighted votive basket on the grave of a maiden. Be that as it may, though the Corinthian order appeared in the fifth century B.C., for almost a century it was used on the inside of the temple only. It is uncertain whether this is to be attributed to religious conservatism, which would tend to preserve a feature that had taken on a certain sanctity from its function at the temple's center, or whether experiments with the Ionic were continuing and a Doric tradition persisting. In any event, full emergence of the Corinthian order on a public exterior takes place about the same time as Lysippos' freeing of the sculptured figure from its two-aspect limits.

A capital from the tholos at Epidaurus (FIG. 5-61), where a Corinthian colonnade stood inside the cella of a Doric structure, illustrates a step along the Corinthian order's elaborative route, which culminates in the characteristic Hellenistic and Roman luxuriance. Here the bell is thickly clothed with acanthus leaf and manifests that same increasing attention to the deep and detailed sculpturing of stone surfaces that was noted in sculptured figures.

The monument of Lysicrates (FIG. 5-62), constructed in Athens in 334 B.C., shows the first known use of the Corinthian order on the outside of a building. Significantly, the innovation appears not on a religious but on a commemorative monument. The graceful cylinder to which the Corinthian columns are engaged memorializes the victory of a choric group whose patron was Lysicrates and which had won the prized trophy of the tripod in the wild, dithyrambic contest of song in honor of Dionysos. The little tholos serves as a base for the monumentalized tripod. Henceforth, the Corinthian order will be more and more in use on the exterior of public buildings until it comes to

5-61 Corinthian capital from the tholos at Epidaurus, *c.* 350 B.C. Museum, Epidaurus.

exclude almost all other orders in the architectural design of the Romans. In addition to having solved the vexing problems of both the Doric and Ionic orders—the corner-triglyph and the corner-volute dilemmas—the Corinthian order, with its ornateness, was bound to suit the developing taste for sumptuous elaboration of form and realistic representation that guided artistic effort in the Hellenistic world.

The Hellenistic Period

Philip of Macedon brought the once free Greek city-states into subjection. His son, Alexander the Great, educated in Hellenism, the culture of Greece, by none other than Aristotle, returned the visit the Persians had made to Greece a century and a half before, overthrew their empire, and conquered all the Near East, including Egypt. Greek conquest of this vast area produced a culture and period called Hellenistic, a curious mingling of Western and Eastern ideas, religions, and arts, and a long period of Greek cultural—and partly political—dominance that made her the cosmopolitan heir of Sumer, Babylon, Egypt, Assyria, and Persia. Greedy for the lands their young leader had conquered, his generals asked Alexander on his death bed, "To which one of us do you leave your empire?" In the skeptical manner of the age, but also with more than a tinge of an older irony, he is supposed to have answered, "To the strongest." Although probably apocryphal, this exchange points up the near inevitability of what followed—the division of Alexander's far-flung empire among his Greek generals and their subsequent naturalization among the Orientals whom they held subject.

The centers of culture in the Hellenistic period were the court cities of these Greek kings—Antioch in Syria, Alexandria in Egypt, Pergamum in Asia Minor, and others. An international culture united the Hellenistic world, and its language was Greek. Hellenistic princes became enormously rich on the spoils of the East, priding themselves on their libraries, art collections, scientific enterprises, and skill as critics and connoisseurs, as well as on the learned men they could assemble at their courts. The world of the small, austere, and heroic city-state passed away

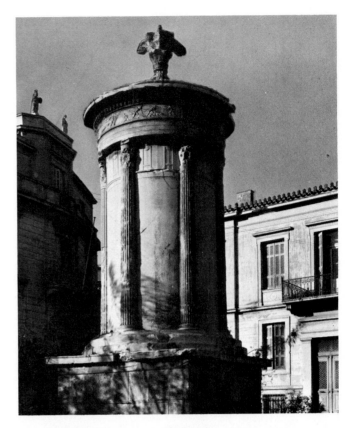

5-62 The monument of Lysicrates, Athens, c. 334 B.C.

as had the power and prestige of its center, Athens, and a "world" civilization, much like today's, took its place.

SCULPTURE

The tendencies traced thus far all the way from the Archaic period are not interrupted by this change but simply go on to anticipated completions. In sculpture, the "environment" that opened up around the *Apoxyomenos* of Lysippos (FIG. 5-60) is opened still more around the *Nike of Samothrace* (FIG. 5-63). The goddess of victory is here represented as alighting upon the prow of a war galley, triumphant in some conflict among the successors of Alexander in the Greek world around 190 B.C. One of the masterpieces of the Hellenistic age, the *Nike*, windswept, her wings still beating, brings strength, weight, and airy grace into an equipoise one would not expect to be achieved in the hard mass of sculptured

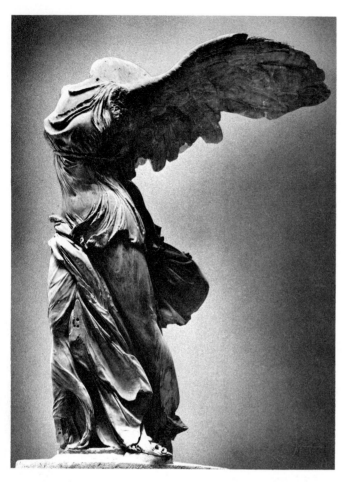

5-63 *Nike of Samothrace, c.* 190 B.C. Marble, approx. 8′ high. Louvre, Paris.

marble. But it is a fact that the sculptors are here working their stone with a freedom emulative of painters. They achieve shadows and gradations of shadows by variations of surface carving, almost as if they were using broad as against light brush strokes. The gauzelike stretch of material across the stomach and the waves of drapery around the striding thighs and legs amount not only to an exercise in virtuosity of stonecraft but a successful effort to make stone do what poetry and painting do—that is, render at the same time the visual nuances of the moment and the ongoing essence of action. In the end, the sculptor wants us to sense, from the figure itself, an atmosphere of wind and sea. We recall the billowing sail of Exekias' *Dionysos* (FIG. 5-7), where it all seems to have begun.

The extension of the spatial environment of the figure, so as to suggest a stage upon which it may and does act, appears in sculptures associated with the Hellenistic kingdom of Pergamum and the island republic of Rhodes, from the third through the first century B.C. From a group dedicated by Attalus I of Pergamum (241–197 B.C.) there survives a figure, in Roman copy, of a *Dying Gaul* (FIG. 5-64). The figure is on stage, realistic, and also historical, since it is meant to represent a Gallic casualty in the wars Attalus had just fought with barbarian invaders. Comparison of the *Dying Gaul* and the *Fallen Warrior* from Aegina (FIG. 5-30) shows that, in a little more than

5-64 *Dying Gaul,* bronze original, Pergamum, *c.* 240 B.C. Roman copy, marble, life-size. Museo Capitolino, Rome.

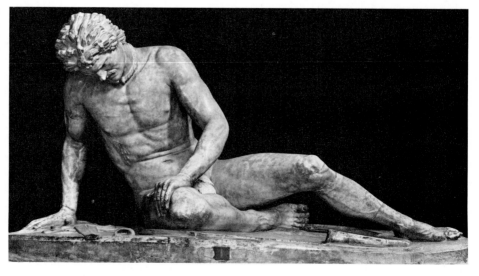

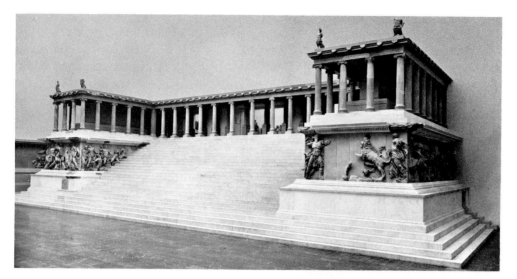

two centuries, the principle of uniformity of movement has been well learned. The Gaul, dying from a chest wound that bleeds heavily, slowly loses strength, his weight falling rapidly upon his last support, the trembling right arm; its collapse will be his own. This the observer reads at once from the lines and planes of the body, visually, and with no need of interpretation or filling-out of the meaning. The statue is a triumph of realism. It may mark also the surrender of the interests of sculpture to the stage, where, we know, spectacles of human suffering painted with all realism of detail were sapping the great tradition of drama and diminishing human life in bloody scenes that could only present it as worthless. With the *Dying Gaul* the sculpture of action degenerates into brutal stagecraft. Realism can go no further, even while it triumphs.

A later school of Pergamum exhibits a realism not quite so explicit, yet nonetheless belonging to the Hellenistic taste for tableaux of monumental suffering. A section of the great frieze of the *Battle of Gods and Giants* from the Pergamum Altar of Zeus and Athena (FIGS. 5-65 and 5-66) illustrates the highly dramatic kind of figurative sculpture that descended from Scopas and Lysippos. The altar was erected about 180 B.C. by the son and successor of Attalus I to glorify his father's victories. In a representation less factual than the group of dying Gauls, the artists here revert to

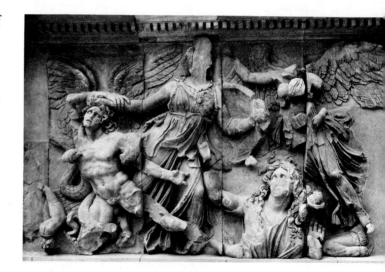

the traditional Greek approach of presenting historical events in mythological disguise. The suffering and death, the writhing gesticulation, are somewhat formalized, and we do not feel so much that we are in the presence of pain that ordinary men might feel. In the figure of Alcyoneus, the young giant whom Athena takes by the hair (FIG. 5-66), one finds the anguish of the face to be based upon Scopas and the twisting of the figure upon the athleticism of both Scopas and Lysippos. The tragic content is read through the increasingly dramatic style of stonecraft. The Greek vision of the climactic instant is still seen against a neutral background. Now, however,

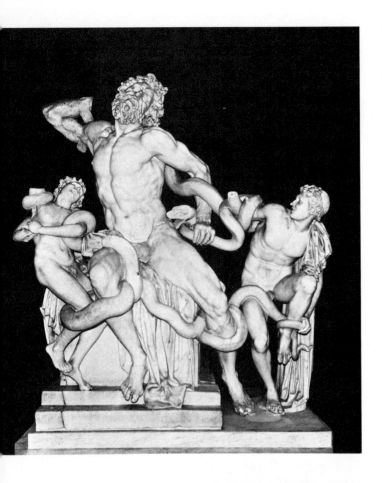

the background is almost obscured by shadows, from which the figures project like bursts of light. All these devices are "baroque" and closely related to those developed in seventeenth-century Europe. The unity of the design is achieved by a fluid, yet binding organization of parts—not unlike that of the figures of the three goddesses of the Parthenon (FIG. 5-42). Indeed, the two major figures of the frieze, Zeus and Athena, are directly inspired by the figures of Poseidon and Athena from the Parthenon pediments; yet this dynamic integration of the whole composition is unlike the carefully studied relationships of *separate* parts seen in the Early Classical period. In such pictorial unity, produced by the movement of light and the contrast of shade, we again recognize the strong influence of painting.

The theme of suffering is so pervasive in the Hellenistic world and its art that it could almost be understood as *the* interpretation of life by men who felt the hopelessness attendant upon the decline of an older, more reasonable system. A late work of Hellenistic sculpture is the *Laocoön* group, a product of a still quite active school of Rhodes (FIG. 5-67). It shows the Trojan priest, Laocoön, and his sons being strangled by sea serpents—some say because of his defiance of

5-67 Above: *Laocoön* group, early first century B.C. (?) Marble, 8′ high. Vatican Museums, Rome. (Partially restored.)

5-68 Right: AGESANDER, ATHANADOROS, and POLY-DOROS, *Odysseus' Helmsman Falling*, c. 150 B.C. (?) Marble, approx. life-size. Sperlonga Museum.

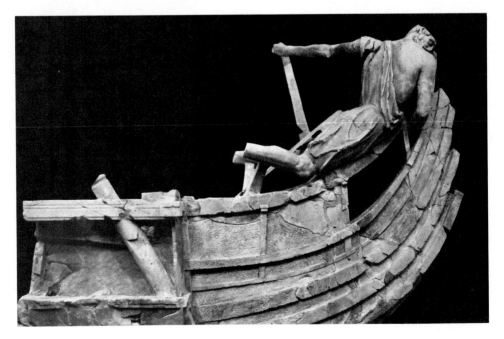

Apollo, others because he offended Poseidon (who sided with the Greeks) by warning his Trojan compatriots of the strategy of the Trojan Horse. Whatever his offense, Vergil has described his plight with unsparing realism:

> Laocoön . . . they [the sea serpents] seize and bind in mighty folds; and now, twice encircling his waist, twice winding their scaly backs around his throat, they tower above with head and lofty necks. He the while strains his hands to burst the knots, his fillets steeped in blood and black venom; the while he lifts to heaven hideous cries, like the bellowings of a wounded bull that has fled from the altar and shaken from its neck the ill-aimed axe.

The spectacular torment of Laocoön and his sons is presented with all the devices of rhetorical realism available to artists as well as poets—the tortuous poses, straining muscles, and swelling veins—yet curiously there are lapses from consistent visual fact, as in the—perhaps deliberate—disproportion of the size of the sons in relation to the size of the father, indicating them as *sons*, though they appear simply as small men. The exceedingly popular group was reproduced frequently, sometimes on a colossal scale, and in the eighteenth century the analysis of it by Gotthold Lessing led to his designation of art and poetry as opposed in function and to the foundation of the branch of philosophy called esthetics.

Pliny named three Rhodians—ATHANADOROS, AGESANDER, and POLYDOROS—as the sculptors of the *Laocoön* group. The same three names are inscribed on the stern of a marble ship (FIG. 5-68) that formed part of one of several sculptured groups, fragments of which have been found in a large grotto near the sea at Sperlonga, some eighty miles south of Rome. The cave, adjacent to a large imperial Roman villa built early in the first century A.D., had been used as a kind of dining room. Multifigured sculptured groups appear to have been displayed in two niches and in a round central pool within the grotto. At least some of the sculptures must have been brought from Rhodes and were installed in the grotto around A.D. 29, when the cave was refashioned after a partial collapse.

A definitive interpretation of the scenes is most difficult, since the groups were found only in

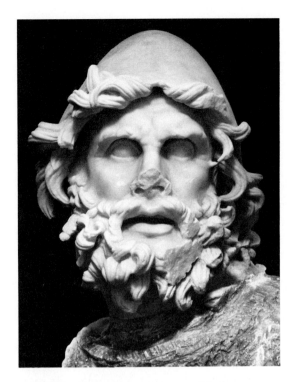

5-69 AGESANDER, ATHANADOROS, and POLYDOROS, *Head of Odysseus*, c. 150 B.C. (?) Marble, life-size. Sperlonga Museum.

fragments, the figures evidently having been smashed to make lime or out of religious fanaticism. At least two scenes from the *Odyssey* seem to have been represented: the blinding of Polyphemos (among the finds are the legs of a colossus that must have stood nearly twenty feet high) and Scylla attacking Odysseus' ship. FIG. 5-68 shows the terrified helmsman falling from the stern of the ship as his comrades (not shown) battle the monster, which has boarded the vessel. Probably the finest of the fragments is the head of Odysseus (FIG. 5-69). Less convulsed and emotional than Laocoön's head, it nevertheless reflects strikingly the horror of the situation and the fear of impending death. The effect is produced—without the use of grimaces or the exaggerated eyes and anguished mouth of Laocoön—by the wind-tossed, whirling hair and beard that frame the face of the Homeric hero, merely suggesting the blast of terror sparked by the fearful battle aboard the ship. While the dating of the Sperlonga sculptures remains uncertain,

The Fourth Century and the Hellenistic Period 175

323 B.C. c. 300 c. 240 c. 175 146 c. 50 30 B.C.

| Hunter Mosaic, Pella | Dying Gaul, Pergamum | Altar of Zeus and Athena, Pergamum | Roman "liberation" of Greece | APOLLONIUS (?) Seated Boxer |

H E L L E N I S T I C P E R I O D

←——————— EARLY ———————→ ←——— LATE ("GRECO-ROMAN") ———→

it is felt that they must be earlier than the *Laocoön*, as they show the expressive power of the Rhodian sculptors at its height, before it succumbed to the theatrical exhibitionism that marks the latter group.

Side by side with the drama of suffering, Hellenistic sculpture continued the tradition of ideal, Praxitelean beauty, as in the *Aphrodite of Cyrene* (FIG. 5-57) already referred to. Another Hellenistic descendant of this Praxitelean line is the *Aphrodite of Melos* (FIG. 5-70), the famed *Venus de Milo*. Here, as in the former, the ideal is taken out of the hypersensible world of reasoned proportions and made into an apparition of living flesh—like the coming alive of Pygmalion's statue of Galatea. The feeling for stone as stone has quite surrendered to the ambition of

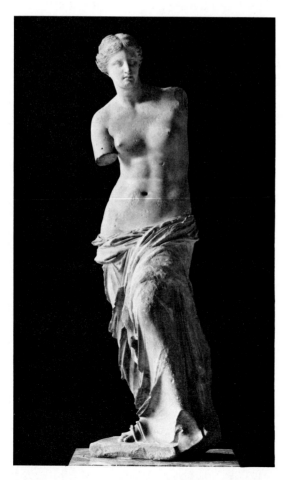

5-70 *Aphrodite of Melos, c.* 150–100 B.C. Marble, approx. 6′ 10″ high. Louvre, Paris.

making stone look as though it were the soft, warm substance of the human body. Such effects as these can be obtained only by an artist with brilliant technical facility working in the conviction that the business of the artist is to produce from stone a vision of beauty, faithful to optical reality, yet so modified as to make the keenest appeal to the senses as a flawless manifestation of the human form. Faithfulness to optical fact can also lead the sculptor to represent, with unflattering explicitness, the opposite of beauty, as in the *Old Market Woman* (FIG. 5-71). The bent, hobbling creature is offered to the viewer as an object of contempt, pity, or disgust, depending upon his temperament.

The disparity in subject of these two works reflects the wide scope of theme and the visual curiosity of Hellenistic sculptors. The sculptor aims to move the observer in terms of the theme of his work. He wishes, moreover, for recognition by the observer of those traits in the statue that the observer knows in life, so that a large part of the response to the statue comes from the observer's familiarity with its model or type in the context of his own experience. Thus, while the Classical sculptor generally showed young adults at the height of their physical development, the Hellenistic artist expanded his subject matter to include not only the very old but also the very young. It seems unlikely that a fifth-century B.C. sculptor would have imagined that a boy strangling a goose (FIG. 5-72) could be a subject worthy of representation. The sculpture may strike us as somewhat unpleasant, with its sadistic overtones, but doubtless it was intended to be "cute" and to elicit fond smiles as well as praise of the artist, BOETHOS, for his ingenuity in inventing a curious subject. And it must be admitted that Boethos has succeeded, from the formal point of view, in converting a trivial subject into a remarkably effective work of art. The swirling forms have been contained in a compact, pyra-

Color Plates 1-1 to 6-4

Other plates are distributed as follows:
6-5 to 13-5, after page 364; 13-6 to 16-5, after page 584; 16-6 to 22-5, after page 772

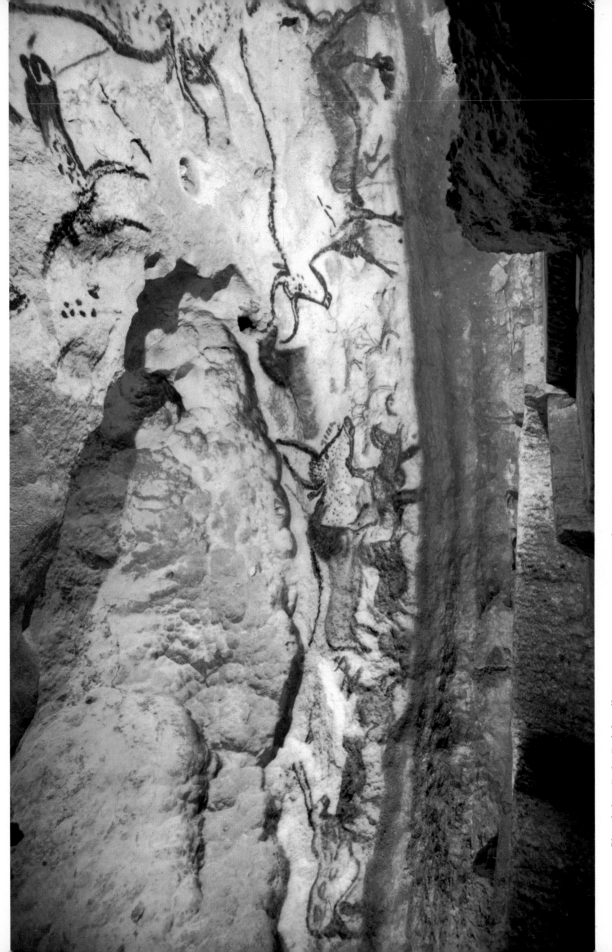

Plate 1-1 *Hall of Bulls*, left wall, Lascaux, c. 15,000–10,000 B.C. Dordogne, France.

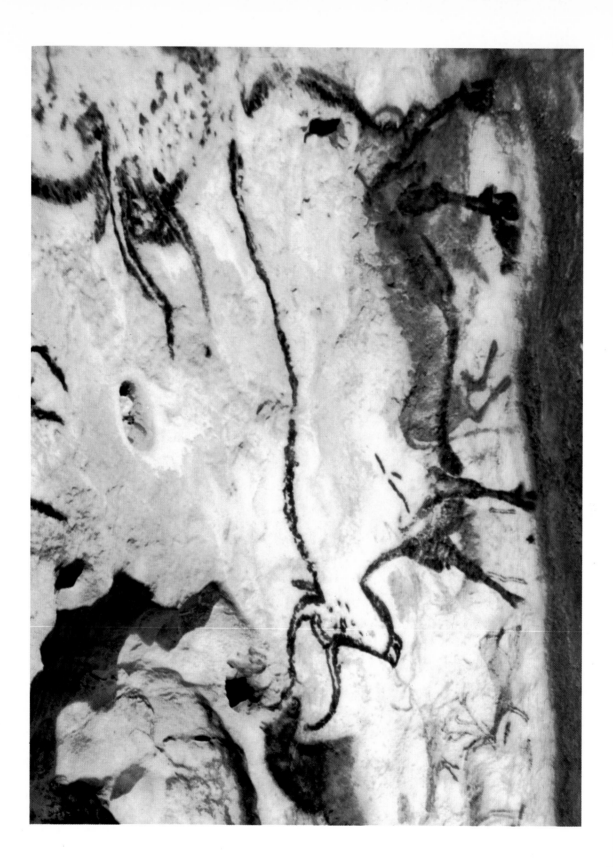

Plate 1-2 *Second Bull*, detail of PLATE I-I. Bull approx. 11′ 6″ long.

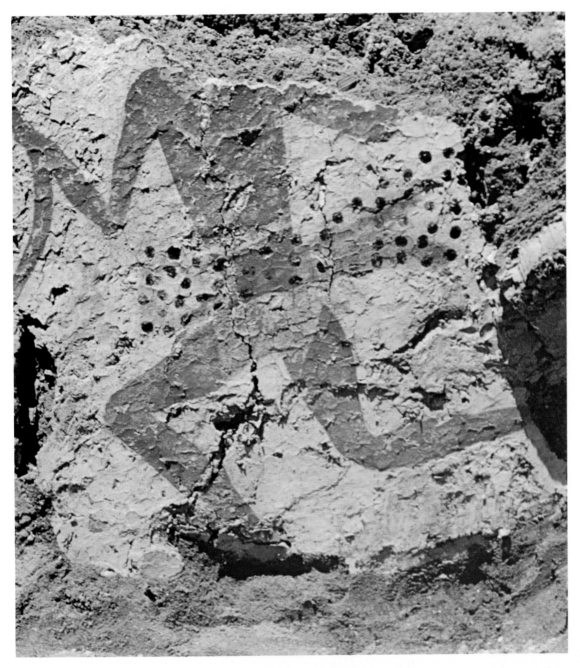

Plate 2-1 *Dancing Hunter*, fragment of a wall painting, Level III,
Çatal Hüyük, *c.* 5750 B.C.

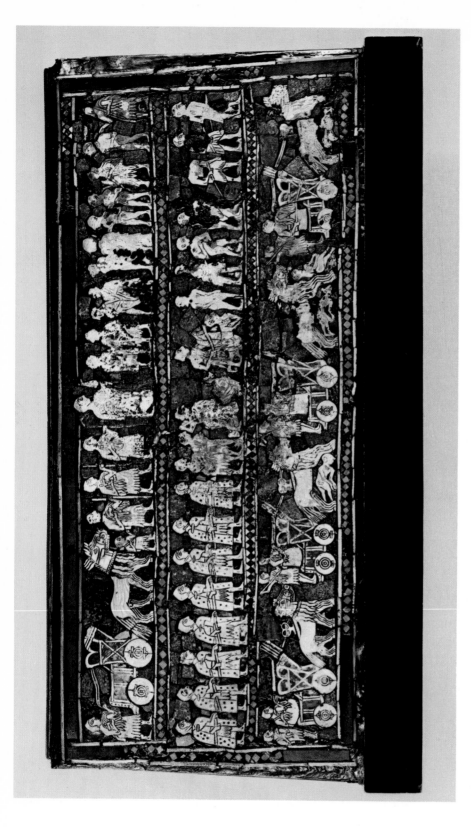

Plate 2-2 *Scenes of War*, panel from the *Standard of Ur*, c. 2700 B.C. Panel inlaid with shell, lapis lazuli, and red limestone.
Each panel approx. 8″ × 19″.
British Museum, London.

Plate 2-3 The Ishtar Gate (restored), Babylon, c. 575 B.C. Staatliche Museen, Berlin.

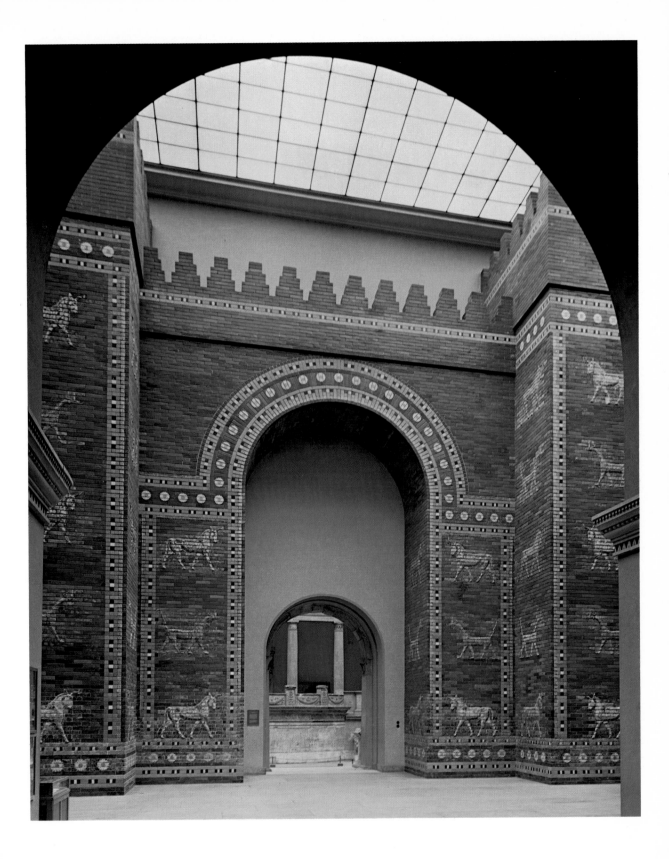

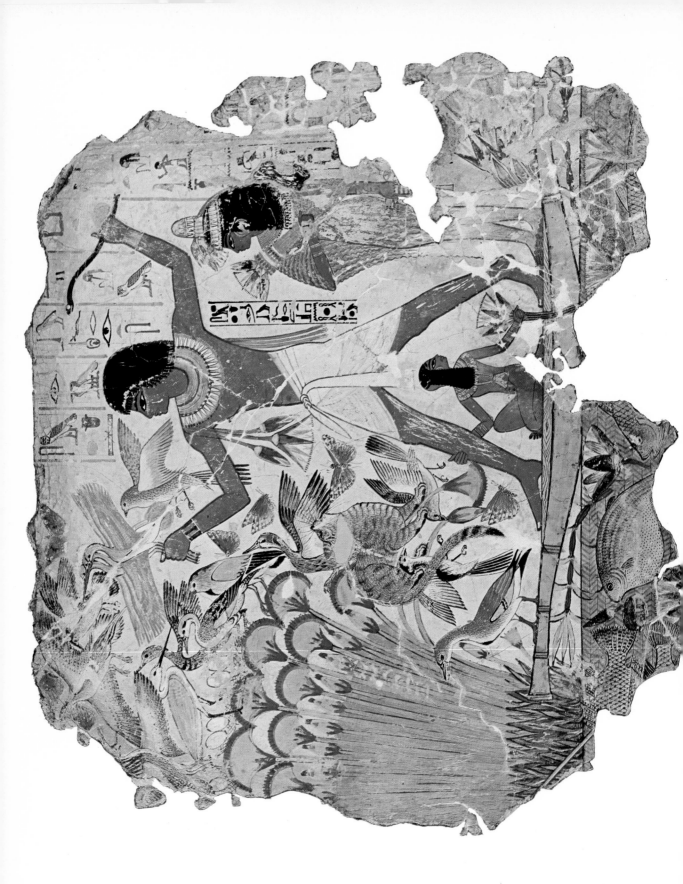

Plate 3-1 *Fowling Scene*, wall painting from the tomb of Amenemheb, Thebes, *c.* 1450 B.C. Dry fresco. British Museum, London.

Plate 3-2 *Queen Nefertiti*, Tell el-Amarna, *c.* 1360 B.C. Limestone, approx. 20″ high. Berlin Ägyptisches Museum.

Plate 4-1 *La Parisienne*, fragment of a fresco, Knossos, *c.* 1500 B.C. Approx. 10″ high. Archeological Museum, Herakleion.

Plate 4-2 Inlaid dagger blades from the royal tombs at Mycenae, *c.* 1600–1500 B.C. Bronze, longest blade approx. 9″ long. National Museum, Athens.

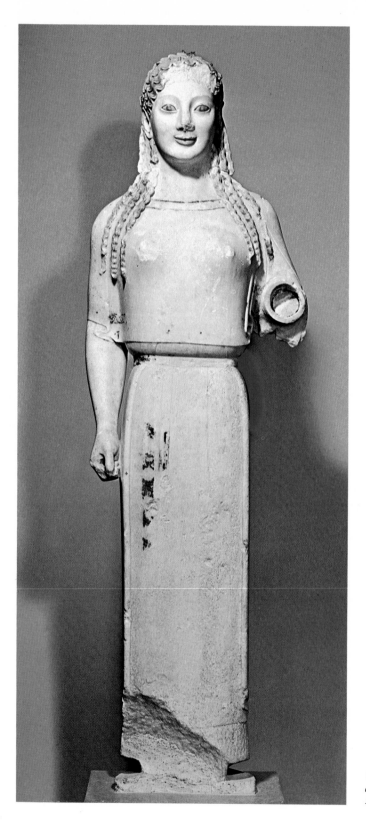

Plate 5-1 *Peplos Kore*, Acropolis, Athens,
c. 530 B.C. Marble, approx. 48″ high.
Acropolis Museum, Athens.

Plate 5-2 Phiale Painter, *Hermes Bringing the Infant Dionysos to Papposilenos,* krater, Vulci, *c.* 440–435 B.C. Approx. 14″ high. Vatican Museums, Rome.

Plate 5-3 *Hunter*, detail of the *Lion Hunt* mosaic, Pella, *c.* 300 B.C. Pebble mosaic, approx. 5′ 6″ high.

Plate 6-1 *Revelers*, wall painting from the Tomb of the Leopards, Tarquinia, c. 470 B.C. Approx. 42″ × 76″.

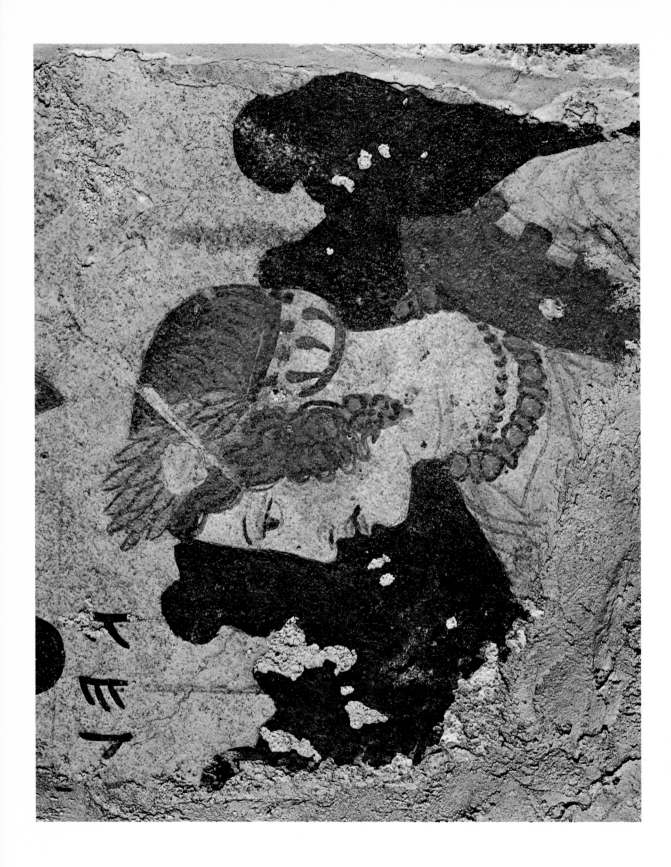

Plate 6-2 Detail of the *Woman of the Velcha Family*, wall painting from the Tomb of Orcus (Hades), Tarquinia, c. 470 B.C.

Plate 6-3 Details of a frieze from the Villa of the Mysteries, Pompeii, c. 50 B.C. Second-style ("architectural") wall painting. Figures approx. 4½–5′ high.

Plate 6-4 *Garden Scene*, detail of a wall painting from the House of Livia, Primaporta, late first century B.C. Portion shown approx. 9′ wide. Museo Nazionale Romano, Rome.

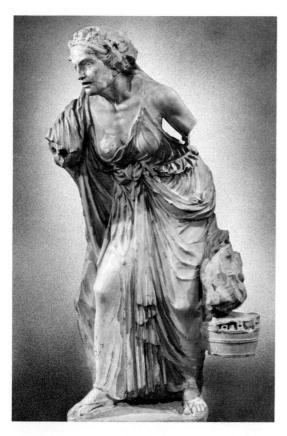

midal composition that is at once complex and unified and in which the voids, like the solids, have been carefully studied and used as functioning parts of the whole. Occasional references to the "decline" of Greek art during the Hellenistic period certainly cannot be interpreted as meaning that the artist lost his former skill. What is meant, undoubtedly, is that the artistic sights were lowered from lofty ideals to the trivia of life.

The *Seated Boxer* (FIG. 5-73), a very late Hellenistic work (perhaps more properly referred to as Greco-Roman, since it dates about a century after the absorption of Greece into the Roman empire), shows a heavily battered veteran of the arena resting, perhaps beaten and listening to the berating of his manager. The boxer is a man of huge physique, but his smashed face, broken nose, and deep scars tell the gist of his story. The sculptor appeals not to our intellect but to our emotions as he strives to evoke compassion for

5-73 APOLLONIUS (?), *Seated Boxer*, c. 50 B.C. Bronze, approx. 4′ 2″ high. Found in Rome. Museo Nazionale Romano, Rome.

5-71 *Old Market Woman*, second century B.C. Marble, 4′ 1½″ high. Metropolitan Museum of Art, New York (Rogers Fund).

5-72 BOETHOS, *Boy Strangling a Goose*, second century B.C. Marble, approx. 2′ 9″ high. Staatliche Antikensammlungen, Munich.

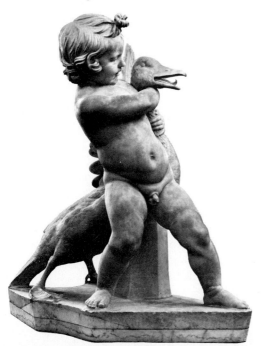

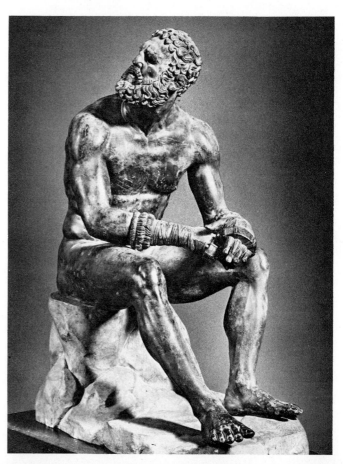

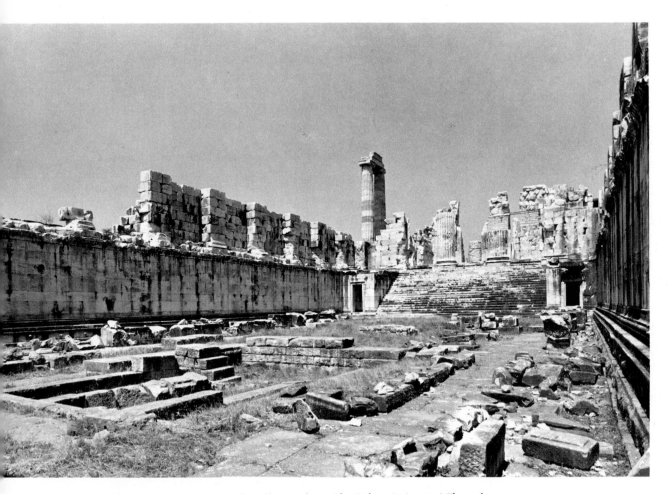

5-74 Interior of the Temple of Apollo at Didyma (the Didymaion), near Miletus, begun 313 B.C.

the battered hulk of a once mighty fighter. Story, realism, and human interest become the Hellenistic artist's interest at the end of the development of Greek sculpture, which thus ran, in a few centuries, a spectrum of possibilities and realizations from the *Apollo* of Olympia to a brutish boxer past his prime.

ARCHITECTURE

The greater variety, complexity, and sophistication of Hellenistic culture called for an architecture on an imperial scale and of wide diversity —far beyond what the Classical city-state could ever require. Building activity shifted from the old centers on the Greek mainland to the opulent cities of the Hellenistic monarchs in Asia Minor,

sites more central to the Hellenistic world. Great scale and ingenious development of interior space, the latter peculiarly a feature of Hellenistic architecture, are shown in the Temple of Apollo at Didyma (the Didymaion) near Miletus, the old Ionian city on the west coast of Asia Minor (FIGS. 5-19f and 5-74). This dipteral Ionic temple is raised upon a seven-stepped base some thirteen feet above the level of the large cella, which was intentionally left open to the sky (*hypethral*). The temple is 167 by 358 feet, the great columns over sixty-four feet high. The deep and column-filled pronaos precedes an antechamber from which a grand flight of steps some fifty feet wide sweeps down to the open courtyard, making a dramatic approach to the diminutive prostyle shrine that protected the cult statue, the foundations of which may be seen in the illustration.

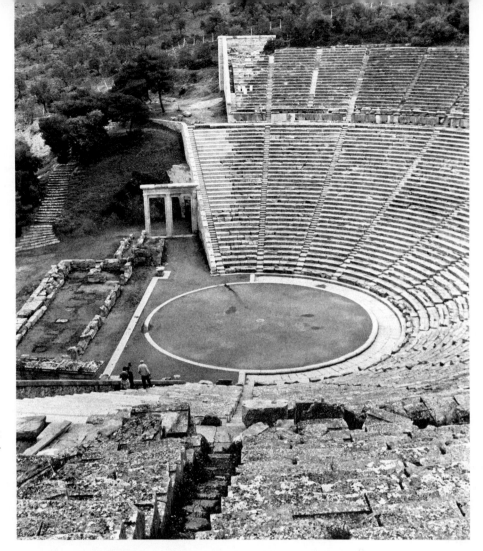

5-75 View of the theater at Epidaurus, *c.* 350 B.C.

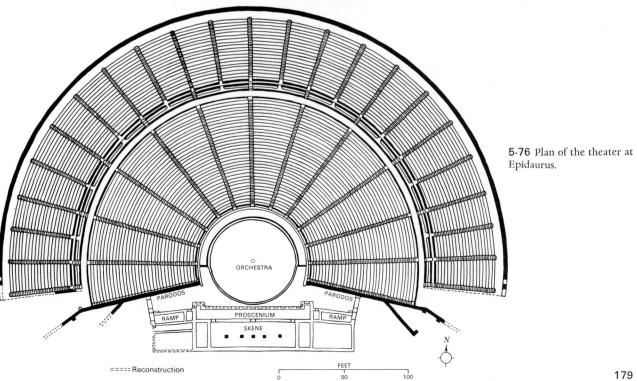

ORCHESTRA

PARODOS

PARODOS

RAMP

PROSCENIUM

RAMP

SKENE

5-76 Plan of the theater at Epidaurus.

===== Reconstruction

FEET
0 50 100

N

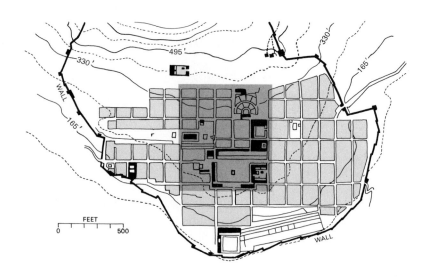

5-77 Simplified ground plan of Priene. Darker-toned rectangle indicates area shown in detail below.

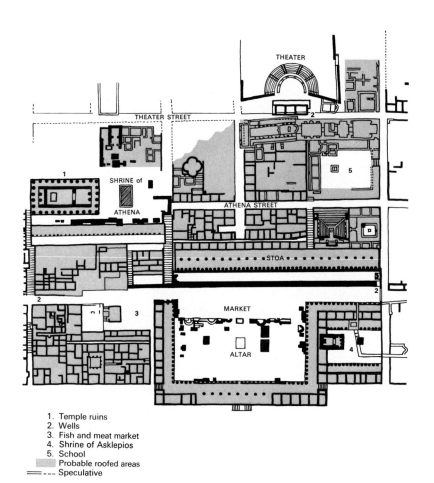

1. Temple ruins
2. Wells
3. Fish and meat market
4. Shrine of Asklepios
5. School
▨ Probable rooted areas
═══--- Speculative

This complex spatial planning of large interiors leads directly into later Roman practice and marks a sharp departure from Classical Greek architecture, which stressed the exterior of the building almost as a work of sculpture, and left the interior relatively undeveloped.

Another example of dexterous planning of uncovered space is the theater at Epidaurus, which Pausanias declared to be the best in Greece (FIGS. 5-75 and 5-76). Although the building (about 350 B.C.) is late Classical rather than Hellenistic and belongs to a period when theaters were relatively primitive, it has all the functioning units and formal arrangement of later theaters. The slightly more than semicircular auditorium is built into the side of a hill, and the diameter of its projected circle is 387 feet. Staircase aisles, laid out on radii projected from the center of the circular *orchestra*, where the plays were performed, separate blocks of stone benches, which themselves are separated into two tiers by a broad corridor. The orchestra, the *proscenium*, and the *skene* are arranged for maximum convenience of view of the performance and of preparations of the actors. The *parodos* (passageway between stage and audience) on each side is wide enough to permit rapid exit. This careful thinking-out of the plan for the convenience of an audience marks, as do the New Comedy plays acted at this time, increasing concern for individual views and responses.

The thoughtful adaptation of space to human uses, rather than, as in ancient times, to honor gods and to satisfy the whims of kings, is part of Greek humanism's contribution to history. The Hellenistic Greeks also broadened their conception of architectural design to take in whole cities. The regular street patterns of the gridiron type, which go back to the Archaic period in Greece were systematized during the fifth century B.C. by HIPPODAMOS, a Milesian architect, whose name has been linked with the checkerboard plans of Hellenistic cities like Priene (FIG. 5-77).[4]

[4] Knowledge of ancient urbanism is rather scanty, since archeologists generally prefer to investigate limited sites, and it is rarely economically feasible for them to uncover and trace miles of city streets. The fragmentary evidence shows, however, that cities with regular, usually rectangular street plans existed in both ancient Egypt and Mesopotamia.

The Hippodamian scheme, as illustrated by Priene, consists of a close-meshed network of streets that intersect at right angles, without any particular axial emphasis that might suggest dominant traffic patterns. Here the plan has been superimposed upon an irregular, sloping site without regard to the nature of the terrain. Only the defensive walls on the city's perimeter closely follow the topographical contours, with the result that walls and street plan are unrelated. On the other hand, the system is neat and orderly and, by making few distinctions of either a social or economic nature, essentially democratic.

The major ordering principle of the Hippodamian plan was the agora, which was centrally located and thus easily accessible to all citizens. It was partially surrounded by long, roofed, colonnaded stoas which housed markets and offices and were the architectural expression of

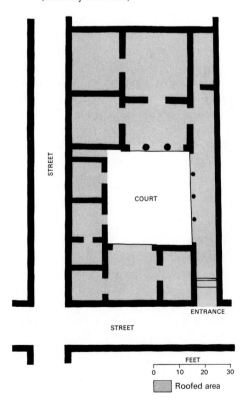

5-78 Plan of House XXXIII, Priene. (Partially restored.)

STREET

STREET

COURT

ENTRANCE

STREET

FEET
0 10 20 30

Roofed area

the public life of the city. Here its business and politics, its administration and its gossip went on, and it is from the fact that they taught their rational moral discipline in a stoa that the philosophy of the Stoics takes its name.

It is at this point in the history of architecture that we can speak of domestic building as such and discover (also in Priene) the look of an ordinary human dwelling capable of being called a house (FIG. 5-78). Typically, the lot on which the Hellenistic house stood was enclosed by a wall to shut out the dirt and noise of the narrow street. A single door opened into an office, or service quarters, from which a covered passage led to the main unit through a courtyard into which opened roofed chambers. Wealthier residents had, in addition to the forecourt (similar to the Roman *atrium*) a colonnaded garden, the *peristyle*. On a small scale the Priene house reflects the general Hellenistic interest in designing convenient interior spaces, as well as the growing concern for utility and convenience in the daily life of the ordinary individual.

Priene was a provincial town, and its houses were relatively unpretentious. It was in the capitals of the Hellenistic kingdoms—at Alexandria in Egypt, Pergamum in Asia Minor, and Pella in Macedonia—that life unfolded its richest and most sumptuous aspects. Here the kings and their retainers surrounded themselves with luxury that became proverbial, and their way of life set a standard that was to be surpassed only by the Roman emperors in later antiquity. Among the most lasting symbols of Hellenistic luxury were the floor mosaics with which the wealthy residents of these court cities embellished their houses.

MOSAICS

Mosaic as an art form had a rather prosaic and utilitarian beginning. (The Sumerian custom of covering walls with baked clay cones and the technique of shell inlay, as found in the *Standard of Ur*, PLATE 2-2, were not long-lived.) In the Mediterranean region the mosaic technique seems to have been invented primarily for the purpose of developing a flooring that was both inexpensive and durable. Originally, small pebbles collected from beaches and riverbanks were set into a thick coat of plaster. It was soon discovered, however, that the stones could be arranged in decorative patterns. At first these were quite simple and confined to geometric shapes; examples of this type that date back to the eighth century B.C. have been found at Gordium in Asia Minor. Eventually the stones were arranged to form more complex pictorial designs, and by the fourth century B.C. the technique had been developed to the point where mythological subjects could be represented on a large scale and with rich coloristic effects.

The most famous of these fourth-century pebble mosaics were found at Olynthus, which was destroyed by Philip of Macedon in 348 B.C., and at Pella, the Macedonian capital under King Archelaus around 400 B.C. Although almost forgotten until the late 1950's (excavations there were begun in 1957), it was at Pella that Alexander was born, that Aristotle taught, and that Euripides died. Under Alexander, Pella became virtually the capital of the world, as he ruled his vast empire from there. Although little has been preserved of the buildings' superstructures, furniture, or other works of art, the uncovered floor mosaics give ample evidence of the luxury and beauty of Pella's houses. A detail from one of several well-preserved pebble mosaics shows an almost life-sized figure from a scene representing a lion hunt (PLATE 5-3). The stones that have been arranged to form the picture are neither hewn nor shaped but natural pebbles. A variety of colors has been used to produce a polychrome effect, but the chief pictorial impact is derived from a strong dark and light contrast. Some outlines and interior markings are defined with thin strips of lead, a refinement that increases the clarity of the design but which was to enjoy no lasting favor.

Because they were cheap and durable, pebble mosaics remained popular through Roman times; in fact, they are still used for decorative pavements in Mediterranean countries. However, the desire for ever greater pictorial realism led to the simple but revolutionary practice of cutting stones to desired shapes so they could be fitted together more closely. At first these shaped stones, or *tesserae*, which permitted more precise

description of detail, were used together with pebbles in limited areas that were felt to require greater definition. But by the second century B.C., "true" mosaics, composed entirely of cut stones, were designed at Pergamum and Delos, and the technique had been perfected to include colored glass (*smalto*) for strong colors, such as pure blue, red, and green, that are rarely found in natural materials. One of the most durable of the artistic media, mosaic was highly refined and popular in Roman times and became one of the chief vehicles for pictorial expression of early Christian and Byzantine artists.

While Alexander and his successors were Hellenizing the East, a power was rising in the western Mediterranean that in its own way would, like Greece, greatly determine the history of Europe and the Europeanized world. In one fateful year, 146 B.C., that power—Rome— sacked the Greek city of Corinth and destroyed an old enemy, Carthage, absorbing the small Greek states into the Roman province of Achaia and constructing around the ruins of Carthage the province of Africa. Thus, in a double stroke, Rome took under its aegis the culture of Greece and brought to an end in the Mediterranean West the ancient Near Eastern civilization that had continued to flourish in the old Phoenician sea-empire. Although this constituted another step in the Westernizing of the ancient world, it did not mean a blocking of the channels of commercial and intellectual intercourse with the East. For what Rome adopted from Greece it passed on to the Medieval and modern worlds in a form much transformed by the Oriental message of Christianity. If Greece is peculiarly the inventor of the European spirit, Rome is its propagator and amplifier.

Chapter Six

Etruscan and
Roman Art

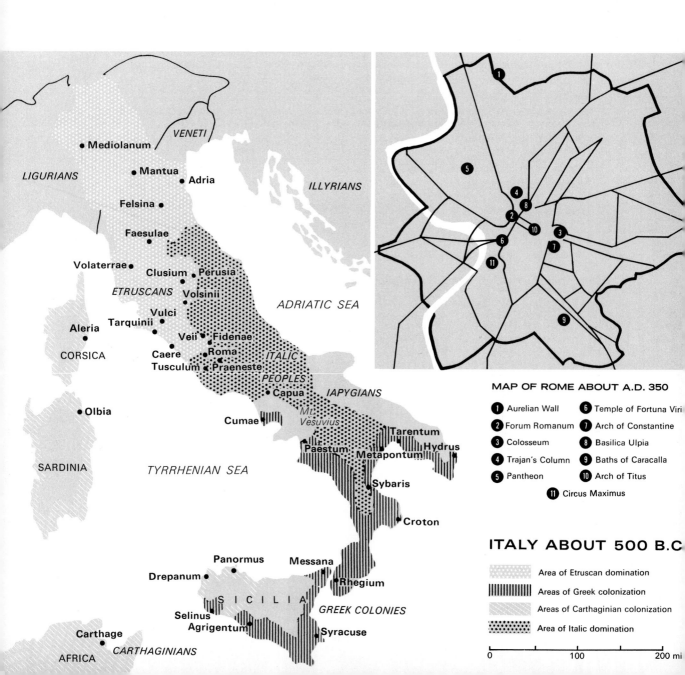

VENETI

LIGURIANS

ILLYRIANS

• Mediolanum

• Mantua
• Adria

Felsina •

Faesulae •

Volaterrae •
Clusium • • Perusia

ETRUSCANS
Volsinii •

Vulci •
Tarquinii •

Aleria •
CORSICA

Veii • • Fidenae
Caere • • Roma
Tusculum • • Praeneste

ITALIC
PEOPLES

• Capua
IAPYGIANS

Cumae •
Mt. Vesuvius

• Olbia

Paestum • Metapontum
Tarentum
Hydrus

SARDINIA

TYRRHENIAN SEA

• Sybaris

• Croton

ADRIATIC SEA

Panormus •
Drepanum •
Messana
Rhegium

SICILIA
Selinus •
Agrigentum •
GREEK COLONIES
Syracuse •

Carthage •
AFRICA CARTHAGINIANS

MAP OF ROME ABOUT A.D. 350

1 Aurelian Wall 6 Temple of Fortuna Viri

2 Forum Romanum 7 Arch of Constantine

3 Colosseum 8 Basilica Ulpia

4 Trajan's Column 9 Baths of Caracalla

5 Pantheon 10 Arch of Titus

11 Circus Maximus

ITALY ABOUT 500 B.C

Area of Etruscan domination

Areas of Greek colonization

Areas of Carthaginian colonization

Area of Italic domination

0 100 200 mi

THE PEOPLE of Italy, while touched at an early date by the radiance of Greece, had deep and tenacious qualities of their own. Etruscan (or Etrurian) and Roman art, like any other, must be recognized as a synthesis of influences from outside sources and of elements indigenous to the country. Roman art, the immediate heir of all earlier Mediterranean cultures, was in many ways a synthesis of the arts of antiquity, in a manner quite distinct from that of Greek art. Rome was also deeply involved in bringing civilization to western Europe. The art of Rome was, therefore, in later times often regarded as the symbol of the art of antiquity.

In terms of political development, the early histories of Greece and Italy are roughly parallel, but the vigorous advance in Greece after the Persian Wars of the fifth century B.C., culminat-

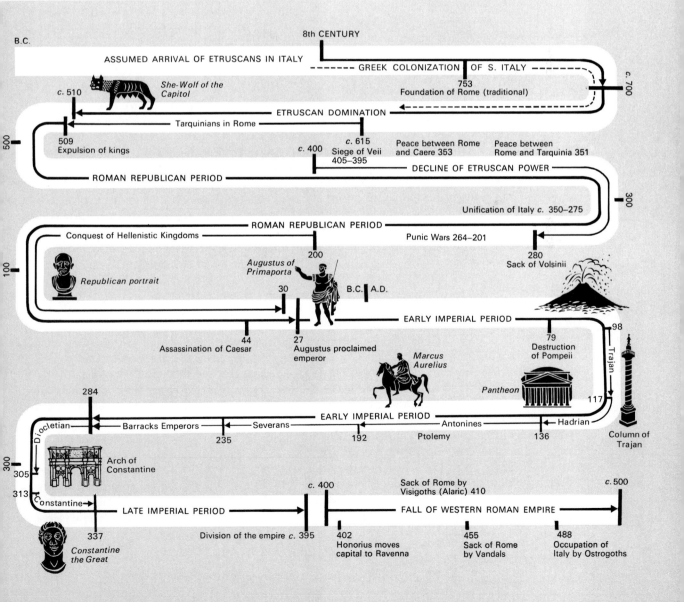

8th CENTURY

B.C.

ASSUMED ARRIVAL OF ETRUSCANS IN ITALY

------ GREEK COLONIZATION OF S. ITALY ------

She-Wolf of the Capitol

c. 510

753
Foundation of Rome (traditional)

c. 700

ETRUSCAN DOMINATION

Tarquinians in Rome

509
Expulsion of kings

500

c. 400

c. 615
Siege of Veii
405–395

Peace between Rome and Caere 353

Peace between Rome and Tarquinia 351

ROMAN REPUBLICAN PERIOD

DECLINE OF ETRUSCAN POWER

300

Unification of Italy c. 350–275

ROMAN REPUBLICAN PERIOD

Conquest of Hellenistic Kingdoms

Punic Wars 264–201

Republican portrait

Augustus of Primaporta

200

280
Sack of Volsinii

100

30

B.C. A.D.

44
Assassination of Caesar

27
Augustus proclaimed emperor

EARLY IMPERIAL PERIOD

79
Destruction of Pompeii

98

Trajan

Marcus Aurelius

Pantheon

117

284

EARLY IMPERIAL PERIOD

Diocletian

Barracks Emperors

Severans

Antonines

Hadrian

235

192

Ptolemy

136

Column of Trajan

300

Arch of Constantine

305

Constantine

313

LATE IMPERIAL PERIOD

c. 400

Sack of Rome by Visigoths (Alaric) 410

FALL OF WESTERN ROMAN EMPIRE

c. 500

Constantine the Great

337

Division of the empire c. 395

402
Honorius moves capital to Ravenna

455
Sack of Rome by Vandals

488
Occupation of Italy by Ostrogoths

ing in the Age of Pericles, found no counterpart in Italy, where culture was retarded by the bitter struggles among competing Italic peoples and between them and the Etruscans.

THE ETRUSCANS

The origin of the Etruscans, like that of the Mycenaeans, has long been one of the mysteries of the ancient world. Their language, though written in a Greek-derived script and extant in inscriptions that are still obscure, is unrelated to the Indo-European linguistic family. Ancient historians, as fascinated by the puzzle as are modern scholars, generally felt that the Etruscans emigrated from Asia Minor, and Herodotus, the "father of history," specifically declares that they came from Lydia. This tradition has persisted, and since the Etruscan culture emerges as distinct from those of other Italic peoples around 700 B.C., their arrival in Italy has long been put at the eighth century B.C. Such a view seems too simple, however, and does not explain adequately the evident connections between the Etruscan and earlier Italic cultures. Some modern scholars feel that the Etruscans are the direct descendants of very old pre-Indo-European people who had moved into Italy from the north. But this theory, in turn, cannot fully account for certain elements of the Etruscan culture, particularly the elaborate burial cult, which seems to be linked with Oriental customs.

A compromise theory points out that Herodotus gives no dates and that the migration he refers to could well have occurred during the period of the great Mediterranean shake-up and shifting of peoples that occurred around 1200 B.C. and caused the collapse of the Mycenaean civilization. At that time, immigrants from Asia Minor could have settled in Italy, mingled with the native population, and produced the culture of the so-called Villanovans, who, in turn, may have been the direct predecessors of the Etruscans. The changes that produced the Etruscan culture proper would then have to be explained in terms of increasing exposure to foreign influences—first Oriental and then Greek—brought about by expanding commerce and trade. In this connection

it is noteworthy that the Etruscans enjoyed high repute as skilled seafarers (or disrepute as pirates) in antiquity and that they emerged into the light of history during the so-called Orientalizing period.

It is now generally conceded that Etruscan art developed largely as a consequence of the Greek colonization of southern Italy during the eighth and seventh centuries B.C. Although responsible for halting further Greek expansion northward along the Tyrrhenian coast, and despite deep-rooted distrust and antagonism toward their southern neighbors, the Etruscans—without relinquishing any of their native characteristics—eagerly absorbed Greek influences. Using the Greek colonial cities as a model, the Etruscans shifted from village life to an urban civilization and established themselves in strongly fortified hilltop cities. By the sixth century B.C. they controlled most of northern and central Italy from such strongholds as Tarquinii (modern Tarquinia), Caere (modern Cerveteri), Veii, Perusia (modern Perugia), and Volsinii (modern Orvieto). But these cities never united to form a state, and so it is improper to speak of an Etruscan nation or kingdom. The cities coexisted, flourishing or fading independently and at different times, and any semblance of unity among them was based primarily upon common linguistic ties and religious beliefs and practices. This lack of political cohesion eventually made the Etruscans relatively easy prey for Roman aggression. During the ten-year siege of Veii, for instance, no Etruscan city came to the aid of its beleaguered cousin.

Architecture

Little is known of Etruscan architecture. Their cities were either razed or rebuilt by the Romans, and those that survived were located on sites so well chosen that they continue to be inhabited to this day, making excavation impossible. Scattered remnants suggest that the Etruscans, at least during their later history, made considerable use of the masonry arch, a structural device not favored by the Greeks but one that was to become of profound importance for later Roman building.

The early Etruscan house is known to us chiefly through clay models that served as cinerary urns,

and from tomb chambers in which domestic interiors were re-created. To judge from the interior of the third-century B.C. Tomb of the Reliefs (FIG. 6-3), an originally simple rectangular structure with sloping roof grew progressively more elaborate, reaching its climactic development in the *atrium* houses of Pompeii and Herculaneum. Invention showed itself in the development of the atrium, a high, square or rectangular central hall that was lighted through a large opening in the roof and around which the other rooms were symmetrically arranged. This atrium was the focus of family life and the shrine for the *lares* and *penates*, the household gods. The ancient sacred hearth of Mediterranean family religion found an appropriate architectural expression in the noble atrium, which gave to Italic domestic architecture an importance and dignity beyond that developed by the Greeks.

Our knowledge of the Etruscan temple is based upon a few preserved foundations and a description given by the ancient Roman authority on architecture, Vitruvius (FIG. 6-1). It may very possibly have had its origins in Greece. Its plan, for example, closely resembles the Greek prostyle plan (FIG. 5-19b). Yet the Etruscan adaptation, in typical fashion, developed its own characteristics. Resting on a high base (*podium*) with steps at one end only, it was constructed mostly of wood and sun-dried brick in a post-and-lintel system and had a heavy wooden superstructure richly deco-

rated with brightly painted terra-cotta reliefs. The Etruscan emphasis on a highly ornate façade, with relatively spare treatment of the sides and rear, concentrated attention upon the entrance porch. There was an axial organization quite different from that of the Greek temple. Behind the sunlit pavilion of the porch, the shrine, divided into three cellae of equal size, formed dark cave-like spaces. The temple was not meant to be seen as a sculptural mass from the outside and from all directions, like the Greek temple, but was intended instead to function primarily as an interior space. It was a place of shelter, protected by the wide overhang of its roof.

It is in the remains of their elaborate burial grounds that the Etruscans reveal themselves with the greatest clarity. In a rich array of wall paintings and painted reliefs with which they decorated the interiors of their tombs, they recount their zestful lives, their banquets, and their dances, which, in their suppleness and verve, seem partly Ionian and partly barbarian. They tell us both of their athletic contests and of their wars. Their rise and fall from power is reflected in a gradual change from optimism to pessimism and in the choice of ever more morbid and blood-thirsty subjects as their political fortunes declined. Although the Etruscans' reputation for cruel and unrestrained behavior is based largely upon the testimony of the ancient Greeks and Romans, who were their enemies, elements in their tomb

6-1 Plan, section, and elevation of an Etruscan temple. (After Vitruvius.)

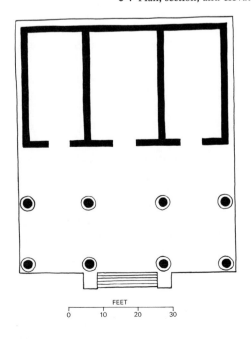

FEET
0 10 20 30

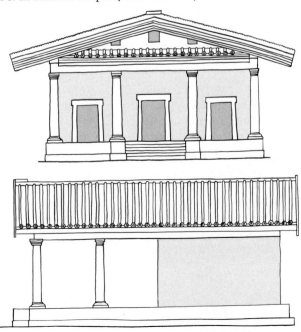

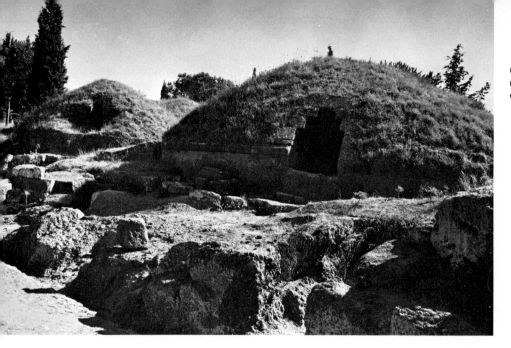

paintings indicate that their society had many aspects that were in fact violent and extravagant. Indeed, these qualities may have played a decisive role in the formation of an energetic and creative culture that was to contribute to the rise to world rulership of their Roman successors.

The Etruscans built their cemeteries at some distance from their cities. Hundreds of tombs arranged in orderly manner along a network of streets produce the effect of veritable cities of the dead (*necropolises*). The tombs varied according to region and local custom. In the northern part of Etruria they were usually constructed above ground, while in the south they were often excavated from the live rock, particularly in areas where tufa soil facilitated digging. Tufa, primarily strongly compressed volcanic ash, is easily excavated and hardens to a concretelike consistency on exposure to the atmosphere. Tufa can also be cut into durable building blocks that require no firing; it was used extensively by the Etruscans and Romans, and a minor tufa brick industry flourishes in Italy today.

The most common Etruscan tomb type is the *tumulus*, a round structure that has been partially excavated and covered with earth (FIG. 6-2). This form was favored in Cerveteri and, in view of its domical shape, seems to carry on an ancient Mediterranean tradition. The majority of Etruscan tomb interiors, however, including those of the tumuli, are rectangular and reproduce the

rooms of domestic architecture. A striking example is the Tomb of the Reliefs (FIG. 6-3), a large underground chamber in Cerveteri, in which massive piers with pseudo-Ionic (Aeolic) capitals support a slanting beamed ceiling. The piers are *reserved*—that is, formed by cutting away the live tufa until the remaining rock has the shape of a column, as in the Egyptian rock-cut tombs at Beni Hasan (FIG. 3-16). This, like most Etruscan tombs, was designed for multiple burials, the final resting place of an entire family and its servants. Sarcophagi, cinerary urns, and other tomb furnishings were placed in niches and on the benchlike projection at the base of the walls. Decoration in the Tomb of the Reliefs consists of painted plaster reliefs representing weapons, tools, and kitchen utensils, and displays a generous inventory of Etruscan objects of daily use.

Painting

Unlike the Caerans, the Tarquinians adorned the walls of their subterranean tomb chambers with colorful and lively murals. Although the subjects of tomb painting in Etruria are sometimes drawn from Greek legend, they are more often concerned with scenes of banquet and revel, as in the Tomb of the Leopards in Tarquinia (PLATE 6-1). This small chamber tomb is decorated in the manner favored in Tarquinia during the fifth century

B.C.: a banquet scene on the wall opposite the entrance and groups of dancers and musicians on the side walls. These wonderfully vital pictures express especially well the peculiarly life-affirming exuberance that fills Etruscan art as it must have filled Etruscan existence. Three young men, one clad only in a light scarf, the other two in the elegant *chlamys* (cloak), seem to be hurrying through a grove of graceful little laurel trees, the leader carrying a cup of wine and beckoning, the others playing the double flute and the seven-stringed lyre. They seem already to be dancing, facing rhythmically in opposite directions as if performing some circling step. The gestures have a kind of choreographic exaggeration, especially those of the enlarged hands and fingers of the flutist, which hold and touch the instrument with such sureness and delicacy. It is rare in the painting of the ancient world that spirited movement is portrayed so convincingly, and it would be difficult to find from that time so fitting a monument to the beauty of youth, springtime, music, and the dance. The picture is a kind of fresco painting on a thin slip applied to the living rock wall or on a stucco paste made from the rock. The colors—blacks, blues, blue-greens, and ocher-reds—still retain much of their original freshness and harmonize easily and naturally with the creamy yellow ground.

But the later Etruscans seem to have surrendered their native, joyous vigor for a quiet, classicizing formalism like that in the *Woman of the Velcha Family*, from a chamber in the Tomb of Orcus (Hades) in Tarquinia (PLATE 6-2). The composed, even reflective, expression of this splendidly painted head suits the somber theme that is its context—the sufferings of the dead in Hades in the midst of the menacing demons of the underworld. The earlier Etruscan euphoria has disappeared, extinguished by the more cosmopolitan religions of the Hellenistic world, which stressed not the last happiness of the funeral revels but the sadness of man's fate.

Sculpture

The Etruscan tombs yield a notable furniture of sculptured objects in both clay and bronze, materials that the Etruscans apparently preferred, though numerous stone sarcophagi survive. The forms are modeled rather than carved, modeling being a technique that would be congenial to the impetuous temperament and fluid style characteristic of the Etruscans. Funerary urns and sarcophagi with recumbent portrait figures present some of the best examples of Etruscan sculpture. A canopic (cinerary) urn (FIG. 6-4) from Clusium

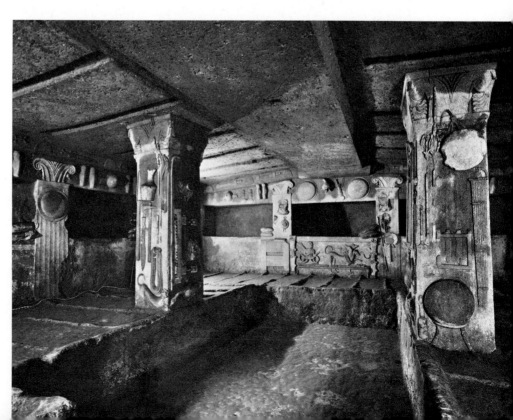

6-3 Tomb of the Reliefs, Caere (Cerveteri), fifth to fourth centuries B.C.

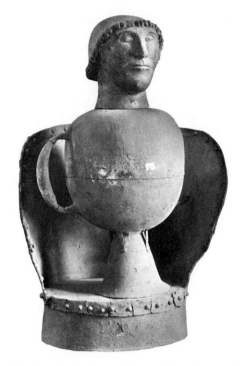

6-4 Canopic urn from Clusium (Chiusi), second half of the seventh century B.C. Hammered bronze with terra-cotta head, approx. 33″ high. Museo Etrusco, Chiusi.

(modern Chiusi) has a terra-cotta head as a lid, the whole set in a bronze model of a chair; the head is obviously intended as a portrait likeness of the deceased whose ashes are here contained. The strongly rounded form of the urn has a crude vitality that is carried into the head, with its blunt, aggressive features and massive neck. The accent upon the individuality of the deceased is specifically Etruscan and is seen to fullest advantage in the reclining effigies of a man and his wife on the lid of a sarcophagus from Cerveteri (FIG. 6-5). The work is a kind of throwing into three dimensions and a formalizing of the animated banquet scenes painted on Etruscan tomb walls to satisfy the demands of some cult ritual of the dead, the details of which are unknown. But there is nothing here of the solemn or the macabre, and the Etruscan instinct for the lifelike is preserved. The figures shown are relaxed and genial—much in contrast with the funerary formality of Egyptian statues—and the Archaic features of style, though present, produce no stiffness or awkwardness.

The *Apollo of Veii* (FIG. 6-6), an acroterion figure from the ridgepole of an Etruscan temple, is evidence that, like the Greeks, the Etruscans made use of architectural sculpture. But the Greek Archaic elements, though immediately evident, are superficial; the awkward, lurching vigor of the powerful figure is a forceful example of Etruscan clay-modeling techniques and the use to which the confident, quick-conceiving, and quick-executing sculptor could put them. In contrast with, say, the serene majesty of the *Apollo* at Olympia (FIG. 5-35), this one moves like a dangerous giant. His overpowering physical presence reflects small concern for the Greek preoccupation with harmonious proportions or idealized humanity. The Ionian elaboration of the drapery lines bespeaks the Eastern component in Etruscan art, but the animal force, the huge, swelling contours, and the plunging motion are anything but Ionian and little enough mainland Greek. The *Apollo of Veii*, given its architectural function, naturally differs from the painted Etruscan forms we have seen; yet it has in common with them the peculiarly Etruscan strength, energy, and excitement.

The absorption of Greek influences by the Etruscans continued during the height of the latter's power—when they were sending their own art commodities throughout the Mediterranean, including Greece—and through the centuries of their decline. The so-called *Mars of Todi* exemplifies Etruscan interpretation of the Greek Classical style (FIG. 6-7) in the beginning of the fourth century B.C. The figure, dressed in more or less contemporary military garb, executes a peculiar movement of the whole body, involving sideways and contrary directions of head, torso, arms, and legs, without seeming to move from his position. The sculptor may have been exaggerating the Polykleitan weight-shift stance, but there is a kind of agility to it, quite unlike the balanced weight-and-poise of the -Polykleitan type. We find again, as in the much earlier *Apollo of Veii*, that an Etruscan interpretation of prevailing Greek style brings out the native quality of energy, whether in the blunt drive of the *Apollo* or in the almost sprightly stance of the *Mars*.

One of the most famous animals in the history of world art, the *She-Wolf of the Capitol* (FIG. 6-8) owes her fame not simply to her antiquity and

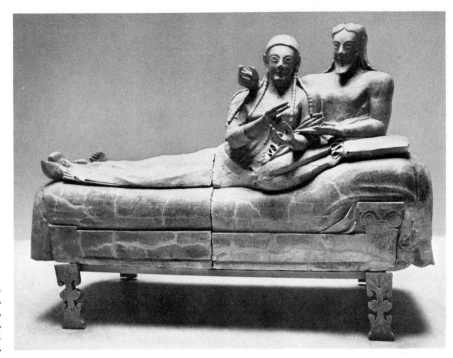

6-5 Sarcophagus from Caere (Cerveteri), c. 520 B.C. Terra-cotta, approx. 6′ 7″ long. Museo Nazionale di Villa Giulia, Rome.

6-6 *Apollo of Veii*, c. 510 B.C. Terra-cotta, approx. 70″ high. Museo Nazionale di Villa Giulia, Rome.

6-7 *Mars of Todi*, early fourth century B.C. Bronze, approx. 4′ 8″ high. Vatican Museums, Rome.

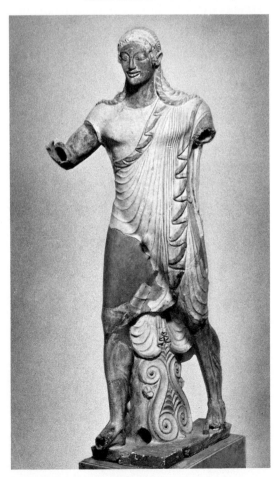

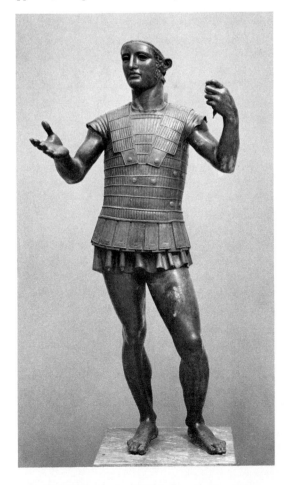

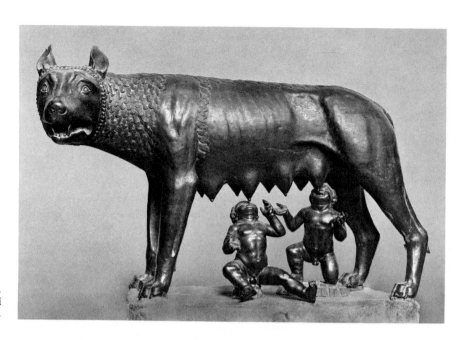

6-8 *She-Wolf of the Capitol, c.* 500 B.C. Bronze, approx. 33½″ high. Musei Capitolini, Rome.

her magnificence as a work of art, but to the fact that for centuries she has been the totem of the city of Rome. Ancient legend tells us that the founding heroes of Rome, Romulus and Remus, being abandoned as infants, were suckled by a she-wolf. The cult of Romulus and Remus was as old as the fourth century B.C., and we know that a statue of a she-wolf was dedicated on the Capitoline Hill in Rome in 296 B.C. We do *not* know whether the present statue of the she-wolf on the Capitoline Hill is the original (the suckling infants were made in the Renaissance); its dating has been hotly debated, but its Etruscan origin is now widely accepted. The vitality we have noted in the human figure of Etruscan art is here concentrated in the tense, watchful animal body, with its spare flanks, gaunt ribs, and taut and powerful legs. The lowering neck and head, the alert ears, glaring eyes, and ferocious muzzle render the psychic vibrations of the fierce and, at the same time, protecting beast; the incised lines along the neck give us its rising hackles as it watches danger approach. Not even the great animal reliefs of Assyria can match, much less surpass, this profound reading of animal temper.

Somewhat later we have the splendid *Chimera* from Arezzo (FIG. 6-9), a bronze monster with a rough-maned lion's head, a serpent's tail (restored in the Renaissance by Benvenuto Cellini), and a second head—that of a goat—whose right horn

is seized by the serpent. Although the *Chimera* bears the wounds inflicted by the hero Bellerophon, who hunted and slew it, it is not merely illustrative of the event; rather, the figure almost certainly has some further demonic significance. The Etruscans, much of whose art is associated with mortuary ritual, had a well-developed demonology, an aggregation of demonic types that plague the dead in the underworld. Unlike the Greeks, who preferred to humanize their demons, the Etruscans, with their roots partly in Asia, employed their customary expressive force to represent them as dreadful animal hybrids. The precedents for the monster types go back to the sphinxes of Egypt and the winged, man-headed bulls of Mesopotamia, as well as to the ornamental animal bronzes of Luristan and the associated animal-heraldic style of much of the metalwork of central Asia. It may be that these traditions lingered in the Etruscan spirit, and the manifestation of them in such powerful form as the *Chimera*—so anti-Greek and so Asiatic—attests most firmly to the Eastern component in Etruscan culture. By the time of the Middle Ages, a whole population of monsters swarmed through the art of the West.

Also assimilated from the East and passed on by the Etruscans to the Romans was the practice of divination, whereby the future, as a product of arcane forces (personified as gods or demons) was

192 *Etruscan and Roman Art*

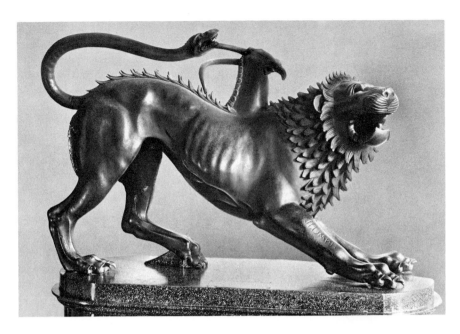

6-9 *Chimera*, Arezzo, fifth to fourth centuries B.C. Bronze, approx. $31\frac{1}{2}''$ high. Museo Archeologico, Florence.

thought to be predictable to some degree. On the assumption that all nature constituted a universe of affinities, prediction—the art of the priesthood—was based on the state of the viscera of sacrificed animals (especially the liver), the flight of flocks of birds, and unseasonable and unusual events. The engraved back of a bronze mirror (FIG. 6-10)—exquisitely wrought, with all the refinement for which the Etruscan craft arts were celebrated—represents a winged figure labeled Calchas, a priest in Homer's *Iliad*, divining from a liver that he holds in his hand and upon which he muses. The figure is a kind of miniature emblem for that world of benign and malign forces that surrounded ancient men and which they tried to approach or fend off by prophecy, sacrifice, oracle, omen, spell, incantation. Greek rationalism made little headway against the ancient world's overwhelming faith in the magical manipulation of nature.

Closely related to the delicately incised, Classical mirrors of the fourth century B.C., like the Calchas one, are the bronze cists of Praeneste (modern Palestrina), which doubtless echo the styles of the great Greek masters of mural painting—Polygnotos, Euphranor, and others. Etruscan bronze vessels and mirrors with incised mythological scenes were famous and highly prized objects in Greece. Perhaps the outstanding member of this type is the so-called *Ficoroni Cist*

of NOVIOS PLAUTIOS (FIG. 6-11). Most significantly, the artist, Novios Plautios, is not Etruscan; he signed his work in Latin and made it in Rome. He has made a skillful adaptation of a frieze of Greek figures, faithfully taking over the idealized naturalism of the Late Classical period. Naturalistic innovations appear: figures seen entirely from behind or in three-quarter rear view, complicated seated poses, figures on several levels rather than rigidly attached to a single groundline, details of landscape, and a kind of approxi-

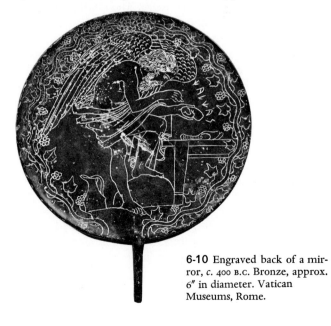

6-10 Engraved back of a mirror, *c.* 400 B.C. Bronze, approx. 6″ in diameter. Vatican Museums, Rome.

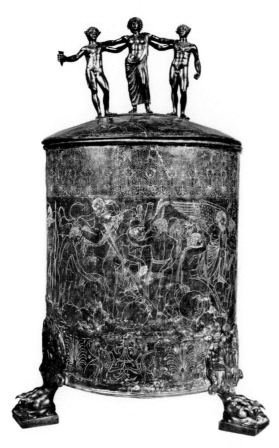

6-11 Novios Plautios, *The Ficoroni Cist*, Praeneste (Palestrina), late fourth century B.C. Bronze, approx. 21″ high. Museo Nazionale di Villa Giulia, Rome.

mate perspective space. The artist represents in his work the passing of the Etruscan genius and the acceptance of the irresistible influence of Greece. Yet something of the Etruscan sense for the real will persist through the formal Classicism of Greece, which, in turn, will partly direct the course of the art of Rome; and this earlier Etruscan sense will sharpen into the characteristic Roman taste for the factual in art as in human affairs.

THE ROMANS

The Roman power that succeeded and replaced the Etruscan compelled the contesting peoples of Italy into a Roman state and, eventually, the peoples of western Europe, the Mediterranean, and the Near East into a Roman empire. The rise and triumph of Rome, and the awesome spectacles of its decline and fall, make, in the stately words of the great historian of it, Edward Gibbon, "a revolution which will ever be remembered, and is still felt, by the nations of the earth." From the Tigris and Euphrates to the borders of Scotland stretched a single government under whose energetic and efficient—if often ruthless and brutal—rule lived people of innumerable races, creeds, tongues, traditions, and cultures: Britons, Gauls, Spaniards, Germans, Africans, Egyptians, Greeks, Syrians, Arabs, to name only a very few. If the Greek genius, as we review it, shines most brightly in art, science, philosophy, history, and —in general—the things of the intellect and imagination, the Roman genius shines in the realm of worldly action—in law and in government. Roman monuments of art and architecture are distributed throughout the world that the Romans governed and are the most conspicuous and numerous of all the remains of ancient civilizations we have so far studied. But Roman monuments of a kind also survive in our concepts of law and government, in our calendar, in our festivals, rituals, languages, and religions, in the nomenclature of many of the sciences, and, for our special interest here, in the concept of art as worthy of historical study and criticism.

The main energies of Rome were devoted to conquest and administration, conquest opening the way for the spread of Roman civilization. Roman cities sprang up not only all around the Mediterranean basin but also as far north as the Danube, the Rhine, and the Thames. Each city was a center for the propagation of Roman government, language, and customs and was closely connected with the city of Rome itself by a well-planned system of roads and harbors. Rome about A.D. 200 was the capital of the greatest empire the world had known, an empire efficiently organized with 50,000 miles of sea routes and expertly engineered highways safe for travel and commerce. Rome itself was both cosmopolitan and splendid. The size, power, and complexity of the empire called for an impressive capital, and while the practical demands arising from

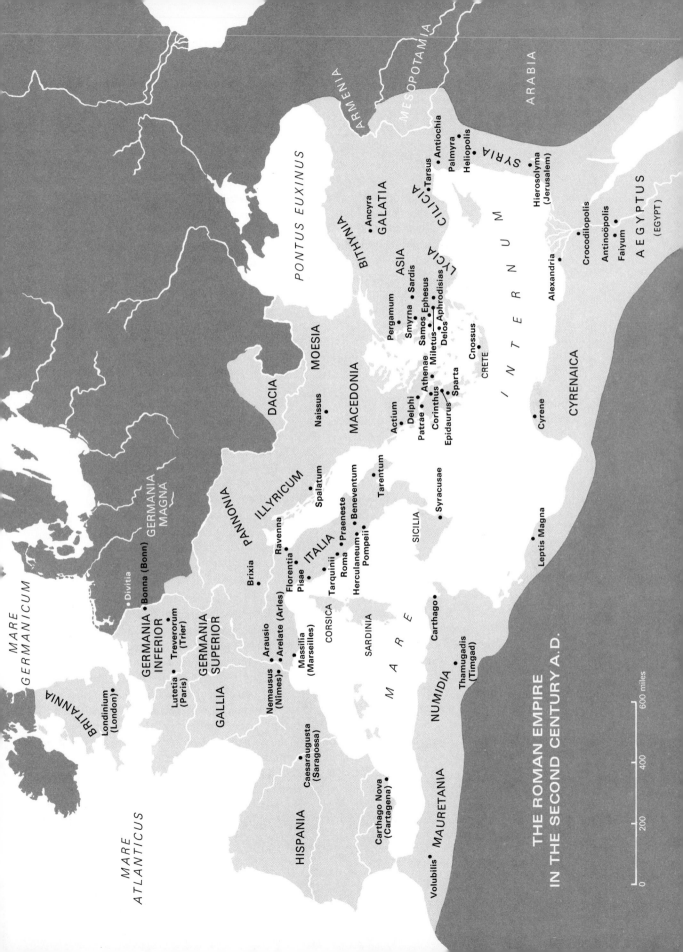

MARE GERMANICUM

MARE ATLANTICUS

BRITANNIA

Londinium (London)

GERMANIA MAGNA

Divitia

GERMANIA INFERIOR

Bonna (Bonn)

Treverorum (Trier)

GERMANIA SUPERIOR

Lutetia (Paris)

GALLIA

Arausio (Orange)

Arelate (Arles)

Nemausus (Nîmes)

Massilia (Marseilles)

HISPANIA

Caesaraugusta (Saragossa)

Carthago Nova (Cartagena)

Volubilis

MAURETANIA

CORSICA

SARDINIA

MARE

Brixia

Ravenna

Florentia

Pisae

ITALIA

Tarquinii

Roma

Praeneste

Herculaneum

Pompeii

Beneventum

Tarentum

SICILIA

Syracusae

Carthago

Thamugadis (Timgad)

NUMIDIA

PANNONIA

ILLYRICUM

Spalatum

DACIA

Naissus

MOESIA

MACEDONIA

PONTUS EUXINUS

Actium

Delphi

Patrae

Corinthus

Epidaurus

Sparta

Athenae

Miletus

Delos

Cnossus

CRETE

Leptis Magna

CYRENAICA

Cyrene

ARMENIA

MESOPOTAMIA

ARABIA

BITHYNIA

Ancyra

GALATIA

ASIA

Pergamum

Smyrna

Sardis

Samos Ephesus

Aphrodisias

LYCIA

CILICIA

Tarsus

Antiochia

Palmyra

Heliopolis

SYRIA

Hierosolyma (Jerusalem)

INTERNUM

Alexandria

Crocodilopolis

Antinoöpolis

Faiyum

AEGYPTUS (EGYPT)

THE ROMAN EMPIRE
IN THE SECOND CENTURY A.D.

0 200 400 600 miles

← to c. 700 B.C.	c. 510	c. 470		c. 300		146	c. 80	27 B.C.		A.D. 70	118		A.D. 284
	Apollo of Veii	Revelers, Tomb of the Leopards		Woman of the Velcha Family, Tomb of Orcus		Conquest of Greece	Sanctuary of Fortuna Primigenia	B.C. A.D.		Colosseum begun	Pantheon begun		
ETRUSCAN DOMI- NATION		R O M A N	R E P U B L I C A N		P E R I O D				E A R L Y	I M P E R I A L	P E R I O D		

the administration of a great empire required high engineering skill for the construction of bridges, roads, sewers, and aqueducts, the imperial ideal called also for public buildings that would adequately express the dignity and diversity of the state. Roman art takes its character in large part from the imperial role the Roman state was required to play.

Although early under both Etruscan and Greek influence, Roman art came to have its own quite distinctive characteristics. The Romans, almost from the beginning of their rise, had been fully aware of Greek art, but it was only in the later Republican and Augustan ages that Hellenism became a conscious fashion. "Conquered Greece," wrote Horace, "led her proud conqueror captive." Shiploads of Greek marbles and bronzes were brought to Rome by generals and provincial governors to adorn their palaces, and, when the supply was exhausted, copies were made or Greek artists were employed to create new works. Fashionable art for a time became to a large extent mere copying of Greek works. Finally a deeper assimilation took place, and the art of Imperial Rome emerged, a product of its richly varied heritage and its unique genius.

This art-historical view of Roman art is comparatively new. Until about 1900 the scholars saw Roman art as merely decadent Greek art, unoriginal and inferior. It is true that, drawing as it necessarily does upon what went before, it does not have the degree of originality that distinguishes the great styles of Egypt, Mesopotamia, Greece, and even Etruria. Yet it is more than a mere "propagator and preserver of the classical heritage"; it is the "first comprehensive stage of western European art." While it makes use of Classical forms, it expresses non-Classical concepts. It combines an interest in individual personality with one in such abstract concepts as "law," "state," and "civilization." The vast body of the material of Roman art—found on three continents, with much of it still not evaluated and with much more still underground—suggests methods almost of mass production, in which the anonymous artist (almost no names survive, in contrast with those of writers and poets) becomes the servant of his patron—private or public, wealthy connoisseur or the Roman state. Nevertheless, in the collective as well as in the individual case, Roman art survives as an imposing style taking its own course from the days of the late republic.

The Republican Period

The Roman republic was founded after the last of the (possibly Etruscan) kings had been driven out. From the fifth century B.C. to the collapse of the republic and the assassination of Julius Caesar in 44 B.C., the external business of Rome was expansion abroad and the consolidation of imperial power in the Western world. In a succession of wars, the most harrowing and dangerous of which were the wars with Carthage, the Romans developed their peculiar qualities of character: disciplined valor, tenacity, practicality, obedience to authority, and a pitiless realism in recognizing the facts of power. Yet the constitutional structure of the republic, adequate to a limited city-state, could not begin to meet the requirements of empire. Internal quarrels between classes—the patricians and the plebeians—were inflamed by dispute over disposition of the enormous wealth won abroad. When successful armies led by popular generals intervened in the politics of the republic, civil war began. Lasting almost a hundred years, during which dictators like Marius, Sulla, Caesar, and Pompey ruled, the war exhausted the state and destroyed its constitution. When the great-nephew of Julius Caesar, Octa-

vian, finally found himself alone at the head of the Roman world (when he called himself Augustus), the republic was no more than a pious, ritualized memory.

It is in this period of the crisis of the republic, even while Greek influence became increasingly strong, that Roman art began to emerge as an entity distinguishable from the late Hellenistic style. In 146 B.C., when Greece was absorbed into the Roman empire as the province of Achaia, a sculptural style came into being that we call Greco-Roman, the term an admission that the two styles cannot be readily separated from each other. Much of the original sculpture of the period was produced by Greek immigrant artists—for instance, the *Seated Boxer* (FIG. 5-73). But the growing Roman fascination with individual traits of personality is apparent in portrait sculpture, a field in which the Romans made one of their most original contributions (the others being architecture and landscape painting) and in which they achieved a quite typical, uncompromising, and often unflattering realism. However, the Hellenizing idealism that is found balancing this hard Roman realism in the last days of the republic bears witness to the peculiar dualism in the Roman attitude toward the defeated Greeks—admiration for their art and grace and contempt for their "unmanly" cleverness and for their lack of skill in managing their own affairs as a people. Cicero described this Roman ambiguity of sentiment and scored the Greeks on their un-Roman insincerity in terms a little like those of nineteenth-century American travelers commenting on the French.

> I grant them literature, I grant them a knowledge of many arts, I do not deny the charm of their speech, the keenness of their intellects, the richness of their diction; finally, if they make other claims, I do not deny them. But truth and honor in giving testimony that nation has never cherished ... Greeks never trouble to prove what they say but only make a display of themselves by talking.

But it was the idealism of Greek art that again and again captivated the Romans. Greek statues in great profusion stood in the Roman forums and in both public and private buildings; villas and baths were museums of Greek sculpture—whether originals, copies, or adaptations

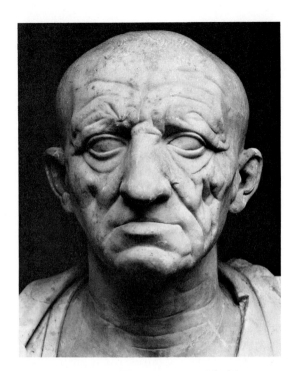

6-12 *Head of a Roman*, c. 80 B.C. Marble, life-size. Palazzo Torlonia, Rome.

to suit Roman taste. We read of 285 bronze and 30 marble statues brought from Corinth in 146 B.C., after the barbarous sack of that city, and of 500 bronzes brought from Delphi by Nero; when the stockpile of originals ran low, the demand for Greek sculpture was satisfied by copies made after Greek works.

PORTRAIT SCULPTURE

But even while under the spell of Hellenism, Roman portraitists produced works that have no parallel in Greek art. During the Hellenistic period, the quality of generalization that had distinguished earlier portraits had already given way to a style that was more particularizing and descriptive. The Roman's desire for literalness, together with his custom of keeping in his house, always before his eyes, the *imagines* (wax masks) of his ancestors, influenced the sculptor to accentuate individual traits still further. Also operative was the Etruscan influence, which, with its expressionistic realism, persisted in Late Republican

portraiture. The *Head of a Roman* (FIG. 6-12), for example, is striking by virtue of its "character," at once alive and masklike. But the character may simply be accidental, the result of the artist's painstaking report of each rise and fall, each bulge and fold, of the facial surface, executed as if he were proceeding like a map-maker, concerned not to miss the slightest detail of surface change. The artist apparently tries neither to idealize the subject—that is, to improve him in conformity with an ideal, as in Greek practice— nor to interpret his personality. The blunt and bald record of his features, the kind given by a life mask or death mask, is quite enough. Thus, this "verism," a kind of superrealism, is the artist's objective, and it is determined not so much by esthetic motives as by religious convention. The habit of mind that demands faithful records of this kind is familiar to us in our curiosity about the fidelity of photographs of our forebears.

A quite different approach to the portrait subject can be seen in a bust of Pompey the Great (FIG. 6-13). A sculptor confronting a powerful and famous man may be conscious of the need for a method different from mere recording; he may want to idealize but also to personalize—that is, interpret the subject's personality. We, coming 2000 years after Pompey, bring to our scanning of him far more knowledge of the man than we could ever bring to the contemplation of a portrait of an unknown Roman. Pompey was first the partner and then the rival of Julius Caesar in the devastating civil war that wrecked the Roman republic in the first century B.C. We know of him as a great general, successful in war and—almost —the proprietor of all the Eastern world held by Rome. We know of him also as a political incompetent and as an ambitious man of the middle class who allowed himself to be made the dupe of the extremists of the Senatorial party. We know of him as hopelessly irresolute, disappointing even his closest friends because he was unable to make up his mind. We know that he lost to Caesar the bloody battle of Pharsalus, after which he was ignominiously assassinated by one of his own men. Yet he was a good man who refused to enrich himself by plunder of the provinces, a practice from which most of his contemporaries

6-13 *Pompey the Great, c.* 55 B.C. Marble, life-size. Frank E. Brown Collection, Rome.

did not scruple to refrain. Cicero wrote of Pompey to a friend: "I knew him as a man honest, grave, and high-minded."

Thus, Pompey is a complex of traits played upon by the accidents of history; yet what kind of man of only slightly more than good talent could have bested Caesar? Knowing what we do about Pompey's strength and weakness, his triumphs and ultimate failure, we naturally approach his portrait bust as we might approach a bust of Washington or Lafayette—with curiosity about the individual man and his history. In the same way, it is likely that the artist of the bust, though different from us in his cultural responses, would still have cared to make a likeness that would be more than a mere facial record. This is evident in the work, which has none of the rigidity of the death mask and possesses a subtly modeled surface over which the light plays softly. The modeling is obviously contrived to suggest rather than to describe. The strong lines of the broad head and the somewhat flat surfaces of the face are softened by a curiously ambiguous expression. Would we be wrong to read in it self-

doubt mingled with affectation or bluster under an official mask of power? At any rate, the very fact that we are tempted to such interpretation testifies to the sophisticated artist's power to make us thoughtful before his image of a great and unfortunate man.

ARCHITECTURE

Striking as is the manifestation of Roman originality in its naturalistic portraiture, it is even more so in its architecture. During the Republican period the Roman identity is first and most fully expressed in architecture and city-planning. Unlike the religious architecture of the civilizations (including the Greek) that preceded it, the Roman temple was not a particularly inventive or conspicuous type. Rather it was upon imposing and utilitarian civic structures and plans that the Roman builders concentrated, though of course they also built temples, which were modeled upon schemes in which Greek and Etruscan elements were blended in unique fashion. The Temple of Fortuna Virilis in Rome (FIG. 6-14), dating from the late second century B.C., looks at first glance like an Ionic peripteral temple. It consists of a large cella located behind a deep porch (see FIG. 6-1). But the building stands on a high Etruscan podium, and the cella occupies its entire width. This means that only the porch columns are freestanding, while those along the exterior walls of the cella are engaged, being purely decorative and having no supporting function. Seen from a distance, they give the illusion of being freestanding; hence the designation "pseudoperipteral" for this type of construction. 'A favorite with Roman builders, this temple type has survived in many examples, most of them larger than the one shown and employing the Corinthian order.

The same superficial resemblance to Greek architecture appears in the Temple of the Sibyl at Tivoli (FIG. 6-15). Built in the early first century B.C., it looks at first like a Corinthian tholos. However, like the Fortuna Virilis, it stands upon a podium, ascent to which is by means of a single flight of stairs that leads to the entrance of the cella. This arrangement introduces an axial alignment that is not found in Greek tholoi and

6-14 Temple of Fortuna Virilis, Rome, late second century B.C.

6-15 Temple of the Sibyl, Tivoli, early first century B.C.

6-16 Sanctuary of Fortuna
Primigenia, Praeneste
(Palestrina), *c.* 80 B.C.

that serves to lessen the isolation of the building from its surroundings, diminishing somewhat the independent sculptural aspect so prized by the Greeks. A closer examination of the Temple of the Sibyl reveals other "un-Greek" features: The columns are monolithic—all of a piece—and not built up in the drum sections that were usual with the Greeks; the Romans preferred to use the monolithic column, often on great scale, wherever possible. The frieze is embellished not with figure sculpture, as would be the case in Greece, but with a favorite Roman decorative motif—garlands held up by *bucrania* (ox skulls), probably symbolic of fertility and of the alternation of death and resurrection; this motif is rhythmically repeated around the whole frieze. Finally, and also in contrast with Greek practice, the cella wall is built not of cut stone but of concrete into which blocks of tufa have been set in an ornamental pattern.

These significant departures from the Greek model are seen even more clearly in the Sanctuary of Fortuna Primigenia at Praeneste (FIG. 6-16), which was dedicated to Fortuna (Fate) and built under the first Roman dictator of the republic, Sulla, around 80 B.C., at a site where oracular lots had long been cast. The great size of the sanctuary reflects the growing taste for colossal Hellenistic designs during the Late Republican period. Seven terraces rising against the

hillside are placed with rigid axial symmetry (FIG. 6-17). The top terrace carried a semicircular double colonnade that contained the sanctuary proper, probably in the form of a small round temple. Although something of it had been studied, we have full knowledge of the great temple only by an accident of war: Palestrina, modern successor of the Medieval town that had been built over Praeneste, was bombed during World War II, and clearing of the resultant ruins disclosed the impressive remains of the Roman buildings. It was seen that the Roman builders had converted an entire hillside into a man-made design in a symbolic and ostentatious display of power and dominion. This assertive subjection of nature to man's will and rational order is the first full-blown manifestation of the Roman imperial spirit and contrasts with the more restrained Greek bent, which crowns a chosen hill with sacred buildings rather than transforms the hill itself into architecture.

The substructures for the terraces (FIG. 6-18) were built in concrete (*opus concretum*), and it is here that we can find in grand scale the use of that favorite Roman building material, developed in the second century B.C. and destined for centuries of application throughout the Roman empire. Concrete (of generally inferior quality) had been used in the Near East, chiefly for the building of fortification walls, but its combination with the

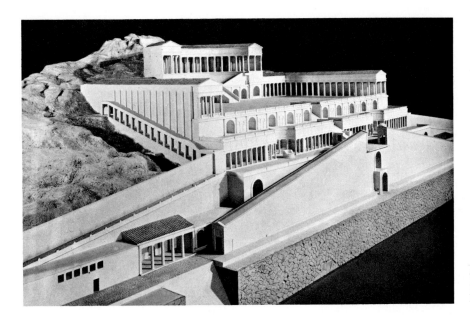

6-17 Reconstruction of the Sanctuary of Fortuna Primigenia. Museo Archeologico, Palestrina.

arch and the vault, as here at Praeneste, was revolutionary. As perfected during the Early Imperial period, concrete vaulting permitted Roman builders to cover, without interior supports, spaces of a scale never dreamt of before. Its use enabled the Roman architect to think of architecture in terms radically different from those of earlier builders—as an architecture of space rather than of sheer mass, as was the case in the Egyptian pyramid or the Mesopotamian ziggurat or even the lighter but still space-encumbering post-and-lintel systems of the Greeks. (See discussion of the Roman Pantheon, pp. 222–23.) Roman concrete, a mixture of lime-mortar,

6-18 Detail of the Sanctuary of Fortuna Primigenia.

water, and volcanic dust, was poured over rubble that had been laid in courses between forms. Once solidified, this rubble concrete was cohesive and strong, though rough in appearance; but it was the custom to face the rough surfaces with marble slabs, plaster, or ornamental brick or stone work. In Praeneste, the concrete is faced with small, flat, irregularly shaped stones that produce a figuration called *opus incertum*.

Systematized concrete building methods gave Roman architecture a characteristic uniformity. No matter where its ruins are found today, in France, Spain, Italy, North Africa, or the Near East—usually without their original decorative facing—they can immediately be identified as Roman.

In the eighteenth century the imagination of Europe was excited by the discovery of the buried cities of Pompeii and Herculaneum, which had been overwhelmed by an eruption of Mount Vesuvius in A.D. 79. Their discovery, prior to the first archeological expeditions to Egypt, fascinated Europe and provided the initial impetus for modern archeological curiosity. What made the discoveries—new ones are still being made in the excavations of both cities—of such poignant human interest, as well as so infinitely valuable for scientific history, was that they revealed to modern eyes, in almost perfect preservation and detail, the everyday communal life of these times and places past. Pompeii, a city of about 20,000 and not very important in its time, had been stopped dead in the very motion of everyday life and had been preserved intact in volcanic ashes, invisible and forgotten for some 1600 years. The remains of the city permit us to reconstruct the Roman way of life during the Early Imperial period with a completeness far beyond that achieved at any other archeological site. The fullness of its record, its appeal to our sense of the dramatic and terrible accidents of life, and its usefulness for describing the architectural and artistic environment of quite ordinary men in an ancient city warrant considerable attention.

Though destroyed during the Early Imperial period, the city and most of its architectural monuments date from the Republican period. The plan of Pompeii, as seen in the parts excavated so far (FIG. 6-19), is not that of the ideal *castrum* type, but rather the irregular plan of a *grown*

city, one that was subjected at various periods to revisions and regularizing. The Roman castrum type of city plan, based on the layout of a military camp, was used in the outlying, frontier, colonial regions and had its major development during the Early Imperial period (see FIG. 6-35), although early forms of it were used at Ostia in the fourth century B.C. and Cosa in the third century B.C. Pompeii, which started as a small, unplanned settlement in the vicinity of the Greek colony of Neapolis (modern Naples), was founded in the sixth century B.C. by the Oscans, early local rivals of the Romans. It was seized in 425 B.C. by the Samnites—also rivals of the Romans—who fortified and replanned it under the influence of expanding Greek concepts of rational urban planning. But the Greek grid system could not be rigidly applied without tearing down most of the city; as a result, the main organizing features—the north-south and east-west thoroughfares—do not intersect at right angles, and the "islands" between them are irregular. The city was conquered by Sulla in the eighties and refounded as a Roman colony in 80 B.C. In A.D. 62 it was partially destroyed by an earthquake; it had not yet been entirely rebuilt by the time of its final destruction seventeen years later. Pompeii has been especially valuable to the historian of Roman architecture since many building types that later become standard are found there in their early, if not earliest, examples; these include the oldest amphitheater extant and the earliest known public baths.

Next to the Roman Forum, from whose design it differs significantly, the forum of Pompeii (FIGS. 6-20 and 6-21) is the most important example of an early Roman civic center. The Pompeian forum is a rectangular court, in the proportion $3\frac{1}{2}:1$, that is unified by and the boundaries of which are defined by continuous colonnades around three sides. The other type of plan, represented by the Roman Forum, is bordered by more monumental, but individual and disconnected, structures. Like most Roman forums, that of Pompeii is set apart from the major traffic arteries, and vehicles could not enter it. Its long, north-south axis is dominated by the Capitolium, a large temple set on a high podium and dedicated to the three gods who protected Rome and her colonies. Several smaller temples flank the long sides of

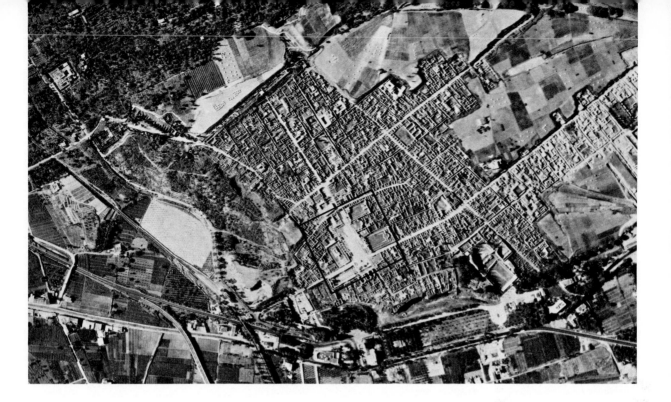

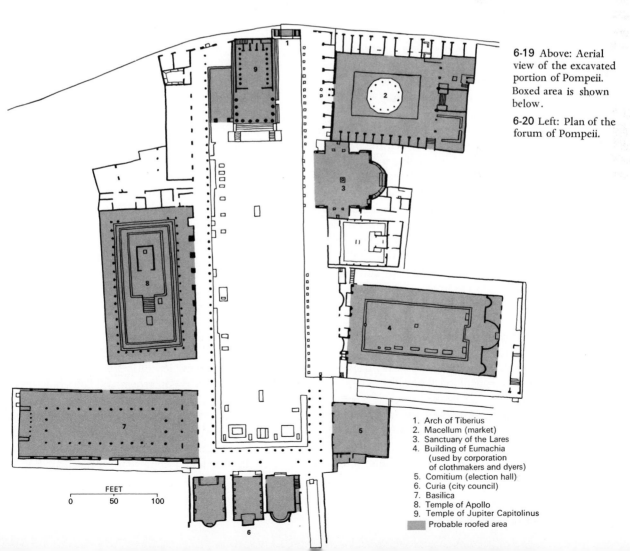

6-19 Above: Aerial view of the excavated portion of Pompeii. Boxed area is shown below.

6-20 Left: Plan of the forum of Pompeii.

1. Arch of Tiberius
2. Macellum (market)
3. Sanctuary of the Lares
4. Building of Eumachia
 (used by corporation
 of clothmakers and dyers)
5. Comitium (election hall)
6. Curia (city council)
7. Basilica
8. Temple of Apollo
9. Temple of Jupiter Capitolinus

▓ Probable roofed area

FEET
0 50 100

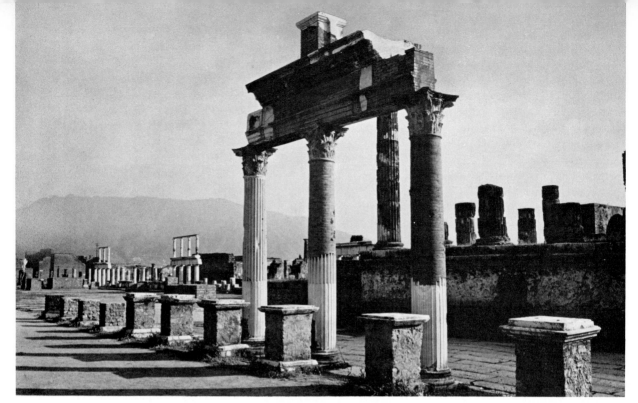

6-21 Forum of Pompeii.

the forum. At the south end stands the triple hall of the Curia (city council), representing civic authority, and the Basilica, the seat of law and business. (This basilica, dating back to about 100 B.C., is an early example of one of the most important and influential classes of Roman buildings, the one from which the basic form of the Christian church building will derive.) Thus, the forum combines the functions of a religious, commercial, and administrative civic center and is the heart of the town. In the same way, it is a kind of imperial center in miniature, and this combination of functions, as architecturally expressed in the Roman Forum, will come to represent the central concerns and focus of the whole Roman empire.

One would not expect the formality of a civic center to be found in the streets that surround it. These would be less monumental and regular, and their spaces less ample—even narrow and cramped. The streets had heavy flagstone pavements with flanking sidewalks. Stepping stones for pedestrians crossing the street were so spaced as to be straddled by the wheels of vehicles. Most intersections had continuously flowing public fountains. The problem of human convenience in an urban society, though not dealt with

on the enormous scale that it is today, was worked out in Pompeii with an efficiency we can believe suited the needs of the people. The town had its commercial sections, like that of the Via dell' Abbondanza, where the streets were flanked by rows of small shops, offices, taverns, bakeries, etc. and where we can still see many painted advertisements on the walls. Here and there the rows of shops were interrupted by a gateway leading into a private residence, which spread out in the back of the shops and was entirely enclosed and isolated from them and from the noise and dust of the street.

The private house is probably the most precious and best-preserved record of urban life to come from Pompeii. The town houses of the well-to-do, like the House of Pansa (FIG. 6-22), an atrium type, protected in Pompeii and Herculaneum by the volcanic ash and lava in which they were buried, are extraordinarily well preserved, with their mural decorations still fresh and sometimes with their equipment and household utensils intact. Such a house stood flush with the sidewalk. Through a narrow door one entered a vestibule that led into the atrium. The latter had an opening in the center of the roof (the *impluvium*) and a depression in the floor below

Etruscan and Roman Art

it to collect rainwater. Along the sides were small rooms; at the end, where the atrium extended the full width of the building, were two wings, *alae*. Behind the atrium was the *tablinum*, in which family archives and statues were kept. The tablinum could be shut off or could afford a passage to the peristyle, a large colonnaded court of Hellenistic origin. This court contained fountains and a garden, around which were arranged the family's private apartments. At the back there was sometimes a vegetable garden or orchard. Along the outer sides of the house and opening onto the street were the shops. Thus the house faced inward, depending upon its courts for light and air. As in the Etruscan atrium, units were symmetrically arranged on a long axis that reached back from the street and, when opened through its entire length, afforded a charming vista of open court, gardens, fountains, statues, colored marbles, mosaics, and brightly painted walls. Some of the largest of these atrium houses in Pompeii rivaled, if they did not surpass, the palaces of Hellenistic kings; the House of the Faun, in which the Alexander mosaic (FIG. 6-32) served as a floor ornament, covered almost 30,000 square feet. Of course, these were the houses of patricians and rich merchants; artisans, craftsmen, and shopkeepers lived in much more modest quarters, the latter often in single rooms in back of or above their shops.

In their fullest development, in the late Roman republic, the elaborate, skillfully planned houses of the great combine an older Italic nucleus with features of the Hellenistic house and represent the highest achievements of domestic architecture in antiquity. That domestic architecture had a prominent place in Roman civilization was manifest in every part of the empire. The character of Roman domestic religion, which exhibited a traditional Italic feeling for the home, family, and hearth as sacred, helps explain the careful elaboration of the domestic architecture.

PAINTING AND MOSAIC

The interiorizing design, with its open and independent arrangement of units, guaranteed complete privacy. Because of the small number of doors and windows, it also offered considerable stretches of wall space suitable for decoration, as the atrium of the House of the Silver Wedding in Pompeii (FIG. 6-23) clearly shows. The decoration commonly used varied between types that emphasized the wall as a barrier and others that visually opened the wall and enhanced the space of the room. The colors were sometimes delicate greens and tans, sometimes striking reds and black (to throw the panels or figures into relief), and there was rich creamy white in the borders. The Romans obtained a certain brilliance of surface by a careful preparation of the wall. After the plaster, which was specially compounded with marble dust, was laid on in several layers, it was beaten with a smooth trowel until it became very dense; it was then polished to a marblelike finish.

The progression from flat to spatial wall decoration in Pompeii and Herculaneum has been

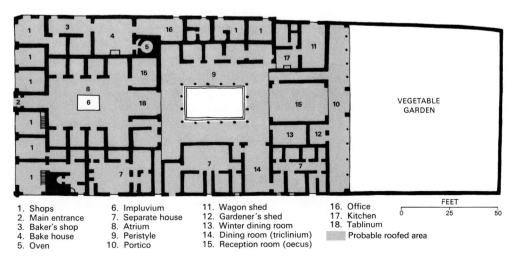

6-22 Plan of the House of Pansa, Pompeii, second century B.C. (After Sir Banister Fletcher.)

VEGETABLE GARDEN

1. Shops	6. Impluvium	11. Wagon shed	16. Office
2. Main entrance	7. Separate house	12. Gardener's shed	17. Kitchen
3. Baker's shop	8. Atrium	13. Winter dining room	18. Tablinum
4. Bake house	9. Peristyle	14. Dining room (triclinium)	▨ Probable roofed area
5. Oven	10. Portico	15. Reception room (oecus)	

FEET
0 25 50

| ← to c. 510 B.C. | c. **60** c. 50 | 27 c. **20** | | | 60 | 79 | to A.D. 284 → |

Villa of the
Mysteries frieze

B.C. | A.D.

Destruction of
Pompeii

to
c. 200
B.C. ← ROMAN REPUBLICAN PERIOD · INCRUSTATION STYLE · · · · ARCHITECTURAL STYLE · · · · E A R L Y I M P E R I A L P E R I O D · ORNATE STYLE · · · · INTRICATE STYLE · · · ·

divided, somewhat arbitrarily, into four successive but overlapping styles. The first style (about 200–60 B.C.), called *incrustation*, divided the wall into bright polychrome panels of solid colors with occasional schematically rendered textural contrasts (FIG. 6-24). This style is a continuation of Hellenistic practice, and examples of it have been found in houses at Priene and on the island of Delos. A wall painting from a villa in Boscoreale, near Pompeii (FIG. 6-25), shows the second, or *architectural*, style (about 60–20 B.C.), in which the decoration is no longer restricted to a single visual plane. The space of the room is made to look as if it extended beyond the room itself by the representation of architectural forms in a visually convincing but not really systematic perspective. Columns, pilasters, and window frames painted on the wall served as enframements of distant views of cities and landscape. In

6-23 Atrium of the House of the Silver Wedding, Pompeii, second century B.C.

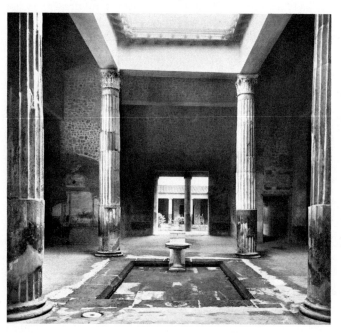

the *herringbone perspective* used, the orthogonals, or lines of perspective projection, do not converge on a single vanishing point on the horizon (as in Renaissance perspective), but tend to converge on an axis that runs vertically through the center of the panel. Though this method is not consistently employed, it does give a somewhat convincing illusion of objects receding in space.

A second-style mural in the Villa of the Mysteries, near Pompeii (about 50 B.C.), displays painted figures that are among the finest to have come down to us from the ancient world (PLATE 6-3). While other rooms in the villa are decorated in a style very similar to the pure architectural style of the villa in Boscoreale, the second-style illusionism here is confined to a painted ledge that looks like a shallow extension of the room proper and which affords the figures a kind of narrow supporting stage. The figures, set against a red-paneled background, in the style of a relief, are part of a large composition that once circled the walls of the room, which may have doubled as a banqueting room and as a place for the celebration of the rites of some mystery cult, perhaps that of Dionysos. The meaning of these scenes is in dispute; we may, however, be fairly certain that this group represents the initiation of a young novice into the cult. Whipped by a winged genius or deity, she crouches for solace in the lap of a solicitous older woman while a splendidly painted nude dances in Bacchic frenzy. The mystery cults, which are discussed below in connection with Christianity, made their way into the Roman empire in increasing numbers and variety from the Hellenized East. All included mysteries that were never to be divulged by the initiate, and which, when understood after painful introduction into the secret rites, would afford salvation through mystical union with a deity. The pictured ceremony from the Villa of the Mysteries is not only a work of art of high order, but a most important record of one aspect of the gradual religious transformation of the

Roman world by the westward migration of Oriental spiritualism. As always with Roman paintings of quality, the question arises, Is it original Roman or derivative from a Greek Hellenistic original in some temple now lost? No decisive answer can be given.

The question arises again, and more insistently, when we look at the second-style *Odyssey Landscapes* (FIG. 6-26) from a house on the Esquiline Hill in Rome. In these landscapes, dating from the late first century B.C. and now in the Vatican, the painted columns divide the otherwise continuous stretch of landscape into eight compartments in which are represented scenes from the Homeric epic. The shimmering landscapes extend the space of the room and almost absorb the subordinated, rapidly sketched figures by their luminosity. At the same time the land-

scapes seem to be brought into the room almost magically. The flickering play of color and light and especially the shaded edges of the solids give a stagelike presence, as of easily shifted props, that suggests distance and isolated action. The second style, though "architectural," here exhibits its versatility, for the sole purpose of the rigid frames is to create the illusion of open and unconstrained landscape. Therefore, if it could be established that the conception of an "all-encompassing" space in works like the *Odyssey Landscapes* is original with Rome, then a solid Roman contribution to the history of art could be acknowledged.

The architectural quality of the second style fades toward the end, and the triumph of the illusionism we see coming forward in the *Odyssey Landscapes* may be seen in the detail of a wall

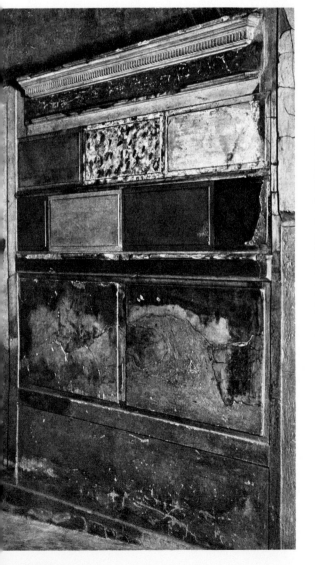

6-24 First-style ("incrustation") wall painting from a Samnite House, Herculaneum, second century B.C.

6-25 Second-style ("architectural") wall painting from the cubiculum of the Villa Boscoreale, near Pompeii, first century B.C. Metropolitan Museum of Art, New York.

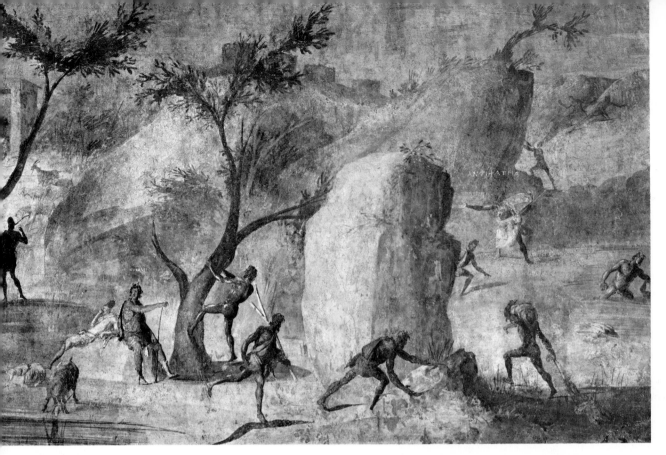

6-26 *Ulysses in the Land of the Lestrygonians*, part of the *Odyssey Landscapes*, second-style ("architectural") wall painting from a house in Rome, late first century B.C. Approx. 5′ high. Vatican Library, Rome.

painting from the House of Livia in Primaporta, near Rome, made toward the end of the first century B.C. (PLATE 6-4). The extension of the space of the room—with its complementary effect, the bringing of the landscape into the room—creates the image of a garden just outside the limit of the wall. (This is a curious anticipation of the widely popular "picture window" of recent modern architecture in which one enjoys a "view" by fixing it within a frame, at the same time thinking of the garden as continuous with the room.) Here "deep" perspectives and distant views are not desired, but rather the intimacy and freshness of natural beauty easily within contact. One may think that in the second style, as it develops, the "view" comes ever closer, until it is one's own garden, free of any human intrusion, enclosed and isolated by the painted limits of the fence and by the back-stopping of the foliage itself, which occupies a plane close to the viewer and shuts out distance.

The passing of the wall from the state in which it is a framed view into nature to that in which

it merely supports smaller framed views takes place in the third, or *ornate*, style (about 20 B.C.–A.D. 60), during the time of the early empire. The style retains some degree of illusionism, as may be seen in a wall from Pompeii (FIG. 6-27), but the articulating architectural members lose their functional appearance. Columns and pilasters become attenuated and at times purely fantastic, like the central columns in our illustration; often they are entwined by garlands and tendrils. The painted architectural elements are apparently no longer intended to represent actual architecture but serve primarily as dividers, framing panels on which are small, individual paintings that have no direct relation to the overall design of the wall. These scenes resemble pictures hung on a wall and are placed with exquisite delicacy.

The fourth Pompeian wall style, called the *intricate*, dates from around A.D. 60 to A.D. 79 and may be seen to good advantage in the Ixion Room from the House of the Vetii (FIG. 6-28). Here, the painters, under the influence of contemporary Roman theatrical design, returned to the use of

architectural frames and open vistas. An aerial perspective, however, rather than a linear one, is created by areas of color flooded with light and atmosphere. It unites the wall in a complex way, incorporating all the lessons of previous experiments in optical illusion. In fact the fourth style is a kind of résumé of its predecessors: The incrustation manner appears along the lower walls, and architectural panels are set into the ornate third-style wall articulation, which is also reflected in the individual picture panels. Though the aerial perspective produces a certain unifying effect, there is no single point of view from which the designs can be taken in or from which they can be related; obviously it is intended that we pass the pictures as we do in a gallery, stopping at each one, aware that it need have no relation in subject or style to its neighbor.

The small panels show a great variety of subject matter, ranging from still life to genre, from mythology to landscape. A still life with peaches and a carafe, from Herculaneum (PLATE 6-5), about A.D. 50, demonstrates that the Roman painter sought illusionistic effects in depicting small objects quite as much as in depicting archi-

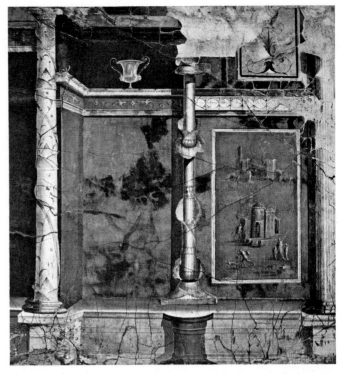

6-27 Third-style ("ornate") wall painting, Pompeii, first century A.D. Museo Nazionale, Naples.

6-28 Fourth-style ("intricate") wall painting from the Ixion Room, House of the Vetii, Pompeii, first century A.D.

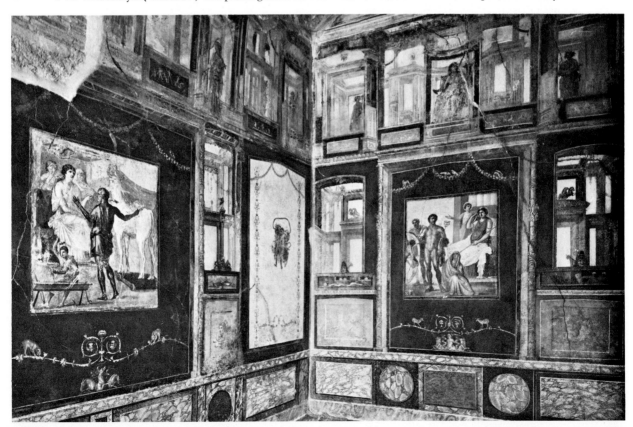

6-29 Genre scene (?), detail of a wall painting transferred to panel, from the House of the Dioscuri, Pompeii, first century A.D. Entire painting approx. 15″ × 17″. Museo Nazionale, Naples.

tectural forms and landscape spaces. Here his method involves light and shade with scrupulous attention to contour shadows and to highlights; doubtless he worked directly from an arrangement he made himself, the fruit, the stem and leaves, and the translucent jar being set out on shelves to give the illusion of the casual, almost accidental, relation of objects in a cupboard. But the picture is exact in neither drawing nor perspective, and the light and shade are approximate. Still, the illusion the painter contrives here marks the point of furthest advance made by the ancients in the technique of representation. He seems here to have an inkling that the look of things is a function of light, and he strives to paint *light* as he strives to paint the touchable *object* that reflects and absorbs it. It is interesting that painters like Paul Cézanne—often called the founder of modern art—in discarding the systematic organizing devices of perspective and chiaroscuro (light and dark), produce distortions and irregularities in painted objects that resemble those of this ancient still life.

A painting from the House of the Dioscuri in Pompeii (FIG. 6-29) offers evidence of the high degree of skillful illusionism achieved by the painters of the fourth style. The subject may be a scene from mythology or a genre scene. A woman seated before a stone building and a small hut receives a cup from a bowing man—or does she extend the cup to him? It is difficult to decide. Whatever the interpretation, the brush technique is a deft impressionism, the strokes firm and practiced; and the painter is entirely sure of the poses and the relationship of the figures in space. The problems of figural attitude, anatomy, movement, and proportion, which we have seen confronting the ancient artist for millennia, seem now to have their familiar solutions, so that the artist of this work proceeds easily and confidently, his brush quickly expressive of his knowledge.

That the style of the Dioscuri painting was contemporaneous with other quite different styles is apparent from a painting from Herculaneum representing Herakles finding the infant Telephos in Arcadia (FIG. 6-30). The subject indicates that the picture was copied from some Hellenistic original—or originals, for the artist proceeds as if he were lifting figures from different sources and arranging them with little relation to one another. Thus, the personification of Arcadia, the large seated figure, is not in proportion to Herakles, nor is the treatment the same: The statuesque Arcadia has the pale, hard

modeling we associate with sculpture, while the play of light and highlight upon the supple surfaces of the Herakles figure is closely related to the effects we expect in pictorial illusionism, though the technique is by no means the free "painterly" one we see in the Dioscuri work. All the figures are precisely modeled, with firm outlines. The artist is concerned chiefly with the solid volumes of the bodies and not with light or with the space the whole group occupies; each figure is contained, as it were, by its own particular space, the space it "fits." The depiction of space as an enveloping and unifying factor in pictorial design may not be characteristic in Greek art, and this picture, as we have said, copies a Greek model. On the other hand, the special Roman contribution to painting may be precisely the representation of space as *surrounding* the whole group of objects and figures in any given composition and not merely coming between them.

It still seems to be a general tendency to deny any originality to Roman paintings and to insist that they are direct copies of or closely inspired by Hellenistic originals. No doubt, many Roman paintings do appear to be direct copies—for example, the *Herakles and Telephos* just discussed and the Alexander mosaic shown in FIG. 6-32. In fact, many paintings were probably done by transplanted Greek artists, and we might even grant that the Greek-derived style was the dominant one. But the Roman *landscape* seems to represent a radically different approach, particularly in its expression of a concept of space that is simply not evident in Greek art, and all attempts to derive Roman landscape painting from Hellenistic Greece lead us into extremely tenuous speculation based on unknown (or nonexistent) Greek prototypes. All extant Greek works show the Greek artist thinking in terms of solid volumes, like those of human figures—as in the *Herakles* painting—and confining space to a mere separating function rather than an all-containing one. Thus, it might be much simpler to credit the Romans with the development of a new concept in painting—namely, the projection of an enveloping, unifying volume of space on a flat surface. This refinement of abstraction—where space, filled with air and light, is actually represented as just as real as the objects it sur-

rounds and contains—would complete the long development of representation that begins with the silhouettes of early Egypt and Mesopotamia and even earlier. At any rate, many now accept the view that the architectural illusionism of the second style is a Roman development and that this illusionism was a step in the transition to the spaces depicted in the smaller landscape panels (FIG. 6-31, PLATE 6-6). For an artist thinking of the wall surface as a kind of extension of the space of the room (as in architectural illusionism), the next step would be to take a segment of the wall and convert it, windowlike, into a small block of framed space that extends "through" the wall and contains its little universe of depicted objects.

In any case, the artist of the fourth style, chiefly interested in representing space, makes the objects as small as possible and unifies the whole composition, as we have seen, with light and atmosphere. Of course, recession in depth is suggested, not accurately projected. As noted

6-30 *Herakles and Telephos,* wall painting, Herculaneum, *c.* A.D. 70. Approx. 86″ × 74″. Museo Nazionale, Naples.

6-31 Sacral-idyllic landscape, wall painting transferred to panel, from the Villa of Agrippa Postumus, near Pompeii, late first century B.C. Portion shown approx. 26″ high. Museo Nazionale, Naples.

above, the Romans had no system of mathematical perspective but used (effectively, if unsystematically) the diminution of figures and objects and particularly atmospheric perspective, with its hazed and sketchy outlines, the shift from local color toward blue, and the blurring of distant contours (compare FIG. 6-26).

The love of country life and the idealizing of nature—what we may call the Arcadian spirit—prevails in these landscapes. Characteristically, they contain shepherds, goats, fauns, little temples, garlanded columns, copses of trees, and other accessories, which from their mood—part religious, part idyllic—have been called sacral-idyllic scenes. The Arcadian spirit of the time

speaks in the formal, pastoral poetry of Vergil, and in one of his odes Horace, proclaiming the satisfactions afforded the city man by his villa in the countryside, where life is beautiful, simple, and natural in contrast with the urban greed for gold and power, asks, "Why should I change my Sabine dale for splendor full of trouble?"

The attitude that celebrates the virtues of rustic life must be very closely associated with an original Roman development in architecture. Many Arcadian landscapes have been found in *villas*—country houses developed by the Romans when congestion in the cities became severe, as it did in Pompeii during the first century B.C. The villas were never located very far from town

(one might call them suburban), and their wealthy owners could enjoy the advantages of city life and the quiet of the countryside. The very spaciousness of the landscape around the villa came to be the subject matter of the wall paintings we have been examining. The modern desire to escape the tensions of the city and to return to nature is ancient in its architectural and pictorial expression, not to mention its appearance in literature. We will encounter this Arcadianism again and again in the history of the West —in the Renaissance and in the nineteenth and twentieth centuries, when urban pressures strain human nerves.

The floors as well as the walls of Roman buildings were ornamented, usually in mosaics. Mosaic had its beginnings in the ancient Near East (see Chapter Five). It was used by the Greeks in place of carpets, often in geometric patterns. The Romans continued the practice and even applied mosaic to walls, though this seems to have been the exceptional case. A striking aspect of Roman mosaics is the attempt frequently made in them to copy not only the subject matter of painting but also the painter's technique in modeling, shading and the like. This was possible only if extremely small tesserae (the bits of glass or stone composing the mosaic) were used, as, for example, in the famous Alexander mosaic from the House of the Faun in Pompeii (FIG. 6-32), which is likely a copy of a Hellenistic original and perhaps should be thought of as more Hellenistic than Roman. The mosaic, which represents the rout of Darius and his army by Alexander the Great, has those qualities of Greek style we have noted: the essentially sculpturesque emphasis upon the solid forms, space defined by the forms themselves, and no attempt to show an enveloping space. Nevertheless, a remarkable taste for fidelity to appearance is shown in the details of action. The horses plunge into and out of the picture at the most daring angles, and the human figures are posed in such variety of descriptive attitude as to convince us the artist was

6-32 *The Battle of Alexander*, from the House of the Faun, Pompeii, third to second centuries B.C. Mosaic, approx. 8′ 10″ × 16′ 9″. Museo Nazionale, Naples.

pursuing an ultimate realism. In keeping with this is the high degree of tonal smoothness that was achieved by the setting-in of tesserae so small that some fifty separate bits were used to describe a single eye perhaps 1½ inches wide. The Romans appear to have developed a taste for this kind of minute workmanship, and the technical quality of mosaics must have been judged by the size of the tesserae used—the smaller the better. Since, after all, the mosaics were seen at a distance of only five or six feet (one walked on them), such a criterion seems natural enough. The standard changes during the Early Christian period, when mosaics were placed high on church walls and apse vaults, making such minute differences scarcely noticeable and such a painstaking technique meaningless.

We may judge the quality of panel painting by a portrait from Faiyum in Egypt, some sixty miles south of modern Cairo (PLATE 6-7). In Greek and Roman times Faiyum was a busy, populous province, and its cemeteries have yielded some 600 portraits painted on wood and attached to the mummy cases of the deceased. The making of such portraits must have been a regional custom, as very few have been found elsewhere; they supply for us our largest gallery of ordinary people of the vast Roman imperial world when it was at the height of its power. While some Pompeian wall frescoes give us hints as to what Greek murals may have looked like, the Faiyum portraits give us the best idea we have of Hellenistic Greek painting techniques. Most of the portraits are done in the encaustic technique (pigments in hot wax—see p. 136), but *tempera* (pigments in egg yolk) was used occasionally. Easel painting, upon small, portable panels, had been highly esteemed in Greece, where the encaustic technique had a long tradition. Polygnotos had worked in it in Classical times and, as mentioned earlier, it had been used for the architectural decoration of buildings like the Parthenon. The example here shows the very highest level of craftsmanship—refined brushwork, soft and delicate modeling, and the subtlest possible reading of a sensitive subject. The Faiyum portraits were probably painted from living persons, and in this instance we have the meeting of an unusually perceptive artist with a

subject whose personality would try his whole skill to render. The composure, the emphasized thoughtful eyes, the Hellenizing hairstyle, are familiar in the portraits made during the time of the Stoic emperor Marcus Aurelius (about A.D. 160) and in the portraits of the emperor himself. The calm demeanor of the subject, the gaze that "sees the world steadily and sees it whole," evokes the philosophy of the emperor himself as set forth in his *Meditations*. As earlier we confronted the bust of Pompey, familiar with his history, so it is an aid to us in meeting this image from the age of the Antonines to read the philosophic emperor as we read the painted features of our subject:

> Every moment think steadily as a Roman and a man to do what you have in hand with perfect and simple dignity. . . . do every act of your life as if it were the last, laying aside all carelessness and passionate aversion from the commands of reason, and all hypocrisy, and self-love, and discontent with the destiny which has been given to you.

Our history has taken us beyond the period of the republic into that of the empire in order to show how Rome carried the ancient world's representation of landscape and of human individuality—begun in Mesopotamia and Egypt— to its most complete expression.

The Early Empire

When Octavian Caesar, the great-nephew and heir of Julius Caesar, routed the forces of Antony and Cleopatra at Actium in 31 B.C., he brought to an end some ninety long years of destructive civil war that had shattered the Roman republic. Though Octavian believed and proclaimed himself the restorer of the republic and the protector of its constitution and traditions, he became in fact the first emperor of Rome and to all intents and purposes ruled as emperor, taking the venerable name "Augustus," which was bestowed upon him by a grateful Senate. The peace that began with Augustus has been called the Pax Romana, for, under the auspices of a long line of emperors, peace prevailed within the Roman world for 150 years, a record in world history.

Augustus, determined to establish his authority unshakably, kept command of the military and financial resources of the empire in his own hands and deliberately set out to build a new and magnificent Rome in order to give a splendid image to the imperial reality. As they carried the boundaries of the empire further in all directions, the Julio-Claudian emperors, Augustus' successors in the first century A.D., continued his policy of glorifying by architecture, art, and a vast variety of public works the visible aspect of empire, sometimes to an extravagant degree. In the second century the empire—under Trajan, Hadrian, and the Antonines—reached its greatest geographical extent and the summit of its power (see map, p. 195); the might and influence of Rome was unchallenged in the Western world, though there was always the pressure of the new, Germanic peoples on its northern borders and of the Parthians and resurgent Persians on the east. These pressures increased in the third century, and, combined with the decline of imperial authority within the empire, disintegration of the economic and administrative structure, and military anarchy, almost brought the empire to collapse. In A.D. 285 it was somehow restored—temporarily—by the last pagan emperor, the capable Diocletian, under whom took place the savage persecution of a sect called the Christians. Within a generation the triumph of this sect was to mark a major turning point in the history of the world.

ARCHITECTURE AND PUBLIC WORKS

The grandiose imperial designs of the early empire are of course reflected in its architecture, perhaps most conspicuously there. The relatively stable conditions produced by the Pax Romana made possible the Romanization of the provinces, and urbanism—the planning and building of cities—played in this process a principal role. The rapid growth of population, especially city population, we have mentioned above as a reason for the escape to the suburban villa. The pressure of population in the city itself made the sprawling atrium house—wasteful of space—obsolete. In Rome, a population of close to one million had to be housed in multistory apartment blocks (*insulae*). Some 45,000 of these—built to the maximum legal height of five stories (sixty to seventy feet high)—accommodated almost 90 per cent of Rome's population. Most of the almost 50,000 inhabitants of Ostia, the port city of Rome, were housed in such apartment houses, some of which have been preserved to the level of the third story. Most were built of brick; some of concrete. The ground floors were occupied by shops, above which were the apartments, accessible by individual staircases. Many of the apartments were substantially more spacious than are most of ours today, the suites sometimes containing as many as twelve rooms, arranged on two levels. A reconstruction of an Ostian insula (FIG. 6-33) shows the apartment

6-33 Reconstruction of an insula, Ostia.

6-34 Pont du Gard, near Nîmes, southern France, first century B.C.

blocks built around a central court, which probably was landscaped and sometimes contained a small shrine. Apparently, many apartments had balconies, still a standard feature of modern Italian apartment houses. Only deluxe apartments had private toilets; others were served by community latrines, usually on the ground floor. The insulae had no private baths, but public baths were conveniently located throughout the various quarters of the city and were equipped with highly developed heating systems, which private houses and apartments lacked. (This is still true of parts of modern Italy.) The crowded conditions encouraged rent-gouging and jerry-building. Deficiency in materials was often compounded by bad design, such as a foundation area too small in relation to the height of a building—the latter a means of maximal exploitation of the limited space available. The poet Juvenal wryly complains about the poorly constructed city buildings:

> ... we inhabit a city propped up for the most part by slats: for that is how the landlord patches up the crack in the old wall, bidding the inmates sleep at ease under the ruin that hangs above their heads.

To an extent greater than is commonly known, the convenience of the ancient Roman of ordinary and less than ordinary means depended on facilities provided by the state—by authority imperial, provincial, or municipal. Millions of indi-

viduals depended upon the government for food distribution, water supply and sanitation, recreation and entertainment, and roads and bridges, not to mention the protection afforded by police and fire-fighters. The administration of these services in the great days of the empire was efficient even by our standards, given of course the limitations we would expect from a less highly developed technology and communication system. Second only to food distribution, an adequate water supply for the populations of the overcrowded cities was the most imperative need. The Romans were the first to incorporate the methodical development of water-supply systems into urban planning. The city of Rome began to build aqueducts for itself as early as the fourth century B.C., and Roman aqueducts or their ruins still stand in many former Roman cities, both in Italy and in the provinces. Water was carried from the source to the city by gravity flow, requiring the building of channels with a continuous gradual decline over distances often exceeding fifty miles; we can appreciate even in modern terms what an outstanding achievement of surveying and engineering this represents. The Pont du Gard near Nîmes (FIG. 6-34), in southern France, is one of the most impressive specimens of Roman engineering skill. Each large arch spans some eighty-two feet and is constructed of uncemented blocks weighing up to two tons each. The quickening rhythm of the small top arches (which carry the channel), placed in groups of

threes over the larger arches, manifest the Roman engineer's sense for the esthetic as well as the practical. The finished aqueduct carried water to Nîmes over a distance of some thirty miles and provided each inhabitant with about 100 gallons a day. Services like this, and the awesome structures through which they were provided, could not help but impress upon the diverse peoples who had come under the rule of Rome the advantages of compliance with such practical power and the benefits that could come from Romanization.

If the construction of aqueducts could show the value of homage to Rome, how much more the erection of a whole city! At Timgad (Thamugadis) in North Africa (FIG. 6-35) the Romans built a city, around A.D. 100, that lasted until its destruction by the Moors in the sixth century A.D. Built along a major military road 100 miles from the sea, it was probably planned to house a military garrison to keep local tribes in check. But this primary function was soon expanded, and no costs were spared to make this little provincial town into an attractive focal point for the local inhabitants. Here the empire was a physical presence to the Africans, the city representative of the authority of the emperor and the civilization of Rome. Like many other colonial settlements, Timgad served as a key to the process of Romanization. The town was planned with great precision, its design based on the layout of the Roman military encampment (the castrum). The typical provincial Roman city has the form of a square divided into equal quarters by two main arteries crossing at right angles, the *cardo* being the north-south axis, the *decumanus* the east-west; the forum is located near this crossing. The quarters are subdivided into square blocks, and the forum and public buildings like the theater, baths, and library occupy areas that are multiples of these blocks. At Timgad monumental gates led into the city, the streets of which were colonnaded. The city covered some thirty acres, and its original population of 2000

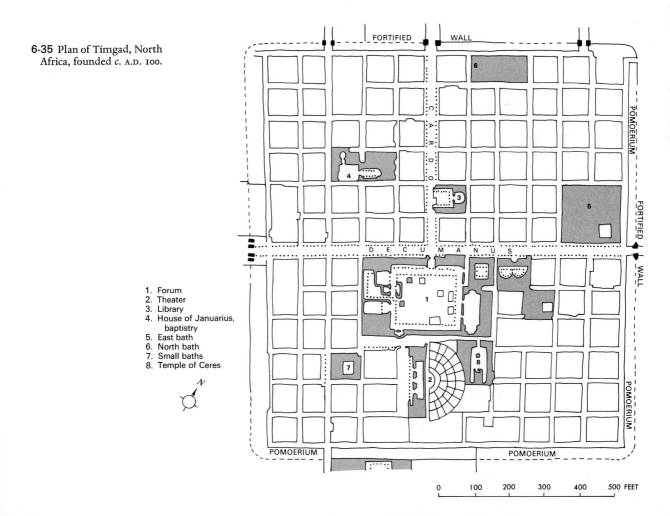

6-35 Plan of Timgad, North Africa, founded *c.* A.D. 100.

1. Forum
2. Theater
3. Library
4. House of Januarius, baptistry
5. East bath
6. North bath
7. Small baths
8. Temple of Ceres

| ← to 27 B.C. | A.D. 70 | 100 | 118 | | 215 | 235 | | 284 | 300 | 315 | A.D. 395 |
| Colosseum begun | Timgad founded | Pantheon begun | | Baths of Caracalla | | | Palace of Diocletian begun | Arch of Constantine | Division of the empire |

E A R L Y I M P E R I A L P E R I O D

← BARRACKS EMPERORS →

L A T E I M P E R I A L P E R I O D

soon grew to 15,000. The whole plan was essentially a modification of the Hippodamian scheme (see p. 181) but more rigidly ordered and systematized, with the forum set off from the main traffic pattern. The fact that most of these colonial settlements were laid out in the same manner—whether in North Africa, the Near East, or England—expresses more concretely than any building type or other construction project the unity and centralized power of the Roman empire at its height.

The architectural images of Rome set up in the far reaches of the empire had their even more monumental equivalents in the capital itself. When all roads did indeed lead to Rome, they could find their symbolic terminus in such stupendous works as the Colosseum (FIGS. 6-36 and 6-37), which for modern men still represents Rome as does no other building. So closely was it identified in the past with the city and the empire that an aphorism out of the early Middle Ages went: While the Colosseum stands, Rome stands; when the Colosseum falls, Rome falls; and when Rome, the world!

The Colosseum is sometimes called the Flavian Amphitheater, because it was begun by Vespasian, first in the Flavian line of emperors. It was dedicated in A.D. 80 by his successor, Titus, who had employed on the building of it prisoners from the Jewish Wars (see FIG. 6-52). The building type is an invention of the Romans, who expanded the "theater" into an "amphitheater," which is essentially two facing theaters enclosing an oval space, the arena. The Roman Colosseum is the largest of its type, but most major cities in the empire had an amphitheater. Some, like that at Verona, are still being used today for theatrical performances or games. The Colosseum was originally meant for the staging of lavish spectacles, battles between animals and gladiators in various combinations. The mythic beast-men struggles we saw represented in Mesopotamian art here came to bloody reality. The extravagant-

ly inhuman shows cost thousands of lives, among them those of many Christians, and the Colosseum has never quite outlived its infamy. The emperors competed with each other over who could produce the most elaborate spectacles. For the opening performance in A.D. 80 the arena was flooded and a complete naval battle, with over 3000 participants, was duplicated.

The oval arena of the Colosseum (FIG. 6-36) is surrounded by steeply rising rows of seats, which had a capacity of over 50,000 spectators. Its substructure consists of a complex system of radial and concentric corridors covered by concrete vaults that rise to support the upper rows of seats. Originally, tall poles around the top of the structure supported ropes on which awnings could be spread to provide shade for the spectators. The basements below the arena proper contained animal cages, barracks for gladiators, and machinery for raising and lowering stage settings as well as the animal and human combatants. A great deal of technical ingenuity involving lifting tackle was employed to suddenly hurl hungry beasts from their dark dens into the violent light of the arena.

Roman ingenuity in the management of architectural space to fit a complex function may be observed even in the exterior of the Colosseum—namely, the arcuated entrance-exit openings that must have permitted rapid filling and emptying of the vast interior space. The relation of these openings to the tiers of seats within was very carefully thought out and, in essence, may be observed in the modern football stadium. The Colosseum exemplifies the Roman talent for matching public and private convenience within large-scale service structures that require the enclosure and the spanning of great spaces.

The exterior of the building (FIG. 6-37), with its numerous functional openings, consists of ashlar masonry in which dry-jointed blocks were held together by metal cramps and dowels, as in Greek architecture. Its present pock-marked ap-

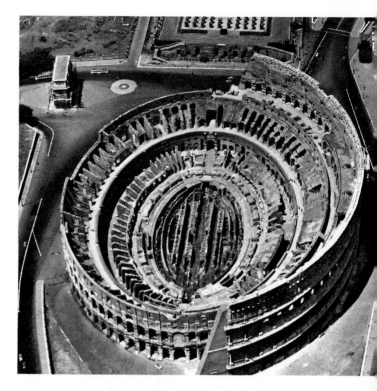

pearance (as if it had been blasted by large shrapnel) is due to the fact that the metal fittings were pried from the joints during the Middle Ages, when metal was very hard to come by. With these jointing units gone, vibrations from modern traffic have been shifting the stones, and the entire structure is in danger of collapse. The exterior walls are 161 feet high, and each of the three stories shows the characteristic combination of the Roman arch and vault construction with one of the ornamentally enclosing Greek orders. This setup, in which an arch is enframed by two engaged columns that carry a lintel, is called the Roman arch order; it appears in triumphal arches and other Roman buildings, and, revived in the Italian Renaissance, has a long, illustrious history in Classical architecture. For the moment it is necessary only to note that although this exterior feature serves no structural purpose, it does have an esthetic function, that of integrating the units of the surface by rhythmic horizontal and vertical repetition of the enframed arch. Although the arrangement of the orders finds no correspondence of a functional sort in the interior of the Colosseum, the rule of the arrangement is strict, following the standard Roman vertical sequence for multistoried buildings: Doric-Ionic-Corinthian, from the ground floor up. This sequence is based on the proportions of the orders, the Doric being the heaviest and thus, visually, the one most likely to be able to support the greatest load.

The imperial forums of the emperors rivaled the Colosseum as majestic expressions of the imperial ideal. The forums were erected not so much as fundamental civic units of direct service to the people as ostentatious glorifications of imperial power. They stood witness to the "piety, might, good fortune, magnanimity and happiness"—as their triumphal inscriptions so often proclaimed—of the successive emperors who built them. They were not planned as a unit, but each forum was added to another, their unity being achieved by strict axial alignment (FIG. 6-38). Most consist of large colonnaded courts designed to set off a temple dedicated to the god

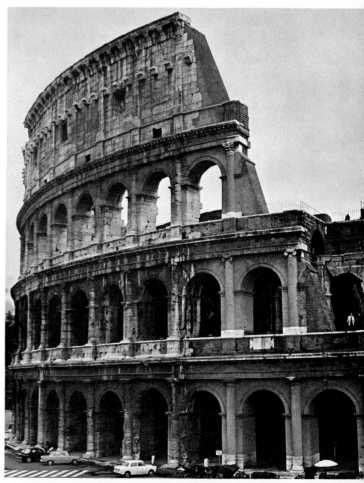

6-37 Outer wall of the Colosseum.

who was the special protector of the emperor. The demands of impressive scale and great, sweeping vistas led sometimes to massive transformation of whole neighborhoods. The building of the Forum of Trajan required relocation and rebuilding of a market district and the modification of an entire hillside.

Dominating the Forum of Trajan was the huge Basilica Ulpia of about A.D. 112 (FIG. 6-39). A derivation from the basilica in Pompeii, it was perhaps the single most characteristic building type developed by the Romans. The basilica was a public hall designed to accommodate large numbers of people on various kinds of business. It was the locale of stock exchanges, law courts, business offices, and administrative bureaus and must have provided a center for civic services analogous to those of multiple-building municipal centers today. Later, the Christians adapted the basilica to religious purposes, modifying it into the typical Christian church building. In plan the basilica was rectangular, with two or more semicircular *apses*. In the Basilica Ulpia one of the apses contained the Shrine of Liberty, where

slaves were set free; the other may possibly have served in ceremonies of the emperor's cult. The entrance was on one of the long sides, an orientation that was changed by the Christians. The building was vast—426 by 138 feet; illumination for this great interior space was afforded by clerestory windows provided by elevation of the timber-roofed nave above the colonnaded aisles. In the Basilica Ulpia we once again encounter the Romans' instinctive feeling for broad, uninterrupted architectural spaces enclosed for the convenience of human transaction. The interior space is what counts here, and though it is a colonnaded space, its effect is not like that of the externally perceived Greek temple but rather like a peripteral Greek temple inverted: It is to be experienced from within, not from without.

One of the best preserved of all Roman monuments is the city of Rome itself; and one of the most renowned and influential buildings in the history of architecture is the Pantheon (FIGS. 6-40 to 6-42), built about A.D. 125, in which the effect of interior space is quite overwhelming, especially since its exterior scarcely suggests it. It is a domed

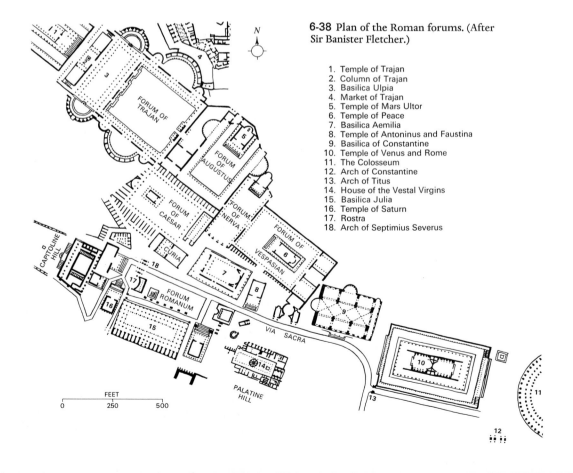

6-38 Plan of the Roman forums. (After Sir Banister Fletcher.)

1. Temple of Trajan
2. Column of Trajan
3. Basilica Ulpia
4. Market of Trajan
5. Temple of Mars Ultor
6. Temple of Peace
7. Basilica Aemilia
8. Temple of Antoninus and Faustina
9. Basilica of Constantine
10. Temple of Venus and Rome
11. The Colosseum
12. Arch of Constantine
13. Arch of Titus
14. House of the Vestal Virgins
15. Basilica Julia
16. Temple of Saturn
17. Rostra
18. Arch of Septimius Severus

FEET
0 250 500

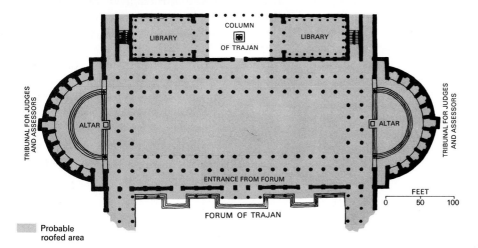

LIBRARY

COLUMN
OF TRAJAN

LIBRARY

TRIBUNAL FOR JUDGES AND ASSESSORS

ALTAR

ALTAR

TRIBUNAL FOR JUDGES AND ASSESSORS

ENTRANCE FROM FORUM

FEET
0 50 100

FORUM OF TRAJAN

Probable
roofed area

rotunda fronted with a rectangular portico that seems not quite fitted to the original round structure and may have been an afterthought. The original effect must have been different, for the building was not freestanding but backed against an older basilica, extensions of which partly covered its sides. Moreover, the portico was preceded and partly embraced by a colonnaded court and originally was the only part of the building that was visible from the front. Built in the time of Hadrian, it may have been designed by that versatile ruler.

The structure is of monumental simplicity and great scale. The circular interior is covered by a hemispherical dome 144 feet in diameter, the summit of the dome being the same distance from the floor. The design is thus based upon the intersection of two circles, one horizontal, the other vertical, imaginable as sections of a globe of "space" inscribed within the building. The

dome is a shell of concrete that gradually thickens toward the base in order to augment structural strength where it is most needed. The center of the dome is dramatically pierced by a round opening (the *oculus*, or "eye") 30 feet in diameter, which, left unglazed and open to the sky, is the only source of light for the interior. Supporting the dome are walls of immense thickness into which have been cut alternating rectangular and semicircular niches, each covered by a vault that channels pressures exerted by the weight of the dome into solid masonry piers. The dome is coffered for the double purpose of making a handsome geometric foil of squares within the vast circle and of reducing the weight and mass of the dome without weakening its structure. The floor of the building is slightly convex, and drains are cut into the shallow depression in the center (directly under the oculus) to carry off any rain that falls through the opening far above.

The Romans 221

Giovanni Pannini's painting of the interior of the Pantheon (FIG. 6-42) exhibits better than any photograph the unity and scale of the design, the simplicity of its relationships, and its breathtaking grandeur. It almost records the experience one has on first entering this tremendous, shaped space, a feeling not of the weight of the enclosing masses, but of the palpable presence of space itself, for the architecture here displayed is first of all an architecture of space. In the architectures so far studied, the form of the space enclosed is almost accidentally determined by the placement of the solids, which do not so much shape it as interrupt it. The solids are so prominent in Egyptian and Mesopotamian architecture that it is the solids we *see*; space is only "negative," simply *happening* between the solids. We think of this as an architecture of mass. Greek architecture, also primarily concerned with masses and their relations, and with the shaping of the solid units, is designated as skeletal or sculptural architecture. It is the Roman architects who initially conceive architecture in terms of units of space that can be shaped by enclosures. The interior of

the Pantheon, in keeping with this interest, is a single, unified, self-sufficient whole, uninterrupted by supporting solids; it is a whole that encloses the visitor without imprisoning him, a small cosmos that opens through the oculus to the drifting clouds, the blue sky, the sun, universal nature, and the gods. To escape from the noise and torrid heat of a Roman summer day into the sudden cool and calm immensity of the Pantheon is an experience almost impossible to describe and one that should be promised oneself. Above all, it is an *architectural* experience.

It should not be forgotten that Roman inventiveness in the construction of great interior spaces depended upon engineering knowledge of the properties of solids and of the statics of inert masses. The arch, the vault, and the dome were structural units appropriated and developed by the Romans with skill unsurpassed in the ancient world and not often since. Basically the problem as the Romans met it was this: how to enclose and roof over a vast space and how to give this space proper illumination while still keeping it open and free of the supports necessary

6-40 The Pantheon, Rome, A.D. 118–25.

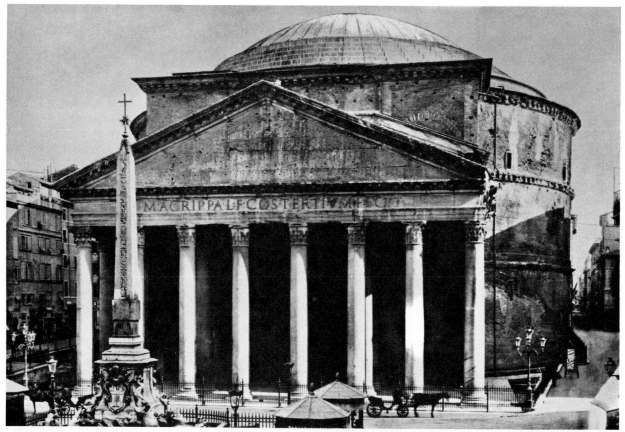

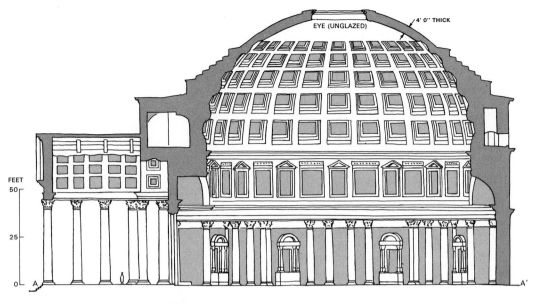

EYE (UNGLAZED) 4' 0" THICK

FEET
50

25

0 A A'

6-41 Plan and section of the Pantheon.
(After Sir Banister Fletcher.)

FEET
0 25 50

A ——————— A

under a flat roof. (Compare this approach with
that embodied in the hypostyle halls of Egypt,
as shown in FIG. 3-27.)

The simplest vault used by the Romans was
the *barrel vault* (FIG. 6-43a)—in essence, a deep
arch that forms a half-cylindrical roof over an
oblong space, the edges of the half-cylinder rest-
ing directly upon the side walls, which must
be either thick enough to support the weight or
reinforced by buttresses. This vault can be made
of concrete by use of a temporary wooden form
(known as *centering*) that is the size and shape of
the finished vault and that holds the fluid con-
crete until it hardens. The vaulting of the central
hall of the Thermae (Baths) of Caracalla (FIG. 6-44)
and of the Basilica of Constantine (FIG. 6-67) was

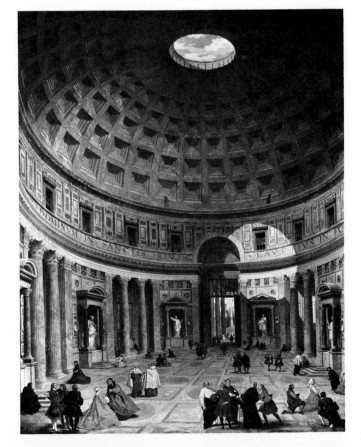

6-42 *Interior of the Pantheon*, painting by Giovanni
Pannini, *c.* 1750. National Gallery of Art, Washington,
D.C. (Samuel H. Kress Collection).

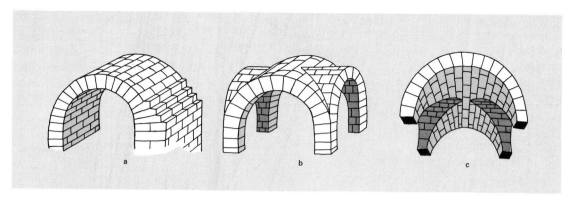

6-43 Roman vaulting systems: (a) barrel vault; (b) cross-barrel vault seen from above; (c) cross-barrel vault seen from below.

made by having the main barrel vault intersected at right angles at regular intervals by other barrel vaults, thus obtaining what is known as the *cross-barrel vault* (FIG. 6-43b and c). If the height of the intersecting and main barrel vaults is the same, the result is a *groin vault*, the line of intersection being called the groin. (Groin lines can be seen readily in FIG. 6-44.) Besides being lighter in appearance than the barrel vault, the cross, or groin, vault requires less buttressing: In the barrel vault the thrust—that is, the downward and outward forces exerted by the vault, like those of the arch—is along the entire length of the wall, requiring a corresponding buttressing; in the groin vault it is exerted only at the points at which the groins converge, and it is only at these points that heavy buttressing is needed. Thus, the interior can be kept free of load-carrying walls, and more light can be admitted through the use of clerestory windows located in the free space where buttressing is not needed (in effect, the ends of the cross vaults). Buttressing can be provided by heavy walls perpendicular to the main wall and pierced by arches, which thus form side aisles to the main hall (FIG. 6-68), and by short wall sections above the aisle roofs that channel part of the vaults' thrust into the outside vaults.

All this was elementary to the builders of the gigantic Baths of Caracalla (FIGS. 6-44 and 6-45), dating from about A.D. 215. The enclosure of great spaces by vaulting was at this time common practice. Although nothing of the covering is left, the baths reveal traces of the vaults that

sprang up from the thick walls to heights of ninety feet; under them, spread out in unending variety, were spaces designed for the intellectual as well as physical recreation of thousands of leisured Romans—all at the expense of the state. Just the central buildings of the huge complex, in which the emperors hoped to keep an unruly and indigent populace preoccupied with pleasure, covered an area roughly 240 by 120 yards; and the baths, which were the center of interest as well as the architectural center of the design, had a capacity of 1600 bathers. The functions of various parts of the complex are still matters of controversy. The design was symmetrical along a central axis occupied by pools that were filled with water of different temperatures: the *frigidarium*, the cold-water pool; the *tepidarium*, the central room containing smaller warm-water pools; and the *calidarium*, a circular hot-water pool in a domed rotunda. The central buildings also contained steam baths, dressing rooms, lounges, lecture halls, and *palaestrae* (exercise rooms). This whole core complex was surrounded by landscaped gardens bordered by secondary buildings that housed shops, restaurants, libraries, gymnasiums, and (perhaps) a stadium. The long side of the entire complex measured almost one-quarter of a mile. Beneath it all was a subterranean world of corridors (some wide enough to accommodate vehicles), storerooms, and heating chambers populated by slaves and stokers, for the halls and the water were heated by a system in which hot air was circulated through tubes and hollow bricks beneath the floors, in the walls,

and sometimes in the vaults. The water was plentifully supplied by an individual aqueduct.

This enormous dedication of human ingenuity in the service of human ease! For a negligible admission fee one could lounge for a whole day at the baths in surroundings of the greatest magnificence. In fact, the baths were so lavish, ornate, and luxurious that moralists of the time complained of their wasteful ostentation. Seneca, comparing his degenerate times with those of the heroic Scipio, who bathed in austerely simple surroundings, complained:

> But who in these days could bear to bathe in such a fashion? We think ourselves poor and mean if our walls are not resplendent with large and costly mirrors; if our marbles from Alexandria are not set off by mosaics of Numidian stone, if their borders are not faced over on all sides with difficult patterns, arranged in many colours like paintings; if our vaulted ceilings are not buried in glass; if our swimming pools are not lined with Thasian marble, once a rare and wonderful sight in any temple . . . What a vast number of statues, of columns that support nothing, but are built for decoration, merely in order to spend money! And what masses of water that fall crashing from level to level! We have become so luxurious that we will have nothing but precious stones to walk upon.

The baths were of course not merely that but social centers in which one could spend the whole day "sweetly doing nothing." And the baths were cultural centers as well, with their libraries, and with their profusion of magnificent statues. A large number of the abovementioned Roman copies after Greek originals were found in public baths, and a few of the most important in the Baths of Caracalla.

SCULPTURE AND MONUMENTAL RELIEF

Sculpture in the empire begins under the influence of Augustan Rome's admiration of Hellenic culture and of the emperor's apparent determination to base a cultural renewal of Rome on it. That the Hellenized glorification of the empire was politically motivated is doubtless true; we have seen in architecture how building was molded to the end of manifesting the imperial authority. But the imperial motivation had the esthetic consequence that work of the highest quality in all

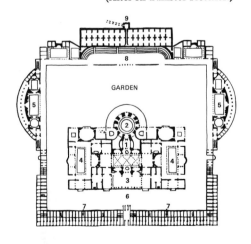

6-44 Tepidarium of the Baths of Caracalla, Rome, c. A.D. 215. (Restoration drawing by G. Abel Blonet.)

6-45 Plan of the Baths of Caracalla. (After Sir Banister Fletcher.)

1. Tepidarium
2. Calidarium
3. Frigidarium, with swimming pool
4. Open peristyles
5. Lecture rooms and libraries
6. Promenade
7. Shops
8. Stadium
9. Aqueduct and reservoirs

6-46 *Augustus of Primaporta*, c. 20 B.C. Marble, 6′ 8″ high. Vatican Museums, Rome.

the arts was produced bearing the seal, as it were, of the Hellenic spirit. The *Augustus of Primaporta* (FIG. 6-46), about 20 B.C., no less than the *Aeneid* of Vergil, is an example of the sedate, idealizing manner we recognize as "Augustan." The statue, which once stood in front of the imperial villa in Primaporta, about ten miles north of Rome, represents Augustus proclaiming a diplomatic victory to the people. The work is of the highest quality and is very likely by a Greek artist. At first glance it might appear to be in the realistic mode of Republican statues, but at the second we find it strongly idealized, made according to Polykleitan proportions and even reminiscent of the *Doryphoros* (FIG. 5-53), especially the walking pose. The reliefs on the emperor's breast plate are Roman in subject and refer to contemporaneous events—at least in the central theme: A Parthian returns a Roman standard to a Roman soldier. But these historical references are enframed by mythological and allegorical figures representing the sky god, the earth goddess, and the pacified provinces of Spain and Gaul. Together the figures symbolize blessings of the new Golden Age expected to come with the Augustan peace. They also place side by side the idealizing and realistic tendencies in Roman art that will alternate and intermingle throughout imperial times.

6-47 Ara Pacis Augustae, Rome, 13–9 B.C. Marble, approx. 35′ wide. (Cornice restored.)

The tendencies mingle in the sculptured figures of the Ara Pacis Augustae (Altar of the Augustan Peace) yet remain distinguishable (FIG. 6-47). Completed and dedicated in January, 9 B.C., to commemorate pacification of Spain and Gaul in 13 B.C., the altar can stand as a monument to the pacification of the whole empire in the Augustan years following the establishment of the new government in 27 B.C. The actual altar is raised upon an interior platform that is surrounded by a nearly square enclosure, 39 by 35½ feet. The exterior and interior surfaces of the enclosing walls are decorated with reliefs. On the interior walls are garlands suspended from bucrania (compare the frieze of the Temple of the Sibyl at Tivoli, FIG. 6-15). The exterior walls have a lower zone of a delicately carved, decorative acanthus leaf pattern arranged in spiral designs. The upper zone depicts a procession of men, women, and children and, on separate panels, allegorical subjects. The wall surfaces are framed by florid Corinthian pilasters in a composition reminiscent of the second style of Pompeian wall painting.

The *Tellus Relief* (FIG. 6-48) represents the ancient Roman earth mother, Tellus, flanked by personifications of the elements, their draperies blowing about them, seated in a fertile landscape against clouds simulated in low relief. Although we have come to think of the interest in the illusion of landscape as Roman, the poses, the style of the draperies, and the lateral placement of the figures in a single plane attest the Greek influence. The whole tableau celebrates the Augustan peace as the source of a new bounty of nature and the new richness and fertility of earth as the foundation of Roman wealth and power.

The *Procession* (FIG. 6-49) on the Ara Pacis, led by the emperor himself, may be intended to represent the actual solemnities when the Altar was dedicated. The historical particularity of the frieze is characteristic of the Roman feeling for the factual, especially as we have seen it expressed in the portrait bust, in a pragmatic architecture, and to a degree in landscape painting. This contrasts with the Greek practice of disguising historical events in the mythological, as in the great frieze of Pergamum, where a historical war between Greeks and Gauls becomes a struggle

6-48 *Tellus Relief*, panel from the Ara Pacis Augustae.

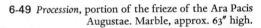

6-49 *Procession*, portion of the frieze of the Ara Pacis Augustae. Marble, approx. 63″ high.

between gods and giants. In some respects the Roman feeling for narrative bound to actual events resembles more the Assyrian approach than the Greek. Yet the style of the figures of the procession is Hellenizing, and may be directly inspired by the Panatheniac frieze of the Parthenon (FIGS. 5-44 and 5-45). In the Ara Pacis the procession moves in several files. Differences in distance are signified by differences in degree of relief—the nearer the figure, the higher the

relief. There is studied differentiation of individual persons; the heads are moderately idealized portraits; and there are "human interest" touches —for example, the clinging, restless children quieted by the adults. The overall demeanor is solemn, as befits the occasion, and we get the impression of a quiet concourse of participants behaving as they think proper to a quasireligious ceremony. The draperies, the quiet dignity, the ordered deployment within a shallow plane of space echo the older Classical style, and the Ara Pacis, with its blend of real and ideal, signifies the Augustan style and that of the empire in general.

The memorializing of actual events in monumental form finds striking expression in the imperial triumphal arch, one of the most popular types of commemorative monuments. Essentially, the triumphal arch is an ornamental version of a city gate moved to the center of the city to permit entry of triumphal processions into the forum. The Arch of Titus (FIG. 6-50), dated A.D. 81, is located at a point where the Via Sacra enters the Roman Forum. As a building type the triumphal arch exerted considerable influence on the architecture of the Renaissance. Closely related to the Colosseum arch order, it consists of a single arch flanked by massive piers to which the Corinthian order has been attached decoratively. Its typical superstructure, the *attic*, bears the commemorative inscription. Occasionally the flanking piers are also pierced by arches, produc-

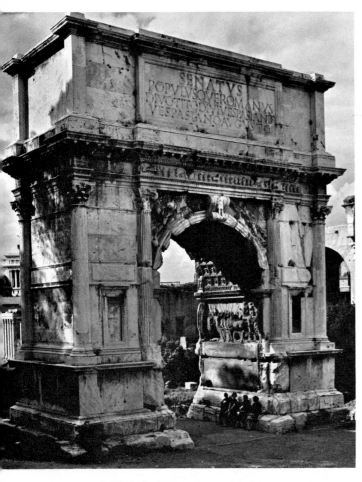

6-50 Arch of Titus, Rome, A.D. 81.

6-51 *Spoils from the Temple in Jerusalem*, relief from the Arch of Titus. Marble, approx. 7' high.

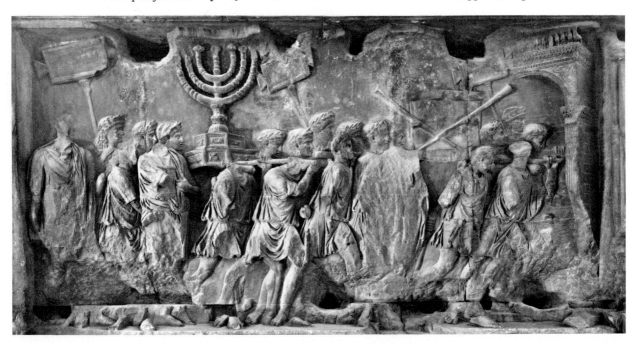

ing a triple arch like that of Constantine (FIG. 6-71). The walls of the passageway of the Arch of Titus are decorated with relief panels representing the triumphal return of Titus from the conquest of Jerusalem at the end of the Jewish Wars (A.D. 66–70). In later arches the sculptural decor is moved to the outside surfaces of the structure as in the Arch of Constantine.

One of the archway reliefs shows soldiers of the Roman army carrying spoils from the temple in Jerusalem, including the seven-branched candelabrum from the Holy of Holies (FIG. 6-51). The panel is much damaged. Beam holes in the upper part date from the Middle Ages, when the family of the Frangipani converted the arch into a private fortress and built a second story into the vault—only one of many examples of later indifference to the esthetic and historic value that recent times have discovered in the ruins of Rome. But enough remains to show that spatial effects aimed at in the Ara Pacis reach full development here. The illusion of movement is complete and convincing. The marching files press forward from the left background into the center foreground and disappear through the obliquely placed arch in the right background. The energy and swing of the column suggest a rapid marching cadence and the chant of triumph. The carving is extremely deep. The heads of the forward figures have been broken off, probably because they stood vulnerably free from the

block, emphasizing their different placement in space from the heads in low relief, which are intact. The deep relief produces dramatically strong shadows, the light and shade quickening the movement and strikingly suggesting the "momentary flash of a passing parade." The work brings to mind the experiments with light and space in Imperial painting and architecture.

Across the archway is represented the *Triumph of Titus* (FIG. 6-52), which has a slower pace, without the thrusting movement of the marching soldiers carrying the spoils from the temple and without the spatial experiments found there. The numerous layers of figures create an illusion of depth, and a bold attempt at representing the overlapping horses turning into the way, drawing the chariot of Titus, persuades us that the sculptor's intentions are alike in both panels. The close correspondence between the event as shown in the panels and a description of it by Josephus (Jewish soldier, statesman, and historian) points up the Roman bent for the factual:

Most of the spoils that were carried were heaped up indiscriminately, but more prominent than all the rest were those captured in the Temple at Jerusalem—a golden table weighing several hundredweight, and a lampstand similarly made of gold. . . . The central shaft was fixed to a base, and from it extended slender branches placed like the prongs of a trident, and with the end of each one forged into a lamp: these numbered seven, signi-

6-52 *Triumph of Titus*, relief from the Arch of Titus. Marble, approx. 7'10" high.

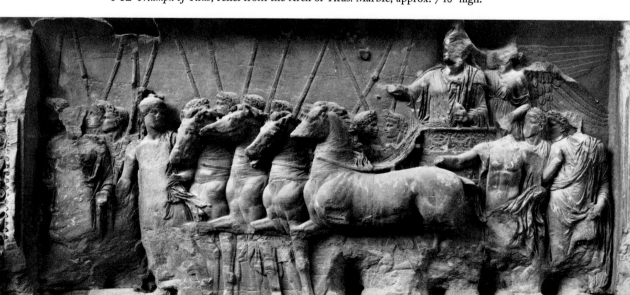

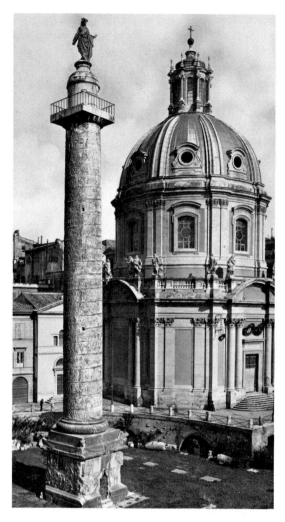

6-53 Column of Trajan, Rome, A.D. 113.

copied: As late as the nineteenth century, in commemoration of the victories of Napoleon, a Trajanic column was set up in the Place Vendôme in Paris. The original column is 128 feet high. It was once crowned by a statue of Trajan, which was lost in the Middle Ages and replaced by a statue of St. Peter in the sixteenth century. The square base served as Trajan's mausoleum, and his ashes were deposited there in a golden urn in A.D. 117. The column records Trajan's two successful campaigns against the Dacians, as a result of which the Roman dominion was extended across the Danube into what is now Hungary and Rumania. Under Trajan the limits of the empire reached their greatest expansion. The marble reliefs, in a 625-foot band that winds the height of the column, represent a continuous record of the campaigns, told in 150 separate episodes with literally thousands of figures. The band increases in width as it moves toward the top of the column (from thirty-six inches to fifty inches) for better visibility from the ground. But recognition of the upper subjects must have been a problem, although the column originally stood in a small courtyard surrounded by two-story buildings, from the upper story or roofs of which the topmost reliefs may have been recognizable.

The carving is of relatively low relief in order to reduce shadows to a minimum, since they would tend to impair the legibility of the work. This low relief constitutes a significant reduction in illusionistic depth; subsequent reliefs will continue to grow ever flatter. The sculptured narrative puts much emphasis on military architecture, fortifications, bridges, and so on, to show the Roman technical superiority over the barbarian foe. At the bottom appears the famous pontoon bridge built across the Danube by Apollodorus, with the Danube as a river god looking on in amazement at the achievement. On the fourth circuit of the column Trajan is shown speaking to his troops. The emperor's figure is seen many times throughout the narrative, appearing as a kind of major motif. The story of the campaigns is told throughout with objectivity; the enemy is not belittled and the Roman victories are hard won.

The Column of Trajan reliefs embody some features of great importance for the art of the Middle Ages. We have indicated one of them

fying the honour paid to that number by the Jews. After these was carried the Jewish Law, the last of the spoils. Next came a large group carrying images of Victory, all fashioned of ivory and gold. Behind them drove Vespasian first with Titus behind him: Domitian rode alongside, magnificently adorned himself, and with his horse a splendid sight.

The Column of Trajan, another kind of commemorative monument, dating from A.D. 113, stood in his forum before the temple of the Trajanic deities (FIGS. 6-53 and 6-54). The column, the work of Trajan's favorite architect and military engineer, APOLLODORUS of Damascus, was often

above, a flattening of relief, and have shown the functional reason for it—better visibility. But the sacrifice of the strong illusionism of the Arch of Titus reliefs, even of those of the Ara Pacis, may have another reason: a desire for completeness of narrative description that requires that a great number of actions be shown in a limited space. Thus *narrative* fact rather than *visual* fact is required, and truth to appearance ("illusionism," "realism"), to greater or less degree, can be sacrificed. A very singular and important sacrifice is made in the Column of Trajan compositions, and that is in the representation of space. In the Ara Pacis and the Arch of Titus the figures are represented as standing and moving on the same groundline, at the eye level of a presumed observer who occupies an imagined place on the same line; thus, all the heads are approximately on the same level. But the figures of the Column of Trajan are placed in rows one above the other, a device altogether different from the approximate perspective of illusionism. From a perspective viewpoint the figures and architecture are entirely haphazard in their arrangement; from the point of view of narrative they occur where the story demands. Often relative proportions are sacrificed: Soldiers are represented as large as the walls they attack, or, though not represented in this illustration, cavalrymen are as large as or larger than their horses. We can say that conventions of Medieval art already appear in the sculptures of the Column of Trajan.

These features were not immediately adopted. They appear in the somewhat later Column of Marcus Aurelius; but in a relief of Marcus Aurelius sacrificing (FIG. 6-55), one of three panels surviving from a triumphal arch dedicated to that emperor and carved about A.D. 180, the older illusionism persists, though not to the degree that we find it in the Arch of Titus. In this relief the procession was cut up into panels (each a part of a larger whole to be imagined by the viewer), since the narrative requirements are not so demanding. There is much of Hellenic Classicism in the poses of the figures and in their draperies. (The drapery of the figure at the left is an echo of the *Nike* of the balustrade of the Temple of Athena Nike on the Acropolis, shown in FIG. 5-52, and the head is an obvious reference to Phidias' Olympian Zeus, FIG. 5-34). Hadrian,

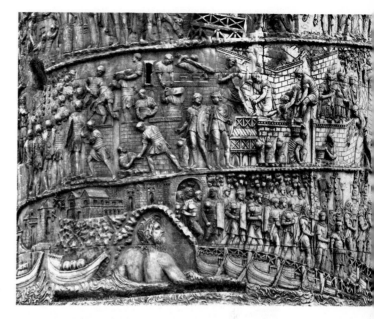

6-54 Detail of the two lowest bands of the Column of Trajan. Marble, bands approx. 36″ high.

6-55 *Marcus Aurelius Sacrificing,* from an arch of Marcus Aurelius, late second century A.D. Marble, approx. $10\frac{1}{2}″$ high. Palazzo dei Conservatori, Rome.

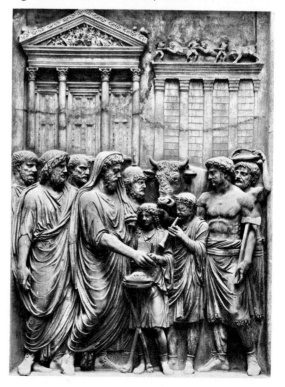

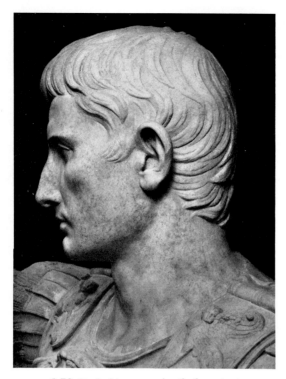

6-56 *Head of Augustus*, detail of FIG. 6-46.

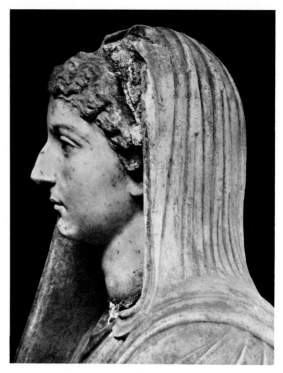

6-57 *Livia*, wife of Augustus, *c.* A.D. 20. Marble, head approx. 15″ high. Antiquario, Pompeii.

Antoninus Pius, and Marcus Aurelius were all Hellenophiles, and it is in their reigns that perhaps the last powerful influence of Classical Greece was felt. The figures in the relief are cut to ideal proportions, but a considerable Roman realism appears in the details and in such illusionistic devices as the perspective of the background architecture and the varying depth of relief to show distance. The bland composure of the faces of the Ara Pacis does not appear here; the times have changed, the end of the Golden Age has come. A kind of brooding solemnity prevails as the grave philosopher-emperor—the sculptor gives us a portrait likeness—prepares the sacrifice that may produce omens of a troubled future for the empire.

PORTRAIT SCULPTURE

Two portrait busts from Republican times have already shown us the Roman aptitude for and skill in this art, an expression of the now familiar Roman instinct for the factual. It is scarcely an accident that the historical reliefs just discussed have portrait figures in them. Literally thousands of portrait busts have been found from the times of the republic and of the empire, and it must be conceded that the best are evidence of the important contribution of the Romans to portrait art. Two tendencies of style determine the production of portrait sculpture—the verism of the republic, and the Hellenizing idealism of the empire; in the later period the tendencies alternate and sometimes converge. It is significant that members of the lower social classes generally are portrayed realistically in all periods, while official portraits (of the ruling class, that is) tend to shift between realism and idealism, depending in part upon the general style of the period or perhaps the preference of the sitters or both.

A portrait of the emperor Augustus (FIG. 6-56), a detail of the Primaporta figure (FIG. 6-46), which can be profitably compared with earlier portraits from the republic (FIGS. 6-12 and 6-13), is very subtly idealized without any apparent loss of likeness. The hair, adhering closely to the skull,

is reminiscent of fifth-century B.C. Greek style and reflects Augustus' Classical taste prevailing over Hellenistic realism. We have met the Classicism of the Augustan age in the Ara Pacis and have pointed out that Vergil's *Aeneid*, deliberately imitating Homer and commissioned by Augustus himself, reveals in its form the same Classical spirit. Livia, the second wife of Augustus and mother of the emperor Tiberius, is shown in a portrait bust as the comely, tactful, and elegant woman she is believed to have been (FIG. 6-57). There is the same Augustan idealization and the same retention of the likeness. The lifelike quality is enhanced by effective use of color, much of which is preserved in the hair, eyes, and lips.

The emperor Vespasian, succeeding Nero, the last of the Julio-Claudian line, which had begun with Augustus, reigned from A.D. 69 to 79. His portrait bust (FIG. 6-58) forcefully reveals the veteran general who had fought successfully in all parts of the empire. Vespasian was a man of simple origin and simple tastes who desired to return to republican simplicity after Nero's extravagant misrule. He was a good administrator —honest, shrewd, and earthily humorous, all of which qualities speak from his portrait. The artist has attempted no flattery; quite possibly Vespasian himself discouraged him from idealizing overmuch, for he preferred to have the blunt, rugged aspect of the soldier. From the portrait we can understand the active man whose care was restoration of the empire and who is reported to have said on his deathbed: "An emperor should die standing." The portrait, while a little subtler in characterization, is almost republican in its directness.

The bust of a lady from the Flavian period (FIG. 6-59)—embracing the reigns of Vespasian and his sons, Titus and Domitian—is a departure from the usually rather stern portraits of Roman women. It is a rare masterpiece in its inimitable union of sensitive beauty, noble elegance, and lucid intelligence. The elaborate coiffure stands in striking textural contrast to the delicate, softly modeled features, and the technique and effort to reproduce the luminosity and glow of actual flesh recalls the art of Praxiteles. This truly regal work, exemplar of Roman portrait art at its height, can be instructively compared with the head of Queen Nefertiti (PLATE 3-2),

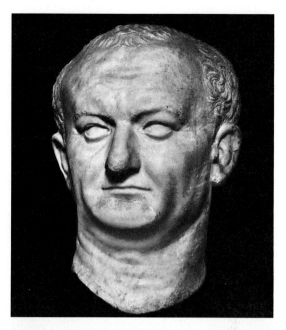

6-58 *Vespasian, c.* A.D. 75. Marble, life-size. Museo Nazionale Romano, Rome.

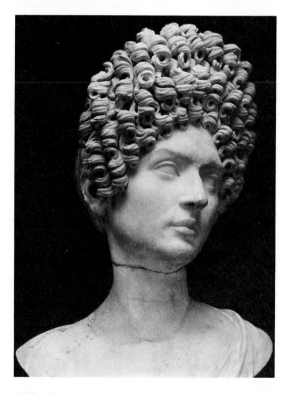

6-59 Above: *Portrait of a Lady, c.* A.D. 90. Marble, life-size. Musei Capitolini, Rome.

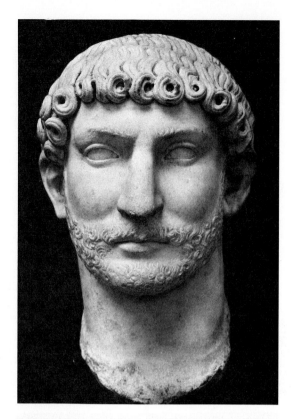

6-60 *Hadrian*, c. A.D. 120. Marble, approx. 16″ high. Museo Ostiense, Ostia.

done in the subtle Amarna style of Egypt.

Great persons of ambivalent qualities are particularly interesting to us, and this makes their portraits—such as that of Pompey (FIG. 6-13)—more interesting perhaps than those of persons of more uniform character. This quality of ambivalence was especially true of the emperor Hadrian (FIG. 6-60). We can approach his portrait informed by the account given of his personality by his ancient biographer, Spartianus. Hadrian, beyond all the other emperors a lover of Greek art and culture and himself a skillful artist and architect, poet, scholar, and writer, is thus described:

> He was grave and gay, affable and dignified, cruel and gentle, mean and generous, eager for fame yet not vain, impulsive and cautious, secretive and open. He hated eminent qualities in others, but gathered round him the most distinguished men of the state; at one time affectionate towards his friends, at another he mistrusted and put them to death. In fact he was only consistent in his inconsistency [*semper in omnibus varius*]. Al-

though he endeavored to win the popular favor, he was more feared than loved. A man of unnatural passions and grossly superstitious, he was an ardent lover of nature. But, with all his faults, he devoted himself so indefatigably to the service of the state, that the period of his reign could be characterized as a "golden age."

We might bring also to the contemplation of his portrait the poem, long famous, that he wrote to his soul at the end of his life:

> Charming, fleeting little soul,
> My body's guest and comrade,
> Where now will you go
> Naked, pallid, unmoving
> Never again to play?

In this portrait Hadrian affects the Greek coiffure, in form much like the early Classical ringlets of the *Apollo* from the Temple of Zeus at Olympia (FIG. 5-35). He adopts also the Greek beard, abandoning the age-old tradition of the clean-shaven face. (This may have been inspired by portraits of Pericles.) In any event, from now on most Roman emperors will be represented bearded. The head is idealized, but with restraint, the features a little regularized and retouched, perhaps, but not so as to interfere with the likeness. A certain ambiguity and inscrutability shadows the face. But, when we know a little of him, we are prepared for this.

The last emperor of the great Imperial age that had begun with Augustus was the Stoic Marcus Aurelius. We have touched on his philosophy in looking at the Faiyum portrait of a man from his time, a man whose serenely gentle and reflective face manifests the emperor's philosophy. A great equestrian bronze portrait statue of Marcus Aurelius (FIG. 6-61) has survived from the ancient world, unique in that it *did* survive, for there are no other examples of what must have been a statue type popular with the Roman emperors. (Medieval Christians probably melted the statues down for their bronze and because they were impious images from the pagan, demonic world of the Caesars. It is thought that the Christians mistakenly took the *Marcus Aurelius* statue for that of the first Christian emperor, Constantine, and that that is why it escaped destruction.) The emperor, whom we have seen earlier in his role of head priest, *pontifex maximus*,

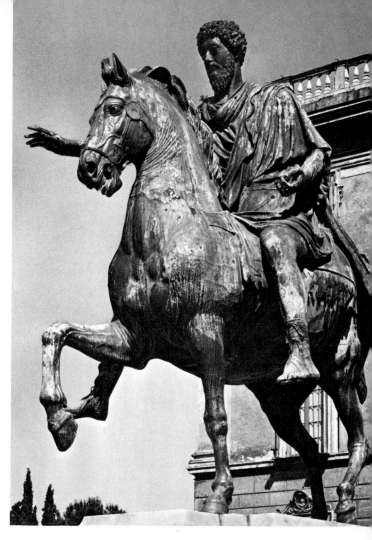

6-61 Equestrian statue of Marcus Aurelius, *c.* A.D. 165. Bronze, over life-size. Capitoline Hill, Rome.

with his toga drawn over his head, is portrayed here exercising his office as commander of the legions, perhaps passing before the people. His gesture here, magisterial, benignly authoritative, much like a later papal blessing, conveys at once the awesome and universal significance of the Roman *imperium*, the almost godlike presiding of the emperor over the whole world. Yet, at closer view, we see the same features as in the sacrifice panel—those of a man calmly aloof, meditative, a little resigned. The magnificent, high-stepping charger, the war horse mettlesome and impatient with the tameness of the parade, breathes hotly through dilated nostrils. This superb bronze was the inspiration and sometimes the despair of the sculptors of the Late Renaissance. It stands today on the Capitoline Hill, the authentic ancient centerpiece of Michelangelo's great architectural design (see Chapter Thirteen), representing as does no other single object the lost authority of empire.

After Marcus Aurelius the downward course of the empire became precipitous, though not at once; Septimus Severus held it level for a while.

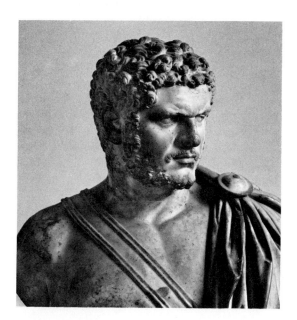

6-62 *Caracalla, c.* A.D. 215. Marble, life-size. Vatican Museums, Rome.

His son Caracalla (FIG. 6-62), under whom the great baths named after him went toward completion, was a brutal man, murderer of his own brother. He reigned briefly between A.D. 211 and 217, and his murder grieved no one. Gibbon writes of him: "Caracalla was the common enemy of mankind." To render his violent traits, the sculptor had to return to realism. We find a burly, suspicious, almost snarling man, more a cut-throat than an emperor, a man who could scarcely be more the opposite of Marcus Aurelius. Significantly for what was to follow—the military anarchy of the third century, when the "barrack emperors" were set up (and pulled down) by the army—Caracalla pursued the tyrant's rule that if one has the loyalty of the army, one need not consider the people. His soldiers, however, were not wary enough to protect him from the dagger of an assassin, and his death was the model death of the tyrant, in form repeated again and again

throughout the terrible third century. "Such," writes Gibbon, "was the end of a monster who disgraced human nature." Yet Michelangelo was later to base his noble bust of Brutus on this bust of Caracalla.

Internal unrest combined with attacks on frontiers by the new Sassanian line of Persian kings in the east and German tribes in the north brought the empire to the verge of collapse. In the space of fifty years some twenty of the barrack emperors were exalted and then assassinated by factions of the army. This created anguish and foreboding throughout the empire, curiously reflected in numerous portraits like that of one of the barrack emperors himself, Philip the Arab (FIG. 6-63). Philip became emperor after having his predecessor, Gordianus, executed. In considering his portrait it will be useful to know something of the close of his career. An adventurer himself, he knew that he was surrounded by adventurers—especially in the army—who were ready to follow his example. Faced with a revolt, Philip appointed a brave and intelligent aristocrat, Decius, to put it down and to calm the army. The army accepted Decius as its leader on condition that he agree to depose Philip or be put to death himself. Decius then led the best of the army against Philip, who was slain; Decius became emperor. The portrait thus shows the face of a man who knows he is utterly without security. Fear, distrust, suspicion work the face into a mask of guilt and anxiety. The brow is furrowed. The deep-set eyes shift sideways. The eye pupils are carved, an innovation that focuses on the psychic state. The hair is cropped short, the beard stubbly. The short, nervous chisel strokes adapt to the nervous mood. (In the works of later sculptors they will become increasingly abrupt and schematic, leading to the geometric patterning of the fourth century.) But it is the face, with its terrible tensions, that was rarely seen before in the history of art. From the Archaic masks we come at last, in the third century A.D., to a face so "modern" in what it reflects of trouble that we experience a shock of recognition. Both the ideal and the real in Roman sculpture are now replaced by something new—expression—wherein the artist is concerned first of all with expressing an emotional state—either his subject's or his own, and perhaps both.

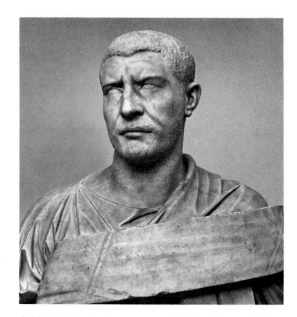

6-63 *Philip the Arab,* A.D. 244–49. Marble, life-size. Vatican Museums, Rome.

The Late Empire

The anarchy of the third century—when at one time as many as eighteen claimants struggled for the throne and it seemed as if the empire would be divided into a number of small, weak states—was brought to an end by a vigorous leader, Diocletian, in A.D. 285. Diocletian saw the impossibility of ruling the vast empire alone, what with the continual German and Persian attacks in the north and east and countless revolts in the provinces. He restored the political order by dividing authority among four persons, the *tetrarchs,* including himself as prime mover. Diocletian appointed a co-ruler called, like himself, "augustus," and each of the two "augusti" then adopted an assistant of slightly lower rank, the "caesar." One augustus and one caesar ruled in the east, and the other pair in the west. Though political control was restored, a fatal precedent was set: the division of authority within the empire.

Under Constantine, who did away with Diocletian's system and ruled alone, the practice was begun of dividing the empire, like personal property, among the emperor's sons—a crippling, divisive custom that was to last into the Middle Ages. Even more divisive was Constantine's founding of a city named after him (Constan-

tinople, now Istanbul, on the site of the ancient Greek city of Byzantium), which led inevitably to the decline of the city of Rome and the shift of imperial emphasis to the east. Byzantium gives its name to the later civilization of the eastern Roman empire.

After the reign of Theodosius, at the end of the fourth century, the empire was irreparably divided, though the emperors of the east, at Constantinople, continued for centuries to claim the west. These claims were in vain, for in the fifth century the barbarians took power in the West—the Ostrogoths in Italy, the Vandals in Africa, the Visigoths in Spain, the Franks and Burgundians in Gaul, the Angles and Saxons in Britain. These Romano-Germanic petty kingdoms succeeded to the once centralized and almost universal power of Rome and became the predecessors of the nations of modern Europe. The eastern half of the empire lived on as the Byzantine empire for a thousand years, until the conquest of Constantinople by the Turks in 1453.

ARCHITECTURE

Developments in architecture powerfully express the ebbing authority of the Roman empire. In the days of Augustus and Trajan the "walls" of the empire had been the might of the legions on its remotest borders; behind the bulwark of the legions a great empire could rest secure. But late in the third century the emperor Aurelian was forced by circumstances to girdle the city of Rome itself with walls, turning it into a fortress; Rome became what it had been at the start, merely a walled city, now dwindling into the ghost of an empire. Aurelian's insecurity was shared by Diocletian, who, unlike Tiberius in the first century B.C., could not afford to retire to the undefended paradise of Capri but had built for his retirement a well-fortified palace on the Dalmatian coast at Spalato (modern Split, in Yugoslavia), about A.D. 300 (FIG. 6-64). The complex, covering about ten acres, is laid out like a Roman colonial city. The plan is almost identical with that of Timgad (FIG. 6-35), which in turn was planned, as we have seen, like an army camp. The relation can be seen in the peristyle before the palace entrance, which corresponds to the forum at Timgad.

A feature of great importance for the history of Medieval architecture appears in the peristyle of Diocletian's palace (FIG. 6-65). The pediment at the far end is broken through by an arch that carries with it the entablature; or perhaps it should be described as an entablature that suddenly arches itself into the face of the pediment. The feature of the broken pediment had appeared earlier, mostly in the eastern provinces of the empire—for example, in the façade of the great temples at Baalbek, in Syria. It is a quite un-Classical device—hardly imaginable in a building like the Parthenon—and represents a transitional stage between the Classical, column-supported, horizontal entablature and the springing of arches directly from column capitals, as is the case in the flanking colonnades of this same peristyle. We are here in the process of change from the *trabeated* (post-and-lintel) architecture of Greco-Roman antiquity (and earlier) to the *arcuated* (arch-column) architecture of the Middle Ages. There were early anticipations of this novel feature, but the arcade at Spalato is the first appearance of it in a perfected form and on a grand scale. It is interesting to observe its gradual emergence from the Roman arch order (FIG. 6-66) and the Roman architect's reluctance to give up the conventional three-part division of the entablature even when it had become only a blocklike fragment, as in the capital from the Baths of Caracalla. Later, Byzantine architects will retain the entablature-block, but will rid it of the old

6-64 Palace of Diocletian, Spalato (Split), A.D. 300–05. (Reconstruction by E. Hebrard.)

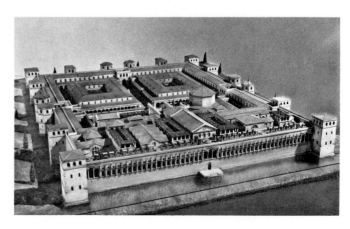

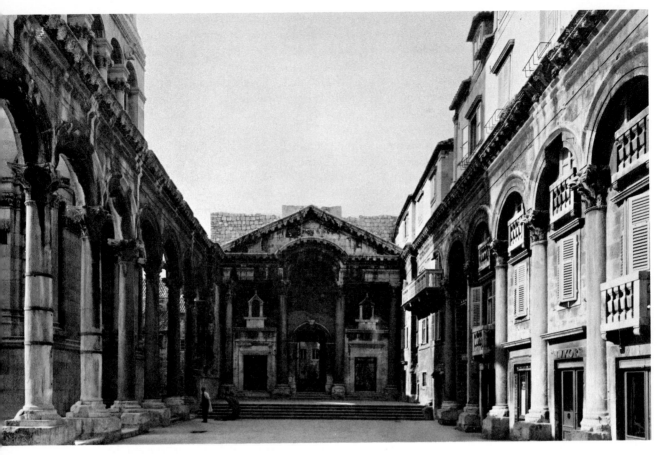

6-65 Peristyle court, palace of Diocletian.

6-66 Development of arcuated architecture from trabeated architecture.
(After Kimball and Edgell.)

1	2	3	4	5	6
COLOSSEUM	PANTHEON	BATHS OF	SPALATO	SPALATO	SPALATO
Roman architectural	Central niche	CARACALLA	Central arch	Porta Aurea	Street arcade
order (*c.* AD 70)	(*c.* AD 125)	(*c.* AD 215)	(*c.* AD 300)		

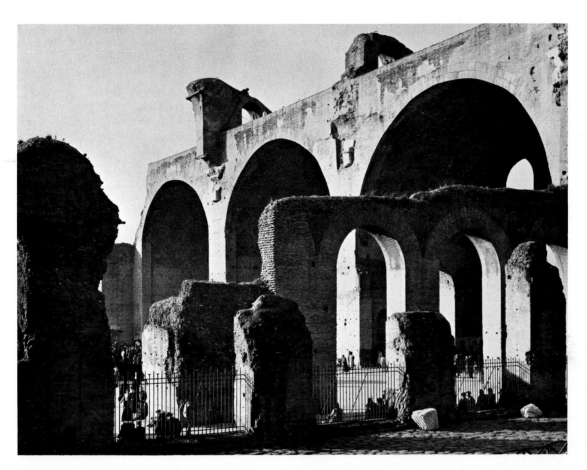

6-67 Basilica of Constantine, Rome, *c.* A.D. 310–20.

6-68 Reconstruction of the Basilica of Constantine.

Classical features, geometrizing it into a flat-sided, trapezoidal "impost" block (FIG. 7-29).

Although the center of empire was moved by Constantine to his new city on the site of ancient Byzantium, he completed some important building projects prior to leaving Rome. One of these was the vast basilica begun between 306 and 310 by Maxentius, rival of Constantine, and finished by Constantine after 313 (FIGS. 6-67 and 6-68). All that remains of the building are three barrel-vaulted bays of the north aisle and brick-faced concrete walls twenty feet thick supporting the coffered vaults. The interior, like that of the Baths of Caracalla, was richly marbled and stuccoed. The ruins are most impressive by virtue of their size and mass yet represent only a small part of the original structure, which measured 300 by 215 feet and had a groin-vaulted central nave

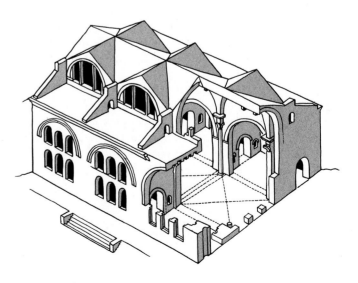

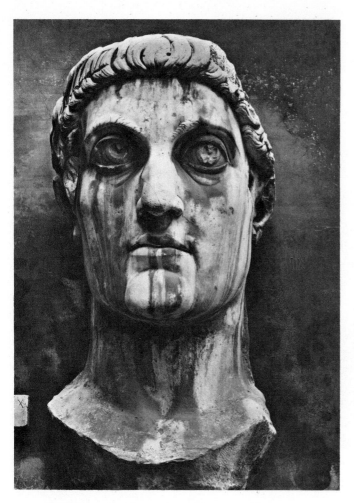

6-69 *Constantine the Great*, c. A.D. 330. Marble, approx. 8′ 6″ high. Palazzo dei Conservatori, Rome.

Exemplar of an architecture of space, it is designed on a grand, imperial scale—spacious, fully illuminated, uninterrupted by rows of vertical supports, and constructed of a highly malleable, versatile, fireproof material. In this it fulfills the requirements of architecture in periods of high civilization; not for 800 years will they be so artfully fulfilled again.

SCULPTURE AND MONUMENTAL RELEIF

In the western apse of the Basilica of Constantine was a colossal statue of the emperor, a seated figure some thirty feet high, the head of which has been preserved (FIG. 6-69). The figure was composed of a brick core, a wooden torso covered with bronze, and head and limbs of marble. The head alone is 8½ feet high and weighs over eight tons. The characteristics of the earlier busts we have described, in which the real and the ideal alternate or blend, are here no longer dominant. Rather we have the onset of traits familiar in the earlier, Archaic period: simplification of detail, with a regularizing of the features and a flattening that make of the face a rigid mask uncompromisingly frontal in aspect. The eyes become enormously large in proportion to the rest of the features, though in the Constantine head they still turn slightly to the side and upward as in certain third-century portraits like that of Philip the Arab (FIG. 6-63). Those unchanging qualities of the permanent form, which we have seen in Egypt and Mesopotamia—particularly in the representation of kings—once more make their appearance. The personality of the emperor is lost in the immense image of eternal authority. It is his authority, not his personality or his psychic state, that the sculptor exhibits. The colossal size, the Archaic rigidities, the eyes directed at no thing or person of this world—all combine to make a formula of overwhelming power appropriate to the exalted position of Constantine as absolute despot, which, by the early fourth century, he had certainly become. It is not surprising that the first of the Christian emperors, in authority the European equivalent of a Rameses II, should be embodied in colossal

rising 114 feet. The reconstruction (FIG. 6-68) shows a groin vault (over the central nave) that permitted lighting of the interior through the ends of the cross vaults, which were left open in an adaptation of the clerestory manner. Buttresses reinforce the vault (where the groins join vertical supports) and channel part of the pressures exerted by the weight of the vault across the aisles and into the outside walls. Remains of the springing of the central vault and of buttresses can be seen in FIG. 6-67. This structural system prefigures that of the flying buttress, developed by Gothic architects. As the last great building of the ancient world, the Basilica of Constantine is a monument to the ingenuity of Roman architects.

form like the giant statues of the Egyptian king at Luxor and (formerly) Abu Simbel.

The profound changes in style that occur at an accelerated pace in the fourth century, introducing the epoch of Medieval art, can be seen in the group called the *Tetrarchs*, dating from about A.D. 305 (FIG. 6-70). Although it is an earlier work than the portrait of Constantine, it reflects much more strongly the trend toward Archaism. Carved from porphyry in one of the eastern provinces (perhaps Egypt), the group represents the four co-rulers of the empire: Diocletian and Maximian (the augusti) and Galerius and Constantius "Chlorus," father of Constantine (the caesars). They embrace each other to symbolize their hoped-for but not realized unity. They seem, even as they embrace, to be huddled in fear and foreboding, facing some impending disaster, in an expression of the already noted prevalent anxiety of the age. Classical features have disappeared; the figures are ill proportioned, with large heads on squat bodies, giving them a gnomelike appearance. The drapery is schematic, the bodies shapeless. Seven hundred years of Greek and Roman idealism and naturalism here terminate. No portrait likenesses are tried; the masklike faces are the same face in quadruplicate. Individuality and personality already belong to the past.

The waning creative power and technical skill of Rome in the west can be seen in the Arch of Constantine (A.D. 312–15) in the city of Rome (FIG. 6-71). It is the last great triumphal arch preserved in the declining city. Dedicated to Constantine by the now figurehead Senate, it commemorates the victory over his rival Maxentius, a victory which made him the absolute monarch of the Roman empire. But the occasion produced no corresponding stimulus for the imagination of his builders. The design of the arch is copied from that of the earlier Arch of Septimius Severus, of the early third century, and most of its decorative sculpture is taken from the monuments of rulers like Trajan, Hadrian, and Marcus Aurelius.

Beneath two Hadrianic medallions are reliefs belonging to Constantine's own period (FIGS. 6-72 and 6-73), which give us an opportunity to estimate the degree of change from the style of the Early Imperial age to a new style that it is not

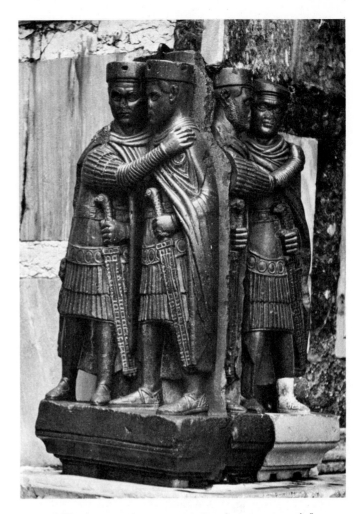

6-70 *The Tetrarchs, c.* A.D. 305. Porphyry, approx. 4′ 3″ high. Piazza San Marco, Venice.

inappropriate to call Medieval. Constantine, surrounded by his entourage, stands at the center of a rostrum, addressing the people. His central position corresponds here to the frontality of his colossal statue and expresses a new, rigid formality of composition that will more and more depend upon fixed positions of figures rather than representation of action. The figures are nonclassical in their lack of proportionality; in this respect they are like the *Tetrarchs*. Moreover, they do not move on any principle of classical-naturalistic movement but rather with the mechanical and repeated stances and gestures of puppets. The relief is flattened back into the block, the forms no longer fully modeled, the details

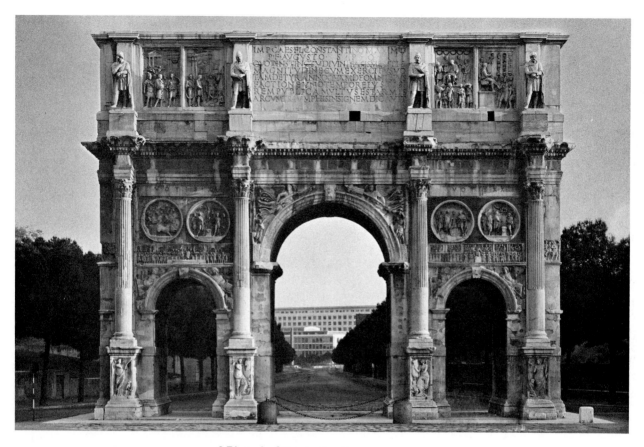

6-71 Arch of Constantine, Rome, A.D. 312–15.

incised. The lines of figures are superposed (a device seen in the Column of Trajan); the spatial arrangement is, as noted, not casual, but a careful head-counting lineup. The gestures are few and, like the uniform heads, reproduced again and again. We have not so much a historical narrative of action as the labeling of an event frozen into a tableau; thus, the ordered groups could quickly be read and labeled as "crowd," "emperor," "servants of the emperor," the artist desiring to include all the essential participants without the ambiguity that can accompany description of particulars. The latter have been reduced to the absolute minimum, their place having been taken by formal placement and repetition of attitude and gesture.

The Archaizing of Greek and Roman figurative art in the Constantinian reliefs reflects a trans-formation in the way the peoples of the late Roman world interpret the structure of appearance. Underlying this change in interpretation is a mighty spiritual change—the assimilation of Christianity into Greco-Roman civilization, a phenomenon so far-reaching in its influence as to separate the psychologies of two millennia, that of Greece-Rome and that of Medieval Christianity. Now, in the words of the medievalist Ferdinand Lot:

The gods are dead, killed by the one God whose commandments impose a rule of life so new that henceforth this world will assume a secondary role; the sage imbued with "the new Philosophy" will place the object of his desires in the sphere of the world beyond. Between the men of the new and those of the ancient times there will no longer be a thought in common.

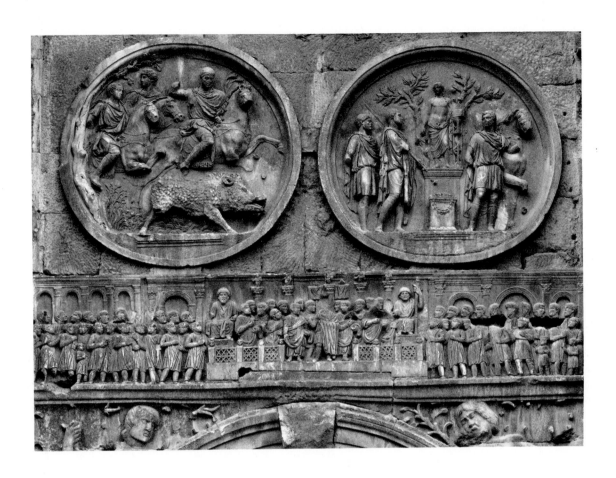

6-72 Above: Reliefs from the Arch of Constantine: medallions, A.D. 117–38; frieze, early fourth century A.D. Marble, frieze approx. 40″ high.

6-73 Left: Detail of the frieze shown in FIG. 6–72.

Chapter Seven

Early Christian,
Byzantine,
and Islamic Art

EUROPE AND THE NEAR EAST ABOUT A.D. 900

ATLANTIC
OCEAN

Ravenna

Rome

BLACK SEA

Constantinople

CASPIAN SEA

ARAL
SEA

Amu Darya

Toledo

Cordoba
Granada

M E D I T E R R A N E A N S E A

Tunis

Tripoli

Alexandria

Cairo

Aleppo

Damascus

Jerusalem

Mshatta

Tigris

Euphrates

Samarra

Baghdad

Samarkand

Indus

Nile

RED SEA

Medina

Mecca

ARABIAN SEA

	Carolingian Empire
	Byzantine Empire
	Moslem World

0 500 1000 miles

CHRISTIANITY, like many Eastern cults, was a peculiarly persuasive religion of salvation. Its immense success in making converts among the teeming populations of the great imperial cities brought it to the attention of the Roman authorities. Because Christians refused to acknowledge the state religion, which was the cult of the emperor, and because they refused to participate in its rather perfunctory rites, they were regarded as politically subversive and were bitterly persecuted. Tacitus, reflecting the attitudes of his time, regarded the Christians as believers in a degenerate doctrine and practitioners of obscene and perverse rites that, he felt, were typical of Eastern cults.

The deep misunderstanding between pagan Roman and Christian Roman can symbolize the even more profound contrast in their world views; indeed, to repeat Ferdinand Lot: "Between the men of the new and those of the ancient times there will no longer be a thought in common." The fundamental opposition between the Eastern and Western spirit proclaimed in Zechariah—"when I have raised up thy sons, O Zion, against thy sons, O Greece . . ." (LX.13)—rings angrily once again in the words of the early

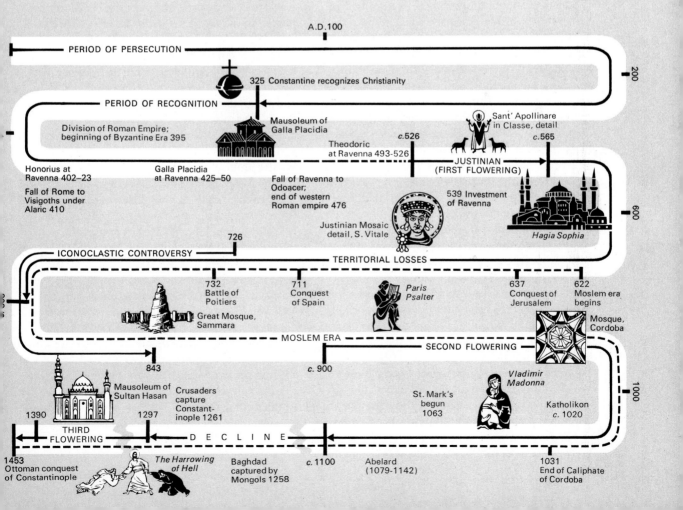

A.D. 100

PERIOD OF PERSECUTION

200

325 Constantine recognizes Christianity

PERIOD OF RECOGNITION

Division of Roman Empire; beginning of Byzantine Era 395

Mausoleum of Galla Placidia

Theodoric at Ravenna 493–526

c. 526

Sant' Apollinare in Classe, detail

c. 565

JUSTINIAN (FIRST FLOWERING)

Honorius at Ravenna 402–23

Galla Placidia at Ravenna 425–50

Fall of Ravenna to Odoacer; end of western Roman empire 476

539 Investment of Ravenna

Fall of Rome to Visigoths under Alaric 410

Justinian Mosaic detail, S. Vitale

Hagia Sophia

600

726

ICONOCLASTIC CONTROVERSY

TERRITORIAL LOSSES

732 Battle of Poitiers

711 Conquest of Spain

Paris Psalter

637 Conquest of Jerusalem

622 Moslem era begins

Great Mosque, Sammara

Mosque, Cordoba

MOSLEM ERA

SECOND FLOWERING

843

c. 900

Vladimir Madonna

1000

Mausoleum of Sultan Hasan

Crusaders capture Constantinople 1261

St. Mark's begun 1063

Katholikon c. 1020

1390

1297

THIRD FLOWERING

DECLINE

1453 Ottoman conquest of Constantinople

The Harrowing of Hell

Baghdad captured by Mongols 1258

c. 1100

Abelard (1079-1142)

1031 End of Caliphate of Cordoba

Christian Tertullian: *Quid Athenae Hierosolymis!* —"What is there in common between Athens and Jerusalem? What between the Academy [of Plato] and the Church?" While the unmitigated hostility of Tertullian was by no means shared by all Christians, an antagonism between the ancient Semitic East and the Hellenic world that had for a while conquered it was inevitable and could not be suppressed. Greek naturalism and rationalism had become integral to the western Roman world and at the same time had become changed through contact with the old civilizations of the Middle East. The mystery cults, with their suspiciously secret rites, their savior gods, their redemptive messages and occult sciences, their solar and fertility myths, drew heavily upon Egypt, Babylon, Persia, and even India; and, although they borrowed a good deal of the intellectual apparatus of Hellenic philosophy, they mysticized it and made of it a kind of magical formulary and a *gnosis*, the privileged knowledge of only an initiated few.

Although Christianity, based as it was on Jewish teaching and tradition, differed radically from many of the crude cults with which Romans like Tacitus confused it, it joined with those cults in the long, vast historical reaction against the Hellenized West—both its world view and that material manifestation of it, the increasingly oppressive Roman empire. To Christians, the empire, with its exactions, cruelties, materialism, wars, and false gods, became *regnum Caesaris regnum Diaboli*—"the kingdom of Caesar, the kingdom of the Devil." But the empire would be inherited by the Christians in A.D. 325 when Constantine recognized Christianity and made it the official religion of the state.

In the eighteenth century, Gibbon, in his monumental history, *The Decline and Fall of the Roman Empire*, accused Christianity of being the principal cause of that—to his times—calamity. We do not now believe that Christianity had that role, but as early as the fifth century A.D., Augustine wrote his *City of God* to defend the Church against the pagan accusation that the sack of the city of Rome (in A.D. 410 by the Goths) was a punishment sent by the ancient gods upon the city because it had become Christian. The disintegration of the empire, beginning with its nominal separation into the western and eastern empires toward the end of the third century, was a phenomenon of considerable complexity and cannot be laid at the door of the Christians, nor entirely at that of the "barbarians"—those Celtic, Germanic, Slavic, and other peoples who had been pressing slowly into the Mediterranean world for thousands of years. (We have met their predecessors in the great migrations that disturbed Egypt, Mesopotamia, Asia Minor, Crete, and Greece.)

At any rate, from the end of the third century on, there was a slow, sometimes hardly perceptible takeover of the empire, not indeed the unified empire, but its already fragmented remains. The spiritual and ideological conquest made by the Christians in the politically consequential form of mass conversion paralleled the gradual infiltration and settlement by the "barbarians," who, for that matter, had long been present in the administrative and military structure as well as in recognized possession of imperial territories. The subsequent actions of these "barbarians," Christianized and in control of the western empire by the end of the fifth century, make up the history of the Middle Ages in the west. The eastern empire, actually but not officially severed from the western by the beginning of the fifth century, goes its own continuous way as the Byzantine empire, reverting to its Greek language and traditions, which, to be sure, had become much "Orientalized." The Byzantine world was a kind of protraction of the life of the late empire and the Early Christian culture that filled it. With a quite Oriental conservatism, which reminds us somewhat of the ancient Near Eastern civilizations, the Byzantine empire remains Greek, orthodox, unchanging for a thousand years, preserving the forms of its origin, oblivious to and isolated from the new.

In the seventh century, Islam, a new spiritual force, erupted from Arabia and swept across the Near East and the southern Mediterranean world with amazing speed. Islam created a new civilization that rivaled Christianity and would have far-ranging influence in medieval Europe. Arabic translations of Aristotle and other Greek writers of antiquity were eagerly studied by Christian scholars of the twelfth and thirteenth centuries; Arabic love lyrics and poetic descriptions of nature inspired the early French troubadours; Arab

scholars laid the foundations of arithmetic and algebra as they are still taught in our schools, and their contributions to astronomy, medicine, and the natural sciences have made a lasting impression in the Western world. While Islamic art may not properly fall within the scope of Western art in the more limited sense, it nevertheless deserves our attention at this point in our survey, particularly since its early monuments share with those of Early Christian and Byzantine art derivation from earlier Near Eastern and Mediterranean artistic traditions. Most early monuments of Islamic art thus belong to the succession of late Roman, early Byzantine, and Iranian art, although different social and religious needs soon transformed similar prototypes into forms quite different from those they were to take in the Christian world.

EARLY CHRISTIAN ART

The style we call Early Christian we could as accurately call Late Roman, or, as art-historical usage has it, Late Antique. Christian works are distinguished from pagan only by subject, not by style. After all, the Christians of the time were as much "Roman" as the pagans; they were trained in the same crafts, were brought up in the same environment, and spoke the same language. The Christian church itself, both in its organization and its philosophy, owed much to the Greco-Roman structure of life; and Early Christian art shows simple transformation of pagan themes into Christian and the freest kind of borrowing of pagan motifs and manners. Hybrid forms are produced throughout the Christianized late empire in the greatest profusion and with the greatest intermingling of regional styles, making it almost impossible to recognize any one style—or even half a dozen—that could definitely be called Early Christian or that could serve as an exclusive exemplar of what we mean by Early Christian.

What happens in the plastic arts is a kind of "denaturing" of Greco-Roman naturalism, something we have seen beginning as early as the Column of Trajan and well advanced in the reliefs from the Arch of Constantine. Archaizing modes supervene upon the old naturalism, and things come to look less and less like the Greco-Roman prototypes from which ultimately they derive. This denaturing process, variously influenced by barbarian styles, continues well into the western Medieval period. It should by no means be thought merely the negation of the Greco-Roman style, or a clumsy botching of it by men who had lost the sense of it and the necessary manual skill. Rather it is the product of an entirely new world view—one that inevitably brings about the transformation of the naturalistic tradition. Early Christian art shows that transformation in process.

The Early Christian era divides conveniently into the Period of Persecution—from the establishment of the earliest communities, in the first century A.D.—and the Period of Recognition—from A.D. 325, when Constantine established Christianity as the official religion of the Roman empire, until about A.D. 500, when the western provinces of the empire had come under the sway of barbarian princes. In the earlier period, as we have seen, the Christians were, in the Roman view, a troublesome, even dangerous, sect that needed to be curbed. During this time it is likely that the Christians, shrinking from the kind of attention public shrines might attract, worshiped in the private houses of their wealthier communicants, perhaps the elaborate atrium houses of the type we have seen in Pompeii (see p. 204). It is quite possible that the atrium forecourt of the later public churches, the basilicas, derived from their liturgical relation to the earlier atrium of the private house.

The Catacombs

The most significant monuments of the Period of Persecution are the least conspicuous of all the monuments of Rome; they are entirely underground. The catacombs, so called, are vast networks of galleries and chambers beneath Rome and other cities, designed as cemeteries for the burial of the Christian dead, many of them sainted martyrs. From the second through the fourth century the catacombs were in constant use, and it is estimated that as many as four

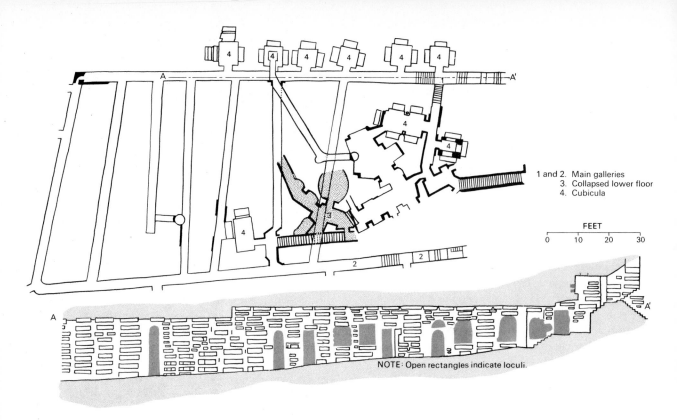

1 and 2. Main galleries
3. Collapsed lower floor
4. Cubicula

FEET
0 10 20 30

NOTE: Open rectangles indicate loculi.

7-1 Plan of the catacomb of Callixtus, Rome, second century A.D., and section through main gallery of oldest region.

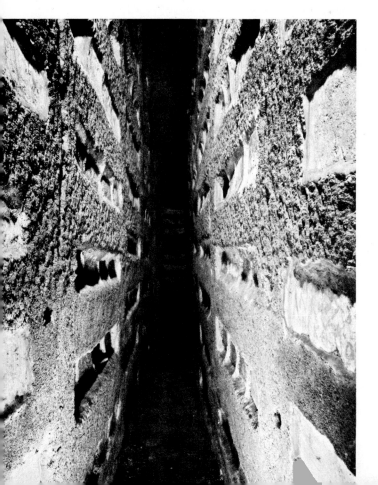

million bodies were accommodated in the Roman catacombs alone. In times of persecution they could have served as places of concealment for fugitives; evidence of this function survives in blocked and cut-off staircases, secret embrasures and passages, and concealed entrances and exits. Doubtless the Christian mysteries must have been enacted here, although the principal function of the catacombs was mortuary.

In Rome the catacombs were tunneled out of the granular tufa stratum, the convenient properties of which had been exploited earlier by the Etruscan necropolis-builders (see p. 188). After a plot of ground had been selected for the cemetery (Christians were not prevented by Roman law from owning property), a gallery three to four feet wide was dug around its perimeter at a convenient level below the surface (FIG. 7-1). In the walls of these galleries, embrasures were opened parallel to the gallery axis to receive the bodies of the dead; these openings, called *loculi*, were one above the other, like shelves (FIG. 7-2). Often, small rooms, called *cubicula*, were constructed in the walls to serve as mortuary chapels,

7-2 Gallery and loculi of the catacomb of Pamphilius, Rome, third century A.D.

and these were variously vaulted. When the original perimeter galleries were full of *loculi* and *cubicula*, other galleries would be cut at right angles to them, the process continuing as long as lateral space permitted. Then lower levels would be dug and connected by staircases, some systems going as deep as five levels. When adjacent burial areas belonged to members of the same Christian confraternity, or by gift or purchase fell into the same hands, communications were opened between the respective cemeteries, which thus spread laterally and gradually acquired a vast extent. After Christianity received official sanction, the catacombs fell into disuse except as holy places, monuments to the great martyrs, which were visited by the pious.

Many *cubicula* were decorated with frescoes that were Late Antique (pagan) in manner and even in subject, the latter interpreted by the Christians to conform with their own beliefs. The geometric patterning of a ceiling in the catacomb of Saints Pietro and Marcellino in Rome (FIG. 7-3) becomes the Dome of Heaven (the large circle), which has been inscribed with the basic symbol of the Christian faith, the cross. The cross-arms terminate in lunettes in which are represented the key episodes from the Old Testament story of Jonah, who is thrown from his ship on the left, emerges from the whale on the right, and, safe on land on the bottom, contemplates the miracle of his salvation and the mercy of God. The compartments between these lunettes are occupied by *orans* figures, members of the Christian community with arms raised in the attitude of prayer, a priestly gesture still made in the ritual of the Roman Catholic mass and likely of great antiquity. The central medallion shows the figure of Christ as the Good Shepherd whose powers of salvation are underscored by his juxtaposition with the story of Jonah. As a theme, the Good Shepherd can be traced back through Greek Archaic to Egyptian art, but here it becomes the symbol for the loyal protector of the Christian flock who said to his disciples, "Feed my lambs, feed my sheep." It is noteworthy that in the catacombs, during the Period of Persecution, Christ was almost invariably represented either as the Good Shepherd or as a teacher. Only later, when Christianity became the official state religion of the Roman empire, did Christ take on imperial attributes such as the halo, the purple robe, the throne, and others denoting rulership.

The style of the catacomb painters is most often the quick, sketchy impressionism we have seen in earlier Roman painting of the last Pompeian period, and the execution ranges from good to inferior, most often the latter. We must take into account that the catacombs were very unpromising places for the art of the mural decorator. The air was spoiled by decomposing corpses, the

7-3 Painted ceiling from the catacomb of Saints Pietro and Marcellino, Rome, fourth century A.D.

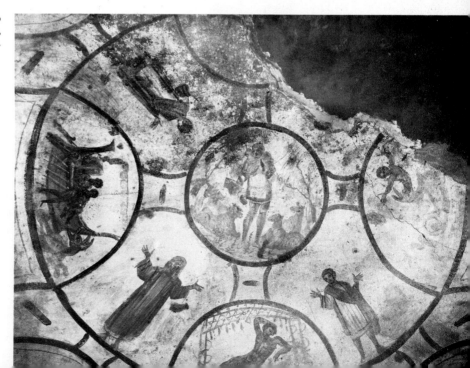

humidity was excessive, and the lighting, provided largely by oil lamps, was entirely unfit for elaborate compositions and painstaking execution. For ceiling designs and those on arches and lunettes the painter was required to assume awkward and tiring poses, and it is no wonder that he proceeded hastily and that his results were poor.

Architecture

Although some ceremonies were held in the catacombs, it is likely that regular services were held in private houses that were rearranged to make "community" houses or in simple columned halls. The latter have not survived intact, having been destroyed in the last great persecutions under Diocletian; the remains of one, a kind of rudimentary basilica, dating from A.D. 311, have been found beneath the cathedral of Aquileia. When Christianity achieved imperial sanction under Constantine, there was suddenly the urgent need to set up buildings that would meet the requirements of the Christian liturgy and would help aggrandize the Christian cult. All the architectural ingredients were present: the atrium house, the catacomb chapel, the Roman basilica. How these combined into the masterful composition that was one of the first Christian church buildings of the new age, old St. Peter's in Rome (FIGS. 7-4 to 7-6), we do not know; discussion about the origins of the Christian basilica has not ended. Dedicated about 330, St. Peter's is probably the most important design in the history of church architecture. Its wide influence was augmented by the belief that it stood where Peter, first of the Apostles, had been buried. Its extraordinary dimensions are difficult to realize from the old drawings; the nave was as long, as high, and twice as wide as the nave of a great Gothic cathedral. Its interior was "one of the most spacious, most imposing, and most harmonious . . . ever built, imperially rich in its marbles and mosaics, grandiose yet forthright and large in the best Roman sense of the word."[1]

[1] Kenneth Conant, *Early Medieval Church Architecture* (Baltimore: Johns Hopkins Press, 1942), p. 6.

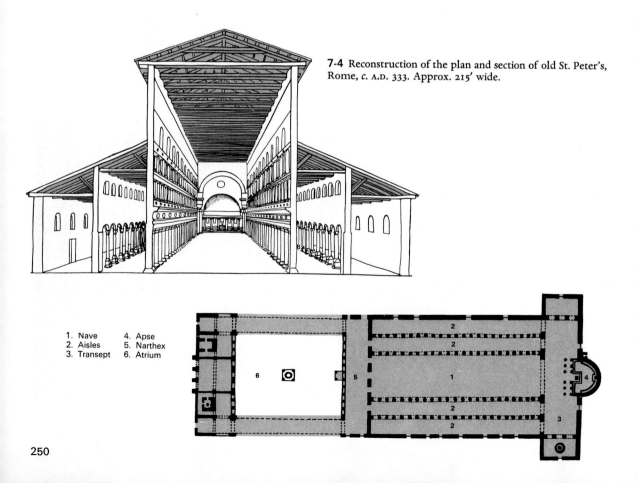

7-4 Reconstruction of the plan and section of old St. Peter's, Rome, *c.* A.D. 333. Approx. 215' wide.

1. Nave 4. Apse
2. Aisles 5. Narthex
3. Transept 6. Atrium

				325	c. 333	c. 350					493	c. 526
c.A.D. 250		306					c. 395	410	c.425			
	"Ludovisi Battle Sarcophagus"	Constantine becomes emperor		Old St. Peter's	Santa Costanza, Rome		Division of the empire	Fall of Rome	Mausoleum of Galla Placidia begun		Theodoric at Ravenna	
PERIOD OF PERSECUTION				PERIOD OF RECOGNITION								

The plan of St. Peter's (FIG. 7-4) shows a rectangular building entered through an open colonnaded court, the atrium, which leads to the *narthex*, or vestibule; the body of the church consists of the nave, low side aisles, apse, and transverse aisle, or *transept*, which is placed between the nave and the apse and projects slightly beyond the walls of the nave and aisles. This fundamental arrangement was used in subsequent Christian architecture, though it would be wrong to think that there is some rigid, standardized basilican design; for instance, the transept, an occasional feature of churches in the city of Rome, is often lacking in other churches, especially in the smaller ones.

The cross section shows a great columned hall that obviously relates to such Roman secular basilicas as the Basilica Ulpia in the Forum of Trajan (FIG. 6-39). Unlike the slightly earlier Basilica of Constantine, St. Peter's was not vaulted, but timber roofed; concrete and vaulted buildings were expensive, and one supposes that the light materials used in the Christian buildings were adopted out of expediency and because they were adequate for the purpose of the ritual. The pagan basilica's lateral entrance is moved to the short side of the Christian church. Only one of the multiple apses is retained, and that is placed opposite and at a dramatic distance from the entrance. Evenly spaced columns no longer surround but flank the central nave, and at St. Peter's they carried a horizontal entablature in the classical tradition (FIG. 7-5). In subsequent church buildings, more and more often the columns support arches in the manner of the peristyle of the Palace of Diocletian at Spalato (FIG. 6-64). All these modifications of the pagan basilica make for a sweeping perspective that converges on the shrine as the focus of the whole design and the place of the central mystery of the Christian faith. The "spiritualizing" of the secular Roman design is expressed not only in the realignment of the building's axis (so as to focus one's whole experience on the center) but in its extreme simplicity of structure and the lightness of its bearing walls and columns. Roman mass—huge walls and ponderous weight, sculptured surfaces in relief and recess, and whole populations of statuary—has been lightened, rarefied, smoothed; we could say it has been "dematerialized" to suit the new orientation toward a spiritual rather than a physical world.

The bird's-eye view of St. Peter's in reconstruction (FIG. 7-6), though partly conjectural, shows the very Roman stepped podium, which we have seen before in the Temple of Fortuna Virilis (FIG. 6-14) and which has Etruscan predecessors; a propylaea and forum-become-atrium are other elements with not only Roman but ancient antecedents. We believe that the exterior was, like that of Christian basilicas in general, unadorned, the whole decorative enterprise being reserved for the interior. It is as if the building imitated the ideal Christian, with grave and plain exterior and a soul glowing and beautiful within.

7-5 Interior of Old St. Peter's in a miniature by Fouquet showing the coronation of Charlemagne.

Early Christian Art 251

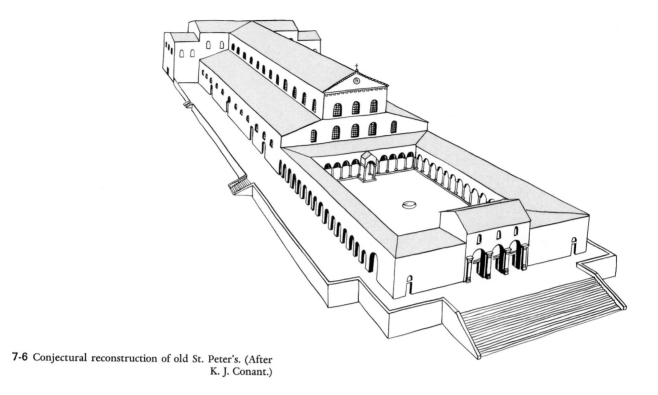

7-6 Conjectural reconstruction of old St. Peter's. (After K. J. Conant.)

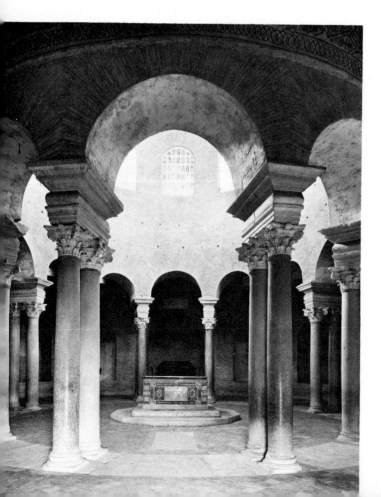

The rectangular basilican church design was long the favorite of the western Christian world. But the Early Christians also adopted another classical building type—the central-plan, a round or polygonal domed structure; this was later favored in the east, where Byzantine architects developed it to monumental proportions and amplified its theme in numerous ingenious variations. In the west the central-plan building type was used generally for smaller structures adjacent and subsidiary to the main basilicas, like mausoleums, baptistries, and private chapels. A highly refined example of this central-plan design is Santa Costanza in Rome (FIGS. 7-7 to 7-9), built in the mid-fourth century. Perhaps a baptistry at first (attached to a now destroyed basilica), it was soon converted to serve as the mausoleum of Constantia, daughter of the emperor Constantine. Its antecedents can be traced to the beehive tombs of the Mycenaeans, although its direct inspiration may have been the Pantheon, or the pool-enclosing rotunda of some public baths, like those of Caracalla. The Pantheon's mass, however, has been metamorphosed, as with the mutation

7-7 Interior of Santa Costanza, Rome, c. A.D. 350.

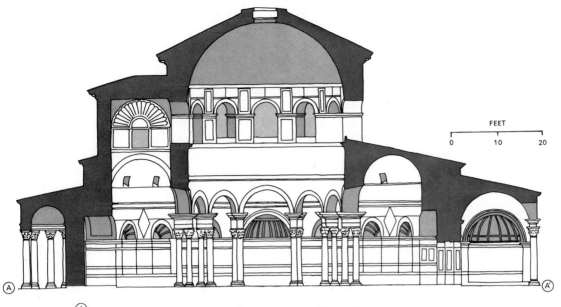

7-8 Plan and section of Santa Costanza.

of the pagan into the Early Christian basilica. In Santa Costanza the circle of paired columns that carries the domed cylinder is well free of the external walls, free enough to leave space for a barrel-vaulted corridor, or *ambulatory*. In fact, it is as if the basilican wall-arcade has been bent around a circle, the ambulatory corresponding to the basilican aisles and, like them, equipped with a high, ample clerestory. The exuberant naturalism of the luxurious mosaics in the vault of the ambulatory (FIG. 7-9) suggests a lingering influence of the pagan spirit.

All the important buildings of the fourth century, including Santa Costanza and the great longitudinal basilicas, are closely associated with Constantine and his immediate relatives, for it was through their patronage and supervision

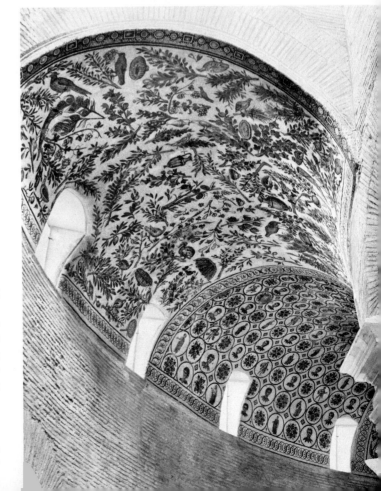

7-9 Detail of mosaics in the vault of the ambulatory, Santa Costanza.

and as an expression of the new ideal of the Christian *imperium* that these buildings came to be. This close relationship of the Constantinians with Constantinian architecture may help to explain a certain consistency of design in the apparently diverse basilicas of the fourth and early fifth centuries. It might also partly explain how such apparently contradictory and opposed designs as the long church and the central church could be imagined as working together in meeting the requirements of Christian belief and ritual. Given centuries of tradition, it would have been perfectly natural for Constantine to memorialize the place of Jesus' death and burial by a traditional type of monument, the domed rotunda. At the same time the existing basilica scheme might have been seen as offering the space needed for the congregations of pilgrims coming to the holiest place in Christendom. For several centuries then, the architectural problem—though

never explicitly stated—was how to integrate the long plan and the central plan.

The mausoleum and basilica types, the central and the long designs, one memorializing a person, the other designed for a congregation, are seen in rather loose relation for the first time in a conjectural reconstruction of the Church of the Holy Sepulcher in Jerusalem (FIGS. 7-10 and 7-11). The emperor, in a letter to the bishop of Jerusalem, asserted that he wanted this basilica to be "more beautiful than any of the others anywhere." There is little if anything to be seen of the original structure. Begun before 333, it was destroyed by the Persians in 613, then built and rebuilt in subsequent centuries. What we can reconstruct shows a relatively small basilica preceded by a shallow atrium leading to the portico on the Roman street. In a courtyard behind the basilica are the two most venerated spots, the rock of Calvary, to one side, and the

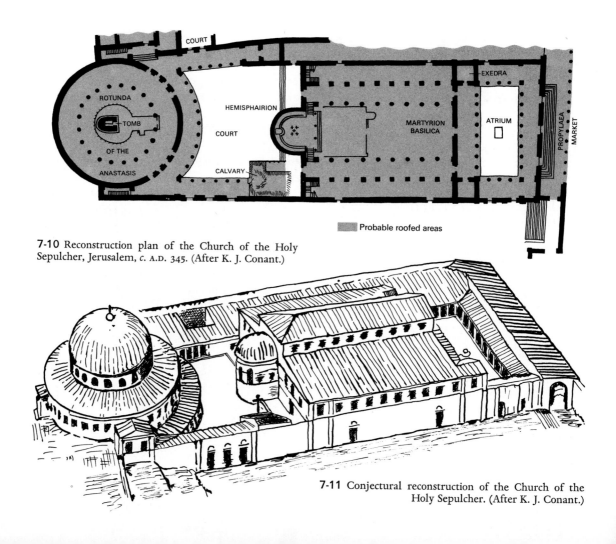

7-10 Reconstruction plan of the Church of the Holy Sepulcher, Jerusalem, *c.* A.D. 345. (After K. J. Conant.)

7-11 Conjectural reconstruction of the Church of the Holy Sepulcher. (After K. J. Conant.)

Holy Sepulcher, covered by a rotunda, in the rear. The buildings are related to each other by ritual function and, architecturally, by a precinct wall. Although superficially resembling that of Santa Costanza, the rotunda of the Holy Sepulcher, the perhaps conical dome of which was timber, may go back to circular buildings, like the tholos at Epidaurus, which were also timber roofed. In any event, the Holy Sepulcher shows us the central- and long-plan building types in architectural relation, even if a rather loose and rambling one. The perfect union of the domed central unit and the basilica will come two centuries later in the great church, Hagia Sophia, in Constantinople. After that synthesis the two structural types will go their separate ways, the long church (often with domed crossing) in the west, the central type in the east.

Mosaic and Painting

As the church-building enterprise under Constantine and his successors was designed to meet the urgent ceremonial needs of Christianity, now suddenly become official and public, so wholesale programs of decoration for the churches were also called for. To advertise the new faith in all its diverse aspects—its dogma, scriptural narrative, and symbolism—and to instruct and edify the believer, acres of wall in dozens of new churches had to be filled in a style and medium that would most effectively carry the message. Brilliantly ornamental mosaics—with sparkling tesserae of reflective glass, rather than the opaque marble tesserae that had been preferred by the Romans—became the standard vehicle of expression almost at once. Mosaics were particularly suited to the flat, shell-like surfaces of the new basilicas, becoming a durable, tangible part of the wall, a kind of architectural tapestry. The light flooding through the clerestories was caught in vibrant reflection by the mosaics, which produced abrupt effects and contrasts and sharp concentrations of color that could focus attention on the central, most relevant features of a composition. Mosaic, worked in the Early Christian manner, is not intended for the subtle changes of tone that a naturalistic painter's approach would require; although, as we have seen in the Roman mosaics, tonality is well within the mosaicist's reach. But in mosaic, color is placed, not blended; and bright, hard, glittering texture, set within a rigorously simplified pattern, becomes the rule. As noted earlier, for mosaics placed high on the wall, far above the observer's head, the painstaking use of tiny tesserae, seen in Roman floor mosaics, becomes meaningless. Early Christian mosaics, designed to be seen from a distance, employ larger stones; the surfaces are left uneven so that the tesserae's projecting edges can catch and reflect the light, and the designs are simple, for optimum legibility. Through several centuries, in the service of Christian theology, mosaic was the medium of some of the supreme masterpieces of world art.

Content and style find their medium; the content of Christian doctrine took centuries to fashion, and for a long time even the proper manner of representing the founder of Christianity was in question. When Christianity became official, Jesus' status changed. In early works he is shown as teacher and philosopher, in later, his image becomes imperialized as the ruler of heaven and earth. In the fourth and fifth centuries there was hesitation about how he should be represented, and variant types of images were produced. After some crucial theological questions on Jesus' nature were resolved, a more or less standard formula for his depiction emerged.

In the minds of simple Christians only recently converted, Jesus could be easily identified with the familiar deities of the Mediterranean world, especially Helios (Apollo), the sun god, or his romanized eastern aspect, Sol Invictus (the Unconquered Sun). The late third-century vault mosaic of a small Christian mausoleum in a pagan cemetery, excavated underneath St. Peter's in Rome in the 1940's (FIG. 7-12), shows Jesus as Apollo, driving the horses of the sun-chariot through the heavens—a conception far more grandiose than that of the Good Shepherd.

The style, or styles, of Christian art came of the transmutation of Greco-Roman art; for the mosaicists, the point of departure was Roman illusionism. In the great mosaic cycles, like those in the Santa Maria Maggiore of early fifth-century Rome, we can witness the union of the old naturalism and the new symbolism. The panel representing the parting of Lot and Abraham (FIG. 7-13) tells its story (Gen. XIII.5–13) succinctly:

7-12 Detail of a vault mosaic from the mausoleum of the Julii, Rome, A.D. 250–75.

flexibility of naturalism toward the significant gesture and that primary method of Medieval representation, *pantomime*, which simplifies all significance into body attitude and gesture. The wide eyes turned in their sockets, the broad gestures of enlarged hands, the opposed movements of the groups, remind us of some silent, expressive chorus that comments only by gesture upon the action of the drama. Thus, the complex action of Roman art stiffens into the art of simplified motion or dumb show, which has great power to communicate without ambiguity and which, in the whole course of Medieval art, will produce the richest kind of variety. Also foreshadowing the character of Christian art is the fact that the figures of the panel have been moved to the foreground and that the artist takes no great pains to describe either space or landscape setting; background town and building are symbolic rather than descriptive. But within this relatively abstract setting, the figures themselves loom with massive solidity. They cast shadows and are modeled in dark and light to give them that three-dimensional appearance that testifies to the artist's heritage of Roman pictorial illusionism. It will require another century and much modification under Eastern influence before he will be able to think of his figures entirely as symbols rather than plastic bodies.

Agreeing to disagree, Lot leads his family and flocks to the right, toward the city of Sodom, while Abraham moves toward a building on the left (the church?). Lot's is the evil choice, and the instrumentalities of the evil, his two daughters, are represented in front of him, while the figure of the yet unborn Isaac, the instrument of good, stands before his father, Abraham. The cleavage of the two groups is emphatic, and each is represented by a shorthand device one could call a "head-cluster," which will have a long history in Christian art. The figures turn from each other in a kind of sharp dialogue of glance and gesture and we recognize here a moving away from the

The Illuminated Manuscript

Santa Maria Maggiore is an early and outstanding example of the complementarity of the new basilican architecture and the new, detailed mosaics and paintings designed for them. But the earlier art of the catacombs could not have provided the resources for narratives as elaborate as those of Santa Maria Maggiore; catacomb painting was much too narrow in scope of subject and much too rudimentary in style and technique. Rather, the church decorators must have drawn upon a long tradition of pictures in manuscripts going back to pharaonic Egypt and highly developed by the Hellenistic Greeks of Alexandria; thousands of texts must have been available to the Constantinian artists, richly illustrated with themes—Hebrew, Greek, and Christian,

7-13 *The Parting of Lot and Abraham*, mosaic from Santa Maria Maggiore, Rome, *c.* A.D. 430.

and combinations of all three. We know that Constantine summoned numerous savants and literati of Alexandria and that he established a library where they gave instruction; we know also that he was a generous donor of manuscripts to the Church. Hence, it is no wonder that Constantinople became a center of traditional and Christian learning that was transmitted by the copying and recopying of manuscripts through the centuries. The dissemination of manuscripts, as well as their preservation, was greatly aided by an important invention in the early Imperial period. The long manuscript scroll used by Egyptians, Greeks, and Romans and made of the fragile papyrus was superseded by the *codex*, which was made much like the modern book, of separate pages bound together at one side and having a cover. Papyrus was replaced by much more durable *vellum* (veal skin) and *parchment* (lamb skin), which provided better surfaces for painting than did papyrus. These changes in the durability, reproduction, and format of texts greatly improved the possibility that the records of ancient civilization could survive long centuries of neglect, even if not in great number.

The sacred texts were copied as faithfully as possible, and so were the pictures in them. After the great fathers of the Eastern Church recommended the didactic use of pictures in churches and books, the picture came to have a significance only slightly less than that of the text from which it drew its authority. The passage from the scroll to the codex—that is, from continuous narrative to a series of individual pictures—can be seen in two manuscripts of different date, the later still reflecting the scroll procedure. The *Vatican Vergil* (FIG. 7-14), from the early fifth century and the oldest painted manuscript known, is pagan in content, representing a scene from Vergil's *Georgics*, in which a seated farmer, at the left, instructs two of his slaves in the art of husbandry, while Vergil, at the right, listens and records the

7-14 Miniature from the *Vatican Vergil*, early fifth century A.D. Approx. 12″ × 12½″. Vatican Library, Rome.

instructions. (One remembers the Roman idealization of country life and nature.) The style is Late Antique and reminiscent of Pompeian landscapes. The quick, impressionistic touches that suggest space and atmosphere, the foreshortened villa in the background, the small, active figures in their wide, spacious setting—all these are familiar features of Roman illusionistic painting. We saw the heavy black frame isolating a single episode in the late Pompeian styles; it contrasts with the form of the *Vienna Genesis* (FIG. 7-15), which uses the continuity of a frieze, or in this case a scroll. The episode from Genesis represents Joseph receiving his brothers (who do not recognize him) in Egypt, where he has become the Pharaoh's chief administrator. They have come from Israel destitute and starving and, forgetting their cruelty to him, Joseph permits them to gather food. Overcome with emotion, he has withdrawn behind a screen to weep. Three distinct episodes are represented, with Joseph in two of them. The picture might almost have been cut out of a continuous scroll, for it seems as if it should continue to the left and right. (Although this is not the case here, pictures often *were* cut out of scrolls and fixed to the pages of a codex.) The figures are the reduced Hellenistic types, acting in a neutral space entirely without landscape and performing in the silhouetted, pantomimic way that presents the story with all possible economy. While the figures retain only a narrative importance, the page itself becomes sumptuous, a rich purple ground lettered in silver. The luxuriousness of ornament that will be more and more typical of sacred books absorbs the human figure or relegates it to a secondary function. What will come to count above all are the spiritual beauty of the text and the material beauty of the vehicle that serves and intensifies it. The luster of holy objects—"sages standing in God's holy fire"—becomes the intent and being of Byzantine art.

Sculpture and Craft Art

The transformations that take place in architecture in the period of early Christianity—whereby the multipurpose pagan basilica is adapted to the single purpose of Christian ritual, and the heavy materiality of Roman buildings is "dematerialized" in the screenlike thinness and lightness of Christian structure—is paralleled in the sculpture of the time. We have seen anticipations of the change as early as the second century in the

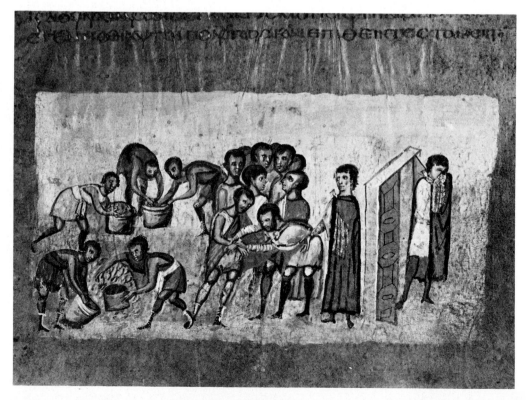

7-15 *Joseph Recognizes His Brothers*, from the *Vienna Genesis*, early sixth century A.D. Approx. 4″ × 7½″. Österreichische Nationalbibliothek, Vienna.

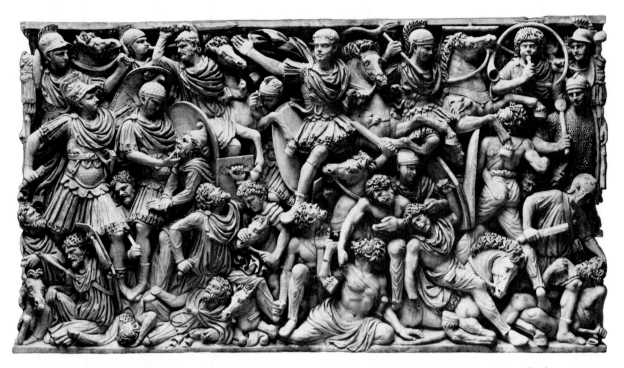

7-16 *Battle Between Romans and Barbarians*, front panel of the so-called *Ludovisi Battle Sarcophagus*, third century A.D. Marble, approx. 4′ 8″ high. Museo Nazionale, Rome.

Column of Trajan (FIG. 6-53), and we have seen the change almost complete in early fourth-century reliefs of the Arch of Constantine (FIGS. 6-72 and 6-73). A third-century relief on the so-called *Ludovisi Battle Sarcophagus* (FIG. 7-16) should be interpolated between them. This representation of a struggle between Romans and barbarians is most instructive as an illustration of the "flattened relief" and the "piled-up" perspective so characteristic of the denaturing of Greco-Roman naturalism and the emerging Medieval style. While a strong descriptive realism persists in details of physiognomy, dress, action, gesture, and accessories, pattern has taken over from figure composition. The writhing figures are all within the same plane; at the same time the "foreground" figures (those at the base of the pattern) are relatively small, while the "background" figures at the top of the pattern are the largest. This *reverse perspective* strengthens the surface into a dense mass with no illusion of space beyond (behind) it. Carving has less and less a role, and quick effects of light and dark are had by gouging, punching, and drilling the surface. As yet the formal placing

of the figures that we find in the Arch of Constantine has not appeared; but of course the subject does not call for that, and the sarcophagus composition represents more the dissolution of the style of the Trajanic reliefs than the advent of Constantinian formalism. But the patterning and constriction of surface, the sacrifice of realism of space and proportion, are all present and recognizably Early Medieval.

Toward the end of the fourth century we find the flattening and patterning process well advanced. The *Good Shepherd Sarcophagus* (FIG. 7-17) has a thick, spaceless surface that is perforated rather than carved, producing a kind of hard lacing of flat darks and lights. This sarcophagus is interesting, too, for what it reveals of Christian adaptation of pagan material. We have seen that the Good Shepherd theme appears in pre-Christian times and that the Christians take it to signify Christ. Here the motif appears three times, possibly in an allusion to the Trinity. Around the Good Shepherd twines a grapevine heavy with grapes and through which climb busy cupids bringing in the harvest. Three cupids crush the

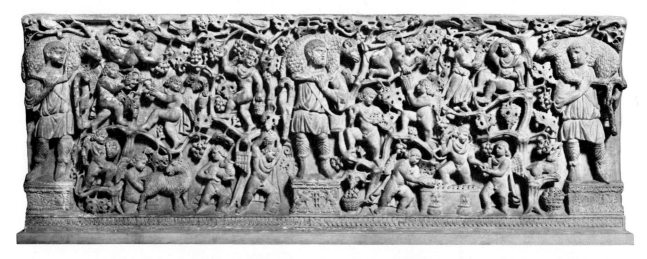

7-17 *The Good Shepherd Sarcophagus,* from the catacomb of Praetextus, Rome, late fourth century A.D. Musei del Laterano, Rome.

grapes in a wine press, and their wine, once sacred to Bacchus, has now become symbolic of the blood of Christ; the cupids themselves, once associated with love and erotic passion (Cupid is the son of Venus), are forerunners of Christian cherubs. Thus, a purely pagan theme with orgiastic overtones is transmuted by Christian intention into a symbol of redemption through the blood of Christ. The figure style, with its stumpy proportions, frontalizing pose, and stereotyping of action, had its predecessor in the reliefs on the Arch of Constantine and is common (with many variations) to a great number of sarcophagi from the fourth, fifth, and sixth centuries.

Monumental sculpture begins its decline in the fourth century and does not recover its place in the history of art until the twelfth. The Christian tended to be suspicious of the freestanding statue, linking it with the false gods of the pagans. In his *Apologia,* Justin Martyr, a second-century ecclesiast mindful of the First Commandment admonition to shun graven images, accuses the pagans of worshiping statues as gods. But the Greco-Roman experience was still a living part of the Mediterranean mentality and, at least in the west, the Semitic ban on images in sacred places was not likely to be adopted. The reasoning of the fathers of the early Church—that the use of pictures and statues could be justified on the grounds that they instructed the illiterate in the mysteries and stories of the faith—was

later supplemented by the theological argument that since Jesus was "made flesh and dwelt among us," he had a human nature and human likeness that could be represented in art.

In any event, and perhaps for many reasons, sculpture dwindled to craft art and small work —sarcophagus reliefs, commemorative ivory panels, church furniture and accessories, book covers, and the like. A very fine example of the quality that could be achieved by the ivory carvers of the eastern empire is a leaf from a diptych dating from the early sixth century and representing St. Michael the Archangel (FIG 7-18). It is evidence that the classical spirit and form had by no means died out or been entirely denatured. The prototype of the *St. Michael* must have been a pagan Victory; the flowing classical and still naturalistic drapery. the delicately incised wings, and the facial type and coiffure are of the pre-Christian tradition. But there are significant divergences from it, even so—misinterpretations or misreadings of the rules of naturalistic representation. Subtle ambiguities in the relation of the figure to its architectural setting appear in such details as the placing of the wings (one in front of the column at the left, one behind the column at the right), the placing of the scepter, and the hovering of the feet above the stair without real relation to it. These matters have, of course, little to do with the striking beauty of the form; they simply indicate the course that sty-

listic change is taking, as the Greco-Roman world fades into history and the Medieval era begins.

We find that change almost completed in the *Diptych of Anastasius* (FIG. 7-19), which represents the emperor Anastasius I, as consul, about to throw down the *mappa* (handkerchief), the signal for the games to start. Though the diptych, dated A.D. 517, is about contemporary with the *St. Michael* ivory, the mutation of classical naturalism is much further advanced (a reminder that the process does not proceed evenly along the same historical front or at the same tempo). The figure of the emperor in both panels is elevated above the lively scenes taking place in the arena. He is enthroned in rigid frontality, making a static, suspended gesture, entirely symbolic, the abstraction of his consular authority. His features are masklike, and his quasidivine status is announced by a halo. The halo, a shell form, would originally have been an architectural feature, part of the pediment of the niche; here—in an excellent example of a misreading of a prototype—it has migrated to its place behind the emperor's head. The details of the architecture are confused and have lost their original architectural significance, and the flattening and patterning of the surface is as we have seen it developing earlier. The work is entirely ornamental and symbolic; the living man is lost in the concept—in this case, the concept of supreme and suprahuman authority. One hundred years after the *Diptych of Anastasius*, the *Sarcophagus of Archbishop Theodore* (FIG. 7-20) is not only ornamented with entirely symbolic forms, but the human figure is dismissed alto-

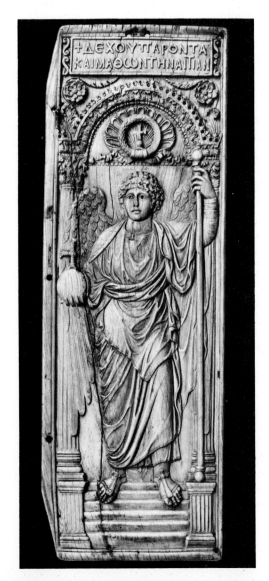

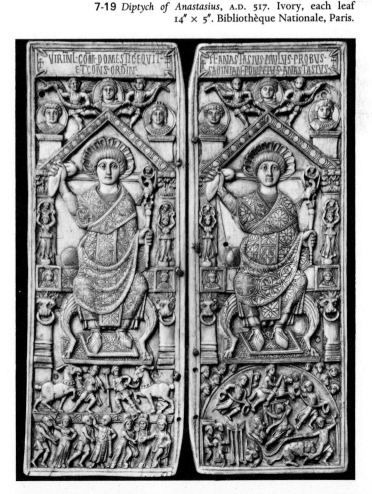

7-18 *St. Michael the Archangel*, leaf of a diptych, early sixth century A.D. Ivory, approx. 17″ × 15½″. British Museum, London.

7-19 *Diptych of Anastasius*, A.D. 517. Ivory, each leaf 14″ × 5″. Bibliothèque Nationale, Paris.

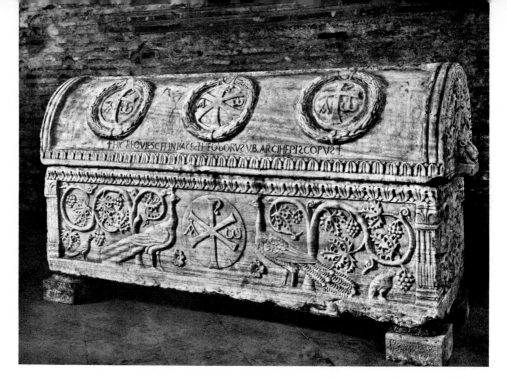

7-20 *Sarcophagus of Archbishop Theodore,* seventh century A.D. Marble. Sant' Apollinare in Classe, Ravenna.

gether. Peacocks, symbolic of eternity, flank a *chi-rho* monogram (XP are the first two letters of "Christ" in Greek). The XP is supplemented in the monogram with the alpha (A) and the omega (Ω), the first and last letters of the Greek alphabet, representing the words of Christ: "I am the Beginning and the End." The fruiting vines behind the peacocks represent, as we have seen, the source of the redeeming blood of Christ. Set within wreaths on the lid of the tomb, the *chi-rho* monogram appears three times, serving as the *labarum* carried upon the standards of the Imperial Christian army. Thus, the hope of the deceased archbishop and the guarantee of his salvation are expressed entirely in symbol: eternity; redemption through the blood of Christ, who stands at the beginning and the end of time; and the triumph of Christianity. The accidents and irregularities of figural representation, the busyness of narrative, are replaced by timeless signs of salvation and immortality.

BYZANTINE ART

The transition from Early Christian to Byzantine art is neither abrupt nor definite and, in fact, defies accurate definition. The almost contemporary diptychs of St. Michael (FIG. 7-18) and of Anastasius (FIG. 7-19) are both products of eastern carvers and might well be classified as Byzantine works. Yet the *St. Michael* is still firmly rooted in the Greco-Roman tradition, while the *Anastasius* panels show the Medieval stress on the event rather than its appearance. In this latter approach, essentially Near Eastern or Semitic, forms evolved into decorative symbols placed before a shallow, often neutral background that makes little if any allusion to optical space.

One point of departure for the abstract, symbolic Eastern Christian art may be a mural painting from Dura-Europos, a small garrison town on the west bank of the Euphrates in the heart of ancient Mesopotamia and on the very edge of the Roman empire (FIG. 7-21). It dates from the second to third century A.D., the time of the Roman occupation. The detail shown here may depict an attendant and priests of a forgotten pagan cult of Parthia or Palmyra (modern Tadmor). The figures stand with formal frontality in front of (within?) an architectural background. Their drapery is rendered by line, not tone, and their gestures are slow, ceremonial, and grave. Each figure is in itself a single vertical design entity, isolated from its neighbor. The bodies are hovering, weightless, their feet in ambiguous relation to the ground and to the architectural setting, reminding us of the *St. Michael* ivory carved centuries later. Although

the meaning of the enacted ceremony is lost to us, it must have been represented with utmost clarity to initiates, who could read the depicted symbols and gestures like a pictorial script, a script that moved laterally across the surface of the printed wall unobstructed by perspective and other illusionistic devices.

As Christian dogma developed, this form of symbolic interpretation of reality was more and more favored, and a flat, decorative, abstract "Byzantine" style, rooted in such Near-Eastern works as the Dura-Europos murals, began to dominate Christian art. And, although Western illusionism was tenacious and enjoyed repeated revivals, the transition was more or less complete by the middle of the sixth century. It can be conveniently observed in the monuments of a single city, Ravenna.

Ravenna

Early in the fifth century, when the Visigoths, under their king, Alaric, threatened to overrun Italy, Emperor Honorius moved the capital of his crumbling empire to Ravenna, an ancient Roman harbor on Italy's Adriatic coast, some eighty miles south of Venice. There, in a city surrounded by swamps and, thus, easily defended, his imperial authority survived the fall of Rome to Alaric in 410. Honorius died in 423, and the reins of government were taken over by his half-sister, Galla Placidia, whose biography reads like an outrageously exaggerated adventure story. Galla Placidia died in 450, some twenty-five years before the last of her weak successors was deposed. In 476 Ravenna fell to Odoacer and eventually, in 493, it was chosen by Theodoric, the Goths' greatest king, to be the capital of his Ostrogothic kingdom, which encompassed much of the Balkans and all of Italy. During the short history of his unfortunate successors the importance of the city declined. But in 539 the Byzantine general Belisarius conquered Ravenna for his emperor, Justinian, and led the city into the third and most important stage of its history. Reunited with the (eastern) "empire," Ravenna remained the "sacred fortress" of Byzantium, its foothold in Italy for 200 years, until its conquest successively by the Lombards and the Franks. It enjoyed

its greatest cultural and economic prosperity during the reign of Justinian, at a time when the "eternal city" of Rome was threatened with complete extinction by repeated sieges, conquests, and sackings.

The seat of Byzantine dominion in Italy, ruled by Byzantine governors, or *exarchs*, Ravenna and its culture became an extension of Constantinople, and its art, more than that of the Byzantine capital (where relatively little has survived outside of architecture), clearly reveals the transition from Early Christian to Byzantine style.

The climactic points of Ravenna's history are closely linked with the personages of Galla Placidia, Theodoric, and Justinian. Each left his stamp on the city with monuments that have survived to our day (one might say miraculously, since the city was heavily bombed in World War II) and that make Ravenna one of the most complete repositories of fifth- and sixth-century mosaics in Italy. The monuments of Ravenna,

7-21 *Priests with Attendant*, detail of a mural from the Temple of the Palmyrene Gods, Dura-Europos, second to third centuries A.D.

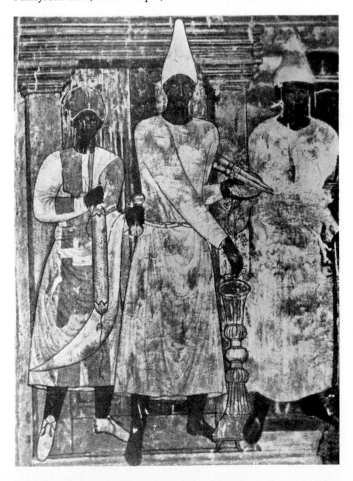

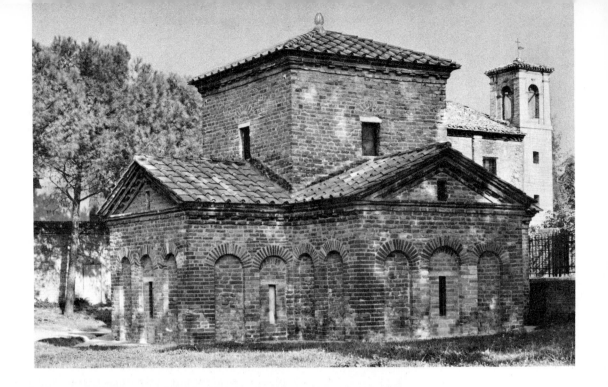

7-22 Above: Mausoleum of
Galla Placidia, Ravenna,
A.D. 425–50.

7-23 Left: Interior of the
mausoleum of Galla Placidia.

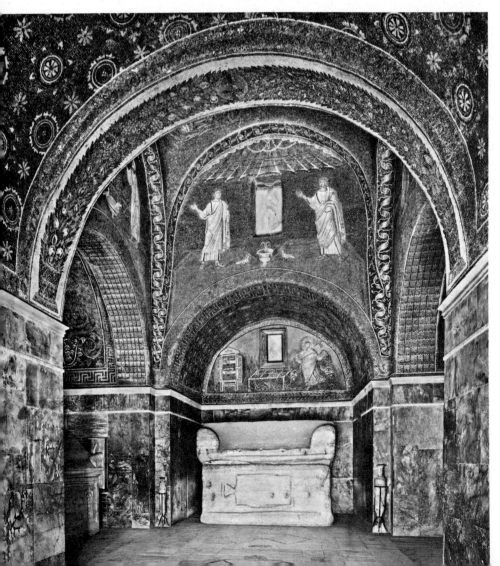

particularly the Justinianic ones, represent ideas that ultimately will determine the forms of culture, and certainly art, of the Middle Ages.

Galla Placidia's own mausoleum (the identity of which has recently been questioned) is a rather small cruciform structure with a dome-covered crossing (FIGS. 7-22 and 7-23). Built shortly after 425, it was originally attached to the narthex of the now greatly altered basilican palace church of Santa Croce. Although its plan is that of a Latin cross, the cross-arms are very short and appear to be little more than apsidal extensions of a square. Thus, all emphasis is placed on the tall, dome-covered crossing, and the building becomes, in effect, a central-plan structure. On the other hand, this small, unassuming building also represents one of the earliest successful fusions of the two basic early church plans, the longitudinal and the central, and introduces us, on a small scale, to a building type that will have a long history in Christian architecture—the basilican plan with a domed crossing.

The mausoleum's plain, unadorned brick shell encloses one of the richest mosaic ensembles in Early Christian art. Every square inch of the interior surfaces above the marble-faced walls is covered with mosaic decor: the barrel vaults of nave and cross-arms with garlands and decorative medallions reminiscent of snowflakes on a dark blue ground; the dome with a large golden cross against a star-studded sky; other surfaces with representations of saints and apostles; and the lunette above the entrance with a representation of Christ as the Good Shepherd (PLATE 7-1). We have seen earlier versions of the Good Shepherd, but none so regal as this. Jesus no longer carries a lamb on his shoulders but is seated among his flock in splendid isolation, haloed and robed in gold and purple. To his left and right the sheep are evenly distributed in groups of three. But their arrangement is rather loose and informal (compare PLATE 7-3), and they have been placed in a carefully described landscape that extends from foreground to background and is covered by a blue sky. All forms are tonally rendered; they have three-dimensional bulk, cast shadows, and are disposed in depth. In short, the panel is replete with devices of Roman illusionism and its creator still has roots deep in the Hellenic tradition. Some fifty years later his

successors will work in a much more abstract and formal manner.

Around 504, shortly after he settled in Ravenna, Theodoric ordered the construction of his own palace church, a three-aisled basilica dedicated to the Savior. In the ninth century, the relics of Apollinaris were transferred to this church, which was rededicated and has been known since as Sant' Apollinare Nuovo. The rich mosaic decorations of the interior nave walls (FIG. 7-24) are arranged in three zones, of which the upper two date from the time of Theodoric. Between the clerestory windows are represented Old Testament patriarchs and prophets, and above them scenes from the life of Christ alternate with decorative panels. The lowest zone originally bore subjects of either Arian or political character. Although Christians, Theodoric and his Goths were Arians—followers of the teachings of Bishop Arius—a sect declared heretical by the Orthodox Church. After the Byzantine conquest of Ravenna, Bishop Agnellus ordered all mosaics that bore reference to Theodoric or to Arianism removed and replaced with the present procession of orthodox saints, male on one side, female on the other. Since Agnellus had no quarrel with the subjects on the upper two levels, they were left intact, and our example, which shows the miracle of the loaves and the fishes (PLATE 7-2), must date from about 500. It well illustrates the stylistic change that has occurred since the decoration of Galla Placidia's mausoleum. Jesus, beardless and in the imperial dress of gold and purple, faces directly toward us as he directs his disciples to distribute the miraculously augmented supply of bread and fish to the great crowd to which he has preached. The artist makes no attempt to supply details to the event. Rather he emphasizes the sacramental character of it, the spiritual fact that Jesus, outstanding in the group, is performing a miracle by the power of God. The fact of the miracle takes it out of the world of time and of incident, for what is important in this scene is the presence of almighty power, which requires nothing but an unchanging presentation in terms of formal, unchanging aspect. The story is told with the bare minimum of figures necessary to make its meaning explicit, and these figures have been aligned laterally, moved close to the foreground, and placed in a shallow picture box that

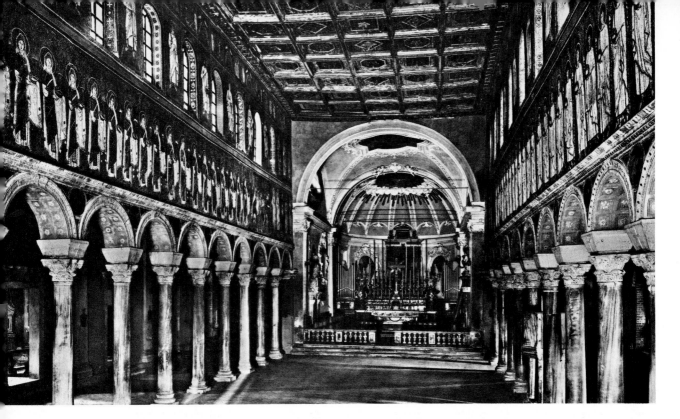

7-24 The nave of Sant' Apollinare Nuovo, Ravenna, *c.* A.D. 504.

is cut off by a golden screen close behind the back of the figures. The landscape setting, which was so explicitly described by the artist who worked for Galla Placidia, is here merely suggested by a few rocks and bushes that enclose the figure group like parentheses. That former reference to the physical world, the blue sky, is now replaced by a neutral gold, which is to be the standard background color from now on. Remnants of the former illusionism are to be found only in the handling of the individual figures, which still cast shadows and retain some of their former volume. But the shadows of the drapery folds have already narrowed into bars and will soon disappear.

The Ravenna epoch closes with the church of Sant' Apollinare in Classe where, in the great apse mosaic, the Byzantine style reaches full maturity. Here, until the ninth century (when it was transferred to Ravenna, as described above), rested the body of St. Apollinaris, who suffered his martyrdom in Classe, Ravenna's port city. The building itself (FIG. 7-25) is of the Early Christian type, a three-aisled basilica with a plan quite similar to that of Theodoric's palace church in Ravenna. The peculiar design of the apse,

which combines a semicircular interior with a polygonal exterior, is typical for Ravenna churches and is probably of Byzantine origin. As usual for the period, the outside of the building is plain and unadorned. (The cylindrical bell tower, or *campanile*, is of later date.) The interior decoration in this case is confined to the triumphal arch and the apse behind it. Of these mosaics the one decorating the semivault above the apse (PLATE 7-3) was probably completed by 549, when the church was dedicated. It shows, against a gold ground, a large blue medallion with a jeweled cross, symbol of the transfigured Jesus. Just above, the hand of God and the dove issue from the clouds on an axis with the cross, the three together symbolizing the Trinity. On either side in the clouds appear the figures of Moses and Elijah, who had appeared before Christ during his transfiguration; below these two figures are three sheep, the three disciples who accompanied Christ to the foot of the Mount of the Transfiguration. Beneath, in the midst of green fields with trees, flowers, and birds, stands with uplifted arms the patron saint of the church, Apollinaris, accompanied by twelve sheep repre-

senting the twelve apostles and forming, as they march in regular file across the apse, a wonderfully decorative base.

Comparison with the Galla Placidia mosaic (PLATE 7-1) shows how the style and the artist's approach to his subject have changed during the course of a century. In each case we are looking at a human figure and some sheep in a landscape. But now, in the mid-sixth century, the artist no longer tries to re-create a segment of the physical world but tells his story in terms of flat symbols, lined up side by side. All overlapping is carefully avoided in what must have been an intentional effort to omit all reference to the three-dimensional space of the material world and physical reality. Shapes have lost their volume to become flat silhouettes into which details have been inscribed with lines. The effect is that of an extremely rich flat tapestry design that tells its story directly and explicitly without illusionistic devices. The Byzantine style becomes the ideal vehicle for the conveyance of the extremely complex symbolism of the fully developed Christian dogma. Our apse mosaic, for example, has much more meaning than first meets the eye. The transfiguration of Christ—here into the image of the cross—symbolizes his own death, with its redeeming consequences, but also the death of his martyrs—in this case, St. Apollinaris. The lamb is also a symbol of martyrdom and is appropriately used to represent the martyred apostles. The whole scene expands above the altar, where the sacrament of the Eucharist is celebrated, the miraculous recurrence of the supreme redemptive and transfigurative act. The very altars of Christian churches, where the mystery of the Eucharist takes place, were from early times sanctified by the bones and relics of martyrs; thus the mystery and the martyrdom were joined in one concept—namely, that the death of the martyr, in imitation of Christ, is a triumph over death that leads to eternal life. The images above the altar present a kind of inspiring vision to the eyes of the believers, for the way of the martyr is open to them, and the reward of eternal life is within their reach. The organization of the symbolism and of the images is hieratic, and the graphic message must have come to the faithful with overwhelming force. Looming above

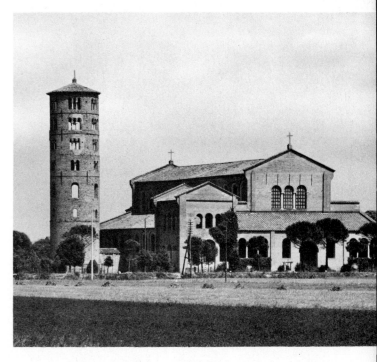

7-25 Sant' Apollinare in Classe, Ravenna, *c.* A.D. 533–49.

their eyes is the apparition of a great mystery ordered in such a way as to make perfectly simple and clear the "whole duty of man" seeking salvation. That the anonymous artists working under the direction of the priests expended every device of their craft to render the idea explicit is plain enough; believing men could read it as easily as an inscription. The martyr's glorification beneath the cross inscribed in the starry heavens presented in one great tableau the eternal meaning of Christian life in terms of its deepest mystery.

The Byzantine style, born of the Orientalizing of Hellenistic naturalism, appears in monumental grandeur and ornamental splendor in the mosaics of San Vitale (PLATE 7-4), which, in the high quality they share with the beautiful building itself, symbolize the achievements of the age of the emperor Justinian and are worthy representatives of the First Byzantine Golden Age. Begun shortly after Theodoric's death and dedicated by Bishop Maximianus in 547, San Vitale (FIG. 7-26) shares with the other Ravenna churches its plain exterior (slightly marred by a Renaissance portal) and the polygonal apse. But beyond that it is an

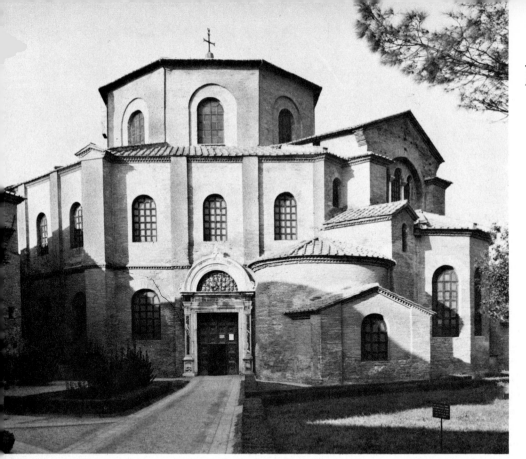

7-26 San Vitale, Ravenna, A.D. 526–47.

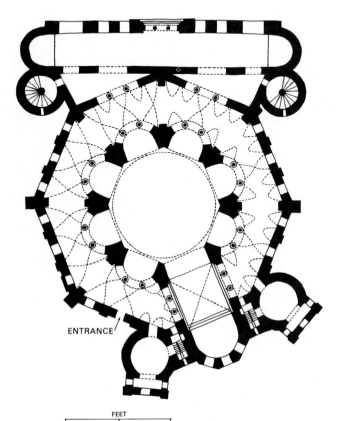

ENTRANCE

FEET
0 25 50

entirely different building (FIG. 7-27). The structure is centrally planned and consists of two concentric octagons of which the dome-covered inner one rises above the surrounding one to provide the interior with clerestory lighting. The central space is defined by eight large piers that alternate with curved, columned niches, pushing outward into the surrounding ambulatory and creating, on the plan, an intricate, multifoliate design. These niches effect a close integration between inner and outer spaces that otherwise would simply have existed side by side as independent units. A cross-vaulted sanctuary preceding the apse interrupts the ambulatory and provides the plan with some axial stability. This effect is weakened, however, by the unsymmetrical placement of the narthex, the odd angle of which has never been fully explained. (The no longer extant atrium may have paralleled a street that ran in that direction.) As shown in FIG. 7-28, the ambulatory has been provided with a second story, the

7-27 Plan of San Vitale.

so-called gallery, which was reserved for women and is a typical feature of Byzantine churches. Probably also of Byzantine origin are the so-called impost blocks, which have been inserted between the simply profiled but richly patterned column capitals and the springing of the arches (FIG. 7-29). Resembling an inverted, truncated pyramid, these impost blocks appear in most Ravenna churches (compare FIG. 7-24) and may be highly abstracted reflections of entablature segments that had been inserted between column and arch by Late Roman architects.

The sum of San Vitale's intricate plan and elevation produces an effect of great complexity. Walking through the building, one is struck by the rich diversity of ever changing perspectives. Arches looping over arches, curving and flattened spaces, and shapes of wall and vault seem to change constantly with the viewer's position. Light filtered through alabaster-paned windows plays over the glittering mosaics and glowing marbles that cover the building's complex surfaces, producing an effect of sumptuousness that is not Western but Oriental. And, indeed, the inspiration for this design is to be found in Byzantium rather than Rome. In Constantinople, some ten years before the completion of San Vitale at Ravenna, a church had been dedicated to the Saints Sergius and Bacchus that looks like a rough preparatory sketch for the later church in which the suggestions of the earlier plan may be seen developed to their full potential.

Slightly earlier than those of Sant' Apollinare in Classe, but of higher quality, the mosaics that decorate the sanctuary of San Vitale, like the building itself, must be regarded as one of the climactic achievements of Byzantine art. Completed less than a decade after the surrender of Ravenna by the Goths, the decorations of apse and forechoir proclaim the triumph of Justinian and of the orthodox faith. The multiple panels of the sanctuary form a unified composition, a theme of which is the holy ratification of the emperor's right to Ravenna and to the whole of the western empire of which it was now the principal city. The apse mosaics are portrait groups representing Justinian on one wall and his empress, Theodora, on the other (FIGS. 7-30 and 7-31). The monarchs are accompanied by their retinues in a

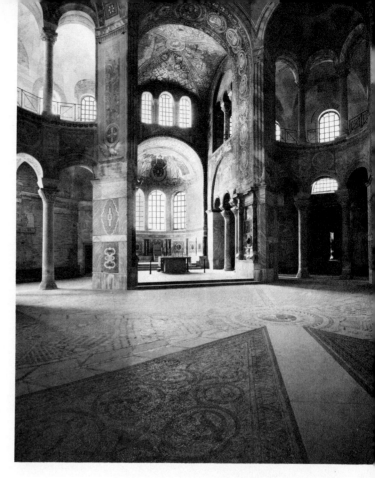

7-28 Above: Interior of San Vitale.

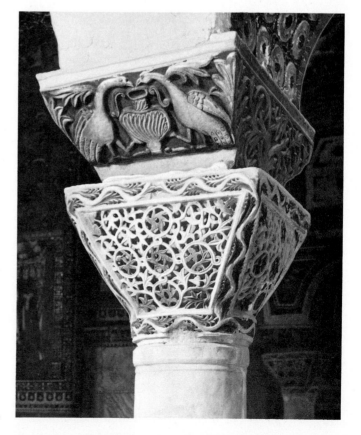

7-29 Capital from San Vitale.

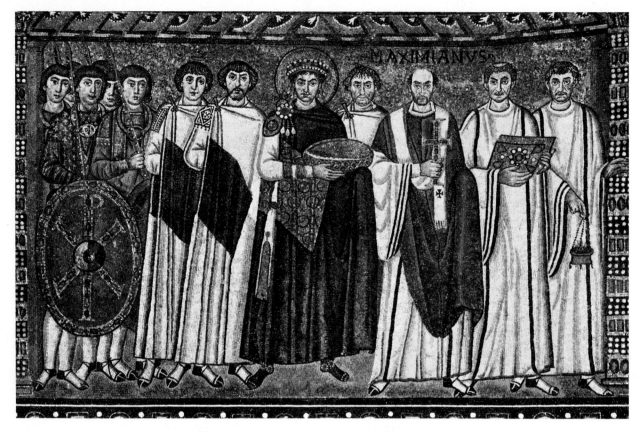

7-30 *Justinian and Attendants,* apse mosaic from San Vitale.

depiction of the offertory procession, that part of the liturgy when the bread and wine of the Eucharist are brought forward and presented. Justinian, represented as a priest-king, carries a vessel containing the bread, and Theodora the golden cup with the wine. Images and symbols covering the entire sanctuary express the single idea of man's redemption by Christ and the reenactment of it in the Eucharist. Moses, Melchizedek, Abraham, and Abel are represented as prefigurations of Christ and also as priestly leaders of the faithful whose offerings to God were declared acceptable to Heaven. In the representation of the Second Coming (PLATE 7-5), Christ, seated on the orb of the world, with the four rivers of Paradise beneath him and rainbow-hued clouds above, extends a golden wreath of victory to Vitalis, the patron saint of the church, who is here introduced by an angel. At Christ's left another angel introduces Bishop Ecclesius, in whose

time the foundations of the church were laid, and who carries a model of it. The arrangement recalls Christ's prophecy of the last days of the world: "And then shall they see the Son of man coming in the clouds with great power and glory. And then shall he send his angels, and shall gather together his elect from the four winds, from the uttermost part of the earth to the uttermost part of heaven" (Mark XIII.26-27). It appears that Justinian's offering is also acceptable, for the crown extended to St. Vitalis is also extended to him where he stands in a dependent mosaic (FIG. 7-30 and PLATE 7-6). Thus, his rule is confirmed and sanctified by these rites in which, as is so typical of such expressions of the Byzantine imperial ideal, the political and the religious are one:

In the atmosphere of Byzantium, the Christian emperor appeared as a Christ-like high priest and . . . the principles of his administration seemed to be symbolized in the liturgical rite. In the offer-

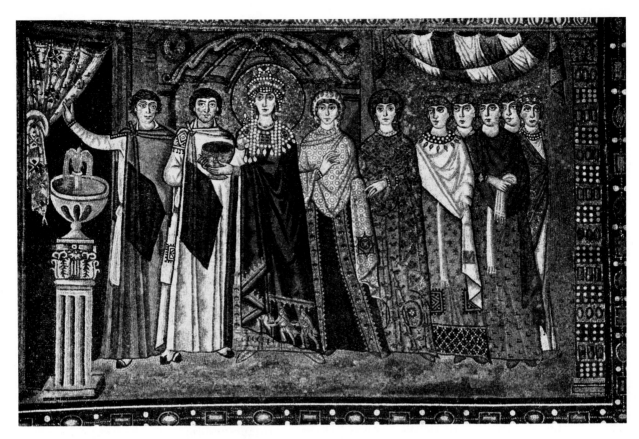

7-31 *Theodora and Attendants,* apse mosaic from San Vitale.

tory procession he appeared like the priest-king Melchizedek, "bringing forth bread and wine" on behalf of his people, to propitiate God.[2]

The laws of the Church and the laws of the state, united in the laws of God, are manifest in the person of the emperor and in his God-given right. The pagan emperors had been deified; it could not have been difficult, given that tradition, to accept the deification of the Christian emperor. Justinian is distinguished from his dignitaries not only by his wearing of the imperial purple, but by the halo, a device emanating from ancient Persia and originally signifying the descent of the honored one from the sun—and hence his godlike origin and status.

The etiquette and protocol of the imperial court fuse here with the ritual of the liturgy of

the church. The positions of the figures are all-important, since they express the formula of precedence and the orders of rank. Justinian is exactly at center. At his left is Bishop Maximianus, the architect of his ecclesiastical-political policy and the one responsible for the completion of San Vitale and its consecration in 547. The bishop's importance is stressed by the label giving his name, the only identifying inscription in the composition. The figures are in three groups— the emperor and his staff (standing for the imperial administration), the clergy, and the army, who bear a shield with the *chi-rho* monogram seen on the *Sarcophagus of Archbishop Theodore* (FIG. 7-20). Each group has a leader, one of whose feet precedes (by overlapping) the feet of those who follow. There is a curious ambiguity in the positions of Justinian and Maximianus; though the emperor appears to be slightly behind the bishop, the sacred vessel he carries overlaps the

[2] Otto von Simson, *Sacred Fortress: Byzantine Art and Statecraft in Ravenna* (Chicago: Univ. of Chicago Press, 1948), p. 35.

←to c. A.D. 395 493 c.504 c.526 532 539 c.565 to c.800 →

	Sant' Apollinare Nuovo		Hagia Sophia begun	Investment of Ravenna		
EMERGENCE OF BYZANTINE (EASTERN ROMAN) EMPIRE			FIRST FLOWERING			TERRITORIAL LOSSES
←———THEODORIC AT RAVENNA———→			←————————JUSTINIAN————————→			

bishop's arm. Thus, symbolized by place and gesture, the imperial and churchly powers are in balance. The paten carried by Justinian, the cross carried by Maximianus, and the book and censer carried by his attendant clerics produce a movement that modifies strikingly the rigid formality. There is no indication of a background; the observer is expected to understand the procession as taking place in this very sanctuary, where the emperor will appear forever as participant in the sacred rites and proprietor of this royal church, the very symbol of his rule of the western empire. The portraits of the empress Theodora and her entourage, on the other hand, are represented within a definite architecture, perhaps the narthex of San Vitale. The empress stands in state beneath an imperial canopy, waiting to follow the emperor's procession and to pass through the curtained doorway to which she is beckoned by an attendant. The fact that she is outside the sanctuary and only about to proceed attests that in the ceremonial protocol her rank is not quite that of her consort—even though the representation of the Three Magi on the border of her robe recalls their offerings to the infant Christ and makes an allusive connection between Theodora and the Virgin Mary.

The figure style shows the maturing of conventions of representation that go back to Dura-Europos and earlier. Tall, spare, angular, and elegant, the figures have lost the rather squat proportions characteristic of much Early Christian work. The gorgeous draperies fall straight, stiff, and thin from the narrow shoulders; the organic body has dematerialized, and, except for the heads, we have a procession of solemn spirits gliding noiselessly in the presence of the sacrament. Byzantine style will preserve this hieratic mood for centuries, no matter how individual variations will occur within its conventions.

One can hardly talk of Byzantine art without using the term "hieratic." Christianity, originating as a mystery cult, kept mystery at its center;

one might say that the priest becomes a specialist in mystery. The priestly supernaturalism that disparages matter and material values prevails throughout the Christian Middle Ages, especially in orthodox Byzantium, and it is that hieratic supernaturalism that determines the look of Byzantine figurative art—an art without solid bodies or cast shadows, with blank, golden spaces, with the perspective of paradise, which is nowhere and everywhere.

The portraits in San Vitale are individualized despite the prevailing formality (PLATE 7-6); however, this is true only of the principals, those of the lesser personages on the outskirts of the groups being more uniform. There can be little doubt that in these portrait groups, which memorialize the dedicatory ceremony, it was intended that close likenesses be made of those centrally involved—the emperor and empress and the high officials of church and state. Since pagan times, the image of the deified emperor in public and sacred places had been tantamount to his actual presence, for the image and the reality were taken to be essentially one. The setting up of the image of the emperor was "an act which furnished the occasion for the declaration of submission on the part of the people";[3] and those who gazed on the images must have known that they owed them absolute reverence: "In these awe-inspiring images the sovereigns, though far away in Byzantium, had actually set foot on the soil of Italy."[4]

Thus the symbol, the image, and what they represent are most often one and the same. Just as the image of Justinian or Theodora or a saint is venerated as if it were the person, so are a cross, relics, and mementoes. Even vessels associated with holy rites come to be venerated as real presences of sacred powers that can cure not only spiritually but physically. To the believer, this

[3] *Ibid.*, p. 28.
[4] *Ibid.*, p. 39.

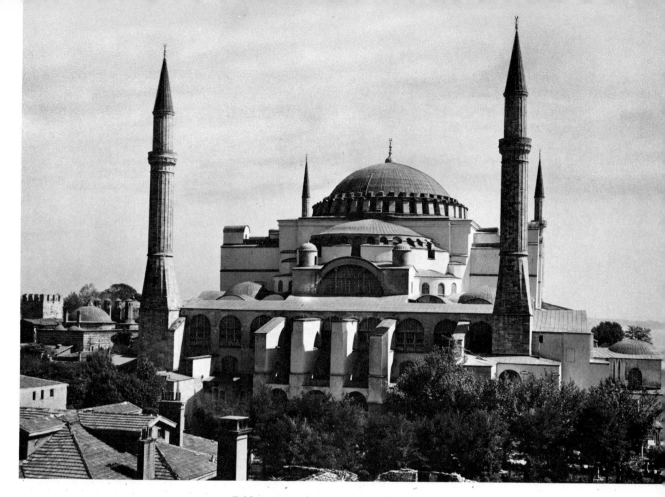

7-32 Hagia Sophia, Constantinople, A.D. 532–37.

communion of reality between objects and what they represent is logical enough; if the body of Christ is reproducible through the ritual of the Eucharist, then representations of all holy things ought to be just as real as what they represent. Symbols, images, narratives, sacramental objects —the furniture and accessories of ritual—can all be venerable and spiritually potent in themselves; this is like the magic of the Paleolithic caves, where the hunter-artists believed they summoned and controlled their animal quarry by the miracle of representation.

In Ravenna a powerful statecraft under the management of Justinian and Maximianus had been able to combine in a group of monuments the full force of Christian belief and political authority. In the process there was made a model of religious art, sacramental-magical in its power, that could work in the service both of the Church and the sanctified imperial state; this model, image, or ideal unity of the spiritual and temporal would strongly influence the Middle Ages in both east and west. The hieratic style of Byzantium, matured and exemplified in Ravenna, will remain as both the standard and the point of departure for the content and form of the art of the Middle Ages.

Byzantium

Ravenna, the city that had become the successor to Rome as imperial capital in Italy, and then, as the so-called Exarchate, the beachhead of Byzantium in the Germanized west, finally passed from Byzantine control. The images of Justinian and Theodora in San Vitale, proclaiming that the empire was still whole, were powerless to make it so. But the east remained firmly in the hands of successions of emperors for a thousand years, and Constantinople became the magnificent citadel of Byzantine civilization whence streamed its influence to all points of the compass. At the time the imperial presence in Ravenna was being

symbolized in architecture and art, the vast church of Santa Sophia, or more properly Hagia Sophia, Church of the Holy Wisdom, was being built for Justinian in Constantinople by the architects ANTHEMIUS of Tralles and ISIDORUS of Miletus between 532 and 537. The church remains today one of the supreme achievements in the history of world architecture (FIGS. 7-32 to 7-35). Its dimensions alone, formidable for any structure not made of steel, would attract attention. In plan it is about 240 by 270 feet; the dome is 108 feet in diameter, its crown some 180 feet above the pavement. It rivals in scale the great buildings seen so far in pagan and Christian Rome—the Pantheon, the Baths of Caracalla, the Basilica of Constantine. In exterior view the great dome dominates the structure; but the external aspects of the building are much changed from their original appearance—by huge buttresses added to the original design and by four towering Turkish minarets added after the Ottoman conquest of 1453, when Hagia Sophia became an Islamic mosque. The building was secularized in the twentieth century and is now a museum.

The characteristic Byzantine plainness and unpretentiousness of exterior, which in this case also disguises the great scale, scarcely prepares us for the interior of the building (FIG. 7-33). One encounters first the huge narthex with its many entrances, and then the open, tremendous space above, where the soaring dome, canopylike, rides on a halo of light provided by windows in the dome's base. The impression made on the people of the time, an impression not lost on us, is given in the words of the poet Paulus, an usher at the court of Justinian:

> About the center of the church, by the eastern and western half-circles, stand four mighty piers of stone, and from them spring great arches like the bow of Iris, four in all; and, as they rise slowly in the air, each separates from the other . . . and the spaces between them are filled with wondrous skill, for curved walls touch the arches on either side and spread over until they all unite above them . . . The base of the dome is strongly fixed upon the great arches . . . while above, the dome covers the church like the radiant heavens . . . Who shall describe the fields of marble gathered on the pavement and lofty walls of the church? Fresh green from Carystus, and many-colored Phrygian stone of rose and white, or deep red and silver; porphyry powdered with bright spots; emerald-green from Sparta, and Iassian marble with waving veins of blood-red and white; streaked red stone from Lydia, and crocus-colored marble from the hills of the Moors, and Celtic stone, like milk poured out on glittering black; the precious onyx like as if gold were shining through it, and the fresh green from the land of Atrax, in mingled contrast of shining surfaces [5]

The dome rests upon four *pendentives*. In pendentive construction (FIG. 7-36)—developed, apparently after many years of experiment, by builders in the Near East and *the* contribution of Byzantium to architectural engineering—a dome rests upon what is in effect a second and larger dome from which have been omitted the top portion and four segments around the rim—the latter forming four arches whose planes bound a square. By transferring the weight to piers rather than to the wall itself, pendentive construction

[5] In W. R. Lethaby, "Santa Sophia, Constantinople," *Architectural Review*, April 1905, p. 12.

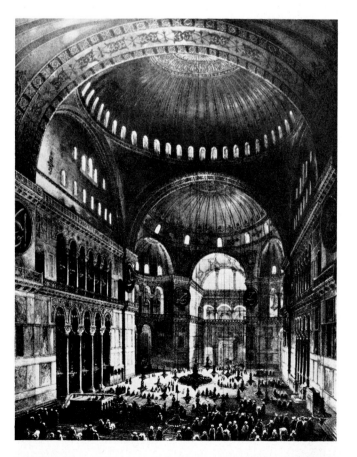

7-33 *Interior of Hagia Sophia*, lithograph by Gaspare Fossati, *c.* 1850.

makes possible a lofty, unobstructed interior space such as is particularly evident in Hagia Sophia. In our view of the interior the arches that bound two of the great pendentives supporting the central dome can be seen converging on their massive piers. The domes of earlier central-type buildings, like the Pantheon, Santa Costanza, or even San Vitale, had sprung from the circular or polygonal bases of a continuous wall or arcade. The pendentive system is a dynamic solution to the problem of setting a round dome over a square or rectangle. It made possible the union of the central structure and the long basilican type seen in awkward relationship in the Church of the Holy Sepulcher (FIGS. 7-10 and 7-11). Hagia Sophia, in its successful fusion of the types, becomes a domed basilica, a uniquely successful conclusion to several centuries of experiment in Christian church architecture. However, the thrusts of its pendentive construction make other elements necessary: huge wall piers to north and south, and, east and west, half-domes whose thrusts descend in turn into still smaller domes (FIG. 7-34) covering columned niches that give a curving flow to the design, reminiscent of San Vitale. And, as in San Vitale, the wandering space, the diverse vistas, the screenlike, ornamented surfaces, mask the lines of structure. The arcades of the nave and galleries have no real structural function; like the walls they pierce they are only part of a fragile "fill" between the great piers. Structurally, though Hagia Sophia may seem Roman in its great scale and majesty, it does not have Roman organization of its masses. The very fact that what appears to be wall in Hagia Sophia is actually a concealed (and barely adequate) pier indicates that Roman monumentality was sought after as an *effect* and not derived directly from Roman building principles.

What struck early visitors to Hagia Sophia, and many generations of them since, was the quality of light within it and the effect it had upon one's spirit. The forty windows at the base of the dome gave the peculiar illusion that the dome rested upon the light that flooded through them, so that an observer of the time thought that it looked as if the dome were suspended by a "gold chain from Heaven." Procopius, the historian of the age of Justinian, wrote: "One would declare that the place were not illuminated from the outside

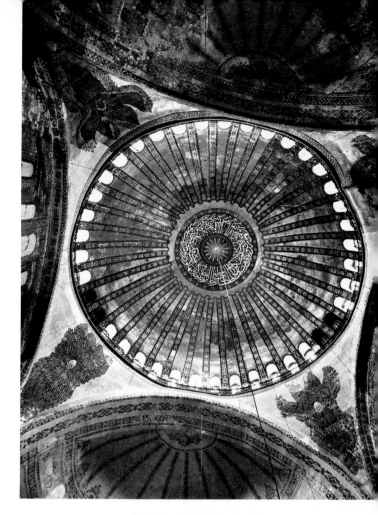

7-34 Vaults of Hagia Sophia.

by the sun, but that the radiance originated from within, such is the abundance of light which is shed about this shrine." Paulus, whom we have already quoted, observed: "the vaulting is covered over with many little squares of gold, from which the rays stream down and strike the eyes so that men can scarcely bear to look." We thus have a vastness of space shot through with light and a central dome that *appears* to be supported by the light it admits. Light is the mystic element, light that glitters in the mosaics, that shines forth from the marbles, that pervades and defines spaces that in themselves seem to escape definition; light becomes the agent that seems to dissolve material substance and transform it into an abstract, spiritual vision. At Hagia Sophia, the intricate logic of Greek theology, the ambitious scale of Rome, the vaulting tradition of the Near East, and the mysticism of Eastern Christianity

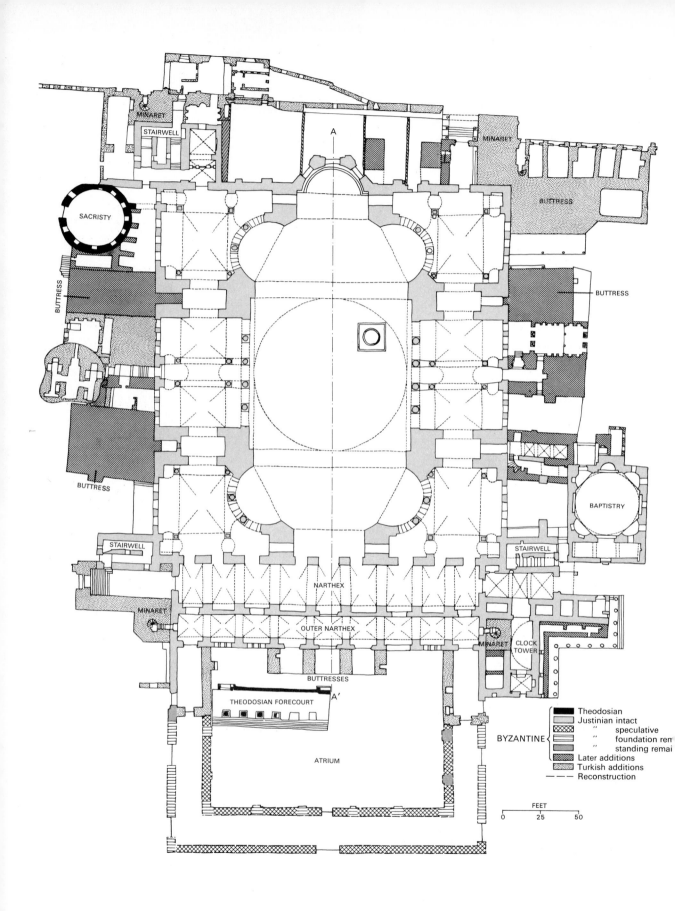

MINARET

STAIRWELL

A

SACRISTY

BUTTRESS

BUTTRESS

MINARET

BUTTRESS

BUTTRESS

BUTTRESS

STAIRWELL

STAIRWELL

BAPTISTRY

NARTHEX

OUTER NARTHEX

MINARET

MINARET

CLOCK TOWER

BUTTRESSES

THEODOSIAN FORECOURT

A'

ATRIUM

BYZANTINE

Theodosian
Justinian intact
" " speculative
" " foundation rem
" " standing remai
Later additions
Turkish additions
Reconstruction

FEET
0 25 50

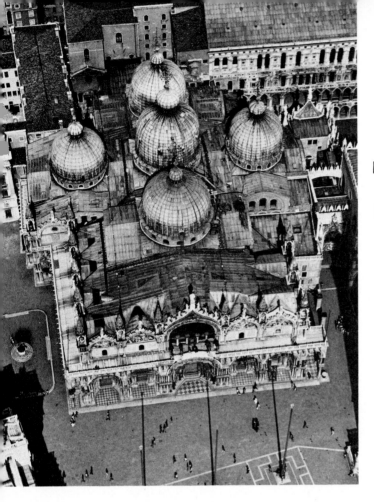

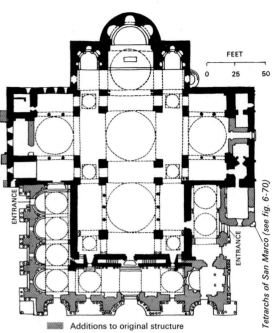

7-41 Plan of St. Mark's. (After Sir Banister Fletcher.)

Tetrarchs of San Marco (see fig. 6-70)

Additions to original structure

7-40 St. Mark's, Venice, begun 1063.

trasting with the helmetlike shapes of its auxiliaries. The bright metal caps, peaked with crosses like miniature masts, reflect the moody Russian skies and proclaim, as if in architectural polyphony, the glory of the orthodox faith.

Painting

While architecture enjoyed a fairly continuous development throughout the Byzantine period, that of the representation arts (painting and sculpture) suffered a severe setback during the eighth and ninth centuries, when they became the subject of a violent controversy. The Iconoclastic Controversy over the propriety of religious imagery, which raged for more than 100 years (730–843), began with the temporary victory of the image-destroyers (iconoclasts), who interpreted the biblical ban against graven images literally. In 730 an imperial edict banned religious imagery throughout the Byzantine empire, and artists were either forced to migrate to the west, where the edict was unenforceable, or, if they chose to remain in Byzantium, to turn their talents to secular subject matter, which was not affected by the ban. Although little has survived of their work, it may be assumed that those who worked in the secular vein discovered in the classical style a vehicle better suited to the depiction of nonspiritual subjects than the austere, abstract Byzantine manner; for when the ban was lifted in 843 and religious painting was again encouraged, a style emerged that represents a subtle blending of the pictorial Hellenic and the abstract Byzantine.

An eleventh-century crucifixion scene on the wall of the monastery church at Daphne in Greece (FIG. 7-44) shows the simplicity, dignity, and grace

7-38 Domes on pendentives (left) and squinches (right).

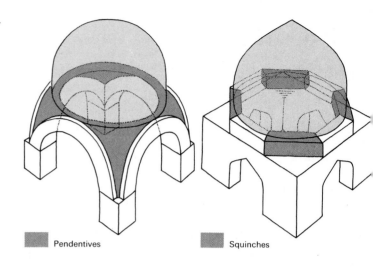

Pendentives Squinches

antine architecture thus seems to aim for complex interior spaces that issue into multiple domes in the upper levels; these, in exterior view, produce spectacular combinations of round forms that shifting perspectives develop dramatically. The splendid Church of Holy Apostles, built in the time of Justinian and now no longer in existence, is reflected in plan in St. Mark's in Venice, which reproduces it (FIGS. 7-40 to 7-42). The original structure of St. Mark's, dating from the eleventh century, is disguised on its lower levels by Romanesque and Gothic additions. But in plan, or from an air view, the domes, grouped along a cross of equal arms (the Greek Cross again) make the Byzantine origins at once evident. The inner masonry shells are covered with swelling, wooden, helmetlike forms sheathed in gilded copper; these not only protect the inner domes but make an exuberant composition appropriate to this great community church of the proud Venetian republic. Venice was, like Ravenna some eighty miles to the south, under strong Byzantine influence, despite the independence it had won early in the Middle Ages and preserved for centuries. The interior of St. Mark's is, like its plan, Byzantine in effect, though its great Justinianic scale and intricate syncopation of domed bays are modified slightly by western Romanesque elements. Certainly its light effects and its rich cycles of mosaics are entirely Byzantine.

Byzantine influence was wide-ranging, not only in Italy but in the Slavic lands and in the regions of the east where Islam had expanded. Byzantium brought its script, its religion, and much of its culture to Russia. The "holy" Russia before the revolution of 1917 was largely Byzantine in its traditions—one might even say, in its mood. Russian architecture, magnificently developed in the Middle Ages, is a brilliant provincial variation on Byzantine themes. In Moscow, within the walls of the Kremlin, stands the Cathedral of the Annunciation, dating from the later fifteenth century (FIG. 7-43). The domed-cross system of Byzantium here receives a most spirited expansion. The domes rise in a kind of crescendo to the triumphant climax of the central unit, with its characteristically Russian onion-shaped form con-

7-39 Interior of the Church of the Katholikon (view facing east).

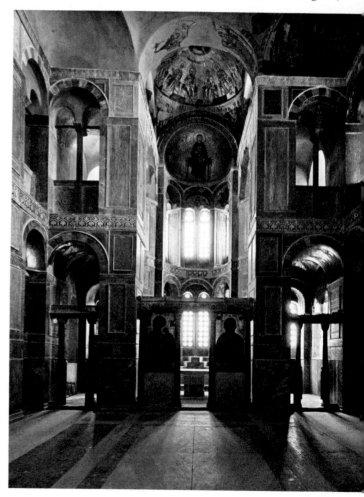

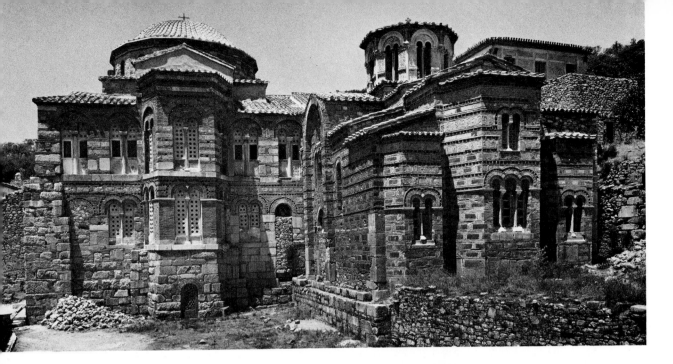

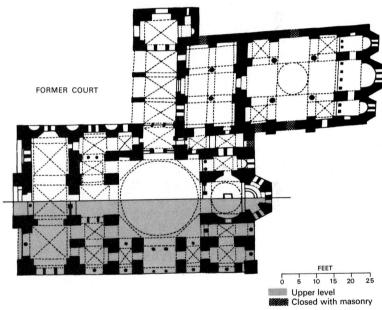

7-36 Monastery churches at Hosios Loukas, Phocis, Greece: Church of the Katholikon, *c.* 1020 (left), and Church of the Theotokos, *c.* 1040 (right).

7-37 Plans of the Church of the Katholikon (bottom) and the Church of the Theotokos (top).

FORMER COURT

FEET
0 5 10 15 20 25

▨ Upper level
▩ Closed with masonry

schemes such as Santa Costanza's circular plan, San Vitale's octagonal, and Hagia Sophia's dome on pendentives rising from a square. The complex core of the Katholikon lies within two rectangles, the outermost being the exterior walls. Thus, in plan, from the center out there is a circle-octagon-square-oblong series whose parts exhibit a remarkably intricate interrelationship.

The interior elevation of the Katholikon reflects its involved plan (FIG. 7-39). Like earlier Byzantine

buildings it creates a mystery out of space, surface, and light and dark. High and narrow, it forces our gaze to rise and revolve: "The overall spatial effect is overwhelmingly beautiful in its complex interplay of higher and lower elements, of core and ancillary spaces, of clear, dim, and dark zones of lighting."[6] Middle and Late Byz-

6 Richard Krautheimer, *Early Christian and Byzantine Architecture* (Baltimore: Penguin, 1965), p. 244.

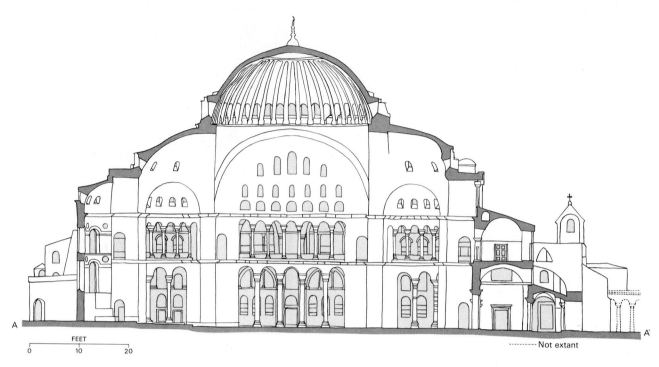

7-35 Plan (left) and section (above) of Hagia Sophia. (After drawings by Van Nice and Antoniades.)

FEET
0 10 20

--------- Not extant

are combined to create a monument that is at once a summation of antiquity and a positive assertion of the triumph of Christian faith.

Hagia Sophia was a unique hybrid, uniting the western basilican with the eastern central plan in a design (FIG. 7-35) without successors, for after it the east forsook the long church for a thousand years or more, developing the central plan, while in the west the basilican plan was consciously revived in Carolingian times.

LATER BYZANTINE ART

Between the later tenth and the twelfth century there occurred, under the auspices of the Macedonian dynasty, what has been called the Second Flowering or Second Byzantine Golden Age, when Byzantine culture reencountered its Hellenistic sources and accommodated them to the styles inherited from the Age of Justinian, the time of the *First* Flowering.

Architecture

In architecture a brilliant series of variations on the domed central theme appeared. From the exterior the typical later Byzantine church building is a domed cube (less often some rectangular form having other than a square as its basis), the dome rising above the square on a kind of cylinder or drum. The churches are small, vertical, high-shouldered, and, unlike earlier Byzantine buildings, have exterior wall surfaces with ornament in relief. In the Church of the Theotokos (FIGS. 7-36 and 7-37), about 1040, at Hosios Loukas in Greece, one can see the form of a domed cross with four equal-length, vaulted cross-arms (the "Greek Cross"). Around this unit, and by the duplicating of it, Byzantine architectural design developed bewilderingly involved spaces. The adjacent, larger Church of the Katholikon (FIGS. 7-36 and 7-37) uses a dome over an octagon inscribed within a square, the octagon formed by *squinches*—arches, corbeling, or lintels that bridge the corners of the square (FIG. 7-38). This arrangement represents a subtle extension of the older

7-42 Interior of St. Mark's (view facing east).

of classicism fully assimilated by the Byzantine artist in a perfect synthesis with Byzantine piety and pathos. Christ is represented on the cross, flanked by the Virgin and St. John. A skull at the foot of the cross indicates Golgotha, the "place of skulls." Nothing is needed to complete the tableau. In quiet sorrow and resignation, the Virgin and St. John point to Christ as if to indicate the meaning of the cross. Symmetry and closed space produce an effect of the motionless and unchanging aspect of the deepest mystery of the Christian religion; and the timeless presence is, as it were, beheld in unbroken silence. The picture is not a narrative of the historical event of the Crucifixion but a devotional object, a thing sacramental in itself, to be viewed by the monks in silent contemplation of the mystery of the Sacrifice. Although elongated, these figures from the Second Golden Age of Byzantine art have regained their organic structure to a surprising

7-43 Cathedral of the Annunciation, Moscow, 1482–90.

A.D. 726	752		843	878	c. 900		975	c. 1020	1063	c. 1100
	Ravenna lost to Lombards			Sicily lost to Arabs	Paris psalter		Damascus retaken	Katholikon, Hosios Loukas	St. Mark's begun, Venice	

ICONOCLASTIC CONTROVERSY

to c. A.D. 565 ◄———— TERRITORIAL DECLINE ————►

SECOND FLOWERING

degree, particularly as compared with those of the Justinian period (compare FIGS. 7-30 and 7-31). The style is a masterful adaptation of Greek statuesque qualities to the linear Byzantine style.

The elongation of saintly figures to stress their noncorporeal, spiritual essence, found in the Ravenna mosaics, becomes a typical "mannerism" of Late Byzantine art. A striking example is the solemn, majestic *Virgin* in the apse mosaic of the cathedral of Torcello, an outlying island of Venice (FIG. 7-45). Tall, slender, small-headed, she stands utterly and triumphantly alone in a golden Heaven, pointing to the Christ child she carries, elevated above the twelve apostles and above all mankind. The mystery of the *Theotokos* ("Mother of God") is made visible in her commanding image. One remembers the great god-desses of the ancient world, their awesome stature and superhuman powers; the Virgin here represented is their spiritual descendant, purged of all dross of matter, a near-hypnotic apparition. The hieratic style we have seen forming in the Age of Justinian and earlier has here reached a peak of expression.

But Byzantine art of the later periods can also represent vigorous action. A recently uncovered fresco in the vault of a side chapel of the Mosque of the Ka'riye in Istanbul (built in 1320 and originally the Church of the Blessed Savior of the Chora) represents, although inscribed *Anastasis* ("Resurrection"), the harrowing of hell (FIG. 7-46). Christ, after his death upon the cross, descends into hell, tramples Satan, and rescues Adam and Eve, while other worthies of the Old Testament stand by awaiting their liberation. The movement of the central figures is highly dramatic. The white-robed, aureole-surrounded figure of Christ is laden with energy as he literally tears the parents of mankind from their tombs. The dynamic postures of the figures are reinforced by swirling draperies, agitated by the winds of a supramaterial force. But we also notice that, here and there, the carefully and precisely drawn drapery folds tend to take on a life of their own, as the Late Byzantine artist often shows delight in creating linear patterns for their own sake. These abstract, decorative, linear patterns tend to obscure the fact that, in its late stages, Byzantine art becomes increasingly realistic.

While the characteristics of Byzantine painting were developed in large-scale mural decorations, it was through miniatures in manuscripts and through small panel paintings, more popularly known as *icons*, that the elements of the style were spread abroad. A fine example of the former is a page from a book of the Psalms of David, the so-called *Paris Psalter* (FIG. 7-47), which reasserts the artistic values of the classical past with astonishing authority. It is believed to date from the

7-44 *The Crucifixion*, mosaic from the monastery church at Daphne, Greece, eleventh century.

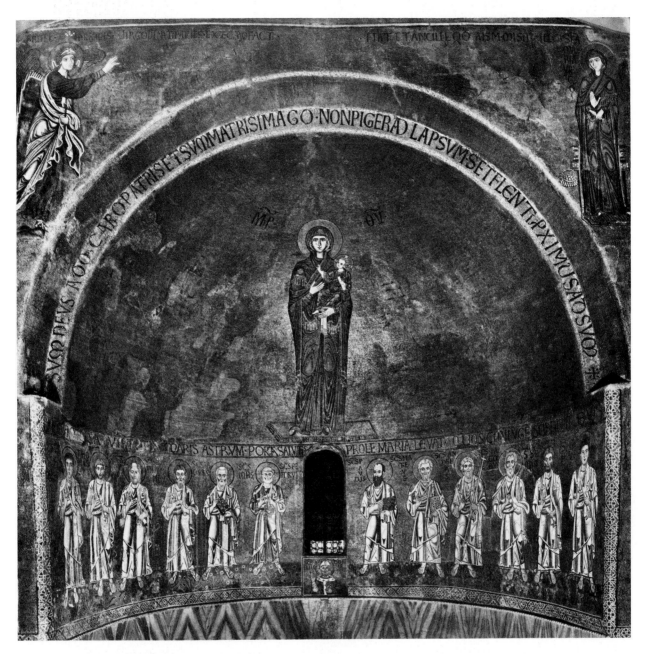

7-45 *The Virgin with Apostles*, apse mosaic from the cathedral of Torcello, eleventh century.

early tenth century, a time of enthusiastic and careful study of the language of ancient Greece as well as its literature, a time when the classics were regarded with humanistic reverence. It was only natural that, in art, inspiration should be drawn once again from the Hellenistic natu-

ralism of the pre-Christian Mediterranean world, especially Alexandria. David, the psalmist, is represented seated with his harp in a flowering, Arcadian landscape recalling those of Pompeian murals. He is accompanied by an allegorical figure of Melody and surrounded by sheep, goats,

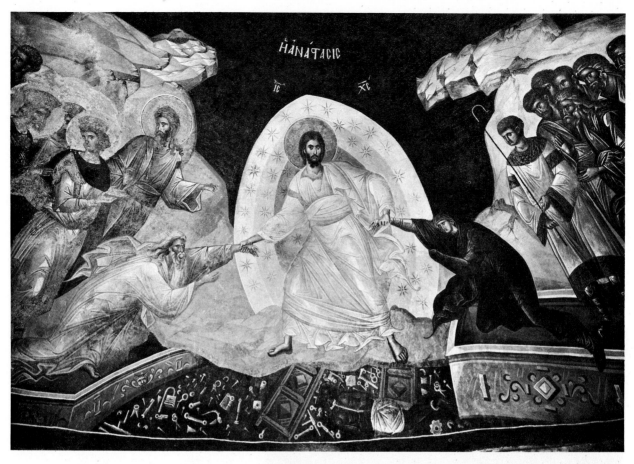

7-46 Above: *The Harrowing of Hell*, fresco from the Mosque of the Ka'riye, Istanbul, *c.* 1310–20.

7-47 Right: *David Composing the Psalms*, page from the so-called *Paris Psalter*, *c.* 900. Approx. 15″ × 11″. Bibliothèque Nationale, Paris.

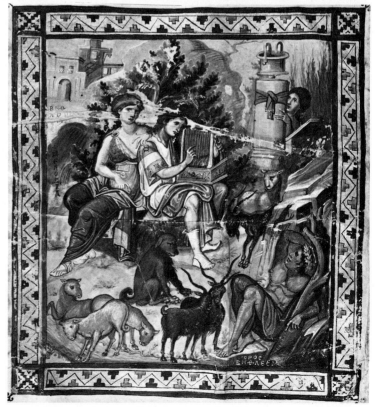

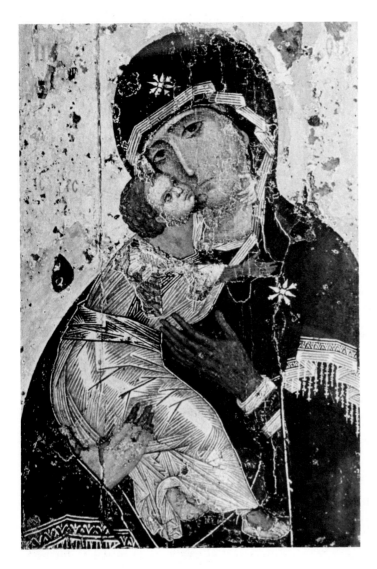

7-48 *The Vladimir Madonna,* eleventh century. Original dimensions of panel approx. 21″ × 30½″. State Historical Museum, Moscow.

and his faithful dog. Echo peers from behind a trophied column, and a reclining male figure, doubtless the river god, Jordan, points to an inscription that identifies him as also representing the mountains of Bethlehem. None of these allegorical figures appears in the Bible; they are the stock population of Alexandrian and Pompeian landscape. Apparently the artist had before him a work from Late Antiquity or perhaps earlier, which he partly translated into Later Byzantine pictorial idiom. In the figure of Melody we find some incongruity between the earlier and later style. Her pose as well as her head and torso are quite Hellenistic; Hellenistic too is the light, impressionistic touch of the brush, but the dra-

pery enwrapping the legs is a pattern of hard line. Byzantine illuminations like this will again and again exert their influence on Western painting in the Romanesque and Early Gothic periods.

An example of the devotional panel is the famous *Vladimir Madonna* (FIG. 7-48), which was probably painted by an artist in Byzantium in the eleventh century, exported to Vladimir, and then taken to Moscow in 1395 to protect that city from the Mongols. As these icons were quickly blackened by incense and the smoke from devotional candles burned before them, they were frequently repainted, often by inferior artists. In our panel, only the faces show the original surface, but the painting retains its Byzantine charac-

teristics in the typical configuration of the Madonna's face, with its long, straight nose and tiny mouth, and in the decorative sweep of the unbroken contour that encloses the two figures and creates a flat silhouette against a golden background. Easily transportable and widely copied, icons spread the Byzantine style throughout the Balkans and Russia, where icon painting flourished for centuries and extended the life of the style well beyond the collapse of the Byzantine empire in 1453.

ISLAMIC ART

In 622 Mohammed fled from Mecca to Medinet-en-Nabi ("City of the Prophet," now Medina). From this flight, known as the Hegira, Islam[7] dates its era.

During the century that followed, the new faith spread with unprecedented speed from Arabia, where it was first espoused, through the Middle East to the Indus Valley and westward across North Africa to the Atlantic Ocean. By 640 Syria, Palestine, and Iraq had been conquered by Arab warriors in the name of Islam. In 642 the Byzantine army abandoned Alexandria, marking the Moslem conquest of Lower Egypt. By 710 all of North Africa had been overrun, and a Moslem army crossed the straits of Gibraltar into Spain. A victory at Jerez de la Frontera in 711 seemed to open all western Europe to the Mohammedans. By 732 they had advanced north to Poitiers in France, where an army of Franks under Charles Martel, the grandfather of Charlemagne, opposed them successfully. Although they continued to conduct raids in France, they were unable to extend their control beyond the Pyrenees. But in Spain the great Caliphate of Cordoba flourished until 1031 and, indeed, it was not until 1492, when Granada fell to Ferdinand and Isabella, that Mohammedan

influence and power in the West came to a close. In the East the Indus River had been reached by 751, and only in Anatolia was stubborn Byzantine resistance able to slow the Mohammedan advance. But relentless Moslem pressure against the shrinking Byzantine Empire eventually caused its collapse in 1453, when the Ottoman Turks conquered Constantinople.

The early lightning successes of Islam were due largely to the zeal and military prowess of Arab warriors who set out to conquer the earth for Allah and who burst upon the Near Eastern and Mediterranean worlds when Persian and Byzantine military power was at a low ebb. But the fact that these initial conquests had effects that endured for centuries can be explained only by the nature of the Islamic faith and its appeal to millions of converts.

Many of the features of the Islamic faith are derived from the Judeo-Christian tradition. Its sacred scripture is the Koran, the collection of Mohammed's revelations ordered to be gathered by the caliph Othman (644–56) and unchanged to the present day. Its basic teachings and ethics are similar to those of the Bible, and the Old Testament prophets as well as Jesus are counted among the predecessors of Mohammed. On the other hand, every Moslem believes he has direct and equal access to Allah without need for complex ritual or an intervening priesthood. Furthermore, a new social order, quite different from the Christian one, was established by Mohammed in that he took charge of the temporal as well as the spiritual affairs of his community. This practice of uniting religious and political leadership in the hands of a single ruler was continued after Mohammed's death by his deputies, the caliphs, who based their claims to authority on their descent from the families of the Prophet or those of his early followers.

Architecture

During the early centuries of Islamic history, the political and cultural center of the Moslem world was the Fertile Crescent (Palestine, Syria, Iraq), that melting pot of East and West strewn with

[7] Islam, "exclusive worship of the one God (Allah)" was Mohammed's name for his new religion. Mohammedan, Muhammadan, Muslim, Moslem—all refer to the same faith.

impressive ruins of earlier cultures that became one of the fountainheads of the development of Islamic art. The vast territories conquered by the Arabs were governed by deputies, originally sent out from Damascus or Baghdad, who eventually gained relative independence by setting up dynasties in various territories and provinces —the Umayyads in Syria (661–749) and in Spain (756–1031), the Abbasids in Iraq (749–945), the Fatimids in Egypt and Tunisia (909–1171), and so on. Despite the Koran's strictures against sumptuousness and license, the caliphs were not averse to surrounding themselves with luxuries commensurate with their enormous wealth and power. This duality is expressed by the two major architectural forms developed during the early Islamic period: the mosque and the palace.

Moslem religious architecture is closely related to Moslem prayer, the performance of which is an obligation laid down in the Koran for all Moslems. Prayer as a private act requires neither liturgical ceremony nor a special locale; only the *qibla*—the direction (toward Mecca) in which the prayer is addressed—is important. But prayer also became a communal act for which a simple ritual was established by the first Moslem community. Once a week the community convened—probably in the Prophet's house, the main feature of which was a large, square court with two *zullahs*, or shaded areas, along the north and south sides. These zullahs consisted of thatched roofs carried by rows of palm trunks; the southern one, wider and supported by a double row of trunks, indicated the qiblah. During these communal gatherings, the *imam*, or leader of collective worship, standing on a pulpit known as *minbar*, near the qiblah wall, pronounces the *khutbah*, which is both a sermon and an act of allegiance of the community to its leader. The minbar thus represents secular authority even as it serves its function in worship. The requirements of this ritual were satisfied by the hypostyle mosque, the origin of which is still in dispute, but one of whose prototypes may well have been the Prophet's house in Medina. Once the Moslems had firmly established themselves in their conquered territories, they began to build on a large scale, impelled perhaps by a desire to create visible symbols of their power

that would surpass those of their non-Islamic predecessors in size and splendor; the great size of some of the early mosques, however, may also be explained by the fact that they were intended to contain the entire Moslem population of a given city.

The Great Mosque of Samarra on the Tigris River (FIGS. 7-49 and 50), built between 848 and 852 but now ruined, is the largest mosque of the Islamic world, measuring 800 by 520 feet. Over half its ten-acre area was covered by a wooden roof carried by 464 supports arranged in aisles around the open central court and leading toward the qiblah wall, the importance of which was emphasized by the greater number of aisles on its side. In the center of the qiblah wall is a niche, the *mihrab*, which became a standard feature in all later mosques. Its origin, purpose, and meaning are still matters of debate; Oleg Grabar feels that it may originally have honored the place where the Prophet stood in his house at Medina when he led the communal prayers. If the mihrab has this symbolic function, it is unusual, since one of the characteristics of early Islamic art is its concerted avoidance of symbols. In this respect, early Islamic art offers a striking contrast to medieval Christian art; the avoidance of religious symbolism, in fact, may reflect conscious rejection of Christian customs and practices.

On the north side of the Great Mosque of Samarra stands a single, large minaret from which a *muezzin* called the faithful to prayer. Although its shape is reminiscent of the ancient ziggurats of Mesopotamia, it was probably inspired not by them but by a certain kind of spiral tower of unknown purpose found in Sassanian Iran. More numerous were minarets that were square in plan and derived from the towers of Early Christian churches in the Near East. Cylindrical minarets, from which evolved the slender needles that are so characteristic of later mosques became popular only in the eleventh century.

The early Moslem hypostyle system, as illustrated by the Samarra mosque, was diffused and, except for the orientation of the building and the position of the qiblah wall, lacked architectural focus and direction. On the other

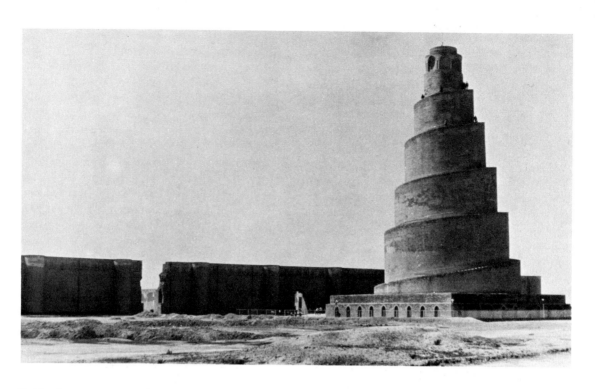

7-49 Above: Great Mosque, Samarra, Iraq, A.D. 848–52.

7-50 Right: Plan of the Great Mosque, Samarra.

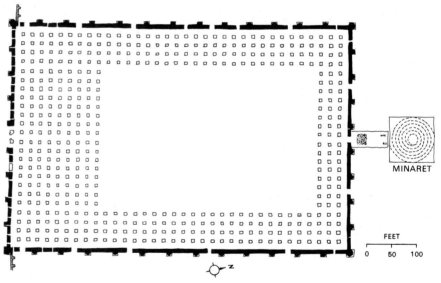

MINARET

FEET

0 50 100

N

hand, it was a flexible system that permitted enlargement and addition with minimum effort. Its main element was the single support, either a column or a pier, which could be multiplied at will and in any desired direction. A striking illustration of the flexibility of this system is the mosque of Cordoba (FIGS. 7-51–52), which was begun in 784 and enlarged several times during the ninth and tenth centuries. The additions followed the original style and arrangement of columns and arches, and the builders were able to maintain a striking stylistic unity for the entire building. The 36 piers and 514 columns are topped by a unique system of double-tiered arches that carried a wooden roof, now replaced by vaults. The lower arches are horseshoe-shaped,

7-51 Plan of the mosque at Cordoba, Spain, eighth to tenth centuries.

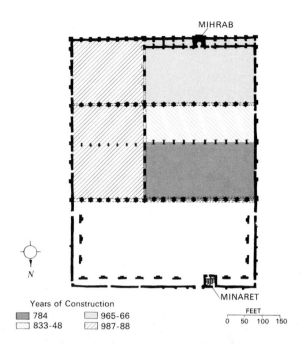

MIHRAB

MINARET

Years of Construction

- 784
- 833-48
- 965-66
- 987-88

FEET
0 50 100 150

N

a form probably adapted from earlier Near Eastern architecture and now closely associated with Moslem architecture. Visually these arches seem to billow out like sails blown by the wind, and they contribute greatly to the light and airy effect of the mosque's interior.

In areas the builders wished to emphasize, like that near the mihrab (FIG. 7-53), the arches become highly decorative, multilobed shapes. Other early Islamic experiments with arch forms had led to the pointed arch, which, however, was not used to cover variable spaces, as in Gothic buildings. Early Islamic buildings had wooden roofs, and the experiments with arch forms were motivated not by structural necessity, but by a desire to create rich and varied visual

7-52 Interior, mosque at Cordoba.

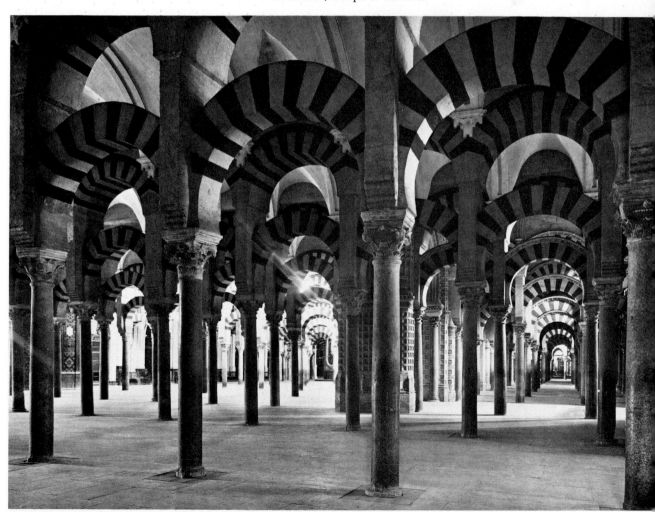

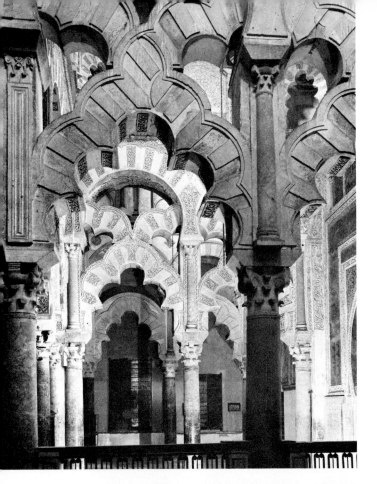

7-53 Mihrab, mosque at Cordoba.

effects. The same desire for decorative effect seems to have inspired the design of the dome that covers the area in front of the mihrab (FIG. 7-54), one of four domes built during the tenth century to stress the axis leading to the mihrab. Here the large ribs that subdivide the hemispherical surface of the dome into a number of smaller sections are primarily ornamental. Only in the hands of Gothic builders, centuries later, were ribs in combination with the pointed arch to become fundamental structural ingredients of a new and revolutionary architectural vocabulary.

Of the early palaces there are only scattered remains, and they are of limited historical importance, serving primarily to illustrate the way of life of Moslem aristocrats and to provide us with some notion of the decorative styles of early Islamic art. Even the purpose of these early palaces is not quite certain. They were built both

7-54 Dome before mihrab, mosque at Cordoba.

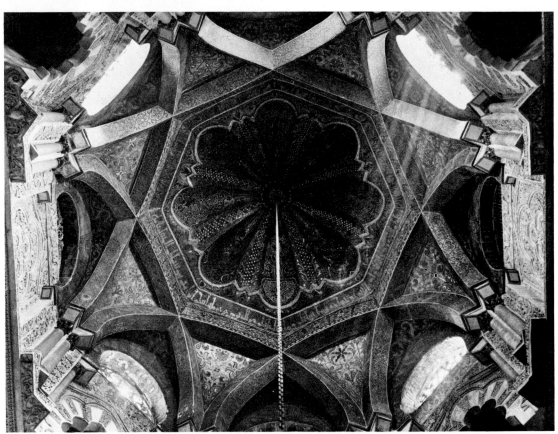

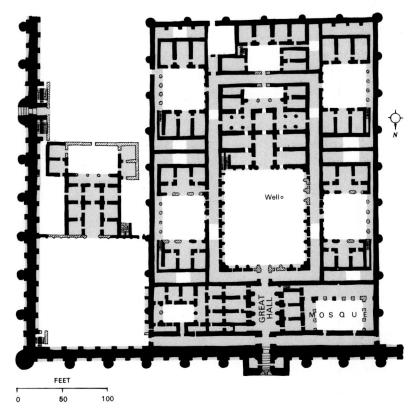

7-55 Plan of the palace at Ukhaydir, Iraq, late eighth century.

FEET

0 50 100

in cities and in the open country. The rural palaces, which are the better investigated, seem to have had a function similar to that of Roman villas. That they reflect an Islamic taste for life in the desert seems too simple an explanation, although a desire to avoid plague-infested cities may well have been at least a partial motivation of their builders. But these rural palaces probably also served as nuclei for the agricultural development of conquered territories; and they may also have been symbols of authority over conquered and inherited lands, as well as expressions of the newly acquired wealth of their owners.

One of the better preserved of these early Moslem palaces is that of Ukhaydir in Iraq (FIGS. 7-55 and 56), built in the second half of the eighth century. Rather larger than most, the palace here is a separate entity within a fortified enclosure. From the outside the high, tower-studded walls look much like those of the Great Mosque of Samarra (FIG. 7-49). This similarity illustrates a flexibility that is characteristic of early Islamic monuments, as relatively minor

changes could convert them from one purpose to another. Differences between a mosque, a palace, or a caravanserai were rarely evident from the exterior; the structures tended to share a rather grim, fortified look that belied their military inefficiency. The high walls may have offered safety from marauding nomadic tribes but, more important to the builders, they may also have fulfilled abstract considerations, like the promise of seclusion for a mosque or, for a palace, privacy for the prince and the symbolic assertion of his power over newly conquered territories.

The plan of the palace at Ukhaydir (FIGS. 7-55 and 56) expresses its dual residential and official function. An elaborate entrance complex, consisting of a monumentalized gate and a Great Hall between two small domed rooms, leads onto the large central court beyond which is a reception hall surrounded by satellite rooms. Flanking this ceremonial axis are four smaller courts, all with three rooms on each of two sides. These grouped rooms appear to be self-contained and

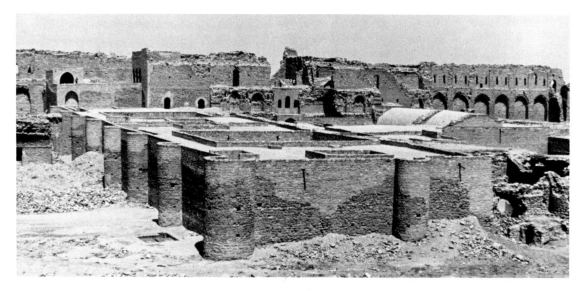

7-56 Palace at Ukhaydir.

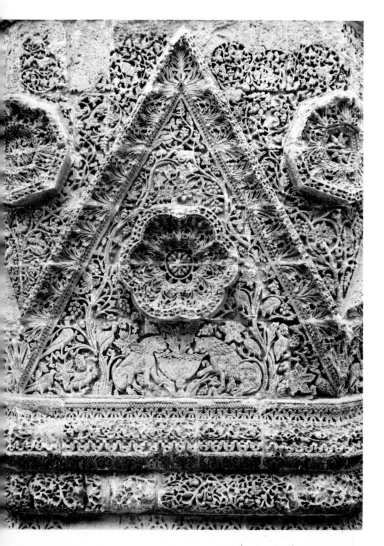

7-57 Portion of stone frieze, palace at Mshatta, Jordan, c. A.D. 743. The reconstruction reflects the mistaken belief that the structure was essentially Roman.

probably served as family living units or guest houses. To the right of the entrance hall is a standard feature of these early palaces—a mosque, here incorporated into the main building complex, though sometimes standing by itself. Most palaces also were provided with fairly elaborate bathing facilities, whose technical features, such as heating systems, were taken over from the Roman tradition of baths. (The baths at Ukhaydir, only recently discovered near the mosque, are not shown on the plan.) Just as in classical antiquity, these baths probably served more than merely hygienic purposes. Large halls frequently attached to them seem to have been used as places of entertainment. Thus a characteristic amenity of classical urban culture that died out in the Christian world survived in medieval Islamic culture.

The decoration of the Ukhaydir palace seems to have been rather sparse and confined to simply molded stucco and occasional decorative brickwork. In this respect, finds made in the western palaces in Syria and Palestine (modern Israel and Jordan) have been much richer. At Mshatta, an unfinished palace in the Jordanian desert, for instance, gate and façade were decorated by a wide, richly carved stone frieze (FIGS. 7-57 and 58). Its design, arrangement, and rela-

tion to its carrier serve well to illustrate the major characteristics of early Islamic decoration.

A long band, almost fifteen feet high, is decorated with a series of triangles of the same size framed by an elaborately carved molding. Each triangle contains a large rosette that projects from a field densely covered with curvilinear vegetal designs; no two of the triangles are treated the same way, and into some of them, as in the example shown, figures of animals are introduced. The sources of the various design elements are easily identified as late Classical, early Byzantine, and Sassanian Persian, but their combination and arrangement are typically Islamic.

Most of the design elements of Islamic ornament are based on plant motifs, which are sometimes intermingled with human and animal shapes. But the natural forms often become so stylized that they are lost in the purely decorative tracery of the tendrils, leaves, and stalks. These arabesques form a pattern that will cover an entire surface, be it that of a small utensil, a manuscript page, or the wall of a building. (This *horror vacui* is similar to tendencies in barbarian art, although other aspects of Islamic design distinguish it from the abstract barbarian patterns.) The relationship of one form to another in the Islamic is more important than the totality of the design: the patterns have no function but to decorate. This system offers a potential for unlimited growth, as it permits extension of the designs in any desired direction. Most characteristic, perhaps, is the design's independence of its carrier, since neither its size (within limits) nor its forms are dictated by anything but the design itself. This arbitrariness

imparts a certain quality of impermanence to Islamic design, a quality that, it has been said, may reflect the Moslem taste for readily movable furnishings, such as rugs and hangings.

Stone carving was only one of several techniques used for architectural decoration. Floor mosaics and wall paintings continued a long Mediterranean tradition. Particularly popular were stucco reliefs, a method of decoration that was known, but not common, in pre-Islamic Iran and Iraq. Cheap, flexible, and effective, the basic material—wet plaster—was particularly adaptable to the execution of the freely flowing line that distinguishes Islamic ornament, and it became a favorite technique.

Some of the very richest examples of stucco decoration are found in the Alhambra palace in Granada, Spain, the last Moslem stronghold in western Europe in the late Middle Ages. In the Court of the Lions and the rooms around it (FIGS. 7-59 and 60) stucco decoration runs the gamut of the medium's possibilities and creates an exuberant atmosphere of elegant fantasy that seems to be the visible counterpart of the visions of the more ornate Moslem poets.

The court itself (FIG. 7-59), proportioned according to the Golden Mean, is framed by rhythmically spaced single, double, and triple columns with slender, reedlike shafts that carry richly decorated block-capitals and stilted arches of complex shape. All surfaces above the columns are covered by colored stucco moldings that seem aimed at denying the solidity of the stone structure that supports them. The resulting buoyant, airy, almost floating appearance of the building is enhanced by the "stalactite" decorations that break up the structural appearance of

7-58 Reconstruction (after Schulz) of façade of the palace at Mshatta.

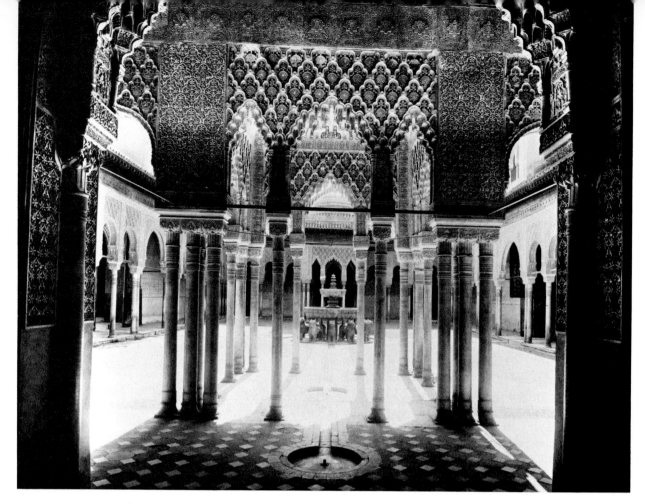

7-59 Court of the Lions, The Alhambra, Granada, Spain, 1354–91.

the arches, transforming them into near-organic forms.

This same tendency to disguise architectural forms is shown even more vividly in the Hall of the Two Sisters (FIG. 7-60), which adjoins the Court of the Lions. Here, all surfaces are covered by a polychromed lacework of stucco and tile in which an almost limitless variety of designs is held together by symmetry and rhythmic order. The overall effect of the incredibly rich decoration is that of tapestries suspended from walls and dome, the "stalactites" resembling pendant tassels. In this hall, the Moorish (North African and Spanish) style, heralded in the Mosque of Cordoba (FIG. 7-52), has reached its ultimate refinement. Its influence on Spanish art remained strong throughout the Middle Ages and well into the Renaissance, and traces of it may be observed in the art of the Hispanic colonies of America.

A very different architectural concept is expressed in the Madrasah and Mausoleum of Sultan Hasan in Cairo (FIGS. 7-61 and 7-62). The madrasah, a combined school and mosque, was a building type developed in Iran and brought westward by the advancing Seljuk Turks during the eleventh century. It shares with the hypostyle mosque the open central court but replaces the Arabic forests of columns with austere masses of brick and stone. The court is now surrounded by four vaulted halls, the one on the qiblah side larger than the other three. Crowded into the angles formed by these halls are the various apartments, offices, and schoolrooms of the Moslem educational institution. Decoration of the main building is confined to moldings around

the wall openings and a frieze below the crenellated roofline. These serve to accentuate, rather than disguise, the geometric clarity of the massive structure, which presents a striking contrast to the filigreed elegance of the contemporary Alhambra.

Attached to the qiblah side of the madrasah is the mausoleum, which is a simple cubical structure covered by a dome of Byzantine derivation. Mausoleums—central-plan domed structures—were adopted from the West, as they had not been a part of the original inventory of Islamic architecture. First built as memorials to Holy Men, they were eventually converted to the secular function of commemorating Islamic rulers. By the tenth century the building type was well established in Iran, whence it spread both east and west; it became especially popular in Egypt, which, of course, had its own age-old tradition of large-scale funerary monuments.

The most famous of all Islamic mausoleums is the fabled Taj Mahal at Agra (FIG. 7-63), which was built by one of the Moslem rulers in India, Shah Jahan, as a memorial to his wife, Mumtaz

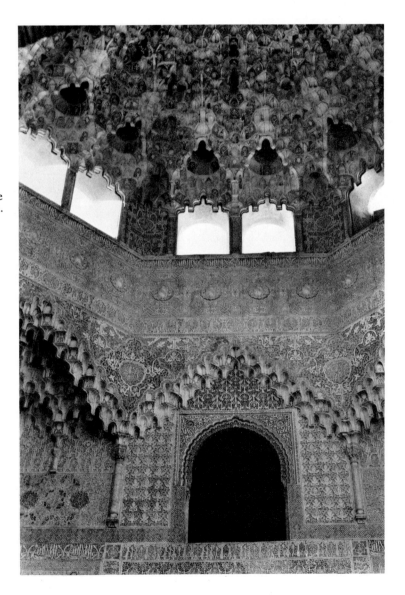

7-60 Hall of the Two Sisters, The Alhambra.

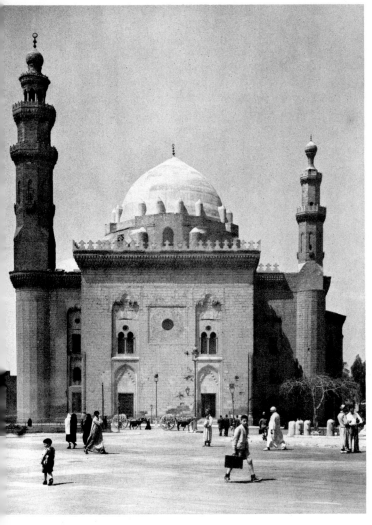

7-62 Plan of the Madrasah of Sultan Hasan, Cairo, Egypt.

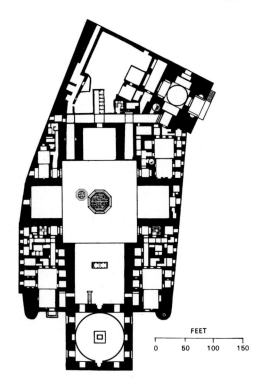

Mahal. The basic shape of the monument is that of the Cairo mausoleum, but modifications and refinements have converted the massive, cubical structure into an almost weightless vision of cream-colored marble that seems to float magically above the tree-lined reflecting pools. The interplay of shadowy voids with gleaming marble walls that seem paper-thin creates an impression of translucency, and elimination of the Cairo structure's heavy, projecting cornice (which separated the blocky base of the earlier building from its dome) ties all the elements together. The result is a sweeping upward movement toward the climactic, balloon-shaped

dome. Carefully related minarets and corner pavilions introduce, and at the same time stabilize, this soaring central theme. While the entire monument recalls the fragile elegance of the Alhambra, it far surpasses the latter in subtle sophistication and represents the high-water mark of Moslem architecture.

Object Art and Textiles

The furnishings of the palaces as well as the mosques reflected a love of rich and sumptuous effects. Metal, wood, glass, and ivory were art-

7-63 Taj Mahal, Agra, India, 1632–54.

fully worked into a great variety of objects for use in mosque or home. Basins (often huge), ewers, jewel cases, writing boxes were made of wrought copper or brass, chased and inlaid with silver; enameled glass was used with striking effect in mosque lamps; richly decorated ceramics of high quality were produced in large numbers. Islamic potters, experimenting with different methods of polychrome painting of their wares, developed luster painting, a new and original technique that gives a metallic shine to a surface. Their designs used the motifs found in architectural decoration. This ready adaptability of motifs to various scales as well as to various

techniques again illustrates both the flexibility of Islamic design and its relative independence from its carrier.

The most prestigious and highly valued objects of all were textiles, which, in the Islamic world, served more than purely utilitarian or decorative purposes. Produced by Imperial factories, they were used not only in homes, palaces, and mosques, but served also as gifts, rewards, and signs of political favor.

The art of the Moslem weavers was probably acquired from the Sassanians in Iran and the Copts in Egypt, where weaving was well developed at the time that the countries were

conquered by the Arabs in the seventh century. From there the art spread across the Islamic world and, by the tenth century, Moslem textiles were famous and widely exported. The art of carpet-making was developed to a particularly high degree in Iran, where the need for protection against the winter cold made carpets indispensable both in the shepherd's tent and in the prince's palace. In houses and palaces built of stone, brick, plaster, and glazed tile, carpets also provided a contrasting texture as floor and divan coverings and wall hangings.

The carpet woven for the tomb-mosque of Shah Tahmasp at Ardebil (PLATE 7-7) is a large example of the medallion type and bears a design of effectively massed large elements surrounded and enhanced by a wealth of subordinated details. The field of rich blue is covered with leaves and flowers (chiefly peonies, a Chinese influence) attached to a framework of delicate stems that weave a spiral design over the whole field. Great royal carpets like the Ardebil are products of the joint effort of a group of weavers who probably were attached to the court. Pile weaving is a slow process at best, and, since a carpet like the Ardebil often has more than 300 knots to the square inch, a skilled weaver working alone would probably have needed about twenty-four years to complete it.

Since the Ardebil carpet was made for a mosque, its decoration excludes human and animal figures, although other carpets from Ardebil show that the Koran's strictures against the representation of man and animal were not taken as seriously in secular art. The ban against the worship of idols, however, had practically eliminated the image of man from Islamic religious art, and even in early secular art it appeared only occasionally in secluded parts of palaces as part of royal imagery. For this reason also, large sculpture in the round and mural or panel painting, as developed in Europe and in the Far East, was rather rare in early Islamic art. Contributing to this lack of interest in monumental plastic art may have been the predilections of the people that made up the Moslem world; many of them—Arabs, Turks, Persians, and Mongols—were nomads, who traditionally preferred small, movable objects (the so-called

"nomad's gear") to large-scale works of art. And so, perhaps, it should not be surprising that, when painting did develop in later times, it was mainly on the small scale of book illumination.

Illumination

The Arabs had no pictorial tradition of their own, and it seems possible that their interest in book illumination developed almost accidentally, as a by-product of their practice of translating and copying illustrated Greek scientific texts. In some of the earliest Islamic illuminated manuscripts, none dating earlier than about A.D. 1200, the illustrations seem to have been drawn by the scribes who copied the texts. From such rather modest beginnings one of the world's great schools of book illumination developed in Persia.

The Persian shahs were lovers of fine books and maintained at their courts not only skilled calligraphers, but also some of the most famous artists of their day. The secular books of the Timurids and the Safawids were illustrated by a whole galaxy of painters. Famous among them were Bihzad (c. 1440–1536), Mirak, and Sultan Muhammad, court painters of Shah Tahmasp (1524–1576), a great art patron. Although the shahs were Moslems, orthodox Islamic restrictions regarding the human figure were rather liberally interpreted by them and did not affect their secular arts, so that the gay scenes of their life of pleasure—the hunt, the feast, music, and romance—and battle scenes fill the pages of their books. In them we feel the luxury, the splendor, and the fleeting happiness of Omar.

In *Laila and Majnun* (PLATE 7-8) the painter Mirak illustrates one of Nizami's romantic poems. The scene represents a school, apparently in a mosque. Seated on a rug is a turbaned *molla*, or teacher, lash in hand, listening to a youth reading; around him are other youths studying, all seated on their knees and heels or with one knee raised, the customary sitting postures of the East. Here and there are cross-legged bookrests. In the foreground one boy is pulling his companion's ear, and at the left, near

the large water jar, two are playing ball. In the middle distance are the lovers Laila and Majnun, each obviously aware of the other's presence. Although the figures are drawn expressively with delicate, flowing lines, they are flat, with no shading and with but a hint of perspective; the tiles in the court and the rugs on the floor appear to be hanging vertically. The painting is conceived from a point of view concerned not with natural appearance but with pattern and vivid color. To this end the tones are kept bright and clear. The decorative quality of the miniature is emphasized by the broad margins of the page, which is tinted pale blue and flecked with gold.

In its general appearance the miniature is much more closely related to the Ardebil carpet than to any European painting or, for that matter, to Chinese painting, by which it was certainly influenced. It falls within the general framework of the Islamic decorative style, which, despite early religious restrictions and the constraints of a limited formal vocabulary, became one of the richest and most harmonious decorative styles in the world.

PART TWO

THE MIDDLE AGES

The poets of the Augustan age were singing the glories of "eternal Rome" while Jesus of Nazareth, obscure founder of the religion that was to transform the city of man into the city of God, was born and died. Within three centuries Christianity had become the official cult of the dying empire and the faith of the new peoples, the barbarians, who were to inherit its remains. While Byzantium, eastern remnant of the Christianized Roman empire, maintained a continuous sovereignty, the empire in the west disintegrated. What had been the imperial provinces broke up into contesting barbarian kingdoms—those of the Franks, Burgundians, Visigoths, Anglo-Saxons, Lombards, and others. Historians have called the ensuing epoch, the thousand years from about 400 to 1400, the Middle Ages or the Dark Ages. For centuries it was thought that this interval between the passing of the Roman empire and the rebirth of its civilization in the Renaissance was rough and uncivilized—in a word, "barbarous." Between the ancient and the modern world life was empty, cruel, and dark, simply a blank between (in the "middle" of) two great civilizations. Even today the word "medieval" is often used disparagingly. But since the late eighteenth century, historians have been thoroughly revising the view, long held, that Medieval art was crude and primitive. The same romantic enthusiasm for past

View of the cloister of St. Pierre, Moissac, twelfth century. The capitals are of both the historiated and decorative types, which appear regularly in Romanesque sculptured capitals in southern France.

civilizations that motivated the archeological revolution and the recovery of the ancient past sent scholars in quest of the meaning of Medieval culture, the meaning of monuments that existed in great number, aboveground and visible. Although we now see these centuries with very different eyes, perceiving their innovation and their greatness, the names "Middle Ages" and "Medieval" remain, simply because it is convenient to use them.

Medieval civilization represents an interrelation of Christianity, Roman tradition, and the new, energetic spirit of the Celtic-Germanic peoples, the barbarians, as the Romans had called them. Christianity, firmly established, provided a unifying force even in the midst of anarchy and chronic warfare. It mitigated the harsh passions of rough warriors. It kept alive learning and knowledge of the useful arts. Though itself often corrupted, it was just as often reformed. By the thirteenth century, when the Church was at the height of its power, western Europe had evolved as a great and original civilization, constantly stimulated by influences from the Greco-Roman past and from Byzantium and the world of Islam but ever reworking those influences in novel ways. The Christian Church, with its monopoly on education, also preserved and handed on Roman materials not directly related to religion: the Latin language, Roman law, Roman administrative organization and practice, the idea and ideal of the Roman empire—all elements used by the Church but, as the Renaissance would show, susceptible of entirely secular application.

Though the spirit of Christianity was oriented toward the world of the supernatural and though its learning was centered in theology, which regarded questions about the nature of the physical world both irrelevant to salvation and irreverent in intention, by the thirteenth century there was stirring, even within the Church, a new curiosity about man's natural environment that could not be entirely stifled by the prevailing religious disposition. In a thirteenth-century summation of Medieval knowledge—the influential encyclopedia called the *Speculum Majus* (*Great Mirror*)—Vincent of Beauvais included the "Mirror of Nature," a compendium of lore about natural things. By no means an objective or scientific analysis of nature in the modern sense, it was rather a descriptive record of the appearances of things as the reflection of God's glory and beneficence. Within the Medieval setting, notwithstanding its thoroughly religious view of nature, a different impulse was being felt, a secular and intellectual curiosity about the world that was to mature into modern science.

In addition, there were technological achievements that pointed to consequences far beyond anything the ancient world had known. The invention of tools and mechanisms that extended man's powers over his environment and facilitated manufacture were encouraged not

least by the new dignity conferred on manual labor and skills by the Church's condemnation of slavery. The free craftsman, not, as in the ancient world, the slave, was the Medieval agent of production; organized in guilds, he constituted the firm foundation of Medieval urban economy. Thriving towns, populated by free men, provided a stimulus for commerce and industry, and most of the prosperous European cities of today were established or underwent renovation at about the twelfth century. Indeed Florence, mother city of the modern world, had early laid the foundations of its wealth and, by the fifteenth century, had the spirit and the means to lead Europe into the bold, creative age of discovery we call the Renaissance.

Early Medieval Art

MEDIEVAL EUROPE A.D. 800–1000

With Routes of Early Migrations

0 200 400 miles

Kingdom of Ostrogoths

Kingdom of Visigoths

Kingdom of Franks

Kingdom of Burgundians

Carolingian Empire

Territory of Byzantine Emp

Arab Caliphate

Lindisfarne

DANES

SAXONS

Sutton Hoo

FRANKS

Hildesheim

ATLANTIC OCEAN

c.420

BURGUNDIANS

LOMBARDS

VANDALS 401

GOTHS 150–200

VANDALS c. 170

HUNS 375

OSTROGOTHS 455

Tours 443 St. Gall

568

VISIGOTHS 375

Roncesvalles

VANDALS 409

VISIGOTHS 480

Ravenna
488

VISIGOTHS 397

Rome 410

455

Constantinople

VANDALS 439

FOR THOUSANDS of years waves of migrating people had moved slowly across the great Eurasian steppes down into the Mediterranean world; we have met them as the Achaeans and Dorians of Mycenaean times, and again as the Gauls, who invaded Asia Minor and were defeated by Attalus I of Pergamum in the third century B.C.

In the second century A.D. the Goths moved southward from the Baltic region and settled on the north shore of the Black Sea, subjugating the Scythians and Sarmatians who had inhabited the area for some eight centuries. On their march, the Goths had met and defeated the Vandals, pushing them toward central Europe and setting in motion one of the longest and most infamous migratory treks in history, one that was to end only in the fifth century with the establishment of a Vandal kingdom in North Africa. The Goths themselves split into two groups in the early

375

Frankish ornaments

Death of Attila 453

Huns reach Gaul 451

376 Invasion of Huns

Anglo-Saxons in Britain 5th Century

400

482–750 Franks in Gaul (Merovingian)

Visigoths in Spain 412–672

Ostrogoths in Italy 489–540

MIGRATION PERIOD — GERMANIC KINGDOMS

600

Lombards in Italy 568–774

Book of Lindisfarne

Sutton Hoo purse cover

CELTIC CULTURE IN IRELAND 600–850

End of Merovingian Period

Codex Aureus

750 Pippin "the Short" 741–68

754 Donation of Ravenna to Pope

St. Matthew from Gospel Book of Charlemagne

Coronation of Charlemagne

800

Charlemagne 768–814

CAROLINGIAN PERIOD

850

Otto III Enthroned from Gospel Book of Otto III

Otto I ("the Great") 936–73

OTTONIAN PERIOD

1002 1015

Adam and Eve, St. Michael's, Hildesheim

fourth century—the Ostrogoths (eastern Goths), who remained in Sarmatia, and the Visigoths (western Goths), who moved on into the Danube river basin.

For centuries these migratory movements had been checked by Roman military might along the Rhine and Danube rivers. Despite constant friction with them since the first century B.C., the Romans had been able to contain the barbarians along their northern frontiers. In the fourth century, however, the eruption of the Huns from the east pressed those tribes and nations against the Roman boundaries, which Rome found more and more difficult to defend. In A.D. 376 the Roman emperor Valens allowed the Visigoths, hard-pressed by the Huns, who had already conquered their Ostrogothic cousins, to settle west of the Danube. Maltreated by Roman officials, the Visigoths revolted two years later and, in a battle near Adrianople, killed the emperor and nearly two-thirds of his army. After this, Rome offered little resistance to the different barbarian nations, who crossed into western Europe almost at will. It is the following four centuries of ethnic upheavals in Europe that we refer to as the Migration period.

THE MIGRATION PERIOD

As the name implies, the invasions of Roman territory by barbarian tribes were in reality migrations of ethnic groups seeking not to overthrow the Roman empire, for which they often had great admiration, but a place where they could settle peacefully. However, they were seldom allowed to do so, as other tribes and nations would press in behind them and force them to move on. The Visigoths, for example, who moved in and out of Italy and formed a kingdom in southern France, were forced southward into Spain under pressure from the Franks, who had crossed the lower Rhine and established themselves in nothern France. The Huns themselves, the force that triggered this chain reaction of ethnic dislocations, reached France and Italy in mid-fifth century, and only the death of their great leader, Attila, in 453 prevented them from consolidating their vast conquests. As Hunnish power waned, the Ostrogoths shook off their yoke, moved first to Pannonia (junction of modern Hungary, Austria, and Yugoslavia) and then to Italy, where, under Theodoric, they established their kingdom only to have it fall less than a century later to the Lombards.

During this time of upheaval, strife, fear, and uncertainty, the Church, benefiting from the prestige of such early leaders as Augustine and Gregory the Great, constituted the only central authority, political as well as spiritual; the popes had in effect succeeded the Roman emperors. It was at this time that the foundations for the later authority of the Church were firmly established. In this connection, we should bear in mind that most of the barbarian tribes entering the Roman empire were already Christian, although of the Arian creed, which had been condemned as heretical by the Orthodox Church. In its contest with the eastern Orthodox Church for leadership in Christendom, papal Rome was strengthened when the Frankish king, Clovis, was converted to Catholicism. During his reign (481–511) the Franks gained control over the Burgundians (who had moved from the Baltic area into the region around Lake Geneva in the early fifth century), the Visigoths, and other groups in the area now France. With the recognition of the pope in Rome by this Frankish kingdom and with the success (in the sixth century) of Augustine's mission to England, where he became the first archbishop of Canterbury, Catholicism and the authority of Rome became firmly established in western Europe.

Accounts of the barbarian character vary. Tacitus, pointing up a moral for his Roman contemporaries, praises their courage, good looks, moral purity, fidelity, and good treatment of women but finds them guilty of drunkenness and wanting in perspicacity in matters of money. We can get a better picture of the Germanic character from their epics, songs, and sagas, which show a somber pessimism built upon a fundamental belief in fate, in the inevitable. Their heroes, like Siegfried and Beowulf, struggle against a pagan world of dreadful monsters.

Fierce joy in battle alternates with bragging and carousing; and narratives of stoic valor, with expressions of despair. Interpersonal loyalty, which became the basis of feudal ties and feudal law, is glorified in their poetry, as in this fragment of an Anglo-Saxon epic describing the last stand of a band of Saxons against the Danes:

Remember the times when we spoke over our mead, when we raised up our boasts along the benches, heroes in the hall in anticipation of a hard fight! Now let us see who is brave. . . . Byrhtivold spoke up, an old retainer . . . he taught his warriors their duty: "Mind shall be the harder, heart the keener, courage the greater as our strength grows less."

The imagination of these wandering people teemed with fantastic creatures of all sorts. Their belief that the deep, dark forests of the north virtually swarmed with zoomorphic and demonic populations was widely shared by the nomadic hunters of all tribes. Dragons, like Siegfried's Fafnir and Beowulf's Grendel, symbolize the mysterious and threatening universe of fierce forces that the later Medieval world will picture as the devils and demons of hell. Medieval man, long after he ceased his wandering and despite Christianization, remained more than half pagan; his terrors were bound up with his tribal experience and the memory of fiend-filled forests and pagan rites. (Charlemagne, in suppressing the Saxons, decreed against human sacrifice.) Against this background, it is not surprising to find that the Germanic tribes readily adopted an art form that, although foreign, was ideally suited to their imagination—the Eastern "animal style" already encountered in Mesopotamian art.

Craft Art

The original art of the Germanic peoples was abstract, decorative, and geometric and ignored the world of organic nature. It was confined to the decoration of small, portable objects—weapons or items of personal adornment such as bracelets, pendants, and belt buckles. Most characteristic, perhaps, and produced in considerable numbers by almost all tribes, was the *fibula*, a decorative pin usually used to fasten

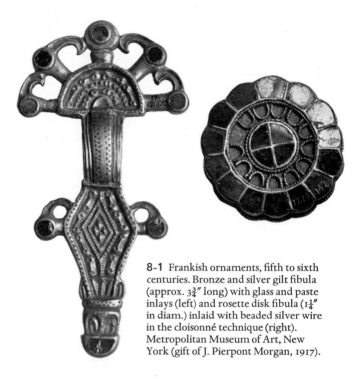

8-1 Frankish ornaments, fifth to sixth centuries. Bronze and silver gilt fibula (approx. $3\frac{3}{4}''$ long) with glass and paste inlays (left) and rosette disk fibula ($1\frac{1}{4}''$ in diam.) inlaid with beaded silver wire in the cloisonné technique (right). Metropolitan Museum of Art, New York (gift of J. Pierpont Morgan, 1917).

garments (FIG. 8-1). The fibulae were made of bronze, silver, or gold and were profusely decorated, often with inlaid precious or semiprecious stones. The entire surface of objects is covered with decorative patterns, reflecting the *horror vacui* so common in the art of primitive cultures. But we also note that the decorative patterns are carefully adjusted to the basic shape of the object they adorn and that they describe and amplify its form and structure, becoming an organic part of the object itself.

This highly disciplined, abstract, and functional type of decorative design was wedded to the animal style during the early centuries of the Medieval era. Probably of prehistoric origin, the animal style had reasserted itself in the Luristan bronzes of the ninth and eighth centuries B.C. and was a dominant element of the artistic repertoire of the Scythians, who passed it on to their Gothic overlords in the third century A.D. From that time on, the Goths became the main transmitters of this style, which was readily adopted by many of the other Germanic tribes. But its application was severely controlled by the native Germanic sense of order and design. Abstracted to the point of absolute integration with domi-

nantly geometric patterns, the zoomorphic elements frequently become almost unrecognizable, and one must often examine a fibula (FIG. 8-1) carefully to discover that it terminates in an animal head.

The art of the Germanic people was expressed primarily in metalcraft. One of their preferred methods of decoration was *cloisonné*, a technique that may be of Byzantine and, ultimately, of Near Eastern origin. In this technique, used in the circular ornament shown in FIG. 8-1, small metal strips (the *cloisons*), usually of gold, are soldered edge-up to a metal background. An enamel paste (to be subsequently fired) or semiprecious stones, such as garnets, or pieces of colored glass, are placed in the compartments thus formed. The edges of the cloisons remain visible on the surface and are an important part of the design. This cloisonné personal gear was highly prized and handed down from generation to generation. Dispersion of some of the princely hoards at an early date would account for discovery of identical techniques and designs in widely divergent areas. Certainly cloisonné ware must have been given to vassals as gifts and tokens of gratitude; everywhere in barbarian poetry the name for the prince and lord is "treasure-giver." Other collections or "treasures" must have been accumulated over time, which could explain the different forms present in the magnificent discovery made

at Sutton Hoo in Suffolk, England, one piece from which is shown in PLATE 8-1.

Excavated in 1939, the Sutton Hoo site is now associated with the ship burial of the East Anglian king Anna, who died in 654. The purse lid shown is by no means the best of the pieces found, fine as it is. There are four symmetrically arranged groups of figures: The end groups consist of a man standing between two beasts, he frontal, they in profile, a heraldic type of grouping that goes back to ancient Mesopotamia (FIG. 2-13), though of course with variation. The two center groups represent eagles attacking ducks, again a familiar predatory motif that both Mesopotamian and Egyptian art yield us. The animal figures are adjusted to each other with the cunning design we associate with the whole animal style through centuries; for example, the convex beaks of the eagles fit against the concave beaks of the ducks. The two figures fit together so snugly that they seem at first to be a single dense, abstract design; this is true also of the man-animals motif. Above these figures are three geometric designs, the outer ones clear and linear in style, the central one showing an interlace pattern, the interlacements turning into writhing animal figures. Although interlacement had been known outside the barbarian world, it was seldom used in combination with animal figures. It has been suggested that the barbarian fondness for the interlace pattern came from the quite familiar experience of interlacing leather thongs. In any event, the interlacement, with its possibilities for great complexity, had natural attraction for the adroit jeweler.

Metalcraft and its vocabulary of interlace patterns and other motifs, beautifully integrated with the animal form, is without doubt *the* art of the Early Middle Ages in the West. Interest in it was so great that the colorful effects of jewelery designs were imitated in the painted decorations of manuscripts, in stone sculpture, in the masonry of the early churches, and in sculpture in wood. A striking example of the last is an animal head from another ship burial, one found near Oseberg in Norway (FIG. 8-2) that dates from the early ninth century. The Oseberg animal head expresses, as do few monuments of its age, the animal fierceness, the untamed, pagan energy of

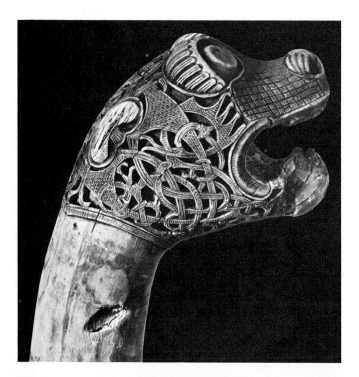

8-2 "Academic" animal head from the Oseberg ship burial, *c*. 825. Wood, approx. 5″ high. University Museum of National Antiquities, Oslo, Norway.

←to 482	632	c.650		c.700	750	to 900 →

	Mohammed dies	Sutton Hoo ship burial		Book of Lindisfarne	Codex Amiatinus	
	M E R O V I N G I A N				P E R I O D	CAROLINGIAN PERIOD

the merciless northern sea-rovers who harassed the Christian-German settlements of western Europe from the late ninth until the eleventh century. It brings together in one composition a strikingly real description of the muzzle of a snarling animal, its eyes protruding in predatory excitement, with a vigorously carved passage of interlacements in areas that would bear a lesser burden of expression—the neck and the space between the flaring nostrils and the grimacing mouth. It is thus a powerfully expressive example of the union of the two fundamental motifs of barbarian art, the animal form and the interlace.

Illumination

When we remember that barbarian art was essentially one of small portable objects, part of the collection of accessories and instruments that made up the nomad's gear, it is not surprising that monumental art—whether architecture, painting, or sculpture—is not to be found in what the migrating peoples have left. The masterpieces of barbarian art, which show the meeting of its decorative tradition with those of the art of the Mediterranean world, are illuminations in liturgical books, for with Christianization of the barbarians, the book became an important vehicle of their art. These books were easily transportable, and we can follow the movements of some of them from place to place, since their styles, copied in or copying other books, are traceable in sequences of influence.

The complicated interchanges of influences recorded in manuscript illumination from the sixth to the eleventh century are the consequence not only of the restless migration of the new people, but also of the missionary activities of the Church as it sought to stabilize the wandering groups and to establish its authority. Foremost

in this activity from the sixth century to the time of Charlemagne was the monastically organized Church of Ireland. Monasticism, a system by which communities of persons lived away from the world and dedicated themselves to the spiritual life, was instituted in the eastern Christian world by Basil in the fourth century and in the west by Benedict in the sixth century. The Celts of Ireland, converted to Christianity in the fifth century, adopted eastern rather than western monasticism and were not firmly connected to the Roman rule or to the papacy. Their independence was strengthened by their historical good luck: They were not invaded by the Germanic migrants. While western Europe from about 400 to 750 sank gradually into conflict, confusion, and ignorance, Ireland experienced a golden age. Irish monks, filled with missionary zeal, founded monastic establishments in the British islands—at Iona, off the coast of Scotland, and at Lindisfarne, on the Northumbrian (northeastern) coast of Anglo-Saxon England. From these foundations, which became great centers of learning for both Scotland and England, Irish monks, filled with a "wonderful spirit of missionary enterprise," journeyed through Europe, founding great monasteries in Italy, Switzerland, Germany, and France and making the names of "Scot" (the old term for "Irish") and "Ireland" familiar in all western Christendom. The spread of Irish-Christian influence was countered by the Church of Rome, which felt that the Irish, long isolated from Roman Christianity, were tainted by heresy and separatism. The right hand of the papacy in this action was the Anglo-Saxon Winfred, or, as he is known to history, St. Boniface, Apostle to the Germans.

This encounter between Irish and Germanic Christianity is curiously reflected in the mingling of design elements in the illuminated pages of gospel books produced in Ireland and England between the seventh and ninth centuries. These

"Hiberno-Saxon" manuscripts combine Irish and Anglo-Saxon motifs, sharing essentially, but by no means in all details, the same style. An ornamental page—only one of several from a gospel book, the *Book of Lindisfarne*—is an exquisite example of Hiberno-Saxon art at its best (PLATE 8-2). Here the craft of intricate ornamental patterning, developed through centuries, is manifested in a tightly compacted design. Serpentine interlacements of fantastic animals devour each other, curling over and returning upon their writhing, elastic shapes. The rhythm of expanding and contracting forms gives a most vivid effect of motion and change, a palpable rippling as in the surface of a rapids. The inscribed cross, a variation upon the stone Celtic crosses familiar in Ireland, regularizes the rhythms of the serpentines and, perhaps by contrast with its heavy immobility, seems to heighten the effect of motion. The motifs are placed in detailed symmetries, with inversions, reversals, and repetitions that must be closely studied with the magnifying glass if one would appreciate not so much their variety as their mazelike complexity. The zoomorphic forms are intermingled with clusters and knots of line, and the whole design pulses and vibrates like an electromagnetic energy field. The color is rich yet cool, the entire spectrum being embraced but in hues of low intensity. Shape and color are so adroitly adjusted that a smooth and perfectly even surface is achieved, a balance between an overall, steady harmony of key (color) with maximum motion of figure and line. The discipline of touch is that of a master familiar with long-established conventions; yet neither the discipline nor the convention stiffens the supple lines that tirelessly and endlessly thread and convolute their way through the design. This joy at working in the small on infinitely complex and painstaking projects—this goldsmith's, jeweler's, and weaver's craft—will live in Northern art throughout the Middle Ages in architectural detail, ivory carving, illumination, stained-glass work, and, ultimately, in panel painting. The instinct and taste for intricacy and precision, propagated in the art of the wandering Celt-Germans, will broaden beyond art into technology and the making of machines. Modern historians make much of Medieval technological invention, declaring that it innovated well beyond Greek and Roman achievement and pointed the way to the technological revolutions of modern times.

The barbarian craft remained, but the Hiberno-Saxon ornamental style, with its gorgeous essays in interlacements, was fated to be replaced by the Mediterranean styles descended from Early Christian and Late Antique art. Political realities hastened its demise. Irish Christianity lost its influence in Anglo-Saxon England and on the continent; the adherents to the rule of Benedict, the Benedictine order of monks, who wholeheartedly followed the papacy and the Roman version of Christianity, gained the upper hand in power and influence, and though the Irish Church held out for some time, eventually it accepted the Roman form. Even while Hiberno-Saxon art prevailed in Ireland, Scotland, and Northumbria, other monastic foundations in England were copying Mediterranean prototypes. Naturally, the ascendancy of the Roman Church would be

8-3 *The Scribe Ezra Rewriting the Sacred Records*, from the Codex Amiatinus, Jarrow, early eighth century. Approx. 14″ × 10″. Biblioteca Medicea-Laurenziana, Florence.

expressed in manuscripts from the Mediterranean area, and wherever the Roman orthodoxy was accepted an orthodox style of manuscript illumination had to follow. The contrast between the two very different styles is particularly striking in juxtaposition. The *Ezra* of the Codex Amiatinus (FIG. 8-3) was copied from an Italian manuscript, the Codex Grandior of Cassiodorus, early in the eighth century by an illuminator with Italian training in some Anglo-Saxon monastery, probably Jarrow. The same original must have been seen and "translated" a few years earlier by an artist trained in the abstract Hiberno-Saxon manner; his version appears as the St. Matthew figure in the *Book of Lindisfarne* (FIG. 8-4). The *Ezra* of the Codex Amiatinus, as well as the architectural environment, is closely linked with the pictorial illusionism of Late Antiquity. The style is essentially that of the brush, the color, though here and there in flat planes, blended smoothly to model the figure and give gradual transitions from light to dark. This procedure must have been continued in the Mediterranean world throughout the Early Middle Ages, despite the formalizing into line that we have seen taking place in mosaics. But the Hiberno-Saxon artist of the *Lindisfarne Matthew*, trained in the use of hard, evenly stressed line, apparently knows nothing of the illusionistic, pictorial technique, nor, for that matter, of the representation of the human figure. Though he carefully takes over the pose, he interprets the form in terms of line exclusively, "abstracting" the unfamiliar tonal scheme of his model into a patterned figure not unlike what we see in the King, Queen, and Jack of a deck of cards. The soft folds of drapery in the *Ezra* become in the *St. Matthew* a series of sharp, curving lines regularly spaced. There is no modeling, no light and shade. The long training in the peculiar linear style of barbarian art made it necessary for the *Lindisfarne* artist to convert the strange Mediterranean forms into the linear idiom familiar to him; he finds before him a tonal *picture* and makes of it a linear *pattern*.

The Medieval artist did not go to nature for his model but to a prototype—another image, a statue or a picture in a book. His copy might be one in a long line of copies, and in some cases we can trace these copies back to a lost original, in-

8-4 *St. Matthew*, from the *Book of Lindisfarne*, Lindisfarne, late seventh century. Approx. 11″ × 9″. British Library, London.

ferring its former existence. The Medieval practice of copying pictures is of course closely related to the copying of books, especially sacred books like the Scriptures and the books used in the liturgy. The Medieval scribe or illuminator (before the thirteenth century, most often a monk) could have reasoned that just as the text of a holy book must be copied faithfully if the copy is also to be holy, so must the pictures be rendered faithfully. Of course, in the process of copying, mistakes are made; and, while scholars seek to purge the book of these textual "corruptions," "mistakes" in the copying of pictures yield new pictorial styles, or represent the confluence of different styles, as in the relationship of the Codex Amiatinus and the *Book of Lindisfarne*. In any event, one should realize that the style of Medieval images, whether in sculpture or painting, was the result of copying from sources thought

8-5 Above: *St. Matthew*, from the *Gospel Book of Charlemagne*, *c.* 800–10. Approx. 6¾″ × 9″. Kunsthistorisches Museum, Vienna.

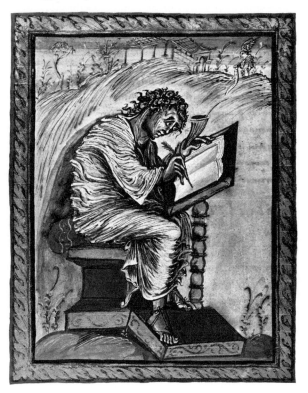

to have sacred authority, and not from the imitation of natural models. Thus, one learned what was true from authorities who declared the truth—the Scriptures and the fathers of the Church—and one painted "true" pictures or sculpted "true" statues from authoritative images. To question authority on one's own, to investigate "nature" on one's own, would be to question God's truth as revealed and interpreted. This would be blasphemy and heresy. It would be wrong, however, to leave the impression that dependence upon authority in art is characteristic solely of the Middle Ages. In the Renaissance and since—and certainly today—new styles gain sudden authority and win widespread reverence and imitation, even if for reasons different from those operative in the Middle Ages.

THE CAROLINGIAN PERIOD

The late eighth and the early ninth century saw the remarkable historical phenomenon now called Charlemagne's renovation, an energetic, brilliant emulation of the art and culture, not to say the political ideals, of Christian Rome. Out of the confusions attendant upon the migrations and settlement of the barbarians, Charlemagne's immediate forerunners built by force and political acumen a Frankish empire that contained or controlled a large part of western Europe. Charlemagne, wishing, like Constantine, whom he consciously imitated, to create a unified Christendom as a visible empire, was crowned by the pope in Rome in A.D. 800 as head of the restored empire; the new entity became the Holy Roman Empire, which, waxing and waning over a thousand years and with many hiatuses, existed as a force in central Europe until its extinction by Napoleon in 1806.

Charlemagne was a sincere admirer of learning and the arts, and in order that his empire should be as splendid as that of Rome (he thought of him-

8-6 *St. Matthew*, from the *Gospel Book of Archbishop Ebbo of Reims*, Hautvilliers near Reims, *c.* 816–35. Approx. 10″ × 8″. Bibliothèque Nationale, Paris.

self as successor to the Caesars) he invited to his court at Aachen the best minds and the finest craftsmen of western Europe and of the Byzantine East. Though himself unlettered and scarcely able to write, he could speak Latin fluently and loved the discourses he frequently held with the learned men he gathered around him. He must also have admired the splendid works created in the scriptorium of the school he had established in his palace. One of his dearest projects had been the recovery of the true text of the Bible, which, through centuries of miscopying by ignorant scribes, had become almost hopelessly corrupt. Part of the great project, undertaken by the renowned scholar Alcuin of York at the new monastery at Tours, was the correction of the actual script used, which, in the hands of the scribes, had become almost unreadable. The Carolingian rehabilitation of the inherited Latin script produced a clear, precise system of letters; the letters on this page are descended from the alphabet renovated by the scribes of Tours.

Painting and Illumination

Charlemagne, his successors, and the scholars under their patronage imported whole libraries from Italy and Byzantium. The painted illustrations in these books must have astonished northern painters, some of whom had been trained in the Hiberno-Saxon pattern-making manner, others in the weak and inept Frankish styles of the seventh and eighth centuries. Here suddenly they were confronted with a sophisticated realism that somehow had survived from the Late Antique amidst all the denaturing tendencies that followed. The famous *Coronation Gospels* (the *Gospel Book of Charlemagne*), formerly in the Imperial Treasury in Vienna, may have been a favorite of Charlemagne himself: An old tradition records that it was found on the knees of the dead emperor when, in the year 1000, Otto III had the imperial tomb at Aachen opened. The picture of St. Matthew composing his gospel (FIG. 8-5) descends from ancient depictions in sculpture and painting of an inspired philosopher or poet seated and writing; its technique is of the same antiquity—deft, illusionistic brushwork that easily and accurately defines the masses of the dra-

pery as they wrap and enfold the body beneath. The acanthus of the frame of the "picture window" recalls the fourth Pompeian style, and the whole composition seems utterly out of place in the north in the ninth century. How were the native artists to receive this new influence, so alien to what they had known and so strong as to make their own practice suddenly obsolete?

The style evident in the *Coronation Gospels* was by no means the only one that appeared suddenly in the Carolingian world; a wide variety of styles in all stages of change from antique prototypes were distributed through the court schools and the monasteries—a bewildering array, one can believe, for the natives, who now attempted their appropriation by copying them as accurately as possible. Thus, Carolingian painting is extremely diverse and uneven, and classification becomes a difficult matter of ascertaining prototypes and the descendants of prototypes. If the *Coronation Gospels* painting is by a Frank, rather than an Italian or a Byzantine, it is an amazing feat of approximation, since, except for the Jarrow copyist, there is nothing to prepare the way for it in the Hiberno-Saxon or Frankish West. Another *St. Matthew*, in a gospel book made for Archbishop Ebbo of Reims (FIG. 8-6), may be an interpretation of a prototype very similar to that used by the *Coronation Gospels* master, for it resembles it in pose and in brushwork technique. But there the resemblance stops: The classical calm and solidity have been replaced by an energy that amounts to frenzy, and the frail saint almost leaps under its impulse. His hair stands on end, the folds of his drapery writhe and vibrate, the landscape behind him rears up alive. He appears in frantic haste to take down what his inspiration, the tiny angel in the upper right hand corner, dictates. All fidelity to bodily proportions or structure is forsaken in the artist's effort to concentrate on the act of writing; the head, hands, inkhorn, pen, and book are the focus of the composition. This contrasts strongly with the settled pose of the *Matthew* of the *Coronation Gospels* with its even stress so that no part of the composition starts out at us to seize our attention. The native power of expression is unmistakable and will become one of the important distinguishing traits of Late Medieval art. Just as the painter of the *Lindisfarne Matthew* transformed the *Ezra* por-

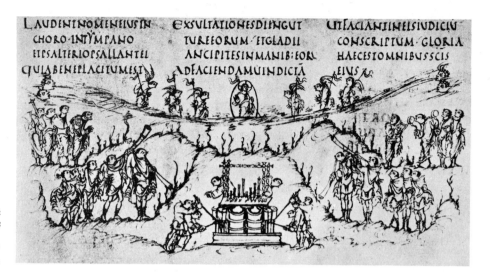

8-7 *Psalm 150*, from the *Utrecht Psalter*, Hautvilliers near Reims, *c.* 830, 4¾″ × 9½″. Utrecht University Library Ms. 32, fol. 83r.

trait in the Codex Amiatinus (FIGS. 8-3 and 8-4) into something original and strong, translating its classicizing manner into his own Hiberno-Saxon idiom, so the Ebbo artist translated his classical prototype into a Carolingian vernacular that left little classical substance. The four pictures should be carefully studied and compared.

Narrative illustration, so richly developed in Early Christian and Byzantine art, was revived by the Carolingians, and many fully illuminated books—some, large Bibles—were produced. One of the most extraordinary and enjoyable of all Medieval manuscripts is the famous *Utrecht Psalter*, written at Hautvilliers near Reims, France, about 830. The text, in three columns, reproduces the Psalms of David and is profusely illustrated by pen-and-ink drawings in the margins. The example shown in FIG. 8-7 depicts figures acting out Psalm 150, in which the psalmist exhorts us to praise the name of God in song and with timbrel, trumpet, and organ. The style shows a vivid animation of much the same kind as the *St. Matthew* of the *Ebbo Gospels* and may have been produced in the same school. The bodies are tense, shoulders hunched, heads thrust forward. The spontaneity of their actions and the rapid, sketchy technique with which they are rendered have the same nervous vitality as the figure in the *Ebbo Gospels*. From details of the figures, their dress and accessories, scholars feel certain that the artist was following one or more

manuscripts done some 400 years earlier; but his interest in simple human emotions and actions, the pantomimic skill in the variety and descriptiveness of gesture, are essentially Medieval characteristics, though they begin in Early Christian art. Note, for example, how the two musicians playing the pipe organ shout at their helpers to pump air more strenuously. It is this candid observation of man, often in his unguarded moments, that is to lend both truth and charm to the art of the Late Middle Ages.

Craft Art

To our knowledge there was little or no monumental sculpture in the Carolingian age. The traditional taste for sumptuously wrought and portable metal objects, which produced the barbarian works we have seen, persisted under Charlemagne and his successors and produced numerous precious and beautiful works like the book cover of the Codex Aureus of St. Emmeram (PLATE 8-3). Dating from the second half of the ninth century, it probably originated at either the St. Denis or Reims court of Charles the Bald, a grandson of Charlemagne. Its golden surface is set with pearls and precious jewels. Within the inscribed, squared cross, Christ appears in an attitude not far removed from that in the apse mosaic of San Vitale (PLATE 7-5). Round him are

seated the Four Evangelists, and there are four scenes from the life of Christ. The style of the figures echoes that of the *Ebbo Gospels* and the *Utrecht Psalter*, though it is modified by influences from other Carolingian schools. There is no trace of the intricate patterns of Hiberno-Saxon art. At the centers of the Carolingian renovation the translated, classicizing style of Italy prevails, in keeping with the tastes and aspiration of the great Frankish emperor who fixed his admiring gaze upon the culture of the south.

Architecture

In his eagerness to reestablish the imperial past, Charlemagne also encouraged the revival of Roman building techniques, and in architecture, as in sculpture and painting, innovations made in the reinterpretation of earlier Roman-Christian sources became fundamental for Medieval designs. Perhaps "importation" is more appropriate here than "revival," since the Mediterranean tradition of stonemasonry could never have been more than an admirable curiosity to northern builders. Although northern Europe was dotted with Roman colonial towns that contained many large and impressive stone structures, the Germanic tribes had always relied upon their vast forests to supply them with building materials; northern architecture was a timber architecture and continued to be so well into the Middle Ages. The typical north European dwelling was a timber-frame structure (FIG. 8-8) that, in its essentials, has survived into our time. Its basic structural unit is the *bay*, which is constructed of four posts placed at the corners of a rectangle and interconnected and braced against each other with horizontal or oblique members. Such a unit is self-supporting; it can be roofed, and, depending upon the desired size of the building, it can be multiplied at will. Thus, the interior of such a structure is characterized by a repetition of identical units that move in orderly progression down the length of the building. The plan of such a building is related to the size and proportions of one of its bays in that the bay is the module, or basic unit of measurement, and the structure a multiple of that unit.

Charlemagne's adoption of southern building principles for the construction of his palaces and churches was epoch-making for the subsequent development of the architecture of northern Europe. For his models he went to Rome and Ravenna, one the former heart of the Roman empire that he wanted to revive, the other the long-term western outpost of Byzantine might and splendor that he wanted to emulate in his own capital at Aachen. Ravenna fell to the Lombards in 751 but was wrested from them only a few years later by the Frankish king, Pippin the Short, founder of the Carolingian Dynasty and father of Charlemagne. Pippin donated the former Byzantine exarchate to the pope and thus founded the papacy's temporal power, which was to last until the late nineteenth century. In 789 Charlemagne visited Ravenna, and historians have long thought that he chose one of its churches as the model for the chapel of his own palace at Aachen. But although its plan (FIG. 8-9) shows a resemblance to San Vitale's (FIG. 7-27), recent study disproves a direct relation between the two buildings. The Aachen plan is simpler, for the apselike extensions reaching from the central octagon into the ambulatory have been omitted, so that the two main units stand in greater independence of one another. This solution may lack the subtle sophistication of the Byzantine building but gains in geometric clarity. A view of the interior of the Palatine Chapel (FIG. 8-10) shows that the "floating" quality of San Vitale has been

8-8 Conjectural reconstruction of an Iron Age house upon foundations excavated at Ezinge, Holland. (After W. Horn.)

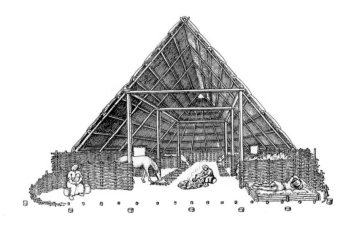

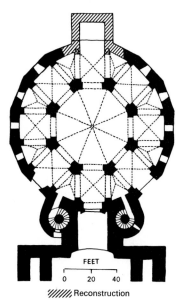

8-9 Restored plan of the Palatine Chapel of Charlemagne at Aachen, 792–805.

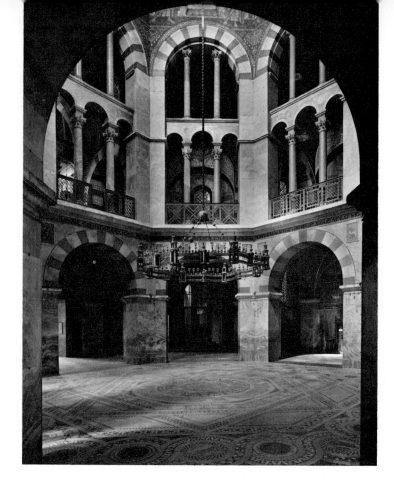

8-10 Interior of the Palatine Chapel of Charlemagne.

converted into blunt massiveness and stiffened into solid geometrical form. The conversion of a complex and subtle Byzantine prototype into a building that expresses robust strength and clear structural articulation foreshadows the architecture of the eleventh and twelfth centuries and the style we call Romanesque.

It was, however, the basilican, not the central plan, that was to provide the basis for and determine the development of Romanesque architecture. Although several churches of the basilican type were built in northern Europe during the reign of Charlemagne, none has survived; nevertheless it is possible to reconstruct the appearance of some of them with fair accuracy. Some appear to have followed their Early Christian examples quite closely, as the abbey church of Fulda (begun in 802), which derives directly from Old St. Peter's and other Roman basilicas with transepts. But in other instances, Carolingian builders subjected the basilica plan to some very significant modifications, converting it into a much more complex organism.

The study of a most fascinating Carolingian document, the ideal plan for a monastery at St. Gall, Switzerland (FIG. 8-11), may give some insight into the motivations of the Carolingian planner. The monasteries, as we have seen, were of central importance in the revival of learning. Monasticism held that the most perfect Christian life should be led in seclusion, removed from the temptations of ordinary life. In 526, Benedict had adapted the earlier regulations to the needs of western Europe. This "Benedictine Rule," which won out over Irish monasticism and which demanded among other things vows of poverty, chastity, and obedience, provided the basic organization for most western monasteries. Daily life was rigidly controlled and each monastic community was self-sufficient. About 819 a schematic plan for such a community was copied from a lost original—probably designed by the abbot

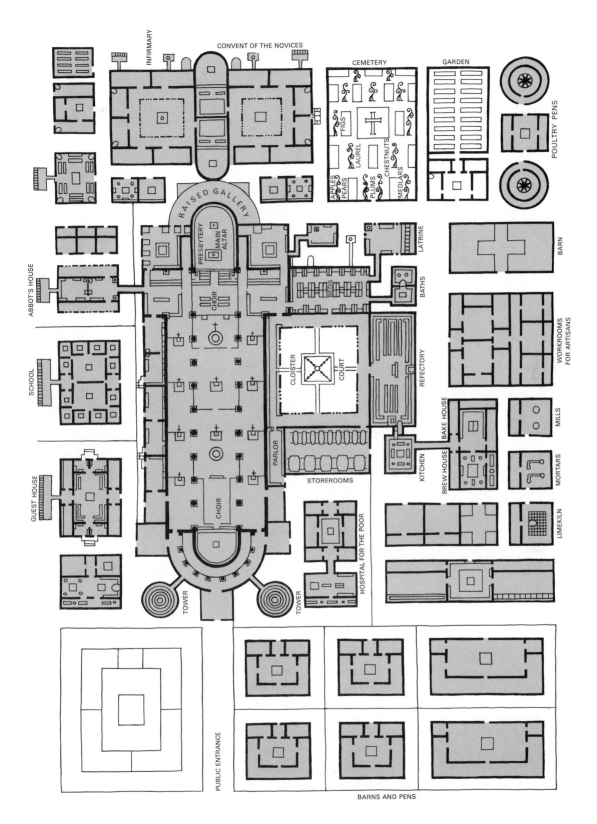

8-11 Schematic plan for a monastery at St. Gall, Switzerland, *c.* 819. (Redrawn after a ninth-century manuscript.)

The Carolingian Period 317

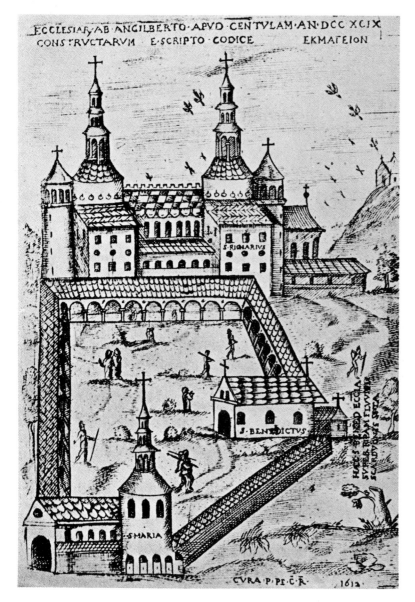

ECCLESIÆ AB ANGILBERTO APVD CENTVLAM AN DCC XCIX
CONSTRVCTARVM E SCRIPTO CODICE EKMAΓEION

8-13 Above: Plan of St. Riquier (reconstructed).

of Reichenau—and sent to the abbot of St. Gall as a guide in his planned rebuilding of that monastery. Near the center, dominating everything, was the abbey church, with the cloister (not unlike the early colonnaded atrium) at one side. Around the cloister were grouped the most essential buildings: chapter house (meeting room), dormitory, refectory, kitchen, and storage rooms. Other buildings—including an infirmary, school, guest house, bakery, brewery, and workshops—were grouped around this central core of church and cloister. That the scheme may have

been meant to be more than an ideal and actually to have been built is indicated by Walter Horn's recent discovery that the original plan must have been laid out on a modular base of $2\frac{1}{2}$ feet and that parts or multiples of this module have been used consistently throughout the plan. Therefore, the width of the nave, indicated on the plan as forty feet, would equal sixteen $2\frac{1}{2}$-foot modules; the length of the monks' beds, $2\frac{1}{2}$ modules (6 feet, 3 inches); and the width of the paths in the the vegetable garden, $1\frac{1}{4}$ modules.

Although the church is essentially a three-aisled

basilica, it has features not found in any Early Christian churches. Most immediately noticeable, perhaps, is the addition of a second apse on the west end of the building. The origin and purpose of this feature have never been satisfactorily explained, but it remains a characteristic regional element of German churches to the eleventh century. Not quite as evident, but much more important for the subsequent development of church architecture in the north, is the fact that the transept has the same width as the nave. Early Christian builders had not been concerned with the proportional relationships among the various portions of their buildings, which they assembled only in accordance with the dictates of liturgical needs. On the St. Gall plan, however, the various parts of the building have been related to each other in a geometric scheme that ties them together into a tight and cohesive unit. Equalizing the widths of nave and transept automatically makes the area in which they cross (the *crossing*) a square. This feature is shared by most Carolingian churches. But the St. Gall planner has also taken the subsequent steps that become fundamental for the development of Romanesque architecture: He has used the crossing square as the unit of measurement for the remainder of the church plan. The arms of the transept are equal to one crossing square; there is one square between transept and apse; and the nave is $4\frac{1}{2}$ crossing squares long. The fact that the aisles are half as wide as the nave integrates all parts of the church in a plan that is clear, rational, lucid, and extremely orderly.

The St. Gall plan reflects a Medieval way of thinking and is important for Romanesque art and architecture. As a guide for the builder of an abbey, it expresses the authority of the Benedictine Rule and serves as a kind of prototype. In the interest of clarity and orderliness the "rule" is worked out with systematic care. There is balancing of units and a kind of division and subdivision of the site. (This parallels the Medieval invention of that most convenient device, the division of books into chapters and subchapters.) The neat "squaring" that characterizes the scheme will especially dominate Romanesque architectural design together with the principle of the balance of clearly defined, simple units. The eagerness of the Medieval mind to explain

the Christian faith in terms of an orderly, rationalistic philosophy built upon carefully distinguished propositions and well-planned arguments finds visual expression in the plan of St. Gall.

Although the rebuilding project for St. Gall was not consummated, the church of St. Riquier at Centula in northeast France gives some idea of what the St. Gall church would have looked like (FIG. 8-12). A monastery church like that of St. Gall, the now-destroyed St. Riquier was built toward the very end of the eighth century and therefore predates the St. Gall plan by approximately twenty years. The illustration, taken from a seventeenth-century copy of a much older drawing, shows a feature not indicated on the plan of St. Gall but most likely common to all Carolingian churches—multiple, integrated towers. The St. Gall plan shows only two towers on the west side of the church, but they stand apart from it in the manner of the Italian campaniles. If we assume a tower above the crossing, the silhouette of St. Gall would have shown three towers rising above the nave. St. Riquier had six towers (not all are shown in the illustration) built directly onto or rising from the building proper. As large, vertical, cubic and cylindrical masses, these towers rose above the horizontal roofline, balancing each other in two groups of three at each end of the basilican nave. Round stair towers on the west end provided access to the upper stories of the so-called *westwork* (entrance structure) and to the big, spired tower that balanced the similar one above the eastern crossing. Such grouping of three towers at the west, quite characteristic of churches built in the regions dominated by the Carolingians and their successors in German lands, probably foreshadows, in rudimentary form, the two-tower façades that were to become an almost universal standard in Late Romanesque and Gothic architecture. The towered westwork contained on the second floor a complete chapel flanked by aisles—a small upper church that could be used for parish services, the main floor of the building being reserved for the use of the clergy. (One must remember that this was a monastery church.) A gallery opened upon the main nave, and from it, on occasion, the emperor and his entourage could watch and participate in the service below. The plan of St. Riquier, as

reconstructed (FIG. 8-13), shows an emphatic handling of the crossing square, which has been set apart from the rest of the building by massive arches. The dimensions of the square have been used once for the fore-choir, and again for the westwork chapel. But beyond that, the plan is not as fully developed as that of St. Gall. The aisles are only one third the width of the nave, the transept arms are about two thirds the crossing square, and the length of the nave has not been related to either the crossing square or any other components of the building's plan. However, the St. Riquier design, particularly the silhouette with its multiple integrated towers, was highly influential, especially in Germany.

THE OTTONIAN PERIOD

Charlemagne's empire survived him by less than thirty years. Intensified incursions of the Vikings in the west helped bring about the collapse of the Carolingians and the suspension of their great cultural effort. The breakup of the empire into numerous weak kingdoms, ineffectual against the invasions, brought a time of darkness and confusion perhaps even deeper than the seventh and eighth centuries. The scourge of the Vikings in the west was complemented by invasions of the Magyars in the east and by the plundering and piracy of the Saracen corsairs in the Mediterranean. Only in the mid-tenth century did the eastern part of the former empire consolidate under the rule of a new line of German emperors called, after the names of the three most illustrious members of the family, the Ottonians. The three Ottos made headway against the invaders from the east, remained free from Viking depredations, and were able to found an empire that, nominally at least, became the successor to Charlemagne's Holy Roman Empire. The culture and tradition of the Carolingian period were not only preserved but advanced and enriched. The Church, which had become corrupt and disorganized, recovered in the tenth century under the influence of a great monastic reform encouraged and sanctioned by the Ottonians, who also cemented ties with Italy and the papacy. When the last of the Ottonian line, Henry II, died in the

8-14 Abbey church of St. Michael at Hildesheim, Germany, *c.* 1001–31. (Restored.)

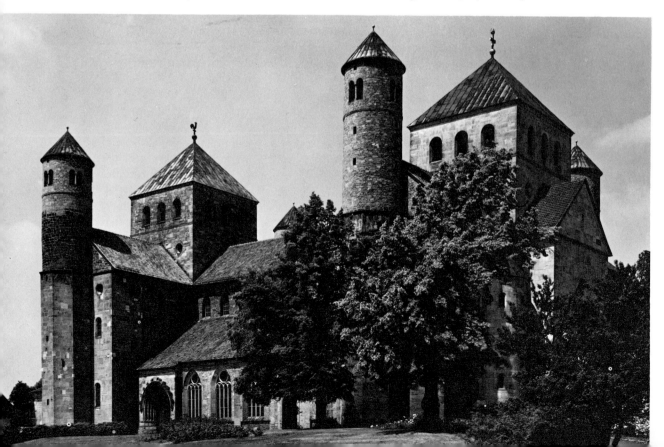

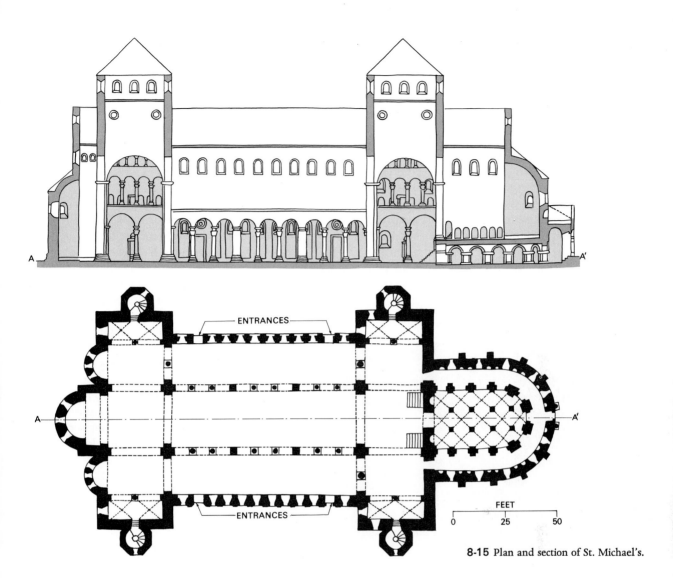

8-15 Plan and section of St. Michael's.

early eleventh century, the pagan marauders had become Christianized and settled, the monastic reforms had been highly successful, and there were signs of a cultural renewal that was destined soon to produce greater monuments than had been known since ancient Rome.

Architecture

Ottonian architects followed the direction of their Carolingian predecessors. St. Michael's, the abbey church at Hildesheim (FIG. 8-14) built between 1001 and 1031, retains the tower groupings and the westwork of St. Riquier, as well as

its massive, blank walls. But the addition of a second transept and apse result in a better balancing of east and west units. The plan and section of St. Michael's (FIG. 8-15) clearly show the east and west centers of gravity, the nave being merely a hall that connects them. Lateral entrances leading into the aisles from north and south are additional factors making for an almost complete loss of the traditional basilican orientation toward the east. More refined and precise than St. Riquier, the marked-off crossing squares have now been used as a module for the dimensions of the nave, which is three crossing squares long and one square wide. This fact is emphasized visually by the placement of heavy piers at the corners of each square. These piers alternate with

pairs of columns as wall supports and the resultant "alternate-support system" will become a standard feature of many of the Romanesque churches in northern Europe. Contrary to one view, the alternate-support system is not related to the development of Romanesque systems of vaulting. It made its first appearance in timber-roofed structures of the tenth century (such as St. Cyriakus at Gernrode, begun in 961) and appears to be the logical outcome of the Carolingian suggestion that the length of a building could be a multiple of the crossing square. Thus, the suitability of the alternate-support system to some Romanesque vaulting systems is only incidental; it seems to have been adopted not as a structural but as an esthetic device that furnishes

visual proof of the geometrical organization of the building's plan. It has been suggested that the alternate-support system is an importation from the Eastern Empire, perhaps from Thessalonica (modern Saloniki). If so, it seems to have been adopted enthusiastically by northern architects who, it has been lately proposed, may have seen it as an ideal means of converting unbroken basilican interiors into the modular units to which they were accustomed in their native timber architecture (see p. 315).

A view of the interior of St. Michael's (FIG. 8-16) shows the a-b-b-a rhythm of the alternating light and heavy wall supports. It shows as well that this rhythm is not yet reflected in the upper nave walls, that in fact it has not yet been carried further than the actual supports themselves. Although its proportions have changed—it has become much taller in relation to its width than a Roman basilica—the nave retains the continuous and unbroken appearance of its Early Christian predecessors. Only when the geometric organization of the church plan is fully reflected in the elevation of the nave walls and the interior space takes on the appearance of being composed of a number of vertical segments do we see a fully developed Romanesque interior.

8-16 The nave of St. Michael's. (Restored.)

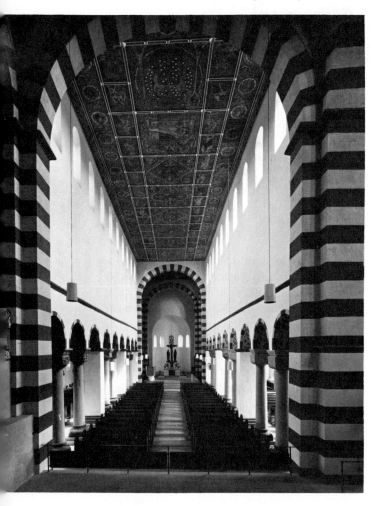

Sculpture

St. Michael's is an important and highly refined transitional monument that fills a gap between the Carolingian and Romanesque styles. Its builder, Bishop Bernward, who made Hildesheim a center of learning, was not only skilled in affairs of state, but an eager scholar, a lover of the arts, and, according to his biographer, an expert craftsman and bronze-caster. His stay in Rome in 1001 as guest of the emperor, Otto III, whom he had tutored and whose friend he was, must have acquainted him with monuments like the Column of Trajan, which may have influenced the great columnlike paschal candlestick he set up in St. Michael's; and the Early Christian wooden doors of Santa Sabina may have inspired the remarkable bronze doors he had cast for his splendid church. The doors were cast in a single piece, the first of their kind since ancient Rome.

8-17 Bishop Bernward, *Adam and Eve Reproached by the Lord*, 1015, from the bronze doors of St. Michael's. Approx. 23″ × 43″.

Carolingian sculpture, like most sculpture since antiquity, had been small art in ivory and metal; the St. Michael's doors anticipate the coming reinstatement of large-scale sculpture in the Romanesque period. The style of the figures on the doors derives from Carolingian manuscript illumination but has an expressive strength of its own—once again a case of the form derived from a prototype becoming something new and firmly itself (FIG. 8-17). God is accusing Adam and Eve after their fall from grace. As he lays upon them the curse of mortality, the primal condemnation, he jabs his finger with the force of his whole body, the force concentrating in the gesture, the psychic focus of the whole composition. The frightened pair crouch not only to hide their shame but to escape the lightning bolt of the divine wrath. Each passes the blame, Adam pointing backward to Eve, Eve pointing downward to the deceitful serpent. The setting, the starkly flat ground, throws into relief the gestures and attitudes of rage, accusation, guilt, and fear; once again the story is given with all the simplicity and impact of skilled pantomime.

We have seen how the instinct for pantomimic pose and gesture guides the representations and narratives of Medieval art from the very beginning. Such pantomime, emphasized by telling exaggeration, appears in an ivory carving that surely is among the masterpieces of the art of the Middle Ages (FIG. 8-18). Only nine by four inches, the panel carries a composition of two intertwined figures beautifully adjusted to the space. The theme is that of the persuasion of Doubting Thomas when, after the Resurrection, Christ appears to his sorrowing disciples. All believe that he is truly Christ and truly risen except the skeptical Thomas, who demands to feel the bodily wounds of the master he has seen crucified. In the panel he explores the wound in Christ's side in a kind of climbing, aggressive curiosity. Christ, his right arm raised to reveal his side, bends over Thomas in an attitude that wonderfully combines gentleness, benign affection, protectiveness, and sorrow. The figures are represented entirely in the context of emotion; the concentration on the single act of Christ's revelation to the doubter, the emotional vibrations that accompany the doubt, and the ensuing conversion of Thomas determine every line of the rendering. We are not aware of the presence here of the influence of a prototype; we seem to have before us an original work of great power.

Painting and Illumination

It must be assumed that by Ottonian times artists had become familiar enough with the Carolingian figurative modes to work with con-

siderable independence, developing a functional, vernacular style of their own. A supreme example of this is an illumination in the *Gospel Book of Otto III* (FIG. 8-19), in which an angel announces to the shepherds the birth of Christ. The angel has just alighted upon a hill, his wings still beating, and the wind of his landing agitates his draperies. He looms immense above the startled and terrified shepherds, filling the sky, and bends upon them a fierce and menacing glance as he

extends his hand in the gesture of authority and instruction. Emphasized more than the message itself is the power and majesty of God's authority. The electric force of God's violent pointing in the Hildesheim doors is seen again here with the same pantomimic impact. Although the figure style may ultimately stem from the Carolingian school at Tours, the painters of the scriptorium of Reichenau (an island in Lake Constance in Switzerland) who produced the *Gospel Book* have made of their received ideas something fresh and powerful; there is a new sureness in the touch that is epitomized by the way the draperies are rendered in a hard, firm line, the planes partitioned in sharp, often heavily modeled shapes. We saw this in Middle and Late Byzantine art, and indeed there was close connection between the Ottonian and Byzantine spheres. Yet, for the most part, the Ottonian artists went their own way, for Ottonian painting was produced for the court and for the great monasteries, for learned princes, abbots, and bishops, and thus had an aristocratic audience that could appreciate independent and sophisticated variations on inherited themes. While an illumination like the *Annunciation to the Shepherds* could by no means be called classical, there is a sculpturesque clarity about it, a strong, relieflike projection and silhouette, that suggests not a hesitating approximation of misunderstood prototypes from antiquity but a confident, if unconscious, catching of the antique spirit. At the same time, the powerful means of expression of the *Annunciation* miniature imply an intensification of Christian spirituality, perhaps related to the broad monastic reforms of the tenth and eleventh centuries. With that force of expression goes a significantly new manner of fashioning the human figure in art, one that is not slavishly dependent upon prototypes, even while prototypes are exchanged and studied. Ottonian figurative art reveals a translation of prototypal material into a kind of ready idiom of forms and a native way of drawing. Although there are exceptions, for the most part Ottonian figures will have lost the old realism of the *Coronation Gospels* (FIG. 8-5), inherited from the antique, and will move with an abrupt, hinged, jerky movement not "according to nature" but nevertheless with sharp and descriptive expressiveness.

8-18 ECHTERNACH MASTER, *Doubting Thomas*, from the *Magdeburg Antependium, c.* 970–90. Ivory, approx. 9″ × 4″. Staatliche Museen, Berlin.

This new manner will be passed on to the figurative artists of the Romanesque period. As the western European spoken and written languages emerge from the polyglot Latin-Germanic of the early centuries into the vernacular tongues we recognize today, so figurative art gradually develops out of the same kind of mixture of Latin, Germanic, and Celtic elements into a new, strong, and self-sufficient vernacular of representation.

Another picture from the *Gospel Book of Otto III*, representing the emperor himself (FIG. 8-20), sums up much of what went before and points to what is coming. The emperor is represented enthroned under a canopy (the *baldachin*), holding the scepter and cross-inscribed orb that represent his universal authority. He is flanked by the clergy and the barons—the Church and the State—both aligned in his support. Stylistically remote, the picture still has a clear political resemblance to the Justinianic mosaic in San Vitale. It was the vestigial imperial ideal, awakened in the Frankish Charlemagne and preserved for a while by his Ottonian successors in Germany, that had given some partial unity to western Europe while the barbarians were settling down. This imperial ideal, salvaged from ancient Rome and bolstered by the experience of Byzantium, would survive long enough to give an example of order and of law to the barbarians; to this extent, ancient Rome lived on to the millennium. But native princes in England, France, Spain, Italy, and eastern Europe would aspire to a sovereignty outside the imperial Carolingian and Ottonian hegemony; staking their claims, they make the history of the Medieval power contests that lead to the formation of the states of Europe as we know them. In the illumination, Otto, sitting between the rival Church and State, represents the very model of the Medieval predicament that will divide Europe for centuries. The controversy of the Holy Roman Emperors with the popes will bring the German successors of the Ottonians to bitter defeat in the thirteenth century; and with that defeat, the authority of ancient Rome will come to an end. The Romanesque period that is to follow will in fact deny the imperial spirit that had prevailed for centuries. A new age is about to begin, and Rome, an august memory, will cease to be the deciding influence.

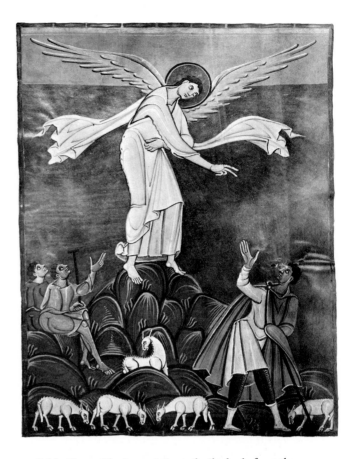

8-19 Above: *The Annunciation to the Shepherds*, from the *Gospel Book of Otto III*, Reichenau or Court School of Otto III, 997–1000. 13″ × 9⅜″. Bayerische Staatsbibliothek, Munich.

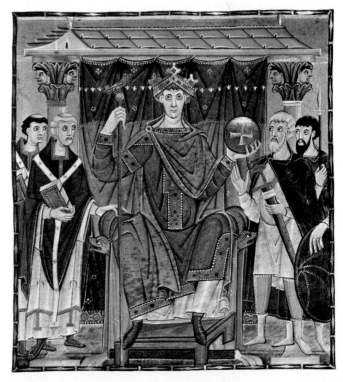

8-20 *Otto III Enthroned Receiving the Homage of Four Parts of the Empire* (flanked by nobility and clergy), from the *Gospel Book of Otto III.* 13″ × 9⅜″. Bayerische Staatsbibliothek, Munich.

Chapter Nine

Romanesque Art

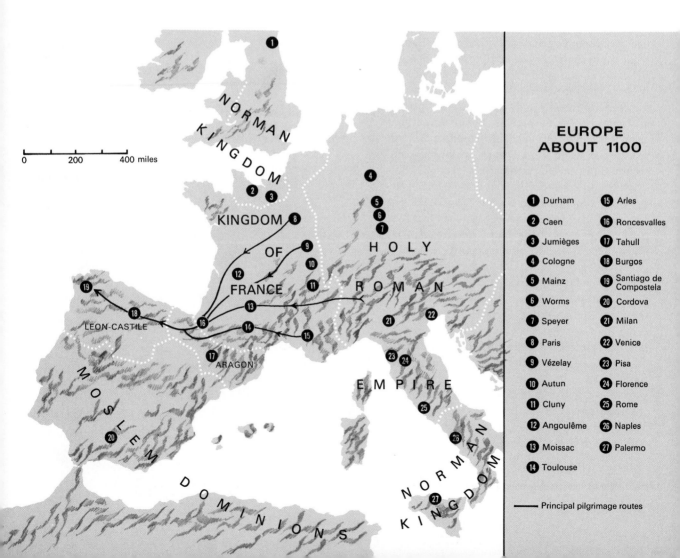

EUROPE ABOUT 1100

1. Durham
2. Caen
3. Jumièges
4. Cologne
5. Mainz
6. Worms
7. Speyer
8. Paris
9. Vézelay
10. Autun
11. Cluny
12. Angoulême
13. Moissac
14. Toulouse
15. Arles
16. Roncesvalles
17. Tahull
18. Burgos
19. Santiago de Compostela
20. Cordova
21. Milan
22. Venice
23. Pisa
24. Florence
25. Rome
26. Naples
27. Palermo

—— Principal pilgrimage routes

THE MID-ELEVENTH century marks a turning point in European history; Europe *as* Europe begins to emerge. In the past there was a boiling confusion of barbarian movements coalescing into settlements that aggregated into "empires" like the Carolingian and Ottonian, which had their spiritual and political roots in the memory of the Roman *imperium*. Now, although a Latin culture and tradition persist and are still accepted with reverence, the Medieval people are not so retrospective; they have new experiences and take new directions.

After the disintegration of the Carolingian state, when the successors to the imperializing Ottonians had begun to limit their concerns to Italy and the German duchies, numerous feudal political entities—petty and great, within and without the outlines of the old Frankish and Saxon "empires"—pursued their own interests and developed in their own ways. Two institutions gave them a certain coherence—the Christian Church and feudalism. If the descendants of the barbarians had anything in common, it was their Christianity above all else. Feudalism, which had

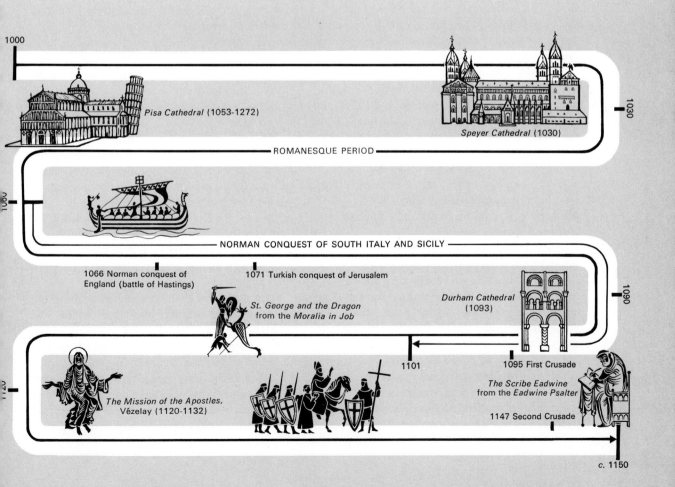

1000

Pisa Cathedral (1053-1272)

Speyer Cathedral (1030)

1030

ROMANESQUE PERIOD

NORMAN CONQUEST OF SOUTH ITALY AND SICILY

1066 Norman conquest of England (battle of Hastings)

1071 Turkish conquest of Jerusalem

St. George and the Dragon from the *Moralia in Job*

Durham Cathedral (1093)

1090

1101

1095 First Crusade

The Mission of the Apostles, Vézelay (1120-1132)

The Scribe Eadwine from the *Eadwine Psalter*

1147 Second Crusade

c. 1150

its origins both in barbarian custom (see Chapter Eight) and in late Roman institutions, preserved a stability, but it was a stability of a local kind, being naturally antagonistic to broad, centralized government.

Essentially, feudalism was an economic system involving a complicated series of interpersonal relations, obligations, and services based on land tenure: One held a piece of land, a *fief*, and paid for it not in money but in service, often military. Feudal obligation led downward from a lord to his vassal to the lower orders of society and ultimately to the serf, who was bound to the land and to the unquestioning service of the lord. The lords or nobles held fiefs in various ways from each other or from an overlord, such as a king. Inevitably many of them became large landowners and so powerful that they ignored their obligations and defied their king. Their time was spent in petty wars to protect or to increase the extent of their holdings. The *château fort*, or castle, surrounded by walls and moats, was the symbol and seat of feudal authority; today the moldering ruins of these castles in the countrysides of Europe recall the modern visitor to an age when government was always visible, singular, personal, and absolute.

The Romanesque baron or knight, still in the heroic tradition of the Germanic hero, was loyal, defiant, and proud. However, being a Christian, he was without the deep barbarian fatalism of the earlier Saxons and Norse and hoped not only for immortal honor in battle (won as much by the power of religious faith as by his own strength and courage), but for life eternal in heaven. This was the mood—the psychological "set"—of the aristocratic, warring magnates who led the crusades and maintained the feudal system.

Monasticism, which reached its peak at the same time as feudalism, provided seclusion from the world, an assurance of salvation, and almost the only means of receiving an education. The history of monasticism, which, as we have seen, began in the Early Middle Ages, is essentially a series of reform movements. Since gifts and bequests to them were potent means of assuring salvation, monasteries grew wealthy. With wealth came luxury and laxness and recurrent reforms to combat them. The reforms led to the formation of new monastic orders. The two great Romanesque orders were the Cluniac and the Cistercian. The former, which especially fostered the arts, was founded early in the tenth century and had its main abbey at Cluny near Mâcon in France. Encouraged by the Ottonian emperors, it owed allegiance only to the pope in Rome and formed, with the vast number of its priories scattered all over Europe, a centrally organized administration in sharp contrast to the decentralizing tendencies of feudalism. The Cluniac reform, based on a liberal interpretation of St. Benedict's original rule, stressed intellectual pursuits, the study of music, and the cultivation of the other arts. The wealth and the vastness of the resources of the Cluniac order soon provoked still another reform, one that emphasized self-denial and the virtues of manual labor and gave rise to the Cistercian order, which also grew rapidly.

Thus, with feudalism and monasticism triumphant and replacing the emperors, the barons and the monastery clergy—the latter often themselves feudal lords—played a peculiarly cooperative role, and the feudal stratification of society into strictly separated classes was given religious sanction. Notwithstanding this cooperation, however, the chief conflict of the time was between the popes and the feudal principals not over the justice or injustice of the feudal system but over the question, Who is the supreme feudal lord; who is king?

There was great movement of population in the endless pilgrimages to innumerable shrines and in the Crusades (the first two of which belong to this period), which saw treks of thousands of people from western Europe to the Holy Land. Most important of the immediate results of the Crusades were the establishment of the Church as a leader of the people and the reopening of commerce with the great trading centers in the Near East.

Pisan ships carried the crusading barons to the Holy Land and brought back their bones. The Pisans prospered, as did the burghers of the towns that the barons left behind them and to whom they had given charters of liberty in return for financing their campaigns. Thus, the Crusades created subcurrents of independence: The towns got their charters, and a middle class of merchants and craftsmen grew up to countervail the power

of feudal barons and the great monasteries. A growing city culture was quick to receive new impulses from abroad. The lines of commerce, often the arteries of ideas, conveyed new learning to Europe. The Crusades, destructive as they were, effected a new insight into Greek science and philosophy through contact with Islam, which had assimilated the Greek culture much earlier. Within a century, the relatively limited knowledge possessed by the Carolingians and Ottonians was expanded to an enormous store. It was from this store that men would draw the materials and inspirations for renaissance after renaissance until, in the sixteenth century, a distinction would come to be made between pagan and Christian antiquity. Within this context of an emerging world, unique though shadowed with a tremendous past, the art called Romanesque appeared. It is a confident art, one that does not hesitate among alternatives and is sure even in the midst of its own changes.

ARCHITECTURE

"Romanesque" is a term first used in the nineteenth century to designate buildings that were supposed to be developing toward a perfected thirteenth-century type called "Gothic." Their round arches and blunt, heavy walls were supposed to bear some resemblance to ancient Roman architecture, just as the developing "Romance" languages were related to Latin. Although the Romanesque style varies widely and embraces numerous provincial differences within its two-century span, architectural historians now regard it as complete within itself and not as the imperfect antecedent of Gothic. Thus, despite its variety, Romanesque architecture is readily recognizable as such and is the first architecture truly of the Middle Ages. An air view of the church of St. Sernin at Toulouse in the south of France (FIG. 9-1) shows certain features that appear in Romanesque buildings no matter how their arrangement differs. There is an overall blocky appearance, a grouping of large, simple, easily definable geometrical masses—rectangles, cubes, cylinders, and half-cylinders. The main masses are sub-

divided by enframing buttresses or colonnettes. Exterior wall surfaces, which had been plain and unadorned through the Ottonian period, now reflect the interior organization of the structure. This enlivening of formerly blank wall surfaces foreshadows the structural translucency that was to typify Gothic architecture.

The new demands of a people with religious as well as commercial reasons to travel shaped the new architecture. The building impulse, which became almost a Medieval obsession, was noted by an eleventh-century monk, Raoul Glaber, who wrote:

> ... there occurred, throughout the world, especially in Italy and Gaul, a rebuilding of church basilicas. Notwithstanding the greater number were already well established and not in the least in need, nevertheless each Christian people strove against the others to erect nobler ones. It was as if the whole earth, having cast off the old ... were clothing itself everywhere in the white robe of the church.[1]

Great building efforts were provoked not only by the pilgrimages and the Crusades and the needs of growing cities, but by the fact (notably in Italy and France) that hundreds of churches had been destroyed during the depredations of the Northmen and the Magyars. Architects of the time seemed to see their fundamental problem in terms of providing a building that would have space for the circulation of its congregations and visitors and would be solid, fireproof, and well lighted. These, of course, are the necessities of any great civic or religious architecture, as we saw in ancient Rome, but in this case fireproofing must have been foremost in the builders' minds, for the wooden roofs of the pre-Romanesque churches of Italy, France, and elsewhere had burned fiercely and totally when set aflame by the marauders from north, east, and south in the ninth and tenth centuries. The memory was fresh in the victims' minds; the new churches would have to be covered with cut stone, and the structural problems arising from this need for a solid masonry were to help determine the "look" of Romanesque architecture.

[1] In E. G. Holt, ed., *Literary Sources of Art History* (Princeton: Princeton Univ. Press, 1947), p. 3.

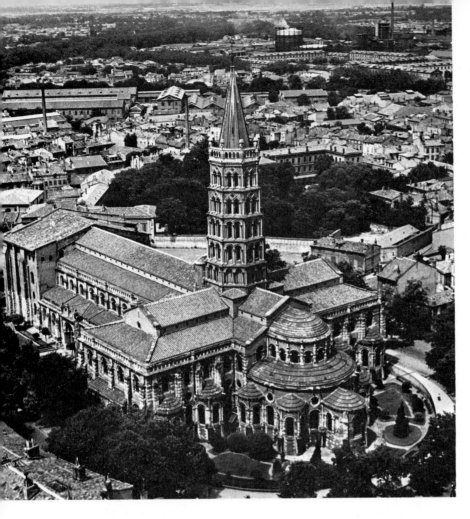

9-1 Aerial view of St. Sernin, Toulouse, *c.* 1080–1120.

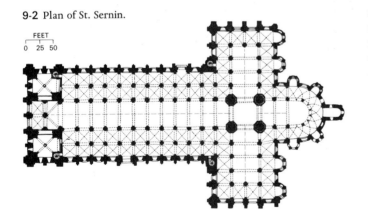

9-2 Plan of St. Sernin.

FEET
0 25 50

The Cluniac-Burgundian Style

St. Sernin was one of the churches constructed in the Cluniac-Burgundian style, that met the requirement for a stone ceiling by the use of a semicircular barrel vault above which was a timber-roofed loft. These churches dominated much of southern France and were closely related to those built along the pilgrimage road to Santiago de Compostela in northwest Spain. The plan of St. Sernin (FIG. 9-2) is of extreme regularity and geometric precision. The crossing square, flanked by massive piers and marked off by heavy arches, has been used as the module for the entire body of the church. In this *square schematism* each nave bay measures exactly one half and each square in the aisles one quarter of a crossing square, and so on throughout the building. The first suggestion of such a planning scheme is seen almost three centuries earlier in the St. Gall plan. Although St. Sernin is neither the earliest nor the only (perhaps not even the ideal) solution, it does represent a crisply rational and highly refined realization of the germ of an idea first seen in Carolingian designs. A view of

the interior (FIG. 9-3) shows that this geometric floor plan is fully reflected in the nave walls, which are articulated by half-columns that rise from the corners of each bay to the springing of the vault and are continued across the nave as transverse arches. Ever since Early Christian times, basilican interiors had been framed by long, flat walls between arcades and clerestories that enclosed a single, horizontal, unbroken volume of space. Now the aspect of the nave is radically changed so that it seems to be composed of numerous, identical, vertical volumes of space that have been placed one behind the other, marching down the length of the building in orderly procession. This segmentation of St. Sernin's interior space corresponds with and renders visual the geometric organization of the building's plan, and as noted above, is also reflected in the articulation of the building's exterior walls. The result is a structure in which all parts have been integrated to a degree unknown in earlier Christian architecture, a structure that is a full-blown representative of the first genuinely Medieval architectural style—the Romanesque.

The grand scale of St. Sernin at Toulouse is frequent in Romanesque churches. The popularity of pilgrimages and of the cult of relics brought great crowds even to relatively isolated places, and large congregations were common at the shrines along the great pilgrimage routes and in the reawakening cities. Additional space was provided by increasing the length of the nave, by doubling the side aisles, and by building, over the inner aisle, upper galleries, or *tribunes*, the latter for overflow crowds on special occasions. Circulation was complicated, though, since the monks' choir often occupied a good portion of the nave. The extension of the aisles around the eastern end to make an ambulatory facilitated circulation, and the opening of the ambulatory (and often the transepts) into separate chapels (as at St. Sernin) provided more space for worshipers and for liturgical processions. Not all Romanesque churches were as large as St. Sernin, however, nor did every one have an ambulatory with radiating chapels, but such chapels are typical Romanesque features, especially when treated as separate units projecting from the mass of the building.

The continuous, cut-stone barrel (or tunnel)

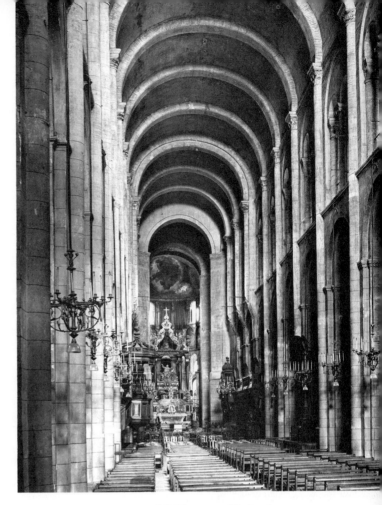

9-3 The nave of St. Sernin.

vaults at St. Sernin (FIG. 9-3) put constant pressure along the entire length of the supporting masonry. If, as in most instances, including St. Sernin (FIG. 9-2), the nave was flanked by side aisles, the main vaults rested on arcades, the thrust being carried to the thick outer walls by the vaults that were over the aisles. In larger churches the tribune galleries and their vaults (in cross section, often a quadrant, embracing a 90-degree arc), were an integral part of the structure, buttressing the high vaults over the nave. The wall-vault system at St. Sernin is successful in its supporting function; its great scale provides ample space, and its squaring-off into cleanly marked bays, as well as the relief of wall and pier, are thoroughly Romanesque. But the system fails in one critical requirement—that of lighting: Because of the great thrust exerted by the barrel vault a clerestory was impossible, and windows cut into the haunch of the vault would make it unstable.

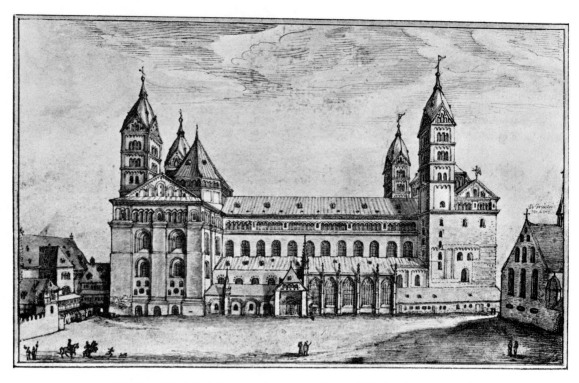

9-4 Speyer Cathedral, Germany, begun 1030. Pen-and-ink drawing by Wenzel Hollar, *c.* 1620. Graphische Sammlung Albertina, Vienna.

9-5 Plan of Speyer Cathedral.

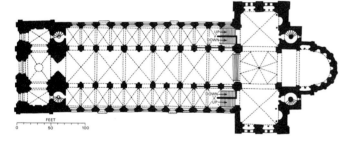

A more complex and efficient type of vaulting was needed; one might say that, structurally, the central problem of Romanesque architecture was the development of a masonry vault system that admitted light.

Romanesque architectural ingenuity in working toward this end had numerous experimental consequences that appear as a rich variety of substyles. We have already mentioned that one of the apparently confusing features of Romanesque architecture is the great variety of regional and local building styles, a variety that makes classification, coordination, and interpretation still very difficult for scholars. Ten or more types may be identified in France alone, each with its distinctive system of vaulting and its varying solutions to the lighting of the interior. To the informed student of Romanesque architecture, savoring the distinctive beauties of its local styles is somewhat like sampling the endless varieties of local wines.

Among the numerous experimental solutions, the groin vault turned out to be the most efficient and flexible. The groin vault had been widely used by Roman builders, who saw that its concentration of thrusts at four supporting points would allow clerestory fenestration. The great Roman vaults were made possible by an intricate system of brick-and-tile relieving arches as well as by the use of concrete, which could be poured into forms and which solidified into a homogeneous mass. The technique of mixing concrete did not survive into the Middle Ages, however, and the technical problems of building groin vaults of cut stone and heavy rubble, which had very little cohesive quality, limited their use to the

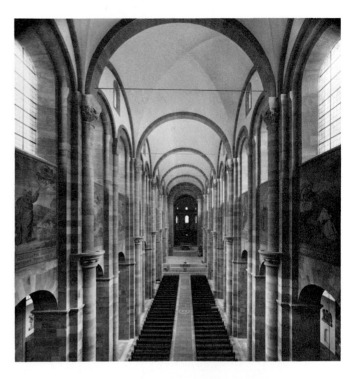

9-6 Interior of Speyer Cathedral.

covering of small areas. But during the eleventh century, Romanesque masons, using cut stone joined by mortar, developed a groin vault of monumental dimensions, which, while still using heavy buttressing walls, eventually evolved into a self-sufficient skeletal support system.

Germany-Lombardy

The progress of vaulting craft can best be seen in two regions, Germany-Lombardy and Normandy-Britain. The cathedral of Speyer in the German Rhineland (FIG. 9-4) was begun in 1030 as a timber-roofed structure. When it was rebuilt by the emperor Henry IV between 1082 and 1106, it was covered with groin vaults. It thus may be one of the earliest fully vaulted Romanesque churches in Europe. Its exterior preserves the Ottonian tradition of balanced groups of towers east and west but adds to it a rich articulation of wall surfaces. A great many of the decorative features, such as the arcades under the eaves, the stepped arcade gallery under the gable, and the moldings marking the stages of the towers, may be of Lombard origin. So may be the inspiration for the groin vaults covering the aisles, since groin-vaulting on a small scale had been used by Lombard builders throughout the Early Middle Ages. The large groin vaults covering the nave (FIG. 9-6), however, probably the achievement of German masons, represent one of the most daring and successful vaulting enterprises of the time. (The nave is 45 feet wide, and the crowns of the vaults 107 feet high.) The plan (FIG. 9-5) shows that the west apse and the Ottonian lateral entrances have been given up, that the entrance has been moved back to the west end, and that the processional axis leading to the sanctuary has been reestablished. The marked-off crossing, covered by an octagonal dome, has obviously been used as the module for the arrangement of the building's east end. Since the nave bays are not square, use of the crossing as a unit is not so obvious. In fact, however, the length of the nave

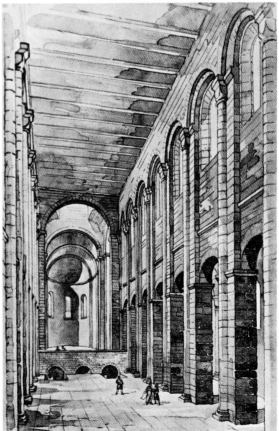

9-7 Reconstruction of the original nave of Speyer Cathedral, c. 1030–60.

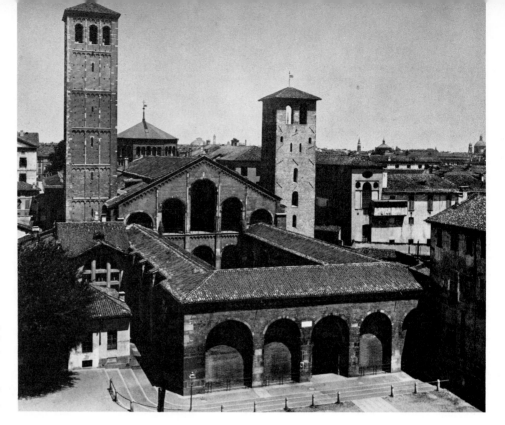

9-8 Right: Sant' Ambrogio, Milan, late eleventh to early twelfth centuries.

9-9 Below: Plan of Sant' Ambrogio.

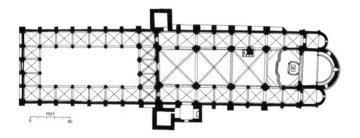

is almost exactly four times the crossing square, and every third wall-support marks off an area in the nave the size of the crossing; the aisles are half the width of the nave. Although the plan has some irregularities and has not been worked out as neatly and precisely as that of St. Sernin, the builders' intention to apply the square schematism is quite clear. Curiously, the alternate-support system, which is now carried all the way up into the vaults (FIG. 9-6), seems to be unrelated to the geometric facts of the plan. This discrepancy may be explained by the fact that the original building of 1030 was a timber-roofed structure and that the walls were articulated by a series of identical shafts that rose to enframe the

clerestory windows (FIG. 9-7). The alternate-support system was introduced in the 1080's (when the building was vaulted) perhaps partially to strengthen the piers at the corners of the large vaults and to provide bases for the springing of the transverse arches across the nave. That every other support was chosen to anchor a nave vault may simply have been because the walls were not as stable as the massive piers that carry the crossing dome, so that it would be safer to reduce each area to be vaulted by one third. The resultant bay arrangement, in which a large unit in the nave is flanked by two small units in each aisle, becomes almost standard in northern Romanesque architecture. Speyer's interior (FIG. 9-6) shows the same striving for height and has the same compartmentalized effect as that of St. Sernin. By virtue of the use of the alternate-support system, the rhythm of the Speyer nave is a little more complex, a little richer perhaps, and since each compartment is individually vaulted, the effect of a sequence of vertical blocks of space is even more convincing.

From Carolingian times, Rhineland Germany and Lombardy had been in close political and

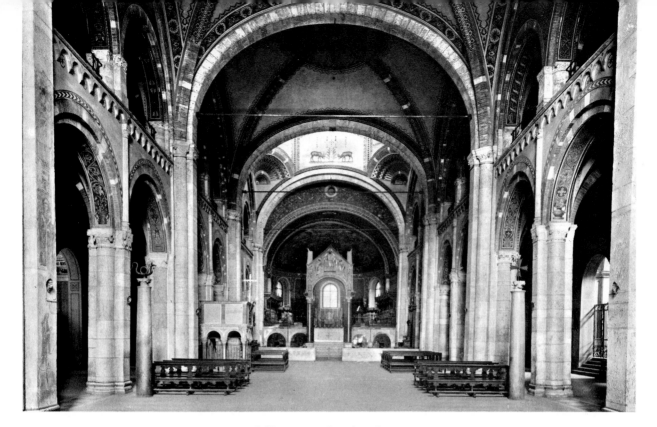

9-10 Interior of Sant' Ambrogio.

cultural contact, and it is generally agreed that the two areas cross-fertilized each other artistically. But no such agreement exists as to which source of artistic influence was dominant—the northern or the southern. The question, no doubt, will remain the subject of controversy until the date of the central monument of Lombard architecture—the church of Sant' Ambrogio in Milan—can be established unequivocally. Dates ranging from the tenth to the early twelfth century have been advanced for the present building (preceded by an earlier church that dated back to the fourth century), with the late eleventh and early twelfth centuries apparently most popular with architectural historians today. Whether or not a prototype, Sant' Ambrogio remains a remarkable building. As shown in FIG. 9-8, it has an atrium (one of the last to be built); a two-story narthex pierced by arches on both levels; two towers joined to the building; and, over the east end of the nave, an octagonal tower that recalls the crossing towers of German churches. Of the façade towers, the shorter one dates back to the tenth century, while the taller north tower was built during the

twelfth. The latter is a sophisticated and typical example of Lombard tower design; it is articulated by pilasters and shafting and divided, by means of corbel tables (horizontal projections resting on corbels), into a number of levels, of which only the topmost (the bell chamber) has been opened by arches. In plan (FIG. 9-9) Sant' Ambrogio is three-aisled and without a transept. The square schematism has been applied with consistency and greater precision than at Speyer, each bay consisting of a full square in the nave, which is flanked by two small squares in each aisle, all covered with groin vaults. The main vaults are slightly domical, rising higher than the transverse arches, and the last bay is covered by an octagonal dome that provides the major light source (there is no clerestory) for the otherwise rather dark interior (FIG. 9-10). The geometric regularity of the plan is perfectly reflected in the emphatic alternate-support system, in which the light supports are interrupted at the gallery level while the heavy ones rise to support the main vaults. These ponderous vaults have supporting arches along their groins and are sometimes claimed to be the first examples of

rib-vaulting (see p. 359); in fact, however, these vaults are solidly constructed groin vaults that have been strengthened by diagonal ribs.

The dating of the Sant' Ambrogio vaults remains controversial. Most scholars seem to feel that they were not built until after 1117, when a severe earthquake caused great damage to the existing building. If so, the Speyer vaults would be earlier than those of Sant' Ambrogio, and the inspiration and technical knowledge for the construction of groin vaults of this size would seem, then, to have come from the north. But such possible influence did not affect the proportioning of the Milanese building, which does not aspire to the soaring height of the northern churches. Sant' Ambrogio's proportions are low

and squat and remain close to those of Early Christian basilicas. As we will see, Italian architects never—not even during the height of the Gothic period—accepted the verticality found in northern architecture.

The fame of German architecture rests on its achievements in the eleventh and early twelfth centuries. After the mid-twelfth century it made no major contribution to architectural design. The architectural statements at Speyer were repeated at Worms and Mainz and other, later churches. German builders were content with refining their successful formula; beyond that, they tended to follow the lead of the more adventurous and progressive Franks and Normans.

The Norman Style

The predatory pagan Vikings settled in northwest France after their conversion to Christianity in the tenth century and almost at once proved themselves skilled administrators and builders. With astounding rapidity they absorbed the lessons to be learned from Ottonian architecture and went on to develop the most progressive of the many Romanesque styles and the one that was to become the major source in the evolution of Gothic architecture. The church of St. Étienne at Caen in Normandy is generally considered to be the master model of Norman Romanesque architecture. It was begun by William the Conqueror in 1067 and must have been completed when he was buried there in 1087. The west façade (FIG. 9-11) is a striking design that looks forward to the two-tower façades of later Gothic churches. Four large buttresses divide it into three bays that correspond to the nave and aisles in the interior. There is also a triple division of the towers above their buttresses and a progressively greater piercing of their walls from lower to upper stages. The spires are a later (Gothic) feature. The tripartite division is employed throughout the façade, both vertically and horizontally, organizing it into a close-knit, well-integrated design that reflects the careful and methodical planning of the entire structure. Like the cathedral of Speyer, St. Étienne was originally planned to have a wooden roof, but from the beginning the walls were articulated in an alternating rhythm

9-11 West façade of St. Étienne, Caen, begun c. 1067.

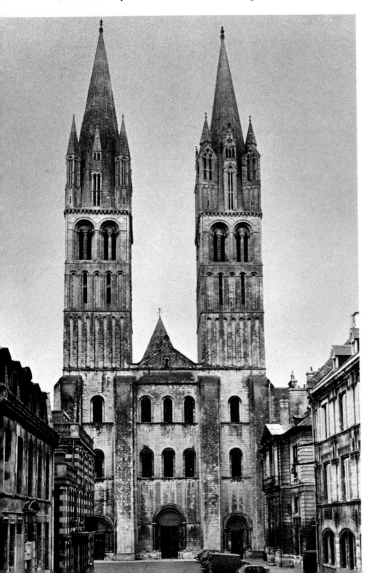

(simple half-columns alternating with shafts attached to pilasters) that mirrors the precise square schematism of the building's plan (FIGS. 9-12 and 9-13). This alternate-support system was effectively utilized some time after 1110—significantly later than Speyer or Milan—when it was decided to cover the nave with vaults. Its original installation, however, must have been motivated by esthetic rather than structural concerns. In any event, the alternating compound piers soar all the way to the springing of the vaults, and their branching ribs divide the large, square vault compartments into six sections, making a so-called sexpartite vault (FIG. 9-12). These vaults, their crowns slightly depressed to avoid the "domed-up" effect of those at Sant' Ambrogio, rise high enough to make an efficient clerestory; they are also viewed as some of the earliest true *rib vaults*, in which the diagonal and transverse ribs compose a structural skeleton that partially supports the as yet fairly massive paneling between them. Rib-vaulting was to become universal practice during the Gothic period, and its development by Norman builders must be rated as one of the major structural innovations of the Middle Ages. There are other elements in St. Étienne that point to the future: the complex piers, their nuclei almost concealed by attached pilasters and engaged columns, forecast the Gothic "cluster-pier"; and the reduction in interior wall surfaces that resulted from use of very large arched openings anticipate the bright curtain walls of Gothic architecture. In short, St. Étienne at Caen is not only a very carefully designed structure but a highly progressive one in which the Romanesque style begins to merge into the Early Gothic.

The conquest of Anglo-Saxon England in 1066 by William of Normandy began a new epoch in English history; in English architecture it signaled the importation of Norman building and design methods. The cathedral of Durham in northern England, begun in 1093, was apparently designed for vaulting at the outset. As with most Romanesque churches in England, it was subjected to many later alterations that, in this case, fortunately were largely confined to the exterior; the interior (FIG. 9-14) has its original, masculine, Romanesque appearance. Ambitious in scale—

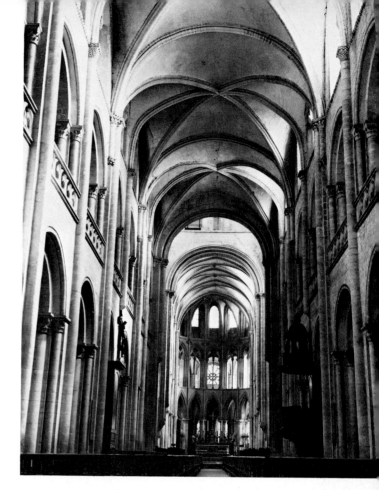

9-12 Interior of St. Étienne, vaulted *c.* 1115–20.

9-13 Plan of St. Étienne.

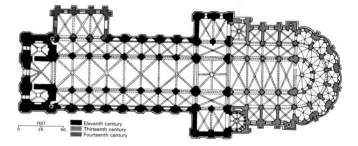

Eleventh century
Thirteenth century
Fourteenth century

wider and longer than either St. Sernin at Toulouse or St. Étienne at Caen—its 400-foot length compares favorably with that of the great imperial cathedral of Speyer. With the latter it also shares its reliance upon mass for stability. But unlike Speyer, this building was conceived from the very beginning as a completely integrated skeleton in which the vaults stood in intimate and continuous relation to the vertical elements of

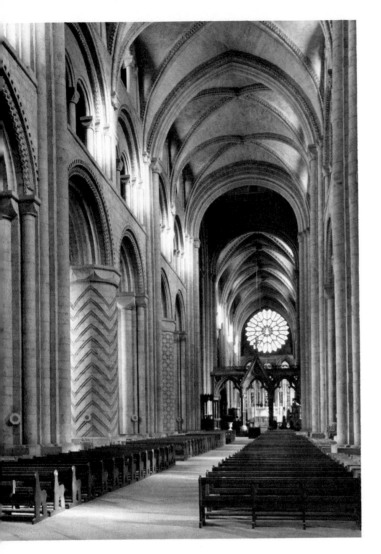

9-14 The nave of Durham Cathedral, England, begun
c. 1093 (view facing east).

9-15 Plan of Durham Cathedral.

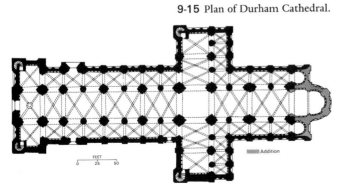

the compound piers that support them. At
Durham the alternate-support system is inter-
preted with blunt power and more emphasis,
perhaps, than in any other Romanesque church.
Large, simple pillars ornamented with abstract
designs—diamond, chevron, and cable patterns
descended from the metalcraft ornamentation of
the migrations—alternate with compound piers
that carry the transverse arches of the vaults. The
pier-vault relationship could scarcely be more
visible or the structural rationale of the building
better expressed. The plan (FIG. 9-15), typically
English in its long, slender proportions and the
strongly projecting transept, does not develop
the square schematism with the same care and
logic as that of Caen. But the rib vaults of the
choir (1104) are the earliest in Europe, and, when
they were combined with slightly pointed arches
in the western parts of the nave (before 1130), the
two key elements that were to determine the
structural evolution of Gothic architecture were
brought together for the first time. Only the
rather massive construction and the irregular
division into seven panels prevent these vaults
from qualifying as Early Gothic structures.

Among the numerous regional Romanesque
styles of architecture it is the northern—more
specifically, the Norman—style that will influ-
ence the development of the Gothic; no other
style had as great a potential for evolution.

Tuscany

Italy south of the Lombard region retained its
ancient traditions and for the most part produced
a conservative Romanesque architecture. The
buildings of Tuscany seem to adhere more closely
than those of any other region to the traditions of
the Early Christian basilica. The cathedral group
of Pisa (FIG. 9-16) manifests, in addition to these
conservative qualities, those of the great classical
"renaissance" of the late eleventh and twelfth cen-
turies, when architects, craftsmen, poets, and
philosophers again confronted classical-Christian
prototypes and interpreted them in an original
yet familiar way. The cathedral is large, five-aisled
and one of the most impressive and majestic of all
Romanesque churches. At first glance, it resem-

bles an Early Christian basilica, but the broadly projecting transept, the dome over the crossing, the rich marble incrustation, and the multiple arcade galleries of the façade soon distinguish it as Romanesque. The interior (FIG. 9-17) also at first suggests the basilica, with its timber roof rather than vault (originally the rafters were exposed as in Early Christian basilicas), nave arcades, and classical (imported) columns flanking the nave in unbroken procession. Above these columns is a continuous, horizontal molding on which rest the gallery arcades. The gallery, of course, is not a basilican feature but is of Byzantine origin. There are other divergences from the basilica, such as the relatively great verticality and, at the crossing, the markedly unclassical pointed arch, which was probably inspired by Islamic architecture. The striped incrustation, produced by alternating dark green and cream-colored marble, provides a luxurious polychromy, which becomes a hallmark of Tuscan Romanesque and Gothic buildings. The leaning campanile, the result of a settling foundation, tilted from the vertical even while it was being built and now inclines some sixteen perilous feet out of plumb at the top. Round, like the Ravenna campaniles, it is much more elaborate, and its stages are marked by graceful, arcaded galleries that repeat the motif of the cathedral's façade and effectively relate the tower to its mother building. Although the baptistry, with its partly remodeled Gothic exterior, may strike a slightly discordant note, the whole composition of the three buildings, with the adjacent Campo Santo (cemetery), makes one of the handsomest ensembles in the history of architecture and expresses dramatically the new building age that was made possible by the prosperity enjoyed by the busy maritime cities of the Mediterranean.

Another Tuscan church, San Miniato al Monte (FIG. 9-18) in Florence, conservatively recalls Early Christian architecture, although the wall arcading and its elaborate, geometrical incrustation in colored marbles make for a rich ornamental effect foreign to the austere exteriors of the earlier buildings. Conservative as San Miniato may appear externally, the interior (FIG. 9-19) is another matter. Though the church is timber-roofed, as are most Tuscan Romanesque churches, the nave is divided into three equal

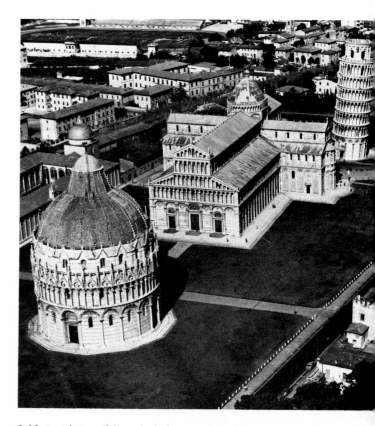

9-16 Aerial view of the cathedral group of Pisa (baptistry, cathedral, and campanile), 1053–1272.

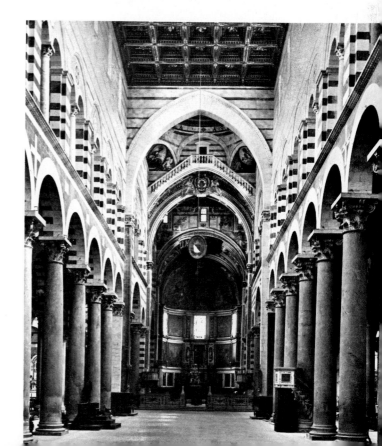

9-17 The nave of the cathedral of Pisa.

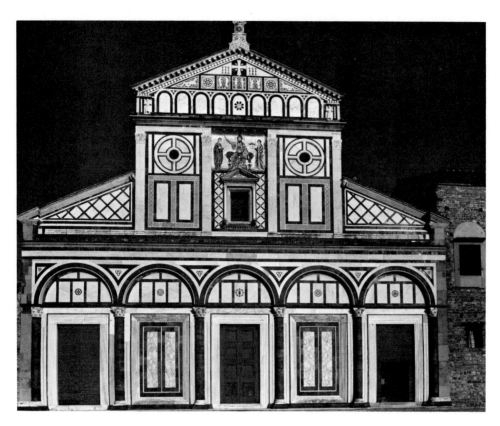

9-18 San Miniato al Monte, Florence, completed *c.* 1062.

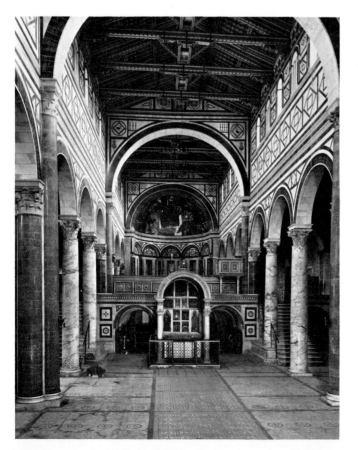

compartments by *diaphragm arches* that rise from compound piers. The piers alternate with simple columns in a–b–b–a rhythm that recalls St. Michael's in Hildesheim. The diaphragm arches, which appear here for the first time (before 1060), had multiple functional and esthetic purposes: They braced the rather high, thin walls; they provided fire-breaks within the wooden roof structure; and they compartmentalized the basilican interior in the manner so popular with most Romanesque builders. Antique, or neo-Antique, motifs appear in the capitals as well as in the incrustation, expressing again the persistence of the classical tradition in Tuscany.

Aquitania

Influences criss-crossed in Romanesque architecture, helping to diversify it and creating exotic hybrids. In the region of Aquitania in southwest France, for instance, it became customary to roof the churches with domes, reflecting the

9-19 Interior of San Miniato al Monte.

c. 1000	1030	1053	**1060**	1066	c. 1080	1095–99	**1101**	c. 1120	1147	c. 1150
	Speyer Cathedral begun	Pisa Cathedral group begun		Norman conquest of England	St. Sernin begun	First Crusade		*Mission of the Apostles*, Vézelay		Second Crusade

R O M A N E S Q U E P E R I O D

NORMAN CONQUEST OF
SOUTHERN ITALY AND SICILY

influence of Byzantium or Armenia. Curiously, most of these Aquitanian churches mate the dome with a longitudinal plan to which, at first glance, it seems ill suited. In the typical Aquitanian church, a longitudinal, aisle-less nave is covered by a sequence of domes, which, in turn, are usually covered by a pitched wooden roof. The result turns out to be highly practical, as the pendentive-supported domes require much less buttressing than, for instance, continuous barrel vaults. Also, the system automatically produces the cherished compartmentalized effect mentioned above. Although they never aimed at the soaring height of northern Romanesque structures, these Aquitanian domed churches not only represent an almost perfect fusion of geometric plan with elevation, but also are visually most effective, clearly exhibiting the functions of all their structural parts (FIG. 9-20).

From about 1050 on, the old dependence of the pre-Romanesque—Carolingian and Ottonian—upon Late Antique and Early Christian design concepts fades gradually, though never completely. Romanesque architecture develops a number of clear characteristics: the square schematism, the alternating-support system, and the increased relief and depth of walls and piers as they connect with the vaults above. The Romanesque architect conceives a building in terms of the geometric relation of its parts, a view basically different from that of the Early Christian architect, who never thought of large units as related geometrically and who thought of the wall not as essentially a structural element, but as a surface to receive applied decoration.

SCULPTURE

The first definite relation of architecture and sculpture appears in the Romanesque style. Figurative sculpture, confined for centuries to small art, flowers again in the new Romanesque churches of the mid-eleventh century. The rich profusion of sculpture and something of its nature may be guessed from Bernard of Clairveaux's famous tirade against it, written in 1127:

> I say naught of the vast height of your churches, their immoderate length, their superfluous breadth, the costly polishings, the curious carvings and paintings.... [Men's] eyes are feasted with relics cased in gold, and their purse-strings are loosed. They are shown a most comely image of some saint, whom they think all the more saintly that he is the more gaudily painted. Men run to kiss him, and are invited to give; there is more admiration for his comeliness than veneration for his sanctity. Hence the church is adorned with gemmed crowns of light....candelabra standing like trees of massive bronze, fashioned with marvellous subtlety of art, and glistening no less bright-

9-20 Interior of St. Pierre, Angoulême, twelfth century.

ly with gems than with the lights they carry. . . . O vanity of vanities, yet no more vain than insane! The church is resplendent in her walls, beggarly in her poor; she clothes her stones in gold and leaves her sons naked in the cloister, under the eyes of the Brethren who read there, what profit is there in those ridiculous monsters, in that marvellous and deformed comeliness, that comely deformity? To what purpose are those unclean apes, those fierce lions, those monstrous centaurs, those half-men, those striped tigers, those fighting knights, those hunters winding their horns? Many bodies are there seen under one head, or again, many heads to a single body. . . . For God's sake, if men are not ashamed of these follies, why at least do they not shrink from the expense?[2]

As we have noted, stone sculpture had almost disappeared from the art of western Europe during the eighth and ninth centuries. The revival of the technique is one of the most important Romanesque achievements. As stone buildings began to rise again, so did the impulse to decorate parts of the structure with relief carving in stone. It was to be expected that the artists should turn for inspiration to surviving Roman sculpture and to sculptural forms such as ivory carving or metalwork; it is obvious that they also relied upon painted figures in manuscripts. But these Romanesque artists developed their own attitude toward ornamental design and its relation to architecture. At first this relation was somewhat random and haphazard; one placed the sculpture wherever there seemed to be a convenient place. A little later, the portals of the church seemed the appropriate setting, both for religious reasons and for the practical matter of display. As Romanesque sculpture turns into Gothic the statuary of the portals becomes integrated with the design of the whole façade, following the lines of the architecture. An example of the earlier, random placement is a figure of Christ in majesty, set into the wall of the ambulatory of St. Sernin at Toulouse (FIG. 9-21). It clearly shows that its source is some prototype made of metal, perhaps a book cover like that of the Codex Aureus of St. Emmeram (PLATE 8-3). The figure has the bulge of metal hammered out from behind, as in the *repoussé* method, and even here in stone one senses the gloss of smooth metal. The signs of the Evangelists at the four corners square off the book-cover-like design and remind one of the corner screws that fix the plate to the book. As yet there is no relation between the relief and its architectural setting: it is "portable," like a work of craft art, and could find its place on any wall. In the later mode the architectural limits of the parts of a portal or the shape of a capital were respected as frames to which the sculptors accommodated

[2] *Ibid.,* pp. 17–18.

9-21 *Christ in Majesty,* late eleventh century, from the ambulatory of St. Sernin, Toulouse.

9-22 Tympanum of the south portal of St. Pierre, Moissac, *c.* 1115–35.

their work. A typical Romanesque portal can be seen in the façade of St. Trophime at Arles in the south of France (FIG. 9-27). Architectural elements of such a portal are: jambs, lintel, semicircular tympanum (beneath the arches or archivolts) and in some instances a pier, or *trumeau*, in the middle of the doorway.

The stirring of the peoples in Romanesque Europe, the Crusades, the pilgrimages, and the commercial journeyings brought a slow realization that Europeans were of the same religion, even if of different ethnic stock. The reception of hitherto unknown documents of Greek thought and learning strongly influenced theology, bringing to it, along with new and deep challenges, a kind of order and concentration. There can be little doubt that theologians dictated the subjects of the Romanesque portals; it was just as important to have the right subjects carved

in the right places as to have the right arguments rightly arranged in a theological treatise. The apocalyptic vision of the Last Judgment, appalling to the imagination of twelfth-century man, was represented conspicuously at the western entrance portal as an inescapable reminder to all who entered.

The semicircular tympanum of the portal of Moissac shows the Second Coming of Christ as King and Judge of the World (FIG. 9-22). As befits his majesty, Christ is centrally enthroned, reflecting a rule of composition we have seen followed since Early Christian times. The signs of the Evangelists flank him: on his right side the Angel of Matthew and the Lion of Mark; on his left, the Eagle of John and the Ox of Luke. To one side of each pair of signs is an attendant angel holding scrolls upon which to record the deeds of mankind for judgment. The figures of crowned

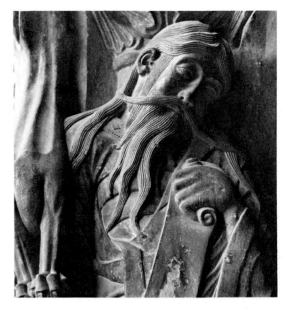

9-23 Left, *The Prophet Isaiah*, from the trumeau of the south portal of St. Pierre, Moissac. Above, the head in detail.

musicians are the twenty-four music-making elders who accompany Christ as the kings of all this world and make music in his praise; each turns to face him, much as would the courtiers of a Romanesque monarch in attendance on their lord. The central group, reminiscent of the heraldic groupings of ancient Mesopotamian art, is set among the elders, who are separated into three tiers by two courses of wavy lines that symbolize the clouds of heaven.

There are as many variations within the general style of Romanesque sculpture as in Romanesque architecture, and the figures of the Moissac tympanum constitute no exception. The architecture of the portal is Islamic and very Spanish in its scalloped jambs, in the intricate rosette motifs

of the lintel, and in the refined arabesquelike treatment of the ornament of the archivolts. Islamic influence may be present in the figures themselves, especially those of the elders; but there are elements here familiar in painting and sculpture throughout western Europe in the eleventh and twelfth centuries. The extremely elongated figures of the recording angels; the curious, cross-legged, dancing pose of the Angel of Matthew; and the jerky, hinged movement are characteristic in general of the emerging vernacular style of representing the human figure. Earlier Carolingian, Ottonian, and Anglo-Saxon manners diffused and interfused to produce the now sure, unhesitating style languages of the Romanesque. The zigzag and dovetail lines of the draperies (the linear modes of manuscript painting are everywhere apparent), the bandlike folds of the torsos, the bending back of the hands against the body, and the wide cheekbones (reminiscent of the ancient Archaic mask) are also common features of this new, cosmopolitan style.

A triumph of the style is the splendid figure of the prophet Isaiah carved in the trumeau of the Moissac portal (FIG. 9-23). His position just below the apparition of Christ as the apocalyptic Judge is explained by his prophecy—recalled by his

9-24 Capitals from the cloister of St. Pierre.

scroll—of the end of the world, when "every mountain and hill shall be made low." He is compressed in the mass of the trumeau behind roaring, interlaced lions of the kind familiar not only in barbarian art but in the art of ancient Mesopotamia and Persia and Islamic Spain. (The totemistic animal is never far from the instinct and imagination of the Medieval artist and certainly not far from Medieval man in general; kings and barons are often named by association with animals thought the most fiercely courageous—for example, Richard the Lion-heart, Henry the Lion, and Richard III of England, whose heraldic animal was the wild boar. It is not unthinkable that the Medieval artist, with millennia of animal lore and ornament in his background, would associate animal strength with architecture, the animal body being thought of as providing support and symbolizing the very forces locked in the architectural fabric. The sphinxes and winged monsters at the palace gates in the ancient world—at Boghazköy, Khorsabad, Persepolis, and Mycenae—are the ancestors of the interlaced lions at Moissac.) The figure of Isaiah is extremely tall and thin, in the manner of the angels of the tympanum, and, like the Angel of St. Matthew, he executes a cross-legged step that repeats the criss-crossing of the lions. There is as yet no

representation of movement in terms of the actual structure of the body or its natural proportions. At this beginning of a new epoch in the history of sculpture, movement is a kind of grotesque, mechanical dance. The placing of the parts of the body is dependent upon the architectural setting, the sculptor's interpretation of his carved or painted model, or the vocabulary of the prevailing vernacular styles; the artist's originality could also play a large part, as in this case. The folds of the drapery are incised in flowing, calligraphic line that ultimately derives from manuscript illumination and here plays gracefully around the elegant figure.

A detail of the head and shoulders (FIG. 9-23) reveals the artist's striking characterization of his subject. The long, sepentine locks of hair and beard (familiar in the vocabulary of French Romanesque details) frame an arresting image of the dreaming mystic. The prophet seems entranced by his vision of what is to come, his eyes wide but unseeing the light of ordinary day; there is an expression slightly melancholy, at once pensive and wistful. For the man of the Middle Ages there were two alternative callings, one to the active life (*vita activa*), the other to the religious life of contemplation (*vita contemplativa*), the pursuit of the beatific vision of God. The

9-25 West tympanum of St. Lazare, Autun, *c.* 1130.

sculptor of the Moissac *Isaiah* has given us the very image of the *vita contemplativa*. It has been said that in Greek sculpture the body becomes "alive" before the head (as in the *Fallen Warrior* from Aegina, FIG. 5-30); in the epoch that begins in the eleventh century, the head becomes humanly expressive well before the body is rendered as truly corporeal. The *Isaiah* is a remarkable instance of this.

Romanesque sculpture is not confined to the portals but appears in delightful variety in the carved capitals within the church and in the cloister walk; it was such sculpture that Bernard complained distracted the monks from their devotions; we are distracted, too, by its ingenuity and decorative beauty. Fifty of the capitals of the Moissac cloister (opening illustration, Part Two and FIG. 9-24) are historiated and some thirty purely decorative. The foremost capital in the general view has an intricate leaf-and-vine pattern with volutes, an echo of the Corinthian capital. The abacus carries rosettes, and its upper edge the fish-scale motif. The capital just beyond has figures seated at a table, probably a representation of the Marriage Feast at Cana. The other capitals (FIG. 9-24) reveal the richness and color of the Romanesque sculptors' imagination; monsters of all sorts—basilisks, griffins, lizards, gargoyles—cluster and interlace and pass grinning before us. We have the Medieval bestiary in stone.

The relatives of the monsters of the Moissac capitals appear as the demons of hell in the awesome tympanum of the church of St. Lazare at Autun in Burgundy (FIG. 9-25). At Moissac we saw the apparition of the Divine Judge before he has summoned man; at Autun the Judgment is in progress. The detail shows the weighing of souls, while below in the lintel, the dead are rising, one plucked from the earth by giant hands. Mankind's pitiful weakness and littleness are distilled in these terror-stricken, weeping dolls, whom an angel with a trumpet summons to judgment. Angels and devils contest at the scales where souls are being weighed, each trying to manipulate the beam for or against a soul. Hideous demons guffaw and roar; their gaunt, lined bodies, with legs ending in claws, writhe and bend like long, loathesome insects. A devil leaning from the dragon-mouth of hell drags souls in, while above him a howling demon crams souls head first into a furnace. The resources of the Romanesque imagination, heated by a fearful faith, provide an appalling scene; one can appreciate the terror the Autun tympanum must have inspired in the believer who passed beneath it as he entered the cathedral.

Another great tympanum, this one at the church of La Madeleine at Vézelay, not far from Autun, varies the theme of the apocalyptic Last Judgment, representing the Ascension of Christ

and the Mission of the Apostles (FIG. 9-26). As related in scripture (Acts i.4–9), Christ foretold that the apostles would receive the power of the Holy Ghost and become the witnesses of the truth of the gospels throughout the world. The rays of light emanating from his hands represent the promise of the coming of the Holy Ghost. The apostles, holding the gospel books, receive their spiritual assignment. Christ had assigned three specific tasks to the apostles and given them the power to perform them: to save or to condemn; to preach the gospel to all nations; to heal the sick and drive out devils. The task of saving or condemning is indicated in the central scene and in the lower four of the compartments surrounding it. The task of preaching the gospel to all nations (some at the very edge of the world) is represented on the lintel. The task of healing the sick and driving out devils is indicated in the upper four compartments. The outer archivolt has a repeated ornamental device, and the inner, medallions with the signs of the zodiac, the seasons, and the works of the months.

The Vézelay tympanum reflects, like a vast mirror, religious and secular writings and the influence of antiquity and the Byzantine East. It is a complete, encyclopedic Mission of the Apostles, in which the mission and the power to perform it are merged in a single subject. The theme has its sources in the Acts and in the gospels, in the prophecies of Isaiah, and in writings of antiquity and of the Middle Ages. The crowding, agitated figures reveal wild deformities. We find people with the heads of dogs, enormous ears, fiery hair, snoutlike noses; there are hunchbacks, mutes, blind men, lame men—a whole lexicon of human defects and ailments. Mankind, still suffering, awaits the salvation to come. The whole world is electrified by the promise of the ascended Christ, whose great figure, seeming to whirl in a vortex of spiritual energy, looms above human misery and deformity. Again, as in the Autun tympanum, we are made emphatically aware of the greatness of God and the littleness of man.

Vézelay is more closely associated with the Crusades than any other church in Europe. Pope Urban II had intended to preach to the First Crusade at Vézelay in 1095, about thirty years before the tympanum was carved. In 1146, some fifteen years after the tympanum was in place, Bernard preached to the Second Crusade, and King Louis VII of France took up the cross. In

9-26 *The Mission of the Apostles*, tympanum of the center portal of the narthex of La Madeleine, Vézelay, 1120–32.

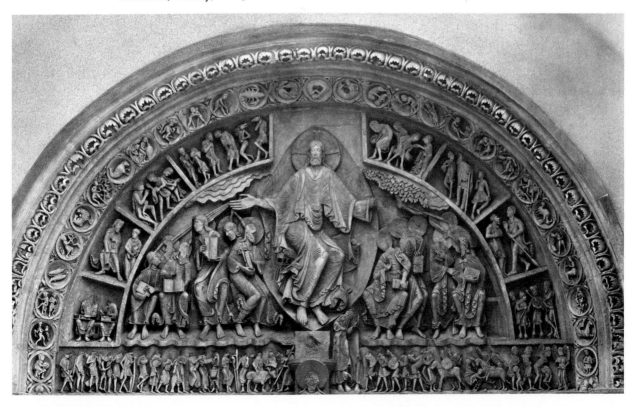

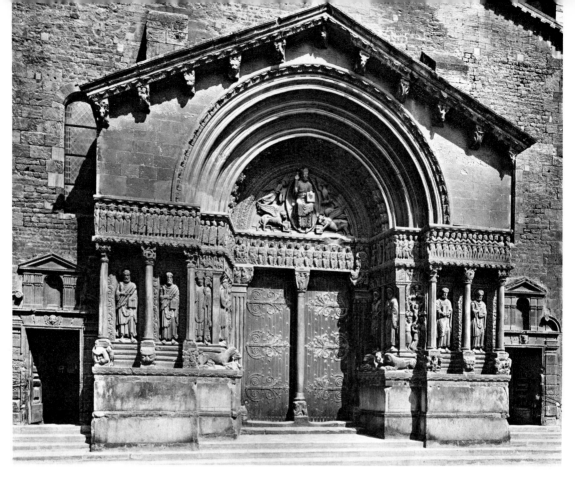

9-27 Portal on the façade of St. Trophime, Arles, late twelfth century.

1190 it was from Vézelay that King Richard the Lion-heart of England and King Philip Augustus of France set out upon the Third Crusade. Doubtless the spirit of the Crusades determined the iconography of the Vézelay tympanum, for it was believed that the Crusades were a kind of second mission of the apostles to convert the infidel: "When the tympanum was created the crusaders had already fulfilled the most important part of their mission. They had recaptured Jerusalem on the 15 July, 1099. Contemporary writers stress the fact that this is the day on which the apostles had dispersed throughout the world to fulfill their mission."[3]

Stylistically, the figures of the Vézelay tympanum display characteristics similar to those of Moissac and Autun: abrupt, jerky movement

(strongly exaggerated at Vézelay), rapid play of line, wind-blown drapery hems, elongation, angularity, and agitated poses, gestures, and silhouettes. The figure of the Vézelay Christ is a splendid essay in calligraphic theme and variation, and is almost a summary of the Romanesque skill with decorative line. The lines of the drapery shoot out in rays; break into quick, zigzag rhythms; and spin into whorls, wonderfully conveying a spiritual light and energy flowing from Christ over and into the animated apostles. The technical experience of centuries of working with small art—with manuscripts, ivories, and metalcraft—is easily read from this monumental translation of such work into stone.

In Provence, in the extreme southeast of France, the vivid linear style of Languedoc (Moissac) and Burgundy (Autun and Vézelay) is considerably modified later in the twelfth century by the influence of the art of antiquity, the Rhône basin (the Provence region) being very rich in the remains of Roman art and architecture. The

[3] Adolf Katzenellenbogen, "The Central Tympanum at Vézelay: Its Encyclopedic Meaning and Its Relation to the First Crusade," *Art Bulletin*, Vol. 26, No. 3 (Sept. 1944), pp. 141–51.

quieting influence of this art is seen at once in the figures of the façade of St. Trophime at Arles and in the design of the portal, which reflects the artist's experience of a Roman triumphal arch (FIG. 9-27). The tympanum shows Christ surrounded by the signs of the Evangelists. On the lintel, directly below him, appear the twelve apostles at the center of a continuous frieze that depicts the Last Judgment; the outermost parts of the frieze depict the saved (on Christ's right) and the damned (on his left) in the flames of hell. Below this, in the jambs and the front bays of the portals, stand grave figures of saints draped in Classical garb, their quiet stance contrasting with the spinning, twisting, dancing figures seen at Autun and Vézelay. The stiff regularity of the figures in the frieze also contrast with the animation of the great Burgundian tympana and remind us of the "lining up" seen in Early Christian sarcophagus sculpture. Their draperies, like those of the large statues below, are also less agitated and show nothing of the dexterous linear play familiar at Moissac, Autun, and Vézelay. The rigid lines of the architecture of the façade as a whole (rather than just an enframing element such as a tympanum) are now determining the placement and look of the sculpture, and the freedom of execution appropriate to small art is sacrificed to a simpler and more monumental adjustment to the architecture. In the north of France, in the area around Paris, a new system of portal sculpture was developing some thirty years earlier than that at St. Trophime. In the Royal Portal of the cathedral of Chartres we shall see the expansion of the whole portal design into a magnificent frontispiece in which the architectural and sculptural elements are in balanced relation, the sculptural style firmly determined by the lines of the building (FIG. 10-13).

PAINTING AND ILLUMINATION

Monumental mural painting, like monumental sculpture, comes into its own once again in the eleventh century. Although we have examples of it from Carolingian and Ottonian times, and al-though there is an unbroken tradition of it in Italy, it blossoms in the Romanesque period. As with architecture and sculpture there are many regional styles and many degrees of sophistication. Sometimes a provincial style—that is, a style that appears at some distance from its origin, in an artistic "province" rather than at an artistic "capitol"—can reveal more clearly than its sophisticated source the elements common to both. Such is the case in the mural painting in the apse of the little church of Santa Maria, at Tahull in Catalonia in the extreme northeast corner of Spain. This painting (PLATE 9-1) could be called provincial Byzantine, as, for that matter, could much Romanesque painting. If we compare it with a Byzantine mosaic like that at Daphne (FIG. 7-44) or the apse mosaic at Torcello (FIG. 7-45), we find that its distance from the Byzantine source —much greater than the distance from Venice or Torcello to Byzantium—results in a loss of subtlety and refinement and some misunderstanding of motifs in the original style. On the other hand, the Tahull painting has a simple and strong directness, even bluntness, that gives it a peculiarly expressive force. One emphatic feature is the partitioning of the draped figures into separate decoratively modeled segments that almost break the figure itself into independent parts. (Note the similarity to the modulation and articulation of Romanesque architecture.) This is especially well seen in the pattern made by the pipelike legs and the ladderlike folds between them. This decorative banding of the surface serves to keep the figures flat and contributes to the effect of stiff formality. The drapery, also with decorative partitioning, is scarcely distinguished from the body. Even the hands of the Madonna are subdivided, as are the heads and necks of other figures. This technique, which had begun to appear in Ottonian painting (FIG. 8-19), is almost universal in Romanesque; it may be seen beneath the whirling linear draperies of Autun and Vézelay and in the angels of the Moissac tympanum. Here the sharp patterning of the figures is assisted by bold coloring, and the whole effect is one of rude strength, not a little of which derives from the architectural planes to which the patterned figures are masterfully adjusted.

The vernacular Romanesque style can be seen almost in exaggeration in a manuscript illumina-

tion from northern France illustrating the life of St. Omer (FIG. 9-28). Here the figures are cut into patterns by hard lines, and the action is remote from even an approximation of organic motion. St. Omer (bound and pulled by the beard) and his captors seem to be performing some bouncing ritual ballet. Although the group is enframed, the frame creates no sense of containment as it did in Anglo-Saxon and Carolingian manuscripts, and bodies and feet move arbitrarily in and out of and across it. Locally different from the Tahull mural, the St. Omer illumination shares its fundamental vocabulary.

The vocabulary, richly applied and gracefully modulated, appears in what surely must be one of the masterpieces of Medieval art, a manuscript illuminated in Bernard's great abbey of Citeaux, the motherhouse of the Cistercian order. Citeaux, and its sister abbey, Clairvaux, where Bernard was abbot, produced magnificent illuminated manuscripts throughout the twelfth century, among which was Gregory's *Moralia in Job*, painted before 1111. A splendid example of Cistercian illumination, the historiated initial from this manuscript (FIG. 9-29) represents St. George, his servant, and the roaring dragon intricately composed to make the letter "R." St. George, a slender, regal figure, raises his shield and sword

against the dragon, a distinguished representation of the age-old animal style so often encountered, while the servant, crouching beneath St. George, runs a lance through the monster. The ornamented initial goes back to the Hiberno-Saxon eighth century; the inclusion of a narrative within the initial is a practice that will have an important future in Gothic illumination. The banding of the torso, the fold partitions (especially evident in the skirts of the servant), and the dovetail folds—all part of the Romanesque manner—are done here with the skill of a master who deftly avoids the stiffness and angularity that result from less skillful management of the vocabulary. Instead, he makes a virtue of stylistic necessity; the partitioning accentuates the verticality and elegance of the figure of St. George, as it does the thrusting action of his servant. The flowing sleeves add a spirited flourish to St. George's gesture. The knight, handsomely garbed, cavalierly wears no armor and aims a single stroke with proud disdain. This miniature may be a reliable picture of the costume of a Medieval baron and of the air of nonchalant gallantry he cultivated.

An illumination of exceeding refinement of execution, exemplifying the sumptuous illustration common to the large Bibles produced in the wealthy Romanesque abbeys, is the frontispiece to the Book of Deuteronomy from the Bury Bible (PLATE 9-2). Produced at the abbey of Bury St. Edmunds in England around the middle of the twelfth century, the work shows two scenes from Deuteronomy enframed by symmetrical leaf motifs in softly glowing, harmonized colors. The upper register shows Moses and Aaron proclaiming the Law to the Israelites; the lower, Moses pointing out the clean and unclean beasts. The gestures are slow and gentle and have quiet dignity; the figures of Moses and Aaron seem to glide. This is quite different from the abrupt emphasis and spastic movement of the earlier Romanesque; here, as the patterning softens, the movements of the figure become more integrated and smooth. Yet the patterning does remain in the multiple divisions of the draped limbs, the lightly shaded volumes being connected with sinuous lines and ladder-folds; the drapery and body are still thought of as somehow the same. The frame now has a quite definite limiting function, and the figures are carefully fitted within it.

9-28 *The Life and Miracles of St. Audomarus (Omer),* illuminated manuscript, eleventh century. Bibliothèque Municipale, Saint-Omer, France.

9-29 Above: *St. George and the Dragon*, from the *Moralia in Job* illuminated manuscript, early twelfth century. 13¾″ × 9¼″. Bibliothèque Municipale, Dijon.

to fall softly, to wrap about the frame, to overlap parts of it, and to follow the movements beneath. The arbitrariness of the Romanesque vernacular style is yielding, slightly but clearly, to the requirements of a more naturalistic representation. The artist's instinct for decorative elaboration of his surface remains, as is apparent in the whorls and spirals of the gown, but it is significant that these are painted in very lightly and do not conflict with the functional lines that contain them.

With the distinction of body and drapery finally achieved in the Gothic art of the thirteenth century, an epoch of increasing naturalism will begin. As did the billowing sail of Exekias' ship of Dionysos (FIG. 5-7), the Eadwine figure marks a turning point—in this case, in the history of Medieval representation. The Late Romanesque and Early Gothic "feel" of body and drapery as surfaces that interact forcefully implies not only a sense of their materiality but also a sense of depth. That sense will sharpen and deepen into the representational art of the Renaissance.

The transition from the Romanesque vernacular style to something new seems to reach a midpoint in a work of great expressive power, the portrait of the scribe Eadwine in the *Eadwine Psalter* (FIG. 9-30), made in Canterbury about the same time as the Bury Bible. Particularly noteworthy is the fact that the portrait represents a living man, a priestly scribe, not some sacred person or King David, who usually dominates the Psalter. While it is true that Carolingian and Ottonian manuscripts included portraits of living men, they were of reigning emperors, whose right to appear in sacred books was God-given, like the right of Justinian and Theodora and their court to be depicted in the sanctuary of San Vitale. Here, the inclusion of his own portrait sanctified the scribe's work, marking a change in attitude that points to the future emergence of the artist as a person and a name.

The style is related to that of the Bury Bible, but, though the patterning is still firm—notably in the cowl and the thigh—the drapery has begun

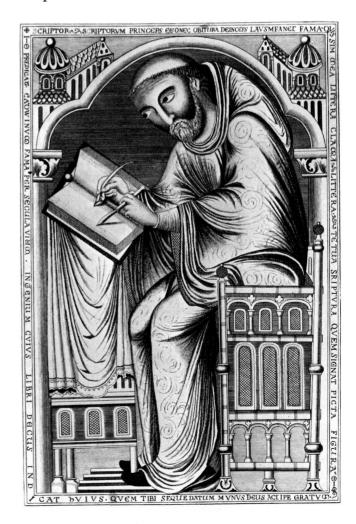

9-30 Right: *The Scribe Eadwine*, from the *Eadwine Psalter*, c. 1150, 19″ × 13″. Trinity College, Cambridge, England.

Chapter Ten

Gothic Art

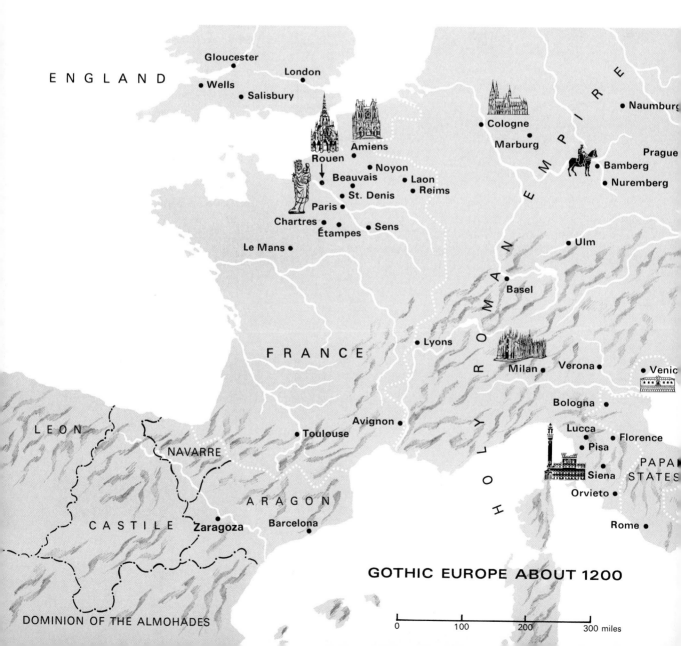

ENGLAND

Gloucester

London

Wells

Salisbury

Rouen

Amiens

Noyon

Beauvais

Laon

St. Denis

Reims

Paris

Chartres

Étampes

Sens

Le Mans

FRANCE

Lyons

Toulouse

Avignon

NAVARRE

ARAGON

Zaragoza

Barcelona

LEON

CASTILE

DOMINION OF THE ALMOHADES

HOLY ROMAN EMPIRE

Cologne

Marburg

Naumburg

Prague

Bamberg

Nuremberg

Ulm

Basel

Milan

Verona

Venic

Bologna

Lucca

Pisa

Florence

Siena

Orvieto

Rome

PAPAL STATES

GOTHIC EUROPE ABOUT 1200

0 100 200 300 miles

GOTHIC WAS FIRST used as a term of derision by Renaissance critics who scorned the lack of conformity of Gothic art to the standards of classical Greece and Rome: "May he who invented it be cursed," wrote one of them. Mistakenly, they thought the style had originated with the Goths, who thus were responsible for the destruction of the good and true classical style. The men of the thirteenth and fourteenth centuries, however, referred to the Gothic cathedrals as *opus modernum* (modern work) or *opus francigenum* (Frankish work). They recognized in these structures that towered over their towns a style of building and of decoration that was original. It was with confidence in their own faith that they regarded their cathedrals as the

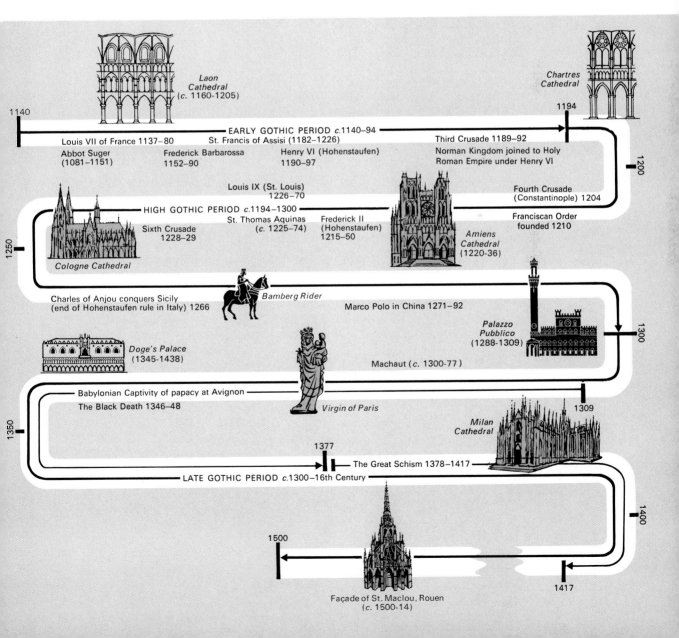

Laon Cathedral (c. 1160-1205)

Chartres Cathedral

1140

EARLY GOTHIC PERIOD c.1140-94

Louis VII of France 1137-80
St. Francis of Assisi (1182-1226)
Abbot Suger (1081-1151)
Frederick Barbarossa 1152-90
Henry VI (Hohenstaufen) 1190-97

Third Crusade 1189-92
Norman Kingdom joined to Holy Roman Empire under Henry VI

1194

1200

Louis IX (St. Louis) 1226-70

HIGH GOTHIC PERIOD c.1194-1300
St. Thomas Aquinas (c. 1225-74)
Sixth Crusade 1228-29
Frederick II (Hohenstaufen) 1215-50

Fourth Crusade (Constantinople) 1204
Franciscan Order founded 1210

Cologne Cathedral

Amiens Cathedral (1220-36)

1250

Charles of Anjou conquers Sicily (end of Hohenstaufen rule in Italy) 1266
Bamberg Rider
Marco Polo in China 1271-92

Palazzo Pubblico (1288-1309)

1300

Doge's Palace (1345-1438)

Machaut (c. 1300-77)

Babylonian Captivity of papacy at Avignon
The Black Death 1346-48
Virgin of Paris

1309

Milan Cathedral

1350

1377

The Great Schism 1378-1417

LATE GOTHIC PERIOD c.1300-16th Century

1417

1400

1500

Façade of St. Maclou, Rouen (c. 1500-14)

real image of the City of God, the Heavenly Jerusalem, which they were privileged to build on earth.

There are strong contrasts between the Gothic and the Romanesque environment and point of view. Romanesque society was dominated by the uncertainties inherent in the anarchical tendencies of feudalism. The great barons of the countryside and the great abbeys enjoyed an almost total independence, and the conflict of their claims to privilege led to constant warfare. Gothic society was also feudal, but it was a comparatively ordered feudalism. Here and there powerful barons had been able to make themselves kings, and monarchy, especially in England and France, asserted itself strongly to limit the independence of lesser lords and the Church. Centralized government was established, and law and order instilled confidence in people of all walks of life. The cities, entirely new or built on the foundations of old Roman ones, began to thrive and become strong; allied for common defense, they were very often powerful enough to defy kings and emperors. Within their walls men who had escaped from the land could find freedom: "The air of the city is the breath of freedom," one slogan had it. City life took on a complex but ordered form; craft guilds, resembling strong unions, were formed to give protection and profit to artisans of the same specialties. A middle class, made up of the craftsmen, merchants, and professionals (lawyers, doctors, teachers, and many others) came to constitute a new and puissant force to check and balance the feudal aristocracy. The fear and insecurity that pervaded the Romanesque world was mitigated by the new alignment of economic and social forces, and the Gothic world emerged.

Romanesque society had been dominated by men. In Gothic society women took on a new importance. Wandering minstrels sang less of the great deeds of heroes in war and more of love, beauty, and springtime. Eleanor of Aquitaine, wife to Louis VII of France and Henry II Plantagenet of England and mother of Richard the Lion-heart and John, was one of the first to rule over a "court of love," where respect for the lady was prerequisite and from which was to emanate the code of chivalry that so decided social relations in the later Middle Ages. The monastic prejudice against women no longer determined the representation of them in art. In the twelfth century *luxuria*, sensual pleasure, is represented at Moissac as a woman with serpents at her breasts; in the thirteenth century it is represented as a pretty girl looking into a mirror. It is almost with relief that the Gothic upper classes turn from the *chansons de geste* to the new amorous songs and romances, in which the lover adores his lady and in which such immortal lovers as Tristan and Isolde are celebrated. Marie de France, herself a noblewoman, introduced this tale, along with many others of the new Arthurian legends, to northern French feudal society. The poetry of the times nicely illustrates the contrast between Romanesque and Gothic taste and mood: While in the Romanesque *Song of Roland* the dying hero waxes rhapsodic over his sword, the German minnesinger of the Gothic period, dreaming in a swooning ecstasy of his lady, is "woven round with delight."

The love of woman, celebrated in art and formalized in life, received spiritual sanction in the cult of the Virgin Mary, who, as the Mother of Heaven and of Christ and in the form of Mother Church, loved all her children. It was Mary who stood compassionately between the judgment seat and the horrors of hell, interceding for all her faithful. The later twelfth and thirteenth centuries sang hymns to her, put her image everywhere, and dedicated great cathedrals to her. Her image was carried on banners into battle, and her name sounded in the battle cry of the king of France: "Sainte Marie . . . Saint Denis . . . Montjoie!" Thus, Mary became the spiritual lady of chivalry, and the Christian knight dedicated his life to her. The severity of Romanesque themes stressing the Last Judgment yields to the gentleness of the Gothic, in which Mary is represented crowned by Christ in Heaven.

It was not alone the new position of women, the lyrical and spiritual exaltation of love, or the cult of the Virgin that softened barbarous manners. In concert with the new mood was the influence of one remarkable man, St. Francis of Assisi, who saw Christ not as the remote and terrible Judge but as the loving Savior who had walked among and had himself been one of the

"rejected of men." The series of reform movements that make up the history of Medieval monasticism culminates in St. Francis' founding of the religious order that bears his name, the Franciscans. St. Francis felt that the members of his order must shun the cloistered life and freely walk the streets of the busy cities as mendicants, preaching the original message of Christ—the love of oneself and one's neighbor. Shortly after Francis' death and against his wish that his followers never settle in monasteries, they commenced the great basilica in his name at Assisi. The historical importance of the Franciscan movement lies in its strengthening of religious faith, its stimulating of the religious emotion among people in cities, and its weakening of the power and influence of the old, Romanesque, countryside abbeys. St. Francis could be said to have brought a kind of democracy to religion in Europe at the expense of its feudal establishment.

Courtly love, the development of chivalry, the cult of the Virgin Mary, and the teaching and example of St. Francis could not, of course, nullify, though they could mitigate, the cruel realities of Medieval life. While St. Francis was still living, the Fourth Crusade sacked Christian Constantinople, visiting atrocities upon it that would outdo those of the later conquest by the Ottoman Turks. The papacy and king of France collaborated in the annihilation of the peoples of Languedoc and Provence in the south of France, the so-called Albigensians, who were accused of heresy but who also stood in the way of the territorial ambitions of royal France. It was this region that had fostered the new poetry of the troubadours and produced the Romanesque sculpture examined earlier. The Albigensian "crusade" produced also that grim and fateful instrument of heretic-hunting, the Inquisition, or "Holy Office," instituted by St. Dominic. The Dominicans, called in fearful derision Domini Canes ("dogs of the Lord"), were in many ways rivals of the Franciscans and saw themselves as rooting out unbelievers and heretics and guarding the purity of orthodox dogma. The Dominicans' concern for theology led them to be teachers, and they produced one of the great Christian theologians and philosophers, St. Thomas Aquinas, who at mid-century was the leading light of the University of Paris.

The institution of the university begins to appear in the early Gothic period, its natural setting the city. The monastic and cathedral schools of the earlier Middle Ages had sought to keep the learning of the fathers of the Church alive and to reassess these teachings in the light of developing Christian thought. From these schools the universities, communities of scholars and their pupils, evolved in the twelfth and thirteenth centuries at Bologna and Padua, Oxford, and Paris. The most important study at the university was theology, but several other subjects were taught, among them mathematics, astronomy, music, grammar, logic, law, and medicine. Ancient Greek philosophy, principally that of Aristotle, was recovered from Arabic translations and had an enormously stimulating effect upon theology. Here appeared a reasoned, systematic method of argument and a treasury of lore and observation of natural things. The philosophers set to work to find some way to adjust this new authoritative knowledge to Christian belief; they sought, in short, to rationalize religion. Their method was to arrive at proofs for the central dogmas of the faith by argument, or disputation. This method, taught in the schools and universities, came to be called scholasticism, and its proponents schoolmen. Scholastic philosophy is still the official philosophy of the Roman Catholic Church. The greatest exponent of this systematic procedure was St. Thomas Aquinas. Typical of the method is his treatise, the *Summa Theologica*, which was laid out into Books, the Books into Questions, the Questions into Articles, each Article into objections with contradictions and responses, and, finally, answers to the objections.

Within this framework the shrewdest and subtlest arguments of the Middle Ages were advanced. The habit of mind it created lasted for centuries, an obstacle to the rise of what we call empirical thought and science; yet much of value is still found in it today. It is quite possible that the scholastic habit of disputation is reflected in the thought processes of Gothic architects, as Erwin Panofsky suggested.

St. Thomas wrote his summary of Christian theology at a time when the great cathedrals were manifesting a kind of architectural "summation" of the Christian universe. At the time, the

papacy ruled supreme in Europe, not only spiritually but temporally. At the beginning of the thirteenth century, Pope Innocent III, who took England away from King John, could claim: "Single rulers have single provinces, and single kings single kingdoms; but Peter . . . is pre-eminent over all, since he is the Vicar of Him whose is the earth and the fulness thereof, the whole wide world and all that dwell therein."

The thirteenth century represents the summit of achievement for unified Christendom. It represents the triumph of the papacy; a successful and inspiring synthesis of religion, philosophy, and art; and the first firm formation of the states that will make modern history. The scene of this great but brief equilibrium of forces favoring religion is the Gothic city; within the city, the soaring cathedral, "flinging its passion against the sky," asserts the nature of the Gothic spirit.

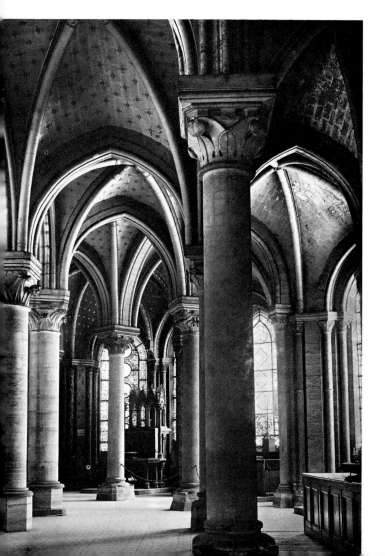

EARLY GOTHIC

Architecture

On June 11, 1144, Louis of France, Eleanor of Aquitaine (his queen), members of the royal court, and a host of distinguished prelates, including five archbishops, as well as a vast crowd, converged on the royal abbey of St. Denis, just a few miles north of Paris, for the dedication of the new choir. This choir, with its crown of chapels radiant with stained-glass windows, set a precedent that the builders in the region surrounding Paris, the Ile-de-France, were to follow for the next half century.

Two eminent persons were particularly influential in the formation of the Gothic style: Bernard of Clairvaux and Suger, abbot of St. Denis. Bernard held the belief that faith was mystical and intuitive rather than rational. In his battles with Abelard, a contemporary scholastic philosopher whose views were a basis for the dialectical method of Aquinas, he upheld this position with all the persuasiveness of his powerful personality and eloquence and by the example of his own holiness. The Cistercian architecture that was being built under Bernard's influence reflected his theology, stressing purity of outline, simplicity, and a form and light peculiarly conducive to meditation.

Although Bernard denounced lavish decoration and elaborate architecture, the Gothic style was initiated by a fellow-abbot who, accepting Bernard's admonitions to reform his monastery, built his new church in a style that surpassed the Romanesque in splendor. The fellow-churchman was the Abbot Suger, who had risen from humble parentage to become the right-hand man of both Louis VI and Louis VII, and, during the latter's absence in the Second Crusade, the regent of France. From his youth, Suger wrote, he had dreamed of the possibility of embellishing the church that had nurtured him, the royal Church of France, within whose precincts its kings had been buried since the ninth century. It was in fact his intention to confer authority on the claims of the kings of royal France to the territory we recognize as France today, for in Suger's time the power of the French king, ex-

10-1 Ambulatory of the abbey church of St. Denis, near Paris, 1140–44.

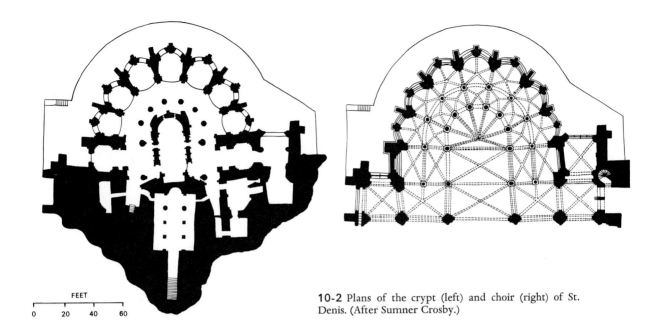

10-2 Plans of the crypt (left) and choir (right) of St. Denis. (After Sumner Crosby.)

cept for scattered holdings, was confined to an area not much larger than Ile-de-France. Thus, Suger's political role and his building role were one: to construct a kingdom and an architectural expression of it. In 1122 he was elected abbot of St. Denis and within fifteen years was at work rebuilding the old monastery, which had been in use for almost 300 years. As he made his plans for the new building, he must have recalled many of the churches seen during his travels, and the workmen and artists who labored to raise the church were summoned from many regions. St. Denis, one of the last great abbey churches to be built, became the monastic inspiration for the city cathedrals and is known as the cradle of Gothic art.

Suger described his new choir at St. Denis (FIG. 10-1) as follows:

Moreover, it was cunningly provided that— through the upper columns and central arches which were to be placed upon the lower ones built in the crypt—the central nave of the new addition should be made the same width, by means of geometrical and arithmetical instruments, as the central nave of the old [Carolingian] church; and, likewise, that the dimensions of the new side-aisles should be the same as the dimensions of the

old side-aisles, except for that elegant and praise-worthy extension . . . a circular string of chapels, by virtue of which the whole [church] would shine with the wonderful and uninterrupted light of most luminous windows, pervading the interior beauty.[1]

The abbot's description is a key to the understanding of Early Gothic architecture. As he says, the major dimensions of the structure were dictated by an older church, but it was the "elegant and praiseworthy extension," the "string of chapels" with "luminous windows," that proclaimed the new style.

Although the crypt at St. Denis served as a foundation for the choir above it, a comparison of their plans and structure of each reveals the major differences between Romanesque and Gothic building (FIG. 10-2). The thick walls of the crypt create a series of separate volumes—careful Romanesque "partitioning" into units—whereas the absence of walls in the choir above produces a unified space. The crypt is essentially a wall construction, and it is covered with groin vaults; the choir, on the other hand, is a skeletal

[1] Erwin Panofsky, trans., *Abbot Suger on the Abbey Church of St. Denis and its Art Treasures* (Princeton, N.J.: Princeton Univ. Press, 1951), p. 101.

construction, and its vaults are Gothic rib vaults (FIG. 10-3).

The ancestors of the Gothic rib vault (at Caen and Durham) were discussed above. A rib vault is easily identified by the presence of crossed, or diagonal, arches under the groins of a vault. These arches form the armature, which serves as the framework for Gothic skeletal construction. The Gothic vault may be distinguished from other rib or arched vaults by its use of the pointed, or broken, arch as an integral part of the skeletal armature; by the presence of thinly vaulted webs, or severies, between the arches; and by the fact that, regardless of the space to be vaulted, all the arches have their crowns at approximately the same level—something the Romanesque architects could not achieve with their semicircular arches (FIG. 10-4). Thus, flexi-

bility is a major advantage of the Gothic vault, permitting the vaulting of compartments of varying shapes, as may be readily seen in the plan of the choir of St. Denis and in many other Gothic choir plans. Moreover, although it does not entirely support the webs, the Gothic armature allows predetermining of the alignment and concentration of thrusts to be buttressed.

Although the Medieval mason unquestionably derived great satisfaction from his mastery of these technical problems and at times must have been preoccupied with them, he did not permit them to be an end in themselves. The ambulatories and chapels at St. Denis are proof that the rib vault was exploited, as Suger wrote, so that the whole church "would shine with wonderful and uninterrupted light." This was, in Medieval terms, the *scientia*—the theory—that motivated the creation of the Gothic style; and it was *ars*—technical knowledge and practical skill—that made it possible. The difference between the two was akin to that between modern physics and engineering; when a Medieval architect spoke of the "art of geometry," he meant not the abstract nature of geometrical forms, but the practical uses to which mathematical formulations might be put in designing a piece of sculpture or in erecting a building. An understanding of Gothic architecture will not be reached, however, by trying to decide whether it was predominantly concerned with *ars* or with *scientia* but rather by realizing that the cathedrals were the result of both. And it is in the stones themselves, in the extraordinary sensitivity of the Gothic mason for stone as a building material that the spirit of Gothic architecture is to be discovered. The fact is that procedure was often hit or miss and rule of thumb; buildings often collapsed and were rebuilt with very large margins of safety. There was no one sure way and certainly no fundamental agreement about method. The certainties of modern engineering—themselves sometimes not so certain—were centuries beyond the Gothic reach. Even so, what still stands of Gothic architecture is a monument to the supreme skill, persistence, and vision of the Gothic architects.

It was the *scientia* of light that led Suger to the invention of the Gothic building, the slender skeletal structure that permitted the flooding

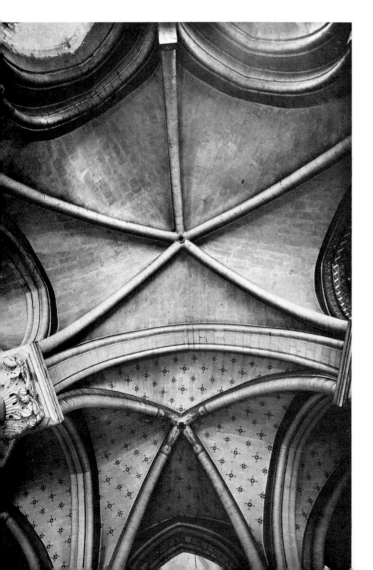

10-3 Vaults of the ambulatory and radiating chapels of the choir of St. Denis.

of the interior with light. This "theory" came from the writings of a fifth-century mystic called the pseudo-Dionysius the Areopagite because of his claim to be the true Dionysius, a first-century Athenian follower of St. Paul. This "'pseudo-Dionysius" had become confused with the patron saint of royal France, St. Denis, making it natural for Suger to take the former's mystical identification of light with the divine as a kind of prescription for any building dedicated to St. Denis. When Suger, steeped in the theology of the Areopagite, envisioned the new St. Denis, he saw it as a mystic radiance. This is another example of the significance of religious authority in the Middle Ages. Not only scripture, but the works of the fathers of the Church were the key to reality, and things had to be interpreted in terms of their authority.

The evolution of Gothic architecture is a continuing adjustment of scale, proportion, buttressing, vault arrangement, and wall and façade design that, in Panofsky's image, is like the steps of a complex scholastic argument. Only the choir of St. Denis was completed in the twelfth century; for a fairly complete view of the Early Gothic style of the second half of the century, one must turn to the cathedral of Laon (FIGS. 10-5 to 10-8). Begun about 1160 and completed shortly after 1200, the building retains many Romanesque features but combines them with the new Gothic structural devices—the rib vault and the pointed arch. Shortly after the building's completion the choir was enlarged and the present plan, relatively long and narrow with a square east end, has a decidedly English flavor. Among the plan's easily discernible Romanesque features are the strongly marked-off crossing square and the bay system composed of a large unit in the nave flanked by two small squares in each aisle (FIG. 10-5). The nave bays are defined by sexpartite rib vaults and an alternate-support system that, in combination, continue the Romanesque tradition of subdividing the interior into a number of separate compartments. Both features, as well as the gallery above the aisles, have been derived from Norman Romanesque architecture, which enjoyed great prestige in northern France throughout the twelfth century (FIGS. 9-12 and 9-13). A new feature of the interior, however, is the *triforium*, the band of arcades below the clerestory that occupies the space corresponding to the exterior strip of wall covered by the sloping timber roof above the galleries. The triforium expresses a growing desire to break up and eliminate all continuous wall surfaces. Its insertion produces the characteristic Early Gothic nave-wall elevation of four parts: nave arcade, gallery, triforium, and clerestory (FIGS. 10-6 and 10-7).

At Laon the alternate-support system is treated less emphatically than in other Early Gothic

10-4 The Gothic rib vault and the domical vault differ in ways that derive from the fact that they are based on the pointed arch and the semicircular arch, respectively. The diagram (1) illustrates this: *ABCD* is an oblong bay to be vaulted; *AC* and *BD* are the diagonal ribs; *AB* and *DC*, the transverse arches; and *AD* and *BC*, the wall arches. If semicircular arches (the dotted arcs) are used, their radii, and therefore their heights (*EF*, *GH*, and *IJ*), will be different. The result will be a domical vault (2), irregular in shape and difficult to light. If pointed arches are used, the points (and hence the ribs) can have the same heights (*IK* and *GL*). The result will be a Gothic rib vault (3), a lighter, more flexible system than the domical, affording ample space for large clerestory windows.

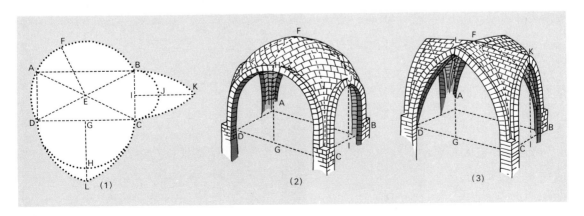

10-5 Plan of Laon Cathedral, c. 1160–1205. Choir extended after 1210. (After E. Gall.)

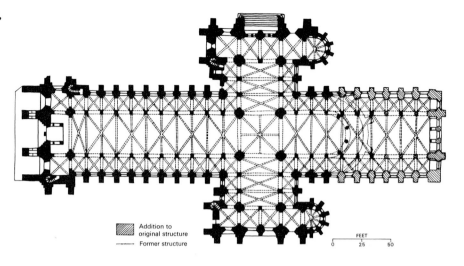

Addition to original structure

- - - - - Former structure

FEET
0 25 50

10-6 Section through the aisle, triforium, and clerestory of Laon Cathedral. (After E. Gall.)

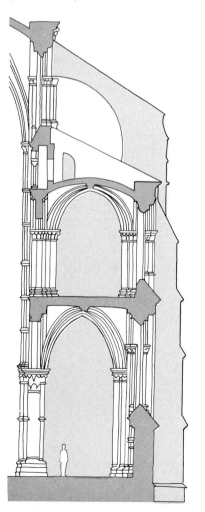

10-7 Nave of Laon Cathedral.

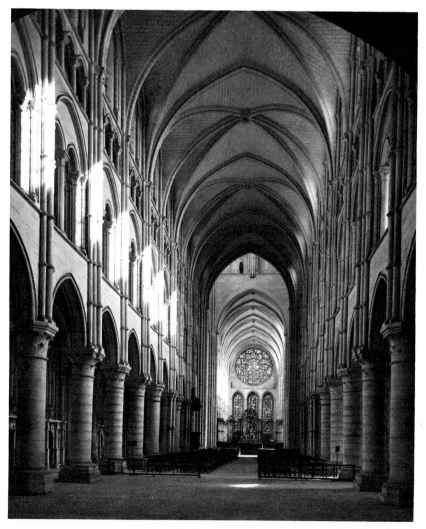

churches (for example, Sens, Noyon). It is not reflected in the nave arcade (although colonnettes were added to a few of the columns as an afterthought), as alternating bundles of three and five shafts have their origin above the level of the main wall supports (FIG. 10-7). It appears that the Laon architect was no longer completely happy with the compartmentalized effect of Romanesque interiors, which tend to make the visitor pause as he advances from unit to unit. Gothic builders aim, as yet rather timidly at Laon, to create an integrated, unified interior space that sweeps uninterruptedly from west to east. The alternate-support system, hugging the ground in Ottonian times and rising to dominate nave walls in northern Romanesque, has lost its footing at Laon and, like the solid masonry of Romanesque walls, is about to evaporate.

Important changes in the design of the church exterior were also part of the Early Gothic experience. At Laon the doorways, under protective porches, and the towers have been treated as integral parts of the mass of the building (FIG. 10-8). The interior stories are reflected in the levels into which the façade is divided. (A noticeable discontinuity between the central and flanking portions of the façade was to be regulated in later designs.) Typically Gothic are the deep embrasures of the doorways and windows and the open structure of the towers. A comparison of the façades of Laon and St. Étienne at Caen (FIG. 9-11) reveals how deep the penetration of the mass of the wall has become. Here, as in Gothic generally, there is operating a kind of principle of reduction of sheer mass by its replacement with intricately framed voids.

Laon has a pair of towers flanking each arm of the transept (only two completed) and a lantern tower over the crossing, which, with the two western towers, gives a total of seven, the perfect mystic number. (Composed of three and four, it represents the Trinity and the Evangelists or the gospels.) This complement of towers was the Early Gothic ideal and continues the German Romanesque tradition of multiple integrated towers. Rarely, however, did building funds suffice for the completion of all towers. Even the façade towers of French cathedrals were seldom finished, most, including those of Laon, lacking the crowning spires planned for them. Eventu-

ally the massed towers of the east end were omitted from building plans and the Norman two-tower façade became the French High Gothic standard.

Transept towers were not part of the plan for the cathedral of Paris, the renowned Notre Dame (FIG. 10-9). Thus, this essentially Early Gothic building has a High Gothic silhouette in which only the slender crossing spire interrupts the long horizontal roof line that extends eastward behind the massive façade towers (FIG. 10-10). Notre Dame of Paris was begun in 1163, only a few years after Laon, and embodies a fascinating mixture of conservative and progressive ideas. Choir and transept were completed by 1182, the nave by 1225, and the façade by 1250. The plan (FIG. 10-11) shows an ambitiously scaled, five-aisled structure in which a Romanesque bay

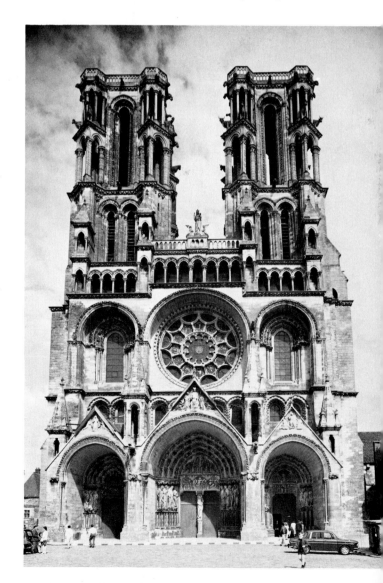

10-8 Façade of Laon Cathedral, begun c. 1190.

gallery by suppressing the rosettes of the triforium. This, in turn, required that the gallery roof be lowered and redesigned. The solution, a pitched roof with one of its slopes inclined toward the nave wall, created a difficult drainage problem that was solved only in the nineteenth century, when Viollet-le-Duc designed a single-slope roof that throws the water outward.

Like the interior, the façade seems to waver between the old and the new (FIG. 10-9). Begun after the Laon façade had been completed, it appears much more conservative and, in the preservation of its "mural presence," more closely related to Romanesque than to High Gothic façades. From the modern observer's point of view, this may be one of its great assets. Less perforated and more orderly than Laon's, Notre Dame's façade exudes a sense of strength and permanence that is lacking in many contemporary and later designs. Careful balancing of vertical against horizontal elements has achieved a quality of restful stability that makes this façade one of the most satisfying and memorable in Gothic architecture.

system is combined with Early Gothic six-part nave vaulting. The original transept was short and did not project beyond the outer aisles. The original nave wall was four-part, in the Early Gothic manner, with a triforium in the form of a series of rosettes.

Barely completed, the building was extensively modified. Between 1225 and 1250, chapels were built into the spaces between buttresses, and in 1250 the transept arms were lengthened. At the same time, perhaps as the result of a fire (according to Viollet-le-Duc, the cathedral's nineteenth-century restorer), but probably to admit more light into the nave, changes were made in the nave wall, although the bays adjacent to the crossing were left in their original form (FIG. 10-12). By this time the nave of the cathedral of Chartres had been completed (see below) and had rendered Early Gothic galleries and four-level wall elevations obsolete. Since the galleries had already been built at Paris, the "modernization" of the nave had to be a compromise. The clerestory windows were lowered to the top of the

Sculpture

Gothic sculpture first makes its appearance in the Ile-de-France and its environs with the same dramatic suddenness as Gothic architecture, and, it is likely, in the very same place, the abbey church of St. Denis. Almost nothing of the sculpture of the west façade of St. Denis remains to be studied, but it was there that sculpture emerged completely from the interior of the church and dominated the western entrances, which were regarded as the "gateways to Heavenly Jerusalem" and as the "royal portals." These royal portals, so called because of the statues of kings and queens on the embrasures flanking the doorways, are typified by the west portals of the cathedral of Chartres (FIG. 10-13), carved between 1145 and 1170. This west façade and its portals are the only surviving parts of an Early Gothic cathedral that was destroyed in a disastrous fire in 1194 before it had been completed. The cathedral was reconstructed immediately, but in the High

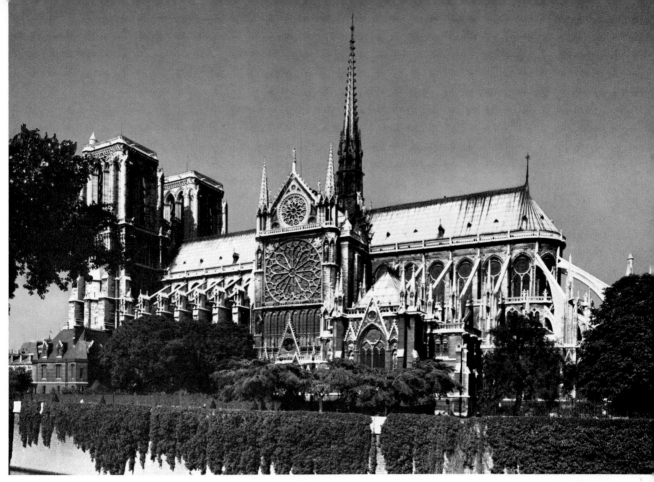

10-10 Above: South flank of Notre Dame.

10-11 Below: Plan of Notre Dame.
(After Frankl.)

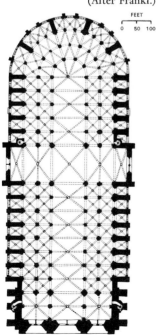

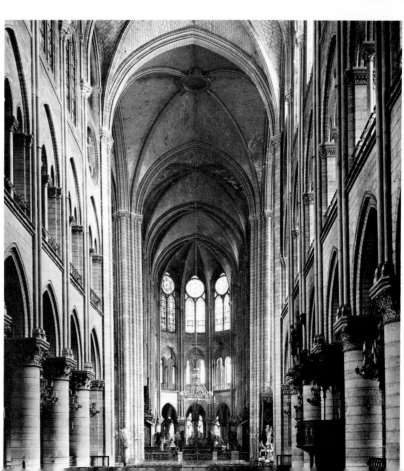

10-12 Right: East end and part of the
nave of Notre Dame, begun c. 1180,
modified 1225–50.

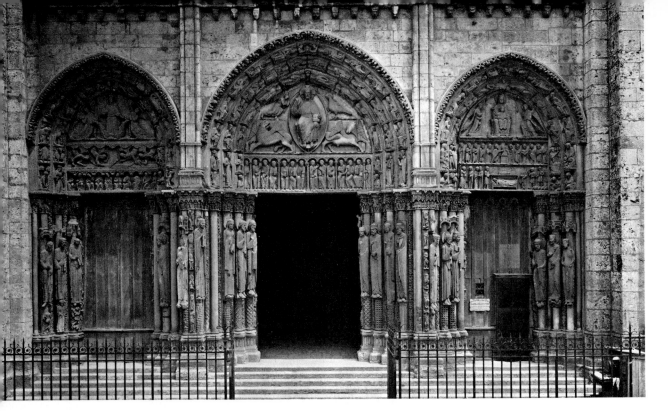

10-13 West ("royal") portals of Chartres Cathedral, c. 1145–70.

Gothic style (see below). The portals, however, constitute the most complete and impressive corpus of Early Gothic sculpture.

The three west portals of Chartres, treated as a unit, proclaim the majesty and omnipotence of Christ. His birth, the Presentation at the Temple, and Christ in Majesty with his Virgin Mother are shown on the right portal, and his Ascension into heaven on the left. Scenes from his life and from the passion are vividly carved on the capitals, which continue as a frieze from one portal to the next. On the central portal is depicted the Second Coming, surrounded by the symbols of the four Evangelists, with the apostles below, seated as representing the corporate body of the Christian Church. The Second Coming, in essence the Last Judgment theme, remains, as in the Romanesque works we have seen (and which are only some twenty years older than the west portals of Chartres), centrally important. Here, however, it has become a symbol of salvation rather than damnation. It is, moreover, combined with other scenes and symbolic figures as part of a larger theme rather than as symbol of the dogma itself. In the archivolts of the right portal are shown

the seven liberal arts, the core of Medieval learning, and therefore symbolic of man's knowledge, which will lead him to the true faith. The signs of the zodiac and scenes representing the various labors of the months of the year are carved into the left-portal archivolts as symbols of the cosmic and of the terrestrial worlds; and around the central tympanum are the twenty-four elders of the Apocalypse, accompanying the Second Coming. Decorating the multiple jambs flanking each doorway are the most striking figures, the great statues of the kings and queens of the Old Testament, the royal ancestors of Christ (FIG. 10-14). It is almost certain that the Medieval observer also regarded them as the figures of the kings and queens of France, symbols of secular as well as of biblical authority. The unity of the triple portal in its message and composition complements the unity of the cathedral itself, which in its fluent, uninterrupted, vast and soaring space compounds earth and heaven in a symbol of the spiritually perfected universe to come.

The jamb statues are among the few original forms of architectural sculpture to have appeared in any age. At first glance they seem—in their

Color Plates 6-5 to 13-5

Other plates are distributed as follows:
1-1 to 6-4 after page 176; 13-6 to 16-5, after page 584; 16-6 to 22-5, after page 772

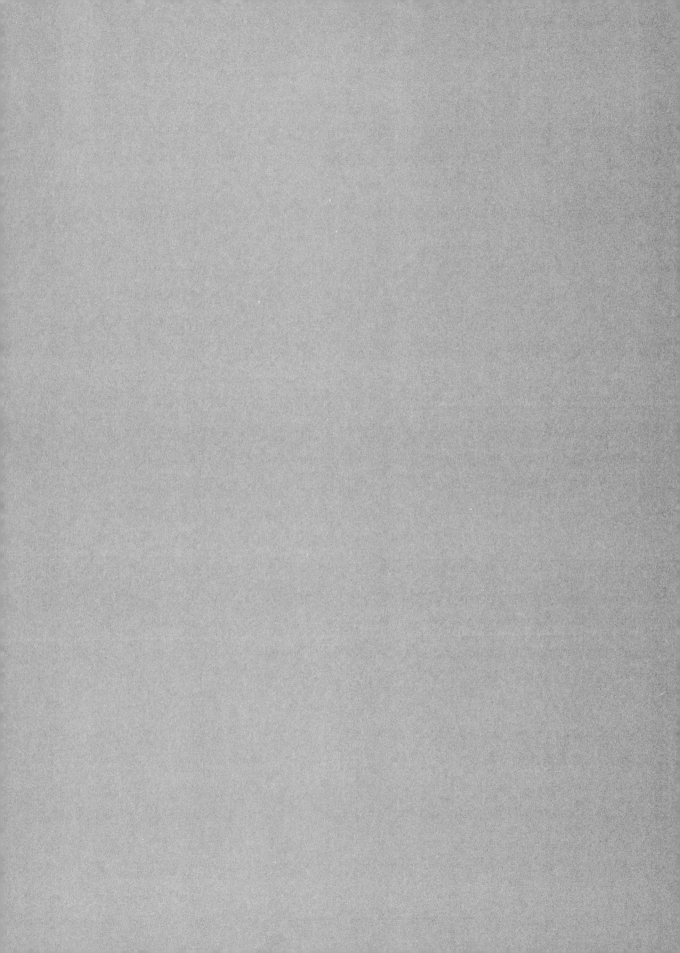

Plate 6-5 *Still Life with Peaches*, wall painting transferred to panel, Herculaneum, *c.* A.D. 50. Approx. 14″ × 13½″. Museo Nazionale, Naples.

Plate 6-7 *Mummy Portrait of a Man*, Faiyum, second century A.D. Encaustic painting on wood panel, approx. $13\frac{3}{4}″ \times 8″$. Albright-Knox Art Gallery, Buffalo (Charles Clifton Fund).

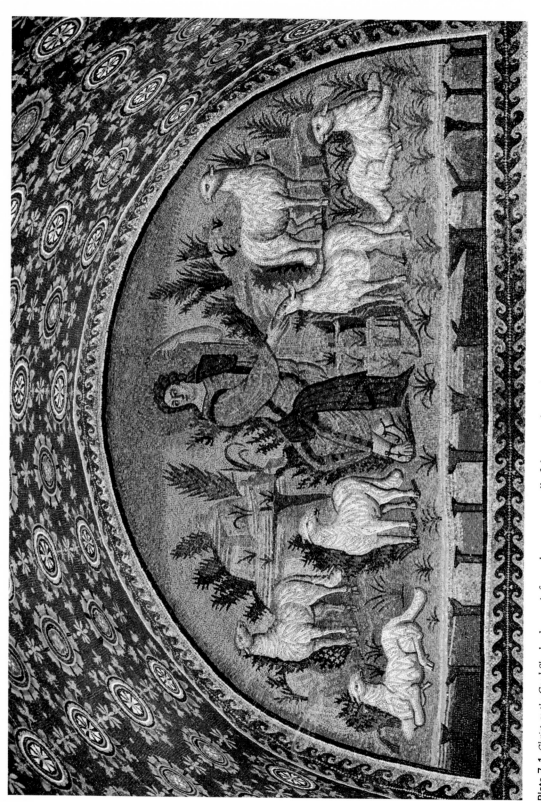

Plate 7-1 *Christ as the Good Shepherd*, mosaic from the entrance wall of the mausoleum of Galla Placidia, Ravenna, A.D. 425–50.

Plate 7-2 *The Miracle of the Loaves and the Fishes*, mosaic from the nave wall of Sant' Apollinare Nuovo, Ravenna, c. A.D. 504.

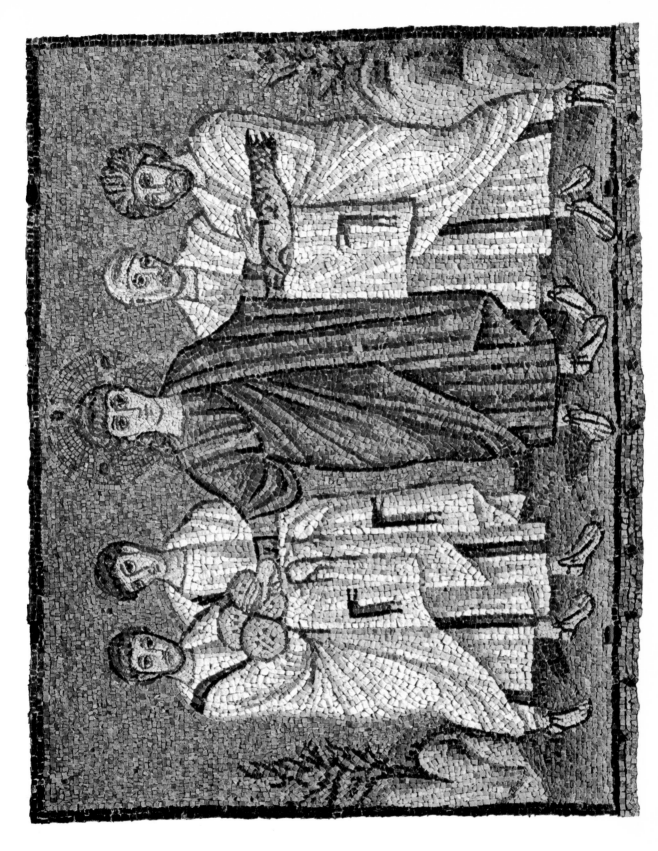

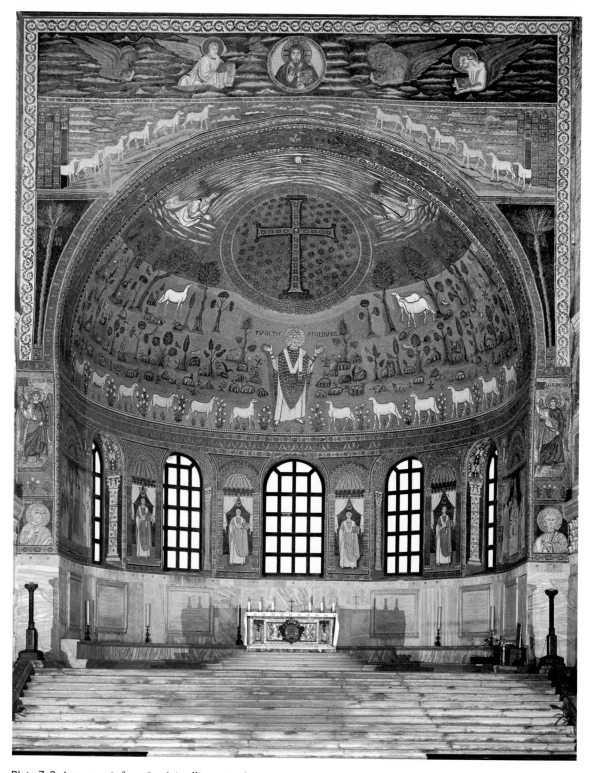

Plate 7-3 Apse mosaic from Sant' Apollinare in Classe, *c.* A.D. 549.

Plate 7-4 Sanctuary of San Vitale, Ravenna, A.D. 526–47.

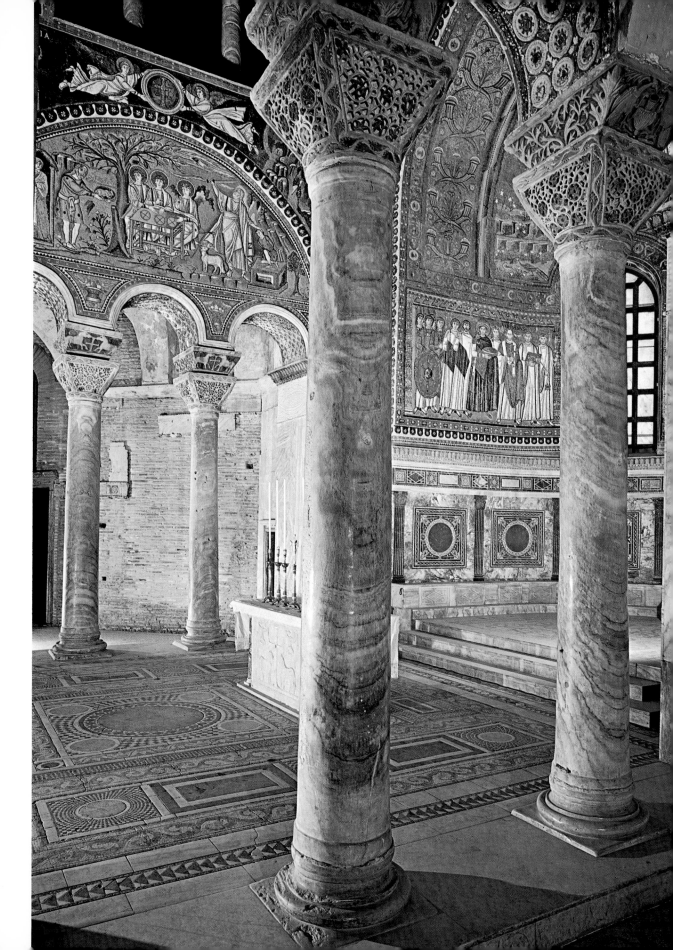

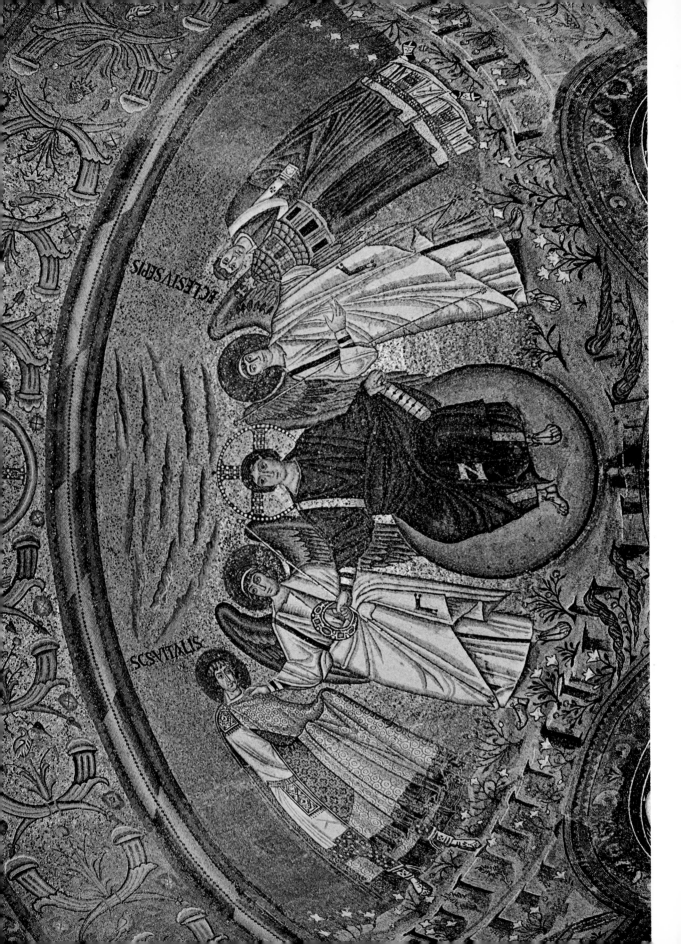

Plate 7-5 *Christ Between Angels and Saints*, apse mosaic from San Vitale.

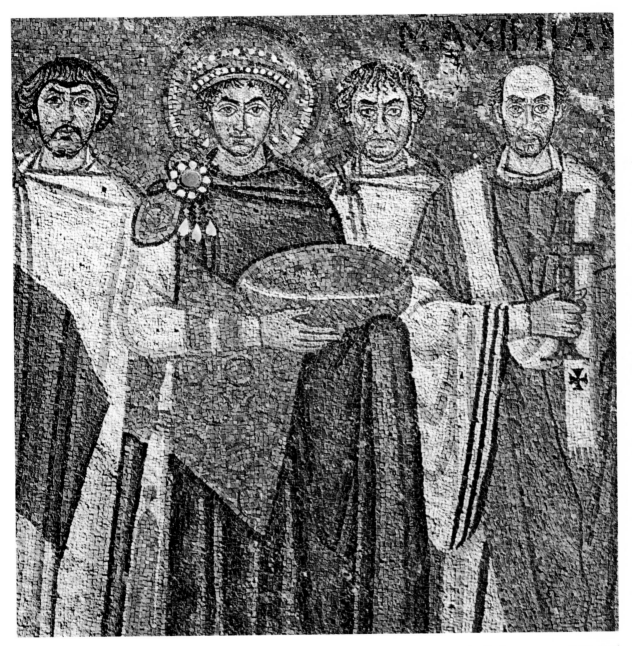

Plate 7-6 *Justinian and Maximianus*, detail of an apse mosaic (FIG. 7-30) from San Vitale.

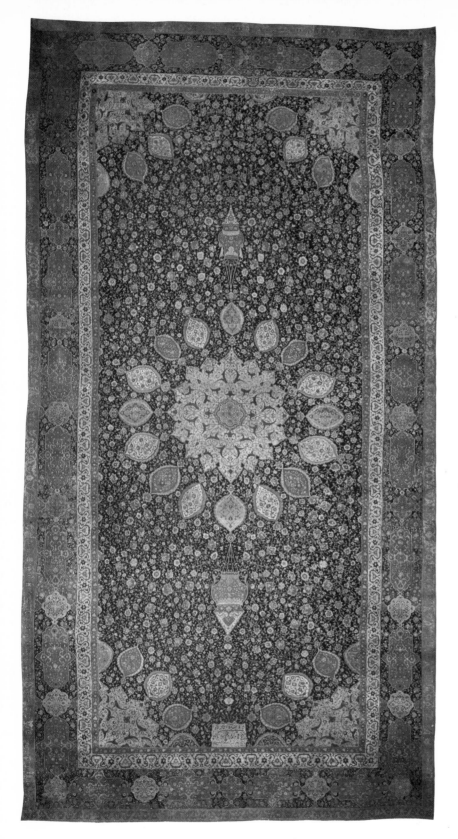

Plate 7-7 Carpet from the tomb-mosque of Shah Tahmasp at Ardebil, Iran, 1540. Approx. 34½′ × 17½′. Victoria and Albert Museum, London.

Plate 7-8 *Laila and Majnun in Love at School*, miniature from a manuscript of the Khamsa of Nizami, 1524–25. Colors and gilt on paper. Metropolitan Museum of Art, New York.

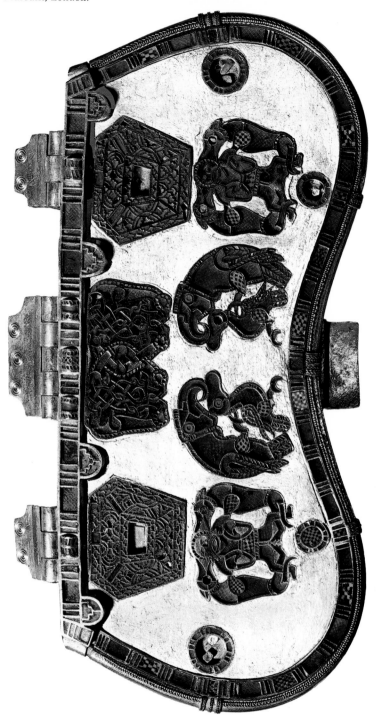

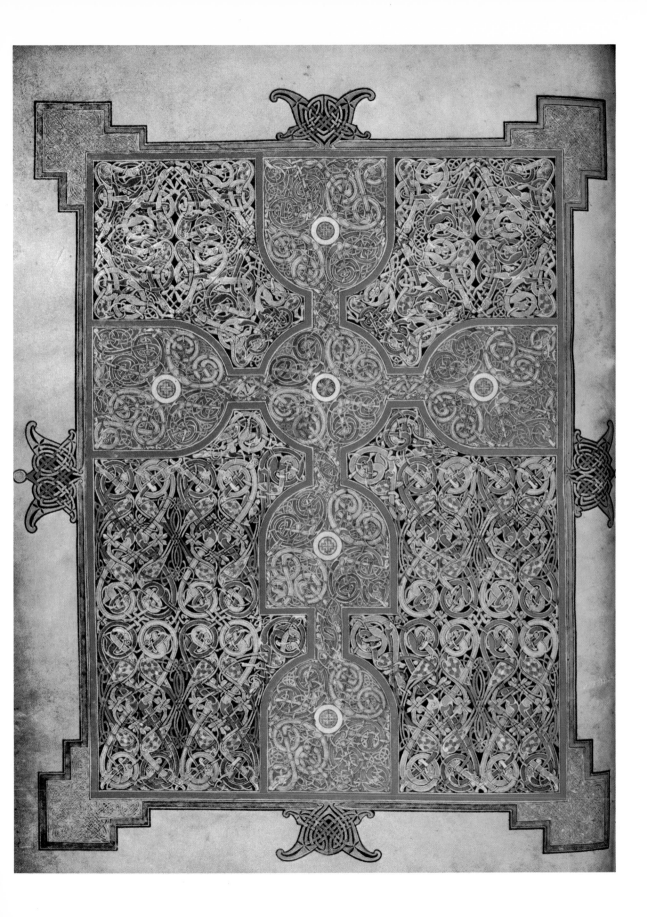

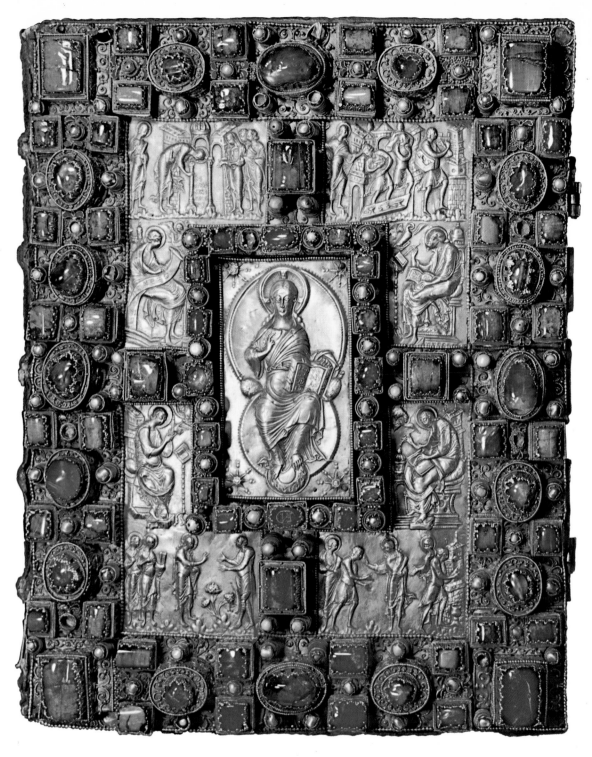

Plate 8-3 *Christ in Majesty, Four Evangelists, and Scenes from the Life of Christ,* cover of the Codex Aureus of St. Emmeram, *c.* 870. Gold set with pearls and precious stones, 17″ × 13″. Bayerische Staatsbibliothek, Munich.

Plate 9-1 *Adoration of the Magi,* apse fresco from Santa Maria, Tahull, Catalonia, eleventh century.

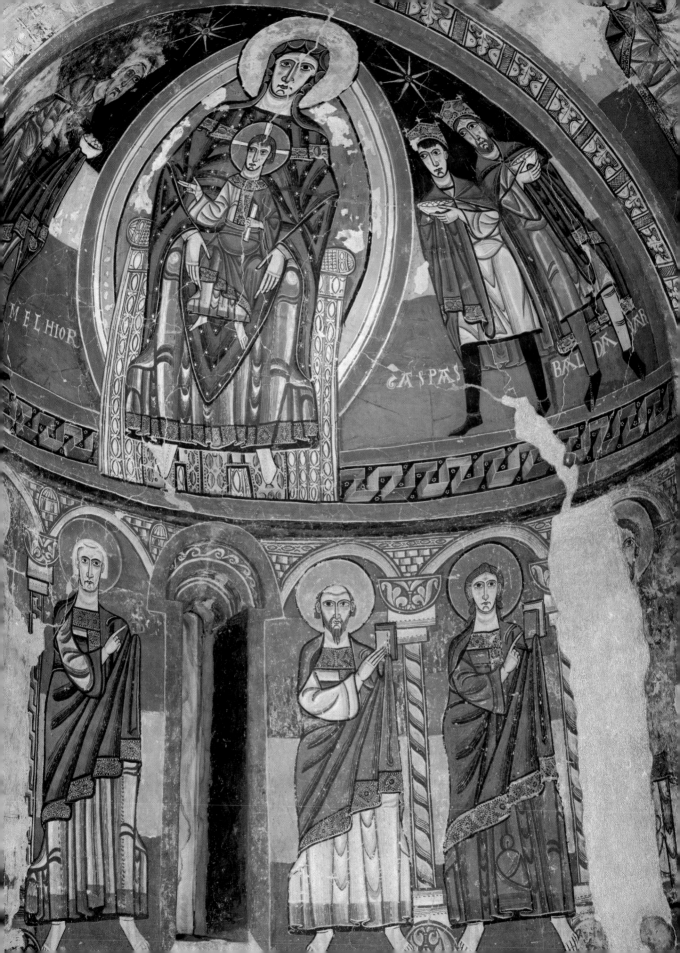

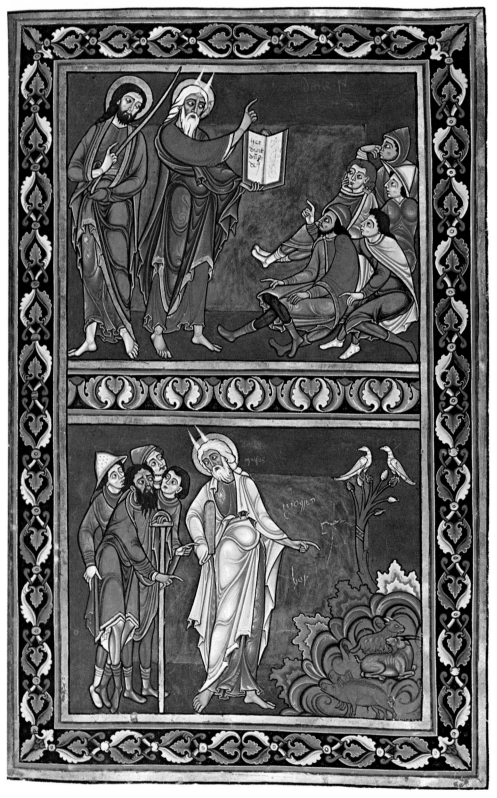

Plate 9-2 MASTER HUGO, *Moses Expounding the Law*, frontispiece of the Book of Deuteronomy of the Bury Bible, the abbey of Bury St. Edmunds, early twelfth century. Illuminated manuscript, approx. 20″ × 14″. Reproduced by permission of the Master and Fellows of Corpus Christi College, Cambridge, England.

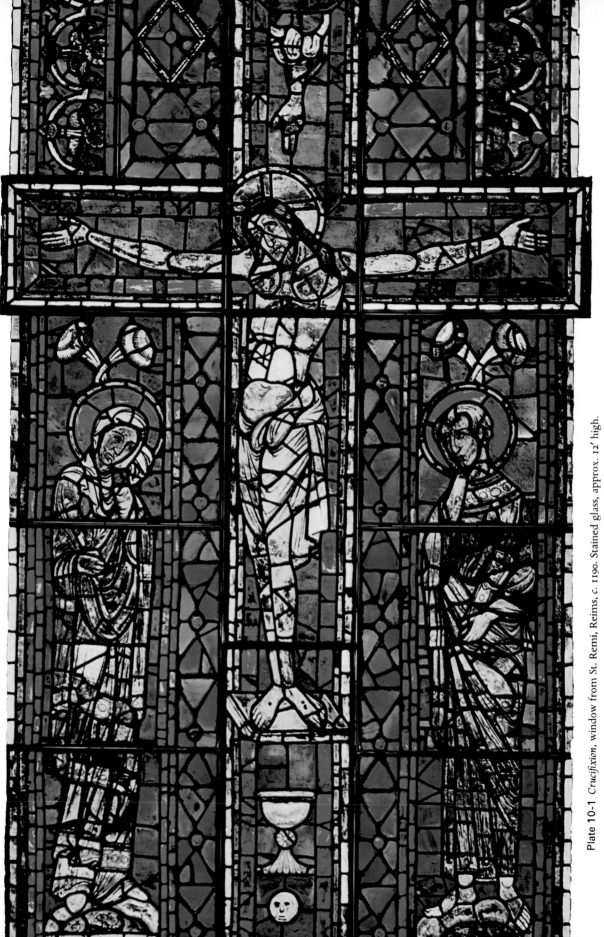

Plate 10-1 *Crucifixion*, window from St. Remi, Reims, c. 1190. Stained glass, approx. 12' high.

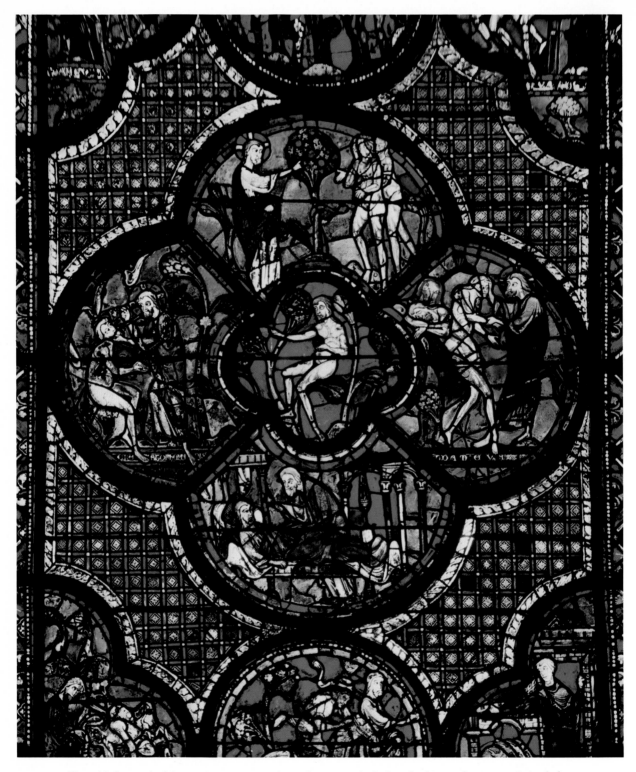

Plate 10-2 Detail of the *Good Samaritan* window, Chartres Cathedral, early thirteenth century. Stained glass.

Plate 11-1 GIOTTO, *Lamentation*, fresco, *c.* 1305. Arena Chapel, Padua.

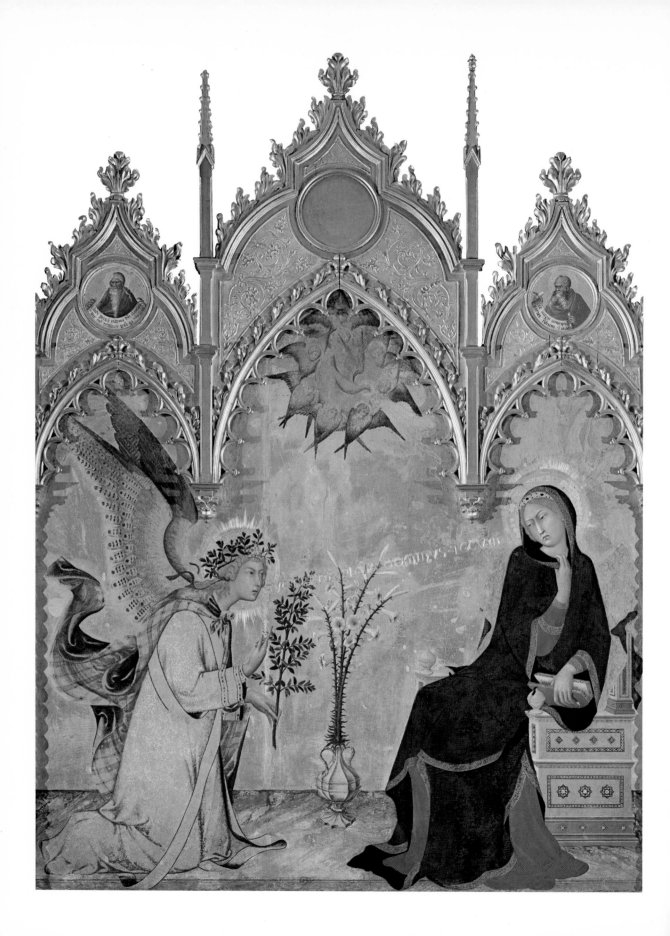

Plate 11-2 SIMONE MARTINI, *The Annunciation*, 1333. Tempera on wood panel, approx. 10′ 1″ × 8′ 8¾″. Galleria degli Uffizi, Florence.

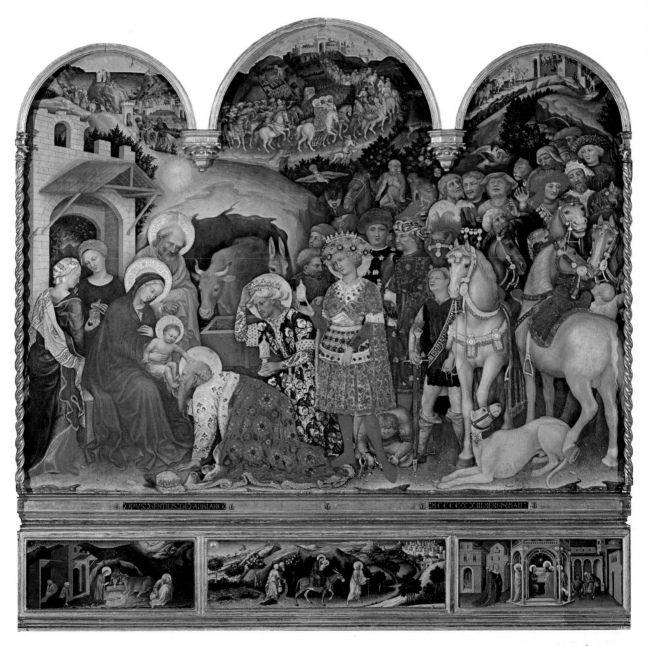

Plate 12-1 GENTILE DA FABRIANO, *The Adoration of the Magi*, 1423. Tempera on wood panel, approx. 9′ 11″ × 9′ 3″. Galleria degli Uffizi, Florence.

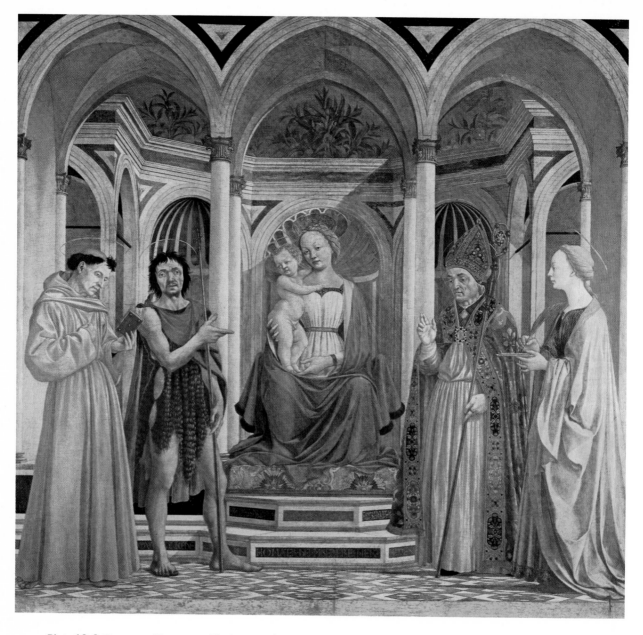

Plate 12-2 DOMENICO VENEZIANO, *The St. Lucy Altarpiece, c.* 1445. Tempera on wood panel, approx. 6′7½″ × 7′. Galleria degli Uffizi, Florence.

Plate 12-3 LUCA DELLA ROBBIA, *Madonna and Child, c.* 1455–60. Terra-cotta with polychrome glaze, approx. 6′ in diameter. Or San Michele, Florence.

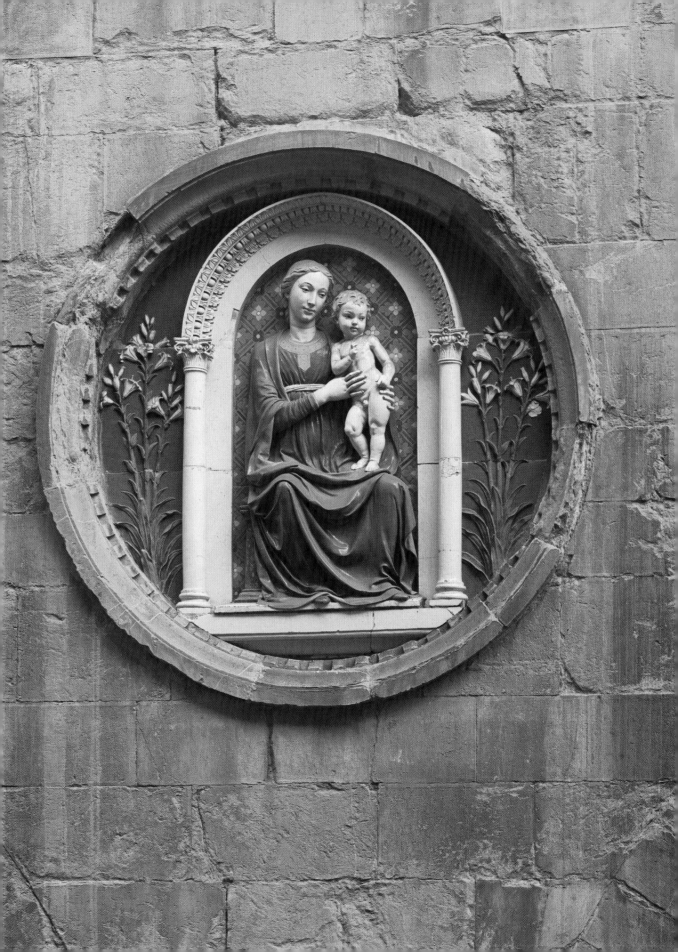

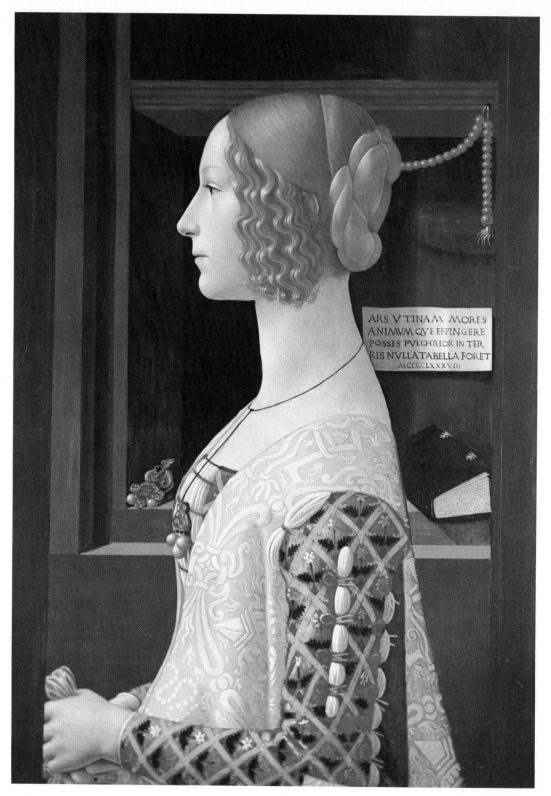

Plate 12-4 Domenico Ghirlandaio, *Giovanna Tornabuoni* (?), 1488. Approx. 30″ × 20″. Sammlung Thyssen-Bornemisza, Lugano.

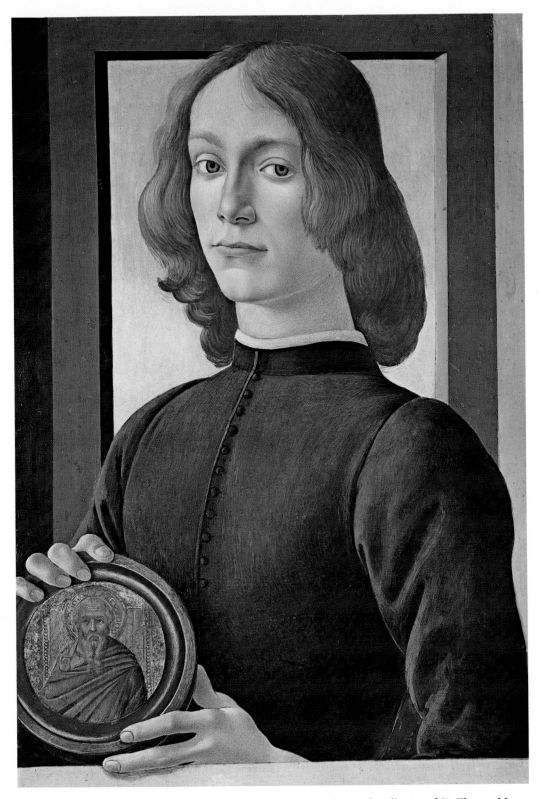

Plate 12-5 Sandro Botticelli, *Portrait of a Young Man*, 1444–45, 23″ × 15½″. Collection of Sir Thomas Merton, Berkshire, England.

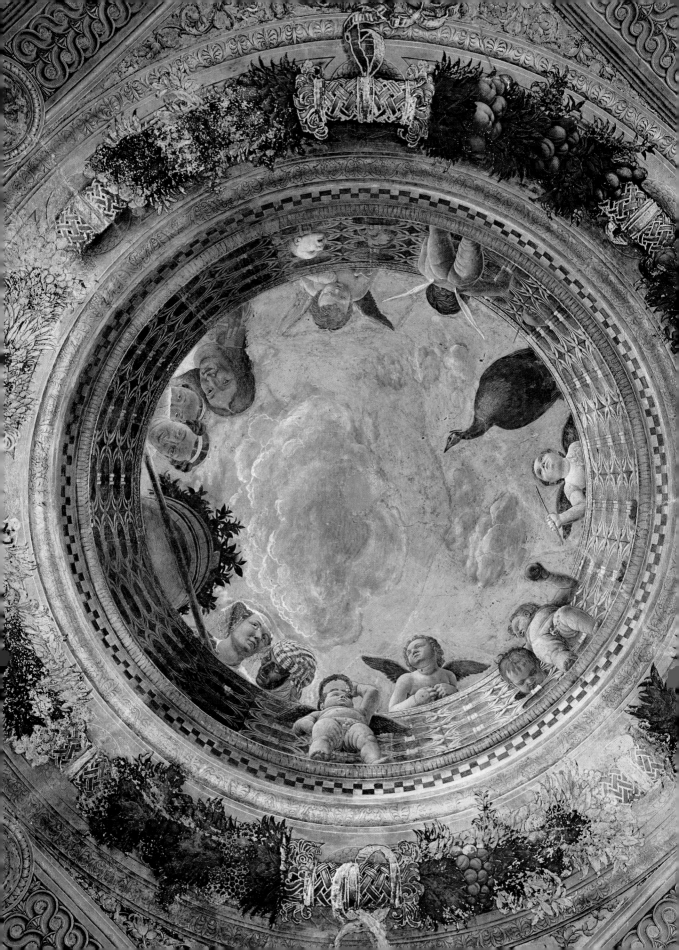

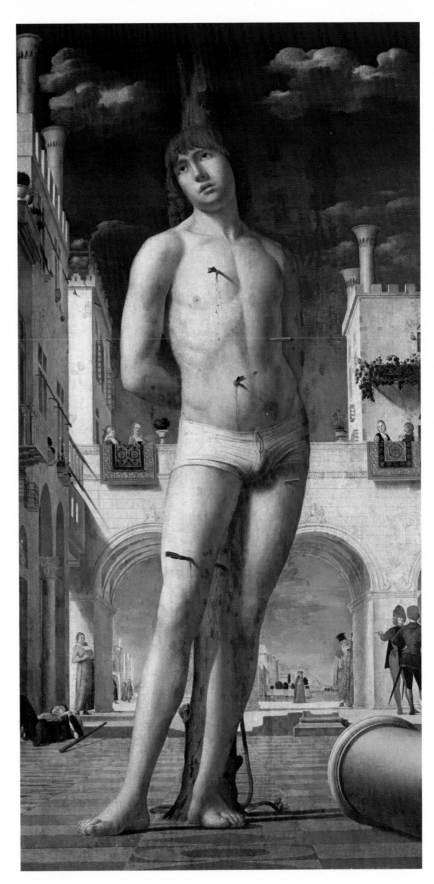

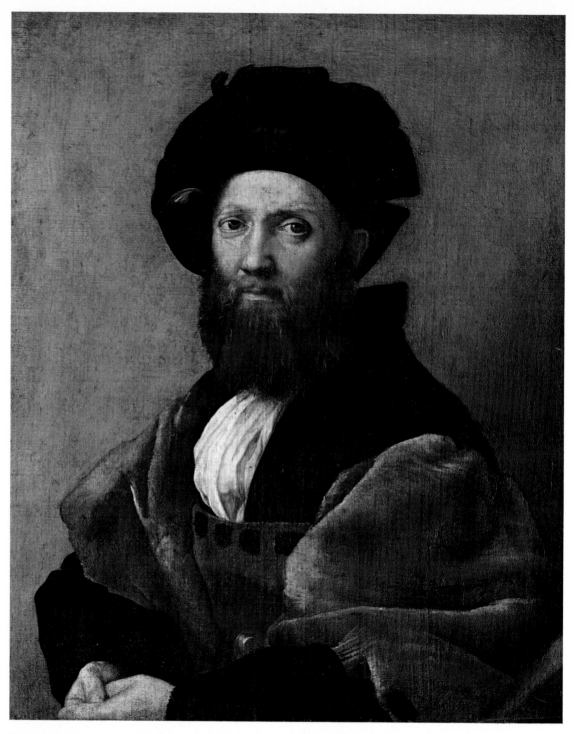

Plate 13-1 Raphael Sanzio, *Baldassare Castiglione*, c. 1514. Approx. $30\frac{1}{4}'' \times 26\frac{1}{2}''$. Louvre, Paris.

Plate 13-2 Michelangelo, *The Creation of Adam*, detail of the ceiling of the Sistine Chapel (FIG. 13-23), the Vatican, Rome, 1508–12.

Plate 13-3 ANDREA DEL SARTO, *Madonna of the Harpies*, 1517. Approx. 82″ × 70″. Galleria degli Uffizi, Florence.

Plate 13-4 Jacopo Pontormo, *The Descent from the Cross*, 1525–28. Approx. 11′ × 6′ 6″. Capponi Chapel, Santa Felicitá, Florence.

Plate 13-5 BRONZINO, *Portrait of a Young Man*, c. 1550. Oil on wood panel, approx. $37\frac{5}{8}''$ × $29\frac{1}{2}''$. Metropolitan Museum of Art, New York (H. O. Havemeyer Collection, bequest of Mrs. H. O. Havemeyer, 1929).

disregard of normal proportions and their rigid adherence to an architectural frame—to follow many of the precepts of Romanesque architectural sculpture. Yet the differences are striking and important. The statues stand out from the plane of the wall; they are not cut back into it. They are conceived and treated as three-dimensional volumes. They move into the space of the observer and participate in it with him. Most significant of all is the first trace of a new naturalism: drapery folds are no longer calligraphic exercises translated into stone; they now either fall vertically or radiate naturally from their points of suspension. Although carefully arranged in regular patterns, these folds suggest that the artist is no longer copying painted images, but that actual models have become his guides. This is true particularly of the figures flanking the central doorway (left foreground in FIG. 10-13), which are the work of the anonymous HEADMASTER, the artist in charge of the overall design and decoration of the portals. The advanced nature of his style becomes particularly noticeable when his figures are compared with those on the outside jamb of the lateral portal (right background in FIG. 10-13), which evidently were carved by a different, perhaps older, certainly more conservative artist. The latter's approach is still deeply rooted in the Romanesque tradition. His figures seem more agitated, their silhouettes curvilinear and broken. The drapery folds are treated decoratively and, here and there, continue to rotate in abstract swirls. Only the wind-blown lower garment edges, characteristic of much Romanesque sculpture, have come to rest —reluctantly it seems and, perhaps, at the Headmaster's insistence. Even so, the figures fail to adjust themselves as neatly and consequently to their architectural setting as do the Headmaster's. The latter's statues, although they have stepped out of the wall and have become corporeal, are severely disciplined and have been rigorously subordinated to their architectural background. Seen from a distance, they appear to be little more than vertical decorative accents within the larger designs of portals and façade. And yet, within and despite its architectural strait jacket, the incipient naturalism has softened the appearance of the figures. This is particularly

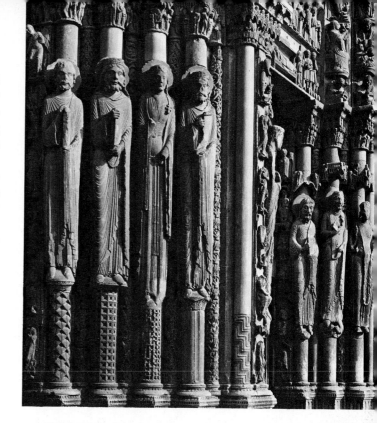

10-14 Detail of the jamb statues, Royal Portal, Chartres Cathedral.

noticeable in their faces, in which the masklike features of the Romanesque are being converted into human likenesses. Here is the faint beginning of a personalizing naturalism that will become transformed first into idealized portraits of the perfect Christian and finally into the portraiture of specific individuals.

At this time, the early twelfth century, great changes were taking place in Western man's view of himself, especially with respect to the relation of body and soul. Previously, the old Augustinian view had prevailed: that the essence of the soul is completely unlike that of the body, the soul being spiritual and immortal, the body material and subject to corruption. With the rediscovery of the main works of Aristotle, it came to be gradually believed that the soul and the body were closely interrelated, that the soul had the *form* of the body, and that, therefore, the body was no longer to be despised as merely the corruptible prison of the soul from which the latter is released when the body dies. One scholastic philosopher saw the soul and the body as meeting, and the combination as responsible for the personality of the individual. Another saw

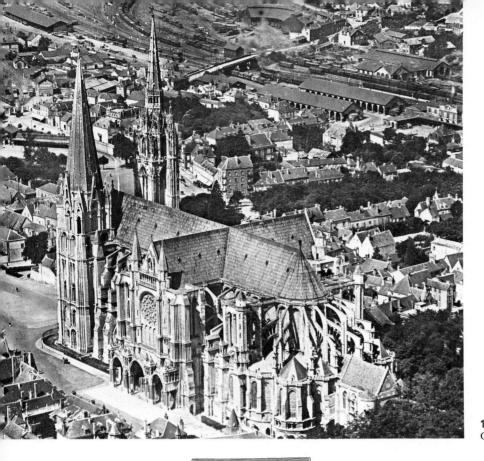

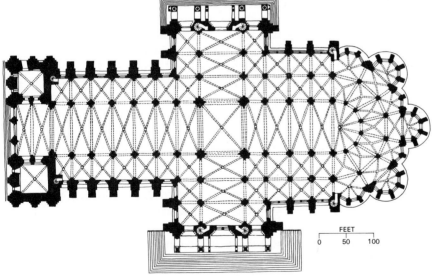

FEET
0 50 100

the soul as ruling the body but also cherishing its prison. These views, in which the body is seen as coming into its own, reflect a universally changing outlook. John of Salisbury, the great English humanist, took the perhaps radical view that the soul is stimulated and acted upon by sensations from the world, rather than directly inspired and moved by entirely spiritual principles. He even declared that some of the principal problems of scholastic philosophy could be solved by psychological examination of the way we think. The West was now speaking with a new voice: Souls must be manifested through bodies, the individual bodies of men and women. Thus, the new

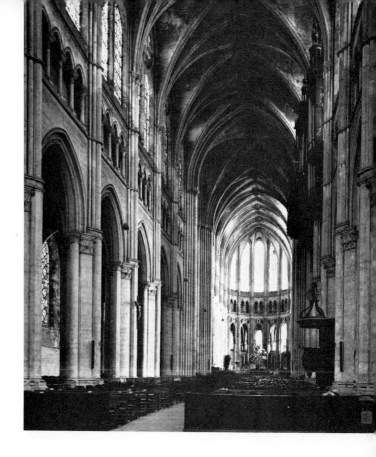

individualized heads of Chartres herald an era of artistic concern with the realization of personality and individuality that may only now, in our times, be terminating. The figures of the Royal Portal hold a place analogous to the works of Greek artists in the late sixth century B.C.; they turn the corner into a historical avenue of tremendous possibility.

HIGH GOTHIC

Architecture

On June 10, 1194, a great fire consumed the town of Chartres. Its cathedral, which had only recently been completed, was again destroyed, except for the crypt, the western towers, and the Royal Portal between them. A new cathedral was begun almost immediately, to be completed for the most part by 1220. This new cathedral of Chartres is usually considered the first of the High Gothic buildings, the first to have been planned from the beginning for the use of flying buttresses.

The flying buttress, that exceedingly useful and characteristic Gothic structural device, seems to have been employed by about 1180 for the bracing of the nave of Notre Dame in Paris, and shortly thereafter at Laon. A section through the latter church (FIG. 10-6) shows how the flying buttress reaches across the lower vaults of aisle and gallery and abuts the nave walls directly at those points where the vaults exert their major thrusts. Similar methods to strengthen the walls of vaulted naves had already been used in Romanesque architecture, but there the buttresses had been concealed under the aisle roofing. Now, however, they are left exposed in a manner that has been either condemned as "architectural crudity" or praised as "structural honesty." An air view of the cathedral of Chartres (FIG. 10-15) shows that a series of these highly dramatic devices have been placed around the *chevet* (the east end of the church), supporting the vaults with permanent arms, like scaffolding left in place. With the mastery of this structural form, the technical vocabulary of Gothic architecture is complete. The buttress eliminates the need for Romanesque walls and permits the construction of a skeletal structure that is self-consistent and self-supporting. The Chartres architect was the first to arrive at this conclusion and to design his building accordingly.

At Chartres, after the great fire, the overall dimensions of the new structure were determined by the towers left standing at the west and by the masonry of the crypt to the east, which, for reasons of economy, was used as a foundation. The earlier forms did not limit the plan (FIG. 10-16), however, and it shows an unusual equilibrium between chevet, transept, and nave, which are almost equal in dimension; more important, perhaps, the plan shows a new kind of organization. The last remnants of square schematism, still present in Early Gothic churches, have been replaced by a "rectangular bay system" that will become the High Gothic norm. Now a rectangular unit in the nave, defined by its own vault, is flanked by a single square in each aisle. This new bay arrangement is accompanied by a change in vault design. The new High Gothic vault, covering a relatively smaller area and more

←—to c.1140　1144　　　c.1160　　　　　　　　　　　　1194　c.1200　　　　1215　c.1220 1226　　1233　　　　　c.1250　　　to **1300**—→

St. Denis completed	Laon Cathedral begun		Chartres Cathedral Nave begun	Façade design, Notre Dame, Paris	Salisbury Cathedral begun	St. Elizabeth, Marburg, begun	*Ekkehard* and *Uta*

E A R L Y　　G O T H I C　　　　H I G H　　G O T H I C

FREDERICK II →←

←————— LOUIS IX (SAINT LOUIS) —————→ to 127C

easily braced than its Early Gothic predecessor, has only four panels. The visual effect of these changes is of an interior that has been decompartmentalized (FIG. 10-17), identical units having been so aligned that they are seen in too rapid a sequence to be discriminated as individual volumes of space. The alternate-support system, of course, is gone, and the nave, though richly articulated, has become a vast, continuous hall.

The organic, "flowing" quality of the High Gothic interior was enhanced by a new nave wall elevation, which admitted more light to the nave through greatly enlarged clerestory windows. The use of flying buttresses made it possible to eliminate the tribune gallery above the aisle, which had partially braced Romanesque

and Early Gothic naves. The new High Gothic tripartite nave elevation, consisting of arcade, triforium, and clerestory, emphasizes the large clerestory windows; those at Chartres are almost as high as the main arcade. A comparison of the elevations of Laon and Chartres (FIG. 10-18) illustrates what radical changes could be achieved by the logical application of the new structural device—the flying buttress—that had been used only tentatively at Laon.

Despite the vastly increased size of the clerestory windows, some High Gothic interiors remain relatively dark, largely because of the light-muffling effects of their colored glass. Chartres has retained almost the full complement of its original stained glass (see below), and though it

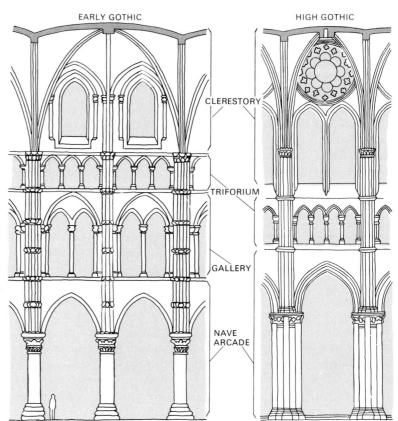

EARLY GOTHIC　　　　　　　　　HIGH GOTHIC

CLERESTORY

TRIFORIUM

GALLERY

NAVE ARCADE

10-18 Elevations of the nave walls of the cathedrals of Laon (left) and Chartres (right). The latter is drawn to a smaller scale than the Laon elevation. Umschau-Verlag, Frankfurt/Main.

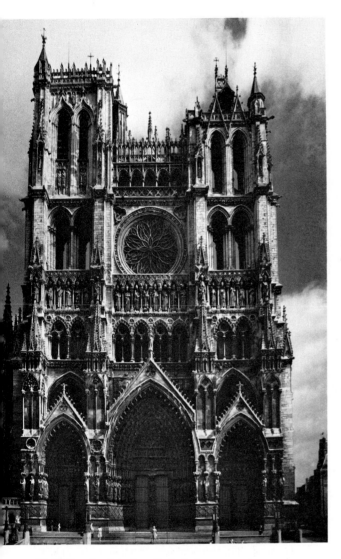

10-19 Façade of Amiens Cathedral, c. 1220–36.

10-20 Plan of Amiens Cathedral. (After Frankl.)

FEET
0 50 100

dims the interior, it sheds a color-shot light of great beauty that has helped to make the cathedral of Chartres the favorite church of lovers of Gothic architecture.

The cathedral of Amiens (FIGS. 10-19 to 10-22) continues the Chartrian manner, gracefully refining it. Amiens was begun in 1220 according to designs of ROBERT DE LUZARCHES. The nave was finished in 1236 and the radiating chapels in 1247, but work on the choir continued until almost 1270. The façade (FIG. 10-19), slightly marred by uneven towers (the shorter dates from the fourteenth, the other from the fifteenth century), was begun at the same time as the nave (1220). Its

lower parts seem to reflect the influence of the Laon façade in the spacing of its funnel-like and gable-covered portals. Unlike Laon's, the Amiens portals do not project from the façade, but are recessed behind the building's buttress-defined frontal plane. The upper parts of the façade, on the other hand, seem to be related to Notre Dame in Paris, the rose window (with fifteenth-century tracery) being placed above the "king's gallery" and between double-arched openings in the towers. But the Amiens façade goes well beyond its apparent models in the richness and intricacy of its surface decoration. The deep piercing of walls and towers seems to have left few continuous

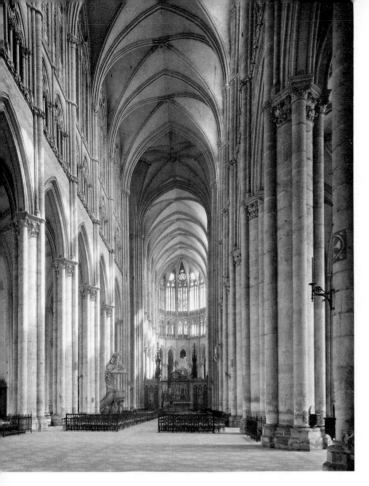

10-21 Nave of Amiens Cathedral.

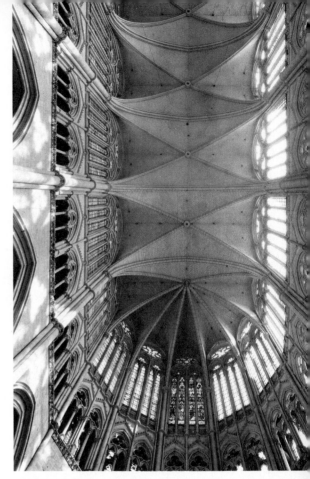

10-22 Choir vault of Amiens Cathedral.

surfaces to be decorated, to be sure, but the remaining ones have been covered with a network of articulating colonnettes, arches, pinnacles, rosettes, and other decorative stone work that screens and nearly dissolves visually the structure's solid core. Despite its decorative intricacy, the façade retains its monumental grandeur and is one of the first to achieve full integration with the building behind it. The cavernous portals correspond in width and placement to the nave and aisles and, although in slightly different proportions, the façade's three-part elevation reflects that of the nave, the rose window corresponding to the clerestory.

The plan of Amiens (FIG. 10-20), like the façade, is exemplary of the grand High Gothic style. Derived from Chartres and perhaps even more elegant in its proportions, it reflects the builder's unhesitating and confident use of the complete Gothic structural vocabulary: the rectangular bay system, the four-paneled rib vault, and a buttressing system that permits almost complete

dissolution of the heavy masses and thick bearing walls of the Romanesque. The concept of a self-sustaining skeletal architecture has reached full maturity; what remains of the walls has been stretched like a skin between the piers and seems to serve no purpose other than to provide a weather screen for the interior (FIG. 10-21). From a height of 144 feet the tense, strong lines of the vault ribs converge to the colonnettes and speed down the shell-like walls to the compound piers, almost each part of the superstructure having its corresponding element below—the only exception being the wall rib (the rib at the junction of the vault and the wall). There is an appearance of an effortless strength (that counters the fact of great weight), of a buoyant lightness one would never associate with the obdurate materiality of stone. Viewed directly from below, the vaults of the choir seem like a canopy, tentlike and suspended from bundled masts (FIG. 10-22). The light flooding in from the clerestory imparts even more "lift" and at the same time blurs

structural outlines. The effect is visionary, and we are reminded of another great building, utterly different from Amiens, in which light plays an analogous role—Hagia Sophia in Constantinople. Not only is the physical mass of the building reduced by structural ingenuity and daring, but what remains is further dematerialized visually by light. As with scholastic philosophy, the logic of the structure is here in the service of mystery. While philosophy might prove the existence of God with reason, the experience of the beatific vision gave the believer a mystical proof, like Dante's experience in Paradise as he gazed, rapt, into the "heart of Light, the heart of Silence."

In examining the interior of Amiens it may be useful to reconsider Panofsky's abovementioned suggestion of a connection between Gothic architecture and scholastic philosophy and the description of the method as typified in Aquinas' *Summa Theologica*. Most striking in the propositions of Aquinas and in the structure of Amiens is an insistence upon an order and unity made up of clearly distinguished and clearly related parts, the philosopher aiming at logical consistency, and the architect at structural coherence. In neither is the order intended to be less than total. Aquinas' *Summa* was designed to treat *all* possible questions where faith and reason touch; in Amiens all individual elements are subordinated to the whole, unlike the case of the sharply subdivided—often opposed—units of Romanesque design. This principle of *manifestatio* ("manifestation," "transparency") determines the look of the philosophic system as it does the look of the cathedral. As Panofsky wrote:

A man imbued with the Scholastic habit [of thought]...would look upon the mode of architectural presentation, just as he looked upon the mode of literary presentation, from the point of view of *manifestatio*. He would have taken it for granted that the primary purpose of the many elements that compose a cathedral was to ensure stability, just as he took it for granted that the primary purpose of the many elements that constitute a *Summa* was to ensure validity.

But he would not have been satisfied had not the membrification of the edifice permitted him to re-experience the very processes of architectural composition just as the membrification of the *Summa* permitted him to re-experience the very

processes of cogitation. To him, the panoply of shafts, ribs, buttresses, tracery, pinnacles and crockets was a self-analysis and self-explication of ... architecture much as the customary apparatus of parts, distinctions, questions and articles was, to him, a self-analysis and self-explication of reason ... the Scholastic mind demanded a maximum of explicitness. It accepted and insisted upon a gratuitous clarification of function through form, just as it accepted and insisted upon a gratuitous clarification of thought through language.[2]

The other principle Panofsky saw at work in philosophy and architecture is that of *concordantia* ("harmony"), whereby contradictory possibilities are accepted and ultimately reconciled. This is achieved by careful debate, the *disputatio*, in which a possibility is stated, one authoritative view is cited, another authoritative view is cited in objection, the solution (a reconciliation of positions) is given, and finally a reply is given to each of the original arguments now rejected. Panofsky saw this process in the resolution of three "questions" in Gothic architecture: the placement and design of the rose window in the west façade, the design of the interior wall beneath the clerestory, and the conformation of the pier. (Very likely the development of the Gothic plan could also be seen as an evolved "solution" to a "question.") Evidence that the habit of mind reflected in the *disputatio* was not exclusive with the scholastics in the universities, but was more broadly shared, is found in a page from the "album" of drawings by the thirteenth-century architect VILLARD DE HONNECOURT. According to the inscription, an ideal plan for a chevet was drawn by Villard and another architect, PIERRE DE CORBIE, the design being arrived at after a discussion—that is, a *disputatio*.

THE RAYONNANT STYLE

From the grand style of the first half of the thirteenth century came a period of great refinement, the so-called *rayonnant* ("radiant") style, which dominated the second half of the century and was associated with the royal Paris court of Louis IX (St. Louis), famed throughout Europe for his justice, chivalry, and piety, and the Medi-

[2] Erwin Panofsky, *Gothic Architecture and Scholasticism* (Latrobe, Pa.: Archabbey Press, 1951), pp. 58–60.

eval ideal of the "saint-king." Royal France, growing increasingly wealthy, powerful, and prestigious, radiated its art and culture through Europe. The king was lavish in embellishing the realm, especially with religious architecture.

A handsome and characteristic example of the new rayonnant style is the Sainte-Chapelle in Paris (FIGS. 10-23 and 10-24). The building, joined to the royal palace, was intended to be a repository for relics of the Passion of Christ brought back by Louis IX after the ill-fated Sixth Crusade. Here the dissolution of the wall and the reduction of the bulk of the supports has been carried to the point where more than three-quarters of the structure is composed of stained glass. The supporting elements have been so reduced that they

are hardly more than large mullions that separate the enormous windows, which measure approximately 49 by 15 feet and are the largest designed up to their time. Although the chapel was heavily restored during the nineteenth century (after being damaged in the French Revolution), it has retained most of its original thirteenth-century glass, which filters the light and fills the interior with an unearthly rose-violet atmosphere. Amid richly colored stone surfaces and shimmering strips of decorative mosaic stand statues of the Apostles. Multicolored also, they stand on soffits almost independent of the architecture, and their related poses, with multiple axes, foreshadow the graceful rhythms of later thirteenth- and fourteenth-century sculpture. Here are technical

10-23 Sainte-Chapelle, Paris, 1243–48. The rose window was installed after 1485.

10-24 Interior of Sainte-Chapelle.

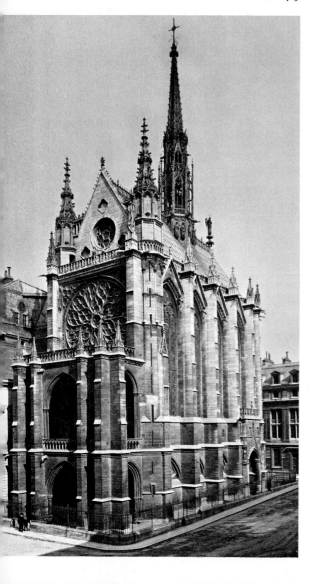

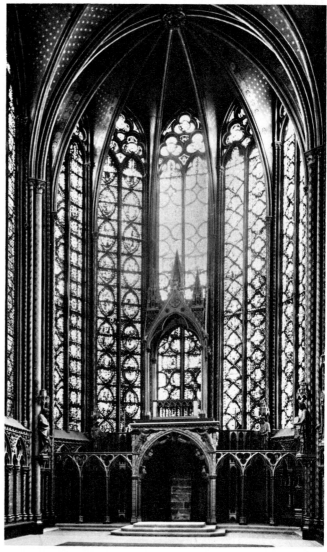

and esthetic refinements that would have upset the solemn harmonies and monumentality of the art of the earlier part of the century. The emphasis upon extreme slenderness of the architectural forms and upon linearity in general, with exquisite color and precise carving of details, recalls the richly ornamented reliquaries of the time; and it has been suggested that the whole building intentionally has been designed to call one to mind.

The rayonnant manner can be appreciated also in the transepts of Notre Dame in Paris (FIG. 10-10), especially if they are compared with those parts of the building that are some sixty years older. The whole wall seems to open into glass; in the south transept the spectacular rose window, echoed by a smaller window in the gable, contrasts strikingly with the earlier rose in the west façade, which still is framed by massive wall. The south transept rose is the wall become transparent, a filigree of bar tracery seeming as fragile and insubstantial as lace.

The choir of the unfinished cathedral of Beauvais (FIG. 10-25) is an example of the Gothic "rush" into the skies. That skyward impulse, seen first in the height of the nave at Paris (at the turn of the century), became an obsession with Gothic builders. With their new skeletal frames of stone, they attempted goals beyond limit, pushing with ever slenderer supports to new heights, aiming always at effects of insubstantial visions floating far beyond the reach of man. The nave vaults at Laon had risen to a height of about 80 feet; at Paris, to 107 feet; at Chartres, to 118 feet; and at Amiens, to 144 feet. In 1272 the builders of the choir of Beauvais tormented stone to what was to be its limit—157 feet. In 1284 the Beauvais vaults collapsed. The piers had been too widely spaced, and the major buttresses too slim; the choir, rebuilt with a broad margin of safety, has intermediate piers and old-fashioned, six-part vaults. Wide-spaced piers and slender buttresses were exactly the features the rayonnant architects had advocated in their effort to make an architecture out of virtually nothing but line and light. This could be done on the scale of Sainte-Chapelle but not on that of Beauvais. Henceforth, the great structural innovations of the High Gothic, and the vast scale in which they were worked out, would be things of the past. Late

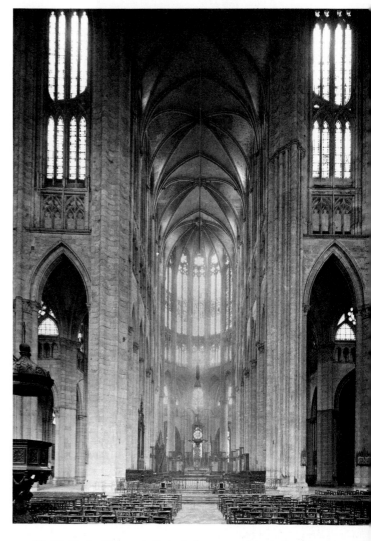

10-25 Choir of Beauvais Cathedral, 1272; vaults rebuilt after 1284.

Gothic architecture, born of the linear rayonnant, would be confined to buildings of quite modest size, conservative in structure and ornamented with restless designs of intricately meshed pointed motifs.

Sculpture

Sculpture was subservient to architecture during the High Gothic period, as it had been since the Romanesque. But rapid changes were taking place. The unity of idea that controls the design of the Royal Portal of Chartres expanded to

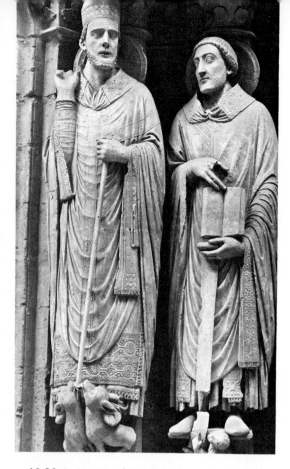

10-26 *St. Martin and St. Jerome, c.* 1220–30, from the Porch of the Confessors, Chartres Cathedral.

accounts of natural phenomena, scriptural themes, and moral philosophy serve a didactic religious purpose.

Nature begins to come forward as important, and man comes forward with it. Two figures from the Porch of the Confessors in the south transept of the cathedral of Chartres illustrate how much the incipient realism of the Royal Portal has advanced (FIG. 10-26). The figures represent St. Martin and St. Jerome, and date from the period 1220–30. Although attached to the architectural matrix, their poses are not determined by it as much as formerly. The setting now allows the figures to communicate quietly with one another, like dignitaries waiting for some solemn procession to begin; they turn slightly toward each other, breaking the rigid vertical lines that, on the Royal Portal, fix the figures immovably. Their draperies are no longer described by the stiff and reedy lines of the figures of the Royal Portal; they fall and lap over the bodies in soft, if still regular, folds.

The faces are most remarkable; they show for the first time since the ancient world the features of specifically Western men, with no admixture whatever of the denatured mask that had come down through a thousand years. Moreover, they seem to have been taken from particular persons as models, and we have no difficulty characterizing them. St. Martin is tall, ascetic, the intense priest with the gaunt features of the Gothic visionary (compare the spiritually moved but not particularized face of the Moissac *Isaiah* of FIG. 9-23); he may have been a saintly canon of Chartres, reluctantly become a bishop; in any event—another realistic touch—his vestments are the liturgical costume of the time. His companion, St. Jerome, appears the humorous, kindly, practical administrator-scholar, who holds his Vulgate translation of the Scriptures. Thus, the two men are not simply contrasted by their poses, gestures, and attributes but most particularly and emphatically as *persons*, so that personality, revealed in human faces, makes the real difference—something that had been rare even in classical art. In another century or so the identifiable portrait will emerge.

The fully ripened Gothic style appears in the west portals of the cathedral of Reims (FIG. 10-27), built in the mid-thirteenth century. At first

embrace the whole cathedral (see the façade of Amiens, FIG. 10-19). The sculptural program came to include not only the huge portals but the upper levels of the building as well. This was at the height of Gothic art, the cathedral-building and cathedral-adorning age, covering the years 1210 to 1260. The range of the iconography of the sculpture is as vast and complex as the building. Most of the carved figures are symbolic, but many, particularly the grotesque gargoyles, used as rain-spouts, and other details of the upper portions, are purely decorative and show the vivacity and charm of the Medieval spirit of this moment, when it was confident in its faith. The iconographic program, no longer (as in Romanesque art) confined almost entirely to the letter of the dogma, is extensive enough to embrace all the categories of Medieval thought. Indeed Émile Mâle showed that many iconographic schemes are based upon the *Speculum majus* ("Great Mirror") of Vincent of Beauvais, a comprehensive summary of Medieval knowledge in which

glance, the jamb statues appear completely detached from their architectural background. The columns to which they are attached have shrunk into insignificance and in no way impede the free and easy movement of the full-bodied figures. (On the Royal Portal of Chartres the background columns occupy a volume equal to that of the figures; see FIG. 10-14.) However, two architectural devices limit the statues' spheres of activity and tie them to the larger design of the portal—the pedestals upon which they stand and the canopies above their heads. Less submissive than their predecessors from the Royal Portal of Chartres, these Reims figures create an electric tension within the portal design; they were designed for this portal, however, and would look incongruous in any other setting. Gothic portal statues placed in museums to protect them from weathering look, without exception, forlorn and out of place.

On the right jamb of the central portal, four figures (FIG. 10-28) represent the Annunciation (left) and the Visitation (right). In their different styles they show the hands of several anonymous

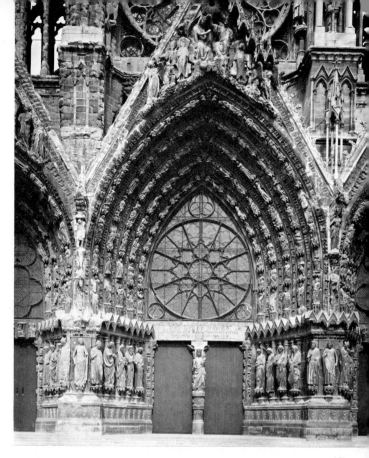

10-27 Central portal of the west façade of Reims Cathedral, c. 1225–90.

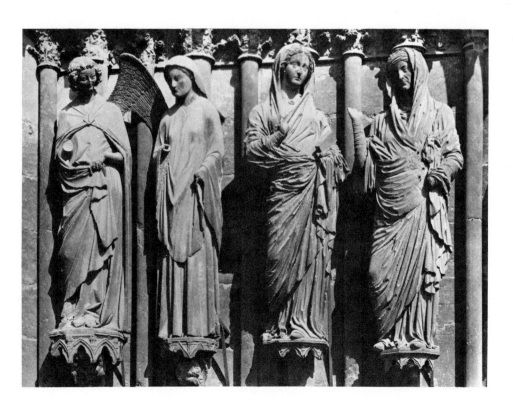

10-28 *The Annunciation* and *The Visitation*, detail of FIG. 10-27.

High Gothic 375

masters. The master of the *Visitation* group, quite original in his manner, manifests a classicizing bent startlingly unlike anything seen since Roman times. The group illustrates the impact on its master carver of either actual classical statuary he had seen or of manuscripts or ivories from Late Antiquity or Byzantium. Whatever the artist's source, the facial types, costumes, and drapery treatment are an astonishing approximation of the naturalistic style traits of ancient figure sculpture. He has even tried to represent the classical contrapposto stance, although the only partially successful result betrays the sculptor's ignorance of human anatomy. The two figures of the *Annunciation* group evidently were carved by different masters. The *Virgin* is by a sculptor who may have worked at Amiens before he came to Reims and whose style is characterized by a weighty, massive quality. Drapery resembling a thick, flannel-like material heavily falls from the figure's shoulders to her feet and, by stressing mass and verticality, imparts an aspect of grave solemnity.

The *Angel* of the *Annunciation* group differs strikingly from the *Virgin*. It is tall and slender, animated by a kind of swaying curve, the head quite small, the face bright with a winsome smile. This almost dainty figure, contrasting with the still and somber *Virgin*, represents the new, courtly style—corresponding to the rayonnant in architecture—that comes in with the reign of Louis IX and the cultural dominance of the Ile-de-France after mid-century. The influence of these great cathedral statues must have been widely felt by those who contemplated them. John of Garland, writing in the thirteenth century on how university students should conduct themselves, advises: ". . . regard as models of deportment the graven images of the churches, which you should carry in your mind as living and indelible pictures."

Stained Glass

The Gothic accomplishment in architecture and sculpture is matched by the magnificent stained glass of the time. This medium is almost synonymous with the Gothic style; no other age has managed it with such craft and beauty. The mysticism of light that induced Suger to design an architecture that would allow for great windows is widespread in Gothic theology. "Stained glass windows," writes Hugh of St. Victor, "are the Holy Scriptures . . . and since their brilliance lets the splendor of the True Light pass into the church, they enlighten those inside." St. Bernard compares the manner in which light is tinted by a stained-glass window to the process of the Incarnation and virgin birth of Jesus. The Gothic mood seems almost to take its inspiration from the Gospel of John: "In him was life; and the life was the light of men. And the light shineth in darkness."

The difference between these words and the sonorous verses of Revelation, which provide the program of the Romanesque "Last Judgments," reflects the difference between the shining walls of colored light, which change with every passing hour or cloud, and the painted walls of Romanesque churches or the shimmering mosaics of the Byzantine.

Colored glass was used as early as the fourth century to decorate the windows of churches. Perfection of the technique must have been gradual, with the greatest advances during the tenth and eleventh centuries. The first accurately dated windows, those of the choir of St. Denis in 1144, show a high degree of skill; Suger states that they were "painted by the exquisite hands of many masters from different regions," proving that the art was widely known at that time. Yet the stained-glass window may be said to be the hallmark of the Gothic style, particularly in northern Europe, where the almost total dissolution of walls left few surfaces suitable for decoration with frescoes.

Imperfections or unexpected results in making colored glass were frequent; yet this was not an art left entirely to chance. The different properties of colors were well understood and carefully controlled. The glass was blown and either "spun" into a "crown" plate of varying thickness or shaped into a cylindrical "muff," which was cut and rolled out into square pieces. These pieces were then broken or cut into smaller fragments and assembled on a flat table, on which a design had been marked with chalk dust. Many of the pieces were actually "painted" with a dark pig-

ment so that details, as of a face or clothing, could be rendered. The fragments were then "leaded," or joined by strips of lead that were used to separate colors or to heighten the effect of the design as a whole (PLATES 10-1 and 10-2). The completed window was strengthened with an armature of iron bands, which in the twelfth century had the form of a grid over the whole design (PLATE 10-1), but in the thirteenth century was shaped to follow the outlines of the medallions and surrounding areas (PLATE 10-2).

The technical difficulties of assembling a large stained-glass window and fixing it firmly within its frame were matched by compositional problems. Illuminated manuscripts, which had been the painter's chief vehicle during the earlier Middle Ages, had little instructional value for artists who had not only to work on an unprecedented scale, but who had to adjust their designs to the larger whole of the church building and its architecture. Sculptors, of course, had already solved these problems and it may not be too surprising to find that painters turned to them for instruction. Certainly the saints flanking the cross in the Reims window (PLATE 10-1) seem vaguely familiar. Their erect poses, the straight, almost unbroken silhouettes, and the rather precarious manner in which they perch upon their hilltop pedestals stamp them as not too distant relatives of the jamb statues from the Royal Portal at Chartres. Here the Romanesque process has been reversed, and the sculptors, the former students who had found their inspiration in paintings, have now become the teachers.

Like the architects and sculptors with whom they worked in close collaboration, the stained-glass artists relied heavily on the *ars de geometria* for their designs, layouts, and assemblies. The sketchbook of Villard de Honnecourt, the mid-thirteenth-century architect referred to earlier, was intended as a text for Villard's students. But he does not confine his instruction to architecture alone. In addition to details of buildings, plans of choirs with radiating chapels, and church towers, he also presents information on lifting devices, a saw mill, and stained-glass windows. Sprinkled liberally through the pages are drawings of figures, religious and worldly, and animals—some surprisingly realistic, others purely fantastic. In the page shown (FIG. 10-29) Villard is evi-

dently informing his students of the usefulness of the *ars de geometria* in designing human heads and animals. In some instances Villard claims to have drawn his animals from nature, but even these appear to have been composed around a skeleton not of bones but of abstract geometrical figures. It seems likely that the designers of stained-glass windows proceeded in a similar manner. No matter how arrived at, the effect of these glowing, translucent paintings, which often seem to be suspended in space, is as spellbinding today as it must have been to the Medieval churchgoer. For the first time in centuries the art of painting had been made accessible to the common man—painting in a form so compelling that the desire to have more and more of it, from pavement to vault, may well have influenced the development of Gothic architecture. By the middle of the thirteenth century, architectural

10-29 VILLARD DE HONNECOURT, page from a notebook, *c.* 1240. Bibliothèque Nationale, Paris.

techniques were so advanced that the space of cathedrals seems to be defined by the burning intensity of the stained-glass windows rather than the stone structure.

LATE GOTHIC

The collapse of the vaults of Beauvais would seem to have brought the great thirteenth-century architectural debate to an unarguable conclusion. Analogously, the followers of Aquinas came to believe that his accommodation of faith and reason was impossible and that both must go their separate ways. It was the beginning of the dissolu-

10-30 *The Virgin of Paris*, Notre Dame, early fourteenth century.

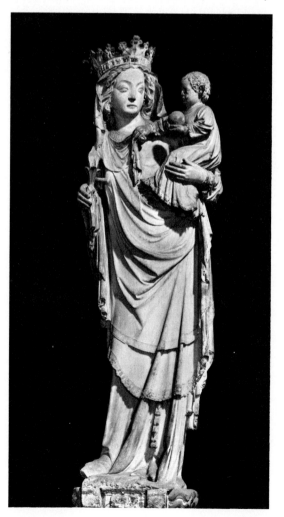

tion of the Medieval synthesis, which would lead to the eventual destruction of the unity of Christendom. The resolution of opposites could not be achieved; the conflict must now begin that would reshape western Europe.

Villard de Honnecourt has left us a record of these years when so much was expected of art since so much had been achieved. The search for an ideal solution for a building and the codification of artistic—as well as philosophic—procedures were essentially academic in spirit, conscious evaluations of a style that had already reached and passed its complete definition. Artistic practice and scholastic method would now spend a long time going over ground already covered but would no longer attempt grandiose enterprises. Both were to be concerned with elaborations of surface forms rather than innovations in structure.

By the early fourteenth century the monumental and solemn sculpture of the High Gothic portals was replaced by the courtly style developed from the *Angel* of Reims (FIG. 10-28), a quite rarefied example of which may be seen in the statue of the Virgin and Child within Notre Dame in Paris (FIG. 10-30). The curving sway of the figure, emphasized by the bladelike sweeps of drapery that converge to the child, has a mannered elegance that will mark Late Gothic sculpture in general. This is the famed Late Gothic S-curve that one encounters again and again during the fourteenth and fifteenth centuries. Superficially it may resemble another S-curve seen much earlier—that of Praxiteles in the fourth century B.C. But, unlike its classical predecessor, the Late Gothic S is not organic, coming from within the figure, nor is it the result of a rational, if pleasing, organization of the figure's anatomical parts; it is an artificial form imposed upon the figure, a decorative device that may produce the desired effect of elegance but which has nothing to do with the figure's structure. In fact, in our example, the body is quite lost behind the heavy drapery, which, deeply cut and hollowed, would almost deny the figure solid existence. The ornamental line created by the flexible fabric is analogous to the complex, restless tracery of the flamboyant style in architecture, which dominated northern Europe in

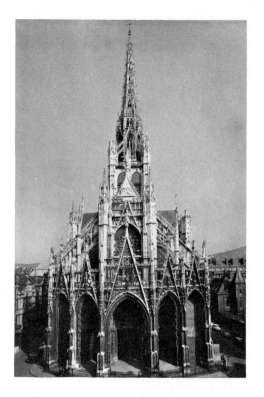

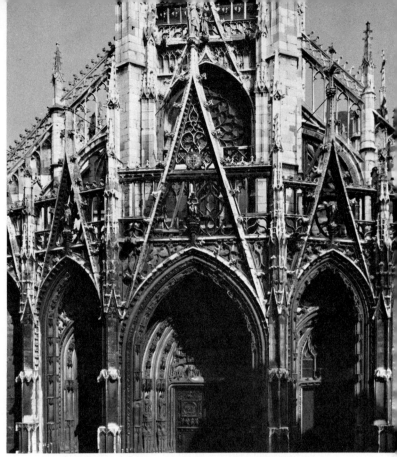

10-31 Above: St. Maclou, Rouen, c. 1500–14;
right: Detail of façade.

the fourteenth and fifteenth centuries; and the emphasis upon ornament for its own sake is in harmony with the artificial prettiness the artist contrives in the Virgin's doll-like face, large-eyed and tiny-mouthed under her heavy, gem-encrusted crown.

The change from rayonnant architecture to the Late Gothic or flamboyant (so called because of the flamelike look of its pointed tracery) took place in the fourteenth century; the style reached its florid maturity toward the end of the fifteenth. This period was a difficult one for royal France; long wars against England and Burgundy sapped its economic and cultural strength, and building projects in the royal domain were either halted or not begun. And so the new style found its most fertile soil in regions outside the Ile-de-France. Normandy is particularly rich in flamboyant architecture, and its close ties with England suggest that the Anglo-Norman school of "decorated" architecture may have had much to do with the development of the flamboyant style. The

church of St. Maclou (FIG. 10-31), in Rouen, the capital of Normandy, presents a façade widely different from those of the thirteenth century. St. Maclou, some 180 feet long and 75 feet high, is almost diminutive compared with the great cathedrals. The five portals, two blind, bend outward in an arc and are crowned by five gables pierced through and filled with sinuous, wiry, flamboyant tracery. Pierced galleries of spidery arcades climb steeply to the center bay, marching along behind the transparent gables. The overlapping of all features, pierced as they are, confuses the structural lines and produces a bewildering complexity of views. It is almost as if the Celtic-Germanic instinct for intricate line, expressed in works like the *Book of Lindisfarne*, was manifesting itself once again against the form and logic newly abstracted from the traditions of the Mediterranean. Yet the Renaissance is not far off, and, within a generation or two of St. Maclou, France will have adopted a new classical style from Italy.

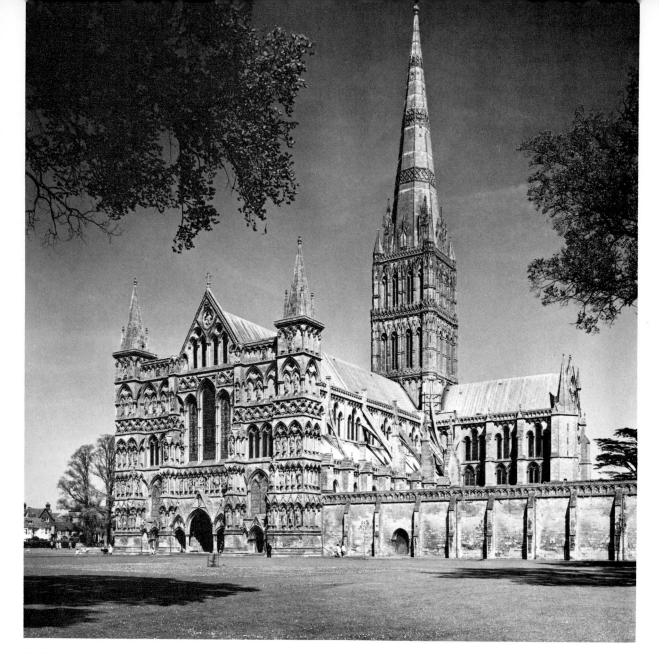

10-32 Above: West façade of Salis-
bury Cathedral, begun c. 1220.

10-33 Right: Plan of Salisbury
Cathedral.

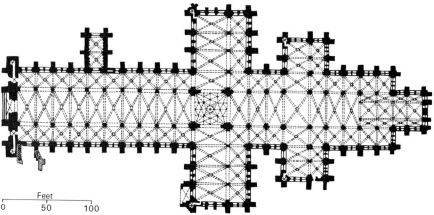

Feet
0 50 100

NON-FRENCH GOTHIC

Around 1269 the prior of a German monastery "hired a skilled architect who had just come from the city of Paris" to rebuild his monastery church. The architect reconstructed the church *opere francigeno*, "in the Frankish manner"—that is, in the Gothic style of the Ile-de-France. In 1268, Pope Clement IV, stipulating the conditions for the building of a new cathedral at Narbonne, wrote that the building was "to imitate the noble and magnificently worked churches . . . which are built in the kingdom of France." The diffusion of the French Gothic style had begun even earlier, but it was in the second half of the thirteenth century that the new style became dominant and that European architecture, in many different ways, turned Gothic. Because the old Romanesque traditions lingered on in many places, each area, marrying its local Romanesque to the new style, developed its own brand of Gothic architecture.

England

The characteristics of English Gothic architecture are admirably embodied in the cathedral of Salisbury (FIGS. 10-32 to 10-35), built between 1220 and 1260. Its location in a park (or close), surrounded by lawns and stately trees, contrasts markedly with that of continental churches, around which the city dwellings nestle closely. The screenlike façade (FIG. 10-32) reaches beyond and does not correspond to the interior; with its dwarf towers, horizontal tiers of niches, and small entrance portals, it is emphatically different from the façades or either Paris or Amiens. Also different is the emphasis on the great crossing tower, which dominates the silhouette. The height of Salisbury is modest compared with that of the almost contemporary cathedral of Amiens; and since height in the English building is not a decisive factor, the flying buttress is used sparingly—as a rigid prop rather than as an integral part of the armature of arches. The exterior of the building, were it not for its pointed features, would look more like an "additive" Romanesque than a Gothic building—if we accept "Gothic" as essentially French.

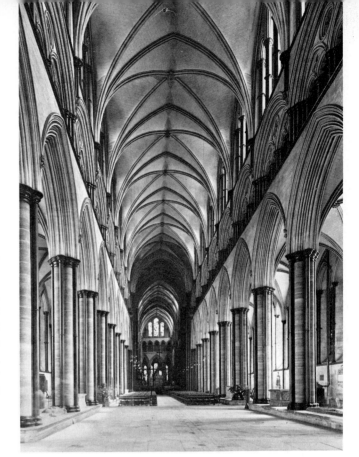

10-34 Nave of Salisbury Cathedral.

Equally distinctive is the long rectilinear plan (FIG. 10-33), with its double transept and flat eastern end, the latter a characteristic of Cistercian churches and favored in England since Romanesque times. The interior (FIG. 10-34), though Gothic in its three-story elevation, in its pointed arches and rib vaults, and in its compound piers, shows conspicuous differences from French Gothic. The pier colonnettes do not ride up the wall to connect with the vault ribs; instead, the vault ribs rise from corbels in the triforium, producing a strong horizontal emphasis. There is rich detail in the moldings of the arches and the tracery of the triforium, which, enhanced by the contrasts of colored stone, gives a peculiarly crisp and vivid sparkle to the interior. The structural craft of the English stonemason is at its best in the Lady Chapel (dedicated to the Virgin Mary) of Salisbury Cathedral (FIG. 10-35). Incredibly slender piers composed of unattached shafts of Purbeck marble seem to tether the billowing vaults to the ground, rather than support them. Not only is this daring construction, but its linear-

10-35 Lady Chapel of Salisbury Cathedral, *c.* 1225.

a fluent unity. The vault ribs, which had begun to multiply soon after Salisbury, have now become a dense thicket of entirely ornamental strands having no structural function. This vault, in fact, is no longer a rib vault, but a continuous barrel vault with applied decorations.

The culmination of the English perpendicular style can be seen in the vault of the Chapel of Henry VII, which adjoins Westminster Abbey (FIG. 10-37) and was built in the first two decades of the sixteenth century. The linear play of ribs has become a kind of architectural embroidery pulled into "fan vault" shapes with pendent keystones resembling stalactites. The vault looks like something organic that has been petrified in the process of melting. The chapel represents the dissolution of structural Gothic into decorative fancy, its original lines being released from function and multiplying, variegating, and flowering into uninhibited architectural virtuosity and theatrics. The "perpendicular" style in this Tudor structure (named after the reigning dynasty founded by Henry VII) expresses peculiarly well the precious, affected, even dainty style of life codified in the dying etiquette of chivalry at the end of the Middle Ages. Life was, of course, as violent as ever, but the description and expression of it in art comes in forms that are delicate rather than robust.

Germany

The architecture of Germany remained conservatively Romanesque well into the thirteenth century. The plan and massing of German churches include the familiar Rhenish double-apse system, with towers flanking both apses, and in many of these the only Gothic feature is the rib vault, which is buttressed, however, by the heavy masonry of the walls. By mid-century, though, the French influence became strongly felt, and the great 150-foot-high choir of the cathedral of Cologne (FIG. 10-44), discussed on p. 360, is a skillful and energetic interpretation of Amiens. A design, probably of French origin, that met with great favor and was broadly developed in Germany is that of the *Hallenkirche*, or hall church. The term applies to those buildings in which the aisles rise to the same height as the

ity and slender forms may well be forerunners of the rayonnant style on the continent.

English architecture early finds its native language in the elaboration of architectural pattern for its own sake; structural logic, expressed in the building fabric, is secondary. The pier, wall, and vault elements become increasingly complex and decorative in the fourteenth century, and English Gothic of that period is described as "decorated." The choir of the cathedral of Gloucester (FIG. 10-36), built about a century after Salisbury, illustrates the passage from the "decorated" to the last English Gothic style, the "perpendicular."

The characteristically flat east end at Gloucester is opened in a single, enormous window divided into horizontal tiers of "transom" windows of like shape and proportion, reminiscent of the screen façade of Salisbury. In the nave wall, however, the strong horizontal accents of Salisbury have been erased, as the vertical wall elements, the *responds*, lift directly from the floor to the vaulting, pulling the whole elevation into

10-36 Right: Choir of Gloucester Cathedral, 1332–57.

10-37 Below: Detail of the vault of the Chapel of Henry VII, 1503–19, Westminster Abbey, London.

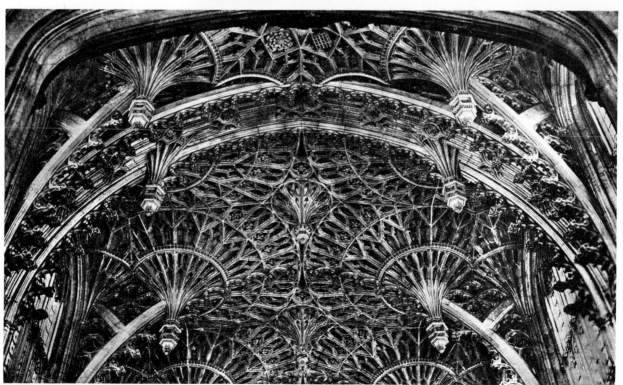

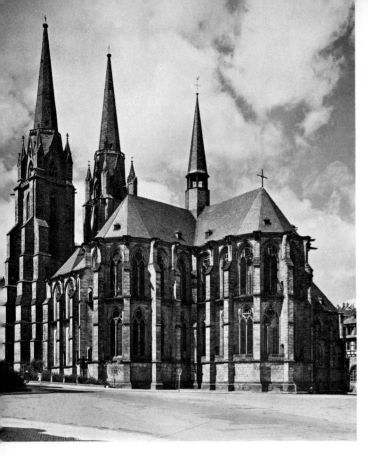

nave (FIG. 10-39). An early and successful example of this type is the church of St. Elizabeth at Marburg (FIGS. 10-38 to 10-40), built between 1233 and 1283. Since the aisles provide much of the bracing for the central vault, St. Elizabeth's exterior is without the dramatic parade of flying buttresses that circle French Gothic chevets and appears rather prosaic. But the interior (FIG. 10-40), lighted by double rows of tall windows, is more unified and free-flowing, less narrow and divided, than those of other Gothic churches. The hall church, widely used by later Gothic architects, heralds the age of the Protestant Reformation in Germany, when the old ritual that focused on the altar will be modified by the new emphasis on preaching, which will center attention on the pulpit.

French sculpture, like architecture, had its effect abroad. Two stately statues from the choir of the German cathedral at Naumburg (FIG. 10-41) show the quiet, regal deportment of the French statuary of the High Gothic portals, but with a stronger tincture of realism. *Ekkehard* and *Uta* represent persons of the nobility who, in

10-38 St. Elizabeth, Marburg, 1233–83.

10-39 Plan and section (through nave) of St. Elizabeth.

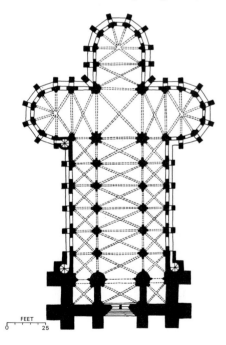

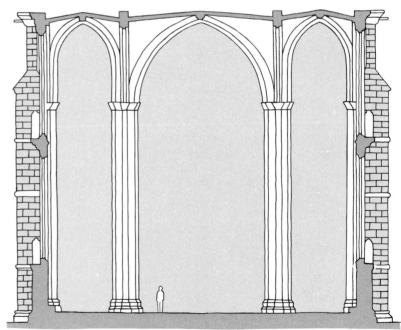

former times, had been patrons of the church; the particularity of costume and visage almost make these figures portrait statues, though the subjects lived well before the sculptor's time. *Ekkehard*, blunt and teutonic, contrasts with the charming *Uta*, who with a gesture wonderfully graceful draws the collar of her gown partly across her face while she gathers up a soft fold of drapery with a jeweled, delicate hand. The drapery and the body it enfolds are now understood as distinct entities. The shape of the arm that draws the collar is subtly and accurately revealed beneath the drapery, as is the full curve of the bosom. The drapery folds are rendered with an accuracy that indicates the artist's use of a model. We have before us an arresting image of Medieval people—a feudal baron and his handsome wife —as they may well have appeared in life. By mid-thirteenth century images not only of sacred but of secular personages had found their way into the cathedral.

The equestrian figure of a Gothic nobleman mounted against a pier in the cathedral of Bamberg (FIG. 10-42) is familiarly known as the *Bamberg Rider*. Like *Ekkehard* and *Uta*, it has the quality of portraiture; some believe it represents the German emperor Conrad III. The artist carefully describes the costume of the rider, the high saddle, the caparison of the horse. The proportions of horse and rider are real, though the anatomy of the animal is not quite comprehended, and thus its shape is rather stiffly schematic. An ever present pedestal and canopy firmly establish the group's dependence upon its architectural setting and manage to hold the horse in strict profile. The rider, however, is turning easily toward the observer, as if presiding at a review of troops, and is beginning to break away from the pull of the wall. The stirring and turning of this figure seem to reflect the same impatience with subordination to architecture as did the portal statues at Reims.

Along with the gradual growth of naturalism during the thirteenth century was its modification during the fourteenth by an impulse toward charmingly ornamental effects and courtly convention, as seen in the *Virgin of Paris* (FIG. 10-30). Also rising was a new intensity of expression, which concentrated on such themes as the Cruci-

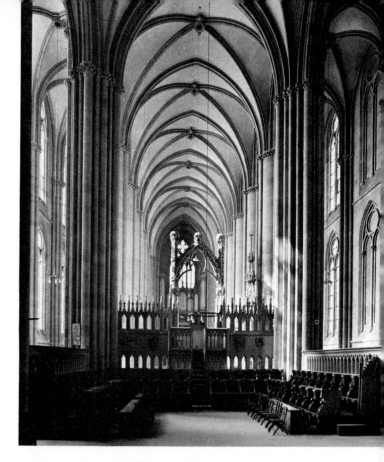

10-40 Interior of St. Elizabeth.

fixion, the Man of Sorrows, and the Sorrows of the Virgin Mary. The head of a crucifix in St. Maria im Kapitol in Cologne (FIG. 10-43), the features wrenched with pain and sorrow, shows the new preference for interpretations of sacred story in terms of human feeling rather than of dogma and mystery. The humanizing that began in the twelfth century is here accelerated. The anguish of the suffering Christ is represented with such force that it could not fail to stir the emotions powerfully, to arouse deep empathy in the observer. As motion is introduced into portal sculpture, so motion, which reads as emotion, activates the human face. Increasingly, images reach out to the observer, not only into his physical space, but into his emotions. The artist wants to do more than simply present the theological tenet in terms of some impersonal symbol; the mystery is brought back to earth once more, incarnate in the image of physical and psychic suffering.

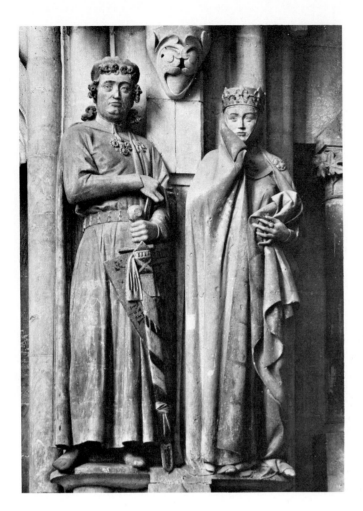

Italy

Few Italian architects accepted the northern Gothic style, and the question has been raised whether it is proper to speak of buildings like the cathedral of Florence (FIGS. 10-45 to 10-47) as Gothic structures. Begun in 1296 by ARNOLFO DI CAMBIO and so large that it seemed to Alberti to cover "all of Tuscany with its shade," the cathedral looks scarcely Gothic at all. Most of the familiar Gothic features are missing: There are no flying buttresses, no stately clerestory windows, and the walls are pierced only here and there by relatively small openings. Like San Miniato's (FIG. 9-18), the building's surfaces are ornamented, in the old Tuscan fashion, with marble-incrusted geometric designs to match it to the eleventh-century Romanesque baptistry nearby. Beyond an occasional ogival window and the fact that the

nave is covered by rib vaults, there is very little that identifies this building as Gothic. The vast gulf that separates this Italian church from its northern European cousins is strikingly evident when the former is compared with a full-blown German representative of the High Gothic, the cathedral of Cologne (FIG. 10-44).

Cologne Cathedral has one of the longest building histories on record. Begun in 1248, it stood without a nave and with only its chevet, transept, and lower parts of the façade towers completed for some five centuries. Only in the early nineteenth century, when the original designs for the building were discovered, was it decided to finish the structure. Its emphatic stress on the vertical produces an awe-inspiring upward rush of almost unmatched vigor and intensity. The building has the character of an organic growth shooting heavenward, its toothed upper portions engaging the sky, the pierced, translucent stone tracery of the spires merging with the atmosphere.

The cathedral of Florence clings to the ground and has no aspirations to flight. All emphasis is on the horizontal elements of the design, and the building rests firmly and massively on this earth. Simple geometric volumes are clearly defined and show no tendency to merge either into each other or into the sky. The dome, although it may seem to be rising because of its ogival section, has a crisp, closed silhouette that sets it off emphatically against the sky behind it. But, since this dome is the monument with which architectural historians usually introduce the Renaissance (it was built by Brunelleschi between 1420 and 1436), a comparison of the campanile with the Cologne towers may be somewhat more appropriate. Designed by the painter Giotto in 1334 (and completed with some minor modifications after his death), the Florence campanile stands apart from the cathedral in the Italian tradition. In fact, it could stand anywhere else in Florence without looking out of place; it is essentially self-sufficient. This can hardly be said of the northern towers; they are essential elements of the building behind them and it would be unthink-

10-42 *The Bamberg Rider*, late thirteenth century, Bamberg Cathedral.

able to detach one of them and place it somewhere else. Heinrich Wölfflin has compared buildings of this kind to a flame, from which no single tongue can be separated. This holds true for every part of the structure, down to its smallest details; no single element seems to be capable of an independent existence; one form merges into the next, in an unending series of rising movements that pull the eye upward and never permit it to rest until it reaches the sky. This structure's beauty is of an amorphous rather than a formal kind; it is a beauty that speaks to the heart rather than to the intellect.

How different the Italian tower! Neatly subdivided into cubic stages, Giotto's tower is the sum of its clearly distinguished parts. Not only could this tower be removed from the building without adverse effects, but each of the component parts, cleanly separated from each other by continuous, unbroken moldings, seems capable of continued, independent existence as an object of considerable esthetic appeal. This compartmentalization is reminiscent of the Romanesque, but it also forecasts the ideal of Renaissance architecture, which was to express itself in clear, logical relationships of a structure's component parts and which aimed for works that were self-sufficient and could exist in complete independence. Compared to the northern towers, Giotto's campanile has a cool and rational quality that appeals more to the intellect than the emotions.

From the plan of the Florence Cathedral (FIG. 10-46) it would seem that the nave was added to the crossing complex as an afterthought; in fact, the nave was built first, pretty much according to Arnolfo's original plans, and the crossing was redesigned in mid-fourteenth century to increase the cathedral's interior space. In its present form the area beneath the dome is the focal point of the design, and the nave leads to it, as Paul Frankl says, "like an introduction of slow chords, to a goal of self-contained finality." To

10-43 Head of a crucifix, 1301. Wood. St. Maria im Kapitol, Cologne.

Non-French Gothic 387

10-44 Right: Cologne
Cathedral, 1248–
nineteenth century.

10-45 Below: South flank
of Florence Cathedral,
1296–1436.

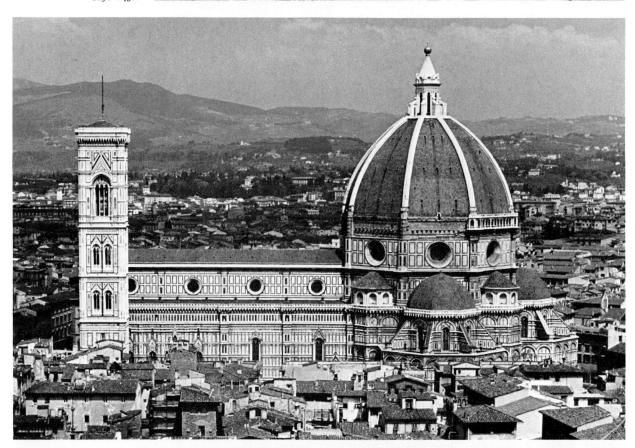

the visitor from the north, the nave seems as strange as the plan; neither has a northern European counterpart. The cathedral dimensions are about the same as those of Amiens, but there the similarity ends. The Florence nave bays (FIG. 10-47) are three times as deep as those of Amiens; the wide arcades permit the shallow aisles to become part of the central nave; the result is an interior that has an unmatched spaciousness. The accent here, as in the exterior, is on the horizontal elements. The substantial capitals of the piers prevent them from soaring into the vaults and emphasize their function as supports. While this interior may lack the mystery of northern naves, its serene calm and clarity tell the visitor that the Tuscan architects had never entirely rejected nor forgotten their classical heritage, and that it is indeed only here, in central Italy, that the Renaissance could have been born.

The façade of the cathedral of Florence was not completed until the nineteenth century, and then in a form much altered from its beginnings. In

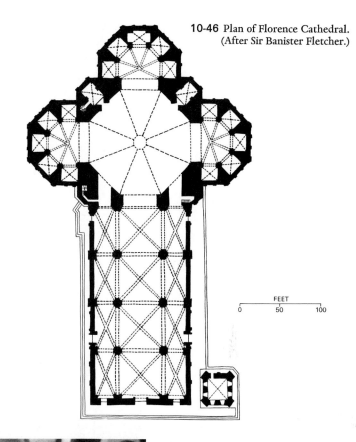

10-46 Plan of Florence Cathedral. (After Sir Banister Fletcher.)

FEET
0 50 100

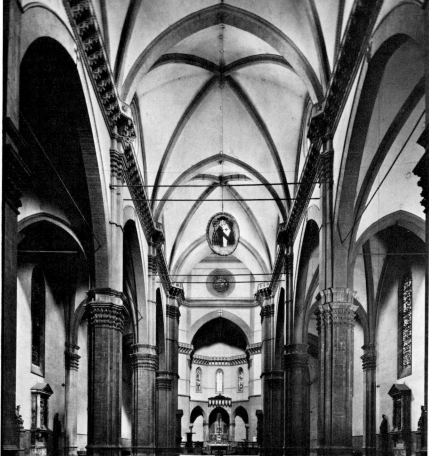

10-47 Nave of Florence Cathedral.

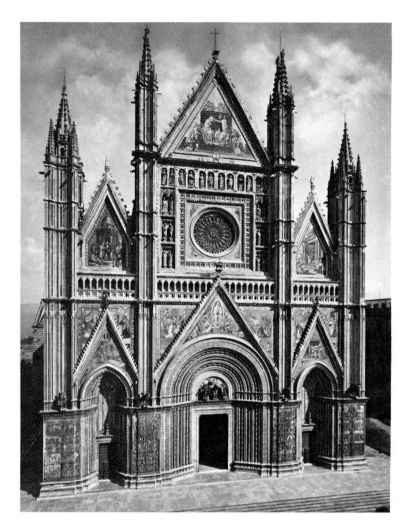

10-48 Façade of Orvieto Cathedral, begun *c.* 1310.

fact, Italian builders seemed little concerned with the façades of their churches, dozens being left unfinished to this day. One of the reasons for this may be that the façades were not conceived as integral parts of the structures but rather as screens that could be added to the fabric at any time. The façade of the cathedral of Orvieto (FIG. 10-48) is a typical and handsome example. Begun in the early fourteenth century, it pays a graceful compliment of imitation to some parts of the French Gothic repertory of ornament, especially in the four large pinnacles that divide the façade into three bays; but these pinnacles—the outer ones serving as miniature substitutes for the big northern west-front towers—grow up, as it were, from an old Tuscan façade and ultimately from the Early Christian. The rectilinearity and triangularity of the old Tuscan marble incrustation, here enframing and pointing to the precisely wrought rose window, is clearly seen behind the transparent Gothic overlay. The whole effect of the Orvieto façade is that of a great altar screen, its single plane covered with carefully placed carved and painted ornament. In principle, Orvieto belongs with San Miniato al Monte or the cathedral of Pisa, rather than Amiens or St. Elizabeth.

Since Romanesque times, northern European influences had been felt more strongly in Lombardy than in central Italy. When the

←to *c.*1194	1296	*c.***1300** 1309	*c.*1322	*c.*1345		1377 1378 1386		1417 to **16th C.**→	
Florence Cathedral begun	Palazzo Pubblico completed, Siena	Façade of Cologne Cathedral begun		Doge's Palace begun, Venice			Milan Cathedral begun		
HIGH GOTHIC	L	A	T	E	G O	T	H	I C	
		←————BABYLONIAN CAPTIVITY————→				←———GREAT SCHISM———→			

citizens of Milan, in 1386, decided to build their own cathedral (FIG. 10-49), they invited and consulted experts not only from Italy, but also from France, Germany, and England. These experts must have carried on a rough *disputatio* about the strength of the foundations and the composition and adequacy of the piers and the vaults—the application of the true geometric *scientia* in working out plan and elevation. The result was a compromise; the proportions of the building, particularly those of the nave, became Italian (that is, wide in relation to height), and the surface decorations and details, Gothic. But even before the cathedral was half finished, the new classical style of the Renaissance had been well launched and the Milan design had become anachronistic. The elaborate façade represents a confused mixture of late Gothic with classical elements, and stands as a symbol of the waning of the Gothic style.

The city churches of the Gothic world were monuments of civic pride quite as much as they were temples or symbols of the spiritual and natural world. To undertake the construction of a great cathedral a city had to be rich, its commerce thriving; and the very profusion of large churches during the Gothic period attests to the affluence of those who built and maintained them, as well as to the general revival of the economy of Europe in the thirteenth century.

The secular center of the community, the town hall, was almost as much the object of civic pride as the cathedral. A building like the Palazzo Pubblico of Siena (FIG. 10-50), the proud

10-49 Milan Cathedral, begun 1386.

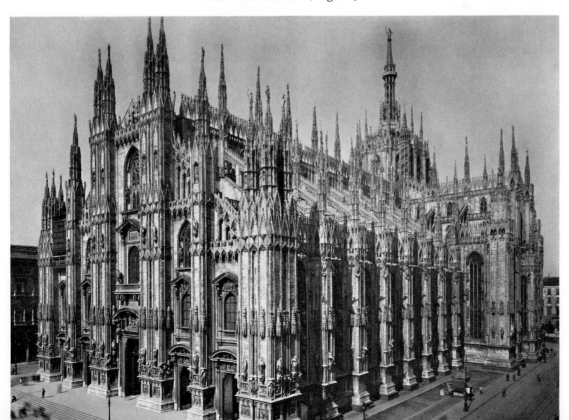

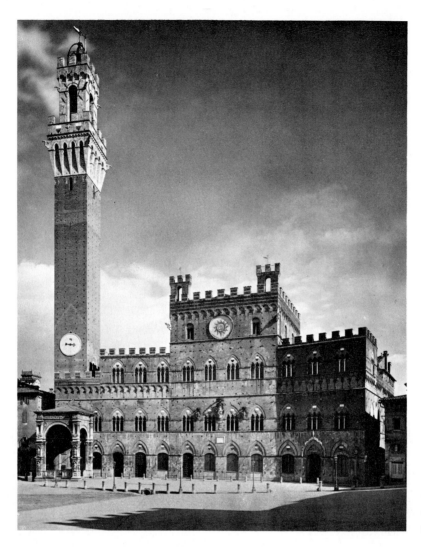

10-50 Palazzo Pubblico, Siena, 1288–1309.

commercial and political rival of Florence, must have drawn the admiration of Siena's citizens as well as of visiting strangers, inspiring in them respect for the city's power and success. More symmetrical in its design than most buildings of its type and period, it is flanked by a lofty tower, which, along with Giotto's campanile in Florence, is one of the finest in Italy. It served as lookout over the city and the countryside around it and as a bell tower from which signals of all sorts could be rung to the populace. The Medieval city, a political unit in itself, had to defend itself against its neighbor cities and often against kings and emperors; but in addition it had to be secure against internal upheavals, in which the history of the Italian city-republics abounds. Feuds between rich and powerful families, class struggle, as well as uprisings of the whole populace against the city fathers were constant threats to a city's internal security. The heavy walls and battlements of the Italian town hall eloquently express the frequent need of city governors to defend themselves against their own citizens. The high tower, out of reach of most missiles, is further protected by machicolated galleries, built out on corbels around the top of the structure to provide openings downward for a vertical defense of the tower's base.

The secular architecture of the Italian mainland tends to have this fortified look. But Venice, some miles out in the Venetian lagoon, was secure from land attack and could rely on her powerful navy to protect her against attacks coming from the sea. Internally, she was a tight corporation of ruling families that for centuries provided an unshakable and efficient establishment, free from disruptive tumults within. This stable internal structure made possible the development of an unfortified, "open" architecture like that of the Doge's Palace (FIG. 10-51), the seat of government of the Venetian republic. This, the most splendid public building of Medieval Italy, seems to invite the passerby to enter rather than to ward him off. In a stately march, the short and heavy columns of the first level support low-pointed arches and look strong enough to carry the weight of the upper structure. Their rhythm is doubled in the upper arcades, where taller and more slender columns carry ogival arches, which terminate in flamelike tips between medallions pierced with quatrefoils. Each story is taller than the one beneath it, the topmost being as high as the two lower arcades combined. And yet the building does not look top-heavy, a fact that is due in part to the complete absence of articulation in the top story and in part to the delicate patterning, in cream and rose-colored marbles, of its walls, which somehow makes them appear paper-thin. The Doge's Palace is the monumental representative of a delightful and charming variant of the Late Gothic. Its slightly exotic style reminds us of Venice's strategic position at the crossroads of the West and the Orient, where it could synthesize artistic stimuli received from either direction. Colorful, decorative, light and airy in appearance, and never overloaded, Venetian Gothic is ideally suited to the lagoon city, which floats between water and air.

10-51 Doge's Palace, Venice, *c.* 1345–1438.

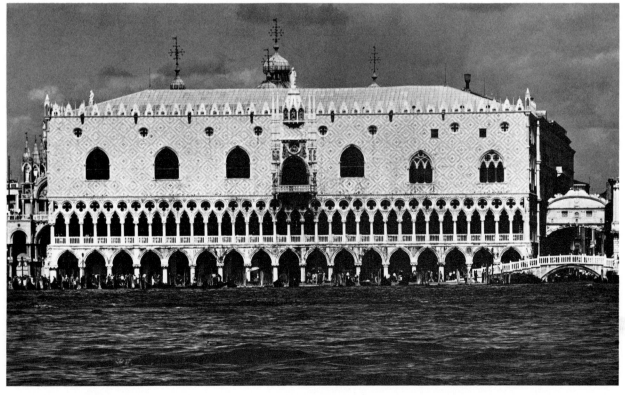

PART THREE

RENAISSANCE AND BAROQUE

As we have noted, the Medieval period was once regarded as a thousand dark and empty years separating the "good" eras—classical antiquity and modern times, the Renaissance being thought of as "early modern." But beginning in the nineteenth century a more cosmopolitan and tolerant taste and a more discerning and accurate historical method readjusted the view, and to us the Middle Ages are no longer so "dark" as once depicted. In the same way the Renaissance ("rebirth"), spanning roughly the fourteenth through the sixteenth century, no longer seems, as it was once thought to be, the abrupt onset of the modern world suddenly shining forth in the fifteenth century to illuminate Medieval darkness with the rekindled light of classical antiquity. Much of the Renaissance has its roots in epochs long preceding the Middle Ages, and much that is Medieval continues in the Renaissance and even much later. Since the mid-nineteenth century, when Jacob Burckhardt wrote his influential and still highly valuable work, *The Civilization of the Renaissance in Italy*, the precise dividing line between the Middle Ages and the Renaissance and even the question of whether there ever was a Renaissance have been disputed. Without reopening those questions, it may be useful to examine the Renaissance characteristics that,

GIANLORENZO BERNINI, detail of the Triton Fountain, travertine, Piazza Barberini, Rome, 1642–43. In this composition of Baroque forms, the jet blown skyward by the merman is the only straight element.

although originating in the earlier period, seem to have matured and become influential from the fourteenth through the sixteenth century.

Medieval feudalism, with its patchwork of baronial jurisdictions and sprawling, inefficient local governments, yielded slowly to the competition of strong cities and city-states that were increasingly in league with powerful kings, both being the natural political enemies of the countryside barons. The outlines of the modern state, with its centralized administrations, organized armies, aggressive expansionism, and "realistic" politics, began to become firm about this time. The discovery of the world outside Europe, especially the Western Hemisphere and Africa, itself so dramatically expressive of Renaissance expansiveness, brought vast treasures of gold and silver into Europe, beginning its transformation into a money economy, a process already begun in the thirteenth century in the commercial cities of Italy. Increasingly, religion came under the direction of the clergy of the cities and of such orders as the Dominicans and the Franciscans; the claims of the popes to temporal as well as spiritual supremacy were surrendered, and they became merely splendid Italian princes. Eventually, with the upheaval of the Protestant Reformation, which fractured the old Medieval religious unity, religion became almost a branch of the state, with kings and princes well in control of it. Dramatic events in science, like Copernicus' enunciation of the heliocentric theory of the solar system, set the scene for the development of the first successful empirical science, mathematical physics. The opening of the heavens to Western man's scrutiny was attended by the renewed physical exploration of the globe, and until recently, the increasing subjugation of it to the will of Europe. Technological advances in navigation, metallurgy, mechanics, and warfare helped greatly to that end.

The religious fanaticism that had launched the Medieval Crusades, Europe's first contact with non-European civilizations, was replaced during the Renaissance by motives of calculated economic interest mingled with the genuine and fruitful curiosity of the explorer. Indeed, the Renaissance was precisely what it has often been called, an age of discovery, when Europe saw before it an almost fantastic realm of possibility open to all men of merit who could perceive it.

Accompanying the great events that quite clearly set the Middle Ages and Renaissance apart were subtler changes of human attitude. There was a slow turning away from the ideas and values of a supernatural orientation to those concerned with the natural world and the life of man. The meaning of the world and of human life came to be couched in terms not exclusively religious. The spirit and dogma of Medieval religion—even its emotional color—were modified as the worldly philosophy of the Greco-Roman tradition revived and took on new strength. But the process of humanization had begun well before the

full influence of the pagan tradition was felt; the twelfth century had seen its beginning. In the thirteenth century the teachings of St. Francis had humanized religion itself and had called man's attention to the beauty of the world and of all things in it, even though he understood the physical beauty he celebrated as really spiritual; nevertheless, his emphasis was clear, and the Franciscan message calls attention to the God-made beauties of the natural order. This message had special significance for the naturalism of proto-Renaissance art. The duty of Medieval man—the focus of his life—was to procure, through the sacred offices of the Church, the salvation of his immortal soul. In the Renaissance, though the obligation and concern remain and the institutions of the Church retain power, nature and the relations among human beings simply become *more interesting* than theological questions. Theology, like institutional Christianity, persisted; so also for centuries did fervent Christian devotion. But there can be no doubt that they were affected by a new spirit—that of pagan humanism—which curiously joined with and reinforced the Christian humanism of St. Francis. The intellectual and artistic history of the modern world is as much the history of Christianity's reaction to this new spirit as it is a history of the challenge of that spirit to Christianity. Actually, the challenge and the reaction modified each other. The dialogue between the late Greco-Roman world and nascent Christianity commenced again in the Renaissance; since that time it has been supplemented and amplified by other even stronger voices, especially those of modern science.

While the veritable face and body of the human being emerged in the change from Romanesque to Gothic sculpture, Renaissance art brings man rapidly into full view in a phenomenon resembling the appearance of the human figure in Greek art in the sixth and fifth centuries B.C. The Renaissance stresses the importance of individual men, especially men of merit. In life and art the focus is sharpened; now at last individual men are real, are solid, and cast a shadow. Medieval man saw himself as corrupt and feeble of will—in fact, capable of acting only by the agency of God's grace. Although many thinkers, both Protestant and Catholic, insisted upon this view for centuries, the Renaissance view is different: Man may make himself. He is assumed to have a power of agency, God-given to be sure, which in the greatest of men becomes the divine gift of "genius." Thus, in the Renaissance, thinking man may overcome the curse of original sin and rise above its devastating load of guilt to make himself, if he will, what he wills. In his *Oration on the Dignity of Man* (the very title of which constitutes a bold new claim), Giovanni Pico della Mirandola, an ingenious and daring Renaissance philosopher, represents God giving this permission to man and does so in a way that reflects a sharp departure from the Medieval sense of man's natural helplessness:

The nature of all other beings is limited and constrained within the bounds of laws prescribed by Us. Thou, constrained by no limits, in accordance with thine own free will . . . shalt ordain for thyself the limits of thy nature. We have set thee at the world's center . . . made thee neither of heaven nor of earth, neither mortal nor immortal, so that with freedom of choice and with honor . . . thou mayest fashion thyself in whatever shape thou shalt prefer.[1]

This option would be almost unthinkable in the Middle Ages: Could man really aspire beyond the angels, or debase himself below the beasts and inanimate nature, given his place in the carefully articulated "chain of being" that God had made permanent?

Whether or not man could indeed so rise or fall, the leading men of the Renaissance were acutely aware of new possibilities open to their talents and did not fail to recognize, and often advertise, the powers they were sure they possessed. The wide versatility of many of the artists of the Renaissance—like Alberti, Brunelleschi, Leonardo da Vinci, and Michelangelo—led them to experimentation and to achievement in many arts and sciences and gave substance to that concept of the archetypal Renaissance genius—*l'uomo universale*, "the universal man." Class distinctions and social hierarchies had loosened, and men of ambition and talent could now take their places even as the friends and companions of princes. Such men could win the award of everlasting fame, and what has been called the "cult of fame" went naturally with the new glorification of individual genius. Indeed, the immortality won through fame may have been more coveted by many great men of the time than the spiritual immortality promised by religion. When the painter Fra Filippo Lippi died in 1469, the town of Spoleto requested to be allowed to keep his remains on the grounds that Florence, his native city, already had many celebrated men buried within the bounds of its walls.

Petrarch, the great poet of the fourteenth century, who may fairly be said to have first propounded those peculiarly Renaissance values of versatile individualism and humanism nourished by the study of classical antiquity, has been called the high priest of the cult of fame and, by many, the founder of the Renaissance. He himself was crowned with the ancient symbol of triumph and fame, the laurel wreath, on the Capitoline Hill in Rome; the occasion was a celebration of his superb sonnets (in native Italian), which open the age of Renaissance literature. Petrarch, developing the cult of fame, postulated that public recognition is never given to an unworthy work or talent and that, therefore, public

[1] Giovanni Pico della Mirandola, *Oratio de hominis dignitate* (1485), trans. by E. L. Forbes, in Ernst Cassirer and others, eds., *The Renaissance Philosophy of Man* (Chicago: Univ. of Chicago Press, 1956), pp. 224–25.

glory is proof of excellence. After Petrarch it would become natural to call both great works and great men "divine," as if they belonged to a kind of religious congregation of a new elect; thus it was with the *Commedia* of Dante and with Michelangelo after his death.

Petrarch's call for men to embrace the new concept of humanism encouraged the resurrection of the spirit of classical antiquity from a trove of ancient manuscripts eagerly hunted, edited, and soon to be reproduced in printed books. With the help of a new interest in and knowledge of Greek (stimulated by the immigration of Byzantine refugee-scholars after the fall of Constantinople to the Turks), the Humanists of the later fourteenth and fifteenth centuries recovered a large part of the Greek as well as the Roman literature and philosophy that had been lost, unnoticed, or cast aside as meaningless in the Middle Ages. While their greatest literary contribution was, perhaps, the translation of these works, they also wrote commentaries on them and used them as models for their own historical, rhetorical, poetic, and philosophical writings. What the Humanists perceived with great excitement in classical writing was a philosophy for living in this world, a philosophy of human focus primarily, that derived not from an authoritative and traditional religious dogma but from reason, supposed as given directly to any man of intelligence and taste. The model, thus, for the Renaissance is no longer the world-despising holy man but rather the great-souled, intelligent man of the world.

Medieval scholars were in possession of vast learning in the inherited culture of antiquity, but this heritage had been viewed in a light different from that prevalent in the Renaissance, The Medieval scholar, usually a theologian, had valued classical learning mostly for its usefulness in arguing Christian dogma; thus Aquinas could use Aristotle as authority for arguments based upon scriptural revelation, while others could point to secular classical literature as a bad example, in its tempting of souls to damnation through atheism and sensuality. The Renaissance Humanists found inspiration in the heroes of antiquity, especially in the accounts of their careers in Plutarch's *Lives*; by the fifteenth and sixteenth centuries, even the lives of prominent contemporary men were thought appropriate as exemplars of life's rule of reason intelligently and nobly followed. The biographies of famous men no longer dealt exclusively with the heroes of antiquity, and artists painted portraits of illustrious contemporaries. The confident, new, "modern" tone rings in Alberti's treatise *On Painting*, where he congratulates his generation on its achievements:

> And I reveal to you, that if it was less difficult for the ancients, having as they had so very many to learn from and imitate, to rise to a knowledge of those supreme arts that are so toilsome for us today, then so much the more our

fame should be greater if we, without teachers or any model, find arts and sciences unheard of and never seen.[2]

Almost prophetically, Alberti asserts that the moderns will go beyond the ancients; but the ancient example had first to be given, both as a model and a point of departure.

Although the Humanists received with enthusiasm the new message from pagan antiquity, they nevertheless did not look upon themselves as pagans. It was possible for the fifteenth-century scholar Laurentius Valla to prove the forgery of the Donation of Constantine (an Early Medieval document purporting to record Constantine's bequest of the Roman empire to the Church) without feeling that he had compromised his Christian faith. The two great religious orders founded in the thirteenth century, the Dominicans and the Franciscans, were as dominant in setting the tone of fourteenth- and fifteenth-century Christian thought as they had been earlier, and they continued to be patrons of the arts. Within the established religious orders Humanist clerics strengthened rather than weakened the reputation of the Church. Humanists, sometimes in religious orders, were appointed to important posts in city governments; the Florentine office of chancellor, for example, was held by distinguished men of letters. On the other hand, secular lords like Federigo da Montefeltro, Lord of Urbino—a skilled general, generous governor of his people, Humanist patron of the arts and letters, and renowned lover of books—chose to die in the arms of the Church after a long and pious spiritual preparation. Here and there the antagonism between the pagan and the Christian traditions may have been manifested, and certainly it was bound to exist, but in general the Renaissance experienced a natural, sometimes effortless, reconciliation of them.

Not least among the leaders of the new age were the artists who, it appears to a number of modern historians, were among its most significant producers. Indeed the products of the plastic arts may have been the most characteristic and illustrious of the Renaissance. Although we now perceive much more of the value of Renaissance literature, philosophy, and science, these branches of human creativity seem, in comparison with the plastic arts, to have been less certain, complete, and developed. But it is noteworthy that the separation of the great disciplines was not as clear-cut as it now is; mathematics and art especially went hand in hand, many Renaissance artists being convinced that geometry was fundamental to the artist's education and practice. In the *School of Athens* (FIG. 13-16) Raphael places his portrait and the portraits of his colleagues among the mathematicians and philosophers and not

[2] In E. G. Holt, ed., *Literary Sources of Art History* (Princeton: Princeton Univ. Press, 1947), p. 109.

among the poets. The old Medieval distinction of *ars* and *scientia* is replaced by a concept (becoming current again) that views them as interrelated. Albrecht Dürer will insist that art without science—that is, without a theory with which to relate the artist's observations—is fruitless. The careful observations of the optical world made by Renaissance artists and the integration of them by such a mathematical system as perspective foreshadow the formulations of the natural sciences. The twentieth-century thinker and mathematician, Alfred North Whitehead, believed that the habit and temper of modern science were anticipated in the patient and careful observation of nature practiced by the artists of the Renaissance. The methodical pursuit of a system that could bring order to visual experience may necessarily precede the scientific analysis of what lies behind what we see. Thus, the art of the Renaissance may be said to be the first monument to later Western man's search for order in nature.

Chapter Eleven

The "Proto-Renaissance" in Italy

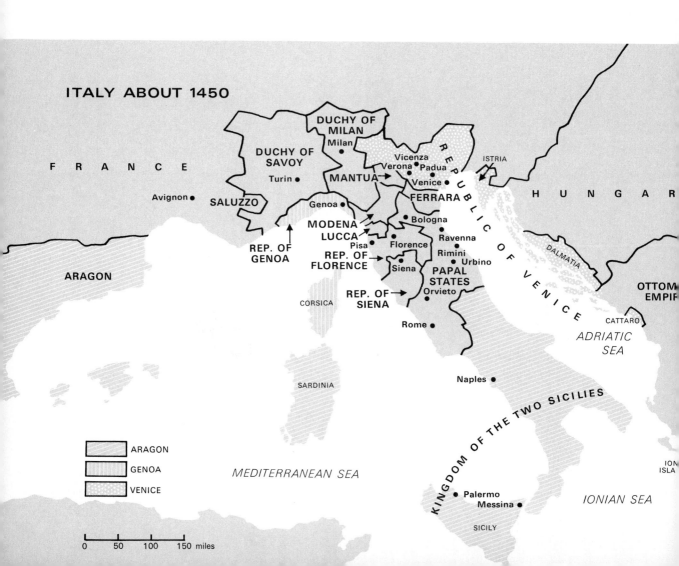

ITALY ABOUT 1450

F R A N C E

Avignon •

ARAGON

DUCHY OF MILAN
Milan •

DUCHY OF SAVOY
Turin •

SALUZZO

MANTUA

Genoa •

REP. OF GENOA

MODENA
LUCCA

Pisa •

REP. OF FLORENCE

Vicenza •
Verona • Padua

Venice •

FERRARA

Bologna •

Florence •

Ravenna •

Rimini •
Urbino •

Siena •

PAPAL STATES

Orvieto •

ISTRIA

R E P U B L I C O F V E N I C E

H U N G A R

DALMATIA

OTTOM
EMPIF

CATTARO •

REP. OF SIENA

Rome •

CORSICA

SARDINIA

ARAGON

GENOA

VENICE

MEDITERRANEAN SEA

Naples •

ADRIATIC SEA

ION
ISLA

IONIAN SEA

K I N G D O M O F T H E T W O S I C I L I E S

Palermo •
Messina •

SICILY

0 50 100 150 miles

SCHOLARS HAVE LONG been uncertain how to classify the art of the late thirteenth and the fourteenth centuries. Most of it still looks quite Byzantine or Gothic; in the countries outside Italy, Gothic traits last into the sixteenth century. But in Italy a new spirit begins to be felt in art in the late thirteenth. Since this new spirit is in fact that of the emerging Renaissance, it is misleading to define its monuments exclusively as "Gothic," even though Gothic traits are obvious in them. (To be sure, Gothic art itself represents a quickening of naturalism, though not the naturalism of the Renaissance; Gothic naturalism is a principal ingredient in the stylistic complex of the Late Medieval world.) What appears in Italy in the thirteenth century is destined to commence a new epoch, one that will have a quite recognizable continuity for centuries—indeed, almost until our own times. To stress the initiative that Italian art takes at this time and in order that the new epoch not be cut off from its beginnings, we have classified Italian art of the later thirteenth and the fourteenth centuries as proto-Renaissance. Although it is not until the

Frederick II born
1194

1215

St. Thomas
Aquinas
(c. 1225–74)

St. Francis of Assisi
(1182–1226)

FREDERICK II (*STUPOR MUNDI*)

1250

1252

DUCCIO
(c. 1255–1319)

CIMABUE
*Madonna Enthroned
with Angels and Prophets*
detail (c. 1280)

1273

GREAT INTERREGNUM

G. PISANO
Nativity
detail (1297)

Dante
Alighieri
(1265–1321)

Roger Bacon
(c. 1214–94)

N. PISANO
Pulpit
(1259)

Papacy moved
to Avignon
1309

William of Ockham
(c. 1280–1349)

Petrarch
(1304–74)

BABYLONIAN
CAPTIVITY

SIMONE MARTINI
(c. 1285–1344)

1348
Black Death
sweeps Europe

1350

A. PISANO
South Door
Baptistry, Florence
Cathedral (1330)

LORENZETTI
*Good Government
Enthroned*
detail (1339)

GIOTTO
Meeting of Joachim and Anna
detail (c. 1305)

Ciompi
revolt
1378

Papacy
returned to Rome
1377

GREAT SCHISM BETWEEN RIVAL POPES

TRAINI
Triumph of Death
detail (c. 1350)

1417

1406
Pisa ruled
by Florence

DI BANCO
Quattro Santi Coronati
(c. 1408)

NOTE Names shown with birth and death dates are placed at
approximately the midpoint of the life of the person named.

fifteenth century that Renaissance art makes its emphatic and quite obvious break with the Gothic, one can discern in the proto-Renaissance the advance of novel tendencies that will lead to the new era.

French Gothic art had risen and flourished in the regions around Paris under the patronage of the kings of France. In Italy the art of the Renaissance was supported by the prosperous merchant classes that ruled the cities after ousting the aristocracies. The reconstitution and expansion of city culture, which we saw beginning as early as the eleventh century, had increasingly broken down old feudal barriers to the advancement of ambitious men of merit from all classes. Communal government (the Italian city-republics were called *communes*) came into the hands of guilds of merchants and bankers. This rule of magnates and their families was thus not by hereditary right but by the authority of power, a power that, often as not, favored republican institutions; thus, the Medici came to rule in Florence not as raw tyrants but as a kind of "first among equals." Behind their power was commercial success, their own as well as the city's, and their skill in business government. During the period of the proto-Renaissance the growth in wealth and power of many Italian cities corresponded with a rise in their wool trade. Florence in particular was noted for her finished cloth, which was sold all over Europe. As their wealth increased, the guilds, including the powerful wool guild, commanded ever greater political influence; eventually the city, and with it much of the patronage of art, was in their hands. Commercial setbacks or jealousies within the guild coalitions created a highly unstable government, in which authority frequently changed hands overnight.

The Ciompi revolt of 1378 in Florence, when the workmen attempted to wrest the government from the merchant guilds, was only one of many social upheavals that followed upon the disaster of the great plague (the "Black Death") in 1348, which almost depopulated Europe. All over Europe there were revolts of peasants in the countryside and of laboring men in the cities. A great and desolating war, destined to last a hundred years, broke out between France and England. The papacy suffered a humiliation that would ultimately destroy its prestige, the popes becoming puppets of the French monarchy and their residence moving from Rome to Avignon in southern France. Their sojourn there for some seventy years was climaxed by the Great Schism, when the throne of St. Peter was claimed simultaneously by three popes, who excommunicated one another. Christendom was permanently changed by this scandal, which contributed mightily to the advent of the Protestant Reformation in the sixteenth century.

Yet, despite turbulence and devastation, a powerful vitality was stirring, and confusion was but one aspect of significant and beneficial change. Old ideas and institutions could be challenged and to a degree discredited, while men of merit, in this age of Petrarch and Giotto, could feel that the times encouraged setting off in new directions.

Events from the twelfth century to the fourteenth constituted a kind of long overture announcing the advent of full, naturalistic representation in European art. Whether we regard the proto-Renaissance as the end of the overture or the raising of the curtain on the first act, the event, especially in painting, is singularly dramatic. The Medieval artist had for centuries depended chiefly on prototypes—pictures and carvings—for his representations of the human figure, with an occasional searching glance at objects and persons in the optical world. Now it is the optical world that offers the artist his prototype and his authority, though not all at once, of course. It is not until the fifteenth century that the "imitation of nature" as an objective will give the artist direction and not until the sixteenth that it will become theory and doctrine. In the proto-Renaissance the artist's procedure is tentative, as if he were suspicious of an approach involving fleeting appearances and devoid of traditionally authoritative formulations. Nevertheless, as the artist carefully treads the threshold of discovery, his experimental groping and the somewhat unsystematic yet hopeful and often confident spirit of the period are unmistakable.

Artists are not philosophers, though in the Renaissance they come very close to sharing in the philosophical enterprise. Certainly in the fourteenth century the way was opening to new and tremendous possibilities, possibilities that would have to be thought through as well as worked

through. In many ways the situation was similar to that of art today: the possibilities so many, the possible directions so diverse, that though rich conclusions may be anticipated, the way to them seems confused.

As the Christian Middle Ages evolved out of the disintegration of the Roman empire, so did a new way of looking at the world emerge from the disintegration of what might be called the Medieval style of thought. Distinct from and in opposition to the balanced Scholasticism of Aquinas, the new views were only in part products of the Christian humanism of St. Francis and the secular humanism of Petrarch and the classicizing scholars. The attack upon the rationalism of Aquinas made by the *later* Scholastics and theologians led to the discrediting of philosophy as a valid form of knowledge and to the unseating of reason, with its logical method, as the ruling faculty that produces it. The unity of theology and philosophy, which Aquinas had achieved by bringing together Christian dogma and Aristotle, was broken, theology going off in the direction of mysticism and pure faith, and philosophy yielding to skepticism and the first faint manifestation of that inquisitive bent of mind that would later mature into experimental science. If knowledge of God was impossible through philosophy and pure reason, so also was knowledge of the world and of nature, God's creation. Thus, pure reason came to be despised for its failure to make intelligible the mysteries of faith *or* of the world. In the fifteenth century, Nicolas of Cusa would disparage philosophy as mere "learned ignorance," and in the sixteenth, Martin Luther would call reason a "whore."

A new approach was needed to the understanding and explaining of nature and God; and it is necessary that we examine the great changes in the Western view of nature that lie behind and accompany fundamental changes in art. William of Ockham, one of the most subtle and ingenious of the Scholastics who attacked the rationalism of Aquinas, seemed to be providing it when, on the verge of a great insight, he stressed the importance of the role of intuitive knowledge and individual experience in the process of knowing: "Everything outside the soul is individual . . . [and] knowledge which is simple and peculiarly individual . . . is intuitive knowledge . . . Ab-

stractive individual knowledge presupposes intuitive knowledge . . . our understanding knows sensible things intuitively"

Such placing of intuition before abstraction was common to *both* the mystical and skeptical critics of Aquinas in the fourteenth century and in effect put human intuition squarely in front of what one would know, whether God (for the mystic) or the world (for the skeptic). This elevation of direct human experience constitutes a kind of exaltation of the knowing, human agent. Of course since Early Christian times, especially since St. Augustine in the fifth century A.D., the tradition of Christian mysticism had understood that the experience of God must be personal; knowledge otherwise must be the result of divine illumination. Thus, the fourteenth-century advocacy of intuitive experience is a kind of renewal of the idea that prevailed before the conviction, held by Abelard and Aquinas in the twelfth and thirteenth centuries, that truth could be achieved by the intellect only by following rules of rational demonstration. Even in the thirteenth century, the importance of experience in acquiring knowledge had been stressed by the remarkable Roger Bacon, the English philosopher, who bore out his convictions on this point with many astonishingly precocious discoveries and inventions in what now would be called the physical sciences and technology. Calling attention to the existence and necessity of experimental science, he insisted that the experimenter "should first examine visible things . . . without experience nothing can be known sufficiently . . . argumentation [that is, logical rational demonstration in the manner of Aquinas] does not suffice, but experience does." In the universities (especially Oxford) of the fourteenth century the followers of men like Bacon and Ockham discussed questions in physics—the acceleration of freely falling bodies, inertia, center of gravity, and the like— anticipating by centuries the age of Galileo.

Particularly noteworthy about the later thirteenth- and fourteenth-century mystical and skeptical thinkers who emphasize personal intuition and experience in seeking divine and natural knowledge is the fact that a large majority were Franciscans. In view of St. Francis' humanizing of Medieval religion—making it a matter of intense personal experience and drawing attention to the

beauty of natural things, the handiwork of God —it is natural that his successors should end by inspecting nature more closely and with a curiosity that would lead to scientific inquiry. St. Francis' independence and his critical posture toward the religious establishment were passed down to many Franciscans, the more radical of whom were often accused by the Church of association with outright "heretics." The Franciscans—conspicuously William of Ockham—challenged the papacy itself, especially its claim of secular lordship over all Christendom. In these challenges there already rings the rebelliousness that will take mature shape in the Protestant Reformation.

What might be called Franciscan radicalism, then, stresses the primacy of personal experience, the individual's right to know by experiment, the futility of formal philosophy, and the beauty and value of things in the external world. It was in the stimulating intellectual and social environment created in part by the Franciscans that the painters and sculptors of the proto-Renaissance began a new epoch—an epoch in which the carved and painted image took its shape from the authority of the optical world and what could be found of that authority in the classical antique. The individual artist, breaking with the formal traditions of a thousand years, now came to depend on his own inspection of the world before his eyes. Applying the Baconian principle of personal discovery through experience—in the artist's case, the experience of *seeing*—he began to project in paint and sculpture the infinitely complex and shifting optical reticulum that we experience as the world.

SCULPTURE

One may encounter many imitations of the art of classical antiquity—during the Carolingian and Ottonian periods, in the Romanesque, and in French Gothic as well. The statues of the *Visitation* group on the west façade of Reims (FIG. 10-28) show an unmistakable interest in late Roman sculpture, even though the modeling of the faces reveals their Gothic origin. However, the thirteenth-century sculpture of NICOLA PISANO (active about 1258–78), contemporary with the Reims

statues, exhibits an interest in the forms of the classical antique unlike that of his predecessors. This may have been due partly to the humanistic culture of Sicily under its brilliant king, Holy Roman Emperor Frederick II, who for his many intellectual gifts and many other talents was known in his own time as "the wonder of the world." Frederick's nostalgia for the grandeur that was Rome fostered a revival of Roman sculpture and decoration in Sicily and southern Italy before the mid-century. It may have been in this environment—though there is now some doubt on this point—that Nicola received his early training. After Frederick's death in 1250, Nicola traveled northward and eventually settled in Pisa, which was then at the height of its political and economic power and a place where a proficient artist could hope to find rich commissions.

In typically Italian fashion Nicola's sculpture was not applied in the decoration of great portals in close harmony with the architecture of which they were a part; thus they are quite unlike French sculpture of the period. Nicola carved marble reliefs and ornament for large pulpits, the first of which he completed in 1260 for the baptistry of the cathedral of Pisa (FIG. 11-1). Some of the elements of the pulpit's design carry on Medieval traditions (for example, the lions supporting some of the columns and the trilobe arches), but Nicola is evidently trying to retranslate into classical terms a Medieval type of structure. The large, bushy capitals are a Gothic variation of the Corinthian; the arches are round rather than ogival; and the large, rectangular relief panels, if their proportions were slightly altered, could have come from the sides of Roman sarcophagi. The densely packed large-scale figures of the individual panels seem also to derive from the compositions found on late Roman sarcophagi. One of these panels represents the Annunciation and the Nativity (FIG. 11-2). The Virgin of the *Nativity* reclines in the ancient fashion seen in Byzantine ivories, mosaics, and paintings. But the face-types, beards, coiffures, and draperies and the bulk and weight of the figures are inspired by classical models and impart a classical flavor to the relief that is stronger than anything seen in several centuries.

Nicola's classicizing manner was strongly reversed by his son GIOVANNI PISANO (about 1250–

1320). Giovanni's version of the Nativity (FIG. 11-3) from his pulpit in Sant' Andrea of Pistoia, finished some forty years after the one by his father in the Pisa Baptistry, offers a striking contrast to Nicola's thick carving and placid, almost stolid, presentation of the theme. Giovanni's figures are loosely and dynamically arranged; an excited animation twists and bends them, and their activeness is emphasized by spaces opening deeply between them, through which they hurry and gesticulate. In the Annunciation episode, which is combined with the Nativity as in the older version, the Virgin shrinks from the sudden apparition of the angel in an alarm touched with humility. The same spasm of diffidence contracts her supple body as she reclines in the Nativity scene. The principals of the drama share in a peculiar nervous agitation, as if they are all suddenly moved by spiritual passion; only the shepherds and the sheep, appropriately, do not yet share in the miraculous event. The swiftly turning, sinuous draperies, the slender figures they enfold, and the general emotionalism of the scene are features to be found not in Nicola's interpretation but in the Gothic art of the north in the fourteenth century. (These deep currents of Gothic naturalism and linear rhythms are evident in most sculpture in Italy throughout the fourteenth century.) Thus, the art of Nicola and

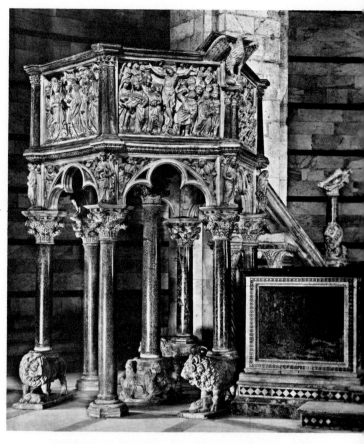

11-1 NICOLA PISANO, pulpit of the baptistry of Pisa Cathedral, 1259–60. Marble, approx. 15′ high.

11-2 NICOLA PISANO, *The Annunciation and the Nativity*, detail of FIG. 11-1. Marble, approx. 34″ × 45″.

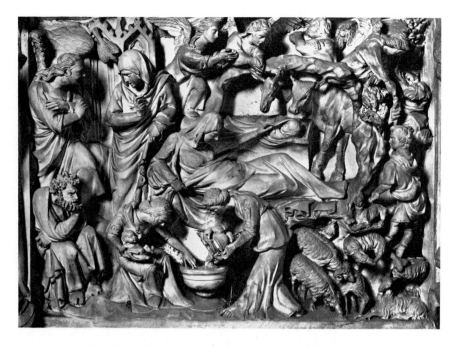

11-3 GIOVANNI PISANO, *The Nativity*, 1297–1301, detail of the pulpit of Sant' Andrea, Pistoia. Marble, approx. 34″ × 40″.

11-4 ANDREA PISANO, south door of the baptistry of Florence Cathedral, 1330–35. Gilt bronze.

11-5 ANDREA PISANO, *The Visitation*, detail of FIG. 11-4. Gilt bronze, approx. 20″ high.

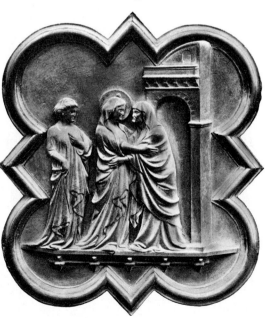

that of Giovanni show, successively, two novel trends of great significance for Renaissance art— a new contact with the antique and a burgeoning native Gothic naturalism.

Sculpture seems to have been more actively pursued in centers other than Florence until ANDREA PISANO (about 1270–1348 and unrelated to Nicola and Giovanni) was commissioned by Florence to make bronze doors for the baptistry (FIG. 11-4). Each door had fourteen panels, each enframing a *quatrefoil*, a motif found in Gothic sculpture and illuminations. Within these, as in the *Visitation* panel (FIG. 11-5), he placed low reliefs with smoothly flowing lines admirably adapted to the complex space of the Gothic frame. The gentle sway of the figures and the bladelike folds of their drapery are quite in the general Late Gothic manner, but Andrea's skill at composition and the quiet eloquence of his narrative make him an oustanding master among the fourteenth-century sculptors who followed the earlier Pisani. The simplicity of Andrea's statements, the amplitude of his forms, and their clear placement in shallow space, point also to the influence of his great contemporary, the painter Giotto.

PAINTING

Maniera Bizantina

Throughout the Middle Ages Italian painting was dominated by the Byzantine style. This Italo-Byzantine style, or *maniera bizantina*, is shown in an altarpiece that represents St. Francis (FIG. 11-6) and is a descendant of those tall, aloof, austere figures that people the world of Byzantine art. The saint, wearing the cinctured canonicals of the Franciscan order, holds a large book and displays on his hands and feet the stigmata, the wounds of Christ imprinted upon him as a sign of Heavenly favor. The saint is flanked by two very Byzantine angels and by scenes from his life, the latter very much suggesting that their source is in Byzantine illuminated manuscripts. A detail of the altarpiece represents St. Francis preaching to the birds (FIG. 11-7). The figures of St. Francis and his two attendants are carefully aligned against a shallow stage-property tower and wall, a stylized symbol of town or city from Early Christian times. In front of the saint is

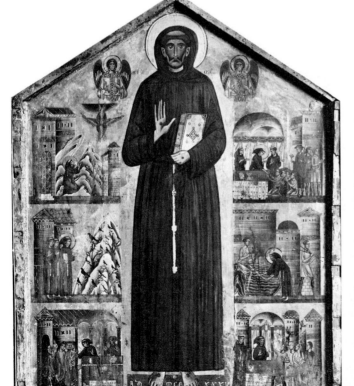

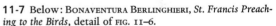

11-6 Left: BONAVENTURA BERLINGHIERI, panel from the *St. Francis Altarpiece*, 1235. Approx. 5′ × 3′ 6″. San Francesco, Pescia.

11-7 Below: BONAVENTURA BERLINGHIERI, *St. Francis Preaching to the Birds*, detail of FIG. 11-6.

| 1250 | 1252 | 1259 | | **1273** 1274 | | _c._1280 | | _c._1291 | | 1297 | | **1309** | | _c._1320 | | to 1377 → |

N. PISANO
Pisa Baptistry pulpit

St. Thomas
Aquinas
dies

CIMABUE
_Madonna
Enthroned_

CAVALLINI
_Last
Judgment_

G. PISANO
Sant' Andrea
pulpit

DUCCIO
_Maestà
Altarpiece_

GIOTTO
Death of St. Francis

GREAT INTERREGNUM

BABYLONIAN CAPTIVITY

to
1215 ← FREDERICK II →

another stage-scenery image of nested, wooded hills populated by alert and sprightly birds and twinkling plants. The strict formality of the composition—relieved somewhat by the sharply observed birds and the lively stippling of the plants—the shallow space, and the linear flatness in the rendering of the forms are all familiar traits of a long and august tradition, now suddenly and dramatically to be replaced.

BONAVENTURA BERLINGHIERI, artist of the St. Francis altarpiece, was one of a family of painters in the Tuscan city of Lucca. It was largely in the busy cities of Tuscany—Lucca, Pisa, Siena, Florence—that the stirrings of the new artistic movement began. It was Florence that was destined to lead the great development toward the new pictorial manner of the Renaissance, just as politically it gradually absorbed the other cities in Tuscany to make the Florentine republic. But during the fourteenth century, its defiant rival,

Siena, which long and stubbornly resisted the encroachment of Florence, was the seat of a spendid school of painting of its own.

Duccio

DUCCIO DI BUONINSEGNA (active about 1278–1319) represents the Sienese tradition at its best. Among his large altarpieces, the _Maestà_, so called because it shows the Madonna enthroned in majesty as Queen of Heaven amidst choruses of angels and saints, illustrates the major aspects of his mature style. The front of the seven-foot-high panel (which is painted on both sides) represents the formal, monumental side of Duccio's art, which remains essentially Byzantine. On the reverse side was a series of small panels illustrating scenes from the life of Christ. These little pic-

11-8 DUCCIO, _The Betrayal of Jesus_, detail of the back of the _Maestà Altarpiece_, 1309–11.

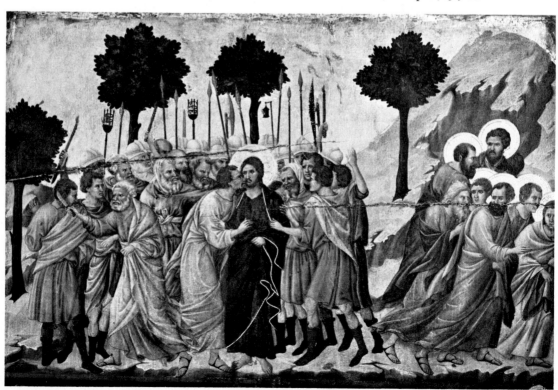

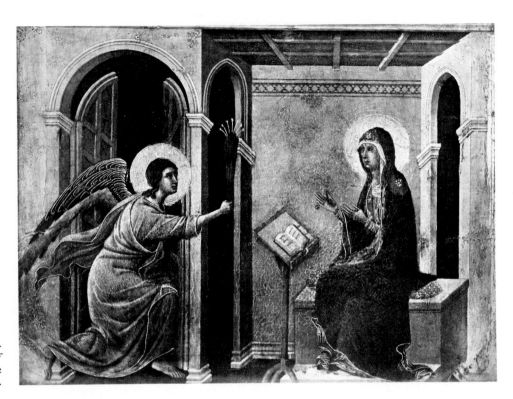

11-9 DUCCIO, *The Annunciation of the Death of Mary*, detail of the *Maestà Altarpiece*.

tures, which show Duccio's power of narration, were dismantled in the sixteenth century and are now scattered through the museums of the world. Given their narrative purpose—they were meant to be read as were the windows of Chartres—Duccio could relax the formalism appropriate to the iconic, symbolic representation of the *Maestà* and could reveal his ability not only as a narrator but as an experimenter with new pictorial ideas. One of the panels shows the Betrayal of Jesus (FIG. 11-8). In a synoptic sequence, the artist represents several episodes of the event: the betrayal of Jesus by Judas' false kiss, the disciples fleeing in terror, St. Peter cutting off the ear of the high priest's servant. Although the background, with its golden sky and its cheeselike rock formations, remains traditional, the figures before it have changed quite radically. They are no longer the flat, frontal shapes of Byzantine art, but have taken on body; they are modeled through a range from light to dark, and their draperies articulate around them convincingly. Only their relation to the ground on which they stand remains somewhat in doubt, as they tend to sway, glide, and incline with a kind of disem-

bodied instability. Even more novel and striking is the manner in which the figures seem to react to the central event. Through posture and gesture —even facial expression—they display a variety of emotions, as Duccio extends himself to differentiate between the anger of Peter and the malice of Judas (echoed in the faces of the throng about Jesus) and the apprehension and timidity of the fleeing disciples. No longer the abstract symbols of Byzantine art, these little figures have become actors in a religious drama and, in a lively performance, interpret it in terms of thoroughly human actions and reactions. In this and similar narrative panels, Duccio takes a decisive step toward the humanization of religious subject matter, an approach that was to become an ever stronger undercurrent in the development of painting in the following centuries.

In the *Annunciation of the Death of Mary* from the same altarpiece (FIG. 11-9), Duccio shows that, in the study of interior space, he is second to none of his contemporaries. Although his perspective is approximate, he creates the illusion of an architectural space that *encloses* a human figure. If we could be sure that the sophisticated ancient

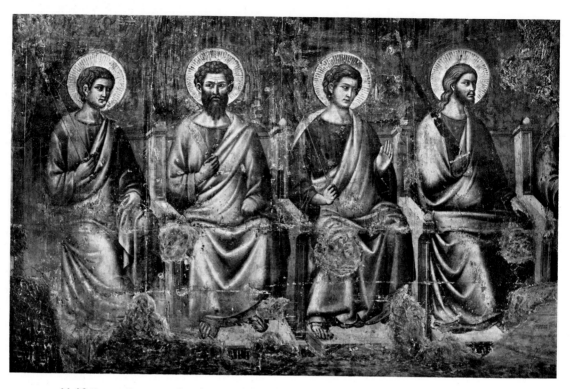

11-10 PIETRO CAVALLINI, *Seated Apostles*, detail of *The Last Judgment*, fresco, *c.* 1291. Santa Cecilia, Trastevere, Rome.

Roman painters had not achieved this effect also, we might say that it had never been done before. Certainly nothing like it is to be found in painting during the 900 years preceding Duccio, and it must be regarded as epoch-making even though it may have been anticipated by the St. Francis master at Assisi a few years earlier and was accomplished in a similar manner by Giotto in the Arena Chapel in Padua (see below) at about the time when Duccio painted his *Maestà*. While the angel's position remains ambiguous, the Virgin has been clearly placed in a cubical space that recedes from the picture plane. The illusion is made quite emphatic by the convergence of the three beams in the ceiling, a phenomenon that Duccio observed and recorded. As yet the perspective is not entirely unified, each of Duccio's planes tending to have its own point of convergence. Nevertheless, the illusion is convincing enough and represents the first step in the progressive construction of a true perspective space, geometrically ordered, that will be completed in the next century.

Florence: Giotto

Duccio resolved his problems within the general framework of the Byzantine style, which he never really rejected. His great Florentine contemporary, GIOTTO DI BONDONE (about 1266–1337), made a much more radical break with the past. The sources of his style are still much debated, although one must have been the style of the Roman school of painting as represented by PIETRO CAVALLINI (active about 1273–1308). As shown in a detail from Cavallini's badly damaged fresco of the Last Judgment (FIG. 11-10) in the church of Santa Cecilia in Trastevere, the style is characterized by a great interest in the sculptural rendering of form. Cavallini, perhaps under the influence of now lost Roman paintings, abandons Byzantine linearism for a soft, deep modeling from light to dark and achieves an imposing combination of Byzantine hieratic dignity with a long-lost impression of solidity and strength. Another—though perhaps a less significant—formative influence upon Giotto might very

likely have been the work of the man presumed to be his teacher, GIOVANNI CIMABUE (about 1240–1302). A Florentine, Cimabue must have been an older rival of Giotto, as Dante suggests in *Il Purgatorio* (XI, 94–96):

> Cimabue thought to hold the field in painting, and now Giotto has the cry, so that the fame of the other is obscured.

Cimabue, like Cavallini, pushed well beyond the limits of the Italo-Byzantine style, inspired by the same impulse toward naturalism as Giovanni Pisano and influenced as well, no doubt, by the Gothic. In an almost ruined fresco of the Crucifixion in San Francesco in Assisi his style can be seen to be—like Giovanni's—highly dramatic, the figures blown by a storm of emotion. On the other hand, he is much more formal in his *Madonna Enthroned with Angels and Prophets* (FIG. 11-11), since the theme naturally calls for unmoving dignity and not for dramatic presentation. This vast altarpiece, over twelve by seven feet, in spite of such progressive touches as the three-dimensional appearance of the throne, is a final summing-up of centuries of Byzantine art before its utter transformation. What that transformation looked like in its first phase can be seen in Giotto's version of the same theme (FIG. 11-12).

The art of Cimabue; the art of Cavallini and of the Roman painters like him, whom Giotto must have seen at work in San Francesco; the art of the Gothic sculptors of France, perhaps seen by Giotto himself, but certainly received by him from the sculpture of Giovanni Pisano; and the ancient art of Rome, both sculpture and painting —all these must have provided the elements of Giotto's artistic education. Yet no synthesis of all these could have sufficed to produce the great new style that makes Giotto the father of Western pictorial art. Renowned in his own day, his reputation has never faltered. No matter the variety of his materials of instruction, his true teacher was nature, the world of visible things.

Giotto's revolution in painting did not consist only in the final displacement of the Byzantine style, in the establishment of painting as a major art for the next six centuries, and in the restoration of the naturalistic approach invented by the ancients and lost in the Middle Ages. He inaugurated a firm method of pictorial experiment

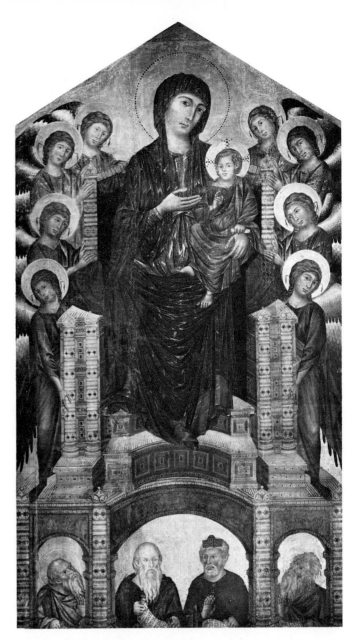

11-11 CIMABUE, *Madonna Enthroned with Angels and Prophets, c.* 1280–90. Tempera on wood, 12′ 7″ × 7′ 4″. Galleria degli Uffizi, Florence.

through observation, and, in the spirit of the experimenting Franciscans, opened an age that might be called early scientific. He and his successors, by stressing the preeminence of the faculty of sight in gaining knowledge of the world, laid the trails empirical science would start out upon; the visual world must be observed before it can be analyzed and understood. Praised in his own and later times for his fidelity to nature, Giotto

was more than an imitator of it; rather he *reveals* nature in the process of observing it and divining its visible order. In fact, he showed his generation a new way of seeing. With Giotto, Western man turns resolutely toward the visible world as the source of knowledge of nature. This new *outward* vision replaced the Medieval *inward* vision that searched not for the secrets of nature but for union with God.

In nearly the same great scale as the Madonna painted by Cimabue, Giotto presents her enthroned with angels (FIG. 11-12) in a work that offers an opportunity to appreciate his perhaps

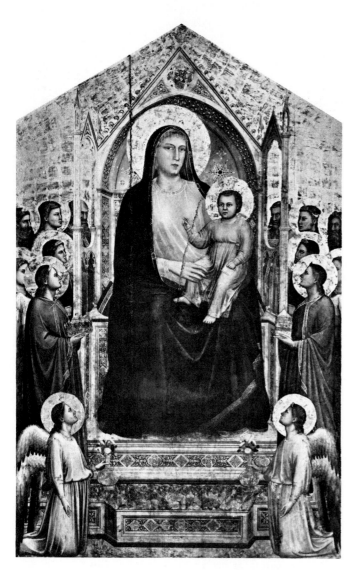

most telling contribution to representational art—sculptural solidity and weight. The Madonna rests within her Gothic throne with the unshakable stability of a granite goddess out of antiquity. The slender Virgins of Duccio and Cimabue, fragile beneath the thin ripplings of their draperies, are replaced by a sturdy, queenly mother, corporeally of this world, even to the swelling of the bosom. The body is not lost; it is asserted. The new art aims, before all else, to construct a figure that will have substance, dimensionality, and bulk—that, like a figure in sculpture, will project into the light and throw a shadow or give the illusion that it does. Thus, in this work the throne is deep enough to contain the monumental figure, breaking away from the flat ground to project and enclose it.

In examining Giotto's work it should be kept in mind that scholars have questioned the attribution of many frescoes to Giotto's hand, noting not only a certain inferiority in the execution of the figures and other details but also a crowding or complexity in the composition inconsistent with the lucidity and monumentality of his other paintings. All are agreed about his authorship of the work at the Arena Chapel (which must date from about 1304 to 1313), his frescoes in the chapels of Santa Croce in Florence (done about 1320), and the *Madonna* in the Uffizi, just described. The most serious controversy revolves around the great cycle of frescoes depicting the life of St. Francis in the Upper Church at Assisi; these are traditionally attributed to Giotto and dated about 1300. Since written evidence is lacking, opinions are based on stylistic analysis, which makes it probable that opinions will continue to vary. Current scholarship suggests that the St. Francis cycle was painted in the 1290's, and while the influence of Giotto's style is not denied, it is felt that it is better exemplified in other works. Scholars now believe that the Assisi frescoes were most likely done by Florentine artists influenced by Giotto, or with a similar background. One of these frescoes, *St. Francis Preaching to the Birds* (FIG. 11-13), is certainly

11-12 Giotto, *Madonna Enthroned*, c. 1310. Tempera on wood, 10′ 8″ × 6′ 8″. Galleria degli Uffizi, Florence.

Giottesque in its simplicity of statement, the reduction of the number of figures to the minimum required for the story, and the sharp psychological touches—such as the eloquent gesture of the saint as he bends forward to the birds, almost commanding them to attend his words, and the astonishment of his disciple. The modeling of the figures is strong; their sculptural relief, emphatic. If the picture is compared with Berlinghieri's version of the theme (FIG. 11-7), the nature of the great stylistic change, happening within less than a century, can be appreciated. Its attribution to the "Master of the St. Francis Cycle" reflects the provisional nature of much of our art-historical knowledge. As the history of art moves into an age of known personalities, the vexatious question of attribution arises with increasing frequency: How can the authorship of a work be verified when documentary evidence is scarce and when internal evidence (evidence from study of individual styles) is controversial?

The projection upon a flat surface of an illusion of solid bodies moving through space presents a duplex problem; the construction of the illusion of body requires at the same time the construction of the illusion of space sufficiently ample to contain that body. In Giotto's fresco cycles—and he was primarily a muralist—he is constantly striving to reconcile these two aspects of illusionistic painting. His *Lamentation* from the fresco cycle in the Arena Chapel (Cappella Scrovegni) at Padua (PLATE 11-1) is undisputed and shows us his art at its finest. The theme is the mourning of Christ's mother, his disciples, and the holy women over the dead body of the Savior just before its entombment and in the presence of angels darting about in hysterical grief. Giotto has arranged a shallow stage for the figures; it is bounded by a thick, diagonal scarp of rock that defines a horizontal ledge in the foreground. The rocky landscape links this scene with the adjoining one of the *Resurrection* and *Noli me tangere*. Giotto provides such linkages of the framed scenes throughout, much as Dante joins the cantos in his epic poem, the *Divine Comedy*. Though rather narrow, the ledge provides the figures with firm visual support, while the scarp functions as an indicator of the picture's dramatic focal point at the lower left. The old centralizing

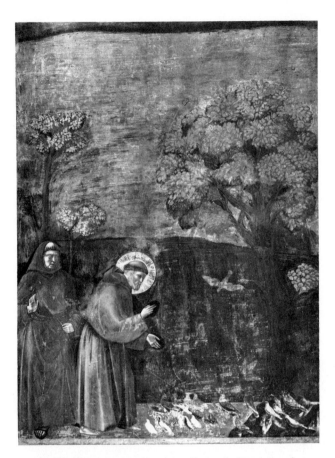

11-13 MASTER OF THE ST. FRANCIS CYCLE, *St. Francis Preaching to the Birds*, fresco, c. 1296 (?). Approx. 9′ × 6′ 8″. Upper church, San Francesco, Assisi.

and frontalizing habits of Byzantine art are here dismissed. The figures are sculpturesque—thought of as simple, weighty volumes, which, however, are not restrained by their mass from appropriate action. Here, postures and gestures that might have been only rhetorical and mechanical convincingly express a broad spectrum of grief, from the mother's almost fierce despair through the passionate outbursts of Mary Magdalene and John, the philosophical resignation of the two disciples at the right, and the mute sorrow of the two hooded mourners in the foreground. Though Duccio had made an effort to distinguish shades of emotion in the *Betrayal of Jesus* (FIG. 11-8), he does not match Giotto in his stage management of a great tragedy. Giotto has indeed constructed a kind of stage, which will

serve as a model for those on which many human dramas will be depicted in subsequent painting. He is now far removed from the old isolation of episodes and actors seen in art until the late thirteenth century. In the *Lamentation* a single event provokes a single, intense response within which there are, so to speak, degrees of psychic vibration. This integration of the formal with the emotional composition was scarcely attempted, let alone achieved, in art before Giotto.

The formal design of this fresco, the way the figures are grouped within the contrived space, is worth close study. Each group has its own definition, and each contributes to the rhythmic order of the composition. Already noted is the strong diagonal of the rocky ledge; with its single dead tree (the tree of knowledge of good and evil, which withered at the fall of Adam) it concentrates our attention on the group around the head of Christ, dynamically off-center in the composition. All movement beyond this group is contained, or arrested, by the massive bulk of the seated mourner in the corner of the painting. The seated figure to the right establishes a relationship with the center group, the members of which, by their gazes and gestures, draw the viewer's attention back to the head of Christ. Figures seen from the back—frequent in Giotto's compositions—emphasize the foreground, helping visually to place the intermediate figures further back in space. This device, the very contradiction of the old frontality, in effect puts the viewer behind the "observer" figures, which, facing the action as spectators, reinforce the sense of stagecraft as a model for paintings with a human "plot." In this age of dawning humanism the old Medieval, hieratic presentation of holy mysteries had evolved into full-fledged dramas employing a plot. By the thirteenth century the drama of the Mass had been extended into one- and two-act tableaux and scenes, and these into simple shows often presented at the portals of churches. (The portal statuary of the Gothic period suggests a discourse among the represented saints, and the architectural settings serve to enframe and enclose them as does a stage the movement of its actors.) Thus, the arts of illusionistic painting and of drama were developing simultaneously, and the most accomplished artists

of the Renaissance and later periods became masters of a kind of stage rhetoric of their own. Giotto, the first master of the tradition, was one of the most expert in the matching of form and action; it is difficult to exaggerate his trail-blazing achievement.

For the Franciscan church of Santa Croce in Florence Giotto painted frescoes of the life and death of St. Francis. Shown is the *Death of St. Francis* (FIGS. 11-14 and 11-15), as restored in the nineteenth century and with the restorations removed.[1] Fortunately, despite the removal of the restorations and the resultant gaps in the composition, there is enough of the original *Death of St. Francis* to give a view of the later style of Giotto. Compared with the *Lamentation*, with which it has considerable spiritual affinity, the St. Francis painting shows significant changes. The Gothic agitation has quieted, and the scene has little of the jagged emotion of the *Lamentation*. It seems, indeed, as if the artist—off-stage— had watched the solemn obsequies: the saint, at center upon his bier, flanked by kneeling and standing monks, the kneeling seen from behind in Giotto's fashion. To left and right come stately processions of friars in profile, as they would be seen in actuality, and not frontally as in a Byzantine procession like that of Justinian at San Vitale (FIG. 7-30). The figures are carefully accommodated on an architecture-enclosed, stagelike space that has been widened and no longer leaves any doubt that the figures have sufficient room in which to move about. They are taller and have lost some of their former sacklike bulk, Giotto now making a distinction between the purely form-defining function of the robes and the fact that they are draped around articulated bodies. The impressive solemnity of the procession is enhanced by the omission of

[1] This painting exemplifies another aspect of the problem of attribution and authenticity already mentioned. Until the historically sensitive twentieth century, it had long been the custom to "renew" old pictures by painting over damaged or faded areas. Modern scholars, in their zeal to know the "real" painter, have advocated stripping even where this leaves only fragments that are perhaps esthetically unsatisfactory. The practice remains controversial, and the historian of art, the expert, the connoisseur, and ultimately the layman always have before them the question of the authenticity of the given work.

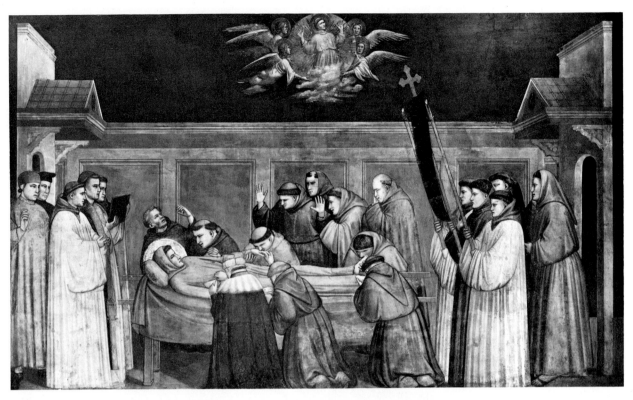

11-14 GIOTTO, *The Death of St. Francis*, fresco, *c.* 1320. Bardi Chapel, Santa Croce, Florence.

11-15 GIOTTO, *The Death of St. Francis* (FIG. 11-14), after removal of nineteenth-century restorations.

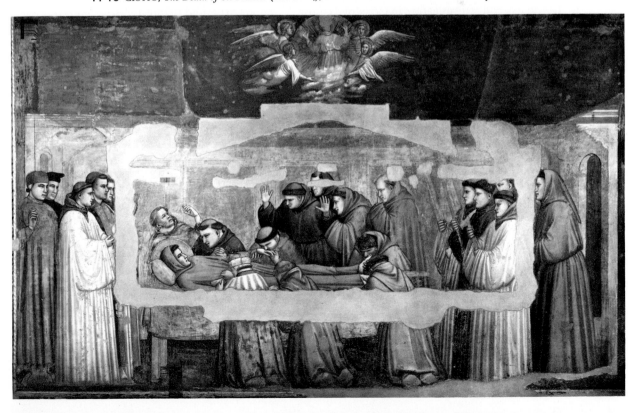

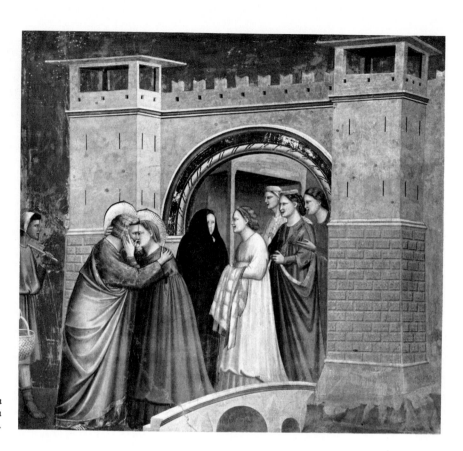

11-16 Giotto, *The Meeting of Joachim and Anna*, fresco, *c.* 1305. Arena Chapel, Padua.

casual and incidental beauties of the world, which were so dear to Sienese and Gothic painters. Giotto sees and records nature in terms of its most basic facts: solid volumes resting firmly on the flat and horizontal surface of this earth. These he arranges in meaningful groups and infuses with restrained emotions revealed in slow and measured gestures. With the greatest economy of means, Giotto achieves unsurpassed effects of monumentality, and his paintings, because of the simplicity and directness of their statements, belong to the most memorable in world art.

Giotto's murals in the Bardi and Peruzzi chapels of Santa Croce served as textbooks for generations of Renaissance painters from Masaccio to Michelangelo and others later. These later artists were able to understand the greatness of Giotto's art better than his immediate followers, who were never capable of absorbing more than a fraction of his revolutionary innovations. Usually their efforts remained confined to the emulation of his plastic figure description. A good example of a diligent follower is Taddeo Gaddi (about

1300–66), Giotto's foster son and his assistant for many years. The difference between the work of a great artist and that of a competent one is readily apparent if we compare Giotto's *Meeting of Joachim and Anna* in the Arena Chapel (FIG. 11-16) with Taddeo's version of the same subject in the Baroncelli Chapel in Santa Croce (FIG. 11-17). Giotto's composition is simple and compact, the figures carefully related to the single passage of architecture, the Golden Gate, where the parents of the Virgin meet in triumph in the presence of splendidly dressed ladies. The latter mock the veiled servant who had refused to believe that the elderly Anna would ever bear a child. The story, related in the Apocrypha, is managed with Giotto's usual restraint, clarity, and dramatic compactness. Taddeo allows his composition to become somewhat loose and unstructured; the figures have no clear relation to the background; the elaborate cityscape, though pleasant in itself, demands too much attention and detracts from the action in the foreground; gestures have become weak and theatrical; and the hunter, dis-

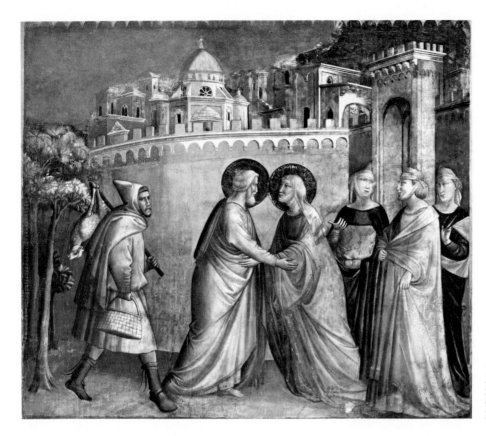

11-17 TADDEO GADDI, *The Meeting of Joachim and Anna*, fresco, 1338. Baroncelli Chapel, Santa Croce, Florence.

creetly cut off and unobtrusive in Giotto's painting, here strides boldly toward the center of the picture, a picturesque genre subject that weakens the central theme. Although his figures retain much of Giotto's solidity, Taddeo has weakened the dramatic impact of the story by elaborating its incidental details. Giotto stresses the essentials and, by presenting them with his usual simplicity and forceful directness, has given the theme a much more meaningful interpretation. Yet we must not seem to disparage Giotto's contemporaries and followers. Taddeo presses forward the investigation of perspective, as his cityscape reveals, and the genre figure attests to the development of a keen interest in realism.

Simone Martini

The successors of Duccio in the school of Siena display an even greater originality and assurance. SIMONE MARTINI (about 1285–1344) was a pupil of Duccio's and a close friend of Petrarch, who praised him highly for his portrait of Laura. Simone worked for the French kings in Naples and Sicily and, during his last years, at the papal court at Avignon, where he came in direct contact with northern painters. By adapting the insubstantial but luxuriant patterns of the French Gothic manner to Sienese art and, in turn, by acquainting northern painters with the Sienese style, Simone became one of the instrumentalities of the so-called International style, which swept Europe during the late fourteenth and early fifteenth centuries. It was a courtly style that appealed to the aristocratic taste for brilliant color, lavish costume, intricate ornament, and themes involving splendid processions in which knights and their ladies, complete with entourages, horses, and greyhounds, could glitter to advantage. Simone's own style does not quite reach the full exuberance of the developed International style. But his famous *Annunciation* (PLATE 11-2), with its elegant shapes and radiant color, its play of flowing, fluttering line, its weightless

11-18 Simone Martini, *Guidoriccio da Fogliano*, fresco, 1328. 11′ × 32′. Palazzo Pubblico, Siena.

figures and spaceless setting, is the perfect anti-thesis of the style of Giotto, of whom Simone certainly must have been aware, but whose art left him just as certainly untouched. The complex etiquette of the chivalric courts of Europe dictates the presentation. The angel Gabriel has just alighted, the breeze of his passage lifting his mantle, his iridescent wings still beating, the white and gold of his sumptuous gown representing heraldically the celestial realm whence he bears his message. The Virgin, dropping her book of devotions, shrinks demurely from Gabriel's reverent genuflection, appropriate in the presence of royalty. She draws about her the deep blue, golden-hemmed mantle, the heraldic colors she wears as the Queen of Heaven. Despite the Virgin's modesty and diffidence and the tremendous import of the angel's message, the scene subordinates drama to court ritual and structural experiments to surface splendor.

For the Palazzo Pubblico in Siena, Simone painted a very different kind of composition, a large mural some eleven by thirty-two feet representing a soldier of fortune, Guidoriccio da Fogliano, in the service of Siena (FIG. 11-18). This is the first in a long line of equestrian paintings and statues that would honor and commemorate those free-booting and ambitious professional soldiers (*condottieri*) who led the armies of the Italian states in their endless petty wars and who often took power themselves. Guidoriccio had recaptured two small Sienese towns from the Pisans, and for this solid service to the state he was represent-ed by Simone cantering in monumental isolation across the barren terrain, his camps to the far right, his banners flying over one city he has just retaken, his resolute and silent course directed toward the hill town at the left still to be conquered. Simone does not concentrate his design around a single episode, as Giotto does, but makes of the portrait a kind of sequential description, giving the progress of the general through time. Nor does he attempt a single viewpoint; the camp, the towns, and the rider are all seen from different angles. Even though this diffuseness is somewhat retrograde it really does not detract from the effectiveness of the great figure on its splendidly caparisoned horse. A quite beautiful touch appears in the diamond pattern shared by horse and rider, which, with the rhythmically fluttering draperies, gives a most astonishing illusion of forward motion. The Gothic feeling for line was that it is primarily ornamental; here line is adroitly employed to produce an illusion of real movement. The subject—a real man placed in a historically real situation—is itself an innovation and bespeaks the new and irresistible advance of worldly interests into life and art.

The Lorenzetti

The brothers Lorenzetti, also students of Duccio, share in the general experiments in pictorial realism that so characterize the fourteenth cen-

tury, especially in their seeking of convincing spatial illusions. PIETRO LORENZETTI (active 1320–48), going well beyond his master, achieved a remarkable success in a large panel representing the Birth of the Virgin (FIG. 11-19). The wooden architectural members that divide the panel into three compartments are represented as extending back into the painted space, as if we were looking through the wooden frame (apparently added later) into a boxlike stage, where the event takes place. The illusion is strengthened by the fact that one of the vertical members cuts across one of the figures, blocking part of it from view. Whether Pietro intended this architecture-assisted perspective illusion is problematical; in any case, the full significance of the device of pictorial illusion enhanced by applied architectural parts was not realized until the next century. There was no precedent for it in the history of Western art; but there was to be a long successful history during the Renaissance and Baroque periods of such visual illusions produced by a union of real and simulated architecture with painted figures. Pietro has made not just a structural advance here; his very subject represents a marked step in the advance of worldly realism. Anna (St. Anne), reclining wearily as the midwives wash the child and the women bring gifts, is the center of an episode that takes place in an upper-class Italian house of the period. A number of carefully observed domestic details and the scene at the left where Joachim eagerly awaits the news of the delivery place the scene

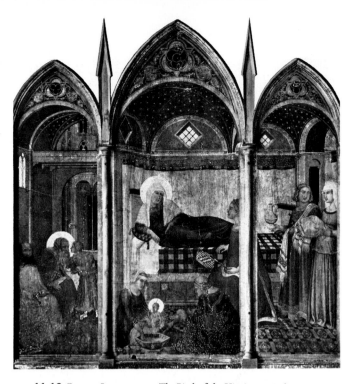

11-19 PIETRO LORENZETTI, *The Birth of the Virgin*, 1342. Approx. 6′ 1″ × 5′ 11″. Museo dell' Opera Metropolitane, Siena.

in an actual household, as if we had slid the panels of the walls back and peered within. Thus, the structural innovation in illusionistic space is one with the new curiosity that leads to careful inspection and recording of what lies directly before our eyes in the everyday world.

Pietro's brother, AMBROGIO LORENZETTI (active 1319–48), elaborated in spectacular fashion the Sienese advances in illusionistic representation,

11-20 AMBROGIO LORENZETTI, *Good Government Enthroned*, fresco, 1339. Palazzo Pubblico, Siena.

to **1309**	1337	1339		1348	c.1350		1374	**1377**	1378		to 1417 →
100 Years' War begins		A. LORENZETTI *Good Government Enthroned*		Black Death	TRAINI *Triumph of Death*			Petrarch dies	Ciompi revolt		

B A B Y L O N I A N C A P T I V I T Y G R E A T S C H I S M

as is shown in his vast mural in the Palazzo Pubblico, in which the effects of good and bad government are allegorically juxtaposed. Good Government (FIG. 11-20) is represented as a majestic figure enthroned and flanked by the virtues of Justice, Prudence, Temperance, and Fortitude, as well as by Peace and Magnanimity; above hover the theological virtues—Faith, Hope, and Charity. In the foreground the citizens of Siena advance to do homage to Good Government and all the virtues that accompany him. The turbulent politics of the Italian cities, the violent party struggles, the overthrow and reinstatement of governments would certainly have called for solemn reminders of the value of justice in high places, and the city hall would be just the place for a painting like Ambrogio's. Beyond the allegories and dedication scene stretches the depiction of the fruits of good government, both in the city and the countryside. The *Peaceful City* (FIG. 11-21) is a panoramic view of Siena itself with its clustering palaces, markets, towers, churches, streets, and walls. Commerce moves peacefully through the city, the guildsmen ply their trades and crafts, and a cluster of radiant maidens hand in hand perform a graceful,

circling dance. The artist has fondly observed the life of his city, and the architecture of it gives him an opportunity to apply Siena's rapidly growing knowledge of perspective. Passing through the city gate to the countryside beyond its walls, Ambrogio presents a bird's-eye view of the undulating Tuscan countryside, its villas, castles, plowed farmlands, and peasants going about their seasonal occupations (FIG. 11-22). In this sweeping view of an actual countryside we have the first appearance of landscape since the ancient world. The difference is that now the landscape—as well as the view of the city—is particularized by careful observation, being given almost the character of a portrait of a specific place and environment in a desire for authenticity. By combining some of Giotto's analytical powers with the narrative talent of Duccio, Ambrogio is able to achieve results that went beyond those of either of his two great predecessors.

The Black Death may have ended the careers of both Lorenzettis; nothing is heard of them after 1348, the year that brought so much horror to defenseless Europe. An unusual and fascinating painting that takes its subject from the holocaust that ensued is called the *Triumph of Death* (FIG.

11-21 AMBROGIO LORENZETTI, *Peaceful City*, from the *Good Government* fresco.

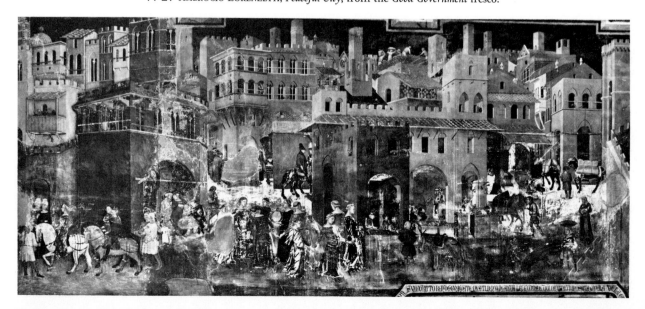

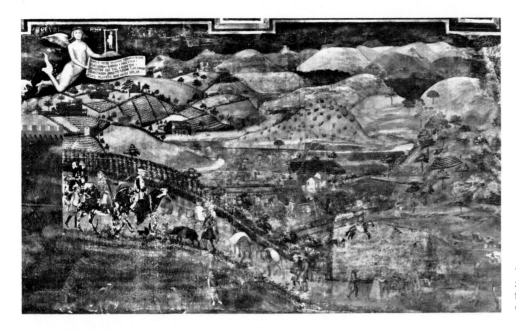

11-23); the work is attributed to FRANCESCO TRAINI (active about 1321–63) and is in the Campo Santo at Pisa. Three young aristocrats and their ladies in a stylish cavalcade come upon three corpses in differing stages of decomposition. As the horror of the confrontation with death strikes them, as the ladies turn away with delicate and ladylike disgust and a gentleman holds his nose (the animals, horses and dogs, sniff excitedly), a holy hermit unrolls a scroll that demonstrates the folly of pleasure and the inevitability of death. In another section the ladies and gentlemen, wishing to forget dreadful realities, occupy themselves in an orange grove with music, gallantries, and lapdogs, while all around them death and judgment occur and angels and demons struggle for souls. The Medieval message is as strong as ever; but gilded youth refuses to acknowledge it. The painting applies all the stock of Florentine-Sienese representational craft to present the most worldly—and mortal!—picture of the fourteenth century. It is an irony of history that, as Western man draws both himself and the world into ever clearer visual focus, he perceives ever more clearly that corporeal things are perishable.

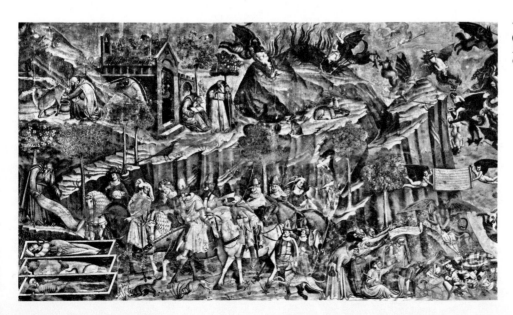

Fifteenth-Century
Italian Art

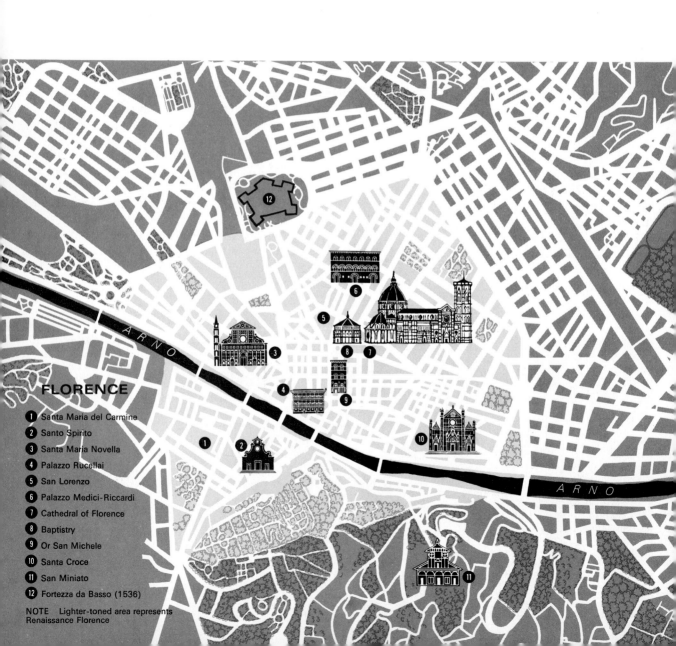

FLORENCE

1 Santa Maria del Carmine
2 Santo Spirito
3 Santa Maria Novella
4 Palazzo Rucellai
5 San Lorenzo
6 Palazzo Medici-Riccardi
7 Cathedral of Florence
8 Baptistry
9 Or San Michele
10 Santa Croce
11 San Miniato
12 Fortezza da Basso (1536)

NOTE Lighter-toned area represents
Renaissance Florence

FLORENCE in the early fifteenth century took cultural command of Italy and inaugurated the Renaissance. According to John Addington Symonds, a nineteenth-century historian of the Renaissance:

... nowhere else except at Athens has the whole population of a city been so permeated with ideas, so highly intellectual by nature, so keen in perception, so witty and so subtle, as at Florence. . . . The primacy of the Florentines in literature, the fine arts, law, scholarship, philosophy and science was acknowledged throughout Italy.[1]

The power and splendor of Florence had long been building; the fifteenth century marked its perfection. Like the Athenians after the repulse of the Persians, the citizens of Florence (who felt a historical affinity with the Athenians)

[1] J. A. Symonds, *Renaissance in Italy*, Vol. 1, (New York: Random House, 1935), p. 125.

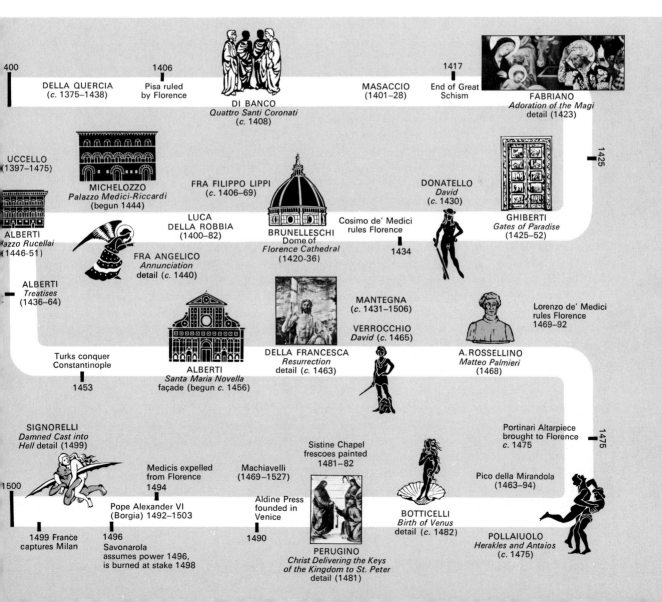

1400

DELLA QUERCIA
(c. 1375–1438)

1406
Pisa ruled
by Florence

DI BANCO
Quattro Santi Coronati
(c. 1408)

MASACCIO
(1401–28)

1417
End of Great
Schism

FABRIANO
Adoration of the Magi
detail (1423)

UCCELLO
(1397–1475)

MICHELOZZO
Palazzo Medici-Riccardi
(begun 1444)

FRA FILIPPO LIPPI
(c. 1406–69)

DONATELLO
David
(c. 1430)

1425

ALBERTI
Palazzo Rucellai
(1446–51)

LUCA
DELLA ROBBIA
(1400–82)

BRUNELLESCHI
Dome of
Florence Cathedral
(1420–36)

Cosimo de' Medici
rules Florence

1434

GHIBERTI
Gates of Paradise
(1425–52)

FRA ANGELICO
Annunciation
detail (c. 1440)

ALBERTI
Treatises
(1436–64)

MANTEGNA
(c. 1431–1506)

VERROCCHIO
David (c. 1465)

Lorenzo de' Medici
rules Florence
1469–92

Turks conquer
Constantinople

1453

ALBERTI
Santa Maria Novella
façade (begun c. 1456)

DELLA FRANCESCA
Resurrection
detail (c. 1463)

A. ROSSELLINO
Matteo Palmieri
(1468)

SIGNORELLI
*Damned Cast into
Hell* detail (1499)

Medicis expelled
from Florence
1494

Machiavelli
(1469–1527)

Sistine Chapel
frescoes painted
1481–82

Portinari Altarpiece
brought to Florence
c. 1475

1475

1500

Pope Alexander VI
(Borgia) 1492–1503

Aldine Press
founded in
Venice

Pico della Mirandola
(1463–94)

1499 France
captures Milan

1496
Savonarola
assumes power 1496,
is burned at stake 1498

1490

PERUGINO
*Christ Delivering the Keys
of the Kingdom to St. Peter*
detail (1481)

BOTTICELLI
Birth of Venus
detail (c. 1482)

POLLAIUOLO
Herakles and Antaios
(c. 1475)

responded with conscious pride to their repulse of the dukes of Milan, who had attempted the conquest of Tuscany. Like the Athenians also, Florentines developed a culture that was stimulated and supported by a vast accumulation of wealth; but unlike the Athenians, only a few illustrious families controlled the wealth. Among the latter, the Medici, bankers to all Europe, became such lavish patrons of art and learning that to this day the name "Medici" means a generous patron of the fine arts. The history of Florence for centuries is the history of the House of Medici. Early in the fifteenth century Giovanni de' Medici had established the family fortune. His son Cosimo, called by the Florentines father of his country, secured the admiration and loyalty of the people of Florence against the noble and privileged; and with this security the Medici gradually became the discreet dictators of the Florentine republic, disguising their absolute power behind a mask of affable benevolence. Scarcely a great architect, painter, sculptor, philosopher, or humanist scholar was unknown to the Medici. Cosimo began the first public library since the ancient world, and it is estimated that in some thirty years he and his descendants expended almost twenty million dollars for manuscripts and books; such was the financial power behind the establishment of humanism in the Renaissance. The Medici, careful businessmen that they were, were not sentimental about their endowment of art and scholarship; Cosimo declared that his good works were "not only for the honor of God but . . . likewise for my own remembrance." Yet the astute businessman and politician had a sincere love of learning, reading Plato in his old age and writing to his tutor, the neo-Platonic philosopher Marsilio Ficino, "I desire nothing so much as to know the best road to happiness." This is the very model of the cultivated, humanist grandee. The grandson of Cosimo, Lorenzo the Magnificent, went, as his name suggests, even beyond his grandfather in munificence. Himself a talented poet, he gathered about him a galaxy of artists and gifted men in all fields, extending the library Cosimo had begun, revitalizing his academy for the instruction of artists, establishing the Platonic Academy of Philosophy, and lavishing funds (often the city's own) upon splendid buildings, festivals, and pageants. If he had as a prime motive the retaining of the affection of the people and, thus, the power of the House of Medici, he nevertheless made of Florence a city of great beauty, the capital of all the newly flourishing arts. His death, in 1492, brought to an end the "Golden Age" of Florence, and the years immediately following saw the invasion of Italy by—as the Italians called them—the barbarian nations of France, Spain, and the Holy Roman Empire. The Medici were expelled from Florence; the reforming, fanatical Savonarola preached repentance in the cathedral of Florence; and the Renaissance moved its light and its artists from Florence to Rome. But one of the most prominent patrons of the Roman Renaissance, Pope Leo X, the patron of Raphael and Michelangelo, was himself a Medici, the son of Lorenzo the Magnificent. Never in history was there a family so intimately associated with a great cultural revolution. It might safely be said of the Medici that they subsidized and endowed the Renaissance.

THE FIRST HALF OF THE CENTURY

Sculpture

The spirit of the Medici and the Renaissance was nothing if not competitive and desirous of fame. But even before Medici rule, civic competitiveness and pride had motivated the adornment of Florence. The history of the Early Renaissance in art begins with an account of a competition—for a design for the north doors of the Baptistry of Florence, the south doors of which Andrea Pisano had designed two generations before. LORENZO GHIBERTI (1378–1455), the sculptor who won the competition, describes his victory in terms reflecting the egoism and the cult of fame characteristic of the period and of the Renaissance artist himself:

> To me was conceded the palm of the victory by all the experts and by all . . . who had competed with me. To me the honor was conceded universally and with no exception. To all it seemed that I had

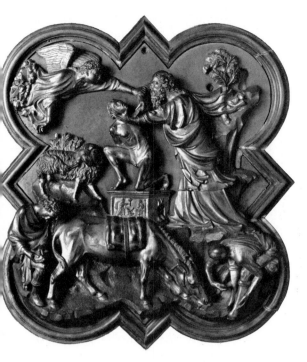

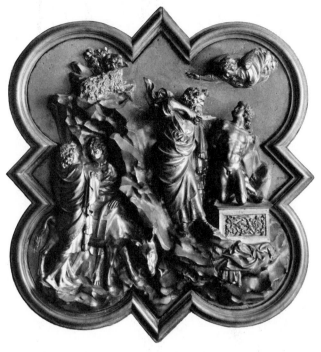

12-1 Filippo Brunelleschi, *The Sacrifice of Isaac*, 1401–02. Gilt bronze, 21″ × 17″. Museo Nazionale, Florence.

12-2 Lorenzo Ghiberti, *The Sacrifice of Isaac*, 1401–02. Gilt bronze, 21″ × 17″. Museo Nazionale, Florence.

at that time surpassed the others without exception, as was recognized by a great council and an investigation of learned men highly skilled from the painters and sculptors of gold, silver, and marble. There were thirty-four judges from the city and the other surrounding countries. The testimonial of the victory was given in my favor by all It was granted to me and determined that I should make the bronze door for this church[2]

This passage indicates also the esteem and importance now attaching to art, when leading men of a city bestow eagerly sought-for commissions, and when great new programs of private and public works are widely undertaken.

The contestants represented the assigned subject, the Sacrifice of Isaac, within panels shaped like the Gothic quatrefoil that was used by Andrea Pisano for the south doors of the Baptistry. Only those by Brunelleschi and Ghiberti have survived. Brunelleschi's panel (FIG. 12-1) shows a

[2] In E. G. Holt, ed., *Literary Sources of Art History* (Princeton: Princeton Univ. Press, 1947), pp. 87–88.

sturdy and vigorous interpretation of the theme, with something of the emotional agitation of the tradition of Giovanni Pisano. Abraham seems all at once to have summoned the dreadful courage needed to kill his son at God's command; he lunges forward, draperies flying, exposing, with desperate violence, Isaac's throat to the knife. Matching Abraham's energy, the saving angel darts in from the left, arresting the stroke just in time. Brunelleschi's figures are carefully observed, and there are elements of a new realism in them. Yet his composition is perhaps overly busy, and the figures of the two servants and the donkey not sufficiently subordinated to the main action.

We can make this criticism more firmly when we compare Brunelleschi's panel to Ghiberti's (FIG. 12-2). In the latter, vigor and strength of statement are subordinated to grace and smoothness; little of the awfulness of the subject appears. Abraham sways elegantly in the familiar Gothic S-curve, and seems rather to feign than to aim a deadly thrust. The figure of Isaac, beautifully posed and rendered, recalls ancient classicism,

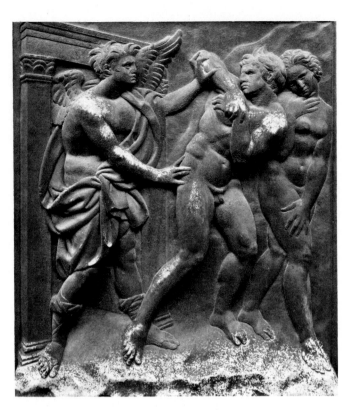

12-3 JACOPO DELLA QUERCIA, *The Expulsion from the Garden of Eden*, c. 1430. Istrian stone, 34" × 27". Main portal, San Petronio, Bologna.

and it could be regarded as the first really classicizing nude since antiquity. Ghiberti was trained both as goldsmith and as painter, and his skilled treatment of the fluent surfaces, with their sharply and accurately incised detail, evidences his goldsmith's craft. As a painter he would share the painter's interest in spatial illusion. The rocky landscape seems to emerge from the blank panel toward us, as does the strongly foreshortened angel. These pictorial effects, sometimes thought alien to sculpture, will be developed in Ghiberti's later work, the east doors of the Baptistry, the execution of which testifies to his extraordinary skill in harmonizing the effects peculiar to sculpture and painting. Here, within the limits of the awkward shape of the panel, Ghiberti achieves a composition that is perhaps less daring than Brunelleschi's but more cohesive and unified, and the jury's choice probably was fortuitous for the course of art, despite accusations of collusion by Brunelleschi's biographer, Manetti. One result of the decision was, apparent-

ly, to resolve Brunelleschi's indecision about his proper calling: Leaving sculpture, he became the first great architect of the Renaissance (see below). As for Ghiberti, his conservative style would be greatly modified by the discoveries of his contemporaries, and their influence upon him would be visible in the later east doors of the Baptistry.

The artists of Florence in the early Renaissance have sometimes been classified as "conservative" or "progressive," depending upon whether they cling to the international Gothic manner or whether they take up the new pictorial experimentalism. The classification cannot be applied consistently, however, for some artists who keep to the old conventions still occasionally adopt what they can use from their more experimental contemporaries, wherever it may be made consistent with their own styles. Whether conservative or progressive, artists may produce work of the highest quality, and we should not think that their excellence is merely a function of their being up-to-date or avant-garde. In some cases, too fertile and inventive an imagination may outrace the artist's powers to systematize his effort, becoming detrimental to his development.

JACOPO DELLA QUERCIA (about 1375–1438), a Sienese sculptor competing for the Baptistry commission, was perhaps the only non-Florentine sculptor of first rank in the fifteenth century. In comparison with the early work of Ghiberti, Quercia's is progressive. His panel representing the Expulsion from the Garden of Eden, from a series of reliefs enframing the portal of San Petronio, in Bologna, is carved in shallow relief and set into the frame in a closely knit pattern of curves and diagonals (FIG. 12-3). The figures are constructed so that they seem capable of breaking out of the confines of the relief. A robust energy animates the powerful, heavily muscled forms and recalls the ideal classical athletes. The conventional Gothic slenderness and delicacy are gone, and Jacopo's massive, monumental forms herald the grand style of the Renaissance. Indeed, though his style is without influence in Florence, he was to be rediscovered by Michelangelo at the end of the fifteenth century; the latter's debt to Jacopo is clearly visible in the great Florentine's painting of the same subject in the Sistine Chapel ceiling.

As the Sienese artist turns to the observation of the mechanics of the human body, a Florentine artist, NANNI DI BANCO (about 1380–1421), explores that other popular avenue of humanistic research, the antique. His life-size figures of four martyred saints, the *Quattro Santi Coronati* (FIG. 12-4), represent the patron saints of the Florentine guild of sculptors, architects, and masons. The group, set into the outside wall of the Medieval Or San Michele, in Florence, is an early near-solution to the Renaissance problem of integrating figures and space on a monumental scale. Here we are on the way to the great solutions of Masaccio and of the masters of the High Renaissance. The emergence of sculpture from the architectural matrix, seen beginning in such works as the thirteenth-century statues of the west front of Reims (FIG. 10-27), is almost complete in Nanni's figures, which stand in a niche that is *in* but confers some separation *from* the architecture. This spatial recess permits a new and dramatic possibility for the interrelationship of the figures. By placing them in a semicircle within their deep niche and relating them to each other by their postures and gestures as well as by the arrangement of draperies, Nanni has achieved a wonderfully unified spatial composition. The persisting dependence upon the architecture may be seen in the abutment of the two forward figures and the enframement of the niche, and the position of the two recessed figures, each in front of an engaged half-column. Nevertheless, these unyielding figures, whose bearing expresses —as in Roman art and stoicism—the discipline through which men of passionate conviction attain order and reason, are joined in a remarkable psychological unity. While the figure on the right speaks, pointing to his right, the two men opposite listen and the one next to him looks out into space, meditating the meaning of the words. This scheme of reinforcing the formal unity of a group with psychological cross-references will be exploited by later Renaissance artists, particularly Leonardo da Vinci.

Nanni di Banco has before him the example of the sculpture of antiquity. If we compare his statues with those of the *Visitation* group at Reims (FIG. 10-28) or with those of Nicola Pisano, we find the classicism of the older works lacking authority and as yet unsure, hesitant steps in a direction

only dimly suspected. The *Quattro Coronati* figures have arrived at a position that, if not identical with the Roman norm, is yet adjacent to it. The Renaissance artist has begun to comprehend the Roman meaning, even if he does not duplicate the Roman form. But duplication is not his purpose; rather it is interpretation or commentary in the manner of the humanist scholars dealing with classical texts.

A new realism based upon the study of man and nature, an idealism found in the study of classical forms, and a power of individual expression characteristic of genius are the elements that constitute the art and the personality of the sculptor DONATELLO (1386–1466), who, in the early years of the century, carried forward most dramatically the search for new forms capable

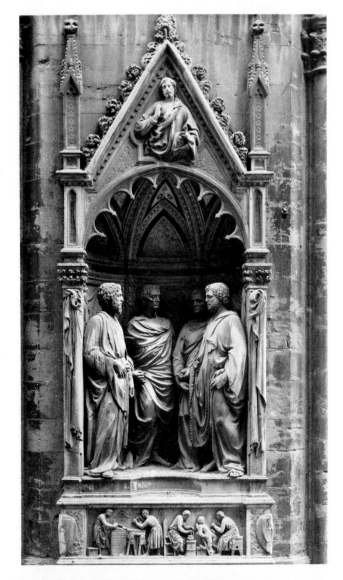

12-4 NANNI DI BANCO, *Quattro Santi Coronati, c.* 1408–14. Marble, approx. life-size. Or San Michele, Florence.

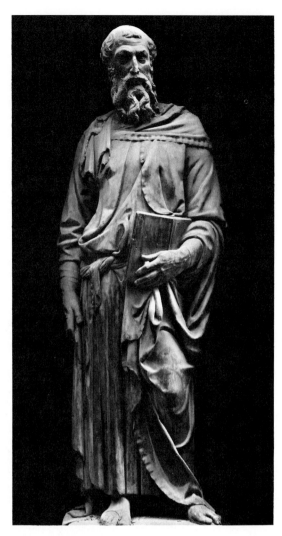

12-5 DONATELLO, *St. Mark*, 1411–13. Marble, approx. 7′ 9″ high. Or San Michele, Florence.

and place, but the greatest artists seem to survive this relativity of judgment, apparently because they reveal something deeply and permanently true about man and broadly applicable to his experience. Shakespeare, for example, seems miraculously familiar with almost the whole world of human nature; similarly, Donatello is at ease not only with the real, the ideal, and the spiritual, but with such diverse human forms and conditions as childhood, the idealized human nude, practical men of the world, military despots, holy men, derelict prelates, and ascetic old age. Others who follow Donatello in the school of Florence might specialize in one or two of these human types or moods; none commands them so completely and convincingly as he. Thus, in the early fifteenth century Donatello defined and took as his province the whole terrain of naturalistic and humanistic art.

Early in his career Donatello took the first fundamental and necessary step toward depiction of motion in the human figure—that is, recognition of the principle of weight-shift (*ponderation*). His *St. Mark* (FIG. 12-5) was commissioned for the Or San Michele and completed in 1413; with it Donatello closed a millennium of Medieval art and turned a historical corner into a new era. We have seen the importance of weight-shift in the ancient world, when Greek sculptors, in works like the *Kritios Boy* (FIG. 5-18) and the *Doryphoros* (FIG. 5-53), grasped the essential principle that the human body is not rigid but a flexible structure that moves by continuous shifting of weight from one supporting leg to the other, the main masses of the body moving in consonance with them. An illuminating comparison may be made between Donatello's *St. Mark* and Medieval portal statuary, or, for that matter, the sculpture of Nicola and Giovanni Pisano or even of the early Ghiberti; in none of these except Donatello's has the principle of weight-shift been grasped. Now all at once, with the same abruptness with which it appeared in ancient Greece in Early Classical art, it is rediscovered by Donatello. In sculpture and painting his successors gradually mastered the representation of bodily motion of the most complex kind.

As the body now "moves," so its drapery "moves" with it, hanging and folding naturally from and around bodily points of support, so

of expressing the new ideas of the humanistic Early Renaissance. Donatello's greatness consists in an extraordinary versatility and depth that led him through a spectrum of themes fundamental to human experience and through stylistic variations that express them with unprecedented profundity and force.

A principal characteristic of greatness is authority: The great artist produces work that his contemporaries and posterity accept as authoritative; his work becomes a criterion and a touchstone for criticism. Judgments of what is authoritative and "best" will of course vary with time

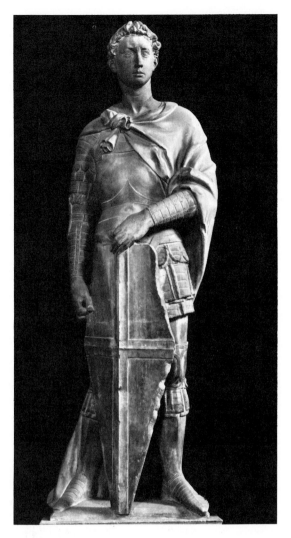

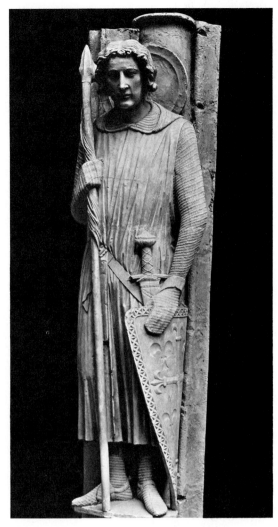

12-6 DONATELLO, *St. George*, 1415–17, from the Or San Michele. Marble, approx. 6′ 10″ high. Museo Nazionale, Florence.

12-7 *St. Theodore*, c. 1215–20, jamb statue from the south portal of Chartres Cathedral.

that we sense the figure as a draped nude, not simply as an integrated column with drapery arbitrarily incised. This adds further to the independence of the figure from its architectural setting. We feel that the *St. Mark* can and is about to move out of the deep niche, as the stirring limbs, the shifting weight, and the mobile drapery suggest. It is easy to imagine the figure as freestanding, unenframed by architecture, without loss of any of its basic qualities.

In his *St. George* (FIG. 12-6), also designed for the Or San Michele (between 1415 and 1417), Donatello provides an image of the proud ideal-

ism of youth. The armored soldier-saint, patron of the guild of armorers, which commissioned the statue, stands with bold firmness, legs set apart, feet strongly planted, the torso slightly twisting so that the left shoulder and arm advance with a subtle gesture of haughty and challenging readiness, as the dragon approaches. His head is erect, turned slightly to the left, the noble features beneath the furrowed brows intent, concentrated, yet composed in the realization of his power, intelligence, and resolution. In its regal poise and tense anticipation, the figure contrasts strikingly with its earlier Gothic coun-

terpart, the *St. Theodore*, from the cathedral of Chartres (FIG. 12-7). St. Theodore the soldier, essentially weightless, seems in some mystic reverie, removed from the world and unaware of his surroundings. The elements of his body are not coordinated in the unity of action we find in the *St. George*. The Medieval figure gives us the *idea* of the chivalric knight but nothing of the *fact* of the soldier confronting his enemy.

Between 1416 and 1435 Donatello carved five statues for the niches on the campanile of the cathedral of Florence, a project that, like the figures for the Or San Michele, had originated in the preceding century. The most striking of the five figures is a prophet, generally known by its nickname *Zuccone*, or Pumpkin-head (FIG. 12-8). It shows Donatello's peculiar power of characterization at its most original. All his prophets are represented with harsh, direct realism, re-

minding us of ancient Roman portrait sculpture. Their faces are bony, lined, and taut; each is strongly individualized and, in the Roman Republican manner, beardless. The *Zuccone* is also bald, a departure from the conventional way of representing the prophets. He is dressed in an awkwardly draped and crumpled togalike garment, the folds deeply undercut. At first view one might suspect Donatello of simply having draped a gaunt, uncouth assistant, placing him in casual stance, and then rendering the subject just as he saw it. Close examination, however, especially of the head (FIG. 12-9), discloses an appalling personality, instinct with crude power, even violence. The deep-set eyes glare under furrowed brows, nostrils flaring, the broad mouth agape, as if the prophet were in the very presence of the disasters that would call forth his declamation. None of this is apparent in the general view

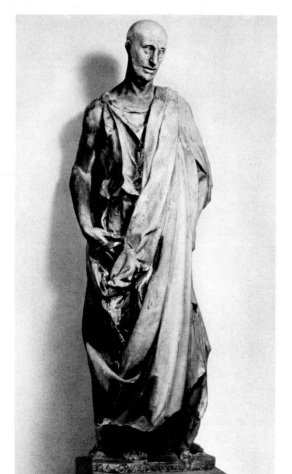

12-8 Left: DONATELLO, prophet figure ("*Zuccone*"), 1423–25, from the campanile of Florence Cathedral. Marble, approx. 6′ 5″ high. Museo dell' Opera del Duomo, Florence.

12-9 Below: DONATELLO, prophet figure ("*Zuccone*"), detail of FIG. 12-8.

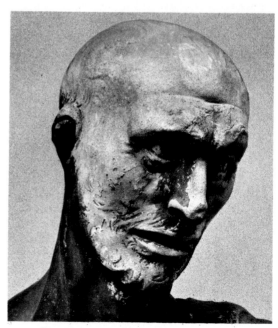

of the figure; only close up can one recognize Donatello's triumph in psychological realism and his acutely personal interpretation of his subject.

In a bronze relief of the Feast of Herod (FIG. 12-10) on the baptismal font in the Baptistry at Siena, Donatello carries his talent for characterization of single figures onto the broader field of dramatic groups. Salome, at the right, still seems to be dancing, even though she has already delivered the severed head of John the Baptist, with which the executioner kneels before King Herod. The actors recoil in horror into two groups; at the right, one figure covers his face with his hand; at the left, Herod and two terrified children shrink back in dismay. The psychic explosion that has taken place drives the human elements apart, leaving a gap across which the emotional electricity crackles. This masterful stagecraft obscures the fact that on the stage itself another drama is being played—the advent of *perspective space*, long prepared for in the proto-Renaissance and recognized by Donatello and his generation as a means of intensifying the reality of the action and the characterization of the actors.

Artists of the proto-Renaissance, like Duccio and the Lorenzetti brothers, had several devices for giving effects of distance, but with the invention of "true" linear perspective, generally attributed to Brunelleschi, the early Renaissance artists were given a method to make the illusion of distance mathematical and certain. In effect, they understood the picture plane as a transparent window through which, from a fixed standpoint, the observer looks *into* the constructed, pictorial world, where all orthogonals (lines perpendicular to the picture plane) meet in a single point on the horizon (a horizontal line that corresponds to the viewer's eye level), and where all objects are unified within a single space system—the perspective. This discovery was of enormous importance, making for what has been called the rationalization of sight, the bringing of our random and infinitely various visual sensations under a simple rule that is expressible mathematically. Indeed, the invention of perspective by the artists of the Renaissance reflects the emergence of science itself, which is, put simply, the mathematical ordering of our observations of the physical world. It is interesting that the artists of the Renaissance were often mathematicians, and a

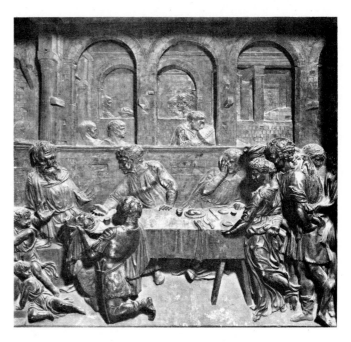

12-10 DONATELLO, *The Feast of Herod*, c. 1425. Gilt bronze, approx. 23″ × 23″. Baptistry, San Giovanni, Siena.

modern mathematician has asserted that the most creative work in mathematics in the fifteenth century was done by the artists. The experimental spirit mentioned in the previous chapter as animating many Franciscans, like Roger Bacon, now came firmly to earth; indeed, Bacon's essays on optics had large influence on Renaissance theorists like Alberti, discussed below. The position of the observer of a picture, looking "through" it into the painted "world" is precisely that of any scientific observer fixing his gaze upon the carefully placed or located datum of his research. Of course the artist was not primarily a scientist; he simply found perspective a wonderful way to order his composition and to clarify it. But there is little doubt that perspective, with its new mathematical authority and certitude, conferred a kind of esthetic legitimacy on painting by making the picture *measurable* and exact. Plato said that "the excellence of beauty of every work of art is due to the observance of measure." This is certainly expressed in the art of Greece, and now, in the Renaissance, when Plato was newly discovered and eagerly read, the artists exalted once again the principle of measure as the foundation of the beautiful in the

fine arts. Projection of measured shapes upon flat surfaces now influenced the character of painting, and it made possible scale drawings, maps, charts, graphs, and diagrams—those means of exact representation without which modern science and technology would be impossible. At this beginning of the modern world, mathematical truth and formal beauty became conjoined in the minds of the artists of the Renaissance. In his relief panel of the Feast of Herod, Donatello, using the device of pictorial perspective, opens the space of the action well into the distance, showing two arched courtyards and groups of attendants in the background. This penetration of the panel surface by spatial illusion replaces the flat grounds and backdrop areas of the Medieval past. The ancient Roman illusionism returns but it is now based on a secure principle never possessed by the ancients.

It is worth comparing Donatello's Siena panel with one from Ghiberti's famous east doors of the Baptistry of Florence, declared by Michelangelo to be "so fine that they might fittingly stand at the Gates of Paradise" (FIG. 12-11). The east doors (1425–52) were composed differently from Ghiberti's earlier north doors. (There are three sets of doors on the Baptistry: The first were made by Andrea Pisano for the eastern doorway (1334–36), which, facing the cathedral, is the most important entrance. These were moved to the south doorway to make way for those made by Ghiberti in 1403–24; and these, in turn, were moved to the north doorway so that the second pair by Ghiberti, the "Gates of Paradise," might be placed in the eastern doorway.) After 1425 Ghiberti abandoned the pattern of the earlier doors and divided the space into ten square panels, each containing a relief set in

12-11 Left: LORENZO GHIBERTI, east doors ("Gates of Paradise") of the baptistry of Florence Cathedral, 1425–52. Gilt bronze, approx. 17′ high.

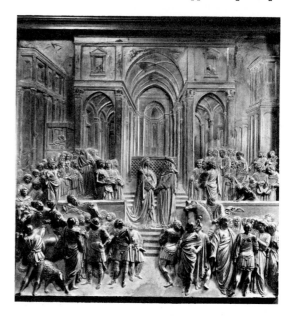

12-12 Below: LORENZO GHIBERTI, *The Meeting of Solomon and the Queen of Sheba*, detail of FIG. 12-11. Approx. $31\frac{1}{2}″ \times 31\frac{1}{2}″$.

plain moldings. When gilded, the reliefs created with their glittering movement an effect of great splendor and elegance.

The individual panels of Ghiberti's doors, such as the *Meeting of Solomon and the Queen of Sheba* (FIG. 12-12), clearly recall painting in their depiction of space as well as in their treatment of the narrative; some exemplify more fully than painting many of the principles Alberti was later to formulate in his *Della pittura* (*Of Painting*). In his relief, Ghiberti created the illusion of space partly by pictorial perspective and partly by sculptural means. Buildings are represented by use of the painter's one-point perspective construction, while the figures (in the lower section of the relief, which actually projects slightly toward the viewer) appear almost in the full round, some of the heads standing completely free. As the eye progresses upward, the relief becomes flatter and flatter until the architecture in the background is represented by barely raised lines, creating a sort of "sculptor's aerial perspective," in which forms are less distinct the deeper they are in space. Ghiberti described the work as follows:

> I strove to imitate nature as closely as I could, and with all the perspective I could produce [to have] excellent compositions rich with many figures. In some scenes I placed about a hundred figures, in some less, and in some more. I executed that work with the greatest diligence and the greatest love. There were ten stories all [sunk] in frames because the eye from a distance measures and interprets the scenes in such a way that they appear round. The scenes are in the lowest relief and the figures are seen in the planes; those that are near appear large, those in the distance small, as they do in reality. . . . Executed with the greatest study and perseverance, of all my work it is the most remarkable I have done and it was finished with skill, correct proportions and understanding.[3]

Thus, an echo of the ancient and Medieval past was harmonized by the new science: "Proportion" and "skill" were perfected by "understanding"; *ars* was perfected by *theoria*. Ghiberti achieved a greater sense of depth than had ever before been possible in a relief. One should note, however, that his figures do not occupy the architectural space he has created for them; rather,

they are arranged along two parallel planes in front of the grandiose architecture. (According to Alberti, in his *Ten Books on Architecture*, the grandeur of the architecture reflects the dignity of events shown in the foreground.) The festive pomp and processional opulence of the scene, including horsemen, soldiers, and Orientals, recall events such as the great church councils of the fifteenth century, in particular the Council of Florence of 1439, which sought to bring together the Byzantine (Orthodox) and Western (Catholic) churches. From Ghiberti's biography we know that he admired and collected classical marbles, bronzes, and coins, and their influence is clearly seen in some of the figures of soldiers and in certain profile heads reminiscent of Roman cameos. The beginning of the practice of collecting classical art in the fifteenth century had much

12-13 DONATELLO, *David*, c. 1430–32. Bronze, approx. 62″ high. Museo Nazionale, Florence.

[3] *Ibid.*, pp. 90–91.

12-14 DONATELLO, equestrian statue of Erasmo da Narni ("*Gattamelata*"), c. 1445–50. Bronze, approx. 11' × 13'. Piazza del Santo, Padua.

to do with the appearance of classicism in the humanistic art of the Renaissance.

For a time Donatello forgot his earlier realism under the spell of classical Rome, whose ruins and antiquities he studied at some length. His bronze statue of David (about 1430–32) is the first freestanding nude statue since ancient times, and here Donatello shows himself once more an innovator (FIG. 12-13). The nude as such had been proscribed in the Christian Middle Ages both as indecent and idolatrous, and was shown only rarely, and then only in biblical or moralizing contexts, like the Adam and Eve story or descriptions of sinners in hell. Donatello reinvented the classical type, even though in this case we have neither god nor athlete but the young David, slayer of Goliath, biblical ancestor and antitype of Christ, and symbol of the Florentine love of liberty. The classically proportioned nude, a balance of opposing axes, of tension and relaxation, recalls, and is perhaps derived from, Roman copies of Hellenic statues. Although the body has an almost Praxitelean radiance and a sensuous quality unknown to Medieval figures, David is

involved in a complex psychological drama unknown to antique sculpture. The glance of this youthful, still adolescent hero is not directed primarily toward the severed head of Goliath but toward his own graceful, sinuous body, as though, in consequence of his heroic deed, he were becoming conscious for the first time of its beauty, its vitality, and its strength. This self-awareness, this discovery of the self, is, as we have stressed, a dominant theme in Renaissance art.

In 1443 Donatello left Florence for Northern Italy to accept the rewarding commission of an equestrian statue of the Venetian *condottiere* Erasmo da Narni, called *Gattamelata* ("slick cat"), set up in the square of San Antonio, Padua (FIG. 12-14). With it Donatello recovered the Roman grandeur of the mounted leader as it existed in the great equestrian statue of Marcus Aurelius (FIG. 6-61), which he must have seen in Rome. The figure stands high upon a lofty, elliptical base to set it apart from its surroundings and becomes almost a celebration of the liberation of sculpture from architecture. Massive and majestic, the great horse bears the armored general easily; together they make an overwhelming image of irresistible strength and unlimited power. Next to the *Gattamelata*, a Medieval equestrian statue like the *Bamberg Rider* (FIG. 10-42), still attached to the wall, looks positively fragile, even ghostlike. The Italian rider, his face set in a mask of dauntless resolution and unshakable will, is the very portrait of the Renaissance individualist: a man of intelligence, courage, and ambition, frequently of humble origin, who by his own resourcefulness and on his own merits rises to a commanding position in the world.

Donatello's ten-year activity in Padua (he received additional commissions for statues and reliefs for the high altar of the church of San Antonio) made a deep and lasting impression on the artists of the region and contributed materially to the formation of a Renaissance style in Northern Italy. After his return to Florence in 1453, Donatello's style changes once more. His last period is marked by an intensely personal kind of expression, in which his earlier realism returns but with purposeful exaggeration and distortion. He turns away from the beauty and grandeur of the classical to a kind of expressionism that seems deliberately calculated to jar

the sensibilities; he gives us the ugly, the painful and the violent. He may in his last years have felt religious remorse for such works as the *David* and may have set about to achieve a kind of antiesthetic manner, well exemplified in his *Mary Magdalene* (FIG. 12-15). The repentant saint in old age, after years of wasting mortification, stands emaciated, hands clasped in prayer. Donatello, in what appears to be a rekindling of Medieval piety, here rejects the body as merely the mortal shell of the immortal soul. The beautiful woman has withered, but her soul has been saved by her denial of physical beauty. Donatello's originality, independence, and insight into the meaning of religious experience are asserted here as he reinterprets Medieval material in his own terms. But Medieval as the *Magdalene* might first appear, we realize that it was carved by the man who made the *David*, and Donatello appears as we first described him, a man with the vast versatility that distinguishes the great artist from the good artist.

Architecture

FILIPPO BRUNELLESCHI (1377–1446) was one of the unsuccessful competitors for the commission to do the doors of the Baptistry of Florence in 1401. He was trained as a goldsmith, but his ability as a sculptor must have been well known at that time. Although his biographer, Manetti, tells us that Filippo turned to architecture out of disappointment over the loss of the Baptistry commission, he continued to work as a sculptor for several years and received commissions for sculpture as late as 1416. In the meantime, however, his interest did turn more and more toward architecture, spurred by several trips to Rome (the first in 1402, probably together with his friend Donatello), where he too was captivated by the Roman ruins. It may well be that it was in connection with his close study of Roman monuments and his effort to record accurately what he saw that he developed the revolutionary system of geometric, linear perspective that was so eagerly adopted by fifteenth-century artists.

Brunelleschi's knowledge of Roman construction principles combined with an analytical and inventive mind permitted him to solve an en-

12-15 DONATELLO, *Mary Magdalene, c.* 1454–55. Wood, approx. 6′ 2″ high. Baptistry, Florence Cathedral.

gineering problem that no other man of the fifteenth century could have solved—the design and construction of a dome for the huge crossing of the unfinished cathedral of Florence (FIGS. 12-16 and 10-46). The problem was staggering, since the space to be spanned was 140 feet wide, much too large to permit construction with the aid of traditional wooden centering. Nor was it possible, because of the plan of the crossing, to support the dome with buttressed walls. Brunelleschi seems to have begun work on the problem about 1417; he was awarded the commission in 1420 after another competition in which he met, but this time defeated, Ghiberti. With exceptional ingenuity Brunelleschi not only discarded traditional building methods and devised new ones but also invented much of the machinery that

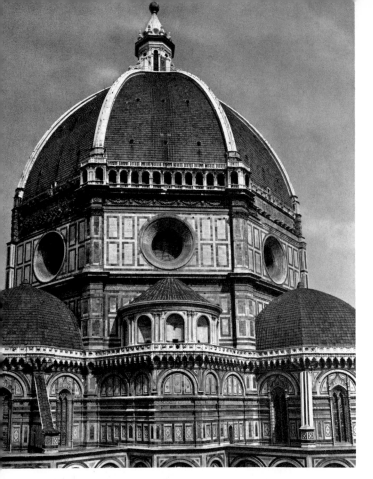

12-16 FILIPPO BRUNELLESCHI, dome of
Florence Cathedral, 1420–36.

was necessary for the job. Although he might
have preferred the hemispherical shape of Roman
domes, Brunelleschi raised the center of his dome
and designed it around an ogival section, which
is inherently more stable, as it reduces the out-
ward thrust around the dome's base. To reduce
the weight of the structure to a minimum, he
designed a relatively thin double shell (the first
in history) around a skeleton of twenty-four ribs,
of which the eight major ones are visible on the
exterior. Finally, in almost paradoxical fashion,
he anchored the structure at the top with a
heavy lantern (built according to his design, but
after his death). This lantern, although adding
to the weight of the dome, has the curious effect
of stabilizing the entire structure, since without
the pressure of its weight the ribs had a tendency
to tilt outward from the center, spreading at the
top.

Although the dome of the cathedral of Florence
is Brunelleschi's most outstanding engineering
achievement, and although he knew of and
admired Roman building techniques, the solu-
tion to this most critical structural problem
was arrived at by the first acknowledged Renais-
sance architect through what were essentially
Gothic building principles. Thus, the dome does
not really express Brunelleschi's own architec-
tural style, which is shown for the first time in a
building that he began shortly before he accepted

12-17 FILIPPO BRUNELLESCHI, façade of the
Ospedale degli Innocenti, Florence, 1419–24.

the commission for the dome, the Ospedale degli Innocenti (Foundling Hospital) in Florence (FIG. 12-17). The basic element of its design—a series of round arches supported by slender columns and framed by pilasters that carry a flat, horizontal entablature—appears to have been inspired either by the church of San Miniato (FIG. 9-19) or by the Baptistry of Florence, both Romanesque buildings. The latter was mistakenly believed to be a Roman temple in Brunelleschi's time. Even if Brunelleschi knew better, he may well have mistaken it for an early Christian building of the fourth or fifth century, a style he associated closely with classical Roman architecture and that had just as much authority for him. But the hospital expresses a style quite different from that of its possible Medieval prototypes. The stress on horizontals, the clarity of the articulation, the symmetry of its design combined with the use of such classical elements as Corinthian capitals and pilasters, as well as windows topped by pediments—all these combine to create an impression of rationality and logic that, in spirit at least, relates the Ospedale degli Innocenti more to classical than to Medieval architecture.

The same clarity of statement is to be found in the two basilican churches that Brunelleschi built in Florence—San Lorenzo and Santo Spirito. Of the two, Santo Spirito is the later and shows the architect's mature style (FIGS. 12-18 and 12-19).

12-18 FILIPPO BRUNELLESCHI, interior of Santo Spirito, Florence, begun 1428.

12-19 FILIPPO BRUNELLESCHI, early plan of Santo Spirito (left), and plan as constructed (right).

FEET
0 50 100

439

Begun in 1428 and completed, with some changes, after Brunelleschi's death, the cruciform building is laid out on the basis of either multiples or segments of the dome-covered crossing square in a manner that is reminiscent of Romanesque planning. But this segmentation is not reflected in the nave, which is a continuous, unbroken space in the tradition of Early Christian basilicas. The aisles, subdivided into small, domically vaulted squares, run all the way around the flat-roofed central space and have the visual effect of compressing the longitudinal design into a centralized one, since the various aspects of the interior resemble each other, no matter where the observer stands. Originally, this effect of centralization would have been even stronger, as Brunelleschi had planned to extend the aisles across the front of the nave as well, as is shown on the plan (FIG. 12-19). Because of the modular basis of the design, this would have demanded four instead of the traditional three entrances in the façade of the building, a feature that was hotly debated during Brunelleschi's lifetime and changed after his death. Also changed was the appearance of the exterior walls, when the recesses between the projecting semicircular chapels were filled in to convert an originally highly plastic wall surface into a flat one. The major features of the interior, however, are much as Brunelleschi had designed them. Compared with those of the Ospedale degli Innocenti, the forms have gained in volume: The moldings project more boldly, and the proportions of the columns more closely approach the classical ideal. Throughout the building, proportions of 1:2 have been used with great consistency: The nave is twice as high as it is wide; arcade and clerestory are of equal height, which means that the height of the arcade equals the width of the nave; and so on. These basic facts about the building have been delineated for the observer by crisp articulations so that they can be read like mathematical equations. The cool logic of the design may lack some of the warmth of Medieval buildings, but it fully expresses the new Renaissance spirit that places its faith in reason rather than the emotions.

Brunelleschi's evident effort to impart a centralized effect to the interior of Santo Spirito suggests that he was intrigued by the compact and self-contained qualities of earlier central-plan buildings such as the Pantheon and Medieval baptistries. His Old Sacristy, built onto the left transept of San Lorenzo, expresses his admiration of the central type. He nearly realized his ideal with his Pazzi Chapel (FIGS. 12-20 to 12-22), which was begun around 1440 and completed in the 1460's, long after his death. The exterior probably does not reflect Brunelleschi's original design, as the narthex, admirable as it is, seems to have been added as an afterthought, perhaps by sculptor-architect Giuliano da Maiano. Behind this narthex stands the first independent building of the Renaissance to be conceived basically as a central-plan structure. Although the plan is rectangular rather than square or round, all emphasis has been placed on the central, dome-covered space; the short barrel-vault sections that brace the dome on two sides appear to be no more than incidental appendages. The articulation of the interior, with dark pilasters on light walls, reflects a subtle and sophisticated system of modular relationships in both plan and elevation and creates a tight network of geometrical patterns that ties all parts of the building together and enhances the effect of compact self-sufficiency.

If Brunelleschi only approximated the central plan in the Pazzi Chapel, he was about to give it

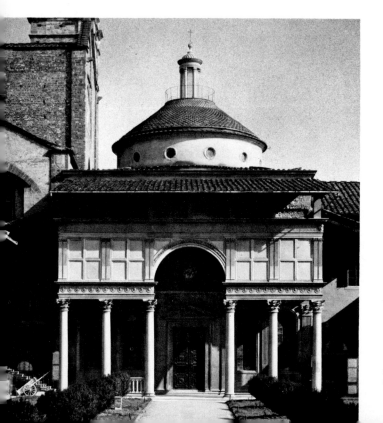

12-20 FILIPPO BRUNELLESCHI, Pazzi Chapel, begun c. 1440. Santa Croce, Florence.

1434	c. 1440	c.1445	c.1455	1464	1468	1469	1474	c.1483	1492
BRUNELLESCHI Pazzi Chapel begun		DONATELLO "Gattamelata"	DELLA FRANCESCA San Francesco frescoes, Arezzo	Gutenberg dies		MANTEGNA Camera degli sposi		VERROCCHIO Bartolomeo Colleoni	
COSIMO DE' MEDICI				PIERO DE' MEDICI	LORENZO DE' MEDICI				

full realization in Santa Maria degli Angeli (FIG. 12-23). Begun in 1434, the project was abandoned, unfinished, in 1437. The plan shows a central octagon, the corner piers of which were undoubtedly intended to carry a dome. Around this core are arranged eight identical chapels (one was to have served as entrance) that are seemingly carved out of the massive masonry that surrounds them. The plastic handling of both exterior and interior wall surfaces recaptures the ancient Roman "sculptured" wall principle and was so far ahead of its time that it was not used again until the very end of the fifteenth century. Alberti must have seen the unfinished building and may well have had it in mind when he praised the central plan in his treatise and implanted a taste for it in generations of later architects.

It seems curious that Brunelleschi, the most renowned architect of his time, did not participate in the upsurge of palace-building that Florence experienced in the late thirties and forties and that testified to the soundness of the Florentine economy and the affluence and confidence of its leading citizens. His one effort in this field ended fruitlessly with a rejected model for a new palace that Cosimo de' Medici intended to build. Cosimo evidently felt that Brunelleschi's project was too imposing and ostentatious to be politically wise. Instead he awarded the commission to MICHE-LOZZO DI BARTOLOMMEO (1396–1472), a younger architect who had been Donatello's collaborator in several sculptural enterprises. Michelozzo's architectural style was deeply influenced by Brunelleschi, and, to a limited extent, the Palazzo Medici-Riccardi may reflect Brunelleschian principles (FIG. 12-24). Built for the Medici and later bought by the Riccardi family, who almost doubled the length of the façade in the eighteenth century, it is a simple, massive structure whose strength is accentuated by the use of heavy rustication on the ground floor. Essentially a geometric block, the building is divided into

12-21 FILIPPO BRUNELLESCHI, plan of Pazzi Chapel.

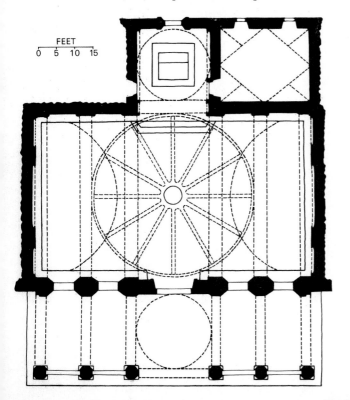

12-22 FILIPPO BRUNELLESCHI, interior of Pazzi Chapel.

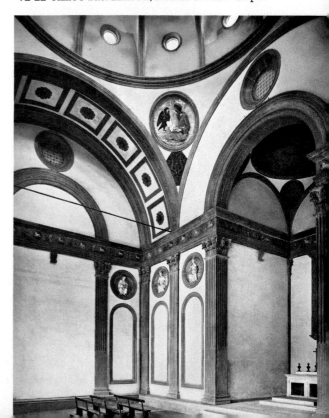

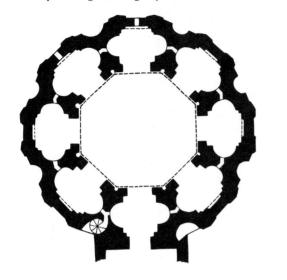

12-23 Plan of Santa Maria degli Angeli, Florence, 1334–37. (After a sixteenth-century drawing of a design by Brunelleschi.)

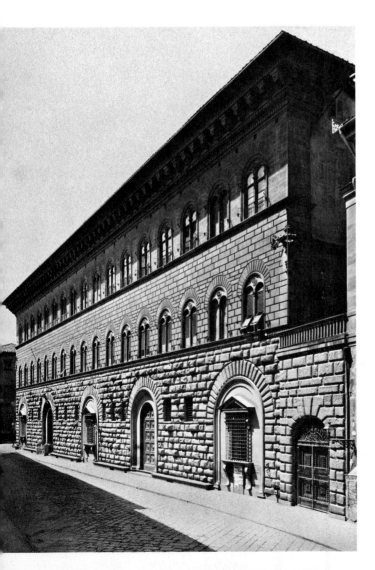

stories of decreasing height by long, unbroken horizontal bands (stringcourses), which give it articulation and coherence. In the upper stories the severity of the ground floor is modified by dressed stone, which presents a smoother surface with each successive story, so that the building appears progressively lighter as the eye moves upward. This effect is dramatically reversed by the extremely heavy, classicizing cornice, which Michelozzo related not to the top story but to the building as a whole. It is a very effective lid for the structure, clearly and emphatically defining its proportions. The palace is built around an open, colonnaded court that most clearly shows Michelozzo's debt to Brunelleschi (FIG. 12-25). The round-arched colonnade, although more massive in its proportions, closely resembles that of the Ospedale degli Innocenti; however, Michelozzo's failure to frame each row of arches with piers and pilasters, as Brunelleschi might have, causes the structure to look rather weak at the angles. Nevertheless, this *cortile* was the first of its kind and was to have a long line of descendants in Renaissance domestic architecture.

Painting

The youngest of the three leading innovators of the early fifteenth century, with Donatello and Brunelleschi, was the painter MASACCIO (1401–28). To understand the almost startling nature of his innovations we should look again at the International style in painting and note that it was the dominant style around 1400 and that it persisted well into the fifteenth century, side by side with the grand new style of Masaccio and his followers. GENTILE DA FABRIANO (about 1370–1427), who was working in Florence at the same time as Masaccio, produced what may be the masterpiece of the International style, the *Adoration of the Magi* (PLATE 12-1). The painter's purpose here is to create a gorgeous surface, spreading across it scores of sumptuously costumed kings, courtiers, captains, and retainers accompanied by a menagerie of exotic and ornamental animals— all in a rainbow of color with much display of gold. We have all the pomp and ceremony of

12-24 MICHELOZZO, Palazzo Medici-Riccardi, Florence, begun 1444.

chivalric etiquette, a picture that proclaims the sanctification of aristocracy in the presence of the Madonna and Child. But there is little basic difference between Gentile's stylistic apparatus and what had been used in the century following the junction of Gothic and Sienese painting.

Masaccio changed everything. Although his presumed teacher, Masolino, had worked in the International style, Masaccio moved suddenly, within the short span of only six years, into wide-open, unexplored territory. No other painter in history is known to have contributed so much to the development of a new style in so short a time as Masaccio, whose creative career was so short and whose death at twenty-seven so untimely. Masaccio is the artistic descendant of Giotto, whose calm, monumental style he revolutionizes by a whole new repertory of representational devices that generations of Renaissance painters would study and develop. He also knew and fully understood the innovations of his great contemporaries Donatello and Brunelleschi and introduced into painting new possibilities both for form and content.

We can see his breakthrough best in his frescoes in the Brancacci Chapel of Santa Maria del Carmine in Florence. In the *Tribute Money* (FIG. 12-26), painted shortly before his death, Masaccio groups three episodes: In the center, Christ, surrounded by his disciples, tells St. Peter that in the mouth of a fish he will find a coin to pay the imperial tax demanded by the collector who stands in the foreground, his back to the spectator. At the left, in the middle distance, St. Peter struggles to extract the coin from the fish's mouth, while at the right, with a disdainful

12-25 MICHELOZZO, court of the Palazzo Medici-Riccardi.

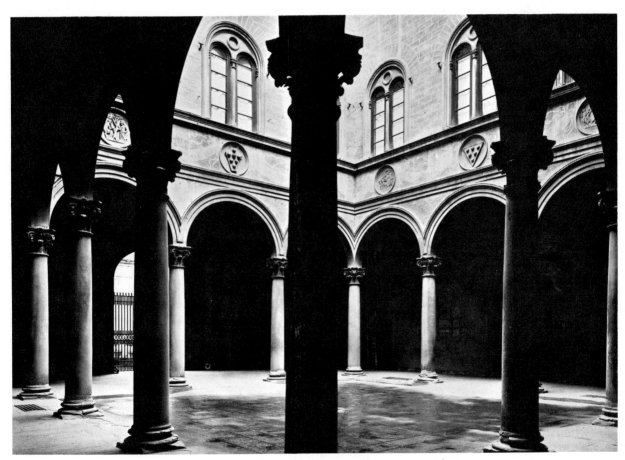

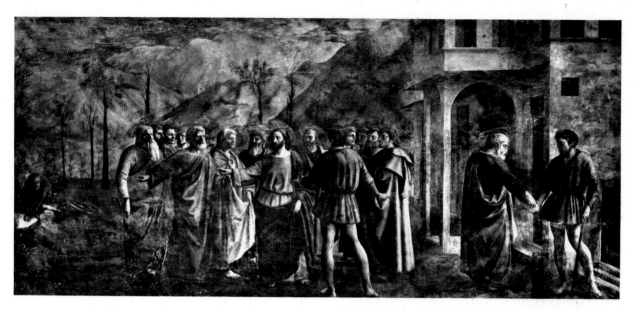

12-26 MASACCIO, *The Tribute Money*, fresco, *c.* 1427. Brancacci Chapel, Santa Maria del Carmine, Florence.

gesture of great finality, he thrusts the coin into the tax-collector's hand. Masaccio's figures recall Giotto's in their simple grandeur, but they stand before us with a psychological and moral self-realization that is entirely new. The bulk of the figures is realized not through generalized modeling with a flat, neutral light without identifiable source, as in Giotto, but by means of a light that comes from a specific source outside the picture, striking the figures at an angle, illuminating the parts of the solids that obstruct its path and leaving the rest in deep shadow. This placing of light against strong dark gives the illusion of deep, sculptural relief. Between the extremes of light and dark, the light is a constantly active but fluctuating force, independent of the figures, and almost a tangible substance. As Masaccio and Donatello's generation learn the separation of body and drapery, and the functional interrelation of them as independent fabrics, so light, which in Giotto is merely the modeling of a mass, in Masaccio comes to have its own nature, and the masses we see are visible only because of the direction and intensity of the light. We imagine the light as playing over forms, revealing some, concealing others as the artist directs it. In the creation of a space filled with atmosphere, Masac-

cio anticipated the achievements of the High Renaissance; no painter between Masaccio and Leonardo da Vinci created with so much realism the illusion of space as a substance of light and air existing between our eyes and what we see.

The individual figures in the *Tribute Money* are solemn and weighty, but they also express bodily structure and function as do Donatello's statues. We feel bones, muscles, and the pressures and tensions of joints; each figure conveys a maximum of contained energy. Both the stately stillness of Nanni di Banco's *Quattro Santi Coronati* and the weight-shifting figures of Donatello are here. The figure of Christ and the two appearances of the tax-collector make us understand what the biographer Vasari meant when he said: "Masaccio made his figures stand upon their feet."

Another important invention, for so we might call it, is the arrangement of the figures. No longer are they a stiff screen in the front planes; here they are grouped in circular depth around Christ, the whole group shown in a spacious landscape rather than in the confined stage space of Giotto's frescoes. The foreground space is generated by the group itself, as well as by the architecture on the right, shown in a one-point perspective construction in which the location

of the vanishing point coincides with the head of Christ. The foreground is united with the distance by aerial perspective, which employs the diminution in light, the shift toward blue, and the blurring of outlines that come with distance. This device, used by Roman painters, was forgotten during the Middle Ages and rediscovered, apparently independently, by Masaccio. Masaccio realized that light and air interposed between ourselves and what we see are part of the visual experience we call "distance." With this knowledge the world as given to ordinary sight can become for the painter the vast pictorial stage of human action.

In an awkwardly narrow panel Masaccio painted the theme, already seen in Jacopo della Quercia's later relief, of the Expulsion from Eden (FIG. 12-27). The representational innovations are all present: the sharply slanted light from an outside source creating deep relief by placing lights and darks side by side, and acting as a strong unifying agent; the structurally correct motion of the figures; their bodily weight and substantial contact with the ground; the hazed, atmospheric background that gives no locale but suggests a space around and beyond the figures. Masaccio's *Expulsion* is one of the supreme masterpieces of Renaissance art and an interpretation of the tragic scene of man's fall perhaps unsurpassed even by Michelangelo's Sistine Chapel ceiling. Adam's feet clearly in contact with the ground mark man's presence on earth, and the cry that issues from Eve's mouth voices the anguish of men deprived of God. Adam and Eve do not resist; there is no physical contact with the angel, nor are the figures crowded against the frame. Rather they stumble on blindly, driven by the will of the angel and their own despair. The composition is starkly simple, its message incomparably eloquent.

In the fresco of the Trinity in Santa Maria Novella (FIG. 12-28), the dating of which is still in dispute, Masaccio gives a brilliant demonstration of the organizing value of Brunelleschi's perspective. He paints a square chapel covered with a coffered barrel vault (the source and meaning of the chapel type are still debated). He places the vanishing point of the perspective construction at the level of the viewer's eye (about five feet from the ground and near the painting's lower

edge), thereby creating the illusion of an actual structure whose interior volume is an extension of the space in which the spectator is standing. This adjustment of the spectator to the pictured space is a first step in the development of illusionistic painting, which so fascinated many artists of the Renaissance and the later Baroque period. Masaccio has been so exact in his metrical proportions that we can actually calculate the numerical dimensions of the chapel; for example, the span of the painted vault is seven feet, and the depth of the chapel, nine. Thus, he achieves not only successful illusion, but a rational metrical coherence, which by maintaining the mathematical proportions of the surface design is responsible for the unity and harmony of this monumental composition. The *Trinity*, standing at the very beginning of the history of Renaissance painting, sums up two principal interests: realism based on

12-27 MASACCIO, *The Expulsion from Eden*, fresco, c. 1425. Brancacci Chapel, Santa Maria del Carmine, Florence.

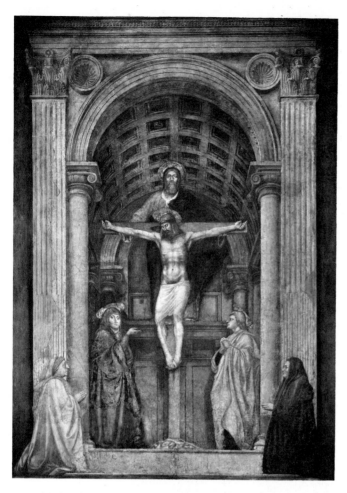

12-28 Masaccio, *The Holy Trinity*, fresco, 1428 (?). Santa Maria Novella, Florence.

observation and the application of mathematics to pictorial organization.

Masaccio's discoveries, like those of Donatello, led to further experiments by his contemporaries and successors, who tended to specialize in one or another of the branches of pictorial science that he founded. Paolo Uccello (1397–1475), a Florentine painter trained in the International style, discovered perspective well along in his career and became obsessed with it, though he was not very successful in harmonizing the old and the new. In his *Battle of San Romano* (fig. 12-29), a large panel painted for the Palazzo Medici, he creates a fantasy that recalls the processional splendor of Gentile da Fabriano's *Adoration of the Magi* (plate 12-1). But the imaginary world of Uccello, in contrast to the surface decoration of

the International style, is constructed of immobilized solid forms—broken spears and lances and a fallen soldier—foreshortened and carefully placed along the converging orthogonals of the perspective to create a base plane like a checker board, on which the volumes could then be placed in measured intervals. All this works very well as far back as the middle ground, where the horizontal plane is met abruptly by the uptilted plane of an International style background. But beyond that, Uccello's sense of design is impeccable. The rendering of three-dimensional form, used by other painters for representational or expressive purposes, became for Uccello a preoccupation; for him it had a magic of its own, which he exploited to satisfy his amazingly inventive and original imagination. His fascination with perspective had little in common with the rationality in Masaccio's concern for defining the dimensionality of space. Uccello's was an irrational passion for arranging the forms of solid geometry in space, and it is perhaps not surprising that he became one of the favorite masters of the cubists of the early twentieth century.

Andrea del Castagno (about 1423–57) interested himself both in perspective and in the representation of imposing, strong, structurally convincing human figures. In his *Last Supper*, painted in the late 1440's and covering a wall of the refectory of the convent of Sant' Apollonia in Florence, we see a severity and clarity of form characteristic of this phase of Florentine painting (fig. 12-30). Christ and the disciples, with Judas isolated at the front of the table in the traditional manner, are painted as static, sculptural solids. Castagno here has the problem of setting his figures within a space so arranged as to give—as in Masaccio's *Trinity*—the illusion that the space of the observer is continuous with that of the marble-paneled alcove where the principals are sitting. But the perspective construction is so strict that it serves rather to limit action; its rigid frame stiffens the figures it controls, and it will not be until Leonardo's famous version of this theme, painted at the end of the century, that the architectural setting will serve the action rather than constrict it.

Castagno is seen at his best in his group of figures of famous people painted in the Villa Pandolfini near Florence around 1450, and now

transferred to the Castagno Museum in Sant' Apollonia. One of them, a portrait of the general "Pippo Spano" (FIG. 12-31) is the very image of the swaggering commander, his feet firmly planted, "powerful among peers," and bristling with insolent challenge. The figure is meant to be seen as standing in a loggia, the space of which is continuous with that of the spectator. The illusion is reinforced by the heavy, armored, foreshortened foot that seems to protrude over a sill of the opening. If Masaccio first "made his figures stand upon their feet," then Castagno followed him faithfully and made the point more emphatically in this splendid figure so alive with truculent energy. And by having parts of his figure appear to project into the space of the viewer, Castagno takes a step beyond Masaccio's *Holy Trinity* in the direction of Baroque illusionism.

Castagno's sometime collaborator, DOMENICO VENEZIANO (about 1420–61), was born and trained in Venice, but settled in Florence in the late thirties. Vasari tells us that Castagno killed Veneziano in a fit of jealous rage by hitting him with

an iron bar; in fact, Andrea fell victim to the plague some four years before Veneziano died. Vasari also claims that Veneziano introduced the mixed-oil technique to Florence, but the artist himself seems to have painted in the traditional tempera. Although he fully assimilated Florentine forms, Veneziano retained some International-style traits that he may have acquired from northern painters active in Venice. He may also have brought from Venice his sensitivity to color and outdoor light, which goes well beyond that of his Florentine contemporaries; it is in this field that he made his major contribution to Florentine art of the mid-century. His *St. Lucy Altarpiece* (PLATE 12-2) is one of the earliest examples of a so-called *sacra conversazione* (holy conversation), in which the saints seem to be conversing either with each other or with the audience, a type of painting that was to enjoy great popularity from this time on. The clarity and precision of the architectural setting, the individualization and the weight and solemn dignity of the figures show Veneziano to be a

12-29 PAOLO UCCELLO, *The Battle of San Romano, c.* 1455. Tempera on wood panel, approx. 6′ × 10′ 5″. Reproduced by courtesy of the Trustees of the National Gallery, London.

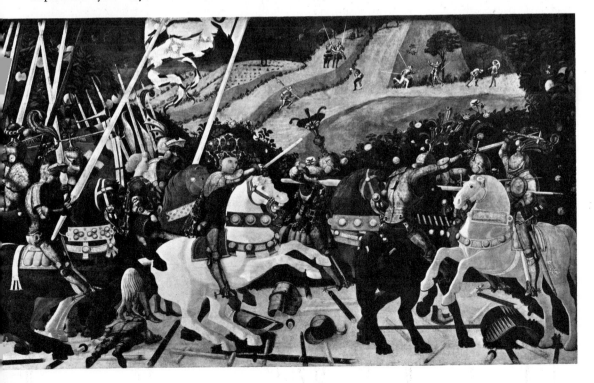

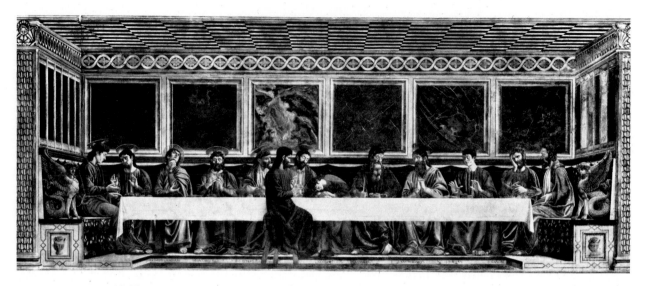

12-30 ANDREA DEL CASTAGNO, *The Last Supper*, fresco, c. 1445–50. Sant' Apollonia, Florence.

worthy heir to Masaccio and Donatello. The composition recalls Nanni di Banco's *Quattro Santi Coronati*; the vaulted niche, however, has here been converted into an airy loggia open to the sky and flooded with bright, outdoor light. The brilliant local colors and ornate surfaces of the International style are muted by this directed light, which falls into the loggia from the upper right and bathes the scene with atmospheric luminosity. Reflected from the architecture, it lightens the shadows, and the modeling of the figures becomes less harsh than in Masaccio, to whom effects of relief had been more important than those of color. The resultant blonde overall tonality is characteristic of Veneziano's paintings and those of his followers.

Veneziano's most important disciple and his assistant in Florence during the early forties was PIERO DELLA FRANCESCA (about 1420–92). Piero's art is the projection of a mind cultivated by mathematics and convinced that the highest beauty is found in those forms that have the clarity and purity of geometrical figures. A skilled geometrician, he wrote the first theoretical treatise on systematic perspective toward the end of his long career after having practiced the art with supreme mastery for almost a lifetime. It is likely that his association with the architect Alberti (see below) at Ferrara and at Rimini around 1450–51 turned his attention fully to perspective—in which science Alberti was an

12-31 ANDREA DEL CASTAGNO, *Pippo Spano*, fresco, c. 1448. Sant' Apollonia, Florence.

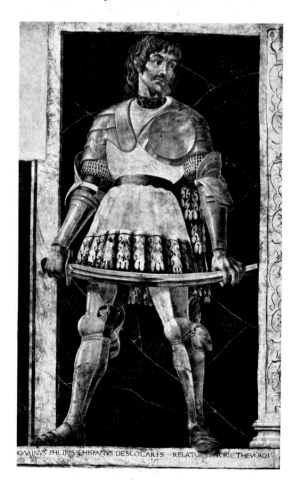

12-32 Piero della Francesca, *Annunciation*, fresco, *c.* 1455. San Francesco, Arezzo.

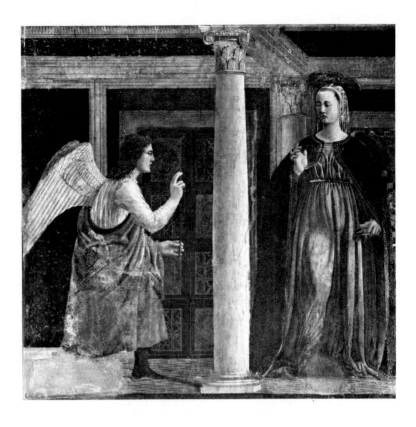

influential pioneer—and helped determine his later, characteristically architectonic compositions. One can fairly say that Piero's compositions are determined almost entirely by his sense for the exact and lucid structures that mathematics defines. Within this context he developed Veneziano's sophistication in the handling of light and color so that color became the matrix of his three-dimensional forms, lending them a new density as well as fusing them with the surrounding space.

Piero's most important work is the fresco cycle in the apse of the church of San Francesco in Arezzo, which represents ten episodes from the legend of the True Cross (the cross upon which Christ died). Painted between 1452 and 1456, the cycle is based on a thirteenth-century popularization of the Scriptures, the *Golden Legend* by Jacopo da Voragine. The *Annunciation* from this cycle (FIG. 12-32) perhaps best illustrates Piero's manner. One of the problems that occupied him all his life was how to establish a convincing architectonic relationship between animate and inanimate objects. The key to his solution in

this painting is the conspicuously placed column that divides the lower part of the depicted space into two vertical, cubic sections. The cylindrical shape of the column is echoed in the simplified, solemn, and immobile form of the Virgin. To make his figures conform to the static quality of the architecture that surrounds them, Piero reduces all action and gestures to the slowest, simplest signals; all emotion is banished. The composition is essentially a cylinder inscribed in a cubic void, and this geometricality of the forms confers a trancelike and abstract quality on the depiction of the event.

In the climactic scene, the *Finding and Proving of the True Cross* (FIG. 12-33), St. Helena, mother of Constantine, accompanied by her retinue, witnesses how the True Cross miraculously restores a dead man (the nude figure) to life. The grouping of the figures is controlled by the architectural background; its medallions, arches, and rectangular panels are the two-dimensional counterparts of the ovoid, cylindrical, and cubic forms placed in front of it. One feels the careful planning behind the placement of each shape and

volume; it is almost the procedure of an architect, certainly that of a man entirely familiar with compass and straight-edge. As the architectonics of the abstract shapes controls the grouping, so, as in the *Annunciation*, does it impart a mood of solemn stillness to the figures, a quiet rapture shown by unindividualized and emotionless faces, the slow gestures like those of a priest's at an altar. The concourse of all these solid forms yet yields an impression of an otherworldly, mystic, and eternally celebrated rite that knows nothing of the passing facts and accidents of this world. We see a union of the unchanging mathematical form with the calm silences of the contemplative spirit.

In addition, of course, Piero's work shows an unflagging interest in the properties of light and color; he suspects that one is the function of the other. He observes that colors turn cool (bluish) in shadow and that they lose intensity with increasing distance from the observer. In his effort to make the clearest possible distinction between forms, he floods his pictures with light, imparting a silver-blue tonality. To avoid heavy shadows, he illumines the dark sides of his forms with reflected light. By moving the darkest tones of his modeling toward the centers of his volumes, he separates them from their backgrounds. As a result Piero's paintings lack some of Masaccio's relieflike qualities but gain in spatial clarity as each shape becomes an independent unit, surrounded by an atmospheric envelope and movable to any desired position, like men on a chessboard.

The *Resurrection*, in the town hall of Borgo San Sepolcro (FIG. 12-34) introduces a compositional device that was to enjoy great favor with later Renaissance artists—the figure triangle. In order to stabilize his composition, Piero arranges his figures in a group that can be circumscribed by a triangle placed centrally in the painting. In this case, the figure of the risen Christ, standing with columnar strength and in the attitude of eternal triumph at the edge of the sepulcher, occupies the upper portion of a triangular arrangement that rests on the broad base of the sleeping soldiers in the foreground. This triangular massing of volumes around a picture's central axis gives a painting great compositional stability and is one of the keys to the symmetry and self-sufficiency

that Renaissance artists strove for in their work.

Portraits by Piero of the Duke and Duchess of Urbino reveal that the artist was at home with realism and could paint exact and unflattering likenesses of human subjects, quite unlike the generalized heads and features of his customary type. Piero's work summarizes most of the stylistic and scientific developments in painting during the first half of the fifteenth century: realism, descriptive landscape, the structural human figure, monumental composition, perspective, proportionality, and light and color.

But there were other good artists active during this period whose style remains rooted in that of an earlier age and whose interest in the new tendencies remained marginal. One such artist was the Dominican painter-monk FRA ANGELICO (about 1387–1455), who was conservative by both training and inclination. Although he was fully aware of what was being done by his more experimentally inclined contemporaries, he adopted only those innovations he could incorporate without friction into his essentially conservative style. While accepting realistic details in anatomy, drapery, perspective, and architecture, he rejected Masaccio's heavy modeling, which would have dulled his bright Gothic coloring. In the *Annunciation* (FIG. 12-35), one of numerous frescoes with which Fra Angelico decorated the Dominican convent of San Marco in Florence between 1435 and 1445, the Brunelleschian loggia is neatly designed according to the rules of linear perspective; but the fact that the vault was too low to allow the figures to stand would have been unacceptable to a Piero della Francesca. However, such considerations were secondary to Fra Angelico; what he wanted above all was to stress the religious content of his paintings, and he did so by using the means, past and present, that he felt were most appropriate. In our example, the simplicity of the statement recalls Giotto, as does the form of the kneeling, rainbow-winged angel; the elegant silhouette of the sweetly shy Madonna descends from Sienese art, and the flower-carpeted enclosed garden (symbolic of the virginity of Mary) is a bit of International Gothic. But all these elements have been combined with lyrical feeling and a great sense for decorative effect, so that nothing seems incongruous. Like most of Fra Angelico's works, this painting has a

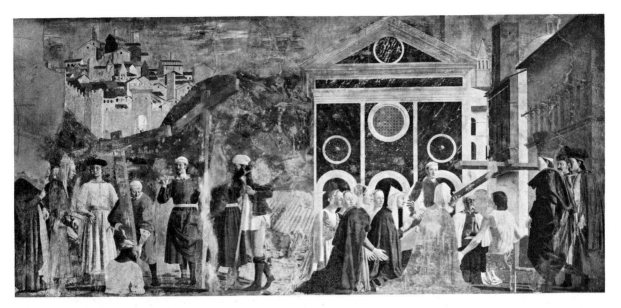

12-33 PIERO DELLA FRANCESCA, *The Finding and Proving of the True Cross*, fresco, *c.* 1455. San Francesco, Arezzo.

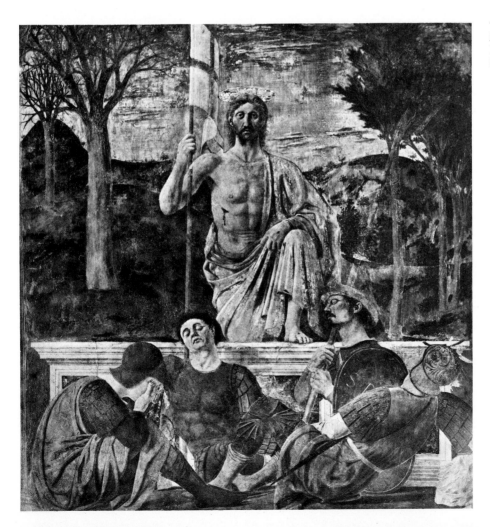

12-34 PIERO DELLA FRANCESCA, *Resurrection*, fresco, *c.* 1463. Palazzo Comunale, Borgo San Sepolcro.

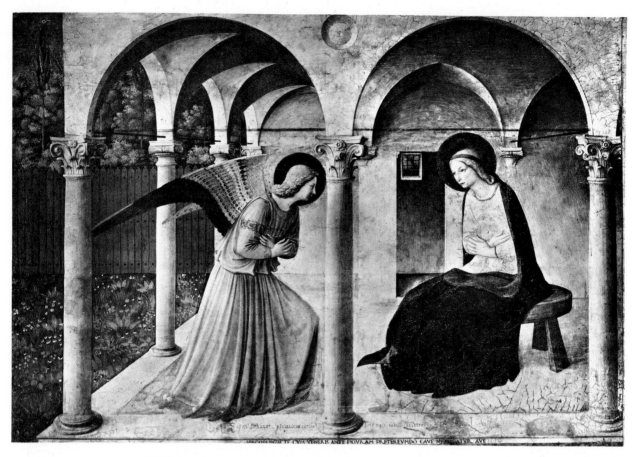

12-35 Fra Angelico, *Annunciation*, fresco, *c.* 1440–45. San Marco, Florence.

naive and tender charm that had, and perhaps still has, an almost universal appeal and fully reflects the character of the artist, who, as Vasari tells us, "was a simple and most holy man . . . most gentle and temperate, living chastely, removed from the cares of the world . . . humble and modest in all his works."

A strong, though perhaps somewhat unlikely contributor to the pictorial humanization of religious subject matter was FRA FILIPPO LIPPI (about 1406–69). Like Fra Angelico, Fra Filippo was a monk, but there all resemblance ends. From reports he seems to have been a kind of amiable scapegrace, quite unfitted for monastic life, who indulged in misdemeanors ranging from forgery and embezzlement to the abduction of a pretty nun, Lucretia, who became his mistress and the mother of his son, the painter Filippino Lippi. Only the Medici's intervention

on his behalf at the papal court preserved him from severe punishment and total disgrace, and he was, despite all, able to produce important and influential work. An orphan, Fra Filippo was raised in a monastery adjacent to the church of Santa Maria del Carmine, and, when about eighteen, he must have met Masaccio there and witnessed the decoration of the Brancacci Chapel. Fra Filippo's early work survives only in fragments, but these show that he tried to work with Masaccio's massive forms. Later, probably under the influence of Ghiberti's and Donatello's relief sculptures, he developed a linear style that emphasizes the contours of his figures and permits him to suggest movement through flying and swirling draperies. A fresh and inventive painting from Fra Filippo's later years, a Madonna and Child with angels (FIG. 12-36) shows his skill in manipulating line at its very best. Beyond

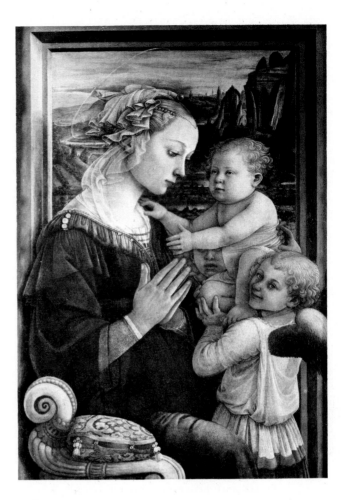

noting its color and modeling, we soon become aware of the wonderful flow of line throughout the picture, making precise yet smooth delineations of the forms, whether of the whole figures or of the details within them. Even without the reinforcing modeling, the forms would look three-dimensional and plastic, as the line is handled in a sculptural rather than in a two-dimensional sense. Fra Filippo's skill in the use of line is rarely surpassed; in the immediate future only his most famous pupil, Botticelli, will use it with greater subtlety.

Fra Filippo has interpreted his subject in a surprisingly worldly manner. The Madonna, a beautiful young mother, is not at all spiritual or fragile, and neither is her plump bambino, the child Christ, who is held up to her by two angels, one of whom turns toward us with the mischievous, puckish grimace of a boy refusing to be subdued by the pious occasion. Significantly, all figures reflect the use of models (that for the Madonna may even have been Lucretia). Fra Filippo plainly relishes the charm of youth and beauty as he finds it in this world; he prefers the real in landscape also, and the background, seen through the window, has, despite some exaggerations, recognizable features of the Arno river valley. Compared with the earlier Madonnas by Duccio and Giotto, this work shows how far the humanization of the theme has been carried. Whatever the ideals of spiritual perfection may have meant to artists in past centuries, those ideals are now realized in terms of the sensuous beauty of this world.

THE SECOND HALF OF THE CENTURY

In the early fifteenth century Florence led Italy in the development of the new humanism; later it shared its leadership. Under the sponsorship of local rulers, important cultural centers developed in other parts of Italy and began to attract artists and scholars: Urbino under the Montefeltri, Mantua under the Gonzaga, Milan under the Sforza, Naples under the kings of Aragon, and so forth.

This later period of humanism is marked by a new interest in the Italian language and literature, the beginnings of literary criticism (parallel to the development of theory in art and architecture), the foundation of academies (especially the Platonic Academy in Florence), and the introduction of the printing press—with all that that could mean for the dissemination of culture.

The conquest of Constantinople by the Turks in 1453 caused an exodus of Greek scholars, many of whom fled to Italy, bringing with them knowledge of ancient Greece to feed the avid interest in classical art, literature, and philosophy. That same conquest closed the Mediterranean to western shipping, making it necessary to find new routes to the markets of the East. Thus began the age of navigation, discovery, and exploration.

In art and architecture a theoretical foundation was now put under the more or less "intuitive" innovations of the earlier generation of artists. We must emphasize again the high value the Renaissance artist placed upon *theory*. In his view, if any occupation or profession were to have dignity and be worthy of honor, it must have an intellectual basis. This requirement we still recognize; a "scientific" pursuit wins utmost respect in our age, and for somewhat similar reasons the "fine" artist today is likely to consider his pursuit superior to that of the "commercial" artist. The Renaissance artist strove to make himself a scholar and a gentleman, to associate with princes and the learned, and to rise above the long-standing ancient and Medieval prejudice that saw him as merely a kind of handicraftsman.

Beginning with Alberti's treatises on painting and architecture, theoretical studies multiplied. For example, the rediscovered text of the ancient Roman architect and theoretician, Vitruvius, became the subject of exhaustive examinations and interpretations, partly because the text found was only a copy, which, unlike the original, was not illustrated. As a result, many passages that referred to illustrations were left obscure and, hence, subject to varying interpretations. Brunelleschi's invention of perspective and Alberti's and Piero's treatises on the subject provided the Renaissance artist the opportunity to demonstrate the scientific basis of the visual arts.

The genius and creative energy required to achieve the new social and intellectual status claimed by the artist were available in abundance. The ideal of *l'uomo universale*, mentioned in the introduction to Part Three, here finds its realization; indeed in LEON BATTISTA ALBERTI (1407–72) it finds one of its first personifications. Writing of himself in the third person, Alberti gives us a most revealing insight into the mind of the brilliant Renaissance man, his universal interests, broad capabilities, love of beauty, and hope of fame.

In everything suitable to one born free and educated liberally, he was so trained from boyhood that among the leading young men of his age he was considered by no means the last. For, assiduous in the science and skill of dealing with arms and horses and musical instruments, as well as in the pursuit of letters and the fine arts, he was devoted to the knowledge of the most strange and difficult things. And finally he embraced with zeal and forethought everything which pertained to fame. To omit the rest, he strove so hard to attain a name in modelling and painting that he wished to neglect nothing by which he might gain the approbation of good men. His genius was so versatile that you might almost judge all the fine arts to be his . . . He took extraordinary and peculiar pleasure in looking at things in which there was any mark of beauty . . . Whatever was done by man with genius and with a certain grace, he held to be almost divine[4]

It is probably no accident that this autobiography sounds like a funeral oration on a great man.

Architecture

Alberti scarcely mentions architecture as a prime interest. He entered the profession rather late in life, but today we know him chiefly as an architect. He was the first to study seriously the treatise of Vitruvius, and his knowledge of it, combined with his own archeological investigations, made him the first Renaissance architect to understand Roman architecture in depth. Alberti's most important and influential theoretical work, the *Ten Books on Architecture* (*De re aedificatoria*), although inspired by Vitruvius, contains much that is new and original material. For later architects, some of the treatise's most significant observations were those in which he advocated a system of ideal proportions, a central-type plan as the ideal Christian church, and avoidance of the column-arch combination (which had persisted from Spalato in the fourth century to Brunelleschi in the fifteenth) as incongruous. Alberti argues that the arch is a wall-opening that should be supported only by a section of wall (a pier) and not by an independent sculptural element (a column); though there are a few exceptions, the Medieval arcade is thus for the most part disposed of for centuries.

Alberti's own architectural style represents a scholarly application of classical elements to

4 In J. B. Ross and M. M. McLaughlin, *The Portable Renaissance Reader* (New York: Viking, 1953), pp. 480 ff.

contemporary buildings. His Palazzo Rucellai in Florence (FIG. 12-37) was begun two years later than the Palazzo Medici-Riccardi but was completed earlier, and it is quite possible that some of its elements, such as the heavy cornice, found their way into Michelozzo's building. However, the façade of the Palazzo Rucellai has been much more severely organized than the latter's. Each story has been articulated by flat pilasters, which support full entablatures. The rustication of the wall surfaces between the smooth pilasters is subdued and uniform, and the suggestion that the structure becomes lighter toward its top is made in an adaptation of the ancient Roman manner by using different articulating orders for each story: Tuscan (resembling the Doric order) for the ground floor, Composite (combining Ionic volutes with acanthus leaves of the Corinthian) for the second, and Corinthian for the third. What Alberti has done is to adapt the articulation of the Colosseum (FIG. 6-37) to a flat façade, which does not allow the deep penetration of the building's mass that is so effective in the Roman structure. By converting the plastic, engaged columns of the ancient model into shallow pilasters that barely project from the wall, Alberti has created a large-meshed, linear net that, stretched tightly across the front of his building, not only unifies its three levels but also emphasizes the flat, two-dimensional qualities of the wall.

The design for the façade of the Gothic church of Santa Maria Novella in Florence (FIG. 12-38) was also a Rucellai commission. Just as Brunelleschi had done occasionally, Alberti takes his cue from a pre-Gothic Medieval design—that of San Miniato (FIG. 9-18). Following his Romanesque model, he designs a small, pseudoclassical portico for the upper part of the façade and supports it with a broad base of pilaster-enframed arcades. But in the organization of these elements Alberti takes a long step beyond the Romanesque planners. The height of Santa Maria Novella (to the tip of the pediment) equals its width, so that the entire façade can be inscribed in a square. The upper structure, in turn, can be encased in a square one fourth the size of the main square;

12-38 Leon Battista Alberti, façade of Santa Maria Novella, Florence, begun c. 1456.

the cornice of the entablature that separates the two levels halves the major square so that the lower portion of the building becomes a rectangle that is twice as wide as it is high; and the areas outlined by the columns on the lower level are squares with sides that are about one third the width of the main unit. And so, throughout the façade, Alberti defines areas and relates them to each other in terms of proportions that can be expressed in simple numerical relations, like 1:1, 1:2, 1:3, 2:3, and so on. In his treatise, Alberti uses considerable space to propound the necessity of such harmonic relationships for the design of beautiful buildings. He shared this conviction with Brunelleschi, and it is this dependence upon mathematics, the belief in the eternal and universal validity of numerical ratios as beauty-producing agents, that most fundamentally distinguishes both from their predecessors.

At San Francesco in Rimini (FIG. 12-39), Alberti once more modernizes a Gothic church, in this case at the behest of one of the more sensational tyrants of the Early Renaissance, Sigismondo Pandolfo Malatesta, Lord of Rimini. Malatesta wanted a temple in which might be enshrined the bones of great humanist scholars like Gemisthus Plethon, who dreamed of a neopagan religion that would supersede Christianity and whose remains Malatesta had brought from

Greece. He intended his "temple" also to memorialize his mistress, Isotta. Alberti's thoroughly Roman design is a monument alike to the tyrant's love of classical learning and to his arrant paganism. Alberti redesigned the exterior shell of San Francesco, making a cubic structure, complete within itself, and fronting it with a façade like a Roman triumphal arch. Four massive engaged columns frame three recessed arches and carry a flat entablature that projects sharply, making a *ressaut*, or "jump," above each capital. Alberti intended the second story, which remains incomplete, to have an arched window framed by pilasters. The heavy relief of this façade contrasts with the flat bandlike elements in most of Alberti's other buildings. The deep, arched niches, rhythmically deployed along the flanks of the building and containing sarcophagi for the remains of famous men, are in keeping with Alberti's conviction that arches should be carried on piers, not columns. These, along with the elements of the façade, provide an effect of monumental scale and grandeur approaching that of ancient Roman architecture.

Adjustment of the classical orders to façade surfaces occupied Alberti throughout his career. In 1470, in his last years, he designed for the site of an eleventh-century church the church of Sant' Andrea in Mantua (FIGS. 12-40 to 12-42). In

12-39 Leon Battista Alberti, San Francesco, Rimini, begun 1450.

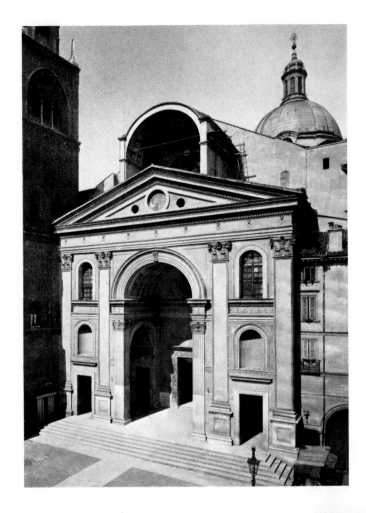

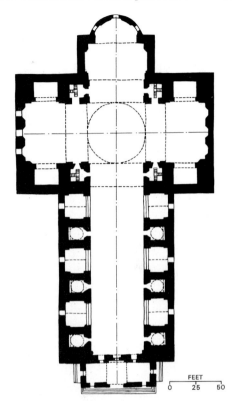

12-40 Leon Battista Alberti, façade of Sant' Andrea, Mantua, designed *c.* 1470.

12-41 Leon Battista Alberti, plan of Sant' Andrea.

FEET
0 25 50

the ingeniously planned façade, which shows the culmination of his experiments, he locks together two complete Roman architectural motifs, the temple front and the triumphal arch. His concern for proportion made him equalize the vertical and horizontal dimensions of the façade, which leaves it considerably lower than the rest of the church behind it. This concession to the demands of a purely visual proportionality in the façade and to the relation of the façade to the small square in front of it—even at the expense of continuity with the body of the building—is frequently manifest in Renaissance architecture, where considerations of visual appeal are of first importance. On the other hand, there *are* structural correspondences in Sant' Andrea: The façade pilasters are of the same height as those on the interior walls of the nave; the façade has the same width as the nave; and the central barrel

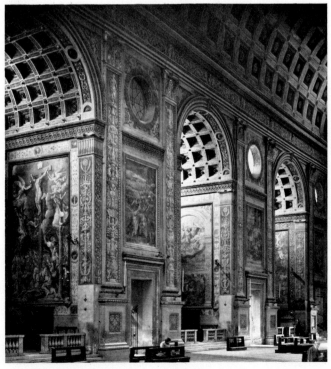

12-42 Leon Battista Alberti, interior of Sant' Andrea.

vault, from which smaller barrel vaults branch off at right angles, introduces (in proportional arrangement, though on a smaller scale) the system used on the interior. The façade pilasters, becoming part of the wall once more, run through three stories uninterruptedly, an early application of the "colossal" or "giant" order that was to become a favorite motif of Michelangelo.

The interior (FIG. 12-42) suggests that Alberti may have been inspired by the tremendous vaults of the ruined Basilica of Constantine (FIG. 6-67). The Medieval columned arcade, still used by Brunelleschi in Santo Spirito, is now forgotten, and the huge barrel vault—supported by thick walls alternating with vaulted chapels and interrupted by a massive dome over the crossing[5]—returns us to the vast interior spaces and dense enclosing masses of Roman architecture. In his treatise, Alberti calls impractical the traditional basilican plan, in which continuous aisles flank the central nave, since the colonnades concealed

[5] It is not known what kind of dome Alberti planned for the crossing; the present dome was added by Iuvara in the eighteenth century.

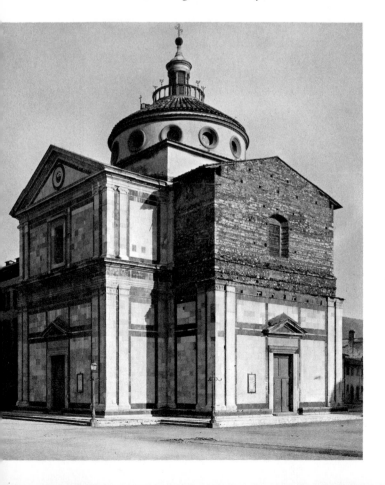

the ceremonies from the faithful in the aisles; hence his design of a single, huge hall from which independent chapels branch off at right angles. This break with a thousand-year Christian building tradition was extremely influential in later Renaissance and Baroque planning.

Although Alberti extolled the virtues of the central plan in his treatise, his one attempt to build a church of this type remained abortive; San Sebastiano at Mantua, begun in 1460, was never completed. To many Renaissance architects and theoreticians the circle was the ideal geometric figure because, without beginning or end, and with all points equidistant from a common center, it seemed to reflect the nature of the universe. This is one of the reasons why the central plan was felt to be so appropriate for religious architecture. (Figures that approached the circle, such as polygons, were considered adequate.) But as firm as this conviction of the architects may have been, the clergy was almost as firm in its demands for traditional longitudinal churches, which, of course, are much more practical for Christian religious services. In addition to the main question of how to accommodate the congregation

12-43 GIULIANO DA SANGALLO, Santa Maria delle Carceri, Prato, 1485.

12-44 GIULIANO DA SANGALLO, plan of Santa Maria delle Carceri.

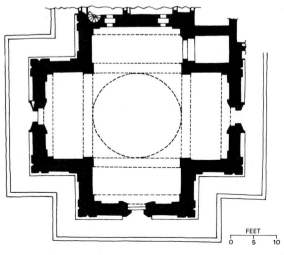

FEET
0 5 10

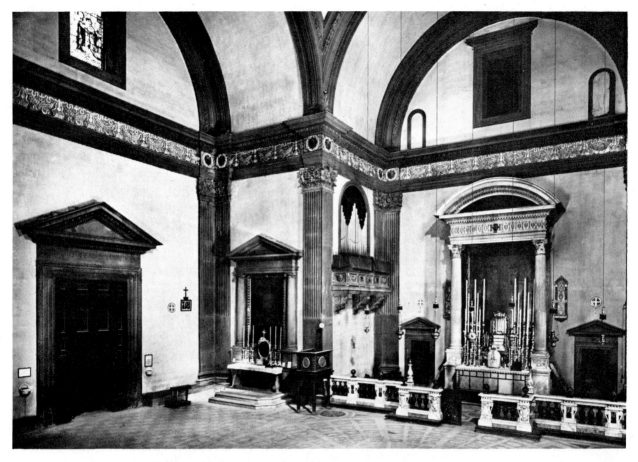

12-45 GIULIANO DA SANGALLO, interior of Santa Maria delle Carceri.

in central-plan churches there was that of where to put the main altar. And so architects were permitted to realize their ideal relatively rarely.

A compromise solution suggested first in Alberti's San Sebastiano in Mantua was realized by GIULIANO DA SANGALLO (1443–1516) in Santa Maria delle Carceri in Prato (FIGS. 12-43 to 12-45). It is built on the plan of a Greek cross in which the cross-arms are so short that the emphasis is on the central, dome-covered square; the building, in fact, very closely approaches the central-plan ideal. Blocklike, it is as high as it is wide, the cross-arms twice as wide as they are deep, the Ionic second story two-thirds the height of the Doric first—in fact, the whole building can be read in terms of the simple numerical relationships that Alberti advocated. Interior articulation, however, is much closer to Brunelleschi and resembles that of the Pazzi Chapel (FIG. 12-22).

The building seems a hybrid of the styles of Giuliano's two great predecessors, but it is also a neat and compact near-realization of an ideal central-plan Renaissance church.

Sculpture

As with the work of Alberti in the latter half of the century, so does the sculpture of the Florentine school pass to new triumphs of humanist classicism. The successors of Donatello refine upon his innovating art and specialize in its many forms and subjects. No monument made by the generation following expresses more beautifully and clearly this dedication to the values of pagan antiquity than the tomb of Leonardo Bruni in Santa Croce (FIG. 12-46). Its sculptor, BERNARDO ROSSELLINO (1409–64), at one time a resident of

12-46 Bernardo Rossellino, tomb of Leonardo Bruni, *c.* 1445–50. Marble, approx. 20′ high to top of arch. Santa Croce, Florence.

Arezzo, like the man whose tomb he built, strove mightily to immortalize the fame of his fellow citizen. The wall tomb has a history reaching back into the Middle Ages, but Rossellino's version is new and definitive and the expression

of an age that turned deliberately away from the Medieval past.

Leonardo Bruni was one of the most distinguished men of Italy, and his passing was widely mourned. An erudite scholar in Greek and Latin, a diplomat and apostolic secretary to four popes, and finally a member of the Chancery of the city of Florence, he summed up in his career the humanistic ideal. The Florentines particularly praised him for his *History of Florence*. In his honor the practice of the funeral oration was revived, as was the ancient custom of crowning the deceased with laurel. It is quite possible that this historic event of the crowning of the dead humanist gave Rosellino his theme and that the tomb is a kind of memorialization of the laureate scene. The forms of antiquity and the historical event of their restoration are thus brought together by the call of fame.

The deceased lies upon the catafalque in a long gown, the *History of Florence* upon his breast, the drapery of his couch caught up at the ends by imperial Roman eagles. Winged genii at the summit of the arch hold a great escutcheon; on the side of the sarcophagus, others support a Latin inscription that describes the Muses' grief at the scholar's passing. At the base of the niche are Roman funeral garlands. The only Christian reference is a Madonna and Child with angels in the tympanum. As with the churches of Alberti, a humanist and pagan classicism controls the mood of the design in an evocation of the ancient Greco-Roman world.

Few could hope for a funeral and tomb like Leonardo Bruni's. But in a humanistic age many wanted to see their memory, if not their fame, perpetuated; also, one may presume, Renaissance man enjoyed seeing likenesses of himself. At the time, Roman portrait busts were being found and preserved in ever greater numbers and, given this model, it was almost inevitable that the Renaissance developed a similar portrait type. The form may have originated in the shop of Antonio Rossellino (about 1427–79), Bernardo's younger brother. An example of Antonio's work is the portrait bust of Matteo Palmieri, apostolic delegate for Pope Sixtus IV (FIG. 12-47). Palmieri, who held high rank in Florence, was a learned man and author of a theological poem,

12-47 Antonio Rossellino, *Matteo Palmieri*, 1468. Marble. Museo Nazionale, Florence.

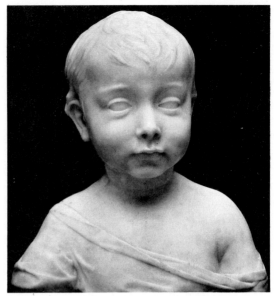

12-48 Desiderio da Settignano, *Bust of a Little Boy*, c. 1455. Marble. National Gallery of Art, Washington, D.C. (Andrew Mellon Collection).

the "City of Life," based formally on Dante. After his death, the poem was declared in part heretical because he had represented the souls of men as originally fallen angels. However, at the time of his death Palmieri received the same state funeral that Bruni had, his book being placed upon his breast and a funeral oration delivered. Antonio's portrait of Palmieri is extremely realistic but avoids the hardness of Roman Republican visages, which suggest the lifeless exactitude of the death mask—from which, indeed, they must have been made. Matteo's almost clownlike face with its enormous nose and endless mouth is filled with a bright, intelligent animation, and the fine eyes seem those of a man engaged in a quick and subtle dialogue. The unsparing realism in the depiction of the ugly yet beguiling face is not surprising for a subject who probably had little difficulty in detecting flattery and rejecting it.

Donatello had shown the sternly real and the gently idealized in his forms; and, indeed, realism and idealism run as parallel tendencies in the later century. Desiderio da Settignano (1428–64) specialized in the sensitive reading of the faces of women and children, which he idealized without diminishing character, as we may see

in his *Bust of a Little Boy* (FIG. 12-48). The proportions and soft contours of the head are wonderfully understood, as is the psychological set—a wondering innocence—captured by Desiderio in the ambiguous pout and in the large eyes directed wide at an adult world. The marble has been carved to give a remarkable smoothness to the planes so that the light will be modulated softly and the impression of living, tender flesh conveyed. The subtlety of Desiderio's surfaces and the consequent effect of life they give have long been admired by the Italians, as is evident in their phrase, *il vago Desiderio, si dolce bello* ("the charming Desiderio, so sweetly beautiful"). A whole school of sculptors worked in this manner, and attributions are often quite uncertain, ranging from Desiderio to the young Leonardo da Vinci. The soft, misty, shadow effects certainly look forward to the *sfumato* ("smoky" light and shade) in Leonardo's paintings.

Since the thirteenth and fourteenth centuries the Madonna and Child theme had become increasingly humanized, until, in the fifteenth century, we might almost speak of a school of sweetness and light, as many sculptors attempt to outdo each other, especially in relief, in render-

12-49 ANDREA VERROCCHIO, *David*, c. 1465. Bronze, approx. 47″ high. Museo Nazionale, Florence.

Because they were cheap, durable, and decorative, these works became extremely popular and the basis for a flourishing family business. The tradition was carried on by his nephew Andrea, whose colors tend to become a little garish, and by the latter's sons (Giovanni and Girolamo) whose activity extends well into the sixteenth century, when the product tends to be purely commercial; we still speak to day of "della Robbia ware." An example of Luca's specialty is the *Madonna and Child* set into a wall of the Or San Michele (PLATE 12-3). The figures are composed within a *tondo*, a circular frame that became popular with both sculptors and painters in the later part of the century, particularly with the della Robbia family. The introduction of high-key color into sculpture adds a certain worldly gaiety to the theme, and the customary light blue grounds (and here the green and white of lilies and the white architecture) suggest the festive season of Easter and the freshness of May, the month of the Virgin. Of course the somber majesty of the old Byzantine style has long since disappeared. The young mothers who would pray before images like this could easily identify with the Madonna and doubtless did. The distance between observed and observer has vanished.

The most important sculptor of the second half of the century was ANDREA VERROCCHIO (1435–88). A painter as well as sculptor, with something of the versatility and depth of Donatello, he had a flourishing *bottega* in Florence that attracted many students, among them Leonardo da Vinci. Verrocchio, also like the great Donatello, had a broad repertory. He too made a figure of David (FIG. 12-49), one that strongly contrasts in its narrative realism with the quiet, esthetic classicism of Donatello's. David, a sturdy, wiry young apprentice clad in a leathern doublet, stands with a jaunty pride, the head of Goliath at his feet. He poses like any sportsman who has just won a game, or hunter with his kill. The easy balance of the weight, the lithe, still thinly adolescent musculature, in which the veins are prominent, show how closely Verrocchio read the text and how clearly he knew the psychology of brash and confident young men. Although the contrast with Donatello's interpretation need hardly be labored, we might note the "open" form of the Verrocchio, the sword and pointed

ing the theme ever gentler and prettier. In the latter half of the century increasing demand for devotional images for private chapels and shrines —rather than for large public churches—contributed to an increasing secularization of the traditional religious subject matter. LUCA DELLA ROBBIA (1400–82), a sculptor in the generation of Donatello and a leader of the trend toward sweetness and light, discovered a way to multiply the images of the Madonna so that they would be within the reach of persons of modest means. His discovery (around 1430) involved application of vitrified potters' glazes to sculpture and led to his production, in quantity, of the glazed terra-cotta reliefs for which he is best known.

12-50 Left: ANDREA VERROCCHIO, *Bartolomeo Colleoni*, c. 1483–88. Bronze, approx. 13' high. Campo dei Santi Giovanni e Paolo, Venice.

12-51 Above: ANDREA VERROCCHIO, *Bartolomeo Colleoni*, detail of FIG. 12-50.

elbow sharply breaking through the figure's silhouette and stressing the live tension of the still alert victor; Donatello's *David*, on the other hand, has a "closed" silhouette, which emphasizes its classical calm and relaxation. The description of the anatomy of the two figures, specific in the former, generalized in the latter, puts further accent on the difference between them. Both statues are masterpieces and show how two skillful and thoughtful men could approach the theme from very different angles.

Verrocchio competes with Donatello again in an equestrian statue of another *condottiere* of Venice, Bartolomeo Colleoni (FIG. 12-50), who, eager to emulate the fame and the monument of Gattamelata, provided for the statue in his will. Both Donatello's and Verrocchio's statues were made after the deaths of their subjects, so that neither artist knew his subject. The result is a fascinating difference of interpretation—like that between the two *Davids*—of what a professional captain of armies would look like. Upon a pedestal even higher than that for the *Gattamelata*,

Verrocchio's statue of the bold equestrian general was placed so that the dominating aggressive figure could be seen above the rooftops, silhouetted against the sky, its fierce authority unmistakably present from all the major approaches to the piazza (the Campo dei Santi Giovanni e Paolo). In contrast with the near repose of the *Gattamelata*, the Colleoni horse moves in a prancing stride, arching and curving its powerful neck, while the commander seems suddenly to shift his whole weight to the stirrups and, in a fit of impassioned anger, to rise from the saddle with a violent twist of his body. The group is charged with an exaggerated tautness; the bulging muscles of the animal, the fiercely erect and rigid body of the man unify brute strength and rage. The commander, represented as delivering the battle harangue to his troops before they close with the enemy, has worked himself into a frenzy that he hopes to communicate to his men. A detail of the head of the *Colleoni* (FIG. 12-51) is almost a caricature, the mask of an infuriated eagle. Donatello had given us in the *Gattamelata*

a portrait of grim sagacity; the *Colleoni* is a portrait of savage and merciless might. Machiavelli wrote that the successful ruler must combine the traits of the lion and the fox; one feels that Donatello's *Gattamelata* is a little of the latter and Verrocchio's *Colleoni* much of the former.

Closely related in stylistic intention to Verrocchio is the work of ANTONIO POLLAIUOLO (about 1431–98). Also important as a painter and engraver, Pollaiuolo infused the nervous movement and emotional expressiveness of Donatello's late style with a new linear mobility, spatial complexity, and dramatic immediacy. He has a realistic concern for movement in all its variety, and for the stress and strain of the human figure in violent action. A good example is his small-scale group of Herakles and Antaios (FIG. 12-52); not quite eighteen inches high, it embodies the ferocity and vitality of elemental, physical conflict. The group illustrates the legend of a wrestling match between Antaios, a giant and son of Earth, and Herakles. (We have seen the story represented by Euphronios on an ancient Greek vase, shown in FIG. 5-9.) Each time Herakles threw him, Antaios sprang up again, his strength renewed by contact with Earth. Finally, Herakles held him aloft so that he could not touch earth and strangled him. The artist strives to convey the excruciating moment, the straining and cracking of sinews, the clenched teeth of Herakles, the kicking and screaming of Antaios. The figures are interlocked in a tightly wound coil, and the flickering reflections of light on the dark, gouged surface of the bronze contribute to the effect of agitated movement and fluid play of planes.

Painting and Engraving

The twisting of Pollaiuolo's figures through space shows a growing interest in realistic action among this generation of artists. This interest, now become an enthusiasm, is further revealed in one of his engravings, the *Battle of Naked Men* (FIG. 12-53). Pollaiuolo belongs to the second generation of experimentalists, who, in their pursuit of realism, were absorbed in the study of anatomy; he may have been one of the first artists actually to perform human dissection. While the problem of rendering human anatomy had been rather well solved by earlier artists like Donatello and Castagno, their figures had usually been shown at rest, or in restrained motion. Pollaiuolo, as in the *Herakles and Antaios*, takes delight in showing violent action and finds his opportunity in subjects dealing with combat. He conceives the body as a powerful machine and likes to display its mechanisms, knotted muscles and taut sinews activating the skeleton as ropes pull levers. To show this to best effect, he developed and used a figure that is thin and muscular, so much so that it appears *écorché*, as if without skin or outer tissue, and with strongly accentuated articulations at wrists, elbows, shoulders, and knees. For his engraving he shows this figure type in a variety of poses and from numerous points of view. If the figures, even though they hack and slash at one another without mercy, seem somewhat stiff and frozen, it is because Pollaiuolo shows *all* the muscle groups at maximum tension. The fact that only part of the body's muscle groups are involved in any action, while the others are relaxed, was to be observed only some decades later by an even greater anatomist, Leonardo da Vinci.

Pollaiuolo's *Battle of Naked Men* is an *engraving*

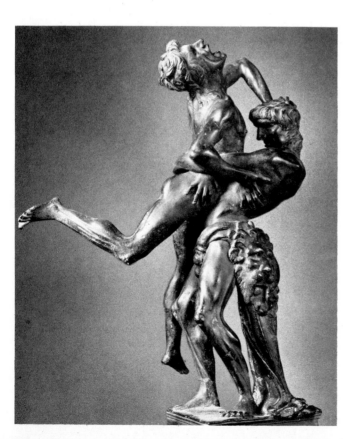

12-52 ANTONIO POLLAIUOLO, *Herakles and Antaios*, c. 1475. Bronze, approx. 18″ high with base. Museo Nazionale, Florence.

—that is, a print made by pressing against a sheet of paper an inked metal plate, into which a drawing has been incised. Developed around the middle of the fifteenth century, probably in northern Europe, engraving proved to be more flexible and durable than the older woodcut, which it gradually replaced during the later part of the century. Since numerous prints could be made from the same plate, they were cheap and, hence, could be widely circulated, bringing art to the common man and spreading new and stimulating pictorial ideas among artists. Being easily transportable, prints were a quick and easy means of interartist communication. Italian prints had important influence on such northern painters as Albrecht Dürer, and the prints of that great master of engraving were widely admired among Italian artists.

The versatile Pollaiuolo experimented in painting, especially with the problem of representing figures in a landscape setting. The problem of relating figures to architecture had already been solved by Piero della Francesca, but the landscape setting had somewhat different requirements,

some of which had been met by Masaccio. The panel representing Apollo and Daphne (FIG. 12-54), contemporaneous with the sculptured group of Herakles and Antaios, indicates that Pollaiuolo is a master not only of anatomy, but also of landscape and light. He has taken here the mythological subject of the pursuit of the nymph Daphne by the ardent Apollo. In answer to her prayer to be delivered from the god, the fleeing Daphne was turned into a laurel tree (*daphne*) just as he reached her. From mid-century on there is sharply increased interest in the pagan mythologies as subjects for painting and sculpture, an interest that will persist well into the nineteenth century. Here the mythological subject has been imagined so vividly that it has been made part of fifteenth-century life and located in the Arno river valley not far from Florence, whose towers appear in the distance. Instead of relating figures and space in a rationally clear, abstract perspective construction, Pollaiuolo observed man and nature more naturalistically and tended to merge them in a bright, hovering atmosphere. This image of the world is not a fixed one like Masac-

12-53 ANTONIO POLLAIUOLO, *Battle of Naked Men*, c. 1465. Engraving, approx. 15″ × 23″. Metropolitan Museum of Art, New York (bequest of Joseph Pulitzer, 1917).

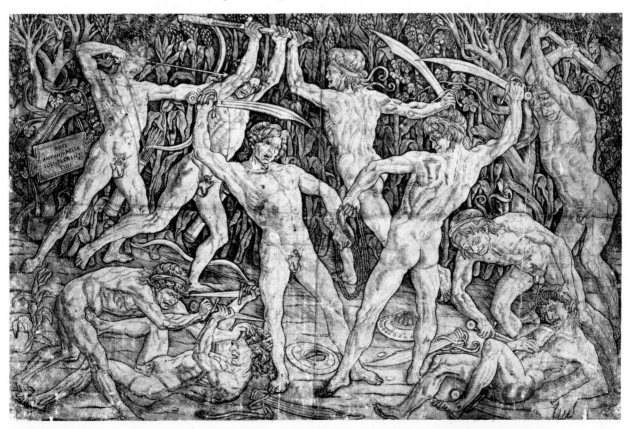

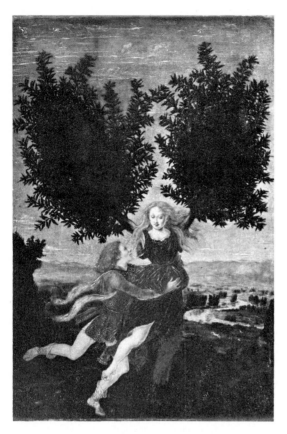

12-54 ANTONIO POLLAIUOLO, *Apollo and Daphne*, c. 1475. $11\frac{5}{8}'' \times 7\frac{7}{8}''$. Reproduced by courtesy of the Trustees of the National Gallery, London.

deep love for his city of Florence, its spectacles and pageantry, its material wealth and luxury. His most representative pictures are in the choir of Santa Maria Novella, a cycle of frescoes representing scenes from the lives of the Virgin and St. John the Baptist from which is shown the *Birth of the Virgin* (FIG. 12-55). In the rich interior of a palace room, embellished with fine *intarsia* (wooden mosaic) and sculpture, the mother of the Virgin, St. Anne, reclines, while midwives prepare the infant's bath. From the left comes a grave procession of ladies led by a member of the Tornabuoni family, the donors of the paintings. This splendidly dressed young woman holds as prominent a place in the composition (close to the central axis) as she must have held in Florentine society; and her appearance in the painting (a different female member of the house appears in each of the frescoes) is conspicuous evidence of the secularization of sacred themes that by this time is commonplace in art. Living persons of high rank are now represented not only as present at biblical dramas but, as here, often stealing the show from the saints. The display of patrician elegance absorbs and subordinates the devotional tableau.

The composition epitomizes the achievements of Early Renaissance painting: clear spatial representation; statuesque, firmly constructed figures; and rational order and logical relation among these figures and objects. If anything of earlier traits remains, it is in the arrangement of the figures, which still somewhat rigidly cling to layers parallel to the picture plane.

One of the Tornabuoni ladies may be the subject of a portrait by Ghirlandaio (PLATE 12-4). The cool formality of the profile pose repeats the lady of the fresco and sets off the proud, sensitive beauty of the aristocratic features. While the profile pose is not primarily intended for a reading of character, this portrait tells us much about the high state of human culture achieved in Florence, the careful cultivation and prizing of beauty in life and art, the breeding of courtly manners, and the great wealth behind it all.

The profile pose was customary in Florence until about 1470, when three-quarter and fullface portraits began to replace it. From the last quarter of the fifteenth century we have a three-quarter view, *Portrait of a Young Man* (PLATE 12-5) by

cio's or Piero della Francesca's, but fluid and changing. The illusion of movement in the graceful figure of Apollo, with his streaming hair and floating scarf, is quite beautifully created; and the group has a delicacy and grace that is not usual in the explosive art of Pollaiuolo. The choice of a subject that demands depiction of both motion (Apollo) and arrested motion (Daphne) was perhaps natural enough, given Pollaiuolo's interest in the action of the human body.

DOMENICO GHIRLANDAIO (1449–94) is of a different character from Pollaiuolo. Neither an innovator nor an experimenter, he is rather a synthesizer who profited from everything that had been done before and who summarized the state that Florentine art had reached by the end of the century. His works express his times to perfection, and for this he enjoyed great popularity among his contemporaries. They also show a

to 1434	1464	c.1465	**1469**	c.1470	c.1475	c.1482	1483	1485	**1492**	1496	1499
COSIMO DE' MEDICI	PIERO DE' MEDICI	VERROCCHIO *David*		ALBERTI Sant' Andrea designed	POLLAIUOLO *Herakles and Antaios*	BOTTICELLI *Birth of Venus*	Raphael born	G. DA SANGALLO Santa Maria delle Carceri		Savonarola assumes power	SIGNORELLI *Damned Cast into Hell*
				L O R E N Z O D E' M E D I C I							

SANDRO BOTTICELLI (1444–1510), originally named Alessandro dei Filipepi and the brightest star of the Florentine galaxy in the later part of the century. Earlier in the century the painters of northern Europe made this three-quarter view common, the head almost fullface, the eyes meeting those of the observer. The Italian painters now take it up, perceiving that it greatly increases our information about the subject's appearance. This almost full view also allows the artist to search and reveal the subject's character, though for a long while Italian artists will prefer—no doubt their sitters would demand—an impersonal formality that presents a calm, undisturbed public face and conceals the private, psychological man. Thus the young man here portrayed measures the observer with impassive nonchalance, as if expecting him to maintain the proper formal distance.

Botticelli was the pupil of Fra Filippo Lippi and must have learned from him the method of "drawing" firm, pure outline with light shading within the contours. The effect of this is clearly given in the portrait, the form explicit and sharply elegant. In the hands of Botticelli the method will be refined infinitely, and he is known in world art as one of the great masters of line. One of the most important monographs on Botticelli is by a Japanese: In Botticelli the Orient recognizes a master from the West.

No discussion of Botticelli can be fully meaningful without some reference to the environment that peculiarly encouraged him—the circle of Lorenzo de' Medici and the Platonic academy. Here he absorbed the philosophy of Plato, or rather of neo-Platonism, for scholars had not yet developed the critical sense that would distinguish between Plato and the neo-Platonic mystics of Alexandria who came centuries after and quite transformed Plato's thought in the direction of a religious system. It was this spiritualized and mystical Platonism that Botticelli absorbed, be-

12-55 DOMENICO GHIRLANDAIO, *The Birth of the Virgin*, fresco, c. 1485–90. Santa Maria Novella, Florence.

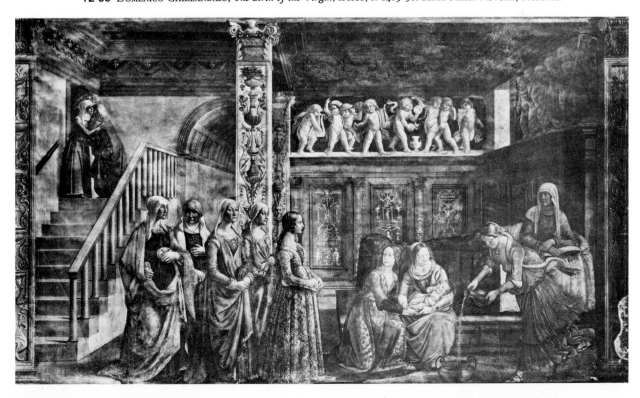

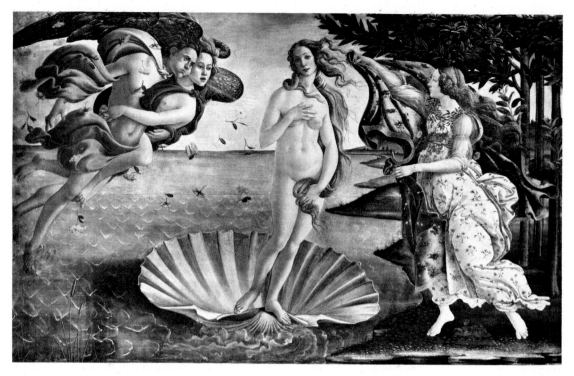

12-56 SANDRO BOTTICELLI, *The Birth of Venus*, c. 1482. Tempera on canvas, approx. 5′ 8″ × 9′ 1″. Galleria degli Uffizi, Florence.

lieving that it was close to Christianity in essence and that the two could be reconciled. He must have heard the humanists around Lorenzo discourse upon these new mysteries in one of the Medici villas in surroundings highly conducive to reflection. A modern historian writes:

> In a villa overhanging the towers of Florence, on the steep slope of that lofty hill crowned by the mother city, the ancient Fiesole, in gardens which Cicero might have envied, with Ficino, Landino, and Politian at his side, he [Lorenzo] delighted his hours with the beautiful visions of Platonic philosophy, for which the summer stillness of an Italian sky appears the most genial accompaniment.[6]

Botticelli had the power to materialize the "beautiful visions," and this he did in a number of works for the Medici villas, among them the famous *Birth of Venus* (FIG. 12-56), inspired, it is believed, by a poem by Politian on that theme.

[6] Henry Hallam, in J. A. Symonds, *op. cit.*, p. 477.

Botticelli is of his generation in his enthusiasm for themes from the classical mythology and along with it in his suiting the ancient pagan materials to a form prepared by the Early Renaissance, a form realistic yet still modified by something of the Medieval past. Competent in all the new representational methods, he seems deliberately to sacrifice them in the interest of his own original manner, rarefying the realism of the Early Renaissance into an inimitable decorative and linear system that generates its own kind of figure and space. Venus, born of the sea foam, is wafted upon a conch shell, blown by the Zephyrs, to her sacred island, Cyprus, where the nymph Pomona, descended from the ancient goddess of fruit trees, runs to meet her with a brocaded mantle. The presentation of the figure of Venus nude was in itself an innovation, since, as we have seen, the nude—especially the female nude—had been proscribed in the Middle Ages. Its appearance on such a scale, and its use of the ancient Venus statue in the collection of the Medici as a model, could have drawn the charge

of paganism and infidelity. But under the protection of the powerful Medici a new world of imagination could open freely with the new Platonism. The high priest of the neo-Platonic cult (for which the *Birth of Venus* could almost have been an altarpiece) was the Humanist already mentioned, Marsilio Ficino, certainly known to Botticelli through Lorenzo's circle. Ficino believed that the soul could ascend toward a union with God through contemplation of beauty, which reveals and manifests the two supreme principles of the Divine: love and light. This kind of mystical approach, so different from the earnest search of the early fifteenth century to comprehend man and the natural world through a rational and empirical order, finds expression in Botticelli's strange and beautiful style, which ignores—or seems to—all the scientific ground gained by experimental art. His style parallels the allegorical pageants in Florence, which were staged as chivalric tournaments but revolved completely around allusions to classical mythology; the same trend is evident in the poetry of the 1470's and 1480's. Artists and poets at this time did not directly imitate classical antiquity, but used the myths with delicate perception of their charm in a way still tinged with Medieval romance. In Botticelli's hands the classical myth takes on a fresh and fascinating quality. The lovely figure of Venus, strangely weightless and ethereal, is the intellectual or spiritual apparition of beauty, not at all the queen of sensual love whom the Venetian Renaissance will create. The lightness and bodilessness of the Zephyrs move all the figures without effort. Draperies undulate easily in the gentle gusts, perfumed by rose petals that fall upon the whitecaps stirred by the Zephyrs' toes. For the Medieval world and for that of neo-Platonism, as distinct from the modern scientific view, everything is linked by infinitely complex lines of affinity; everything is related to everything else; meanings can be read from objects and events, as the ancients read the future from the stars, the entrails of animals, and prodigies. It does not surprise us, then, if any number of interpretations can be made of a picture like the *Birth of Venus*; for, doubtless, it was intended to mean many things at the same time, and to have, so to speak, many layers of significance. For example, a modern scholar sees, beyond the simple depiction of the myth of the birth of Venus, an allegory of the innocence and truth of the human soul naked to the winds of passion and about to be clothed in the robe of reason. We can be sure that such abstruse interpretations and hyperinterpretations were made of paintings and texts at the time; it has been a long-enduring habit of the Western mind.

Botticelli's style, the sensitive vehicle of an intensely sensitive mind, changed with the fortunes of Florence; as he responded to the humanist and neo-Platonic ideas of the circle of Lorenzo de' Medici, so he responded to the overthrow of the Medici, the incursion of the French armies, and especially to the preaching of the Dominican monk Savonarola, the reforming priest-dictator who denounced the paganism of the Medici and their artists, philosophers, and poets. Savonarola called on the citizens of Florence to repent their iniquities, and, when the Medici fled, he prophesied the doom of the city and of Italy and took absolute power over the state. Together with a large number of citizens, Savonarola believed that the Medici had been a political, social, and religious influence for the worse, corrupting Florence and inviting the scourge of foreign invasion. Modern scholarship still debates the significance of Savonarola's brief span of power. Apologists for the undoubtedly sincere monk deny that his actions played a role in the decline of Florentine culture at the end of the century. But he did rail at the neo-Platonist humanists as heretical gabblers, and his banishing of the Medici, Tornabuoni, and other noble families from Florence deprived the local artists of some of their major patrons. Florence lost its position of cultural leadership at the end of the century and never regained it. Certainly the puritanical spirit that moved Savonarola, and which was soon to appear throughout Europe in the reforming preachments of the Protestant Reformation, must have dampened considerably the neopagan enthusiasms of the Florentine Early Renaissance.

The sensitive, highly personal, and exotic style of Botticelli closed the great age of Florentine art on an exquisitely refined note. Artists of his generation outside Florence, though of course

12-57 LUCA SIGNORELLI, *The Damned Cast into Hell*, fresco, 1499–1504. San Brizio Chapel, Orvieto Cathedral.

within the circuit of its influence, continued the experiments of the century and expanded their range. An Umbrian painter, LUCA SIGNORELLI (about 1445–1523) further developed the interests of Pollaiuolo and Verrocchio (in the depiction of muscular bodies in violent action) in a wide variety of poses and foreshortenings. In the chapel of San Brizio in the cathedral of Orvieto he painted scenes depicting the end of the world, of which the *Damned Cast into Hell* (FIG. 12-57) is one. Few figure compositions of the fifteenth century have the same awesome psychic impact. St. Michael and the hosts of heaven hurl the damned into hell, where, in a dense, writhing mass, they are tortured by vigorous demons. The figures are nude, lean, and muscular, and assume every conceivable posture of anguish. Signorelli's skill at foreshortening the figure is one with his mastery of its action; and though each figure is clearly a study from a model, there is an entirely convincing fitting of his theme to the figures. Terror and rage pass like storms through the wrenched and twisted bodies. The fiends, their hair flaming and their bodies the color of putrefying flesh, lunge at their victims in ferocious frenzy; we can imagine the appalling pandemonium. Not even

Pollaiuolo had achieved such virtuosity in the manipulation of anatomy for dramatic purpose. Doubtless Signorelli influenced Michelangelo, who makes the human nude his sole and sufficient expressive motif. The latter's *Last Judgment*, in the Sistine Chapel, shows him much aware of Signorelli's version of the theme.

Signorelli's fellow Umbrian, PERUGINO (Pietro Vannucci, about 1450–1523), was concerned not with the human figure in violent action, as Signorelli was, but with the calm, geometric ordering of pictorial space. Between 1481 and 1483, Perugino, along with several other famous artists including Botticelli, Ghirlandaio, and Signorelli, was summoned to Rome to decorate the walls of the newly completed Sistine Chapel with frescoes. Perugino painted *Christ Delivering the Keys of the Kingdom to St. Peter* (FIG. 12-58), the event upon which the papacy had from the beginning based its claim to infallible and total authority over the Church. Christ gives the keys to St. Peter at the center of solemn choruses of saints and citizens, who occupy the apron of a great stage-space that marches into the distance, stepped off by the parallel lines of the pavement, to a point of convergence in the doorway of a central-plan temple. Figures in the middle distance complement the near group, emphasizing by their scattered arrangement the latter's density and order. At the corners of the great piazza are triumphal arches that resemble the Arch of Constantine and mark the base angles of a compositional triangle having its apex in the central building. The group of Christ and Peter are placed on the central axis, which runs through the temple's doorway, within which is the abovementioned vanishing point of the perspective. Thus, the composition interlocks both the two-dimensional and the three-dimensional space, and the central actors are carefully integrated with the axial center. The spatial science provides a means for organizing the action systematically. Perugino, in this single picture, incorporates the learning of generations. His coolly rational, orderly style and the uncluttered clarity of his compositions will leave a lasting impression on his best-known student, Raphael.

Many Florentine artists had worked in northern Italy: Donatello in Padua; Uccello, Castagno, and Fra Filippo Lippi in Venice. Gradually, the Inter-

12-58 PERUGINO, *Christ Delivering the Keys of the Kingdom to St. Peter*, fresco, 1481–83. Sistine Chapel, Vatican, Rome.

national style, which had lingered long in the north, yielded to the new Florentine art. Around mid-century there appears in northern Italy one of the most brilliant talents of the entire Renaissance, ANDREA MANTEGNA (about 1431–1506) of Padua, where he must have met Donatello, who greatly stimulated and influenced his art. With Mantegna's frescoes in the Ovetari Chapel in the Church of the Eremitani in Padua (destroyed in World War II), northern Italian painting falls into line with the humanistic art of Florence. The *St. James Led to Martyrdom* (FIG. 12-59) reveals the breadth of Mantegna's learning—literary, archeological, and pictorial. The triumphal arch, with its barrel vault, is ornamented with motifs taken from the classical ornamental vocabulary. The soldiers' costumes are studied from antique models; the painter has striven for historical authenticity, much as did the antiquarian scholars of the University of Padua. In perspective Mantegna

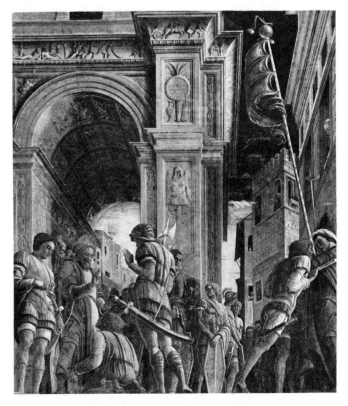

12-59 ANDREA MANTEGNA, *St. James Led to Martyrdom*, fresco, c. 1455. Ovetari Chapel, Church of the Eremitani, Padua (destroyed, 1944).

sets himself difficult problems for the joy of solving them. Here the observer's viewpoint is set very low, as if he were looking up out of a basement window at the vast arch looming above. The lines of the building to the right plunge down dramatically. There are, however, significant deviations from true perspective, since Mantegna, using artistic license, ignores the third vanishing point (seen from below, the buildings should converge toward the top). Disregarding the perspective facts, he prefers to work toward a unified, cohesive composition in which pictorial elements are related to the picture frame. The lack of perspective logic is partly compensated by the insertion of strong diagonals in the right foreground—for example, the staff of the banner.

Mantegna, working for the Gonzaga of Mantua (like the Medici, a great family of art patrons), performed a triumphant feat of pictorial illusionism in their ducal palace, producing the first completely consistent illusionistic decoration of an entire room, the so-called *Camera degli sposi* (FIG. 12-60). Utilizing actual architectural elements, he paints away the walls of the room in a manner that forecasts later Baroque decoration. He represents members of the House of Gonzaga welcoming home a son, a prince of the Church, from Rome. The members of the family, magnificently costumed, are shown in both domestic and landscape setting, and they are rendered carefully in portrait realism. The poses are remarkably unstudied and casual, conveying the easy familiarity of a family reunion. The painting is a celebration of fifteenth-century court life and a glorification of the Gonzaga. The lunettes are filled with garlands and medallions *all' antica* (in the antique manner), motifs that are standard features in northern Italian painting.

Mantegna's daring experimentalism leads him to complete the room's decoration with the first *di sotto in sù* perspective of a ceiling (PLATE 12-6), a technique later broadly developed by the northern Italian painter, Correggio, and the Baroque ceiling decorators. We look directly up at figures looking down at us. Cupids, strongly foreshortened, set the amorous mood of the theme, as the painted spectators smile down on the scene. This tour de force of illusionism climaxes almost a century of experiment in perspective.

One of Mantegna's later paintings, the *Dead Christ* (FIG. 12-61), is a work of overwhelming power, despite the somewhat awkward insertion of the two mourning figures on the left. It is both a harrowing study of a cadaver strongly foreshortened and an intensely poignant presentation of a cosmic tragedy. The harsh, sharp line seems to cut the surface as if it were metal, and conveys by its grinding edge the corrosive emotion of the theme; one thinks of Ernest Hemingway's "the bitter nail holes in Mantegna's Christ." For Mantegna's presentation is unrelievedly bitter, an unforgiving reproach to guilty mankind. What is remarkable is that all the science of the fifteenth century here serves the purpose of devotion. A Gothic religious sensitivity of great depth and intensity, still lingering in the northern Italian sunset of the Middle Ages, is embodied in an image created by a new science.

Mantegna's influence was great in northern Italy, especially in the school of Ferrara, but also in Venice, where his style had a strong formative influence on Giovanni Bellini, who may be regarded as the progenitor of Venetian painting (see Chapter Thirteen). His influence went even further, however, for he was a great engraver (the line in the *Dead Christ* certainly suggests engraving), and his prints found their way across the Alps to influence Albrecht Dürer, father of the Northern Renaissance.

By itself the influence of Mantegna might have stunted Giovanni Bellini's development, and the arrival in Venice of an artist with a style very different from Mantegna's probably was most opportune for Giovanni's artistic growth. ANTONELLO DA MESSINA (about 1430–79) is an enigmatic figure about whose background little is known. He was born in Sicily (the only major artist of the fifteenth century to be born south of Rome) and received his early training in Naples, where he must have come in close contact with Flemish painting. The Flemish influence in some of his works is so strong that it has long been assumed that Antonello actually spent some time in Flanders, a possibility that now seems unlikely. It has also been speculated that Antonello may have had direct contact with the Flemish artist Petrus Christus in Milan during the mid-fifties—a most intriguing possibility, since the styles of the two artists have many similarities. But the pres-

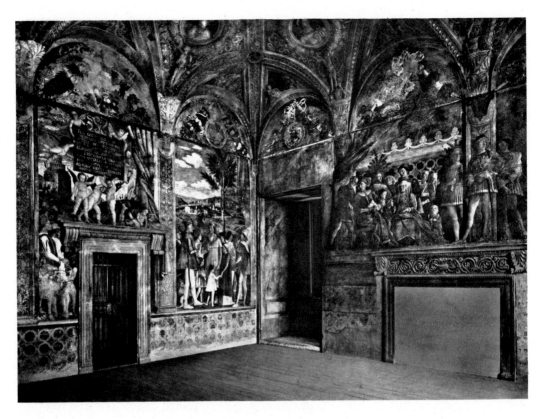

12-60 ANDREA MANTEGNA, *Camera degli sposi*, 1474. Ducal Palace, Mantua.

ence of either man in Milan at that time cannot be definitely proved. In any case, Antonello arrived in Venice in 1475 with a full mastery of the mixed-oil technique and made a strong impression there during his two-year stay.

How different Antonello's style was from that of Mantegna is shown in one of his later works, the *Martyrdom of St. Sebastian* (PLATE 12-7). It has none of Mantegna's brittle, sometimes harsh linearity; the forms are modeled in broad, simplified planes reminiscent of the style of Piero della Francesca, whose work Antonello must have studied very closely indeed. Also Pierfrancescan are the crisp clarity of the spatial composition, the subdued emotion, and the solemn calm with which the saint suffers his martyrdom. But Antonello goes even beyond Piero in bathing his painting in atmospheric luminosity, and his colors tend to be warm rather than cool, with golden brown tones dominating. Compared to earlier works, the painting has a "juicy" colorism that is due, in good part, to Antonello's use of mixed oil, a medium more flexible and wider of coloristic range than either tempera or fresco. Thus,

by combining elements of Piero's style with Flemish painting techniques, Antonello fuses monumental qualities with coloristic effects of unrivaled richness. Giovanni Bellini was one of the first to appreciate the value of Antonello's gift to Venice and to abandon Mantegna's "hard" style, which, within a decade of Antonello's visit to Venice, became hopelessly outdated.

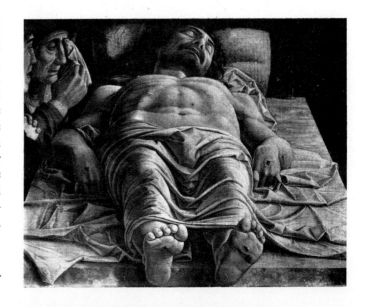

12-61 ANDREA MANTEGNA, *The Dead Christ*, c. 1501. Approx. 26″ × 31″. Pinacoteca di Brera, Milan.

Chapter Thirteen

Sixteenth-Century Italian Art

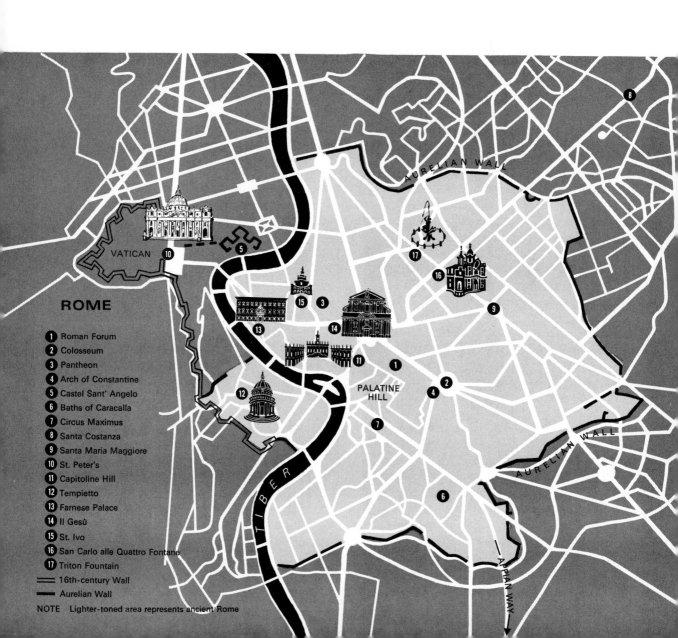

ROME

1. Roman Forum
2. Colosseum
3. Pantheon
4. Arch of Constantine
5. Castel Sant' Angelo
6. Baths of Caracalla
7. Circus Maximus
8. Santa Costanza
9. Santa Maria Maggiore
10. St. Peter's
11. Capitoline Hill
12. Tempietto
13. Farnese Palace
14. Il Gesù
15. St. Ivo
16. San Carlo alle Quattro Fontane
17. Triton Fountain

═══ 16th-century Wall
▬▬▬ Aurelian Wall

NOTE Lighter-toned area represents ancient Rome

B EFORE THE END of the fifteenth century, Florence lost her unique position of leadership in the arts, for the innovations of her artists had become the property of Italian artists regardless of local political boundaries. This is not to suggest that Florence no longer produced the giants of an earlier age. Leonardo and Michelangelo called themselves Florentines even though they spent a great part of their lives outside the city, and the turning point in Raphael's artistic

education occurred as a result of his experience of Florentine art. In addition, Florence, with the early work of Leonardo da Vinci, had already become the source of sixteenth-century style and later shared with Rome the beginnings and growth of Mannerism, a style that was to dominate western Europe during much of the sixteenth century. But there is the fact that Florence had come upon a time of crisis that began with the expulsion of the Medici and the brief and stormy dictatorship

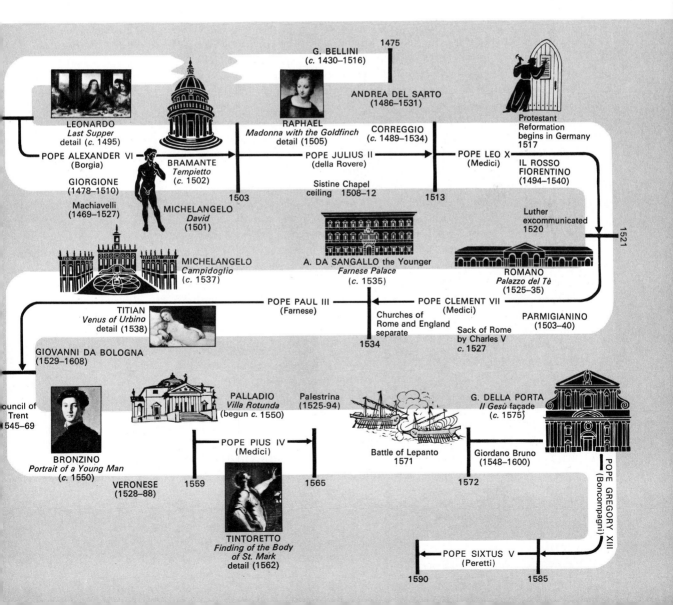

1475

G. BELLINI
(c. 1430–1516)

ANDREA DEL SARTO
(1486–1531)

LEONARDO
Last Supper
detail (c. 1495)

RAPHAEL
Madonna with the Goldfinch
detail (1505)

CORREGGIO
(c. 1489–1534)

Protestant
Reformation
begins in Germany
1517

POPE ALEXANDER VI
(Borgia)

BRAMANTE
Tempietto
(c. 1502)

POPE JULIUS II
(della Rovere)

POPE LEO X
(Medici)

IL ROSSO
FIORENTINO
(1494–1540)

GIORGIONE
(1478–1510)

Sistine Chapel
ceiling 1508–12

Machiavelli
(1469–1527)

MICHELANGELO
David
(1501)

1503

1513

Luther
excommunicated
1520

MICHELANGELO
Campidoglio
(c. 1537)

A. DA SANGALLO the Younger
Farnese Palace
(c. 1535)

ROMANO
Palazzo del Tè
(1525–35)

1521

POPE PAUL III
(Farnese)

POPE CLEMENT VII
(Medici)

TITIAN
Venus of Urbino
detail (1538)

Churches of
Rome and England
separate

PARMIGIANINO
(1503–40)

Sack of Rome
by Charles V
c. 1527

GIOVANNI DA BOLOGNA
(1529–1608)

1534

Council of
Trent
1545–69

PALLADIO
Villa Rotunda
(begun c. 1550)

Palestrina
(1525–94)

G. DELLA PORTA
Il Gesù façade
(c. 1575)

BRONZINO
Portrait of a Young Man
(c. 1550)

POPE PIUS IV
(Medici)

Battle of Lepanto
1571

Giordano Bruno
(1548–1600)

VERONESE
(1528–88)

1559

1565

1572

POPE GREGORY XIII
(Boncompagni)

TINTORETTO
*Finding of the Body
of St. Mark*
detail (1562)

POPE SIXTUS V
(Peretti)

1590

1585

of Savonarola and was to end with the subversion of the Florentine republic by the Spanish and the return of the Medici (a collateral line of the original family) as tyrants under Spanish protection. Finally, in the 1530's, Florentine independence became a thing of the past when the state was made into a grand duchy under the crown of the Hapsburgs.

THE HIGH RENAISSANCE

Between about 1495 and the date of its own invasion and sack in 1527, Rome took the place of Florence, laying claim to the latter's artistic pre-eminence. A series of powerful and ambitious popes—Alexander VI (Borgia), Julius II (della Rovere), Leo X (Medici), and Clement VII (Medici)—created a new power in Italy, a papal state, with Rome as its capital; and Rome became at the same time the artistic capital of Europe. The popes, living in the opulent splendor of secular princes, embellished the city with great works of art, inviting artists from all over Italy and providing them with challenging tasks. In its short duration the High Renaissance saw works of such authority produced that generations of later artists were instructed by them; and the art of Leonardo, Raphael, Michelangelo, and Titian is seen to belong to no school but is, in the case of each, something unique. The masters had of course inherited the pictorial science of the fifteenth century, and they learned from one another. Yet they made a distinct break from the past, occupying new and lofty ground, so lofty indeed as to discourage emulation by their successors.

The High Renaissance not only produced a cluster of extraordinary geniuses, but found in divine inspiration the rationale for the exaltation of the artist-genius. The neo-Platonists found in Plato's *Ion* his famous praise of the poet: "All good poets compose their beautiful poems not by art, but because they are inspired and possessed. . . . for not by art does the poet sing, but by power divine." And what the poet could claim, the Renaissance artist claimed also, raising visual art to the status formerly held only by poetry. Thus at the threshold of the modern world, the artist comes into his own, successfully claiming for his work a high place among the "fine" arts. In the High Renaissance the masters created, in a sense, a new profession, having its own rights of expression, its own venerable character, and its own claims to recognition by the great. The "fine" artist today lives—often without realizing it—on the accumulated prestige won by preceding artists, beginning with those who made the first great gains of the High Renaissance.

Leonardo da Vinci

A man who is the epitome of the artist-genius as well as of the "universal man," LEONARDO DA VINCI (1452–1519) has become a kind of wonder of the modern world, standing at the beginning of a new epoch like a prophet and a sage, mapping the routes that art and science would take. The scope and depth of his interests were without precedent, so great as to frustrate any hopes he might have had of realizing all that his feverishly inventive imagination could conceive. We still look with awe upon his achievement and, even more, upon his unfulfilled promise. His mind and personality seem to us superhuman, the man himself mysterious and remote; as Jacob Burckhardt writes: "The colossal outlines of Leonardo's nature can never be more than dimly and distantly conceived." Although we are here concerned primarily with Leonardo as an artist, we can scarcely hope to do his art credit in isolation from his science, since his scientific drawings are themselves works of art, as well as models for that exact delineation of nature that is one of the aims of science. Leonardo's unquenchable curiosity is best revealed in his voluminous notes, liberally interspersed with sketches dealing with matters of botany, geology, zoology, hydraulics, military engineering, animal lore, anatomy, and aspects of physical science including mechanics, perspective, light, optics, and color. Leonardo's great ambition in his painting, as well as in his scientific endeavors, was to discover the laws underlying the flux and processes of nature. With

this end in mind he also studied man and contributed immeasurably to our knowledge of physiology and psychology. Leonardo believed that reality in an absolute sense is inaccessible to man and that we can know it only through its changing images. Thus, he considered the eyes to be man's most vital organs, and sight his most essential function, since through these man can grasp the images of reality most directly and profoundly. Hence, one may understand Leonardo's insistence, stated many times in his notes, that all his scientific investigations were merely aimed at making himself a better painter.

Leonardo was born near Florence and was trained in the studio of Verrocchio. But he left Florence in 1481, offering his services to Ludovico Sforza, Duke of Milan. The political situation in Florence was uncertain, and the neo-Platonism of Lorenzo de' Medici and his brilliant circle may have proved uncongenial to the empirical and pragmatic Leonardo. It may be, also, that Leonardo felt that the artistic scene in Milan would be less competitive. He devoted most of a letter to the Duke of Milan to advertising his competence and his qualifications as a military engineer, mentioning only at the end his supremacy as a painter and sculptor:

> And in short, according to the variety of cases, I can contrive various and endless means of offence and defence.... In time of peace I believe I can give perfect satisfaction and to the equal of any other in architecture and the composition of buildings, public and private; and in guiding water from one place to another.... I can carry out sculpture in marble, bronze, or clay, and also I can do in painting whatever may be done, as well as any other, be he whom he may.[1]

The letter illustrates the new relation of the artist with his patron, as well as Leonardo's breadth of competence. That he should select military engineering and design to interest a patron is an index, in addition, of the dangerousness of the times. Weaponry had now been developed to the point, especially in northern Europe, where the siege cannon was a threat to the feudal

castles of those attempting to resist the wealthy and aggressive new monarchs. When in 1494 Charles VIII of France invaded Italy, his cannon easily smashed the fortifications of the Italian princes; and by the turn of the century, when Italy's liberties and unity were being trampled by the aspiring kingdoms of Europe, not only soldiers and architects, but artists and humanists were deeply concerned with the problem of designing a new system of fortifications that might withstand the terrible new weapon.

During his first sojourn in Milan, Leonardo painted the *Virgin of the Rocks* (FIG. 13-1), a group that, though it may derive ultimately from Fra Filippo Lippi, is well on its way out of the older

13-1 LEONARDO DA VINCI, *The Virgin of the Rocks, c.* 1485. Oil on wood panel, approx. 75″ × 43″. Louvre, Paris.

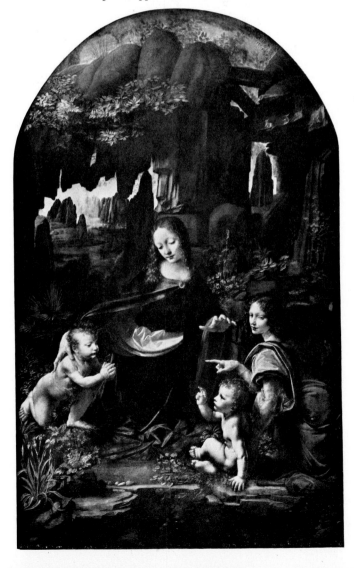

[1] In E. G. Holt, ed., *Literary Sources of Art History* (Princeton: Princeton Univ. Press, 1947), p. 170.

tradition. The old triangular composition now broadens out into three dimensions, making a weighty pyramid. The linear approach, with its musical play of undulating contours and crisp edges, is abandoned, as Leonardo returns through the generations of the fifteenth century to Masaccio's great discovery of *chiaroscuro*, the subtle play of light and dark. What we see is the result of the moving together and interpenetration of lights and darks, and while "drawn" representations—consisting of contours and edges—can be beautiful, they are really not true to the optical facts. Moreover, a painting must embody not only physical chiaroscuro but the lights and darks of human psychology as well. Modeling with light and shadow and the expression of emotional states were, for Leonardo, the heart of painting:

A good painter has two chief objects to paint—man and the intention of his soul. The former is easy, the latter hard, for it must be expressed by gestures and the movement of the limbs....A painting will only be wonderful for the beholder by making that which is not so appear raised and detached from the wall.[2]

The figures in the *Virgin of the Rocks* are knit together not only as a pyramidal group but as figures sharing the same atmosphere, a method of unification first seen in Masaccio's *Tribute Money* (FIG. 12-26). The Madonna, Christ Child, infant John the Baptist, and angel emerge through subtle gradations and nuances of light and shade from the half-light of the cavernous, visionary landscape. Light simultaneously veils and reveals the forms of things, immersing them in a layer of atmosphere between them and our eyes. The ambiguity of light and shade—familiar in the optical uncertainties of dusk—is in the service of the psychological ambiguity of perception. The group depicted, so strangely wrapped in subtle light and shade, eludes our precise definition and interpretation. The figures pray, point, and bless, and these acts and gestures, though their meanings are not certain, unite them visually. The angel points to the infant John, who is blessed by the Christ Child, in turn, sheltered by the Virgin's loving hand. The melting mood of tenderness, enhanced by the caressing light, is compounded of yet other moods. What the eye sees is fugitive, as are the states of the soul, or, in Leonardo's term, its "intentions."

The style of the High Renaissance fully emerges in a *cartoon* (a preparatory sketch) for a painting of the Virgin and the Christ Child with St. Anne and the infant John the Baptist (FIG. 13-2). The glowing light falls gently on the majestic forms, and upon a tranquil grandeur, order, and balance. The figures are robust and monumental, moving with a stately grace reminiscent of the Phidian sculptures of the Parthenon. Every part is ordered by an intellectual, pictorial logic into a sure unity. The specialized depiction of perspective, anatomy, light, and space is a thing of the past; Leonardo has assimilated the whole learning of two centuries and here applies it

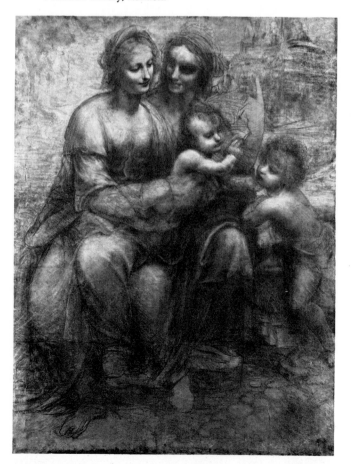

[2] In Anthony Blunt, *Artistic Theory in Italy, 1450–1600* (London: Oxford Univ. Press, 1964), p. 34.

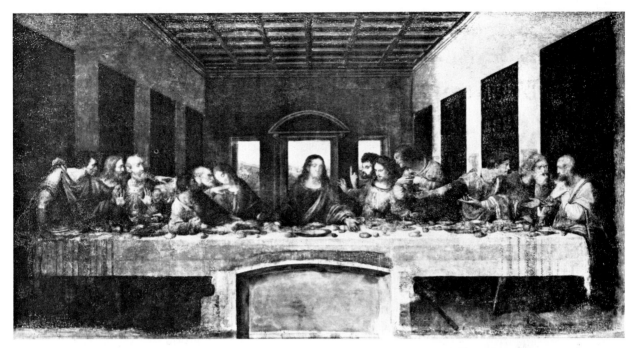

13-3 Leonardo da Vinci, *The Last Supper*, fresco, c. 1495–98. Santa Maria delle Grazie, Milan.

wholly, in a manner that is classical and complete. This manner of the High Renaissance, as Leonardo here authoritatively shows it, is stable without being static, varied without being confused, and dignified without being dull. As in the similar case in Greece, this brief classical moment that Leonardo inaugurated unified and balanced the conflicting experiences of a whole culture. It would be difficult to maintain. In a rapidly changing world the artist might either repeat the compositions and forms of the day in a sterile, academic manner, or revolt against the time by denying or exaggerating its principles. For these reasons the High Renaissance was of short duration, even shorter than the brief span of the Golden Age of Athens in the fifth century B.C.

For the refectory of the church of Santa Maria delle Grazie in Milan, Leonardo painted the *Last Supper* (FIG. 13-3). In spite of its ruined state, in part the result of the painter's own unfortunate experiments with his materials, and although it has often been ineptly restored, the painting is both formally and emotionally his most impressive work. It is the first great figure composition of the High Renaissance, and the definitive interpretation of its theme. Christ and the twelve disciples are seated in a simple, spacious room, at a long table set parallel to the picture plane. The highly dramatic action of the painting is made still more emphatic by the placement of the group in the austerely quiet setting. Christ, with outstretched hands, has just said, "One of you will betray me." A wave of intense excitement passes through the group as each disciple asks himself and, in some cases his neighbor, "Is it I?" Leonardo has made a brilliant conjunction of the dramatic "One of you will betray me" with the initiation of the ancient liturgical ceremony of the Eucharist, when Christ, blessing bread and wine, said "This is my body and this is my blood: do this in remembrance of me." The force and lucidity with which this dramatic moment is expressed are due to the abstract organization of the composition. In the center Christ is in perfect repose, the still eye of the swirling emotion around him. Isolated from the disciples, his figure is framed by the central window at the back, the curved pediment of which (the only curve in the architectural framework and here serving as a halo) arches above his head, which is

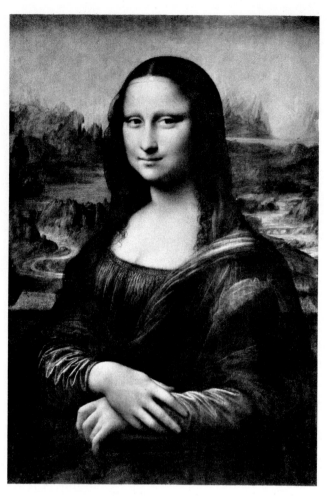

13-4 Leonardo da Vinci, *Mona Lisa*, c. 1503–05. Oil on panel, approx. 30″ × 21″. Louvre, Paris.

Judas on the same side of the table as Jesus and the other disciples. His face in shadow, he clutches a money bag in his right hand and reaches forward his left to fulfill the Master's declaration: "Behold, the hand of him that betrayeth me is with me on the table." The two disciples at either end of the table are more quiet than the others, as if to enclose the overall movement, which is more intense closer to the figure of Christ, whose calm at the same time halts and intensifies it. We know from numerous preparatory studies that Leonardo thought of each figure as carrying a particular charge and type of emotion. Like a skilled stage director—perhaps the first in the modern sense—he has carefully read the gospel story and scrupulously cast his actors as their roles are described. With him begins that rhetoric of classical art that will direct the compositions of generations of painters until the nineteenth century. The silence of Christ is one such powerful rhetorical device. Indeed, Heinrich Wölfflin saw that the classical element is precisely here, for in the silence following Christ's words "the original impulse and the emotional excitement continue to echo and the action is at once momentary, eternal and complete."[3] The two major trends of fifteenth-century painting—monumentality and mathematically ordered space at the expense of movement, and freedom of movement at the expense of monumentality and controlled space—are here harmonized and balanced. The *Last Supper* and Leonardo's career leading up to it are at once a synthesis of the artistic developments of the fifteenth century and a first statement of the High Renaissance style of the early sixteenth in Italy.

If Leonardo's *Last Supper* is the most famous of religious pictures, the *Mona Lisa* (FIG. 13-4) is probably the world's most famous portrait. Since the nineteenth century, perhaps earlier, the enigmatic face has been a part of Western folklore. Painted after Leonardo had returned from Milan to Florence, La Gioconda, wife of the banker Zanobi del Giocondo, is represented seated within a loggia. She is shown in half-length view, her hands quietly folded, and her gaze directed at the

the focal point of all perspective lines in the composition. Thus, the still, psychological focus and cause of the action is at the same time the perspective focus as well as the dead center of the two-dimensional surface; one could say that the two-dimensional, the three-dimensional, and the psychodimensional focuses are one and the same. The agitated disciples, registering a whole range of rationally ordered, idealized, and proportionate responses, embracing fear, doubt, protestation, rage, and love, are represented in four groups of three, united among and within themselves by the gestures and postures of the figures. Leonardo sacrifices traditional iconography to pictorial and dramatic consistency by placing

[3] Heinrich Wölfflin, *Classic Art*, 2nd ed. (London: Phaidon, 1953), p. 27.

observer. The ambiguity of the famous "smile" is really the consequence of Leonardo's fascination and skill with atmospheric chiaroscuro, which we have seen in his *Virgin of the Rocks* and *Holy Family* groups and which here serves to disguise rather than reveal a human psyche. While the light is adjusted subtly enough, the precise planes are blurred (a useful comparison can be made between the *Mona Lisa* and the portraits by Domenico Ghirlandaio and Sandro Botticelli in Chapter Twelve) and the facial expression hard to determine. The romantic nineteenth century made perhaps too much of the enigma of the "smile," without appreciating Leonardo's quite scientific concern with the nature of light and shadow. On the other hand, Leonardo himself must have enjoyed the curious effect he achieved here; it was one of his favorite pictures, one with which he could not bear to part. The superb drawing present beneath the fleeting shadow is a triumph in its rendering of both the head and hands, the latter exceptionally beautiful. It may well have been the artist's intention to confuse the observer, or enchant him, allowing him to interpret the secret personality as he pleased.

Leonardo completed very few paintings; his perfectionism, restless experimentalism, and far-ranging curiosity scattered his efforts. Yet an extensive record of his ideas is preserved in the drawings in his notebooks, one of which was discovered in Madrid in the 1960's. Science interested him increasingly in his later years, and he took knowledge of all nature (given first to the eye) as his proper province. His investigations in anatomy yielded drawings of great precision and beauty of execution—for example, the human embryo in the womb (FIG. 13-5), which, despite some inaccuracies, is so true to the facts that it could be used in medical instruction today. Although Leonardo may not have been the first scientist of the modern world—at least not in the modern sense of "scientist"—he certainly originated the method of scientific illustration, especially cutaway and exploded views. The importance of this has been stressed by Erwin Panofsky: ". . . anatomy as a science (and this applies to all the other observational or descriptive disciplines) was simply not possible without a method of preserving observations in graphic records, complete and accurate in three dimensions."[4]

Leonardo was well known in his own time as both a sculptor and architect, though none of his sculpture has survived and no actual buildings can be attributed to him. From his many drawings of central-plan buildings, it appears that he shared other Renaissance architects' interest in this building type. In Milan, Leonardo must have been in close contact with the architect Bramante (see below), who may well have remembered a drawing by Leonardo when he prepared his original designs for the great church of St. Peter in Rome (FIG. 13-8).

As for sculpture, Leonardo left numerous drawings of monumental equestrian statues, one of which ripened into a full-scale model for a monument to the Sforza; used as a target, it was shot to pieces by the French when they occupied Milan in 1499. Leonardo left Milan outraged at this treatment of his work and worked for a while as military engineer for Cesare Borgia during the latter's campaign to bring the cities of Romagna under the papacy. Eventually, Leonardo returned to Milan in the service of the French. At the invitation of the king he then went to France, where he died at the château of Cloux in 1519, without leaving any impression upon French contemporary art.

Bramante and His Circle

The most important artist with whom Leonardo came into contact in Milan was DONATO BRAMANTE (1444–1514). Born in Urbino and trained as a painter (perhaps by Piero della Francesca), Bramante went to Milan in 1481 and, like Leonardo, stayed there until the arrival of the French in 1499. In Milan he abandoned painting to become the greatest architect of his generation. Under the influence of Brunelleschi, Alberti, and perhaps Leonardo, all of whom had been strongly influenced by the classical antique, he developed the High Renaissance form of the central-plan church. But it was not until after his arrival in

[4] Erwin Panofsky, "Artist, Scientist, Genius," in Wallace K. Ferguson and others, *The Renaissance* (New York: Harper & Row, 1962), p. 147.

13-5 LEONARDO DA VINCI, *Embryo in the Womb*, pen and ink, *c.* 1510. Royal Collection, Windsor Castle. Copyright reserved. Reproduced by Gracious Permission of Her Majesty the Queen.

13-6 Right: Donato Bramante, the Tempietto, *c.* 1502–03. San Pietro in Montorio, Rome.

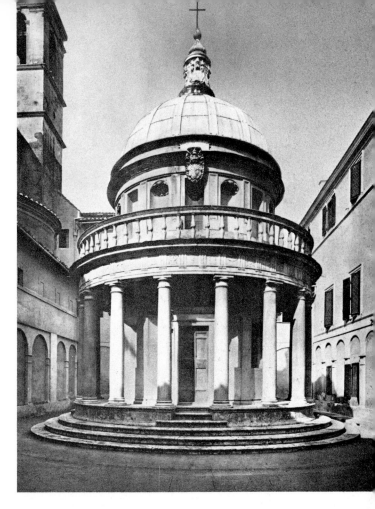

13-6 Right: Donato Bramante, the Tempietto, *c.* 1502–03. San Pietro in Montorio, Rome.

FEET
0 5 10

13-7 Above: Donato Bramante, plan of the Tempietto.

Rome in 1499 that he built what was to be the perfect prototype of classical, domed architecture for the Renaissance and subsequent periods—the Tempietto (FIGS. 13-6 and 13-7), so called because it has the aspect of a small pagan temple from antiquity. This building, designed to mark the spot of St. Peter's crucifixion, indeed gives the appearance of a solid sculptural reliquary; in fact, it was originally planned to stand, somewhat like a reliquary, under the protection of a colonnaded circular court. All but devoid of ornament, the building relies for its effect on the sculptural treatment of the exterior, which creates a sense of volume in movement (as does High Renaissance sculpture and painting). At first glance the Tempietto seems unnecessarily formalistic and rational, with its distinct, cool Tuscan order and abstract plan repeated in the colonnade and in the steps of the stylobate. However, Bramante achieves a wonderful harmony among the parts—the dome, drum, and base—

and the whole. The balustrade accents in shorter beats the rhythms of the colonnade and averts a too rapid ascent to the drum, while the pilasters on the drum itself repeat the ascending motif and lead the eye past the cornice to the ribs of the dome. The strictly regulated play of light and shade around the columns and balustrade and in the alternation of deep-set rectangular windows with shallow shell-capped niches enhances the experience of the building as an articulated sculptural mass, a domed cylinder within the wider cylinder of the colonnade.

The significance of the Tempietto was well understood in the sixteenth century. The architect Palladio, an artistic descendant of Bramante, put it among his survey of ancient temples because "Bramante was the first who brought good and beautiful architecture to light, which from the time of the ancients to his day had been forgotten. . . ." Round in plan, elevated on a base that isolates it from its surroundings, the

The High Renaissance 483

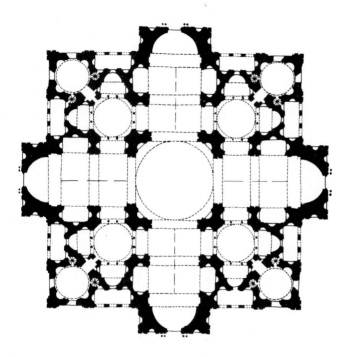

13-8 Donato Bramante, plan for St. Peter's, Rome, 1505.

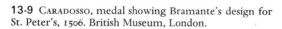

13-9 Caradosso, medal showing Bramante's design for St. Peter's, 1506. British Museum, London.

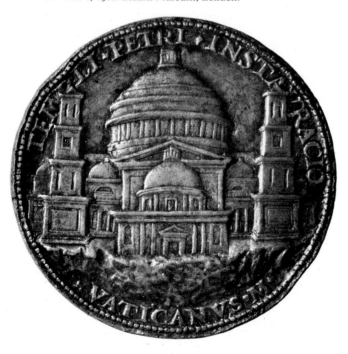

Tempietto conforms with Alberti's and Palladio's strictest demands for an ideal church, demonstrating "the unity, the infinite essence, the uniformity, and the justice of God."

The same architectural concept guided Bramante's plans for the new St. Peter's, commissioned by Pope Julius II in 1505 to replace the Constantinian basilica, old St. Peter's (FIG. 7-6). This structure had fallen into considerable disrepair and, in any event, did not suit the taste for the colossal of that ambitious and warlike pope, who wanted to gain sway over the whole of Italy and to make the Rome of the popes more splendid than the Rome of the Caesars. As originally designed by Bramante, the church (FIG. 13-8) was to have consisted of a cross with arms of equal length, each terminated by an apse. It was intended as a martyrium to mark St. Peter's grave; Julius also hoped to have his own tomb in it. The crossing would have been covered by a large dome, and smaller domes over subsidiary chapels would have covered the diagonal axes of the roughly square plan. Bramante's ambitious plan called for a boldly sculptural treatment of the walls and piers under the dome. The interior space is complex in the extreme, with the intricate symmetries of a crystal; it is possible to detect in the plan some nine interlocking crosses, five domed. The scale was titanic; Bramante is said to have boasted that he would place the dome of the Pantheon over the Basilica of Constantine. A commemorative medal shows how Bramante's scheme would have attempted to do just that (FIG. 13-9). The dome is hemispherical, like the Pantheon's, but otherwise the exterior, with two towers and a medley of domes and porticoes, breaks the massive unity demanded by the design and gives a scheme still essentially anthropometric—that is, scaled down to human proportions—in the Early Renaissance manner. During Bramante's lifetime the actual construction did not advance beyond the building of the piers of the crossing and the lower walls of the choir. With his death the work passed from one architect to another (none of whom advanced it particularly) and finally to Michelangelo, who was appointed by Pope Paul III in 1546 to complete the building (see below).

After Bramante's Tempietto the building that comes closest to realization of the High Renais-

sance classical ideals—order, clarity, lucidity, simplicity, harmony, and proportion—is the church of Santa Maria della Consolazione at Todi (FIG. 13-10). Although its designer is uncertain, it is quite clearly in the manner of Bramante, and we can call it Bramantesque. In plan the church takes the form of a domed cross (FIG. 13-11), its lobelike arms ending in polygonal apses. The interior space, showing a classical purity of arrangement, where the layout is immediately open to the eye, and volumes and spaces are in exquisite adjustment, finds its exact expression on the exterior. Here each level is carefully marked off by projecting cornices. There is a steady increase in rhythm from bottom to top; the unfenestrated first story, marked off into blank panels by pilasters, provides a firm base for the upper structure; the second story is fenestrated, the windows topped by alternating triangular and segmental pediments. The attic story makes a transition to the half-domes, and from the half-domes to the balustraded platform that sets off drum and dome as it makes transition to them. The rhythm of fenestration of the second floor reappears in the drum, but quickened by the interpolation of round-headed niches between the windows, like the appearance of a second voice in a fugue. No matter from which side it is seen, the building presents a completely balanced and symmetrical aspect. Like a three-dimensional essay in rational order, all of its parts are in harmonious relation to each other and to the whole, yet each is complete and independent. To appreciate the wide difference between the Medieval and the High Renaissance view of the nature of architecture, one need only recall the design of a typically Gothic building. In both scale and complexity, Santa Maria della Consolazione stands between the Tempietto and the design for St. Peter's. More amply than the former, with greater purity than the latter, it expresses the architectural ideals of the High Renaissance. Its spirit is that of classical antiquity and, though modern, it speaks only the classical language.

The palaces designed by Bramante have been preserved only in his drawings. From these it is apparent that the Farnese Palace in Rome (FIGS. 13-12 and 13-13), designed by ANTONIO DA SANGALLO the Younger (1483–1546), expresses the classical order, regularity, simplicity, and dignity

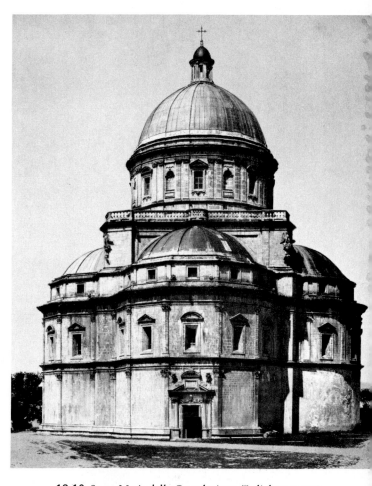

13-10 Santa Maria della Consolazione, Todi, begun 1508.

13-11 Plan of Santa Maria della Consolazione. (After Sir Banister Fletcher.)

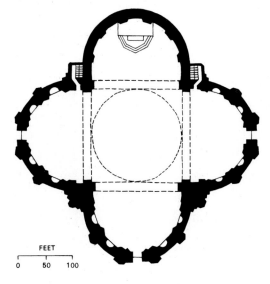

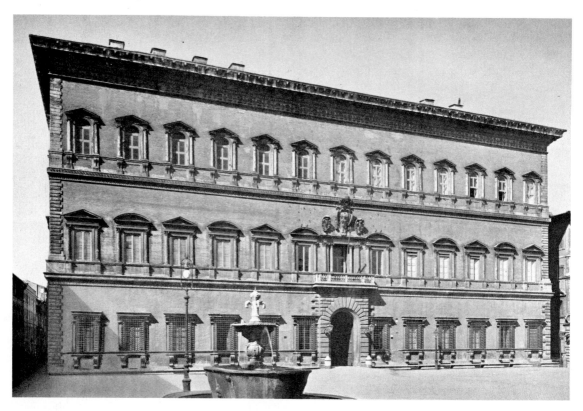

13-12 ANTONIO DA SANGALLO the Younger, Farnese Palace, Rome, *c.* 1535–50. Top story by Michelangelo, 1548.

13-13 ANTONIO DA SANGALLO the Younger, courtyard of the Farnese Palace.

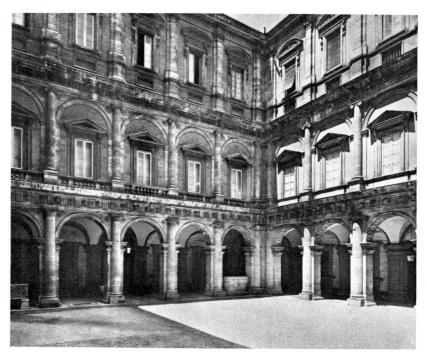

to c.1430 1494 c.1495 c.1500 c.1502 1505 1509 1515 1517 c.1520 1526 c.1527 c.1537 to c.1600 →

| French invade Italy | LEONARDO Last Supper | BRAMANTE Tempietto Plan for St. Peter's | RAPHAEL School of Athens | RAPHAEL Portrait of Baldassare Castiglione | DEL SARTO Madonna of the Harpies | COREGGIO Parma Cathedral dome begun | Sack of Rome | MICHELANGELO Capitoline Hill designed |

EARLY RENAISSANCE HIGH RENAISSANCE LATE RENAISSANCE
 — ROME PREEMINENT —

of Bramante's style. Antonio, the youngest of a family of architects, received his early training from his uncles Giuliano—whom we have seen as the designer of Santa Maria delle Carceri in Prato (Chapter Twelve)—and Antonio the Elder. He went to Rome around 1503 and became Bramante's draftsman and assistant. As Paul III's favorite architect, he received many commissions that might have gone to Michelangelo. He is the perfect example of the professional architect, and his family constituted an architectural firm, often working up the plans and doing the drafting for other architects. Essentially a developer, Antonio has frequently been criticized as unimaginative; but if this is so, it is only by comparison with Michelangelo. He built fortifications for almost the entire papal state and received more commissions for military than for civilian architecture. While he may not have invented it, he certainly developed the modern method of bastioned fortifications to a high degree, and in this demonstrated his ingenuity and originality.

The Farnese Palace, built for Cardinal Farnese, later Paul III, sets a standard for the High Renaissance palazzo. The sixteenth century saw the beginning of the age of the great dynasties that would dominate Europe until the French Revolution. It was an age of royal and princely pomp, of absolute monarchy rendered splendid by art. The broad, majestic front of the Farnese Palace asserts to the public the exalted station of a great family. This proud frontispiece symbolizes the aristocratic epoch that followed the stifling of the nascent, middle-class democracy of the European —especially the Italian—cities by powerful kings heading centralized states. It is thus significant that the original rather modest palace was greatly enlarged—to its present form—after Paul's accession to the papacy in 1534, reflecting the ambitions of the pope both for his family and the papacy. Only the lower stories are by Sangallo; after Sangallo's death in 1546, Michelangelo completed the top story and cornice.

The façade is the very essence of princely dignity in architecture. Facing a spacious paved square, the rectangle of the smooth front is framed and firmly anchored by the quoins and cornice, while lines of windows (with alternating triangular and segmental pediments in Bramante's fashion) mark a majestic beat across it. The window casements are no longer flush with the wall, as in the Palazzo Medici-Riccardi (FIG. 12-24), but project from its surface, so that instead of being a flat, thin plane, the façade becomes a spatially active, three-dimensional mass. Each casement is a complete architectural unit, consisting of a *socle* (a projecting undermember) engaged columns, entablature, and pediment. The variations in the treatment of these units, especially Michelangelo's quite free handling of the windows of the third story, prevent the symmetrical scheme from being rigid or monotonous. The rusticated doorway and second-story balcony surmounted by the Farnese coat of arms, by emphasizing the central axis, bring the horizontal and vertical forces of the design into harmony. This centralizing feature, not present in the palaces of Alberti or Michelozzo, is the external opening of a central-corridor axis that runs through the whole building, and continues in the garden beyond; around this axis the rooms are disposed with strict regularity. The interior courtyard displays a stately Colosseum arch-order on Sangallo's first two levels, and, on the third, Michelangelo's sophisticated variation on that theme, with overlapping pilasters replacing the weighty columns of Sangallo's design.

Raphael

The artist most typical of the High Renaissance is RAPHAEL SANZIO (1483–1520). The pattern of his growth recapitulates the sequence of tendencies of the fifteenth century, and though he was strongly influenced by Leonardo and Michel-

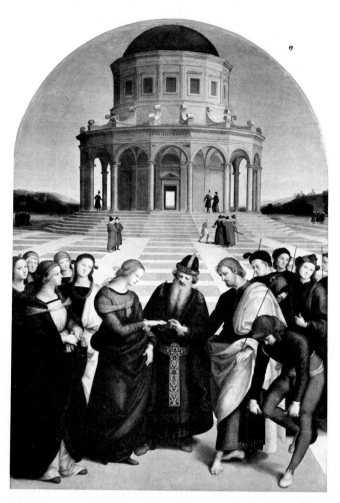

13-14 RAPHAEL SANZIO, *The Marriage of the Virgin*, 1504. Panel, 67″ × 46½″. Pinacoteca di Brera, Milan.

angelo, he developed an individual style that in itself clearly states the ideals of High Renaissance art. His powerful originality prevailed while he learned from everyone; he assimilated what he could best use, and rendered into form the classical instinct of his age. He worked so effortlessly in the classical mood that his art is almost the resurrection of Greek art at its height. Goethe, the renowned German poet and critic, said of Raphael that he did not have to imitate the Greeks, for he thought and felt like them. Born in a small town in Umbria near Urbino, Raphael probably learned the rudiments of his art from his father, Giovanni Sanzio, a provincial painter connected with the court of Federigo da Monte-

feltro. While still a child Raphael was apprenticed to Perugino, who had been trained in Verrocchio's shop with Leonardo. We have seen in Perugino's *Christ Delivering the Keys of the Kingdom to St. Peter* (FIG. 12-58) that the most significant formal quality of his work is the harmony of its spatial composition. While Raphael was still in the studio of Perugino, the latter had painted his *Marriage of the Virgin*, which, in its composition, very closely resembles the central portion of his Sistine Chapel fresco. This panel, now in the Museum of Caen, probably served as the model for Raphael's *Marriage of the Virgin* (FIG. 13-14). Yet Raphael, although scarcely twenty-one, was able to recognize and remedy some of the weaknesses of his master's composition. By relaxing the formality of Perugino's foreground figure screen and disposing his actors in greater depth, he not only provides them with greater freedom of action but also bridges the gap between them and the background building more successfully. The result is a painting that, although resembling its model very closely, is nevertheless more fluid and better unified.

Four years in Florence, from 1504 to 1508, were greatly stimulating for Raphael. Here, in the home of the Renaissance, he discovered that the style of painting he had so painstakingly learned from Perugino was already outmoded. The two archrivals and titans of the period, Leonardo and Michelangelo, were engaged in an artistic battle. Crowds flocked to Santissima Annunziata to see the recently unveiled cartoon for Leonardo's *Virgin and Child with St. Anne and the Infant St. John* (FIG. 13-2), shown here in its original version, done about 1499. Michelangelo responded with the *Doni Madonna*. Both artists were commissioned to decorate the Sala del Consiglio in the Palazzo Vecchio with pictures memorializing Florentine victories of the past. Although neither artist completed his task, and although nothing is left of their labors today, the effect on artists in Florence, and especially on one as gifted as Raphael, must have been considerable.

Under the influence of Leonardo, Raphael began to modify the Madonna compositions he had learned in Umbria. In the *Madonna with the Goldfinch* (*Madonna del Cardellino*), of 1506 (FIG. 13-15), Raphael uses the pyramidal composition

of Leonardo's *Virgin of the Rocks* (FIG. 13-1). The faces and figures are modeled in subtle chiaroscuro, and Raphael's general application of this technique is based on Leonardo's cartoon for the *Virgin and Child with St. Anne and the Infant St. John* (FIG. 13-2). At the same time the large, substantial figures are placed in a Peruginesque landscape, with the older artist's typically feathery trees in the middle ground. Although Raphael experimented with Leonardo's dusky modeling, he tended to return to Perugino's lighter tonalities. Raphael preferred clarity to obscurity, not being, as Leonardo was, fascinated with mystery. His great series of Madonnas, of which this is an early member, unify Christian devotion and pagan beauty; no artist has ever rivaled Raphael in his definitive rendering of this sublime theme of grace and dignity, sweetness and lofty idealism.

Had Raphael painted nothing but his Madonnas, his fame would still be secure. But he was also a great muralist, a master in the grand style begun by Giotto and carried on by Masaccio and the artists of the fifteenth century. In 1508 Raphael was called to Rome to the court of Pope Julius II, perhaps on the recommendation of his relative, Bramante. There, in competition with older artists like Perugino and Signorelli, he received one of the largest commissions of the time, the decoration of the papal apartments in the Vatican. Of the several rooms (*stanze*) of the suite, Raphael painted the first, the Stanza della Segnatura; the others were done mostly by his pupils after his sketches. Upon the four walls of the Stanza della Segnatura, under the headings of Theology, Law, Poetry, and Philosophy, Raphael deploys a host of magnificent figures that symbolize and sum up the learning of the West as understood in the Renaissance. His intention was to indicate the four branches of human knowledge and wisdom, while pointing out the virtues and the learning appropriate to a pope. The iconographical scheme is most complex, and it is likely that Raphael had advice from the brilliant company of classical scholars surrounding Julius. Upon one wall Raphael presented a composition that of itself constitutes a complete statement of the High Renaissance in its artistic form and spiritual meaning—the so-called *School of Athens* (FIG. 13-16). The setting is

not a "school" but rather a concourse of the great philosophers and scientists of the ancient world who now, rediscovered by the Renaissance, hold a convention, where they teach one another once more and inspire a new age. In a vast hall covered by massive vaults that recall Roman architecture and predict the look of the new St. Peter's, the figures are ingeniously arranged around the central pair, Plato and Aristotle. On Plato's side are the ancient philosophers concerned with ultimate mysteries that transcend this world; on Aristotle's side are the philosophers and scientists concerned with nature and the affairs of men. The groups move easily and clearly, with eloquent poses and gestures that symbolize their doctrines and are of the greatest variety. Their self-assurance and natural dignity bespeak the very nature of calm reason, that balance and measure so much admired by Renaissance men as the heart of philosophy. At the lower left Pythagoras writes as a servant holds up the harmonic scale. In the foreground Herakleitos (probably a portrait of Michelangelo) broods

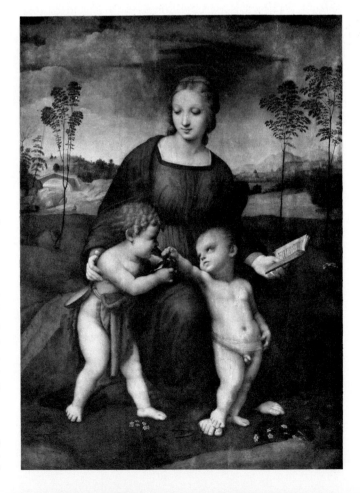

13-15 RAPHAEL SANZIO, *Madonna with the Goldfinch* (*Madonna del Cardellino*), 1505–06. 42″ × 29½″. Galleria degli Uffizi, Florence.

alone. Diogenes sprawls on the steps. At right students surround Euclid, who demonstrates a theorem. This group is especially interesting; Euclid may be a portrait of the aged Bramante, and at the extreme right Raphael places his own portrait.

Significantly, this great Renaissance artist places himself among the mathematicians and scientists, and certainly the pictorial science whose evolution we have been following comes to its perfection in the *School of Athens*. A vast perspective space has been created, in which human figures move naturally, without effort, each according to his own intention, as Leonardo might say. The stage setting, so long in preparation, is complete; the Western artist knows now how to produce the drama of man. That this stagelike space is projected on to a two-dimensional surface is the consequence of the union of mathematics with pictorial science, which yields the art of perspective, here mastered completely. The artist's psychological insight has matured

along with his mastery of the problems of physical representation. Each character here, like those in Leonardo's *Last Supper*, is intended to communicate a mood that reflects his beliefs, and each group is unified by the sharing of its members in the mood. The design devices by which individuals and groups relate to each other and to the whole are wonderfully involved and demand close study. From the center, where Plato and Aristotle stand silhouetted against the clear blue of the sky within the framing arch in the distance, the groups of figures are rhythmically arranged in an elliptical movement that swings forward, looping around the two forward groups to either side, and then back again to the center. Moving through the wide opening in the foreground along the perspective pattern of the floor, we are made to penetrate the assembly of philosophers and are led, by way of the reclining Diogenes, up to the here reconciled leaders of the two great opposing camps of Renaissance philosophy. In the Stanza della Segnatura,

13-16 RAPHAEL SANZIO, *The School of Athens*, fresco, 1509–11. Stanza della Segnatura, Vatican Palace, Rome.

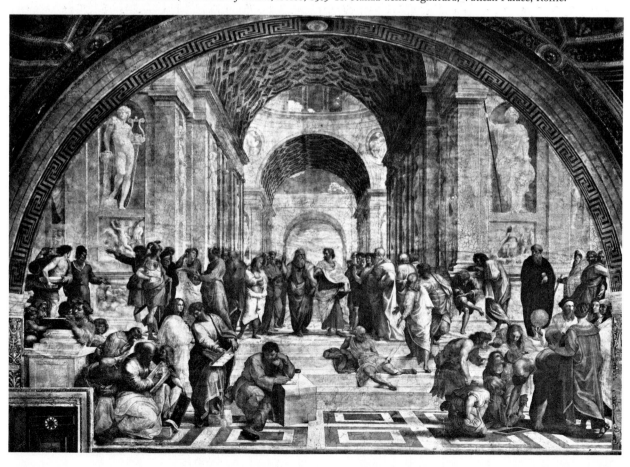

Raphael has reconciled and harmonized not only the Platonists and Aristotelians, but paganism and Christianity, in the very same kind of synthesis manifest in his Madonnas.

Pope Leo X, the son of Lorenzo de' Medici, succeeded Julius II as Raphael's patron, and it was in his pontificate that Rome achieved a splendor it had not known since ancient times. Leo, a worldly, pleasure-loving prince, spent huge sums on the arts, of which, as a true Medici, he was a sympathetic connoisseur. Raphael moved in the highest circles of the papal court, himself the star of a brilliant society, young, handsome, wealthy, and adulated, not only by his followers but by the city of Rome and all Italy. His personality contrasts strikingly with that of the aloof, mysterious Leonardo or the tormented and intractable Michelangelo. Genial, even-tempered, generous, and high-minded, Raphael was genuinely loved. The pope was not his only patron. His friend, the immensely wealthy banker Agostino Chigi, who managed the financial affairs of the papal state, commissioned him to decorate his splendid small palace on the Tiber, the Villa Farnesina, with scenes from the classical mythology. Outstanding among the frescoes painted here by Raphael is the *Galatea* (FIG. 13-17), its theme taken from the popular Italian poem by Poliziano, "La giostra"; Botticelli borrowed from the same work the theme for his *Birth of Venus* (FIG. 12-56). Galatea flees from her uncouth lover, the giant Polyphemos, upon a shell drawn by leaping dolphins, surrounded by sea creatures and playful cupids. The painting erupts in unrestrained pagan joy and exuberance, an exultant song in praise of human beauty and zestful love. The composition artfully wheels the sturdy figures around Galatea in bounding and dashing movement that always returns to her as the energetic center. The figures of the cupids, skillfully foreshortened, repeat the circling motion. Raphael's figures are sculpturally conceived, and the body of Galatea—supple, strong, and vigorously in motion—should be compared with the delicate, hovering, almost dematerialized Venus of Botticelli. Pagan myth presented in monumental form, in vivacious movement, and in a spirit of passionate delight brings back the kernel substance of which the naturalistic art and poetry of the classical world was made. Raphael revives

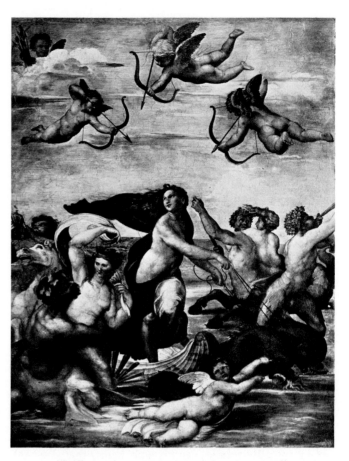

13-17 Raphael Sanzio, *Galatea*, fresco, 1513. Villa Farnesina, Rome.

the gods and heroes and the bright world they populated, not to venerate them, but to make of them the material of art. From Raphael almost to the present, classical matter will hold as prominent a place in art as religious matter. So completely has the new spirit embodied in the *Galatea* taken control that it is as if the Middle Ages had never been.

Raphael was also an excellent portraitist. His subjects were the illustrious scholars and courtiers who surrounded Pope Leo X, among them Count Baldassare Castiglione, a close friend of Raphael and memorable for his handbook on High Renaissance criteria of aristocratic behavior, the *Book of the Courtier*. In the book Castiglione portrays an ideal type of the High Renaissance, a courageous, sagacious, truth-loving, skillful, and cultivated man—in a word, the com-

pletely civilized man, culmination of the line that runs from the rude barbarian warriors who succeeded to the Roman empire through the half-literate knights and barons of the Middle Ages. Castiglione goes on to describe a way of life based upon cultivated rationality in imitation of the ancients. In Raphael's portrait of him (PLATE 13-1), Castiglione, splendidly yet soberly garbed, looks directly at us with a philosopher's grave and benign expression, clear-eyed and thoughtful. The figure is in half-length and three-quarter view, in the pose made popular by the *Mona Lisa*, and we note in both portraits the increasing attention paid by the High Renaissance artist to the personality and psychic state of his subject. The tones are muted and low-keyed, as would befit the temper and mood of the reflective, elderly man; the background is entirely neutral, without the usual landscape or architecture. The composition emphasizes the head and the hands, both wonderfully eloquent in what they report of the man who himself had written so eloquently in *The Courtier* of the way to enlightenment by the love of beauty. Both Raphael and Castiglione, as well as other artists of their age, were animated by such love, and we know from his poetry that Michelangelo shared in this widely held neo-Platonic belief that the soul rises to its enlightenment by the progressively rarefied experience of the beautiful.

Michelangelo

MICHELANGELO BUONARROTI (1475–1564) is a far more complex personality than Raphael, and his art is not nearly so typical of the High Renaissance as Raphael's. Frequently irascible, Michelangelo was as impatient with the shortcomings of others as with his own. His jealousy of Raphael, his dislike of Leonardo, and his almost continuous difficulties with his patrons are all well known. Perhaps these personal problems arose out of his strong and stern devotion to his art, for he was always totally absorbed in the work at hand. He identified himself with the task of artistic creation completely, and his reactions to his rivals were often impulsive and antagonistic. In this respect Michelangelo's character has often been compared with Beethoven's. But the per-

sonal letters of both reveal a deep sympathy and concern for those close to them, and profound understanding of humanity informs their works.

Whatever his traits of character, Michelangelo's career realizes all those Renaissance ideals that we conceptualize as "inspired genius" and "universal man." His work has the authority of greatness, as defined in the discussion of Donatello. His confidence in his genius was unbounded; its demands determined his choices absolutely, often in opposition to the demands of his patrons. His belief that nothing worth preserving could be done without genius was attended by the conviction that nothing could be done without persevering study. Although he was architect, sculptor, painter, poet, and engineer, he thought of himself as first a sculptor, regarding that calling as superior to that of a painter, since the sculptor shared in something like the divine power to "make man." In true Platonic fashion, Michelangelo believed that the image produced by the artist's hand must come from the Idea in his mind; the Idea is the reality that has to be brought forth by the genius of the artist. But the artist is not the *creator* of the Ideas he conceives; rather he finds them in the natural world, reflecting the absolute Idea, which, for the artist, is Beauty. In this way, the strongly Platonic strain makes the Renaissance theory of the imitation of nature a *revelation* of the high truths hidden within nature. The theory that guided Michelangelo's hand, though never complete or entirely consistent, appears in his poetry:

Every beauty which is seen here below by persons of perception resembles more than anything else that celestial source from which we all are come...

My eyes longing for beautiful things
together with my soul longing for salvation
have no other power
to ascend to heaven than the contemplation of
 beautiful things.[5]

One of the best-known observations by Michelangelo is that the artist must proceed by finding the Idea, the image, locked in the stone, as it were, so that by removing the excess stone he

[5] Reprinted by permission of the publisher from *Michelangelo's Theory of Art*, by Robert J. Clements. © 1961 by Robert J. Clements.

extricates the Idea, like Pygmalion bringing forth the living form:

> The best artist has no concept which some single marble does not enclose within its mass, but only the hand which obeys the intelligence can accomplish that Taking away . . . brings out a living figure in alpine and hard stone, which . . . grows the more as the stone is chipped away[6]

The artist, Michelangelo felt, works through many years at this unceasing process of revelation and "arrives late at lofty and unusual things and . . . remains little time thereafter."

Michelangelo did indeed arrive "at lofty and unusual things," for he broke sharply from the lessons of his predecessors and contemporaries in one important respect: He mistrusted the application of mathematical methods as guarantees of beauty in proportion. Measure and proportion, he believed, should be "kept in the eyes." Vasari quotes Michelangelo as declaring that "it was necessary to keep one's compass in one's eyes and not in the hand, for the hands execute, but the eye judges." Thus, he would set aside Vitruvius, Alberti, Leonardo, Albrecht Dürer, and others who tirelessly sought the perfect measure, being convinced that the inspired judgment could find other pleasing proportions, and that the artist must not be bound except by the demands made by the realization of the Idea. This insistence upon the artist's own authority is typical of Michelangelo and anticipates the modern concept of the right of talent to a self-expression limited only by its own judgment. The license thus given to genius to aspire far beyond the "rules" led Michelangelo to create works in architecture, sculpture, and painting that departed from High Renaissance regularity and put in its stead a style of vast expressive strength with complex, eccentric, often titanic forms that loom before us in tragic grandeur. His self-imposed isolation (Raphael spoke of him as "lonely as the hangman"), his creative furies, his proud independence, and his daring innovations led Italians to speak of the dominating quality of the man and his works in one word, *terribilità*—the sublime shadowed with the awesome and the fearful.

[6] *Ibid.*, pp. 9, 16, 22.

As a youth, Michelangelo was apprenticed to the painter Ghirlandaio, whom he left before completing his training. He soon came under the protection of Lorenzo the Magnificent and must have been a young and thoughtful member of the famous neo-Platonic circle. He studied sculpture under one of Lorenzo's favorite artists, Bertoldo, a former collaborator of Donatello who specialized in small-scale bronzes. When the Medici fell in 1494, Michelangelo fled to Bologna, where he executed a work for the church of San Petronio and studied the sculpture of Jacopo della Quercia (FIG. 12-3). Beside his study of Della Quercia—although he claimed that in his art he owed nothing to anyone—Michelangelo made studious drawings after the great Florentines, Giotto and Masaccio, and it is very likely that his consuming interest in representation of the male nude both in sculpture and painting was much stimulated by Signorelli.

Michelangelo's wanderings took him to Rome, whence he returned to Florence in 1501, partly because of the possibility that the city would permit him to work a great block of marble, called the Giant, that no other sculptor had been able to put to use. With his sure insight into the nature of stone, and a proud, youthful confidence that he could perceive its "Idea," Michelangelo added to his already great reputation by carving his *David* (FIG. 13-18), still the marvel it was then. The colossal figure takes up again the theme that Donatello and Verrocchio had used successfully but reflects Michelangelo's own highly original interpretation. David is represented not after the victory, with the head of Goliath at his feet, but rather, turning his head to his left, sternly watchful of the approaching foe. His whole muscular body, as well as his face, is tense with gathering power. The ponderated pose, suggesting the body at ease, is misleading until we read in the tightening sinews and deep frown what impends. Here is an example of that characteristic representation of energy in reserve that gives the tension of the coiled spring to Michelangelo's figures. The anatomy plays an important part in this prelude to action. The rugged torso and limbs of the young David, the large hands and feet giving promise of the giant strength to come, are not composed simply of inert muscle groups, nor are they idealized by simplification into broad masses.

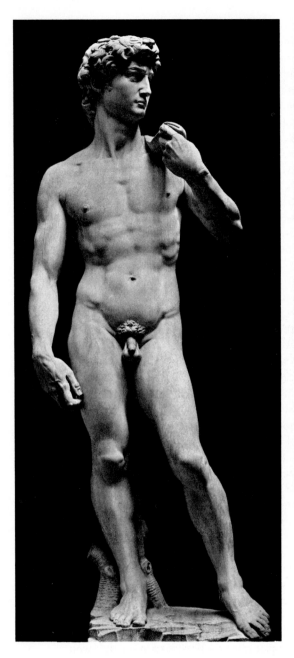

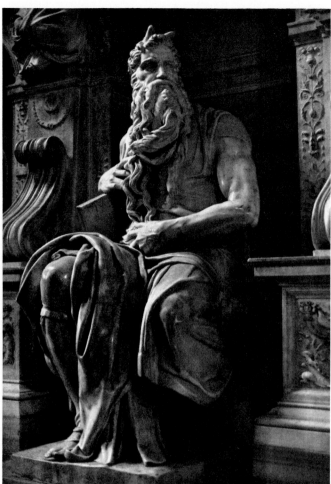

13-19 MICHELANGELO, *Moses*, c. 1513–15. Marble, approx. 8′ 4″ high. San Pietro in Vincoli, Rome.

13-18 MICHELANGELO, *David*, 1501–04. Marble, approx. 18′ high. Galleria dell' Accademia, Florence.

They serve by their active play to make vivid the whole mood and posture of tense expectation. Each swelling vein and tightening sinew amplifies the psychological vibration of the monumental hero's pose. Michelangelo doubtless had the classical nude in mind—antique statues being found everywhere were greatly admired by Michelangelo and his contemporaries for their skillful, precise rendering of heroic physique—but if we compare the *David* with the *Doryphoros* (FIG. 5-53), we can realize how widely his intent diverges from the measured, almost bland quality of the antique statue. As early as the *David*, then, Michelangelo's genius, unlike Raphael's, is dedicated to the presentation of towering, pent-up passion rather than calm,

ideal beauty. His own doubts, frustrations, and torments of mind passed easily into the great figures he created or planned.

The tomb of Julius II, a colossal structure that would have given Michelangelo the room he needed for his superhuman, tragic beings, became one of the great disappointments of Michelangelo's life when the Pope unaccountably lost interest and discontinued the project, whose spirit may be summed up in the one completed figure that survives, the *Moses* (FIG. 13-19). Meant to be seen from below, and balanced with seven other massive forms related in spirit to it, the *Moses* now, in its comparatively paltry setting, can hardly have its full impact. The leader of Israel is shown seated, the tables of the law under one arm, his other hand gripping the coils of his beard. He may be imagined as resting after the ecstasy of the giving of the Law on Mount Sinai, while, in the valley below, the people of Israel give themselves up once more to idolatry. Here again Michelangelo presents the turned head (as in the *David*), which concentrates the expression of awful wrath that now begins to stir in the mighty frame and eyes. One must study the work in detail to appreciate Michelangelo's sense of the relevance of each detail of body and drapery in forcing up the psychic temperature. The muscles bulge, the veins swell, the great legs begin slowly to move. If this titan ever rose to his feet, says one writer, the world would fly apart. The holy rage of Moses mounts to the bursting point, yet must be contained, for the free release of energies in action is forbidden forever to Michelangelo's passion-stricken beings.

Two other figures intended for the Julius tomb, the *Dying Slave* (FIG. 13-20) and the *Bound Slave* (FIG. 13-21), may represent the enslavement of the human soul by matter when the soul has fallen from heaven into the prison house of the body. With the imprisoned soul slumbering, our actions, as Ficino says, are "the dreams of sleepers and the ravings of madmen." Certainly the dreams and the ravings are given in these two figures. Originally there were meant to be some twenty slaves for the tomb in various attitudes of revolt and exhaustion. In the two slaves, as in the *David* and the *Moses*, Michelangelo makes each body a total expression of the Idea, so that the human figure serves not so much as a representation of a concept, as in Medieval allegory, but as the concrete realization of an intense feeling. Michelangelo's own powerful imagination indeed communicates itself in every plane and hollow of the stone. The beautiful, Praxitelean lines of the swooning captive present in their slow, downward pull the weight of exhaustion; the violent contrapposto of the defiant captive is the image of frantic, impotent struggle. Michelangelo's whole art depends upon his conviction that whatever can be said greatly through sculpture and painting must be said through the human figure.

With the failure of the tomb project, Julius II gave the bitter and reluctant Michelangelo the commission to paint the ceiling of the Sistine Chapel (FIG. 13-22). The artist, insisting that painting was not his profession, assented only with the hope that perhaps the tomb project could be revived. The difficulties facing him were enormous: the inadequacy of his training in the art of fresco; the dimensions of the ceiling (some 5800 square feet) and its height above the pavement (almost seventy feet); and the complicated perspective problems presented by the height and curve of the vault. Yet, in less than four years, Michelangelo had produced an unprecedented work, a one-man masterpiece without parallel in the history of world art (FIG. 13-23). Taking for his theme the creation, fall, and redemption of man—the most august and solemn theme of all —he spread across the vast surface a colossal decorative scheme that wove together more than 300 figures in an ultimate grand drama of the human race. A long corridor of narrative panels describing creation as given in Genesis runs along the crown of the vault from God's separation of light and darkness to the Drunkenness of Noah. On either side, where the vault curves down, are seated the Hebrew prophets and pagan sibyls who foretold the Coming of Christ. At the four corner pendentives are four Old Testament prefigurations of Christ—David, Judith, Haman, and the Brazen Serpent. Scores of lesser figures appear: the ancestors of Christ in the triangular compartments above the windows, the nude youths who punctuate the corners of the central panels, and the tiny pairs of putti in mirror image who support the painted cornice surrounding the whole

central corridor. The conception of the whole scheme is astounding enough in itself; the articulation of it in its thousand details is an achievement little less than superhuman. But Michelangelo *was* human; in the first few months of work he made mistakes in the technical application of the fresco that spoiled all he had done up to that time. Also, in the first three panels, beginning at the entrance with the *Drunkenness of Noah*, he had not yet estimated the scale properly, and the composi-

tions are crowded, without the simplicity of the panels beginning with the *Temptation and Fall*.

Unlike the case in Mantegna's Camera degli Sposi in Mantua (FIG. 12-60), the strongly marked, unifying architectural framework is not used to construct "picture windows" through which we may look up into some illusion just above. Rather, our eyes seize upon figure after figure, each sharply outlined against the neutral tone of the architectural setting or the plain background

13-20 MICHELANGELO, *The Dying Slave*, 1513–16. Marble, approx. 7′ 5″ high. Louvre, Paris.

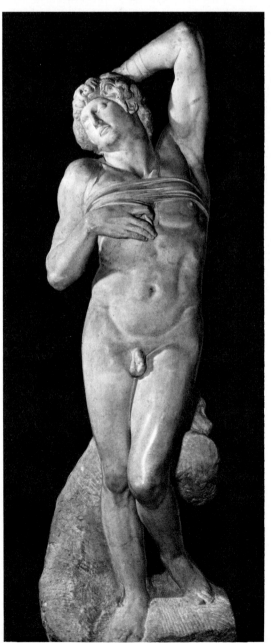

13-21 MICHELANGELO, *The Bound Slave*, 1513–16. Marble, approx. 6′ 10½″ high. Louvre, Paris.

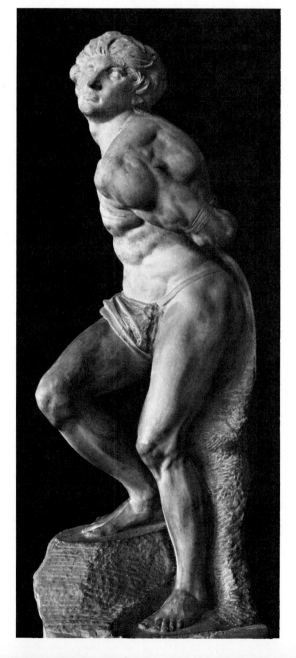

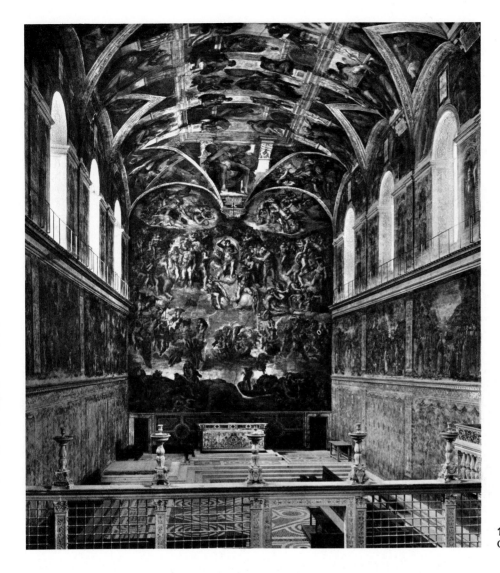

13-22 Interior of the Sistine Chapel, the Vatican, Rome.

of the panels. Here, as in his sculpture, Michelangelo relentlessly concentrates on the human figure for his expressive purpose. To him the body is beautiful not only because of its natural form but because of its spiritual and philosophical significance; the body is simply the manifestation of the soul or of a state of mind and character. Michelangelo represents the body in its most simple, elemental aspect: in the nude or simply draped, with no background and no ornamental embellishment, and always with a sculptor's sense that the figures could be tinted reliefs or full-round statues.

One of the central panels of the ceiling will evidence Michelangelo's mastery of the drama of the human figure. The *Creation of Adam* (PLATE 13-2) is not the traditional representation but a bold, entirely humanistic interpretation of the primal event. God and Adam, members of the same race of superbeings, confront each other in a primordial, unformed landscape of which Adam is still a material part, heavy as earth, while the Lord transcends it, wrapped in his billowing cloud of drapery and borne up by his genius-powers. Beneath his sheltering arm is the as yet uncreated, but apprehensively curious, Eve. Life

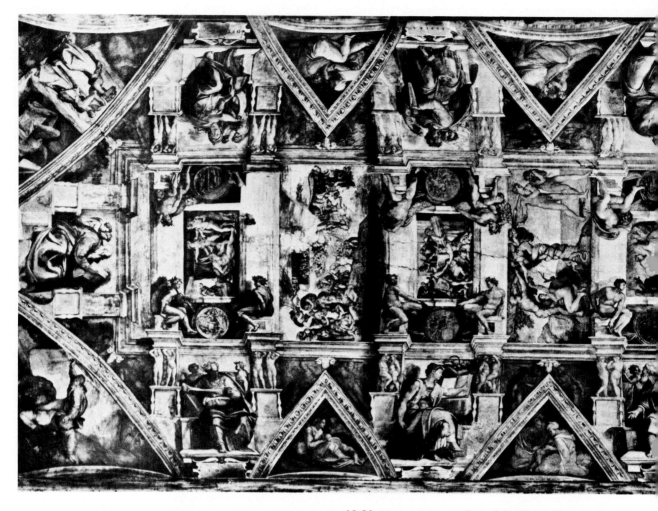

13-23 MICHELANGELO, ceiling of the Sistine Chapel, 1508–12.

leaps to Adam like an electric spark from the extended and mighty hand of God. The communication between gods and heroes, so familiar in classical myth, is here concrete; both are made of the same substance, both are gigantic. This blunt depiction of the Lord as ruler of Heaven in the Olympian, pagan sense, is an indication of how easily the High Renaissance joined pagan and Christian traditions; we could imagine Adam and the Lord as Prometheus and Zeus. The composition is dynamically off-center, its focus being the two hands that join the great bodies by the energy that springs between the fingers. The bodies themselves are complementary, the concave body of Adam fitting the convex body of the Lord. The straight, architectural axes we find in the compositions of Leonardo and Raphael are replaced by curves and diagonals; thus, motion directs not only the figures but the whole composition. The reclining poses, the heavy musculature, and the twisting contrapposto are all a part of Michelangelo's stock, which he will show again in the sculptured figures of the Medici tombs.

Following the death of Julius II, patron of the Sistine Ceiling paintings, Michelangelo went once again into the service of the Medici popes, Leo X and Clement VII. These pontiffs commissioned Michelangelo to build a chapel, the New Sacristy, in San Lorenzo in Florence. Brunelleschi's Old Sacristy was off the left transept of San

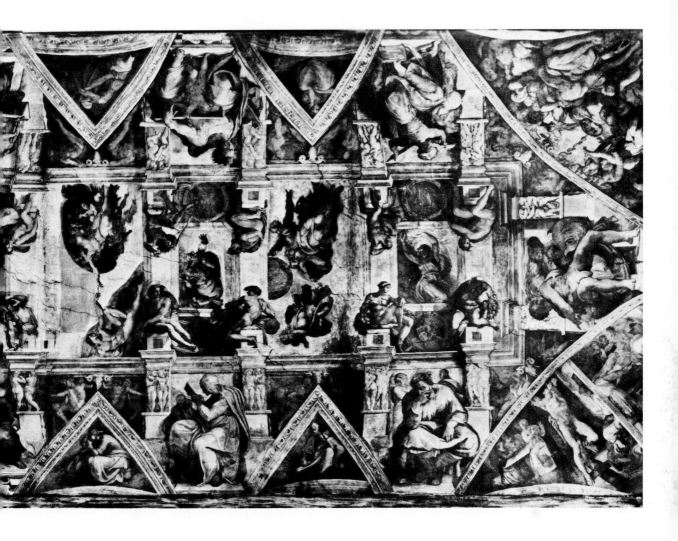

Lorenzo, and Michelangelo built the new addition off the right. He attempted a unification of architecture and of sculpture, designing the whole chapel as well as the tombs. This relationship between the two arts (and in this case painting as well) was a common Medieval feature; we think of the sculptured portals and stained glass of the Gothic cathedral. But the relationship had been broken in the fifteenth century, when sculpture fought free of its architectural core and asserted its independence—so much so that Brunelleschi could complain that Donatello's architectural and sculptural additions to his Old Sacristy spoiled the purity of his design. This new integration by Michelangelo, though

here unfinished, pointed the way to Baroque art, where the architectural-sculptural-pictorial ensemble again becomes standard.

At opposite sides of the chapel stand the tombs of Giuliano, Duke of Nemours, and Lorenzo, Duke of Urbino, son and grandson of Lorenzo the Magnificent. The tomb of Giuliano (FIG. 13-24) is compositionally the twin of Lorenzo's. Both are unfinished; it is believed that statues were designed for the niches flanking the portrait statue —in this case, that of Giuliano—and that pairs of statues were to be placed at the bottom of the sarcophagi, balancing the pairs that rest upon the sloping sides. The composition of the tombs has been a long-standing puzzle: How were they

The High Renaissance **499**

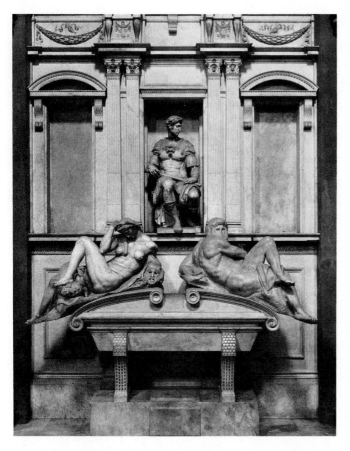

13-24 MICHELANGELO, tomb of Giuliano de' Medici, 1519–34. Marble, central figure approx. 5′ 11″ high. New Sacristy, San Lorenzo, Florence.

ultimately to look? What is their relationship to each other? What do they signify? The present arrangement seems quite unstable; were the sloping figures meant to recline on a flat surface? We can do little more than state some of the questions, without attempting to answer them in full. It has been suggested that the arrangement (planned by Michelangelo but never completed) can be interpreted as the ascent of the soul through the levels of the neo-Platonic universe. The lowest level, represented by river gods, would signify the underworld of brute matter, the source of evil. The two statues on the sarcophagi would then symbolize the realm of time, the specifically human world of the cycles of dawn, day, evening, and night. Man's state in this world of time is one of pain and anxiety,

frustration and exhaustion. The figures represented in the illustration are, at left, the female figure of Night, at right, the male figure of Day. Both are as if chained into never relaxing tensions. Both exhibit that anguished twisting of the masses of the body in contrary directions seen in the *Bound Slave* and in the paintings of the Sistine Chapel. This contrapposto is the signature of Michelangelo. *Day*, with a body the thickness of a great tree and the anatomy of Herakles, strains his huge limbs against each other, his unfinished visage rising menacingly above his shoulder. *Night*, the symbol of rest, twists as if in troubled sleep, her posture wrenched and feverish. The artist has surrounded her with an owl, poppies, and a hideous mask symbolic of nightmares.

The figures of Lorenzo and Giuliano rise above the troubles of the realm of time and take the aspect of the two ideal human types, the contemplative man and the active man. Michelangelo disdained to make portraits of the actual persons; who, he asked, would care what they looked like in a thousand years? What counted was the contemplation of that which was above the corrosion of time. Giuliano, the active man, his features quite generalized, sits clad in the armor of a Roman emperor, holding the baton of a commander, his head turned alertly, as if in council (he looks toward the statue of the Virgin at one end of the chapel). Across the room, Lorenzo, the contemplative man, sits wrapped in thought, his face in deep shadow. In these works, as in many others, Michelangelo has suggested powerful psychic forces incapable of being translated into action, yet ever on the verge of it. His prevailing mood is tension and constraint even in the figures that seem to aspire to the ideal, to the timeless, perfect and unmoving. Michelangelo's style was born to disturb. It brings the serene, brief High Renaissance to an end.

The tensions and ambiguities of Michelangelo's style, which are to pass over into the general style called Mannerism, are strongly felt in his architecture. His building activity for the Medici in Florence centered in and around San Lorenzo (just discussed), and his Laurentian Library, built to house the great collections of the Medici, adjoins it. The building's peculiar layout was dictated by its special function and by its rather

13-25 MICHELANGELO, vestibule of the Laurentian Library, Florence, begun 1524. Stairway designed 1558–59.

constricted site. Michelangelo had two contrasting spaces to work with, the long horizontal of the library proper, and the vertical one of the vestibule (FIG. 13-25). In the latter, everything is massive and plastic, while the planes and solids of the reading room are shallow and played down —perhaps so as not to distract the readers. The need to place the vestibule windows high determined the narrow verticality of its elevation.

The vestibule, much taller than it is wide or long, gives the impression of a vertically compressed, shaftlike space. A vast flowing stairway that almost fills the interior greatly adds to a sense of oppressiveness. One schooled exclusively in the classical architecture of Bramante and the High Renaissance would have been apalled by Michelangelo's indifference to classical norms in

the use of the orders or in proportion. He uses columns in pairs and sinks them into the walls. He breaks columns around corners. He places beneath columns consoles not meant to support them. He arbitrarily breaks through pediments, as well as through cornices and stringcourses. In short, he disposes wilfully and abruptly of classical architecture as the High Renaissance knows it. But some features often called Manneristic were dictated by structural necessity; the recessed columns, for example, that seem neither to support nor to be supported have recently been shown to perform a supporting function, in contrast to the standard applied classical orders, which are purely decorative. These paired stone columns, because of their greater compressive strength, actually add rigidity to the relatively thin brick

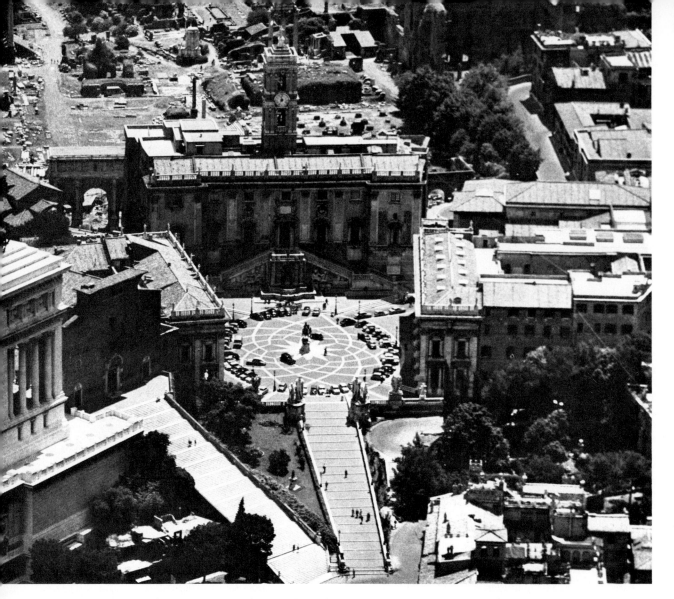

13-26 MICHELANGELO, the Capitoline Hill (the Campidoglio), Rome, designed *c.* 1537.

walls and support the upper part of the structure. The "ambiguity" of the resulting wall surface is illusory, since the columns clearly have been recessed *into* the wall. In any event, Michelangelo, with his usual trail-breaking independence of mind, has sculptured an interior space that conveys all the strains and tensions we find in his statuary and in his painted figures. His style in all three arts is wonderfully consistent. The key to that consistency may be found in his own words: "The members of an architectural structure follow the laws exemplified in the human body. He who ... is not a good master of the nude ...

cannot understand the principles of architecture." His whole inspiration came from the beauty and majesty of the human body, the visible aspect of the human soul.

In his later years, Michelangelo turned increasingly to architecture. In 1537 he undertook to reorganize the Capitoline Hill (the Campidoglio) in Rome (FIGS. 13-26 and 13-27), receiving from Pope Paul III a flattering and challenging commission. The pope wished to transform the ancient hill, which had once been the spiritual as well as political capitol of Rome, into a symbol of power of the new Rome of the popes. The great chal-

lenge of the project consisted in the fact that Michelangelo was required to incorporate into his design two existing buildings—the Medieval Palazzo dei Senatori (Palace of the Senators) on the east, and the fifteenth-century Palazzo dei Conservatori (Palace of the Conservators) on the south—and that these buildings formed an eighty-degree angle. These preconditions might well have defeated a lesser architect, but Michelangelo converted what seemed to be a handicap into the most impressive design of a civic unit of the entire Renaissance.

Michelangelo had reasoned that architecture should follow the form of the human body to the extent of disposing units symmetrically around a central and unique axis, in a relationship like that of the arms to the body or the eyes to the nose. It must have been with arguments like this that he convinced his sponsors that it was necessary to balance the Palazzo dei Conservatori, for which he was going to redesign the façade, with a similar unit on the north side of the square. To achieve balance and symmetry in his design, Michelangelo placed the new building (originally only planned as a portico with single rows of offices above and behind it) so that it stood at an angle to the Palazzo dei Senatori that corresponded to that at which the Palazzo dei Conservatori stood, thus arriving at a trapezoidal rather than a rectangular plan for his piazza (FIG. 13-27). All other elements of the design were subsequently adjusted to this unorthodox but basic feature.

The statue of Marcus Aurelius, the only equestrian statue of a Roman emperor that had survived the Middle Ages, became the focal point for the whole design. It was brought to the hill at the pope's orders and against the advice of Michelangelo, who perhaps would have preferred to carve his own centerpiece. The symbolic significance of the statue, which seemed to link the Rome of the Caesars with the Rome of the popes, must have appealed to Paul III. To connect this central monument with the surrounding buildings, Michelangelo provided it with an oval base and placed it centrally in an oval pavement design, the twelve points of which may have had ancient or Medieval cosmological connotations. Michelangelo's choice of the oval is significant, since it was considered to be an unstable geomet-

ric figure and was shunned by older Renaissance architects. But given the trapezoidal shape of the piazza, the oval, which combines centralizing with axial qualities, was the figure best suited to relate to one another the various elements of the design. It was to become the favorite geometric figure of the Baroque period.

Facing the piazza, the two lateral palazzi have identical two-story façades (FIG. 13-28). They introduce us again to the giant order, first seen in somewhat timid fashion in Alberti's Sant' Andrea in Mantua (FIG. 12-40). Michelangelo uses it with much greater gusto and authority. The giant pilasters not only tie the two stories of the building together but provide a sturdy skeleton that fully expresses its actual function of being the main support of the structure. Walls have been all but eliminated. At ground level the transition from the massive bulk of the pilaster-faced piers to the deep voids between them has been softened by the interposed columns. These columns carry straight lintels in the manner advocated by Alberti, but Michelangelo uses them with even greater logic and consistency than Alberti. The façade of the third building on the piazza, the three-storied Palazzo dei Senatori,

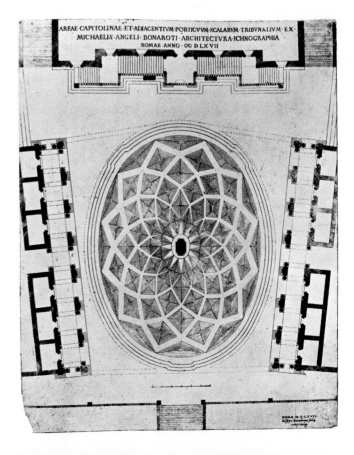

13-27 MICHELANGELO, plan for the Capitoline Hill. (Engraving by Dupérac.)

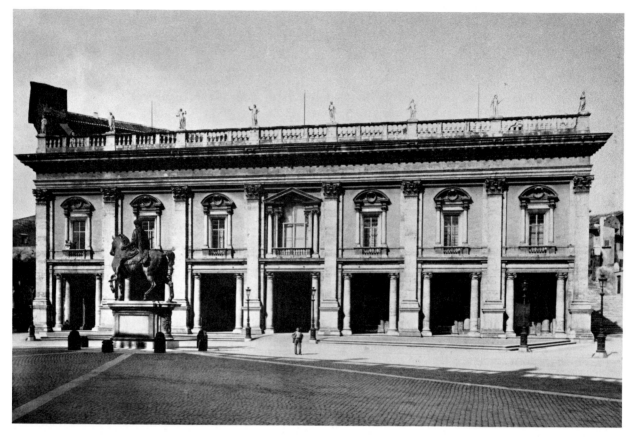

13-28 MICHELANGELO, façade of the Palazzo dei Conservatori, Capitoline Hill.

uses the same design elements as the other two but in a less plastic fashion. The axial building, with its greater height, thus becomes a distinctive and commanding accent for the ensemble without disrupting its unity.

The piazza might have become a roomlike enclosure, as Renaissance squares often were and as Alberti had advised that they be (in his treatise). But again Michelangelo parts with tradition and points to the future. Instead of enclosing his piazza with four walls, with entrances leading through their centers, as a roomlike enclosure would seem to demand, he left the fourth side open. A fourth wall is merely suggested with a balustrade and a thin screen of classical statuary that effectively defines the limits of the piazza without obstructing a panoramic view across the city's roofs toward the Vatican. The accidental symbolism of this axis must have pleased the pope quite as much as the piazza's dynamic design and the sweeping vista must have pleased later Baroque planners.

Michelangelo took over the supervision of the building of St. Peter's a few years after he had designed the Capitoline Hill; neither project was finished at the time of his death. His work on St. Peter's, after efforts by a succession of architects following the death of Bramante, became apparently a show of dedication, thankless and without pay, on his own decision. Writing in May 1557 to his friend Vasari, he complains:

> God is my witness how much against my will it was that Pope Paul forced me into this work on St. Peter's in Rome ten years ago. If the work had been continued from that time forward as it was begun, it would by now have been as far advanced as I had reason to hope[7]

[7] In Robert J. Clements, ed., *Michelangelo: A Self-Portrait* (Englewood Cliffs, N.J.: Prentice-Hall, 1964), p. 57.

Among Michelangelo's difficulties had been his struggle to preserve and carry through (with modifications) Bramante's original plan, which he praised even as he changed it:

> It cannot be denied that Bramante was a skillful architect and the equal of any one from the time of the ancients until now. It was he who drew up the original plan of St. Peter's, not full of confusion but clear and straightforward It was considered to be a fine design, and there is still evidence that it was so: indeed, every architect who has departed from Bramante's plan . . . has departed from the right way[8]

Michelangelo's respect for a good plan we have seen in his carrying out of Sangallo's Farnese Palace design with only minor modifications. With Bramante's plan for St. Peter's Michelangelo managed a major concentration, reducing the central fabric from a number of interlocking crosses to a domed Greek cross inscribed in a square and fronting the whole with

[8] In E. G. Holt, ed., *op. cit.*, p. 195.

a Pantheon-like double-columned portico (FIG. 13-29). Without destroying the centralizing features of Bramante's plan (the nave was lengthened after Michelangelo's death), Michelangelo, with a few strokes of the pen, converted its snowflake complexity into massive, cohesive unity.

The same striving for a unified and cohesive design can be seen in Michelangelo's treatment of the building's exterior. Since the front of the church was changed later, his style and intention are best seen on the west (or apse) end (FIG. 13-30). The colossal order again serves him nobly, as the giant pilasters march around the undulating wall surfaces, confining the movement without interrupting it. The sculpturing of architecture, which Michelangelo began in the Laurentian Library, here extends itself up from the ground through the attic stories and moves on into the drum and dome, the whole building being pulled together into a unity from base to summit. The Baroque architects will learn much from this kind of integral design, which is based ultimately on Michelangelo's conviction that architecture is one with the organic beauty of human form. The

13-29 Below: MICHELANGELO, plan for St. Peter's, Rome.

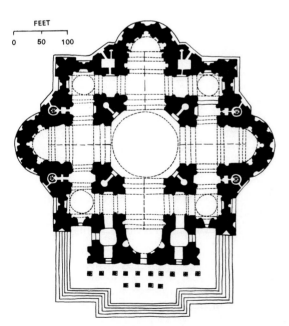

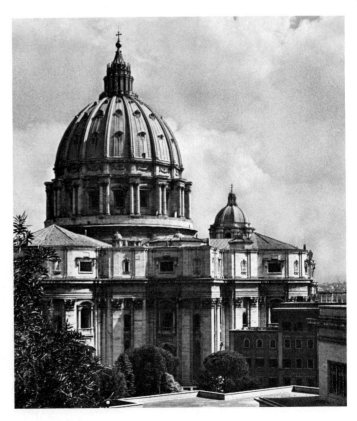

13-30 Right: MICHELANGELO, St. Peter's, 1546–64 (view from the west). Dome completed by Giacomo della Porta, 1590.

The High Renaissance 505

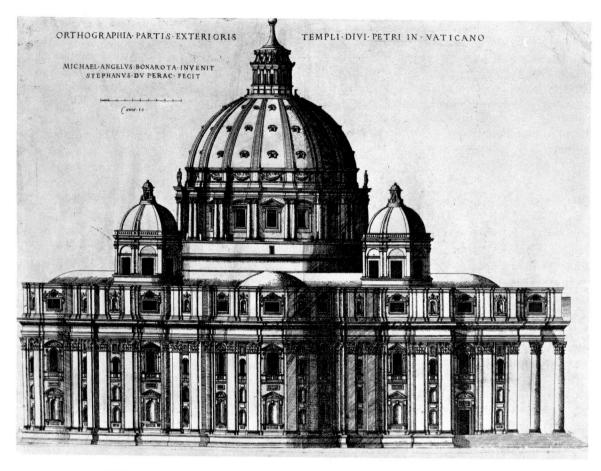

13-31 MICHELANGELO, south elevation of St. Peter's. (Engraving by Dupérac, c. 1569.)

domed west end, majestic as it is today and influential as it has been on architecture through centuries, is not quite as it was intended to be. Originally Michelangelo had planned a dome with a raised silhouette, like that of the cathedral of Florence. But in his final version he decided on a hemispherical dome (FIG. 13-31), to moderate the verticality of the design of the lower stories and to establish a balance between dynamic and static elements. But when Giacomo della Porta executed the dome after Michelangelo's death, he restored the earlier high design, ignoring Michelangelo's later version. Giacomo's reasons were probably the same that had impelled Brunelleschi to use an ogival section for his Florentine dome (see above): greater stability and ease of construction. The result is that the dome seems to be rising from its base, rather than resting firmly on it, an effect that might not have been approved by Michelangelo. Neverthe-

less, the dome of St. Peter's is probably the most impressive and beautiful in the world and has served as model to generations of architects down to our time.

While Michelangelo endured the tribulations of age and the long frustrations of art, his soul was further oppressed by the events that had erupted around him from the time he had fled Florence as a young man after the fall of the Medici. The liberties of Florence were destroyed; the Medici had returned as tyrants, and Michelangelo felt himself an exile, even while he worked for them. Italy was laid waste by the French and Spanish invasions, and the Protestant Reformation divided Christendom into warring camps. The Catholic Counter Reformation gained, and for more than a century Europe was racked by religious war. The glories of the High Renaissance faded, and the philosophy of humanism retreated before the resurgence of a religious spirit often

pessimistic, moralizing, and grimly fanatical, whether Protestant or Catholic. Michelangelo himself turned from his humanist beginnings to religious preoccupation, deeply concerned for the fate of man and for that of his own soul. His sense that the world had run mad, and that man, forsaking God, was doomed, must have been sharpened by his still vivid memory of Savonarola's foreboding summons of sinners to repent and by his reading of Dante, in whom he was expert. In this spirit he undertook the great *Last Judgment* of the altar wall of the Sistine Chapel (FIG. 13-32). The change from the mood of the ceiling paintings of twenty years before is radical. Fallen man was to have been exalted by the coming of the Redeemer, everywhere announced in the thronging figures of the ceiling. Now, on the altar wall, Christ indeed has come, but as the Medieval judge of the world, a giant whose mighty right arm is lifted in a gesture of damnation so broad and universal as to suggest he will destroy all creation, heaven and earth alike. The choirs of heaven surrounding him pulse with anxiety and awe. The spaces below are crowded with trumpeting angels, the ascending just, and the downward-hurtling damned. On the left the dead awake and assume flesh, on the right the damned are tormented by demons whose gargoyle masks and burning eyes revive the demons of the Romanesque tympana. Martyrs who suffered especially agonizing deaths crouch below the Judge. One of them, St. Bartholomew, who was skinned alive, holds the flaying knife and the skin, in which hangs a grotesque self-portrait of

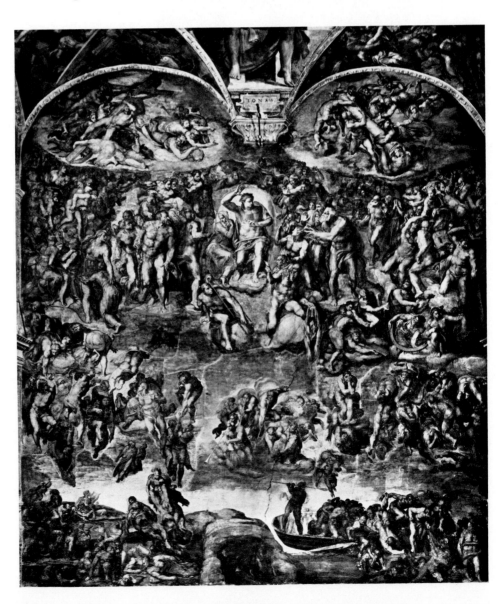

13-32 MICHELANGELO, *The Last Judgment*, fresco on the altar wall of the Sistine Chapel, 1534–41.

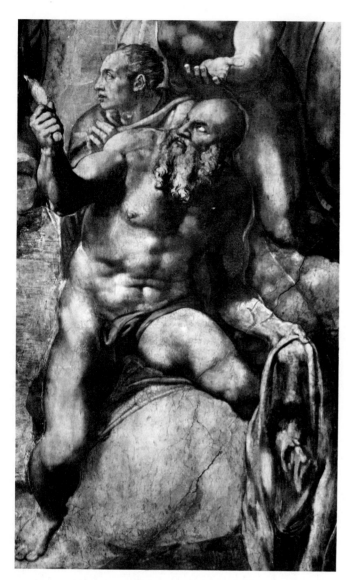

13-33 MICHELANGELO, detail of FIG. 13-32, with "self-portrait."

Michelangelo (FIG. 13-33). In all this there is no trace of the old neo-Platonic aspiration to beauty. The figures are grotesquely huge, violently twisted, with small heads and contorted features. The expressive power of ugliness and terror in the service of a terrible message reigns throughout the composition.

Michelangelo's art began in the manner of the fifteenth century, rose to an idealizing height in the High Renaissance, and at the end moved toward the Baroque. Like a colossus he bestrides three centuries. He became the archetype of the supreme genius who transcends the rules by making his own. Few artists could escape his influence, and variations on Michelangelo's style will constitute much of artistic experiment for centuries.

Andrea del Sarto and Correggio

The towering achievements of Raphael and Michelangelo in Rome tend to obscure everything else that was done during their time. Nevertheless, aside from the flourishing Venetian school (see below), some excellent artists were active in other parts of Italy during the first part of the sixteenth century. One of these was the Florentine ANDREA DEL SARTO (1486–1531), whose early paintings express the ideals of the High Renaissance with almost as much clarity and distinction as do Raphael's. His *Madonna of the Harpies* (PLATE 13-3) shows the Madonna standing majestically on an altarlike base decorated with sphinxes (misidentified as harpies by Vasari, hence the name of the painting). The composition is based on a massive and imposing figure pyramid, whose static qualities have been relieved by the opposing contrapposto poses of the flanking saints, a favorite and effective High Renaissance device to introduce variety into symmetry. The potentially rigid pyramid is further softened by the skillful coordination of the figures' poses into an organic movement that leads from St. Francis, on the left, to the Virgin, to St. John the Evangelist, and from him downward toward the observer. This main movement is either echoed or countered by numerous secondary movements brought into perfect formal balance in a faultless compositional performance. The soft modeling of the forms is based on Leonardo but does not affect the colors, which are rich and warm. Andrea's sense of and ability to handle color set him well apart from his central Italian contemporaries, and he was perhaps the only Renaissance artist who was able to transpose his rich color schemes from panels into frescoes. In his later works, Andrea's compositions tend to become less firmly knit and his color schemes move toward the cool harshness that becomes typical of Mannerist painting. Though he was greatly ad-

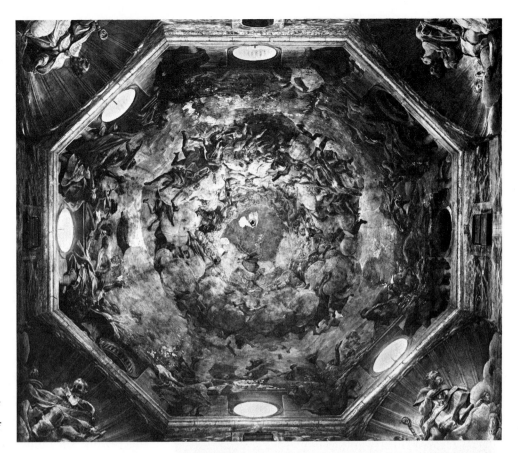

13-34 CORREGGIO, *The Assumption of the Virgin*, fresco, 1526–30. Dome of Parma Cathedral.

mired in the sixteenth and seventeenth centuries, Andrea's fame has waned, and today he seems to be remembered primarily as the teacher of Pontormo, Il Rosso, and Vasari and, thus, as one of the forerunners of Mannerism.

While Andrea del Sarto may still be firmly placed in the High Renaissance camp, his north Italian contemporary, CORREGGIO (Antonio Allegri, about 1489–1534), of Parma, is almost impossible to classify. A solitary genius, Correggio brings together many stylistic trends, including those of Leonardo, Raphael, and the Venetians; yet he developed a unique personal style, which, if it must be labeled, might best be called proto-Baroque. Historically, his most enduring contribution was the development of illusionistic ceiling perspectives to a point seldom surpassed by his Baroque emulators. At Mantua, Mantegna had painted a hole into the ceiling of the Camera degli Sposi; some fifty years later, Correggio painted away the entire dome of the cathedral of Parma (FIGS. 13-34 and 13-35). Opening up the

13-35 CORREGGIO, detail of FIG. 13-34.

13-36 CORREGGIO, *Jupiter and Io*, c. 1532. Approx. 64½″ × 27¾″. Kunsthistorisches Museum, Vienna.

cupola, the artist shows his audience a view of the sky, with concentric rings of clouds among which hundreds of soaring figures perform a wildly pirouetting dance in celebration of the Assumption of the Virgin. These angelic creatures, twinkling their rosy toes at the spectators below, will become permanent tenants of numerous Baroque churches in later centuries. Correggio was also an influential painter of religious panels, in which he forecast many other Baroque compositional devices; as a painter of erotic mythological subjects he had few equals. *Jupiter and Io* (FIG. 13-36) depicts suavely sensual visions out of the pagan past. The painting is one of a series on the loves of Jupiter that Correggio painted for the Duke of Mantua, Federigo Gonzaga. The god, who assumed many disguises to hide his numerous liaisons from his wife, Juno, here appears as a cloud that embraces the willing nymph. The soft, smoky modeling (*sfumato*), derived from Leonardo, is fused with glowing color and renders with exquisite subtlety the voluptuous moment. Even Titian (see below), in his mythological paintings, was rarely able to match the sensuous quality here expressed by Correggio. Unlike Andrea del Sarto, Correggio was little appreciated by his contemporaries; only during the seventeenth century did Baroque painters recognize him as spiritual kin.

MANNERISM

The term "Mannerism" refers to certain leading tendencies in the art of the Late Renaissance, the period from the death of Raphael (1520) to the end of the sixteenth century. The word in its broadest sense means excessive or affected adherence to a distinctive manner, especially in art and literature, and, in its early application to these tendencies, carried the pejorative connotation that the term has in description of individual behavior. Today we view these styles more objectively and appreciate much that is excellent in them.

The Early Renaissance and the High Renaissance had developed their characteristic styles

from the studious observation of nature and the formulation of a pictorial science. By the time of the Mannerists' maturity, after 1520, all the representational problems had been solved; a vast learning was there to be drawn upon. In addition, there had now set in an age of antiquarianism and archeology that was bringing to light thousands of remnants of ancient Roman art. The Mannerists, instead of continuing former research into nature and natural appearance, turned for their models to the masters of the High Renaissance, especially Michelangelo, and to Roman sculpture, especially relief sculpture. Thus, instead of nature as their teacher, they took art. One could say that whereas their predecessors had sought nature and found their style, the Mannerists looked first for a style and found a manner.

Following Michelangelo's example in one respect, the Mannerists declared the artist's right to his own interpretation of the rules, looking for inspiration to the Platonic Idea—referred to by them as the *disegno interno*—which fired their creative fervor. They saw a roughness in nature that needed refining, and they turned to where it had already been refined in art. From the antique and the High Renaissance, each artist, to the limit of his own ingenuity and skill, abstracted forms that he further idealized, so that the typical Manneristic picture or statue looks like an original essay in human form at some remove from nature. Since *maniera* (as the style was called by Mannerist theorists themselves) is an art of the human figure almost exclusively, its commonest expression is in paintings involving numerous figures in what appears to be a complicated dance and pantomime, the compositions, as well as the fanciful gestures and attitudes, deliberately intricate. One thinks not of the great stage dramatics of the High Renaissance but rather of an involved choreography for interpretive dancers, so studied and artificial are the movements. Where the art of the High Renaissance strives for balance, Mannerism seeks instability. The calm equilibrium of the former is replaced by a restlessness that leads to distortions, exaggerations, and bizarre posturings on the one hand and sinuously graceful, often athletic attitudes on the other. The figures' positions and actions need have little to do with the sub-

ject. The Mannerist requirement of "invention" leads its practitioner to the *maniera*, a self-conscious stylization involving complexity, caprice, bizarre fantasy (the "conceit"), elegance, preciosity, and polish. This is an art made for aristocratic patrons by artists who sense that their profession is worthy of honor and the admiration of kings. It is an age when monarchs and grandees may plead for anything from the hands of Raphael and Michelangelo, if only a sketch. The concepts of "classic" and "old master" are abroad, and artists are being called *divino*. The artist becomes conscious of his own personality, powers of imagination, and technical skill, and he acquires learning and aims at virtuosity. He cultivates not the knowledge of nature but the intricacies of art.

In Painting

The *Descent from the Cross* (PLATE 13-4) by JACOPO PONTORMO (1494–1556) exhibits almost all the stylistic features that are characteristic of the early phase of Mannerism in painting. The figures crowd the composition, pushing into the front plane, almost completely blotting out the setting. The figure masses are disposed around the frame of the picture, leaving a void in the center, where the High Renaissance artists had concentrated their masses. The composition has no focal point, and the figures swing around the edges of the painting without coming to rest. The representation of space is as strange as the representation of the figure. Mannerist space is ambiguous; we are never quite sure where it is going or just where the figures are in it. We do not know how far back the depicted space extends; its limit is defined by the figure at the top. But we do know that the space is really too shallow for what is taking place in it. For example, there is no room in Pontormo's work for the body belonging to the head that appears immediately over Christ's. The centrifugal effect of the positions of the figures is strengthened by the directions of the curiously anxious glances that the actors direct out of the picture in all directions. There is an athletic bending and twisting, with distortions (there is no way for a torso to bend at the point

where the foreground figure's does), elastic elongations of limbs, and rendering of the heads as uniformly small and oval. The composition is further jarred by clashing colors, which are unnatural and as dissimilar as possible to the sonorous primary color chords used by painters of the High Renaissance. The mood of the painting is hard to describe; it seems the vision of an inordinately sensitive soul, perhaps itself driven, as are the actors, by nervous terrors. The psychic dissonance of the composition would indeed appear out of tune to a classical artist.

IL ROSSO FIORENTINO (1494–1540), like Pontormo a pupil of Andrea del Sarto, uses means similar to Pontormo's to compress space but fills it with

13-37 IL ROSSO FIORENTINO, *Moses Defending the Daughters of Jethro*, 1523. Approx. 5′ × 4′. Galleria degli Uffizi, Florence.

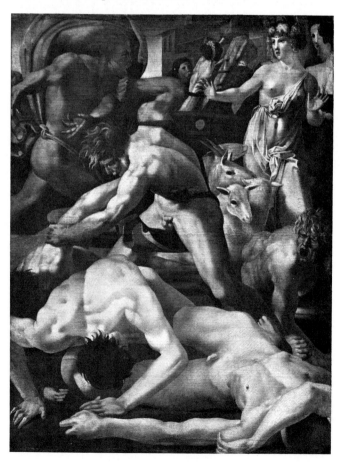

turbulent action. His painting of Moses defending the daughters of Jethro (FIG. 13-37) recalls the titanic struggles and powerful musculature of Michelangelo's figures in the Sistine Chapel ceiling, but his purpose is not expressive so much as inventive of athletic poses. At the same time, though the figures are modeled for three-dimensional effect, they are compressed within a limited space, so that surface is emphasized as a two-dimensional pattern. By 1530, when Francis I of France called him to decorate the palace at Fontainebleau, Il Rosso had all but forsaken this early furor for more graceful, elongated forms.

Correggio's pupil PARMIGIANINO (1503–40) in his best-known work, the *Madonna with the Long Neck* (FIG. 13-38), achieves the elegance that is a principal aim of Mannerism. He smoothly combines the influences of his master and of Raphael in a picture of exquisite grace and precious sweetness. The small oval head of the Madonna, her long slender neck, the unbelievable length and delicacy of the hand, and the sinuous, swaying elongation of her frame, are all marks of the aristocratic, gorgeously artificial taste of a later phase of Mannerism. Here is Leonardo distilled through Correggio. To the left is a bevy of angelic creatures, melting with emotions as soft and smooth as their limbs (the left side of the composition is entirely Correggio). To the right is a line of columns without capitals, an enigmatic setting for an enigmatic figure with a scroll whose distance from the foreground is ambiguous.

The Mannerists sought a generally beautiful style that had its rules—but rules, as we have seen, that still permitted the artist the free play of his powers of invention. Thus, while all Mannerist painting has factors in common, each artist, as it were, has his recognizable signature. All the points made so far about Mannerist composition are recognizable in *Venus, Cupid, Folly, and Time* (FIG. 13-39) by BRONZINO (1503–72). A pupil of Pontormo, Bronzino was a Florentine and painter to Cosimo I, first Grand Duke of Tuscany. In this painting he manifests the Mannerist fondness for extremely learned and intricate allegories; we are far from the simple and monumental statements and forms of the High Renaissance. Venus, fondled by Cupid (desire), is uncovered by Time, while Folly bombards

them with roses; other figures represent Hatred and Inconstancy. The masks, a favorite of the Mannerists, symbolize falseness. The idea of the picture is that love, accompanied by its opposite, hatred, and plagued by inconstancy, is foolish, and its folly will be discovered in time. The figures are drawn around the front plane and almost entirely block the space, though there really is no space. The contours are strong and sculptural, the surfaces of enamel smoothness. Of special interest are the heads, hands, and feet, for the Mannerists considered the extremities to be the carriers of grace and the clever depiction of them evidence of skill in *maniera*.

The sophisticated elegance most sought by the Mannerist painter was often achieved in portraiture, in which Mannerism excels. Bronzino's *Portrait of a Young Man* is exemplary of the type (PLATE 13-5). The subject is a proud youth, a man of books and intellectual society rather than a man of action or a merchant. His cool demeanor is carefully affected, a calculated attitude of nonchalance toward the observing world. This austere and incommunicative formality is standard for the Mannerist portrait. It asserts the rank and station of the subject but not his personality. The haughty poise, the graceful, long-fingered hands, the book, the masks, the severe architecture—all suggest the traits and environment of the high-bred, disdainful patrician. The somber Spanish black of his doublet and cap (this is the century of Spanish etiquette) and the olive green walls of the room make a color scheme that is deeply restrained, a muted background for the sharply defined, impassive silhouette.

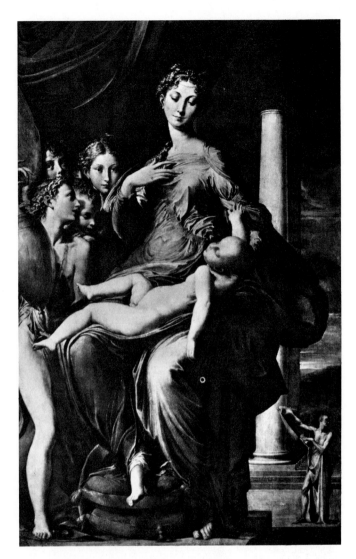

13-38 PARMIGIANINO, *Madonna with the Long Neck, c.* 1535. Oil on panel, approx. 85″ × 52″. Galleria degli Uffizi, Florence.

In Sculpture

With Bronzino, Florentine Mannerism in painting virtually comes to an end. But a quite remarkable person, as Mannerist in his action as in his art, has left us in sculpture the mark of the prevailing style. BENVENUTO CELLINI (1500–71), perhaps best known for his *Autobiography*, had, to judge by that fascinating work, an awesome proficiency as an artist, statesman, soldier, lover, and many other things. He was first of all a goldsmith. The influence of Michelangelo led him to attempt larger works, and, in the service of Francis I, he cast in bronze the *Diana of Fontainebleau* (FIG. 13-40), a figure that sums up Italian and French Mannerism. The figure is derived from the reclining tomb figures in the Medici Chapel, but it exaggerates their characteristics: The head is remarkably small, the torso stretched out, and the limbs elongated without end. The contrapposto is more apparent than real, for it is flattened out almost into the forward plane, as of course

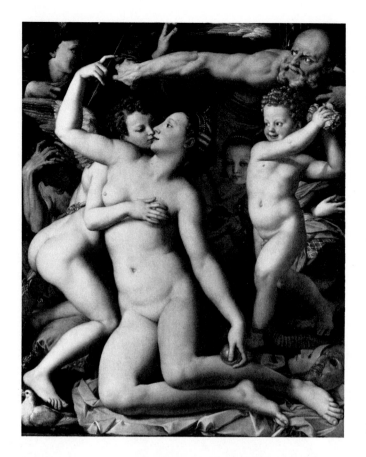

the Mannerist design sense dictates. This almost abstract figure, along with Mannerist works in painting done by Il Rosso and others, had considerable influence in the development of French Renaissance art, particularly in the school of Fontainebleau.

Italian influence, working its way into France, had strength enough to draw a brilliant young French sculptor, Jean de Boulogne, to Italy, where he practiced his art under the Italian cognomen GIOVANNI DA BOLOGNA (1529–1608). Although his quality and importance have not always been recognized, he is the most important sculptor in Italy after Michelangelo and is the stylistic link between that great master and the Baroque sculptor Bernini. Giovanni's *Rape of the Sabine Women* (FIG. 13-41) wonderfully exemplifies Mannerist principles of composing figures and, at the same time, shows an impulse to break out of the Mannerist formulas of representation. The title was given to the group after it was raised, and it

13-39 BRONZINO, *Venus, Cupid, Folly, and Time*, c. 1550. Approx. 57″ × 45″. Reproduced by courtesy of the Trustees of the National Gallery, London.

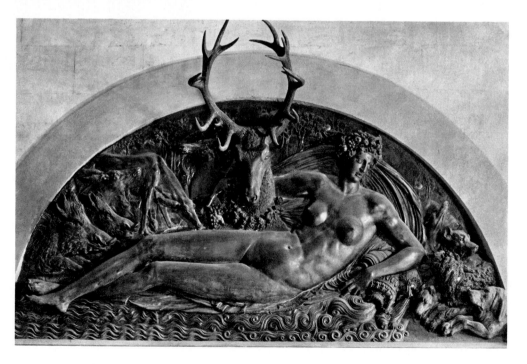

13-40 Right: BENVENUTO CELLINI, *Diana of Fontainebleau*, 1543–44. Bronze, over life-size. Louvre, Paris.

is likely that Giovanni intended only an interesting figure composition involving an old man, a young man, and a woman. The story, derived from mythic Roman history, tells how the Romans took wives for themselves from the neighboring Sabines. The amateurs, critics, and scholars who flock around works of art in this age of Mannerism, naming groups in any way they find appropriate, are an indication of how important the visual arts had become, and how valued. The artist himself is learned in his sources; here Giovanni twice adapts the *Laocoön* (FIG. 5-67), discovered early in the century—in the figure of the crouching old man and in the gesture of the woman, one arm flung up. The three bodies interlock on an axis along which runs a spiral movement; significantly, the figures do not break out of this vortex but remain as if contained within a cylinder. The appearance of the cylinder changes with our viewpoint. It is necessary to walk around the group to appreciate this and to understand that, despite its confinement, the group changes aspect radically according to the point from which one views it. One reason is that the open spaces that pass through the masses— for example, that between an arm and a body— count as much in the effect as the solids. This is the first large-scale group to be composed for multiple points of view since Hellenistic sculpture, which it recalls. But as yet the figures do not freely reach out into space and relate to the environment. The fact that they remain "enclosed" prevents our calling them Baroque. Yet the Michelangelesque potential for action and the athletic flexibility of the figures are there. The Baroque period will see the release of the sculptured figure into full action.

In Architecture

Mannerism in painting and sculpture has been studied fairly extensively since the early decades of this century. But only in the 1930's was it discovered that the term could also be applied to much of sixteenth-century architecture. However, the corpus of Mannerist architecture that has been compiled since then is far from homo-

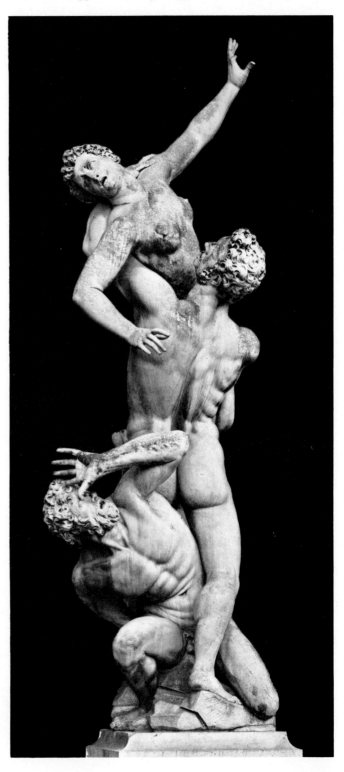

13-41 Giovanni da Bologna, *Rape of the Sabine Women*, completed 1583. Marble, approx. 13′ 6″ high. Loggia dei Lanzi, Florence.

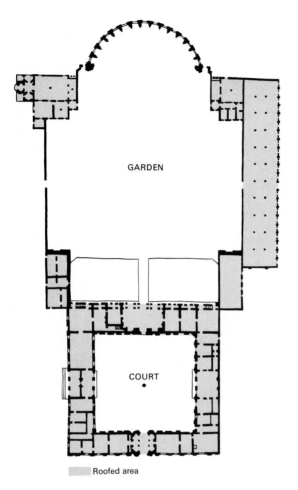

GARDEN

COURT

☐ Roofed area

dox manner does not necessarily make him a Mannerist architect. Certainly in his designs for St. Peter's (see above) he was striving for those effects of mass, balance, order, and stability that are the very hallmarks of High Renaissance design. And even some of the most unusual features in the Laurentian Library (FIG. 13-25) were dictated by structural necessity. Michelangelo never really aimed to baffle or confuse, while this was exactly the goal of Giulio Romano when he designed the Palazzo del Tè, in Mantua, and, with it, formulated almost the entire architectural vocabulary of Mannerism.

GIULIO ROMANO was born either in 1492, if we accept Vasari's suggestion, or in 1499, if we disallow the possibility of error in a document that states that he died in Mantua in 1546 at the age of forty-seven. If we give credence to the latter birthdate, however, Giulio must have been one of the most precocious young prodigies in the history of world art, as he could then have been little more than sixteen years old when he became Raphael's chief assistant in the decoration of the Vatican stanze. After Raphael's premature death in 1520, Giulio became his master's artistic executor by completing Raphael's unfinished frescoes and panel paintings. In 1524 Giulio went to Mantua, where he found a patron in Federigo Gonzaga, for whom he built and decorated the Palazzo del Tè (FIG. 13-42) between 1525 and 1535.

The Palazzo del Tè was intended to combine

geneous and includes many works—for example, those of Palladio (see below)—that seem really not to fit the term "Mannerism." And the fact that Michelangelo was using classical architectural elements in a highly personal and unortho-

13-43 GIULIO ROMANO, garden façade of the Palazzo del Tè.

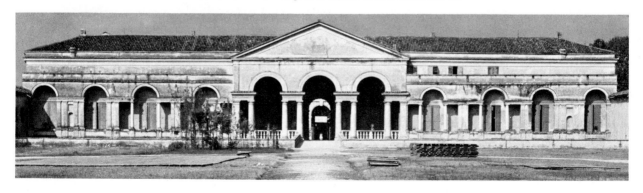

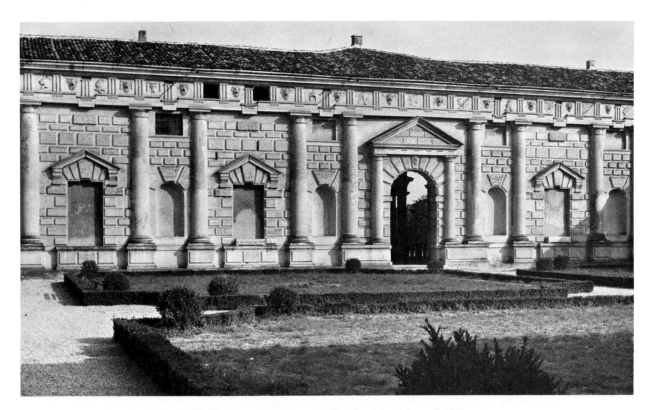

13-44 GIULIO ROMANO, court façade of the Palazzo del Tè.

the functions of a suburban summer palace with those of a stud farm for the duke's famous stables. Built around a square court, the palazzo has a main entrance that faces west. A large garden, flanked on its south side by the stables, extends eastward from the building, so that the dominant axis formed by buildings and garden is at right angles to that of the entrance, a striking departure from the High Renaissance practice of introducing and stressing the main axis of a building with the central placement of the main portal. This divergence from convention serves as an overture to a building so laden with structural surprises and contradictions that the whole becomes an enormous parody on the classical style of Bramante. To be sure, the appreciation of the joke required a highly sophisticated audience, and the recognition of some quite subtle departures from the norm presupposed thorough familiarity with the established rules of classical architecture. It speaks well for the duke's sophistication that he accepted Giulio's form of architectural humor.

Only a few of the building's irregularities can be pointed out here. In the main façade the bays flanking the central portal are of unequal widths and rhythm; some are framed by single, others by double pilasters, and here and there a window has been placed intentionally off center. Similar discords, with variations, appear in the walls facing the court, and in the garden façade (FIG. 13-43), where, in addition to their irregular spacing, some arches are supported by columns, others by piers, and still others by both. Most of the architectural chaos faces the court (FIG. 13-44), where keystones seem to be slipping from arches; where massive Tuscan columns carry ridiculously narrow architraves (their structural insufficiency stressed by the fact that they break midway between columns, evidently unable to support the weight of the triglyphs above); and where the walls have been rusticated in such a way that the viewer is uncertain whether he is looking at a wall with projecting stones or one with a deeply channeled surface.

In short, in the Palazzo del Tè, all the classical rules of order, stability, and symmetry have been deliberately flouted, and every effort has been made to startle and shock the beholder. This desire to create ambiguities and tensions is as typical of Mannerist architecture as it is of Mannerist painting, and many of the devices invented by Giulio Romano for the Palazzo del Tè will become standard features in the formal repertoire of later Mannerist building.

VENICE

In the sixteenth century, Venetian art became a strong, independent, and influential school in its own right, touched, if at all, only very slightly by the fashions of Mannerism that swept Western Europe. Venice had long been the proud maritime mistress of the Mediterranean and its coasts, and, as the gateway to the Orient, it "held the gorgeous east in fee; and was the safeguard of the west." At the height of its commercial and political power during the fifteenth century, Venice saw its fortunes decline in the sixteenth; even so, Venice and the papal state were the only Italian sovereignties that retained their independence during the century of strife when all the others were reduced to dependency on either France or Spain. While the fundamental reasons for the decline of Venice were the discoveries in the New World and the economic shift from Italy to the Hapsburg Germanies and Netherlands, other more immediate and pressing events drained her wealth and power. Venice was constantly embattled because of the Turks, who, after their conquest of Constantinople, began to contest with Venice its control of the eastern Mediterranean. Early in the century Venice also found itself attacked by the European powers of the League of Cambrai, formed and led by Julius II, who coveted Venetian holdings in Romagna. Although this wearing, two-front war sapped its strength, Venice's vitality endured, at least long enough to overwhelm the Turks in the great sea battle of Lepanto in 1571. This time Europe was on Venice's side.

Architecture: Palladio

The Venetian independence from contemporary currents can be seen in the work of the architect ANDREA PALLADIO (1508–80). Beginning as a stonemason and decorative sculptor, Palladio, at age thirty, turned to architecture, the ancient literature on architecture, engineering, topography, and military science. Unlike the universal scholar, Alberti, Palladio became more the specialist. He made several trips to Rome and studied the ancient buildings at first hand. He illustrated Daniele Barbaro's edition of Vitruvius (1556), and he wrote his own treatise on architecture, *I quattro libri dell' architettura* (*Four Books on Architecture*), which was originally published in 1570 and had a wide-ranging influence on succeeding generations of architects throughout Europe. Palladio's influence outside Italy, most significantly in England and in colonial America, was probably stronger and more lasting than that of any other architect.

Palladio is best known for his numerous villas built on the Venetian mainland, of which nineteen still stand; the villas were especially influential on later architects. The same Arcadian spirit that prompted the ancient Romans to build villas in the countryside (see Chapter Six) and that will be expressed so eloquently in the art of the Venetian painter Giorgione, motivated a similar villa-building boom in the sixteenth century. One can imagine that the congestion of Venice, with its very limited space, must have been worse than that of any ancient city. But a longing for the countryside was not the only motive: declining fortunes prompted the Venetians to develop their long-neglected mainland possessions. Citizens who could afford it were encouraged to set themselves up as gentlemen-farmers and to develop swamps into productive agricultural land. Wealthy families could look upon their villas as providential investments. The villas were thus gentleman-farms (like the much later American plantations, which were architecturally influenced by Palladio) surrounded by service outbuildings that Palladio generally arranged in long, low wings that branched out from the main building, usually enclosing a large rectangular court area.

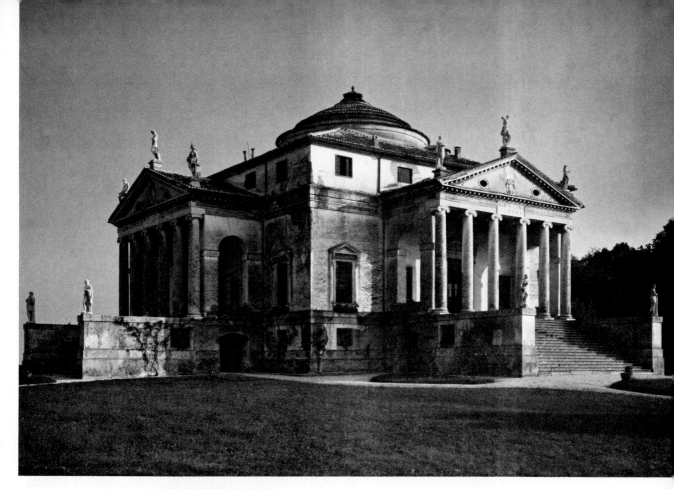

13-45 Above: ANDREA PALLADIO,
Villa Rotunda, Vicenza, begun
c. 1550–53.

13-46 Left: ANDREA PALLADIO, plan
of the Villa Rotunda.

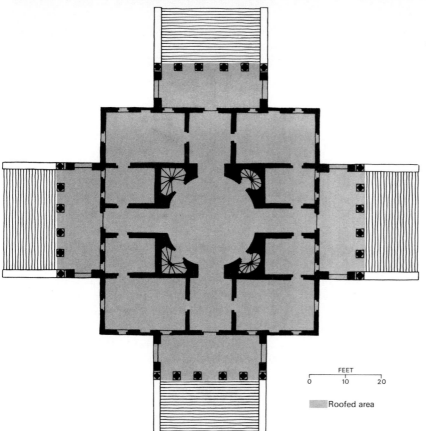

FEET

0 10 20

Roofed area

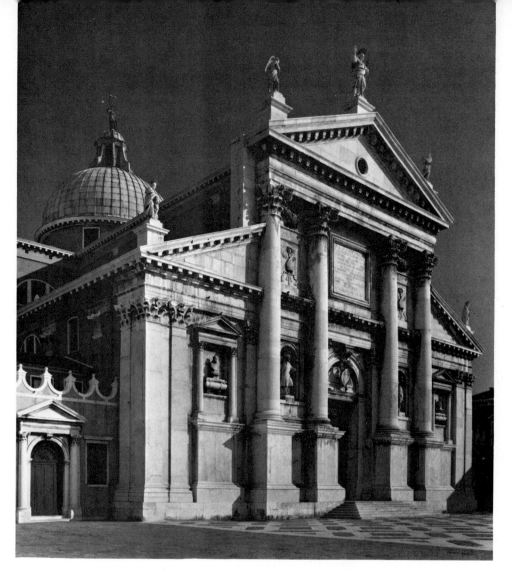

13-47 Andrea Palladio, San Giorgio Maggiore, Venice, 1565.

Although it is the most famous, the Villa Rotunda (FIG. 13-45), near Vicenza, is not really typical of Palladio's general villa style, since it was not built for an aspiring gentleman-farmer, but for a retired monsignor who wanted it for social events. Located on a hilltop, it was built without the usual wings of secondary buildings and was planned and designed as a kind of *belvedere*. Its central plan (FIG. 13-46), with four identical façades and projecting porches, is, therefore, both sensible and functional, as each of the porches could be used as a platform from which one could enjoy a different view of the surrounding landscape. This also makes the central dome-covered rotunda logical, since it functions as a kind of revolving platform from which the visitor

can turn in any direction for the preferred view. The result is a building whose parts are functional and systematically related to one another in terms of calculated mathematical relationships. The Villa Rotunda, like Santa Maria della Consolazione at Todi, thus embodies all the qualities of self-sufficiency and formal completeness of which most Renaissance architects dreamed. In his formative years, Palladio had been influenced by Alberti, by Bramante, and briefly by Giulio Romano. By 1550, however, he had developed his own personal style, which, in its clarity and lack of ambiguity, was as different from contemporary Mannerism as it was, in its static qualities and rather dry, "correct" classicism, different from the dynamic style of Michelangelo.

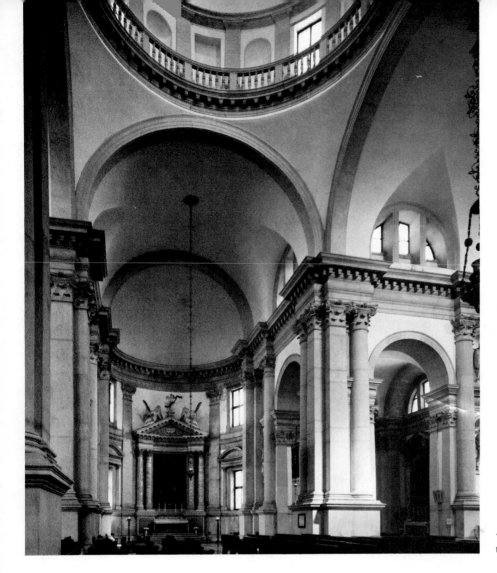

13-48 Andrea Palladio, interior of San Giorgio Maggiore.

San Giorgio Maggiore (FIG. 13-47), directly across the Grand Canal from the Piazza San Marco, is one of the most dramatically placed buildings in Venice. The façade is strictly Palladian. Dissatisfied with earlier solutions to the problem of integrating a high central nave and lower aisles into a unified design, Palladio solved it by superimposing a tall, narrow, classical porch upon a low, broad one. This not only reflects the interior arrangement of the building, but also introduces the illusion of three-dimensional depth, an effect intensified by the strong projection of the central columns and the shadows they cast. Though the result seems at first a rigid formalism, the play of shadow across the building's surfaces, its reflection in the water, and its gleaming white against sea and sky create a remarkably colorful effect. The interior of the church (FIG. 13-48) is flooded with light, which crisply defines and, at the same time, softens the contours of the rich wall articulations—pedestals, bases, shafts, capitals, entablatures—all beautifully and "correctly" profiled, the exemplar of what classical architectural theory means by "rational" organization.

Painting: Giovanni Bellini and Giorgione

The soft, colored light of Venice, which could relax the severe lines of Palladio's architecture,

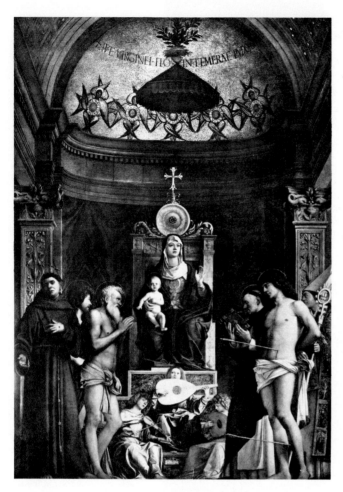

13-49 Giovanni Bellini, *San Giobbe Altarpiece*, c. 1485. 15' 4" × 8' 4". Galleria dell' Accademia, Venice.

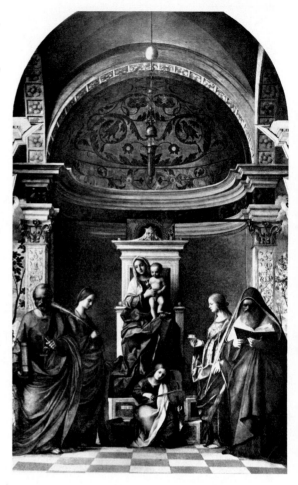

13-50 Giovanni Bellini, *San Zaccaria Altarpiece*, 1505. Approx. 16' 5" × 7' 9". San Zaccaria, Venice.

lives at its fullest in Venetian painting. In the career of GIOVANNI BELLINI (about 1430–1516) we find the history of that style. Always alert to what is new, Bellini, in his long, productive life, never ceased to develop artistically and, almost by himself, created what is known as the Venetian style, so important to the subsequent course of painting. Trained in the tradition of the International style by his father, who was a student of Gentile da Fabriano, Giovanni worked in the family shop and did not develop his own style until after his father's death in 1470. His early independent works show him to be under the dominant influence of his brother-in-law, Mantegna. But in the late seventies, impressed by the possibilities

offered by the new oil technique (see Chapter Fourteen) that Antonello da Messina introduced during a visit to Venice, Bellini abandoned the Paduan's harsh, linear style and developed a sensuous, coloristic manner that was to become characteristic of Venetian painting.

Giovanni Bellini is best known for his many Madonnas, which he painted both half-length in small devotional panels and in large, monumental altarpieces of the *sacra conversazione* type. Two of the latter, the *San Giobbe Altarpiece* (FIG. 13-49) and the *San Zaccaria Altarpiece* (FIG. 13-50), illustrate not only a stunning development in Bellini's art but also the essential differences in the Early and the High Renaissance treatment of

the same subject. The two altarpieces were painted about twenty years apart, and they have similar settings and figure groupings. In the earlier work, the *San Giobbe Altarpiece*, although the space is large, airy, and clearly defined, the figures seem to be crowded; they cling to the foreground plane and are seen in a slightly forced, Mantegnesque "worm's-eye" perspective. The drawing remains sharp and precise, particularly in that charming Venetian trademark, the group of angel-musicians at the foot of the Madonna's throne. The figures are already arranged in the pyramidal grouping preferred by the High Renaissance, but they tend to exist as individuals rather than parts of an integrated whole. Seen by itself, the *San Giobbe Altarpiece* is an orderly, well-balanced painting that can hold its own with any produced during the Early Renaissance. But side by side with the subsequent *San Zaccaria Altarpiece* it suddenly seems cluttered and overly busy. By adding simplicity to the order, balance, and clarity of the earlier painting, Bellini has taken the long step into the High Renaissance.

In the *San Zaccaria Altarpiece*, in contrast to his earlier treatment of the theme, Bellini raises the observer's viewpoint and makes the perspective more relaxed and natural. The number of figures has been reduced, and they have been more closely integrated with each other and with the space that surrounds them. Combined into a single, cohesive group, the figures no longer cling to the front of the painting; disposed in depth, they now move in and out of the apse instead of standing before it. Their attitudes produce a rhythmic movement within the group, but all obvious gestures have been eliminated and former busyness has changed to serene calm. In addition, Bellini's method of painting has become softer and more luminous; line is no longer the chief agent of form but has been submerged in a sea of glowing color, a soft radiance that envelops the forms with an atmospheric haze and enhances their majestic serenity.

The San Zaccaria Madonna is the mature work of an old man who, in a single lifetime, spanned the development that took three generations in Florence. Departing from the Gothic, he moved through the Early Renaissance and arrived in the High Renaissance even before Raphael and Michelangelo. And at the very end of his long life, this astonishingly apt old artist was still willing and able to make changes in his style and approach that kept him abreast of his times; he began to deal with pagan subjects.

The *Feast of the Gods* (PLATE 13-6) represents a feedback of influence from one of Bellini's own students, Giorgione, who had developed his master's landscape backgrounds into poetic, Arcadian reveries. (In this case Titian, another of Bellini's pupils, probably completed the right background.) After Giorgione's premature death, Bellini embraced his student's interests and, in the *Feast of the Gods*, developed a new kind of mythology in which the Olympian gods appear as peasants enjoying a heavenly picnic in a shady northern Italian glade. His source is Ovid's *Fasti*, which describes a banquet of the gods. The figures are spread across the foreground: Satyrs attend upon the gods, nymphs bring jugs of wine, a child draws from a keg, couples engage in love play, and the sleeping nymph at the right receives amorous attention. The mellow light of a long afternoon glows softly around the gathering, touching the surfaces of colorful draperies, smooth flesh, and polished metal. Bellini here announces the delight the Venetian school will take in the beauty of texture revealed by the full resources of color gently and subtly harmonized. Behind the warm, lush tones of the figures, a background of cool, green, tree-filled glades reaches into the distance; at the right a screen of trees makes a verdant shelter. The atmosphere is idyllic, a floral countryside making a setting for the never ending pleasure of the immortal gods. The poetry of Greece and Rome, as well as that of the Renaissance, is filled with this pastoral mood, and the Venetians make a specialty of its representation. Its elements include the smiling landscape, eternal youth, and song and revelry, always with a touch of the sensual.

Thus, with Bellini, Venetian art becomes the great complement of the schools of Florence and Rome. The Venetians' instrument is color; that of the Florentines and Romans, sculpturesque form. These two run parallel—sometimes touching and engaging—through the history of Western art from the Renaissance on. Their themes are different. Venice paints the poetry of the

senses and delights in the beauty of nature and the pleasures of mankind. Florence and Rome attempt the sterner, intellectual themes—the epic of man, the masculine virtues, the grandeur of the ideal, the lofty conceptions of religion as they involve the heroic and the sublime. The history of later Western art can be broadly understood as a dialogue between the two traditions.

The inspiration for Bellini's late arcadianism is to be found in paintings like the so-called *Pastoral Symphony* (PLATE 13-7) by his illustrious student GIORGIONE DA CASTELFRANCO (1478–1510). Out of a mist of color shadow emerge the soft forms of figures and landscape. The theme is as mysterious as the light. Two nude females, accompanied by two clothed young men, occupy the rich, abundant landscape through which a shepherd passes; in the distance, a villa crowns a hill. The pastoral mood is so eloquently evoked here that we need not know (as we do not) the precise meaning of the picture; the mood is enough. The shepherd is symbolic of the poet; and the pipes and the lute, of his poetry. The two nymphs accompanying the young men may be thought of as their invisible inspiration, their muses; one turns to lift water from the sacred well of poetic inspiration. The great, golden bodies of the nymphs, softly modulated by the smoky shadow, become the standard Venetian type. It is the Venetian school that resurrects the Venus figure from antiquity, making her the fecund goddess of nature and of love. The full opulence of the figures should, of course, not be read according to modern preferences in womanly physique but as poetic personifications of the abundance of nature. Giorgione, himself a pastoral poet in the pictorial medium and one of the greatest masters in the handling of light and color, praises the beauty of nature, music, woman, and pleasure. Vasari reports that Giorgione was an accomplished lutist and singer, and adjectives from poetry and music seem best suited to describe the pastoral air and muted chords of his painting. He casts over the whole scene a mood of tranquil revery and dreaminess, evoking the landscape of a lost but never forgotten paradise. Arcadia and its happy creatures persist in the subconscious memory and longing of mankind.

Among the Italians it was the Venetians who first expressed a love of nature and a realization of its potentialities for the painter, though they never represent it except as inhabited by man. The ancient spirits, the deities of field and woodland, still inhabit it too, and landscape, manifesting the bounty of Venus and sanctified by her beauty, as yet simply provides the inspiring setting for the poet, without whom it would be incomplete.

Titian

Giorgione's arcadianism passed not only to his much older, yet constantly learning master, Bellini, but to Tiziano Vecelli, whose name we anglicize into TITIAN (about 1490–1576). Titian is the most prodigious and prolific of the great Venetian painters. He is among the very greatest painters of the Western world, a supreme colorist and, in a broad sense, the father of the modern mode of painting. An important change that took place in his time was the almost universal adoption of canvas, with its rough-textured surface, in place of wood panels for paintings. It is the painting of Titian that establishes oil color on canvas as the typical medium of our pictorial tradition. A contemporary of Titian describes his technique:

> . . . Titian [employed] a great mass of colors, which served . . . as a base for whatever he was going to paint over it . . . I myself have seen his determined brushstrokes laden with color, sometimes a streak of pure earth-red which served him (one might say) as a half-tone, other times with a brushstroke of white lead; and with the same brush colored with a red, black and yellow, he formed a highlight; and with these rules of technique made the promise of an excellent figure appear in four brushstrokes.

> After having laid these important foundations, he then used to turn the pictures to the wall, and leave them—sometimes for as long as several months—without looking at them; and when he wanted to apply his brush to them again, he [examined] them most rigorously . . . whether he could find any defects in them or discover anything which would not be in harmony with the delicacy of his intentions Working thus, and

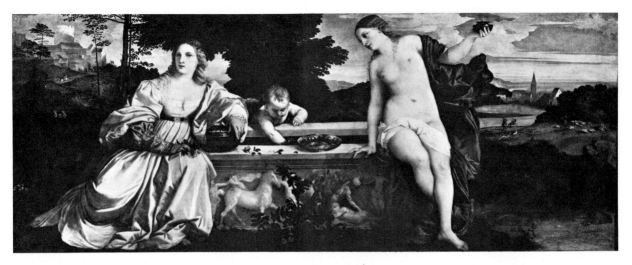

13-51 TITIAN, *Sacred and Profane Love*, c. 1515. Oil on canvas, approx. 42″ × 100″. Galleria Borghese, Rome.

redesigning his figures, Titian brought them into a perfect symmetry which could represent the beauty of Art as well as of Nature. After this was done, he put his hand to some other pictures until the first was dry, working in the same way with this other; thus gradually he covered those quintessential outlines of his figures with living flesh. . . . He never painted a figure all at once, and used to say that he who improvises his song can form neither learned nor well-turned verses. But the final polish . . . was to unite now and then by a touch of his fingers the extremes of the light areas, so that they became almost half-tints . . . at other times, with a stroke he would place a dark streak in a corner; to reinforce it he would add a streak of red, like a drop of blood. . . . in the final phase [he] painted more with his fingers than with his brushes.[9]

Trained by both Bellini and Giorgione, Titian learned so well from them that there is still no general agreement as to the degree of his participation in their late works. He completed several unfinished works of Bellini's and of Giorgione's, among them Bellini's *Feast of the Gods* (PLATE 13-6), for which, as we have seen, he painted the landscape in the right background. An early

work, the *Sacred and Profane Love* (FIG. 13-51) is very much in the manner of Giorgione, with its Arcadian setting, its allegory, and its complex and enigmatic meaning. Two young women, one draped, the other nude, flank a sarcophagus into which a cupid reaches. Immediately behind them is a screen of trees, and, to left and right, deep vistas into different landscapes. The two figures may represent the different neo-Platonic levels of love, the sumptuously draped woman a kind of allegory of vanity and the love of this world; the nude who holds aloft her lamp may signify the highest level of love that can be reached—love of the divine (nudity being symbolic of truth). Titian's figures are not suffused with the glowing, mysterious tones of Giorgione's; they are firmly drawn and boldly and brilliantly colored, and the artist manifests his chief interest in the play of light over the rich satins and the smooth volumes of the body and glossy flesh. The world given to the eye is a world of color before it is a world of solid forms. And it is this truth that the Venetians were the first to grasp.

Upon the death of Giovanni Bellini in 1516, Titian was appointed painter to the republic of Venice. Shortly thereafter he painted the *Madonna of the Pesaro Family* (FIG. 13-52) for the church of the Frari. This great work, which established the reputation and personal style of Titian, was present-

[9] Palma Giovane, as quoted by Boschini (1674). *All the Paintings of Titian* by F. Valcanover. Copyright © 1960 by Rizzoli Editore, s.p.e. Published by Hawthorn Books, Inc., 70 Fifth Avenue, New York.

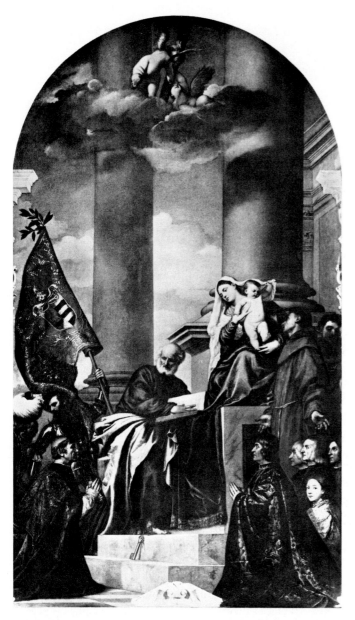

13-52 TITIAN, *Madonna of the Pesaro Family*, 1519–26. Approx. 16' × 9'. Santa Maria dei Frari, Venice.

ed to the church by Jacopo Pesaro, Bishop of Paphos in Cyprus and commander of the papal fleet, in thanksgiving for a successful expedition (in 1502) against the Turks during the Venetian-Turkish war. In a stately sunlit setting, the Madonna receives the commander, who kneels at the foot of her throne. A soldier (St. George?) behind the commander carries a banner with the arms of the Borgia (Pope Alexander VI); behind

him is a turbaned Turk, a captive of the Christian forces. St. Peter occupies the steps of the throne, and St. Francis introduces other members of the Pesaro family, who kneel solemnly in the right foreground. The massing of monumental figures, singly and in groups, within a weighty and majestic architecture is, as we have seen, characteristic of the High Renaissance. But Titian does not compose a horizontal and symmetrical arrangement, as does Leonardo in the *Last Supper* (FIG. 13-3) or Raphael in the *School of Athens* (FIG. 13-16). Rather he places the figures on a steep diagonal, in occult balance, the Madonna, focus of the composition, coming well off the central axis. Attention is directed to her by perspective lines, by the inclination of figures, and by the directional lines of gaze and gesture. The design is beautifully brought into poise by the banner that inclines toward the left, balancing the rightward and upward tendency of the main direction. This kind of composition naturally is more dynamic than what we have so far seen in the High Renaissance. The forces already moving in it promise a new kind of pictorial design, one built upon movement rather than rest. In his rendering of the rich surface textures Titian gives a dazzling display of color in all its nuances. The human—especially the Venetian—scene is one with the heavenly, as the Madonna and saints find themselves honoring the achievements of particular men in this particular world. A quite worldly transaction is taking place between a queen, her court, and her loyal servants; the tableau is constructed in terms of Renaissance protocol and courtly splendor.

As Praxiteles had brought the motif of the feminine nude into ancient Greek art, so Giorgione and Titian re-create it for the art of the modern West. In 1538, at the height of his powers, Titian painted for the Duke of Urbino the *Venus of Urbino* (PLATE 13-8), which gives us the compositional essentials for the representation of a theme that will be popular for centuries. His version, based upon an earlier and pioneering one painted by Giorgione, was to become official for paintings of the reclining nude, no matter how many variations. Venus reclines on a gentle slope made by her luxurious, pillowed couch, the linear play of the draperies contrasting

c. 1500	c. 1508	c. 1515	c.1520	1525	1527		1538		1545	1548			1569	1570		c. 1585		to c.1600 →

GIORGIONE	TITIAN	ROMANO	Sack		TITIAN		TINTORETTO		TITIAN		VERONESE
Pastoral	*Sacred and*	*Palazzo*	of Rome		*Venus of*		*Miracle of*		*Crowning*		*Triumph of*
Symphony	*Profane Love*	*del Té*			*Urbino*		*the Slave*		*with Thorns*		*Venice*
	HIGH	begun									
	RENAISSANCE			L A T E			R E N A I S		S A N C E		
							←——— COUNCIL OF TRENT ———→				

with the sleek continuous volume of her body. At her feet is a pendant (balancing) figure, in this case a slumbering lapdog. Behind her is a simple drape that serves both to place her figure emphatically in the foreground and to press a vista into the background at the right half of the picture. In the vista are two servants who search in a chest for a gown for their mistress; beyond them is a smaller vista into a landscape. The steps backward into space, and the division of the space into progressively smaller units are beautifully contrived. The resources of pictorial representation are all in Titian's hands, and he uses them here for original and exquisite effects.

Deep Venetian reds set off against the pale, neutral whites of the linen and the warm ivory-gold of the flesh are echoed in the red tones of the matron's skirt, the muted reds of the tapestries, and the neutral whites of the matron's sleeves and the gown of the kneeling girl. One must study the picture carefully before one realizes what subtlety of color planning is responsible, for example, for the placing of the two deep reds—in the foreground cushions and the background skirt—that function so importantly in the composition as a gauge of distance. Here color is not used simply for the tinting of pre-existing forms but as a means of organization that determines the placement of forms.

Titian could paint with equal zeal a Virgin Mary or a nude Venus. Neither he nor the connoisseurs of his time were aware of any contradiction. Yet it is significant that the female nude reappears in Western art as Venus, the great goddess of the ancient world whom Medieval Christianity had especially feared, and whom it damned in exalting virginity and chastity as virtues. Now Venus returns, and the great Venetian paintings of her almost constitute pagan altarpieces. The Venetian Renaissance resurrects a formidable competitor of the saints.

Titian was not only a prolific painter of mythological and religious subjects, but also a highly esteemed portraitist, and one of the very best. Of the well over fifty portraits by his hand that have survived, one early example, the *Man with the Glove* (FIG. 13-53), must suffice to illustrate his style. The portrait is a trifle more than half-length. The head is turned slightly away from the observer, the right hand gathers the drapery of a mantle, and the gloved left hand holds another glove. The blade-shaped shirt-front directs attention to the right hand; the subject's gaze controls the left. These dexterous compositional arrangements, creating a kind of "three-spot" relation among head and hands, had already been made by Leonardo in his *Mona Lisa*. A Titian portrait, as well as many of the Venetian and subsequent schools, generally makes much

13-53 TITIAN, *Man with the Glove*, c. 1519 (?). Approx. 39″ × 35″. Louvre, Paris.

of the psychological reading of the most expressive parts of the body—the head and hands. We are not immediately aware how these subtle placements influence our response to the portrait subject. In fact, a portrait must be as skillfully composed as a great figure composition. The mood of this portrait is Giorgionesque—that is, one of dreamy preoccupation. The eyes turn away from us, as if, in conversation, the subject had recalled something that set him musing in silence. Titian's *Man with the Glove* is as much the portrait of a cultivated state of mind as of a particular individual: It is the meditative, poetic youth, who is at the same time Castiglione's ideal courtier, perfectly poised and self-assured, handsome, gallant, debonair, the "glass of fashion and the mold of form." There is no portrait quite like this one to give us so much of the Renaissance manner in a single individual, unless it be Raphael's *Castiglione* (PLATE 13-1).

Honor and glory attached to Titian as he grew older. He was known to and sought after by all the great of Europe. He was painter to and close friend of Emperor Charles V, who made him a knight of the Holy Roman Empire; afterward he painted numerous pictures for Charles's son, Philip II of Spain. The great Hapsburg collections of paintings were centered around Titian's works, and his fame and wealth recall the success of Raphael. Toward the end of his life his work becomes increasingly introspective, and a religious picture like the *Christ Crowned with Thorns* (FIG. 13-54) seems to be a sincerely devotional theme that repudiates the paganism of his prime. In this picture he shows Christ tormented by the soldiers of Pilate, who twist a wreath of thorns around his head. The drama is achieved by the limited number of figures, the concentration upon the figure of Christ, and the muted, flickering light that centers the action. The color scheme is almost monochrome; and the light and color play freely within and beyond contours, making a patchy, confused mixture of lights and darks, in which it is difficult to read the forms with precision. But this enhances the mystery, the gloomy environment, and the mood of torment. Titian's intention here is not so much to stage the event as to give his religious and personal response to it. His very brushstroke— broad, thick, and freely applied—bespeaks the directness of his approach. It melts and scatters solid form so as to produce the wavering, supernatural glow that encircles spiritual vision. Titian's art here looks forward to the painting of Rembrandt in the next century.

Tintoretto and Veronese

TINTORETTO (1518–94), originally named Jacopo Robusti, claimed to be a student of Titian and aspired to combine the color of Titian with the drawing of Michelangelo. He is usually referred to as the outstanding Venetian representative of Mannerism. He adopts many Mannerist pictorial devices, but his dramatic power, depth of spiritual vision, and glowing Venetian color schemes do not seem to fit the general Mannerist mold. We need not settle here the question of whether

13-54 TITIAN, *Christ Crowned with Thorns*, c. 1573–75. Approx. 9′ × 6′. Alte Pinakothek, Munich.

13-55 TINTORETTO, *The Miracle of the Slave*, 1548. Oil on canvas, approx. 14′ × 18′. Galleria dell' Accademia, Venice.

Tintoretto is a Mannerist; we need only mention that he has some things in common with central Italian Mannerism, and that in other respects he really looks forward to the Baroque. The art of Tintoretto is always extremely dramatic. In his *Miracle of the Slave* (FIG. 13-55) we find some of his typical stageplay. St. Mark hurtles downward to the assistance of a Christian slave, who is about to be martyred for the faith, and shatters the instruments of torture. These are held up by the executioner to the startled judge as the throng around the central action stares. The dynamism of Titian is here greatly accelerated, and the composition is made up of contrary and opposing motions; for any figure leaning in one direction, there is another to counter it. At the extreme left a group—two men, a woman, and a child—winds contrapuntally about a column, resembling the later Mannerist twisting of Giovanni da Bologna's *Rape of the Sabine Women* (FIG. 13-41).

The main group curves deeply back into space. But the most dynamic touch of all is made by the central trio of the slave, the executioner, and the inverted St. Mark. The three figures sweep together in a great upward, serpentine curve, the motion of which is checked by the plunging figure of St. Mark, moving in the opposite direction. The entire composition is a kind of counterpoint of motion that is characteristic of Mannerism. The motion, however, is firmly contained within the picture frame, and the robustness of the figures, their solid structure and firm movement, the clearly composed space, and the coherent action have little that is Manneristic. And the tonality—the deep golds, reds, and greens—is purely Venetian.

The *Finding of the Body of St. Mark* (FIG. 13-56), painted some fifteen years later than the *Miracle*, is even more spectacular. It is Tintoretto's skillful theatricality and sweeping power of execution

that most set him apart from the Mannerists and make of him a forerunner of the Baroque, the age of theater and opera. St. Mark appears to the astonished group that is seeking his burial place and with a mighty, commanding gesture discloses it. The vast perspective of the barrel vault is a plunging diagonal (Tintoretto loves the effect of speedy motion that a diagonal perspective gives) that converges to its point precisely in the upflung hand of the saint. The tilting, twisting, gesticulating figures are Tintoretto's own variation on Mannerist posture; but his placement of them in the great space and the dramatic air of mystery and tension, heightened by the dark shadows along the vaults and by the deep reds of the figures emerging from the gloom, shows Tintoretto to be a master of theater and its rhetoric.

The last of the great Venetian masters was Paolo Cagliari, known as VERONESE (1528–88). Where Tintoretto had gloried in monumental drama and deep perspectives, Veronese specialized in splendid pageantry painted in superb color and set within a majestic, classical architecture. Like Tintoretto, Veronese painted on a huge scale, with canvases often as large as twenty by thirty feet. His usual subjects, painted for the re-fectories of wealthy monasteries, afforded him an opportunity for the display of magnificent companies at table. *Christ in the House of Levi* (PLATE 13-9) is a good example. Here, in a great open loggia framed by three monumental arches (the style of the architecture somewhat resembles the classicism of Palladio, a contemporary of Veronese) Christ is seen seated at the center of splendidly garbed grandees of Venice, while with a courtly gesture, the very image of gracious grandeur, the chief steward welcomes guests. The spacious loggia is crowded not only with robed magnificoes but with their colorful retainers, clowns, dogs, and dwarfs. The Holy Office of the Inquisition accused Veronese of impiety in painting such creatures so close to the Lord, and he was required to make changes in some paintings at his own expense. As Palladio looked to the example of the classical architecture of the High Renaissance, so Veronese returns to High Renaissance composition, its symmetrical balance, and its ordered architectonics. His shimmering color is drawn from the whole spectrum, though he avoids solid colors for half-shades—light blues, sea-greens, lemon-yellows, rose, and violet—creating veritable flower beds of tone.

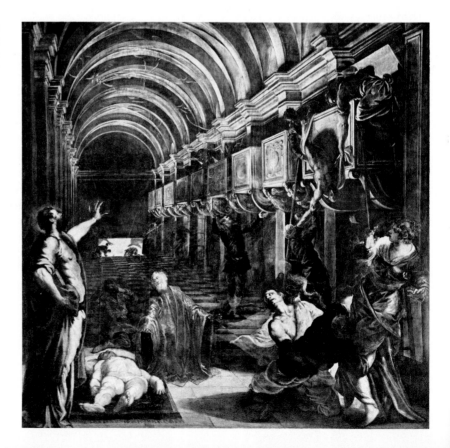

13-56 TINTORETTO, *The Finding of the Body of St. Mark*, 1562–66. Oil on canvas, approx. 14′ × 14′. Pinacoteca di Brera, Milan.

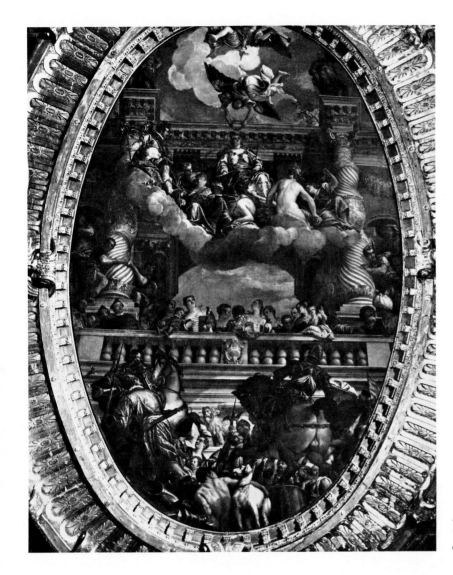

13-57 VERONESE, *The Triumph of Venice*, c. 1585. Oil on canvas. Ceiling of the Doge's Palace, Venice.

Tintoretto and Veronese were employed by the republic of Venice to decorate the grand chambers and council rooms of the Doge's Palace. A great and popular decorator, Veronese shows himself master of imposing, illusionistic ceiling compositions like the *Triumph of Venice* (FIG. 13-57), where, within an oval frame, he presents Venice, crowned by Fame, enthroned between two great twisted columns in a balustraded loggia garlanded with clouds, and attended by figures symbolic of her glories. This work represents one of the very first modern pictorial glorifications of a state, a subject that becomes very popular during the Baroque period. Veronese's perspec-tive is not, like Mantegna's or Correggio's, projected directly up from below; rather it is a projection of the scene at a 45-degree angle to the spectator, a technique that was to be used by many later Baroque decorators, particularly the Venetian Tiepolo in the eighteenth century.

It is fitting that we close our discussion of Italian art in the sixteenth century with a scene of triumph. For indeed the century witnessed the triumph of architecture, sculpture, and painting. They achieve the status of fine arts, and a tradi-tion is established by masters of prodigious genius whose works inspire all the artists who follow but never surpass them.

The Renaissance in Northern Europe

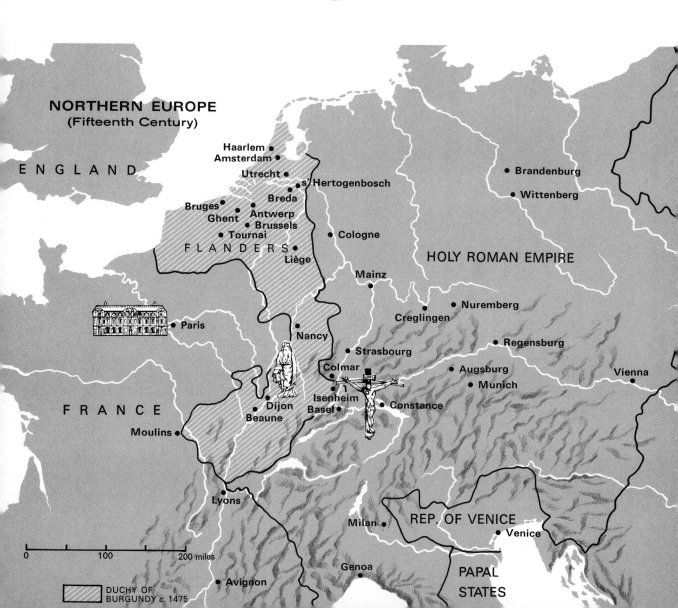

NORTHERN EUROPE
(Fifteenth Century)

ENGLAND

Haarlem
Amsterdam
Utrecht
s'Hertogenbosch
Breda
Bruges
Ghent • Antwerp
Brussels
Tournai
FLANDERS
Liège
Cologne

Brandenburg
Wittenberg

HOLY ROMAN EMPIRE

Mainz

Paris

Nancy

Creglingen

Nuremberg

Regensburg

Strasbourg
Colmar
Augsburg
Munich
Vienna

Isenheim
Dijon
Beaune
Basel
Constance

FRANCE

Moulins

Lyons

Milan

REP. OF VENICE
Venice

0 100 200 miles

DUCHY OF
BURGUNDY c. 1475

Avignon

Genoa

PAPAL
STATES

WHILE THE GREAT artistic events we have described were happening in Italy, the lands beyond the Alps were still immersed in the Gothic manner that Italy had never really accepted as its own. Gothicism persisted in architecture well into the sixteenth century in the north, though in the fifteenth century we can find in sculpture and painting the stirring of new artistic forces. The north had never known classical antiquity as had the Italians. In Italy the remains of the classical world were everywhere, and the Italians believed themselves the descendants of the ancient Romans. The Gothicizing International style of the fourteenth century was, for the Italians, only a passing fashion; coming between Giotto and Masaccio, it constituted hardly more than a brief interruption of a new stylistic movement that would carry along with it the future of European art. In the north, too, the International style would pass, giving way to a powerful realism, which, even without the inspiration by the classical antique, was destined to break with the past and point directions of its own.

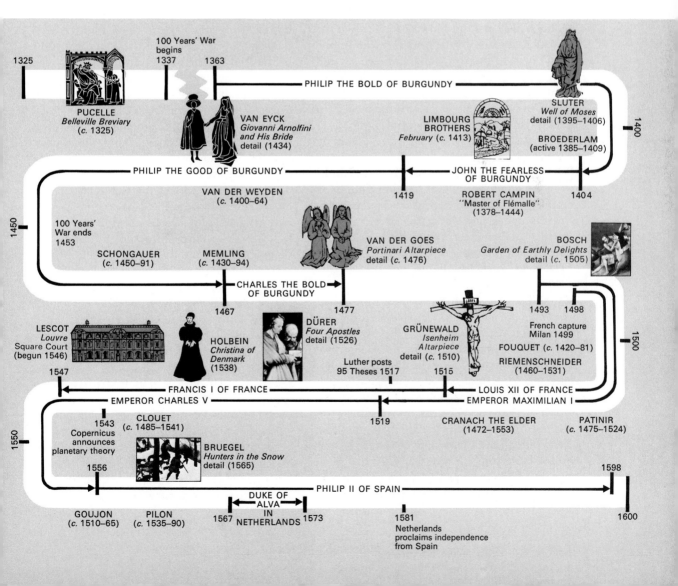

The northern painter, evolving out of the illuminator, finds, as did the artist in Italy, a new prestige and place. Though coexistent with a development of commerce and wealth almost modern in tone, the social structure of the north adhered in the fifteenth century to the hierarchies of the Middle Ages. The nobles and clergy continued to rule, though the true source of wealth and power was the bourgeoisie. This large middle class, in turn, was still organized and controlled by the guild system that had taken form in the Middle Ages. In the north the guild dominated the life of the average man to an even greater extent than in Italy. To pursue a craft, a man had to belong to the guild controlling that craft—the painter, for example, to the Guild of St. Luke, which included the saddlers, glass-workers, and mirror-workers as well. To secure membership in the guild, the aspiring painter was apprenticed in boyhood to a master, with whom he lived as a son and who taught him the fundamentals of his craft: how to make implements; how to prepare panels with gesso; and how to mix colors, oils, and varnishes. When the youth had mastered these procedures and had learned to work in the traditional manner of his master, he usually spent several years as a journeyman, working in various cities, observing and gaining ideas from other masters. He was then eligible to become a master and was admitted to the guild. Through the guild he obtained commissions; the guild inspected his painting for honest materials and workmanship and secured him adequate payment. The result was the solid craftsmanship that characterizes the best work of Flanders as well as of Italy.

This craftsmanship involved mastery of the new oil medium, which, as has been shown, had great influence upon Venetian painters at the end of the fifteenth century; we have spoken of Titian's management of it (p. 524). Traditionally Jan van Eyck is credited with the invention, a century before Titian, of oil painting, although the facts surrounding its early history still remain mysterious. Flemish painters built up their pictures by superimposing translucent paint layers, called glazes, on a layer of opaque monochrome underpainting, which in turn had been built up from a carefully planned drawing made upon a white-grounded panel of wood.

The binding medium for the pigments had a fast-drying oil as a base. This oil had been known and used by certain painters in the Late Middle Ages. The secret of the new technique seems to have been an unidentified supplement to the usual composition of the glazes. With the new medium painters were able to create colors seemingly lit from within and richer than had previously been possible. As a result, northern painting of the fifteenth century is characterized by a deep, intense tonality, glowing light, and hard, enamel-like surfaces quite unlike the high-keyed color, sharp light, and rather matte surfaces of Italian tempera (a water-base paint using a binder such as glue or egg yolk).

The brilliant and versatile new medium was exactly right for the formal intentions of the northern painters, who aimed at a sharp-focused, hard-edged, and sparkling clarity of detail in the representation of thousands of objects ranging in scale from large to almost invisible. While the Italians were interested primarily in the *structure* behind the appearances given to the eye—that is, in perspective, composition, anatomy, the mechanics of bodily motion, and proportion through measure—the northern painters were intent on rendering the *appearances* themselves, the bright, colored surfaces of things touched by light. Their tradition of stained glass and miniatures made their realism a realism of radiant, decorative color rather than of sculpturesque form. The differences between the painting of Italy and northern Europe are emphasized by the fact that, when oil painting spread to Italy after the mid-century, it did not radically affect Italian sensibility to form. Although the color of Italian painting became richer, particularly in Venice, the new medium, which in time completely replaced tempera, was exploited in the service of the structural purposes of Italian art. On the whole, until the early sixteenth century, artistic communication between the north and south of Europe seems to have been limited to that among only a relatively few individuals, both areas tending to develop independently of each other.

The political background against which the development of northern art took place in the fifteenth century was not unlike that of Italy. At the beginning of the century the commercial free cities dominated the scene. Gradually they fell

under the rule of princes until the beginning of the sixteenth century saw the emergence of powerful states—France, England, and the Hapsburg empire, comprising Spain, the Germanies, and the Netherlands. As in Italy the wealth and leisure necessary to encourage the growth of the arts was based on commerce and on the patronage of the powerful princes and rich merchants who controlled it.

THE FIFTEENTH CENTURY

Flanders

The most important of the prosperous commercial cities of the north was Bruges, which, like Florence, derived its wealth from the wool trade and from banking. Until late in the fifteenth century, an arm of the North Sea, now silted up, reached inland to Bruges. Here ships brought raw wool from England and carried away with them the fine manufactured woolen cloth famous throughout Europe. The wool trade brought bankers, among them representatives of the House of Medici, and Bruges became the financial clearing-house for all northern Europe. In its streets, merchants from Italy and the Near East rubbed shoulders with traders from Russia and Spain. Despite the flourishing economies of its sister cities—Ghent, Louvain, and Ypres—Bruges so dominated Flanders that the Duke of Burgundy chose to make the city his capital and moved his court there from Dijon early in the fifteenth century.

The dukes of Burgundy were probably the most powerful rulers in northern Europe during the first three-quarters of the fifteenth century. Although cousins of the French kings, they usually supported England (on which they relied for the raw materials of their wool industry) during the Hundred Years' War and, at times, were in control of much of northern France, including Paris. Through intermarriage with the House of Flanders they annexed the Low Countries, and, during the height of their power, their lands stretched from the Rhône River to the North Sea. Only the rash policies of the last of

their line, Charles the Bold, and his death at the battle of Nancy in 1477 brought to an end the Burgundian dream of forming a strong middle kingdom between France and the Holy Roman Empire. After Charles's death the southern Burgundian lands were reabsorbed by France, while the Netherlands passed to the Holy Roman Empire by virtue of the dynastic marriage of Charles's daughter, Mary of Burgundy, to Maximilian of Hapsburg.

Philip the Bold of Burgundy, who ruled from 1364 to 1404, and his brother John, Duke of Berry, were the greatest sponsors of the arts of their time in northern Europe. Their interests centered in illuminated manuscripts, Arras tapestries, and rich furnishings for their numerous castles and town houses throughout their duchies. Philip's largest single artistic enterprise was the foundation of the Charterhouse of Champmol, near Dijon. It was intended to receive the tombs of the family, and its magnificent endowment attracted artists from all parts of northern Europe. The outstanding representative of this short-lived Burgundian school was the sculptor CLAUS SLUTER (active about 1380–1406).

For the cloister of the Charterhouse of Champmol, Sluter designed a symbolic well in which Moses and five other prophets surround a base that had once supported a Crucifixion group. The prophets of this *Well of Moses* (FIG. 14-1) recall the jamb figures of Gothic portals, but they far surpass even the most realistic of those in the intense observation and rendering of minute detail and in their bulk, which manages to contain the wealth of detail that might otherwise be distracting. The life-sized figures are swathed in heavy draperies with voluminous folds, characteristic of Sluter's style, and the artist manages to make their difficult, complex surfaces seem remarkably lifelike. This effect is enhanced by the skillful differentiation of textures, from coarse drapery to smooth flesh and silky hair (FIG. 14-2), and by the paint, still partly preserved. This fascination with the specific and tangible in the visible world will be one of the chief characteristics of fifteenth-century Flemish painting. But despite its realism, the *Moses* of Sluter, if compared with Donatello's *St. Mark* (FIG. 12-5), reveals what is yet missing in the northern concept of the figure: the principle of interior movement, or weight-shift.

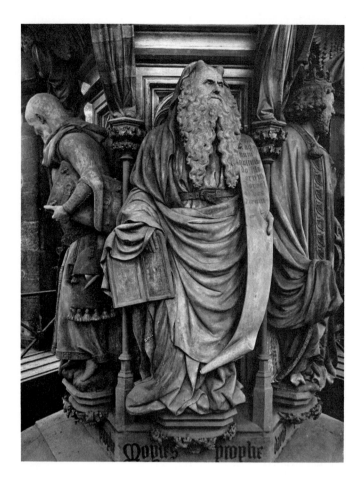

14-1 Left: CLAUS SLUTER, *The Well of Moses*, 1395–1406. Figures approx. 6′ high. Chartreuse de Champmol, Dijon.

14-2 Above: CLAUS SLUTER, *Moses*, detail of FIG. 14-1.

The Charterhouse of Champmol must have been furnished with numerous altarpieces, but only one of these has survived, a carved altarpiece representing the Adoration of the Magi. The odd-shaped wings for this altarpiece were painted by MELCHIOR BROEDERLAM (active 1385–1409), a Flemish painter who had been drawn to Dijon. Shown on the inside of the left wing are the *Annunciation* and the *Visitation*; on the right wing (FIG. 14-3), the *Presentation* and the *Flight into Egypt*. The paintings show that Broederlam was a major northern exponent of the International style. His compositional devices have already been seen in such southern works as Gentile da Fabriano's *Adoration of the Magi* (PLATE 12-1): the uptilted plane of the landscape in the *Flight* scene, with its high horizon topped by a castle; the serpentine recession into the background; the

elegant silhouettes of the figures, reminiscent of Sienese art. Also pointing back to Sienese art is Broederlam's modest essay into perspective and the delicate architectural enframement of the *Presentation* scene. All this has been combined with the minutest observation and rendering of realistic details. That Broederlam was not immune to the influence of Sluter is seen in the handling of the voluminous drapery folds and, near the panel's right border, the strikingly massive figure of Joseph, planted like a tree-stump, taking a draught from his cup—and looking like a figure from a Bruegel painting of some 150 years later.

It is sometimes pointed out that Broederlam's miniaturistic style is ill suited for the size of the panels, which are some five feet high. The reason for this disproportion lies in the fact that, being

the earliest surviving examples of northern panel paintings, these works still reflect some of the long-standing northern painting traditions from which they are a revolutionary departure. For centuries the characteristic painted surface in the north had been either stained glass or the illuminated page of a manuscript. Gothic architecture in northern Europe had successfully eliminated solid walls and had left few continuous, blank surfaces that invited painted decorations, contrary to the case in Italy, where climate and architecture favored mural painting in fresco. The northern artist was accustomed to working not only in miniature but with rich, jewel-like color, which, especially in stained glass, has a profound luminosity, the light seeming to irradiate the forms. Thus, he came into the fifteenth century habituated to deep color worked into exquisitely tiny and intricate shapes and patterns. When the northern miniaturist became acquainted, through the International style, with Italian forms and ideas, he saw himself forced to reduce to page size, or smaller, the inventions used in large compositions by Italian wall and panel painters like Duccio, Giotto, Simone Martini, and others. This development, which led to a kind of "perspective naturalism," was inconsistent with the basic function of book illumination—namely, to decorate a page and illustrate part of the written text. Toward the end of the fourteenth century, illuminations began to take on the character of independent paintings, expanding upon the page until they occupied it completely. By about 1400, these new forces generated in miniatures seemed to demand larger surfaces, and the shift was made to panel painting.

The first steps toward the illumination's expansion within the text appear in the work of JEAN PUCELLE (active about 1320–70), a Parisian illuminator who revitalized the stagnating Gothic manner of the Paris school. A page from the so-called *Belleville Breviary* (PLATE 14-1), of about 1325, shows how the entire page has become the province of the illuminator. The borders, extended to invade the margins, include not only decorative tendrils and a profusion of spiky ivy and floral ornaments, but also a myriad of insects, small animals, and grotesques. In addition, three narrative scenes encroach upon the columns of the text, the graceful postures and flowing draperies of the figures reflecting Sienese influence. One feels that any of these narratives could have been expanded into a full-page illustration or even a panel painting.

Such an expansion has occurred in the calendar pages of a gorgeously illustrated "Book of Hours" made for the Duke of Berry, brother of the king of France and of Philip the Bold of Burgundy. The manuscript, called *Les Très Riches Heures du Duc de Berry* (PLATE 14-2, FIG. 14-4), was completed in 1416 by the three LIMBOURG BROTHERS— Pol, Hennequin, and Herman. Such Books of Hours became favorite possessions of the northern aristocracy during the fourteenth and fifteenth centuries. As prayer books, they replaced the traditional psalters, which had been the only liturgical books in private hands until the mid-thirteenth century. The books usually contained expanded versions of the Scriptures based on one or another of the popularizations of the biblical text, such as the *Golden Legend* by Jacopo de Voragine of the mid-thirteenth century or the *Meditations on the Life of Christ* by an anonymous

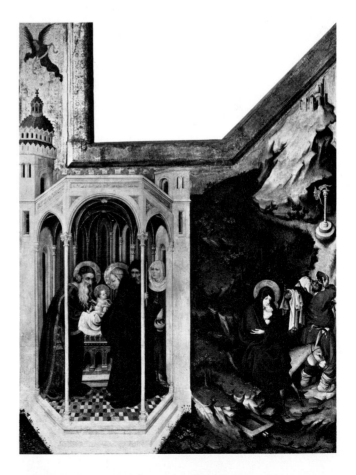

14-3 MELCHIOR BROEDERLAM, *The Presentation and the Flight into Egypt*, 1394–99. Approx. 64″ × 51″. Musée des Beaux-Arts, Dijon.

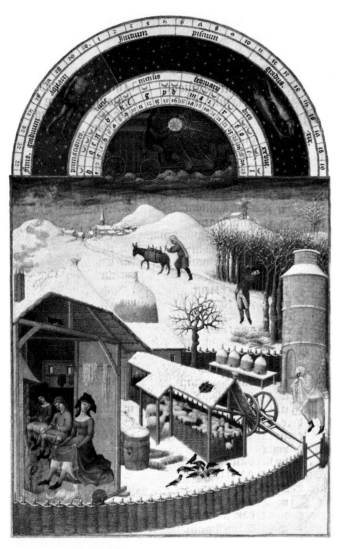

14-4 The Limbourg Brothers, *February*, from *Les Très Riches Heures du Duc de Berry*, 1413–16. Approx. 8¾″ × 5½″. Musée Condé, Chantilly.

Italian Franciscan of the late thirteenth century. They also often included an illustrated calendar.

The calendar pictures of *Les Très Riches Heures* are perhaps the most famous in the history of manuscript illumination. They represent the twelve months of the year in terms of the associated seasonal tasks, alternating the occupations of nobility and peasantry. Above each picture is a lunette representing the chariot of the sun as it makes its yearly round through the twelve months and signs of the zodiac, with numerical notations designating the zodiacal degrees passed

through in the course of the year. The picture for the month of February (FIG. 14-4), under the signs of Aquarius and of Pisces the fish, displays a snowy landscape, bare trees, a woodsman at work, another driving a donkey laden with faggots to the distant village. A woman blowing upon her fingers moves through a farmyard toward the house, where the red-capped master of the domicile and his womenfolk warm themselves before a fire. The high horizon and steep, carefully laidout landscape, in which the details of the ordinary environment are carefully enumerated and depicted, recall the landscape of the Lorenzetti murals of *Good Government* in Siena (FIGS. 11-20 to 11-22); it is possible that one of the Limbourg brothers had seen these or works like them. In any event the *February* exemplifies the International style in its northern flowering. Even more representative, perhaps, is the colorful *May* from the same series (PLATE 14-2). Here, a cavalcade of patrician ladies and gentlemen, preceded by trumpeters, rides out to celebrate the first of May, a spring festival observed by the courts throughout Europe. They are clad in springtime green, garlanded with fresh leaves, and sparkle with ornate finery. Behind them is a woodland and the château of Riom. These great country seats of the French royalty loom in the backgrounds of most of the calendar pictures and are so faithfully represented that those surviving today are easily recognized. The spirit of the picture is Chaucerian (the *Canterbury Tales* is hardly a generation older), lightsome, artificial, chivalric, and pleasure-loving, and, of course, much in contrast with the peasant mood. The elegant silhouettes, rich colors, and decorative linear effects again recall Sienese art. *February* and *May* were evidently painted by different artists (note especially the differences in figure representation), but it has never been possible to assign specific pictures to the various Limbourg brothers. Nevertheless, while their styles may have differed, their main interests were the same. Within the confines of the International style they represented as accurately as possible the actual world of appearances and the activities of man, peasant or aristocrat, in his natural surroundings at specific times of the year. Thus, the traditional field of subject matter has been expanded to include genre subjects, and they are

given a prominent place even in a religious book. Secular and religious subjects remain neatly separated, but during the course of the fifteenth century they will increasingly encroach upon each other to produce as thorough a humanization of religious subject matter as that we saw in Italy.

With the work of the Limbourg brothers, manuscript illumination reaches a climactic end. Illumination will linger on for a few decades until, in mid-century, it is dealt a final blow by the invention of printing; even before then it had been largely replaced by panel painting.

Hardly a decade after *Les Très Riches Heures*, which is an example of the International style at its peak, we have a work of quite different and novel conception, the so-called *Mérode Altarpiece* (FIG. 14-5) by the Master of Flémalle, who is now identified as ROBERT CAMPIN (about 1378–1444), the leading painter of the city of Tournai. The aristocratic taste, romantic mood, and ornamental style of the International painters vanish and are here replaced with a relatively blunt, sober realism in setting and characterization. The old theme of the Annunciation occupies the central panel of the triptych, and something of Internationalism remains in its decorative line play. But the donors, depicted in the left panel, set the tone. Man and wife, they are of the grave and sedate middle class; unostentatiously prosperous, quietly dressed, they kneel in a little courtyard and peer through a crack in the door at the mystery taking place. Discreetly set apart from it, they take the mystery as a fact, and factualness determines the artist's whole approach. All the objects in the *Annunciation* scene are rendered with careful attention to their actual appearance, and the event takes place in an everyday, middle-class Flemish interior, in which all accessories, furniture, and utensils are indicated, lest the setting be incomplete. But the objects represented are not merely that; book, candle, flowers, sink (in the corner recess), fire screen, polished pot, towels, and settee symbolize in different ways the Virgin's purity and her divine mission. The artist's crypto-signature appears on the vase on the table. In the right panel Joseph makes a mousetrap, symbolic of the theological tradition that Christ is bait set in the trap of the world to catch the Devil. The carpenter's shop is completely inventoried by the painter—down to the vista into a distant city street. We have thus a thorough humanizing of a traditional religious theme, one could say a complete transformation of it in terms of a particular time and place—a middle-class house, courtyard, and shop in a fifteenth-century city of Flanders. So close is the status of

14-5 ROBERT CAMPIN (Master of Flémalle), *The Mérode Altarpiece*, c. 1425–28. Oil on wood, center panel approx. 25″ × 25″, wings approx. 25″ × 11″. Metropolitan Museum of Art, New York (Cloisters Collection).

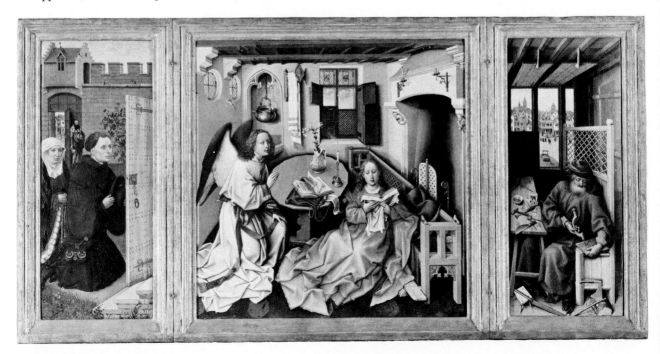

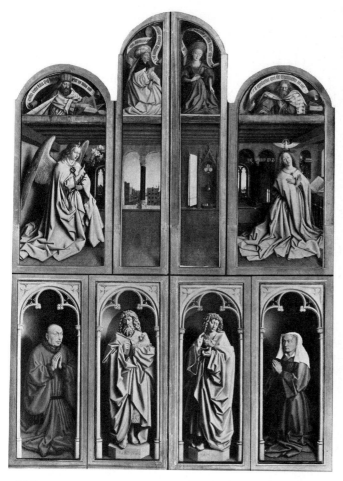

14-6 HUBERT and JAN VAN EYCK, *The Ghent Altarpiece* (closed), completed 1432. Tempera and oil on panel, approx. 11′ 3″ × 7′ 3″. St. Bavo, Ghent.

the sacred actors to the human level that they are even represented without haloes; this does not happen in Italy until the end of the century.

We have been tracing the humanization of art from the thirteenth century. The distance between the sacred and the secular has now narrowed to such a degree that they become intermixed. Johan Huizinga, renowned modern student of the fifteenth century, describes it thus:

> Individual and social life, in all their manifestations, are imbued with the conception of faith. There is not an object nor an action, however trivial, that is not constantly correlated with Christ or salvation All life was saturated with religion to such an extent that the people were in constant danger of losing sight of the distinction between things spiritual and things temporal. If, on the one hand, all details of ordinary life may be raised to a sacred level, on the other hand, all that is holy sinks to the commonplace, by the fact of being blended with everyday life . . . the demarcation of the spheres of religious thought and that of worldly concerns was nearly obliterated.[1]

Hence, the realistically painted commonplace objects in a Flemish painting become suffused with religious significance, and as such take on the nature of sacramental things. With this justification for their existence in art, the ordinary things that surround man, and man himself, share the realm of the saints; conversely, the saints now occupy the realm of man. But man, as well as the things of man, will remain when, with the secularization of art, the saints and sanctity have disappeared.

JAN VAN EYCK

The *Ghent Altarpiece* (the *Adoration of the Mystic Lamb*) in the church of St. Bavo in Ghent (FIGS. 14-6 to 14-8), one of the great paintings of the fifteenth century, is the work of JAN VAN EYCK (about 1390–1441) and his older brother HUBERT, though the nature and extent of their collaboration in the painting is controversial. An inscription in Latin on the frame of the large polyptich reads: "The painter Hubert van Eyck, than whom none was greater, began it; Jan, second in art, having completed it at the charge of Jodoc Vyt, invites you by this verse on the sixth of May to contemplate what has been done." The last line of the inscription gives the date—1432.

The large size of the altarpiece would seem to indicate collaboration of some sort and perhaps successive changes in the design of the whole. The present, rather awkward arrangement of the panels is not the original. It has been suggested that the panels originally were part of a great three-dimensional reliquary shrine, surrounded by elaborate carving, and that they were placed at different levels according to their symbolic meanings. It has been further suggested that

[1] Johan A. Huizinga, *The Waning of the Middle Ages* (Garden City, N.Y.: Doubleday, 1954), p. 156.

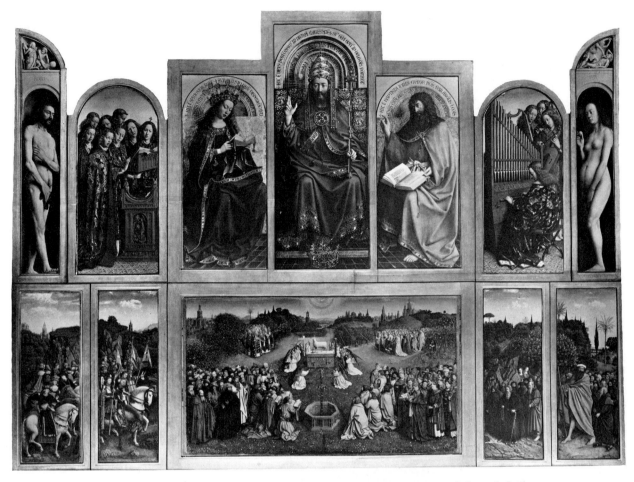

14-7 HUBERT and JAN VAN EYCK, *The Ghent Altarpiece* (open), approx. 11′ 3″ × 14′ 6″.

Hubert was the sculptor of the shrine, and Jan, the painter; but this remains speculation. We do know that the panels were removed from the original frame and hidden in the year 1566 to protect them from Protestant iconoclasts who may have destroyed the frame. The panels were reinstalled in a new and much simplified frame in 1587.

As a whole the *Adoration of the Mystic Lamb* is an outstanding example of the large folding altarpiece typical of the north, with new meanings disclosed to the observer as the unfolding of the panels reveals new subjects in sequence. The very form of the folding altarpiece expresses the Medieval tendency to uncover truth behind natural appearances, to clothe thought in alle-

gory, to find "essential" meaning hidden beneath layers of secondary meanings. When closed (FIG. 14-6) the *Ghent Altarpiece* shows the Annunciation and simulated statues of St. John the Baptist and St. John the Evangelist flanked by the donors, Jodoc Vyt and his wife; above, in the lunettes, are the Prophet Zechariah with the Erythraean sibyl and the Prophet Micah with the Cumaean sibyl. All these are symbolic references to the Coming of Christ. The *Annunciation* figures are set in a raftered room in which there are both Romanesque and Gothic architectural elements that may symbolize the Old and the New Testaments, respectively. As it does in the *Mérode Altarpiece*, a vista opens on a distant street. The angel and the Virgin are bundled in the

heavy flannel draperies of the Burgundian school, resembling those of Sluter's *Moses*. Although the architecture is spacious, the figures are in ambiguous relation to it and quite out of scale; as yet there is little concern for a proportioned space adjusted to the human figure.

When opened (FIG. 14-7) the altarpiece reveals a sumptuous, superbly colored representation of the Medieval conception of the redemption of man. In the upper register, God, wearing the triple tiara of the papacy, and resplendent in a deep-scarlet mantle, is flanked by the Virgin, represented as Queen of Heaven, with a "crown of twelve stars upon her head," and St. John the Baptist. To either side are a choir of angels and, on the right, St. Cecilia at her organ; in the far panels are Adam and Eve. The inscriptions in the

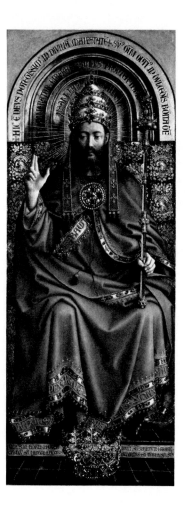

14-8 HUBERT and JAN VAN EYCK, *God the Father*, detail of FIG. 14-7.

arches above the Virgin and St. John extol the virtue and purity of the former and the greatness of the latter as forerunner of Christ. That above the head of the Lord, particularly significant, translates: "This is God, all-powerful in his divine majesty; of all the best, by the gentleness of his goodness; the most liberal giver, because of his infinite generosity"; and the step behind the crown at the Lord's feet bears the inscription: "On his head, life without death. On his brow, youth without age. On his right, joy without sadness. On his left, security without fear." This is a most concise and beautiful statement of the change from the concept of God as a stern, Medieval judge of mankind to the benevolent Franciscan father of the human race. The entire altarpiece amplifies this central theme; though man is sinful—symbolized by Adam and Eve— he will be saved because God, in his infinite love, will sacrifice his own son for this purpose.

The figures are rendered in a shimmering splendor of color that defies reproduction. Both Hubert and Jan van Eyck had been trained as miniaturists, and not the smallest detail escapes their eyes; they amplify the beauty of the most insignificant objects as if it were a work of piety as much as art. The soft texture of hair, the glitter of gold in the heavy brocades, the luster of pearls, the flashing of gems, are given with tireless fidelity to appearance (FIG. 14-8). The new medium of oil paint, here in its very beginning, shows its marvelous magic.

The panels of the lower register extend the symbolism of the upper. In the central panel the community of saints comes from the four corners of the earth through an opulent, flower-spangled landscape. They move toward the altar of the Lamb, from whose heart blood flows into a chalice, and toward the octagonal fountain of life into which spills the "pure river of water of life, clear as crystal, proceeding out of the throne of God and of the Lamb" (Rev. xxii.1). On the right advance the twelve apostles and a group of martyrs in red robes; on the left, with minor prophets, the four Evangelists arrive carrying their gospels. In the right background come the holy virgins, and in the left background, the holy confessors. On the wings, other approaching groups symbolize the four cardinal virtues: the hermits,

Temperance; the pilgrims, Prudence; the knights, Fortitude; the judges, Justice. The altarpiece celebrates the whole Christian cycle from the fall to redemption, presenting the Church triumphant in the heavenly Jerusalem. The uncanny naturalism and the precision of rendering, while in the miniaturist tradition, aim to make the great event as concrete and credible as possible to the observer. And the realism is so saturated with symbolism that we might almost think of it as a kind of superreality or "surrealism," since what is given to the eye is more than the eye alone can report.

Jan van Eyck's matchless color craft is evident in his *Virgin with the Canon van der Paele* (PLATE 14-3), painted in 1436. The figures are grouped in a manner reminiscent of the *sacra conversazione* paintings that appear in Florence about the same time. The architecture, the elaborately ornamented rug, and the figures all lead the eye to the Madonna and Child, who sit in the apse of a church. The rich texture of her red robes makes a strong contrast with the white surplice of the kneeling Canon van der Paele. A similar contrast plays across the space between the dull glint from the armor of St. George, the patron saint of the canon, and the rich brocades of St. Donatien, the patron of the church for which the painting was commissioned. The incredibly brilliant profusion of color is carefully controlled so that the forms are clearly distinguished in all detail. The symbolism is as profuse and controlled as the color, incorporating again the complete cycle of the fall and the promise of redemption. The arms of the Virgin's throne and the historiated capitals of the pilasters behind her make reference to the Old Testament prefiguration of the Coming of Christ, so well known in the Middle Ages.

There is evidence in the picture of Van Eyck's use of perspective—not a single perspective that would consistently unify the space, but several. His intention here appears once again to be indirect, the multiple perspectives directing attention to the principal figures. For example, if we project the line of the column base at the far right, it would lead to the head of the canon; the orthogonals of the floor tiles converge on the midpoint of the figure of the Virgin; and the base of the throne can be projected to the Infant Christ. Thus, there is no real spatial unification. The figures do not interrelate as we might expect, but each fills his own space with, as it were, its own perspective. Although St. George lifts his helmet to the Virgin, the direction of his gaze goes well beyond her; this disorientation is true also of the other figures. Jan van Eyck and his generation still essentially conceive the organization of the two-dimensional picture surface in terms of shape, color, and symbol; they have not yet thought of it as a window into a constructed illusion of the third dimension, as the painters of the later Flemish schools will.

The portrait head of Canon van der Paele shows the same nonstructural approach. The heavy, wrinkled visage of the canon is recorded in precise detail, almost to the pores; the artist makes a relief map of his subject, delineating every minute change of the facial surface. Unlike the Italian portraitists who think first of the structure of the head, and then draw the likeness over it, Jan van Eyck works from the outside inward, beginning with the likeness and shaping the head incidentally. This is what gives the masklike aspect to the canon's face, despite the portrait's fidelity to physiognomy; the surface is all there, with the illusion of three-dimensional mass only implied.

We have seen three works that included painted portraits of their donors—the *Mérode Altarpiece* (FIG. 14-5), the *Ghent Altarpiece* (FIG. 14-6), and the *Virgin with Canon van der Paele* (PLATE 14-3). These portraits mark a significant revival of a genre unknown since antiquity. A fourth portrait, Jan van Eyck's *Man in a Red Turban* (FIG. 14-9) marks another step in the humanization process. In the *Mérode* and *Ghent* altarpieces the donors were depicted apart from the saints. In the Canon van der Paele portrait the donor associates with the saints at the throne of the Virgin. In this portrait (possibly the artist himself) the image of a living individual apparently needs no religious purpose for being, but only a personal one, the portrait being simply a record of one's features interesting to oneself or another. These private portraits now begin to multiply, as both artist and patron become interested in the reality they reveal, for the painter's close observation of the lineaments of a human face is as revealing of the

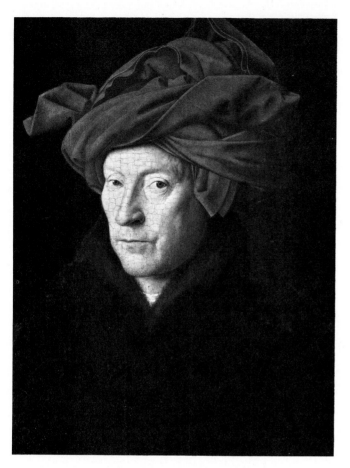

14-9 JAN VAN EYCK, *Man in a Red Turban (Self-Portrait?)*, 1433. Approx. 10¼″ × 7½″. Reproduced by courtesy of the Trustees of the National Gallery, London.

real world as his observation of objects in general. As man confronts himself in the painted portrait, he objectifies himself as a self, as a person. In this confrontation the otherworldly anonymity of the Middle Ages must fade away. The *Man in a Red Turban* looks directly at us, or perhaps at himself in a mirror. So far as is known this is the first painted portrait in a thousand years that does so. The level, composed gaze, directed from a true three-quarter pose of the head, must have impressed observers deeply. There is the illusion that no matter from what angle we observe the face the eyes still fix us. A painting of this kind by the great Rogier van der Weyden (see below)

must have inspired the writing of the *Vision of God* by Nicolas of Cusa, who says, in the preface to that work:

> To transport you to things divine, I must needs use a comparison of some kind. Now among men's works I have found no image better suited to our purpose than that of an image which is *omnivoyant* [all-seeing]—its face, by the painter's cunning art, being made to appear as though looking on all around it—for example . . . that by the eminent painter, Roger, in his priceless picture in the governor's house at Brussels this I call the icon of God.

He advises those who are going to use his book in their meditations to set up such an "icon of God":

> This picture, brethren, you shall set up in some place, let us say on a north wall, and shall stand around it, a little way off, and look upon it. And each of you shall find that, from whatsoever quarter he regards it, it looks upon him as if it looked on none other the picture's face will keep in sight all as they go on their way, though it be in contrary directions.

Nicolas goes on with praise of sight and vision that amounts to a sanctification of it:

> Thou, Lord . . . lovest me because Thine eyes are so attentively upon me . . . where the eye is, there is love I exist in that measure in which Thou art with me, and since Thy look is Thy being, I am because Thou dost look at me, and if Thou didst turn Thy glance from me I should cease to be.

> Apart from Thee, Lord, naught can exist. If, then, Thine essence pervade all things, so also does Thy sight, which is Thine essence Thou Lord, seest all things and each thing at one and the same time

Nicolas of Cusa is a contemporary of the great Flemish painters, and it is likely that he spoke in a sense they could understand and in a mood they could share. The exaltation of sight to divine status and the astonishing assertion that the essence of God is sight—not, as with St. Thomas, being—are entirely in harmony with the new vision in painting. As sight and being in God are essentially the same, so the painter's sight, instru-

mental in making likenesses, brings them into being. And as the contemplative man achieves union with God by making himself like God, the imitation of objects in the sight of—hence caused by—God must be a holy act on the part of the painter, since, seeing what God sees, he achieves the reality of God's vision and reveals it to others. It is in the light of Nicolas' doctrine that the minute realism of the Flemish painters can be understood. God sees everything, great and small alike, and Nicolas' fundamental doctrine that all opposites and contradictions are resolved and harmonized in God makes God present in the greatest and in the smallest, in the macrocosm and in the microcosm, in the whole earth and in a drop of water. In the whole world of vision, *caused* by God's sight, everything is worthwhile, since it is seen by God—even the "meanest flower that blows." In Nicolas' sanctification of the faculty of sight we find the Flemish painters' religious warrant for their application of sight in the investigation of the given world; painters in the north will continue the investigation until long after the original religious motive is gone.

Above all, an age had begun in both the Netherlands and Italy in which men gloried in the faculty of sight for what it could reveal of the world around them. The artist now began to show Western man "what things look like," and he took extreme pleasure in recognizing a revelation. The level gaze of the *Man in a Red Turban*, in all its quiet objectivity, is not only the omnivoyant "icon of God," but, in its historical destiny, the impartial, eternally observant face of science. It is also, significantly, man beginning to confront nature in terms of himself. This is the climax of the slow but mighty process that brings man's eyes down from the supernatural to the natural world, a process that is expressed with just as much conviction and vigor in the north as it is in Italy.

The humanization of pictorial themes advances another step in Jan van Eyck's double portrait of *Giovanni Arnolfini and His Bride* (FIG. 14-10). The Lucca financier, who had established himself in Bruges, and his lady occupy the scene, empty of saints, though charged with the spiritual: Almost every object depicted is in some way symbolic of the holiness of matrimony. The persons themselves, hand in hand, take the marriage vows. Shoes have been removed, for the sacrament of matrimony makes the room a holy place. The little dog symbolizes fidelity (the origin of the common canine name, Fido). Behind the pair, the curtains of the marriage bed have been opened. The finial of the bedpost is a tiny statue of St. Margaret, patron saint of childbirth; from the finial hangs a whisk broom, symbolic of domestic care. The oranges on the chest below the window may refer to the golden apples of the Hesperides, representing the conquest of death. And the presence of the omnivoyant eye of God seems to be referred to twice, once in the single candle burning in the ornate chandelier, and again in the mirror in which the entire room is reflected (FIG. 14-11). The small medallions set into the mirror's frame show tiny scenes from the Passion of Christ and represent Van Eyck's ever present promise of salvation for the figures reflected on the mirror's convex surface. These figures include not only the principals, Arnolfini and his wife, but two persons who look into the room through the door. One of these must be the artist himself, since the florid inscription above the mirror, *Johannes de Eyck fuit hic*, announces that he was present. The purpose of the picture, then, is to memorialize and sanctify the marriage of two particular persons. In this context, man comes to the fore in his own setting; the spiritual is present, but in terms of symbol, not image.

The paintings of Jan van Eyck have a weighty formality that banishes movement and action. His symmetrical groupings thus have the stillness and rigidity of the symbol-laden ceremony of the Mass; each person and thing has its prescribed place and is adorned as befits the sacred occasion. The long tradition of manuscript illumination accepted that the Holy Book must be as precious as the words it contains; Jan van Eyck, himself a miniaturist and illuminator, instinctively created a rich and ornamental style in which to proclaim his optimistic message of human salvation. In their own way, the paintings of Jan van Eyck were perfect and impossible to surpass. After him, Flemish painting looked for new approaches, and Van Eyck had few, if any, emulators.

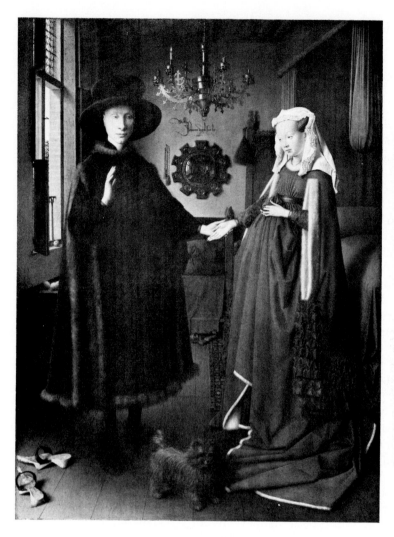

14-11 Jan van Eyck, *Mirror and Chandelier*, detail of FIG. 14-10.

VAN DER WEYDEN, CHRISTUS, AND BOUTS

The art of ROGIER VAN DER WEYDEN (about 1400–64) had a much greater impact upon northern painting of the fifteenth century. A student of Robert Campin, Rogier evidently recognized the limitations of Van Eyck's style, although it had not been without influence on his early work. By sweeping most of the secondary symbolism from his paintings, Rogier cleared his pictorial stage for fluid and dynamic compositions that stress human action and drama. He concentrates on themes like the Crucifixion and the Pietà, where he can move the observer by the

sufferings of Christ. For the symbolic bleeding lamb of Van Eyck, he substitutes the tortured body of the Redeemer and his anguished mother. His paintings are filled with deep religiosity and powerful emotion, for he conceives his themes as expressions of a mystic yearning to share in the Passion of Jesus.

The great *Escorial Deposition* (PLATE 14-4) sums up Rogier's early style and content. Instead of creating a deep landscape setting, as Jan van Eyck might have, he compresses the figures and action onto a shallow stage to concentrate the observer's attention. Here he imitates the large, sculptured shrines so popular in the fifteenth century, especially in Germany, and the device

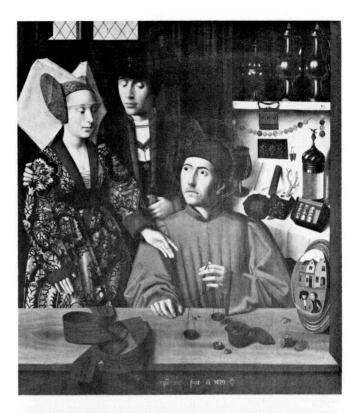

serves well his purpose of expressing maximum action within disciplined structure. The painting resembles a stratified relief carving in the crisp drawing and precise modeling of its forms. A series of lateral undulating movements gives the group a unity, a formal cohesion, that is underlined by physiological means—that is, by the desolating anguish common to all the figures. Few painters have equaled Rogier in the rendering of passionate sorrow as it vibrates through a figure or distorts a tear-stained face. His depiction of the agony of loss is the most authentic in religious art and, in a painting as bare of secondary symbolism as the *Deposition*, the emotional impact upon the observer is immediate and direct. One can understand from this single example why Rogier's art became authoritative for the whole fifteenth century outside of Italy.

Although evidence that Rogier traveled to Italy is not unequivocal, some of his paintings clearly show his acquaintance with Italian pictorial devices; his religious sincerity and concern with sin and guilt, however, remained undimmed by them. The appearance of these mid-century Italian influences in Rogier's paintings was not an isolated instance in Flemish art. The work of Petrus Christus (about 1410–72) shows so marked an interest in the depiction of space and cubic form that, though the idea is now largely discounted, it has often been felt that he too traveled to Italy. Little is known of his life, except that he may have been a student of Jan van Eyck's and that he settled and worked in Bruges. Not particularly well regarded by art critics and historians, he has been called an "eclectic who limits himself to the imitation of the great masters" and whose work is "homely and plain to the point of artlessness." In fact, the style of Petrus Christus vacillates between that of Jan van Eyck and Rogier van der Weyden. Still, his interests really are quite different from those of his models. His painting of Saints Eligius and Godeberta (FIG. 14-12) seems

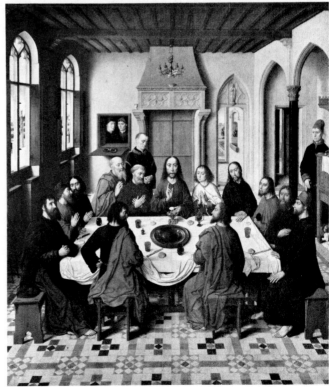

14-13 Dirk Bouts, *The Last Supper*, 1464–68. Approx. 6′ × 5′. St. Peter's, Louvain.

at first glance to exhibit all the miniaturistic traits of Van Eyck, from the stitching on the lady's gown to the carefully enumerated attributes that identify the seated saint as patron of the goldsmith's guild. Even the convex mirror seems to have been extracted from Van Eyck's Arnolfini portrait, and the two "witnesses" reflected in it suggest that this may also be a wedding picture. But Christus' concept of reality and his approach to it are quite different from Van Eyck's; he is much more concerned with the structure that underlies an object's appearance and, in this respect, more closely related to the Italian than to the northern approach. The three solidly constructed figures within the cubic void defined by desk and room corner represent, in fact, an essentially southern essay in pictorial form that has been overlaid with Van Eyck's surface realism. Curiously, in his effort to make the structure of his picture clear, Christus resorts to the same kind of simplification of forms seen in the paintings of Uccello and Piero della Francesca (FIGS. 12-29 and 12-32 to 12-34). Even more striking, perhaps, is the similarity of Christus' "volumetric" portrait heads to those by Antonello da Messina (see Chapter 12). The speculation that these two artists may have met, either in Flanders or in Italy, remains tempting, despite the lack of solid documentation.

A slightly younger artist with similar temperament and interests, who may have had some contact with Petrus Christus, is DIRK BOUTS (about 1415–75). Rogier van der Weyden may have known about the Italian science of linear perspective; Petrus Christus may even have used it; but the central panel of *Altarpiece of the Holy Sacrament* by Bouts is the first northern painting in which the use of a single vanishing point for the construction of an interior can actually be demonstrated. The setting for the altarpiece's *Last Supper* (FIG. 14-13) is probably the refectory of the head-quarters of the Louvain Confraternity of the Holy Sacrament, by which the painting was commissioned. All orthogonals of the depicted room lead to a single vanishing point in the center of the mantelpiece above the head of Christ. This is not only the most successful fifteenth-century northern representation of an interior but also the first in which the scale of the figures has been realistically adjusted to the space they occupy. So far, however, the perspective unity is confined to single units of space only; the small side room has its own vanishing point, and neither it nor that of the main room falls on the horizon of the landscape seen through the windows. The tentative manner with which Bouts solves his spatial problem suggests that he arrived at his solution independently and that the Italian science of perspective had not yet reached the north, except perhaps in fragments. Nevertheless, the works of Christus and Bouts clearly show that by mid-century northern artists had become deeply involved with the same scientific, formal problems that occupied Italian artists during most of the fifteenth century.

The mood of Bouts's *Last Supper* is neutral. While the gathering is solemn enough, it lacks all pathos and dramatic tension. It almost seems that the artist was more concerned with the solution of a difficult formal problem than with the pictorial interpretation, either personal or traditional, of the sacred event.

VAN DER GOES AND MEMLING

The highly subjective and introspective paintings of HUGO VAN DER GOES (about 1440-82) seem to be a reaction to the impersonal quality and to express a discontent with what the artist must have felt was a loss of religious meaning in the paintings of his older contemporaries. Hugo van der Goes was dean of the painter's guild of Ghent

from 1468 to 1475 and an extremely popular painter. At the height of his success and fame, he entered a monastery as a lay brother. While there he suffered a mental breakdown in 1481 and died a year later. His retirement to the monastery did not immediately interrupt Hugo's career as a painter, for he continued to receive commissions and probably completed his most famous work, the *Portinari Altarpiece* (FIG. 14-14), within the monastery's walls. Hugo painted the triptych for Tommaso Portinari, an agent of the Medici who appears on the altarpiece's wings with his family and their patron saints. The central panel represents the Adoration of the Shepherds (PLATE 14-5). On a large surface Hugo displays a scene of solemn grandeur muted by the artist's introspective nature. The high drama of the joyous occasion is stilled, and the Virgin, Joseph, and the angels seem to brood on the suffering that is to come rather than to meditate on the miracle of the Nativity. On a tilted ground that has the expressive function of centering the main actors the Virgin kneels, somber and monumental. From the right enter three shepherds, represented with powerful realism in attitudes of wonder, piety, and gaping curiosity. Their lined, plebeian faces, work-worn hands, and uncouth dress and manner are so sharply characterized as to make us think of the characters in such literature of the poor as *Piers Plowman* and the *Second Shepherd's Play.* The three panels are unified by the symbolic architecture and a continuous, wintry, northern landscape. Symbols are scattered plentifully throughout the composition: Iris and columbine symbolize the Sorrows of the Virgin; a sheaf of wheat stands for Jerusalem; and the harp of David emblazoned over the portal of the far building signifies the ancestry of Christ. To further stress the meaning and significance of the depicted event, Hugo revives Medieval pictorial devices and casts aside the unities of time and action so treasured by other Renaissance artists, wherein a single episode in time is confined to a single framed piece. Small scenes shown in the background of the altarpiece represent (from left to right across the three panels) the Flight into Egypt, the Visitation, the Annunciation to the Shepherds, and the Arrival of the Magi. Also out of the past is the manner in which Hugo varies the scale of his figures in order to differentiate them according to their importance in relation to the central event. At the same time he puts a vigorous, penetrating realism to work in a new direction, the characterization of human beings according to their social level while showing their common humanity, and the painting becomes a plea for all men to join the Brotherhood of Man.

Portinari placed his altarpiece in the church of Sant' Egidio in Florence, where it created a con-

14-14 HUGO VAN DER GOES, *The Portinari Altarpiece* (open), *c.* 1476. Oil on wood, center panel 8′ 3½″ × 10′. Galleria degli Uffizi, Florence.

14-15 HANS MEMLING, *The Mystic Marriage of St. Catherine*, center panel of the *St. John Altarpiece*, 1479. Approx. 5′ 9″ × 5′ 9″. Hospitaal Sint Jan, Bruges.

siderable stir among Florentine artists. Although the painting as a whole must have seemed unstructured to them, Hugo's brilliant technique and what they thought of as incredible realism in representing drapery, flowers, animals, and, above all, human character and emotion made a deep impression on them. At least one Florentine artist, Ghirlandaio, paid tribute to the northern master by using his most striking motif, the adoring shepherds, in one of his own Nativity paintings a few years later.

Hugo's contemporary, HANS MEMLING (about 1430–94), though, like him, esteemed by all, and called the "best painter in all Christendom," was of a very different temperament. Gentle and genial, he avoided the ambitious, dramatic compositions of Rogier van der Weyden and Hugo van der Goes, and his sweet, slightly melancholy style fits well into the twilight of the waning fifteenth century. His specialty is the Madonna, of which he has left many; they are slight, pretty, young princesses, the infant Christ a doll. A good example of his work is the central panel of a triptych, representing the mystical marriage of St. Catherine (FIG. 14-15). The composition is balanced and serene, the color sparkling and luminous, the execution of the highest technical quality. (Memling's paintings are among the best preserved from the fifteenth century.) The prevailing sense of isolation and the frail, spiritual human types contrast not only with Hugo's monumental and somber forms but with Jan van Eyck's robust and splendid ones. The century had begun, with Van Eyck's sumptuous art, on a note of humanistic optimism. It ends with a waning strength of spirit, an erosion of confidence in the

moral and religious authority of the Church. Contemporary poetry is filled with dreary pessimism and foreboding, anticipating another Fall of Man and seeming to see ahead the disasters of Christendom in the time of the Reformation.

HIERONYMUS BOSCH

This time of pessimistic transition finds its supreme artist in one of the most fascinating and puzzling painters in history, HIERONYMUS BOSCH (about 1450–1516). Interpretations of him differ widely: Was he a satirist or an irreligious mocker? Was he a pornographer? Was he a heretic or an orthodox fanatic like Savonarola? Was he obsessed by guilt and the universal reign of sin and death? Certainly his art is born from the dark pessimism of his age, burdened with the fear of human fate, with the conviction that man's doom is approaching. A contemporary poet, Eustache Deschamps, wrote:

> Now the world is cowardly, decayed and weak,
> Old, covetous, confused of speech:
> I see only female and male fools
> The end approaches . . .
> All goes badly.

In a much copied and imitated series of small panels with half-length figures, Bosch describes the Passion of Christ. The *Carrying of the Cross* (FIG. 14-16) of this group is certainly a bitter judgment of humanity. Christ is surrounded by hate and evil, his executioners showing a sadistic delight in the suffering of their victim. Heedless of spatial effects, Bosch packs the entire surface of his panel with hate-distorted faces. In the upper right corner, a grinning scoundrel in monk's habit exhorts the repentant thief; in the lower right corner, the unrepentant thief grimaces at two leering comrades, forming with them a triad of stupidity, bestiality, and hate; and on the lower left, St. Veronica, representing the Church, turns away from Christ and becomes a symbol of vanity. No further interpretation of this panel seems needed, as Bosch not only makes his meaning clear but expresses it with unrivaled ferocity.

Much more difficult to understand are Bosch's large altarpieces, which are packed with obscure meaning and symbolism. But even if we may not fully understand his teeming fantasies, we can appreciate the incredible scope of an imagination that makes him the poet of the nightmarish subconscious. The dreaming and waking worlds are one in Bosch as he draws upon the tradition of beast and monster that we have followed from Mesopotamia to the Gothic gargoyle.

His most famous work, the so-called *Garden of Earthly Delights* (FIG. 14-17, PLATE 14-6), is also his most puzzling, and no interpretation of it is universally accepted. The left wing of the triptych shows the birth of Eve in the Garden of Eden. Eve here is not the mother of mankind, as she is in Jan van Eyck's *Ghent Altarpiece*, but rather the seductress whose temptation of Adam resulted in the original sin, the central theme of the main panel. Evil lurks even in Bosch's paradise; a central fountain of life is surrounded by ravens, the traditional symbols for nonbelievers and magicians, while an owl hiding in the dark hole in the fountain's center represents witchcraft and sorcery. The central panel (PLATE 14-6) swarms with the frail nude figures of men and women sporting licentiously in a panoramic landscape that is studded with fantastic growths of a quasisexual form. Bosch seems to show erotic temptation and sensual gratification as a universal disaster, the human race, as a consequence of original sin, succumbing to its naturally base disposition. The subjects are derived in part from three major sources: Medieval bestiaries, Flemish proverbs, and the then very popular dream books, all

14-16 HIERONYMUS BOSCH, *The Carrying of the Cross*, c. 1510 (?). Approx. 30″ × 32″. Musée des Beaux-Arts, Ghent.

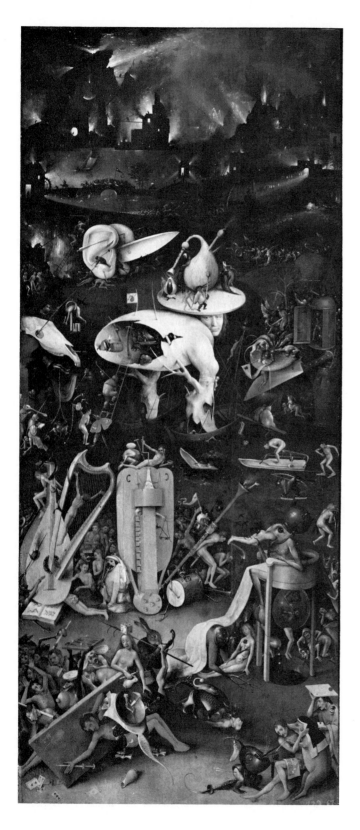

14-17 Hieronymus Bosch, *Hell*, right panel of *The Garden of Earthly Delights*, c. 1505 (?). 86½″ × 36″. Museo del Prado, Madrid.

mixed in the melting pot of Bosch's astoundingly inventive imagination. In addition, there are frequent allusions to magic and alchemy, and animal and vegetable forms are mingled in the most absurd combinations. Symbols are scattered plentifully throughout the panel: fruit for carnal pleasure, eggs for alchemy and sex, the rat for falsehood and lies, dead fish for memories of past joys. A couple in a glass globe may illustrate the proverb "Good fortune, like glass, is easily broken." To many of Bosch's symbols we have lost the key, but it may be assumed that they were well enough known to his contemporaries. In the right panel (FIG. 14-17) the fruits of license are gathered in hell. There sinful mankind undergoes hideous torments to diabolic music, while the hellish landscape burns. This symphony of damnation apparently comments on the wickedness of music, with which the Devil lures souls away from God. In this context the ears and the musical instruments would represent the erotic, soul-destroying thoughts engendered by music. A man is crucified on a harp, another shut up in a drum. A gambler is nailed to his own table. A girl is embraced by a spidery monster and bitten by toads. The observer must search through the hideous enclosure of Bosch's hell to take in its fascinating though repulsive details. The great modern poet Baudelaire catches the mood in his *Flowers of Evil*:

Who but the Devil pulls our walking-strings!
Abominations lure us to their side;
Each day we take another step to hell,
Descending through the stench, unhorrified . . .

Packed in our brains incestuous as worms
Our demons celebrate in drunken gangs . . .

. . . in this den of jackals, monkeys, curs,
Scorpions, buzzards, snakes . . . this paradise
Of filthy beasts that screech, howl, grovel, grunt—
In this menagerie of mankind's vice

The triptych as a whole may thus represent the false paradise of this world between Eden and hell. But this is only one interpretation. Another has it that Bosch belonged to a secret, heretical

sect, the Adamites, and that the central panel was thought of as a kind of altarpiece celebrating symbolically its rites and practices. Whatever the case, mankind does not appear to advantage in the art of Hieronymus Bosch. Abandoned to evil by the Fall, man merits hell.

Bosch was a supreme narrative painter, and the visions of his bubbling imagination demanded quick release. His technique is less labored than the traditional Flemish manner, more rapid and spontaneous. He seemed to have had no time for the customary monochrome underpaintings or careful modeling of figures. His method forecasts the *alla prima* technique of the seventeenth and eighteenth centuries, as he puts down with quick and precise strokes the myriad creatures that populate his panels. His use of *impasto*, which did not require the traditional laborious application of numerous glazes, was ideally suited to the spinning of his mordant fantasies. And if he extends no hope of salvation for man, he only anticipates Michelangelo, who, in his *Last Judgment*, came to the same conclusion some thirty years later.

France and Germany

The bourgeoisie in France was not comparable to that in the Netherlands—wealthy, localized in strong towns, and interested in fostering the arts. For France the Hundred Years' War had wrecked economic enterprise and prevented stability. During the fifteenth century the anarchy of war and the weakness of the kings resulted in a group of rival duchies. The strongest of these, as we have seen, was the duchy of Burgundy; it had occupied the Netherlands through marriage and political alliance and became essentially Flemish, particularly in the art commissioned by the court. In France, artists joined the retinues of the wealthier nobility—the dukes of Berry, Bourbon, and Nemours—and sometimes the royal court, where they were able to continue to develop an art that is typically French despite its regional variations. But no artist of the fifteenth century north of the Alps could escape the influence of the great artists of Flanders; French art accepted

it, and works of high quality were produced, although only one really major figure emerged. JEAN FOUQUET (about 1420–81) is the outstanding French artist of the fifteenth century. During his career he worked for the king, Charles VII, for the Duke of Nemours, and for Étienne Chevalier, the king's minister of finance. Fouquet's portrait of Chevalier with his patron, St. Stephen (FIG. 14-18) shows, in addition to Flemish influence, the effect of the two years he spent in Italy, between 1445 and 1447. The kneeling donor with his standing saint is familiar in Flemish art, as are the three-quarter stances and the sharp, clear focus of the portraits. The reading of the surfaces, however, is less particular than in the Flemish practice, as the artist is trying to represent the forms underneath the surfaces, in the Italian manner. Also of Italian inspiration are the architectural background and its perspective rendering. The secularizing tendency so rapidly advancing in the fifteenth century shows in the familiar, comradely demeanor of the two men; nothing whatever distinguishes them as being of different worlds,

14-18 JEAN FOUQUET, *Étienne Chevalier and St. Stephen*, c. 1450. 36½″ × 33½″. Staatliche Museen Preubischer Kulturbesitz Gemäldegalerie Berlin (West).

with the detailed landscapes of Flemish painting. No matter what his sources, the painter is deeply sensitive to his theme. Along with Rogier's version, the *Avignon Pietà* is one of the most memorable in the history of religious art.

To an even greater extent than in France, the development of German painting in the fifteenth century was strongly colored by the achievements of Flemish painting. In northern Germany the influence of Jan van Eyck joined the tradition of the International style to produce the gentle, pictorially ornate world of delicacy and charm of STEPHAN LOCHNER (about 1400–51), the leading master of the school of Cologne. He was noted for his compositions on the idyllic theme of the Madonna in the rose garden (FIG. 14-19), which seems particularly well suited to his sophisticated and refined sensibilities. Sometimes referred to as the "soft" style because of its feminine suavity and curvilinear rhythm, Lochner's manner was very different from the sculptural, blocky "hard" style of southern Germany as we find it in the work of the Swiss painter CONRAD WITZ (about 1400–47). Although the *Miraculous Draught of Fish* (FIG. 14-20) by this remarkable painter also shows Flemish influence, particularly that of Jan van Eyck, the painting demonstrates Witz's powerful and original sense of realism. Witz shows precocious skill in the study of water effects: the sky-glaze on the slowly moving lake surface, the mirrored reflections of the figures in the boat, the transparency of the shallow water in the foreground. This is one of the first pictures of the Renaissance in which the landscape not only predominates over the figures but is also the representation of a specific place—the shores of Lake Geneva, with the town of Geneva on the right and the ranges of the Alps in the distance.

The Gothic style persisted along with the growth of the Renaissance in the north. In the work of Germany's greatest sculptor of the fifteenth century, TILMAN RIEMENSCHNEIDER (1460–1531), we find scarcely a trace of the Italian Renaissance. The canopy of his *Creglingen Altarpiece* (FIG. 14-21) is an intricate weaving of flamboyant Gothic forms, and the endless and restless

unless it be that St. Stephen, who holds the stone of his martyrdom, is dressed as a priest.

An isolated masterpiece of great power is the *Avignon Pietà* (PLATE 14-7), which, painted in the extreme south of France by an anonymous artist, has elements both Flemish and Italian. Rogier van der Weyden's great *Deposition* comes at once to mind when we see the Avignon work, though the balanced, almost symmetrical massing is of the Italian Renaissance. The donor, now familiarly present at the sacred event, kneels at the left. His is a strikingly characteristic portrait, the face gnarled, oaken, ascetic. The group of Christ and saints is united by the splendidly painted figure of Christ and by the angular shapes that seem deliberately simplified for graphic emphasis. As in Italian art, surface ornament is suppressed in the interest of monumental form. The luminous gold background against which the figures are silhouetted, and into which the haloes are incised, is a strangely conservative feature, contrasting

line is communicated to the draperies of the figures. The whole design is thus in motion and complication and no element functions without the rest. The draperies float and flow around bodies lost within them, serving not as description but as design elements that tie the figures to each other and to the framework. The spirituality of the figures, immaterial and weightless as they appear, is heightened by a facial expression common to Tilman's figures and consonant with the age of troubles that is coming—a look of psychic strain. They brood in pensive melancholy, their brows often furrowed in anxiety. A favorite theme in Late Gothic German sculpture was the *Schmerzensmann* (man of sorrows); for Tilman all his actors are men of sorrow—weary, grave, unsmiling.

With the sculptor-painter MICHAEL PACHER (about 1435–98), we come to the first important meeting of German art with the Italian Renaissance. Pacher, a Tyrolean, must have journeyed down the Po valley and become familiar with the style of Mantegna and his school. In his painting *St. Wolfgang Forces the Devil to Hold His Prayerbook* (FIG. 14-22), we find the hard, wiry linearity of Mantegna and a combination of Late Gothic and Mantegna's drapery style. The figure of St. Wolfgang has now the monumental solidity of Italian form. The whole setting is Italian Renaissance: Familiar in north Italian and Venetian composition are a perspective down a street—the plunging orthogonals remind one of Mantegna's architecture in the painting of *St. James Led to Martyrdom* (FIG. 12-59)—and the figures standing on a fretted balcony, which slows the swift recession of the perspective to the horizon. But the gargoylish Devil tells us that the Gothic is still very much in the northern environment.

In Germany, where printing with movable type was developed, one could expect that the graphic arts should be well represented by competent masters. And indeed, MARTIN SCHONGAUER

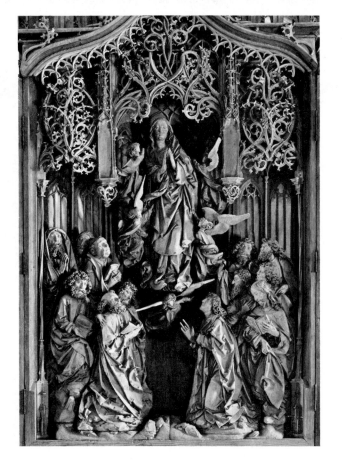

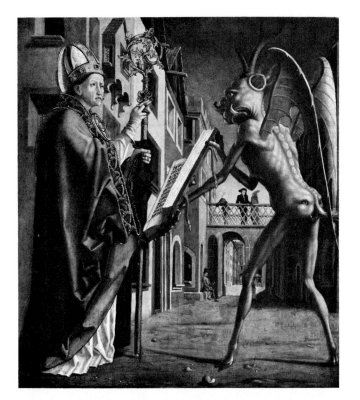

14-21 TILMAN RIEMENSCHNEIDER, *The Assumption of the Virgin*, center panel of the *Creglingen Altarpiece*, c. 1495–99. Carved wood. Parish church, Creglingen.

(about 1450–91) was the century's most skilled and subtle northern master of the new metal engraving technique. Printing pictures from woodblocks was developed in Europe around 1400 (the Chinese had known the technique centuries before) and remained popular, especially for book illustration, well into the 1500's. But engraving upon metal surfaces, begun, as we have seen, in the 1430's and well developed by 1450, proved a much more flexible technique and, in the second half of the century, widely replaced the woodcut. Schongauer's *St. Anthony Tormented by the Demons* (FIG. 14-23) shows both the versatility of the medium and the artist's mastery of it. Although better known for his gentle Madonnas in a style based on that of Rogier van der Weyden, Schongauer here displays almost the same taste for the diabolical as Bosch, his stoical saint caught in a revolving thorn-bush of spiky demons, who claw and tear at him furiously. With unsurpassed skill and subtlety the artist makes marvelous distinctions of tonal values and textures, from smooth skin to rough cloth, from the furry and feathery to the hairy and scaly. The method of describing forms with hatching that follows the forms was probably developed by Schongauer and became a standard with German graphic artists. The Italians preferred parallel hatching—compare Pollaiuolo's engraving (FIG. 12-53)—and rarely adopted this method, which, in keeping with the general northern approach to art, tends to describe the surfaces of things, rather than their underlying structures.

THE SIXTEENTH CENTURY

Germany

The art of northern Europe during the sixteenth century is characterized by a sudden awareness of the advances made by the Italian Renaissance

14-22 MICHAEL PACHER, *St. Wolfgang Forces the Devil to Hold His Prayerbook*, panel from the *Altar of the Fathers of the Church*, c. 1481. Approx. 58″ × 37″. Alte Pinakothek, Munich.

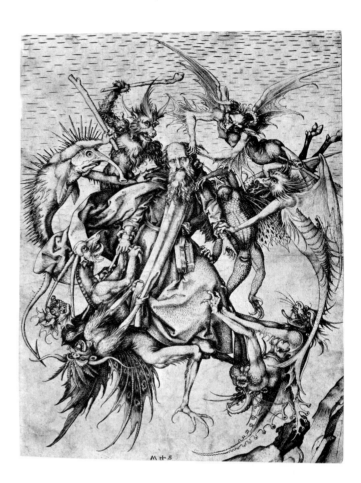

and by a desire to assimilate this new style as rapidly as possible. Many artists traveled to Italy to study the new art at first hand; others met it either directly, in the form of Italian artists who came to the north, or indirectly, through the numerous Italian engravings that circulated throughout northern Europe. One of the most prolific Italian engravers was Marcantonio Raimondi; he rarely invented his own compositions but copied those of other artists, particularly Raphael. In this way, many of the panel paintings and frescoes by the artists of the Italian Renaissance became the common property of all Europe. Naturally, the impact of Italian art varied widely according to the artist, the time, and the place. Many artists never abandoned existing local traditions, whereas others were frequently content to borrow only single motifs or the general form of a composition. In Germany the wealthy merchant class maintained close commercial relations with Venice, and German humanists were in contact with the neo-Platonic academy of Florence. As a result, Albrecht Dürer's art (see below) frequently illustrates Florentine thought clothed in Venetian and German forms.

During the fifteenth century, German painting practiced in the wealthy towns of southern Germany had developed along its own expressionistic lines under the dominant influences of Flemish art. Around the turn of the century it suddenly burst into full bloom. By 1528, with the death of its two greatest exponents, Dürer and Grünewald, it had spent itself. Thus its most brilliant period corresponds almost exactly to that of the High Renaissance in Italy. Its decline around 1530 is just as abrupt as its rise, the reason not certain. The almost incessant religious wars devastated the German lands, and puritanism, accompanying the triumph of Protestantism in the north, may have opposed humanistic paganism in the figurative arts. With the exception of Holbein the main representatives of the German school were born within ten years of one another and were contemporaries of Michelangelo, Raphael, Giorgione, and Titian.

ALTDORFER AND CRANACH

ALBRECHT ALTDORFER (about 1480–1538) is the primary representative of the *Donaustil* (Danube style), which flourished along the Danube River from Regensburg—Altdorfer's home town—eastward into Austria. The style is formed around the depiction of landscape and stresses mood sometimes heightened to passion. Altdorfer's own style is highly personal and only occasionally modified by the influence of Dürer. He was a gifted colorist and observer of atmospheric and light effects. He loved forests and ruins, in which his figure groups are half-submerged. He painted at least one landscape without figures, making it perhaps the first landscape in Western art painted entirely for its own sake.

His most renowned work, the *Battle of Issus* (FIG. 14-24), has little resemblance to a Danube

setting, though it does give a bird's-eye view of an Alpine landscape. Altdorfer here spreads out in awesome detail the battle in which Alexander the Great overthrew the Persian king, Darius; a huge inscription hanging in the clouds relates this. Swarms of warriors from both sides contest upon a plain backed by cities, mountains, seas, and the opposed forces of nature, the sun and the moon in an illuminated sky. This sudden opening up of space, with its subordination of the human figure to the cosmic landscape, bespeaks a new view of nature, a view that will see man as an insignificant mote in an infinite universe. We need not suppose that German artists knew of the work of the contemporary astronomer, Copernicus, who was to revise the age-old view that the earth is fixed and to suggest instead that the earth and the other "fixed" planets revolve about the sun. It is interesting that these high-horizoned, "topographical" landscapes (we might better call them cosmographical) anticipate the

coming cosmic view that the sciences of physics and physical astronomy will open to the Western world. Altdorfer's technique is still that of the miniaturist, yet his setting is no longer a page but a world—one in which his insectlike combatants are all but lost. In this first vision of the immense space and power of the cosmos, Altdorfer seems to suggest what all subsequent philosophers, scientists, and churchmen, as well as artists, must confront—the fact of the littleness of man.

The early works of LUCAS CRANACH the Elder (1472–1553) are close to the *Donaustil*, which immerses man in the breadth of nature. At Wittenberg, where he was summoned by the elector of Saxony, he became a friend and follower of Luther; he has been called the outstanding representative of German Protestant painting. His later works are marked by a shift from religious to humanistic subject matter, mythology, history, and portraits. Best known are his figure compositions featuring the nude, which he

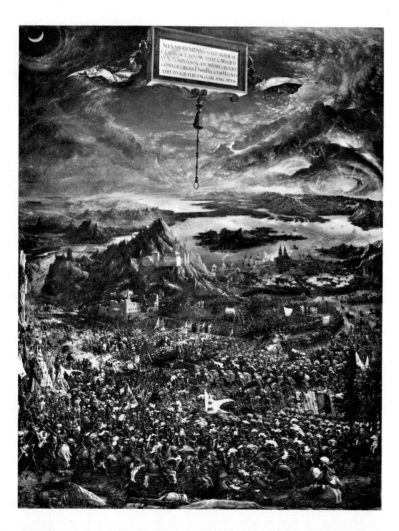

14-24 ALBRECHT ALTDORFER, *The Battle of Issus*, 1529. Oil on panel, 63″ × 46″. Alte Pinakothek, Munich.

renders with a charming, provincial naiveté. A good example is his *Judgment of Paris* (FIG. 14-25). Here Paris and Mercury consult, while the spindly little goddesses show off their pretty contours: One of them bashfully stands on one foot; the other coquettishly calls attention to her charms; another stands by, wearing a fashionable hat. Cranach makes no effort to dress his gods after the antique manner; they wear the functional armor of German knights attached to provincial courts; doughty and square-faced, they could have just come in from the field of honor. The background landscape reflects Cranach's earlier *Donaustil* in its meticulous description of foliage. And so far, only Dürer's approach to the nude is tutored by Italian art.

MATTHIAS GRÜNEWALD

One of the greatest individualists of the Renaissance and an artist of highly original genius is Mathis Neithardt, known as MATTHIAS GRÜNEWALD (about 1480–1528). Forgotten until our time, he appears to have had the wide interests of the individualistic Renaissance artists. Working for the archbishops of Mainz from 1511 on as court painter and decorator, he also served them as architect, hydraulic engineer, and superintendent of works. He doubtless had Lutheran sympathies. He participated in the Peasant Revolt in 1525, and, after its collapse, had to flee to northern Germany, where he settled at Halle in Saxony. The sources of Grünewald's style are not certain. He may have been to Italy, but there is little of Renaissance classicism in his art. He knew of the work of Dürer and may have been familiar with that of Bosch. A brilliant colorist, he is not interested in the construction of the monumental, idealized figure in the Italian manner. His color is characterized by subtle tones and soft harmonies on the one hand, and shocking dissonance on the other. Uninterested in natural landscape, Grünewald shows us either the celestial or the infernal.

In his appalling *Crucifixion* from the *Isenheim Altarpiece* (FIG. 14-26) Grünewald gives us perhaps the most memorable interpretation of the theme in the history of art. The altar is composed of a carved wooden shrine with two pairs of movable panels, one directly in back of the other. Painted by Grünewald between the years 1510 and 1515 for the monastic hospital order of St. Anthony at Isenheim, the panels show three scenes, with the *Crucifixion* outermost, visible when the altar is closed. The dreadful aspect of the painting may partly be due to its placement in a house of the sick, where it may have admonished the inmates that another had suffered more; the Isenheim *Crucifixion* was one of four versions, some of which were similarly placed. Nevertheless, it was Grünewald's own inflamed imagination that produced the terrible image of the suffering Christ. Against the pall of darkness lowered upon the earth the devastated body looms, dead, the flesh already discolored by decomposition and studded with the thorns of the lash. In death the strains of the superhuman agony twist the blackening feet, tear at the arms,

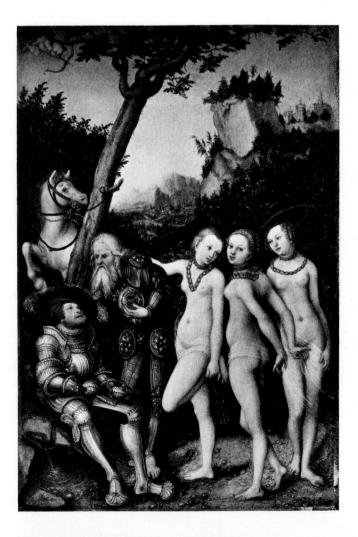

14-25 LUCAS CRANACH the Elder, *The Judgment of Paris*, 1530. Approx. 14″ × 9″. Staatliche Kunsthalle, Karlsruhe.

wrench the head to one side, and turn the fingers into crooked spikes. One has only to tense his fingers in the position of Christ's to experience the shuddering tautness of nerves expressive of every line of the figure. No other artist has produced such an image of the dreadful ugliness of pain. The sharp, angular shapes of anguish appear in the figures of the swooning Virgin and St. John, and in the shrill delirium of the Magdalene. To the other side, the gaunt, spectral form of John the Baptist stands in ungainly pose, pointing with a finger sharp as a bird's beak to the dead Christ, indicating in a Latin inscription Christ's destiny as Redeemer and his own as mere precursor: "It is fitting that he increase and I diminish." The bright, harsh, dissonant colors —black, blood-red, acid-yellow, and the dreadful green of death—suit the flat, angular shapes. Placed in a wilderness of dark mountains, the

scene is relieved by a flood of glaring light that holds the figures in a tableau of awful impact.

When we turn from the Good Friday of the *Crucifixion* to the Easter Sunday of the *Resurrection*, an inner panel of the *Isenheim Altarpiece*, the mood changes from disaster to triumph (PLATE 14-8). Christ, in a blazing aureole of light so incandescent that it dissolves his form and overwhelms the guards, rises like a great flame into the starlit heavens. The fluttering Gothic line prevails in the ascending Christ, and something of the awkward angularity of the *Crucifixion* scene shapes the fallen soldiers. The highly expressive light in both scenes is supernatural, not the light of common day. Certainly it is not the even, flat light that models Piero della Francesca's *Resurrection* (FIG. 12-34). Indeed, in these two pictures we find the fundamental differences that set the German school apart from the

14-26 MATTHIAS GRÜNEWALD, *The Isenheim Altarpiece* (closed), *c.* 1510–15. Center panel approx. 8′ 10″ × 10′ 1″. Musée Unterlinden, Colmar.

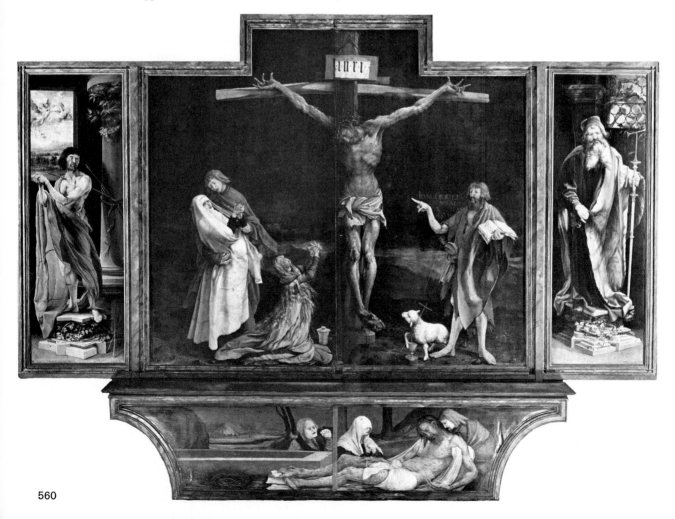

| 1493 | 1495 | c. 1498 | 1504 | c. 1510 | 1514 1515 | 1517 | 1519 |

RIEMENSCHNEIDER
*Creglingen
Altarpiece*

DÜRER
*Four Horsemen
of the
Apocalypse*

DÜRER
Adam and Eve

GRÜNEWALD
*Isenheim
Altarpiece*

DÜRER
Melancolia I

Luther posts
95 Theses

L O U I S X I I O F F R A N C E

E M P E R O R M A X I M I L I A N I

Italian school in the Renaissance. Piero's typically represents the event in terms of a static grouping of solidly rendered figures in a completely balanced, measured composition. The central figure of Christ stands solid as a column, one foot placed weightily on the edge of the sarcophagus. Grünewald converts everything into flowing motion; his Christ is disembodied, almost formless, and the composition has the irregularity and free form of a flaming cloud. It is color that determines everything here, not sculpturesque form and geometric composition as with Piero. Moreover, Grünewald's intention is to render the supernatural in a bodiless way appropriate to it; Piero makes Christ as massive and corporeal as the stone sarcophagus he stands upon. From the Italian point of view the visionary flashing and flickering of Grünewald's *Resurrection* must have appeared crude, formless, and utterly devoid of the order that theory, based upon the study of nature and measurement, could confer.

ALBRECHT DÜRER

We know that Grünewald's great contemporary ALBRECHT DÜRER (1471–1528) felt this way about much of the art of the north and that, in comparison with Italian art, it appeared to him old-fashioned, clumsy, and without knowledge. In the introduction to an unfinished and unpublished treatise on painting, Dürer writes:

> Now, I know that in our German nation, at the present time, are many painters who stand in need of instruction, for they lack all real art theory For as much as they are so numerous, it is very needful for them to learn to better their work. He that works in ignorance works more painfully than he who works in understanding; therefore let all learn to understand art aright.

While still a journeyman, Dürer became acquainted with, and began to copy, prints by Mantegna and Pollaiuolo. Fascinated with classical ideas as transmitted through Italian Renaissance artists, Dürer became the first northern artist to travel to Italy expressly to study Italian art and its underlying theories at their source. After his first journey in 1495 (he made a second trip in 1505–06) it became his life mission to bring the modern—that is, the Italian Renaissance—style north and establish it there. Although Dürer did not always succeed in fusing his own native German style with the Italian manner, he was the first northern artist who fully understood the basic aims of the southern Renaissance.

Dürer was also the first artist outside of Italy to become an international art celebrity. Well-traveled and widely admired, he knew many of the leading humanists and artists of his time, among them Erasmus of Rotterdam and Giovanni Bellini. A man of wide talents and tremendous energy, he became the "Leonardo of the North," achieving fabulous fame in his own time and a firm reputation ever since. Like Leonardo, Dürer wrote theoretical treatises on a variety of subjects, such as perspective, fortification, and the ideal in human proportions. Through his prints he exerted strong influence throughout Europe, especially in Flanders, but also in Italy. Moreover, he was the first northern artist to make himself known to posterity through several excellent self-portraits, through his correspondence, and through a carefully kept, quite detailed and readable diary.

In his own time Dürer's fame and influence depended upon his mastery of the graphic arts, and we still think that his greatest contribution to Western art lies in this field. Trained as a goldsmith before he took up painting and printmaking, he developed an extraordinary proficiency in the handling of the burin, the engraving tool. This technical ability, combined with a feeling for the form-creating possibilities of line, enabled him to create a corpus of graphic work in woodcut and engraving that has seldom been rivaled for quantity and quality. In addition to illustrations for books, Dürer circulated and sold prints in single sheets, which men of ordinary

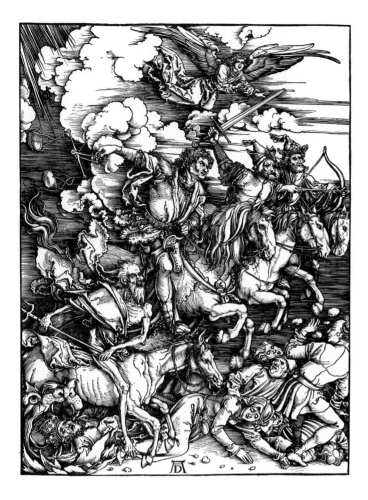

14-27 ALBRECHT DÜRER, *The Four Horsemen of the Apocalypse, c.* 1498. Woodcut, approx. 15¼″ × 11″. Metropolitan Museum of Art, New York (gift of Junius S. Morgan, 1919).

means could buy and which made him a "people's artist" quite as much as a model for professionals. It also made him a rich man.

An early and very successful series of woodblock prints illustrates on fourteen large sheets the Apocalypse, or Revelations of St. John, the last book of the Bible. With great force and inventiveness, Dürer represents terrifying visions of doomsday, and of the omens preceding it. The fourth print of the series, the *Four Horsemen of the Apocalypse* (FIG. 14-27), represents, from foreground to background, Death trampling a bishop, Famine swinging scales, War wielding a sword, and Pestilence drawing his bow. The human race in the last days of the world is trampled by the terrible Four. Technically, this, and the other prints of the series, are of a virtuosity that has never been surpassed in a woodblock print. By adapting to the woodcut the form-following hatching from Schongauer's engravings, Dürer

converted the former primitive contrasts of black and white into a gliding scale of chiaroscuro, achieving a quality of luminosity that had never been seen in woodblock prints. The dynamic composition retains some Late Gothic characteristics in the angularity of shapes and the tendency of forms to merge one into the other. On the other hand, Mantegna's influence can be found in the plastic and foreshortened poses of the trampled victims in the right foreground and in the head of Famine. But despite such Italicisms, the dramatic complexity of the composition remains essentially northern.

From 1500 on, Dürer became increasingly interested in the theoretical foundations of Italian Renaissance art; an engraving of Adam and Eve (FIG. 14-28) represents the first distillation of his studies of the Vitruvian theory of human proportions. Clearly outlined against the dark background of a northern forest, the two idealized figures of Adam and Eve stand in poses reminiscent of the *Apollo Belvedere* and the Medici Venus. Preceded by numerous geometric drawings in which he tried to systematize sets of ideal human proportions in balanced contrapposto poses, the final print presents Dürer's 1504 concept of the "perfect" male and female figures. Adam does, in fact, approach the southern ideal quite closely, but the fleshy Eve remains a German matron, her individualized features suggesting the use of a model. Northern also is the elaborate symbolism of the background "accessories" to the main figures: the choleric cat, the melancholic elk, the sanguine rabbit, and the phlegmatic ox represent the four humors of man, and the relation between Adam and Eve at the crucial moment of the Fall is symbolized by the tension between cat and mouse in the foreground.

The *Adam and Eve* shows idealized forms and strongly naturalistic ones in a close combination that, depending upon the viewer's attitude, may be regarded either as complementing or as conflicting. They remain closely allied ingredients in most of Dürer's works. For he agreed with Aristotle (and the new critics of the Renaissance) that "sight is the noblest faculty of man," and

14-28 ALBRECHT DÜRER, *The Fall of Man (Adam and Eve)*, 1504. Engraving, approx. 10″ × 7½″. Centennial Gift of Landon T. Clay, Courtesy of Museum of Fine Arts, Boston.

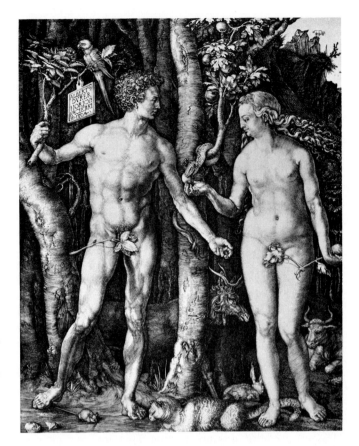

that "every form brought before our vision falls upon it as upon a mirror." "We regard," says Dürer, "a form and figure out of nature with more pleasure than any other, though the thing itself is not necessarily altogether better or worse." This is a new and important idea for artists. Nature holds the beautiful, says Dürer, for him who has the insight to extract it. Thus, even in humble, perhaps ugly, things lies beauty, and the ideal, which by-passes or would improve upon nature, may not be in the end the truly beautiful. There is the hint here that uncomposed and ordinary nature might be the reasonable object of the artist's interest, quite as much as its composed and measured aspect. With an extremely precise watercolor study of a piece of turf (FIG. 14-29), Dürer allied himself to the scientific studies of Leonardo; for with both artists observation yields truth. Sight, sanctified by mystics like Nicolas of Cusa and artists like Jan van Eyck, becomes the secularized instrument of modern knowledge. The "mirror" that is "our vision" will later become telescope, microscope, and television screen. The remarkable *Piece of Turf* is as scientifically accurate as it is poetic; the botanist can distinguish each springing plant and variety of grass: dandelions, great plantain, yarrow, meadow grass, heath rush. "Depart not from nature in your opinions," says Dürer, "neither imagine that you can invent anything better for art stands firmly fixed in nature, and he who can find it there, he has it." The exquisite still life one finds in the northern paintings of the fifteenth century is irradiated with religious symbolism. Dürer's still life is of and for itself; he has found it in nature, and its representation no longer requires religious justification.

As Dürer closely studies floral nature, so he makes his portraits readings of character. The fifteenth-century portrait, like Van Eyck's *Man in a Red Turban* (FIG. 14-9) or the *Canon van der Paele* (PLATE 14-3), is a graphic description of features; Dürer's portraits, like that of Hieronymus Holzschuher (FIG. 14-30) are interpretations of personality. It might be, however, that they are as much projections of Dürer's personality as

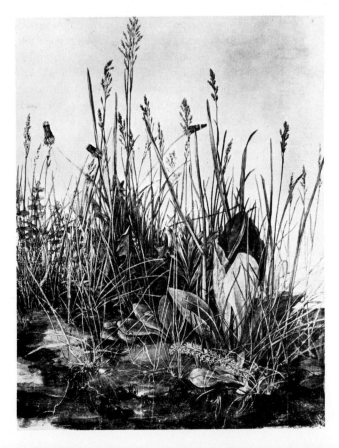

14-29 ALBRECHT DÜRER, *The Great Piece of Turf*, 1503. Watercolor, approx. 16″ × 12½″. Graphische Sammlung Albertina, Vienna.

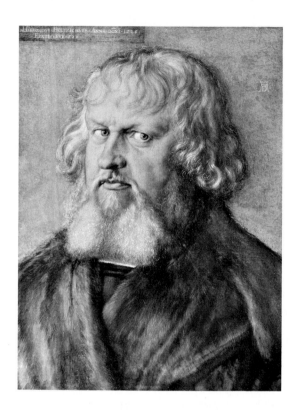

14-30 ALBRECHT DÜRER, *Hieronymus Holzschuher*, 1526. Approx. 19″ × 14″. Staatliche Museen Preubischer Kulturbesitz Gemäldegalerie Berlin (West).

readings of the sitters'; for his portraits of men all show the subject as bold and virile, square-jawed, flashing-eyed, and truculent. One and all the subjects appear intense and intently aware of the observer. This strong psychic relationship to the external world, when the features are precisely particularized, makes for an extremely vivid presence. Holzschuher, a friend of Dürer's and town councilor of Nuremberg, fairly bristles with choleric energy and the burly belligerence of Nuremberg citizens who, on many an occasion, had defended the city against all comers, including the emperor himself. Leaving the background blank except for an inscription, the artist achieves a remarkable concentration upon the forceful personality of his subject. The portrait in Italy never really brings the subject into such tense personal relationship to the observer.

Dürer always found it quite difficult to reconcile his northern penchant for precise naturalism with his intellectual theoretical pursuits and the demands of southern High Renaissance art for simplified monumentality. This life-long dilemma seems to be expressed in *Melancolia I* (FIG. 14-31), one of the so-called master prints Dürer made between 1513 and 1514. The three engravings (the other two are *Knight, Death, and the Devil* and *St. Jerome in his Study*), probably intended to symbolize the moral, theological, and intellectual virtues, carry the art of engraving to the highest degree of excellence. Dürer uses his burin to render differences in texture and tonal values that would be difficult to match even in the much more flexible medium of etching, which was developed later in the century. The complex symbolism of *Melancolia I* is based primarily on concepts derived from Florentine neo-Platonism. About the seated winged figure of Melancolia, the instruments of the arts and sciences lie strewn in idle confusion; she is the personification of knowledge that, without divine inspiration, lacks the ability to act. Also, according to then current astrological theory, the artist, or any man engaged in creative activity, is the subject of Saturn. As such he is characterized by a melancholia bordering on madness that either

plunges him into despondency or raises him to the heights of creative fury; Michelangelo was regarded as subject to this humor. Like Michelangelo also, Dürer conceived of the artist (and thus of himself) as a genius who struggles to translate the pure Idea in his mind into gross but visible matter. Thus, the monumental image of the winged genius, with burning eyes in a shaded face and wings that do not fly, becomes the symbol for divine aspirations defeated by human frailty and, in a way, a "spiritual self-portrait of Albrecht Dürer."

Only toward the very end of his life, and in one of his very last paintings, was Dürer finally able to reconcile the two opposed tendencies that had struggled for dominance in his entire oeuvre—northern naturalism and southern monumentality. He painted the *Four Apostles* (FIG. 14-32) without commission and presented the two panels to the city fathers of Nuremberg in 1526 to be hung in the city hall. The work has been called Dürer's religious and political testament, in which he expresses his sympathies for the Protestant cause and warns against the dangerous times, when religion, truth, justice, and the vir-

14-31 ALBRECHT DÜRER, *Melancolia I*, 1514. Engraving, approx. $9\frac{1}{2}'' \times 7\frac{1}{2}''$. Fogg Museum of Art, Harvard University, Cambridge, Massachusetts (bequest of Francis Calley Gray).

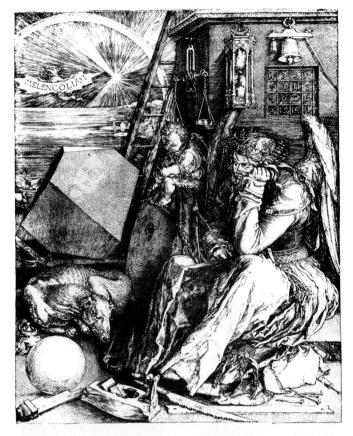

tues all seemed to be threatened. The four apostles—John and Peter on one panel, Mark and Paul on the other—stand on guard for the city. Quotations from each of their books in the German of Luther's translation of the New Testament are written on the frames. They warn against the coming of perilous times and the preaching of false prophets who will distort the word of God. The figures of the apostles summarize Dürer's whole craft and learning. Representing the four temperaments, or humors, of the human soul as well as the four ages of man and other quaternities, the apostles are portrait-like characterizations that have no equal in the idealized representations of Italian saints. At the same time, the art of the Italian Renaissance is felt in the monumental grandeur and majesty of the figures, heightened by a vivid color and sharp lighting. Dürer here unites the northern sense of minute realism with the Italian tradition of balanced forms, massive and simple. The result is a vindication of the artist's striving toward a new understanding, a work that stands with the greatest of the masters of Italian art.

HANS HOLBEIN

What Dürer had struggled all his life to formulate and construct was achieved almost effortlessly by his younger contemporary, HANS HOLBEIN the Younger (1497–1543). Holbein's specialty was portraiture, in which he displayed a thorough assimilation of all that Italy had to teach of monumental composition, bodily structure, and sculpturesque form. He retains the northern traditions of close realism as elaborated in fifteenth-century Flemish art, for the color surfaces of his paintings are as lustrous as enamel, his detail exact and exquisitely drawn, and his contrasts of light and dark never heavy.

Holbein knew Erasmus of Rotterdam in Basel, where Holbein was first active. Because of the imminence of a religious civil war in Basel, Erasmus suggested that Holbein leave for England and gave him a recommendation to Thomas

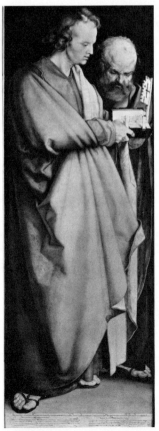
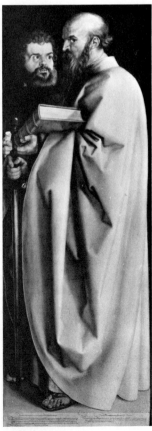

14-32 ALBRECHT DÜRER, *The Four Apostles*, 1526. Oil on wood panels, each $85'' \times 30''$. Alte Pinakothek Munich.

More, chancellor of England under Henry VIII. Holbein did leave and became painter to the English court. While there he painted a superb double portrait of the French ambassadors to England, Dinteville and De Selve (PLATE 14-9). The two men, both ardent humanists, stand at either side of a side-table covered with a rich tapestry and a collection of objects reflective of their interests—mathematical and astronomical models and implements, a lute with a broken string, compasses, a sundial, flutes, globes, and an open hymn-book with Luther's translation of *Veni, Creator Spiritus* and of the Ten Commandments. The still-life objects are rendered with the same meticulous care as are the men themselves, the woven design of the deep emerald curtain behind them, and the floor tiles constructed in faultless perspective; not a figure is missing from the astronomical instruments. The stable, balanced, serene composition is interrupted only by a long gray shape that rises diagonally from the floor. When viewed from the proper angle, this shape is recognizable as a death's-head, for, like Dürer, Holbein was interested in symbolism as well as in radical perspectives. The color harmonies are adjusted in symphonic complexity and richness. The portraits—grave, even somber —indicate that Holbein follows the Italian portrait tradition, which gives the face a neutral expression, rather than Dürer's practice of giving it an expression of keen intensity. The *Ambassadors* exhibits the peculiar talents of Holbein—his strong sense of composition, his subtle linear patterning, his gift for portraiture, his marvelous sensitivity to color, his faultlessly firm technique. This painting may have been Holbein's favorite; it is the only one signed with his full name.

In his later works his style underwent a gradual change. He eliminated inventories of objects, confining himself to a simple neutral ground behind the subject. In the portrait of Christina of Denmark (FIG. 14-33) his simplification is carried over to the figure itself, to its costume, and to the face. The handsome young widow (of Duke Francesco Maria Sforza), with whom Henry VIII tried unsuccessfully to arrange a marriage, is shown at full length, a format reserved for the most eminent personages (bust portraits or half-lengths sufficed for Holbein's numerous portraits of merchants and court officials). Noth-

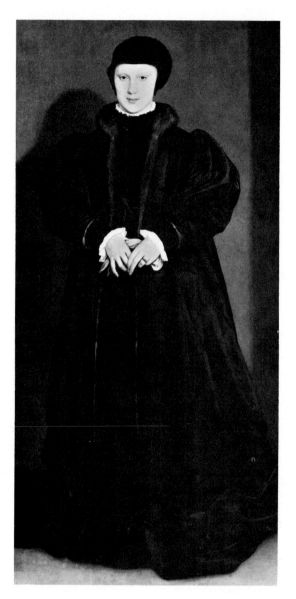

14-33 HANS HOLBEIN the Younger, *Christina of Denmark*, 1538. Approx. 70″ × 32″. Reproduced by courtesy of the Trustees of the National Gallery, London.

ing is shown that might detract from the subject. With flawless draftsmanship Holbein renders the figure firm and solid, his descriptive line subtly reinforced with flat modeling. The complete lack of perspective space may make us think of Mannerism, but we do not feel any ambiguity here, since the volume of the figure itself clearly defines the space it occupies. Thus, with utmost restraint and simplicity, Holbein, in his late

portraits, is able to achieve the monumental effects of the High Renaissance.

Holbein died prematurely in 1543, and with him the great German school of the Renaissance. But in 1532, when he left Basel for England, he had already taken the Renaissance with him. There were no significant successors. German art faded in the uproar of a century of religious war.

The Netherlands

The resurgence of France and the eclipse of the House of Burgundy robbed the Flemish schools of their precedence. The tremendous acclaim of Albrecht Dürer when he visited Antwerp in 1520 indicates a reverse for Flanders; Germany, which had followed, now led developments in the north. The decay of the old Flemish tradition both in form and content left a void that was filled by the confusing appearance of Italian ideas, received at second hand through the example of Dürer. As with any new, inspiring, but ill-understood fashion, there arose a number of conflicting mannerisms, which had in common, if anything, only their misunderstanding of the principles behind the novel forms. There is much delight in decorative extravagance in which pedantic allusion to the classics is combined with exotic settings made of piled-up fragments of Italianate ornament. For a generation or so the north, as it has been said, "simply could not get its Renaissance on straight."

But from all this confusion new and confident movements could begin. For one thing, remnants of the Medieval tradition had to be swept away; and this happened. The dominance of religious conventions yielded to experiments in subject matter and form; though religious material persisted, it no longer prevailed in art. We have seen how it had been modified by humanization for over a century; now it had to share the artist's interest in portraiture, mythology, landscape, and genre. The structural basis for a new, humanistic realism had been introduced by the great German painters. It was upon this that an international, European art, dealing primarily with human interests, had to be built.

JAN GOSSAERT (about 1478–1535), working for the later Philip of Burgundy, associated with humanist scholars and visited Italy. There, Gossaert (who adopted the name MABUSE after his birthplace, Maubeuge) became fascinated with the antique and its mythological subject matter. Giorgio Vasari, Italian historian and Gossaert's contemporary, wrote that "Gossaert was almost the first to bring the true method of representing nude figures and mythologies from Italy to the Netherlands," though it is obvious that he derived much of his classicism from Dürer. The composition and poses in his *Neptune and Amphitrite* (FIG. 14-34) are borrowed from Dürer's *Adam and Eve* (FIG. 14-28), though Gossaert's figures have been inflated, giving an impression

14-34 JAN GOSSAERT (MABUSE), *Neptune and Amphitrite, c.* 1516. Oil on panel, 74″ × 49″. Staatliche Museen, Berlin.

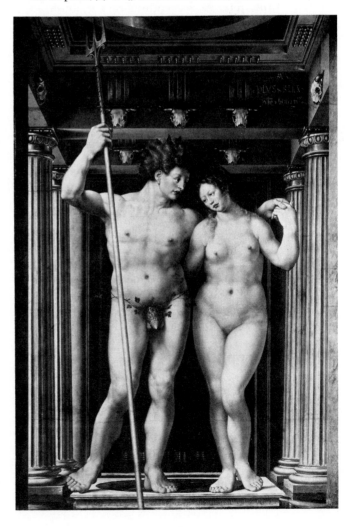

of ungainly weight. While the artist might approximate the classical stance, he seems to have been more interested in nudity than in a classical, ideal canon of proportions. The setting for the figures is a carefully painted architectural fantasy that illustrates a complete lack of understanding of the classical style. Yet the painting is executed with traditional Flemish polish, and the figures are skillfully drawn and modeled. Although Gossaert also painted religious subjects in the traditional style, attempting unsuccessfully to outshine the fifteenth-century Flemish masters, his *Neptune* aligns him firmly with the so-called Romanists, in whose art Italian Mannerism joins with fanciful native interpretations of the classical style to make a highly artificial, sometimes decorative, but often bizarre and chaotic manner.

An outstanding representative of a very different trend in sixteenth-century Flemish art is JOACHIM PATINIR (about 1475–1524). He is the first Netherlandish landscape painter and the counterpart of the German Albrecht Altdorfer. A highly valued specialist in this field, he often collaborated with other artists, either painting the landscape backgrounds for their figure compositions or letting them paint figures into his landscapes. Little is known of Patinir's background, and although no definite links can be established between the two artists, Bosch may well have provided the initial inspiration for his panoramic vistas. Significantly, however, in Bosch's paintings the landscapes are of secondary importance and serve only as broad stages on which his figures can perform their fantastic frolics; in Patinir's works the landscapes take on primary importance, and the figures become mere accessories. In his *Landscape with St. Jerome* (FIG. 14-35) the insignificant figure of Patinir's title saint is almost hidden in the left middle ground. The vast panorama is seen from a mountaintop, and the artist works like a cartographer in building up his landscape in strips or layers that are parallel to the picture plane. The effect of recession is achieved by the careful diminution of familiar things such as houses, trees, and figures, and by the emphatic use of *aerial perspective*, in which the generally warm foreground colors shift to cool blue ones in the back. Realism is confined to the description of details: Plants are painted with botanical accuracy, and trees and

rock formations are rendered with great feeling for their textural differences. Patinir's paintings have a rich multiplicity, with activity almost everywhere, but all drawn together by strong design and an extremely effective dark-light pattern. The tiny figures scattered throughout his landscape effectively contrast human frailty and the power of nature.

A similar interest in the interrelationship of man and nature is expressed in the works of the greatest and most original Flemish painter of the sixteenth century, PIETER BRUEGEL the Elder (about 1525–69), whose early, high-horizoned, "cosmographical" landscapes were probably influenced by Patinir. But in Bruegel's paintings, no matter how huge a slice of this world he may show, the activities of man remain the dominant theme. Bruegel was apprenticed to a "Romanist," Pieter Coecke, and like many of his contemporaries, traveled to Italy, where he seems to have spent almost two years, going as far south as Sicily. But unlike his contemporaries, he was not overwhelmed by classical art, and his Italian experiences are only incidentally reflected in his paintings, usually in the form of Italian or Alpine landscape features that he had recorded in numerous drawings during his journey. Upon his return from Italy, Bruegel was exposed to the works of Bosch, and the influence of that strange master, strongly felt in Bruegel's early paintings, must have swept aside any "Romanist" inclinations he may have had.

The *Hunters in the Snow* (FIG. 14-36) is one of five surviving paintings of a series in which Bruegel illustrated the months of the year. It shows man and landscape locked in winter cold. The weary hunters return with their hounds, wives build fires, skaters skim the frozen pond, the town and its church huddle in their mantle of snow; and beyond the typically Flemish winter scene lies a bit of Alpine landscape. Aside from this bit of fantasy, however, the landscape is realistic and quite unlike Patinir's; it is developed smoothly from foreground to background and draws the viewer diagonally into its depths. The artist's consummate skill in the use of line and shape and his subtlety in tonal harmony make this one of the great landscape paintings in history and an occidental counterpart of the masterworks of classical Chinese landscape.

14-35 Joachim Patinir, *Landscape with St. Jerome*, c. 1520 (?). 30″ × 36″. Museo del Prado, Madrid.

Bruegel, of course, is not simply a landscapist. In his series of the months he presents, in a fairly detached manner occasionally touched with humor, the activities of man at different times of the year. And he chooses for his purpose that social class that is most directly affected by seasonal changes, the peasantry. But usually Bruegel is much more personal as he makes satirical comments on the dubious condition of man. His meaning in specific cases is often quite as obscure as Bosch's and he seems to delight in leading us into his pictures through devious paths and confronting us sometimes with mystery, sometimes with an appalling revelation. As a vehicle for his sarcasm he again chooses the peasant, whom he sees as an uncomplicated representative of humanity; a member of society whose actions and behavior are open, direct, and unspoiled by the artificial cultural gloss that disguises, but does not alter, the city-dweller's natural inclinations. These good countryfolk are shown enjoying themselves in the *Peasant Dance* (PLATE 14-10), which is no mincing quadrille, but a boisterous, whirling, hoe-down in which plenty of sweat is shed. One can almost hear the feet stomping to the rhythm of the bagpipe. With an eye much more incisive than any camera lens, the artist grasps the entire scene in its most charac-

14-36 PIETER BRUEGEL the Elder, *Hunters in the Snow*, 1565. Approx. 46″ × 64″. Kunsthistorisches Museum, Vienna.

14-37 PIETER BRUEGEL the Elder, *The Parable of the Blind*, 1568. Tempera on canvas, approx. 34″ × 60″. Museo Nazionale, Naples.

1515	c.1516	1519	c.1520	1526	1529	1535	1538	1543	1546	1547	1548
GOSSAERT *Neptune and Amphitrite*		PATINIR *Landscape with St. Jerome*		DÜRER *Four Apostles*	ALTDORFER *Battle of Issus*	Rabelais's *Gargantua*	HOLBEIN *Christina of Denmark*	Copernicus' planetary theory	LESCOT Square Court, Louvre, begun		GOUJON *Nymphs*

← F R A N C I S I O F F R A N C E → ← E M P E R O R C H A R L E S V → to 1556

teristic aspect and records it in a broad technique that discards most of the traditional Flemish concern for detail. Weak modeling emphasizes the active, solidly drawn silhouettes, which, combined with strong local colors, give the painting the popular robustness so suited to its subject. From the hilltop that he shared with the *Hunters*, Bruegel has descended into the village to look more closely at its life and amusements. And he finds that not all is well in this rustic paradise. A fight is brewing at the table on the left; everyone is turning his back to the church in the background; nobody is paying the least attention to the small picture of a Madonna tacked to the tree on the right; and the man next to the bagpiper is wearing the feather of a peacock—a symbol of vanity—in his cap. And what about the young couple kissing unashamedly in public in the left middle ground? Is Bruegel telling us, like Bosch in his *Hell* (FIG. 14-17), that music is an instrument of the Devil and a perverter of morals? In short, a closer inspection of the painting shows that Bruegel is telling much more than the simple story of a country festivity. He is showing that a *kermesse*, a festival celebrating a saint, has become a mere pretext for man to indulge his lust, anger, and gluttony.

Toward the end of his life, Bruegel's commentary on man takes on an increasingly bitter edge. The Netherlands, racked by religious conflict, is the seat of cruel atrocities, which become even more cruel with the coming of the power of Catholic Spain to put down the Reformation. We do not know whether Bruegel took sides; like the great satirist he was, he may have preferred to make all mankind, not just partisans, the object of his commentary. His secret meanings may partly be explained by the danger of too much outspokenness. His biographer, Karel van Mander (1548–1606), wrote:

Many of Bruegel's strange compositions and comical subjects one may see in his copper engravings ... he supplied them with inscriptions which, at the time, were too biting and too sharp, and which he had his wife burn during his last illness, because of ... fear that most disagreeable consequences might grow out of them.

Like Dürer, fearful that the Scriptures were being given wilder and wilder interpretations by false prophets who would lead man astray, Bruegel invoked Christ's warning that the blind would lead the blind and that both would fall into the ditch. In the *Parable of the Blind* (FIG. 14-37) a staggering file of blind beggars, their empty eye sockets sunk in brutal or silly masks and in various stages of instability, follow their blind leader into the ditch. The background is a smiling landscape with a church; the foreground a stage upon which the scene of human baseness and folly is played by actors whom the producer has deliberately made ugly. Bruegel knew well how to disguise his intent—so well that in his day he was called Peter the Droll, because, as Van Mander wrote, "there are very few works from his hand that the beholder can look at seriously, without laughing."

France

Divided and harried during the fifteenth century, France under strong kings had reorganized herself by the end of the century and was strong enough to undertake an aggressive policy toward her neighbors. By the time of Francis I, the French had a firm foothold in Milan and its environs. The king eagerly imported the Renaissance into France, bringing Leonardo da Vinci and Andrea del Sarto to his court. But they left no permanent mark upon French art, and it was Florentine Mannerists like Il Rosso and Cellini who implanted the Italianate style that replaced the Gothic. Francis' attempt to glorify the state and himself meant that the religious art of the Middle Ages was finally superseded, for it was the king and

14-38 JEAN CLOUET, *Francis I, c.* 1525–30. Tempera and oil on panel, approx. 38″ × 29″. Louvre, Paris.

elegant, and erotic. The sculptors and painters working together on the decoration of the new royal palace at Fontainebleau under the direction of the Florentines Il Rosso and Primaticcio are known as the school of Fontainebleau. Il Rosso Fiorentino, whose work in Italy was mentioned in Chapter Thirteen, became the court painter of Francis I shortly after 1530. In France his style no longer showed the turbulent harshness of *Moses Defending the Daughters of Jethro* (FIG. 13-37) but became consistently more elegant and graceful. When he decorated the Gallery of Francis I at Fontainebleau, Il Rosso combined painting, fresco, imitation mosaic, and stucco sculpture in low and high relief. The abrupt changes in scale and textures are typically Mannerist (FIG. 14-39), as is the composition of the central painting, which shows Venus reproving Love in compressed Mannerist space with elongated grace and mannered poses. The same artificial grace can be seen in the flanking caryatids, and the viewer is jarred by the shift in scale between the painted and the stucco figures. However, the combination of painted and stucco relief decorations became extremely popular from this time on and remained a favorite decorative technique throughout the Baroque and Rococo periods.

It has been said of Francis I that his one obsession besides women was building. In his reign (1515–47) several large-scale châteaux were begun, among them Chambord in 1519 (FIG. 14-40). Reflecting the more peaceful times, these châteaux were developments from the old countryside fortresses and served as country houses for royalty. They were usually built near a forest to serve as hunting lodges. The plan of Chambord (FIG. 14-41) was originally drawn up by a pupil of Giuliano da Sangallo and shows Italian concepts of symmetry and balance imposed upon the irregularity of the old French fortress. There is a central square block with four corridors in the shape of a cross; these lead to a broad central staircase that gives access to groups of rooms, ancestors of the modern suite of rooms or apartments. The square plan is punctuated at the four corners by round towers, and the whole is surrounded by a moat. From the exterior, Chambord presents a carefully contrived horizontal accent on three levels, the floors separated by

not the Church who now held power. A portrait of Francis I by JEAN CLOUET (about 1485–1541), in the Franco-Italian manner, shows a worldly prince magnificently bedizened in silks and brocades, wearing a gold chain, and caressing the pommel of a dagger (FIG. 14-38). One would not expect the king's talents to be directed to spiritual matters. Legend has it that the "merry monarch" was a great lover and the hero of hundreds of "gallant" situations. The flat light and suppression of modeling give equal emphasis to head and costume, the king's finery and his face entering equally into the effect of royal splendor. Yet despite this Mannerist formula for portraiture, the features are not entirely immobile; there is the faintest flicker of an expression that we might read as "knowing."

The personal tastes of Francis and his court must have run to an art at once suave, artificial,

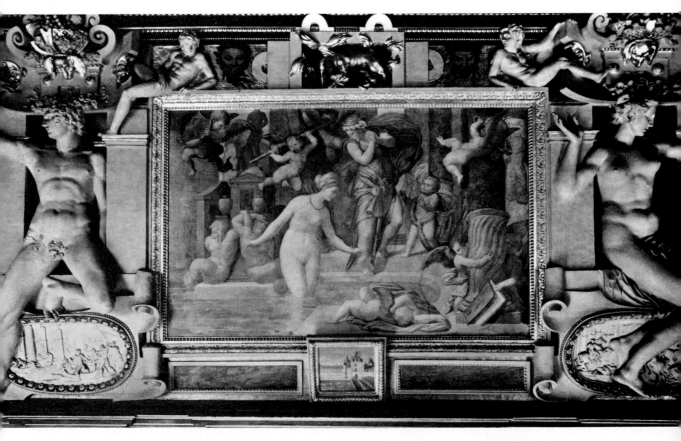

14-39 Il Rosso Fiorentino, *Venus Reproving Love,* c. 1530–40. Gallery of Francis I, Fontainebleau.

continuous moldings. Windows are placed exactly over one another. This matching of horizontal and vertical features is, of course, derived from the Italian palazzo. But above the third level the lines of the structure break chaotically into a jumble of high dormers, chimneys, and lanterns that recall the soaring, ragged, skyline silhouettes of the Gothic.

The architecture of Chambord is still French at heart. During the reign of Francis' successor, Henry II (1547–59), however, treatises by Italian architects were translated, and Italian architects came to work in France, while at the same time the French turned to Italy for study and travel. This interchange brought about a more thorough-going revolution in style, though it never eliminated certain French elements persisting from the Gothic tradition. Francis began the enlargement of the Louvre in Paris (FIG. 14-42) to make a

new royal palace but died before the work was well begun. His architect, Pierre Lescot (1510–78), continued under Henry II, and with the aid of the sculptor Jean Goujon (about 1510–65) produced the classical style of the French Renaissance. While Chambord had incorporated the formal vocabulary of the Early Renaissance, particularly from Lombardy, Lescot and his associates were familiar with the High Renaissance of Bramante and his school. Each story forms a complete order, and the cornices project enough to furnish a strong horizontal accent. The arcading on the ground story reflects the ancient Roman arch-order and is recessed enough to produce more shadow than that in the upper stories, thus strengthening the visual base of the design. On the second story, the pilasters rising from bases and the alternating curved and angular pediments supported by consoles have direct ante-

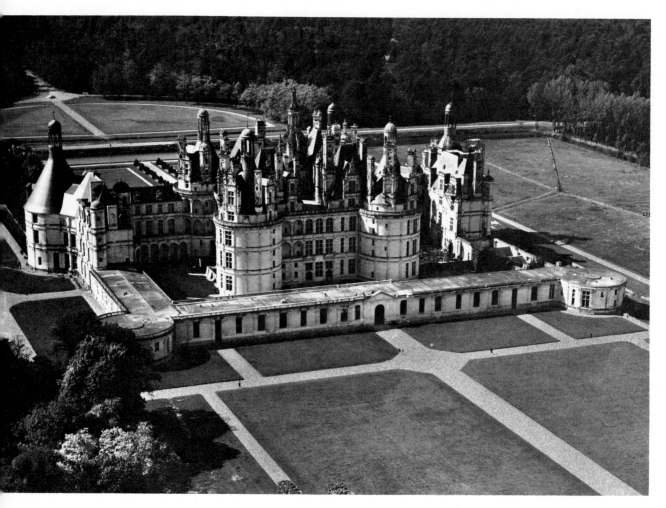

14-40 Aerial view of the Château de Chambord, begun 1519.

cedents in several Roman High Renaissance palaces. On the other hand, the decreased height of the stories, the proportionately much larger windows (given the French weather!), and the steep roof are northern. Especially French are the the pavilions that jut from the wall. These are punctuated by a feature that the French will long favor, the double columns framing a niche. The vertical lines of the building remain strong, the wall is deeply penetrated by openings, and—in un-Italian fashion—profusely sculptured. This French classical manner—double-columned pavilions, tall and wide windows, profuse statuary, and steep roofs—will be widely imitated in other northern countries, with local variation. The mannered classicism produced by the French will be the *only* classicism serving as a model for northern architects through most of the sixteenth century. The south courtyard façade of the Louvre is the best of French Renaissance architecture; eventually the French will develop a quite native classicism of their own, cleared of Italian Mannerist features.

The statues of the Louvre courtyard façade, now much restored, were the work of Goujon. We can best appreciate the quality of Goujon's style from his *Nymphs* from the Fountain of the Innocents in Paris (FIG. 14-43). Like the architec-

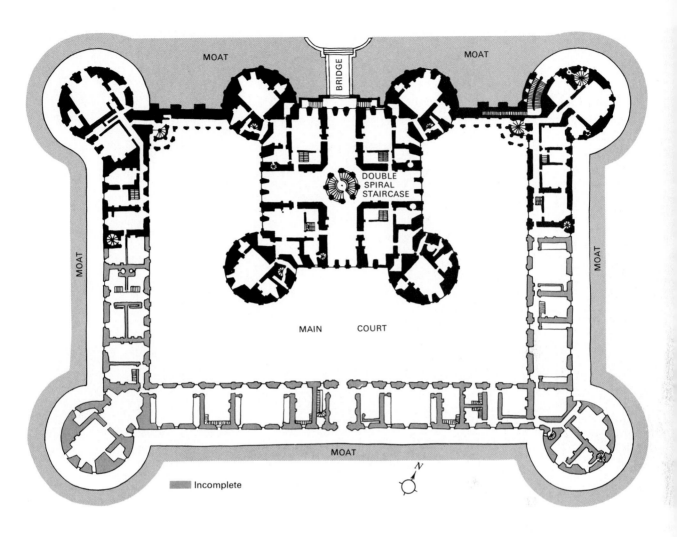

MOAT

MOAT

BRIDGE

MOAT

MOAT

DOUBLE
SPIRAL
STAIRCASE

MAIN COURT

MOAT

Incomplete

N

14-41 Plan of the Château de Chambord.

ture of the Louvre, Goujon's nymphs are intelligent and sensitive French adaptations of the Italian Mannerist canon of figure design. Certainly they are Mannerist in their balletlike contrapposto and the flowing, clinging drapery, which recalls the ancient "wet" drapery of Hellenic sculpture—for example, the figures of the parapet of the Temple of Athena Nike (FIG. 5-52). The slender sinuous figures perform their steps within the structure of Mannerist space, and it is interesting that they appear to make one continuous motion, an illusion produced by the reversing of the gestures as they might be seen in a mirror. The style of Fontainebleau, and ul-

timately of Primaticcio and Cellini, guides the sculptor here, but Goujon has learned the manner so well that he can create originally within it. The nymphs are truly French masterpieces, with lightness, ease, grace, and something of a native French chic that saves them from being mere lame derivatives of the Italian Mannerist norm.

In France, as in all Europe in the sixteenth century, the influence of Italian art was direct and overpowering. But as the century progressed native French artists adapted the new elements to the strong Gothic traditions and created a distinctively French expression. An example of this maturing is the sculptor GERMAIN PILON

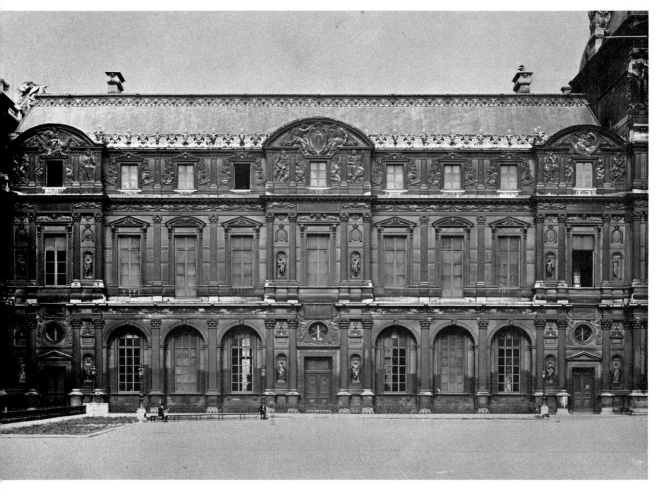

14-42 Pierre Lescot, Square Court of the Louvre, Paris, begun 1546.

(about 1535–90), who made his reputation in the carving of monumental tomb sculpture, especially that for the monument of Henry II and Catherine de' Medici in St. Denis, Paris. Like Goujon and other French sculptors, he had begun in the Fontainebleau style, emphasizing artifice in pose and gesture and graceful, sinuous contour. Gradually his style changed as he made contact with the still strong tradition of Late Gothic realism. A bronze relief of the Entombment (FIG. 14-44) recalls monumental compositions of Rogier van der Weyden and the master of the *Avignon Pietà*. Unlike them, Pilon shows in the great, elongated, muscular *Christ* the influence of Mannerism; but like them, he has a quiet, yet profound, pathos that Mannerism could not sincerely convey. The realistic element appears in the very staging of the drama: The Virgin, consoled by a holy woman, is removed from the center of the action; those in authority are at the head and feet of the Christ. There is a curiously steady, almost serene, reading of the emotions of those present. The curving lines of the draperies have lost the angularity of the Gothic but are not arranged in the contrived patterns of Mannerism. Pilon, from a fusion of the old tradition with the new fashion, has risen to a bold statement of his own, a statement making use of both while it transcends them in a moving, personal interpretation of the Medieval theme.

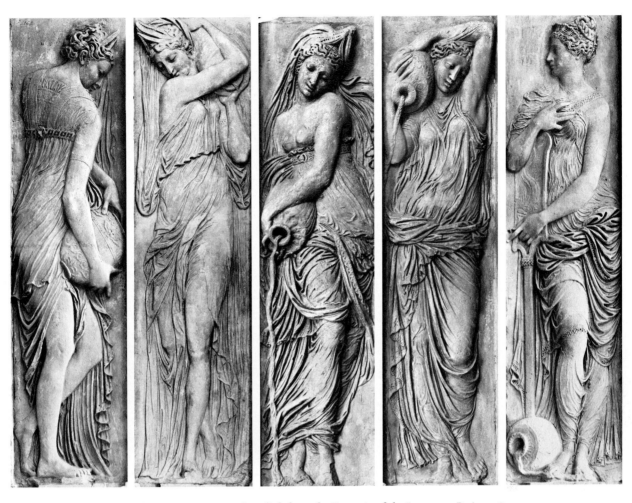

14-43 Jean Goujon, *Nymphs*, reliefs from the Fountain of the Innocents, Paris, 1548–49.

14-44 Germain Pilon,
Descent from the Cross,
1583, 19″ × 32½″.
Bronze relief. Louvre, Paris.

Chapter Fifteen

Baroque Art

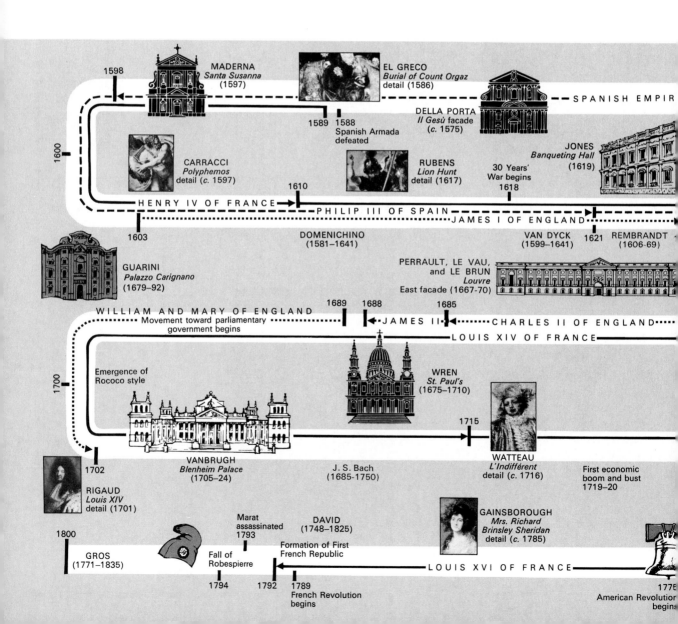

MADERNA
Santa Susanna
(1597)

1598

EL GRECO
Burial of Count Orgaz
detail (1586)

SPANISH EMPIR

1589 1588
Spanish Armada
defeated

DELLA PORTA
Il Gesù facade
(*c.* 1575)

JONES
Banqueting Hall
(1619)

1600

CARRACCI
Polyphemos
detail (*c.* 1597)

1610

RUBENS
Lion Hunt
detail (1617)

30 Years'
War begins
1618

HENRY IV OF FRANCE ➤ PHILIP III OF SPAIN
JAMES I OF ENGLAND

1603

DOMENICHINO
(1581–1641)

VAN DYCK
(1599–1641)

1621 REMBRANDT
(1606-69)

GUARINI
Palazzo Carignano
(1679–92)

PERRAULT, LE VAU,
and LE BRUN
Louvre
East facade (1667-70)

WILLIAM AND MARY OF ENGLAND 1689 1688 1685
Movement toward parliamentary
government begins

JAMES II ◄ CHARLES II OF ENGLAND

LOUIS XIV OF FRANCE

1700

Emergence of
Rococo style

WREN
St. Paul's
(1675–1710)

1715

1702

VANBRUGH
Blenheim Palace
(1705–24)

J. S. Bach
(1685-1750)

WATTEAU
L'Indifférent
detail (*c.* 1716)

First economic
boom and bust
1719–20

RIGAUD
Louis XIV
detail (1701)

Marat
assassinated
1793

DAVID
(1748–1825)

GAINSBOROUGH
*Mrs. Richard
Brinsley Sheridan*
detail (*c.* 1785)

1800

GROS
(1771–1835)

Fall of
Robespierre

Formation of First
French Republic

LOUIS XVI OF FRANCE

1794 1792 1789
French Revolution
begins

1775
American Revolution
begins

THE GENERAL PERIOD we have labeled Renaissance continues without any sharp stylistic break into the seventeenth and eighteenth centuries. The art of this later period we call Baroque, though there is no one Baroque style or set of stylistic principles. The origin of the word is not clear. It may come from the Portuguese word *barroco*, meaning an irregularly shaped pearl. Certainly the term was originally used in a disparaging sense, especially of post-Renaissance architecture, which nineteenth-century critics regarded as decadent classical—unstructural, overornamented, theatrical, and grotesque. But the use of "Baroque" as a pejorative has faded, and the term has long been current in art-historical vocabulary as a blanket designation for the art of the period covering roughly 1600 to 1750. Scholars gradually came to see that the Baroque styles were quite different from those of the Renaissance; the Baroque, for example,

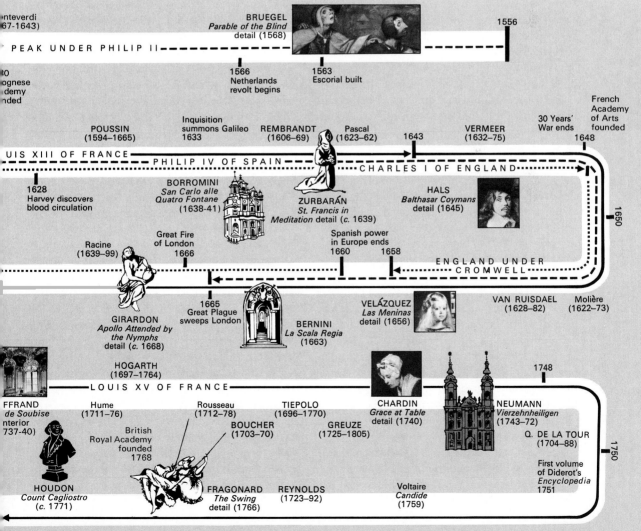

KEY: Spanish reigns ━ ━ ━ ━ French reigns ━━━━ English reigns •••••••••

looks dynamic, the Renaissance relatively static. This led to the claim that the two are fundamentally in opposition; there is still disagreement about the historical and formal relation of the two stylistic periods. The historical reality lies in the flow of stylistic change, and "Baroque" is a classification useful in isolating for examination the tendencies and products of stylistic change. Thus, traits that the styles of the seventeenth and eighteenth centuries seem to have in common we shall designate as Baroque.

Like the art it produced, the Baroque era was manifold—spacious and dynamic, brilliant and colorful, theatrical and passionate, sensual and ecstatic, opulent and extravagant, versatile and *virtuoso*. It was an age of expansion following upon an age of discovery, and its expansion led to yet further discovery. The rising national powers colonized the globe. Wars between Renaissance cities were supplanted by wars between continental empires, and the fate of Europe could be decided by battles fought in the North American wilderness and in India. Baroque expansiveness extended well beyond earth in the conceptions of the new astronomy and physics of Galileo, Kepler, and Newton. The same laws of mechanics were found to govern celestial bodies moving at great velocity and a falling apple. Man's optical range was expanding to embrace the macroscopic spaces of the celestial world and the microscopic spaces of the cellular. There is in the Baroque almost an obsession with the space of the unfolding universe. Descartes makes extension (space and what occupies it) the sole physical attribute of being; there exist only mind and extension, the former proving the reality of the latter—in Descartes's famous phrase, *Cogito, ergo sum* (I think, therefore I am). Pascal confesses in awe that "the silence of these infinite spaces frightens me." Milton expresses the Baroque image of space in a phrase—"the vast and boundless deep." Scarcely less fascinating to the Baroque mind is light. Light, for thousands of years thought of and worshiped as the godlike sun or the truth of the Holy Spirit, now becomes a physical entity that is propagated in waves (or corpuscles) through Pascal's "infinite spaces" and is capable of being refracted into color by a prism. Its religious meaning diminished, light yet remained a metaphor for truth. The age of the new science would be called the "Enlightenment," signifying that the old, dark, mythical way of reading the world had been given up and that the light of knowledge had brought a new day. Alexander Pope, expressing the enthusiasm of his day for the discoveries of Newton, made them out to be a kind of second revelation:

Nature, and Nature's laws lay hid in night.
God said: "Let Newton be!" and all was Light!

The throwing open of the two universes, the macroscopic and microscopic, to man's scrutiny did not distract him from his age-old curiosity about himself; since he was one with nature, the knowledge of himself must be part of the knowledge of nature. The Baroque is the age of the theater, when Shakespeare holds "the mirror up to nature" to present and analyze the spectrum of human actions and passions in all its degrees of lightness, darkness, and intensity. In this great era of the stage, tragedy and comedy are reborn. At the same time the resources of music greatly expand, creating the opera and refining the instruments of the modern orchestra. All the arts approve the things of the senses and the delights of sensuous experience. Though it is true that here and there the guilty fear of pleasure lingers from the times of Hieronymus Bosch, in all countries poetry and literature acquire a richly expressive language capable of rendering themes that involve the description, presentation, conflict, and resolution of human emotions. In the Catholic countries every device of art is used to stimulate pious emotions, sometimes, it might be thought, to the pitch of ecstasy. Luxurious display and unlimited magnificence and splendor frame the extravagant life of the courts, cost notwithstanding; the modes of dress are perhaps the most ornate and unfunctional ever designed. That is, even in externals a dramatic, sensuous elaborateness is the rule. However, what men wear and what they do must approach perfection, with the added flourish of seeming effortlessness. Not only courtiers, at one end of the Baroque society, and brigands and pirates at the other, but also the men who fashion the arts and the sciences are brilliant performers. They are virtuosi proud of their technique and capable of astonishing quantities of work.

15-1 GIACOMO DELLA PORTA, façade of Il Gesù, Rome, c. 1575–84. Interior by Giacomo da Vignola, 1568. (Engraving by Sandrart.)

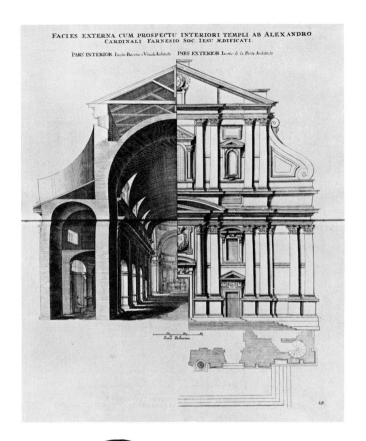

THE SEVENTEENTH CENTURY

Italy

The age of the Baroque has been identified with that of the Catholic reaction to the advance of Protestantism. Though it extends much more widely in time and place than seventeenth-century Italy, and though it is by no means only a manifestation of religious change, there can be little doubt that Baroque art had papal Rome as its birthplace. Between the pontificates of Paul III (Farnese) from 1534 to 1549 and of Sixtus V (Peretti) in the 1580's, the popes led a successful military, diplomatic, and theological campaign against Protestantism, wiping out many of its gains in central and southern Europe. Interrupted for a while, the building program begun under Paul III (with Michelangelo's Capitoline Hill design) was taken up again by Sixtus V, who had greatly augmented the papal treasury and whose intention it was to construct a new and more magnificent Rome, an "imperial city that had been subdued to Christ and purged of paganism." Sixtus was succeeded by a number of strong and ambitious popes—Paul V (Borghese), Urban VIII (Barberini), Innocent X (Pamphili), and Alexander VII (Chigi)—the patrons of Bernini and Borromini (see below) and the builders of the modern city, upon which they left their Baroque mark everywhere. The energy of the Counter Reformation, transformed into art, radiated throughout Catholic countries and even into Protestant lands, which found in their own art a response to it.

ARCHITECTURE AND SCULPTURE

The Jesuit order, newly founded (in 1534, in the pontificate of Paul III), needed an impressive building for its mother church. Because Michelangelo was dilatory in providing the plans, the church, called Il Gesù (Church of Jesus), was designed and built between 1568 and 1584 (FIG. 15-1) by GIACOMO DA VIGNOLA (1507–73), who designed

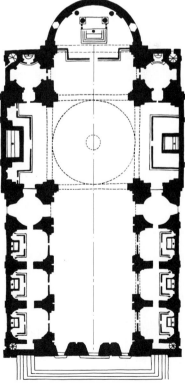

15-2 GIACOMO DA VIGNOLA, plan of Il Gesù.

FEET
0 25 50

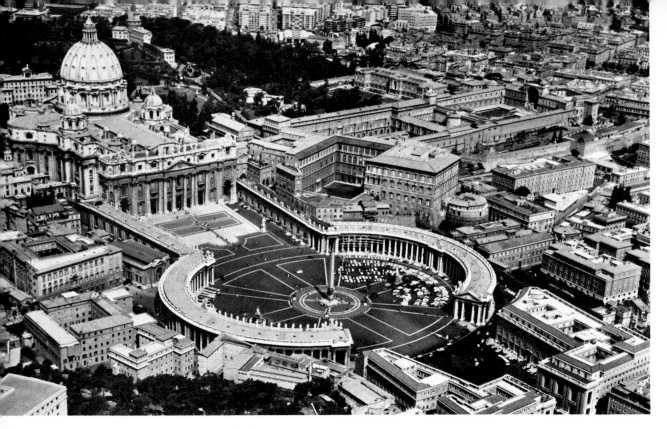

15-3 Aerial view of St. Peter's, Rome.

the ground plan, and GIACOMO DELLA PORTA (1537–1602), who is responsible for the façade. Its façade is important as the model for the façades of Roman Baroque churches for two centuries, and its basic scheme is echoed and reechoed through Catholic countries, especially in Latin America. It is not entirely original; the union of the lower and upper stories effected by scroll buttresses goes back to Alberti's Santa Maria Novella (FIG. 12-38), and its classical pediment is familiar in Alberti and Palladio; its paired pilasters appear in Michelangelo's design for St. Peter's. But the façade is a skillful synthesis of these already existing motifs; the two stories are well unified, the horizontal march of the pilasters and columns builds to a dramatic climax at the central bay, and the bays of the façade snugly fit the nave-chapel system behind them. The many dramatic Baroque façades of Rome will be architectural variation upon this basic theme. The plan (FIG. 15-2) is a monumental expansion of Alberti's scheme for Sant' Andrea in Mantua (FIG. 12-41), the nave taking over the main volume

15-4 CARLO MADERNA, Santa Susanna, Rome, 1597–1603.

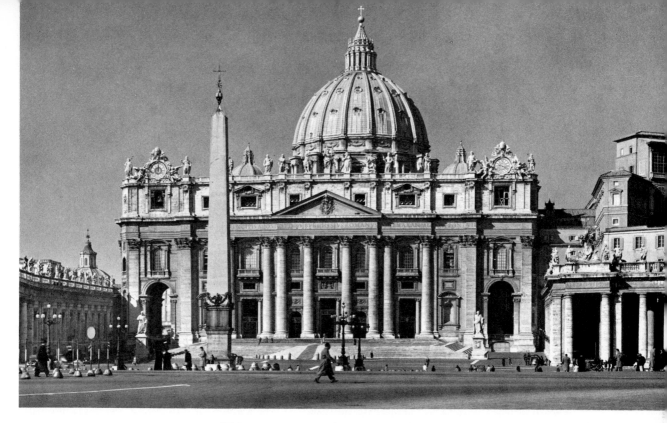

15-5 CARLO MADERNA, façade of St. Peter's, 1606–12.

of space, so that the structure becomes a great hall with side chapels, the approach to the altar emphasized by a dome. The wide acceptance of the Gesù plan in the Catholic world, even until modern times, seems to attest that it is ritually satisfactory. The opening of the church building into a single great hall provides an almost theatrical setting for large promenades and processions that would seem to combine social with sacerdotal functions.

The great Baroque project in Rome was the completion of St. Peter's (FIG. 15-3). Bramante's and Michelangelo's central plan was unsatisfactory to the clergy of the seventeenth century, who thought it smacked of paganism and who felt is was inconvenient for the ever growing assemblies. Under Paul V, CARLO MADERNA (1556–1629) was commissioned to add three bays of a nave to the earlier nucleus and to provide the building with a façade. Before he received the St. Peter's commission, Maderna had designed the façade of Santa Susanna (FIG. 15-4), concentrating and dramatizing in it the major features of the

façade of Il Gesù. Strong shadows cast by the vigorously projecting columns and pilasters of Santa Susanna mount dramatically toward the emphatically stressed central axis, the sculptural effect being enhanced by the recessed niches, which contain statues.

The façade of St. Peter's (FIG. 15-5) is a gigantic expansion of the elements of Santa Susanna's first level. But Maderna overextended his theme, and the compactness of Santa Susanna's façade is lost. The elements are spread too wide, and the quickening rhythm of pilasters and columns from the sides toward the center has become slack. The role of the central pediment has been reduced to insignificance by the façade's excessive width. In fairness to Maderna, it must be pointed out that his design for the façade was never completely executed. The two outside bays are the first stages of two flanking towers, which were never built and whose vertical accents might well have visually compressed the central part of the façade. As it stands, this unfinished, watered-down frontispiece is almost universally criticized by artists

15-6 Plan of St. Peter's, with adjoining piazza.

FEET
0 150 300
▒ Roofed area

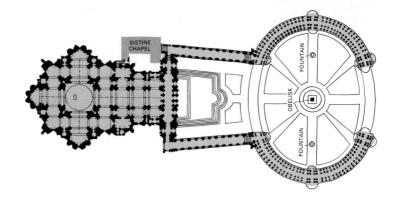

and historians and has, unfortunately, become the dominant feature of the church's exterior. Lengthening the nave moved the façade outward and away from the dome, and the effect that Michelangelo had planned, namely that of a structure pulled together and dominated by its dome, is seriously impeded. Viewed at close range, the dome hardly emerges above the soaring cliff of the façade, and seen from farther back it appears to have no drum; one must go back beyond the piazza in order to see the dome and drum together and to experience the effect Michelangelo intended. Today, to see the structure as it was originally intended one must view it from the back (FIG. 13-30).

The design of St. Peter's, evolving since the days of Bramante and Michelangelo and engaging all the leading architects of the Renaissance and Baroque, was completed (except for details) by GIANLORENZO BERNINI (1598–1680). Bernini was architect, painter, and sculptor, one of the most brilliant and imaginative artists of the Baroque era, and, if not the originator of the Baroque, probably its most characteristic and sustaining spirit. His largest and most impressive single project was the design for a monumental piazza in front of St. Peter's (FIGS. 15-3 and 15-6). Like Michelangelo in the case of the Capitoline Hill, Bernini had to adjust his design to some preexisting structures on the site: an ancient obelisk brought from Egypt and a fountain designed by Maderna. He used these features to define the long axis of a vast oval embraced by colonnades that are joined to the façade of St. Peter's by two diverging wings. Four files of huge Tuscan columns make up the two colonnades, which terminate in severely classical temple fronts. The dramatic gesture of embrace made by the colonnades

symbolizes the welcome given its communicants by the Roman Catholic Church. Thus, the compact, central designs of Bramante and Michelangelo are expanded by a Baroque transformation into a dynamic complex of axially ordered elements that reach out and enclose spaces of vast dimension. Where the Renaissance building stood in self-sufficient isolation, the Baroque design expansively relates it to its environment.

The wings that connect St. Peter's façade with the oval piazza flank a trapezoidal space also reminiscent of the Capitoline Hill. But here the latter's visual effect is reversed; as seen from the piazza, the diverging wings counteract the natural perspective and tend to bring the façade closer to the observer. Emphasizing the façade's height in this manner, Bernini subtly and effectively compensated for its excessive width.

The Baroque delight in illusionistic devices is expressed again in the Scala Regia (FIGS. 15-7 and 15-8), a monumental stairway leading to the papal apartments in the Vatican. Here, Bernini has the ascending corridor narrow toward the top, the slight convergence of the walls emphasizing the perspective effect and making the already long staircase appear even longer. Then, to draw the visitor upward through the long tunnel, Bernini employs a highly refined psychological device that was to enjoy considerable popularity in Baroque design: Playing upon the natural human inclination to move from darkness toward light, he placed a bright light-source at the top of the stairs. To make the long ascent more tolerable, he provided an intermediate goal in the form of an illuminated landing that promises a midway resting point. The result is a highly sophisticated design, both dynamic and dramatic, which repeats on a smaller scale, but perhaps

Color Plates 13-6 to 16-5

Other plates are distributed as follows:
1-1 to 6-4, after page 176; 6-5 to 13-5, after page 364; 16-6 to 22-5, after page 772

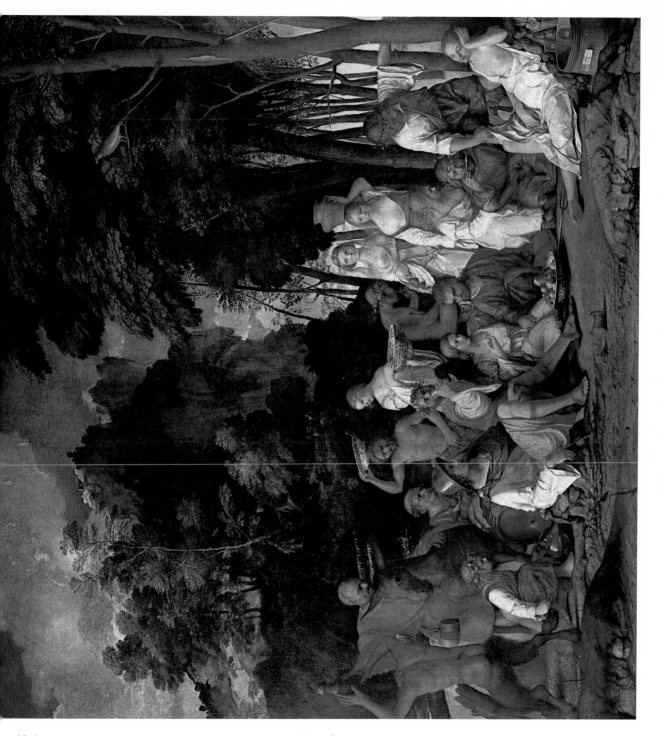

te 13-6 GIOVANNI BELLINI, *The Feast of the Gods*, 1514. Approx. 67″ × 74″. National Gallery of Art, Washington, D.C. (Widener Collection).

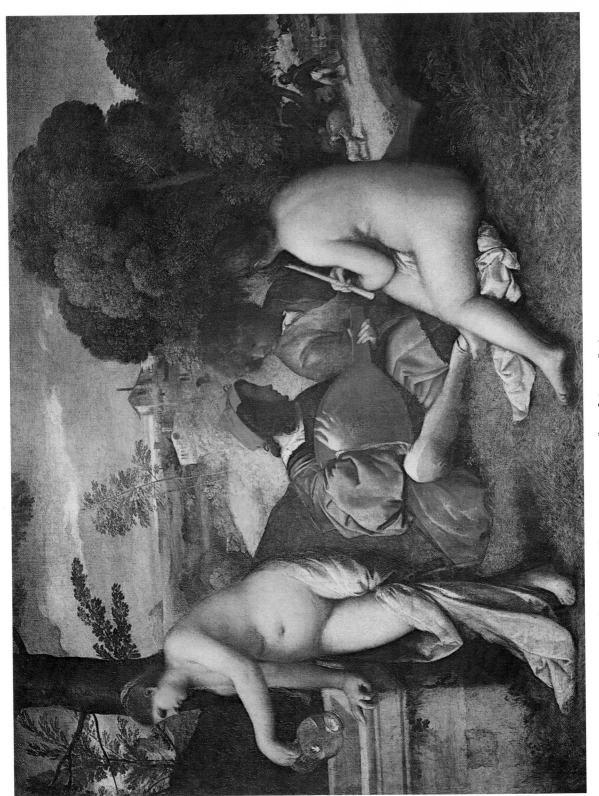

Plate 13-7 GIORGIONE, *Pastoral Symphony*, c. 1508. Oil on canvas, approx. 43″ × 54″. Louvre, Paris.

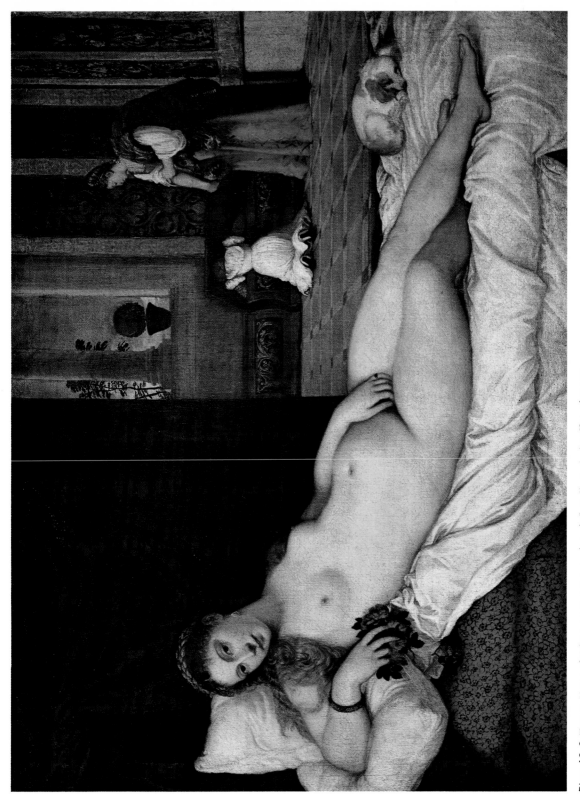

Plate 13-8 TITIAN, *Venus of Urbino*, 1538. Approx. 4' × 5' 6". Galleria degli Uffizi, Florence.

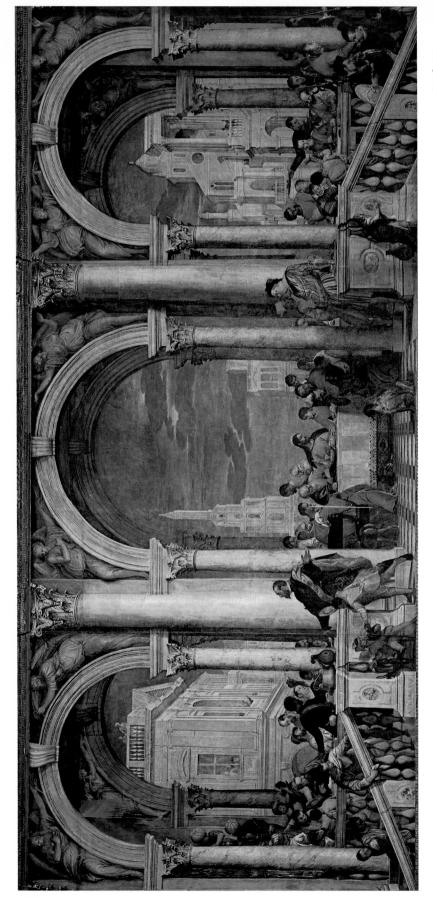

Plate 13-9 Veronese, *Christ in the House of Levi*, 1573. Oil on canvas, approx. 18′ 6″ × 42′ 6″. Galleria dell' Accademia, Venice.

Plate 14-1 Jean Pucelle, page from the *Belleville Breviary*, illuminated manuscript, *c.* 1325. Approx. $9\frac{1}{2}″ × 6\frac{3}{4}″$. Bibliothèque Nationale, Paris.

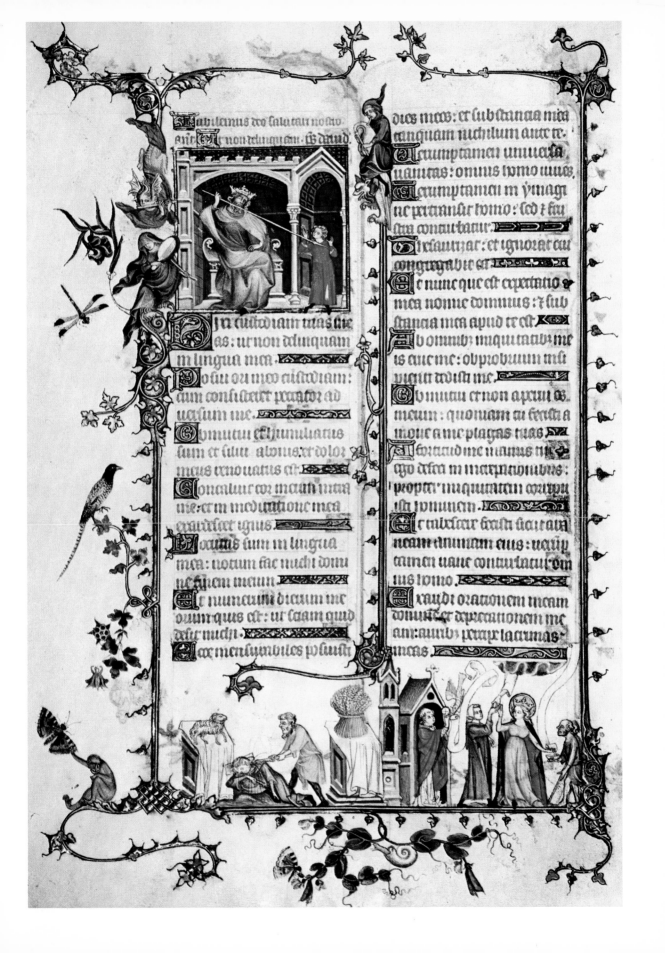

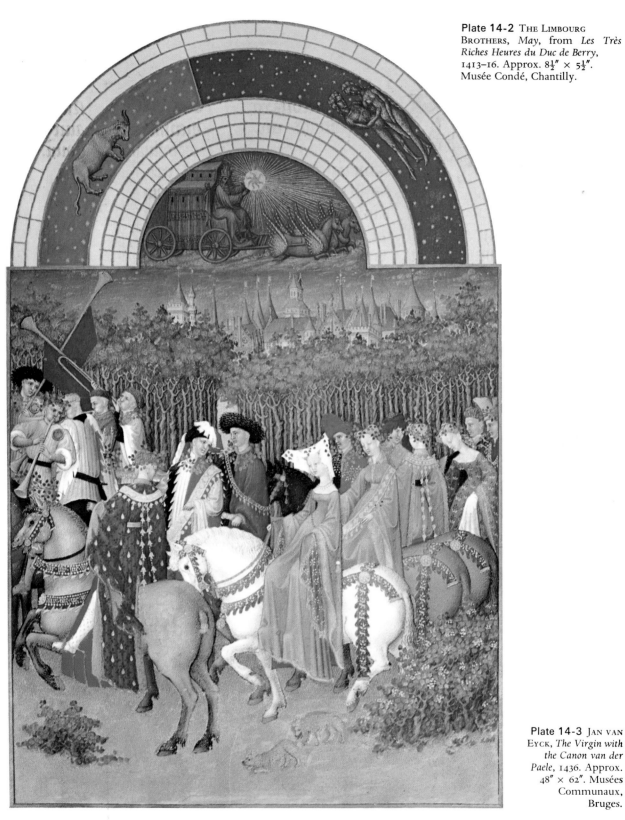

Plate **14-2** THE LIMBOURG BROTHERS, *May,* from *Les Très Riches Heures du Duc de Berry,* 1413–16. Approx. 8½″ × 5½″. Musée Condé, Chantilly.

Plate **14-3** JAN VAN EYCK, *The Virgin with the Canon van der Paele,* 1436. Approx. 48″ × 62″. Musées Communaux, Bruges.

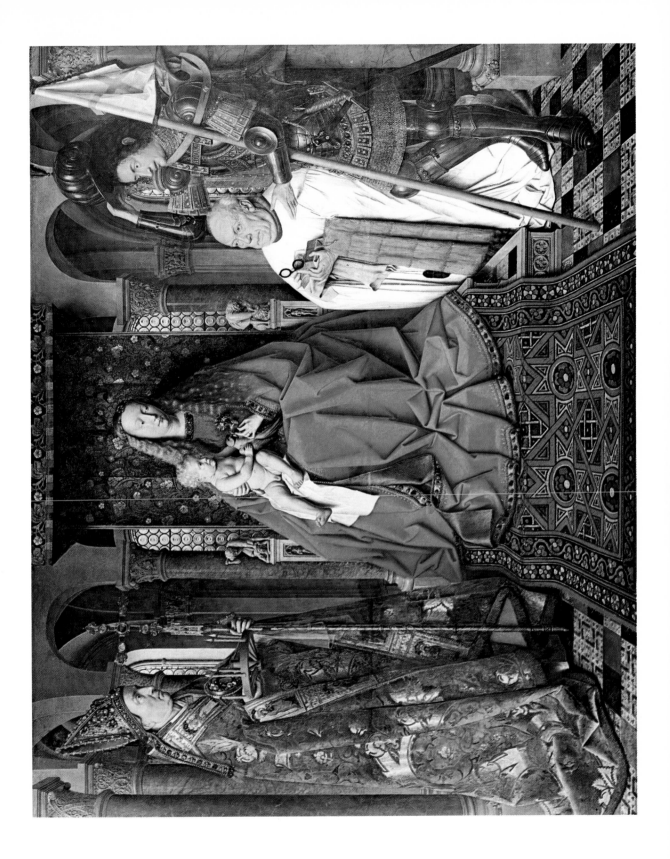

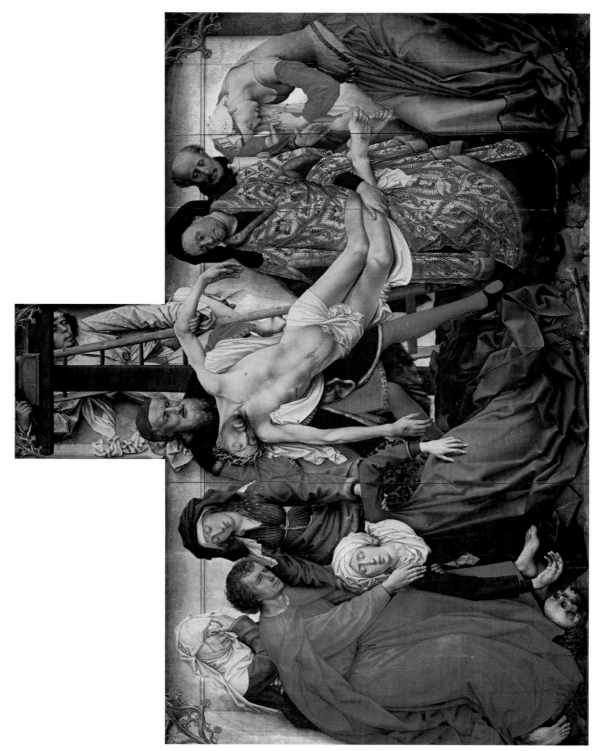

Plate 14-4 ROGIER VAN DER WEYDEN, *The Escorial Deposition, c.* 1435. Tempera on wood panel, approx. 7′ 3″ × 8′ 7″. Museo del Prado, Madrid.

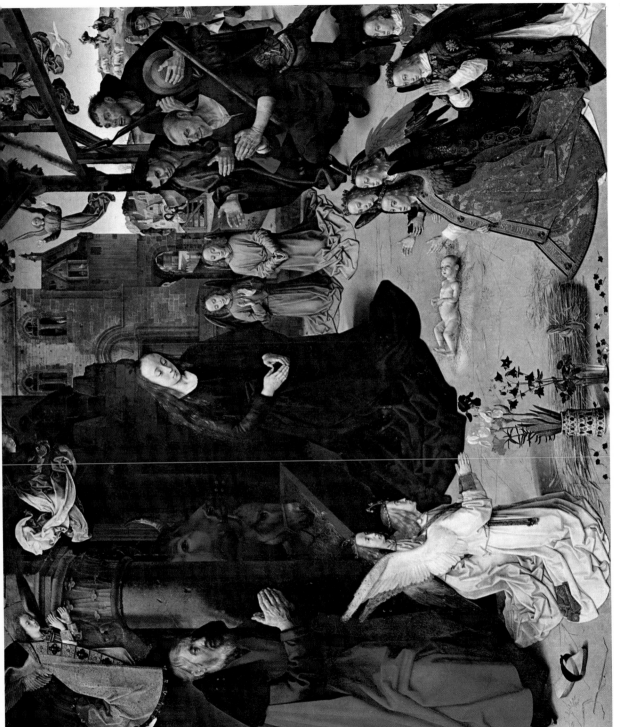

Plate 14-5 HUGO VAN DER GOES, *The Adoration of the Shepherds*, center panel of the *Portinari Altarpiece* (FIG. 14-14), c. 1476, Oil on wood panel, approx. 8′ 3″ × 10′. Galleria degli Uffizi, Florence.

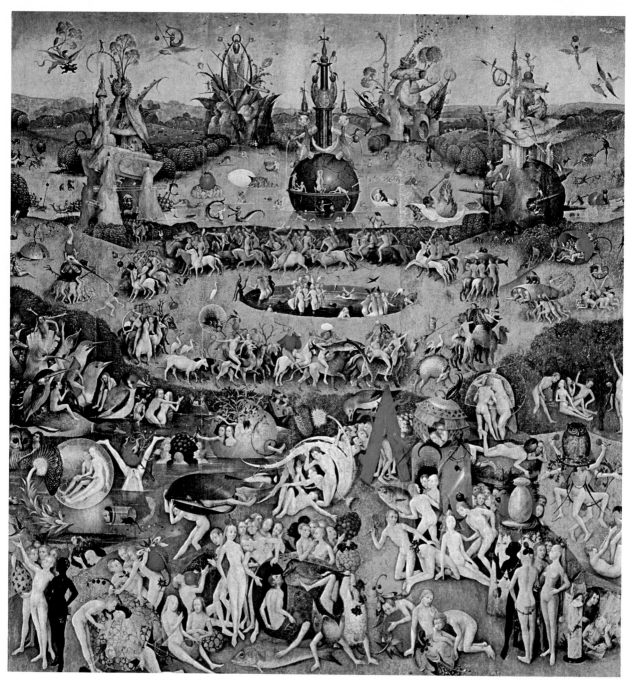

Plate 14-6 HIERONYMUS BOSCH, center panel of *The Garden of Earthly Delights, c.* 1500. Approx. 86″ × 77″. Museo del Prado, Madrid.

Plate 14-7 ANONYMOUS MASTER, *The Avignon Pietà, c.* 1455. Tempera on wood panel, approx. 64″ × 86″. Louvre, Paris.

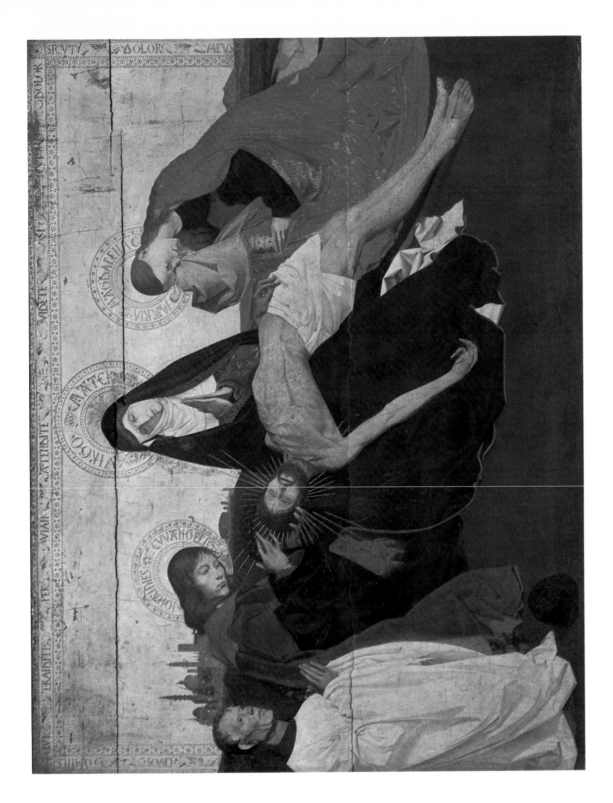

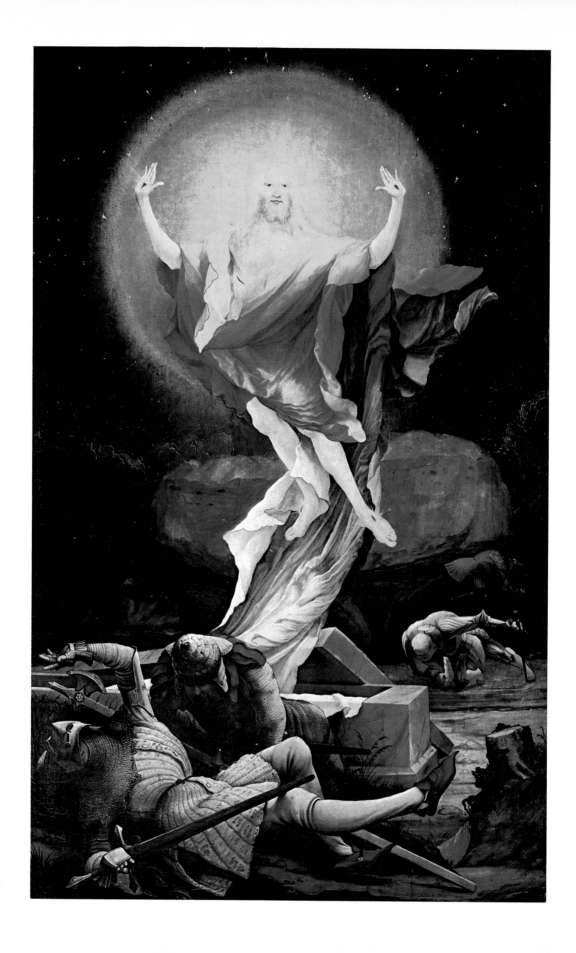

Plate 14-8 MATTHIAS GRÜNEWALD, *Resurrection*, detail of the right panel of the *Isenheim Altarpiece* (open), *c.* 1510–15. Approx. 8′ 10″ × 4′ 8″. Musée Unterlinden, Colmar.

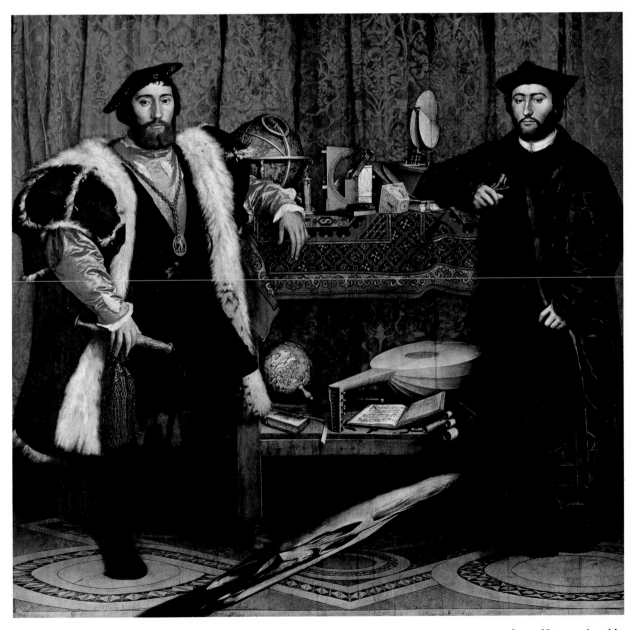

Plate 14-9 HANS HOLBEIN the Younger, *The French Ambassadors*, 1533. Oil and tempera on wood, approx. 80″ × 81½″. Reproduced by courtesy of the Trustees of the National Gallery, London.

Plate 14-10 Pieter Bruegel the Elder, *The Peasant Dance, c.* 1567. Approx. 45″ × 65″. Kunsthistorisches Museum, Vienna.

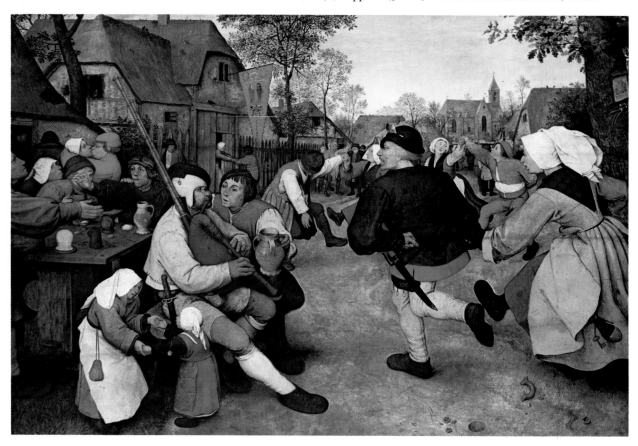

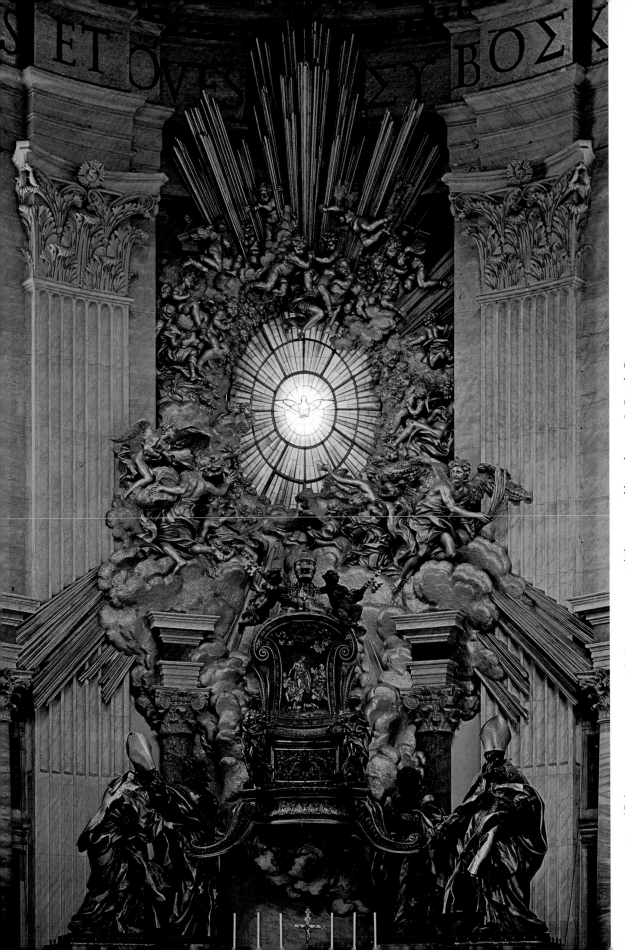

Plate 15-1 GIANLORENZO BERNINI, *Cathedra Petri*, 1656–66. Gilt bronze, marble, and stucco. St. Peter's, Rome.

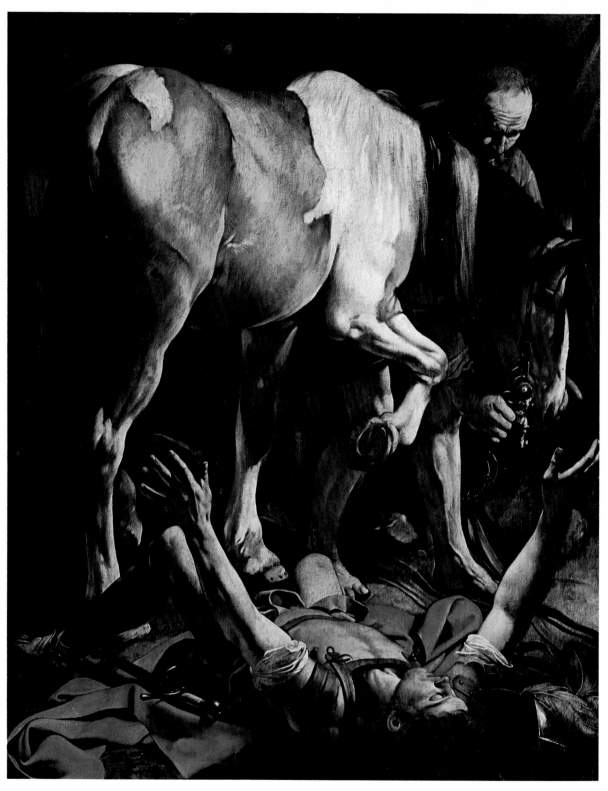

Plate 15-2 CARAVAGGIO, *The Conversion of St. Paul, c.* 1601. Oil on canvas, approx. 90″ × 69″. Santa Maria del Popolo, Rome.

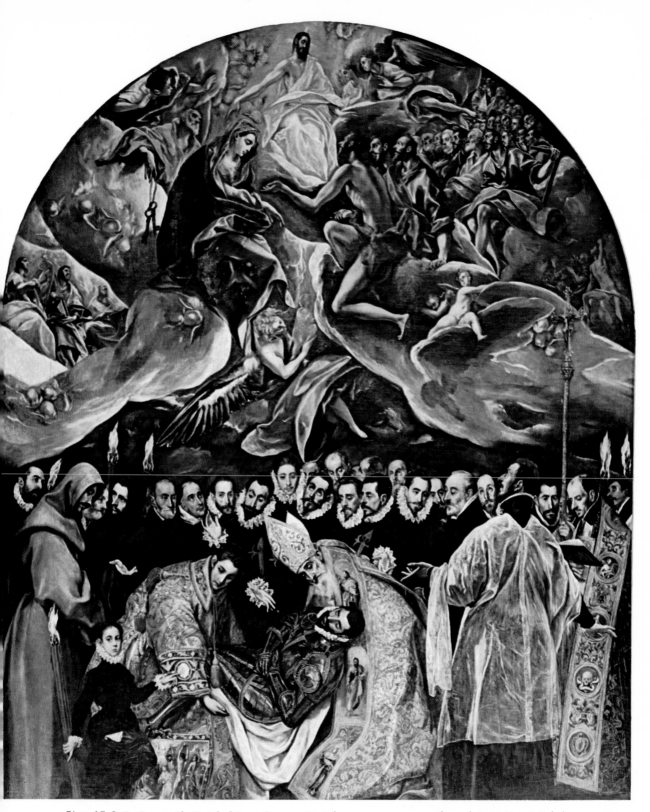

Plate 15-3 EL GRECO, *The Burial of Count Orgaz*, 1586. Oil on canvas, approx. 16′ × 12′. Santo Tomé, Toledo.

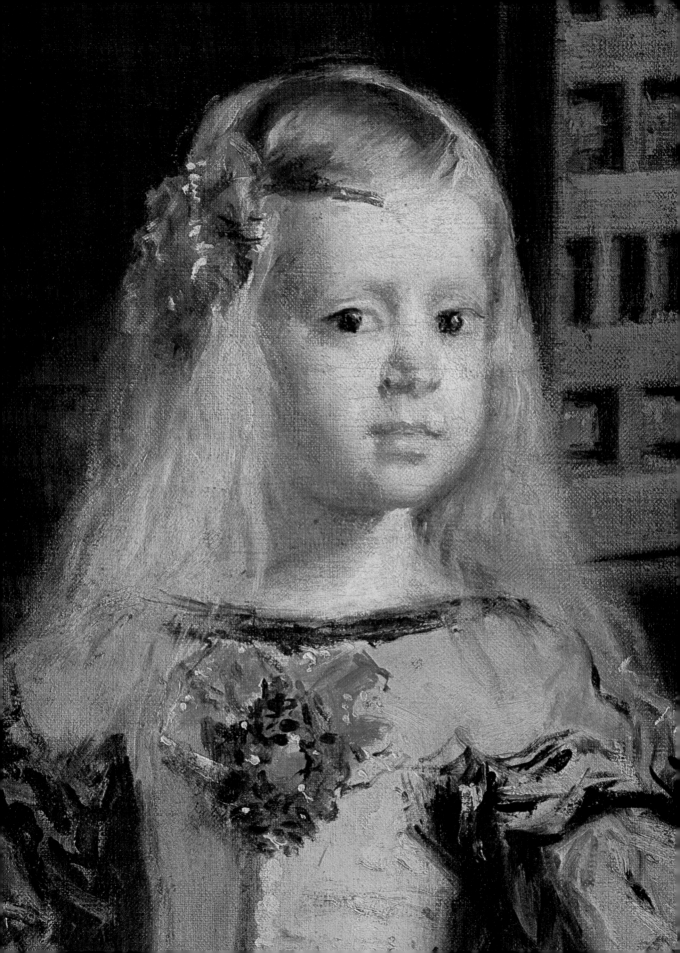

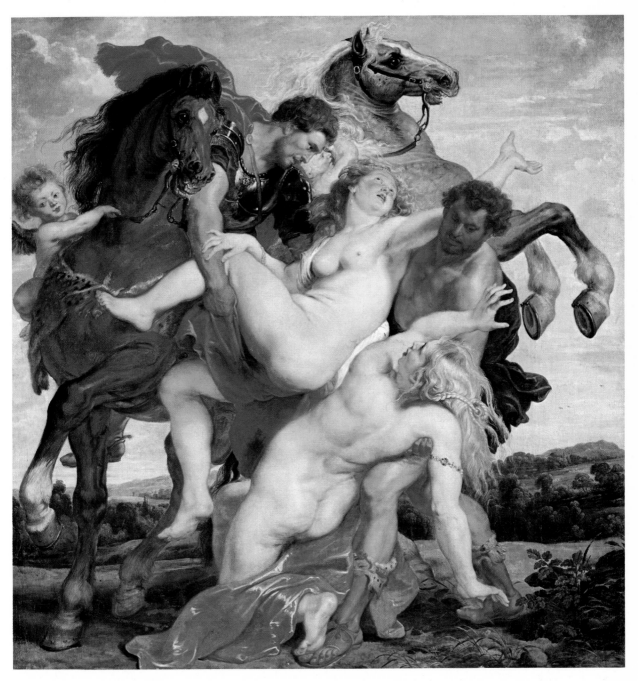

Plate 15-5 PETER PAUL RUBENS, *The Rape of the Daughters of Leucippus*, 1617. Oil on canvas, approx. 7′ 3″ × 6′ 10″. Alte Pinakothek, Munich.

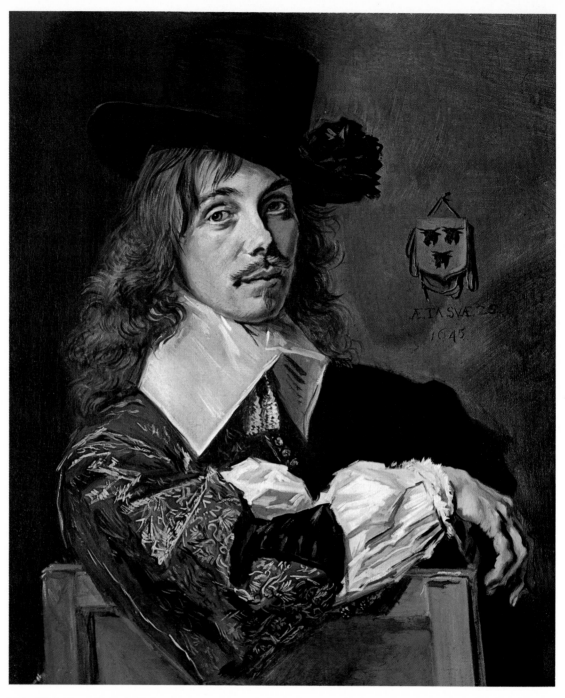

Plate 15-6 FRANS HALS, *Balthasar Coymans*, 1645. Approx. 30¼″ × 25″. National Gallery of Art, Washington, D.C. (Andrew Mellon Collection).

Plate 15-7 REMBRANDT VAN RIJN, *Syndics of the Cloth Guild*, 1662. Approx. 6′ 2″ × 9′ 2″. Rijksmuseum, Amsterdam.

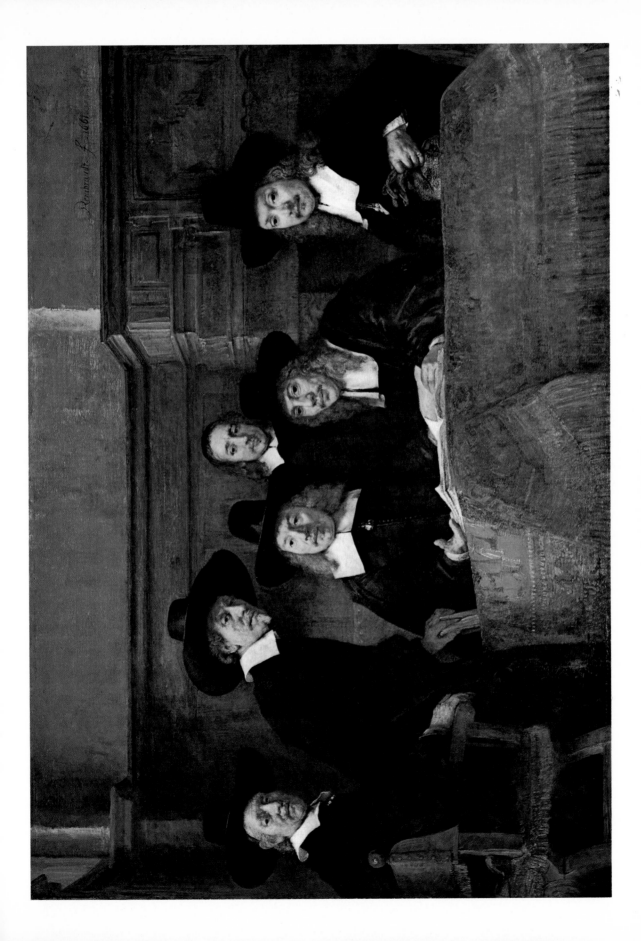

Plate 15-8 JAN VERMEER, detail of *Young Woman with a Water Jug* (FIG. 15-43), 1665. Oil on canvas. Metropolitan Museum of Art, New York.

Plate 15-9 WILLEM KALF, *Still Life*, 1659. Approx. 20″ × 17″. Royal Picture Gallery (Mauritshuis), the Hague.

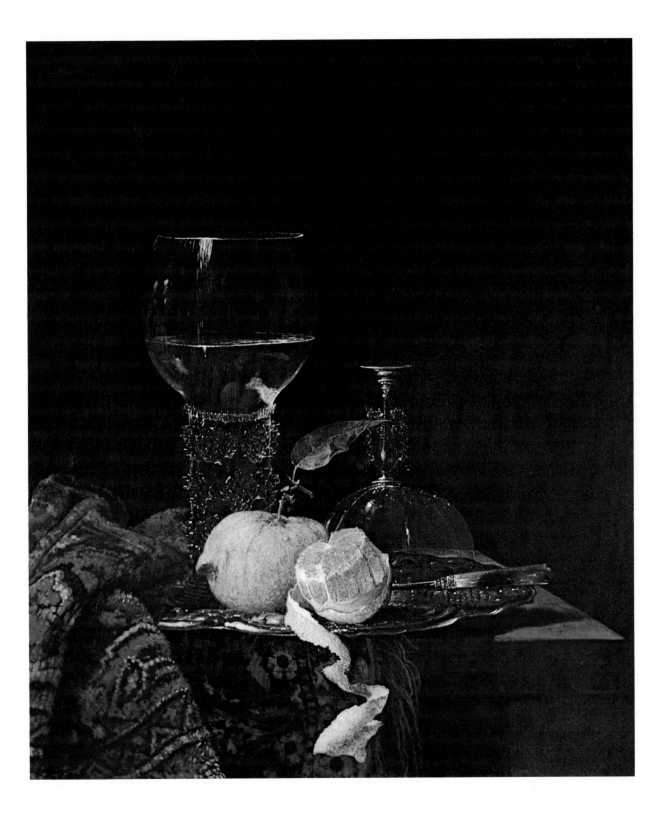

Plate 15-10 Jacob van Ruisdael, *View of Haarlem from the Dunes at Overveen, c. 1670.* Approx. 22″ × 25″. Royal Picture Gallery (Mauritshuis), the Hague.

Plate 15-11 Antoine Watteau, *Embarkation for Cythera, 1717–19.* Oil on canvas, approx. 51″ × 76″. Louvre, Paris.

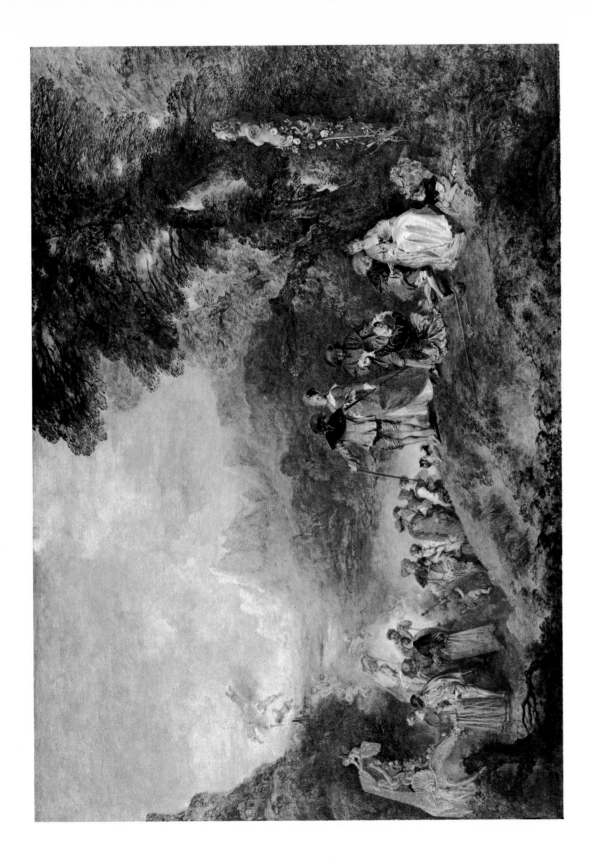

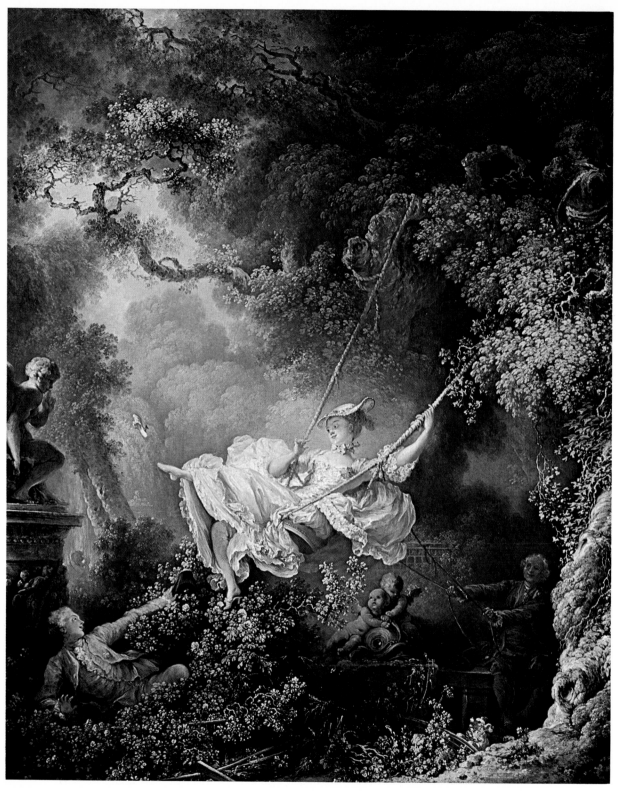

Plate 15-12 JEAN-HONORÉ FRAGONARD, *The Swing*, 1766. Oil on canvas, approx. 32″ × 35″. Reproduced by permission of the Trustees of the Wallace Collection, London.

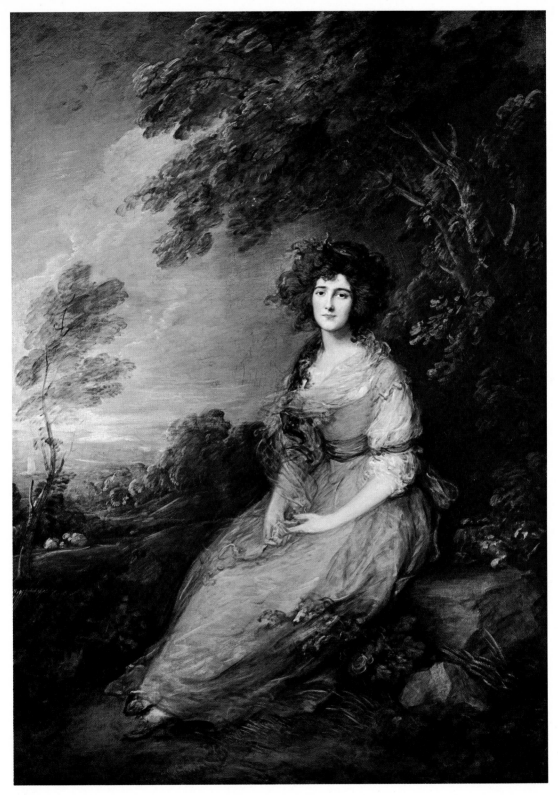

Plate 15-13 THOMAS GAINSBOROUGH, *Mrs. Richard Brinsley Sheridan, c.* 1785. Oil on canvas, approx. 60″ × 86″. National Gallery of Art, Washington, D.C. (Andrew Mellon Collection).

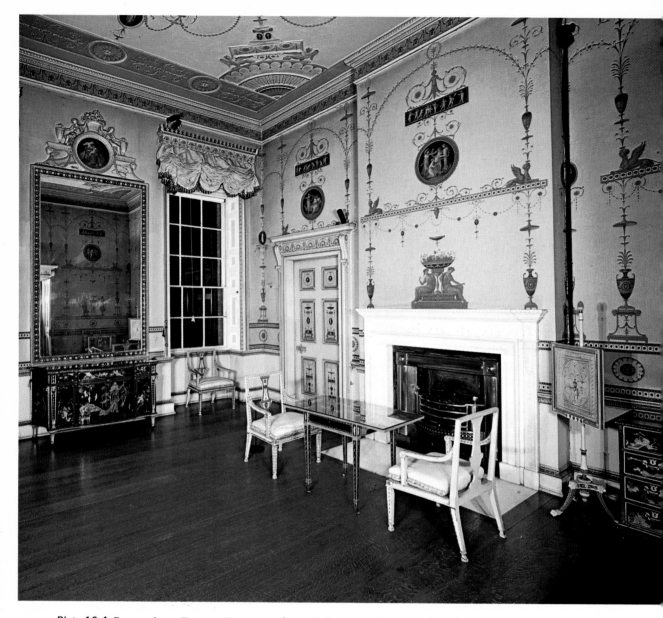

Plate 16-1 ROBERT ADAM, Etruscan Room, Osterley Park House, Middlesex, England, begun 1761.

Plate 16-2 FRANCISCO GOYA, *The Third of May, 1808*, 1814. Oil on canvas, approx. 8′ 8″ × 11′ 3″.
Museo del Prado, Madrid.

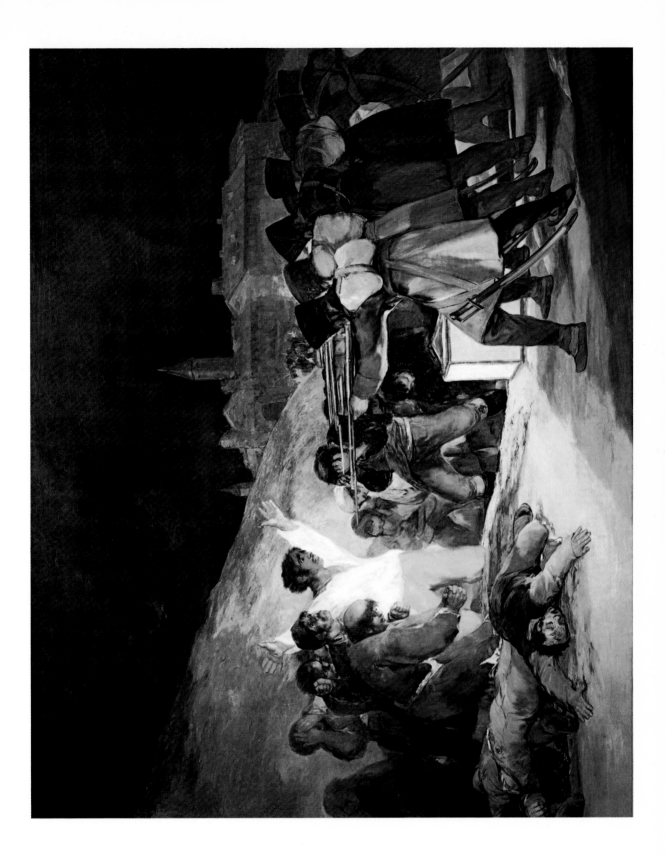

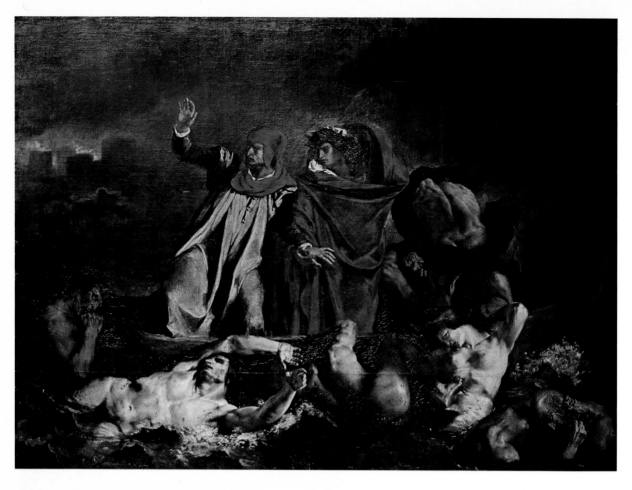

Plate 16-3 EUGÈNE DELACROIX, *The Bark of Dante*, 1822. Oil on canvas, 74″ × 97″. Louvre, Paris. Left: Detail of magnified water drops on a nude, from *The Bark of Dante*.

Plate 16-4 JOSEPH MALLORD WILLIAM TURNER, *The Fighting Téméraire*, 1838–39. Oil on canvas, approx. $35\frac{3}{4}″ × 48″$. Reproduced by courtesy of the Trustees of the National Gallery, London.

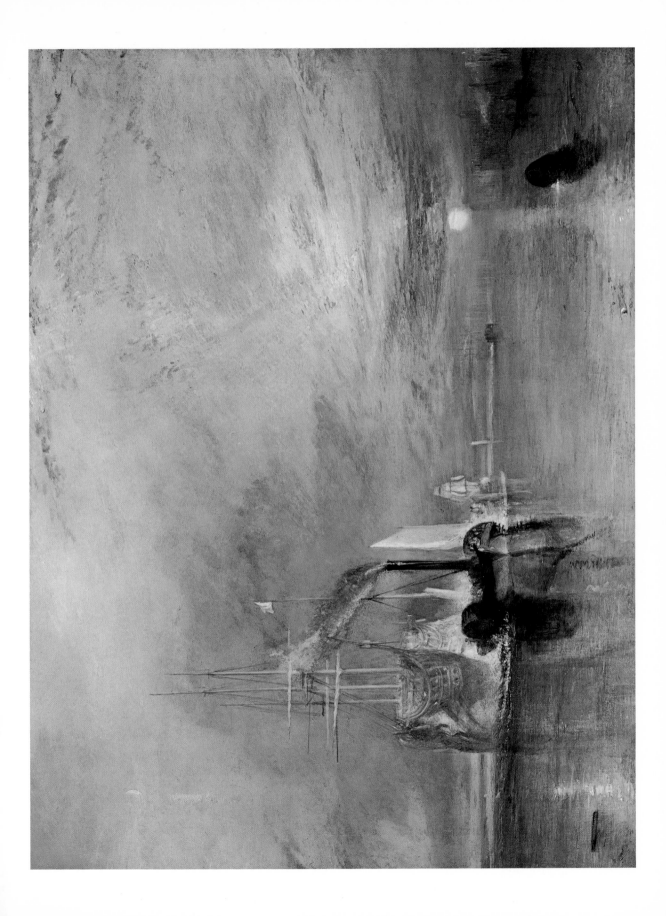

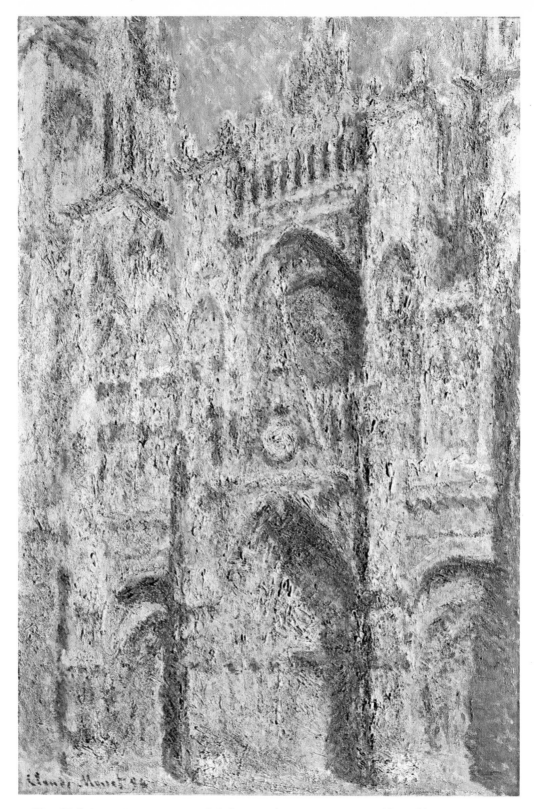

Plate 16-5 Claude Monet, *Rouen Cathedral*, 1894. Oil on canvas, approx. $39\frac{1}{4}'' \times 25\frac{7}{8}''$. Metropolitan Museum of Art, New York (Theodore M. Davis Collection, bequest of Theodore M. Davis, 1915).

even more effectively, the processional sequence found inside St. Peter's.

Long before the planning of the piazza and the completion of the Scala Regia, Bernini had been at work decorating the interior of St. Peter's. His first commission called for the design and erection of the gigantic bronze *baldacchino* above the main altar under the cathedral's dome (FIG. 15-9). Almost 100 feet high (the height of an average eight-story building), this canopy is in harmony with the tremendous proportions of the new church and is a focus of its splendor. Its four spiral columns, partially fluted and wreathed with vines, seem to deny the mass and weight of the tons of bronze resting upon them. At the same time they communicate their Baroque energy to the four colossal angels standing guard at the upper corners and to the four serpentine brackets that elevate the orb and the cross, symbols of the triumph of the Church.

Indeed it is this theme of triumph that dictates the architectural as well as sculptural symbolism both inside and outside St. Peter's. Suggesting a great and solemn procession, the main axis of the complex traverses the piazza, slowed by the central obelisk, and enters Maderna's nave. It comes to a temporary halt at the altar beneath the *baldacchino*; but it continues on toward its climactic destination at another great altar in the apse, the *Cathedra Petri* (PLATE 15-1), also the

15-7 GIANLORENZO BERNINI, Scala Regia, the Vatican, Rome, 1663–66.

15-8 Plan and section of the Scala Regia. (Engraving by Carlo Fontana.)

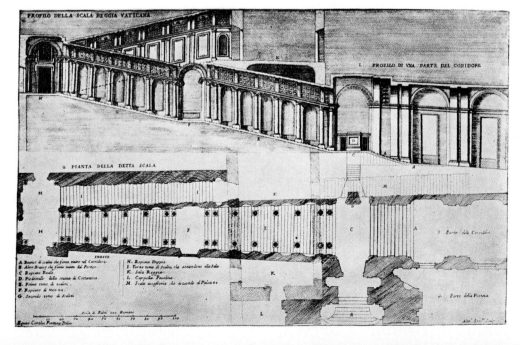

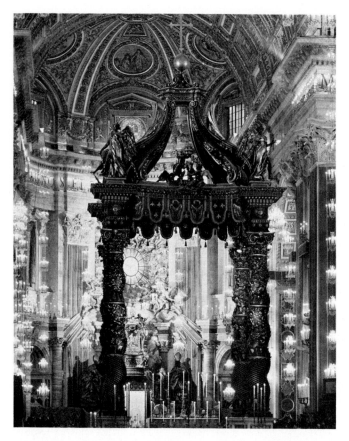

15-9 GIANLORENZO BERNINI, *baldacchino* for St. Peter's, 1624–33.

work of Bernini. In this explosively dramatic composition, the Chair of St. Peter is exalted in a burst of light in which appears the dove of the Holy Ghost amidst flights of angels and billowing clouds. Four colossal figures in gilt bronze seem to support the chair miraculously, for they scarcely touch it. The two in the foreground represent two fathers of the Latin Church— Saints Ambrose and Augustine. Behind them, and less conspicuously, stand Saints Athanasius and Chrysostom, representing the Greek Church; the grouping of the figures constitutes an appeal for unity within Christianity, while at the same time suggesting the subservience of the Eastern Church to the Western. The *Cathedra Petri* represents the quintessence of Baroque composition. Its forms are generated and grouped not by clear lines of structure but by forces unfolding from a center of violent energy.

Everything moves, nothing is distinct, light dissolves firmness, and the effect is visionary. The vision asserts the triumph of Christianity and the papal claim to doctrinal supremacy.

Much of Bernini's prolific career was given to the adornment of St. Peter's, where his works combine sculpture with architecture. Although Bernini was a great and influential architect, his fame rests primarily upon his sculpture, which, like his architecture, expresses the Baroque spirit to perfection. It is expansive and dramatic, and the element of time usually plays an important role in it. Unlike the states of rest or tension that one finds in the *Davids* of Donatello (FIG. 12-13), Verrocchio (FIG. 12-49), and Michelangelo (FIG. 13-18), Bernini's version (FIG. 15-10) aims at catching the split-second action. His muscular legs widely and firmly planted, David is beginning the violent, pivoting motion that will launch the stone from his sling. A moment before his body was in one position, the next moment it will be in a completely different one. Bernini selects the most dramatic of an implied sequence of poses, so that the observer has to think simultaneously of the continuum and of this tiny fraction of it. The implied continuum imparts a dynamic quality to the statue that suggests a bursting forth of the energy one sees pent in Michelangelo's figures. And as the figure seems to be moving through time, so does it through space. This is not the kind of statue that can be inscribed in a cylinder or confined to a niche; its implied action demands space around it. Nor is it self-sufficient in the Renaissance sense, as its pose and attitude direct the observer's attention beyond itself and to its surroundings, in this case toward an unseen Goliath. For the first time since the Hellenistic era, a sculptured figure moves out into and partakes of the physical space that surrounds it and the observer.

The expansive quality of Baroque art and its disdain to limit itself to firmly defined spatial settings are encountered again in the *Ecstasy of St. Theresa* in the Cornaro Chapel of the church of Santa Maria della Vittoria (FIG. 15-11). In this chapel Bernini draws upon the full resources of architecture, sculpture, and painting to charge the entire area with crosscurrents of dramatic tension. St. Theresa was a nun of the Carmelite

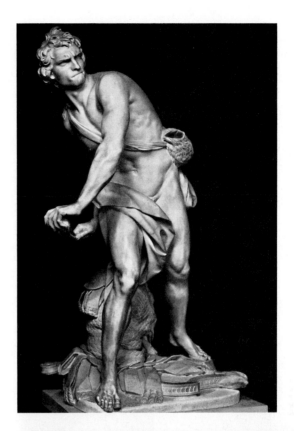

15-10 Gianlorenzo Bernini, *David*, 1623. Marble, life-size. Galleria Borghese, Rome.

order and one of the great mystical saints of the Spanish Counter Reformation. Her conversion took place after the death of her father, when she fell into a series of trances, saw visions, and heard voices. Feeling a persistent pain in her side, she came to believe that its cause was the fire-tipped dart of Divine love, which an angel had thrust into her bosom and which she described as making her swoon in delightful anguish. The whole chapel becomes a theater for the production of this mystical drama. The niche in which it takes place is a proscenium crowned with a broken Baroque pediment and ornamented with polychrome marble. On either side of the chapel are sculptured opera boxes in which portraits of the Cornaro family represent an audience watching with intent piety the denouement of the heavenly drama. Bernini shows the saint in ecstasy, unmistakably a mingling of spiritual and physical passion, swooning back upon clouds, while the smiling angel aims his arrow (FIG. 15-12). The group is of white marble, and the artist goes to extremes of virtuosity in his management of textures: the clouds, rough monk's cloth, gauzy material, smooth flesh, feathery wings—all carefully differentiated and yet harmonized in an effect visual and visionary. Light from a hidden window pours down bronze rays that are meant to be seen as bursting forth from a painting of Heaven in the vault. Several tons of marble seem to float in a haze of light, the winds of heaven buoying draperies as the cloud ascends. The remote mysteries of religion, taking on recognizable form, descend to meet the world of man half-way, within the conventions of Baroque art and theater. Bernini had much to do with the establishment of the principles of visual illusion that guided both.

The evident desire of the time to instill designs with dynamic qualities finds expressive release in the design of monumental fountains. The challenge of working with an element that actually *is* in motion fascinated Baroque artists, and it may not be too surprising to find that Bernini was one of the most inventive and most widely imitated designers in this field. It is

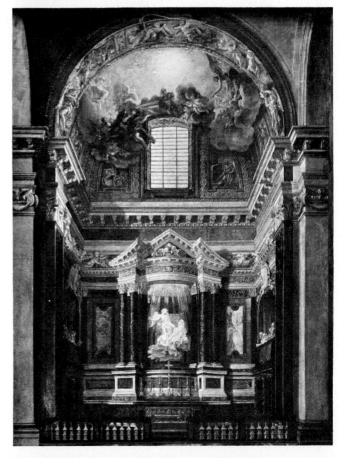

15-11 Gianlorenzo Bernini, interior of the Cornaro Chapel, 1645–52. Santa Maria della Vittoria, Rome. Eighteenth-century painting, Staatliches Museum, Schwerin.

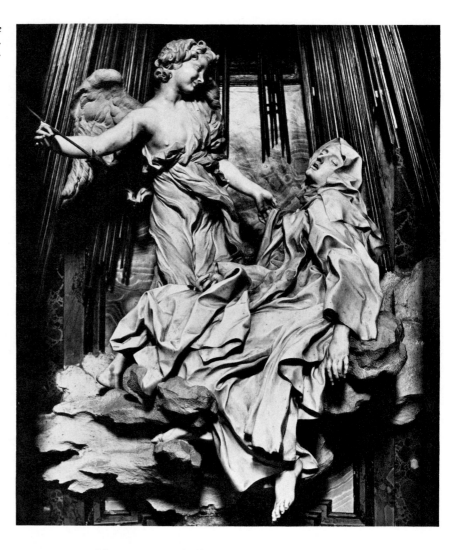

15-12 GIANLORENZO BERNINI, *The Ecstasy of St. Theresa*, 1645–52. Marble, life-size, Cornaro Chapel.

largely his doing that Rome is a city of fountains. One of his most charming inventions is the Triton Fountain (opening illustration, Part Three), in which Bernini shows the male counterpart of the mermaid seated on a shell supported by dolphins and blowing a jet of water toward the sky. The jet falls back into the shell, from whose corrugated edges the water dribbles in thin rivulets into the collecting basin below. The maritime group, risen from the depths of the ocean, is enveloped in rising and falling sprays of water. Sunlight reflected from the constantly agitated surface of the collecting pool around the base of the monument ripples across the stone surfaces of the sculptured group in ever changing patterns that make the triton seem alive, his bellowslike chest heaving with the effort of blowing into his

shell. For centuries he has performed his task for Urban VIII, the Barberini Pope whose emblems (the bees) decorate the fountain's base.

It seems curious that Bernini, whose sculpture expresses the very essence of the Baroque spirit, should remain relatively conservative in his architecture. Frequently planning on a vast scale and employing striking illusionistic devices, Bernini always used the classical orders in a sober and traditional manner. One might almost call his architectural style academic, in comparison with the unorthodox and quite revolutionary manner of his contemporary FRANCESCO BORRO-MINI (1599–1667). An entirely new dynamism appears in the little church of San Carlo alle Quattro Fontane (FIG. 15-13), where Borromini goes far beyond any of his predecessors or con-

15-13 Francesco Borromini, façade of San Carlo alle Quattro Fontane, Rome, 1665–67.

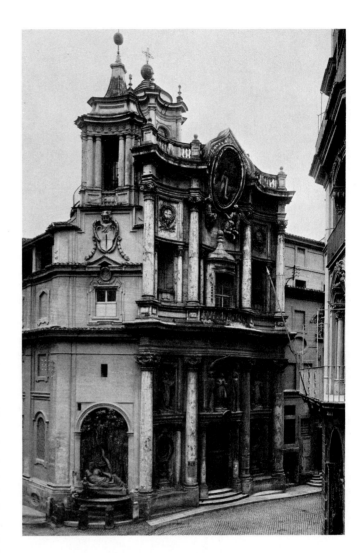

temporaries in the plastic handling of a building. Maderna's façades of Santa Susanna and St. Peter's are deeply sculptured, but they develop along straight, lateral planes. Borromini, perhaps thinking of Michelangelo's apse wall in St. Peter's (FIG. 13-30), sets his whole façade in serpentine motion forward and back, making a counterpoint of concave and convex on two levels (note the sway of the cornices), the sculptured effect emphasized by deeply recessed niches. This is no longer the traditional flat frontispiece that defines a building's outer limits but is a pulsating membrane inserted between interior and exterior space, designed not to separate but rather to provide a fluid transition between the two. This functional interrelation of the building and its environment is underlined by the curious fact that it has not one but two façades; the second, a narrow bay crowned with its own small tower, turns away from the main façade and, following the curve of the street, faces an intersection.

The interior is a provocative variation upon the theme of the centrally planned church. In plan (FIG. 15-14) it looks like a hybrid of a Greek cross and an oval, with a long axis between entrance and apse. The side walls move in an undulating flow that reverses the motion of the façade. Vigorously projecting columns articulate the space into which they protrude quite as much as they do the walls to which they are attached. This molded interior space is capped by a deeply coffered oval dome that seems to float on the light entering through windows hidden in its base. Rich variations on the basic theme of the oval, dynamic relative of the static circle, create an interior that appears to flow from entrance to altar, unimpeded by the segmentation so characteristic of Renaissance buildings.

The unification of interior space is carried even further in Borromini's Chapel of St. Ivo in the courtyard of the Jesuit College of the Sapienza (Wisdom) in Rome (FIG. 15-15). In his characteris-

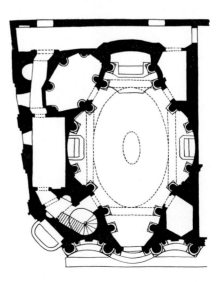

15-14 Plan of San Carlo alle Quattro Fontane, 1638–41.

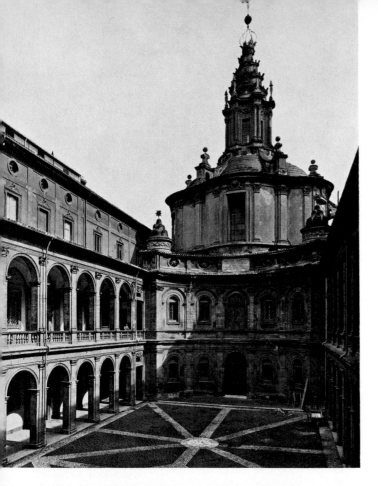

15-15 Francesco Borromini, St. Ivo, Rome, begun 1642.

tic manner, Borromini plays off concave against convex forms on the exterior of his chapel. Above the inward curve of the façade, its design adjusted to the earlier arcades framing the court, rises a convex, drumlike structure that supports the lower parts of the dome. Powerful pilasters restrain the forces that seem to push the bulging forms outward. Buttresses above the angle pilasters curve upward to brace a tall, plastic lantern topped by a spiral that seems to fasten the structure, screwlike, to the sky. The centralized plan is that of a six-pointed star with curving sides (FIG. 15-16). Indentations and projections along the angled, curving walls create a highly complex plan, all the elements of which are fully reflected in the interior elevation. From floor to lantern, the wall panels rise in a continuous tapering sweep that is halted only momentarily by a single horizontal cornice (FIG. 15-17). The dome is thus not, as in the Renaissance, a separate unit placed upon the supporting block of a building, but rather an organic part that evolves out of and shares the qualities of the supporting walls from which it cannot be separated. The complex horizontal motion of the walls is transferred fully into

15-16 Plan of St. Ivo.

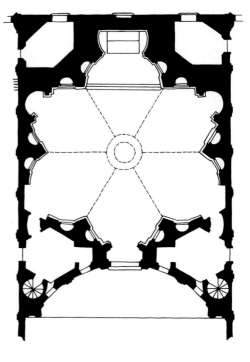

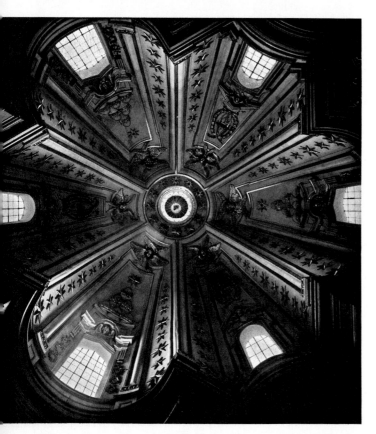

15-17 View into the dome of St. Ivo.

to 1589	c.1601	**1610**	1613	1617	1618	1623	c.1630	1642	**1643**	1645	1648	to 1715

| CARAVAGGIO *Conversion of St. Paul* | | RENI *Aurora* | RUBENS *Lion Hunt* | BERNINI *David* | | POUSSIN *Et in Arcadia Ego* | | BORROMINI *St. Ivo begun* | BERNINI *Cornaro Chapel begun* | | |

| HENRY IV OF FRANCE | | L O U I S X I I I | | | | | | | L O U I S X I V | | Pope Alexander VII (1655–67) |

←— THIRTY YEARS' WAR —→

←— Pope Paul V (1605–21) —→ ←— Pope Urban VIII (1623–44) —→ ←— (1655–67) —→

the elevation, creating a dynamic and cohesive shell that encloses and energetically molds a scalloped fragment of universal space. Few architects have matched Borromini's ability to convert extremely complicated designs into masterfully unified and cohesive structures such as St. Ivo.

The heir to Borromini's sculptured architectural style was GUARINO GUARINI (1624–83), a priest, mathematician, and architect who spent the last seventeen years of his life in Turin, converting that provincial town into a fountainhead of architectural theories that would sweep much of Europe. In his Palazzo Carignano (FIG. 15-18) Guarini effectively applies Borromini's principle of undulating façades. He divides his long façade into three units—the central one of which curves much like the façade of San Carlo alle Quattro Fontane (FIG. 15-13) and is flanked by two block-like wings. This lateral three-part division of

façades is characteristic of most Baroque palazzi and is probably based upon the observation that the average human can instinctively recognize up to three objects as a unit, while a greater number will require that he count each object individually. A three-part organization of extended surfaces thus gives the artist the opportunity to introduce variety into his design without destroying its unity. It also permits him to place added emphasis upon its central axis, which Guarini has done here most effectively by punching out deep cavities in the middle of his convex central block. The variety of his design is enhanced by richly textured surfaces (all executed in brick) and by pilasters, which further subdivide his units into three bays each. High and low relief create shadows of different intensities and add to the decorative effect a drama that makes this one of the finest façades of the late seventeenth century.

15-18 GUARINO GUARINI, Palazzo Carignano, Turin, 1679–92.

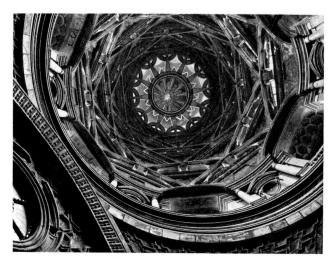

15-19 Above: Guarino Guarini, Chapel of the Santa Sindone, Turin, 1667–94 (view into dome).

15-20 Right: Raphael Sanzio, Sant' Eligio degli Orifici, Rome, *c.* 1509 (view into dome).

Guarini's mathematical talents seem to have guided him when he designed the extraordinarily complex dome of the Chapel of the Santa Sindone (Holy Shroud), a small central-plan building attached to the cathedral of Turin (FIG. 15-19). A view into this dome reveals a bewildering display of geometric figures appearing to wheel slowly around a circular focus that contains the bright dove of the Holy Ghost. The traditional dome has here been dematerialized into a series of figures that seem to revolve around each other in contrary motion; while defining it, they no longer limit the interior space. A comparison of Guarini's dome with that of the church of Sant' Eligio degli Orifici in Rome (FIG. 15-20), designed by Raphael, indicates that a fundamental change has taken place: The static "dome of heaven" of architecture and philosophy has been converted into the dynamic apparition of a mathematical heaven of calculable motions.

The architectural style of Borromini and Guarini will move across the Alps to inspire the architecture in Austria and South Germany in the late seventeenth and early eighteenth centuries. Popular in the Catholic regions in Europe and the New World (especially in Brazil), it exerted little influence in France, where the more conservative style of Bernini was favored.

PAINTING

Italian painters of the seventeenth century, with the possible exception of Caravaggio and the later decorators, were somewhat less adventurous than the sculptors and architects. The painters of the High Renaissance had bequeathed to them a tradition that had authority as great as that of classical antiquity. After the sixteenth century the artists of Europe drew from both traditions, and the history of painting well into the nineteenth century—that is, well into modern times—is an account of the interpretation, development, and modification of these traditions. The three most influential stylistic bequests of the High Renaissance were the styles of Raphael, of Michelangelo, and of Titian, with an additional subdominant trend inspired by Correggio. Baroque painting is the consequence of many and varied interchanges among these styles, with the antique sometimes supplementing them, sometimes appealed to against them. Outside the traditions of the an-

tique and of the Renaissance there rises what might be called native naturalism, a style that seems hostile to both authorities and that is based on the assumption that the artist should paint what he sees without regard for either the antique or the Renaissance masters. This native naturalism appears as a minority style in Italy and France but plays an important role in Spain and a predominant one in the Dutch school.

The Baroque gets well under way in Italian painting around the year 1600, with the decoration of the gallery of the Farnese Palace by ANNIBALE CARRACCI (1560–1609). His generation, weary of the strained artifice of Mannerism, returned for a fresh view of nature, but only after they had carefully studied the Renaissance masters. Annibale had attended an academy of art in his native city of Bologna. Founded by his cousin Ludovico, the Bolognese academy is the first significant institution of its kind in the history of Western art. Its premise was that art can be taught—the basis of any academic philosophy of art—and that the materials of instruction must be the traditions, the antique and the Renaissance, in addition to the study of anatomy and drawing

from life. The Bolognese painters were long called academics, sometimes eclectics, since they appeared to assume that the development of a correct style in painting is learned and synthetic. In any event, we can tell from the gallery of the Farnese Palace that Annibale was familiar with Michelangelo, Raphael, and Titian, and that he could make clever illusionistic paintings in addition. The ceiling program is the Loves of the Gods. The scenes are painted in panels that make them look like framed pictures set within the coves of the ceiling. The pictures are flanked by seated nude youths and standing giants (FIG. 15-21), motifs taken directly from Michelangelo's Sistine Ceiling. Here the Cyclops Polyphemos, his advances to Galatea rejected, hurls a rock after the fleeing Acis, her lover. The figure of the one-eyed giant is obviously inspired by the superhuman massiveness of Michelangelo's *Last Judgment* types (FIG. 13-32). It is noteworthy that the chiaroscuro is not the same for both the picture and the painted figures supposed to surround it. Polyphemos is modeled in an even, sculptured light; the outside figures are lit from below, as if they were three-dimensional statues

15-21 ANNIBALE CARRACCI, *Polyphemos*, 1597–1600. Detail of the ceiling frescoes in the Farnese Gallery, Farnese Palace, Rome.

illuminated by torches in the gallery below. This careful distinction of pictorial "realities" in the interest of illusion is thoroughly Baroque. In the crown of the vault a long panel representing the Triumph of Bacchus is a quite ingenious crossing of Raphael and Titian and represents Carracci's adroitness in adjusting their authoritative styles so as to make something of his own.

Another artist trained in the Bolognese academy, GUIDO RENI (1575–1642), selected Raphael for his inspiration, as we see in his *Aurora* (FIG. 15-22). Aurora, the dawn, leads the chariot of Apollo, while the Hours dance about it. There is a suave, almost swimming motion, soft modeling, and sure composition, though without Raphael's sculpturesque strength. It is an intelligent interpretation of the master's style, but in every sense learned—that is, "academic." It is remarkably conservative also, in that even though working 100 years after Raphael, Guido ignores the whole development in illusionistic ceiling perspective, as he simply transfers a wall painting to the ceiling.

GIOVANNI GUERCINO (1591–1666), also of the Bolognese school, takes advantage of the ceiling perspective when he interprets the same theme and gets a very different result (FIG. 15-23). Taking his cue from the illusionistic figures in the Farnese Gallery and from its central ceiling panel, he converts the ceiling into a limitless space in which the procession sweeps past. The observer's eye is led toward the celestial parade by converging painted extensions of the room's architecture. While the perspective of the figures may still seem a little forced, Guercino's *Aurora* inspired a new wave of enthusiasm for illusionistic ceiling paintings that culminated in some of history's most stupendous decorations.

Although the Bolognese painters were willing enough to imitate nature as directly as possible, they believed that the Renaissance and the antique masters had already captured much of its essence and that it was necessary to learn from them by way of preparation for the study of nature. Michelangelo de Merisi (1573–1610), called CARAVAGGIO after the north Italian town from which he came, thought very much otherwise and was proud to declare that his only teachers were the people in the street, meaning that to paint from them gave him sufficient knowledge of nature. His outspoken disdain for the classical masters (probably more vocal than real) drew bitter criticism from many painters, one of whom denounced him as the anti-Christ of painting. Yet many paid him the genuine compliment of borrowing from his innovations. We can appreciate how startling these must have been when we look at a work he painted for the Roman church of Santa Maria del Popolo, the *Conversion of St. Paul* (PLATE 15-2). The saint is represented flat upon his back, his arms thrown up, while an ostler appears to maneuver the horse away from its fallen master. Many of Caravaggio's works

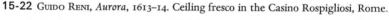

15-22 GUIDO RENI, *Aurora*, 1613–14. Ceiling fresco in the Casino Rospigliosi, Rome.

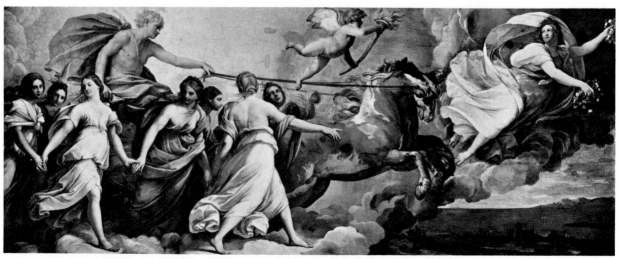

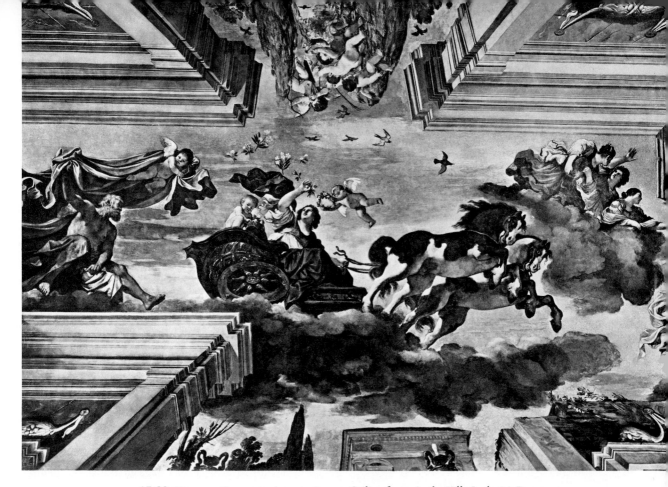

15-23 GIOVANNI GUERCINO, *Aurora*, 1621–23. Ceiling fresco in the Villa Ludovisi, Rome.

were refused on the ground that they lacked decorum—that is, fitness or propriety—and this could be one of them. We are not so much in the presence of a great saint overcome by a great miracle, as of a mere stable accident. A young man who has drunk too much has fallen from his horse and is in imminent danger of being stepped on. There is nothing to indicate who he is; he might be anyone. The ostler is a swarthy, bearded old man, well acquainted with stables. The horse fills the picture as if it were the hero, and its explicitness and the unusual angle from which it is viewed must have scandalized the clergy. Caravaggio has paid no attention to the usual dignity appointed to scenes from scripture. He bluntly dismisses all the formal graces of Renaissance figure, composition, and color. The harsh light that he hurls like a lance into the darkness catches the reality of the scene with the stark matter-of-factness of a police camera's flash. It is this feature of violently contrasting light and dark that first shocked and then fascinated Caravag-

gio's contemporaries. The sharp and sudden relief it gives to the forms and the details of form emphasizes their reality in a way that an even or subtly modulated light could never do. Dark side by side with light is naturally dramatic; we do not need a director of stage lighting to tell us this. Caravaggio's device, a profound influence upon European art, has been called *tenebrism*, or the "dark manner." It goes quite well with material that is realistic. It is another mode of Baroque illusionism by which the eye is almost forced to acknowledge the visual reality of what it sees. Though tenebrism was widespread in Baroque art, it had its greatest consequences in Spain and the Netherlands.

One would think that the Carracci (Annibale and Ludovico) and their colleagues at the academy would carefully avoid the dangerous art of Caravaggio. Quite the contrary; all borrowed from it, some more than others, unconsciously integrating it into the tradition and into their own work. A painting so typical of the Catholic

Baroque, so expressive of the Counter Reformation and its ideals that we can hardly find its equal as a document of the times is the *Last Communion of St. Jerome* (FIG. 15-24), painted by another Bolognese disciple, DOMENICHINO (1581–1641). In a Renaissance loggia that opens into a Venetian landscape background, St. Jerome, propped up to receive the viaticum, is surrounded by sorrowing friends. The realism of Caravaggio stamps the old man's sagging features; his weakened, once rugged body; and the faces of at least three of his attendants as well as that of the grave old priest. The sharpened darks and lights are also out of Caravaggio, while the general composition, the architecture, the floating putti, and the turbaned spectator echo Titian, Correggio, and the mood of the High Renaissance. A painting like this would seem to be necessarily an academic pastiche; but all its borrowed elements have been successfully synthesized in a rare, effective unity. Domenichino's *St. Jerome* is a successful "school" picture, nourished as it is by all the sources, traditional and contemporary, available to him.

After the Carracci and Caravaggio, the Italian schools of the seventeenth century lost strength in all areas of painting save one—ceiling decoration. This had a tradition going back to Mantegna and passing through Michelangelo, Correggio, Veronese, and the Carracci themselves. The large new churches of Baroque Rome stimulated anew the interest of artists in the problems of ceiling painting. The problems, of course, are special: Looking *up* at a painting is different from simply looking *at* a painting, for there is an element of awe in the experience of looking at what is above us, particularly when it is at considerable height. Guercino saw this in *his* Aurora, while apparently Guido Reni did not in *his*. The Baroque artist finds a ceiling surface high above the ground a natural field for the projection of visual illusion. The devout Christian, thinking of heaven as "up," must be overwhelmed with emotion when, looking up, he sees its image before his eyes. In the Sistine Ceiling, Michelangelo made no attempt to project an image of the skies opening into heaven, but rather represented an epic narrative of events of no physical place or time that could be read almost as well from walls as ceilings. The *illusion* of bodies actually soaring above was of no interest to him; the truth of certain events in the history of Genesis was, and these events and figures could be shut off in their own compartments, self-contained. It is quite otherwise with a Baroque master of ceiling painting like FRA ANDREA POZZO (1642–1709). Pozzo, a lay brother of the Jesuit order and a master of perspective, on which he wrote an influential treatise, designed and executed the vast ceiling painting of the church of Sant' Ignazio in Rome depicting the glorification of St. Ignatius (FIG. 15-25). The artist intends an illusion of the opening of heaven above the heads of the congregation — indeed, of the very congregation that fills this very church of Sant' Ignazio. For, in *painted* illusion, he continues the actual architecture of the church into the vault, so that the roof seems lifted off, as heaven and earth commingle and St. Ignatius is carried to the waiting Christ in the presence of the four corners of the world. A metal plate in the nave

15-24 DOMENICHINO, *The Last Communion of St. Jerome*, 1614. Approx. 13′ 9″ × 8′ 5″. Vatican Museums, Rome.

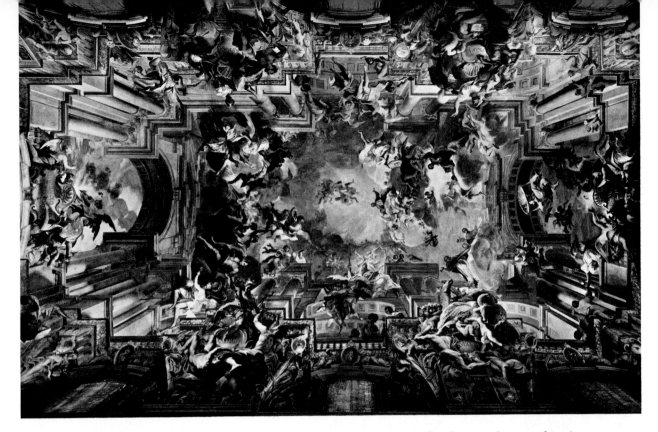

15-25 Fra Andrea Pozzo, *The Glorification of St. Ignatius*, 1691–94. Ceiling fresco in the nave of Sant' Ignazio, Rome.

floor marks the standpoint for the whole perspective illusion. Looking up from this point, the observer takes in the celestial-terrestrial scene as one, for the two are meant to fuse in Pozzo's design without the interruption of a boundary. To achieve his visionary effects, the artist employs all means offered by architecture, sculpture, and painting, and unites them in a fusion that surpasses even the Gothic effects of total integration.

To light as a vehicle of ecstasy and vision in the Baroque experience, one may add sound, for we know that churches were designed with acoustical effect in mind. One can imagine how, in a Baroque church filled with Baroque music, the power of both light and sound would be vastly augmented. Through simultaneous stimulation of both visual and auditory senses, the faithful might be transported into a trancelike state that would indeed, in the words of Milton, "bring all Heaven before [their] eyes." But this transport would always have to be effected by physical means, for although in the Middle Ages men were able to find the vision within, in the Baroque period men demanded that mystery be made visible to the outward sight. Thus, to be credible, heaven must more and more visually resemble the domain of earth; Dante could see heaven in a dream, but Pozzo wanted to see it unfold above him while he was awake and walking in a church. Medieval man aspired to heaven; Baroque man wanted heaven to come down to his station, where he might see it, even inspect it. Sight is the supreme faculty in seventeenth-century art and science.

Baroque expansiveness is expressed not only in the characteristic movement toward the infinite horizontal but in an emphasis on the vertical as well. The heavens are more and more within reach; Newton will penetrate them to find the laws of their movement. The clouds of heaven are not simply the seat of angels; the seventeenth century discovers that they are water vapor. The bright air through which light is propagated has density and weight. As the heavens become physical, so man may dream of taking possession of them someday by flight; not the flight of the soul, but the flight of the body. The Baroque period transforms spirit into matter in motion, as Fra Pozzo's ceiling relates.

Spain

In Spain, as in the other countries of Europe, Italianate Mannerism was adopted in the sixteenth century, and cast off in the Baroque period. But along with Mannerism, Spain seemed to reject *all* that the Italian Renaissance had stood for, just as it was to reject for a long time the scientific revolution and the Enlightenment. Since the Middle Ages Spain had maintained a proud isolation from the events of Europe, an isolation not entirely ended today.

There appear to be two sides to the Spanish genius in the period of the Counter Reformation and the Baroque: fervent religious faith and ardent mysticism on the one hand and an iron realism on the other; St. Theresa of Avila and St. John of the Cross can be taken as representing the first; the practical St. Ignatius of Loyola, founder of the Jesuit order, the latter. It is possible for the two tempers to be found in the same persons and works of art, but it is commoner to find them apart. Interestingly enough, it was a painter of foreign extraction who was able to combine them in a single picture. Domeniko Theotokopoulos (about 1547–1614), called EL GRECO, was born in Crete but emigrated to Italy as a young man. In his youth he was trained in the traditions of Late Byzantine frescoes and mosaics. While still young he went to Venice, where he was connected with the shop of Titian, although Tintoretto's painting seems to have made a stronger impression on him. A brief trip to Rome explains the influences of Roman and Florentine Mannerism on his work. By 1577 he had left for Spain to spend the rest of his life in Toledo. His art is a strong personal blending of Late Byzantine and Late Italian Mannerist elements. The intense emotionalism of his paintings, which naturally appealed to the pious fervor of the Spanish, and the dematerialization of form along with great reliance on color, bind him to sixteenth-century Venetian art and to Mannerism. His strong sense of movement and use of light, however, prefigure the Baroque. El Greco's art is not strictly Spanish, though it appealed to certain segments of that society, for it had no Spanish antecedents and had little effect on future Spanish painting.

Nevertheless, this hybrid genius made paintings that interpret Spain for us in its Catholic zeal and yearning spirituality. Such is his masterpiece, the *Burial of Count Orgaz* (PLATE 15-3), painted in 1586 for the church of Santo Tomé in Toledo. The theme illustrates the legend that the Count of Orgaz, who had died some three centuries before and who had been a great benefactor of the church of Santo Tomé, was buried in the church by Saints Stephen and Augustine, who miraculously descended from heaven to lower the count's body into its sepulcher. The earthly scene is irradiated by the brilliant heaven that opens above it, El Greco carefully distinguishing the terrestrial and celestial spheres. The terrestrial is represented with a firm realism, the celestial in his quite personal manner, with elongated, undulant figures, fluttering draperies, cold highlights, and a peculiar kind of ectoplasmic, swimming cloud. Below, the two saints lovingly lower the count's armor-clad body, the armor and heavy draperies painted with all the rich sensuousness of the Venetian school. The background is filled with a solemn chorus of black-clad Spanish grandees, in whose carefully individualized features El Greco shows us that he was also a great portraitist. These are the faces that looked upon the greatness and glory of Spain when she was the leading power of Europe, the faces of the *conquistadores* who brought her the New World, and who, two years after this picture was completed, would lead the Great Armada against Protestant England and Holland.

The lower and upper spheres are linked by the upward glances of the figures in the lower and by the flight of an angel who carries the soul of the count in his arms as St. John and the Virgin intercede for it before the throne of Christ. El Greco's deliberate change in style to distinguish between the two levels of reality shown in this painting gives the viewer the opportunity to see in the same work, one above the other, the artist's early and late manners. The relatively sumptuous and realistic presentation of the earthly sphere shows a still strong root in Venetian art. But it is the abstractions and distortions that El Greco uses to show the immaterial nature of the heavenly realm that will become characteristic of his later style. Pulling heaven down to earth, he will paint worldly inhabitants in the same abstract manner as celestial ones. His elongated figures will exist in undefined spaces, bathed

in a cool light of uncertain origin. For this El Greco has been called the last and greatest of the Mannerists. But it is difficult to apply that label to him without reservations. Although using Manneristic formal devices, El Greco was not a rebel, nor was he aiming for elegance in his work; he was concerned primarily with emotion and with the effort to express his own religious fervor or to arouse the observer's. To make the inner meaning of his paintings forceful he developed a highly personal style in which his attenuated forms become etherealized in dynamic swirls of unearthly light and color. While there may be some ambiguity in El Greco's forms, there is none in his meaning, which is an expression of devout ecstatic mysticism and spirituality.

The hard, unsentimental realism that is the other side of the Spanish character appears in the painting of Jóse de Ribera (1591–1652), who, because he early emigrated to Naples and settled there, is sometimes called by his Italian nickname, Lo Spagnoletto, "the little Spaniard." The realism of his style, a mixture of a native Spanish strain and the "dark manner" of Caravaggio, gives shock-value to his often brutal themes, which express at once the harsh times of the Counter Reformation and a Spanish taste for the representation of courageous resistance to pain. His *Martyrdom of St. Bartholomew* (FIG. 15-26) is grim and dark in subject and form. St. Bartholomew, who suffered the torture of being skinned alive, is being hoisted into position by his executioners. The saint's rough, heavy body and swarthy, plebeian features express a kinship between him and his tormentors, who compose the same cast of characters we found in the painting of Caravaggio and the Neapolitan school. Ribera, of course, scorns idealization of any kind, and we have the uncomfortable feeling that he is recording rather than imagining the grueling scene. In that age of merciless religious fanaticism on both sides, torture, as a means of saving stubborn souls, was a common and public spectacle.

Francisco de Zurbarán (1598–1664) softened realism with an admixture of the mystical. His principal subjects are austere saints, represented singly in devotional attitudes and usually sharply lighted from the side. He shows us St. Francis kneeling (FIG. 15-27), his uplifted face almost completely shadowed by his cowl, clutching to

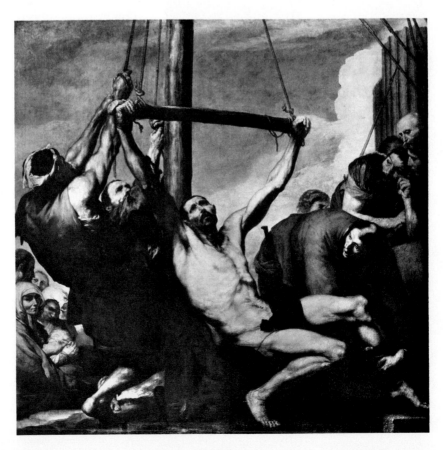

15-26 José de Ribera, *The Martyrdom of St. Bartholomew*, c. 1639. Approx 72″ × 78″. Museo del Prado, Madrid.

his body a skull, the *memento mori*, the constant reminder to the contemplative of his own mortality. The stark light and somber dark, and the bare, unfurnished setting are the bleak environment of this entranced soul. We see enough to read this as an image of rapt meditation—the parted lips, the tensely locked fingers, the rigid attitude of a devotee utterly unaware of his surroundings, mystically in contact with God. Zurbarán gives us here a personification of the fierce devotion of Catholic Spain.

In the Baroque age, visions and the visual go together. It may be that DIEGO VELÁZQUEZ (1599–1660), one who set aside visions in the interest of what is given to the eye in the optical world, stands among the great masters of visual realism of all time. Although he painted religious pictures, he was incapable of idealism or high-flown rhetoric, and his sacred subjects are bluntly real. Velázquez, trained in Seville, early came to the attention of the king, Philip IV, and became the

court painter at Madrid, where save for a few excursions he remained for the rest of his life. His close personal relationship with Philip and his high office of marshal of the palace gave him prestige and a rare opportunity to fulfill the promise of his genius with a variety of artistic assignments. In an early work, *Los Borrachos*, "The Drinkers" (FIG. 15-28), Velázquez shows his cool independence of the ideals of Renaissance and Baroque Italy in a native naturalism that has the strength and something of the look of Caravaggio. Commissioned to paint Bacchus among his followers, Velázquez makes mock of classical conventions in both the theme and the form. He burlesques the stately classical Bacchic scenes, making the god a mischievous young *bravo*, stripped to the waist, crowning a wobbly tippler who kneels before him. The rest of the company is of the same type—weather-beaten, shabby roisterers of the tavern crowd, who grin and jape at the event uncouthly, enjoying the game for what it is. Painting the crude figures in strong light and dark that is evenly distributed so as not to obscure them, Velázquez makes sharp characterizations of each person, showing not only his instinct for portraiture but a Baroque interest in human "types." And, typically Spanish, he caricatures by use of realism an Italianate subject that ordinarily would be idealized. Enrique Lafuente, a modern critic, states the Spanish attitude:

> Spain refuses to accept the basic ideas which inspire the Italian Renaissance because they are repugnant to its sense of the life of the Spanish man. The Spaniard knows that reality is not Idea but Life The supreme value of life is linked with experience and the moral values that are based on personality. Idea, beauty, formal perfection, are abstractions and nothing more. Art, in its turn is bound to concern itself with realities and not with dreams.[1]

To Velázquez, as to many Spanish artists, the academic styles of Baroque Italy must have seemed pretentious and insincere, not to say pagan.

Of course, Velázquez was fully aware of the achievements of the great masters like Michel-

[1] Enrique Lafuente, *Velázquez* (New York: Oxford Univ. Press, 1943), p. 6.

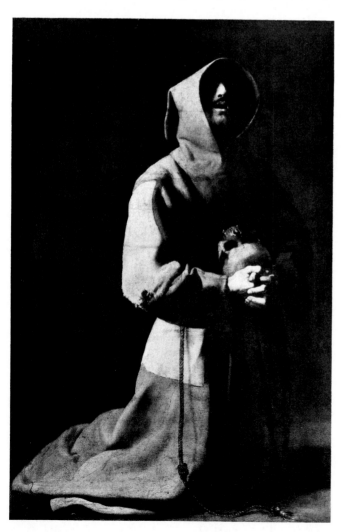

15-27 FRANCISCO DE ZURBARÁN, *St. Francis in Meditation*, c. 1639. Oil on canvas, 60″ × 39″. Reproduced by courtesy of the Trustees of the National Gallery, London.

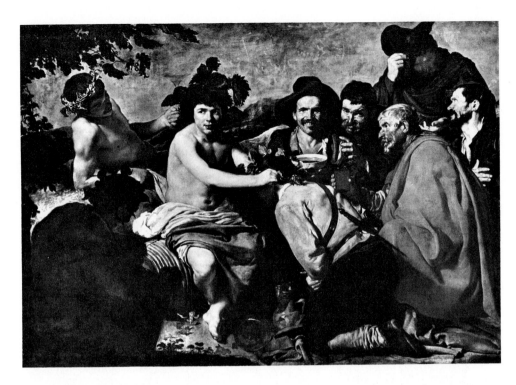

15-28 Diego Veláz-
quez, *Los Borrachos,*
c. 1628. Oil on canvas,
approx. 66″ × 90″. Museo
del Prado, Madrid.

angelo, Titian, and Tintoretto. He knew them from the king's collections, of which he had charge, and he studied them further in Venice and Rome, where he had journeyed at the suggestion of the great Flemish painter Peter Paul Rubens, whom he met when the older Rubens was copying the Venetians in the collections at the Madrid court. But his studies in Italy did not make a "Romanist" of Velázquez. Their most notable effects were a softening of his earlier, somewhat heavy-handed realism, and a lighter palette, which gave his paintings a brighter and subtler tonality.

Looking at his masterpiece, *Las Meninas,* "The Maids in Waiting" (FIG. 15-29), we must view Velázquez as a master of a brilliant optical realism that has seldom been approached and has never been surpassed. The painter represents himself in his studio before a large canvas upon which he may be painting this very picture or, perhaps, the portraits of the king and queen, whose reflections appear in the mirror on the far wall. The little infanta, Margarita, appears in the foreground with her two maids in waiting, her favorite dwarfs, and a large dog. In the middle ground

are a duenna and a male escort; in the background, a gentleman is framed in a brightly lit open doorway. On the wall above the doorway, faintly recognizable, are pictures by Rubens and Pietro da Cortona. Our first impression of *Las Meninas* is of an informal family group (it was long called "The Family" by the Austrian kings of Spain) casually arranged and miraculously lifelike; one could think of it as a genre painting —"A Visit to the Artist's Studio"—rather than as a group portrait. But though Velázquez intends an optical report of the event, authentic in every detail, he seems also to intend a pictorial summary of the various kinds of images in their different levels and degrees of "reality"—the "reality" of canvas image, of mirror image, of optical image, and of the two imaged paintings. The work, with its cunning contrasts of mirrored spaces, "real" spaces, picture spaces, and pictures within pictures, itself appears to have been taken from a large mirror that reflects the whole scene, which would mean that the artist has not painted the princess and her suite, but himself in the process of painting them. It should not surprise us that in the Baroque period, when artists were

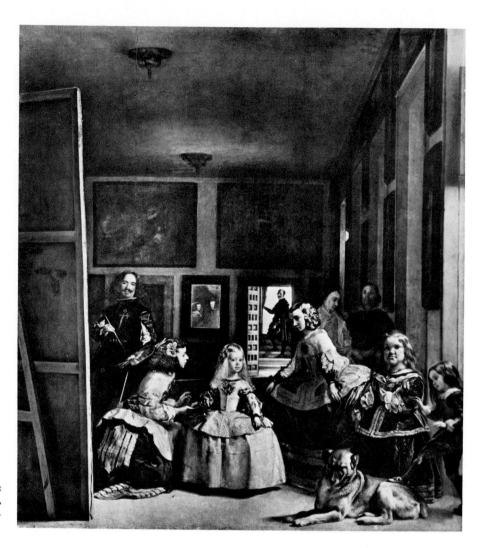

15-29 Diego Velázquez, *Las Meninas*, 1656. Oil on canvas, approx. 10′ 5″ × 9′. Museo del Prado, Madrid.

taking very seriously Leonardo's dictum that "the mirror is our master," mirrors and primitive cameralike devices should be used to achieve optimum visual fidelity in painting. *Las Meninas* is a pictorial summary as well as a commentary on the essential mystery of the visual world and on the ambiguity that results when we confuse its different states or levels.

How does Velázquez achieve this stunning illusion? He opens the spectrum of light and the tones that compose it. Instead of putting lights abruptly by the side of darks—as Caravaggio, Ribera, and Zurbarán would do or as he himself, in earlier works like *Los Borrachos*, had done —he allows a great number of intermediate

values of gray to come between the extremes. Thus, he carefully observes and records the subtle gradations of tone, matching with graded glazes what he sees in the visible spread of light-dark, using strokes of deep dark and touches of highlight to enliven the neutral tones in the middle of the value scale. This essentially cool, middle register of tones is what gives the marvelous effect of daylight and atmosphere to the painting. Velázquez's matching of tonal gradations approaches effects that the age of the photograph will later discover. His method is an extreme refinement of that developed by Titian. No longer does Velázquez think of figures as first drawn, then modeled into effects like those of statuary,

and then colored. He thinks of light and tone as the whole substance of painting, the solid forms being *suggested* only, never really constructed (see PLATE 15-4). Observing this reduction of the solid world to purely optical sensations in a floating, fugitive skein of color tones, one could say that the old sculpturesque form has disappeared. The extreme thinness of Velázquez's paint and the light, almost accidental touches of thick pigment here and there destroy all visible structure; we examine his canvas closely, and everything dissolves to a random flow of paint. As a wondering Italian painter exclaimed of a Velázquez painting: "It is made of nothing, but there it is!" Three hundred years later, painters will realize that Velázquez's optical realism constituted a limit. Their attempts to analyze it and take it further will lead in a direction opposite to that taken by the great Spanish master, to the abstract art of our own time.

Flanders

In the sixteenth century the Netherlands came under the crown of Hapsburg Spain when the emperor Charles V retired, leaving the Spanish throne and his Netherlandish provinces to his only son, Philip II. Philip's repressive measures against the Protestants led to the breaking away of the northern provinces from Spain and the setting up of the Dutch republic under the House of Orange. The southern provinces remained with Spain, and their official religion continued to be Catholic. The political distinction of modern Holland and Belgium reflects more or less this original separation, which in the Baroque period signalized not only religious differences but artistic ones also. The Baroque art of Flanders (the Spanish Netherlands) remained in close contact with the Baroque art of the Catholic countries, while the Dutch schools of painting developed their own subjects and styles consonant with their reformed religion and the new political, social, and economic structure of the middle-class Dutch republic.

The brilliant Flemish master PETER PAUL RUBENS (1577–1640) shared with Bernini the development and dissemination of the Baroque style. Rubens' influence was international, and

it was he who drew together the main contributions of the masters of the Renaissance—Michelangelo and Titian—and those of the Baroque—the Carracci and Caravaggio—to synthesize in his own style the first truly European manner. Thus, he completes the work begun by Dürer in the previous century. The art of Rubens, even though the consequence of his wide study of many masters, is no weak eclecticism but an original and powerful synthesis. From the beginning his instinct was to break out of the provincialism of the old Flemish Mannerism and to seek abroad for new ideas and methods. His aristocratic education; his courtier's manner, diplomacy, and tact; as well as his classical learning early made him the associate of princes and scholars. He became court painter to the dukes of Mantua (descended from the patrons of Mantegna), friend of the king of Spain and his adviser on art collecting, painter to Charles I of England and Marie de' Medici, queen of France, and permanent court painter to the Spanish governors of Flanders. Rubens also won the confidence of his royal patrons in matters of state, being entrusted often with diplomatic missions of the highest importance. In the practice of his art he was assisted by scores of associates and apprentices, turning out large numbers of paintings for an international clientele. In addition, he functioned as an art dealer, buying and selling works of contemporary art and classical antiquities. His numerous enterprises made him a rich man, with a magnificent town house and a château in the countryside. Wealth and honors, however, did not spoil his amiable, sober, self-disciplined character. We have in Rubens, as in Raphael, the image of the successful, renowned artist, the consort of kings, and the shrewd man of the world, who is at the same time the balanced philosopher. The Renaissance claim for the preeminence of the artist in society is more than made good in Rubens.

Rubens became a master in 1598 and went to Italy two years later, to remain there until 1608. It was during these years that he formed the foundations of his style. Shortly after his return from Italy he painted the *Elevation of the Cross* (FIG. 15-30) for the cathedral of Antwerp. This work shows the result of his long study of Italian art, especially of Michelangelo, Tintoretto, and

Caravaggio. The scene is a focus of tremendous, straining forces and counterforces, as heavily muscled giants strain to lift the cross. The artist has the opportunity here to show foreshortened anatomy and the contortions of violent action—not the bound action of Mannerism, but the tension of strong bodies meeting resistance outside themselves. The body of Christ is a great, illuminated diagonal that cuts dynamically across the picture and at the same time inclines back into it. The whole composition seethes with a power that we feel comes from genuine exertion, from elastic human sinew taut with effort. Strong modeling in dark and light marks Rubens' work at this stage of his career; it will gradually give way to a much subtler, coloristic style.

The vigor and passion of Rubens' early manner never leaves his painting, though its vitality is modified into forms less strained and more subtle, depending of course, upon the theme. Yet in general, Rubens has the one, general theme—the human body, draped or undraped, male or female, freely acting or free to act in an environment of physical forces and other interacting bodies. There is nothing profoundly tragic in Rubens' conception of the human scene, nor is there anything manneristically intellectual, enigmatic, or complex. His forte is the strong animal body described in the joyful exuberant motion natural to it. His *Rape of the Daughters of Leucippus* (PLATE 15-5) describes the abduction of two young mortals by the gods Castor and Pollux, who have fallen in love with them. The amorous theme permits departures from realism, especially in the representation of movement and exerted strength. The gods do not labor at the task of sweeping up the massive maidens—the descendants of the opulent Venuses of Giorgione (PLATE 13-7) and Titian (PLATE 13-8)—nor do the maidens energetically resist. The figures are part of a highly dynamic, slowly revolving composition that seems to turn upon an axis, a diamond-shaped group that defies stability and the logic of statics. The surface pattern, organized by intersecting diagonals and verticals, consists of areas of rich, contrasting textures—the soft luminous flesh of the women, the bronzed tan of the muscular men, lustrous satins, glinting armor, and the taut, shimmering hides of the horses. And around this surface pattern is knit a tight massing of volumes that move in space, the solid forms no longer described simply in terms of the dark-light values of Florentine draftsmanship but now built up in color and defined by light as in Venetian painting.

The impact of Rubens' hunting pictures lies in their depiction of ferocious action and vitality. In his *Lion Hunt* (FIG. 15-31) a cornered lion, three lances meeting in his body, tears a Berber hunter from his horse. A fallen man still grips his sword while another, in a reversed position, stabs at a snarling cat. Horsemen plunge in and out of the picture space, and the falling Berber makes a powerful diagonal across the composition. The wild melee of thrusting and hacking, rearing and plunging is almost an allegory of the bound tensions of Mannerism exploding into the extravagant activity of the Baroque.

Rubens shared heartily in the Baroque love of magnificent pomp, especially as it set off the majesty of royalty, in which Rubens, born courtier that he was, heartily believed. The

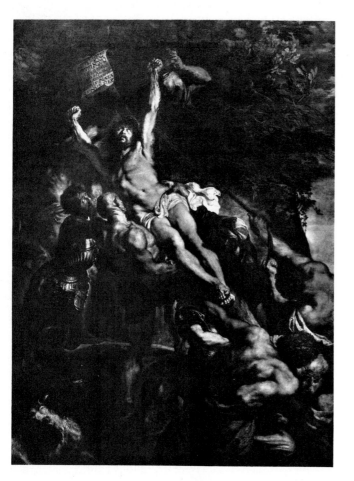

15-30 PETER PAUL RUBENS, *The Elevation of the Cross*, 1610. 15′ 2″ × 11′ 2″. Antwerp Cathedral.

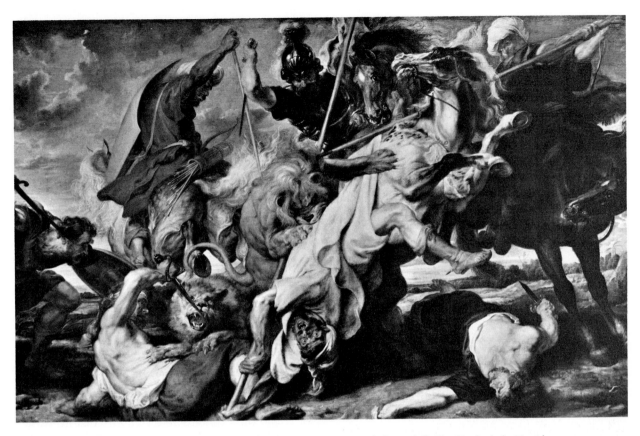

15-31 PETER PAUL RUBENS, *The Lion Hunt*, 1617–18. Approx. 8′ 2″ × 12′ 5″. Alte Pinakothek, Munich.

Baroque age saw endless extravagant pageants and festivals produced whenever the great or even lesser dynasts moved. Their authority and right to rule was forever being demonstrated by lavish display; we have seen that the popes themselves, the princes of the Church, made of St. Peter's a permanently festive monument to papal supremacy. Marie de' Medici commissioned Rubens to paint a cycle memorializing and glorifying her career and that of her late husband, first of the Bourbon kings, Henry IV. A small preparatory color sketch for the *Debarkation of Marie at Marseilles* (FIG. 15-32) may be taken as exemplary of the mood and style of the great cycle, in which Rubens' unfailing sense of the dramatic transforms a rather dull and uneventful life into an adventure story. Marie, a member of the famous Florentine House of Medici, has arrived in France after the sea voyage from Italy. Surrounded by splendid ladies, she is welcomed by an allegory of France, a figure draped in the fleur-de-lis. The sea and the sky rejoice at her safe arrival; Poseidon and the Nereids salute her, and a winged, trumpeting Fame swoops overhead. These broad and florid compliments, in which heaven and earth join, are standard in Baroque pageantry, where honor is done to royalty: We have already met in Italian Baroque art the collaboration of the celestial and earthly spheres in the glorification of religious themes. The artist enriches his surfaces with a decorative splendor that pulls the whole composition together; and the same audacious vigor that customarily enlivens Rubens' figures, beginning with the monumental, twisting sea creatures, vibrates through the entire design. Rubens' imposing, vigorous figure compositions were not his only achievement. He produced rich landscapes and perceptive portraits, and elaborate allegories. His versatility rivals that of Bernini.

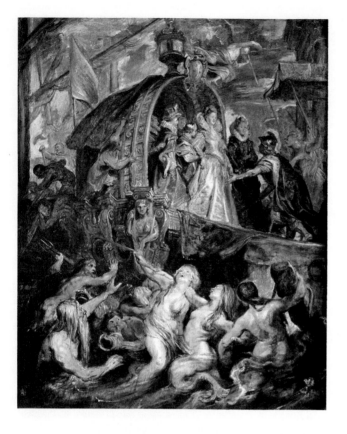

15-32 Peter Paul Rubens, *The Debarkation of Marie at Marseilles*, 1622–23. Approx. 25″ × 20″. Alte Pinakothek, Munich.

Most of Rubens' successors in Flanders had been his assistants. The most famous, Anthony van Dyck (1599–1641), had probably worked with his master on the canvas of the *Rape of the Daughters of Leucippus*. Quite early the younger man, unwilling to be overshadowed by the undisputed stature of Rubens, left his native Antwerp for Genoa and then London, where he became court portraitist to Charles I. Although he attempted dramatic compositions, his specialty became the portrait, and he developed a courtly manner of great elegance that was to be internationally influential. His style is felt in English portrait painting down to the nineteenth century. One of his finest works is *Charles I Dismounted* (FIG. 15-33), in which he shows the ill-fated Stuart king standing in a Venetian landscape (with the river Thames in the background!), attended by an equerry and a page. Although the king personates a nobleman out for a casual ride in his park, there is no mistaking the regal poise and the air of absolute authority that his parliament resented and was soon to rise against. The composition is exceedingly artful in the placement of the king—off-center, but balancing the picture with a single keen glance at the observer. The full-length portraits by Titian and the cool composure of the Mannerists have alike contributed to Van Dyck's sense of pose and arrangement of detail. For centuries, artists who make portraits of the great will have Van Dyck very much in mind.

Holland

For all intents and purposes, the style of Peter Paul Rubens is the style of Baroque Flanders; he had few rivals of significance and a monopoly on commissions. The situation is so completely different in Holland that it is difficult to imagine how, within such a tiny area, two such opposite artistic cultures could flourish. The Dutch and Flemish went their separate ways after the later sixteenth century—the Dutch were Protestant

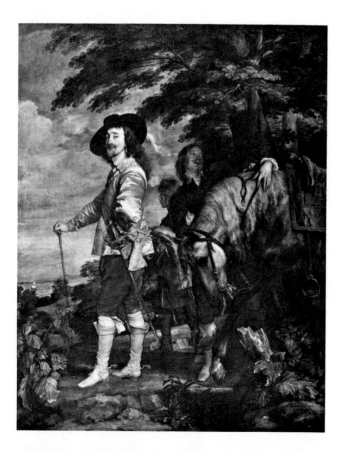

15-33 Anthony van Dyck, *Charles I Dismounted*, c. 1635. Oil on canvas, approx. 9′ × 7′. Louvre, Paris.

1621 1622	c.1628	c.1635	c.1639	**1648** c.1650	1656	c.1659 1662	**1665**
RUBENS *Medici Cycle*	VELÁZQUEZ *Los Borrachos*	VAN DYCK *Charles I Dismounted*	ZURBARÁN *St. Francis in Meditation*	Dutch attain independence	HALS *Malle Babbe*	VELÁZQUEZ KALF *Las Meninas Still Life*	REMBRANDT *Syndics of the Cloth Guild*

P H I L I P I V O F S P A I N

and the Flemish Catholic. Ethnically the Dutch were closer to the Germans, whereas the Flemish were related to the French. A Catholic, aristocratic, and traditional culture reigned in the Flanders of Rubens. In Holland severe, Calvinistic Protestantism was puritanical toward religious art, sculptural or pictorial. The churches were swept clear of images, and any recollection of the pagan myths, the material of classicism, or even historical subjects was proscribed in art. During the Middle Ages and the Renaissance, religious subjects or, later, classical and historical subjects, had been the major stimuli for artistic activity. Divested of these sources, what then remained to enrich the lives of wealthy Hollanders? For they *were* wealthy! During the early part of the Spanish rule, the Dutch, like the Flemish, had prospered. The East India Company had been formed, and the discovery of the New World had opened up further opportunities for trade and colonization. The wars of independence from Spain made Holland the major maritime country of Europe, with her closest rival England, another Protestant power in the times of the Spanish decline. The great Dutch commercial cities, such as Haarlem and Amsterdam, had been stimulated and enriched, and civic pride was strong. Although it was not internationally recognized until the Peace of Westphalia in 1648, Holland had been independent from Spain in fact since about 1580 and was extremely proud of its hard-won freedom. Under these circumstances

> Dutch painting . . . was and could be only the portrait of Holland, its exterior image, faithful, exact, complete, with no embellishments. Portraits of men and places, citizen habits, squares, streets, country-places, the sea and the sky—such was to be . . . the program followed by the Dutch school, and such it was from its first day to the day of its decline.[2]

[2] Eugène Fromentin, *The Masters of Past Time: Dutch and Flemish Painting from Van Eyck to Rembrandt*, trans. by A. Boyle (London: Phaidon, 1948), p. 130.

Thus it came about that the Dutch painters pried into the pictorial possibilities of everyday life and kept an eye on their customers, the middle-class burghers, who wanted paintings to hang on their walls as evidence of their growing wealth and rising social position.

We have followed the secularization and humanization of religious art since the thirteenth century. In the Dutch school of the seventeenth century the process is completed. A thousand years and more of religious iconography is dismissed by a European people who ask for a view of the world from which angels, saints, and deities have been banished. The old Netherlandish realism remains, but it no longer serves religious purposes. The Dutch artists rise to the occasion, matching the open, competitive, Dutch society, which is thoroughly middle class, with an equally open arrangement of their own, in which the painter works not for a patron, but for the market. He becomes a specialist in any one of a number of subjects—genre, landscape, seascape, cattle and horses, table still life, flower still life, interiors, and so on. In short, he paints subjects that he feels will appeal to his public and, hence, will be marketable. This independence from the patron gives the Dutch painter a certain amount of freedom, even if it is only the freedom to starve on the free picture-market. With respect to the artist-market relationship, the contrast between Flanders and Holland in the seventeenth century is poignantly reflected in the careers of Rubens and Rembrandt: The former *is* the market in Flanders, his genius determining it; the latter, after having found a place in the market, is rejected by it when his genius is no longer marketable.

The realism of Dutch art is made up of the old tradition, which goes back to the Van Eycks, and the new "realism of light and dark" brought back to Holland by Dutch painters who had studied Caravaggio in Italy. One of these night painters, as they were called, is GERARD VAN

15-34 GERARD VAN HONTHORST, *The Supper Party*, 1620. Approx. 84″ × 56″. Galleria degli Uffizi, Florence.

HONTHORST (1590–1656) of Utrecht, who spent several years in Italy absorbing Caravaggio's style. He is best known for gay genre scenes like the *Supper Party* (FIG. 15-34), in which unidealized human types are shown in an informal gathering. Fascinated by nocturnal effects, Honthorst frequently places a hidden light source (two in this case) in his pictures and uses it as a pretext to work with dramatic and violently contrasted dark-light effects. Without the incisive vision of Caravaggio, Honthorst is nevertheless able to match, and sometimes to surpass, the former's tenebristic effects.

The Dutch schools were as various as their cities—Utrecht, Haarlem, Leyden, Amsterdam —although all had in common the lesson of Caravaggio as interpreted by Dutch "Caravaggisti" like Honthorst. FRANS HALS (about 1580–1666), the leading painter of the Haarlem school and one of the great realistic painters of the Western tradition, appropriates what he needs from the new lighting to make of portraiture—his special-

ty—an art of acute psychological perception as well as a kind of comic genre. The way light floats across the face and meets shadow can be arranged by the artist, as can the pose and the details of costume and facial expression. Frans Hals shows himself a master of all the devices open to a portraitist who need no longer keep the distance required by the strictly formal portrait. The relaxed relation between the portraitist and his subject is apparent in the engaging portrait of *Balthasar Coymans* (PLATE 15-6), dated 1645. Although the subject is a young man of some importance, the artist seems to be taking a great deal of liberties with his portrait. The young man leans on one arm with a jaunty air of insolence, his hat cocked at a challenging angle, a look of contemptuous drollery in his eyes. The illusion of life is such that we take cues from the subject's expression as if we were face to face with him. Hals's genius lies in this capture of the minute expressional movements by which, in everyday life, we appraise the man across from

us. This kind of intimate confrontation had never been seen in painting. It is a kind of contradiction of the masks of formal portraiture created in the Renaissance. We are in the presence of an individual without formal introduction; the gap between us and the subject is reduced until we are almost part of his physical and psychological environment. The casualness, immediacy, and intimacy are intensified by the execution of the painting: The touch of the painter's brush is as light and fleeting as the moment in which the pose is caught; the pose of the figure, the highlights upon the sleeve, the reflected lights within face and hand, the lift of the eyebrow—all are the instant prey of time. Thus, the evanescence of time that Bernini caught in the *David* (FIG. 15-10) is recorded far to the north a few years later in a different subject and a different medium. Both are Baroque.

Frans Hals is a genius of the comic. He had precedents in the gargoylism and grotesquerie of the northern Middle Ages and, in later times, in Bosch and Bruegel. But Hals's comedy is that of character, rather than situation; he shows us— as Aristotle would demand for comedy—men as they are and somewhat less then they are; this puts us at ease, out of superiority, so that we can laugh at others. Hals took his comic characters, as did Shakespeare, his contemporary, from the depths of society. The *Malle Babbe*, "Mad Babbe" (FIG. 15-35), with her owl and her shiny pewter tankard, holds her cackling own in a verbal exchange, doubtless in some cellar tavern. In the Baroque era, as the heavens descend to earth, so hell rises and becomes familiar in human forms; all the spheres tend to meet. Hals's dashing, *alla prima* brushwork (perhaps more studied than it appears) seems to catch the quick outburst in almost the moment it would take it to be heard. This instant reportage is an inspired development out of the deliberate, almost static method of Caravaggio. No painter, not even among the Impressionists, has wanted more than Hals to bring the instantaneous image of life before us.

Good-humored stageplay brightens Hals's great canvases of units of the Dutch civic guard, which played an important part in the liberation of Holland. These companies of archers and musketeers met on their saints' days in dress uniform

15-35 FRANS HALS, *Malle Babbe*, c. 1650? Approx. 30″ × 25″. Staatliche Museen Preußischer Kulturbesitz Gemäldegalerie, Berlin (West).

for an uproarious banquet, giving Hals an opportunity to attack the problem of adequately representing each subject of a group portrait while retaining action and variety in the composition. Earlier group portraits in the Netherlands represented the sitters as so many jugs on a shelf; Hals undertakes to correct this, and in the process produces dramatic solutions to the problem, like that in his *Archers of St. Adrian* (FIG. 15-36). The troopers have finished their banquet, the wine has already gone to their heads, and each in his own way is sharing the abundant high spirits. As a stage director Hals has no equal. In quite Baroque fashion he balances directions of glance, pose, and gesture, making compositional devices of the white ruffs, broad-brimmed black hats, and banners. Although the instantaneous effect, the preservation of every detail and facial expression, is, of course, the result of careful planning, the vivacious brush of Hals seems to have moved spontaneously, directed by a plan in the artist's mind, but not traceable in any preparatory

15-36 FRANS HALS, *Assembly of Officers and Subalterns of the Civic Guard of St. Adrian at Haarlem,* c. 1633. Oil on canvas, approx. 6′ 9″ × 11′. Frans Halsmuseum, Haarlem.

scheme on the canvas. The bright optimism of this early period of Dutch freedom is caught in the swaggering bonhomie of the personalities, each of whom plays his particular part within the general unity of mood. This is the gregariousness that goes with the new democracy as well as the fellowship that grows from a common experience of danger.

With Hals, Baroque realism concentrates on the human subject, so intimately that we are forced to relate him to ourselves. We and the subject look at each other, as if in a sharing of mood; there is a confrontation of personalities. Yet it is still mostly a public image that the subject is willing to present; in this respect Hals has not entirely broken away from the tradition of formal portraiture that goes back to the fifteenth century. The first deep look into the *private* man is made by Hals's younger contemporary, REMBRANDT VAN RIJN (1606–69).

Rembrandt's way was prepared spiritually by the Protestant Reformation and the Dutch aspira-tion to freedom, and formally by the Venetian painters, by Rubens, and by Caravaggio and his Dutch imitators. The richness of this heritage, however, cannot alone account for the extra-ordinary achievement of this great artist, one of the very greatest among those geniuses who have revealed Western man to himself. Rembrandt made painting a method for probing the states of the human soul, both in portraiture and in his uniquely personal and authentic illustration of the scriptures. The abolition of religious art by the Reformed Church in Holland did not prevent him from making a series of religious paintings and prints that synopsize the Bible from a single point of view—that of a believing Christian, a poet of the spiritual, convinced that its message must be interpreted in human terms for human beings. In Rembrandt, the humanization of Medieval religion is now completed in the vision of a single believer. In this Baroque age this is roughly parallel to the sighting of a new planet by some single "watcher of the skies."

Rembrandt's pictorial method involves refining light and shade into finer and finer nuances, until they blend with one another. (Caravaggio's absolute light has, in fact, many shadows; his absolute darks, many lights.) We saw that Velázquez understood this and rendered optical reality as a series of values—that is, a number of degrees of lightness and darkness. Thus, the use of abrupt lights and darks gives way in the work of men like Rembrandt and Velázquez to gradation, and though the dramatic effects of violent chiaroscuro may be sacrificed, the artist gains much of the truth of actual appearances, for to the eye light and dark are not static but always subtly changing. Changing light and dark can suggest changing human moods; we might say that the *motion* of light through a space and across human features can express *emotion*, the changing states of the psyche.

The Renaissance represented forms and faces in a flat, neutral, modeling light (even Leonardo's shading is of a standard kind), just as it represented action in a series of standard poses. The Renaissance painter represented the *idea* of light and the *idea* of action, rather than the actual *look* of either. Light, atmosphere, change, and motion are all concerns of Baroque art, as well as of Baroque mathematics and physics, as we have already suggested. The difference from what went before lies largely in the new desire to *measure* these physical forces. For example, as the physicist in the seventeenth century is concerned not just with motion, but with acceleration and velocity —with degrees of motion—so the Baroque painter discovers degrees of light and dark, of difference in pose, in the movements of facial features, and in psychic states. These differences he arrives at *optically*, not conceptually or in terms of some ideal. Rembrandt found that by manipulating light and shadow in terms of direction, intensity, distance and texture of surface, he was able to render the most subtle nuances of character and mood, whether of persons or of whole scenes. Rembrandt discovered for the modern world that differences of light and shade, subtly modulated, can be read as emotional differences. In the visible world light, dark, and the wide spectrum of values between them have a charge of meaning and feeling sometimes independent of the shapes and figures they modify. The lighted stage and the photographic arts have long accept-

ed this as the first assumption behind all their productions. What Masaccio and Leonardo had begun, the age of Rembrandt completes.

In his early career in Amsterdam, Rembrandt's work was influenced by Rubens and by the Dutch Caravaggiesque painters like Honthorst. Thus, in a work like the *Supper at Emmaus*, from about 1630 (FIG. 15-37), he represents the subject with high drama—in sharp light and dark contrast— even using the device, familiar among his contemporaries, of placing the source of illumination behind an obstructing form, in this case the head of Christ. (This puts the darkest shadow in front of the brightest light, making for an emphatic, if obvious, dramatic effect.) The poses of the two alarmed disciples to whom the risen Christ reveals himself are likewise a studied stage maneuver. Some eighteen years later, another painting of the same subject (FIG. 15-38) shows the mature Rembrandt forsaking the earlier melodramatic means for a setting serene and untroubled. Here, with his highly developed instinct for light and shade, he gives us no explosive contrasts; rather, a gentle diffusion of light mellows the whole interior, condensing just slightly to make an aureole behind the head of Christ. The disciples only begin to understand what is happening; the servant is unaware. The Christ is Rembrandt's own interpretation of the biblical picture of the humble Nazarene—gentle, with an expression both loving and melancholy.

15-37 REMBRANDT VAN RIJN, *Supper at Emmaus, c.* 1628–30. 14½″ × 16⅛″. Musée Jacquemart-André, Paris.

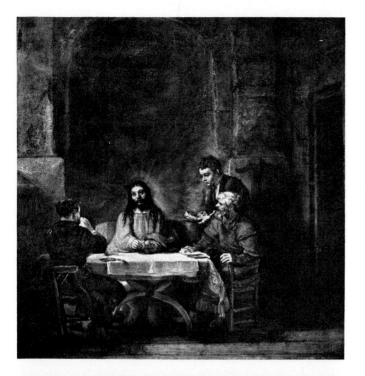

15-38 Rembrandt van Rijn, *Supper at Emmaus, c.* 1648. Approx. 27″ × 26″. Louvre, Paris.

The spiritual stillness of Rembrandt's religious painting is that of inward-turning contemplation; it is far from the choirs and the trumpets and the heavenly tumult of Bernini or Fra Pozzo. Rembrandt gives us not the celestial triumph of the Church, but the humanity and humility of Jesus. His psychological insight and his profound sympathy for human affliction produce at the very end of his life one of the most moving pictures in all religious art, the *Return of the Prodigal Son* (FIG. 15-39). Tenderly embraced by his forgiving father, the son crouches before him in weeping contrition while three figures, immersed in varying degree in the soft shadows, note the lesson of mercy. The scene is wholly determined by the artist's inward vision of its meaning. The light, everywhere mingled with shadow, controls the arrangement of the figures, illuminating father and son, largely veiling the witnesses. Its focus is the beautiful, spiritual face of the old man; secondarily it touches the contrasting, stern face of the foremost witness. There is no flash or glitter of light or color; the raiment is sober as the characters are grave. Rembrandt, one feels, has put the official Baroque style far from him and has developed a personal style completely in tune with the simple eloquence of the biblical passage. One could not help but read the Bible differently, once given the authority of Rembrandt's pictorial interpretations of it.

Rembrandt carries over the spiritual quality of his religious works into his later portraits by the same means—what we might call the psychology of light. Light and dark are not in conflict in his portraits; they are reconciled, merging softly and subtly to produce the visual equivalent of quietness. The prevailing mood is that of tranquil meditation, of philosophic resignation, of musing recollection—indeed a whole cluster of emotional tones heard only in silence. He records the calamities of his own life and the age-old ones of the Jewish people (he had many friends in the Jewish quarter of Amsterdam) in the worn faces

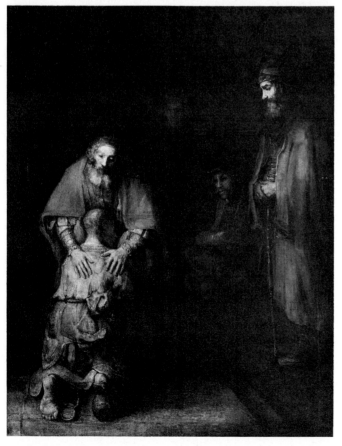

15-39 Rembrandt van Rijn, *The Return of the Prodigal Son, c.* 1665. Approx. 8′ 8″ × 6′ 8¾″. State Hermitage Museum, Leningrad.

of aged and silent men. His study of the influence of time upon the human features was one with his study of light; the mood of reflection conveyed by the slow movement of lights and darks complements the appearance of the aged face in slanting light—a sunken terrain crisscrossed with deep lines. In a long series of self-portraits Rembrandt preserved his own psychic history—from the bright alert optimism of youth to the worn resignation of his declining years. These last years, when he was at the height of his artistic powers, cost him much physically if we are to judge from two portraits only eight years apart. The earlier (FIG. 15-40) shows the artist in his maturity—confident, even challenging, confronting the observer as if he would see his credentials. Rembrandt hooks his thumbs into the belt of his studio smock, stands on no formality, waits for the observer to declare himself. In its familiarity and lack of formality the portrait is a radical departure from the Renaissance tradition still alive in Van Dyck. The later portrait is an almost shocking contrast (FIG. 15-41). The light from above and from the artist's left pitilessly reveals a face ravaged by anxiety and care. The pose is that of Raphael's *Castiglione* (PLATE 13-1), which Rembrandt had seen in Holland and of which he had made an earlier copy in a self-portrait. The difference between the Raphael and the Rembrandt portraits can tell us much about the difference between the approaches of the two artists and between the philosophies of their times. In Raphael's subject the ideal has modified the real; Rembrandt shows himself as he appears to his own searching and unflattering gaze. Here an elderly man is not idealized into the image of the courtly philosopher: he is shown merely as he is, a human being in process of dwindling away. For some, the portrait and self-portrait, which began as a medium for the recording of likeness, came to be painted out of motives of vanity; with Rembrandt it is the history of everyman's painful journey through the world.

In the group portrait, an area of painting in which Frans Hals excelled, Rembrandt showed himself to be the supreme master. In the *Syndics of the Cloth Guild* (PLATE 15-7), representing an archetypal image of the new businessmen, Rembrandt applied all that he knew of the dynamics and the psychology of light, the visual suggestion of time, and the art of pose and facial expression. The syndics, or board of directors, are going over the books of the corporation. The observer has entered, and they are just at the moment of becoming aware of him, each head turning in his direction. Rembrandt gives us the lively reality of a business conference as it is interrupted; yet he renders each portrait with equal care and with a studied attention to personality one would expect to be possible only from a long studio sitting for each man. Although we do not know how Rembrandt proceeded, this harmonizing of the instantaneous action with the permanent likeness seems a work of superb stage direction that must have needed long rehearsal. The astonishing harmonies of light, color, movement, time, and pose have few rivals in the history of painting.

Rembrandt's virtuosity extends to the graphic media, in particular, etching. Here again he ranks at the summit, alongside the original master, Dürer, who, however, was an engraver. Etching, perfected early in the seventeenth century, was rapidly taken up, since it was far more manageable than engraving and allowed greater freedom in drawing the design. In etching, a copper plate is covered with a layer of wax or varnish in which the design is drawn with an etching needle or any pointed tool, exposing the metal below but not cutting into its surface. The plate is then immersed in acid, which etches, or eats away, the exposed parts of the metal, acting in the same capacity as the burin in engraving. The softness of the medium gives the etcher greater freedom than the woodcutter and the engraver, who work directly in their more resistant media of wood and metal. Thus, prior to the invention of the lithograph (in the nineteenth century) etching was the most facile of the graphic arts and the one offering the greatest subtlety of line and tone.

If Rembrandt had never painted, he would still be renowned, as he principally was in his lifetime, for his prints. Prints were a major source of income for him and he often reworked the plates so that they could be used to produce a new issue or edition. The illustration here shows the fourth state, or version, of his *Three Crosses* (FIG. 15-42). In the earlier states he had represented the hill of Calvary in a quite pictorial, historical way, with crowds of soldiers and spectators, all descriptively and painstakingly rendered. In this

15-40 REMBRANDT VAN RIJN, *Self-Portrait*, 1652. Approx. 45″ × 32″. Kunsthistorisches Museum, Vienna.

a tasteless painter, concerned with the ugly and ignorant of color. This prejudice lasted well into the nineteenth century, when finally his genius was acknowledged. We see him now as one of the great masters of the whole tradition, an artist of great versatility, and the unique interpreter of the Protestant conception of scripture. For our time he stands as the archetype of the modern artist, the isolated and courageous master who finds his own way to new heights of expression no matter the barriers of misunderstanding raised against him.

THE "LITTLE DUTCH MASTERS"

The pictorial genius of the Dutch masters of the seventeenth century surpassed all others in its comprehensiveness of subject, taking all that is given to the eye as its province. The whole world of sight is explored, but especially the things of man in their ordinary use and aspect. In some ways the old Netherlandish tradition of Jan van Eyck lives on in the rendering of things in the optical environment with a loving and scrupulous fidelity to their appearances. Dutch painters come to specialize in portraiture, genre, interiors, still life, landscape and seascape, and even in more specialized subdivisions of these. With many, the restriction of their professional interest is all to the good; though they may not create works of grand conception, within their small compass they produce exquisite art.

The best-known and most highly regarded of these painters, once referred to as the "little Dutch masters," is JAN VERMEER (1632–75) of Delft, who was rediscovered in the twentieth century. Vermeer's pictures are small, few, and perfect within their scope. While the fifteenth-century Flemish painters did interiors of houses occupied with persons who were usually of sacred significance, Vermeer and his contemporaries composed neat, quietly opulent interiors of Dutch middle-class merchants in which they placed men, women, and children engaged in household tasks or some little recreation—actions totally commonplace, yet reflective of the values of a comfortable domesticity that has a simple beauty. Vermeer usually composed with a single figure, though sometimes with two or more. His *Young*

last state, not the historical but the symbolic significance of the scene comes to the fore. As if impatient with the earlier detail, Rembrandt furiously eliminated most of it with hard, downward strokes of the needle, until what appears like a storm of dark lines pours down from heaven, leaving a zone of light upon the lonely figure of the crucified. Rembrandt here seems clearly to show that "the entire biblical story is meant to lead us to the cross."

The art of his later years was not really acceptable to Rembrandt's contemporaries, though occasionally he got important commissions, like that for the *Syndics of the Cloth Guild*. It was too personal, too eccentric; many, like the Italian biographer Baldinucci, thought Rembrandt was

Woman with a Water Jug (FIG. 15-43) can be considered typical. The girl opens the window to water flowers in a window box outside. This action is insignificant in itself and only one of hundreds performed in the course of a domestic day. Yet Vermeer, in his lighting and composing of the scene, raises it to the level of some holy, sacramental act. The old Netherlandish symbolism that made every ordinary object a religious sign is gone; but this girl's slow, gentle gesture is almost liturgical. The beauty of humble piety, which Rembrandt finds in human faces, is here extended to a quite different context. The Protestant world, abjuring great churches, finds a sanctuary in a modest room illuminated by an afternoon sun. Yet the light is not the mysterious, spiritual light that falls upon the face in a Rembrandt portrait, like an outward manifestation of the "inner light" of grace stressed in Protestant mysticism; it is ordinary daylight, observed with a keenness of vision unparalleled—unless we think of Velázquez—in the history of art. Vermeer is master of pictorial light and so comprehends its functions that it is completely in the service of the artist's intention, which is to render a lighted depth so faithfully that the pic-

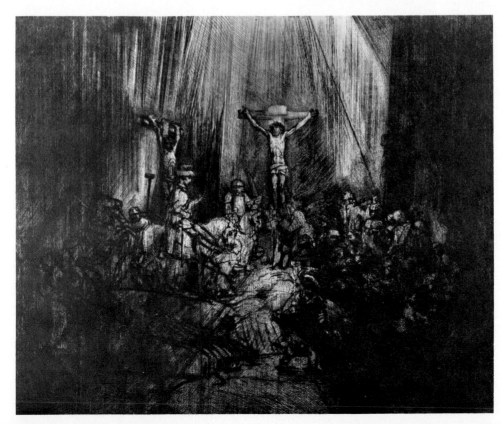

15-41 Above: REMBRANDT VAN RIJN, *Self-Portrait*, c. 1660. Approx. 33″ × 26″. National Gallery of Art, Washington, D.C. (Mellon Collection).

15-42 Left: REMBRANDT VAN RIJN, *The Three Crosses*, 1653. Fourth-state etching, approx. 15″ × 18″. British Museum, London.

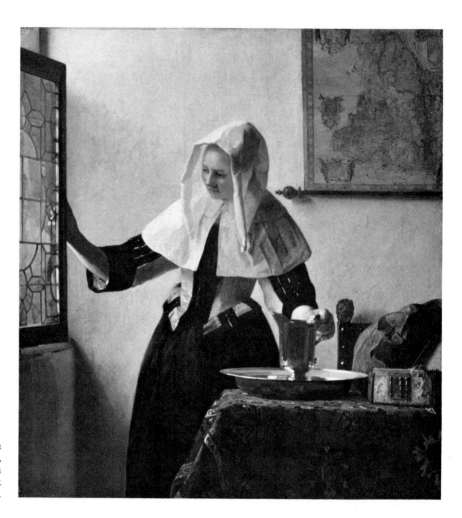

15-43 JAN VERMEER, *Young Woman with a Water Jug*, c. 1665. Oil on canvas, approx. 18″ × 16″. Metropolitan Museum of Art, New York (gift of Henry G. Marquand, 1889).

ture surface is but an invisible glass through which we look immediately into the constructed illusion. We know that Vermeer made use of mirrors and of the *camera obscura*, an ancestor of the modern camera in which a tiny pinhole, acting as a lens, projected an image upon a screen or the wall of a room or, in later versions, upon a ground-glass wall of a box, the opposite wall of which contained the pinhole. This does not mean he merely copied the image; these aids helped him to results that he reworked compositionally, arranging his figures and the furniture of the room in a beautiful stability of quadrilateral shapes that gave his designs a matchless classical calm and serenity. This quality is enhanced by a color so true to the optical facts and so subtly modulated that it suggests Vermeer was far ahead of his time in color science. A detail of our

picture (PLATE 15-8) shows, for one thing, that Vermeer realized that shadows are not colorless and dark, that adjoining colors affect one another,[3] and that light is composed of colors; thus, the blue drape is caught as a dark blue on the side of the brass pitcher, and the red of the carpet is modified in the low-intensity gold hue of the basin. It has been recently suggested that Vermeer also perceived the phenomenon called by photographers *disks of confusion*. These appear in out-of-focus films, and Vermeer could have seen them in images projected by the primitive

[3] Because of the phenomenon of *complementary after-image*, in which, for example, the eye retains briefly a red image of a green stimulus; thus, a white area adjoining a green will appear "warm" (slightly pink), and a blue adjoining the same green will shift toward violet (blue plus the after-image red).

lenses of the camera obscura. These he approximates in light dabs and touches that, in close view, give the impression of an image slightly "out of focus"; when we draw back a step, however, as if adjusting the lens, the color spots cohere, giving an astonishingly accurate illusion of a third dimension. All these technical considerations reflect the scientific spirit of the age, but they do not explain the exquisite poetry of form and surface, of color and light, that could come only from the sensitivity of a great artist. In Proust's *Swann's Way*, the connoisseur hero, trying unsuccessfully to write a monograph on Vermeer, admits that no words could ever do justice to a single patch of sunlight on one of Vermeer's walls.

With the "little Dutch masters," the humblest objects, which receive their meaning by their association with human uses, are treated as reverently as if they were sacramentals. The Dutch painters of still life isolate these objects as profoundly interesting in themselves and made of them both scientific and poetic exercises in the revelation of the functions and the beauties of light. There are many fine examples of Dutch still life, all done with the expertness of the specialist in analytical seeing. A still life by WILLEM KALF (1619–93) can serve as exemplary of the school (PLATE 15-9). Against a dark ground the artist arranges glass goblets, fruit, a silver salver, and a Turkish carpet, making a rich counterpoint of absorptive and reflective textures. The glossy, transparent shells of the goblets gleam like night skies with galaxies of sparklets and light filaments, contrasting with the slightly duller highlights that edge the salver. There is a textural gradation from the glass to the silver, from a lemon to a pomegranate to the muted glow of the light-absorbing Turkish carpet. The luminous flesh of the peeled lemon gleams as if lighted from within. (Oranges, emblem of the ruling House of Orange, are more usual in Dutch still life than are lemons.) This little masterpiece shows how this age of seeing must have taken pleasure in the infinite variety of the play of light in the small universe as well as the large. This is not dull imitation; it is revelation of what can be seen if the eye will learn to see it.

The Baroque world discovers the infinite, whether the infinitely small or the infinitely great. The spark of light that lifts the rim of a glass out of darkness becomes, when expanded, the sunlit heavens. The globule of dew on a leaf in a Dutch flower painting becomes the aqueous globe of Earth itself. The space that began to open behind the figures of Giotto now, in Dutch landscape, takes flight into limitless distance, and man dwindles into insignificance—"his time a moment, and a point his place." In some of the works of JACOB VAN RUISDAEL (1628–82) the human figure does not appear or appears only minutely. In his *View of Haarlem* (PLATE 15-10) we have almost a portrait of the newly discovered infinite universe, the sky taking up two thirds of the picture space. Ruisdael, one of the great landscape painters of all time, turned to the vast and moody heavens that loom above the flat dune-lands of Holland. His sullen clouds, in great droves never quite scattered by the sun, are herded by the winds that blew the fortunes of Holland's fleets as well as the disaster of the invading seas. Storms are always breaking up or gathering; the earth is always drenched, or about to be. As Rembrandt read the souls of men in their faces, so Ruisdael reads the somber depths of the heavens. No angels swoop through his skies or recline on his clouds, for clouds now are simply water vapor. Like Rembrandt's, his is a "Protestant" reading of nature. The difference between northern and southern Baroque is evident at once and completely in a comparison of Fra Pozzo's *Glorification of St. Ignatius* (FIG. 15-25) and Ruisdael's *View of Haarlem*. It is the difference between the heavens of Jesuit vision and the heavens of Newton and Leibniz.

France

In the second half of the seventeenth century the fortunes of both Holland and Spain sank before those of France, whose "sun king," Louis XIV, dominated the period of European history between 1660 and 1715. The age of Louis XIV saw the ascendancy of French power in Europe, politically and culturally, and the achievement of an international influence in taste that France has still not entirely lost. The French regard this period as their golden age, when Paris began to replace Rome as the art center of Europe; when

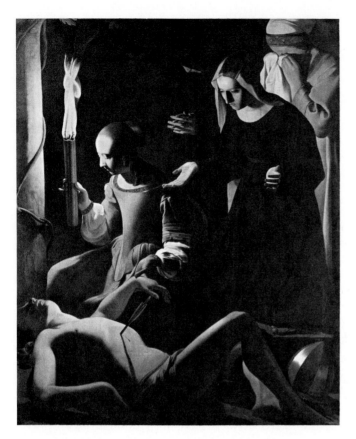

15-44 GEORGES DE LA TOUR, *The Lamentation over St. Sebastian*, 1630's. Approx. 5' 3" × 4' 3". Staatliche Museen PreuBischer Kulturbesitz Gemäldegalerie Berlin (West).

Baroque. Even though we can find much that is Baroque in the "classical" art produced in the time of *le roi soleil*, classicism came to be thought of as standard by the French for centuries.

PAINTING

The earlier part of the seventeenth century saw the slow recovery of France from the anarchy of the religious wars. While Cardinals Richelieu and Mazarin painfully rebuilt the power and prestige of the French throne, French art remained under the influence of Italy and Flanders. Even so, artists of originality emerged—for example, GEORGES DE LA TOUR (1593–1652), a painter who learned of Caravaggio possibly through the Dutch school of Utrecht. Much as De la Tour uses the devices of the northern Caravaggisti, his effects are strikingly different from theirs. His *Lamentation over St. Sebastian* (FIG. 15-44) shows us the type of night scene favored by that school, as we have seen it in Honthorst (FIG. 15-34). However, he places the source of illumination—the flaming torch—within the picture, not shielding it. His strong light falls upon forms greatly simplified, almost abstract, with no complication of surface, drapery, or texture to deflect or splinter the light and shade. This geometric simplicity of light upon smooth volumes gives a kind of classical stability and a calm stillness that—in another place and time—belonged especially to the art of Piero della Francesca. In the *St. Sebastian*, only the light is dramatic; the gestures and attitudes of the figures are coolly understated.

LOUIS LE NAIN (about 1593–1648) bears, with his contemporary, De la Tour, comparison with the Dutch: Subjects that in Dutch painting are an opportunity for boisterous good humor are managed by the French with a cool stillness. Le Nain's *Family of Country People* (FIG. 15-45) express-es the grave dignity of a family close to the soil, one made stoic and resigned by hardship. Le Nain obviously sympathizes with his subjects and seems here to want to emphasize their rustic virtue, far from the gorgeous artificiality of the courts. Stress on the honesty, integrity, and even innocence of uncorrupted country folk in the following century will become sentimentality. Le Nain's objectivity, however, permits him to

the French language became the polished instrument of discourse in diplomacy and in the courts of all countries; and when French art and criticism, fashion and etiquette, were imitated universally. Art and architecture came into the service of the king as once they had been in the service of the Church; and the unity of style so conspicuous in them is the result of the taste of Louis XIV himself, imposed upon the whole nation through his able minister Colbert and through the new academies Colbert set up to regularize style in all the arts.

The king's taste and, therefore, the taste of France favored a stately and reserved classicism in place of the lavish and emotional Baroque of Italy and most of the rest of Europe. The severe classical regularity of form in the plays of Corneille and Racine, in the Corinthian colonnade of the Louvre (FIG. 15-51), and in the painting of Poussin (see below) is exceptional in the age of the

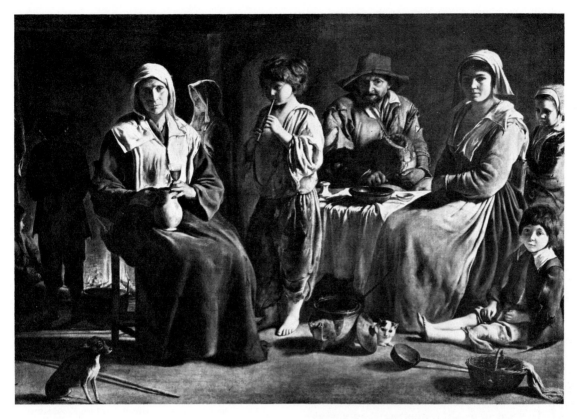

15-45 LOUIS LE NAIN, *Family of Country People*, c. 1640. Oil on canvas, approx. 44″ × 62″. Louvre, Paris.

record a group of such genuine human beings that the picture rises above anecdote and the picturesqueness of genre.

Although there is calm simplicity and restraint in De la Tour and Le Nain in comparison with other northern painters inspired by Caravaggio, and although these qualities suggest the classical, it remains for another contemporary of theirs, NICOLAS POUSSIN (1594–1665), to establish classical painting as peculiarly expressive of French taste and genius in the seventeenth century. Poussin, born in Normandy, spent most of his life in Rome. There, inspired by its monuments and the landscape of the Campagna, he produced his grandly severe and regular canvases and carefully worked out a theoretical explanation of his method. He worked for a while under Domenichino but shunned the exuberant Italian Baroque; first Titian and then Raphael were the models that he set himself. Of his two versions of a single theme, the earlier is strikingly Titianesque (FIG. 15-46). The picture is named *Et in*

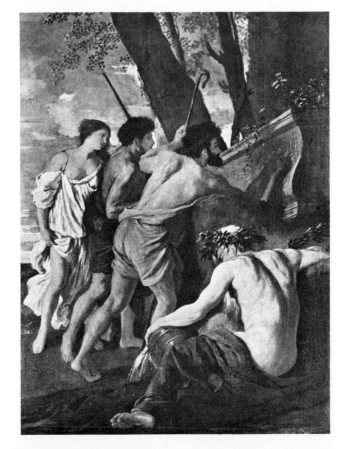

15-46 NICOLAS POUSSIN, *Et in Arcadia Ego*, c. 1630. Approx. 40″ × 32″. Reproduced by permission of the Trustees of the Chatsworth Settlement, Chatsworth.

Arcadia Ego ("I, too, in Arcadia" or "Even in Arcadia, I [am present]") from the inscription on the tomb being examined by two youthful shepherds and a shepherdess. There is all the warm, rich tonality of the Venetian master and the figure-types of his earlier period. We recognize in the tilted head of the shepherdess that of Sacred Love in *Sacred and Profane Love* (FIG. 13-51); and the shepherds and the seated river god Alpheus, in alternating light and shade, with the screen of trees and placid sky, are all familiar in Titian's idyllic "bacchanals." But in the end the rational order and stability of Raphael proved most appealing to Poussin. His second version of *Et in Arcadia Ego* (FIG. 15-47) shows what he has learned from Raphael but also directly from antique statuary; landscape, of which Poussin became increasingly fond, expands in the picture, reminiscent of Titian but also indicative of Poussin's own study of nature. The theme is somewhat obscure and has interested modern scholars. As three shepherds living in the idyllic land of Arcadia spell out an enigmatic inscription upon a tomb, a stately female figure quietly places her hand upon the shoulder of one of them. She may be the spirit of death, reminding these mortals, as does the inscription, that death is found even in Arcadia, where naught but perfect happiness is supposed to reign. The compact, balanced grouping of the figures; the even light; and the thoughtful, reserved, elegiac mood set the tone for Poussin's art in its later, classical phase.

In notes for an intended treatise on painting, Poussin outlined the "grand manner" of classicism, of which he became the leading exponent in Rome. One must first of all choose great subjects: "...the first requirement, fundamental to all others, is that the subject and the narrative be grandiose, such as battles, heroic actions, and religious themes." Minute details should be avoided, as well as all "low" subjects—like genre: "Those who choose base subjects find refuge in them because of the feebleness of their talents." This would rule out a good deal of both the decorative and realistic art of the Baroque; it was to lead to a doctrinaire limitation on artistic enterprise and experiment in the rules of the French Academy, which took Poussin as its greatest modern authority. Though Poussin could create with ease and grandeur within the scope of his rather severe

maxims, in the hands of academic followers his method could become wooden and artificial.

Poussin represents that theoretical tradition in Western art that goes back to the Early Renaissance and that asserts that all good art must be the result of good judgment—that is, a judgment based upon sure knowledge. In this way art can achieve correctness and propriety, two of the favorite categories of the classicizing artist or architect. Poussin praises the ancient Greeks for their musical "modes," by which, he says, "they produced marvelous effects." He observes that "this word 'mode' means actually the rule or the measure and form which serves us in our production. This rule constrains us not to exaggerate by making us act in all things with a certain restraint and moderation." "Restraint" and "moderation" are the very essence of French classical doctrine; in the age of Louis XIV we find it preached as much for literature and music as for art and architecture. Poussin tells us further that

> The Modes of the ancients were a combination of several things . . . in such a proportion that it was made possible to arouse the soul of the spectator to various passions. . . . the ancient sages attributed to each style its own effects. Because of this they called the Dorian Mode stable, grave, and severe, and applied it to subjects which are grave and severe and full of wisdom.[4]

Poussin's finest works, like the *Burial of Phocion* (FIG. 15-48), are instances of his obvious preference for the "Dorian" mode. His subjects are chosen carefully from the literature of antiquity, where his age would naturally look for the "grandiose," and it is with Poussin that the visual arts draw more closely to literature than ever before. Here he takes his theme from Plutarch's life of Phocion, an Athenian hero who was unjustly put to death by his countrymen but then given a public funeral and memorialized by the state. In the foreground, Poussin represents the body of the hero being taken away, his burial on Athenian soil having been forbidden. The two massive bearers and the bier they carry are starkly isolated in a great landscape that throws them into solitary relief, eloquently expressive of the hero abandoned in death. The landscape is composed

[4] In E. G. Holt, ed., *Literary Sources of Art History* (Princeton: Princeton Univ. Press, 1947), p. 380.

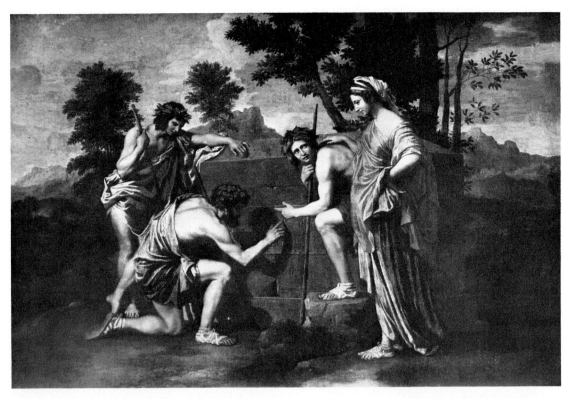

15-47 NICOLAS POUSSIN, *Et in Arcadia Ego, c.* 1640. Oil on canvas, approx. 34″ × 48″. Louvre, Paris.

15-48 NICOLAS POUSSIN, *The Burial of Phocion,* 1648. Oil on canvas, approx. 70″ × 47″. Louvre, Paris.

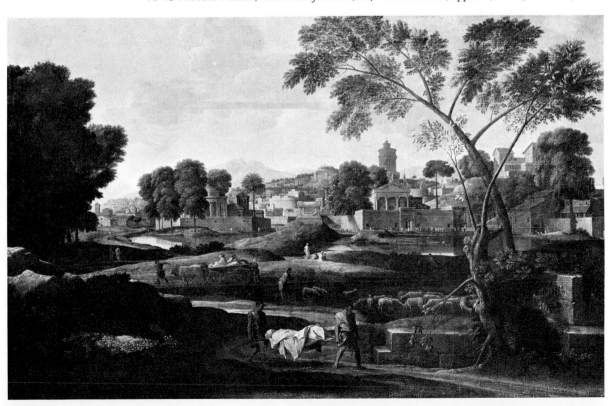

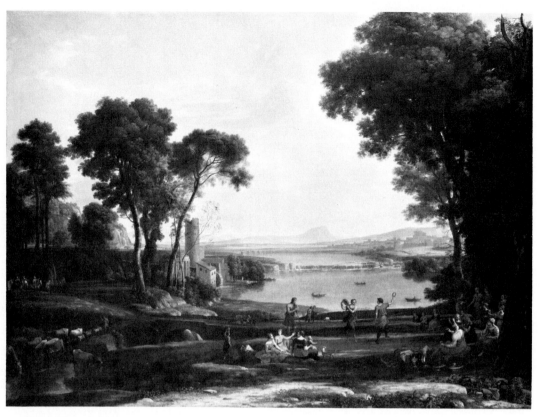

15-49 CLAUDE LORRAINE, *The Marriage of Isaac and Rebekah* (*The Mill*), 1642. Approx. 59″ × 77″. Reproduced by courtesy of the Trustees of the National Gallery, London.

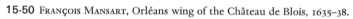

15-50 FRANÇOIS MANSART, Orléans wing of the Château de Blois, 1635–38.

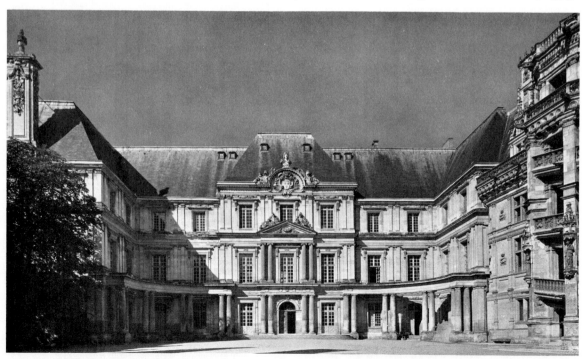

of interlocking planes that slope upward to the lighted sky at the left, carefully arranged terraces that bear slowly moving streams, shepherds and their flocks, and, in the distance, whole assemblies of solid geometrical structures—temples, towers, walls, villas. The skies are untroubled, the light even and form-revealing. The trees are few and carefully arranged, like curtains lightly drawn back to reveal a nature carefully cultivated as a setting for a single human action. For, unlike Ruisdael's *View of Haarlem* (PLATE 15-10), this is not the scene of a particular place and time; it is the construction of an *idea* of a noble landscape to frame a noble theme. The *Phocion* landscape is nature subordinated to a rational plan, much like the gardens of Versailles (see below); it is eminently of the "age of reason."

The disciplined, rational art of Poussin, with its sophisticated revelation of the geometry of landscape, is modulated in the softer style of Claude Gellée, called CLAUDE LORRAINE (1600–82), and sometimes only Claude. Unlike Poussin's pictures, Claude's are not "Dorian," the figures in his landscapes telling no story, pointing no moral, praising no hero; indeed, they often appear added as mere excuses for the radiant landscape itself (FIG. 15-49). For Claude has essentially one theme, the beauty of a broad sky suffused with the golden light of dawn or sunset that makes its glowing way through hazy atmosphere. The setting may be a seaport, a wooded dell, watered plains; generally there are screens of dark trees to left or right, sometimes at the center, making stagelike wings that intensify the central light. Occasionally, a classical temple will appear in the cool shadows, and some little idyl will play itself out inconspicuously in the foreground. In essence Claude seeks to capture the mood of the Italian landscape; he, like Poussin, was a French expatriate in Italy, and like him a lover of the broad Campagna with its romantic ruins. His own pensive and nostalgic mood blends with his setting, and it is his stress on the subjective side of nature that made his work so popular with the early Romantics at the end of the eighteenth century.

ARCHITECTURE AND SCULPTURE

In architecture as in painting France maintained an attitude of cautious selectivity toward the Italian Baroque. The classical bent early asserted itself in the work of FRANÇOIS MANSART (1598–1666), as may be seen in the Orléans wing of the château at Blois, built between 1635 and 1638 (FIG. 15-50). Here are the polished dignity and sobriety that become the hallmarks of French "classical-baroque" in contrast with the more daring, excited, and fanciful styles of the Baroque in Italy and elsewhere. The strong rectilinear organization and tendency to design in terms of repeated units remind one of Italian Renaissance architecture, as does the insistence on the purity of line and sharp relief of the wall articulations. Yet the emphasis on a focal point, achieved through the curving colonnades, the changing planes of the walls, and the concentration of ornament around the portal, is characteristic of Baroque architectural thinking in general.

The formation of the French classical style accelerated with the foundation of the Royal Academy of Painting and Sculpture in 1648, of which Poussin was a director, and with the determination of Louis XIV and Colbert to organize art and architecture in the service of the state. No pains were spared to raise great symbols and monuments to the king's absolute power and to regularize taste under the academies. The first project undertaken by the young king and Colbert was the closing of the east side of the Louvre court, which Lescot had left incomplete in the sixteenth century. Bernini, as the most renowned architect of his day, was summoned from Rome to submit plans. But he envisioned an Italian palace on a monumental scale that would have involved the demolition of all previous work. His scheme rejected, Bernini returned to Rome in high indignation. The east façade (FIG. 15-51) is the result of a collaboration between CLAUDE PERRAULT (1613–88), LOUIS LE VAU (1612–70), and CHARLES LE BRUN (1619–90) and is a brilliant adjustment of French and Italian classical elements brought to a new and definitive formula. The French pavilion system is retained, the central pavilion being in the form of a classical temple front, while a giant colonnade of paired columns, resembling the columned flanks of a temple folded out like wings, is contained by the two salient pavilions at either end. The whole is mounted upon a stately basement, or podium,

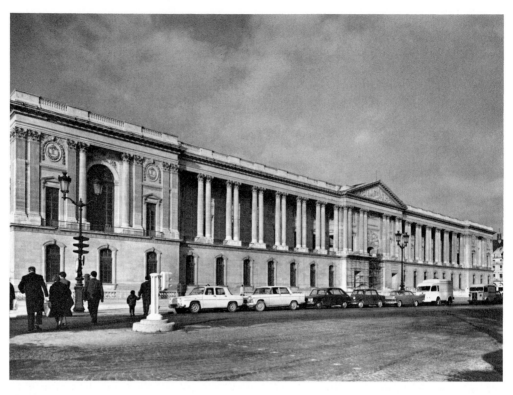

15-51 Claude Perrault, Louis le Vau, and Charles le Brun, east façade of the Louvre, Paris, 1667–70.

15-52 Palace of Versailles and a small portion of the surrounding park. The white trapezoid in the lower part of the plan on the facing page outlines the area shown here.

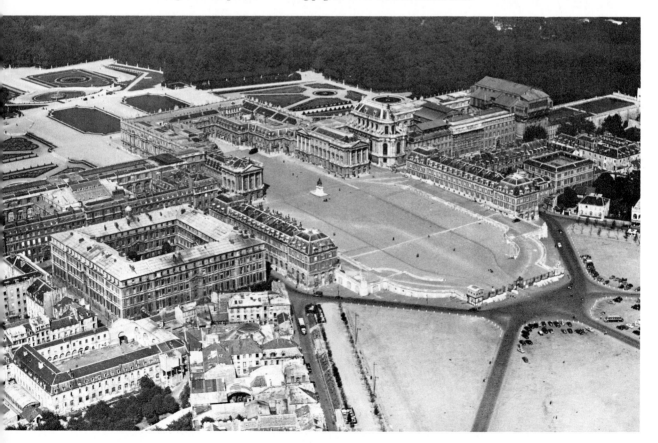

while an even roof line, balustraded and broken only by the central pediment, replaces the traditional French pyramidal roof. All memory of Gothic verticality is brushed aside in the emphatically horizontal sweep of this façade. Its stately proportions and monumentality are both an expression of the new official French taste and a symbol for centrally organized authority.

Work on the Louvre had hardly begun when Louis XIV decided to convert a royal hunting lodge at Versailles, a few miles outside Paris, into a great palace. A veritable army of architects, decorators, sculptors, painters, and landscape architects was assembled under the general management of a former Poussin student, Charles le Brun, the king's impresario of art and dictator of the Academy. In their hands the conversion of a simple hunting lodge into a palace became the greatest architectural project of the age (FIG. 15-52 and facing-page plan).

Planned on a gigantic scale, the project called not only for a large palace facing a vast park but

A plan (after a seventeenth-century engraving by Blondel) of the Palace of Versailles and related buildings, Le Nôtre's vast surrounding park (1661–68), and a portion of the town of Versailles. The area outlined in white (lower center) is shown in FIG.. 15 -52.

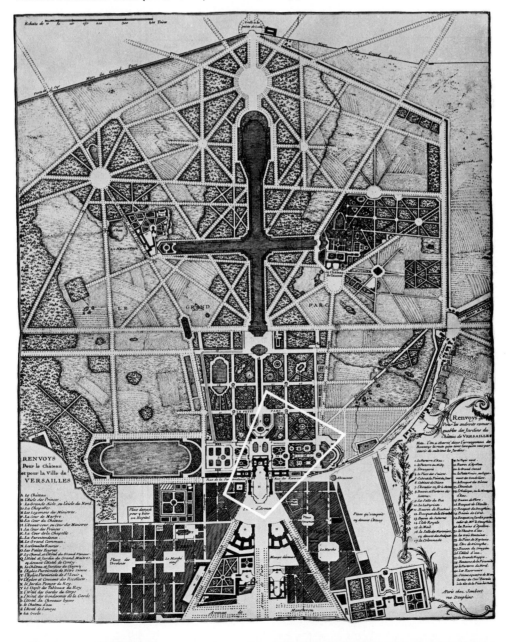

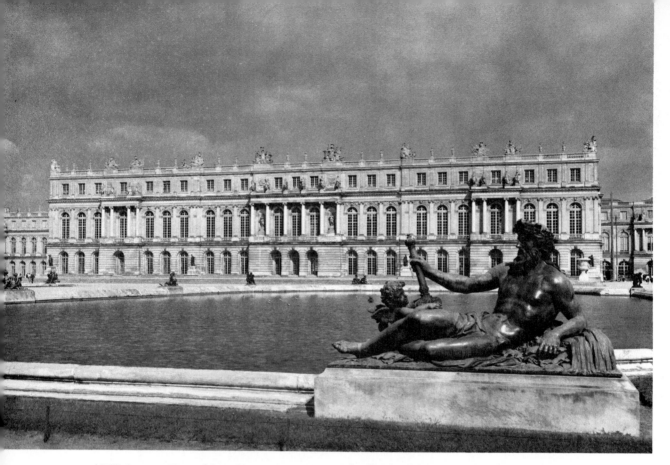

15-53 Louis le Vau and Jules Hardouin Mansart, garden façade of the palace at Versailles, 1669–85.

also for the construction of a satellite city to house court and government officials, military and guard detachments, courtiers, and servants. This town was laid out to the east of the palace along three radial avenues that converge on the palace, their axes, in a symbolic assertion of the ruler's absolute power over his domains, intersecting in the king's bedroom. (As the site of the king's morning levee, this bedroom was actually an audience room, a state chamber.) The palace itself, over a quarter of a mile long, is placed at right angles to the dominant east-west axis that runs through city and park. Its most impressive feature is the garden façade (FIG. 15-53), begun by Le Vau and continued in his style by JULES HARDOUIN MANSART (1646–1708), a great-nephew of François who took over the project after Le Vau's death in 1670. In typical Baroque fashion, the vast lateral extension of the façade has been broken up into units and subunits of threes, an organizational device that even on this scale is effective.

Careful attention was paid to every detail of the extremely rich decoration of the palace's interior; everything from wall paintings to doorknobs was designed in keeping with the whole and executed with the very finest sense of craftsmanship. Of the literally hundreds of rooms within the palace, the most famous is the Galerie des Glaces (Hall of Mirrors), which overlooks the park from the second floor and extends along most of the width of the central block (FIG. 15-54). Although deprived of its original sumptuous furniture, which included gold and silver chairs and bejeweled trees, it retains much of its splendor today. Its tunnel-like quality is alleviated by hundreds of mirrors, which, set into the wall opposite the windows, illusionistically extend the width of the room. The mirror, that ultimate source of illusion, was a favorite element of Baroque interior design; here it must have harmonized as it augmented the flashing splendors of the great festivals of which Louis XIV was so fond.

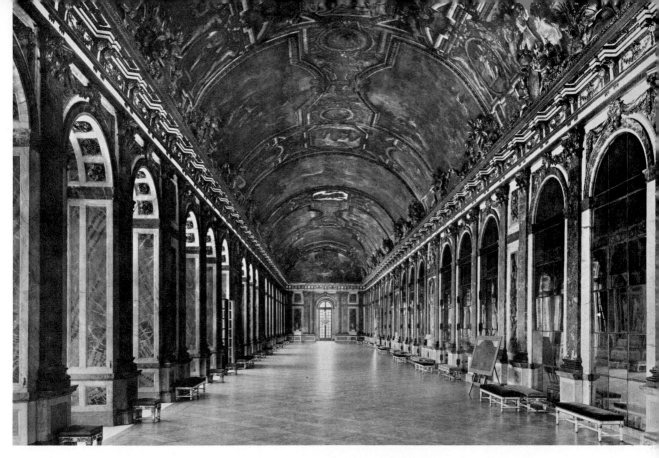

15-54 Jules Hardouin Mansart and Charles le Brun, Galerie des Glaces, palace at Versailles, *c.* 1680.

The enormous palace might appear unbearably ostentatious, were it not for its extraordinary setting in the vast park to which it becomes almost an adjunct. The Galerie des Glaces, itself a giant perspective, is dwarfed by the sweeping vista (seen from its windows) down the park's tree-lined central axis and across terraces, lawns, pools, and lakes toward the horizon. The park of Versailles, designed by André Le Nôtre (1613–1700), must rank as one of man's greatest works of art, not only in size, but also in concept. Here an entire forest was transformed into a park. While the geometric plan may appear stiff and formal, the park, in fact, offers an almost unlimited variety of vistas, as Le Nôtre utilized not only the multiplicity of natural forms, but also the slightly rolling contours of the terrain with stunning effectiveness. A rational transition from the frozen forms of the architecture to the living ones of nature is provided by the formal gardens near the palace. Here, tightly designed geometric units are defined by the elegant forms of trimmed

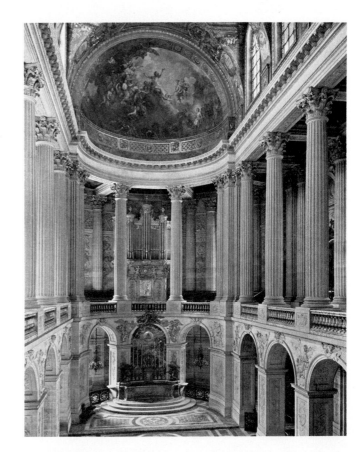

15-55 Jules Hardouin Mansart, Royal Chapel of the palace at Versailles, 1698–1710.

shrubs and hedges, each one different from its neighbor and each one having a focal point in the form of a sculptured group, a pavilion, a reflecting pool, or perhaps a fountain. Farther away from the palace, the design becomes looser as trees are used in shadowy masses, screening or framing views into bits of open countryside, all vistas carefully composed for maximum effect. Dark and light, formal and informal, dense growth and open meadows, are played off against each other in unending combinations and variations. No photograph or series of photographs can reveal the full richness of the design; the park unfolds itself only to the person who actually walks through it. In this respect it is a temporal work of art whose aspects change with time and the relative positions of the observer.

As a symbol of the power of absolutism, Versailles is unsurpassed. It also expresses, in the most monumental terms of its age, the rationalistic creed, based upon the mathematical philos-

ophy of Descartes, that all knowledge must be systematic and all science the consequence of the imposition of the intellect upon matter. The whole stupendous design of Versailles proudly proclaims the mastery of human intelligence over the disorderliness of nature.

On the garden façade of Versailles, Mansart had followed the style of his predecessor, Le Vau. When he was commissioned to add a royal chapel to the palace in 1698, he was in a position to give full play to his talents. The interior of the chapel (FIG. 15-55) is a masterful synthesis of classical and Baroque elements. It is essentially a rectangular building with an apse as high as the nave, giving the fluid central space a curved Baroque quality. But the light entering through the large clerestory windows lacks the directed, dramatic effect of the Italian Baroque, illuminating brightly and evenly the precisely chiseled details of the interior. Pier-supported arcades carry a majestic row of Corinthian columns that define the royal gallery, the back of which is occupied by the royal pew, accessible directly from the king's apartments. The decoration is restrained and, in fact, only the illusionistic ceiling decorations (1708–09) by Antoine Coypel can be called Baroque without reservation. Throughout the architecture, Baroque tendencies are severely checked by classicism.

The stylistic dialogue between classicism and the Italian Baroque in seventeenth-century French sculpture also ends with the former's victory. The strained dramatic and emotional qualities in the work of PIERRE PUGET (1620–94) were not at all to the taste of the court. His *Milo of Crotona* (FIG. 15-56) represents the powerful ancient hero, his hand trapped in a split stump, helpless before the attacking lion. There is nothing here of heroic idealism; with physical and psychical realism, Puget presents a study of immediate and excruciating agony. This ran counter to the official taste as dictated by the king and Le Brun, and although he was very briefly in vogue, the most original French sculptor of his time never found acceptance at the court.

Much more fortunate was FRANÇOIS GIRARDON (1628–1715), whose style was admirably adjusted to the taste of his sponsors. His *Apollo Attended by the Nymphs* (FIG. 15-57) was designed as a tableau group for the Grotto of Thetis in the gardens of

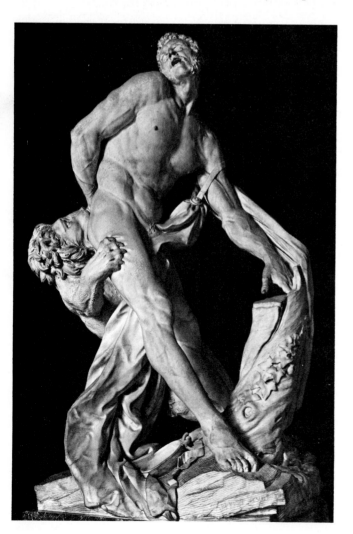

15-56 PIERRE PUGET, *Milo of Crotona*, 1671–82. Marble, approx. 8' 10" high. Louvre, Paris.

15-57 François Girardon, *Apollo Attended by the Nymphs, c. 1666–72.* Marble, life-size. Park of Versailles.

Versailles. (The arrangement of the figures was slightly altered when the group was moved to a different grotto in the eighteenth century.) The style of the figures is heavily conditioned by the artist's close study of Hellenistic sculpture; the arrangement is inspired by Poussin's figure compositions. And if this combination did not suffice, the group's rather florid reference to Louis XIV as the god of the sun was bound to assure its success at the court. Girardon's style and symbolism were found to be ideally suited to the glorification of royal majesty.

England

English art has been mentioned little since the Middle Ages because, except for its architecture, England is outside the main artistic streams of the Renaissance and the Baroque. It is as if the English genius were occupied enough with its prodigious creation in dramatic literature, lyric poetry, and music, and not, after all, particularly suited to the purely visual arts. Not until the eighteenth

century does England develop an important native school of painting and extend its distinguished architectural tradition.

Gothic practices lived on in English building, as in French, long after Renaissance architects in Italy had struck out in new directions. During the sixteenth century the English made minor concessions to Italian architectural ideas. Classical ornament made frequent appearances in the decoration of buildings, and there was a distinct trend toward more regular and symmetrical planning. But not until the early seventeenth century was there a wholehearted acceptance of the principles that governed Italian architectural thinking. The revolution in English building was primarily the work of one man, Inigo Jones (1573–1652), who was surveyor (that is, architect) to James I and Charles I. Jones spent considerable time in Italy. He disliked the work of Michelangelo as intensely as he admired Palladio's, whose treatise on architecture he studied with great care. From the stately palaces of Palladio, Jones selected certain motifs and systems of proportions that he used as the basis of his own archi-

15-58 INIGO JONES, Banqueting Hall at Whitehall, London, 1619–22. British Crown Copyright.

tectural designs. The nature of his achievement is evident in the Banqueting Hall at Whitehall (FIG. 15-58). The structure is a symmetrical block of great clarity and dignity using two orders superimposed in the form of columns in the center and pilasters near the ends. The balustraded roof line, uninterrupted in its horizontal sweep, anticipates Perrault's Louvre façade by more than forty years. There is almost nothing here that Palladio would not have recognized and approved, but the building as a whole is no copy. While working within the architectural vocabulary and syntax of the revered Italian, Jones retains his own independence as a designer, and for the next two centuries his influence is almost as authoritative in English architecture as Palladio's. It is noteworthy that Jones's interior at Whitehall was adorned with paintings by Rubens in a fruitful collaboration recalling the combination of painting by Veronese and architecture by Palladio in northern Italian villas.

Until almost the present day, the dominant feature of the London skyline has been the majestic dome of St. Paul's (FIG. 15-59), the work of England's most renowned architect, CHRISTOPHER WREN (1632–1723). Wren, a mathematical genius and skilled engineer whose work had won the praise of Isaac Newton, had begun as a professor of astronomy and had taken an amateur's interest in architecture. Asked by Charles II to prepare a plan for the restoration of the old Gothic church of St. Paul, he proposed to remodel the building "after a good Roman manner," rather than "to follow the Gothic rudeness of the old design." Within a few months, the great fire of 1666, which destroyed the old structure and many churches in the city, gave Wren his opportunity. He built not only the new St. Paul's but numerous other churches. Wren was one of those Baroque virtuosi of many talents, the archetype of whom we have seen in Bernini. He was strongly influenced by the work of Jones, but he also traveled in France, where he must have been much impressed by the splendid palaces and state buildings being created in and around Paris at the time of the competition for the Louvre design.

Wren must also have studied closely prints illustrating Baroque architecture in Italy, for Palladian, French, and Italian Baroque features are harmonized in St. Paul's. In view of its size the cathedral was built with remarkable speed—in a little over forty years—and Wren lived to see it completed. The form of the building was constantly refined as it went up, and the final appearance of the towers was not determined until after 1700. The splendid skyline composition, with the two foreground towers acting so effectively as foils to the great dome, must have been suggested to Wren by similar schemes devised by Italian architects to solve the problem of the façade-dome relation of St. Peter's in Rome. Perhaps Borromini's solution at Sant' Agnese in Piazza Navona influenced him. Certainly the upper levels and lanterns of the towers are Borrominesque, while the lower levels are Palladian, and the superposed, paired columnar porticoes remind us of Perrault's Louvre façade. Wren's skillful eclecticism brings all these foreign features into a monumental unity.

Wren's designs for the city churches are masterpieces of Baroque planning ingenuity. His task was never easy, for the churches often had to be fitted into small, irregular areas. Wren worked out a rich variety of schemes to meet awkward circumstances. In designing the exteriors of the churches he concentrated his attention on the towers, the one element of the structure that would set the building apart from its crowding neighbors. The skyline of London as left by Wren was punctuated with such towers, which served as prototypes for later buildings both in England and colonial America.

THE EIGHTEENTH CENTURY

At first sight it might appear that the eighteenth century is merely an extension of the Baroque, a mellowing and refinement of it, and not sharply distinguishable from it either chronologically or spiritually. Yet there are differences, not sharp to be sure, but enough to make distinctive characteristics come to mind when we speak of the eighteenth century.

15-59 CHRISTOPHER WREN, St. Paul's Cathedral, London, 1675–1710.

The political world takes new shapes. This is the century of the rise to great power of the maritime British empire, which disputes with France the continent of North America and the subcontinent of India. Against the awkward and shaky Holy Roman Empire rises the small but aggressive state of Prussia, soon to become a significant military power. Farther to the east looms the unsuspected might of half-Asiatic Russia, accelerating its slow turn toward the West under Peter the Great. Spain is sunk in decadence, Italy a jumble of properties owned by the great powers. The real domain of the once universal Church is confined to a narrow strip of territory in Italy called the States of the Church; elsewhere the State controls, and the Church is subordinate to the sovereign. New ideas are being propagated that will attack both Church and State—democratic ideas of the freedom and equality of all men. "Enlightened" monarchs cultivate outspoken men like Voltaire, who call for reforms of old abuses and for a limitation of the privileges of monarchy, aristocracy, and cler-

gy. Reason and common sense are urged as the real remedies of human ills, and progress is claimed as a law of human development. In the eighteenth century it is as if all Europe were waiting breathlessly for the tremendous revolutions to come.

The period between the death of Louis XIV (1715) and the outbreak of the American Revolution (1775) is a period of relative relaxation after the exhausting "world" wars waged by the great kings; though wars continue to be fought, they are of the nature of balancing maneuvers among the various states and are waged by professionals with a kind of chessboard formality. The ruling aristocracies, as if conscious of their waning historical significance, gradually abandon their administrative—even executive—function to men of the ambitious "third estate," the increasingly wealthy and influential middle class. Without fully realizing it, royalty and nobility are slowly becoming obsolete. Yet in this time they remain the patrons of the arts; and the arts express to a remarkable degree the philosophy of the aristocracy in decline. Life for the aristoc-

racy is simply the pursuit of pleasure, the escape from boredom; art is luxurious, frivolous, sensual, clever; the great themes of the Baroque, religious and classical, presented in the grand manner of the masters, are forgotten. Intricate and witty artifice is the artist's objective in all the arts—drama, music, painting, sculpture.

The Continent: Rococo

All Europe breathed a sigh of relief at the death of Louis XIV. The court of Versailles was at once abandoned for the pleasures of town society, and the *hôtels* (town houses) of Paris became the centers of the style we call Rococo, which was the reaction to the style of Louis XIV. With respect to this change, it has been well said that the seventeenth century ends with a portrait of a king and the eighteenth century begins with a portrait of a clown. Hyacinthe Rigaud's portrait of Louis XIV (FIG 15-60) set side by side with Antoine Watteau's *L'Indifférent* (FIG. 15-61) illustrates exactly the contrast of the periods. On the

15-60 HYACINTHE RIGAUD, *Louis XIV*, 1701. Oil on canvas, approx. 9' 2" × 6' 3". Louvre, Paris.

15-61 ANTOINE WATTEAU, *L'Indifférent*, c. 1716. Approx. 10" × 7". Louvre, Paris.

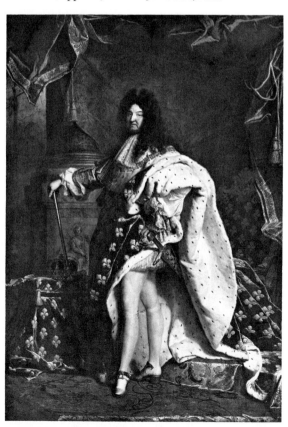

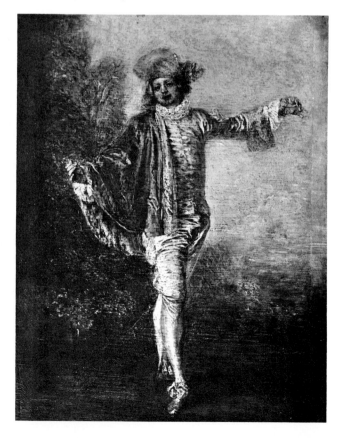

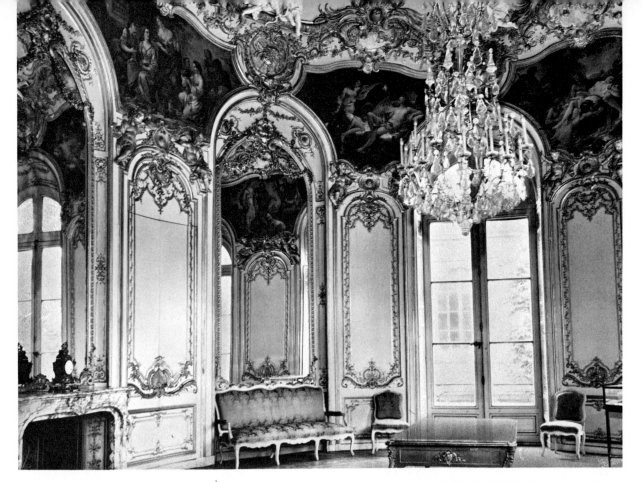

15-62 Salon de la Princesse, Hôtel de Soubise, Paris, 1737–40. Decorations by Germain Boffrand. British Crown Copyright.

one hand pompous majesty is in slow and stately promenade as if reviewing throngs of bowing courtiers at Versailles; on the other is a languid, gliding ballet dancer whose mincing minuet might almost mimic the monarch's solemn pacing. In the first, stout architecture, bannerlike curtains, flowing ermine, and fleur-de-lis exalt the king, while fanfares of trumpets blast; in the second, the dancer, to the silken sound of strings, moves in a rainbow shimmer of color from the wings onto the stage of the comic opera. The portrait of the king is very large, the "portrait" of the clown quite small; the one is Baroque, the other Rococo.

The sparkling gaiety cultivated by the new age, associated with the regency that followed upon Louis XIV's death and then with the reign of Louis XV, finds perfectly harmonious expression in Rococo. The word "Rococo" comes from the French *rocaille*, which literally means "pebble," but which refers especially to the small stones

and shells used to decorate the interiors of grottoes. Such shells or shell forms are the principal motifs in Rococo ornament. The Rococo is essentially an interior style; it is a style preeminently of small art, and furniture, utensils, accessories; objects of all sorts, useful and otherwise, are exquisitely wrought in the characteristically delicate, undulating Rococo line. A typically Rococo room is the Salon de la Princesse (FIG. 15-62) of the Hôtel de Soubise in Paris, decorated by GERMAIN BOFFRAND (1667–1754). If we compare it with the Galerie des Glaces at Versailles (FIG. 15-54), we see at once the fundamental difference. The strong architectural lines and panels of the earlier style are softened into flexible, sinuous curves; the walls melt into the vault; the cornices are replaced by irregular shapes that are painted, surmounted by sculpture, and separated by the typical shells of *rocaille*. Painting, architecture, and sculpture make a single ensemble. The profusion of curving tendrils and sprays of foliage combine

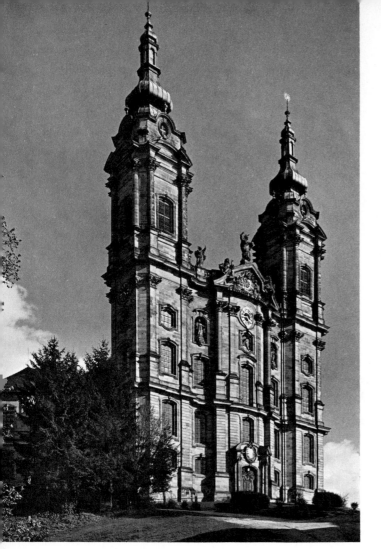

with the shell forms to give an effect of freely growing nature and to suggest that the Rococo room is permanently decked for a festival. Such rooms, with their alternating gilded moldings, vivacious relief sculpture, and daintily colored ornament of flowers and garlands, must have harmonized with the chamber music played in them, with the elegant and elaborate costumes of lustrous satins and brocades, and with the equally elegant etiquette and sparkling wit of the people who graced them.

The Rococo salon is the locale of Parisian society, and Paris is the social capital of Europe in the eighteenth century. Wealthy, ambitious, and clever society women vied with one another to attract the most famous, the wittiest, and most accomplished men to their salons. The medium

of social intercourse was conversation spiced with wit, repartee as quick and deft as a fencing match. The feminine look of the Rococo style suggests that the age was dominated by the taste and the social initiative of women; and to a large extent it was. Women held the highest places in Europe—Madame de Pompadour in France, Maria Theresa in Austria, Elizabeth and Catherine in Russia—and female influence was felt in any number of smaller courts. The masculine heroics and rhetoric of the Baroque are replaced by dainty gallantries and pointed sallies of wit. Artifice reigns supreme, and it is considered bad taste to be "original" or "enthusiastic"—that is, eccentric or sincere. One can find the spirit of the age perfectly expressed in Lord Chesterfield's *Letters to His Son*, instructing him in the manners of the Rococo salon. The honest Dr. Johnson, when he complained that the letters taught "the manners of a dancing master and the morals of a whore," may have been indicting the whole age.

The Rococo in architecture quickly became an international style during the early eighteenth century. The great prestige enjoyed by France gave impetus to this development, but there had been indications throughout late seventeenth-century Europe of a general shift toward a lighter, gayer, more decorative type of expression. One of the most distinctive variants of Rococo architecture developed in southern Germany and Austria, an area that had lain dormant artistically during the seventeenth century but that was the scene of a great wave of church building in the eighteenth. Here the new style was not confined to interiors but appeared in exteriors and plans. The chief influence, moreover, was not French but stemmed from the architecture of Borromini and Guarini, so that it is perhaps more accurate to think of it as late Baroque with strong stylistic affinities to Rococo. One of the most splendid of the German buildings is the pilgrimage church of Vierzehnheiligen (Fourteen Saints) by BALTHASAR NEUMANN (1687–1753). The rounded corners and the undulating center of the façade (FIG. 15-63) recall Borromini without approaching his dra-

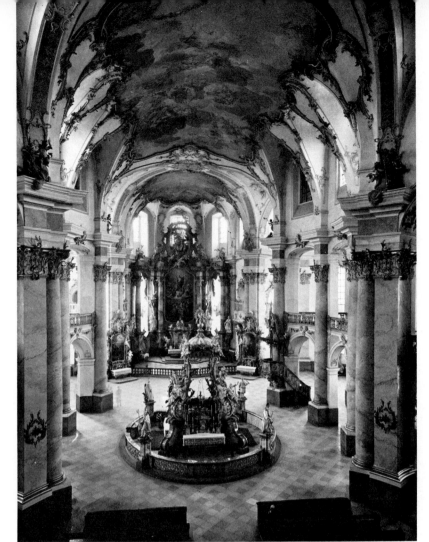

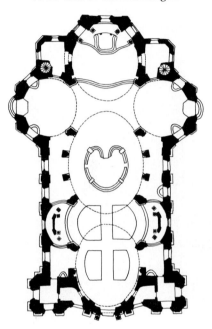

15-65 Plan of Vierzehnheiligen.

matic intensity. Numerous large windows in the richly articulated but continuous walls flood the interior with an even, bright, and cheerful light. The interior (FIG. 15-64) exhibits a vivacious play of architectural fantasy that retains the dynamic but banishes all the dramatic qualities of the Italian Baroque. The features pulse, flow, and commingle as if they were plastic ceaselessly in the process of being molded. The fluency of all line, the floating and hovering surfaces, make us reach for the analogy of music; and indeed, in this great age of music, the intricacy of the voices in a Bach fugue are brought to mind by the interwoven spaces and dematerialized masses of a structure that is the image of "frozen music." The complexity of Vierzehnheiligen is readable in its ground plan (FIG. 15-65), which has been called "one of the most ingenious pieces of architectural design ever conceived." The straight line seems to have been deliberately banished; the composition is made up of tangent ovals and circles, so that within the essential outlines of the traditional Gothic church (apse, nave, and western towers) an interior effect of a quite different sort is achieved—an undulating space in continuous motion, creating unlimited vistas bewildering in their variety and surprise effects. We must think of this kind of church as a brilliant ensemble of architecture, sculpture, music, and painting in which the boundaries of the arts dissolve in visionary unity.

The ceiling decorations of Vierzehnheiligen, like those of most German Rococo churches, are inspired by the last great Italian painter who

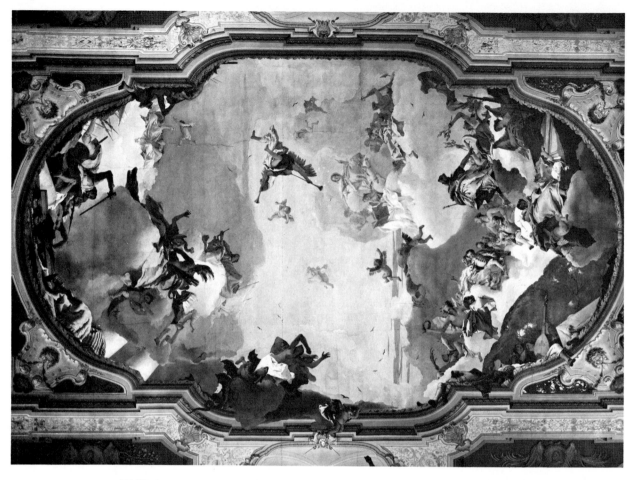

15-66 GIAMBATTISTA TIEPOLO, *The Apotheosis of the Pisani Family*, 1761–62. Ceiling fresco in the Villa Pisani, Stra.

had an international impact, GIAMBATTISTA TIEPOLO (1696–1770). Of Venetian origin, Tiepolo worked for patrons in Austria, Germany, and Spain, as well as Italy, leaving a strong impression wherever he went. His bright, cheerful colors and his relaxed compositions were ideally suited to Rococo architecture. The *Apotheosis of the Pisani Family* (FIG. 15-66) shows airy populations fluttering through vast sunlit skies and fleecy clouds, their figures making dark accents against the brilliant light of high noon. While retaining the illusionistic tendencies of the seventeenth century, Tiepolo discards all dramatic bombast and creates gay and brightly colored pictorial schemes of great elegance and grace, which, for sheer effectiveness as decor, are unsurpassed.

It is the painters of France in the eighteenth century who give to the Rococo its earthly setting—the salon, the theater, and the boudoir—and create its sensuous moods and luxuriant intimacy. The painter above all others whom we associate with the Rococo is ANTOINE WATTEAU (1684–1721). We have already cited his *L'Indifférent* to exhibit what is typical of the Rococo in painting. His masterpiece (he made two versions of it) is the *Embarkation for Cythera* (PLATE 15-11), which he painted between 1717 and 1719 as his acceptance piece for admission to the Academy. Watteau was Flemish, and his style is a beautiful derivative from that of Rubens, a kind of rarefaction and refinement of it. At the turn of the century the Academy had been rather sharply

to 1643 | c.1665 | c.1680 | 1710 1715 | c.1716 | 1743 | 1761 1766 | 1774 1778 | 1792 c.1795 1799

VERMEER — *Young Woman with Water Jug* | MANSART & LE BRUN — Galerie des Glaces | WATTEAU — *L'Indifférent* | NEUMANN — Vierzehnheiligen begun | TIEPOLO — *Apotheosis of Pisani Family* | FRAGONARD — *The Swing* | Voltaire dies | FIRST FRENCH REPUBLIC

L O U I S X I V | L O U I S X V | LOUIS XVI

RISE OF PRUSSIA AND RUSSIA

divided between two doctrines: The one stated what Le Brun had derived from the art and writings of Poussin—that form is the most important element in painting, and that, as Poussin had asserted, "the colors in paintings are, as it were, blandishments to lure the eyes," merely something added for effect, and not really essential; the other doctrine proclaimed the supremacy of color as natural and the coloristic style as the proper guide to the artist. Depending upon which side they took, the members of the Academy were called "Poussinistes" or "Rubénistes." With Watteau, the latter carried the day, and the Rococo style in painting was established on the colorism of Rubens and the Venetians.

The *Cythera* represents a group of lovers preparing to embark for (or, as some now suggest, depart from) the island of eternal youth and love, sacred to Aphrodite. Young and luxuriously costumed, they perform, as it were, an elegant, tender, graceful ballet, moving from the protecting shade of a woodland park peopled with amorous cupids and voluptuous statuary, down a grassy slope to where a golden barge awaits. The attitudes of the figures are carefully studied; Watteau has never been equaled for his distinctive poses, which so beautifully combine elegance and sweetness. Watteau composed his generally quite small paintings from albums of superb drawings, which are still preserved and in fine condition. In these we find him observing slow movement from difficult and unusual angles, obviously with the intention of finding the smoothest, most poised, and most refined of attitudes. As he seeks nuances of bodily poise and movement, so Watteau strives for the most exquisite shades of color difference, defining in a single stroke the shimmer of silk at a bent knee or the iridescence that touches a glossy surface as it emerges from shadow. Here the color craft of the Venetians and Rubens is exquisitely specialized in the hands of a master of the nuance. It has

long been noted that in Watteau's pictures the theme of love and Arcadian happiness (which we have seen since Giorgione and which Watteau may have seen in works by Rubens) is slightly shadowed with wistfulness, even melancholy, as if in his own short life Watteau had opportunity to meditate on the swift passage of youth and pleasure. Although his mood is never easily described, it is caught in a contemporary work, not of painting, but of poetry—Pope's *Rape of the Lock*. This extraordinary passage from that work shows how widespread the Rococo was in the arts:

But now secure the painted vessel glides,
The sunbeams trembling on the floating tides;
While melting music steals upon the sky,
And softened sounds along the waters die
The lucid squadrons round the sails repair:
Soft o'er the shrouds aërial whispers breathe,
That seemed but zephyrs to the train beneath.
Some to the sun their insect wings unfold,
Waft on the breeze, or sink in clouds of gold;
Transparent forms, too fine for mortal sight,
Their fluid bodies half dissolved in light,
Loose to the wind their airy garments flew,
Thin glittering textures of the filmy dew,
Dipped in the richest tincture of the skies,
Where light disports in ever-mingling dyes,
While every beam new transient colors flings,
Colors that change whene'er they wave their
 wings.

The poet's and the painter's language are in perfect harmony. The haze of color, the subtly modeled shapes, the gliding motion, the air of suave gentility—all are the objective and achievement of the Rococo artist and all are to the taste of his aristocratic patronage in its last age.

The successors of Watteau never quite match his taste and subtlety. Their themes concern love artfully and archly pursued, erotic frivolity and playful intrigue. After Watteau's untimely death, his follower FRANÇOIS BOUCHER (1703–70),

painter to Madame de Pompadour, rose to the dominant position in French painting. Although he was also an excellent portraitist, Boucher's fame rests primarily on his gay and graceful allegories, in which Arcadian shepherds, nymphs, and goddesses cavort in shady glens, engulfed in pink and sky-blue light. The *Cupid a Captive* (FIG. 15-67) presents the viewer with a rosy pyramid of infant and female flesh, set off against a cool, leafy background, the figures' nakedness both hidden and revealed by fluttering draperies. Boucher uses all the Baroque devices to create his

masterful composition: the dynamic play of criss-crossing diagonals, curvilinear forms, and slanting recessions. But powerful Baroque curves have been dissected into a multiplicity of decorative arabesques, and Baroque drama has evaporated into sensual playfulness. Gay and superficial, Boucher's artful fantasies were the mirrors in which his patrons, the French aristocracy, saw the cherished reflections of their own ornamented decadence.

Boucher's student JEAN-HONORÉ FRAGONARD (1732–1806) was a first-rate colorist whose decorative skill almost surpassed his master's. An example of his manner can stand as characteristic not only of him, but of the later Rococo in general. The *Swing* (PLATE 15-12) is a typical intrigue picture. A young gentleman has managed an arrangement by which an unknowing, friendly old bishop swings the gentleman's pretty sweetheart high and higher, while he himself, strategically placed, ardently admires her. The young lady is quite aware of his presence, and boldly kicks off her shoe at the little statue of the god of discretion, who holds his finger to his lips. The landscape setting is out of Watteau—a luxuriant perfumed bower in a park that resembles very much a stage scene for the comic opera. The glowing pastel colors and soft light convey almost by themselves the sensuality of the theme.

Along with this courtly style of the Rococo, patronized by such "first ladies" of Louis XV as Madame de Pompadour and Madame du Barry, there developed a different taste, one much more likely to appeal to the middle classes of Paris, who disapproved of the licentious gallantries of Fragonard. JEAN-BAPTISTE-SIMÉON CHARDIN (1699–1779), briefly the teacher of Fragonard, made a specialty of simple interiors and still life, which he painted masterfully in his own mode, rivaling the Dutch masters of the previous century. In his *Grace at Table* (FIG. 15-68) Chardin gives us an unpretentious room in which a mother and her small daughters are about to dine. The mood of quiet attention is at one with the hushed lighting and mellow color and the closely studied still life accessories, whose worn surfaces tell their own humble domestic history. In his own way, Chardin is the poet of the commonplace and master of its nuances. A gentle sentiment prevails in all

15-67 FRANÇOIS BOUCHER, *Cupid a Captive*, 1754. Approx. 66″ × 34″. Reproduced by permission of the Trustees of the Wallace Collection, London.

his pictures, not contrived and artificial, but born of the painter's honesty, insight, and sympathy.

The informality of the Rococo after the pomp of the age of Louis XIV is evident in portraiture, where, though the subject presents his public aspect to the observer, he does not present it as a composed and coolly expressionless mask. Rather, the eighteenth-century face as given in portrait painting is open and lively, with a bright look of amiable and active intelligence. QUENTIN DE LA TOUR (1704–88), a painter whose portraits in pastels were in great demand, has given us a self-portrait (FIG. 15-69) that could well be an image of the *esprit* of the Enlightenment. Indeed, one finds here, as in so many portraits of the time, what has been called the "smile of the eighteenth century"—confident, interested, amused, slightly mocking, the face one wears to the salon to confront the brilliant society of the *beau monde*.

But the greatest and most successful portraitist of his time was not a painter, but a sculptor, JEAN-ANTOINE HOUDON (1741–1828). Throughout his long life, Houdon had the opportunity to have as his subjects some of the greatest men of the age: Voltaire, Rousseau, Franklin, Washington, Jefferson, Lafayette. His art comes between the mannered Rococo and the mannered neoclassicism of the Napoleonic period. Houdon's is a strong, perceptive realism that penetrates at once to personality, catching its most subtle shade. For his *Count Cagliostro* (FIG. 15-70) Houdon had a subject not so much great as notorious. Cagliostro (the name was an alias), one of the most successful confidence men in history, a brilliant fake, mountebank, quack, and impostor, charmed European society (especially the ladies) even as he swindled it. Houdon renders him in open-necked, romantic dishabille, turning a large-eyed, innocent gaze heavenward, as if in protestation of the purity of his motives and of his love and sympathy for credulous mankind. Houdon's *Cagliostro*, like Molière's earlier *Tartuffe*, presents with exquisite acuteness the character of the sanctimonious fraud.

In the work of a younger painter, who became widely popular as the Rococo style waned in the fifties and sixties of the eighteenth century, genuine sentiment has changed to sentimentality. JEAN BAPTISTE GREUZE (1725–1805) expressed per-

15-68 Above: JEAN-BAPTISTE-SIMÉON CHARDIN, *Grace at Table*, 1740. 19″ × 15″. Louvre, Paris.

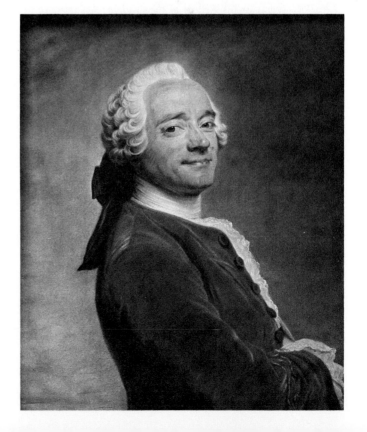

15-69 QUENTIN DE LA TOUR, *Self-Portrait*, c. 1751. Approx. 25″ × 21″. Louvre, Paris.

fectly the transition of taste from the Rococo to nineteenth-century Romanticism, his vogue coming in the interim period, which is sometimes called the age of sensibility. Almost overnight, France—and Europe—abandoned the wanton frivolity and luxuriance of the Rococo and became serious and moralistic, but especially "sensible" and "feeling," which is to say *emotional*. Against what he considered the cold, heartless, and selfish culture of courts, Rousseau, one of the most influential writers of modern times, called for the sincere expression of sympathetic and tender emotions. He exalted the simple life of the peasant as the most "natural" and set it up as a model to be imitated. The joys and sorrows of uncorrupted "natural" people, now described everywhere in novels, soon drowned Europe in a flood of tears; it became fashionable to weep, to fall on one's knees, to swoon, and to languish in hopeless love. This kind of contrived and melodramatic emotion, this *sentimentality*, has been a fundamental ingredient of popular art from the time of its appearance in the eighteenth century until the present. Greuze won wide acclaim with paintings entitled the *Father of the Family Reading the Bible to His Children*, the *Village Bride*, and the *Father's Curse*, in all of which he pointed a moral and sentimentalized his characters. In his *Return of the Prodigal Son* (FIG. 15-71) the theme is plain enough and the action rather crudely obvious. Yet Greuze's moralizing *does* look forward to that of David and "Neoclassicism," and we may credit him with a kind of pioneer work in an orientation that meets with more general acceptance at present, when his reputation, suffering from later criticism, has been to a degree restored.

It is noteworthy that Diderot, the great *philosophe* and scholar advanced the cause of Greuze for a while but afterward saw through him. Diderot described the work (the sketch, not the painting) as follows:

> This is the sight which meets the eyes of the ungrateful son. He comes forward, he is on the threshold His mother meets him at his entrance; she is silent, but with her hand points to the corpse as if to say: "See what you have done."
> The ungrateful son is struck with amazement;

his head falls forward and he strikes his forehead with his hand. What a lesson is here depicted for fathers and children! I do not know what effect this short and simple description . . . will produce on others, but for my own part I could not write it without emotion.[5]

We feel today that the attitudes and gestures of Greuze's figures are somewhat inauthentic and forced; in fact, they are out of the stock vocabulary of the academic tradition and will be repeated ever more provincially in melodramatic stageplays throughout the nineteenth century.

England

Beginning with England's prosperous expansion into the New World, most particularly after the Restoration, in the latter half of the seventeenth century, there arose a demand for fine mansions on great estates, and the country houses of England in the eighteenth century, both in number and quality of design, are outstanding in European architecture. In the hands of a small group of architects associated with the aging Wren, the

[5] E. G. Holt, *Literary Sources*, p. 520.

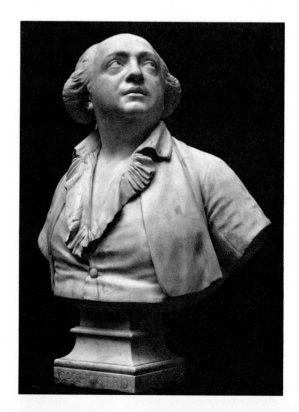

15-70 Jean-Antoine Houdon, *Count Cagliostro* (Giuseppe Balsamo), 1771–89. Marble, approx. 25" high without base. National Gallery of Art, Washington, D.C. (Samuel H. Kress Collection.)

Baroque briefly triumphs over the accepted Palladian style. The best known of this group was JOHN VANBRUGH (1664–1726), who began as a writer of witty and popular comedies and as the designer of a theater in which to produce them. Certainly his architecture tends toward the theatrical on a mighty and extravagant scale. This shows in the palace he built for the Duke of Marlborough at Blenheim (FIG. 15-72). Erected at the commission of the British government in commemoration of and in gratitude for the victory the duke had won against the powerful forces of Louis XIV, its picturesque silhouette, massing, and invention in architectural detail are thoroughly Baroque. The design has the love of variety and contrast tempered by a desire for focus found so frequently in the architecture of seventeenth-century Italy. The vast forecourt, hugely projecting pavilions, and extended colonnades simultaneously recall St. Peter's and Versailles. Vanbrugh is not alone in the Baroque in sacrificing convenience to dramatic effect, as, for example, in placing the kitchens at Blenheim some 400 yards from the dining salon. But even in his own time his piling up of colossal masses of masonry was ridiculed. Great as Blenheim is as scenic art, Voltaire could remark that if the rooms had only been as wide as the walls were

thick, the palace would have been convenient enough. Vanbrugh's Baroque architecture did not please his patrons long; before Blenheim was complete there was criticism of what were considered its ponderous and bizarre qualities.

England had no painters comparable to its architects in the seventeenth century. The second-rate work of native painters was submerged in that of distinguished foreigners invited from abroad: Holbein, who had come in the time of Henry VIII; Rubens and Van Dyck in the reigns of James I and Charles I; and Peter Lely, a Dutch painter, in the time of the Restoration. These artists had set the styles in portrait painting accepted by the royalty and aristocracy.

In the second quarter of the eighteenth century a truly English style in painting emerges with WILLIAM HOGARTH (1697–1764). Hogarth waged a lively campaign throughout his career against the English feeling of dependence upon and inferiority to continental art. Though Hogarth himself would have been the last to admit it, his own painting owes much to the work of his contemporaries across the Channel in France, the artists of the Rococo. He used the same bright, opaque colors, applied with dash and virtuosity. Yet his subject matter, which was frequently moral and satirical in tone, is distinctively English. It was the

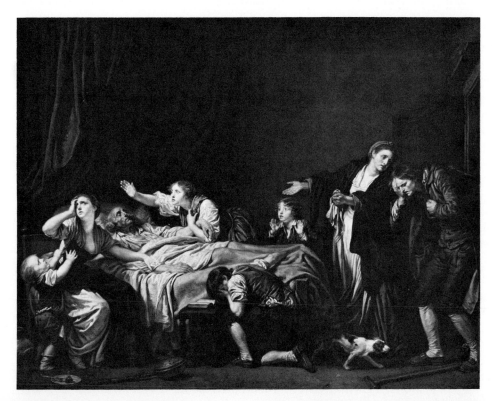

15-71 JEAN BAPTISTE GREUZE, *The Return of the Prodigal Son*, 1777–78. Approx. 51″ × 65″. Louvre, Paris.

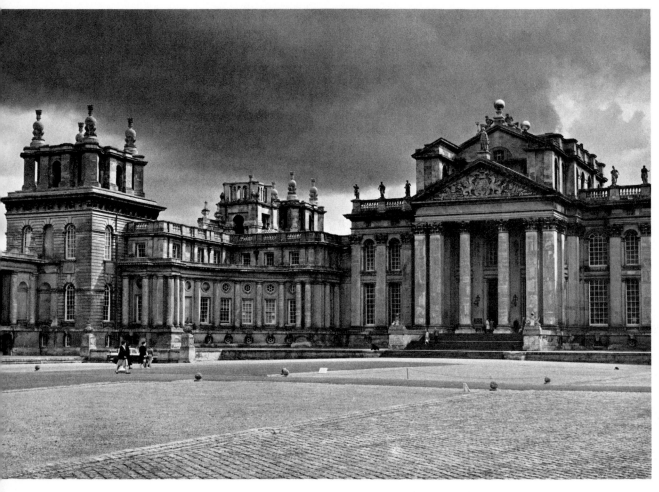

15-72 John Vanbrugh, Blenheim Palace, Oxfordshire, 1705–22.

great age of English satirical writing, and Hogarth, who knew and admired this genre and included Henry Fielding, author of *Tom Jones*, among his closest friends, clearly saw himself as translating it into the visual arts. He says: "I therefore turned my thoughts to . . . painting and engraving modern moral subjects I have endeavored to treat my subjects as a dramatic writer; my picture is my stage, and men and women my players, who by means of certain actions and gestures, are to exhibit a dumb show"[6]

[6] In Peter and Linda Murray, "Hogarth," in *A Dictionary of Art and Artists* (Baltimore: Penguin, 1959), pp. 152–53.

Hogarth's favorite device was to make a series of narrative paintings and prints that follow a character or group of characters in their encounters with some social evil, in a serial sequence like chapters in a book or scenes in a play. He is at his best in a picture such as the *Breakfast Scene* (FIG. 15-73) from the *Marriage à la Mode*, in which the marriage of the young viscount, arranged through the social aspirations of one parent and the need for money of the other, is just beginning to founder. The bright, gay character of the Rococo style is admirably suited to the situation. The situation, however, must be read completely from its large inventory of detail if we are fully to enjoy it. It is past noon. Husband and wife are

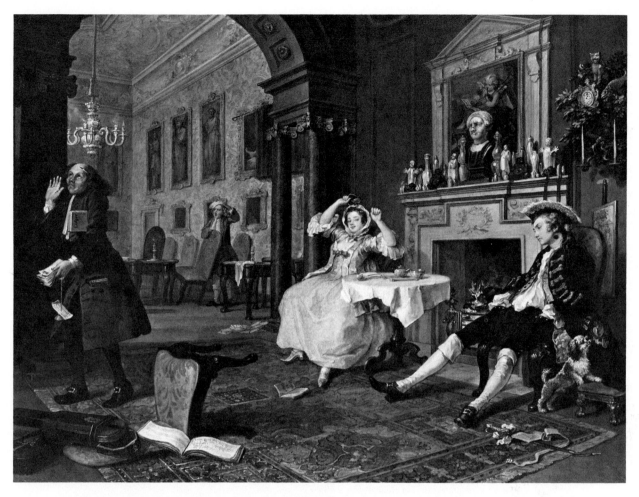

15-73 WILLIAM HOGARTH, *Breakfast Scene*, from *Marriage à la Mode, c.* 1745. Oil on canvas, approx. 28″ × 36″. Reproduced by courtesy of the Trustees of the National Gallery, London.

very tired after a long night spent in other company. The young nobleman keeps his hat on in his wife's presence; his hands are sunk deep in his pockets, emptied by gambling; and the little dog sniffs suspiciously at a lace cap that protrudes from a pocket. The broken sword suggests that the master has been in a fight. An overturned chair signifies that the previous evening has been somewhat spirited. A steward, his hands full of unpaid bills, account books under his arm, raises his eyes to heaven in despair at what this family is coming to. The setting is overly grand: Hogarth is poking fun at the interior style of decoration and mocks the classical taste in the bust on the mantelpiece. There is a great deal more; typi-

cally, Hogarth proceeds as a novelist would, elaborating on his subject with carefully chosen detail, which, as we continue to discover it, heightens the comedy.

Hogarth believed that it was not his own genre but portraiture that was the forte of the English school of painting. The accumulating fortunes of both the English nobility and merchants in the eighteenth century, in the first days of the empire, led to the demand not only for fine buildings, but also for portraits. The tradition of Van Dyck still flourished and was taken up again by a whole school of painters, who, however, gradually modified it for the more modern taste. THOMAS GAINSBOROUGH (1727–88),

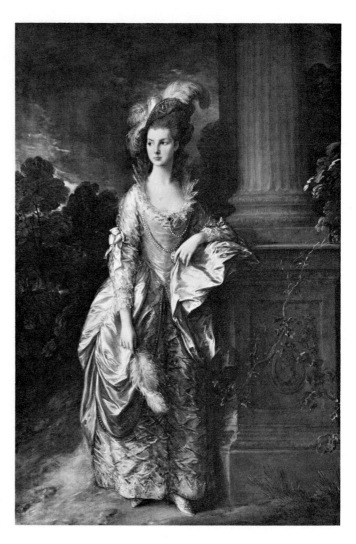

15-74 Thomas Gainsborough, *The Honourable Mrs. Graham*, 1775. $93\frac{1}{2}'' \times 60\frac{3}{4}''$. National Gallery of Scotland, Edinburgh.

who began as a landscape painter and always preferred landscape to portrait, gives us in the *Honorable Mrs. Graham* (FIG. 15-74) the very essence of the early preferred Vandyckian manner. Dressed in Rococo flamboyance of feathers and brocade, silver and crimson, the young gentlewoman poses haughtily by a great column and against a deep Venetian background of dark russet. The pride of birth and station is announced in every detail. Full-length, life-sized canvases like this were intended to decorate the grand stairways of the great country houses of affluent England. But there is a different intention and result in Gainsborough's portrait of Mrs. Richard Brinsley Sheridan (PLATE 15-13). The lovely lady,

dressed informally, is seated in a rustic landscape faintly reminiscent of Watteau in its soft-hued light and feathery brushwork. (The artist had intended to give the picture "an air more pastoral than it at present possesses" by the addition of sheep, which he did not live to paint in.) Gainsborough intends to match the unspoiled beauty of natural landscapes with the natural beauty of the subject, whose dark brown hair blows freely in the slight wind, and whose clear, unassisted "English" complexion and air of ingenuous sweetness are in sharp contrast with the pert sophistication of continental Rococo portraits. The Romantic view of life and nature, already manifest in the transitional "age of sensibility," is

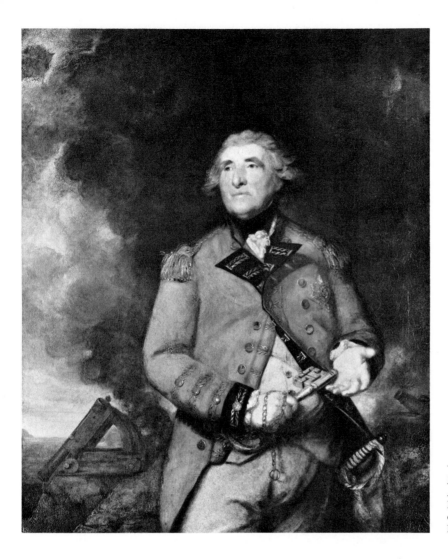

15-75 JOSHUA REYNOLDS, *Lord Heathfield*, 1787. Approx. 56″ × 45″. Reproduced by courtesy of the Trustees of the National Gallery, London.

pretty much the creation of England. That view is rooted in the concept of naturalness, against the artificiality of the Baroque and the Rococo, at least in their official guise.

JOSHUA REYNOLDS (1723–92), rival of Gainsborough and president of the Royal Academy of Arts from its foundation in 1768, in theory kept very close to the academic Baroque, as one can read in his *Discourses*. There he expounds a doctrine from which, luckily, he often deviated in practice—namely, that "general" nature, as represented by the Bolognese, the Carracci, *et al.*, is always superior to "particular" nature, as rendered by the Dutch. Yet he showed himself capable of sturdy, characterful portraits like that

of Lord Heathfield (FIG. 15-75). Accustomed to highly formal portraits in the tradition of Van Dyck, Reynolds seems almost relieved when he can turn to a subject like this burly, brandy-flushed English officer, commandant of the fortress of Gibraltar during the American Revolution. Lord Heathfield doggedly defended the great rock against the Spanish, and his victory is symbolized by the key of the fortress, which he holds so casually. The heavy, honest, unidealized face belongs to a different world from that of De la Tour (FIG. 15-69). This is a world of camps, battles, wars, and revolutions now taking shape in deadly earnest as the old regime, with all its esthetic artifice, fades into the past.

PART FOUR

THE MODERN WORLD

Our era, the "modern" era, differs from the past as a result of several fundamental revolutions that radically changed—and continue to change—the world. Least dramatic in its arrival, but by far the most fateful for mankind, was the industrial revolution, the revolution that introduced the age of the machine. To match the importance of the industrial revolution we should have to go back thousands of years to the development of agriculture. For, in two centuries, an extremely short span of historical time, we have created a universe of machines that replace physical labor and extend enormously the powers of the brain, bringing changes in the conditions of life with such speed that we find it difficult to adjust to them. Human knowledge, dawning in the Old Stone Age, reaches a high noon in our own times. Control of nature is now widespread and tenacious; science has become our most authoritative source of natural knowledge, and the application of it in technology and industry has become the characteristic activity or ambition of modern societies.

As science and technology challenged old views of the physical world, so political revolution, beginning in the late eighteenth century, challenged the old absolutisms of Church and Realm, setting up such new

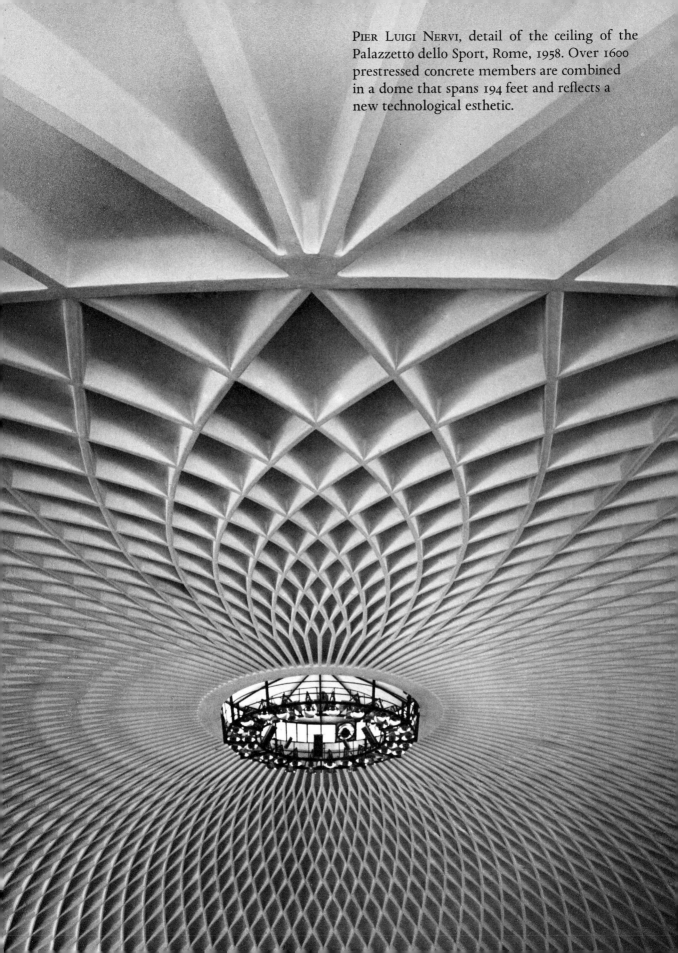

PIER LUIGI NERVI, detail of the ceiling of the
Palazzetto dello Sport, Rome, 1958. Over 1600
prestressed concrete members are combined
in a dome that spans 194 feet and reflects a
new technological esthetic.

aims and values as democracy, nationalism, and social justice. Subsequent revolutions transformed the social and economic organization of vast areas of the world, with regions colonized by Europe since the Renaissance rising against her to the call of her own revolutionary slogans. Thus, as Europeans conquered and colonized the non-European world they unwittingly began an exchange not only of goods, but of ideas and culture. In the twentieth century, many European colonial empires decline and vanish, and non-European nations rise as their rivals. The trend appears to be away from civilizations toward a *world* civilization, while the peculiarly European traits that took form in the Renaissance lose their distinctive character. In all sectors of Western culture the humanistic image of man created in the Renaissance is being blurred and, here and there, effaced. In the modern view man has been displaced from the commanding position the Renaissance assigned him as master of the Nature that God had created for him. Now, though man holds greater control than ever before over his environment, he is seen to be as much the despoiler and victim of it as he is its master. Within Western nations, established values and institutions are challenged on all sides, especially among the youth. In fear and mistrust of what the West has created—great evil that seems to outweigh great good—many turn to non-Western cultures to find fresh and alternative interpretations of life. With many thoughtful persons there is the poignant feeling that the West has had its day and that its fundamental assumptions about human values have been discredited. They hear, with André Malraux, voices clamoring for the abdication of the West.

The revolutionary changes of the modern world on all fronts—scientific, technological-industrial, political, social, economic, and cultural—make for the characteristic temper of our age: a mixture of restlessness, obsession with progress and novelty, and a ceaseless questioning, testing, and challenging of authority. Old certainties give place to new, and the new give place to still newer. There is scarcely a traditional value, system, institution, or rule that has not in the modern world received relentless critical analysis. At the same time, discovery and invention, proceeding at an always accelerating pace, have made the once impossible both possible and actual; today's nonsense, as Alfred North Whitehead put it, may be demonstrated truth tomorrow. The rapid obsolescence of ideas and things gives to life a tentative and temporary quality and makes confusion a constant in its ever changing patterns.

It is little wonder then that art in this period is a sequence and medley of competing "movements," each seeking to establish its authority, each with its own ideology, and each subject to displacement in the bewilderingly rapid process of stylistic turnover. We describe these movements in terms (rarely precise) that aim to define their artistic

content, form, and intention: "Romanticism," "Realism," "Impression-
ism," and the like. There is implicit in words like these the notion of
doctrine; certainly the principles and issues of the movements were
hotly and widely argued in their time, ultimately spreading beyond
territorial and national boundaries. Appropriately enough, for an age
that sees the making of a world civilization, modern art in all its com-
ponent movements tends to be international, like modern science,
technology, industry, and politics.

Chapter Sixteen

The Nineteenth
Century

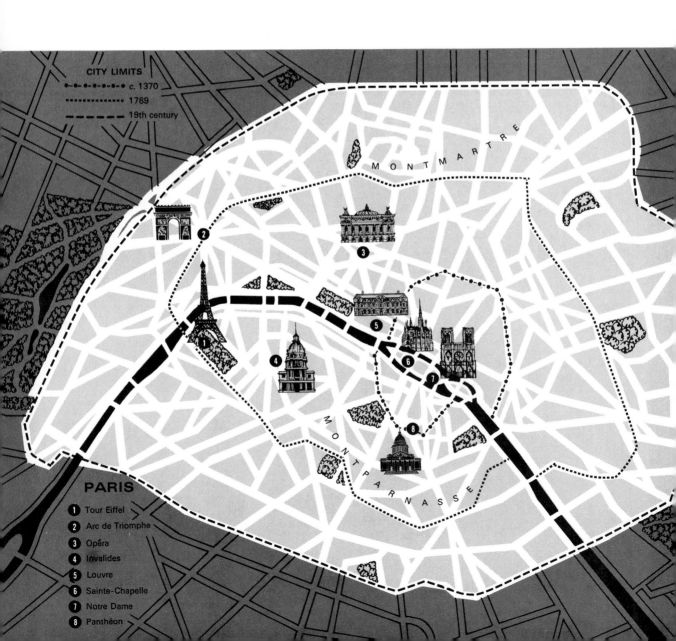

CITY LIMITS
—•—•—•—•—•— *c.* 1370
················· 1789
— — — — — 19th century

MONTMARTRE

MONTPARNASSE

PARIS

1 Tour Eiffel
2 Arc de Triomphe
3 Opéra
4 Invalides
5 Louvre
6 Sainte-Chapelle
7 Notre Dame
8 Panthéon

THE STYLES—for it is no *single* style—that we call Romanticism rise and decline between roughly 1750 and 1850, although in all truth much that is "Romantic" persists into the present. "Romanticism" is a term almost indispensable in the history of the modern arts, yet it is quite inefficient. It originated, toward the end of the eighteenth century, among German critics who aimed to distinguish peculiarly "modern" traits in the arts from the "classical" traits, which had advanced once more against the Baroque and Rococo in the eighteenth-century battle of tastes. "Romance," which can refer as much to the novel, with its sentimental hero, as it does to the old Medieval tales of fantastic adventure written in the "romance" languages, has never quite fitted with the broader term "romantic," nor has "romantic" ever covered all

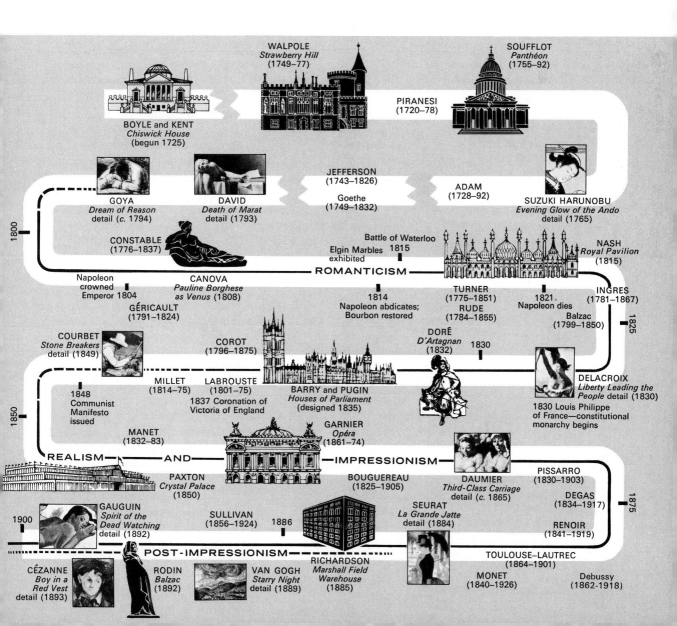

WALPOLE
Strawberry Hill
(1749–77)

SOUFFLOT
Panthéon
(1755–92)

PIRANESI
(1720–78)

BOYLE and KENT
Chiswick House
(begun 1725)

JEFFERSON
(1743–1826)

ADAM
(1728–92)

Goethe
(1749–1832)

SUZUKI HARUNOBU
Evening Glow of the Ando
detail (1765)

GOYA
Dream of Reason
detail (c. 1794)

DAVID
Death of Marat
detail (1793)

1800

CONSTABLE
(1776–1837)

Battle of Waterloo
Elgin Marbles 1815
exhibited

NASH
Royal Pavilion
(1815)

Napoleon
crowned
Emperor 1804

CANOVA
*Pauline Borghese
as Venus* (1808)

— ROMANTICISM —

INGRES
(1781–1867)

GÉRICAULT
(1791–1824)

1814
Napoleon abdicates;
Bourbon restored

TURNER
(1775–1851)
RUDE
(1784–1855)

1821.
Napoleon dies

Balzac
(1799–1850)

1825

COURBET
Stone Breakers
detail (1849)

COROT
(1796–1875)

DORÉ
D'Artagnan
(1832)

1830

DELACROIX
*Liberty Leading the
People* detail (1830)

1848
Communist
Manifesto
issued

MILLET
(1814–75)

LABROUSTE
(1801–75)

1837 Coronation of
Victoria of England

BARRY and PUGIN
Houses of Parliament
(designed 1835)

1830 Louis Philippe
of France—constitutional
monarchy begins

1850

MANET
(1832–83)

GARNIER
Opéra
(1861–74)

REALISM — — AND

PAXTON
Crystal Palace
(1850)

— IMPRESSIONISM —

BOUGUEREAU
(1825–1905)

DAUMIER
Third-Class Carriage
detail (c. 1865)

PISSARRO
(1830–1903)

DEGAS
(1834–1917)

1875

GAUGUIN
*Spirit of the
Dead Watching*
detail (1892)

1900

SULLIVAN
(1856–1924)

1886

SEURAT
La Grande Jatte
detail (1884)

RENOIR
(1841–1919)

POST-IMPRESSIONISM

RICHARDSON
*Marshall Field
Warehouse*
(1885)

TOULOUSE–LAUTREC
(1864–1901)

CÉZANNE
*Boy in a
Red Vest*
detail (1893)

RODIN
Balzac
(1892)

VAN GOGH
Starry Night
detail (1889)

MONET
(1840–1926)

Debussy
(1862-1918)

we seem to understand by it. We shall attempt no precise definition of Romantic art here, but rather try, through use of examples, to manifest its complex aspects.

This much we can say: In the modern world civilized men seem increasingly to seek through art—and other means—unusual sensations and emotions for their own sakes. Among many there is an urge to go outside the traditions and conventions of both Christianity and classical humanism, not to mention those of contemporary society, and to affirm the value of intense personal experience as expressive of a heroic vitality and authenticity of soul. Close to the beginning of the period, Werther, the young Goethe's archetype of Romantic sensibility, cries: "We desire to surrender our whole being, that it may be filled with the perfect bliss of one glorious emotion!" The sensuousness of the Rococo sharpens into the irritable sensitivity of Romanticism, which reaches out restlessly for impassioned experience wherever it can be had and at whatever risk. Yet it is not *entirely* a question of emotion indulged in for its own sake. The preoccupation with feeling could lead to fresh experience and perhaps a new knowledge independent of all authority of the past. As preached by Rousseau, there was a widely held belief in this doctrine of the free quest for self-identity, for a reality deeper than convention and tradition, for the "natural" man hidden beneath the conventional man formed by society. Its persistence in our own time suggests that this is one of the respects in which the Romantic age has never really ended.

Freedom of inquiry and expression goes along with freedom of criticism, and the eighteenth century is eminently an age of criticism, its judgments leveled at established forms and values of all sorts. Alternatives are proposed, and energetic debates about "good" and "bad" in life and art and institutions provide the intellectual background of Romanticism. In art, especially in architecture, we find new criteria arising for stylistic judgment. For example, architecture is no longer necessarily "good" because it is harmonious in proportion and correct in detail but because it can arouse pleasant emotions in the beholder; one uses architecture as a kind of stimulus of the feelings. For this purpose almost any style will do if it brings to the imagination associations of a poetic kind—say, the august and inspiring events of some distant age. Thus, one need know nothing of architecture to "enjoy" Independence Hall in Philadelphia; its associations with the founding of a nation and with great men is enough. Further, if the building has certain irregularities, surprise effects, and spectacular arrangements, then it is enjoyable as *picturesque*, a fundamental criterion of quality in early Romanticism.

ROMANTICISM

In Architecture

In England, where Romanticism was born, the revolt against the "regularity" of classical architecture stirred early; in the late seventeenth century there began an enthusiasm for Chinese art, in particular the Chinese garden. An English critic of the time, William Temple, comparing the Chinese garden with the symmetry and uniformity of the English garden, described the beauty of the former as "without ... order or disposition of parts that shall be commonly or easily observed" The Chinese term for this quality is defined as "being impressive or surprising through careless or unorderly grace." Within a generation of Temple's observation, English gardens were being designed along the Oriental lines. In the eighteenth century the English garden became a vogue throughout Europe, and the formality of gardens such as those at Versailles was thought unnatural.

Thus, "naturalness" rather than formal order in architecture came to be the quality in demand, and "natural" styles like Gothic, which had never entirely died out in England, became very popular. In 1718 John Vanbrugh, the architect of Baroque Blenheim (FIG. 15-72) designed his country house to look like a Gothic castle, so as to give it a "masculine"—that is, an unaffected or "natural"—appearance. The picturesque qualities of the Gothic style had already begun to be appreciated when an aristocratic devotee and patron of architecture, RICHARD BOYLE (1695–

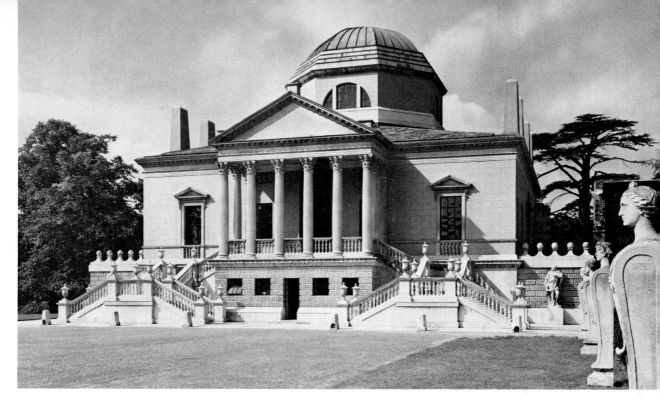

16-1 RICHARD BOYLE and WILLIAM KENT, Chiswick House, near London, begun 1725. British Crown Copyright.

1753), Earl of Burlington, enthusiastically restated a formal style in Chiswick House (FIG. 16-1), begun in 1725. A free variation on the theme of Palladio's Villa Rotunda (FIG. 13-45), it was doubtless intended as a "rational" answer to the "confusions" of Baroque on the Continent—and to the pomp and magnificence of Versailles. Although Chiswick House in its simple symmetry, unadorned planes, right angles, and stiffly wrought proportions looks very classical and "rational," it was intended, as were so many Palladian villas in England, to be set within informal gardens, where "irregularity" would dominate the design. However, it was placed in a formal garden of unrelieved symmetry, prompting this criticism by Pope:

> His [Burlington's] gardens next your admiration call;
> On every side you look, behold the wall!
> No pleasing intricacies intervene;
> No artful wildness to perplex the scene;
> Grove nods at grove, each has a brother,
> And half the platform just reflects the other.[1]

[1] From Epistle IV of *Moral Essays*.

The contradiction between the formal villa and informal gardens was apparently not at once felt; for one thing, in the early eighteenth century the meaning of "nature" had not been agreed upon; was it, in the classical sense, a regularity of proportion, or, in the newer sense, the irregularity of growing things with their wildness and accidents—in a word, their picturesqueness? In the end it would be decided that *all* historical styles are "natural," since they evolved historically from the artistic instinct of peoples, who are after all part of nature.

We have, then, a number of almost-simultaneous "revivals" of styles that parade the romantic past before the eyes and imaginations of the romantically inclined public. Lord Burlington's Palladian revival was in course, having been made current and popular by the designs of WILLIAM KENT (1684-1748), who was also a pioneer of the picturesque garden. HORACE WALPOLE (1717-97) a wealthy architectural dilettante, renovated his villa at Twickenham in the rising "gothick" fashion, converting it into a sprawling "castle," with turrets, towers, battlements, galleries, and corridors, "whose fretted roofs, carved panels, and illuminated windows," as de-

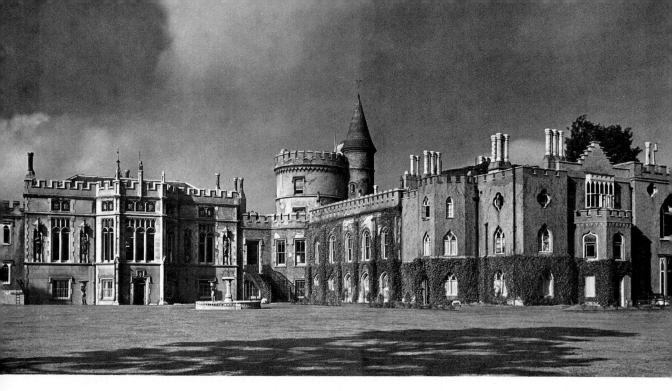

16-2 Horace Walpole, Strawberry Hill, Twickenham, 1749–77.

scribed by Sir Walter Scott, "were garnished with the appropriate furniture of escutcheons, armorial-bearings, shields, tilting lances, and all the panoply of chivalry." Indeed, at Strawberry Hill (FIG. 16-2), Walpole's villa in Twickenham, the master could enjoy his favorite pastime, which was "to gaze on Gothic toys through Gothic glass." The features of the structure are, of course, pseudo-Gothic, the kind of fairy-tale vision raised in our own times by the late Walt Disney. But Walpole's trifling with Gothic architecture was to be as influential as were his Gothic novels.

The thrill produced by contemplation of the vanished past was cultivated by garden designers in England, who, when the opportunity offered, decorated the irregularities of random copses of trees, little rustic bridges, and winding streams with replicas of period architecture. Sometimes a single garden would boast four or five different styles. Typical are the gardens at Hagley Park, where a sham Gothic ruin of 1747 stands near a Doric portico built in 1758 (FIGS. 16-3 and 16-4). The latter is of special interest as the work of JAMES STUART (1713–88), who with Nicholas Revett introduced to Europe the splendor and the originality of Greek art in their enormously influential *Antiquities of Athens*, the first volume of which was published in 1762. These volumes firmly

distinguished Greek art from the derivative Roman, which had served as the model of classicism since the Renaissance. Stuart's efforts were greeted with enthusiasm by those who had no use for the Rococo, the Chinese, the Gothic, or any of the "irregular" manners in art. A contemporary journal hoped that Stuart's writings and Robert Wood's magnificently illustrated *Ruins of Palmyra* (1753) and *Ruins of Baalbek* (1757) would "expel the littleness and ugliness of the Chinese, and the barbarity of the Goths, that we may see no more useless and expensive trifles; no more dungeons instead of summer houses." [2]

By mid-century the rediscovery of Greek art and architecture turned the romanticizing taste of Europe in a new direction and inaugurated the style we call Neoclassicism. Neoclassicism was once thought of as in opposition to Romanticism, but we understand it now as simply one of the many fashions within that general movement, but in opposition to the "irregularity" of Romantic styles like neo-Gothic and Chinese. By 1763 the German critic Friedrich Grimm could write that "everything is being done today in the Greek mode." Earlier, in 1755, Johann Winckelmann,

[2] In F. H. Taylor, *The Taste of Angels* (Boston: Little, Brown, 1948), p. 479.

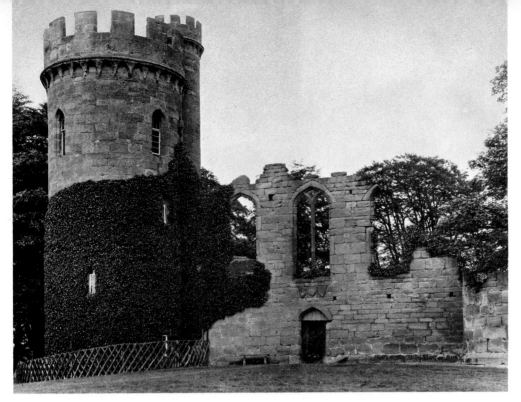

16-3 SANDERSON MILLER, sham Gothic ruin, Hagley Park, Worcestershire, 1747. Copyright, *Country Life*, London.

the first modern historian of art, published his *Thoughts on the Imitation of Greek Art in Painting and Sculpture*, in which he uncompromisingly designated Greek art as the most perfect from the hands of man and the only model to be followed, for doing so would confer "assurance in conceiving and designing works of art, since they [the Greeks] have marked for us the utmost limits of human and divine beauty."[3]

Winckelmann characterized Greek sculpture as manifesting a "noble simplicity and quiet grandeur," and in his *History of Ancient Art* (1763) he undertook to describe each monument as an element in the development of a single grand style. Before Winckelmann the history of art was a matter of biography, as with Vasari; with Winckelmann begins the modern method of classification and description on the basis of general stylistic traits that change in time. Winckelmann, strangely enough, did not know genuine Greek art; he had for study only late Roman copies, and he never visited Greece, where he might have seen the genuine thing. Despite the obvious defects of his work, its pioneering character cannot be overlooked. Winckelmann had

[3] In E. G. Holt, ed., *Literary Sources of Art History* (Princeton: Princeton Univ. Press, 1947), p. 529.

wide influence, and his writings laid a theoretical and historical foundation for Neoclassicism.

Within Neoclassicism's admiration for the art of Greece, sentiment for the art of Rome arose again; "the glory that was Greece / And the grandeur that was Rome" summarized the conception of a noble classical world. The first great archeological event of modern times—the discovery and first excavations of the ancient buried Roman cities of Pompeii (see Chapter Six) and Herculaneum in the 1730's and 1740's—startled and thrilled all Europe. This was the veritable resurrection of the ancient world, not simply a dim vision of it inspired by a few moldering ruins; historical reality could now replace fancy with fact. The wall paintings and other artifacts of Pompeii inspired the slim, straight-lined, elegant "Pompeian" style that, after mid-century, almost entirely displaced the curvilinear Rococo. In France the new manner was associated with Louis XVI; in England it took the name of its most artful practitioner, ROBERT ADAM (1728–92), whose interior architecture was as influential in Europe as the English garden. The Etruscan Room in Osterley Park House (PLATE 16-1), begun in 1761, compared with the Rococo salon of the Hôtel de Soubise (FIG. 15-62), shows how completely symmetry and rectilinearity have re-

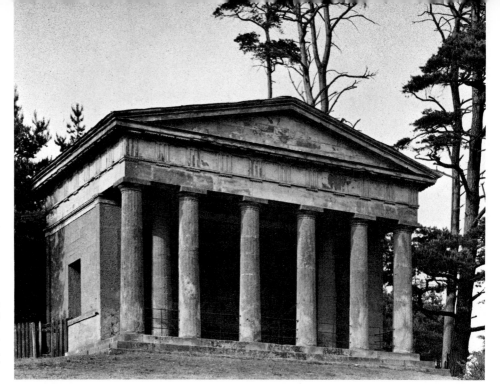

16-4 Right: JAMES STUART, Doric portico, Hagley Park, Worcestershire, 1758. Copyright, *Country Life*, London.

16-5 Below: GIOVANNI BATTISTA PIRANESI, *The Temple of Saturn, c.* 1774. Etching, from the *Views of Rome*. Metropolitan Museum of Art, New York (Rogers Fund, 1941).

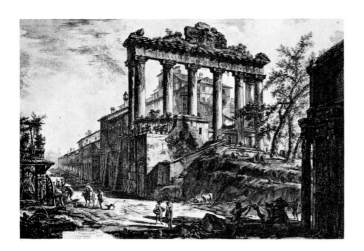

turned, but with great delicacy and none of the massive splendor of the style of Louis XIV. The decorative motifs are taken from Roman art—medallions, urns, vine scrolls, paterae, sphinxes, and tripods—and, as in Roman stucco work, are arranged sparsely within broad, neutral spaces and slender margins.

Adam was an archeologist as well as an architect and had explored and written accounts of the ruins of the palace of Diocletian at Spalato (FIG. 6-64). His Kedleston House in Derbyshire, Adelphi Terrace in London, and many other structures show the influence of Spalato on his work.

The Romantic fascination for ruins blended with archeological curiosity about the facts. In Rome, GIOVANNI BATTISTA PIRANESI (1720–78) began in the late 1740's his famous *Views of Rome*, some 135 prints that romantically presented the eternal city's majestic ruins (FIG. 16-5) and that served for generations as the standard image of Roman grandeur. Edward Gibbon wrote his monumental *Decline and Fall of the Roman Empire*, which matches in words the stately and august subjects of Piranesi's *Views*. The Roman ruins at Baalbek, especially a titanic colonnade, inspired the Neoclassical portico of the church of Ste. Geneviève (FIG. 16-6), now the Panthéon, in Paris, designed by JACQUES GERMAIN SOUFFLOT (1713–80). The columns, reproduced with studied archeological exactitude, were the first revelation of Roman grandeur in France. The walls are severely blank, except for a repeated garland motif in the attic level. The colonnaded dome, a Neoclassical version of those on St. Peter's in Rome and St. Paul's in London, rises above a Greek-cross plan, and both vaults and dome rest upon an interior grid of splendid, freestanding Corinthian columns, as if the colonnade of the portico were continued within. Although the whole effect—inside and out—is Roman, the structural principles employed are essentially Gothic. Soufflot had early maintained that Gothic engineering was

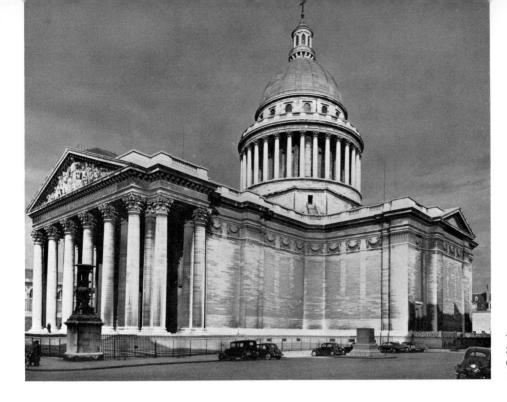

16-6 Jacques Germain Soufflot, the Panthéon (Ste. Geneviève), Paris, 1755–92.

highly functional structurally and could be applied in modern building. We have in Soufflot the curious, but not unreasonable, conjunction of Gothic and classical, not in mere decorative juxtaposition as they appear at Hagley Park, but in structural integration. Thus, he anticipates the nineteenth-century admiration of Gothic engineering that results in a firmer and more authentic Gothic manner than the stage sets favored by Walpole.

International Neoclassicism extends across continent and ocean, from the Russia of Catherine the Great to the new American republic. THOMAS JEFFERSON (1743–1826) showed his feeling for the classical past by going beyond architects who had incorporated only elements of ancient architecture in their buildings. He took the complete Roman temple form as his model for the Virginia statehouse at Richmond (FIG. 16-7). He had seen the Roman temple at Nîmes called the Maison Carrée (which resembles the Temple of Fortuna Virilis, FIG. 6-14) while serving in France as American ambassador. Jefferson's choice was based on the admiration he felt for the original both as an embodiment of the pure beauty of antiquity and as a symbol of idealized Roman Republican government. Its selection reflects as well the attempt, also found in the thought of Jefferson's contemporary French revolutionaries, to rediscover in antiquity certain principles of life that had presumably been distorted during the intervening centuries. The young United States adopted many Roman symbols: the eagle; the lictor's ax and rods; "Columbia," the allegorical figure of the nation (as a kind of new "Roma"). Its national motto was in Latin: *e pluribus unum*. Washington was honored as a new Cincinnatus, who, after liberating his country, retired to his farm when he could have been king; the upper house of Congress was named after the Roman Senate; the official architecture of Washington has long been Neoclassical, and the Capitol itself is named after the ancient Roman hill.

While Neoclassicism flourished, the Gothic taste by no means died; it paralleled the former and took on a new significance, a religious and national one. In 1802 Chateaubriand published his important *Genius of Christianity*, a defense of religion against the rationalism of the Enlightenment and the French Revolution, on the grounds not of its truth but of its beauty and mystery. "There is nothing," said Chateaubriand, "of beauty, sweetness, or greatness in life that does not partake in mystery." This is in significant contradiction of the classical injunction "Be thou clear!" Christian ritual and Christian art, born of mystery, move adherents by their strange and ancient beauty. Gothic cathedrals, said Chateau-

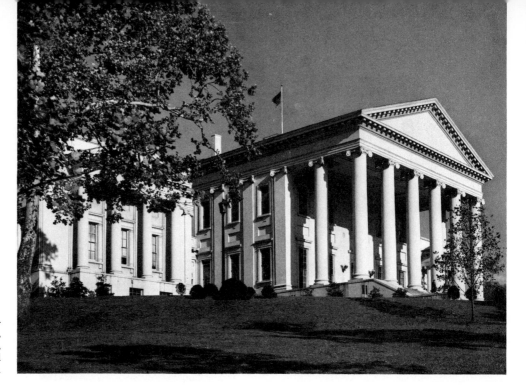

16-7 THOMAS JEFFERSON, State Capitol, Richmond, Virginia, designed 1785–89.

briand, are translations into stone of the sacred groves of the druidical Gauls and must be cherished as manifestations of France's holy history. In his view the history of Christianity and that of France merged in the Middle Ages. As the nineteenth century gathered the documentary materials of European history in a stupendous historiographical enterprise, each nation came to value its past as evidence of the validity of its ambitions and claims to greatness. The art of the remote past was now appreciated as a product of racial and national genius. In 1773, Goethe, praising the Gothic cathedral of Strasbourg in *Of German Architecture*, declared that the German art scholar "should thank God to be able to proclaim aloud that it is German architecture, our architecture . . ."; he bid the observer "approach and recognize the deepest feeling of truth and beauty of proportion emanating from a strong, vigorous German soul" This was at a time when Gothic architecture, even though enjoyed as picturesque, was generally disparaged as a style inferior to classical architecture.

Modern nationalism thus brought a new evaluation of the art in each country's past. In London, when the old Houses of Parliament burned in 1834, the Parliamentary Commission decreed that designs for the new building should be either "Gothic or Elizabethan." CHARLES BARRY (1795–1860), with the assistance of A. W. N. PUGIN

(1812–52), submitted the winning design in 1835, and the work was carried on from the 1840's into the 1860's (FIG. 16-8). By this time style had become a matter of selection from the historical supply. Barry preferred the classical, but Pugin influenced him successfully in the direction of English Late Gothic. Pugin was one of a group of English artists and critics that included William Morris and John Ruskin, who saw moral purity and spiritual authenticity in the religious architecture of the Middle Ages, glorifying the careful Medieval craftsmen who produced it. The industrial revolution was now flooding the market with cheaply made and ill-designed commodities; handicraft was replaced by the machine, and men like Pugin believed in the necessity of restoring the old craftsmanship, which had honesty and quality. The design of the Houses of Parliament, however, is not genuinely Gothic, despite its picturesque tower groupings. It has a formal axial plan and a kind of Palladian regularity beneath its Tudor detail. Pugin himself is recorded to have said of it: "All Grecian, sir, Tudor details on a classic body."[4]

Neoclassical and Gothic architecture dominated the early nineteenth century, but exotic styles of all sorts, with fancifully mixed ingredients bor-

[4] In Nikolaus Pevsner, *An Outline of European Architecture* (Baltimore: Penguin, 1960), p. 627.

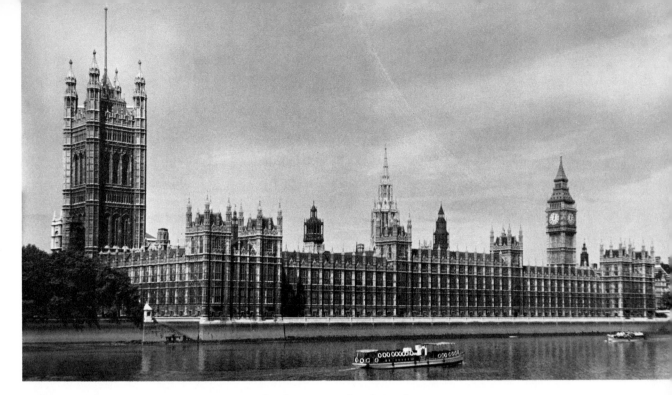

16-8 CHARLES BARRY and A. W. N. PUGIN, Houses of Parliament, London, designed 1835.

16-9 JOHN NASH, Royal Pavilion, Brighton, 1815–18.

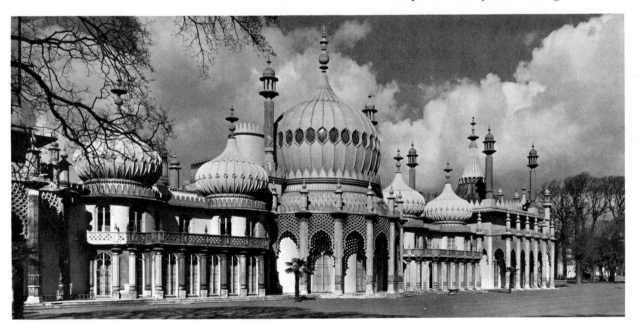

rowed from the East, appeared, especially in connection with places of recreation. At Brighton, England, the shore resort fashionable during the reign of the prince regent, later George IV, JOHN NASH (1752–1835) built the Royal Pavilion from 1815 to 1818 (FIG. 16-9). A confection of Islamic domes, minarets, and screens, this "Indian Gothic" structure is appropriate enough as a backdrop for gala throngs pursuing pleasure by the seaside and was the prototype of any number of playful architectural exaggerations that can still be found at European and American resorts.

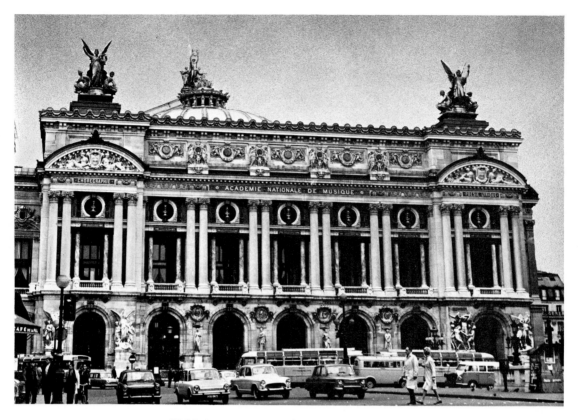

16-10 CHARLES GARNIER, the Opéra, Paris, 1861–74.

By mid-century, Renaissance and Baroque had been added to the stylistic repertory. France under Napoleon III, the "Second Empire," had expanded its vast holdings in Africa and Asia, and its businessmen had obeyed the statesman Guizot's patriotic admonition—made early in the previous reign of Louis Philippe—to get rich. The opulence of the period is mirrored in CHARLES GARNIER's Paris Opéra (FIG. 16-10), which was built between 1861 and 1874, and parades a front almost embarrassingly ostentatious, like a bejeweled and befeathered lady of the newly rich; to be fair, it must be remembered that it was built to be festive and spectacularly theatrical. It should be compared with the façade of the Louvre, which it mimics to a degree; the difference between aristocratic and bourgeois taste is graphically stated. The interior is quite Baroque in its sweeping staircases, Italianate motifs, and broad trumpeting of magnificence. Until World War I, theaters and opera houses would gaudily reflect the Paris Opéra design.

In Sculpture

As in architecture, there are several Romantic styles in nineteenth-century sculpture, but their sequence and character are naturally closer to those of painting. A Romantic classicism is strongly determinative of the work of ANTONIO CANOVA (1757–1822). His reclining portrait-figure of Pauline Borghese (FIG. 16-11) as the victorious Venus shows him to be learned in the traits of classicism—in drapery, pose, form, and feature. That he adroitly draws the likeness of his subject within the almost standard outlines of a classical statue shows him not slavishly bound by Neoclassical doctrine. At the same time, with quite remarkable discretion, he creates a daring image of seductive charm that is generalized enough to personify the goddess of love rather than exhibit the living person. Both the voluptuousness and the tact with which he veils it recall the earlier Rococo, when esteemed ladies were often represented as seminude goddesses; the realism

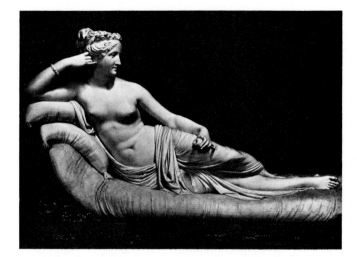

of the couch and its drapery, however, almost betray Canova into a too graphic presentation. Despite a lingering Rococo charm and realistic accessories, the sculptor is firmly Neoclassic in his approach. Considered the greatest sculptor of his time, Canova has suffered greatly in reputation since. Present criticism has restored it a little, though he still carries, as the most typical of Neoclassicists, something of the burden of negative criticism laid upon that often doctrinaire and artificial style. Its defects can be seen well enough in a statue of George Washington (FIG. 16-12) by the American sculptor HORATIO GREENOUGH (1805–52). Here the sculptor aims at monumental majesty, perhaps with a classical Zeus in mind; but whether his subject was not susceptible of deification, or whether the realistic temper of the period simply could not bring the concepts of ancient god and modern man together, in Greenough's time the statue was considered a failure. The father of his country, wearing his eighteenth-century wig and with ancient drapery and nude torso, approximated the period's image of a majestic law-giver. The statue manifests, more than many of its Neoclassical age, the contradictions that sometimes develop when idealization and realistic illusionism meet. Canova appears to harmonize them; Greenough puts them in opposition. Most nineteenth-century monumental sculpture in the Neoclassical mode seems stiff, cold, or simply unconvincing. One monumental group, however, done between 1833 and 1836 and recalling the Baroque, still moves us—the so-called *Marseillaise* (FIG. 16-13) by FRANÇOIS RUDE (1784–1855). The colossal figures, in bold relief against the Arc de Triomphe in Paris, represent French volunteers leaving to defend the borders of France against the foreign enemies of the revolution in 1792. They are dressed in classical armor, and the Roman war goddess, Bellona (who may be thought of here as La Marseillaise or the Goddess of Liberty), shouts the battle cry as she rallies the militia forward. The classical accessories do not disguise the essentially Baroque qualities of the group—the densely packed masses, jagged contours, violence of motion.

If we were to think here of the classical at all it would be of the post-classical "baroque" of Hellenistic works like the great frieze at Pergamum. This explosive style, here effective enough in sculpture, finds its natural medium in Romantic painting. Stormy emotion and untamed nature, those obsessions of Romanticism, require a style full of movement and color; and to make them sharply convincing to the spectator, they require as realistic a representation as possible. Animal ferocity, which nineteenth-century taste does not permit to be shown at the full in man,

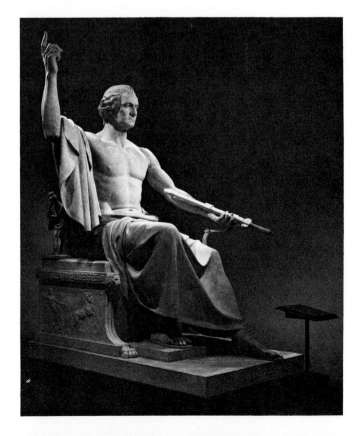

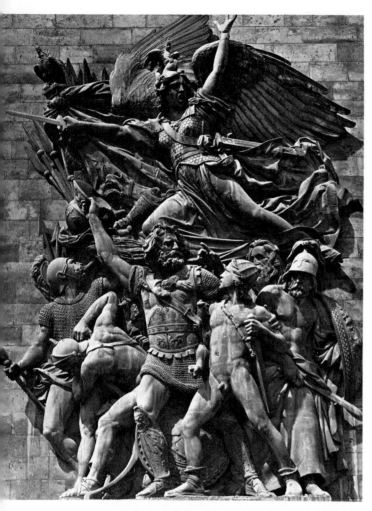

16-13 François Rude, *"La Marseillaise,"* Arc de Triomphe, Paris, 1833–36. Approx. 42′ × 26′.

Indeed, the naturalistic bent of Romanticism increasingly asks a realistic form. Fortunately, nineteenth-century sculpture drew a line at complete realism, a line that separates the art of the sculptor from the art of the wax museum; thus, a sculptured figure is more than a human figure frozen into a tableau. Where sculpture became too "lifelike" it gave up its proper domain to nineteenth-century painting, photography, and acting, which developed in a specialized manner to express the time's bent for the optically real. A model of Romantic realism is Gustave Doré's *D'Artagnan* (1832), representing the hero of Dumas's *Three Musketeers*, which was placed at the author's monument (FIG. 16-15). Doré was an enormously popular mid-century illustrator and engraver, who carried over a taste for pictorial realism into sculpture, with the resultant lack of authenticity we find here. The dashing D'Artagnan is a modern Romantic actor playing the Romantic part written for him; he is by no means a gentleman of the royal court guard opposed to Cardinal Richelieu in the early seventeenth century. He is so "real" that he occupies the space we do, but his "fact" is in reality fiction; he has failed to keep the necessary distance that sculpture must keep; he is real and is not. This is a defect common to thousands of realistic statues produced in the nineteenth century. Romantic art cannot recapture the past; it can just pretend to. Only at the end of the nineteenth century will there appear a sculpture that turns its back upon acting in costume and faces the tremendous task of adventuring into new forms.

In Painting

Painting in the nineteenth century, touched strongly by the spirit of Romanticism, proves to be a far more sensitive medium for the kind of personal expression we should expect from the romantic subjectivity of the time. At the very beginning of the modern period stands the imposing figure of Francisco Goya (1746–1828), the great independent painter of Spain. Founder of no school and acknowledging indebtedness to Velázquez, Rembrandt, and "nature," Goya takes his place as an unclassifiable giant. He ranges from the late Venetian baroque of Tiepolo, through a brilliant impressionistic realism of his

Romanticism describes in brute beasts. Antoine-Louis Barye (1795–1875) was a specialist in such depiction. His *Jaguar Devouring a Hare* (FIG. 16-14), painful as the subject is, draws us irresistibly by its fidelity to brute nature; the belly-crouching cat's swelling muscles, hunching shoulders, and tense spine—even the switch of the tail—tell of Barye's long sessions of observing the beasts in the Jardin des Plantes in Paris. The work tells too of the influence of the vast, exotic world of animal life, whose geography was opening before the naturalistic eyes and temper of the nineteenth century and from which artists, novelists, and poets, as well as scientists, would draw increasing knowledge and inspiration.

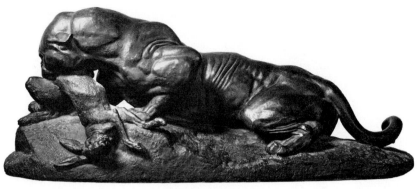

16-14 ANTOINE-LOUIS BARYE, *Jaguar Devouring a Hare*, 1850–51. Bronze, approx. 16″ × 37″. Louvre, Paris.

own, to a late expressionism in which dark and powerful distortions anticipate much of the violence, pain, and psychic upheaval in the art of the twentieth century. His very scope and variety, of both subject matter and form, place him beyond any definition. Goya is a great transitional figure who changes the tradition while he manifests the present and prophesies the future of pictorial art. From a much higher vantage point than most of his contemporaries he depicts, in a bitter and unsparing revelation, the capacity of man for evil. Great Spanish painting is rarely sentimental; it insists, often with ruthless honesty, on the cruel facts of life. The art of Goya is no exception; it is for the strong-minded and the strong-nerved.

Little of the grim account of humanity that is to come can be seen in Goya's early, vivacious manner, brilliantly adapted from Tiepolo (FIG. 16-16). At the royal court in Madrid, where his precocious talent had brought him early in his career, Goya produced a series of genre paintings designed to serve as models for tapestries. Their prevailing mood is gaiety, the mood of the Rococo, with, however, a vigor unlike the languid delicacy of Watteau. Rather, one feels in these pictures the breadth and brightness of Tiepolo, with Tiepolo's device of sharp shadow accents against wide, sunlit skies.

The noonday blitheness of Goya's early style soon wanes. His experiences as painter to Charles IV, at whose sensationally corrupt court he lived, must have fostered his unsentimental, hard-eyed realism. In his large painting of the family of Charles IV (FIG. 16-17), probably inspired by Velázquez's *Las Meninas* (FIG. 15-29), Goya presents with a straight face a menagerie of human grotesques who, critics have long been convinced, must not have had the intelligence to realize that the artist was caricaturing them. This superb revelation of stupidity, pomposity, and vulgarity, painted in 1800, led a later critic to summarize the subject as the "grocer and his family who have just won the big lottery prize." The painter, by his canvas, is dimly discernible at the left; his features impassively ironical, he looks beyond his subjects to the observer. Goya here exhibits his extraordinary skill as a colorist and manager in the oil medium. The colors float with a quiet iridescence across the surface, and the paint is

16-15 GUSTAVE DORÉ, *D'Artagnan*, monument of Alexandre Dumas, Paris, 1832.

16-16 Francisco Goya, *The Parasol*, 1777. Painting for tapestry, approx. 41″ × 59″. Museo del Prado, Madrid.

16-17 Francisco Goya, *The Family of Charles IV*, 1800. Approx. 9′ 2″ × 11′. Museo del Prado, Madrid.

applied with deft economy. Great solidity is suggested by the most transparent tones. A magician of optical pictorialism, Goya uses the methods of his great predecessor Velázquez.

Goya sharpened his criticisms of human vanity and vice in a series of satirical paintings and prints done between 1794 and 1799 called *Los Caprichos*, "The Caprices" (FIG. 16-18), in which monsters, grotesques, and caricatured men and women represent the repulsiveness of stupidity and folly. But the intervention of Napoleon Bonaparte in Spain in 1808 and the ensuing conflict gave him a new subject: not the foolishness of human ways, but the horror of war. In paintings and etchings, Goya, without national bias (though he was a patriot) and without mercy for the viewers' sensitivities, exhibited the atrocities men visit upon one another, no matter the issues, no matter the persons involved. His is a peculiarly modern vision; Picasso, in his *Guernica* (FIG. 17-9), which he calls "brutality and darkness," gives us Goya's vision once again, translating his truth into a different formal language.

In the *Third of May, 1808* (PLATE 16-2) a French firing squad butchers by lamplight citizens of Madrid after the fall of the city. Unlike the subtle, even suave, realism of the *Family of Charles IV*, the method here is coarse and extreme in its departure from optical fact. The postures and gestures of the figures are shockingly distorted to signal defiance, hatred, and terror. In keeping with the distortions of the figures, the color is acid and harsh, wrenched out of any normal harmony. Violent suffering and death can be rendered only in painful dissonances of shape and color.

Goya's perception of the insignificance of human life, of death and suffering in war and the obscenity of human wreckage is vented bitterly in a series of aquatint etchings, the *Disasters of War*. In that series a print called *Tampoco*, "Neither Nor" (FIG. 16-19), shows a soldier, brutalized by his profession to the point of utter indifference to the death of others, lounging in a grove of hanged Spanish peasants and gazing with vague boredom at a miscellaneous victim. Goya, one of the greatest masters of the graphic arts, is at his very best in the *Disasters* as he sets out in the most striking simplicity of sharp shapes, light and dark, the ghastly tableau of death. Employing

16-18 FRANCISCO GOYA, *"The Dream of Reason,"* c. 1794–99. Pen-and-sepia drawing, from *Los Caprichos*, approx. 8″ × 5″. Museo del Prado, Madrid.

16-19 FRANCISCO GOYA, *Tampoco*, 1810. Etching, from the *Disasters of War*. New York Public Library Print Collection.

16-20 Francisco Goya, *Saturn Devouring His Children*, 1819–23. Detail of a detached fresco on canvas, full size approx. 4′ 9″ × 2′ 8″. Museo del Prado, Madrid.

monsters who worship the devil and swarm in nightmares. *Saturn Devouring His Children* (FIG. 16-20) is one product of this pessimistic and misanthropic style. Saturn (Time), glaring in idiotic frenzy, rips apart the body of a small man and crams a fragment into his mouth. The forms are torn and jagged, the colors livid. Life is in time, and time devours us all. Goya's horror is not merely of man's inhumanity to man, but of life itself. This appalling work came from a supreme artist who had evidently become convinced of the words seen in an early print from *Los Caprichos* (FIG. 16-18): "The dream of reason produces monsters."

If Goya is impossible to classify, JACQUES LOUIS DAVID (1748–1825) has suffered in the past from too narrow a classification. This leader of the French school in the age of the French Revolution and Napoleon, though he is now being intelligently reappraised, was commonly designated as a Neoclassicist; he is still regarded as father of the academic art produced under official patronage in nineteenth-century France. We have seen that Neoclassicism is only one of the revival styles of Romanticism. The fact is, too, that classical art had a long tradition in Europe and France before the time of David and that academies had long based their existence on the principle that art can be taught according to rules (taken from the ancients and the great masters of the Renaissance). David reworked in his own quite individual and often nonclassical style the classical and academic traditions. He rebelled against the Rococo as an "artificial taste" and exalted classical art as, in his own words, "the imitation of nature in her most beautiful and perfect form." He praised Greek art enthusiastically, though he, like Winckelmann, knew almost nothing about it firsthand: "I want to work in a pure Greek style. I feed my eyes on antique statues; I even have the intention of imitating some of them" But David's doctrine of the superiority of classical art was not based on an isolated esthetic; believing, as he wrote, that "the arts must . . . contribute forcefully to the education of the public," he was prepared both as artist and politician when the French Revolution offered the opportunity to create a public art, an art of propaganda.

David was active in the revolution as a Jacobin friend of the radical Robespierre, as a member of

an overriding irony and ingenious compositions, his refined art served as a scourge of human complacency. Goya's strength as a graphic artist lies in his astonishing economy of means. Like a master of pantomime, he gives us only a few cues, strengthening the force and meaning of gestures by abbreviating and simplifying them; he reduces all to the essential. It is this that recommended Goya to painters and graphic artists who followed him, like Daumier.

The folly and brutalities he witnessed and his own increasing infirmities, including deafness, combined to depress Goya's outlook and led to his late "dark style." In ominous midnight colors he creates a whole population of subhuman

the Revolutionary Convention that voted for the death of the king, and as quasidictator of the Committee on Public Education, where he directed the art programs of the new republic. He joined scholars and artists in soliciting the revolutionary government to abolish the old Royal Academy and established in its place panels of experts to guide the reformation of taste. His position of power made him dominant in the transformation of style, and his own manner was the official model for many years.

Although painted in 1784, before the revolution, David's *Oath of the Horatii* (FIG. 16-21) reflects his politically didactic purpose and his doctrine of the educational power of classical form, as well as his method of composing the Neoclassical picture. Most important of all to David, as artistic descendant of the old academy, is the choice of subject matter: It must have grandeur and a moral. If effectively presented, David wrote, the "marks of heroism and civic virtue offered the eyes of the people will electrify its soul, and plant the seeds of glory and devotion to the fatherland." For this *Oath*, David selected a story from Republican Rome, the heroic phase of Roman history that had been pushed to the foreground of public interest by the sensational archeological discoveries made at the time at Herculaneum and Pompeii. The subject exploits a conflict between love and patriotism and is based on a play by Cor-

neille that had been performed in Paris several years earlier and thus was known to the Parisian public. According to the story, first told by Pliny and Plutarch, the leaders of the Roman and Alban armies, poised for battle, decided to resolve their conflicts in triple combat among three representatives from each side. The Roman choice fell on the three Horatius brothers, that of the Albans on the three sons of the Curatius family.

David's painting shows the Horatii as they swear on their swords to win or die for Rome, oblivious to the anguish and sorrow of their sisters, one of whom was the bride-to-be of a Curatius. The theme is stated with admirable force and clarity. The rigid and virile forms of the men effectively eclipse the soft, curvilinear shapes of the mourning women in the right background. Such manly virtues as courage, patriotism, and unwavering loyalty to a cause are emphasized over the less heroic emotions of love, sorrow, and despair, which are symbolized by the women. The message is clear and of a type with which the prerevolutionary French public could readily identify. The picture created a sensation when it was exhibited in Paris in 1785, and with it the Neoclassical style became the semi-official voice of the revolution. David may have been in the academic tradition, but he makes of it something new, a program for arousing an audience to a pitch of patriotic zeal. From David's *Oath* onward,

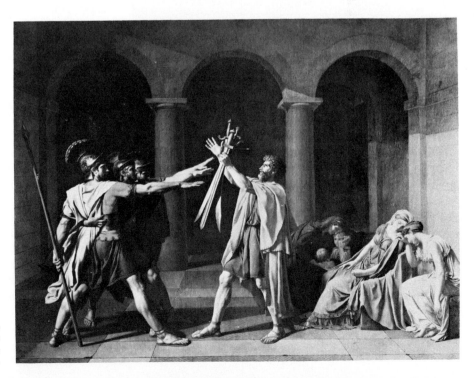

16-21 JACQUES LOUIS DAVID, *Oath of the Horatii*, 1784. Oil on canvas, approx. 14' × 11'. Louvre, Paris.

art becomes political, if not often in the sense of serving a state or party, then in its division into trends, movements, and ideologies.

In its form, the *Oath of the Horatii* is a paragon of Neoclassical academicism. In a shallow picture box, defined by a severely simple architectural framework, statuesque and carefully modeled figures are deployed laterally and close to the foreground in a manner reminiscent of ancient relief sculpture. But caught up in the general mid-eighteenth-century enthusiasm for the archeological recovery and study of great civilizations, David desired to describe precisely the monuments and personages of the historical past. Thus, the man who complained that Raphael—that paragon of classicism—erred by putting people of different periods into the same picture, was compelled by his almost pedantic dedication to historical reality to modify his Neoclassical

formula. While in later work he sought to avoid such changes in formula and even stiffened his style in keeping with his concept of the antique, in a painting like the *Death of Marat* (FIG. 16-22) the classical elements—closed outline and compact composition—though present, are made to serve the ends of a dramatic realism of strong, psychic impact. The cold, neutral space above the densely organized figure-group makes for a chilling oppressiveness. Here the scene is shaped by historical fact, not Neoclassical theory; and the "stele"-like composition reveals that David had closely studied Michelangelo, especially the Christ of the *Pietà* in St. Peter's. Marat, a personal friend of David and a revolutionary radical, is stabbed to death in his bath by Charlotte Corday, a political enemy. Narrative circumstances—the knife, the wound, the blood, the letter by which the young woman gained entrance—are all vividly placed details intended to sharpen the sense of pain and outrage, but above all to confront the viewer with the scene itself. The *Marat*, given David's personal involvement, is a poignantly felt theme realized with almost painful sincerity. It is convincingly *real*; yet it loses nothing of pose, composition, and rendering of light and shadow in David's astonishingly calm execution.

From modernizing classical antiquity in the quasirealism of the *Oath of the Horatii*, David eventually moved to the point where he was classicizing the modern, as in his *Madame Récamier*, in which a Parisian socialite, dressed and coiffed *à la grecque*, reclines on a Pompeian couch in a severely formal setting. The corner is turned, and we now get the staged, rather than the real, classicism, much like a modern motion picture concerned with historical events. This is the consequence of David's mobilization of the classical manner in the service of contemporary political struggles, for the core idea of classicism is changeless generality that supposedly transcends the accidents of time. However, even before David's time it had been discovered that classical philosophy and art *were* historical and that they did, after all, belong to a particular time and place.

Thus, for all his loyalty to classical theory, David turns out not to be a classicist at all, and his pupils and successors either drop his program altogether or change classicism into a decorative,

16-22 JACQUES LOUIS DAVID, *The Death of Marat*, 1793. Oil on canvas, approx. 5' 3" × 4' 1". Musées Royaux des Beaux-Arts de Belgique, Brussels.

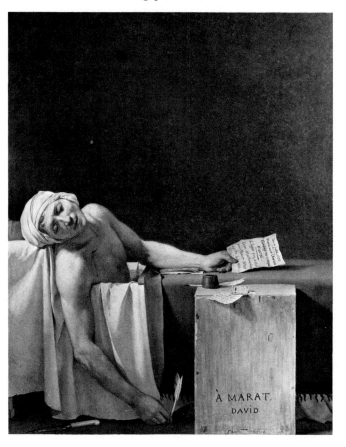

16-23 ANNE LOUIS GIRODET, *The Burial of Atala*, 1808. Approx. 6′ 11″ × 8′ 9″. Louvre, Paris.

contour manner (of forms outlined and filled in with color), valued not for its idealism or truth, but for its purely visual qualities. David's avowed purpose was to "electrify the soul," while he believed that art must be "of the reason, and rise above the passions." This contradiction, symptomatic of the turbulent change from the age of reason to the age of revolution, makes his art inconsistent, and his followers, although they will agree with the romantic purpose of "electrifying the soul," will break it into different combinations and directions using a variety of stylistic means, for all the styles of past times and distant places are now becoming available to the artist.

David demanded that his pupils select their subjects from Plutarch, ancient author of the *Lives of the Great Greeks and Romans* and principal source of standard classical subject matter. For the most part, they found their subjects elsewhere. ANNE LOUIS GIRODET (1767–1824) turned to a popular novel by Chateaubriand, *Atala*, and produced in his *Burial of Atala* (FIG. 16-23) a picture that is almost a set piece of Romanticism. Atala, sworn to lifelong virginity, falls passionately in love with a wild young savage of the Carolina wilderness. Rather than break her oath she com-mits suicide and is buried in the shadow of the cross by her distracted lover; Holy Church is represented in the person of a gentle priest. Thus, Girodet daringly puts religion and sexual passion side by side, binding them with the theme of death and burial. Hopeless love, perished beauty, the grave, the consolation of religion—these are some of the thematic constants of Romanticism that Girodet has successfully interwoven. The picture's composite style combines classicizing contours and modeling with a dash of the erotic sweetness of the Rococo and the dramatic illumination of the Baroque. The appeal is to the viewer's private world of fantasy and emotion, unlike David's appeal to the feelings that manifest themselves in public action. If David's purpose is to "electrify the soul," Girodet's is, in the language of Rousseau, to "wring the heart." In either case, the artist speaks to our emotions, rather than inviting philosophical meditation or revealing some grand order of nature and form. The Romantic artist, whether David, Girodet, or any other, wants to excite his audience.

Another pupil of David's, the Baron ANTOINE JEAN GROS (1771–1835) deviated from his master's teachings quite as much as, and much more in-

16-24 Antoine Jean Gros, *Pest House at Jaffa*, 1804. Oil on canvas, approx. 17′ 5″ × 23′ 7″. Louvre, Paris.

fluentially than, Girodet. In his *Pest House at Jaffa* (FIG. 16-24), which was painted in 1804, he takes a radically independent tack, sorting through and selecting numerous Baroque pictorial devices of light, shade, and perspective to stage as dramatically as possible a tableau testifying to the superhuman power and glory of Napoleon Bonaparte. A comparison of the *Horatii* with the *Pest House* illustrates Gros's departure from David. Though the works are similar in that they stage an action within an architectural enframement, the figures being deployed before an arcade, David's arcade is Roman and Gros's is Moorish, and there is a vista through the latter's to a distant landscape, a fortress, and the tricolor flag of the revolution. Time has changed the setting, and the painter's means have changed to suit the present. Gros, using every device to focus the viewer's attention

upon the central figure of the hero, dismisses most theoretical considerations of classical balance and modeling and poses Napoleon as a stage director would, making the fullest use of stage lights and dramatic darkness to center the figure of the chief protagonist. His purpose is to elevate a historical event to an act of almost religious significance and solemnity, in which Napoleon, the messiah of democracy, plays simultaneously the roles of Alexander, Christ, and Louis XIV. Bonaparte, the First Consul, not yet Emperor Napoleon I, at the end of the disastrous Egyptian campaign, has retreated up the coast of Palestine, modern Israel. His army is stricken with the plague, and he is shown visiting his sick and dying soldiers in a hospital in the ancient city of Jaffa. There in the midst of the dead and dying, the fearless genius of the New Order touches the plague sores of a

| c.**1800** | 1804 | 1808 | 1814 | 1815 | 1818 | **1830** | 1837 | 1838 | 1847 | 1848 | 1857 | to c.1886 → |

| | INGRES | GOYA | NASH | GÉRICAULT | DELACROIX | | TURNER | COUTURE | Communist | MILLET | |
| | *Oedipus* | *3rd of May* | Royal Pavilion | *Raft of Medusa* | *Liberty Leading the People* | | *Fighting Téméraire* | *Romans of the Decadence* | Manifesto | *The Gleaners* | |

R O M A N T I C I S M R E A L I S M

← NAPOLEON I → ← LOUIS PHILIPPE → ← VICTORIA → to 1901

sick soldier who stares at him in awe, as if he were the miracle-working Christ. The staff officers stop their noses against the stench of the place, but the general is calm and unperturbed, like the king curing by the King's Touch. In the left foreground men brood, crouch, and sprawl in a gloom of misery and anguish—figures that will be of special interest to later Romantic artists like Géricault and Delacroix. The whole scene is wrapped in the glamor of its Near Eastern setting: the turbaned Moslem physician and his assistants, the Moorish arches, the exotic landscape. As with Girodet, we have identifiable, if not identical, themes: suffering and death, faith and personal heroism, the lure of distant places, patriotism— all that can appeal to the modern need for emotional stimulation; in a word, Romanticism.

With THÉODORE GÉRICAULT (1791–1824), a pupil of Guérin, the program classicism of the

Davidian school fades, while David's sharp, Caravaggio-like light and shade and his realism come to the fore. This maturing of the realistic element present in David and his successors is, in Géricault's masterpiece, the *Raft of the Medusa* (FIG. 16-25), quickened by the catalytic influences of Michelangelo and Rubens. David and Gros had already initiated the trend toward huge canvases dramatically presenting contemporary events. Géricault takes for his theme the ordeal of the survivors of the French ship *Medusa*, which, laden with Algerian immigrants, had foundered off the west coast of Africa. The incident, a result of tragic mismanagement, caused a scandal, and Géricault's depiction of the anguish of the survivors on the raft was construed by the government as a political attack. Géricault chooses the most dramatic moment of the episode, when the frantic castaways attempt to attract the attention of a

16-25 THÉODORE GÉRICAULT, *Raft of the Medusa*, 1818–19. Oil on canvas, approx. 16′ × 23′. Louvre, Paris.

distant ship. The figures are piled upon one another in every attitude of suffering, despair, and death, recalling the foreground figures in Gros's *Pest House* (FIG. 16-24). Powerful light and dark contrasts suit the violence of the twisting and writhing bodies. Though Baroque devices are everywhere present, Géricault's use of shock tactics that stun the viewer's sensibilities amounts to something new, a new tone and intention that distinguish the second and "high" phase of Romanticism. In this phase an instinct for the sublime and the terrible, qualities already celebrated by the esthetic theory of the mid-eighteenth century, finds sharpest expression in the method of reportorial realism already noted in certain pictures by David. Géricault, like a painstaking reporter out to "get the facts," interviewed survivors of the *Medusa* and made careful studies of dying men and dead bodies.

His *Mounted Officer of the Imperial Guard* (FIG. 16-26), painted in 1812, shows the Romantic's admiration for fierce power. Géricault's generation is born of the French Revolution and the Napoleonic Wars, in the midst of the thunder of cannon and cavalry. Military splendor, the glamor and pomp of war, its valor and terror, are natural themes of the times, and pictures by Géricault and his contemporaries celebrate war's furious excitement rather than its horror and degradation. In his *Officer*, man and horse are as if one, part man, part beast. The Romantic obsession with the forces of nature extends to the subhuman in man and the "innocent cruelty" of beasts of prey. Here Géricault throws his horse and rider into exaggerated gyrations in an effort to create an illusion of explosive action. His color and "open" form recall Rubens, but his intent is to thrill the viewer with the contemporary apparition of fury as he exalts the idea of the Napoleonic hero.

The interest in mental aberration contributes, later in the nineteenth century, to the development of modern psychopathology and is part of the Romantic fascination with the irregular and the abandoned. The inner storms that overthrow rationality could hardly fail to be of interest to the rebels against the age of reason. Géricault, like many of his contemporaries, studied the influence of mental states on the human face and believed, as they did, that a man's face accurately reveals his character, especially in madness and at the instant of death. He made many studies of inmates of hospitals and institutions for the criminally insane, and he studied the severed heads of victims of the guillotine. Scientific and artistic curiosity are not easily separated from the morbidity of the Romantic interest in derangement and death. Géricault's *Madwoman* (FIG. 16-27), her face twisted, her eyes red-rimmed, leers with paranoiac hatred in one of several "portraits" of insane subjects that have a peculiar hypnotic power as well as astonishing authenticity in presentation of the psychic facts. The *Madwoman* is only another example of the increasingly realistic core of Romantic painting. The closer the Romantic involves himself with nature, sane or mad, the more he hopes to get at the truth. Increasingly this will mean for painting the *optical* truth, as well as truth to "the way things are." Meanwhile, for the Romantic, the "real" is nature wild and untamed. In Géricault's paintings, suffering and death, battle frenzy, and madness amount to nature itself, for nature in the end is formless and destructive:

It is evident that nature cares very little whether man has a mind or not. The real man is the savage; he is in accord with nature as she is. As soon as man sharpens his intelligence, increases his ideas and the way of expressing them, and acquires need, nature runs counter to him in everything.

In these words EUGÈNE DELACROIX (1798–1863) succinctly gives us a clause from the Romantic's testament of nature and of man in nature.

We have seen that the qualities of the sublime and the terrible, and the emotions of awe and admiring wonder that they produce, are most sought after by the Romantic poet and artist. As Delacroix writes in his famous journal: "Baudelaire[5] . . . says that I bring back to painting . . . the feeling which delights in the terrible. He is right" Delacroix, who knew and admired Géricault, greatly expanded the expressive possibilities of Romantic art, developing its themes and elaborating its forms in the direction of ever greater emotional power—in Romantic parlance, "sublimity." Literature of like power supplied

[5] Charles Baudelaire (1821–67), one of the nineteenth century's finest and most influential poets, was also one of its most prominent art critics.

him his subjects, and, as Baudelaire remarks in this regard, he "inherited from the great Republican and Imperial school [of David] a love of the poets and a strangely impulsive spirit of rivalry with the written word. David, Guérin, and Géricault kindled their minds at the brazier of Homer, Vergil, Racine, and Ossian. Delacroix was the soul-stirring translator of Shakespeare, Dante, Byron, and Ariosto" Since David, literature and art had been developing an ever more intimate association. Their relation had already been established in the Renaissance. But in the Romantic age much painting could almost be said to be "programed" by literature, as could most music, such as the operas of Richard Wagner. As we speak of "program" music, we can also speak of "program" art, and it is the "story picture" produced by this art that evolved into the genre of the motion picture, a composite of drama, narrative, sound, and pictures. In Delacroix, what started with David culminates in the literature-inspired staging of exciting and disturbing human events, real or imaginary, and a concern for the most accurate visual means of conveying them. From David to Delacroix and in their lesser followers there is a belief that the purpose of

pictorial art is to stir, to "electrify," and to render accurately and sympathetically the modern spirit in a modern look. This art is aimed at large publics—to move and to appeal to the new, populous democratic society. With the great, programatic pictorialism of the Romantic period we begin the truly modern and familiar experience of public spectacular drama, the production of thrilling stories, thrillingly staged.

Although the faculty of mind most valued by the Romantic is imagination, Delacroix realized that skill and restraint must go along with it. "In his eyes," Baudelaire writes of Delacroix, "imagination was the most precious gift, the most important faculty, but [he believed] that this faculty remained impotent and sterile if it was not served by a resourceful skill which could follow it in its restless and tyrannical whims." Delacroix's picture dramas are products of his view that the power of imagination, nourished and continually kindled by great literature, art, and music, will synthesize works that catch and inflame the imagination of the observer. To be intensely imaginative is to be intensely alive.

An example of pictorial grand opera on a colossal scale is Delacroix's *Death of Sardanapalus*

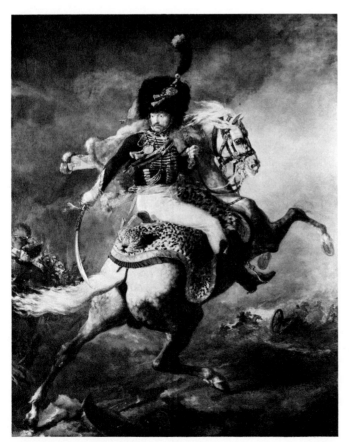

16-26 Left: THÉODORE GÉRICAULT, *Mounted Officer of the Imperial Guard*, 1812. Approx. 9′ 7″ × 6′ 4½″. Louvre, Paris.

16-27 THÉODORE GÉRICAULT, *Madwoman*, 1822–23. Oil on canvas, approx. 28″ × 21″. Musée des Beaux-Arts, Lyons.

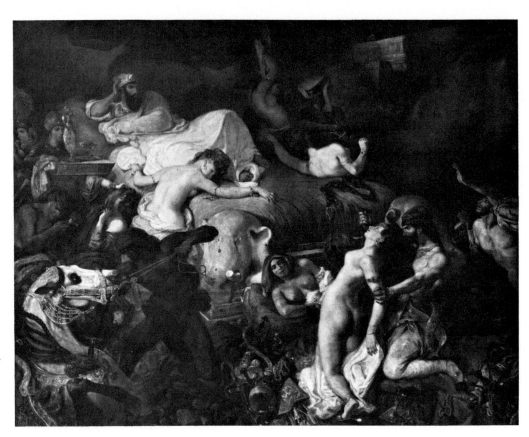

16-28 Eugène Delacroix, *The Death of Sardanapalus*, 1826. Oil on canvas, approx. 12′ 1″ × 16′ 3″. Louvre, Paris.

(FIG. 16-28), which he painted in 1826. Delacroix was no doubt inspired by Lord Byron's narrative poem *Sardanapalus* and perhaps by other ancient sources, but here he relates the last hour of the ancient king in a much more tempestuous and crowded setting than Byron described. Hearing of the defeat of his armies and the enemies' entry into his city, the king has all his most precious possessions destroyed in his sight—his women, slaves, horses, and treasure—while he watches gloomily from his funeral pyre, soon to be set alight. The king presides like a genius of evil over the panorama of destruction, most conspicuous in which are the tortured and dying bodies of his Rubenesque women, the one in the foreground dispatched by a slave almost ecstatically murderous. This carnival of suffering and death is glorified by superb drawing and color, the most daringly difficult and tortuous poses, and the richest intensities of hues and contrasts of light and dark. The king is the center of the calamity, the quiet eye of a hurricane of form and color. It testifies to

Delacroix's art that his center of meaning, away from the central action, entirely controls it.

Generally Delacroix chose his stories from either pre- or postclassical periods and literature, but occasionally he dealt with a Greek subject that moved him. His *Medea* (FIG. 16-29) is drawn from the tragedy of that name by Euripides, and it is unlikely that any other painter could have done the theme such justice. Medea, abandoned by Jason, in a mad fit of vengeful rage kills their children, and at the end is transformed into a goddess of evil, a witch. The subject had been treated many times by ancient artists. Medea, the beautiful and fatal woman whose very charms destroy, is a prominent figure in the cast of Romantic characters; she is familiar as *la belle dame sans merci*. In Delacroix's version, not only is she the *femme fatale* but also the royal virago (such as Lady Macbeth), the woman scorned, the desperate mother torn between love and hate. The setting is a weird grotto, and the hideous act that impends is foreshadowed in the tension

—that "indefinable thing which makes of an *odious object an object of art*" (his emphasis).

Also a source of subjects were the events of his own time, notably popular struggles for freedom: the ill-fated revolt of the Greeks against Turkish rule in the 1820's; the Parisian revolution of 1830, which overthrew the restored Bourbons and placed Louis Philippe on the throne of France. In *Liberty Leading the People* (FIG. 16-30), done in 1830, Delacroix makes no attempt to represent realistically a specific incident. Instead he gives us an allegory of revolution itself. Liberty, a partly nude, majestic woman, whose beautiful features wear an expression of noble dignity, waves the people forward to the barricades, the familiar revolutionary apparatus of Paris streets. She carries the banner of the republic, the tricolor, and a musket with bayonet and wears the cap of Liberty. The path of her advance is over the dead and dying of both parties—the people, and the royal troops. Arrayed around her are bold Parisian types, the street boy brandishing his pistols, the menacing *prolétaire* with a cutlass, the intellectual dandy in plug hat and with sawed-off musket. The towers of Notre Dame rise through the smoke and clamor as witness to the ancient tradition of liberty cherished by the people of Paris through the centuries. The *Liberty* is a document of the intimate union of revolution and Romanticism, and conveys more powerfully than any other early nineteenth-century painting the political temper of revolutionary Europe.

In terms of form, the *Liberty* still reflects the strong impression made on Delacroix by the art of Géricault, especially the latter's *Raft of the Medusa*; the fact that he makes an allegory of *Liberty* shows him familiar with traditional conventions. The clutter of sprawling bodies in the foreground provides a kind of base supporting the pyramiding figures in the central ground, a buildup to frantic energy from the heavy and the inert. The light flashes like the fire of guns, and the darks mingle freely with the lights like drifting smoke roiled by cannon fire. The forms are generated from the Baroque as they are in Géricault, but with Delacroix's sharp agitation

of Medea's monumental figure, in the panicky squirming of the children, the glint of the long dagger, the furtive turn of Medea's head, and the black shadow that not quite conceals her wild eyes. Rage, guilt, fear, and horror commingle in her attitude. One can imagine the difficulty of staging this terrible episode. The murder itself cannot be shown; how much can be shown, how much concealed? What cues are necessary to bring the observer to dreadful comprehension of the impending crime? At what moment in the short span of the action should the artist arrest the quick motions of the figures, and in what attitudes? The most disciplined artistic restraint and seasoned judgment must dictate the answers. Perhaps more than any other of his works, the *Medea* shows Delacroix's consummate mastery of dramatic painting. He solves the most difficult problems of interpretation and presentation with such success as to make of this work the definitive realization of Euripides' passionate heroine. In Delacroix's painting there is—in his own words

of them creating his own special brand of tumultuous excitement.

Delacroix, who could assert that "style can result only from great research," was ever studying the problems of his craft and ever searching for fresh materials to supply his imagination. He was able to visit North Africa in 1832, and what he found there shocked his imagination with impressions that would last his life. He discovered, in the sun-drenched landscape and in the hardy and colorful Arabs dressed in robes reminiscent of the Roman toga, new insights into a culture built on proud virtues, and one that he believed more classical than anything European Neoclassicism could conceive. "The Greeks and the Romans," he wrote to a friend, "they are here, within my reach. I had to laugh heartily about the Greeks of David." Their gallantry, hardihood, valor, and fierce love of liberty made them in Delacroix's eyes "nature's noblemen"—the unspoiled heroes, uninfected by European decadence.

The Moroccan journey renewed Delacroix's Romantic conviction that there is beauty in the fierceness of nature, natural processes, and natural beings, especially animals. After Morocco, Delacroix's subjects more and more involve combats between beasts, and men and beasts. He paints snarling tangles of lions and tigers, battles between horses, and clashes of Arabs with great cats in swirling hunting scenes. In these, what he had learned from the hunting pictures of Rubens (FIG. 15-31) mingles in explosive combination with his own visions, reinforced by his memories of the North African scene.

What Delacroix learned about color he passed on to later painters of the nineteenth century, most particularly to the Impressionists. He observed that pure colors are as rare in nature as lines, color appearing only in an infinitely varied

16-30 EUGÈNE DELACROIX, *Liberty Leading the People*, 1830. Oil on canvas, approx. 10′ 8″ × 8′ 6″. Louvre, Paris.

scale of different tones, shadings, and reflections, which he tried to recreate in his paintings. He recorded his observations in his *Journal*, which became a veritable corpus of pre-Impressionistic color theory, being acclaimed as such by the neo-Impressionist painter Paul Signac in 1898–99. Delacroix anticipated the later development of Impressionist color science, but that science had to await the discoveries by Chevreul and Helmholtz of the laws of light decomposition and the properties of complementary colors before its problems could be properly formulated. Nevertheless, Delacroix's observations are significant: "It is advisable not to fuse the brushstrokes," he writes, "as they will [appear to] fuse naturally at [a] . . . distance. In this manner, color gains in energy and freshness" (PLATE 16-3). This observation had been suggested to him by his examination of a group of Constable landscapes. Constable, the great English landscape painter (see below) had strongly impressed Delacroix even before his color experiences in Morocco. "Constable," he wrote, "said that the superiority of the green he uses for his landscapes derives from the fact that it is composed of a multitude of different greens. What causes the lack of intensity and of life in verdure as it is painted by the common run of landscapists is that they ordinarily do it with a uniform tint. What he said about the green of meadows can be applied to all other tones." While these are primarily matters of technique and execution, Delacroix expresses most forcibly his radical colorism in the following statement: "Speaking radically, there are neither lights nor shades. There is only a color mass for each object, having different reflections on all sides." These observations were stimulated by Delacroix's Moroccan visit; they do not consistently apply to the early works done under the influence of Géricault. This conception of the optical world as planes of color will find a new realization in the art of Cézanne, who will make color planes serve a structural purpose in locking the composition together.

No other painter of the time explores as thoroughly and definitively as Delacroix the domain of Romantic subject and mood, and none matches his style and content. Delacroix's technique—impetuous, improvisational, instinctive, rather than deliberate, studious, and cold—epitomized Ro-

mantic painting, catching the impression at the very beginning and developing it in the process of execution. We know how furiously Delacroix worked once he had his idea, keeping the whole painting progressing at once. The fury of his attack matches the fury of his imagination and his subjects. He is indeed the artist of passion. Baudelaire summed him up as "passionately in love with passion . . . an immense passion, reinforced with a formidable will—such was the man." At the end, his friend Silvestre, in the language of Romanticism, delivered a eulogy that amounts to a definition of the Romantic artist: "Thus died, almost with a smile on August 13, 1863, that painter of great race, Ferdinand-Victor-Eugène Delacroix, who had a sun in his head and storms in his heart; who for forty years played upon the keyboard of human passions and whose brush—grandiose, terrible or suave—passed from saints to warriors, from warriors to lovers, from lovers to tigers, and from tigers to flowers."

INGRES AND THE ACADEMY

The history of nineteenth-century painting in its first sixty years has often been interpreted as a contest between Delacroix the colorist and Ingres the draftsman. A mid-nineteenth-century cartoon (FIG. 16-31) represents their antagonism as a joust of knights taking place before the French Institute. Delacroix, at the left, has a paintbrush for a lance, Ingres a pencil as they revive the century-old quarrel between "Poussinistes" and "Rubénistes." This controversy, which reached back to the end of the seventeenth century, pitted the conservative defenders of academicism, who held that drawing was superior to color, against the "Rubénistes," who proclaimed that color was not only more important to a painting than drawing, but that it had wider appeal than the more intellectual, and thus restrictive, quality of line.

JEAN-AUGUSTE-DOMINIQUE INGRES (1781–1867) came to the studio of David after Gros and Girodet had left to set up for themselves. But he did not stay very long, for he broke with David on matters of style. Ingres believed that David's art was too heavily "real" and adopted a manner based on what he believed to be the true and pure Greek style: flat and linear figures approxi-

mating those of Greek vase paintings. This early manner was severely criticized as "primitive," even "Gothic," and one critic ridiculed his work as being the vision of "a Chinaman wandering through the ruins of Athens." Ingres's departure, both in form and content, from David and the Academy made him a kind of rebel; and the attacks of the critics did not cease until the mid-1820's, when an even greater enemy of the official style appeared, namely Delacroix. Then the critics suddenly perceived that Ingres's art, despite its innovations and deviations, in fact contained many elements that adhered to the official classicism; he was soon to become the leader of the academic forces in their battle against the "barbarism" of Géricault, Delacroix, and their party. Gradually Ingres warmed to the role in which he was cast by the critics and came to believe himself destined to be the conservator of the principles of good and true art against those advanced by the "destroyers" of art.

Ingres's *Oedipus and the Sphinx* (FIG. 16-32), painted in 1808, shows his avowed attempt to get at the reality of Greek art instead of the academic myth. He gives us the wise hero, Oedipus, answering the three fatal questions of the Sphinx, a winged, taloned female monster who

16-31 Caricature of Delacroix and Ingres jousting in front of the Institut de France. *Delacroix*: "Line is color!" *Ingres*: "Color is Utopia. Long live line!" (After a nineteenth-century print.)

16-32 JEAN-AUGUSTE-DOMINIQUE INGRES, *Oedipus and the Sphinx*, 1808. Oil on canvas, 74" × 56". Louvre, Paris.

terrified the city of Thebes, killing all passers-by who could not answer her questions. Oedipus answered, slew the Sphinx, delivered the city, and was made king of Thebes by the grateful citizens. His subsequent tragic history is related in one of the most magnificent dramatic works of ancient Greece, Sophocles' *Oedipus the King*. Comparison of Ingres's *Oedipus* with Delacroix's *Medea* reveals the fundamental differences between their pictorial styles. In Ingres's work the figure is placed in the foreground like a piece of low-relief sculpture; the pose is stable—even rigid—and the gestures a kind of pantomime of asking and answering. The value Ingres places on the flow of the contours is characteristic of him, not only in his early period, but for the rest of his career. For contour, which is simply shaded line, is all in all for Ingres, as is drawing, the means for creating contour. Ingres has been credited with the famous slogan, the battle cry of his school—"Drawing is the probity of art"—and with the statement, which places him squarely against Delacroix and resolutely for the view that the past must provide the model for the present—"Never a color too warm! it is antihistorical!" But Ingres is not

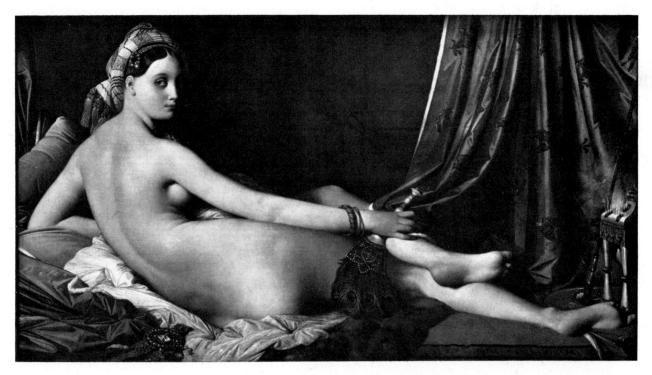

16-33 Jean-Auguste-Dominique Ingres, *Grande Odalisque*, 1814. Oil on canvas, approx. 35¼″ × 63¾″. Louvre, Paris.

always consistent in following his own doctrine —that is, to improve upon nature as the Greeks had. Some years after painting the *Oedipus* he angrily denied that he had "idealized" his model, insisting that the figure was the very image of his model, whom he had copied as faithfully as he could; Ingres is not always sure whether he is following the Greeks or his own often quite realistic bent in his search for beautiful form.

Although the *Grande Odalisque* of the Louvre (FIG. 16-33), painted in 1814, drew acid criticisms ("she has three vertebrae too many," "no bone, no muscle, no life . . ."), it seems today to sum up Ingres's artistic intentions. But it also illustrates the rather strange mixture of Ingres's artistic allegiances. His subject, the reclining nude figure, is traditional, going back to Giorgione and Titian; but by converting her into an odalisque, an inhabitant of a Turkish harem, he makes a strong concession to the contemporary Romantic taste for the exotic. Ingres treats the figure in his own "sculpturesque" style: polished surfaces and simple rounded volumes controlled by rhythmically flowing contours. The smoothness of the planes of the body is complemented by the

broken, busy shapes of the drapery. His admiration for Raphael is shown in the borrowing of that master's type of female head and headdress, and in the inclination of the head, as it can be seen in Raphael's *Madonna of the Chair*. But Ingres is drawing not only from the High Renaissance, for his figure's languid pose and her proportions (small head, elongated limbs) betray his debt to such Mannerists as Parmigianino, as does the generally cool color scheme.

Often criticized for not being a colorist, Ingres, in fact, had a superb color sense. It is true that he did not seem to think of his paintings primarily in terms of their color, as did Delacroix, but he did far more than simply tint his drawings for emphasis, as recommended by the Academy. In his best paintings Ingres creates color and tonal relationships so tasteful and subtle as to render them unforgettable.

Although always aspiring to become a history painter in the academic sense Ingres never was really successful with multifigured compositions. He is at his best when he paints single figures and portraits, and as a portraitist he must be ranked among the greatest masters—one of the last in a

16-36) discloses the difference of approach that separates the two artists. Both painters were passionately fond of music, and Ingres was a creditable violin amateur who knew Paganini personally. His version, executed with that marvelously crisp precision of descriptive line that we find in his pencil portraits, is quite literal, relative to Delacroix's. He gives us the man's appearance and public deportment, one might say his official likeness, enhanced by Ingres's powers of suggestive characterization and sense of setting; Paganini, sharing with violin and bow a certain delicacy —both being fragile and supple—seems about to make his introductory obeisance to his audience. Above all, Ingres's portrait is *formal,* as is his subject, face to face with the public world; but it is a graceful, not stiff formality. Delacroix's *Paganini* presents a likeness not of the virtuoso's *form* but of his *performance.* Forgetting his audience, no longer in formal confrontation with them, Paganini yields himself completely to the whirlwind of his own inspiration, which envelops his reedlike frame, making it vibrate in tune to the quivering strings of his instrument. Delacroix tries to give us the portrait, as it were, of Paganini's music, as it plays to his own ear and spirit. Ingres gives us the outward aspect of his subject, Delacroix the inner substance. With Delacroix, the musician is transformed by his music, as Delacroix himself is. Ingres tries to perfect the form given to the eye; Delacroix tries to realize the truth as given to the imagination.

Critics now regard both masters as equally great, yet in the end Delacroix may have been more generously endowed with imagination, that faculty of supraperception that catches the essential in experience and unifies its multiplicity of particulars, giving it a force and coherence that mundane experience cannot have. Delacroix called the art of Ingres "the complete expression of an incomplete intellect." Yet he found much to admire in Ingres, especially his drawings; and though it was necessary that they go their separate ways in theory and practice, it is pleasant to hear that their personal antagonism may in

field that was soon to be dominated by the camera. While the portrait of Granet (FIG. 16-34) is not by itself sufficient to demonstrate Ingres's great distinction in this field, it does show the artist's stagecraft in arranging the pose and adjusting the costume so as to bring out Granet's amiability, self-confident poise, and ever-so-slight swagger. Never insisting on likeness for its own sake, Ingres rarely fails to produce a striking characterization and, analogously to the smooth, formal treatment he gives his nudes, never fails to impart to both characterization and setting an air of suave elegance. In his portraits, as with his nudes, Ingres contrasts the simple and regular volume of the head with the broken, irregular, and complicated folds of the drapery and costume. His apparently cool detachment from his models and his search for "pure form" commend him to the twentieth-century taste for the "abstract."

Comparison of Ingres's pencil portrait of the great violin virtuoso, Paganini (FIG. 16-35), with Delacroix's version of the same personality (FIG.

16-35 JEAN-AUGUSTE-DOMINIQUE INGRES, *Paganini*, 1819. Approx. 12″ × 8½″. Louvre, Paris.

the end have softened. The painter Chenavard relates how he and Delacroix by accident encountered Ingres on the steps of the French Institute, at a time late in the lives of both great artists. Although Ingres had been instrumental in preventing Delacroix's election to the Académie des Beaux Arts until 1857, he now, after an awkward pause, impulsively extended his hand to Delacroix, who shook it sincerely.

Nevertheless, even while they lived, the mainstream of modern art was dividing into two—the Academy and those who rebelled against its authority. True, debate about style had gone on a long time, since that between the Poussinistes and the Rubénistes in the old Academy during the reign of Louis XIV; but that had remained pretty much within the Academy and had not amounted to a public debate and an open challenge to the Academy, as it now did. Ingres, though an early rebel, came to be identified with the Academy and all it stood for; Delacroix was the champion of the rebels and the "progressives." Now the side one took became crucial to one's career.

Academic art had for the most part the support of the critics, the public, and the government, though it is true that Delacroix was given many government commissions; but Delacroix's case was exceptional. A broad public sanction, backed by rich patronage, encouraged the development of an official art that was accepted by the public as "good art" against the strange new styles that the anti-academics were beginning to produce; and there begins at mid-century that public attitude against innovation that echoes still today in the question: "Do you call *that* art?"

An early and representative specimen of the academic art of the nineteenth century is the *Romans of the Decadence* (FIG. 16-37) by THOMAS COUTURE (1815–79). Vastly popular in the Salon of 1847, it descends from the archeologizing dramatics of David and the "academies" of Ingres but has some flourishes of pictorial realism of its own. Couture's *Romans* is a stage in the evolution of the pictorial drama that was born of Romanticism and flourished throughout the nineteenth century

16-36 EUGÈNE DELACROIX, *Paganini*, c. 1832. Oil on cardboard, approx. 17″ × 11½″. The Phillips Collection, Washington, D.C.

until its transformation into the cinema of our time. It directly solicits the public's attention by its historical references, its sensational setting and action, and its somewhat sardonic moralism. It is in fact an allegory of the decadence of the July Monarchy of 1830. Briefly, we view a drunken orgy of Romans of the late empire who have fallen below the severe morality of their forefathers, whose statues frown their disapproval. The Salon public's taste for history and morality would be flattered by the easily apprehended clues in architecture and costume, and by the display of dissoluteness that they felt themselves to be above. We have what amounts now to the academic formula-picture: figures, nude and draped, arranged within or before an architectural frame, and majestic devices—architectural, sculptural, historical—easily manufactured to give importance to themes of somewhat dubious authenticity. We see emerging, under the auspices of public patronage, what is familiar enough in our own experience, the cleverly designed picture meant to be popular.

Ingres's hope of achieving an ideal, formal beauty in the figure becomes a sensual daydream in academics like GUILLAUME-ADOLPHE BOUGUE-REAU (1825–1905). His *Birth of Venus* (FIG. 16-38),

of 1879, is a pastiche of Raphael (*Galatea*), Ingres (*La Source*), and various academic recipes for smooth figure drawing. Added to this mixture is an obviously borrowed photographic realism, such that faces and facial expressions, let alone bodies, are so dated as to be embarrassingly of their time and place. The idealization is thus lost, and the higher standards of realism introduced by photography make the ideal dwindle into a somewhat sly exhibition. The devotion to realism, strongly present as early as David, broadens and intensifies until it will force its own change of subject: The birth of Venus becomes absurd in front of a camera held by an academic painter ready to touch up its plates. But one must admit that at this time in the nineteenth century, during the first triumphs of science, all myths seem absurd, and the Romantic lexicon of themes inevitably becomes anachronistic.

The *Thumbs Down!* (FIG. 16-39) of JEAN-LÉON GÉRÔME (1824–1904) completes, at least for still pictures, the historicizing "picture-drama" trend that began with David. But here the classical architecture-figure-relief formula has been entirely transformed. There are indeed figures that can be identified as ancient Romans acting within an identifiable Roman architecture, but how

16-37 THOMAS COUTURE, *Romans of the Decadence*, 1847. Oil on canvas, approx. 15′ 1″ × 25′ 4″. Louvre, Paris.

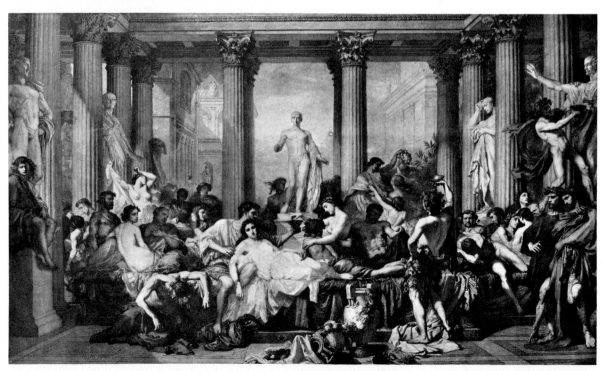

thoroughly different from the *Horatii* and their setting! These are professional killers and gladiators who battle one another on the sands of the vast amphitheater in Rome, the Colosseum, in the historically authentic presence of masses of figures identifiable as spectators at the imperial games. The fallen man appeals to the audience, the vanquisher looks to them for their verdict. Their verdict, "thumbs down," means that the fallen gladiator is killed on the spot. There is nothing heroic in this, certainly nothing that David would have recognized as such. The action is sordid, the setting factual; the purpose is not to elevate, but to amuse the public with a convincing spectacle of an ancient atrocity in a studiously reconstructed historical setting. Gérôme's technique is "photographic"; that is, everything is rendered as part of a consistent tonal range, such as could be recorded by the passive, sensitized plate had a photographer been present at the scene. The academic tradition merges with the new style of the staged and "photographed" academic tableau, and the heroic acts of the Davidian stage become the movie murders of the new "photographic" spectacle. The *Thumbs Down!* looks like a clip from an old movie; in fact, its subject and technique laid down the conditions

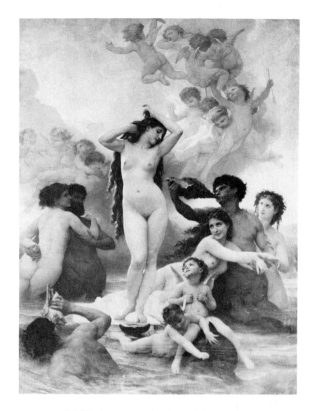

16-38 GUILLAUME-ADOLPHE BOUGUEREAU, *The Birth of Venus, c.* 1879. Present location unknown.

16-39 JEAN-LÉON GÉRÔME, *Thumbs Down! (Pollice Verso), c.* 1859. Oil on canvas, 69″ × 40″. Phoenix Art Museum purchase.

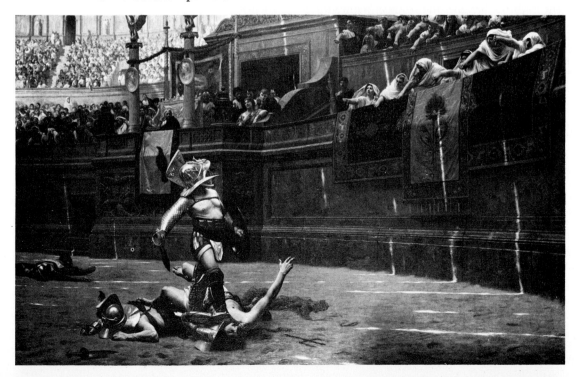

within which the movies would have to be created. This precinematic picture draws to a conclusion the premise of David that art can be public and still valid art.

LANDSCAPE PAINTING AND THE BARBIZON SCHOOL

Even before David's *Horatii* had enforced, in France, a new view of art and human nature, peoples of other countries had shifted their view of nature itself toward a romantic interpretation. In England as early as the 1740's there had begun a school of poets that would reach its height in the early 1800's. These poets, interested in describing nature's looks and moods, read the natural landscape closely and sympathetically, until they came to see it almost as a projection of themselves; in a word, they subjectivized it.

There is no better introduction to the English school of landscape painting, so widely influential in the Romantic movement, than the works of these poets. In the poems of Wordsworth, Byron, Shelley, and Keats we find the same theme and temper as in the paintings of Constable, Girtin, and Turner. Nature, emotionalized in both its grand and minute manifestations, lives in the canvases of the English school; and as literature is a key to the art of the French Romantics, so is it to the English landscapists.

In the works of J. M. W. TURNER (1775–1851) one finds the breadth and scope of nature intermixed with the pathos of time, change, distance, and the past. His *Fighting Téméraire* (PLATE 16-4), painted in 1839, though a seascape rather than a landscape, illustrates this well. At the battle of Trafalgar in 1805, when the English fleet defeated the combined French and Spanish fleets, the *Téméraire* was second ship of the line after Lord Nelson's *Victory*. Here the stately old ship, obsolete in the age of steam yet still beautiful in her lines, is being towed away by an ugly, puffing steam tug, to be junked. "A dying glory fades" in the ruddy light of the setting sun. The proud and gallant aristocrat of the seas has fallen prey to a busy, practical, indifferent age. The passing of what is good, beautiful, and brave touches us and makes us reflect on the transitory condition of our lives. Turner's painting recalls Wordsworth: "The clouds that gather round the setting sun / Do take a sober coloring from an eye / That hath kept watch o'er man's mortality." The colors are bold, varied, and intense, and although Turner has learned much about light, atmosphere, and water reflections from Claude Lorraine and Dutch marine painters like Willem van de Velde, he expands the role of light, raising the overall color key and, in general, greatly increasing the role of pure color. In this picture, of course, Turner is less concerned with optical fidelity to the facts of color than he is with romantic effects. But in his later paintings he increasingly reveals his awareness that color and light are so closely related as to be the same, and he brings his art to a point where it foreshadows Impressionism (see below).

JOHN CONSTABLE (1776–1837), an influence on Delacroix, and one of the major artists of the English landscape tradition, also anticipates Impressionism in both attitude and method. He is, in fact, an early leader in the development of the whole modern style. "Painting," he said, "is a science, and should be pursued as an inquiry into the laws of nature. Why, then, may not landscape be considered as a branch of natural philosophy, of which pictures are but experiments?" Indeed, the Romantic love of nature becomes the science of nature in the nineteenth century, and Constable's experiments look forward to the experiments of Monet. The scientific function of painting, rarely noted by historians, is stressed by Constable: "I hope to show that ours is a regularly taught profession; that it is *scientific* as well as *poetic*; that imagination never did, and never can, produce works that are to stand by a comparison with *realities*" Thus, fifty years before Courbet's adoption of the term "Realism" for his own art, Constable states the realistic philosophy.

Despite his realistic method, Constable's *Salisbury Cathedral from the Bishop's Garden* (FIG. 16-40), painted about 1826, conveys the same gentle pathos of age that Turner's *Téméraire* does. A tinge of faintly melancholy sentiment blends with the mellow afternoon sun that irradiates the ancient Gothic church. The poet Tennyson succinctly matches the sentiment:

16-40 JOHN CONSTABLE, *Salisbury Cathedral from the Bishop's Garden*, c. 1826. Oil on canvas, 35″ × 44¼″. The Frick Collection, New York.

Tears, idle tears, I know not what they mean,
Tears from the depth of some divine despair
Rise in the heart, and gather to the eyes,
In looking on the happy autumn-fields,
And thinking of the days that are no more.

. . .

O Death in Life, the days that are no more!

The subject, doubtless, is Romantic, but Constable's method of rendering it brings all his sharp, realistic observation into play. The fugitive effects of light on stone, stream, and foliage are rendered with his bright stipplings of fresh color to produce a strikingly fresh luminosity. The word "fresh" peculiarly denotes Constable's sparkling technique. In speaking of the qualities he intended in his pictures he mentions: "light—dews—breezes—bloom—and freshness; not one of which has yet been perfected on the canvas of any painter in the world." These were the qualities that startled the young Delacroix when he saw Constable's paintings in the Salon of 1824

and that let light into the modern canvas. The bold self-confidence of Constable's assertion that such qualities had never before been achieved in painting and his certainty that painting partakes of science were Constable's challenge and bequest to Delacroix and the Impressionists.

Landscape painting outside of England does not show these innovations; on the other hand, in at least one figure, the German painter CASPAR DAVID FRIEDRICH (1774–1840), we have Romanticism in its very essence. In *Cloister Graveyard in the Snow* (FIG. 16-41) we see, through the leafless, winter-blasted trees of a snow-covered cemetery, a funeral cortege bearing a coffin into a ruined Gothic chapel. The symbols of death are everywhere: crosses and tombstones, the procession itself, the death of nature in winter, the death of men, the chapel mutilated by time's passage. The Romantic obsession with death is manifested by poets and painters in whose work gloomy heroes and heroines meditate upon death in churchyards and among ruins, write in praise of death, and yearn for it. It is a world "Where,"

16-41 Caspar David Friedrich, *Cloister Graveyard in the Snow*, 1810. Approx. 47″ × 70″. National-Galerie, Staatliche Museen, Berlin. (Painting destroyed during World War II.)

writes Keats, "youth grows pale and specter-thin, and dies; / Where but to think is to be full of sorrow / And leaden-eyed despairs / Now more than ever it seems rich to die, / To cease upon the midnight with no pain"

In France, the most prominent painter of landscape before the Impressionists is Jean Baptiste Camille Corot (1796–1875). He has two styles, which differ greatly; one of highest quality, the other a salon-pleasing manner aimed at a wide public. His *Harbor of La Rochelle* (fig. 16-42) shows the finer of these manners. In it we can see the artist's interest in the full tonal spread, the careful arrangement of dark and light values, which the new device of photography was automatically achieving. Corot's method is to be as faithful as possible to the scale of light to dark. His procedure is interesting. "The first two things to study are form and values," he writes in his notebooks:

For me, these are the bases of what is serious in art. Color and finish put charm into one's work. In preparing a study or a picture, it seems to me very important to begin by an indication of the darkest values . . . and continue in order to the lightest value. From the darkest to the lightest I would establish twenty shades

In *La Rochelle* we can appreciate these careful gradations of tone. At the same time the composition is not the random one of a snapshot; the forms are carefully placed, and the general ordering of them recalls the classical landscape tradition of Poussin. Both Constable and Corot point toward the Impressionists, but in different ways: Constable in his brilliant freshness of color and divided brushstroke; Corot in his concern for the rendering of outdoor light, climate, and atmosphere in terms of values.

Corot's other style is a somewhat mannered essay in twilight atmosphere, with hazy, gray-green tones floating vaguely and unstructurally through woodland settings. Corot repeated himself in this type of composition, in which he seems to be content to suggest atmosphere in indefinitely spread tones of gray rather than by means of color.

Corot painted in close association with members of the "Barbizon school," a group of landscape and figure painters who had settled near the village of Barbizon in the forest of Fontainebleau. Chief among these was Jean François Millet (1814–75). Of peasant stock, Millet undertook to glorify the humble country folk of France. In *The Gleaners* (fig. 16-43), done in 1857, he characteristically poses them as monumental

16-42 Jean Baptiste Camille Corot, *The Harbor of La Rochelle*, 1851. Oil on canvas, approx. $19\frac{7}{8}'' \times 28\frac{1}{4}''$. Yale University Art Gallery, New Haven, Connecticut (bequest of Stephen Carlton Clark, B.A., 1903).

16-43 Jean François Millet, *The Gleaners*, 1857. Approx. $33'' \times 44''$. Louvre, Paris.

figures against the flat, dull land and sky. The quiet design of Millet's paintings accents his scrupulous truth of detail and contributes to the dignity he gives to even the simplest rural tasks. This solemn grandeur with which Millet invests the poor causes him to be identified with socialism of a kind prevalent in his lifetime. Actually it is a late echo of the Romantic intuition, held by men such as Wordsworth, which found a touch of nobility in the humblest lives. The objective, carefully realistic landscapes of other painters of the Barbizon school, like T. Rousseau, Daubigny, and Diaz, were to have powerful influence on the Impressionists and Post-Impressionists.

16-44 HONORÉ DAUMIER, *Rue Transnonain*, 1834. Lithograph, approx. $11\frac{7}{8}'' \times 17\frac{1}{2}''$. Philadelphia Museum of Art.

REALISM AND IMPRESSIONISM

Corot and his friends in Barbizon were little concerned with the course of events in Paris, where the rapid development of an urban industrial civilization created acute political and social unrest. But in a Parisian studio only a few steps from Notre Dame, the lithographer and painter HONORÉ DAUMIER (1808–79) was in close

touch with this social ferment. For forty years, from the July Monarchy of 1830 through the Second Empire, he contributed satirical lithographs to the leading humor journals. In this prodigious output of some 4000 prints his keen insight, coupled with his sympathy for human beings, was constantly expressed in superb draftsmanship. The sharpness of his political criticism often put him into conflict with the government, as one would expect in view of such prints as the *Rue Transnonain* (FIG. 16-44). Soldiers, fired upon from a building on the Rue Transnonain in the working quarter, entered the building and massacred the inhabitants. Daumier, with the power of Goya, gives us a view of the atrocity from a sharp realistic angle of vision, almost as if we ourselves were among the felled victims. The broken, scattered forms lying in the midst of violent disorder are reported as found, with every available device of Daumier's skill used to make the situation real. Long before the age of the police photographer, a great artist snaps the picture of a brutal crime done at a certain place and a certain

16-45 HONORÉ DAUMIER, *The Third-Class Carriage*, c. 1862. Oil on canvas, $25\frac{3}{4}'' \times 35\frac{1}{2}''$. Metropolitan Museum of Art, New York (Havemeyer Collection, bequest of Mrs. H. O. Havemeyer, 1929).

time. The harsh fact speaks for itself; the artist does not have to interpret it for us. The print's significance lies in its *factualness*; the artist is now becoming concerned with fact as his subject and the optical realization of fact as his method. Not that Daumier uses the tonal realism of the new medium of photography; he does not. His manner is rough and spontaneous and carries the strong mark of caricature exaggeration and dash; this is part of its remarkable force. Thus, while Daumier is true to life in content, his style is uniquely personal.

Although in his lifetime Daumier was known principally for his lithographs, he was also a very powerful painter and after 1848 was acclaimed as such. His *Third-Class Carriage* (FIG. 16-45) gives us a glimpse into the rude railway compartment of the 1860's, in which sit the poor, who can afford only third-class tickets. The disinherited masses of nineteenth-century industrialism were Daumier's indignant concern, and he makes them his subject over and over again. He does not set them off with the sometimes romantic idealism of Millet, but simply shows them to us in the unposed attitudes and unplanned arrangements of the millions thronging through the modern city,

anonymous, insignificant, dumbly patient with a lot they cannot change. Not only is Daumier's subject real, but so is his view of it; he sees people as they ordinarily appear, their faces unprepared for any observer—vague, impersonal, blank. The artist, in a novel approach, tries to achieve the real by isolating from the continuum of ordinary vision an entirely unrehearsed collection of random aspects of human existence; this is prophetic of the candor that will be introduced into the visual arts by use of the modern surreptitious camera.

With the same blunt, rugged, unfinished but forceful style, Daumier gives us, in *The Uprising* (FIG. 16-46)—a work earlier than the *Third-Class Carriage*—a street agitator haranguing a crowd. This is not the stately declamation of David's *Horatii* nor the stormy allegory of revolution that is Delacroix's *Liberty*, but the real thing—the shouts; the pale, tense faces; the psychic electricity in the air that precedes thunder and violent action. While its form is not photographically realistic, the subject is taken from the contemporary life of a great nineteenth-century city. This selection, made also by Daumier's contemporaries in literature—men like Hugo, Balzac,

16-46 HONORÉ DAUMIER, *The Uprising*, c. 1860. Oil on canvas, approx. 33¾″ × 43⅞″. The Phillips Collection, Washington, D.C.

and Dickens, or Turgeniev and Dostoevski—brings us to Naturalism and the exclusive depiction of aspects of modern life at the expense of themes drawn exclusively from fiction, history, or imagination.

"To be able to translate the customs, ideas, and appearances of my time as I see them—in a word, to create a living art—this has been my aim," stated GUSTAVE COURBET (1819–77). According to him, "The art of painting can consist only in the representation of objects visible and tangible to the painter ," who must apply "his personal faculties to the ideas and the things of the period in which he lives" "I hold also that painting is an essentially *concrete* art, and can consist only of the representation of things both *real* and *existing* an *abstract* object, invisible or non-existent, does not belong to the domain of painting." "Show me an angel and I'll paint one"

Courbet's words betray a certain truculence toward public taste and art juries, such as the one that had rejected two of his major works for the Paris International Exhibition in 1855 on the grounds that his subjects and figures were too coarsely materialistic (so much so as to be plainly "socialistic") and too large. Plain people of the kind he had shown in the *Stone Breakers* (FIG. 16-47), accepted in 1855, and in the *Burial at Ornans* (FIG. 16-48) were considered (by the public) unsuitable for artistic representation and were linked in the middle-class mind with the dangerous, newly defined working class, which was finding outspoken champions in men like Marx, Engels, and Proudhon. Courbet, rejected by the exhibition jury, set up his own gallery outside the grounds, calling it the Pavilion of Realism.

Courbet's pavilion and his utterances amounted to the manifestoes of a new movement, although he maintained that he founded no school and was of no school: "The title of 'realist' has been imposed upon me, as the men of 1830 had imposed upon them the title of 'romantics.'" However, as the name of his pavilion suggests, he accepted the term as descriptive of his art. With the unplanned collaboration of Millet and Daumier, Courbet challenged the whole world of pretty inanities, stock classicism, and empty heroics that made up much of the Academy's art and summoned public attention to what Baudelaire called the "heroism of modern life." The battle between the new attitude and that of the Academy was amusingly caricatured by Daumier in a lithograph that shows a tattered clown of the Paris streets advancing upon a nude professor of

16-47 GUSTAVE COURBET, *The Stone Breakers*, 1849. Approx. 5′ 5″ × 7′ 10″. Gemäldegalerie Abt. Neue Meister, Staatliche Kunstammlungen Dresden. (Painting lost during World War II.)

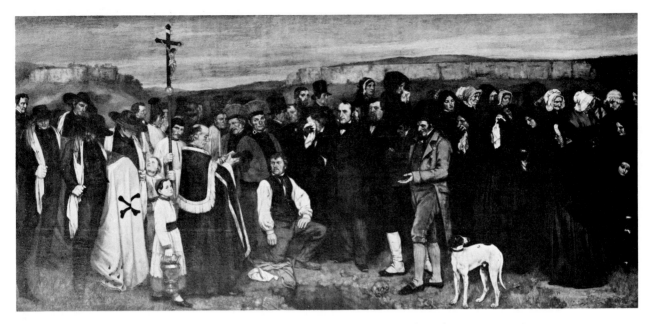

16-48 GUSTAVE COURBET, *Burial at Ornans*, 1849. Approx. 10′ × 22′. Louvre, Paris.

the Academy, who strikes the classical attitude of defense seen in a painting by David. For the public, it was a contest between the painters of the "ugly" and the painters of the "beautiful"—as the public understood those qualities.

The *Stone Breakers* stirred violent protests because of the allegedly commonplace character of the subject. But Courbet's bold, somber palette was essentially traditional and certainly in harmony with his subject matter. Lights and darks converge abruptly along the edges of simplified planes, and a surface richness results from the way he used his pigments. To his contemporaries his methods seemed unbearably crude. Since he intentionally sought the simplest and most direct methods of expression, in composition as well as in technique, he was called a primitive. For example, he introduced the palette knife, with which large daubs of paint could be quickly placed and unified, giving a roughly wrought surface. His example inspired the young men who worked with him—later Impressionists like Monet, Renoir, and Manet—but the public accused him of carelessness, and the critics wrote of his "brutalities." As we have seen, Courbet insisted that he wished only to paint the life of his own times in the costumes of the day, and toward

such an end he "studied without prejudice the art of the old and modern masters." We know from his own statement that the *Stone Breakers* was inspired by the sight of an old man and a boy working on the roads. Although their poverty touched him and he thought that he was presenting his own vision as directly as possible, we can see how much he relied on tradition if we compare the figures with those of the shepherds in Poussin's *Et in Arcadia Ego* (FIG. 15-47), painted two centuries before. But to the public, which believed that only the ideal or imaginary subject was suitable for major paintings, Courbet's assertion that he could not paint an angel because he had never seen one sounded blasphemous.

The *Burial at Ornans* represents a funeral in a bleak, provincial landscape, attended by obscure persons "of no importance," people of the kind presented by Balzac and Flaubert. Garbed in rusty black, they cluster dumbly around the excavation, while the officious clergyman reads the Office of the Dead. Their faces register all degrees of response to the situation, a gallery of funeral expressions and faithful portraits of the poor. Courbet monumentalizes a theme that could hardly have been of less concern to the salon-going public of Paris, but that promises

to have full and wide development in all avenues of nineteenth-century life and art: humanitarianism and concern for social reform. The heroic, the sublime, and the terrible are not here, but the drab fact of undramatized life and death. What the artist now finds interesting is in his own environment; it is people—not as superhuman or subhuman actors on a grand stage, but as themselves, moved by the ordinary rhythms of modern life.

Though Courbet was often embattled with the critics over the spirit and the form of Realism, from 1855 onward he had secure official backing, and in his later years he painted with greater intention to please the public. Indeed these pictures were done in a mode recalling the Baroque, with dark underpainting, heavy chiaroscuro, and subject matter familiar in the popular salon. This conservatism disappointed the younger artists who had come to rely strongly on his vigorous style and technique and his courageous individualism. Most of the Impressionists in their early years had associated and exhibited with him; but Courbet failed to catch the drift of the new style that was emerging in their work. He spoke disparagingly of Manet's *Olympia*, a reclining nude, as "flat"—that is, without a strong chiaroscuro. He still used dark underpainting when Manet and Monet had begun to paint on a white surface for greater luminosity. As close to the new generation of painters as he had been, he could say of Manet, in 1867, when the curtain had already risen on a new act: "I myself shouldn't like to meet this young man . . . I should be obliged to tell him that I don't understand anything about his painting and I don't want to be disagreeable to him." But the Impressionists could not deny, nor could history itself, the impetus Courbet's art had given the movement toward a modern style based on observation of the modern environment.

In the fall of 1864 the English painter Dante Gabriel Rossetti wrote home about French Realism as he had seen it in visits to the studios of Courbet and Manet: "There is a man named Manet . . . whose pictures are for the most part mere scrawls, and who seems to be one of the lights of the realist school. Courbet, the head of it, is not much better." This comment, though a priggish dismissal of them, yet links the two great Realists. With ÉDOUARD MANET (1832–83) the course of modern painting shifts into a new phase, accelerating its move toward that point, at the end of the century, when there will occur the major transformation of the great tradition that began with Giotto. Almost at the moment when the Realists are discarding romantic subject matter in order to represent what they see around them, Manet (in his later works) and the Impressionists seem to raise the question whether *what* we see is not a matter of *how* we see it. What is more real for a painter who seeks the "real"—a world of solid objects moving in space or simply his optical sensations of light and color in fleeting patterns? In a sense, naturalistic Impressionism continues the Romantic preoccupation with the *self* of the artist, except that now he consults not so much his feelings and imagination as his purely visual sensations. The world out there is no longer a given order of masses in space. Rather it is the source of sensations of light and color with no fixed order whatever; the only order is that which the artist creates from his own optical experience, the record of the stimulation of the optic nerve by light.

Although the term "Impressionism" was first used in 1874 by a journalist ridiculing a landscape by Monet (see below) called *Impression—Sunrise*, the bitter controversy that raged for twenty years over the merits of Impressionism began eleven years earlier, in 1863, at the Salon des Refusés, an exhibition held, following the artists' angry protests, to accommodate the exceptionally numerous works rejected by the jury for the salon that year. It was here that Manet shocked the public with his *Déjeuner sur l'Herbe*, "Luncheon on the Grass" (FIG. 16-49), the portrayal of a nude woman and two clothed men, seated in a wood. Like Courbet, Manet had tried to combine the modern setting with an earlier design, for the composition and even the theme derived from sixteenth-century Italian art, probably an engraving by Marcantonio Raimondi, a pupil of Raphael. But Manet's refusal to idealize the figures or make the event seem less contemporary offended many. It was thought to report a public indecency and to be more the concern of the police than of lovers of art. Manet had drawn away the concealing veil of classical illusion and brought the nude up to date. The lady in the *Déjeuner* is obviously not a nymph or a Venus but a modern

Parisienne—perhaps of dubious profession—and, to judge from her bold look directly at the viewer, a person who cares little for what people think.

What neither the public nor the critics noticed was the new method Manet used to present his figures. His light is photographic, but in a novel way, throwing a harsh, strong illumination directly on the figures so as to produce a kind of flashbulb effect similar to that seen in newspaper photographs of night scenes. The middle values, so carefully observed and recorded by Corot, are blotted out; there is a "crowding of the lights" and a compensating "crowding of the darks" whereby many values are summed in one or two lights or darks. The effect is both to flatten the form and to give it a hard, snapping presence. In the *Déjeuner* it is this harsh light of common day that reveals so mercilessly the nude and her companions. Manet, until the day he died, could not understand the animosity shown him by the public and the critics. After all, as he said, the chief actor in the painting is the light; *what* the light reveals becomes purely incidental. Goya made paintings whose purpose was to shock; though Manet produced many paintings that shocked, he could never understand why they did.

One of the by-products of the new technique is impersonality. The artist, quite honestly indifferent to his subject matter, except as it gives him an opportunity to arrange his light-sensations in a new way, creates pictures in which his feelings seem utterly uninvolved. Manet offers the same impersonality and "scientific" detachment in works reporting contemporary events. Without perhaps realizing it, he has given us a representation of man the automaton and man the disposable object—not the rational animal, the immortal soul, the hero, the darling of nature and the universe, but an ever changing physical datum whose value is primarily statistical. In this product of the nineteenth-century successes of the biological and social sciences, man is a mere adaptive mechanism, an insignificant unit that blends its biological, political, and social backgrounds. Manet's masterpiece, the *Bar at the Folies-Bergère* (FIG. 16-50), painted in 1882, reflects an analogous absorption of the human figure into the pictorial context. The surface of the canvas

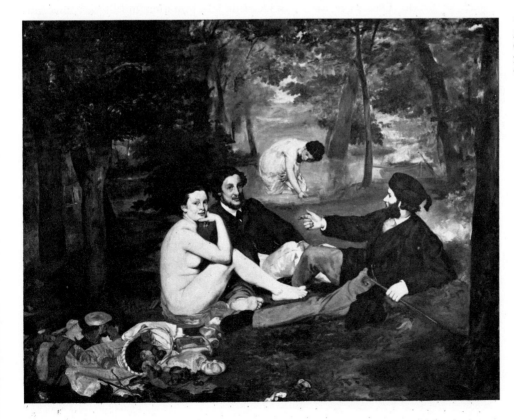

16-49 Édouard Manet, *Déjeuner sur l'Herbe*, 1863. Oil on canvas, approx. 7' × 8' 10". Galerie du Jeu de Paume, Paris.

vibrates with the reflections of light spilling from the gas globes onto the figures and the brilliant still life of fruit and bottles on the counter. In this study of artificial light, both direct and reflected in the mirror background, the subject matter has lost its earlier importance. Manet tells us little about the barmaid, and less about her customers, but much about his optical experience of this momentary pattern of light, in which the barmaid is only another *motif*—a larger still life amid the glittering bottles. There is no story, no moral, no plot or stage direction; there is simply an optical event, an arrested moment, in which lighted shapes of one kind or another participate. One is reminded of the novels of Manet's friend Zola, especially of *Nana*, whose heroine is nothing but a meaningless human consequence of an intersection of social forces that create and destroy her. Nothing in herself, the barmaid in Manet's painting is automatic and nonpersonal.

The *Folies-Bergère* illustrates another quality that was to loom with increasing importance in the works of later painters. While the effect was perhaps unplanned, Manet's painting made a radical break with tradition by redefining the function of the picture surface. Ever since the Renaissance the picture had been conceived as a "window" and the viewer as looking *through* the painting's surface at an illusory space developed behind it. Manet, by minimizing effects of modeling and perspective, forces the viewer to look *at* the surface and to recognize it once more as a flat plane covered with patches of paint. This "revolution of the color patch," combined with Manet's cool, objective approach, points painting in the direction of abstraction, with its indifference to subject matter and emphasis on optical sensations and the problem of organizing them into form. In the twentieth century not only the subject matter will disappear but even its supposed visual manifestation in the external world.

From the middle of the 1860's such Impressionist painters as Monet, Pissarro, Renoir, and Degas followed Manet's lead in depicting scenes of contemporary life and landscape. Their desire for a more modern expression led them to prize the immediacy of visual impression and persuaded the landscapists, especially Monet and Pissarro, to work out of doors. From this custom of painting directly from nature came the spontaneous revelation of atmosphere and climate so characteristic of Impressionist painting. Their rejection of idealistic interpretation and literary anecdote was paralleled by their scrutiny of color and light.

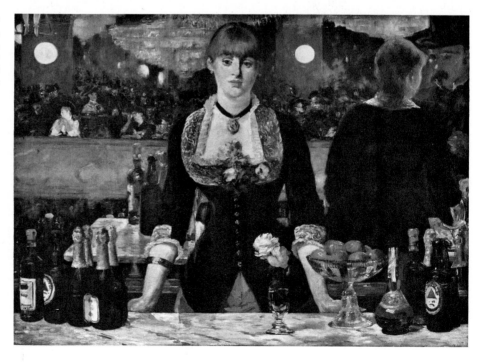

16-50 ÉDOUARD MANET, *Bar at the Folies-Bergère*, 1882. Oil on canvas, approx. 37″ × 51″. Courtauld Institute Galleries, London.

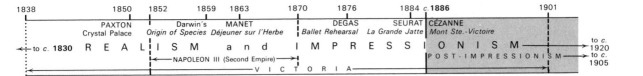

1838	1850	1852	1859	1863	1870	1876	1884	c.1886	1901

PAXTON / Crystal Palace — Darwin's / *Origin of Species* — MANET / *Déjeuner sur l'Herbe* — DEGAS / *Ballet Rehearsal* — SEURAT / *La Grande Jatte* — CÉZANNE / *Mont Ste.-Victoire*

to c. 1830 R E A L I S M a n d I M P R E S S I O N I S M → to c. 1920
P O S T - I M P R E S S I O N I S M → to c. 1905

← NAPOLEON III (Second Empire) →
← V I C T O R I A →

Scientific studies of light and the invention of chemical pigments increased their sensitivity to the multiplicity of colors in nature and gave them new colors with which to work. Most of their eight cooperative exhibitions, held between 1874 and 1886, irritated the public. But their technique was actually less radical than it seemed at the time; in certain respects they were simply developing the color theories of Leonardo and the actual practice of Rubens, Constable, Turner, and Delacroix.

The Impressionists sought to create the illusion of forms bathed in light and atmosphere. This required an intensive study of light as the source of our experience of color, which revealed the important truth that local color—the actual color of an object—is usually modified by the quality of the light in which it is seen, by reflections from other objects, and by the effects produced by juxtaposed colors. Complementary colors, for example, if used side by side in large enough areas, intensify each other. In small quantities, though, or mixed, they fuse into neutral tone. Shadows do not appear gray or black, as many earlier painters had thought, but seem composed of colors modified by reflections or other conditions. (Vermeer had evidently observed this.) Furthermore, the juxtaposition of colors on the canvas for the eye to fuse at a distance produces a more intense hue than the mixing of the same colors on the palette. (Delacroix had already noticed this phenomenon, as we saw in PLATE 16-3.) Although it is not strictly true that the Impressionists used only the primary hues, juxtaposing them to create secondary colors (blue and yellow, for example, to produce green), they achieved remarkably brilliant effects with their characteristically short, choppy brushstrokes, which so accurately caught the vibrating quality of light. The fact that at close range the surfaces of their canvases look unintelligible and that the forms and objects appear only when the eye fuses the strokes at a certain distance accounts for much of the early adverse criticism

—such as the conjecture that the Impressionists fired their paint at the canvas with a pistol.

Of the Impressionists, CLAUDE MONET (1840–1926) carried the method furthest, especially in series of paintings of the same subject. He painted sixteen views of Waterloo Bridge in London and twenty-six views of Rouen Cathedral, the one shown (PLATE 16-5) dated 1894. In each case the cathedral was observed from the same point of view, but at different times of day and under various climatic and atmospheric conditions. Monet, with a scientific precision, has given us an unparalleled and unexcelled record of the passing of time as seen in the movement of light over identical forms. Later critics accused Monet and his companions of destroying form and order for the sake of fleeting atmospheric effects, but we may feel that light is properly the "form" of Monet's finest paintings, rather than accept the narrower definition that recognizes "formal" properties only in firm, geometrical shapes. The Impressionist artist does not paint the world we presumably "see"—the world of Corot's "values," of graduated tones of lights and darks; rather he records his own sensations of color, and the outlines and solidities of the world interpreted by common sense melt away.

The *Place du Théâtre Français* (FIG. 16-51) by CAMILLE PISSARRO (1830–1903) shows the same qualities. The artist's visual sensations of a crowded Paris square, viewed from several stories above street level, yield a panorama of blurred, dark accents against a light ground. Like Monet, Pissarro is after the most fugitive effects of movement, but (unlike Monet) not so much of light, as of the life of the street. He achieves a deliberate casualness in the arrangement of the figures, an effect like that which a single glance from a window would provide if prolonged only a few seconds. Ceaseless change of position and ceaseless change of color are the new order of the painter's experience. There is no longer a standard of unchanging optical truth, just as there is no longer a standard way of seeing. The artist's subjective

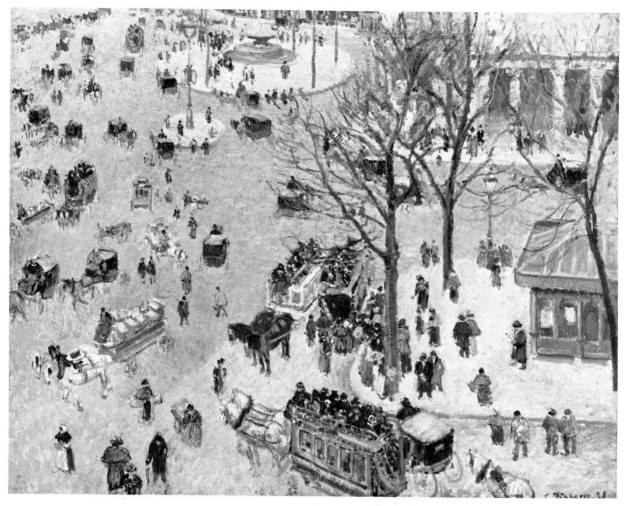

16-51 CAMILLE PISSARRO, *Place du Théâtre Français*, 1895. Oil on canvas, approx. 28½″ × 36½″. Los Angeles County Museum of Art (the Mr. and Mrs. George Gard De Sylva Collection).

experience is all he has to deal with, and for him "nature" is simply the source of his sensations. When Pissarro writes, in a letter to his son Lucien, "we have to approach nature sincerely, with our own modern sensibilities," we should understand him as meaning not the "nature" of the great landscape tradition, but "nature" precisely as revealed to our modern senses. For the Impressionist this means that the modern sensibility gets at what is *real* in nature, namely the color stimuli it provides the analytic eye of the modern painter.

In the later nineteenth century, artists are not alone in emphasizing the prime reality of sensation in the process of apprehending nature or the world. Scientists, philosophers of science, and psychologists in great number assert that reality *is* sensation, or that knowledge can be based only upon the analysis of our sensations. Indeed, the Austrian physicist Ernst Mach could hold that the *sole* reality is sensation, and all the laws and principles of physics are only a kind of shorthand referring to complex linkages of the data of sense. And modern experimental psychology, of course, begins with the measurement of sense experience.

What we might call "color sensationism" and fugitive effects of light and motion are what link the Impressionist artists; for upon closer view, each has very much his own manner, despite the more or less fundamental agreements. For example, AUGUSTE RENOIR (1841–1919) is a specialist in the human figure, a sympathetic admirer of

what is beautiful in the body and what is pleasurable in the simple round of human life. The bright gaiety of his *Moulin de la Galette* (PLATE 16-6), where a Sunday throng enjoy themselves in a popular dance hall of Paris, is a characteristic Renoir celebration of vivacious charm. People crowd the tables and chatter while others dance energetically. The whole scene is dappled by sunlight and shade, artfully blurred into the figures themselves, to produce just that effect of floating and fleeting light so cultivated by the Impressionists. The casual, unposed placement of the figures, the suggested continuity of space spreading in all directions and only accidentally limited by the frame introduce us as observers into the very scene. We are not, as with the tradition, observing a performance on a stage set; rather we are ourselves part of the action. Renoir's subjects are quite unconscious of the presence of an observer; they do not pose but merely go about the business of the moment. In his search for the real, Renoir not only analyzes his own visual sensations but attempts to capture the process of events, to catch nature utterly unawares, in order to find some unique and particular aspect of it that will never recur in quite the same way. As classical art seeks the universal and typical, Realistic art seeks just the opposite— the incidental, momentary, and passing.

EDGAR DEGAS (1834–1917), more than any of his contemporaries, studied the infinite variety of particular movements that make up continuous motion. Ballerinas in arrested movement, a split-second pose cut from the sequence of their dance, make one of his favorite subjects. In *Ballet Rehearsal (Adagio)* (FIG. 16-52) Degas uses several devices to bring the observer to the pictorial space: The frame cuts off the spiral stair, the windows of the background, and the group of figures in the right foreground; the rapid diagonals of the wall bases and floor boards carry us into and along with the directional lines of the swift dancers; the figures are uncentered and "accidental" in arrangement; and, as is customary in Degas's ballet pictures, there is a large, off-center, empty space, which creates the illusion of a continuous floor that connects us with the pictured figures. By standing on the "same" surface with them, we seem to be drawn into their space. This cunning spatial projection derives from careful observation and may have been inspired by hints from Japanese prints (such as that shown in FIG. 16-53), in which diverging lines not only organize the flat shapes of the figures but function as lines directing the viewer's attention into the picture space. The Impressionists, familiar with these prints as early as the 1860's, greatly admired their space organization, the familiar and intimate themes, and the flat, unmodeled color areas, and drew much instruction from

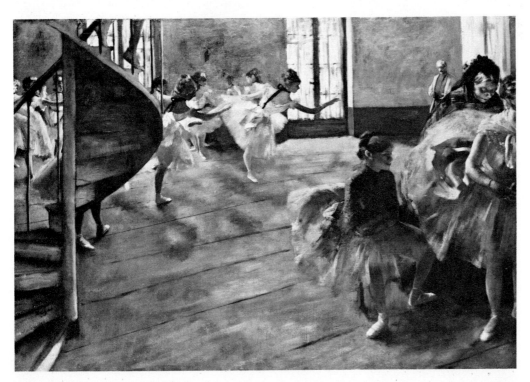

16-52 EDGAR DEGAS, *Ballet Rehearsal (Adagio)*, 1876. 23″ × 33″. Burrell Collection, Glasgow Art Galleries and Museum.

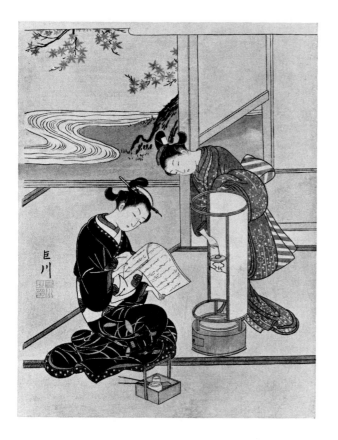

them. It is the popular Japanese print of the eighteenth century, "discovered" by European artists in the mid-nineteenth, that has the first definitive non-European influence upon European pictorial design. Earlier borrowings from China, India, and Arabia had been superficial.

Degas's *Viscount Lepic and His Daughters* (FIG. 16-54), painted in 1873, summarizes what he had learned from his own painstaking research and what in general had been learned from the Japanese print by his generation: the clear, flat pattern; the unusual point of view; the informal glimpse of contemporary life. Whatever his subject, Degas—mindful of Ingres, whose work he greatly admired—sees it as a clear line and pattern, observed from a new and unexpected angle. In the divergent movement of the father and his small daughters, of the man entering the picture at the left, and of the horse and carriage passing across the background, we have a vivid pictorial account of a moment in time at a particular position in space, much as Monet in his own way defined such space and time in landscape painting. In another instant there would be no picture, for each of the figures would have moved in a

16-53 Above: SUZUKI HARUNOBU, *The Evening Glow of the Ando*, 1765, $11\frac{1}{4}'' \times 8\frac{1}{2}''$. Art Institute of Chicago.

16-54 Right: EDGAR DEGAS, *Viscount Lepic and His Daughters*, 1873. Approx. $31\frac{3}{4}'' \times 47\frac{3}{8}''$. Present location unknown.

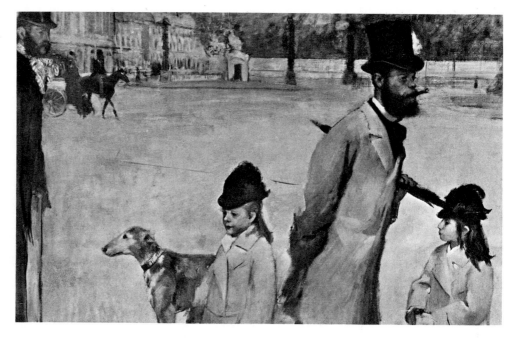

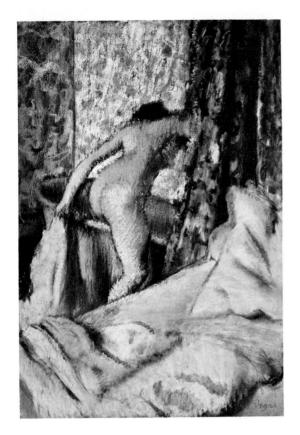

hind the picture plane; and we are always aware of the elastic strength of his firmly drawn contours. However, Degas does specialize in studies of figures in rapid and informal movement, recording the quick impression of arrested motion, and he does use the spectral color, the fresh, divided hues of the Impressionists, especially when he works in his favorite medium, pastel. These dry sticks of powdered pigment cannot be "muddied" by mixing them on a palette, so that they produce, almost automatically, those fresh and bright colors so favored by the Impressionists. All this is seen in the *Morning Bath* (FIG. 16-55), which in its informality and intimacy is like Renoir's treatments of the same subject but totally unlike it in the indifference to either formal or physical beauty. Degas's concern is with the unplanned realism of the purely accidental attitude of the human figure seen in an awkward yet natural enough moment. The nude body makes a broken volume that twists across "Japanese" angles, flat planes, and patterns. It is the verity of motion that Degas seeks above all other things. Mingling the method of Ingres with that of the Impressionists, Degas makes a picture entirely unacademic, one that is appropriate to and consistent with the dawning age of the motion picture.

POST–IMPRESSIONISM

By 1886 the Impressionists were accepted as serious artists by most of the critics and by a large segment of the public. But just at the time when their gay and colorful studies of contemporary life no longer seemed crude and unfinished, the painters themselves and a group of young followers came to feel that too many of the traditional elements of picture-making were being neglected in the search for momentary sensations of light and color. A more systematic examination of the properties of three-dimensional space; of the expressive qualities of line, pattern, and color; and of the symbolic character

different direction, and the group would have dissolved. Here again, Degas makes clever use of the empty space of the street to integrate the viewer in the space containing the figures. Actually, the painter seems to be taking into account the range of sweep of our glance—what we would see in a single split-second inspection.

When Degas was a very young man and about to enter on a career as painter he met Ingres, who advised him: "Draw lines, young man, many lines, from memory or from nature; it is this way that you will become a good painter." Degas, faithful to the old linearist's advice, became a superb master of line, so much so that his identification as an Impressionist—in the sense that Monet, Pissarro, and Renoir are Impressionists—has often seemed to many critics mistaken. Certainly his designs do not cling to the surface of the canvas, as do Manet's and Monet's; they are developed in depth and take the viewer well be-

of subject matter was undertaken by four men in particular: Seurat, Cézanne, Van Gogh, and Gauguin. Since their art diverges so markedly from earlier Impressionism, although each painter had at first accepted the Impressionist methods and never rejected the new and brighter palette, they have come to be known as the Post-Impressionists, a classification that signifies simply their chronological position in nineteenth-century French painting. A sound understanding of their individual styles and achievements is necessary to fully comprehend twentieth-century art.

At the eighth and last Impressionist exhibition in 1886, GEORGES SEURAT (1859–91) showed his *Sunday Afternoon on the Island of La Grande Jatte* (PLATE 16-7), which set forth Impressionist interest in holiday themes and the analysis of light in a new and monumental synthesis that seemed strangely rigid and remote. Seurat had worked out a system of painting in small dots that stood in a relation to each other that was based on the color theories of Delacroix and of the color scientists Helmholtz and Chevreul. (The method was called "divisionism" by Seurat and was often confused with pointillism, the latter having the dots of color distributed systematically on a white ground that remains partially exposed and hence visually functional.) It was a difficult procedure, as disciplined and painstaking as the Impressionist method had been spontaneous and exuberant. Seurat is less concerned with the recording of his immediate color sensations than he is with their careful and systematic organization into a new kind of pictorial order. The free and fluent play of color is disciplined into a calculated arrangement by prior rules of design accepted and imposed by the artist. The effect is ambiguous, as it produces both a surface pattern and a perspective depth. The apparent formlessness of Impressionism hardens into severe regularity. The pattern in the *Grande Jatte* is based on the verticals of the figures and trees, the horizontals in the shadows and the distant embankment, and the diagonals in the shadows and shoreline, each of which contributes to the pictorial effect. At the same time, by the use of meticulously calculated values, the painter carves out a deep rectangular space. In creating both pattern and suggested space he plays upon repeated motifs: the profile of the lady, the parasol, and the cylindrical forms of the figures, each so placed in space as to set up a rhythmic movement in depth as well as from side to side. The picture is filled with sunshine, but not broken into transient patches of color. Light, air, people, and landscape are fixed in an abstract design in which line, color, value, and shape cohere in an organization precise as a machine. This is a severely intellectual art of which Seurat himself said: "They see poetry in what I have done. No, I apply my method, and that is all there is to it." There is in this statement something of the scientific attitude we have found manifesting itself all along in nineteenth-century painting. On the other hand, there is something of Renaissance geometric formalism also; and the stately stage space, with its perspective and careful placement of figures, is reminiscent of an art, descended from Paolo Uccello and Piero della Francesca, that moves us by its serene monumentality. Manet, in the *Déjeuner*, had used a Renaissance composition to manifest new techniques; Seurat, in the *Grande Jatte*, turns traditional pictorial stage space into pattern in applying a color formula of which space is only a fairly unimportant variable. For our optical experience of space can only be a function of color. Whereas in the tradition of Giotto and Raphael the reality was space, with color something superadded, now with Seurat (and, as we shall see, with Cézanne), color is the reality and spaces and solids merely figments. Having found the formula of color relationships, the artist need no longer rely on the dubious evidence of his impressions. Signac, Seurat's friend and collaborator in the design of the "neo-Impressionist" method, described it with bland confidence:

> By the elimination of all muddy mixtures, by the exclusive use of the optical mixture of pure colors, by a methodical divisionism and a strict observation of the scientific theory of colors, the neo-impressionist insures a maximum of luminosity, of color intensity, and of harmony—a result that has never yet been obtained.

One remembers Constable's assertion that landscape painting is a natural science! One remembers also that the formulas of optical science of

the nineteenth century develop into those of the twentieth century and that what is scientific can have technological application. In one respect—the breaking of mass into discrete particles (and color into dots of component colors)—Seurat's *Grande Jatte* may be said to have been the forerunner of modern techniques of photo-engraving and color reproduction.

In a conversation with the influential art dealer Vollard, about 1883, Renoir said: "I had wrung Impressionism dry, and I finally came to the conclusion that I knew neither how to paint nor how to draw. In a word, Impressionism was a blind alley, as far as I was concerned" This conviction was probably one that had come to other Impressionists; certainly it must have come early to PAUL CÉZANNE (1839–1906). Although a lifelong admirer of Delacroix, he allied himself with the Impressionists, especially Pissarro, and at first accepted their theories of color and their faith in subjects chosen from everyday life. Yet his own studies of the old masters in the Louvre persuaded him that Impressionism lacked form and structure. As he said: "I want to make of Impressionism something solid and lasting like the art in the museums."

The basis of Cézanne's art is his new way of studying nature (FIG. 16-56). Of course, this could be said of all the nineteenth-century landscapists from Constable on; however, each artist's concept of what *is* is different. Cézanne's aim is not truth to appearance, especially not photographic truth, nor is it the "truth" of Impressionism. Rather he seeks for a lasting *structure* behind the formless and fleeting screens of color the eye takes in. If all that we see is color, then color must fulfill the structural purposes of the old perspective and the old light and shade; color alone must give depth and distance, color alone must give shape and solidity. But since color is only optical sensation, as the Impressionists had shown, then the structure sought in the optical world is, after all, the structure of one's own sensation. Face to face with nature, Cézanne attempts to bring an intellectual order—rather than the random approach of the Impressionists—into his sensations of it, constantly and painfully checking with that part of the scene—he calls it the motif—that he is studying. When he

says, "We must do Poussin over again, this time according to nature," he apparently means that Poussin's effects of distance, depth, and solidity must be achieved not by perspective and chiaroscuro but entirely in terms of the color-relief maps provided us by our analysis of nature.

The old tonal coherence lost, Cézanne sets out to find a new one. Although he never reduces natural objects to geometrical abstractions—this will be the work of the Cubists—the monumentality of his forms suggests that they have been stripped of the accidental variations of individual appearance. In this sense we can read his famous remark to a young follower—that the painter should "treat nature in terms of the cylinder, and the sphere and the cone"—as an injunction to present natural forms in terms of their simplest and broadest dimensions, rather than to replace them with geometric constructions.

Cézanne's method is to use his intense powers of visual concentration to observe the motif, sustaining the process of minute inspection through days and months and even years. He resembles the contemporary scientist who proves his hypothesis with repeated tests. He explored with special care the properties of line, plane, and color, and their interrelationships: the effect of every kind of linear direction, the capacity of planes to create the sensation of depth, the intrinsic qualities of color, and the power of colors to modify the direction and depth of lines and planes. Through the recession of cool colors and the advance of warm ones he controlled volume and depth. Having observed that saturation (or the highest intensity of a color) produces the greatest effect of fullness of form, he would paint an object chiefly in one hue—apples, for example, in green—achieving convincing solidity by the control of color intensity alone, in place of the traditional method of modeling in light and dark.

In the *Still Life* of 1890 (PLATE 16-8) Cézanne's method may be seen at its best. The individual forms have lost something of their private character as bottles and fruit and approach the condition of cylinders and spheres. There is a sharp clarity of planes and the edges of planes that set forth the objects as if they had been sculptured. Even the highlights of the glassware

are as sharply defined as the solids. The floating color of the Impressionists has been arrested, held, and analyzed into interlocking planes. Cézanne gives us here what might be called, paradoxically, an architecture of color.

The still life was the ideal vehicle for Cézanne's experiments, as a limited number of selected objects can be arranged by the artist to provide him with a well-ordered point of departure. The landscape does not afford the artist this advantage, the problems of representation being complicated by the need to select from the multiplicity of disorganized natural forms those that seem most significant and to order them into a pictorial structure that will have cohesive unity. To apply his methods to the painting of landscapes was one of Cézanne's greatest challenges. Thus, just as landscape had been the principal mode of Impressionist theory and experiment, so it became the subject for Cézanne's most complete transformation of Impressionism.

La Montagne Sainte-Victoire (FIG. 16-56), done about 1886, is one of the many views that Cézanne painted of the mountain near his home in Aix-en-Provence. In it we can see how transitory effects of changing atmospheric conditions, effects such as occupied Monet, have been replaced by a more concentrated, lengthier analysis of large lighted spaces. This space stretches out behind and beyond the plane of the canvas (emphasized by the pattern of the pine tree in the foreground) and is made up of numerous small elements such as roads, fields, houses, and the aqueduct in the far right, each seen from a slightly different point of view. Above this shifting, receding perspective rises the largest mass of all, the mountain, with an effect—achieved by stressing background and foreground contours equally—of being simultaneously near and far away. This is close to the actual experience a person might have of such a view when the forms of the landscape are apprehended piecemeal and the relative proportions of objects vary rather than being fixed once and for all by a strict one- or two-point perspective such as a photograph normally shows. Cézanne immobilizes the shifting colors of Impressionism, creating a kind of façade of color divided into an array of clearly defined planes. It will be the further analyses of these color planes by the Cubists that give them an indepen-

16-56 PAUL CÉZANNE, *La Montagne Sainte-Victoire, c.* 1886–88. Oil on canvas, approx. 26″ × 35½″. Courtauld Institute Galleries, London.

dent existence in which there is little reference to the full optical range of nature.

The *Boy in a Red Vest* (FIG. 16-57) shows Cézanne's application of his method to the human figure. Here the breaking up of the pictorial space, the volumes of the figure, and the drapery into emphatic planes is so advanced that the planes almost begin to take over the picture surface. The geometric character of the color area pushes to the fore, and we become at once aware of the egglike shape of the head and the flexible, almost metallic shapes of the prominent planes of the body and drapes. The disproportionally long left arm is obvious, for the distortions and rearrangement of natural forms that may go unnoticed in landscape and still-life paintings are immediately apparent in the human figure and often disturbing to the viewer. Still, we may be sure that Cézanne's distortions—and they occur in most of his figure paintings—are not accidental. What Cézanne does, in effect, is rearrange the parts of his figure to shorten and to lengthen them in such a way as to make the pattern of their representation in two dimensions conform to the proportions of his picture surface. Thus Cézanne draws the first conclusion from the Impressionists: deemphasis of subject matter. However, while the depicted object is primarily a light-reflecting surface to the Impressionists, to Cézanne it becomes a secondary aid in the organization of the picture plane. By further reducing the importance of subject matter, Cézanne automatically enhances the value of the object he is making—the picture, which has its own independent existence and must be judged entirely in terms of its own inherent pictorial qualities. In Cézanne's works the simplification of the shapes, and their sculpturelike relief and weight, give that peculiar look of stable calm and dignity that reminds one of the art of the fifteenth-century Renaissance and has led modern criticism to find in Cézanne some vestige of that ancient Mediterranean sense of monumental and unchanging simplicity of form that produced classical art.

Unlike Seurat and Cézanne, who, in different ways, sought by almost scientific investigation new rules for the ordering of the experience of color, VINCENT VAN GOGH (1853–90) impetuously and arbitrarily exploits the new color to express

16-57 PAUL CÉZANNE, *Boy in a Red Vest*, 1893–95. Oil on canvas, $35\frac{1}{4}'' \times 28\frac{1}{2}''$. Collection of Mr. and Mrs. Paul Mellon.

his emotions as he is confronted by nature. A Hollander by birth, son of a Protestant pastor, he believed that he had a religious calling and did missionary work in the slums of London and the mining districts of Belgium. Repeated failures exhausted his body and brought him close to despair. Only after he turned to painting and mastered the Impressionist technique did he find a means to communicate his experience of the sun-illuminated world of so many of his landscapes, which he represented pictorially in terms of his favorite color, yellow. His insistence on the expressive values of color led him to develop a corresponding expressiveness in his very application of the paint. The thickness, shape, and direction of his brushstrokes create a tactile counterpart to his intense color schemes. Now a thickly loaded brush moves vehemently back and forth or at right angles, giving a textilelike effect; now

the tube squeezes dots or streaks upon the canvas. This bold, almost slapdash attack might have led to disaster had it not been controlled by Van Gogh's sensibility.

Van Gogh left a rich source of his thought on his art in the letters he wrote to his brother Theo. In one of these he says: "instead of trying to reproduce exactly what I have before my eyes, I use color more arbitrarily so as to express myself forcibly . . . "; and in another letter he explains that the color in one of his paintings is "not locally true from the point of view of the stereoscopic realist, but color to suggest any emotion of an ardent temperament." This sounds like Delacroix, and indeed Van Gogh writes: "And I should not be surprised if the Impressionists soon find fault with my way of working, for it has been fertilized by the ideas of Delacroix rather than by theirs," by which he seems to mean that he took his color method from Delacroix directly rather than from the Impressionists.

The *Night Café* (PLATE 16-9), as Van Gogh writes, is meant to convey an oppressive atmosphere of evil, through every possible distortion of color. The scene, a café interior in a dreary provincial town, is supposed to be felt rather than only observed. The slumped denizens are the very color of the mood in which they drown, a melancholy pale blue. The ceiling is a poisonous green, in dizzying contrast with the febrile red walls; the floor is an acid yellow, the shadow of the billiard table green. The yellow haloes of light are like accumulations of mephitic gases. The proprietor, the pale demon that rules over the place, rises like a specter from the edge of the billiard table, itself in a steeply tilted perspective that suggests the spinning, vertiginous world of nausea.

Even more illustrative of the Expressionist's method is *Starry Night* (FIG. 16-58), painted in 1889. Van Gogh does not envision the sky as we see it when we look up on a clear dark night—a spangling of twinkling pinpoints of light against a deep curtain of blue. Rather he feels the vastness of the universe filled with whirling and exploding stars and galaxies of stars, beneath which the earth and men's habitations huddle in anticipation of cosmic disaster. Mysteriously, a great cypress is in the process of rapid growth far above the earth's surface and into the com-

bustion of the sky. The artist does not seek or analyze the harmony of nature here. Instead he transforms it by projecting upon it a vision entirely his own.

A similar rejection of objective representation in favor of subjective expression is found in the work of PAUL GAUGUIN (1843–1903). Gauguin wrote disparagingly of Impressionism:

> The Impressionists study color exclusively, but without freedom, always shackled by the need of probability. For them the ideal landscape, created from many different entities, does not exist. Their edifice rests upon no solid base and ignores the nature of the sensations perceived by means of color. They heed only the eye and neglect the mysterious centers of thought, so falling into merely scientific reasoning. When they speak of their art, what is it? A purely superficial thing, full of affectations and only material. In it thought does not exist.

Gauguin also used color in new and unexpected combinations, but his art is very different from Van Gogh's. It is no less tormented, perhaps, but more learned in its combination of rare and exotic elements and more broadly decorative. Gauguin had painted as an amateur, but after taking lessons with Pissarro he resigned from his prosperous brokerage business in 1883 to devote his time entirely to painting. Although his work did not sell and he and his family were reduced to poverty, he did not abandon his painting, for he felt that, in spite of ridicule and neglect, he was called to be a great artist. In his search for provocative subjects as well as for an economical place to live he lived for some time in small villages in Brittany and visited Martinique. Thus, even before he settled in Tahiti in 1891, tropical color and subjects drawn from primitive life had entered his art. In his attitude toward color Gauguin broke with the Impressionists' studies of minutely contrasted hues. As he said: "A meter of green is greener than a centimeter if you wish to express greenness How does that tree look to you? Green? All right, then use green, the greenest on your palette. And that shadow, a little bluish? Don't be afraid. Paint it as blue as you can." His influence was felt especially by members of the younger generation, such as Maurice Denis, who declared:

16-58 Vincent van Gogh, *The Starry Night*, 1889. Oil on canvas, approx. 29″ × 36¼″. Collection, the Museum of Modern Art, New York (bequest of Lillie P. Bliss).

Gauguin freed us from all the restraints which the idea of copying nature had placed upon us. For instance, if it was permissible to use vermilion in painting a tree which seemed reddish . . . why not stress even to the point of deformation the curve of a beautiful shoulder or conventionalize the symmetry of a bough . . . ?

Gauguin's art, too, can be understood as a complex mixture of Eastern and Western elements, of themes common to the great masters of the European Renaissance treated in a manner based on his study of earlier arts and of non-European cultures. In Tahiti and the Marquesas, where he spent the last ten years of his life, he expressed his love of primitive life and brilliant color in a series of magnificent, decorative canvases. The design is often based, although indirectly, on native motifs, and the color owes its peculiar harmonies of lilac, pink, and lemon to the tropical flora of the islands. But the mood of such works is that of a sophisticated modern man interpreting an ancient and innocent way of life already threatened by European colonization. Although the figure and setting in *Spirit of the Dead Watching* (PLATE 16-10) are Tahitian, the theme of a reclining nude with a pendant, watching figure—that is, a matching or balancing figure—belongs to the Renaissance and after. The simplified linear pattern and broad areas of flat color recall Byzantine enamels and Medieval stained glass, which Gauguin admired, and the slight distortion of the flattened forms is not unlike similar effects in Egyptian sculpture. Romantic art began with the admiration of exotic lands peripheral to Europe, as well as the natives thereof; it is with Gauguin that a kind of adaptation of their very style begins. He represents a new rebelliousness not only against the artistic tradition but against the whole of European civilization. "Civilization," he said, "is what makes you sick." The search for vitality in new peoples and new life styles, begun in the eighteenth century, now quickens. The twentieth century will draw artistic inspiration from Japan, from the Pacific islands, and from much of the non-European world.

Dissatisfaction with civilization, anxious awareness of the psychic strains it imposes, and percep-

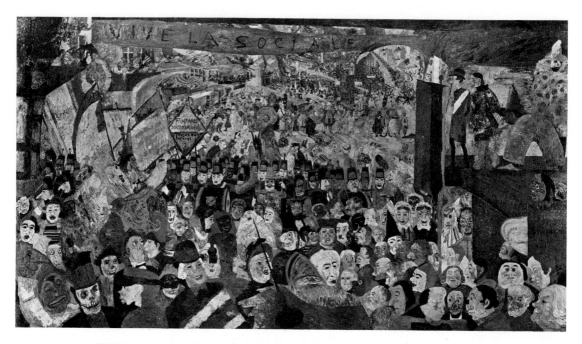

16-59 JAMES ENSOR, *The Entry of Christ into Brussels*, 1888. Approx. 8' 5" × 14' 1". Koninklijk Museum voor Schone Kunsten, Antwerp.

tion of the banality and degradation it can bring with it color the mood of the artist toward the end of the century and during the years before World War I. This is the period of the *fin-de-siècle*, "the end of the century," when art and literature languish in a kind of malaise compounded of despondency, boredom, morbidity, and hypersensitivity to the esthetic. From recording the contemporary scene, with all its variety and human interest, as the Impressionists had done, painters, influenced by Gauguin and Van Gogh, now often interpret it in bitter commentary communicated in harsh distortion—both of form and of color. In the work of HENRI DE TOULOUSE-LAUTREC (1864–1901), who deeply admired Degas, the old master's cool scrutiny of contemporary life is transformed into grim satire and mordant caricature. Lautrec's art is, to a degree, the expression of his life. He was a dwarf self-exiled from the high society that his ancient, aristocratic name would have entitled him to enter. He became a denizen of the night world of Paris, consorting with a tawdry population of entertainers, prostitutes, and other social outcasts. His natural environment became the din and nocturnal colors of cheap music halls, cafés, and bordellos.

In his *At the Moulin Rouge* (PLATE 16-11) the influence of Degas and the Japanese print can be seen in the oblique and asymmetrical composition, the spatial diagonals, and the strong patterns of line and dissonant color. But each element, although closely studied in actual life and already familiar to us in the work of the older Impressionists, has been so emphasized or exaggerated that the tone is new. Compare, for instance, the mood of this painting with the relaxed and casual atmosphere of Renoir's *Moulin de la Galette* (PLATE 16-6). Lautrec's scene is night life, with its glaring artificial light, brassy music, and assortment of corrupt, cruel, and masklike faces. (He includes himself in the background: the tiny man with the derby accompanying the very tall man, his cousin.) The distortions by simplification of the figures and faces anticipate the later Expressionism, when the artist will become ever more arbitrary in altering what he sees (in translation onto canvas) in order to increase its impact on the observer. Lautrec and his contemporaries are transitional from Impressionism to a highly subjective strain in twentieth-century art.

The pessimistic critique of modern, urban civilization continues in the work of artists out-

	1884	c. **1886**		1889	1891	1893	1895	
	SEURAT *La Grande Jatte*			VAN GOGH *Starry Night*	First movie Camera patent	MUNCH *The Scream*	PISSARRO *Place du Théâtre Français*	

I M P R E S S I O N I S M ⟶ to c.
1920

c. ⟵ R E A L I S M P O S T - I M P R E S S I O N I S M ⟶ to c.
48 1905

side of France. The Belgian painter JAMES ENSOR (1860–1949) creates a spectral and macabre world in which grotesques, masked skeletons, and hanged men populate sideshows, carnivals, and city streets. His best-known work, severely criticized at the time for blasphemy, is the *Entry of Christ into Brussels* (FIG. 16-59). In spirit it recalls the demonizing, moralizing pictures of Bosch and Bruegel that represent Christ surrounded by false and ugly creatures utterly unworthy of his mission. But here, in modern fashion, the human creatures are masked "hollow men" who have no real substance, no genuine identity, but are only "images." This is a theme often sounded in modern criticism of modern civilization. Ensor's color is hard, strident, and spotted, a tonal cacophony that matches the sound of the repulsive crowd.

Linked in spirit to Ensor is the art of the Norwegian painter and graphic artist EDVARD MUNCH (1863–1944), who is also a moralizing critic of modern man. His chief themes are pain, death, and perverse love. In *The Scream* (FIG. 16-60) he gives us a quite disturbing vision of neurotic panic breaking forth in a dreadful but silent scream, the scream heard within the mind cracking under prolonged anxiety. Like his friend, the dramatist Strindberg, Munch can present almost unbearable pictures of the tensions and psychic anguish that beset modern men and the ultimate loneliness that, according to the modern philosophy of existentialism, is the inescapable lot of all. Influenced by the strong patterns and color of Gauguin, as well as by Gauguin's use of the print medium, Munch transmitted the influence through his own work to the German Expressionists of the early twentieth century.

Protest against the disease of civilization sent Gauguin to the South Seas in search of primitive innocence. HENRI ROUSSEAU (1844–1910) was a "primitive" without leaving Paris, an untrained amateur painter who held a post as customs collector—hence his sobriquet, *le douanier*. Rous-

seau produced an art of dream and fantasy in a style that has its own sophistication and that makes its own departure from the artistic currency of the *fin-de-siècle*. His apparent visual, conceptual, and technical naiveté were compensated by a natural talent for design and an imagination teeming with exotic images of mysterious, tropical landscapes. In perhaps his best-known work, *The Sleeping Gypsy* (FIG. 16-61), a desert world, silent and secret, dreams beneath a pale, perfectly round moon. In the foreground a lion, like a stuffed but somehow menacing animal doll, sniffs at the gypsy. A critical encounter impends, not like that possible for most of us in the waking world, but all too common when our vulnerable subconscious selves are menaced in uneasy sleep. Rousseau early mirrors the landscape of the sub-

16-60 EDVARD MUNCH, *The Scream*, 1893. Approx. 36″ × 29″. Nasjonalgalleriet, Oslo.

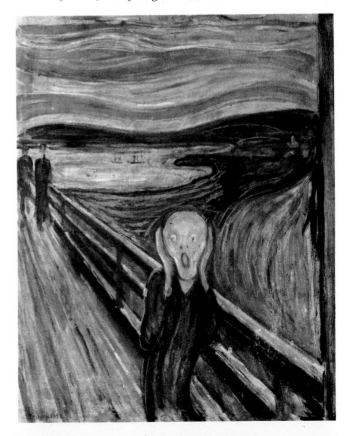

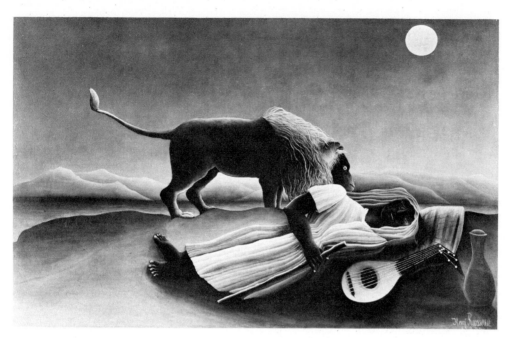

16-61 Henri Rousseau, *The Sleeping Gypsy*, 1897. Oil on canvas, 51″ × 79″. Collection, the Museum of Modern Art, New York (gift of Mrs. Simon Guggenheim).

conscious, and we may regard him as the fore-runner of the Surrealists in the twentieth century, who attempt to represent the ambiguity and contradiction of waking and dreaming experience taken together.

By the end of the nineteenth century the Western artist's vision of reality had changed. Attitudes stemming from the rise of experimental science could not help but stimulate the artist's interest in the distinction between *what* he sees and *how* he sees it. There was aroused in him a curiosity about and taste for experiment with the tools of his trade, new pigments, and new theories of light and color. These markedly influenced the procedure of Impressionists and Post-Impressionists alike. At the same time, the invention of photography profoundly affected the pictorial mode and the artist's manner of expression, offering a mechanical means of recording the spectrum of values—of light and shade—and of achieving the utmost fidelity to appearances. The pictorial artist, until then the sole maker of flat images and revealer of the structure of appearance, seemed suddenly to be technologically displaced, much as the Medieval scribe was displaced by the invention of printing. The academic painter Paul Delaroche is said to have exclaimed upon hearing of Louis Daguerre's perfection of

his photographic process: "Henceforth painting is dead!" And, around 1900, an attitude common to many of his fellow-painters was summed up by Maurice de Vlaminck: "We hate all that has to do with photography." The artist had, then, to look for new purposes and new means for his craft. His searches would ultimately lead him to break altogether with the long tradition of imitative painting based upon the optical check of nature; in the twentieth century the separation between art and natural appearance is stated by Picasso: "Nature and art, being two different things, cannot be the same thing. Through art we express our conception of what nature is not."

By mid-century the nineteenth-century painter was replacing the thematic material of Romanticism with scenes from the modern public world. His new interest paralleled widespread scientific curiosity about human society and group behavior. The artist's method, like the photographer's or the sociologist's, was at first descriptive, but in the latter part of the century this was gradually replaced by analysis and expression, and the artist came to realize that his activity is a function of his tools and materials. He discovered that his canvas is not a transparent window opening on the optical world of nature, but a tangible surface upon which pigments are arranged in a variety

of ways. This was now the reality he confronted. Whether, as with Cézanne, he examines color sensations to devise a system of color use, or, as with Van Gogh, he regards the surface and colors simply as means for expressing his emotional states, the artist finally separates himself from the pictorial tradition that had begun with Giotto.

The testament of Seurat and Cézanne, Van Gogh and Gauguin is presented to the twentieth-century artist by Denis in his famous positivist definition of painting: "Remember that a picture —before being a war horse, a nude woman, or some anecdote—is essentially a plane surface covered with colors assembled in a certain order."

Rodin: From Impressionism to Expressionism

Sculpture, like painting, had come through the nineteenth century borrowing the historical styles and toying with the kind of stagy Realism found in Doré's *D'Artagnan* (FIG. 16-15). It took an artist of supreme talent, AUGUSTE RODIN (1840–1917), to restore sculpture to its traditional eminence and to make of it again a powerfully expressive medium. Essentially, Rodin did for sculpture what Impressionism did for painting.

Respecting it for the three-dimensional art it is, Rodin refused to make it a source of wax-museum images appropriate to the photograph or the stageset. Instead he studied anew its peculiar properties of material and form, learning (from the works of Michelangelo) to appreciate its unique possibilities for expressive bodily pose and gesture. As a contemporary of the Impressionists Rodin's esthetic was based upon a similar acceptance of the world of appearances revealed through light upon surface. A modeler of soft material rather than a carver of hard, Rodin could work his surfaces with fingers sensitive to the subtlest variations of plane, catching the fugitive play of living motion as it changes fluidly under light. His touch is analogous to that of the deft Impressionist brushstroke. But, although Rodin's technique and formal sense aligned him with Impressionism, his subjects were still in the Romantic vein, and his Realism strongly bent toward Expressionism as he searched for new forms in which to cast his Romantic themes. Without resorting to the repertory of historical styles, he found for his subjects fitting and powerful forms out of his own exercise of an "impressionist realism." A splendid example is the group of life-size figures, the *Burghers of Calais* (FIG. 16-62), commemorating a heroic episode of the Hundred Years' War, when seven leading citizens

16-62 AUGUSTE RODIN, *Burghers of Calais*, 1886. Bronze, $82\frac{1}{2}'' \times 95'' \times 78''$. Hirshhorn Museum and Sculpture Garden, Smithsonian Institution.

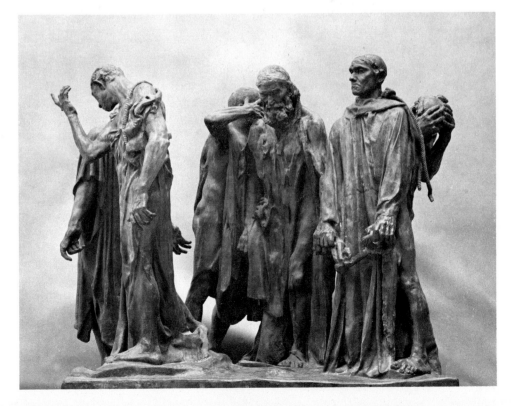

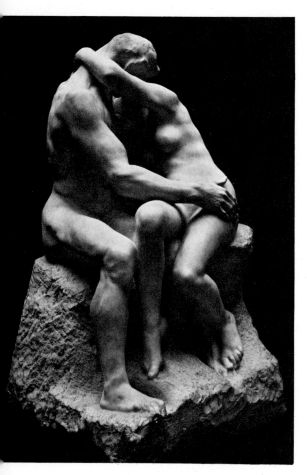

16-63 AUGUSTE RODIN, *The Kiss*, 1886–98. Marble, over life-size. Musée Rodin, Paris.

of Calais, which had been taken by the English, offered their lives in return for those of all their fellow citizens. Each of the individual figures is a convincing study of despair, resignation, or quiet defiance. The psychic effects, the result of the technical management, are achieved through the movement of a few simplified planes whose rugged surfaces catch and disperse the light. But moving though the work is, it is difficult to believe that Rodin visualized the group as a unit; indeed the separate figures were conceived as individual pieces and then shifted about until their relationship was considered satisfactory.

Rodin's mastery of dramatic gesture, so evident in the eloquent pantomime of the *Burghers*, finds expression in a very different theme in *The Kiss* (FIG. 16-63). Intended to be only one of a number of groups composing the monumental Gates of Hell, which was never finished, *The Kiss* is a subtle, if explicit, essay in a contrast of ardent approach and clumsily shy response, the attitude of the figures suiting perfectly the artist's poetic conception of the event. The group was meant to represent sensual love absorbed in self and rooted in matter. The artist may have carried in his mind a memory of Michelangelo's *Temptation of Adam and Eve*, one of the masterpieces of the Sistine Ceiling. Rodin, who declared that his encounter with the art of Michelangelo had been decisive in the formation of his style, was struck by that master's many uncompleted sculptures and admired the half-finished figures left in the rough block, as here. The lovers' figures are modeled to a smoothness that suggests the supple surfaces

and texture of living bodies. We recall the *sfumato* of Correggio, which melts all harshness and angularity and which here contrasts with the rugged stone from which the figures emerge.

Incompleteness of figure becomes both means and end for Rodin. Most of his projects remained unfinished, or were deliberate fragments. Seeing the esthetic and expressive virtue of it, modern sculpture has taken this mannerism from Rodin. The half-completed, the fragment, the vignette lifted out of context, the sketch—all have the power of suggestion and understatement. Rodin's *Balzac* (FIG. 16-64) reveals the method most successfully. Features are not carved but are only suggested by indefinite surfaces that variegate the light and dark in deft blurs and smudges with an entirely sketchlike effect. Contours melt away; volumes are not permitted to assert themselves. The great novelist, who surveyed mankind in his *La Comédie Humaine* (*The Human Comedy*), draws himself up to a towering height. Wrapped in what seems to be an enormous cloak he surveys again, from the lofty standpoint of immortality, the littleness of man. It is characteristic of Rodin's art that, though we feel its power, we cannot quite describe what traits make us feel it. His Impressionistic methods, through daring emphasis and distortions, achieve an overwhelmingly Expressionistic effect.

Rodin's personal passage from Impressionism to Expressionism was a historical one. While he was still living, sculpture was firmly set upon the base he had constructed.

REALISM IN ARCHITECTURE

Paralleling pictorial Realism was an epoch-making development in international architecture that could well be called realistic—though just as well rational, practical, or functional. For the nineteenth-century architect comes gradually to abandon sentimental and romantic designs from the historical past in the interest of an honest expression of his building's purpose. Since the eighteenth century, inconspicuous utility architecture —factories, warehouses, dockyard structures,

mills, and the like—had often been built simply and without historical ornament, and sometimes out of the new, convenient material, cast iron. Iron, along with other materials of the industrial revolution, permitted engineering advances in the construction of larger, stronger, and more fire-resistant structures. The tensile strength of iron (and especially of steel, available after 1860) allowed new designs involving vast enclosed or spanned spaces, as in the great train sheds of railroad stations and in exposition halls.

The Bibliothèque Ste.-Geneviève (1843–50), built by HENRI LABROUSTE (1801–75), shows an interesting adjustment of Romantic, revived style —in this case Renaissance—to a Realistic interior, the skeletal elements of which are cast iron (FIG. 16-65). The row of arched windows of the façade recalls the flank of Alberti's San Francesco at Rimini (FIG. 12-39), yet the division of its stories distinguishes the levels of the interior, the lower reserved for stack space, the upper for the reading rooms. The latter consist essentially of two tunnel-roofed halls separated by a row of slender cast-iron columns on concrete pedestals. The iron columns, recognizably Corinthian, support the iron roof arches, which are pierced with intricate vine-scroll ornament out of the Renaissance architectural vocabulary. One could scarcely find a better example of how the forms of traditional masonry architecture are esthetically transformed by the peculiarities of the new structural material. Nor could one find a better example of how reluctant the nineteenth-century architect is to surrender traditional forms even when fully aware of the new possibilities for design and construction. For many years architects would scoff at "engineer's architecture" and clothe their steel and concrete structures in the romantic "drapery" of a historical style. Many a great railroad station juxtaposed the romantic with practical, "undraped" construction in steel, historically decorated ticket concourses contrasting with open steel sheds just behind them.

Standardization and prefabrication of structural members permitted the construction by JOSEPH PAXTON (1801–65) in 1850–51 of the exposition building in London called the Crystal Palace (FIG. 16-66), a work almost wholly of iron and glass, in the unheard-of time of six months. The climax of nineteenth-century enterprise in wide-span con-

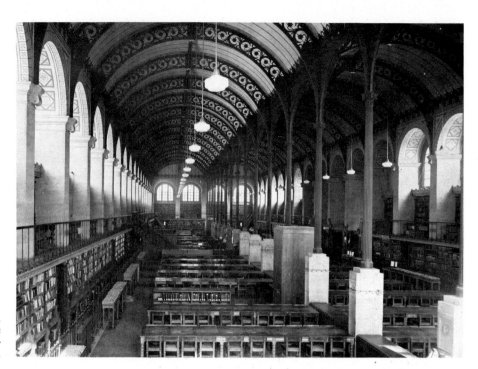

16-65 HENRI LABROUSTE,
reading room of the
Bibliothèque Ste.-
Geneviève, Paris, 1843–50.

struction was the 375-foot span of the 1365-foot-long Galerie des Machines (FIG. 16-67) erected at the Paris Exhibition of 1889. The building had no intermediate supports, so that as many as 100,000 visitors could circulate daily through its vast interior, their movement facilitated by a great rolling bridge from which they could look down at the panorama of operating machines far below. The structural scheme was composed of hinged (at apex and bases), nearly parabolic metal arches that supported a framework on which broad sheets of glass rested. Alexander Eiffel's daring tower, symbol of modern Paris, was also built at this time, and these two feats of engineering jolted some of the architectural profession into a realization that the new materials and new processes might contain the germ of a completely new style—something that picturesque, historical Romanticism had failed to produce.

The desire for greater speed and economy in building, as well as reduction of fire hazards, encouraged the use of cast and wrought iron for many other building programs, especially commercial ones. Both England and America enthusiastically developed cast-iron architecture until a series of disastrous fires in the early 1870's in New York, Boston, and Chicago demonstrated

that cast iron by itself was far from impervious to fire. This led to the practice of encasing the metal in masonry, combining the strength of the first with the fire-resistance of the second.

In cities, convenience required buildings to be closely grouped, and increased property values forced architects literally to raise the roof. Even attics could command high rentals if the newly invented elevator was also provided, as it was for the first time in the Equitable Building in New York (1868–71). Metal could support such tall structures, and the American skyscraper was born. It was only with rare exceptions, however, as in the work of LOUIS SULLIVAN (1856–1924), that this original type of building was treated successfully and produced distinguished architecture.

Sullivan's predecessor, HENRY HOBSON RICHARDSON (1838–86), frequently used heavy round arches and massive masonry walls, and because he was particularly fond of the Romanesque architecture of the Auvergne in France, his work was sometimes thought of as a Romanesque revival. This designation does not do credit to the originality and quality of most of the buildings Richardson designed during the brief eighteen years of his practice. While Trinity Church in Boston and his smaller public libraries, residences,

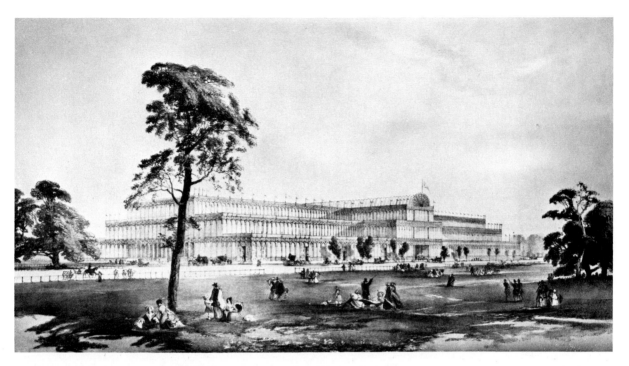

16-66 Joseph Paxton, Crystal Palace, London, 1850–51.

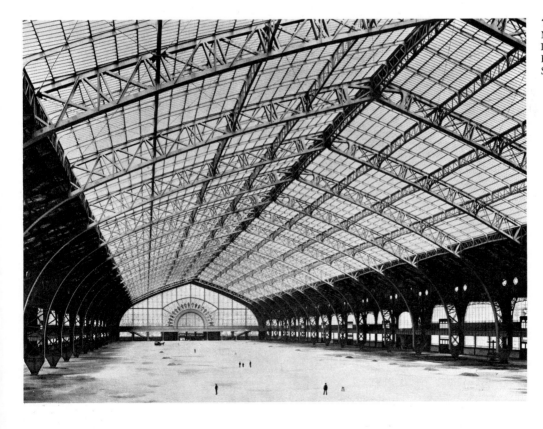

16-67 Galerie des Machines, Paris International Exhibition, 1889. Steel and glass.

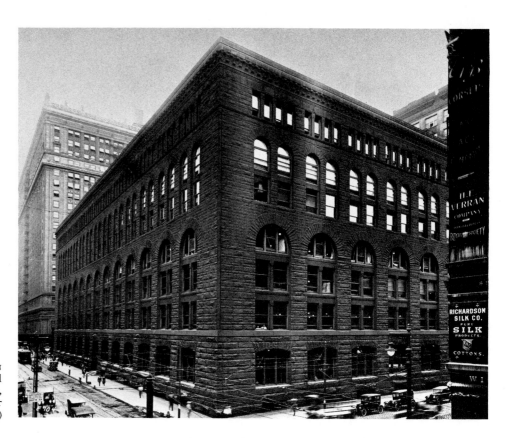

16-68 HENRY HOBSON RICHARDSON, Marshall Field Warehouse, Chicago, 1885–87. (No longer standing.)

railroad stations, and court houses in New England and elsewhere best demonstrate his vivid imagination and the solidity—the sense of enclosure and permanence—so characteristic of his style, his most important and influential building was the Marshall Field Warehouse (now demolished) in Chicago, which was begun in 1885 (FIG. 16-68). The vast building, occupying a city block and designed for the most practical of purposes —storage—yet recalls historical styles without being at all in mere imitation of them. The tripartite elevation of a Renaissance palace or of the aqueduct at Nîmes may have been close to Richardson's mind, but he uses no classical ornament, makes much of the massive courses of masonry, and, in the strong horizontality of the window sills and in the interrupted courses that define the levels, stresses the long sweep of the building's lines as well as its ponderous weight.

Although the structural frame still lies behind and in conjunction with the masonry screen of the Marshall Field Warehouse, the great glazed arcades, in opening up the walls of a large-scale building, point the way to the modern total penetration of the wall and the transformation of it into a mere screen or curtain that serves to express the structural grid and protect it from the weather.

Louis Sullivan, who has been called the first truly modern architect, recognized Richardson's architectural suggestions early in his career and worked forward from them to his new "tall buildings," especially in the Guaranty Building in Buffalo, built 1894–95 (FIG. 16-69). Here the fact that the interior is subdivided into identical-sized units is expressed on the exterior, as is the skeletal (as opposed to the bearing-wall) nature of the supporting structure, with nothing more substantial than windows occupying most of the space between the terra-cotta-clad vertical members. In Sullivan's designs one can be sure of an equivalence of interior and exterior design, as one could not in Richardson's warehouse or in Labrouste's library. Yet something of old habits of thought hangs on: The Guaranty Building has a base and cornice. The base, however, is penetrated in such a way as to suggest the later free supports of modern architecture.

16-69 LOUIS SULLIVAN, Guaranty (Prudential) Building, Buffalo, 1894–95.

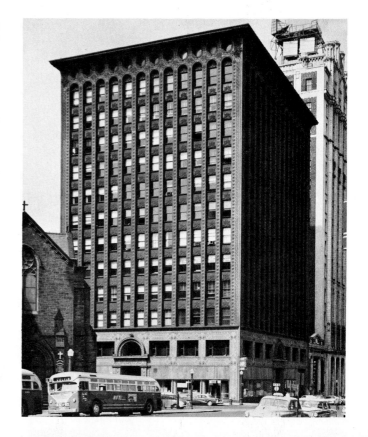

The form of the building, then, is now beginning to express its function, and Sullivan's famous "form follows function," long the slogan of early twentieth-century architects, finds its illustration here. It is important to note that Sullivan did not mean by this slogan a rigid and doctrinaire correspondence between external design and interior but rather a free and flexible relationship—one that his great pupil Frank Lloyd Wright would later describe as like that between the bones and tissue of the hand (see below).

Sullivan took a further step in the unification of exterior and interior in his Carson, Pirie, Scott Building in Chicago, built 1899–1904 (FIG. 16-70). A department store, this building required broadly opened display spaces, well illuminated. The steel structural skeleton, being minimal, could allow singular achievement of this goal. The relationship of spaces and solids here is so logical that nothing need be added by way of facing, and the skeleton is clearly revealed in the exterior. The decklike stories, faced in white ceramic slabs, seem to sweep freely around the building and show several irregularities (notably the stressed bays of the corner entrance) that help it break out of the cubical formula of his older buildings. In the general search for a new style at the end of the century, Sullivan was a leader. He gave as much attention to finding new directions in architectural ornament as in architecture itself. In this respect he is an important figure in the movement called Art Nouveau (see Chapter Seventeen), which sought an end to all traditional ornamental styles—indeed to the whole preoccupation with historical style that had been postponing the true advent of a modern method in the arts of form. The lower two levels of the Carson, Pirie, Scott Building are given over to an ornament (of Sullivan's invention) made of wildly fantastic motifs that bear little resemblance to anything traditional architecture could show. Though experiment with ornament had its brief vogue in Art Nouveau, it was the twentieth century that would sweep away wholesale the traditional systems and discover its own ornament as it discovered its own principles of design.

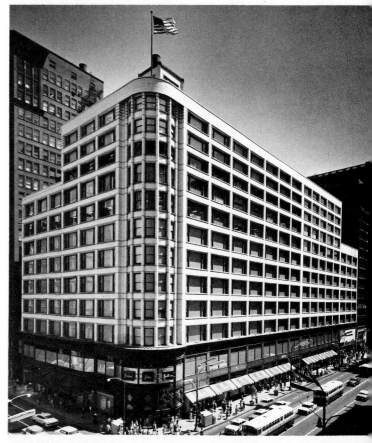

16-70 LOUIS SULLIVAN, Carson, Pirie, Scott Building, Chicago, 1899–1904.

Chapter Seventeen

The Twentieth
Century

Movie camera
patented
1891

Freud's first
psychoanalytic work
1895

DUCHAMP
To be Looked at, etc.
(1918)

LÉGER
(1881–1955)

MAN RAY
(b. 1890)

LIPCHITZ
*Man with
Mandolin*
(1917)

ROUAULT
Old King
detail (1916)

ARCHIPENKO
*Woman Combing
her Hair*
(1915)

CHAGALL
(b. 1887)

1918
Bauhaus
founded

D A D A / D E S T I J L / F U T U R I S

BRAQUE
(1882–1963)

PICASSO
Three Musicians
detail (1921)

1922

BECKMANN
(1884–1950)

RIETVELDT
Schroeder House
(1924)

GROSZ
(1893–1959)

SCHWITTERS
(1887–1948)

BARLACH
War Monument,
Güstrow Cathedral
(1927)

BRANCUSI
Bird in Space
(c. 1927)

Russian
Revolution

Dada
movement

191
Work
War
begin

KLEE
Twittering Machine
detail (1922)

1924
Surrealist
Manifesto

GROPIUS
Shop Block, Bauhaus
(1925)

C U B I S M / S U R R E A L I S M

1927
Lindbergh flies the Atlantic

1929
Stock market
crash

LE CORBUSIER
*Notre Dame
du Haut*
(1950–55)

GABO
*Linear
Construction*
(1950)

GIACOMETTI
City Square
(1948)

POLLOCK
Lucifer
detail (1947)

A B S T R A C T F O R M A L I S M

A B S T R A C

BACON
Number VII etc.
(1953)

WYETH
Christina's World
detail (1948)

1954

NERVI
Palazzetto dello Sport
(1958)

TINGUELY
(b. 1925)

KIENHOLZ
(b. 1927)

KLINE
Painting 1952
(1955)

VAN DER ROHE
Seagram Building
(1956)

1957

JOHNS
Painted Bronze
(1960)

1959

O P / P O P

BECAUSE we are in the midst of it and, hence, still being shaped by it, the twentieth century is perhaps more difficult to characterize than any in history. It has been said that the Renaissance died finally in the holocaust of World War I; it is certain that this century has brought to a close an epoch of a thousand years, from the dim time in the Romanesque era when Europe began a new life until now, when it is blending into a world civilization. This century is a continuing crisis in which man is making himself into something different from what he has been, at a cost he cannot yet estimate and with consequences he cannot guess. Our historical knowledge has already placed our abandoned traditions an unbridgeable distance behind us and left us self-conscious and isolated in the stream of time, confronted with tremendous possibility

or appalling disaster. Science has utterly changed man's picture of the physical world and of himself. Our technology has provided unique experiences: high-speed flight, instantaneous communication over great distances, expanded ranges of sensory perception, and—for a minority as yet—conditions of physical ease never before imaginable. But the new patterns of life that are separating us so decisively from the past have brought new and difficult problems of adjustment. The passing of old traditions and beliefs has robbed civilized men of assurances and securities; he is often doubtful of the meaning and purpose of life and of the very source and nature of his own identity. We hear much of modern man's "alienation," his sense of strangeness and loneliness in the world, where he is, like the figures in Giacometti's *City Square* (FIG. 17-45), only an aimless unit in a "lonely crowd."

This problematic quality of modern life is the result of the constantly shifting grounds of our beliefs; an axiom for our time could well be "where nothing is certain, everything is a question," the fundamental question being: What is "real"? The twentieth century seems chronically and constitutionally skeptical about all answers to this question, especially the traditional ones. But of one thing it appears to be certain: "Reality" is infinitely complex, perhaps ultimately elusive, and by no means given to us in our everyday, conventional, commonsensical experience. "Seeing" is certainly no longer ground for "believing." The world of common sense is simply not what it seems. At the beginning of the century new theories in physics, particularly the quantum theory and the theory of relativity, describe subsensible and suprasensible universes of electrical fields in which there is no absolute space or time and in which all motion is relative to systems themselves in motion. There is no stable "center" in this headlong, expanding universe swarming with electronic and galactic events, no absolute standpoint that can certify our measurements of space and time. A principle of "indeterminacy" reigns in the world of the electron and of outer space, where the speeds of events approach the speed of light. The world of familiar solids and spaces thus dissolves, upon physical analysis, into a "dance of atoms," whose configurations have apparently little relation to what we see and feel

as "real." In such a world picture, the stature of man, so elevated in the Renaissance, shrinks to infinitesimal dimensions.

If physical science's picture of the world drastically reduces our central role in the old classical–Christian cosmos, modern biology has done little to restore it. In the nineteenth century man's privileged status in nature had been questioned by the hypothesis that he had evolved from lower forms of life. In the newly developed social sciences, biological concepts were adapted to explanations of human culture and of individual differences, and the human individual came to be seen as a resultant of the interacting factors of heredity and environment. Thus, life may be determined rather than free. And man in the collective comes to be studied statistically, like the subatomic particles of physics.

A further blow to age-old beliefs is delivered in the twentieth century by the new psychology, associated in its early development with Freud. Though it has its roots deep in Romanticism, this restatement of man's essential irrationality struck at a thousand years of explanations of human conduct and may be seen as a modern revision of the theme of original sin. In the new view our actions are seen as largely determined by motives operating beneath consciousness—at an unconscious or "subconscious" level.

A further modern development contributes to uncertainty and the uneasiness that accompanies it. We might call this the information-communication crisis. Literacy has been widespread in the Western world since the end of the nineteenth century, and printing has been supplemented by radio and television as media of communication. The resulting expansion in communication *services* has been accompanied by a diminution in credibility and belief; thus, though technical competence has increased, its application may have little relevance to deeper human concerns. Much analytical research is aimed at improving process and achieving unambiguous definition, but art and life are rich in ambiguity, and to eliminate it would impoverish and trivialize both.

In our time "meaning" and "truth" join "reality" as problematic and relative terms. The reduction of truth from absolute, transcendental, and eternal to public, relative, and debatable makes our acquisition of it conditional on lan-

guage. And ordinary verbal language is ambiguous.

The success of experimental science has had everything to do with making meaning and truth into functions of instruments and languages. Our knowledge of the physical world is obtained by the manipulation of instruments, and the language mediating that knowledge is the specialized one of mathematics. Thus the meaning, truth, and reality of scientific experience—that is, scientific knowledge—are contained in its media and inseparable from them. This is true also of the arts in this age of science and mechanism. As we saw in Chapter Sixteen, Maurice Denis insisted that before a picture is *of* anything it is simply a flat surface covered with colors arranged in a certain way. By a similar reduction, a poem is only a sequence of words or word-images, and a piece of music a sequence of sounds. A dominant modern view defines art as consisting in the free manipulation of such elements in arrangements that need have no reference to anything outside themselves—that is, they need not *represent* anything. The arrangement is complete and self-contained; one cannot find its message by demanding that it point to something recognizable beyond itself. The modern artist, like the scientist, "experiments" with his medium, investigates its possibilities, and discovers, or invents, new forms. But unlike the scientist, searching for new uniformities and regularities, most modern artists seek the singular and unique; Juan Gris, one of the best of the Cubist painters, remarked: "My aim is to create new objects which cannot be compared to any object in actuality." The task of projecting the optical order of the world upon a flat surface, the task of generations of painters since Giotto, is given up; for, given the new view of the world, the optical "look" of it is problematic, and to make pictures that copy it is futile. New forms must be discovered or created out of the possibilities of the physical medium itself in order that new and profound reality can be expressed. Paul Klee, one of the great masters of modern art, put it this way:

We used to represent things visible on earth Now we reveal the reality of visible things, and thereby express the belief that visible reality is merely an isolated phenomenon latently outnumbered by other realities. Things take on a broader and more varied meaning, often in seeming contradiction to the rational experience of yesterday In the end a formal cosmos will be created out of purely abstract elements of form quite independent of their configurations as objects, beings, or abstract things like letters or numbers.

In other words, the reality of visible things is now no longer merely their visibility; the visible state of a thing, given in a single perspective as in traditional art, is an extremely limited account of it; the reality is much more than that. For example, said Klee, "An apple tree in bloom is in effect a complex of stages of growth, its roots, the rising sap, its trunk, the cross-section with the annual rings, the blossom, its structure, its sexual function, the fruit, the core with its seeds." Klee wants to express this complexity of parts as a whole that is, in effect, more than the sum of its parts; that has a meaning that cannot be apprehended by the analysis of the apple tree into parts and phenomena. Thus, the ambiguity that science tries to eliminate from its procedures, findings, and communicated information is the very essence of the reality the artist deals with. Klee continued:

In the highest sense, an ultimate mystery lies behind the ambiguity which the light of the intellect fails miserably to penetrate. Yet one can to a certain extent speak reasonably of the salutary effect which art exerts through fantasy and symbols. Fantasy, kindled by instinct-born excitements, creates illusory conditions which can rouse or stimulate us more than familiar, natural, or supernatural ones. Symbols reassure the mind that we need not depend exclusively upon mundane experience [1]

The mystery that modern science tries to dispel, modern art cultivates as at the heart of our human experience of reality. The union of art and science in the Renaissance, made on the basis of humanistic reason, is dissolved in the twentieth century. Even though the arts in one respect—the experiment with forms and materials—have paralleled modern logic and mathematics and are now drawing close to technology,

[1] In Margaret Miller, ed., *Paul Klee* (New York: Museum of Modern Art, 1946), pp. 12-13.

their intention and their results have led them in a precisely opposite direction. The artist-experimenter is at the same time the artist-prophet. Working ceaselessly at the possibilities of his physical medium, he seeks a reality behind the screen of the conventional world. His search depends not upon a general, public agreement about reality, or a general pictorial language for communicating it, but upon his own instincts, insight, inner experience, which he expresses as a kind of personal vision—strange, ambiguous, mystifying, impossible to communicate in words. It is little wonder that, as modern art has developed in its many movements, the general public has been most often hostile to it, and, undoubtedly, the artist most often invites that hostility, for almost from the beginning it has been his intention to *épater le bourgeois*, to shake up the stodgy citizen and make him see and think in a new way. Picasso insists that art, in this respect, must be subversive, essentially revolutionary. The modern artist, in this view, must live in the avantgarde of society, his very life a model of defiant freedom from spirit-destroying convention.

What has been said by way of background to the ensuing discussion of the art of the twentieth century is, of course, a simplification, and it should be understood only as a partial and uncertain explanation of the central fact—that modern art looks very different from the art of the past. We have generalized modern art and the modern artist, and particular cases escape generalization; what remains unequivocal is the picture of the artist in a dangerous, confused world, experimenting to find a free means of expression of his insights. His task is to reconstruct reality from his private experience.

PAINTING BEFORE WORLD WAR II

Symbolism and Art Nouveau

We have already observed this manifestation of private experience in the work of Gauguin, Van Gogh, Munch, Ensor, and Toulouse-Lautrec and their contemporaries, all of whom reveal a restless, self-conscious search for freedom of expression so characteristic of the end of the century—so characteristic, indeed, of the Romantic temper, which those Post-Impressionists recover and intensify. They break impatiently with Impressionism and Realism and adopt an approach to subject-matter that associates them in a general European style and movement called *Symbolism*. The term has application to both art and literature, which, as critics in both fields noted, were in especially close relation at this time. A manifesto of literary Symbolism appeared in Paris in 1886, and in 1891 a critic, Albert Aurier, applied the term to the painting of Gauguin and Van Gogh. Symbolism disdains "mere fact" as trivial and asserts that fact must be transformed into a symbol of the inner experience of that fact. Fact is thus nothing in itself; mentally transformed it is the utterance of a sensitized temperament responding in its own way to the world. In Symbolism the subjectivity of Romanticism becomes radical; it will continue so into the art of the twentieth century. The artist's task is not to *see* things but to *see through* them to a significance and a reality far deeper than what is given in their superficial appearance. In this function, the artist, as the poet Rimbaud insists, becomes a seer, a being of extraordinary insight. (One symbolist group of painters called itself *Nabis*, the Hebrew word for prophet.) Rimbaud, in the preface to his *Illuminations*, poems that had great influence on the artistic community, goes so far as to say that the artist, in order to achieve the seer's insight, must become deranged or, as he says in effect, must systematically unhinge and confuse the everyday faculties of sense and of reason, which serve only to blur his vision. The objects given us in our common sense world must be converted by the artist's mystical vision into symbols of a reality ultimately beyond it.

The extreme subjectivism of the Symbolists led them to cultivate the recondite and occult and to urge the exclusiveness, not to say the elitism, of the artist against the vulgar materialism and conventional mores of industrial and middle-class society. Above all they wished to purge art of anything utilitarian, to cultivate an exquisite esthetic sensitivity, and to make the slogan "art for art's sake" into a doctrine and way of life.

Walter Pater, an English scholar and esthete, puts forward this point of view as early as 1868 in the conclusion to his work *The Renaissance*:

Our one chance lies in expanding that interval [of our life], in getting as many pulsations as possible into the given time. Great passions may give us this quickened sense of life Only be sure it *is* passion—that it does yield you this fruit of a quickened, multiplied consciousness. Of such wisdom, the poetic passion, the desire of beauty, the love of art for its own sake has most. For art comes to you proposing frankly to give nothing but the highest quality to your moments as they pass, and simply for those moments' sake.

The subject matter of the Symbolist, determined by this worshipfulness toward art and exaggerated esthetic sensation, becomes increasingly esoteric and exotic, weird, mysterious, visionary, and dreamlike. (It is noteworthy that, contemporary with the Symbolists, Sigmund Freud begins the new century and the age of psychology with his *Interpretation of Dreams*, an introduction to the concept and the world of unconscious experience.) The Symbolists draw their inspiration from sources other than the common nineteenth-century stock of historical, mythological, and anecdotal themes, turning to the relatively unfamiliar ones of the Orient, Oceania, Byzantium, Persia, the early Middle Ages, the early Renaissance.

It is in these uncommon sources that the Symbolists search for new forms. The picture-box of the pictorial tradition is replaced by flat surfaces decoratively embellished with figures that are not modeled, or, if modeled, are often set in contrast with flat patterns. An example of this experimental adjustment of planar shapes and plastic forms is the painting *Death and Life* (Plate 17-1) by the Viennese artist GUSTAV KLIMT (1862–1918). In 1903 Klimt had visited Ravenna and seen its great mosaics. Though Byzantine art had begun to be appreciated early in the nineteenth century, Klimt approaches it here not as critic, historian, or connoisseur, but as an artist open to fresh inspiration, ready and competent to assimilate form from outside his own tradition in order to express a modern mood. The painting is quite typically Symbolist in both content and form. Bright colors, mosaic-like or enamel-like, stud

the surfaces that enwrap the voluptuously somnolent figures in the "Life" group, where intertwined images of infancy, youth, maturity, and old age celebrate life as bound up with love. Outlined shapes are modeled to the extent needed to show the softness of flesh and the firmness of sinew. It is characteristic of Klimt to contrast the often quite realistic modeled forms with flat patterns. The tableau of defenseless sleep is set off against the spectre of Death, the nocturnal assassin, who advances threateningly upon it. The shroud of the fleshless Death is appropriately dark as night, only dimly decked with funereal black crosses and chieromantic symbols. While Life, sated with love, sleeps, Death, its enemy, wakes. The grim interval between Life and Death will soon be crossed.

In this and other Symbolist works, the ornamental flatness of the drapery, the organic, undulating contours, and the arbitrary placement of figures, such that they seem to float and hover as they would in a dream, contradict the presuppositions of realistic representation. From this contradiction and from the example of art outside the Western tradition arise new possibilities of form independent of pictorial Realism that produced an international style, Art Nouveau, which dominated the arts from 1890 to World War I. Art Nouveau was a protest not simply against a sterile Realism, but against the whole drift toward industrialization and mechanization and the unnatural artifacts they produced. The forms of nature, growing, sinuous, and graceful, were set against the blunt, ugly masses of the encroaching machine. Art Nouveau called for renovation of a taste corrupted by mass-produced objects and cluttered urban environments, which seemed to be assuming dominance in the name of unesthetic utility.

The sources of Art Nouveau, as of Symbolism, lay in the arts and crafts of other cultures and times and in the exotic styles cultivated by innovating artists like Gauguin, Van Gogh, and their contemporaries. The Japanese print played an important part, as did the movement led by Ruskin and William Morris, who extolled careful craftsmanship in all the arts, stressing the moral as well as the esthetic value of honest, individual craft. Art Nouveau, especially effective in archi-

tecture and the handicrafts (p. 758), influenced decisively the figural arts; and most of the great modern painters of the early twentieth century participated in or were touched by the movement at the beginning of their careers.

The Fauves and Expressionism

The first signs of a new and specifically twentieth-century movement in painting appeared in Paris in 1905. In that year, at the third Salon d'Automne, a group of younger painters under the leadership of Henri Matisse exhibited canvases so simplified in design and so shockingly brilliant in color that a startled critic described the artists as *fauves* ("wild beasts"). The influence of the non-European cultures of the new colonial dominions was everywhere apparent. The "Fauves" were encouraged by the newly discovered exotic arts to seek more personal forms of expression than had been known in the West. In African fetishes, in Polynesian decorative woodcarvings, and in the sculptures and textiles from the ancient cultures of Central and South America they saw unexpected shapes and colors that suggested new ways of communicating emotion. This led them individually into various paths of free invention and took them once and for all out of the traditions of the Renaissance. Deft, spirited painters, they produced canvases of great spontaneity and verve, with a rich surface texture, lively linear patterns, and boldly clashing effects of primary colors. Their subject matter was as varied as their methods of painting, although many subjects familiar in Impressionist and Post-Impressionist painting—such as landscapes, still lifes, and nude figures—still appeared. Thus, the Fauves carried on and expanded the trends begun by Van Gogh and Gauguin, whose works had become better known through extensive retrospective exhibitions held in Paris in 1901 and 1903.

The Fauves brought color to a new intensity with startling discords of vermilion and emerald green, cerulean blue and vivid orange held together by sweeping brushstrokes and bold patterns. Relationships to the past and contributions to the present can be seen in a painting such as the one exhibited in the 1905 Salon d'Automne entitled *London Bridge* (PLATE 17-2) by ANDRÉ DERAIN (1880–1954), whose Fauve work remains among his finest. We can judge how thoroughly the Fauve painters had broken with most of the art of the late nineteenth century when we recall that Monet had completed his series of views of Waterloo Bridge in London only three years before. Derain rejected entirely the subtle harmonies of Impressionism, so expressive of atmospheric and climatic conditions, in favor of a distorted perspective emphasized by clashing yellows, blues, greens, and reds against the black accents of the arches. Implicit in such work is the philosophy already adopted by Van Gogh and Gauguin and fundamental to Expressionism: the artist's presentation of his emotional reaction to the subject in the boldest color and strongest linear pattern is more important than any attempts at objective representation. In this way the Fauves freed color from its traditional role as the description of the local tone of an object and helped prepare both artists and public for the use of color as an expressive end in itself. In a sense color becomes the "subject" of the picture.

The Fauve movement was never an official organization of painters and was short-lived; within five years most of the artists modified their violent colors and found their own more personal treatment of the medium.

The artist who remained most faithful to the Fauve principles yet, through his extraordinary sensitivity for color, transformed them into one of the strongest and most influential personal expressions in modern art, was HENRI MATISSE (1869–1954). Throughout his long life his gift for combining colors in unsuspected ways and for inventing new combinations never flagged. He preferred working in two dimensions but, by the subtlest of color accents, his surfaces, no matter how apparently flat, convey effects of three-dimensional space. In an early painting, *Le Luxe* (FIG. 17-1), the background of sea, hills, and sky seems to stretch out behind the figures, although it is executed in the simplest method by overlapping planes of undifferentiated color. Despite the limitations of the schematic method by which Matisse renders the figures, they show his mastery of human anatomy; it is interesting that though once a pupil of the Symbolist Moreau

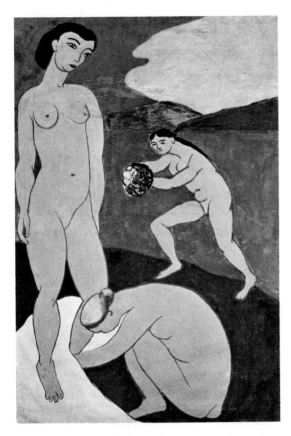

17-1 HENRI MATISSE, *Le Luxe*, 1907–08. Approx. 82½″ × 54¾″. Statens Museum für Kunst, Copenhagen (Rumps Collection).

and of the academic Bouguereau, he shows here the strong influence of Cézanne. To his contemporaries such apparent distortion and elimination of detail seemed horrifyingly unnatural. We can now understand that only through such extreme simplifications could Matisse convey his expression of a serene, detached world of forms wherein line, shape, and color exist almost independently of the subject; where the subject, as we have suggested, is only a secondary element shaped by the artist's feelings in the process of expressing it. Matisse put the matter of Expressionism very succinctly:

> What I am after, above all, is expression I am unable to distinguish between the feeling I have for life and my way of expressing it The whole arrangement of my picture is expressive . . . everything plays a part. Composition is the art of

arranging in a decorative manner the various elements at the painter's disposal for the expression of his feelings All that is not useful in the picture is detrimental.[2]

Studying his *Red Room* (*Harmony in Red*) (PLATE 17-3), we find that Matisse used the color craft of Gauguin and Cézanne for his own decorative-expressive purpose. The composition is an essay in the contrast of warm and cool colors and curving and straight lines; and though the planes of the picture seem to resolve into a single flat spread, directional lines and the variation in the strength of color suggest a front and back, though in a kind of contrived spatial ambiguity. Matisse himself tells us that his procedure is one of continuous adjustment of color to color, shape to shape, and color to shape until the exactly right "feel" is achieved and the painting completed. This way of letting the picture "emerge" out of deep, even unconscious, feeling, letting one's artistic sensitivity and instinct be one's guide, is common in the practice not only of Expressionism but in modern art in general.

Much modern art is based upon severely intellectual doctrines (frequently proclaimed in manifestoes), and may require for its enjoyment some understanding of the artist's relation to contemporary currents of thought. Though Matisse intellectualized painting, as his *Notes of a Painter* reveals, his art reflects a great love of nature, of color, and of joyous subjects. He observed that he did not care for weighty themes and moods and that art should be restful as a comfortable chair after a hard day. For this reason his art is sometimes disparaged as too decorative and lacking profundity. But this is to overlook its very special and very French qualities, those that an early critic of Matisse expressed as "simplicity, serenity and clarity." It is significant that these qualities, so evident in classicism, are manifest in his subjects as well as his forms: he was concerned almost exclusively with figure painting.

In a vein very different from that of Matisse, GEORGES ROUAULT (1871–1958) treated themes of grave social and religious import. His studies of sad clowns and broken prostitutes and his long

[2] In Robert Goldwater and Marco Treves, eds., *Artists on Art* (New York: Pantheon, 1945), pp. 409–10.

series of religious paintings are Fauve in their simplified designs, and are constructed with black outlines like the leads in Medieval stained glass, which Rouault, who had worked as a glassmaker's apprentice in his youth, had always admired. These strongly effective black barlike divisions and the somber tonalities he preferred —the glowing reds, greens, and midnight blues of stained glass—are harmonized in Rouault's powerful evocation of the Old King (PLATE 17-4). The fierce aquiline features, dark complexion, and thick black hair and beard recall some ancient Assyrian despot in brooding reverie, almost an icon of absolute and pitiless authority. The sharp and rugged simplification of the forms and the harsh, hacked-out edges convey with the blunt force of certain Medieval statues an aspect of monarchic vengefulness.

The influence of the Fauves was almost immediately felt outside of France, coalescing with that of Ensor and Munch in the German schools of the early twentieth century. Here the element of immediate personal expression, especially characteristic of Fauve painting, appealed to groups of German painters who had organized into movements: *Die Brücke* (the Bridge, symbolizing the unity of nature and emotion) in Dresden and *Der Blaue Reiter* (the Blue Rider, after a picture of that name by Kandinsky) in Munich. These painters carried even further the tendencies in the work of Derain and Matisse. In Germany there was less concentration than in France on purely formal problems. German Expressionism was a manifestation of subjective feeling toward objective reality and the world of the imagination. With bold, vigorous brushwork, emphatic lines, and bright color the German painters produced splendid, almost savagely powerful canvases, particularly expressive of intense human feeling. A striking example is *The Bride of the Wind* (PLATE 17-5) by OSKAR KOKOSCHKA (b. 1886), a Viennese painter who was early influenced by Klimt. The theme of the painting has its roots far back in high Romanticism and (even farther back) in the pathetic story of Paolo and Francesca told by Dante in the *Inferno* (V, 73–142). Two lovers are swept by turbulent winds through a nightmare landscape, neither they nor the winds ever to be at rest. The anguish of love,

its lacerating power, and not its delight and ecstasy, is expressed in the violence of shredded contours, alternating cold and lurid color, and painfully agitated brushwork. The painting is a passionate expression of the state of two souls who embrace not in joy but in unmitigated sorrow. Kokoschka gives us here a clear instance of the transition from Symbolism to Expressionism.

German Expressionism is in the direct line of descent from earlier German painting and engraving, especially in its strong color, linear pattern, emphasis on subject matter of a highly emotional character, and frequent transcendental overtones. Those elements appear most effectively in the work of EMIL NOLDE (1867–1956), an especially good example of which is *St. Mary of Egypt Among Sinners* (PLATE 17-6). Though he learned much from the masks of Ensor and the color of Matisse, Nolde's painting has an original force of its own, reminiscent of Grünewald and Bosch in its expressive violence. Mary, before her conversion, entertains lechers whose brutal ugliness is magnified by their lust. The distortions of form and color (especially the jarring juxtapositions of red and green) work to the same end, an appalling tableau of subhuman and depraved passion, in which evil wreaks its visible consequence in the repulsive faces and gestures.

MAX BECKMANN (1884–1950), an independent and forceful Expressionist, has left some of the most memorable works of the German schools. His art was elicited by some of the darkest moments of the twentieth century, when Nazi tyranny threatened European civilization. While his message is bitter, its reference is not specific to one time or place, concerning human cruelty and suffering in general. In perhaps his best-known painting, a triptych entitled *Departure* (FIG. 17-2), he organizes figures rendered in caricaturelike distortion and simplification, their sculptural relief accentuated by hard, black line. In the left panel there is a scene of torture prophetic of the death camps: A bound man stands in a barrel of water, another's hands have been severed, a trussed woman crouches in the foreground, the executioner wields his ax. The horror is continued in the right panel, partly staged as a mad carnival. In striking contrast, the central panel

17-2 Max Beckmann, *Departure*, triptych, 1932–35. Oil on canvas, center panel 84¾″ × 45⅜″. Collection, Museum of Modern Art, New York (given anonymously).

represents the departure of a royal family in calm daylight, the figures resigned and serene, departing the terrors of night in what may be an allusion to Beckmann's own flight from Nazi Germany after his work, along with that of most of the Expressionists, had been condemned and banned by Hitler as "degenerate." The hard, bright color, beautifully harmonized, carries in itself a large burden of the meaning.

Beckmann's visions of human disaster were shared by many artists of his generation who had witnessed at first hand the carnage on the battlefields of France and the shattered and corrupted society of postwar Germany. Sensitized by their experience, they often made works that were in an almost prophetic strain, like *Punishment* (FIG. 17-3) by GEORGE GROSZ (1893–1959). This is both a recollection of the destruction of Sodom and Gomorrah and a premonition of the apocalyptic

obliteration of the world by bombs. A wildly free brush configures blazing explosions, thunderclouds of smoke, the cascading debris of buildings in a furious image of man-made hell where no figure of man survives. Curiously, Grosz's picture is but a step from the total nonobjectivity of Kandinsky's *Improvisations* (PLATE 17-7), in which coherent images are lost in an apparent chaos of shape and color.

The emotional range of German Expressionism is very great, from the terror and indignation of artists like Nolde, Beckmann, and Grosz to the poignantly expressed pity for the poor in the moving prints of KÄTHE KOLLWITZ (1867–1945). The graphic art of Gauguin and Munch had stimulated a revival of the print medium in Germany, especially the woodcut, and the forceful block prints cut in the days of the German Reformation proved inspiring models. The harsh,

17-3 GEORGE GROSZ, *Punishment*, 1934. Watercolor, approx. $27\frac{1}{2}'' \times 20\frac{1}{2}''$. Collection, Museum of Modern art, New York (gift of Mr. and Mrs. Erich Cohn).

17-4 KÄTHE KOLLWITZ, *Memorial to Karl Liebknecht*, 1919. Woodcut.

black, splintered lines of the woodblock print were ideal for the stark forms and blunt emphasis of message prized by the German Expressionists. In her *Memorial to Karl Liebknecht* (FIG. 17-4), Käthe Kollwitz, one of the outstanding women artists of the twentieth century, produces a classic of the Expressionist print. The composition is both a masterful presentation of mute sorrow at the bier of a lost leader and a strong political protest. We have seen to what effective political use Daumier put the graphic medium. Regrettably, modern methods of reproduction have largely usurped the public role of the graphic arts.

The emphasis upon color by the Fauves and the German Expressionists made it almost logical that color by itself, without any figurative material, could come to constitute the full "content" of a picture.

In the Blue Rider group the Russian painter VASILY KANDINSKY (1866–1944) carried his research into the emotional and psychological properties of color, line, and shape to the point where subject matter and even representational elements were entirely eliminated. Now that abstract art has become so much a part of our experience, we tend to forget the courage such a step required and the creative imagination needed to undertake so completely new a direction in the art of painting. By 1914 Kandinsky had perfected his methods and established, in two groups of works, two principal kinds of painting. He called one kind *Compositions*, the title for this group implying that such arrangements of geometrical shapes were consciously planned and intellectually ordered; on the other hand, in his *Improvisations* (an example of which is shown in PLATE 17-7), he approached the canvas with no preconceived theme but allowed the colors to come as they would, prompted by subconscious feelings. In these works the brilliant colors flow across the canvas with as little conscious order or control as possible on the artist's part. In thus utilizing subconscious sensations Kandinsky uncovered an area soon to be exploited by other artists, notably the Surrealists. Kandinsky described his methods and the philosophical connotations of his art in his influential treatise, *Concerning the Spiritual in Art*, wherein he proclaims the independence of color and the spiritual value inherent in it. In Kandinsky's view colors have

← to c.1886	c.1905	1907	1908	1911	1912	1914	1916	1919	to c.1939 →
Einstein's theory of relativity	Third Salon d'Automne	PICASSO *Demoiselles d'Avignon*	MATISSE *Red Room*	PICASSO *Accordionist*	DUCHAMP *Nude Descending a Staircase #2*	KOKOSCHKA *Bride of the Wind*	ROUAULT *Old King*	TATLIN *Memorial to III International*	

POST-IMPRESSIONISM

—CUBISM—ART NOUVEAU—EXPRESSIONISM—DADAISM—DE STIJL—FUTURISM—

—————————— IMPERIAL–COLONIAL RIVALRIES ——————————

deep-seated psychic correlations in the prerational, utterly uninhibited expression of which the artist's being is revealed to him. The "rational" world given to ordinary vision is hopelessly deceptive, and we must set aside reasoned "seeing" and planning so that the deeper reality of ourselves, living in the instinctual world of the subconscious, may rise into sight. This view harmonizes with Freud's conclusions concerning the subconscious and with Rimbaud's claim that the true artist is a visionary.

Cubism and Its Derivatives

Just as Expressionism, with its emphasis on subjective experience, can be traced back through all its branches to the examples of Van Gogh and Gauguin, so two other important currents in modern art, Cubism and Constructivism, can be shown to have vital connections with the Post-Impressionist, Paul Cézanne. Though Matisse and other members of the Fauve group had been familiar with Cézanne's work, they admired it chiefly for the color and expressive linear distortions. Cézanne's death in 1906, the retrospective exhibition of his work (held the following year at the Salon d'Automne), and especially the publication by Émile Bernard that year of Cézanne's famous letter—in which he wrote of treating nature in terms of the cylinder, sphere, and cone—enabled the younger painters for the first time to recognize Cézanne's principal intention: to establish substantial forms within a space in which the actual properties of the two-dimensional picture surface and the illusionary effects of three dimensions were consciously and subtly adjusted. Beginning with Cézanne, this adjustment of new sensations of color and form to the physical medium became the common task.

This aspect of Cézanne's practice and theory became the chief concern of a group of younger French painters soon to be known as the Cubists. They drew encouragement from the remarkable personality and achievements of the Spanish painter PABLO PICASSO (1881–1973), whose adult life was spent in France and whose works are inseparably connected with the history of modern French art. From his earliest studies in the Barcelona Academy of Art, Picasso had shown precocious ability. At an age when others have learned only the rudiments of their art, Picasso mastered all aspects of late nineteenth-century Realist techniques. For one so greatly gifted, not only in terms of manual dexterity but also in powers of pictorial visualization, there could be no question of quietly following conventional methods of painting, and it is not surprising that Picasso should have investigated more than one aspect of picture-making; even so, the public was ill prepared for the astonishing variety of his "styles" and "periods." Picasso is characteristic of the modern age in his constant experimentation, in his sudden shifts from one kind of painting to another, and in his startling innovations in painting and even sculpture. He is said to have been amused at the attempts of critics and historians to "explain" him and to follow the bewildering turns of his development. But it is a fact that his work over a long period manifested most of the significant modern trends that have prevailed from the beginning of the period through World War II.

When Picasso settled permanently in Paris in 1904, his work had evolved from the sober Realism of Spanish painting, through a brightening of color in an Impressionistic manner (for a while he was influenced by the early Toulouse-Lautrec), and into the so-called Blue Period (1901–05), in which he painted worn, pathetic, alienated figures in the pessimistic mood of the *fin-de-siècle*—a "blue" mood conveyed appropriately in a predominantly blue tonality. Around 1905–06 Picasso became aware almost simultaneously of the importance of the art of Cézanne, of the primitive art of Africa and Oceania, and especially of the sculpture of ancient Iberia. He detected in them a way of organizing formal elements that was

17-5 PABLO PICASSO, *Portrait of Gertrude Stein*, 1906. Oil on canvas, $39\frac{3}{8}'' \times 32''$. Metropolitan Museum of Art, New York (bequest of Gertrude Stein, 1946).

Barcelona's red-light district. Comparing it with Matisse's *Le Luxe* (FIG. 17-1), we find Matisse still of the tradition, his figures conceived as continuous volume in motion. But in *Les Demoiselles* the fracturing of the volumes is well advanced, and the jagged planes that result are slipping well beyond the bodies' contours. The images are disintegrating into their planes. The process had begun in the landscape and figures of Cézanne, and Picasso has taken it here to the threshold of a radically new kind of painting. Not only does he challenge the traditional concept of an orderly, constructed, unified pictorial space that mirrors the world, but he dismisses the idea of the human figure as a dynamic unity and, especially in the two figures at the right, twists and breaks it into grotesque dislocation. Three of the heads are adaptations of African masks. Indeed, it was in the abrupt dislocations of African and Iberian sculpture, as well as in the art of Cézanne, that Picasso found a hint of how to dissect natural forms into their essential planes and volumes, a task that occupied him for the next few years.

By 1910 Picasso, with his experimenting colleague Georges Braque (see below), had laid the basis for this new kind of painting, which was soon nicknamed "Cubism" by a critic who was amused by the approximately geometrical forms in many of their works. The name was soon accepted by the painters and their critics, but it suggests very little of the seriousness and originality of the Cubists' achievements. Very simply this consists in their discovery of a new kind of pictorial space, which replaces that developed since the time of Giotto. Like Cézanne's, this space is based on the principle of basic, simplified forms and a shifting point of view, but with the latter feature expanded to the point where the Cubists presented an object as if seen from several markedly different angles.

From the time of Masaccio, painting had been assumed to give, in one- or two-point perspective, a fixed and complete "view," in which everything in one plane appeared simultaneously with everything else. But this is neither true to visual fact (the fact of seeing the objects rendered) nor even

different from anything in Western tradition, a way that would give them esthetic independence from pictorial realism and a new and vivid value of their own. In the *Portrait of Gertrude Stein* (FIG. 17-5) Picasso approximates Cézanne's method, carefully analyzing forms into simple planes, making contours strong and precise, and, particularly in the face, assuming different viewpoints, which makes for an ambiguous perspective. The two sides of the masklike face do not fit, the near side reading almost as a profile (a favorite trick of Picasso's). This breaking-up of smoothly continuous volumes into separate if interlocking planes leads sharply away from Realism to a concept of design independent of nature. African figures like the one shown in FIG. 22-29 must have given Picasso many a lead as to the direction his abstraction from nature could take. A painting that shows the painter well on the path of the reduction of visual fact to abstract form is the startling *Les Demoiselles d'Avignon* (FIG. 17-6), "Avignon" here being the name of

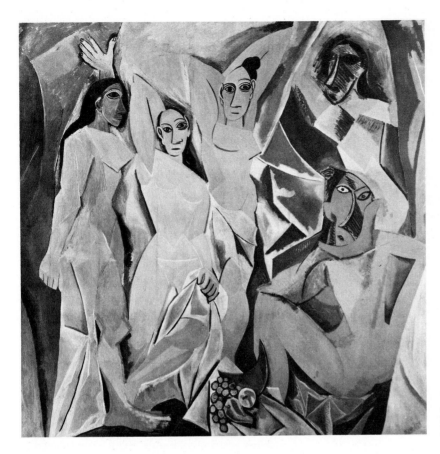

17-6 PABLO PICASSO, *Les Demoiselles d'Avignon*, 1907. Oil on canvas, 8' × 7' 8". Collection, Museum of Modern Art, New York (bequest of Lillie P. Bliss).

to the way we see the picture of these objects, our view of the picture being the result of a great number of eye movements that we make as we take it in. In essence, this is the basis of Cézanne's innovation with respect to a shifting viewpoint. The Cubists, however, went beyond this purely optical reason for using multiple viewpoints. They wished to present the total essential reality of forms in space, and since objects appear not only as they are seen from one viewpoint at one time, it became necessary to introduce multiple angles of vision and simultaneous presentation of discontinuous planes. This of course shatters the old continuity of composition imposed by the Renaissance single viewpoint. The Cubist painter believed that "in order to discover one true relationship it is necessary to sacrifice a thousand surface appearances."[3]

[3] Albert Gleizes and Jean Metzinger, "Cubism," in R. L. Herbert, *Modern Artists on Art* (Englewood Cliffs, N.J.: Prentice-Hall, 1964), p. 3.

Since the concept of reality thus became separated from that of appearance, the resemblance of essential form to ordinary vision was no longer important. The assumption, beginning in the Renaissance, that what we see in nature should find correspondence in the forms that the artist paints, was given up, and the epoch that began with Giotto and Masaccio came to an end in the twentieth century.

Cubism's break with the world of ordinary vision was not simply a matter of esthetic fashion, random experiment, or quixotic exhibitionism, though it has been denounced as all these things and worse: "Cubists," claimed the New York *Times* on the occasion of the 1913 Armory show in that city, "are making insanity pay." However, as we have noted throughout the book, affinities of thought and imagination give a certain coherence to historical periods; seen within the context of the new, Einsteinian vision of the physical world, the new art seems less strange. It has

But in the space-time of Einstein's relativity it is impossible to prove that two physical events at an astronomical distance are actually simultaneous, because time elapses in the very process of their measurement.

Perspective space in Western painting since Masaccio assumes a continuous, unbroken space fixed from a single point of view. We can say of this rigid, geometric space that all the represented objects in it are *simultaneous*; the single *scene* constitutes a single *event*. Cubism, with its new kind of simultaneity, the simultaneity of different viewpoints, destroyed consistency of image and appearance and yielded in its place "abstract" form. The process is well begun in *Les Demoiselles d'Avignon*.

Thus, the recognition and involvement of time in the very pictorial process destroyed the structure of appearance constructed through centuries. It replaced appearances with the unlimited possibilities of form. Being no longer restricted to a single viewpoint, the artist might see any given object in the world not as a fixed appearance or shape, but as a universe of possible lines, planes, and colors. The world of appearance becomes analyzable into a world of patterns open to endless exploration and adjustment. The shattering of the rigid Renaissance structure of appearance comes to be regarded as a means by which art has been returned to its fundamental functions.

Analysis of these functions is a process that gives its name to the earlier phase of Cubism—the "analytic" phase, a striking example of the style of which is Picasso's *Accordionist* (FIG. 17-7), a construction of large intersecting planes that suggest the forms of the man and his instrument. Hosts of smaller shapes—each probably a simplification of some aspect of the original subject—hover in and interpenetrate the large planes. The total effect is that of a new kind of pictorial reality. We are no longer obliged to contemplate merely a man playing an accordion; we can let our eyes set out on another kind of adventure as they probe the manifold aspects of an object that has been disintegrated, so to speak, and then reintegrated to offer us a great variety of views from different angles.

Picasso's experiments worked a still more radical change in what could be called pictorial "reality." From 1908 on, he had occasionally at-

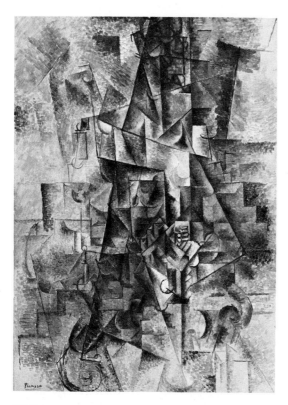

17-7 PABLO PICASSO, *Accordionist*, 1911. Oil on canvas, approx. 51¼″ × 35¼″. Solomon R. Guggenheim Museum, New York.

been said that Cubist pictorial space suggests the addition of the dimension of time to spatial dimensions, since objects are given not as seen at any one moment, but in temporal sequence; that is, to perceive the many views of the object as given would have required movement by the viewer (or at least his eyes) through some temporally sequential positions. In Einstein's description of the physical world there is a similar merger of space and time. Time is "assimilated" to the three dimensions of space in such a way that measurements of space and of time, especially where astronomical distances are involved, are functions of each other, and never independent. This is decisively different from the Baroque, Newtonian concept of space and time, where both are absolute and independent and where, no matter the distance between two events, it is possible for them to be simultaneous; by extension, simultaneous events presuppose a continuous space that is invariant with respect to them.

tached extraneous materials to the canvas in a technique called *collage*. In his *Still-life with Chair-caning* (FIG. 17-8) he combines an oilcloth replica of a caned chair seat with elements recovered from disintegrations of pictorial form such as we see in *Accordionist*. This produces a startling confrontation—or juxtaposition—of a commonplace, manufactured surface, familiar in everyday experience, with the painted abstract shapes. The composition not only introduces violent contrasts of texture but presupposes the painting surface to be in itself an object given to touch as well as sight, a plane surface upon which materials other than paint can be placed. This texturing of the surface is new and asserts the painting to be not a "picture" as it were, but a flat area that can receive almost any kind of application of apparently unrelated substances. Pictorial art here takes a step toward becoming relief sculpture, the effect intensified by the rope frame. Collage had great importance for later Russian Constructivism and Dada (p. 736), as well as for various movements today, in which there is a studied ambiguity in the relation of sculpture and painting. Picasso's and Braque's experiments with this new medium marked the end of the first or "analytic" phase of Cubism.

The premises of analytic Cubism were so rational, and the artists' application of their theories so intellectual and logical, that the styles of different painters in the "school" began to become almost indistinguishable. The similarity of the products of analytic Cubism became even more apparent when the artists, in their excessive concern with matters of pure form, began to neglect color, so that their paintings became almost monochrome. When the artists recognized this defect—and the fact that they had placed upon themselves a stylistic strait jacket—analytic Cubism yielded to "synthetic" Cubism, which used stronger color and allowed greater freedom of expression. Again Picasso led the way by developing a style in which a more limited number of views of an object were selected for their decorative rather than their exclusively spatial significance. The mingling of forms became more spontaneous, their colors stronger, their textures more varied. An early and superbly decorative example of this aspect of Picasso's work is the *Three Musicians* (PLATE 17-8). Here the space is

much flatter, scarcely deeper than a series of planes laid like playing cards one upon another, as if different parts, the consequence of multiple views, had been reassembled before a single viewpoint. There is a strong tendency to reduce each form to a simple rectangular shape, but for all that, the figures of the clown, the harlequin, and the monk, their instruments and music, and the table at which they are sitting can be detected without effort. The broken shapes, filled with flat, bright color against dark tonal variations, move with a syncopated rhythm and vivid dissonance analogous to those of modern music.

Although the invention of Cubism must be considered one of Picasso's greatest achievements, he was never content to work for long in any one mode. While still painting synthetic Cubist pictures he also made Ingres-like drawings and painted figure subjects in a broadly realistic manner often influenced by antique sculpture. In the late 1920's he created, with heavy swirling lines and rich color, visual distortions that seemed related to contemporary Expressionism. The climax of this personal style came in 1937 in his large mural *Guernica* (FIG. 17-9), painted for the Spanish pavilion of the Paris International Exposition of that year to protest the bombing of the open town, Guernica, during the Spanish Civil

17-8 PABLO PICASSO, *Still-life with Chair-caning*, 1911–12. Oil and pasted paper simulating chair-caning on canvas, $10\frac{5}{8}'' \times 13\frac{3}{4}''$. Collection of the artist.

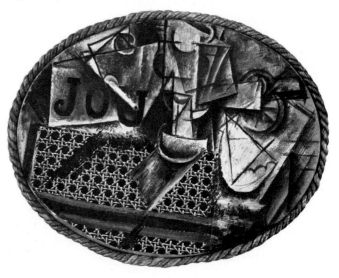

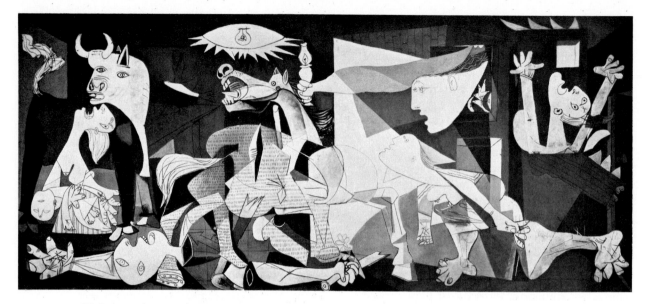

17-9 Pablo Picasso, *Guernica*, mural, 1937. Oil on canvas, approx. 11′ 6″ × 25′ 8″. Museum of Modern Art, New York (on extended loan from the artist).

War. In this allegorical presentation of the plight of his native country, where brute force seemed momentarily triumphant, Picasso used all the resources of his Cubist experience. The severe colors—the blacks, whites, and grays—emphasize the marvelously complex design of interpenetrating planes; the unexpected and violent linear distortions communicate the horror of the event. In the figures of the dead warrior, the dying horse, and the bellowing bull Picasso created impressive and public symbols for the plight of his native country; in his own words, he expressed here an age of "brutality and darkness." The contention that modern forms of expression in art were unequal to the task of interpreting the humanistic values of modern society was contradicted by this painting, for in it Picasso set forth in masterly terms an indictment of the evils of modern totalitarianism and his conviction that art is the most effective means of affirming the preeminent worth of individual human beings.

In contrast to Picasso's violence—of form as well as of expression—Georges Braque (1882–1963) worked in a more lyrical and even, one might say, more French manner. The rhythmic effect of *The Table* (plate 17-9) reveals his admiration for the great masters of French decorative painting; such a work, although entirely contem-

porary, would not be out of place in an eighteenth-century drawing room. Much of the effect of Braque's work depends upon his mastery of two-dimensional design, for he maintained that a painting is a flat surface and should remain a flat surface, animated by line, color, and texture. He worked within a narrow range of restrained but subtly related colors, often using grays and whites to advantage, with frequent unexpected passages of modulated textures. "The aim of painting," said Braque, ". . . is not to reconstruct an anecdotic fact, but to constitute a pictorial fact We must not imitate what we want to create. The aspect of things is not to be imitated, for the aspect of things is the result of them."[4]

Fernand Léger (1881–1955) was a friend to and, in his approach to painting, derives from the original Cubists. His works have the sharp precision of the machine, whose beauty and quality Léger was one of the first to discover. He has been preeminently the painter of modern urban life, incorporating into his work the massive effects of modern posters and bill-board advertisements, the harsh flashing of electric lights, the noise of traffic, the robotlike movements of mechanized

[4] In Maurice Raynal, *Modern French Painting*, trans. by Ralph Roeder (New York: Brentano's, 1928), pp. 51–52.

people. An early work in which these effects appear—modulated, however, by the esthetic of synthetic Cubism—is *The City* (FIG. 17-10). Its monumental scale proves that Léger, had he been given the opportunity, would have been one of the great mural painters of our age. In a definitive way he here presents the mechanical commotion of the contemporary city. A modern composer, George Antheil, composed a score for a Léger film, *Ballet Mécanique*; it is significant that the work included the sound of an airplane engine.

Outside of France, Cubism received its most significant reception in the Italian school of Futurism, inaugurated in 1909 by the manifesto of the poet Filippo Marinetti. Enraptured by the machine age, Marinetti proclaimed a new art of "violence, energy, and boldness," which went along with an extreme dislike of all traditional art and an uncompromising demand for modernism. In the words of the Futurist Umberto Boccioni:

We propose . . . to sweep from the field of art all motifs and subjects that have already been exploited . . . to destroy the cult of the past . . . to despise utterly every form of imitation . . . to extol every form of originality . . . to render and glorify the life of today, unceasingly and violently transformed by victorious science.[5]

In principle the Futurist painters attempted to present aspects of modern mechanized society seen in moments of violently energetic movement; in practice they adopted the Cubist analysis of space, but by repetition of forms across the plane of the canvas they attempted to impart movement to the static Cubist compositions. Movement and time obsessed the Futurists. Boccioni's manifesto of 1910 rings with a new recognition of universal process:

Everything moves, everything runs, everything turns swiftly. The figure in front of us never is still, but ceaselessly appears and disappears. Owing to the persistence of images on the retina, objects in motion are multiplied and distorted, following one another like waves through space. Thus a galloping horse has not four legs; it has twenty, and their movements are triangular.[6]

[5] In Goldwater and Treves, *op. cit.*, p. 435.
[6] *Ibid.*

17-10 FERNAND LÉGER, *The City*, 1919. Oil on canvas, approx. 7′ 7″ × 9′ 9½″. Philadelphia Museum of Art (A. E. Gallatin Collection).

A method accommodating observations like these was devised from the example of photography by the French painter MARCEL DUCHAMP (1887–1968) in his *Nude Descending a Staircase #2* (FIG. 17-11). The effect is that of a closely spaced series of "still" photographs of an action, though Duchamp had analyzed the figure first into planes in the manner of Cubism. About this time, of course, the motion picture was being developed; this would give the illusion of movement not through the analysis of forms within a single framed space, but through the rapid (relative to the eye's ability to retain an image briefly) projection of a sequence of still photographs (or "frames") of an action. Futurism reaches the limits of the traditional static picture's ability to yield a visual impression of motion. The best

Futuristic work was done in sculpture, notably that of Boccioni (see below).

It seems inevitable, once Cubism had broken the Renaissance structure of fixed appearance into a limitless world of forms, that the questions should repeatedly arise: How may these forms be recognized, invented, appropriated, arranged? Assuming the need for completely new principles of pictorial design (or restoration of the old, fundamental ones), how is this to be achieved? The many answers to these questions have produced the many schools and "isms" of modern art. Cubism had hardly made its crucial point when criticisms of it were voiced by artists who wanted to go beyond it to an even more abstract "purer" formalism. The special effect of Cubist painting is found in the balance maintained between the appearance of the original object or figure, as the spectator may remember it, and the degree of abstraction with which it has been transformed into a work of art. That Cubist technique would almost inevitably lead to a greater and finally absolute degree of abstraction is implicit in Juan Gris's remark:

> Cézanne turns a bottle into a cylinder, but I begin with a cylinder and create an individual of a special type: I make a bottle—a particular bottle—out of a cylinder. Cézanne tends towards architecture, I tend away from it. That is why I compose with abstractions (colors) and make my adjustments when these colors have assumed the form of objects.[7]

But what would happen if one started with the geometrical shape and did not develop the resemblance, no matter how remote, to any actual object? Such was the proposal of the Dutch painter PIET MONDRIAN (1872–1944), who felt, as he later wrote, that "Cubism did not accept the logical consequences of its own discoveries; it was not developing abstraction toward its ultimate goal, the expression of pure reality."

Mondrian himself had begun painting as an Expressionist, influenced by his most famous countryman, Vincent van Gogh. But after study-

[7] In D. H. Kahnweiler, *Juan Gris, His Life and Work*, trans. by Douglas Cooper (New York: Valentin, 1947), p. 138.

17-11 MARCEL DUCHAMP, *Nude Descending a Staircase #2*, 1912. Oil on canvas, approx. 58″ × 35″. Philadelphia Museum of Art (Louise and Walter Arensberg Collection).

ing in Paris just before World War I he turned toward a stricter conception of pictorial design. When hostilities began, he was obliged to return to Holland, where he remained during the war, meditating upon the theories of Cubist painting and continuing his own researches into the absolute properties of artistic order. His investigations led him to renounce all representational elements and to concentrate upon a severely limited vocabulary of colors and shapes: black and white and the primaries—red, yellow, and blue—and straight lines, squares, and rectangles. With these elements he constructed two-dimensional designs arranged in such subtle asymmetrical balances of line, color, and area that even slight changes destroy the composition. His rectilinear purism is closely related to the architecture of the De Stijl movement, as one may see from an examination of Gerrit Rietveldt's Schroeder House in Utrecht (FIG. 17-51). In his *Composition in Blue, Yellow, and Black* (PLATE 17-10), Mondrian has adjusted the design so carefully that no single portion of the surface is more important than any other; the tension between the rectangles is maintained to the very edges. The power of the colors to hold the viewer's attention is subtly equivalent to the attraction exercised by the much larger blank areas, and the proportions of each of these areas are cunningly varied to avoid a mechanical uniformity of the general equilibrium. Mondrian held the firm belief that

> true reality is attained through dynamic movement in equilibrium. Plastic art affirms that equilibrium can only be established through the balance of unequal but equivalent oppositions. The clarification of equilibrium through plastic art is of great importance for humanity It is the task of art to express a clear vision of reality.[8]

To compare Mondrian with the Kandinsky of the *Improvisations* is to become aware of the range of experimentation within which the search for a new basis for the arts of design took place (though it must be acknowledged that Kandinsky's Com-

17-12 KASIMIR MALEVICH, *Suprematist Composition: White on White,* c. 1918. Oil on canvas, approx. $31\frac{1}{4}''$ × $31\frac{1}{4}''$. Collection, Museum of Modern Art, New York.

positions have much of the "hard-edge" quality of Mondrian).

In Russia the influence of Cubist painting led to a somewhat similar concern with basic elements of design. Before 1914 Cubist and even Futurist paintings had been exhibited in Moscow and St. Petersburg, and Russian artists of the younger generation were anxious to contribute to the modern movement. KASIMIR MALEVICH (1878–1935), after working in the Cubist and Futurist manners, created what he called Suprematist paintings in which his intention was the expression of nonobjectivity, a form of expression removed as far as possible from the world of natural forms. In this way he arrived at "the supremacy of pure feeling or perception," for "the essential thing [in pictorial art] is feeling—in itself and completely independent of the context in which it has been evoked." The most nonobjective of Malevich's works is his famous *Suprematist Composition: White on White* (FIG. 17-12). Here color, shape, and line are reduced to the elements of an off-white square superimposed upon a larger off-white square, the two shapes differentiated only by their size, angle of inclination, and slight modulations in texture and "color"; that is, one is cool in tone, one warm.

[8] Piet Mondrian, *Plastic Art and Pure Plastic Art* (New York: Wittenborn, 1951), p. 10.

The other important movement descending, with Cubism, from Cézanne's "geometric" view of nature was Constructivism. Its principles, manifested in painting by a lithe austerity of line and a formal geometricity, were stated by the Russian artist Antoine Pevsner and his brother, Naum Gabo (see p. 752). Pevsner's belief that art must express contemporary culture led to the use of "modern" materials—sheet-metal, plastics, wire—which were particularly suited to the expression of the dynamic character of the emerging industrial culture of the time. Constructivists strove for an effect of interpenetration and simultaneity, which was more readily achieved in "constructions" and sculpture (see below). Emotion—apart from a purely esthetic one—was largely secondary in their work.

Dada to Surrealism

The purist artists, Constructivist and Suprematist, tried to create a new art of clarity and order; elsewhere other attitudes toward the times led to a basically destructive artistic expression. In several places and at nearly the same time—in Zurich, Barcelona, and New York in 1916 and 1917—a number of artists independently stated their disgust with the war and life in general by making works of nonart. This movement was early christened Dada, a nonsense or baby-talk term, thus indicating the conviction that European culture had lost any real meaning. Those who professed to respect the art of the past had been unable to prevent the outbreak of the holocaust and were now eagerly destroying one another. The artists, refugees from the war, set out in their bitterness to mock all the values of what they believed to be a culture gone mad. "Dada," said one of its historians, "was born from what it hated." Since the artists' intentions were fundamentally nihilistic, Dada works are difficult to interpret and are best approached with their creators' avowed spirit of nonart or even antiart in mind: "Dada is against everything, even Dada" —that is, against all that had become organized, formalized. In this sense the works may be considered as destructive criticism of artistic expression of the present and recent past. Such a critical attitude appears in Duchamp's famous photograph of the *Mona Lisa*, upon which he drew a mustache as if defacing a billboard. The public was shocked—as Duchamp intended it to be— and interpreted the defacement as an outrage upon the *Mona Lisa* itself; however, we can now see that Duchamp's intention was rather an indirect and witty attack upon those he felt had betrayed the humanistic ideals of the Renaissance, of which the *Mona Lisa* remains one of the noblest expressions. Modern artists did not escape: A Dadaist, Picabia, exhibited (in 1920) a toy monkey nailed to a door and called it *Portrait of Cézanne*. After 1918 Dadaism spread quickly through Europe, especially France and Germany, where it appealed to the respective national moods of disillusion in the Pyrrhic victory and despair in defeat.

Since the Dadaists claimed that they were not creating art, it is perhaps unfair to examine their works in a critical spirit. Nevertheless, certain positive contributions emerged from their intentionally negative attitude; among these are the collage compositions by the German artist KURT SCHWITTERS (1887–1948), which he called by the meaningless name of *Merz Pictures*. Although the *Merz Pictures* were put together from the

17-13 KURT SCHWITTERS, *Merz Picture 19*, 1920. Collage, approx. $7\frac{1}{4}'' \times 5\frac{1}{8}''$. Yale University Art Gallery, New Haven, Connecticut (Collection, Société Anonyme).

contents of the gutter and the trash basket (*merz*, a syllable of the German word for "commercial," caught Schwitters' fancy while he was cutting the word into pieces), they always show Schwitters' sensitivity for texture and design (FIG. 17-13). The typical Dada disdain for conventional techniques accounts for the materials used, but truly artistic feeling for color and form endows these works with appeal beyond their historical significance.

In Duchamp, whom we have already seen as a Futurist, the Dada movement found its most provocative and witty champion, as well as its most eloquent philosopher. Dada, according to Duchamp, was "a metaphysical attitude . . . a sort of nihilism . . . a way to get out of a state of mind—to avoid being influenced by one's immediate environment, or by the past: to get away from *clichés*—to get free." This escape from conventional forms and modes of expression can be seen in Duchamp's glass constructions. Unlike the painting and sculpture of the Russian Constructivists, who had a proud sense of public responsibility, Duchamp's painted glass is his own private jest about the world and art. And if its meaning is inseparable from its nonmeaning, as in the title of *To be looked at (from the other side of the glass) with one eye, close to, for almost an hour* (FIG. 17-14), at least we can admire the perfection with which he has designed and painted the geometrical shapes in such irrational perspective upon the sheet of plate glass. Not the least perplexing aspect of Duchamp's work is his scrupulous regard for craftsmanship combined with apparently quite irrelevant subject matter. When at a later date this and other glass objects by Duchamp were accidently cracked, Duchamp insisted that the unexpected pattern of fractures completed his original design.

Although much Dada work was intentionally ephemeral, and the movement came to a sudden end in 1922, it had important consequences for later art, reinforcing a trend away from the reasoned, formal aim and cool disciplinary requirements of Cubism and abstract art toward a spontaneous intuitive expression of the whimsical, fantastic, humorous, sardonic, and absurd. Those aspects of experience, expressed in earlier art, had been neglected by Cubism and Constructivism. Now a whole new realm of artistic possibility opens, in which the remnants of the

17-14 MARCEL DUCHAMP, *To be looked at (from the other side of the glass), with one eye, close to, for almost an hour*, 1918. Framed double glass panel, with oil paint, collage of paper, lens, etc. $20\frac{1}{8}'' \times 16\frac{1}{8}'' \times 1\frac{3}{8}''$. Collection, Museum of Modern Art, New York (bequest of Katherine S. Dreier).

optical world shattered by compositional analysis can return in whole and in part to play new expressive roles. Without the demand that they function in exactly the old context, perspective and chiaroscuro reappear, their purpose entirely at the command of the artist. The artist's free imagination now draws upon materials lying deep in his consciousness, and his act of expression is the proclamation of new realities not less real because they are psychic. In the psychoanalytic view of Freud and others, developing contemporaneously, art is a powerfully practical means of self-revelation and catharsis, and the images that rise out of the subconscious have a truth of their own independent of the world of conventional vision. Dreaming fancy demands its own stage and its own means of production in the new fantastic painting that arises almost at the same

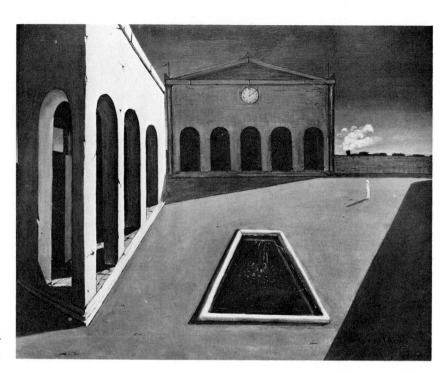

17-15 Giorgio de Chirico, *The Delights of a Poet*, c. 1913. Oil on canvas, approx. 27⅜" × 34". Collection of Helen and Leonard Yaseen, New York.

time as Cubism but that diverges from it. The historical past as well as the dynamic present can provide inspiration. In the early work of the Greco-Italian painter Giorgio de Chirico (b. 1888), the squares and palaces of Roman and Renaissance Italy are visualized in a mood of intense and mysterious melancholy. In his *Delights of a Poet* (FIG. 17-15), De Chirico gives us a strange, tilted perspective of a street with arcades, a fountain, a wraith, a distant train, a clock, a blank sky. The hard light fills the emptiness with sharp shadows; there is a foreboding sense of departure and of a time long past yet always present, as in T. S. Eliot's picture:

In death's dream kingdom
.
There, the eyes are
Sunlight on a broken column
There, is a tree swinging
And voices are
In the wind's singing
More distant and more solemn
Than a fading star.

The *Delights* is not only visually disturbing, with its sharp inclinations of space and shadow, but philosophically so puzzling that De Chirico's works between 1911 and 1919 are considered to belong to the short-lived school of the *pittura metafisica* in modern Italian art. De Chirico himself has supplied some evidence for a philosophical interpretation by remarking that he was inspired to paint such architectural scenes by Nietzsche's poetic interpretation of autumn afternoons in northern Italian cities. Although such "metaphysical painting" does not, strictly speaking, introduce supernatural elements, it does communicate a feeling of reality very different from our ordinary experience. And for that reason De Chirico has been considered a source of inspiration for those artists who created the Surrealist movement in the early 1920's.

The Surrealists' intention was to discover and explore the "more real than real world behind the real"—in other words, the world of psychic experience as it had been revealed by psychoanalytical research, especially that of Freud. In 1924 the French poet André Breton formulated this intention in his *Surrealist Manifesto*. The aim was to resolve "conscious" and "subconscious" reality into a new and absolute reality—a superreality (*surréalité*)—and so "to reestablish man as psychology instead of anatomy." Thus, the dominant motivation of Surrealist painting and construction is to bring together into a single

composition aspects of outer and inner "reality" in much the same way that seemingly unrelated fragments of life combine in the vivid world of dreams. The projection in visible form of this new conception required new techniques and new ways of pictorial construction. At first the Surrealists adopted some of the Dadaist devices, but with new purposes. Thus, they used automatic writing and various types of planned "accidents" not so much to reveal a world without meaning as to provoke in the spectator reactions closely related to his subconscious experience. And since Surrealism appeared so soon after the formulations of the principles of abstract and nonobjective art,[9] the techniques of the latter and even some of its adherents were enlisted in the cause.

Originally a Dada activist in Cologne, MAX ERNST (b. 1891), became one of the early adherents of the Surrealist circle around André Breton, the formulator of the manifesto of Surrealism. The chance association of things and events, the dislocation of images and meanings, the scrambling of conventional contexts, the exploration of the subconscious, the radical freedom of artistic choice, which together make up the creative bases of Surrealism, are manifest in an early Ernst work, *Two Children are Threatened by a Nightingale* (FIG. 17-16). The heavy frame and the house and gate in actual relief give a concreteness to the dreamlike vision while forcing a shock of contrast between representation and the actual. The artist himself writes revealingly of the Surrealist management of subject-matter: "He never imposes a title on a painting. He waits until a title imposes itself. Here however the title existed *before* the picture was painted." The artist had earlier written a poem, a line of which provided the title. Its subject found, the picture simply happened. Ernst's later work shows his experimentation with the texture of the picture surface, in which he left surface effects much to the laws of chance. His procedures were widely adopted and influential.

9 An *abstract* work has been "abstracted" from natural appearance, and vestiges of figures or objects may still be detected in it, as in Cubist paintings. A *nonobjective* work has no reference, in conception or execution, to natural appearances, as in the later paintings of Kandinsky and Mondrian.

Loosely related or allied to Surrealism, the abstract paintings of JOAN MIRÓ (b. 1893) incorporate aspects of organic imagery that lend them a weird and disturbing humor. Intensive work in collage in various mediums led Miró to a greater simplification of shapes, with stress on curved lines and amoebalike organisms that seem to float in an immaterial space. In *Painting* (FIG. 17-17), black shapes—solid or in outline and with dramatic accents of white and vermilion—appear against a dark background of closely related reds, blues, and greens. These elements give the canvas, which is quite large, a handsome decorative quality. Several figures are recognizable, such as a dog and an ox. But as Miró often attempts to work automatically, and as his brush moves over the surface with as little direction as possible from his conscious mind—as in automatic writing—he cannot himself always explain the meaning of his pictures. They are in the truest sense spontaneous and intuitive expressions of the little-understood, submerged, unconscious life.

17-16 MAX ERNST, *Two Children Are Threatened by a Nightingale*, 1924. Oil on wood with wood construction, $27\frac{1}{2}'' \times 22\frac{1}{2}'' \times 4\frac{1}{2}''$. Collection, Museum of Modern Art, New York (purchase).

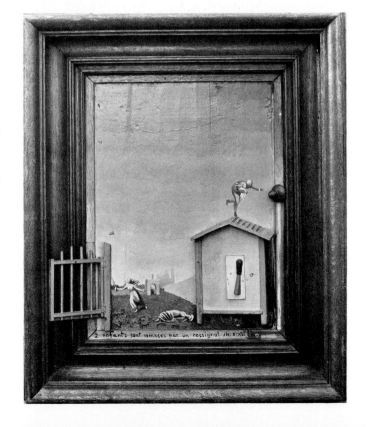

A new interest in subject matter was perhaps the most important contribution of the Surrealists to modern painting. Miró has said:

I am attaching more and more importance to the subject matter of my work. To me it seems vital that a rich and robust theme should be present to give the spectator an immediate blow between the eyes before a second thought can intervene. In this way poetry pictorially expressed speaks its own language.[10]

It is important to note that the title, announcing the subject matter, often plays an important role in modern art. Most often it is ambiguous, seeming to have little relation to what the spectator sees before him; there may be a seeming conflict between it and the picture's meaning, which the spectator must struggle to resolve. Indeed this sense of contradiction of title and picture is like an "immediate blow between the eyes," and the spectator is knocked off balance, his expectations defeated, his preconceptions challenged. Much

of the impact of a work of modern art begins with the spectator's sudden intuition of the incongruous and the absurd.

Nowhere is the tension of divergent title and image so evident as in surrealistic works using dream imagery. Dream imagery is, of all forms of nonconscious experience, the most common and the most vivid, but its presentation requires more than a mastery of abstract design. In order to project the world of dreams as convincingly as possible the Catalan painter SALVADOR DALI (b. 1904) restudied the masters of seventeenth-century realism, especially the Dutch masters of genre. Since, in dreams, objects and situations collide and interpenetrate in ceaseless metamorphoses, Dali uses multiple images of multiple symbolic meaning to suggest evocations from his subconscious. He has also developed a fundamental Surrealist method, the juxtaposition of seemingly irrelevant and certainly unrelated objects in unexpected situations. This method was suggested to the Surrealists by a metaphor originated by one of their spiritual predecessors, the somewhat obscure nineteenth-century French poet Isadore Ducasse (known as the Comte de

[10] In James T. Soby, *Joan Miró* (New York: Museum of Modern Art, 1959), p. 13.

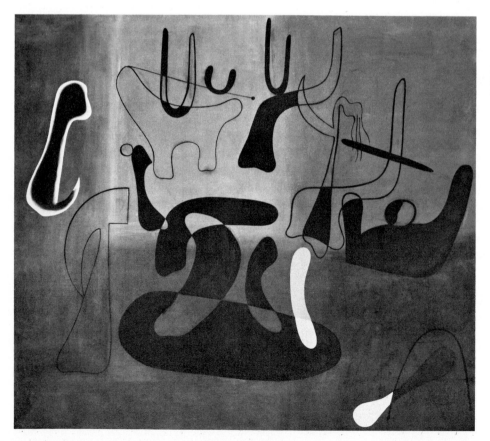

17-17 JOAN MIRÓ, *Painting*, 1933. Oil on canvas, approx. $68\frac{1}{2}'' \times 77\frac{1}{4}''$. Collection, Museum of Modern Art, New York (gift of the Advisory Committee).

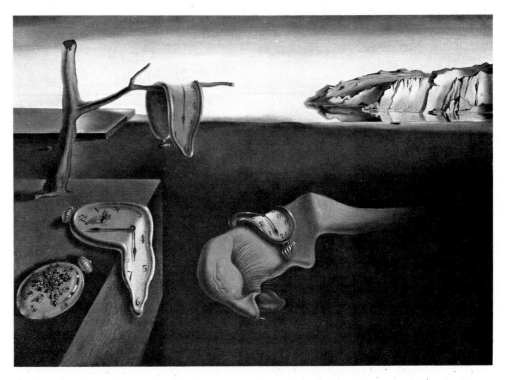

17-18 SALVADOR DALI, *The Persistence of Memory*, 1931. Oil on canvas, 9½″ × 13″. Collection, Museum of Modern Art, New York (given anonymously).

Lautréamont), who, in one of his works, spoke of a situation as "beautiful as the encounter of an umbrella and a sewing-machine on a dissecting table." The surprise effect of Dali's work depends upon his presentation of such incongruities in a meticulous, miniaturelike technique.

These several aspects of his style can be seen in perhaps the most familiar of his works, the *Persistence of Memory* (FIG. 17-18). Here he creates his most haunting allegory of empty space in which time is at an end. The barren landscape, without horizon, drifts to infinity, lit by some eerie never setting sun. An amorphous creature sleeps in the foreground, draped with a limp watch. Another such watch hangs from the branch of a dead tree, and yet another hangs half over the edge of a rectangular form. The watches are visited by ants and a fly, as if they were decaying organic life, soft and viscous. Here is the impact of contradiction at its sharpest: The watch a metallic, intricate, and precise instrument, is metamorphosed into an object devourable by busy ants. The impossible landscape and its impossible contents we recognize as perfectly possible in the dream world.

In painting dream images, the artist is handicapped by the fact that each dream is the experience of a single individual and depends for its meaning on the events in the private life of that one person; the clearer and more detailed its description, the less likely that it will be comprehensible to others. Thus, Surrealist art almost inevitably presented feelings so private that communication with an audience of any appreciable size became difficult if not impossible except when the artist, through his choice of familiar symbols, described experiences common to groups of people. Such a broadened use of symbol and fantasy occurs in the work of MARC CHAGALL, who was born in 1887 in Russia and studied and worked in Paris, Berlin, and New York. Although he accepted many aspects of the most sophisticated theories and practices of the times—Expressionism, Cubism, Fauvist color—Chagall never forgot his early life in an obscure Russian village. Themes from his childhood return as if in dreams and memories; some, gay and fanciful, suggest the simpler pleasures of folk life; others, somber and even tragic, recall the trials and persecutions of the Jewish people. In his *Cruci-*

fixion (FIG. 17-19) the terror of wars and pogroms is suggested by the pitiful little figures and the village in the background, while resignation and hope are expressed in the flying angel, the Torah scroll, and the rabbi-Christ figure on the cross. The work is a moving portrayal of the artist's feeling that faith is important in a world of war and brutality. Although the very free, floating composition with unexpected juxtapositions of the actual and the unearthly is Surrealistic in the sense that it perpetuates the fantastic content of a dream, the individual symbols refer to much more than Chagall's personal psychic life. A comparison of Chagall's interpretation of war with Picasso's in the *Guernica* illuminates the broad scale of expressive emotion upon which art can play.

The most subtle and one of the most influential of all the masters of fantasy was the German-Swiss artist PAUL KLEE (1879–1940). In his contempt for illusionistic art, which, as a member of the Blue Rider school (see above), he believed to be superseded, he turned to the art of children and primitives for a new kind of brevity, simplicity, and

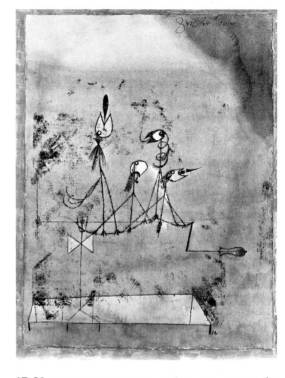

17-20 PAUL KLEE, *Twittering Machine*, 1922. Watercolor and pen-and-ink, approx. $16\frac{1}{4}'' \times 12''$. Collection, Museum of Modern Art, New York (purchase).

primeval significance unknown to civilized conventions and rational modes of thought. With this inspiration he was able to make, in exquisite line and color, pictorial records of his own sensitive and perceptive reaction to the modern world. His wry whimsy uses strangely delineated figures of men, animals, and fantastic creatures as commentary upon human weakness and folly, though his tone is almost always gentle and his irony subdued. Although his paintings and drawings are usually very small, and although they would seem at first to be the most private of visual communications, they are charged with meaning that gradually becomes clearer to the imaginative spectator. His *Twittering Machine* (FIG. 17-20), in its title and execution, compels at first a smile. Primitive, flimsy bird "mechanisms" stand on or are attached to an equally flimsy crankshaft. We assume that the shaft can be turned and that, when it is, the "birds" twitter. Here we have most effectively the cooperative ten-

17-19 MARC CHAGALL, *Crucifixion*, 1943. Oil on canvas, $55\frac{1}{8}'' \times 39\frac{3}{4}''$. Collection of the artist, Pierre Matisse Gallery.

sion of title and design. One does not usually think of machines and birds in association or of machines as ludicrous hand-driven works made of bent picture wire. Out of these forced associations and distortions there seems to emerge a new entity that slyly spoofs the machine age: Although the device "works," it has no real purpose, unless it is to twitter, and birds do this much better. It has recently been suggested that the sly humor of the work may conceal a mordant comment on man's mortality. The heads of the creatures, each carefully distinguished as one of the four temperaments, resemble metallic lures capable of trapping real birds. Below them is a rectangular trough on short legs—perhaps a death trap. The lures and death trap can symbolize the entrapment of all of us by existence. Perhaps no other artist of the century matches the subtlety of Klee as he adroitly plays with sense, making an artistic means of ambiguity and understatement.

Klee shared the widespread modern apprehension concerning the rationalism behind a technological civilization that could be as destructive as it was constructive. As do some psychologists, he sought clues to man's deeper nature in primitive shapes and symbols; like his compatriot, the psychologist Jung, Klee seems to have accepted the existence of a collective unconscious that reveals itself in archaic signs and patterns going back to prehistoric times and everywhere evident in the art of primitive peoples. His *Death and Fire* (PLATE 17-11) manifests his interest in the ideogram—the simple, picturelike sign filled with implicit meaning. A white death's-head, heavily outlined, rises from a glowing sun and seems to balance a round object like a shot. From the right strides a man with a staff; three bars precede him. The features of the skull could be letters. It has been suggested that the cool blue-green, so definitely harmonized with the chords of red, could suggest the element of water reconciled with fire in the ever changing alternation of life and death. The eerie color, the primitive starkness of the images, and the mysterious arrangement itself convey a sense of awe almost religious, as if one were in the presence of a totem having magical powers. Enigmatic as the subject is, we feel its sources in the religious experience, an experience probably as old as human history.

Social Realism

It is noteworthy that alongside the busy experimentalism in Western art there persisted a conservative Realism only slightly affected by it, a Realism most often enlisted in the service of social and political movements. This "Social Realism," as it may be called, is an international phenomenon, a genre in which the environment, the labors, and the struggle of the working classes are sympathetically described and exalted. In the West this kind of art flourished in the thirties—especially in Mexico and the United States, frequently with overtones critical of "the Establishment." The painter DAVID ALFARO SIQUEIROS (1898–1974), one of the brilliant muralists who, with Rivera and Orozco, made the Mexican school of international importance in the 1930's, makes a violent antiwar protest of his *Echo of a Scream* (FIG. 17-21). The amplification of the infant's cry is made surrealistically by duplicating

17-21 DAVID ALFARO SIQUEIROS, *Echo of a Scream*, 1937. Duco on wood approx. 48″ × 36″. Collection, Museum of Modern Art, New York (gift of Edward M. M. Warburg).

17-22 BEN SHAHN,
Handball, 1939. Tempera
on paper mounted on
composition board, approx.
$22\frac{3}{4}'' \times 31\frac{1}{4}''$. Collection,
Museum of Modern Art,
New York (Abby Aldrich
Rockefeller Fund).

17-23 EDGARDS ILTNERS, *Strong Hands*, 1962. Oil on canvas,
approx. $72\frac{1}{2}'' \times 68\frac{1}{2}''$. Latvian Art Museum,
Riga, Latvia.

and augmenting dreadfully the pathetic head.
Realistic and Expressionistic techniques combine
in the rendering of the shattered landscape
heaped with the wreckage of war. Again, a com-
parison with the *Guernica*, painted in the same
year, emphasizes the variety of expressive means
opening to the artist who wants to comment
upon his times. In a quite different subject and
mood the American painter BEN SHAHN (1898–
1969), just two years later, shows a pronounced—
if, perhaps, unconscious—eclecticism in his *Hand-
ball* (FIG. 17-22). Shahn fused his various borrow-
ings into a sharply expressive personal style. The
painting recalls the geometry of Cubism; the
haunted space of Surrealism, with its weird
vacancy; the still perspectives of Italian painting
in the fifteenth century; and the quick, accidental
poses and changes of scale of the candid photo-
graph.

In Soviet Russia it became and still is the official
style of the state, and in Marxist-socialist move-
ments and regimes throughout the world, Social
Realism advertises the merits of revolutionary
socialism. The Soviet Latvian painter EDGARDS
ILTNERS (b. 1925) shows in *Strong Hands* (FIG. 17-

KLEE	GROPIUS	BARLACH	LE CORBUSIER	DALI	MIRÓ	WRIGHT	PICASSO	KLEE
Twittering	Shop Block,	*War Monument*	*Villa Savoye*	*Persistence*	*Painting*	Kaufmann	*Guernica*	*Fire and Death*
Machine	Bauhaus			*of Memory*		House		WORLD
								WAR II

————— SURREALISM/CUBISM/EXPRESSIONISM —————

←———————— THE GREAT DEPRESSION ————————→

23), a work typical of the genre, a group of steel workers pausing in their labors while the fiery glow of the furnaces bathes their muscular bodies. There is little here that reflects the major experiments of modern art. The approach is factual, obviously approving. The artist preaches the dignity of labor and the superior humanity of the socialist proletariat. Art is entirely the servant of the State and the faithful illustrator of its ideology. The socialist artist describes the machine age with conservative realism as a triumph of collective human energy and will.

Ironically, similar elements are manifest in the official art of Germany and Italy in the thirties and early forties, although their Fascist political philosophy is generally held to be diametrically opposed to that of Soviet Marxism. It would appear that the highly centralized twentieth-century dictatorship not only favors conservative Realism in art but also uses art for propagandistic ends, denying the "art-for-art's-sake" orientation of much modern art. Much the same could be said of many government-subsidized WPA art projects in the United States during the Great Depression of the 1930's.

SCULPTURE BEFORE WORLD WAR II

Rodin was the greatest sculptor of the nineteenth century, an artist whose international reputation rivaled that of Michelangelo and Bernini; he was also a great teacher. His reputation brought to his studio in Paris, as pupils or admirers, many of those of the younger generation who were to develop new kinds of sculpture, either influenced by Rodin or in reaction against him.

The French sculptor ARISTIDE MAILLOL (1861–1944) turned from Rodin's evanescent effects of light and broken planes to a style simple and weighty. He began his career as a painter, executing broadly decorative designs in the manner of Gauguin, and was also known as a graphic artist through his book illustrations. About 1900 he turned to sculpture and, until the end of his life, scarcely deviated from his chosen subject—the female figure—which he interpreted in massive planes and volumes devoid of historical stylization or literary anecdote. One of his first and most important works was the seated figure *Mediterranean* (FIG. 17-24). It is conceived as an organization of almost abstract volumes simplified from the endless complexity of the human figure. It has weight and solidity, and the largely unbroken surfaces of the smoothly modeled masses take the light evenly and quietly. The pose itself, familiar in several Tahitian figures of Gauguin,

17-24 ARISTIDE MAILLOL, *Mediterranean, c.* 1901. Bronze, approx. 41" high, base 45" × 24¾". Collection, Museum of Modern Art, New York (gift of Stephen C. Clark).

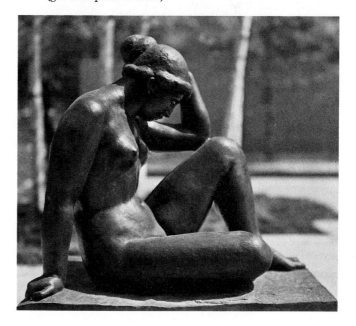

17-25 WILHELM LEHMBRUCK, *Standing Youth*, 1913. Cast stone, approx. 7′ 8″ high. Collection, Museum of Modern Art, New York (gift of Abby Aldrich Rockefeller).

tion of human dimensions. His *Standing Youth* (FIG. 17-25), elegantly slender and tall, poses in solemn reverie, making a slow, deliberate, and eloquent gesture, as if participating in some grave ritual. Without specific subject or historical reference, Lehmbruck's figure "tells" by pose and gesture alone, its mood entirely a function of its form. The extreme proportions recall Gothic and even Mannerist attenuation and announce a new freedom to interpret the human figure quite without regard for the measure of it established in antiquity and in the Renaissance.

whose art Maillol greatly admired, has also in its tranquil closure, monumentality, and dignity more than a little of the early classical sculpture of Greece. The figure carries its own meaning (that is, it refers to nothing outside itself, the title "Mediterranean" having been added later); the form alone is sufficient to the artist's purpose.

The Expressionistic element in Rodin proved most sympathetic to the young German sculptor WILHELM LEHMBRUCK (1881–1919). Lehmbruck, perceiving in Rodin's later work the possibilities of distortion, developed an impressive style of his own that he based on elongation and attenua-

17-26 GASTON LACHAISE, *Standing Woman*, 1912–27. Bronze, approx. 70″ high. James G. Forsyth Fund, Albright-Knox Gallery, Buffalo.

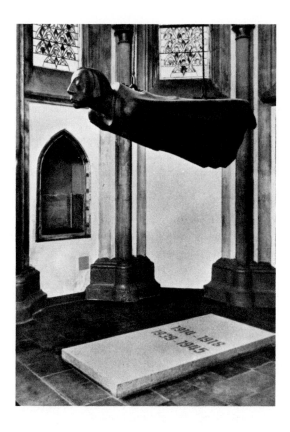

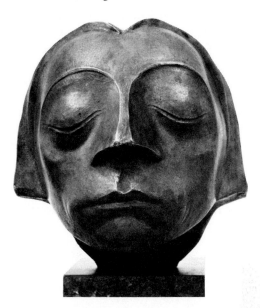

17-27 Left: ERNST BARLACH, *War Monument*, Güstrow Cathedral (general view), 1927. Bronze. Schildergasse Antoniterkirche, Cologne.

17-28 Above: ERNST BARLACH, *Head*, detail of FIG. 17-27. Approx. 13½″ high. Collection, Museum of Modern Art, New York (gift of Edward M. M. Warburg).

GASTON LACHAISE (1882–1935), of French descent but active most of his life in the United States, specialized, like Maillol, in sculpture of the female figure and, like Lehmbruck, dealt freely with the proportions of the human body. His life-size *Standing Woman* (FIG. 17-26) is as broadly modeled as Maillol's but with a more sensuous treatment of the anatomy. The strongly felt movement swells rapidly upward from the lightly poised, delicate feet to the large rounding hips; thence, after a sharp accent in the angle of the waist, it again swells into the broad shoulders and bent arms. There is an elastic, abstract rhythm both of volume and contour and a beautiful union of weight and grace. Bronze is an ideal medium for this beautifully contrived equilibrium of opulent mass with delicate supporting strength. If we compare Lehmbruck's *Standing Youth* with Lachaise's figure, we can appreciate how widely varied the formal and expressive results can be where the sculptor experiments with noncanonical proportions.

Symbolism and Art Nouveau had opened to the modern artist the stylistic troves of other ages and cultures. Thus the Expressionist sculptor could find in Medieval art both unsophisticated and intense spirituality and abstract forms as yet uncomplicated by Realism. Although the sculptors discovered Romanesque and Gothic art much later than did the architects, they made of their borrowing from it something far more genuine. A German sculptor much influenced by Medieval carving was ERNST BARLACH (1870–1938), whose work combines sharp, smoothly planed forms with intense action and keen expression. His war memorial for Güstrow Cathedral (FIGS. 17-27 and 17-28) is one of the most poignant monuments of World War I. The sculptor depicts a dying soul at the moment when it is about to awaken to everlasting life—the theme of death and transfiguration—and the rigid economy of surfaces concentrates attention on the superb head. The spiritual anguish evoked by the disaster of war, and the release from that anguish through the hope of salvation, are rarely expressed as movingly as they are in this work.

Cubism to Constructivism

Although sculpture does not register as clearly as does painting the major stylistic groupings—Expressionism, Cubism, and Surrealism—we still may discern them. On the other hand, sculpture, the three-dimensional art, is perhaps more at home in the age of metals and three-dimensional, industrially produced artifacts; later in the century it is sculpture particularly that achieves the inevitable linkage of art and technology. The Expressionism of Lehmbruck and Lachaise overlaps the new experience of Cubism, which, concerned with the creation of effects of three-dimensional space on a flat surface, was not easily adapted to the sculptural mode. Nevertheless, we can see a development from the Rodinesque mode to total Cubist abstraction in two figures (FIGS. 17-29 and 17-30) by Henri Matisse (p. 723), who was a sculptor as well as a painter. Though these figures, the first and last of a series of four made between 1909 and 1929, are not in the more characteristic linear mode (or "arabesque," as Matisse called it) preferred by the artist, they reveal with great force a profound change in sculptural vision. The first of these representations of back views of the female nude is not far removed from the roughly modeled surfaces of Rodin's sculptures and a believable anatomy. *Back II* and *Back III* (not illustrated here), made in quick succession in 1913 and 1914, show a rapid breaking up—an abstraction—of the main bodily shapes. *Back IV*, the final version, made in 1929, is the last stage of the disintegration and embodies the emergence of a totally different concept and procedure, the geometrizing, radical simplifications of Cubism.

Matisse's "exercise in the progressive reduction and concentration of form" took place as an exclusively sculptural enterprise, independent of painting. On the other hand, the earlier works of JACQUES LIPCHITZ (1891–1973)—born in Poland

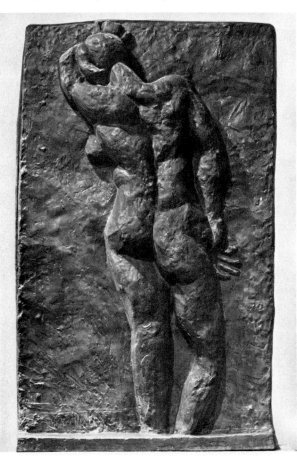

17-29 HENRI MATISSE, *Back I, c.* 1909. Bronze, $74\frac{3}{4}'' \times 46'' \times 7\frac{1}{4}''$. Tate Gallery, London.

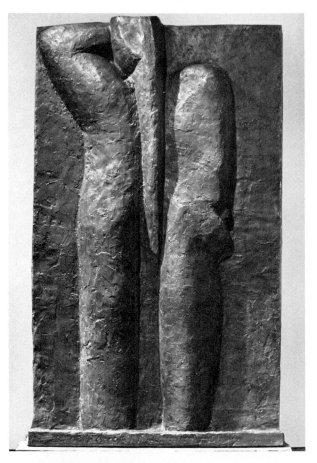

17-30 HENRI MATISSE, *Back IV, c.* 1929. Bronze, $74\frac{1}{2}'' \times 44\frac{1}{2}'' \times 6\frac{1}{4}''$. Tate Gallery, London.

17-31 Left: JACQUES LIPCHITZ, *Man with Mandolin*, 1917. Stone, approx. 29¾″ high. Yale University Art Gallery, New Haven, Connecticut (Collection, Société Anonyme).

17-32 Right: ALEXANDER ARCHIPENKO, *Woman Combing Her Hair*, 1915. Bronze, approx. 13¾″ high. Collection, Museum of Modern Art, New York (bequest of Lillie P. Bliss).

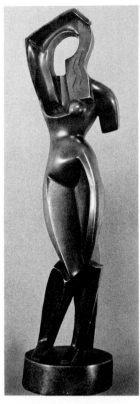

but long resident in France and the United States —such as the *Man with Mandolin* (FIG. 17-31) are among the most successful solutions to the problem of developing in three dimensions the spatial feeling of Cubist painting. The continuous form is broken down into planes that, no matter the direction of the light, can be read as flat shaded surfaces. As with Cubist painting, there is now no single point of view, no continuity or simultaneity of image contour. But even more decisive a break with the long tradition of Western sculpture than this analysis of mass into planes is the piercing of the mass. An early example of this new turn can be seen in *Woman Combing Her Hair* (FIG. 17-32) by Russian sculptor ALEXANDER ARCHIPENKO (1887–1964). This statuette, recalling in its graceful contrapposto something of Renaissance Mannerism, introduces in place of the head a void with a shape of its own that figures importantly in the whole design. Enclosed spaces had always existed in figure sculpture—for example, that between the arm and the body when the hand rests on the hip, as in Verrocchio's *David* (FIG. 12-50). But here there is penetration of the continuous mass of the figure, and shaped space (often referred to as "negative space") occurs with shaped mass in the same design. Archipenko's figure shows the same slipping of the planes that we have seen in pictorial Cubism, and the relation of the planes to each other is similarly complex. Thus, in painting and sculpture the traditional limits are broken through and the media transformed.

While Archipenko's figure is still quasirepresentational, sculpture (like painting) executed within the Cubist orbit tended to cast off the last vestiges of representation. By 1913 UMBERTO BOCCIONI (1882–1916), already mentioned as a Futurist and both painter and sculptor, had pushed his forms so far toward abstraction that the title of his *Unique Forms of Continuity in Space* (FIG. 17-33) calls attention to the formal and spatial

17-33 UMBERTO BOCCIONI, *Unique Forms of Continuity in Space*, 1913. Bronze, approx. 43½″ high. Collection, Museum of Modern Art, New York (bequest of Lille P. Bliss).

effects rather than to the fact that the source for these is the striding human figure. The "figure" is so expanded, interrupted, or broken in plane and contour that it disappears, as it were, behind the blur of its movement; only the blur remains. Boccioni's search for plastic means with which to express dynamic movement reached a monumental expression here. In its power and sense of vital activity this sculpture surpasses similar efforts in painting (by Boccioni and his Futurist companions) to create images symbolic of the dynamic quality of modern life. To be convinced by it, one need only reflect on how details of an adjacent landscape appear in our peripheral vision when we are traveling at great speed—as on a highway or in a low-flying airplane. Although there is a curious resemblance of Boccioni's figure to the ancient *Nike of Samothrace* (FIG. 5-63), a cursory comparison will reveal how the modern work departs from the ancient.

The Rumanian sculptor CONSTANTIN BRANCUSI (1876–1957) carried abstraction to the limit beyond which the representational element is lost entirely. At the same time he extracted from the material—whether marble, metal, or wood—its maximum effect. It may be that it is with Brancusi's scrupulous attention to the nature of his materials that the pervading doctrine and mystique of modern art—"truth to the material"—arises. This doctrine demands of the artist respect for the material he works with, so that his formal intentions will never abuse its peculiar nature: what is appropriate for bronze is not so for marble, what is appropriate for marble is not so for wood, and so on. This respect for the function of the material is of course a necessity in industrial production. This truth to material goes along with the modern quest for purity or "reality" of form. As the painter Mondrian had believed rectilinear form to be most "real," so Brancusi visualized an extended ovoid shape as the most "natural" shape, and simplified the most complex natural forms, and even natural movements, so that they were reduced to variations on this fundamental shape. In his famous *Bird in Space*

(FIG. 17-34) everything accidental has been eliminated or compressed into the most direct and economical expression, yet the form as a whole suggests the essence of a bird's sudden upward movement through space. Even more, there is a remarkable suggestion of airflow, as it has been delineated by modern aerodynamics, and Brancusi's means of conveying flight is not unrelated to those that the modern engineer generally uses in designing "streamlined" industrial forms. There is the same study of the nature of the material, the same meticulous attention to proportions, contour, and surface finish. Thus, even at this early stage the coming together of art and technology is predictable. At the same time there appears what might be thought a contradiction of the technological connection, namely, *biomorphic abstraction*, in which the artist derives forms from living and growing things.

A friend of Brancusi and Picasso, JULIO GONZALEZ (1876–1942), shared their interest in the artistic possibilities of new materials and new methods borrowed both from industrial tech-

17-35 Julio Gonzalez, *Woman Combing her Hair*, c. 1930–33. Iron, 57" high. Collection, Moderna Museet, Stockholm.

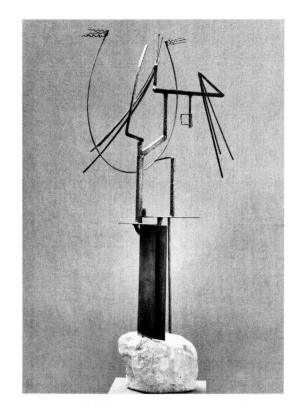

nology and traditional metal-working. Constructed or "direct" shapes (that is, those using ready-made bars, sheets, rods, or the like) of welded or wrought iron and bronze can produce effects simple or incredibly complex, in which we have, in effect, sculptured *spaces* in a kind of fluent openwork, the solids functioning only as contours, boundaries, or dividing planes. In *Woman Combing Her Hair* (FIG. 17-35)—one should compare it with Archipenko's version of the same subject (FIG. 17-32)—fantasy is restrained by no traditional convention of representation, and the actual making process is unimpeded by the more demanding methods of carving and casting. Sculptors in the sixties and seventies were to exploit fully the advantages of this method: linear effects impossible for other modes, flexibility in construction, speed of execution, and easy correction of errors or changes in intention. The direct metal method in the hands of contemporary sculptors will parallel—as we shall see—the methods used by the so-called "Abstract Expressionist" painters. Of Gonzalez it should be noted that, though he innovates in material and method, he still thinks (as the title of this piece indicates) of the human figure as a point of departure for abstraction, even though the forms could, like Brancusi's, stand without external reference to the natural world. After years as an unsuccessful painter, Gonzalez was asked by Picasso for technical help in constructing metal sculpture. From that time his influence has been continuous, with a special impact, as we have remarked, on today's sculptors.

Unlike Gonzalez or Brancusi, artists of De Stijl and Constructivism preferred to work with forms that make no reference at all to the natural world but rather to the worlds of mathematics and mechanism. The constructions of GEORGES VANTONGERLOO (1886–1965) resemble the paintings of Mondrian. There is the same careful manipulation of rectangular elements in a formal, machinelike relationship (in this case in three dimensions), as in his *Raumplastik, $y = ax^3 - bx^2 + cx$* (FIG. 17-36). The search for pure form naturally led to mathematics—or, as here, a sly

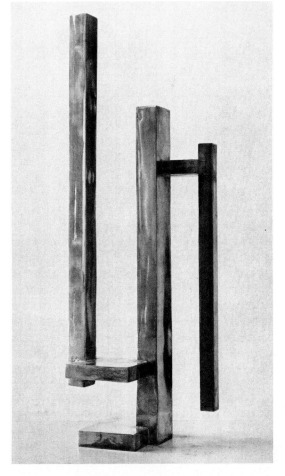

17-36 Georges Vantongerloo, *Raumplastik, $y = ax^3 - bx^2 + cx$*, 1935. Nickel silver, 15" high. Kunstmuseum, Basel.

simulation of it—the abstract and impersonal beauty of which would be projected into three dimensions. But it also reflected the sculptor's impulse toward the "engineering" and machining of forms "to specification"—as with use of a blueprint or plan.

Moving in the same direction as Vantongerloo and, in fact, preceding him and going further in its research into form, was *Constructivism*, a movement originated in Russia. (See also p. 736.) Early in the development of Synthetic Cubism a group of Russian artists working in Moscow became interested in applying techniques of industrial engineering to sculpture. Their point of departure was some of the more three-dimensional collages of Picasso, which used miscellaneous recognizable objects out of the environment, such as bottles, pipes, guitars. Some of these collages were seen by VLADIMIR TATLIN (1885–1953) when he visited Picasso in Paris in 1913. On his return to Moscow he made similar collage-reliefs, which, however, significantly excluded all representational motifs and recognizable objects. His compositions were completely abstract, the first of their kind. These he called "constructions," giving a name to that very influential movement. Tatlin was the moving spirit among a group of progressive Constructivists whose experiments were eventually banned by the new Soviet regime in 1922; some left Russia and spread their ideas and practices through the West.

Shortly before Constructivism was banned in Russia, Tatlin had designed a prodigious monument, never built, but the model of which has survived (FIG. 17-37). A tower called *Monument to the Third International*, 1919–20, and intended to be about 1300 feet high, it a was spiraling, leaning openwork structure composed of steel, wood, and glass and was to have contained three vast, moving geometrical elements—a cube, a pyramid, and a cylinder. These would have housed facilities for cultural, political, administrative, and scientific activities and were to revolve upon their axes at different speeds ranging from one revolution a year to one a day.

In 1920 the Constructivists divided, Tatlin allying himself with the so-called "Productivists," who renounced art altogether in favor of productive, collective engineering. The Productivist position was rejected by the brothers ANTOINE PEVSNER (1886–1962) and NAUM GABO (b. 1890), who championed the individual freedom of the artist and his right to free experimentation. In 1920 they issued a *Realist Manifesto* in which they called for the representation of a "new reality":

> In order to interpret the reality of life, art must be based upon two fundamental elements: space and time. Volume is not the only concept of space. Kinetic and dynamic elements must be used to express the true nature of time. The static rhythms are no longer sufficient. Art must not be more imitative, but seek new forms.

We have seen something of this last statement already explicit in Brancusi, Gonzalez, and Van-

17-37 VLADIMIR TATLIN, *Monument to the Third International*, 1919–20. Model in wood, iron, and glass. Re-created in 1968 for exhibition at the Moderna Museet, Stockholm.

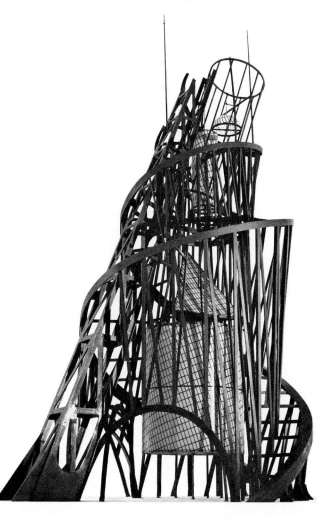

tongerloo; and the rotating elements of Tatlin's *Monument* anticipate the expression of time in space. And in their placing of mass to make, enframe, and divide spaces, as we have seen in Gonzalez especially, we have the essential procedure laid down by Pevsner and Gabo in their manifesto:

> Mass and space are two concrete and measurable things. We consider and use space as a new and absolutely sculptural element, a material substance which really enters into construction.

Architecture had always implicitly admitted the reality of space. For sculpture to admit it was a triumph, already announced in the "pierced" figure by Archipenko. It now appeared that space could be "sculptured" quite as much as mass. In their concern with the properties of space Pevsner and Gabo created objects in which voids acted as forcefully as the elements of solid mass, conceding that, for sculpture, mass and void can be made esthetically equivalent. This is a radical position indeed in view of the fact that the essence of sculpture had been commonly thought of as pure mass. Gabo turned to the new synthetic plastic materials as many younger sculptors have since. He used first celluloid and later nylon and lucite for constructions in which space seems to flow through as well as around the transparent materials. His prewar experiments culminated in some of his most subtle postwar compositions. In his *Linear Construction* (FIG. 17-38) space is caught and held in suspension, as it were, by the most delicate combination of hovering planes. In the "fields of force" of physics, conventional "solids" and "voids" alike are only mathematical expressions; in the subatomic universe solids and voids are always in ambiguous relation and never definitely one or the other. Like the mathematician, the artist may express his conception of this undecidable relation of space and mass. Like Mondrian, Gabo believed that indeed "such artfully constructed images are the very essence of the reality of the world which we are searching for." In our time science and art alike make their models of the reality of the physical world.

From the "transparency" of mass, and the consequent creation of interior spaces, it seems but a step to the attempt to create actual move-

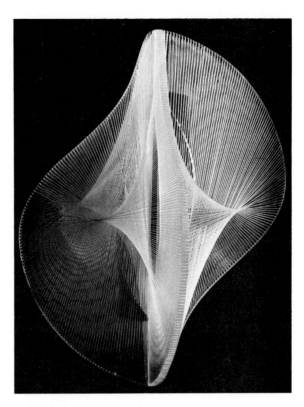

17-38 NAUM GABO, *Linear Construction*, 1950. Plastic and nylon thread. Collection of Mrs. George Heard Hamilton, Williamstown, Massachusetts.

ment in space. Anticipating today's kinetic sculptors, Gabo in 1920 designed *Kinetic Sculpture*, which consisted of a vertical metal rod vibrated by an electric motor (FIG. 17-39). The vibrations created an apparent volume greater than the actual dimensions of the slender rod, much like the effect of a vibrating cord. Yet movement must come as a reality in which the positions of the work or of the spectator or both are constantly changing. The American sculptor ALEXANDER CALDER (b. 1898) was the first to set his works in continuous and "natural" (that is, unmotorized) motion. His mobiles, as they are appropriately called, are made of rods, wires, and sheet-metal forms so balanced that the slightest current of air moves the parts within a carefully planned pattern, creating a constantly shifting "definition" of space. Traditionally, sculpture has had very few standards of space and these have demanded its fixity and sometimes the fixity of the spectator. A remark of Salvador Dali's

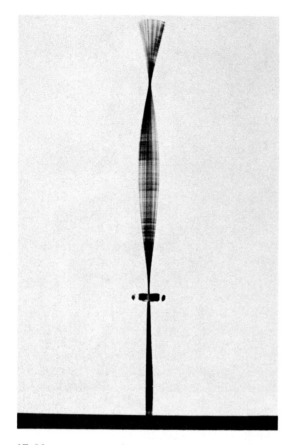

17-39 Naum Gabo, Above: *Kinetic Sculpture: Standing Wave*, 1920. Wood and metal, motorized, $24\frac{1}{4}'' \times 9\frac{1}{2}'' \times 7\frac{1}{2}''$. Tate Gallery, London.

expresses our traditional view of the sculptural mode: "... the least one can expect of sculpture is that it stand still." Calder's work, most often nonrepresentational, is sprightly and witty and contains many unexpected felicities of line and shape. In this respect it often reminds us of the paintings of Miró (FIG. 17-17). In *Horizontal Spines* (FIG. 17-40) the delicate grace and precision of pure line in the fine steel wires contrasts and combines in constantly changing relationships with the sharp accents of the flat shapes.

Dada and the Fantastic

The biting Dadaist critique of modern life cut across the whole development of formalizing, abstract sculpture, bringing with it a new permissiveness. Objects out of the ordinary environment of modern man were selected and exhibited in the Dada shows as works of art. Duchamp, with serene impudence, mocked serious artistic intention with chance selection of objects like a bicycle wheel (FIG. 17-41), bottle washer, urinal, corkscrew, and other "ready-made" commonplace things. These André Breton called "manufactured objects promoted to the dignity of objects of art through the choice of the artist." For Duchamp, as for a generation of artists after him, life and art are a matter of chance and arbitrary choice; the essence of the artistic act is willful selection, each act individual and unique. He said: "Your chance is not the same as mine, just as your throw of the dice will rarely be the same as mine." This philosophy of utter freedom for the artist is fundamental to the history of art in the twentieth century, and Duchamp can stand as perhaps the shrewdest and most perceptive theorist of the modern movement. The freedom he granted himself to select a bicycle wheel and place it fork down upon a kitchen stool, he granted to the visitor in allowing him to spin the wheel as he chose.

The "ready-mades" of Duchamp led to "found objects" like the random junk that Schwitters used to compose his *Merz Pictures* (FIG. 17-13); the collages of Cubism had pointed the way. The interest in "found objects" spread to the general public, who began to collect interesting oddments such as rocks, driftwood, and fragments of manu-

17-40 Left: Alexander Calder, *Horizontal Spines*, 1942. Approx. 54″ high. Gallery of American Art, Phillips-Andover Academy, Andover, Massachusetts.

17-41 MARCEL DUCHAMP, *Bicycle Wheel*, 1951 (third version after lost original of 1913). Metal wheel mounted on painted wooden stool, $50\frac{1}{2}'' \times 25\frac{1}{2}'' \times 16\frac{5}{8}''$. Museum of Modern Art, New York (gift of the Sidney and Harriet Janis Collection).

17-42 Above: PABLO PICASSO, *Bull's Head*, 1943. Handlebars and seat of a bicycle. Galerie Louise Leiris, Paris.

17-43 Left: MAN RAY, *Gift*, c. 1958 (replica after destroyed original of 1921). Painted flatiron with metal tacks, $6\frac{1}{8}'' \times 3\frac{5}{8}'' \times 4\frac{1}{2}''$. Collection, Museum of Modern Art, New York (James Thrall Soby Fund).

factured objects. A happy conjunction of two ordinary objects, never before appearing together in this way, makes up Picasso's *Bull's Head* (FIG. 17-42). The never failing ingenuity of this modern master turned the handle bars and seat of a bicycle into an image of a bull, beautifully stylized. The work, which at first might seem only a clever trick, illustrates an important method in modern art—the unexpected unity that two objects can make when taken out of their usual context and brought into a radically new relationship. We have seen this phenomenon of new meanings arising out of uncommon juxtaposi-

tions in the case of the seemingly opposed caption and image in painting. Much of the pungency and surprise of modern painting and sculpture, its impact, is the result of such strenuous feats of conjunctive imagination.

The ordinary manufactured objects and utensils can be modified just enough to create a startling paradox. MAN RAY (b. 1890), Duchamp's collaborator in the latter's brief reintroduction of Dada to the United States in 1921, equips a laundry iron with a row of wicked-looking spikes, contravening its proper function of smoothing and pressing (FIG. 17-43). The malicious humor of

Gift is seen throughout Dada and, indeed, through much of contemporary art, giving it a characteristic edge, which can cut the unwary. Contradiction, paradox, irony, even blasphemy, are the bequest of Dada. They are, in the view of Dada and its successors, the free and defiant artist's weapons in what has been called his "hundred years' war with the public."

In these later years of that "war," sculptors, like painters, have explored numerous avenues of possibility. Where human reference would seem to have been once and for all expelled from the

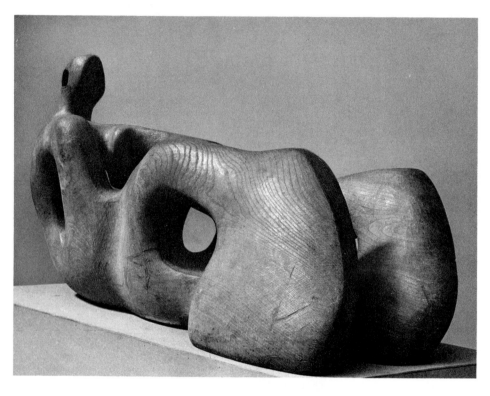

17-44 HENRY MOORE, *Reclining Figure*, 1939. Elmwood, 81″ long. Detroit Institute of the Arts. (gift of the Dexter M. Ferry, Jr., Trustee Corporation).

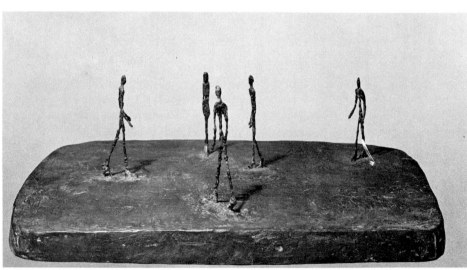

17-45 ALBERTO GIACOMETTI, *City Square (La Place)*, 1948. Bronze, $8\frac{1}{2}″ \times 25\frac{3}{8}″$. Collection, Museum of Modern Art, New York (purchase).

sculptor's interest by exclusively formal concerns, it yet insistently reappears. The English sculptor HENRY MOORE (b. 1898) has created many variations upon the human figure, some more abstract than others but all reflecting an instinctive feeling for the dignity of the human form. Moore often also disregards the human form in favor of pure biomorphic abstraction and, like his colleague Barbara Hepworth (b. 1903), shows a profound love for and knowledge of natural forms and materials. In such a work as the 1939 *Reclining Figure* (FIG. 17-44) the massive interlocking shapes reflect the discipline of abstract art, particularly the architectonic counterpoint of mass and void, but their total visual reality relates the human being to the enduring world of natural experience, even as the smooth, polished wooden surfaces suggest the action of wind and water upon natural materials. Quite another treatment of the human figure is found in the work of ALBERTO GIACOMETTI (1901–66). This Swiss sculptor, long a resident of Paris, participated in both the Cubist and Surrealist movements and contributed significant works in each mode. But in 1947 he turned to representational sculpture, to produce unexpectedly poignant figures that seem immediate projections of modern experience of bewilderment, loss, alienation. At the beginning of this chapter we referred to Giacometti's *City Square* (FIG. 17-45) as projecting peculiarly the image of the modern isolated individual in the "lonely crowd." It is noteworthy that Giacometti disapproved of any such classification of his work and believed that he was simply trying to render the effect of great space as it presses around a figure—nothing more. But this is precisely the point: The lone modern man is only too aware of the vastness of the space that separates him from his neighbor by only a few feet. The artist's verbally expressed intention and our own verbally expressed interpretation may seem to differ, as is the case so often in modern art; yet we recognize when he is speaking for his age through his art. The pencil-thin, elongated figures striding abstractedly through endless space never meet and never can. At certain angles the forms are so attenuated that they almost disappear, as, often in the human condition, people fade noiselessly out of sight. If we compare Gia-

cometti's figures with those in Rodin's *Burghers of Calais* (FIG. 16-62), we can readily appreciate what changes have been wrought by half a century of revolution in the interpretation of man in art.

ARCHITECTURE BEFORE WORLD WAR II

The structural promise of steel and concrete, only partly recognized in the later nineteenth century, finds its fulfillment in the twentieth. Like painting and sculpture, architecture is revolutionized by industrial materials and by the example of the pure functionalism of machines. Radical contradictions and reversals of tradition, analogous to what we have seen in the figurative arts, produce in architecture styles with no precedent in the past. Architecture, with all the other arts, is brought within the dominance of modern technology. In the words of the critic Siegfried Giedion, "Mechanization takes command!" This does not mean that individual talent became submerged in collective production; rather, architects of genius welcomed the machine and its potential for inspiring new form. Indeed, architecture and engineering draw closer, often being embodied in one person; and technology, if not altogether taking initiative in inspiring modern architecture, is always implicit in it. It is intriguing that the old Renaissance ideal of the union of theory and practice seems to find its full realization in a style fundamentally different from that of the Renaissance. In any event, we find in the history of modern architecture—more conspicuously than in the past—a kind of tension between the individual architect's impulse toward personal expression and the demand for vast, public, impersonal projects that impose their uniformity upon whole cities. Within the titanic scale of modern, collective, public design the old individualism of a Michelangelo or a Bernini would be likely to lose some of its distinctiveness. The modern architect is more like the Medieval master of works than the isolated Renaissance genius imposing his will upon the whole form. To a degree, though modern archi-

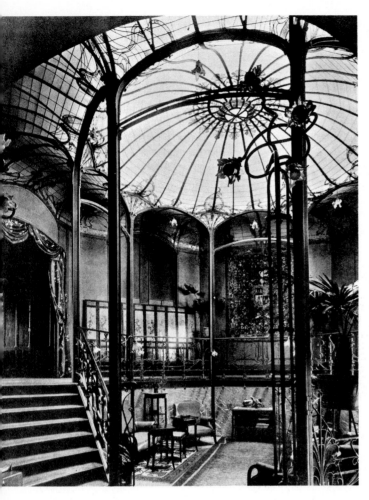

17-46 Victor Horta, Hotel van Eetvelde, Brussels, 1895.

architectural ornament independent of tradition. In this respect he was the leading American representative of an international movement that the French called Art Nouveau, though it had various names in various countries. Art Nouveau, contemporary with the period of Post-Impressionism between about 1890 and World War I, was primarily an ornamental style based on organic forms, especially those suggesting movement and growth. Its typical motif is an undulant, sweeping, serpentine line that wraps about or rises from structural members, its weaving spirals ending in tense scrolls. It was easily adaptable to light metal construction and was used especially in private houses, though many of the Paris Metro entrances were decorated with Art Nouveau motifs. A good example of the style is the staircase in the Hotel van Eetvelde (FIG. 17-46), built in Brussels in 1895 by VICTOR HORTA (1861–1947), whose name is particularly associated with Art Nouveau in architecture. This decorative experiment was hailed enthusiastically as a truly modern style, though in fact it was the last appearance of the old "craftsman" style of the nineteenth century. A number of influences can be identified in Art Nouveau; they range from the rich, foliated, two-dimensional ornament and craftsman's respect for materials of William Morris' Arts and Crafts movement in nineteenth-century England to the free, sinuous, whiplash curve of Japanese designs. The boldness of Horta's use of metal may also be seen in the light supports, the ductile, curvilinear ornamentation, and the candor with which design and structure were integrated.

In Horta's hands Art Nouveau was most effective as interior design, though all the arts were under its sway, from architecture to book illustration. On a monumental architectural scale the style may be seen in the Casa Milá apartment house (FIG. 17–47), erected in Barcelona in 1907 by ANTONIO GAUDI (1852–1926), an inventive architect who strove mightily to create forms utterly divorced from tradition and as close as possible to the randomness of nature. He superposed bulky layers of cut stone in restless undulation, banishing the straight line altogether. The surfaces of the stone are left in the rough, suggesting naturally worn rock; entrance portals are like eroded

tecture has its heroes, the architect of our times tends, like his brother sculptors and painters, to take his character from the broad, collective movements of style, rather than to create them. Men like Frank Lloyd Wright seem to be the rule-proving exceptions.

We have seen in "exhibition" architecture and the mercantile buildings of Richardson and Sullivan the move toward a utilitarian architecture of a scale large enough to accommodate the traffic of thousands of people. The metal frames of the Americans' buildings, as with Labrouste's Bibliothèque Ste.-Geneviève (FIG. 16-62) were clothed in a fabric reminiscent of traditional styles, though Sullivan was deeply interested in devising an

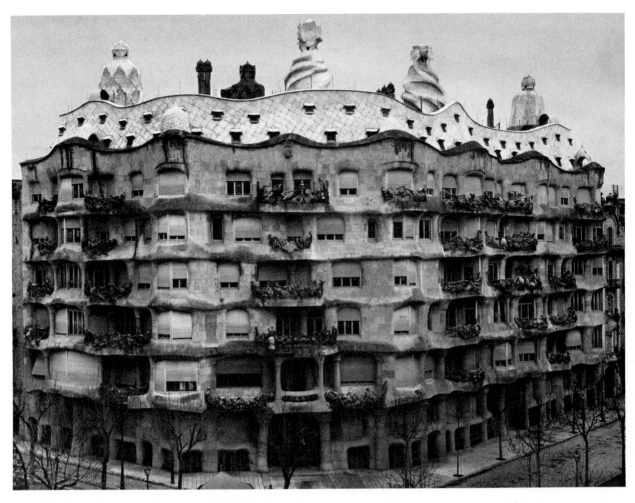

17-47 Antonio Gaudi, Casa Milá, Barcelona, 1907.

sea caves. Passionate naturalism, seeking to escape from all regularity of artifice into the formless dynamism of nature, has never had more striking expression. Gaudi's work is the spiritual kin of the Expressionistic painting and sculpture.

The work of Horta and Gaudi provides components for a new and deeply searching art: a declaration of independence from all tradition, a profound respect for nature and the nature of materials, and the expectation that an entirely new architecture was possible. As with painting and sculpture, an age of experiment opened for architecture at the turn of the century. The most striking and original personality in the development of a "modern" architecture is unquestion-

ably FRANK LLOYD WRIGHT (1867–1959), whose experimental projects still startle the world. Always a believer in architecture as "natural"— that is, "organic"—Wright saw it in the service of free men who have the right to move within a "free" space—that is, as an asymmetrical design in natural surroundings. He sought to develop an organic unity of planning, structure, materials, and site. He identified the principle of *continuity* as fundamental to the understanding of his view of organic unity:

Classic architecture was all fixation Now why not let walls, ceilings, floors become seen as component parts of each other, their surfaces flowing

into each other You may see the appearance in the surface of your hand contrasted with the articulation of the bony structure itself. This ideal, profound in its architectural implications . . . I called . . . *continuity*.[11]

The concept of flux, of constant change, of evolution and progress is inherent in this principle, as it was in the views of Walt Whitman, also a prophet of continuity. It appears, too, in the work of the then greatly influential philosopher Henri Bergson, a contemporary of Wright, who stressed the reality of vitalism, of living process, above any other.

A pupil of Sullivan, Wright could well understand the former's long-debated slogan "form follows function" as the difference between the surface of the hand and its bony structure, the relation being dynamic and necessary, determined yet flexible. His vigorous originality was early manifested, and by 1900 he had arrived at a style entirely his own; in his work during the first decade of this century his cross-axial plan and his fabric of continuous roof planes and screens (derived from Richardson's "shingle-plan" resort houses) defined a new domestic architecture. Although the skeleton frame had made its significant appearance in the works of Sullivan and others, Wright attacked the concept in his studies of other systems. He demanded "no posts, no columns In my work the idea of plasticity may now be seen as the element of continuity." He acclaimed "the new reality that is space *instead* of matter." As for architectural interiors, he declared: "I came to realize that the reality of a building was not the container but the space within."

These elements and concepts were fully expressed in Wright's Robie House in Chicago (FIG. 17-48), built between 1907 and 1909. This building, like others of his houses at the time, was called a "prairie house." The long, sweeping, ground-hugging lines, unconfined by abrupt limits of wall, seemed to reach out toward and express the great flatlands of the Middle West. This is a good example of Wright's "naturalism" in the adjustment of building to site, although in this particular case the confines of the city lot provided less opportunity than did the sites of some of Wright's more expansive suburban villas. In the "wandering" plan of the Robie House (FIG. 17-49), intricately articulated spaces—some large and open, others closed—are grouped freely around a great central fireplace. (Wright felt strongly the age-old domestic significance of the hearth.) Wright's new and fundamental spatial arrangement of the interior is matched in his treatment of the exterior. Symmetry is disposed of, the façade disappears, the roofs extend far beyond the walls, the windows are in continuous strips, and the entrance is all but concealed. Masses and voids have come into equilibrium, the flow of space determining the placement of the walls as mere screens. The "Cubist" aspect of the exterior, with its sharp angular planes meeting at apparently odd angles, matches the complex play of interior solids, where the solids function not as inert containing surfaces but as equivalent in role to the spaces in the design.

The implied message of this new architecture is *space*, not *mass*—a space that fits the life of the patron and that is simply enclosed and divided as required. Wright took special pains to meet the requirements of his clients, often designing the accessories of the house himself—including, in at least one case, the gowns of his client's wife! Discerning clients commissioned his works, but his reputation grew more rapidly in Europe, especially in Holland and Germany, than in America. The publication in Berlin in 1910 of a portfolio of Wright's work hastened destruction of the dying Art Nouveau and stimulated younger men to turn in the new direction. Had Wright died at that time, his work would still have a revolutionary significance. In 1940, Mies van der Rohe, himself a great modern architect, wrote:

At this moment (1911), so critical for us, the exhibition of the work of Frank Lloyd Wright came to Berlin The encounter was destined to prove of great significance to the European development The dynamic impulse from his work invigorated a whole generation. His influence was strongly felt even when it was not actually visible.[12]

[11] Frank Lloyd Wright, *American Architecture*, ed. by Edgar Kaufmann (New York: Horizon, 1955), pp. 205, 208.

[12] In Philip Johnson, *Mies van der Rohe*, rev. ed. (New York: Museum of Modern Art, 1954), pp. 200–01.

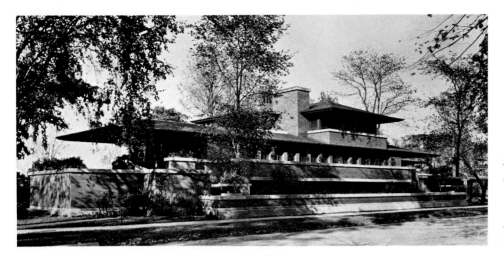

17-48 Left: FRANK LLOYD WRIGHT, Robie House, Chicago, 1907–09.

17-49 Below: FRANK LLOYD WRIGHT, plan of the Robie House.

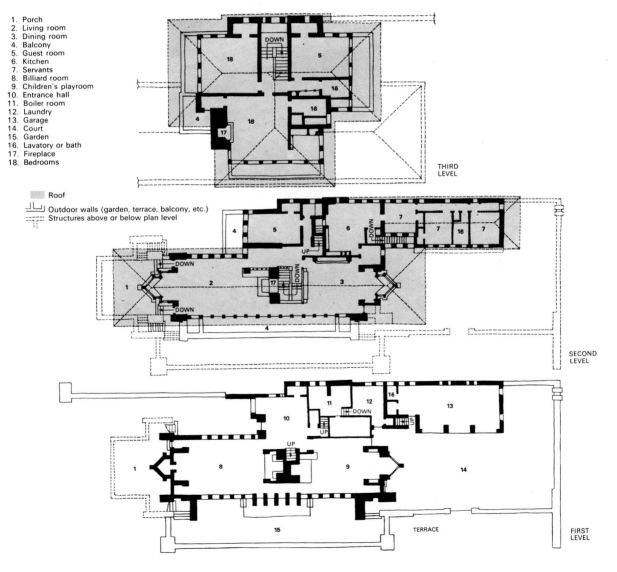

1. Porch
2. Living room
3. Dining room
4. Balcony
5. Guest room
6. Kitchen
7. Servants
8. Billiard room
9. Children's playroom
10. Entrance hall
11. Boiler room
12. Laundry
13. Garage
14. Court
15. Garden
16. Lavatory or bath
17. Fireplace
18. Bedrooms

Roof
Outdoor walls (garden, terrace, balcony, etc.)
Structures above or below plan level

The International Style

World War I had been the dividing line for European architecture, eliminating the blind alley of Art Nouveau and bringing Wright's ideas into broad acceptance and eager expansion. Until even after World War II, American and European architects would practice what could be called an International style, so close were they in agreement upon fundamental principles. One of these is the new principle of *structure*. In the modern building the great tensile strength of steel and the great crushing (or compression) strength of concrete are employed together to support enormous loads. The steel framework obviates the historic necessity of bracing thrust pressures with resisting mass and makes heavy bearing walls unnecessary, so that the walls become mere screens or "curtains." The long cantilever, another product of the use of steel, can reach out into space with support at only one end; and with the development of prestressed concrete,[13] load and support become one. Thus, the demands of stability and support can be subordinated to concerns of utility and esthetics as never before in the history of architecture.

Another of the principles basic to the International style deals with a radically different approach to the *plan*. The enormous strength of the new building materials now at the architect's disposal give him an unprecedented flexibility in the planning of the interiors of his buildings. With steel and concrete, spans without interior supports can be constructed on a scale that goes far beyond the wildest dreams of earlier builders. The resultant interior space can be arranged and rearranged with movable, nonbearing partitions or thrown open completely for an "open plan." Glass "walls" often make interior and exterior ambiguous in their relationship. "Out" and "in" become relative, as did "forward" and "back" in Cubist art. New demands are placed on the

viewer: He must move through the interior in order to comprehend its "wandering" space-flow.

Third of the principles animating the International school was the architectural philosophy of *functionalism*. In this view, naturally related to the new approaches to structure and design, the function of the building is conceived as coming first and determining the building's form. Thus, there is no given form into which a function is made to fit; a building cannot be made that will function just as well as an art school, a hospital, and a warehouse. The functions to be enclosed must be particularized and then a building designed that encloses and expresses beautifully those functions. Just as the plan is determined first by the space, so the function of the building —the activities that are to take place in it— must dictate form. The parts of the building should distinguish visually between its functions; for example, its servant spaces should be distinct from its primary spaces.

The essentials of the problem stated above and the solution are graphically shown in the 1914 drawing (FIG. 17-50) by the Swiss architect Charles Edouard Jeanneret-Gris (1887–1965), called LE CORBUSIER. A Cubist painter as well as an influential writer on modern architecture, Le Corbusier applied himself principally to the design of the "functional" house, which he described, in a phrase that acquired wide currency, as a "machine for living." The drawing shows the skeleton of a dwelling in which the properties of ferro-concrete have been utilized with maximum efficiency. Reinforced concrete slabs, serving the double function of ceiling (for the lower story) and floor (for the upper), are supported by steel posts that rise freely through the interior space of the structure. Exterior walls can be suspended from the projecting edges of the concrete slabs like free-hanging curtains. Because the skeleton is self-supporting, the architect has complete freedom to subdivide the interior as he wants with nonbearing walls. Furthermore, the unit shown can be repeated almost indefinitely (as a kind of module) both horizontally and vertically, as indeed it is in most modern office buildings and skyscrapers. (See FIGS. 17-57 and 17-58). While Le Corbusier did not invent the system shown (it had been anticipated about half a decade earlier by Peter Behrens, with whom Le Corbusier

[13] In *reinforced concrete*, steel bars are embedded in concrete, and the resulting member combines the respective *tensile* and *compression* strengths of the two materials. In *prestressed concrete*, the embedded bars are fastened at the ends of the member in such a way that they are kept under tension, thus increasing tensile strength.

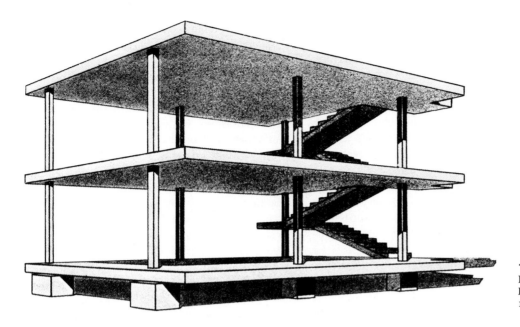

17-50 Le Corbusier, Perspective Drawing for Domino House Project, 1914.

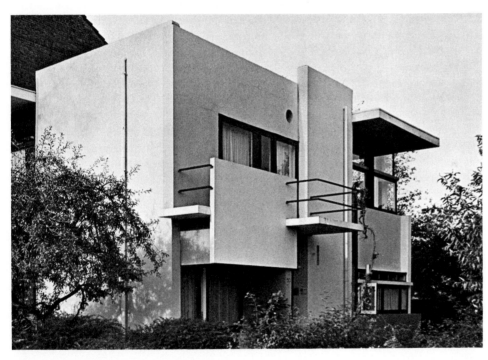

17-51 Gerrit Rietveldt, Schroeder House, Utrecht, 1924.

worked in his early career, and by Walter Gropius), the drawing states clearly the basic structural principles on which much of twentieth-century architecture is based.

Early examples of the International style show its very close relationship to Cubist and formalist developments in painting. The Schroeder House at Utrecht in Holland (FIG. 17-51), built in 1924 by GERRIT RIETVELDT (1888–1964), shows the influence of painters like Mondrian and Van Doesburg and De Stijl purists, and the influence—in its sweeping planes and overhanging roofs—of

Frank Lloyd Wright. A severe and doctrinaire insistence upon the rectilinearity of the planes, which seem to slide across each other like movable panels, makes of Rietveldt's house a kind of three-dimensional projection of the rigid but carefully proportioned flat planes in Mondrian's paintings. Ornament is of course entirely banished; Adolph Loos, a forerunner of this kind of purist trend, equated ornament with "crime." A triumph of International purism is the Villa Savoye (FIG. 17-52) at Poissy, near Paris, by Le Corbusier. The building is a cube of lightly enclosed and deeply penetrated space, supported, at least visually, on thin columns (called *pilotis*), a seemingly deliberate analogy with the isolated, "machined" space of an ocean liner; the flat roof-terrace may appropriately be called a "deck," as the modern flat roof now commonly is. There is no façade; the approach does not define an entrance, and one must walk around and through the building to comprehend its layout. Spaces and masses interpenetrate so fluently that there is the familiar Internationalist ambiguity of "inside" and "outside." The machine-planed smoothness of the surfaces, entirely without adornment, the slender "ribbons" of continuous window, the buoyant lightness of the whole fabric, present a total effect the very reverse of the traditional country house (compare Palladio's Villa Rotunda and Vanbrugh's Blenheim). There are no basement walls of masonry; the "load" hovers lightly upon its slender supports, the inverse of the traditional scheme where the light elements are above and the heavy below. Le Corbusier's use of color—dark-green base, cream walls, and rose and blue superstructure (a windscreen)—is a deliberate analogy with contemporary painting, in which he was actively engaged.

The Villa Savoye is set conspicuously within its site, tending to dominate it, and has a broad view of the landscape. In this way it *does* resemble the Palladian villa and sharply contrasts with Frank Lloyd Wright's dwellings, which hug and adjust to the landscape, almost as if they were intended to be part of it and concealed by it. Wright's Kaufmann House (FIG. 17-53), built at Bear Run, Pennsylvania, in 1939, crouches within its isolated woodland site, reaching out almost protectively over a little waterfall. The machine-planed decks of the International style function like the broad overhanging roofs of the Robie House, meeting and intersecting dramatically. Although he disliked the cubic regularity of the International style, Wright here makes a virtue of the contrast between the sharp, clean lines and planes of the International deck with the rockwork and freely falling water of the natural site. Thus Wright's customary naturalism, his love of free and irregular forms, the "organic" in its unspoiled setting, is beautifully adjusted to the severe regularity of the European designs, as if he were editorializing on the International style.

Wright accepted the machine as a challenge to be met, but he warned against being overcome by it. In Europe, architecture was long dominated by what might be called the romanticism of the machine. Le Corbusier's vision of the house as a "machine for living" expresses this, and we have

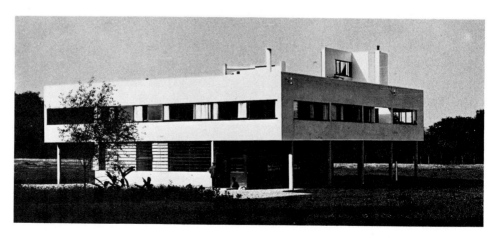

17-52 LE CORBUSIER, Villa Savoye, Poissy-sur-Seine, 1929.

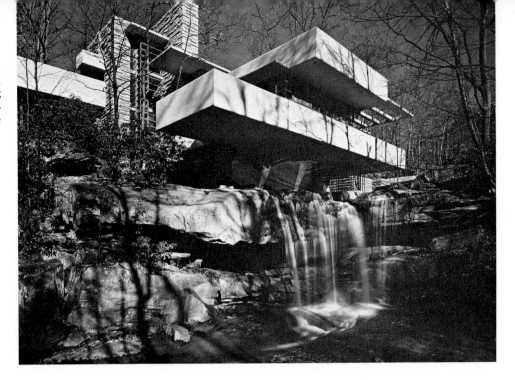

17-53 Frank Lloyd Wright, Kaufmann House ("Falling Water"), Bear Run, Pennsylvania, 1936–39.

seen the broad influence of machine design and dynamics on painting and sculpture. In German architecture particularly, in the factories and industrial buildings of Behrens and Gropius, there is revealed a deep respect for the machine, its parts precisely tooled, seemingly unrelated, and functioning only as parts of a whole. This may be seen in the Bauhaus in Dessau, Germany, which was originally founded in 1906 as the Weimar School of Arts and Crafts by the Dutch architect-designer Henry van de Velde (1863–1957). He was an outstanding representative of Art Nouveau, and his educational program emphasized craftsmanship along with free creativity and experimentation. Van de Velde left Weimar at the outbreak of World War I and recommended a young German architect, Walter Gropius (1883–1969), as his successor. Gropius assumed the directorship of the school in 1919; he reorganized the various departments of the original school under the new name of Das Staatliche Bauhaus, Weimar, and in 1925 moved it to the newly built quarters in Dessau (Fig. 17-54). The redesigned curriculum stressed the search for solutions to contemporary problems in such areas as housing, urban planning, and high-quality, utilitarian mass production—all vital needs in impoverished post–World War I Germany. Under the guidance of

Lyonel Feininger, Kandinsky, and Klee, the Bauhaus, which takes its name from the German word for building (bau), offered courses not only in architecture, but also in music and drama, and, in particular, painting. In design, handicraft was considered the natural training device for mass production and the natural basis for experimental models leading to industrial products. In these respects, and in the minimizing of philosophy and other "verbal" disciplines, the Bauhaus was the earliest working example of much that is still sought in design education. Its training was rooted in the Arts and Crafts movement of earlier generations and in Friedrich Froebel's and others' work with children's art, but its vision was firmly fixed on the requirements and potentialities of its day.

Gropius' design for the Bauhaus buildings, which included a workshop, a studio, a school, and an administrative office, firmly established the principles of the International style, an expression of the machine age as the Europeans of the 1920's wished to see it. Planned as a series of cells, each with its own specific function, it is the direct expression, in glass, steel, and thin concrete veneer, of the technical program (that is, the function) of the building. The forms are clear, cubic units—the epitome of classicizing purity.

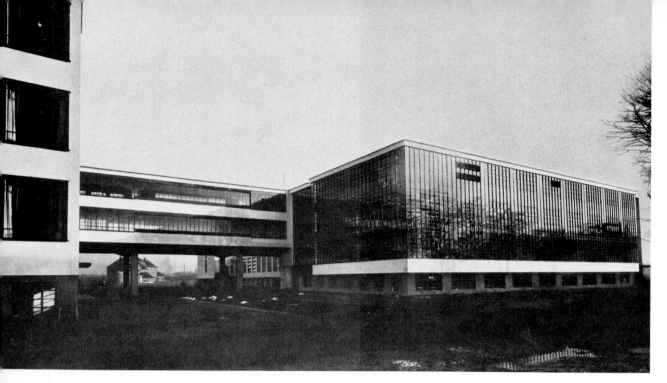

17-54 WALTER GROPIUS, shop block, the Bauhaus, Dessau, 1925–26.

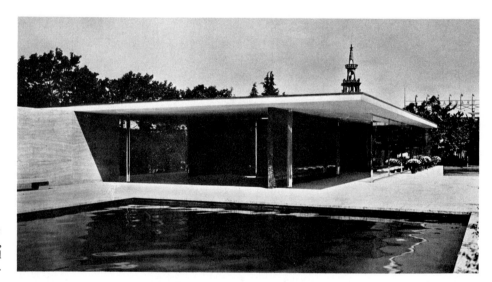

17-55 LUDWIG MIES VAN DER ROHE, German Pavilion, Barcelona International Exhibition. 1929.

The workshop block (FIG. 17-54) is a cage of glass that extends beyond and encloses its steel supports in a realization of Le Corbusier's early schematic sketch (FIG. 17-50). Here the new concept of flexible structure triumphs. The transparent block makes an equilibrium of inner and outer space.

In the work of LUDWIG MIES VAN DER ROHE (1886–1969) the International style found its most imaginative solutions and perhaps a new order. His German Pavilion (FIG. 17-55), built for the International Exposition at Barcelona in 1929, has a program—an information center and rest house—so simple that the architect was able

17-56 GEORGE HOWE and WILLIAM E. LESCAZE, Philadelphia Savings Fund Society Building, Philadelphia, 1931–32.

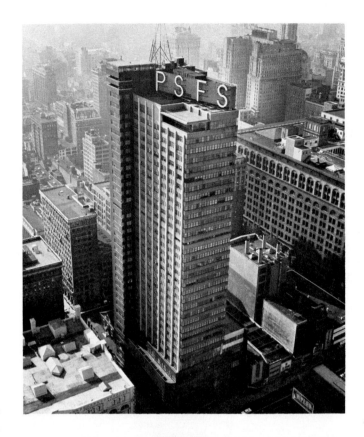

to concentrate almost exclusively (as is the case in many exposition buildings) on the dramatic principles of the new style. Fine stone and marble, chromium and glass, water and sculpture molded the space and subtly led the visitor through a succession of areas that varied in their degree of enclosure, now open on several sides, now closed by two, three, or four walls. Grace and elegance, refined and subtle harmonies, were realized to a degree comparable to that in such eighteenth-century masterpieces as the Hôtel de Soubise (FIG. 15-62) and Robert Adam's Osterley Park House (PLATE 16-1), but in this instance in a language and spirit wholly of the twentieth century.

Though American architecture had not kept up with the progressive International style during the 1920's, the example of its mighty skyscrapers had stimulated the imagination of European architects. For a time the typical American skyscraper was clothed in traditional stylistic features, but something of the new International manner appeared just at the end of the skyscraper age in the early 1930's. A good example is the Philadelphia Savings Fund Society Building (FIG. 17-56) by Howe and Lescaze, in which the horizontal banding, ribbon windows, and clean geometrical planes of the International style appear along with the soaring scale of the American urban office building. Mies van der Rohe had been inspired by the skyscraper as early as 1920, when he made a startlingly beautiful model for a glass building (FIG. 17-57), a work that was never carried out but which showed a profound understanding of the technical and esthetic possibilities of steel, glass, and concrete in symphonic relationship. The structure's transparency—which may have influenced Gropius' Bauhaus design (FIG. 17-54)—the weblike delicacy of its lines, its radiance, and the illusion of movement created by reflection and by light-changes seen through it prefigure the contemporary glass skyscraper slabs of our major cities. Indeed the model anticipates by thirty years Mies's design (carried out in collaboration with Philip Johnson) of the Seagram Building (FIG. 17-58), built in New York City in 1956-58. The towering, prismatic block, raised on

17-57 LUDWIG MIES VAN DER ROHE, model for a glass skyscraper, 1920–21. Present location of model unknown.

17-58 LUDWIG MIES VAN DER ROHE, Seagram Building, New York, 1956–58.

performed by thousands of human beings revealed in a luminous cage of glass that, at the same time, serves as a vast, almost pictorial reflective surface that mirrors the titanic city. Enclosure and disclosure are simultaneous; the building is the perfect expression of an anonymous public world articulated by innumerable impersonal functions. Yet Mies, no matter his belief that architectural beauty may be as impersonal as its function, spared no pains in his attention to detail, for "God," he said, "dwells in the details."

SCULPTURE AND PAINTING AFTER WORLD WAR II

Since World War II brilliant variations have been made upon the great central themes stated in the classical age of modern art, when most of our contemporary artists were born. The shock of the war and its "cold" aftermath, the persisting threat of atomic annihilation, the widening recognition of human suffering in a large part of the world, and a haunting fear among many that life has no meaning or value have sharpened the protest of highly sensitive artists against a mechanized culture that often appears to have no place in it for the nonconforming individual. Expressionism becomes harsher, more defiant and rebellious; Dadaistic satire, more bitter; and formalistic art insists on an ever more radical abstraction from the world of appearance. As European-American civilization broadens into world civilization a crisis of values is taking place—or, rather, continues to take place. Traditional values and the values of organized modern life are criticized mercilessly and declared to be largely false. It is almost as if the only value left is the belief in the artistic process itself on the grounds that in creativity alone resides true humanity. The artist's way of life becomes a possible model for all human life, with its religion of free expression, its pursuit of identity and self-knowledge through art, and its overtones of prophetic mysticism. On the other hand, neither art nor artist

piers, is measured out in modular units, each detail of surface and silhouette dictated by Mies's sense for the purity of straight line and uncomplicated rectilinear shape. Here is completed the evolution of function-form, the myriad operations

has escaped the peculiar dynamics of modern society. Art has become a big business, and the artist might sometimes be thought of as a kind of piece-work employee of ambitious and commercially minded galleries. The work of art becomes a commodity on the art "market," and methods familiar to modern advertising promote it. The old divisions between the arts are vanishing: Painting, sculpture, and architecture interfuse, and all are increasingly bound to developments in technology. The revolution that began even before the century itself continues at an ever more rapid pace.

It is of course impossible to do historical justice to contemporary events, especially when the men and women who create them are still living. The selection and presentation of certain contemporary monuments suggests that a judgment of their superiority has already been made by history. This is not the case; historical judgment moves slowly, and its selection of the touchstone masterpieces of the epoch has scarcely begun for the twentieth century.

At first glance, developments in sculpture and painting after World War II seem all confusion, with bewildering overlaps and intersections of tendencies and influences. Yet closer study reveals a certain order susceptible of at least rough classification. This order appears as a fundamental (though by no means clear-cut) dualism that seems to arise in the work of the fathers of modern art, Cézanne on the one hand, Gauguin and Van Gogh on the other. One can believe it is the old familiar dualism in Western art between classicizing formalism directed by intellect and baroque-romantic expressivism prompted by sensation and feeling.

As indicated in the chart of twentieth-century art (p. 770), Cubism and Expressionism and the styles derivative from them dominated the art of the first half of the century (the period before World War II). Some semblance of order can be brought into the seemingly chaotic profusion of post-war trends and styles by grouping them on the basis of the approach of the artist to his medium, which can be either predominantly rational-formalistic or predominantly emotional-expressive. Accordingly we have grouped most of the postwar trends as descendants of either Cubism or Expressionism (though we are aware of the cross-currents and interchanges of influence) under the generic headings Abstract Formalism and Abstract Expressionism. Admittedly the organization is rough and oversimplified and undoubtedly subject to future modifications as increasing distance from contemporaneous events allows us to view them with greater detachment.

Expressionism: Figural and Abstract

Against the Constructivist depersonalizing of the work of art and against the prevailing social realism, Expressionists after World War II strenuously asserted the artist's personality, individuality, identity, even pathology. In this they had the example and the precepts of the distinguished tradition of Expressionism going back to Gauguin, Van Gogh, Kandinsky, and their contemporaries and successors. But among the later artists the Expressionist conviction and method seem stronger. Basically, setting them apart from the earlier Expressionists is the question whether to retain the human figure and related images, or to banish them altogether from painting. The Expressionists accepting the first alternative can be conveniently designated "figural"; the others, "abstract."

The distortion of the human figure in painting for the purpose of the expression of strong emotion is, as we have seen, a very old practice in Western art and by no means solely a modern invention. That distortion works strongly in many works of the British painter FRANCIS BACON (b. 1910), in which is expressed an excruciating crisis of nerves that goes well beyond Munch, for example, in its emphasis. A subject that Bacon often returns to is the human being locked in a boxlike space by a malignant, glittering mesh of spectral light rays. His 1953 *Number VII from Eight Studies for a Portrait* (FIG. 17-59) shows us Pope Innocent X (from the Velasquez portrait) as if restrained by a straitjacket and capable of no action but a continuing, dreadful scream. The picture is an almost unbearable image of insane terror. Our age is the "age of psychology" and it is obsessed as perhaps no other age before it with the fear and the fact of mental illness.

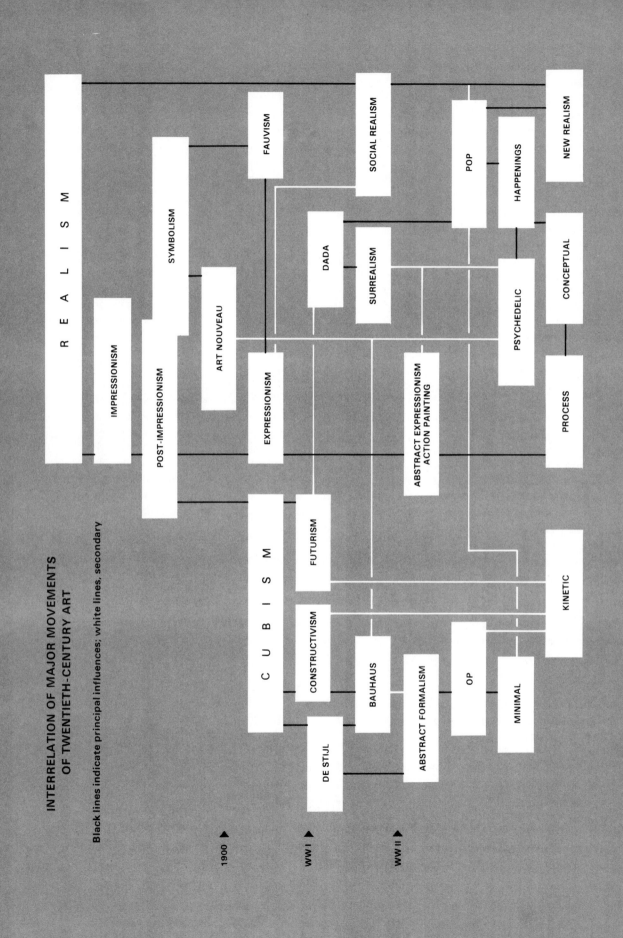

INTERRELATION OF MAJOR MOVEMENTS
OF TWENTIETH-CENTURY ART

Black lines indicate principal influences; white lines, secondary

R E A L I S M

C U B I S M

IMPRESSIONISM

POST-IMPRESSIONISM

SYMBOLISM

ART NOUVEAU

FAUVISM

EXPRESSIONISM

SOCIAL REALISM

DADA

SURREALISM

POP

HAPPENINGS

NEW REALISM

PSYCHEDELIC

ABSTRACT EXPRESSIONISM
ACTION PAINTING

CONCEPTUAL

PROCESS

FUTURISM

CONSTRUCTIVISM

BAUHAUS

DE STIJL

ABSTRACT FORMALISM

OP

MINIMAL

KINETIC

1900

WW I

WW II

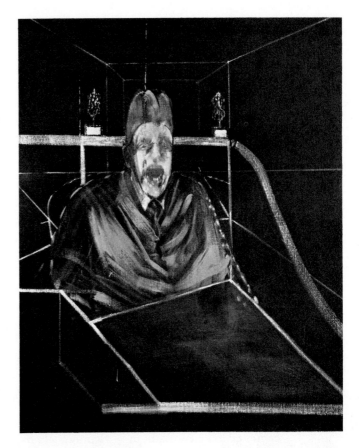

17-59 Francis Bacon, *Number VII from Eight Studies for a Portrait*, 1953. Oil on canvas, approx. 60″ × 46⅛″. Collection, Museum of Modern Art, New York (gift of Mr. and Mrs. William A. M. Burden).

The construction of the new art seems almost to have required the destruction of the ideals of the old; thus destructiveness, as Gertrude Stein recognized, plays a large role in the new art's vitality: "everything destroys itself in the twentieth century, and nothing continues...." (*Cf.* Tinguely's *Homage*, p. 782.) This wide destruction involves not only the Cubist shattering of perspective and the denial that there is only one perspective; it also dismisses the traditional notion—both Greek and Renaissance—of beauty in art as being a reflection of human beauty, for, as Gauguin thought, beauty in this sense is nothing but a lie. The Expressionist artist is only too aware of pain and suffering in his age. Thus the French painter Jean Dubuffet (b. 1901) gives the lie to human beauty in his 1950 *Nude, Olympia* (fig. 17-60), a brutally distorted, primitivistic-fetishistic version of that venerable tradition of the female nude that goes back to the Venetians. Dubuffet's medium and technique suit the harsh crudity of his forms. Having in mind the graffiti of Paris walls, the accidental collages built upon their surfaces with posters and fragments of posters, smeared, scrawled over and cut into, Dubuffet prepared a coarse ground of sand, earth, glues, and other materials into which he roughly incised his figures, making use of every accident in the process. Treated this way, the surface becomes a tactile reality in itself, at the same time manifesting figural and symbolic shapes of primeval power or, as here, of hideous decomposition. The message of this work is echoed in the view of the novelist Louis-Ferdinand Céline, a contemporary of Dubuffet, who saw human nature as essentially vile. As he expressed it in his appalling *Journey to the End of the Night*, when people are off guard and unrestrained, one sees in them what "you see on a pretty beach when the tide goes out: reality, heavy-smelling pools of slime, the crabs, the carcasses, the scum."

Although his intuitive manner of painting seems related to the methods of the Abstract Expressionist painters, Dubuffet, like Bacon, is largely independent of international Abstract Ex-

17-60 Jean Dubuffet, *Nude, Olympia*, 1950. Oil on canvas, approx. 45¾″ × 35″. Collection of Mrs. M. Victor Leveritt.

pressionism and provides a kind of figural reaction against the movement's more abstract tendencies. Abstract Expressionism carries all before it after World War II, especially in America, to which the artistic center of gravity appears to shift from Europe. The style or, rather, method has its roots in Kandinsky's automatic and spontaneous nonobjectivity and his mystical interpretations of color and line. (The label "Abstract Expressionism" was attached to Kandinsky's art as early as 1919.) It also owes much to Surrealists like Max Ernst, who experimented with chance effects of manipulating paint and surface in ways other than by the brush. Most immigrant European artists in the thirties and forties were Constructivists like Mondrian. On the other hand, HANS HOFMANN (1880–1966) developed in his later years in America an expressionistic method of painting that directly preceded the native American school of Abstract Expressionism and had a deep influence on it. Hofmann's double career as artist and art teacher spanned two generations and two continents. As a young man he was the associate and friend of the founders of abstract art—Matisse, Braque, Picasso, Delaunay. Later, in America, he became an influential teacher and expressed his new ideas in a vigorous, almost violent method of painterly attack. He charges his surfaces with primary color of unparalleled richness, in jolting contrasts and conflicts, painting impastos densely and with dashing spontaneity, leaving each stroke or splash unmodified. The painted surface becomes only that—a record of the artist's intense experience of the process of painting, arbitrary, accidental, unthinking, automatic, direct. In *Effervescence, 1944* (PLATE 17-12) Hofmann mixes media (oil, india-ink, casein, enamel)—a method common in Abstract Expressionist painting. Colors explode in a chaos controlled only by the picture frame—a chaos that seems to have sucked the artist into its swirl and to have painted itself.

Hofmann's method in effect produces painting that is a record of the producing action—one could almost say a *picture* of that action. This is the rationale behind the designation "action painting," attached to many Abstract Expressionist works. Painting is thus a largely uncontrolled, prerational action or event; the process of painting becomes more real than the painted surface.

An artist who certainly must have subscribed to this "action" view and who was the central figure of the New York School in the late forties and fifties was JACKSON POLLOCK (1912–1956). Pollock had once practiced the Social Realism of Siqueiros; his abrupt turnabout to Abstract Expressionism typifies the post-war situation in the arts. At the height of his powers, in the years before his untimely death in 1956, Pollock shared with his brilliant colleagues in New York a collective achievement that has been called the most original and distinctive in the history of American art. The principal method in American Abstract Expressionism—for there were other methods— was the painting-action revealed through the brush gesture and the signature left by the fall and touch of the paint. Pollock would roll out a large canvas on the floor and drip and splatter paint upon it while he himself was in energetic motion along its edge or sometimes within it. For him, the expression of the artist's whole content, which is inward, is directed by mysterious psychic forces; hence, in his view, to label the look of such painting "accidental" would be misleading. Yet there is something of the mystique of the materials (cf. Brancusi) motivating the action painter; the random fall and scatter of the paint emphasizing the liquid nature of the medium itself, which enters into the sum of the painting's qualities. The jarring dynamism of the large-scale paintings, in turn, echoes the restless —perhaps rootless—life style of the postwar years. It manifests too in its extremely personal nature the interest of many expressionistic artists in Existentialism, the widely adopted philosophy of the post-war years that stressed absolute freedom of choice in life and art as a human commitment.

In an early (1947) example of Pollock's art, his *Lucifer* (PLATE 17-13), the materials are oil, aluminum paint, and enamel dragged, dripped, and splattered from well above the surface in a process of excited movement that has in its tracing and retracing a remarkable coherence of direction and pattern. The painter strives for unplanned immediacy and directness and for an effect of unstudied spontaneous freshness of

Color Plates 16-6 to 22-5

Other plates are distributed as follows:
1-1 to 6-4, after page 176; 6-5 to 13-5, after page 364; 13-6 to 16-5, after page 584

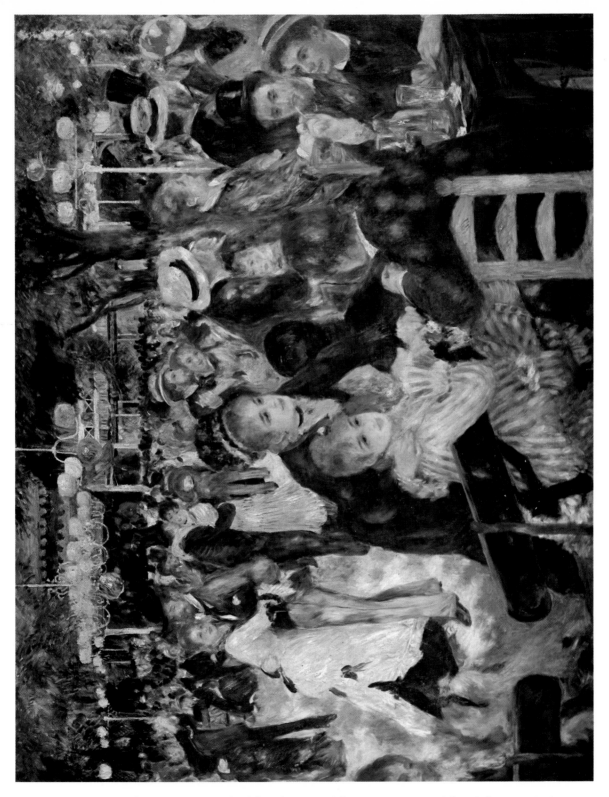

Plate 16-6 Auguste Renoir, *Le Moulin de la Galette*, 1876. Oil on canvas, approx. 5' 8" × 4' 3". Louvre, Paris.

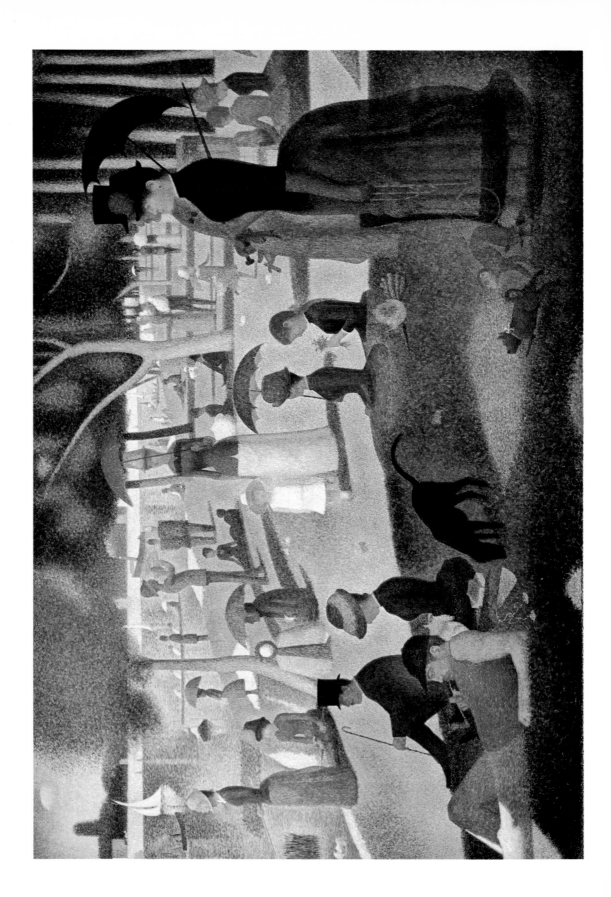

Plate 16-7 Georges Seurat, *Sunday Afternoon on the Island of La Grande Jatte*, 1884–86. Oil on canvas, approx. 8′ 9″ × 10′. Art Institute of Chicago (Helen Birch Bartlett Memorial Collection).

Plate 16-8 Paul Cézanne, *Still Life*, c. 1890. Approx. 26″ × 32⅜″. National Gallery of Art, Washington, D.C. (Chester Dale Collection, 1962).

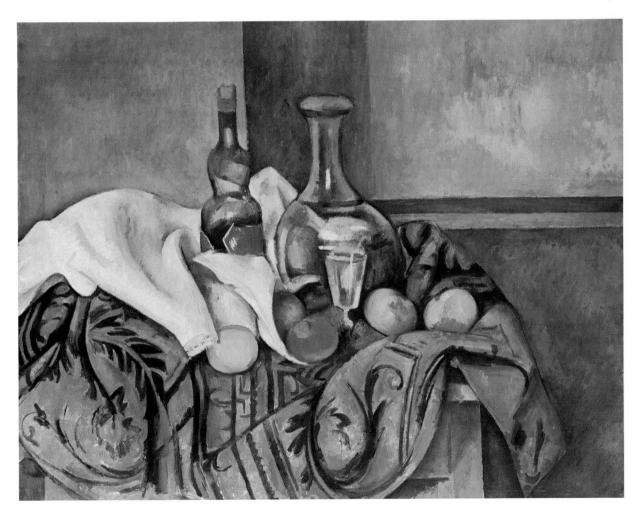

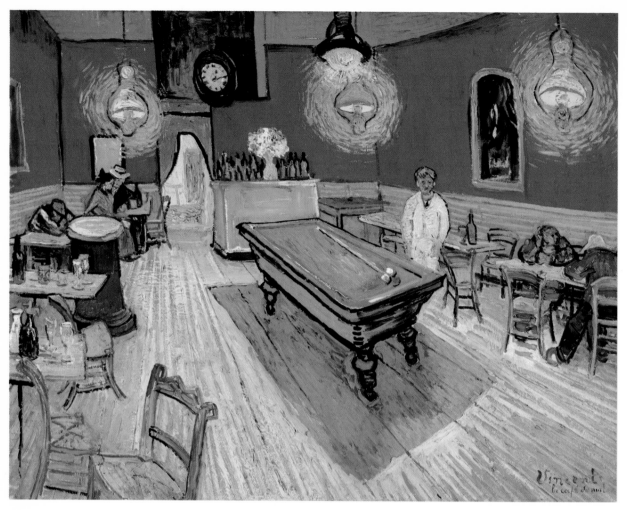

Plate **16-9** Vincent van Gogh, *The Night Café*, 1888. Oil on canvas, approx. 28½″ × 36¼″. Yale University Art Gallery, New Haven, Connecticut (bequest of Stephen Carlton Clark, B.A., 1903).

Plate 16-10 Paul Gauguin, *The Spirit of the Dead Watching*, 1892. Oil on canvas, approx. 38¾" × 36¼". Albright-Knox Art Gallery, Buffalo (A. Conger Goodyear Collection).

Plate 16-11 Henri de Toulouse-Lautrec, *At the Moulin Rouge*, 1892. Oil on canvas, approx. $48\frac{3}{8}'' \times 55\frac{1}{4}''$. Art Institute of Chicago (Helen Birch Bartlett Memorial Collection).

Plate **17-1** Gustav Klimt, *Death and Life*, 1908 and 1911. Oil on canvas, 70″ × 78″. Collection of Marietta Preleuthner, Salzburg.

Plate **17-2** ANDRÉ DERAIN, *London Bridge*, 1906. Oil on canvas, approx. 26″ × 39″. Collection, Museum of Modern Art, New York (gift of Mr. and Mrs. Charles Zadok).

Plate **17-3** HENRI MATISSE, *Red Room (Harmony in Red)*, 1908–09. Approx. 71″ × 97″. State Hermitage Museum, Leningrad.

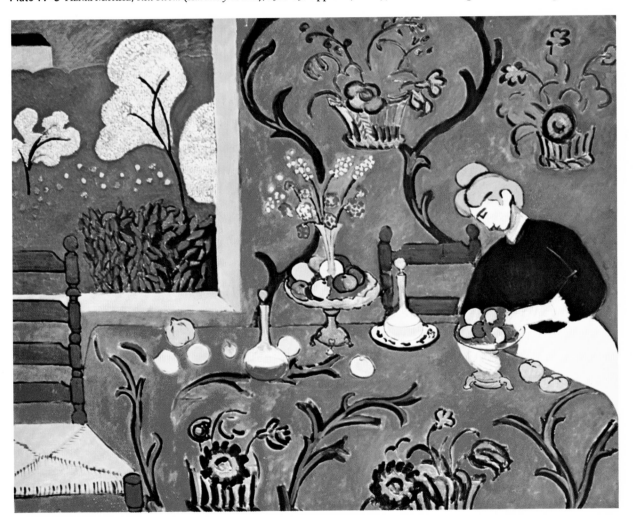

Plate 17-4 Georges Rouault, *The Old King*, 1916–38. Oil on canvas, approx. $30\frac{1}{4}'' \times 21\frac{1}{4}''$. Collection, Museum of Art, Carnegie Institute, Pittsburgh (Patrons Art Fund).

Plate **17-5** Oscar Kokoschka, *The Bride of the Wind*, 1914. Oil on canvas, $71\frac{1}{2}'' \times 86\frac{1}{2}''$. Kunstmuseum Basel, Basel.

Plate 17-6 EMIL NOLDE, *St. Mary of Egypt Among Sinners*, left panel of a triptych, 1912. Approx. 34″ × 39″. Kunsthalle, Hamburg.

Plate 17-7 Vasily Kandinsky, *Improvisation 28*, 1912. Oil on canvas, approx. 44″ × 63¾″. Collection, Solomon R. Guggenheim Museum, New York.

Plate 17-8 PABLO PICASSO, *Three Musicians*, 1921. Oil on canvas, approx. 6′ 7″ × 7′ 3¾″. Collection, Museum of Modern Art, New York (Mrs. Simon Guggenheim Fund).

Plate 17-9 GEORGES BRAQUE, *The Table*, 1928.
Oil on canvas, approx. 70¾" × 28¾".
Collection, Museum of Modern Art, New
York (bequest of Lillie P. Bliss).

P M 36

Plate 17-10 Piet Mondrian, *Composition in Blue, Yellow, and Black,* 1936. Oil on canvas, approx. 17″ × 13″. Kunstmuseum, Basel (Emmanuel Hoffman-Stiftung).

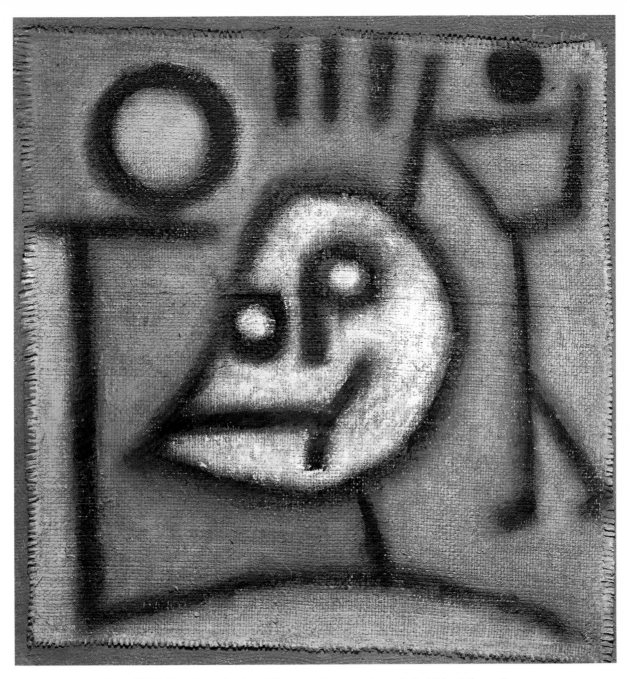

Plate 17-11 Paul Klee, *Death and Fire*, 1940. Approx. 18″ × 17″. Paul Klee-Stiftung, Bern.

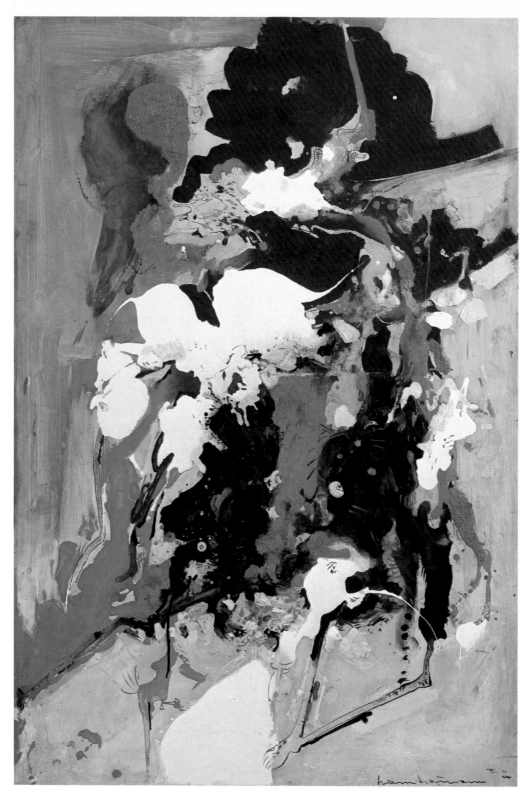

Plate 17-12 HANS HOFMANN, *Effervescence*, 1944. Oil, India ink, casein, and enamel on plywood, $54\frac{1}{2}'' \times 36''$. University Art Museum, Berkeley, California.

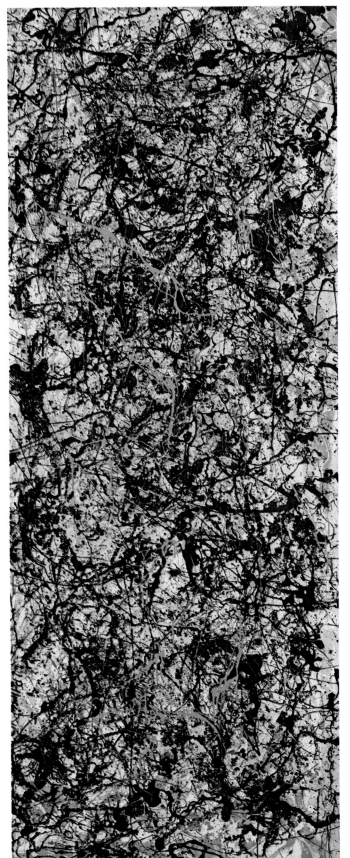

Plate 17-13 JACKSON POLLOCK, *Lucifer*, 1947. Oil, aluminum paint, and enamel on canvas, approx. 41″ × 81″. Collection of Harry W. Anderson.

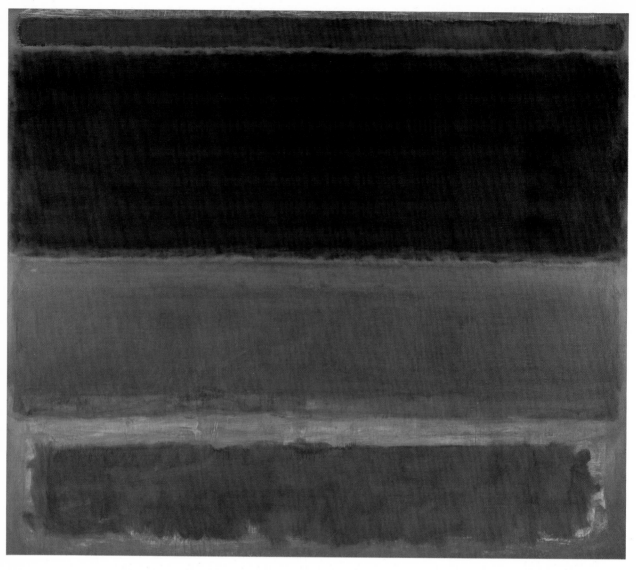

Plate 17-14 MARK ROTHKO, *Four Darks on Red*, 1958. Oil on canvas. 102″ × 116″. Collection of the Whitney Museum of American Art (gift of the Friends of the Whitney Museum of American Art, Mr. and Mrs. Eugene Schwartz, Mrs. Samuel A. Seaver, Charles Simon, and purchase).

Plate 17-15 Ellsworth Kelly, *Red, Blue, Green*, 1963. Oil on canvas, approx. 7′ × 11′ 4″. Courtesy of the Sidney Janis Gallery.

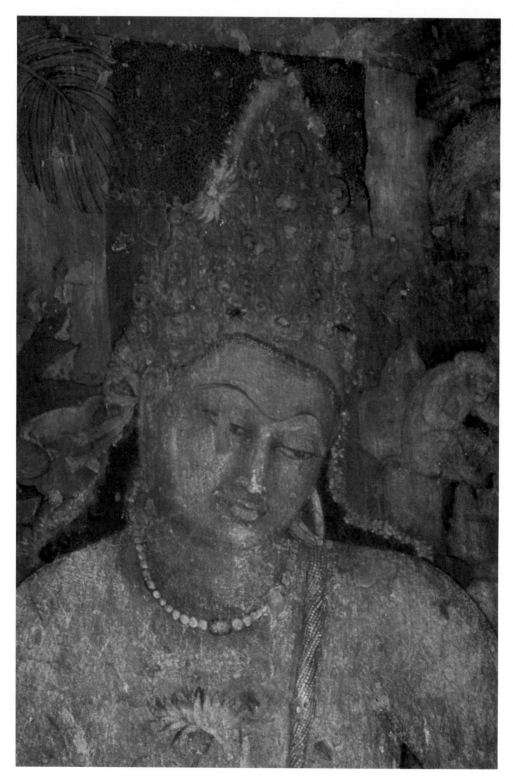

Plate 18-1 *Beautiful Bodhisattva Padmapani*, fresco from Cave 1, Ajanta, 600–650.

Plate 18-2 *The Disappointed Mistress, c.* 1740. Gouache, 8¼″ × 6″. Private collection, Los Angeles.

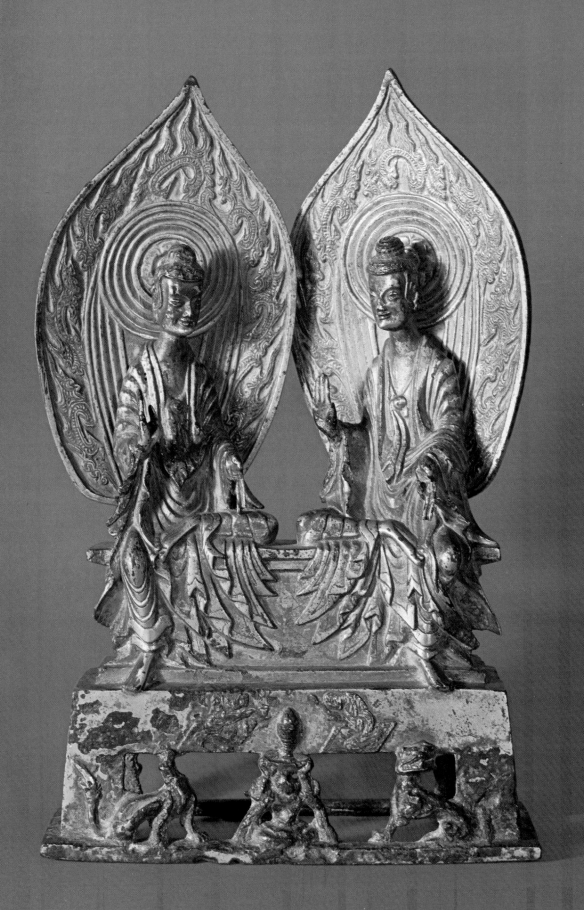

Plate **19-1** *Prabhutaratna and Śākyamuni, c.* 518.
Gilt bronze, 10½″ high. Musée Guimet, Paris.

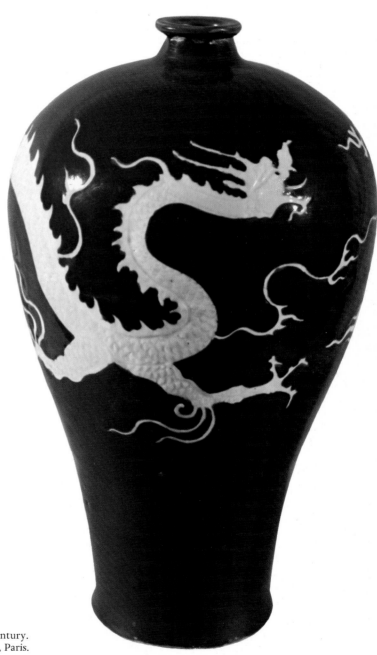

Plate **19-2** Vase, Ming dynasty, fourteenth century.
Cobalt blue glaze on porcelain. Musée Guimet, Paris.

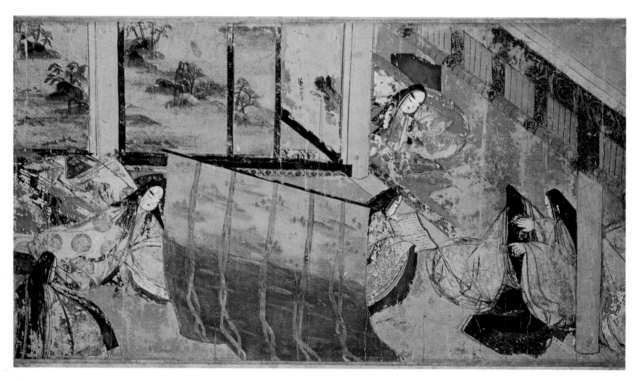

Plate 20-1 TAKAYOSHI, detail of *The Tale of Genji*. Late Heian period, twelfth century. Scroll, color on paper, $8\frac{1}{2}'' \times 15\frac{3}{4}''$. Tokugawa Museum, Nagoya.

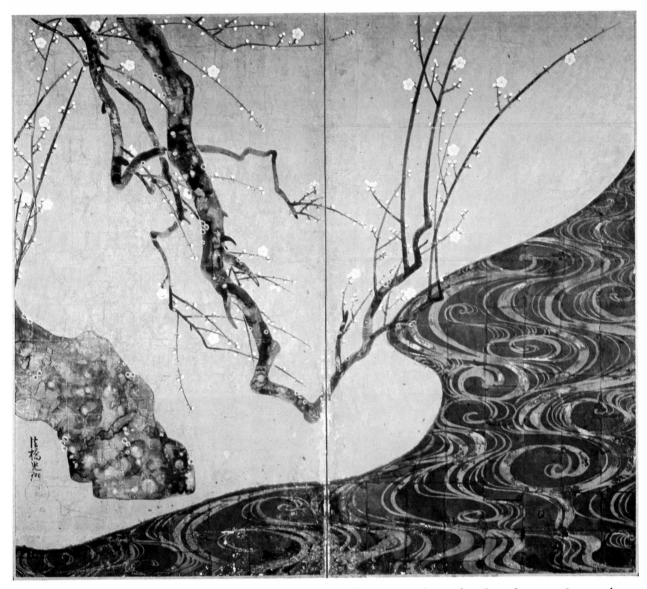

Plate 20-2 OGATA KŌRIN, *White Prunes in the Spring*, Tokugawa period, late seventeenth to early eighteenth century. Screen, color on gold paper, 62″ high. Tokyo National Museum.

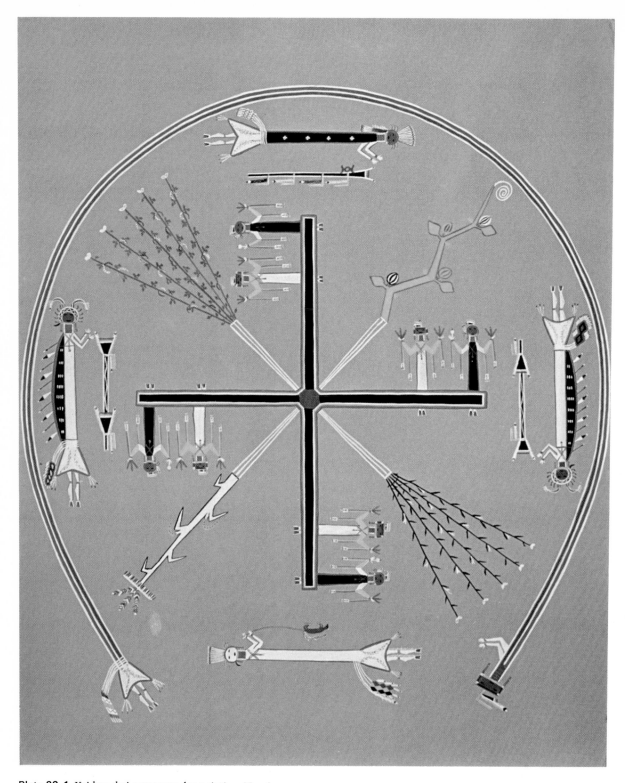

Plate 22-1 Yei-bet-chai ceremony dry painting, Navajo, 1952.

Plate 22-2 KARL BODMER, *Mandan Chief Mato-Tope*, 1840. Lithograph, 10″ × 14″. Thomas Gilcrease, Institute of American History and Art, Tulsa.

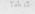

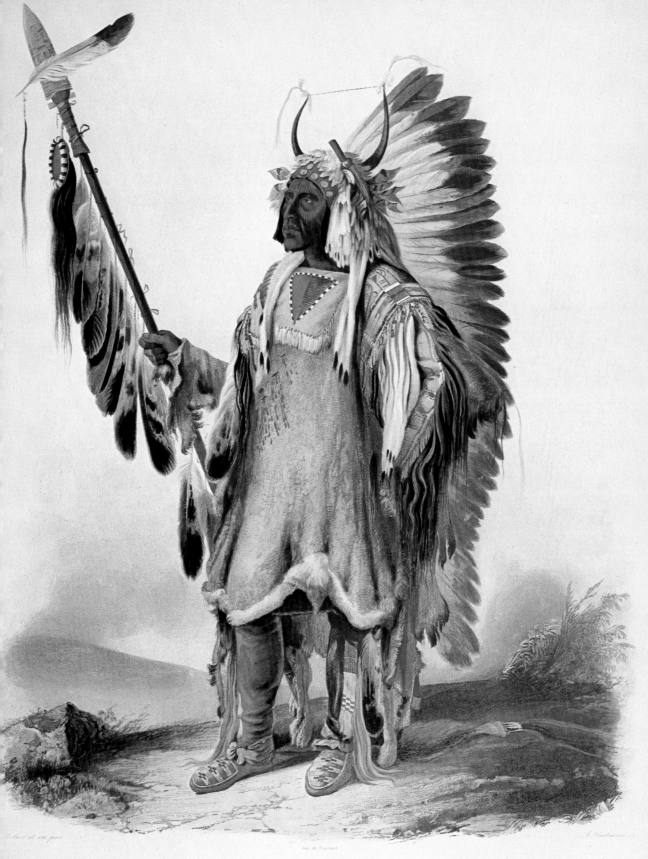

Tab 13.

MATÓ-TOPE

Mandan Chief *Chef Mandan*

A MANDAN CHIEF.

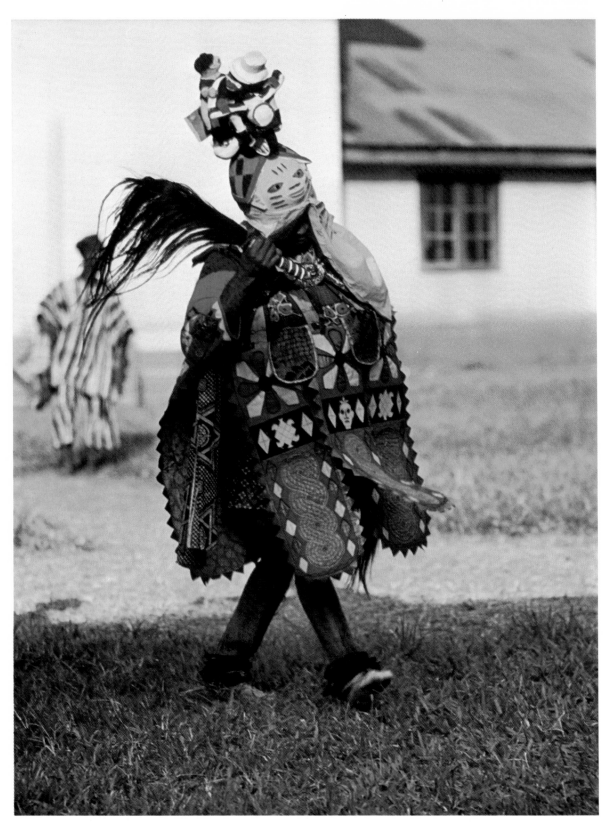

Plate 22-3 Dancer of the gelede society of Meko, Yoruba, 1969.

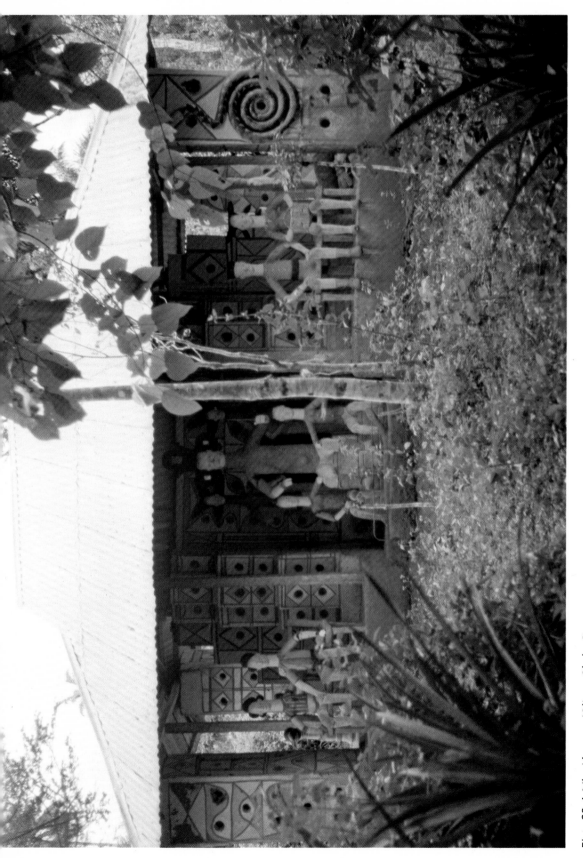

Plate **22-4** Mbari house at Ndiama Obube, Ibo.

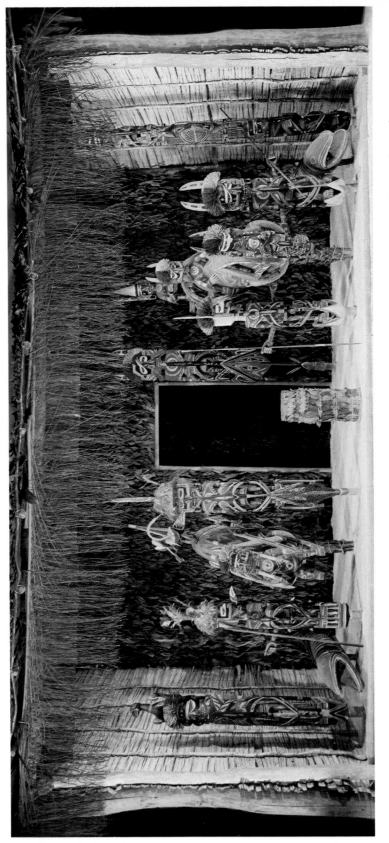

Plate 22-5 Malanggan tableau, New Ireland. Bamboo, palm and croton leaves, painted wood, approx. $8' \times 16\frac{1}{4}' \times 10'$. Museum für Volkerkunde, Basel.

statement. As Pollock said: "... it doesn't make much difference how the paint is put on as long as something has been said. Technique is just a means of arriving at a statement." The statement arrived at is at the same time the record, the signature as it were, of the creating process itself, which *arrives* at something rather than aiming intentionally. Modern philosophy, where it is influenced by the views of modern biology, often stresses the reality of process over structure, and if Pollock's painting is an image of anything, it is of process itself in its never ending, never wearying creation of nature. Action painting completes, moreover, that introduction of time and motion into the static arts of form that began in Futurism. Now the artist himself is truly in motion, his viewpoint constantly changing. It is significant that for his creative "dance" the easel picture is inappropriate, and as he moves he looks not out (as from a viewpoint) but *down*, seeing his "landscape" unfold somewhat as we see the earth from an airplane moving through the air some 10,000 feet up. Thus, though action painting may seem strange and formless at first, we need only reflect upon the vast new vocabulary of forms that the surface of the earth itself yields to modern eyes and imagination. To these are added the marvelous formal complexities of the microcosm and the macrocosm revealed by microphotography and our probing of outer space. The macroscopic and microscopic worlds, where endless and intricate processes weave endless and intricate relations of living forms, are given a visual presence in the dense, entangled skeins of lines and colors in Pollock's art.

Abstract Expressionism had many possible methods of approach. In the work of FRANZ KLINE (1910–62) it is a vehicle of very personal psychic revelation that is possibly as mysterious to the artist as to the observer. Kline himself admitted that there was no way to find a verbal equivalent for his meaning, or sometimes even a caption. He painted, in black and white upon large canvases, ragged bars and stripes of black enclosing (or overlapped by) rectilinear white areas sharp-edged as broken planes of glass (FIG. 17-61). These configurations suggest Chinese characters boldly brushed and greatly magnified, a kind of ideogram of the artist's psychic states. As hieratic

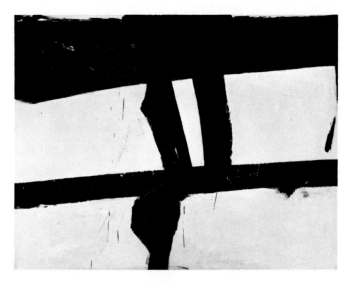

17-61 FRANZ KLINE, *Painting 1952*, 1955–56. Oil on canvas, approx. 6′ 5″ × 8′ 4″. Present location unknown.

and quasimagical shapes, they can be interpretable as the observer pleases; as purely nonobjective forms in a wide variety of arrangements, they appeal through their blunt esthetic force and bold, free execution.

Of the New York action painters, WILLEM DE KOONING (b. 1904), a native of Holland who began as a figure and portrait painter, has practiced a quick alternation between abstract and figural painting. The tension between the two approaches is itself expressive of de Kooning's attitude; he has been called an "artist who makes ambiguity an hypothesis on which to build."[14] Ambiguity prevails in an art and in an age where nothing, as de Kooning himself says, is certain but self-consciousness. Shapes and colors play through, over, and across one another with no definable order, with no completeness of decision. De Kooning's best-known works are those composing his series of paintings of female nudes on large canvases, a gallery of sometimes harsh and biting, sometimes sinister and menacing, sometimes jovial and sensuous caricatures. In *Woman I* (FIG. 17-62) the attack is carried out with manic excitement, the figure slashed out with brush at arm's length and at full speed. There is a curious effect, typi-

[14] Thomas B. Hess, *Willem de Kooning* (New York: Museum of Modern Art, 1968), p. 25.

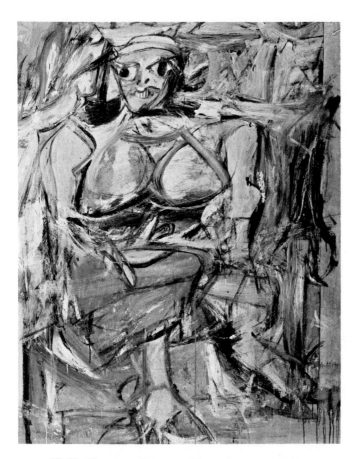

17-62 WILLEM DE KOONING, *Woman I*, 1950–52. Oil on canvas, approx. 76″ × 58″. Collection, Museum of Modern Art, New York (purchase).

cally ambiguous, of simultaneous delineation and defacement, of construction and cancellation, a conflict between sketch and finished picture. The brazen and baleful mask mixes the toothpaste smile with the grimace of the death's head. The enormous sketch is carried through by the compulsive drive that marks the action painter.

That Abstract Expressionism is a good deal less homogeneous in style than once seemed to be the case is particularly apparent in the work of MARK ROTHKO (1903–1973). Although he was a friend and contemporary of Pollock, Kline, and de Kooning, his paintings exhibit none of the aggressive attack or slashing brushwork that characterize theirs. *Four Darks on Red* (PLATE 17-14) dismisses the usual *brio* of "action painting" for a calm and contemplative mood. Subtle tonal variations transcend the essentially monochromatic theme and create a mysterious effect of

forms or images hovering in an ambiguously defined space. Where the dynamics of the other Abstract Expressionists might be taken as visual metaphors of the hostility and alienation implicit in contemporary Existential philosophy, Rothko's work seems more in tune with a Zen viewpoint —the one a call to action, the other an invitation to meditate. Yet, despite the profound differences, all these painters share a primary interest in the painterly problem of painting—that is, a concern with the actual process of applying paint to canvas rather than with questions of narrative content.

Realism

It is indicative of the diversity of modern trends that, at the height of its vogue, Abstract Expressionism was by no means universally adopted. It was possible in the general debate about styles and the purposes of art for voices old and new to be heard—and in many stylistic accents. The painting of ANDREW WYETH (b. 1917) is still the subject of considerable disagreement among critics. Contemporaneous with the vivid action painting of the New York School, Wyeth's painting is a meticulous Realism treating of the American scene in the tradition of the Regionalists of the 1930's. But he interprets his subjects in a muted poetic way that has something of the dreaming detachment of Surrealism without Surrealism's fantasy. At first glance, Wyeth's spirit seems utterly untouched by the storms of twentieth-century artistic revolution; but the odd angles of his compositions and his carefully selected perspectives and vignettes show that he is no stranger to experiments in modern design. His quiet appeal to the long-established taste of America for Realism speaks in pictures like *Christina's World* (FIG. 17-63), a work that is almost exactly contemporary with Pollock's *Lucifer* (PLATE 17-13). Here his skilled representation of the optical world does not intrude upon the genuinely felt human situation and its gentle pathos. The title, in the modern fashion, seems askew from the theme, and the subject is not literally given but only alluded to, in familiar modern ambiguity. In its own way the picture is as per-

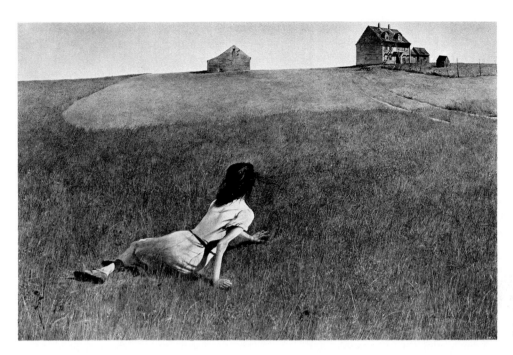

17-63 ANDREW WYETH, *Christina's World*, 1948. Tempera on gesso panel, approx. $32\frac{1}{4}'' \times 47\frac{3}{4}''$. Collection, Museum of Modern Art, New York (purchase).

sonal and introspective as the works of the Abstract Expressionists.

Abstract Formalism

An early phase of the Formalist approach is epitomized by the work of the productive and influential American painter STUART DAVIS (1894–1964), who was the first to assimilate French Cubism and naturalize it in the American setting. His long career extends from his exhibit in New York at the Armory show of 1913 (which introduced modern art to the general public in this country) to the fifties and sixties. Beginning with the lesson of collage, Davis gradually eliminated all representational and associative forms from his compositions. (There are some exceptions; for example, Davis sometimes introduced advertising signs into his work, anticipating Pop Art.) This process of elimination and the achievement of a total abstraction can be followed in his famous series of "egg-beater" paintings, wherein, beginning with an image of that ordinary kitchen utensil, Davis gradually evolved an organization of line, shape, and color that showed no trace of the original image. But Davis is not merely a

foreign member of the French school of abstract art; he is an original master who developed his own style, expressive of the vivid syncopation of the American scene; and he is at least partly responsible for raising the level of competence of American painting to that of the European schools. Throughout his career Davis yielded little to the pressures of new vogues, maintaining with astonishing consistency the principles of Cubist art as he had reinterpreted them to suit his purpose. At the same time he retained the respect of modern innovators who acknowledged him as the dean of American abstract painters. In *Colonial Cubism* (FIG. 17-64) Davis shows, in a densely organized composition, the play of angular and rectilinear shapes and flat, hard colors in the characteristic Cubist ambiguity of figure and ground, where "forward" and "backward" alternate rapidly. Here the "subject" of the painting is nothing but the carefully adjusted elements of a purely formal, two-dimensional order. The whole visual field is a lively vibration of colors and shapes in combination and contrast.

The formalistic interest represented by Stuart Davis withstood the powerful competition of America's original postwar style—Abstract Expressionism or "action painting" (p. 772), with

its subjectivity and painterly extravagance. We must keep in mind the context of these movements and counter-movements. Restless experimentation, the rapid successions of inventions and obsolescences of stylistic conventions, and the fluctuations of a highly sensitive art market keep producing almost violent reversals of interest and tendency in contemporary art. The formalistic reaction to Abstract Expressionism is generally called post–Painterly Abstraction (a phrase of the critic Clement Greenberg), a movement with allied manifestations such as Op Art and Hard-edge and Color-field painting. In these the disciplined line favored by the tradition of Cubism, Constructivism, and De Stijl comes to be appreciated once again, and the painter aims at radical simplicity and purity of shape and color. The work of ELLSWORTH KELLY (b. 1923) is of a kind described as Color-field painting, and his *Red, Blue and Green* (PLATE 17-15) shows a scrupulous management of pure color for its own sake and a knife-edge clarity in the contours that contain it. The caption declares clearly enough what the artist considers to be the painting's exclusive meaning. The fundamental modern Formalist and Constructivist claim that the "subject" of the painting should be its form and nothing else is here powerfully stressed.

It is but a slight step from an interest in the elementary properties of line, shape, and color to an interest in our mode of perceiving them. Here is the reverse of the whole traditional process of seeing a picture. Originally we "looked through" the picture "window" of a constructed perspective space; then, with modern art, the canvas itself became the perceptual object, with its arrangement of lines, shapes, and colors. Now, in "perceptual abstraction," or "Op Art," the optical "illusion," which has its seat in the brain, is the object. Thus the picture is meant to reach out and stimulate, even disturb, our actual seeing. *Current* (FIG. 17-65), painted in 1964 by BRIDGET RILEY (b. 1931) seems to swim in contrary motions. If we stare at it long, its vibrations seem to penetrate the eye and cause some discomfort.

It is noteworthy that the elements of the patterns in *Current* stand in a definable mathematical relation to one another, and patterns like this have been generated by computer. Technologically created forms such as this can produce an esthetic response—as, for example, the pattern of a sinusoidal wave with a linearly increasing period, which gives an overwhelming impression of motion. Technology has been a most powerful influence on the arts throughout the era since the French Revolution—that era that has no name as yet but "modern." At first the camera (since 1840) and the example of the machine in general,

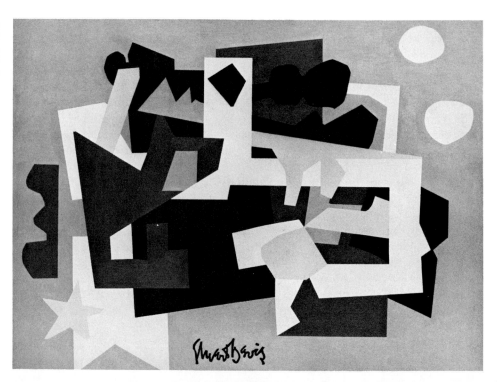

17-64 STUART DAVIS, *Colonial Cubism*, 1954. Oil on canvas, 45″ × 60″. Collection, Walker Art Center, Minneapolis.

and now a whole new world of materials and instruments have stimulated—even forced—the arts into radical innovation.

At the same time, much of modern art, as we have seen, is made of reaction *against* the mechanization and standardization of human life imposed by technology. Yet any kind of making—and the artist is engaged in *making* art—inevitably has to acknowledge, adapt to, even yield to, the irresistible presence, example, and power of technology. This is especially true of the art of sculpture, which, since World War II, has changed profoundly as it has adopted new technological materials and procedures and has come to command as wide a field of action and interest as contemporary painting.

We have already observed in sculpture before World War I and between the world wars the rapid advance of Formalism in the guise of Cubism and Constructivism; the availability of industrial materials and technical procedures accelerated that advance. Gonzalez had taught Picasso the method of "direct metal sculpture," the quasi-industrial procedure of welding together pieces of basic metal "stock"—rod, tube, etc.—an early instance of the application of modern metalworking techniques to art. This involved the shaping and assembling of metal elements by the artist more or less from the start. EDUARDO PAOLOZZI (b. 1924) went a step farther, welding together (and rendering immobile) elements already machined to perform mechanical functions. This separation of machined elements from their functions is all-important here, both as a kind of reaction against the growing presence in human life of the functioning machine and as an opportunity for the creation of an utterly new medium and Constructivist style. For one thing, the Formalist-Structuralist artist has in the found object or engine component a starting point, a "pure" form already produced and with no meaning other than its own form. However, Paolozzi can and does arrange these components in unconventional, bizarre ways—as biomorphic constructions, for example. His *Medea* (FIG. 17-66), with its welded aluminum slab and writhing, pipelike tubules, imposes organic shape upon the inorganic material, at the same time setting the shapes of the slab and tubules in inorganic-organic opposition. The caption is a kind of Dadaist

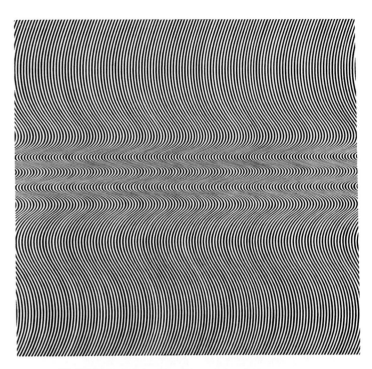

17-65 BRIDGET RILEY, *Current*, 1964. Synthetic-resin paint on composition board, approx. $53\frac{3}{8}'' \times 58\frac{7}{8}''$. Collection, Museum of Modern Art, New York (Philip Johnson Fund).

reinforcement of the ambiguity of the piece, a literary reference without images to illustrate it.

Paolozzi's enthusiasm for machine elements not only foreshadows Pop Art (p. 782) but is itself partly responsible, along with the efforts of his older contemporary DAVID SMITH (1906–1965), for recent sculptors' fascination with metal sculpture and the simplicity of machined surface. A master of this material and mode, a master of what one might call the "personality" of steel, Smith worked earlier in a delicate, linear, open style. His later *Cubi* compositions (FIG. 17-67), done in the 1960's, are monumental constructions in stainless steel in which he arranged solid-geometrical masses in remarkable equilibrium of strength and buoyancy. Smith, like his Structuralist contemporaries, was at ease in the age of the machine; he declared that machinery was in his nature. "His ambition," writes Barbara Rose,

was to turn his studio into a factory, where he could produce sculpture whose forms were as

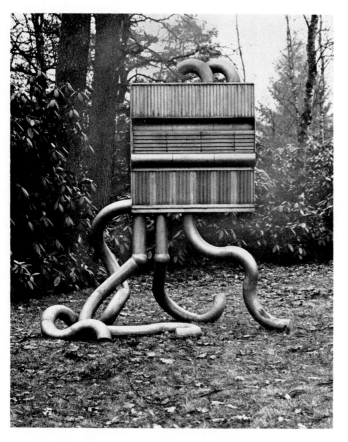

17-66 EDUARDO PAOLOZZI, *Medea*, 1964.
Welded aluminum, 81″ × 72″ × 45″. National Museum
Kröller-Müller, Otterlo, Netherlands.

impressive, monumental, and contemporary as the locomotive. He preferred to work in iron and steel because it "possesses little art history. What associations it possesses are those of this century: power, structure, movement, progress, suspension, destruction, brutality."[15]

We thus find in the art of David Smith and in his characterization of it the aim of the Formalist-Structuralist to eliminate the human element from art altogether—almost as a source of impurity?—and to present blunt metal in its unmitigated "power ... brutality."

The influence of David Smith, Paolozzi, and the great tradition of Constructivism to which they belong is widely accepted by the metal sculptors of the sixties and of today, among them RONALD BLADEN (b. 1918). Typically, Bladen carries to its ultimate conclusion the Constructivist reaction against romantic subjectivism, allusive representation, extraneous meaning. Bladen and his Structuralist contemporaries seek a purism of such austere simplicity—a simplicity rooted in geometry—as to remove any signature of the artist's self from his work. The elimination of every vestige of personality amounts to the elimination of the artist himself; the artist seeks to

[15] Barabara Rose, *American Art Since 1900* (New York: Praeger, 1967), pp. 253–254,

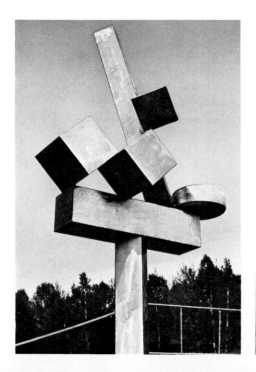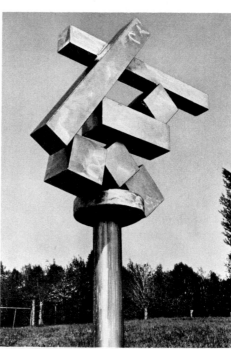

17-67 DAVID SMITH, left: *Cubi XVIII*, 1964. Stainless steel, 9′ 7¾″ high. Courtesy of the Museum of Fine Arts, Boston (gift of Stephen D. Paine). Right: *Cubi XIX*, 1964. Stainless steel, 9′ 5⅛″ high. Tate Gallery, London. Both courtesy of the Estate of David Smith and the Marlborough-Gerson Gallery, New York.

to 1939	1944	**1945**	1947	1950	1954	1956	1959	1962	1964	1967	1969	1971
HOFFMAN *Effervescence* WORLD WAR II			POLLOCK *Lucifer*	LE CORBUSIER Notre Dame du Haut begun	DAVIS *Colonial Cubism*	MIES Seagram Building	WRIGHT Guggenheim Museum	LICHTENSTEIN *Blam!*	PAOLOZZI *Medea*	DNA molecule elucidated	Man lands on moon	OTTO Olympic roof

ABSTRACT EXPRESSIONISM/OP/POP/KINETIC/MINIMAL/NEW REALISM/CONCEPTUAL

KOREAN WAR VIETNAM WAR

achieve the impersonal, anonymous aspect of the machine. (No one troubles himself about who built any particular machine.) The forms preferred by these artists have been called "minimal" or "primary," hence the labels of this school: Minimal Art, Primary Art. The works are constructed to great scale, asserting their severity of outline, economy of means, and domination of the environment; above all they emphasize their isolation from human personality and affects. They are a new kind of object that silently commands the environment, natural or artificial. Bladen's *X* (FIG. 17-68) manifests the Structuralist's credo; a stark, tremendous form painted black, it confronts the observer with an overpowering weight and awesome blankness. It must be noted that *X* is made of wood, a full-scale model of the metal object it is designed to become. But metal on this scale is extremely expensive, and the artist must await a patron. Here the ambition of the metal Structuralist may take him beyond possibility of the realization of his design in his chosen medium, the properties of which inspired the design in the first place.

The great scale of much Minimal Art naturally brought to the fore the problems of the relation of the piece to its site or environment. Concerned that sculpture too emphatically separates its reality from the reality of its site, a number of sculptors trained in Minimal Art, ROBERT SMITHSON (1938–1973) among them, sought a solution to the problem of sculpture-site in an entirely new context for their art, the unbounded spread of the earth itself. Their method and results, though widely differing in look, have been called Earth Art, which consists in manipulating—with earth-moving equipment—vast quantities of earth and rock (usually in desolate terrains in the American West) to produce a new unity of sculpture, site, and context. One Smithson work, *Spiral Jetty* (FIG. 17-69), in Great Salt Lake, the making of which he filmed, is a vast spiral of earth and stone built out from a shore of the lake and ex-

pressing monumentally, though in open form (unlike the closed shapes of Minimal Art), the reality of time, which is missing from sculpture—Minimal or traditional. Smithson's movie describes carefully the forms and life of the whole site, even the difficult approach to it, as he builds within it; he shows both the work and the context in reciprocal relation, sharing the same reality. Against the boundedness and closure of sculpture and its architectural sites, as well as against the limits of "differentiated" thinking, Smithson tries for an indissoluble unity of art and nature, much like the suspension of the boundaries between "self" and "non-self" that he asks of the critic. (Smithson was killed when the airplane in which he was surveying a site for a new earth sculpture crashed.) The Earth artist's work thus is neither imitation of nor flight from physical nature; rather it asserts the unity of the physical reality of the world. The prodigious energy that goes into this reshaping of physical nature, embodied in the great earth-movers (FIG. 17-70) and the masses of earth they lift and place, represents in itself the shaping forces of the physical world in which the artist shares.

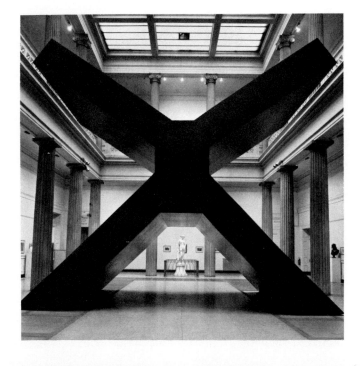

17-68 RONALD BLADEN, *X*, 1967. Painted wood, 22′ × 26′ × 14′. Fischbach Gallery, New York.

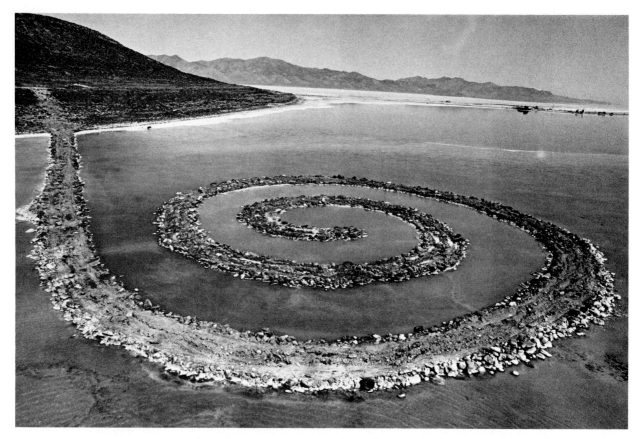

17-69 ROBERT SMITHSON, *Spiral Jetty*, 1970, April. Black rocks, salt crystal, earth, red water, algae, 1500' long, 15' wide. Great Salt Lake, Utah.

17-70 Earth-moving equipment used in construction of *Spiral Jetty* (FIG. 17-69).

Earth Art differs only in method and matter from the Structuralist search for formal truth and purity that leads to minimal or primary constructions that take their inspirations from the hard, clean, precisely machined surfaces of industrial metal. But ingredient in the model of machinery (and, indeed, in all nature) is also the fact of motion. Early Constructivists like Tatlin and Gabo had perceived this, and the Futurists had made it central to their philosophy. Pevsner and Gabo, in their *Realist Manifesto* of 1920, had included time with space as a prime reality for the modern experience; and the combination of time and space made for motion. Motion then must be a reality for modern art as for modern life, and the construction of forms in motion, powered by some form of motor energy, has come to be called Kinetic Art.

Paolozzi, David Smith, and Bladen express the power of static form. Artists like POL BURY (b.

1922) say in effect that, for art, motion is as real and as interesting as stasis and is the very model of industrial process. The motion that Bury and his associates in the international movement of Kinetic Art experiment with is not at all like the freely disposed "air-sketching" of Calder (p. 754), where delicately cut and poised filaments and fins move buoyantly on natural currents of air. Rather, it is motion produced by a mechanical drive; the difference between it and Calder's art being somewhat like that between a glider and an airplane. Though it is, of course, impossible to represent the kinetic object in a still picture, some sense of it may be had in Bury's *Broad Flatheads* (FIG. 17-71) from the blur caused by the movement of the nails (see detail, FIG. 17-71). The movements are very slow and subtle and must be observed carefully over a considerable period of time, much of the work's appeal being derived from the changing relationships of the moving parts. Of course, all sorts and degrees of movement can be made by varying speed, rate of variation, and interval; and these are often augmented by accompanying sound and light effects. Kinetic art in the area of pop entertainment has had great currency, bringing together plastic art, sound, and light into sometimes overpowering orchestration.

Constructivism, in its search for ultimate form and a consistent logic of procedure, can lead to contradictions. It may lead to forms, motions, spaces, and times that are already complete in themselves and do not need the artist's hand— for example, the machined parts and fixed motions of an existing machine. Or, as the artist strives to eliminate himself from the form he has produced, so the form might be made to eliminate itself—that is, to "self-destruct." Or, again, the artist might have to concede his own replacement by, say, the machine. Still farther, he might intrude meaning upon his nonobjective forms by bestowing titles upon them. JEAN TINGUELY (b. 1925) seems to have pondered all these possibilities. At ease with paradox—one of his own being: "the only stable thing is movement"— Tinguely has built Kinetic sculptures somewhat in the satiric, Dadaistic spirit of Marcel Duchamp and often with the droll import of Klee's *Twittering Machine* (FIG. 17-20). His art manifests a kind of dangerous playfulness and a gusto for the absurd. His *Homage to New York* (FIG. 17-72), 1960, was a giant, motorized, explosive "junk sculpture" crowned with a weather balloon. The construction was designed to destroy itself, which it resolutely did in the garden of the Museum of Modern Art in New York. The gesture may have been of profounder historical significance than was first supposed. Earlier, as a spoof of Abstract

17-71 POL BURY, *Broad Flatheads*, 1964. Wood and nails, approx. $39\frac{1}{2}'' \times 29\frac{1}{2}''$. Collection of Mr. and Mrs. Frank M. Titelman, Altoona, Pa.

Detail of FIG. 17-71.

17-72 Jean Tinguely, *Homage to New York*, 1960, just prior to its self-destruction in the garden of the Musem of Modern Art, New York.

important differences) and that has been called, among many things, Neo-Dada, but now Pop (for *popular* art). (The English critic Lawrence Alloway, who is generally credited with inventing the label "Pop Art," asserts that it refers not so much to the art as to the new attitudes that led to it, principally an acceptance of the prevalence of mass art media—advertising, industrial design, photography, cinema, etc.) The Pop artist turns outward to his environment—not the natural environment, but the artificial one of mass popular culture—finding his material in the manipulated and programed folkways and the mass-produced commodities of modern urban and suburban life. Pop art challenges the tradition of the "Fine Arts," insisting that the common culture in its multitudinous forms is as valid as—and indeed continuous with—the fine arts. The tone of Pop Art is for the most part sympathetic with mass culture, though in fact it can range from sympathetic to neutral to hostile. As against the extremely personal and private symbolic utterances of Abstract Expressionism, Pop seeks a hard, tough, impersonal objectivity in the mood of composer John Cage's remark: "Object is *fact*, not symbol." The Pop fact is as visibly in front of us as the cans of soup on our shelves and the billboards along our highways. Its appearance commands our responses daily. It is one of billions of shapes that continually rain upon us in the visual explosion of the twentieth century. The Pop fact is an expendable object, its expendability part of its immediacy in our experience and of its significance for that experience. We are continually confronted with the expendable products of Hollywood, Detroit, and Madison Avenue. Taken together, Pop facts make a vast universe of fascinating images, which can, like any "facts," become the source of new fantasy.

The origins of Pop Art are not precisely traceable. It had an early start in London in the mid-fifties, and a restatement in New York and Los Angeles about 1960 and after. In London the influence of Paolozzi (p. 777) was strong, especially

Expressionism, which held almost alone the international art stage of the late forties and fifties, Tinguely had designed a painting machine, which he called *Metamatic-Automobile-Odorante et Sonore*. This machine, during the first Biennial of Paris in 1959, produced forty thousand "Abstract Expressionist" paintings: Here, indeed, might be the ultimate elimination of the painter.

Pop Art and Other Trends

In the later fifties, the tendencies to total "inwardness" had hardly been established by the mode of Abstract Expressionism before it received a jarring reversal from the rise of a movement that had striking resemblances in both attitude and method to Dada (though there are

his conviction of the importance of the interaction of man and technology, his sincerely cultivated taste for popular culture, and his sense of the presence of a new universe of images there, with manifold possibilities of significance. Paolozzi was a member of the pioneering Independent Group, who shared his interest in mass culture. Among the members were architects, critics, designers, painters, and sculptors who were especially aware of the lessons of Duchamp's "anti-art," the collages of Schwitters, and the work of Picasso and of Dubuffet, much of which, as we have seen, owed something to the hard facts of the street culture of Paris. A member of the Independent Group was RICHARD HAMILTON (b. 1922), a display artist. He shows us in a small collage (FIG. 17-73), later turned into a photomural, an interior laden with the images of mass culture, in effect, the contents of a mass mind: muscle man, magazine female, fetish figure, television ad, canned ham, tape recorder, posters, automobile logo, and so on. This is a collage or montage of images lifted from specific contexts and brought together with almost sardonic effect, whether or not the artist intended a pointed comment. We have here a kind of Realism in the images, while the composition and context repudiate traditional Realism altogether.

Pop Art in America developed slightly later than in England, and differently. The influence of Duchamp's philosophy of art and life was active, as was, to a degree, the influence of Léger's art with its acceptance of the machine culture. Further, the example of the so-called "cool" Abstract Expressionists like Rothko and of the "post-painterly Abstraction" or "color-field" painters like Ellsworth Kelly provided the formal means. ROBERT RAUSCHENBERG (b. 1925), whose work bridges Abstract Expressionism and the American Pop movement, in 1955 began working with collages, which he called "combine paintings" and which were composed of photographs, news clippings, prints, and the like. Unlike the collages of Schwitters and the Dadaists, Rauschenberg's compositions were topical, with reference to events of the day or to commonly seen objects used in the mass environment; they were, moreover, of far greater scale. The evanescence of the referent events and objects is expressed in the

ordinariness and expendability of the items chosen by Rauschenberg. This led naturally to collages or constructions in three dimensions composed of perishable or throwaway materials, as in *Monogram* (FIG. 17-74), a stuffed ram wearing an automobile tire and mounted on a collage base, with dense passages of free-brush painting pulling the whole together in a tour-de-force of mixed-media procedure. Dada, Surrealism, and Abstract Expressionism here meet in ambiguous equilibrium.

It is noteworthy that Rauschenberg originally was part of the Abstract Expressionist movement. It is symbolic of his personal rebellion against it—symbolic perhaps of the whole reaction of Pop against action painting—that he obtained a drawing from de Kooning, erased it, and then exhibited it as *Erased de Kooning by Robert Rauschenberg*. The gestures of modern artists have much in common, no matter the diversity of their styles.

An early associate of Rauschenberg and of the influential musician John Cage, mentioned above, is JASPER JOHNS (b. 1930). Like Duchamp, Johns takes the commonplace out of context and makes us *look* at it, not simply use it and throw it away. Part of the modern cultural landscape, the beer

17-73 RICHARD HAMILTON, *Just What Is It That Makes Today's Homes So Different, So Appealing?*, 1956. Collage, 10¼″ × 9¾″. Collection of Mr. Edwin Janss, Jr., California.

17-74 ROBERT RAUSCHENBERG, *Monogram*, 1959. Construction, 48″ × 72″ × 72″. Collection, Moderna Museet, Stockholm.

can is reconstituted as an object not to be discarded but to exist for our attention (FIG. 17-75). Johns goes beyond Duchamp in solemnly exalting the banal by casting it in bronze, faithfully reproducing its label, and placing it firmly upon a base, so that the flimsy and disposable con-

17-75 JASPER JOHNS, *Painted Bronze*, 1960. Approx. 5½″ × 8″ × 4¾″. Wallraf-Richartz-Museum, Cologne, Sammlung Ludwig.

tainer, intended to be used and forgotten, is monumentalized and made permanent as a profoundly symbolic twentieth-century artifact. As has been the case with so many ancient cultures, it is by our manufactured products—at least by the less perishable ones—that we are and will be known. The irony of Johns and Duchamp echoes T. S. Eliot's prediction that nothing will survive us but a thousand lost golf balls.

The ephemeral and the banal in popular art naturally attracted the attention of the Pop artist, though we must remember that the Pop philosophy accepts and approves the art (such as illustration and comic strips) and artifacts of mass culture as entirely valid art in themselves. To reconstruct in giant scale the thudding clichés and ear-splitting rhetoric of certain of the comic strips devoured daily by millions was to comment wordlessly on the taste and fantasy life of the public. A good example of this punishing presentation of what can be forgotten quite as much as an empty beer can is *Blam!* (FIG. 17-76), painted in 1962 by ROY LICHTENSTEIN (b. 1923). Familiar as its form and iconography are, written large and out of context they create a powerful effect. The new landscape and still life of Pop replace the traditional; they offer a view of a

world in which we are surrounded by garish artifice only too clearly reflecting ourselves.

The new universe of shapes and colors yielded by mass culture and its visual explosion supplied Pop Art its material, its new fact. But, as we have seen (FIG. 17-74), instant fact can be made fantasy simply by shattering factual contexts and re-aligning and regrouping the elements composing conventional aggregates of facts. The effect of this process is to surprise and defeat expectation —the old Dada aim to shake up ("épater") the observer. The sympathetic neutrality of the Pop attitude toward mass culture could, under the impact of this mischievous Dada impulse, very quickly yield to mockery of that culture through fantastic exaggeration and paradox. This is the case in the art of CLAES OLDENBURG (b. 1929), where once more the example of the good-humoredly cynical Duchamp seems to have been influential. Oldenburg's *Soft Toilet* (FIG. 17-77) gives us a shock by knocking our perceptions (categories) of "hard" and "soft" sharply together and confusing our responses. What is conventionally hard, rigid, and prophylactic is shown as soft, sagging, and positively unsanitary. The artist makes fun of our modern dependence upon our prized household appliances, which for the mass can be the ultimate expressions of civilized living.

The flat, severe planes and hard edges of much modern design could find satirical reversal in Pop forms, soft or simulating softness. An early example of this whimsical opposition of soft to hard appears, in spirit, in Salvador Dali's reply to the architect Le Corbusier's query concerning how Dali envisioned his (Le Corbusier's) future buildings: "soft and hairy." Soft and unresistant materials of almost every kind made or found are used by EDWARD KIENHOLZ (b. 1927) to produce his realistic-fantastic tableaux—three-dimensional constructs that combine theater (stage sets), sculpture, architecture, furniture, and mannequins, and recall the grotesquerie of Surrealism while mirroring the tawdry aspects of modern life. His *Birthday* (FIG. 17-78) depicts a hospital maternity room with draped patient and hospital accessories. The pangs of childbirth are represented as great, transparent, plastic arrows rising and branching out from the patient's body. Hard reality and eerie fantasy mingle in this emphatic restatement of the Pop absorption in the forms and events of the mass scene.

The world of fancy that hovers above Pop seems to win a place of its own in what has been called psychedelic art, presumably from its visual

17-76 Below: ROY LICHTENSTEIN, *Blam!*, 1962. Oil on canvas, approx. 60″ × 80″. Collection of Richard Brown Baker, New York.

17-77 CLAES OLDENBURG, *Soft Toilet*, 1966. Vinyl, plexiglass, and kapok, 55″ × 28″ × 33″. Collection of Mr. and Mrs. Victor W. Ganz, New York.

17-78 EDWARD KEINHOLZ, *Birthday*, 1964. Tableau, approx. 7′ × 10′ × 15′. The Frederick and Marcia Weismann Foundation.

approximations of visions produced by "mind-expanding" drugs. Its formal roots are in Art Nouveau, Beardsley, Odilon Redon, Kandinsky, Klee, and others of the extremely subjective Expressionist camp. Though worldwide in extent, it has belonged mostly to the American Pop scene in the late sixties and seventies, its media primarily the poster and the underground comic strip, that area of Pop already explored by the young. Seemingly a contradiction of Pop factualism, Psychedelic art presents simply another kind of fact, that induced by the drugs that widely circulate among the youthful consumers of Pop art and culture. ISAAC ABRAMS (b. 1939) presents in *Untitled* (FIG. 17-79) a painfully vivid record—or so it would seem—of the kind of hallucinatory apocalypse familiar in descriptions by users of such hallucinogens as LSD. Color sensation is intensified far beyond normal experience. The spectral hues at almost unendurable degrees of brightness and saturation explode and exfoliate in bursts, changing kaleidoscopically in varying velocities, beyond the control of the drugged subject. Shapes and forms swim through the chaos in myriads of unfamiliar distortions and combinations. Here again is the phenomenon of the vanishing artist, for the drug becomes the agent of the artistic process, and the artist, merely its medium. The drugs are purported to be the means to instant nirvana; presumably the pictorial record can never do justice to the hallucinated vision.

17-79 ISAAC ABRAMS, *Untitled*, 1968. Oil on canvas, 40″ × 40″. Private Collection, New York.

In the study of the art of the twentieth century we almost become used to the shock of stylistic contrast, and it may be appropriate to conclude that study with yet another contrast—that between Abrams's Pop-Psychedelic painting and a work of the Pop-born "New Realism." In *Nedick's* (FIG. 17-80) RICHARD ESTES (b. 1936) gives us the portrait of a familiar, short-order restaurant and fountain with all the glassy fidelity of a photograph taken through a pristine plate-glass window with the latest high-speed camera. We have seen (FIG. 17-73) the importance of the camera in supplying Pop Art with unlimited images for collages made of fragments taken out of their visual contexts. But here all the images are back in context, pulled together by the habit of a long tradition of Realism and brought into sharp focus by the camera in a single scene in an infinitesimal interval of time. This last gives a peculiar stillness to the picture, arresting all action and concentrating the viewer's attention upon the wide range of "information" given. By projecting a photograph onto a canvas and then painting over it as if it were a cartoon, the artist uses the camera as a means to the picture, and not the photograph as an end in itself. Yet the photograph from which the artist renders is his new "nature," replacing both the natural and artificial environments that traditional Realism had drawn upon or that Pop had exhibited without transformation.

Two terms that have come into currency recently—Process Art and Conceptual Art—seem to be the product of a search for some unifying agent among the widely diverging trends of post-Pop Art. In its literal sense, Process Art claims that the act of making an object is more important than the eventual product. If such is the case, the product will have meaning primarily to the artist and to those who participated with him in the "process." This attitude would be similar to that of the action painters of the Ab-

17-80 RICHARD ESTES, *Nedick's*, 1969–70. Oil, 48″ × 66″. Collection of Mrs. Donald Pritzker.

stract Expressionist movement. Conceptual Art, seemingly, carries this notion one step further by claiming that the artistic concept, the creative thought, is more important than either the process or the product. Though based on different premises, Process and Conceptual Art tend to differ little in actual practice.

Both Process and Conceptual Art aim at the elimination of the isolated art object or product as such and endeavor to arrange instead "environments," which are composed of both objects and audiences. The process of creation and the concepts directing it become superior to any made form. The audience is introduced into a setting that is automated, sometimes in such a way that the audience itself becomes an element of the circuitry, functioning, via "feed back," like a component of some modern electronic system. Objects and audience are the shifting foci of relationships of interdependent events: process is reality, and reality is process—as some modern physicists understand the way of things.[16] Light, sound, color, automata, among numerous other devices—and materials adapted from industrial technology—function together to saturate audiences with intensified and continually varying sensory experiences. Or, latterly, environments are constructed that reduce sense stimuli so that an effect of soundless isolation is produced; this is one extreme of "systemic" art that supplies "information" that directs audience response, creating a programed situation much like that experienced by astronauts in their spacecraft, or, for that matter, by anyone operating a machine, since the latter (if it is not totally automated) compels responses from the former. As receptors of the informational output the audience need not deal with images and appearances that stay to be evaluated; rather, they need only react. This means that the artist is himself a node in such a network of informational relationships, rather than an isolated system. In the transactions between himself and the environment—which includes the audience—the artist becomes part of unlimited, ceaselessly varying process. Art, artist, and audience become functions of systems modeled on those of modern electron-

ically controlled universes. Here, as in much of human life today, technology directs our experience.

ARCHITECTURE AFTER WORLD WAR II

After World War II, while Mies van der Rohe brought the International style to its ultimate refinement, Le Corbusier moved in another direction, toward almost sculptural conceptions. In 1946, immediately following the war, he designed the Unité d' Habitation (FIG. 17-81) in Marseilles as an answer to one of modern man's insistent problems: a design for urban living. Here a new module—standing man—gives a powerful scale and an immediate reference to the program while providing a mystical system of proportions recalling, in a way, the ancients' notion of the Golden Mean. The mighty piers (so different from the slender stilts of the Villa Savoye) support a framework in which each apartment is an integral unit that extends the depth of the building. The individual porches, each with a sunbreak, create a new sculptural mass, so that the building exists neither as a skeletal framework enclosed in a membrane nor as a solid mass. The solids and voids are in direct relation, as in Greek temples, which to Le Corbusier sounded "clear and tragic like brazen trumpets."

The startling forms of Le Corbusier's Notre Dame du Haut (FIG. 17-82) built at Ronchamp, France, in 1955, challenge us in their fusion of architecture and sculpture in a single expression Here, in Le Corbusier's own terms, is a "vessel" on a "high place," intended to respond to a "psychology-physiology of the senses," and to "a reverberating landscape, holding the four horizons as witness." (Could the architect have been thinking of the first temple after man's first cataclysm, the ark of Noah stranded on Mount Ararat by the receding waters of the Flood? It is noteworthy that we speculate, as with a work of figurative art, upon his possible meaning.) In these powerful, surging masses, these sculptural solids and voids, is a new environment in which man may find new values, new interpretations

[16] Cf. the fundamental work of the philosopher A. N. Whitehead, *Process and Reality*.

17-81 Le Corbusier, Unité d'Habitation, Marseilles, 1947–52.

of his sacred beliefs and of his natural environment. The interior (FIG. 17-83) is illuminated fitfully and mysteriously by deeply recessed windows placed almost randomly. The absence of ornament reminds us not so much of Internationalist purism as of the chaste severity of the Cistercian architecture of the twelfth century. Ronchamp is a unique work that could not possibly find membership in a movement. The extremely personal touch is that of a sculptor who has made a unique masterwork.

The long, incredibly productive career of Frank Lloyd Wright, meanwhile, ends with a testament to art itself, the Guggenheim Museum (FIGS. 17-84 and 17-85), built in New York City in 1943-59. The principle of dynamic continuity that had guided Wright through his life is here triumphantly stated. The immense structure is boldly composed as essentially a cylinder expanding with height, its floors expressed on the exterior as a spiraling strip of skylight, in levels marked by shadow by day, and by light at night. The cantilevered decks of the Kaufmann House are here drawn around an immense circle determined by the function of circulation: Visitors are brought by elevator to the top of the building and descend by foot the gently inclined spiral ramp, against

whose outer wall the pictures are displayed. The bold, monumental design, the assertion of a powerful personality, merges space and void without remainder and despite its overwhelming strength subtly sets off the pictures on exhibition. Wright's humanism directs him here, as ever, to serve human needs. In this case one of the highest experiences given to modern, urban man—delighting in the works of his gifted fellows—is facilitated and honored in a building that itself must be an enduring contribution. Yet it seems here that Wright, the great Jeffersonian, agrarian democrat, turns his back on the city. The rounded, closed form, like a visitor from outer space, is entirely at odds with the rectilinear urban pattern and fabric. The building turns in upon itself, the long gallery area opening onto a ninety-foot well of space that seems to provide an environment secure from the hostile city.

The later works of Le Corbusier and Wright illustrate the post-war movement away from the formalistic rigidity of the International style with its insistence upon a purely rectilinear frame of reference. At the same time, new developments in building technology increasingly became a part of the expressive vocabulary of the modern movement. The engineer PIER LUIGI NERVI (b.

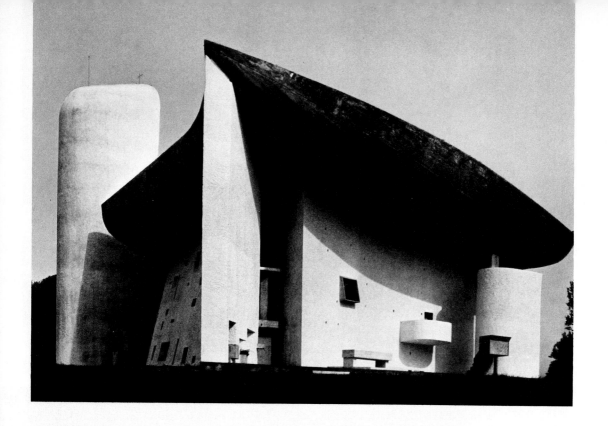

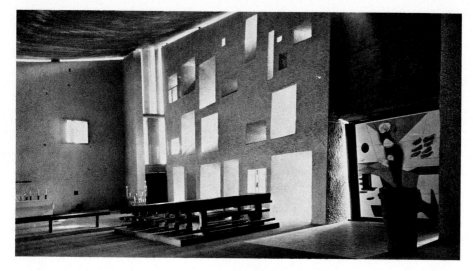

17-82 Above: LE CORBUSIER,
Notre Dame du Haut,
Ronchamp, 1950–55.

17-83 Left: LE CORBUSIER, in-
terior of Notre Dame du Haut.

1891), using the remarkable tensile strength of prestressed concrete, has been able to cover huge spaces with designs that offer dazzling geometric beauty as well as great economy of materials. His method and material make it possible to omit the steel columns of the International style—as in the Palazzetto dello Sport in Rome (opening illustration, Part Four and FIG. 17-86), built in 1958—and his vast roofs seem to soar daringly with a grace and crispness of detail that leave severe rectilinearity behind and bring a new vision of architectural form, an organic rather than a mechanical one. Yet, despite his more personal statement, Nervi shows keen interest and insight concerning one of the ongoing themes of modern architectural theory: the rational ex-

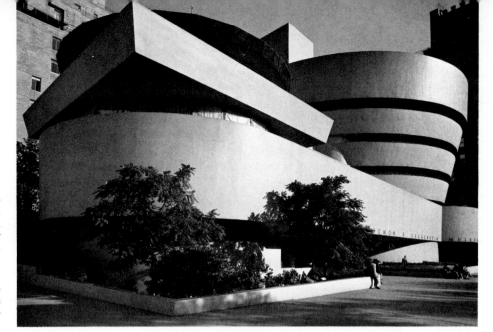

17-84 Right: FRANK LLOYD WRIGHT, Solomon R. Guggenheim Museum, New York, 1943–59 (exterior view from the north).

17-85 Below: FRANK LLOYD WRIGHT, interior of the Solomon R. Guggenheim Museum (view from the dome).

pression of structural elements. With the grace and surety of a Gothic flying buttress, Nervi's structural members make visible the force lines of the building, carrying, with a technical elegance, the lateral thrust of the vault to the ground.

Our summary of trends in modern architecture has, of necessity, stressed the contributions of those men who, in our foreshortened historical perspective, appear to have been pioneers in the creation of an architecture free of reference to earlier architectural styles. It seems certain that Wright, Mies van der Rohe, and Le Corbusier will be recognized as such by future generations; their work continues to inspire younger architects even while they experiment to expand the horizons of both building form and building technology. The rapid development and exploitation of new engineering possibilities can be seen in a comparison of Nervi's Olympic Palazzetto with the buildings constructed in Munich by FREI OTTO (b. 1925) for the 1972 Olympic Games (FIG. 17-87). Nervi's structure, light and graceful as it is, seems massive and dense next to the airy, transparent, tentlike enclosures of Otto. Part of the difference is due to Otto's revolutionary approach to structure; Nervi, for all his experiments with prestressed concrete, still conceives of structure in traditional terms of *compression*, the principle that underlies all architecture studied in

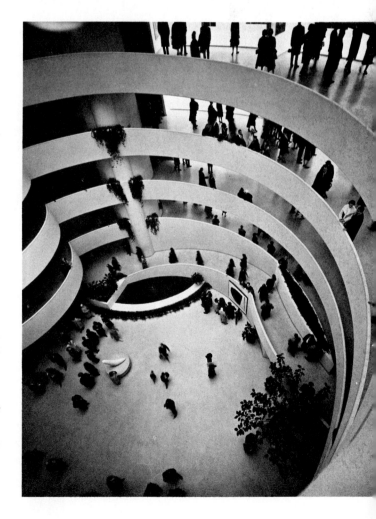

17-86 Pier Luigi Nervi, Palazzetto dello Sport, Rome, 1958.

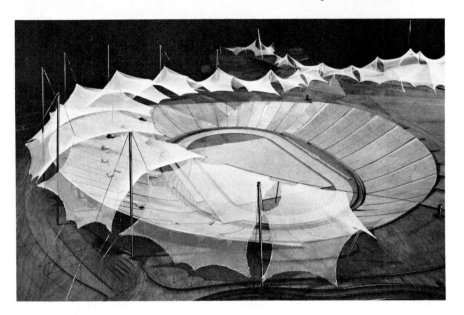

17-87 Frei Otto, Above: Model for the roofs of the Olympic Stadium, Munich, 1971–72. Right: Portion of the Stadium.

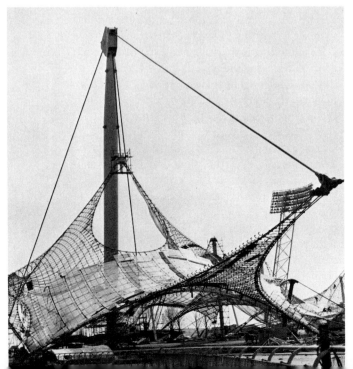

17-88 GUNNAR BIRKERTS, Federal Reserve Bank, Minneapolis, 1972–73.

this history, from the Egyptians onward. Otto, on the other hand, exploits the tensile strength of steel to create a structural system based on *tension*, the same engineering principle that permits the construction of the light-appearing but remarkably strong free spans of suspension bridges. No less up-to-date is Otto's selection of a kind of gossamer plastic membrane to sheathe the building, a sheathing that provides shelter without confinement, just as his radical structural system provides vast enclosures without the interruption of interior supports.

The soaring, graceful forms of Otto's giant tent may appear limited in their application to the solution of more common architectural problems; but just as the Crystal Palace had been thought to be a building of limited potential about a century and a half ago, yet proved to be the prototype of a dominant structural form of our time, so perhaps tension structures will revolutionize architectural concepts of the future. In any case, the same principles can be seen at work in an office building designed by GUNNAR BIRKETS (b. 1925) in Minneapolis. His Federal Reserve Bank Building (FIG. 17-88) combines the tension

of great cables strung in a catenary curve between massive end towers with more traditional compression members that support the stack of floors above the cables; the floors below the catenary are also carried by the cables, but this time in suspension. The result of this extremely complex system is a free span structure of 330 feet between the supporting towers, which contain service facilities, elevators, fire stairs, and so forth. Le Corbusier's original idea of raising a building on slender columns or "pilotis," thus freeing the site for other uses, is here carried a step further; Birkert's structure leaves an open, virtually unobstructed urban space of over 100,000 square feet, framed and articulated by the office block. The principle functional elements of the bank, the vaults and other high-security facilities, meanwhile, are tucked away beneath the huge "piazza" that becomes a gift to the city and a fine urban amenity.

The increasing urbanization of world population, a by-product of the Industrial Revolution, has brought into focus one of the critical building problems of our time, namely that of providing adequate housing for an ever expanding urban

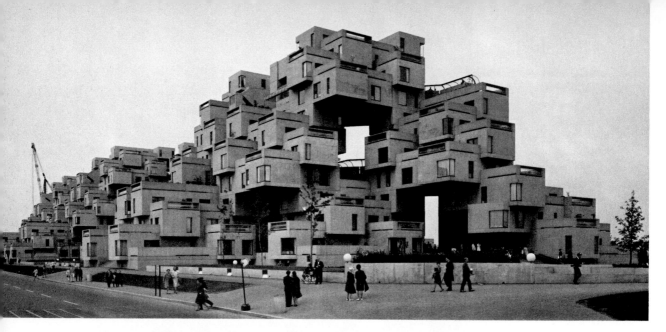

17-89 MOSHE SAFDIE, Habitat, Montreal, 1967–68. Below, a 70-ton module being lifted into place during construction.

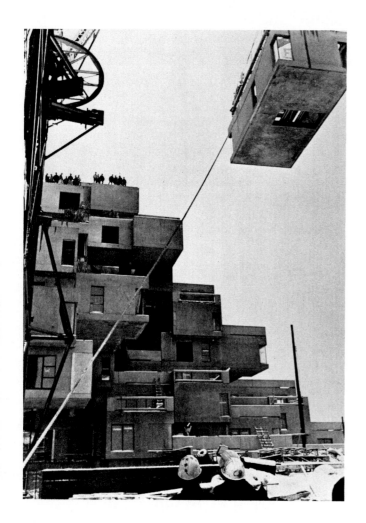

population. With land becoming more and more precious in cities, the single-family house is increasingly considered to represent an inefficient use of a dwindling resource, and architects have responded with a variety of proposals for mass housing. We have already examined Le Corbusier's contribution to the discussion in his Marseilles apartment block with its clear attempt to return a sense of dignity to the urban dwelling by having each apartment run the width of the building and so approximate the characteristics of a free-standing house. This idea was carried a step further by the young Israeli architect MOSHE SAFDIE (b. 1938) in his Habitat (FIG. 17-89), a demonstration building constructed for Montreal's Expo '67. An experiment in the application of mass production and complete prefabrication to the building industry, Habitat carried Le Corbusier's handling of each apartment as a hypothetically independent unit to its logical realization; here each apartment is reduced to a single, boxlike, precast concrete module made at a plant and trucked to the site. Like outsized children's building blocks, the units were then lifted into their appropriate slots in the matrix of the building by a huge crane. The heroic scale of the undertaking, with its implication of a kind of fully industrialized architecture, seems to fulfill the Crystal Palace's promise of prefabrication. Visually, the building has a

boldly sculptural look that appeals to both contemporary sensibilities and to the rational insistence upon structural clarity while providing an appropriate setting for modern urban living.

The growing realization among some architects that our twentieth-century cities are rapidly becoming uninhabitable because of building practices that sacrifice human values for material gain has prompted design of a number of buildings that seem dedicated to Aristotle's observation that "men come together in the city to live; they remain in order to live the good life." The Oakland Museum in Oakland, California (FIG. 17-90), goes even farther than Birkert's Minneapolis bank building in providing a parklike oasis in the center of a large city. Designed by KEVIN ROCHE (b. 1922) and JOHN DINKELOO (b. 1918), successors to the firm of the late Eero Saarinen, the Oakland Museum is actually three separate museums—of natural history, history, and art—stacked one above the other so that a good part of the site could be devoted to walled-in lawns and gardens. Moreover, roof areas of various levels of the building serve as landscaped terraces for the next higher level. Extensive planting on all levels tends to mask and soften and make humanly approachable the massive, fortresslike concrete walls of the building, which seem to dissolve into a parklike setting in a manner that

would have pleased Frank Lloyd Wright. The result is a quiet, self-effacing structure whose deliberate anonymity provides a green, civilizing touch in the midst of the grey core of a metropolitan area and the proof, as well, that ecological considerations and urbanization need not war with each other.

Our review, of necessity, has not mentioned the many architects, who, by their own interpretation of an organic or an absolute architecture, have proved that these new vocabularies of form have had meaning for the generations of this century. The past decades have witnessed an energy expended in building that recalls the words of Raoul Glaber who, after the end of the first millennium, saw the earth covered by a "white robe" of churches (Chapter Nine). Not all our buildings have been churches, but as one surveys the landscape, urban or rural, of the Western world, there is no denying that a new environment has been created and is, in fact, still in the very process of creation. Future historians will evaluate more accurately than we the true significance of these contributions to the history of man's willed environment. The wide variety of creative interpretations available in the vocabulary of modern architecture demonstrates that the "modern" idiom is no longer an idiom but a common language.

17-90 ROCHE & DINKELOO, Oakland Museum, 1969.

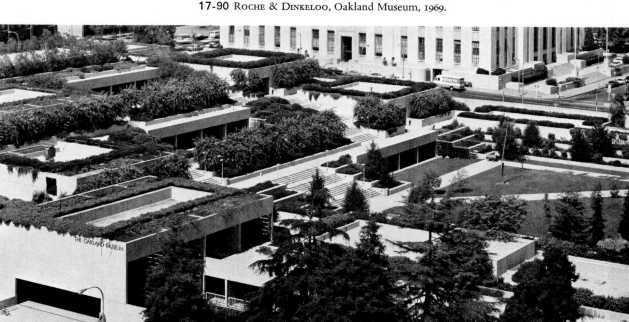

THE NON-EUROPEAN WORLD

The arts of the non-European world encompass a vast variety of ideas and forms from distant and exotic peoples who, as twentieth-century technology has advanced, have, in effect, become our next-door neighbors. As cross-currents of influence have modified traditional and formerly isolated art forms, the art of the twentieth century has become international rather than European.

Of the art of the non-European world, that of Islam has already been surveyed (Chapter 7, pages 286–99). The enormous remainder can be roughly subdivided into Oriental and "Third World" art. The former embraces Southeast Asia, China, and Japan, and the latter, the essentially tribal arts of the North and South American Indian, of Africa, and of Oceania.

The earliest art works from the great Eastern civilizations in India, China, and Japan are from paleolithic and neolithic times. Buddhism was the common denominator of the later arts of these different countries, although each developed a distinctive style, or, rather, series of styles.

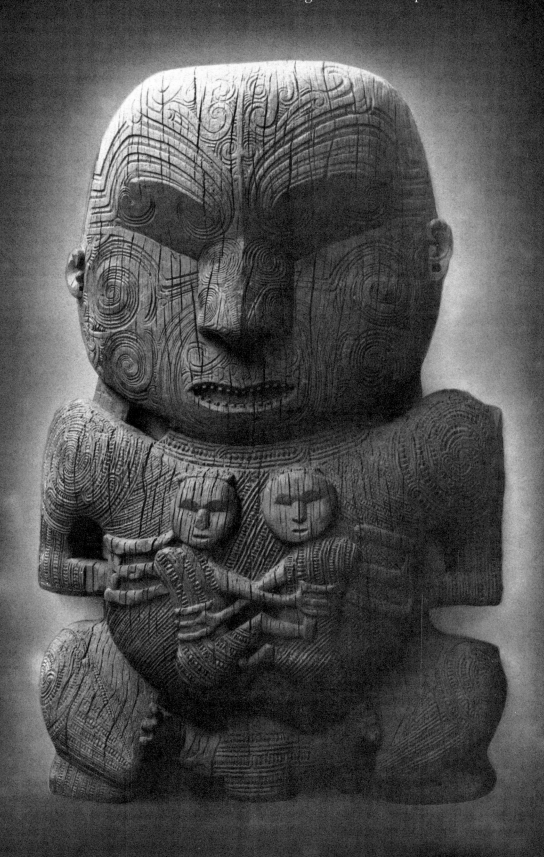

A Maori wood sculpture, *The Chieftain Pukai*, blends bold, massive forms with detailed geometric surface patterns.

Indian sculpture from its beginnings has been characterized by a pulsating vigor in reproducing the living body. Early Chinese bronzes display amazing technical virtuosity in the use of highly symbolic, though abstract, decorative motifs. In later dynasties, in sculpture and particularly in painting, carefully observed details are lyrically rendered and produce a haunting image of nature. Japanese art, in spite of recurring waves of foreign influence, especially from China, insistently returns to native traditions. Painting and, above all, architecture show a sensitivity to the relationship between decorative designs and natural forms.

In pre-Columbian Mexico, Central America, and the Andean region of South America, highly cultured peoples using a Stone Age technology erected great temple complexes elaborately decorated with reliefs and practiced the crafts of weaving and pottery with great skill. About A.D. 500 the North American Indian began to settle in agricultural communities. Some tribes, such as the Pueblo, reached a highly developed state in the eleventh, twelfth, and thirteenth centuries. Their stylized arts present an extraordinary understanding of the decorative qualities of abstract design.

The peoples native to Africa and the South Sea Islands produced a distinguished and individual art until contact with Europeans either modified it or brought it to a halt. This art, far from being technically or esthetically crude, is sophisticated in its presentation of conceptual rather than naturalistic images. Its rhythmical, abstract forms have been a resource for many modern artists of great distinction and originality. Since the seventeenth century the art of the non-European world has asserted itself in the West with always stronger effect and to ever more respectful recognition and appreciation. Earliest interest was in the superficial traits of Chinese ornament, which became fashionable by virtue of its exoticism and picturesqueness. In the eighteenth century imports from China taught the West a new word for its tableware—and "china" soon largely replaced the metal plate. The late nineteenth century saw the design vogue of the Japanese print and screen, so strongly influential on artist and decorator; we have seen this in Impressionism and Art Nouveau. The art of Gauguin introduced into modern art ornamental modes and colors from Oceania; and in 1905, African sculpture exhibited in Paris caught and held the attention of the Fauves. We have seen the commanding influence of non-European art on the generation of Picasso in the early twentieth century. As the modern artist undertook the analysis of the visual world into structures that had little resemblance to it, he could find, especially in African and Oceanic art, that such analysis had in effect already been made. The geometrical common denominators of two- and three-dimensional design were here revealed with striking ingenuity and refinement, and a whole new vocabulary of

forms that were strange to the West was offered to the European artist at the very moment when, in a restless spirit, he was breaking with his own tradition.

It is clear that the art of the non-European peoples was, through its inspiration and example, among the principle forces that, over the last 200 years, has helped make the art of the Western world a truly cosmopolitan art.

Chapter Eighteen

The Art of India

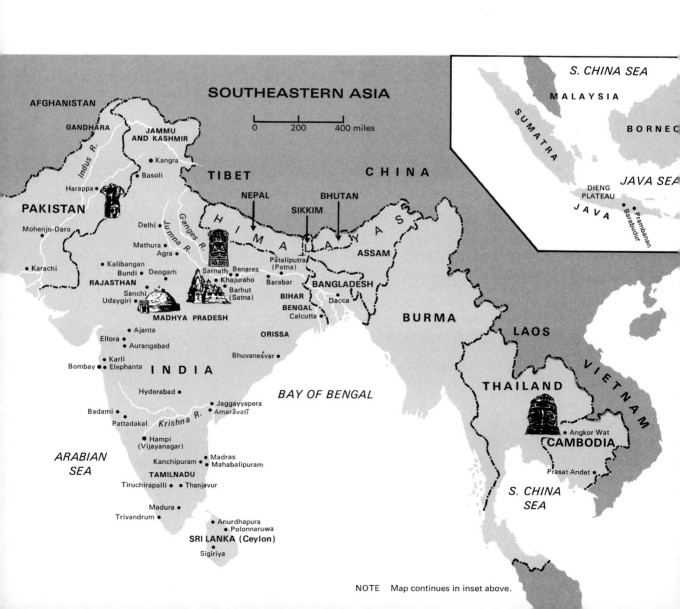

NOTE Map continues in inset above.

THE SUBCONTINENT OF INDIA, contiguous with the Asian mainland on its northern boundaries, has three distinct geographical areas: the northeast, where the massive Himalayas, the traditional home of the gods, rise as a barrier; the fertile, densely populated area to the northwest and to the south of the Himalayas, where the valleys of the Indus and the Ganges rivers lie; and peninsular India, composed of tropical tablelands separated from the northern rivers by mountains and forests. In these areas are great extremes of climate, from tropical heat to perpetual snow and glaciers; from desert conditions to the heaviest rainfall in the world.

The ethnic characteristics and religions of the peoples vary as much as the geography. The most common language of north central India is Hindi, a Sanskrit derivative. Urdu, also Sanskritic, is spoken by most of the Moslem population. In the south, several Dravidian languages, unrelated to Sanskrit, are spoken. Hinduism is the main religion of India, as Islam is of Pakistan, but Jainism and Christianity have many adherents, and Buddhism and Judaism, a few.

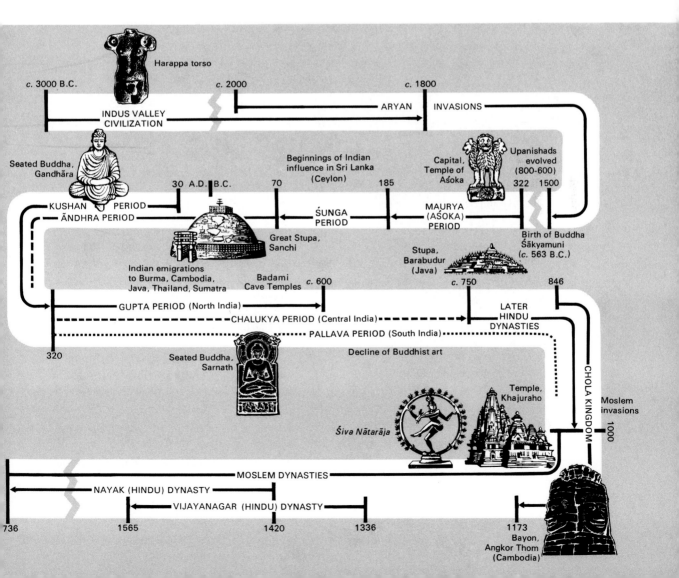

Harappa torso

c. 3000 B.C. *c.* 2000 *c.* 1800

INDUS VALLEY CIVILIZATION ARYAN INVASIONS

Seated Buddha, Gandhāra

Beginnings of Indian influence in Sri Lanka (Ceylon)

Capital, Temple of Aśoka

Upanishads evolved (800–600)

30 A.D. B.C. 70 185 322 1500

KUSHAN PERIOD
ĀNDHRA PERIOD ŚUNGA PERIOD MAURYA (AŚOKA) PERIOD

Great Stupa, Sanchi

Birth of Buddha Śākyamuni (*c.* 563 B.C.)

Stupa, Barabudur (Java)

Indian emigrations to Burma, Cambodia, Java, Thailand, Sumatra Badami Cave Temples *c.* 600 *c.* 750 846

GUPTA PERIOD (North India)
CHALUKYA PERIOD (Central India) LATER HINDU DYNASTIES
PALLAVA PERIOD (South India)

320 Seated Buddha, Sarnath Decline of Buddhist art

Temple, Khajuraho

CHOLA KINGDOM Moslem invasions 1000

Śiva Naṭarāja

MOSLEM DYNASTIES
NAYAK (HINDU) DYNASTY
VIJAYANAGAR (HINDU) DYNASTY

736 1565 1420 1336 1173 Bayon, Angkor Thom (Cambodia)

BEGINNINGS

The first major culture of India centered around the upper reaches of the Indus River valley during the third millennium B.C. Mohenjo-Daro and Harappa in Pakistan were the chief sites. Recently other important centers of this culture have been found farther south at Kalibangan, in Rajasthan, India, and near Karachi, Pakistan.

The architectural remains of Mohenjo-Daro suggest a modern commercial center, with major avenues along a north-south orientation; streets as wide as forty feet; multistoried houses of fired brick and wood; and elaborate drainage systems.

Some sculptures from this Indus civilization reflect Mesopotamian influences, while others indicate the presence of a thoroughly developed Indian tradition. The latter is exemplified by a

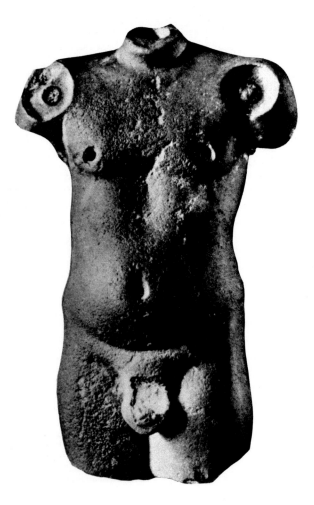

miniature torso from Harappa (FIG. 18-1), which, at first glance, appears to be carved according to the precepts of Greek naturalism. (Some question the dating of this piece.) The emphasis given (by polishing) to the surface of the stone and to the swelling curves of the abdomen, however, reveals an interest, not in the logical anatomical structure of Greek sculpture, but in the fluid movement of a living body. This sense of pulsating vigor and the emphasis on sensuous surfaces remain chief characteristics of Indian sculpture for four thousand years.

Great numbers of intaglio steatite seals, also found at Mohenjo-Daro, exhibit a blend of Indian and Near Eastern elements (FIG. 18-2). Indeed, it was the finding of a Mohenjo-Daro seal at a datable Mesopotamian site that enabled scholars to assign dates to the Indus valley cultures. The script on the seals has not been deciphered. Varied devices worked into the stone, such as trees (sometimes associated with animals and humanoid figures), are represented as objects of worship. The beasts most common on the seals are the humped Brahman bull, the water buffalo, the rhinoceros, and the elephant. Fantastic animals and anthropomorphic deities are also represented. On one seal a seated three-headed figure appears in what is later known as a yoga position. The heads are surmounted by a trident-shaped device that two thousand years later was used to symbolize both the buddhist trinity and the Hindu deity Śiva. Around the deity are various animals, including the bull and the lion, which were also to become symbols of Śiva. Given its date, this seal probably represented a prototype of that god. Such continuity of iconography indicates the deep roots of religious tradition in India. Style, too, shows a continuous tradition. The animals on the Indus valley seals have the flowing contours and sensuous surfaces mentioned above (with reference to the Harappa figure) as being characteristic of sculpture through most of Indian history. This artistic continuity is remarkable, not

18-1 Male nude, Harappa, third to second millenium B.C. Stone, $3\frac{1}{2}''$ high. Central Asian Antiquities Museum, New Delhi.

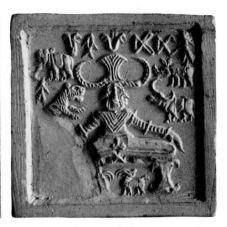

18-2 Seals, Mohenjo-Daro, third millenium B.C. Steatite. Central Asian Antiquities Museum, New Delhi.

only because of the time spanned, but because, for the period between the disappearance of the Indus civilization (about 1800 B.C.) and the rise of the Maurya empire (third century B.C.), there are virtually no remains of the visual arts. The Aryan invasions, which began about 1800 B.C., may account for the break in the sequence of Indian art. It is even more amazing, then, in view of the Aryans' profound effect on Indian culture, that so many indigenous traits persisted. Destruction by the invaders, as well as the perishability of the materials used, undoubtedly account for the disappearance of many of the objects by which Indian traditions were passed on during those two thousand years following the collapse of the Indus civilization.

The Aryans brought with them to India the Vedic religion. The term derives from the hymns (Vedas), which have survived to this day. These are addressed to the gods, who are personified aspects of nature. The warrior god Indra is thunder, Sūrya, the sun, and Varuna, the sky. There are many others. All were worshiped by means of hymns and sacrificial offerings in conformity to strict laws of ritual. There were no temples, but fire altars, built according to prescribed formulas, served as the focus of devotion. So important was the act of ritual that in time Agni, the sacrificial fire, and Soma, the sacrificial brew, became personified as gods in their own right. The rather simple form of religion and propitiation so beautifully expressed in the Vedic hymns was greatly elaborated in the Upanishads (800–600 B.C.), a series of treatises on the nature of man and the universe that introduced a number of concepts alien to the simple nature worship of the northern invaders. Chief among the new ideas were those of *saṁsāra* and *karma*. Saṁsāra meant the transformation of the soul into some other form of life upon the death of the body. The type of existence into which the reborn soul entered depended upon karma, the consequence of actions in all previous lifetimes. A bad karma meant a dark future, rebirth in a hell or in this world as a lower animal—a reptile, for example, or an insect. A good karma meant that the soul might go into the body of a king, a priest, or even a god, for gods also were subject to eventual death and to the endless cycle of rebirth. The goal of religion therefore became the submersion of individual life in a world soul. This was attainable only after an individual's karma had been perfected through countless rebirths. Penance, meditation, and asceticism were believed to speed the process.

During the sixth century B.C. two major religions developed in India. One, Buddhism, exerted a profound influence on the culture and art of India as a whole from the third century B.C. to the sixth or seventh century A.D. (In some parts, like Bengal and Bihar, it was influential to the eleventh century, and, in the south, to an even later date.) Although Jainism, the other major religion, never achieved Buddhism's dominance, it continues to the present day as a small but

distinct religion in India, while Buddhism is practically extinct there.

The arts of many Asian countries derive from Indian Buddhism, which began with the birth of the Buddha Śākyamuni about 563 B.C. The son of a king who ruled a small area on the border of Nepal and India, the child, according to legend, was miraculously conceived and sprang from his mother's side. Named Siddhārtha, and also known as Gautama, the child displayed prodigious abilities. A sage predicted that he would become a Buddha—an "enlightened" holy man destined to achieve nirvana. After a series of confrontations with old age, sickness, and death, Siddhārtha renounced courtly luxury. While meditating under a peepul tree in the city of Gaya, Gautama obtained illumination—the complete understanding of the universe that is Buddhahood. His teaching may be summed up as follows: All existence implies sorrow; the cause of existence is attachment to work and the self; this attachment can be dissolved through the elimination of desires, which also bind the self to a countless succession of rebirths; the cessation of rebirth can be accomplished by following the Eightfold Path, which prescribes simple practices of right thought, right speech, and right action. This initial formulation of Buddhism, in which salvation was achieved by individual efforts, was later known as Hīnayāna Buddhism.

The religion of Buddhism, so conceived, was not opposed to basic Hindu thought, but was rather a minor heresy deriving from certain speculations in the Upanishads. What Buddhism did was to offer a specific method for solving the ancient Indian problem of how to break the chain of existence so that the individual soul could find ultimate peace within the world soul.

EARLY ARCHITECTURE AND SCULPTURE: BUDDHIST DOMINANCE

The earliest known examples of art in the service of Buddhism (from the middle of the third century B.C.) are both monumental and sophisticated.

Emperor Aśoka (272–232 B.C.), grandson of Chandragupta, founder of the Maurya dynasty (c. 321–184 B.C.), was converted to Buddhism after witnessing the horrors of the brutal military campaigns by which he himself had forcibly unified most of northern India. His palace at Pātaliputra (the modern Patna in Bihar) was designed after the Achaemenid palace at Persepolis (FIG. 2-29). Megasthenes, a Greek ambassador at Aśoka's court, has left a glowing report of Pātaliputra. Only the foundations of buildings and remnants of a wood palisade now remain, but we may draw some idea of the architectural details from a series of commemorative and sacred columns that Aśoka raised through much of northern India. These monolithic pillars were of polished sandstone, some as high as sixty or seventy feet. The capital of one (FIG. 18-3) now in the Sarnath Museum near Benares typifies the

18-3 Capital of column erected by Emperor Aśoka (272–232 B.C.), Pātaliputra. Archeological Museum, Sarnath.

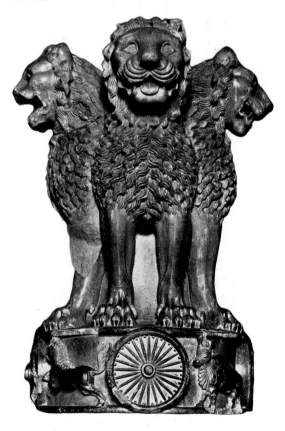

style of the period. It consists of a lotiform capital resting on a horizontal disk sculptured with a frieze of four animals alternating with four wheels. Seated on the disk are four addorsed lions that originally were surmounted by another huge wheel. All the forms are symbolic. The lotus, traditional symbol of divinity, also connoted man's salvation in Buddhism. The wheel represented the cycle of life, death, and rebirth. This "wheel of life" often had other levels of meaning. In this instance it was the teaching of Buddha—the "turning of the wheel of the law." The wheel itself (probably developed from ancient sun symbols), and the four animals (the four quarters of the compass), with which it is here associated, imply a cosmological meaning in which the pillar as a whole symbolizes the world axis. The lions also had manifold meanings but were here specifically equated with Śākyamuni Buddha, who was known as the lion of the Śākya clan.

The pillars are noteworthy not only for their symbolism but also because they exemplify continuity of style. Although the stiff heraldic lions are typical of Persepolis, the low-relief animals around the disk are treated in the much earlier fluid style of Mohenjo-Daro. So too are the colossal figures of *yakshas* and *yakshīs* sculptured during Aśoka's time or somewhat later. These male and female divinities, originally worshiped as local nature spirits, gods of trees and rocks, were now incorporated into the Buddhist and Hindu pantheons.

The Cave Temple

The Mauryan period also witnessed the beginnings of a unique architectural form—sanctuaries cut into the living rock of cliffs. Parts of the exteriors (and, later, interiors) of these caves were carved to imitate in accurate detail the wooden constructions of their period. The Lomas Rishi cave, hollowed out during Aśoka's reign, has an entrance (FIG. 18-4) of a type that was to be perpetuated for a thousand years. The faithful replica of a wooden façade has a doorway with a curving eave that mimics a flexible wood roof bent over rectangular beams. A decorative frieze of ele-

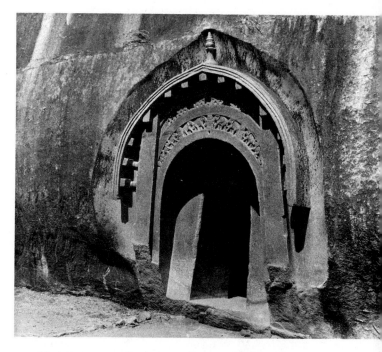

18-4 Entrance to the Lomas Rishi Cave, Barābar Hills, 272–232 B.C.

phants over the doorway carries on the indigenous sculptural traditions.

The fall of the Mauryan dynasty around the beginning of the second century B.C. led to the political fragmentation of India.

The Stupa

Under the Śungas and the Āndhras, who were the chief successors of the Mauryas, numerous *chaityas* (Buddhist assembly halls) and *vihāras* (monasteries) were cut into the hills of central India from the west to the east coast. At the same time, the stupa, which was originally a small burial or reliquary mound of earth, evolved as an important architectural program. (Aśoka is supposed to have built thousands of stupas throughout India.) By the end of the second century B.C. they had grown to huge proportions. Sculptured fragments from early stupas have been found at Mathura, at Bharhut (modern Satna), and elsewhere in India, but the grandeur of this type of structure can be seen best at Sanchi in the state of Madhya Pradesh. There, on a hill overlooking

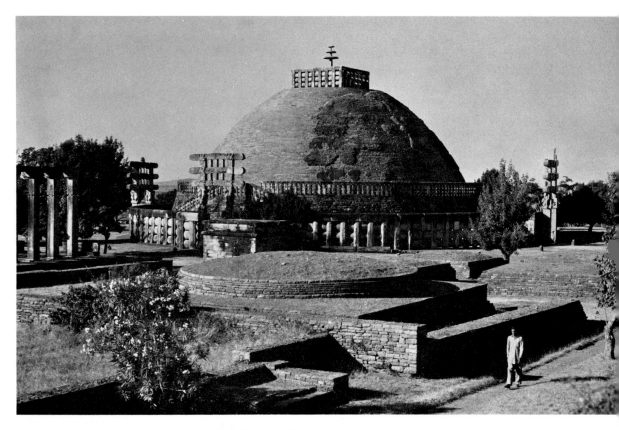

18-5 *The Great Stupa*, Sanchi, *c.* 10 B.C.–A.D. 15.

a wide plain, several stupas containing sacred relics were built over a period of centuries. Of these, the *Great Stupa* (FIG. 18-5), the tallest and finest, was originally dedicated by Aśoka. Enlarged and finally completed about the middle of the first century B.C., it stands now as the culminating monument of an era.

A double stairway at the south leads to the base —a drum about twenty feet high—and permits access to a narrow railed walk around the solid dome, which rises to a height of fifty feet above the ground. Surmounting the dome is the *harmikā*, a square enclosure from the center of which arises the *yasti* or mast. The yasti is itself adorned with a series of *chatras* (umbrellas). Around the whole structure is a circular stone railing with ornamented *toranas* (gateways, FIG. 18-6) at the north, east, south, and west.

The stupa, like most Indian structures, has more than one function. As a receptacle for relics it is an object of adoration, a symbol of the death of the Buddha, or a token of Buddhism in general. Devotion is given the stupa by the believer, who circumambulates its dome. But, in another sense, the stupa is a cosmic diagram, the world mountain with the cardinal points emphasized by the toranas. The harmikā symbolizes the heaven of the thirty-three gods, while the yasti, as the axis of the universe, rises from the mountain-dome and through the harmikā, thus uniting this world with the paradises above.

The railings and domes of some stupas were decorated with relief sculpture. The toranas at Sanchi are covered with Buddhist symbols, deities, and narrative scenes, but the figure of the Buddha never appears. Instead, he is symbolized by such devices as an empty throne, the tree under which he meditated, the wheel of the law, his footprints.

The awe expressed in this iconographic restraint—echoed by the quiet mass of the dome itself—is strikingly and paradoxically contra-

to 322 B.C.	185	70	c. 50		50	c. 100	
MAURYA PERIOD	SUNGA PERIOD	Great Stupa, Sanchi, completed	B.C. \| A.D.		Buddha, Gandhāra		
		Ā N D H R A			P E R I O D	KUSHAN PERIOD to 320 →	to c. 300 →

dicted by the sculptural luxuriance that crowds the toranas. Lush foliage mingles with the flowing forms of human bodies, and warm vitality pervades both animal and man. Sensuous yakshīs hang like ripe fruit from tree brackets. This almost hedonistic expression is alien to the Buddhist renunciation of life. It is an assertion, rather, of a basic Indian attitude that at all times unites and dominates almost all of Buddhist, Hindu, and Jain art.

As Sanchi is the greatest constructed monument of early Buddhism, so the chaitya at Karli is the finest of the sculptured cave temples. During the second and first centuries B.C. the cave sanctuaries had developed complexities far beyond the simple beginnings in the Lomas Rishi cave. Splendid façades reproducing wood architecture in exact detail were given permanence in stone. Around A.D. 50 at Karli, in the Western Ghats near Bombay, a peak was hollowed out and carved into an apsidal temple nearly 125 feet long and 45 feet high. The nave of the chaitya leads to a monolithic stupa in the apse, and on either side of the nave is an aisle formed by a series of massive columns crowned with male and female riders on elephants (FIG. 18-7). These great columns follow the curve of the apse, thus providing an ambulatory behind the stupa (FIG. 18-8). The inner wall of the narthex, despite some later additions, is almost intact, and today it functions as a magnificent façade. On each side of the entrance massive elephants, like atlantes, support a multistoried building, while flanking the central doorway are what appear to be benefactors—male and female pairs who enhance the already rich surfaces with heroic and voluptuous forms. These undulant figures contrast with the immobile severity of the stupa within and, like the yakshīs of Sanchi, speak of life, not death (FIG. 18-9).

18-6 Eastern gateway, Sanchi, front view, second to first centuries B.C.

THE BUDDHA IMAGE

For four hundred years before the second century A.D., the Buddha was represented, as we have noted, by symbols only. Then, at the end of the first century, simultaneously in Gandhāra and Mathura, he was suddenly depicted in anthropomorphic form. The explanation is partly to be found in the development of the Buddhist movement, which, during the first century, was divided by two conflicting philosophies. The

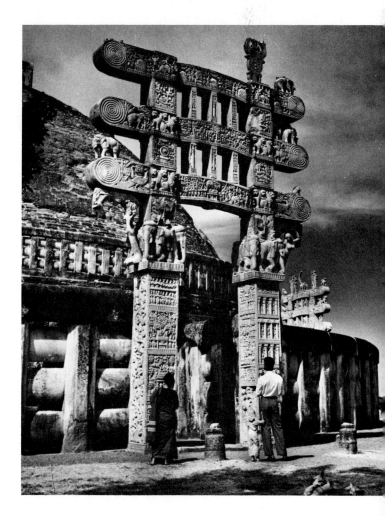

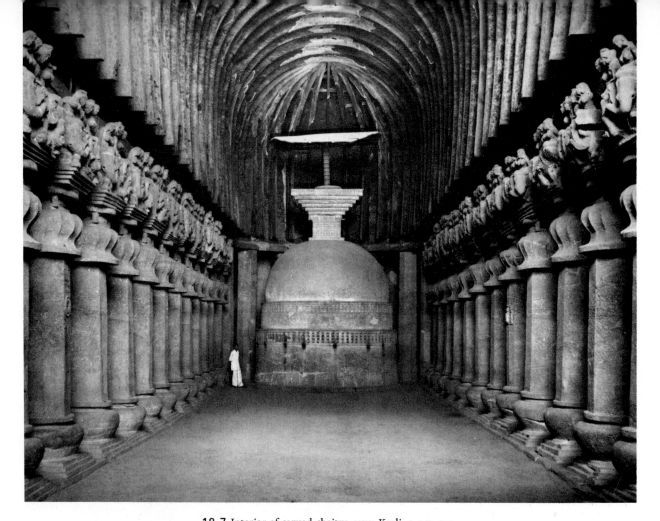

18-7 Interior of carved chaitya cave, Karli, *c.* A.D. 100.

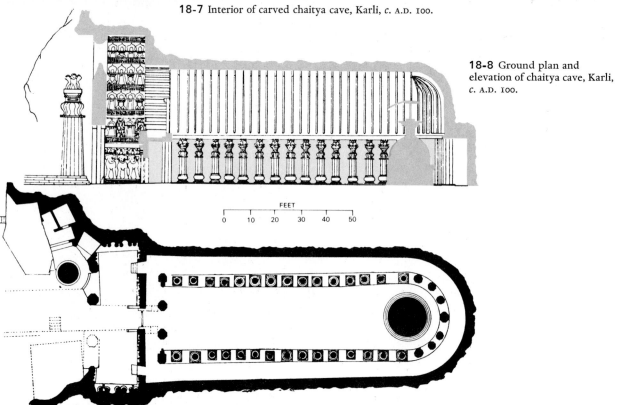

18-8 Ground plan and elevation of chaitya cave, Karli, *c.* A.D. 100.

FEET

0 10 20 30 40 50

more traditional believers regarded the Buddha as a great teacher who had taught a method by which man might ultimately attain nirvana. The newer thought, called Mahāyāna (the Great Vehicle) as opposed to the older Hīnayāna (the Lesser Vehicle), deified the Buddha and provided him with a host of divinities (Bodhisattvas) to aid him in saving mankind. According to the older belief, Śākyamuni was the last of seven Buddhas to have existed on earth. The Mahāyānists peopled the universe with thousands of Buddhas, of whom Amitābha, Lord of the Western Paradise, and Maitreya, a messiah who is to appear on this earth, soon rivaled Śākyamuni in popular favor. Symbols of the Buddha were too cold and abstract to appeal to great masses of people and were not suited to the pageantry of the new faith. In addition, Buddhism had borrowed from a reviving Hinduism the practice of *bhakti* (the adoration offered a personalized deity), which demanded the human figure as its focus. Thus Buddhism, out of emulation of its rival, produced its most distinct symbol, the Buddha image.

Gandhāra, where one of the two versions of the anthropomorphic Buddha had appeared, comprised much of Afghanistan and part of modern Pakistan, the westernmost section of northern India. In 327 B.C. it had been conquered by the armies of Alexander the Great. Although the Greek occupation lasted only a short time, it led to continued contact with the Classic West. It is not surprising, then, that the Buddha image that developed at Gandhāra had Hellenistic and Roman sculpture as its model (FIG. 18-10). Indeed, the features of the Master often suggest those of a marble Apollo, while many details—such as drapery patterns and coiffures—recall successive styles in contemporaneous Roman carving. While the iconography was Indian, even the distinguishing marks of the Buddha (*lakshanas*) were sometimes translated into a Western idiom. Thus the *ushnisha*, a knoblike protuberance on the head, took on the appearance of a Classic chignon. At times even the robe of the Indian monk was replaced by the Roman toga, and minor divinities were transformed into Western water gods, nymphs, or atlantes.

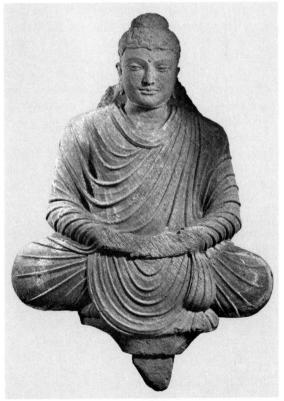

18-10 Seated Buddha, Gandhāra, late third century A.D. Yale University Art Gallery.

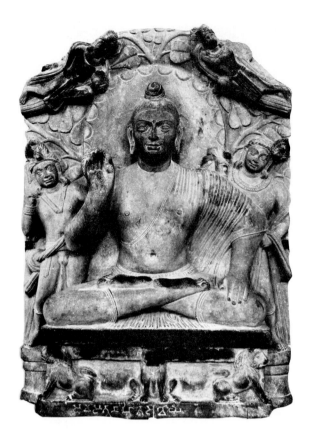

second in the clinging drapery, which reveals the human form.

HINDU RESURGENCE

Architecture and Sculpture

While Buddhism was at its height, Hinduism was slowly gathering the momentum that was eventually to crush its heretical offspring. Buddhism owed its original victory to the clearness of its formula for achieving salvation. About the first or second century B.C., Hinduism's answer appeared in the *Bhagavad-Gita*, a poetic gospel that, ever since, has been fundamental to Hindu doctrine. According to the *Gita*, meditation and reason can lead to ultimate absorption in the godhead; so too can the selfless fulfillment of everyday duties. Since the *Gita* also stressed bhakti, which focused on adoration of a personalized

While this intrusion of Western style was dominating the northwest, the purely Indian version of the anthropomorphic Buddha was evolving in the holy city of Mathura, a hundred miles south of Delhi. This image derived directly from the yaksha of popular art and, like the yaksha, it was draped in a mantle so thin and clinging that at first glance it seems to be nude (FIG. 18-11). The Mathura Buddha also has broad shoulders, a narrow waist, and a supple grace. Only such iconographic details as the ushnisha, the *urna* (a whorl of hair between the brows, represented as a dot), and the long-lobed ears distinguish the Buddha from the earlier yaksha.

By the third century A.D. the two anthropomorphic Buddha types began to coalesce into a form that served as a model for the earliest Chinese versions. But it is the Buddha at Sarnath (FIG. 18-12), from the end of the fifth century A.D., that conveys both the abstract idealism of the religion and the sensuousness of Indian art, the first in the simplified planes of the face, the

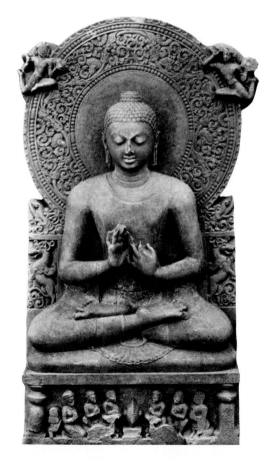

18-12 Seated Buddha, Sarnath, fifth to sixth centuries A.D. Archeological Museum, Sarnath.

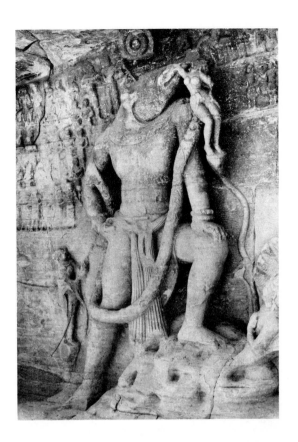

18-13 *Boar Avatar of Vishnu*, Cave V at Udaygiri, Madhya Pradesh, *c.* 460 A.D. Vishnu is 12′ 8″ high.

deity as a means of achieving unity with it, and since this answered a fundamental emotional need, the *Gita* swept Hinduism to final supremacy in the sixth and seventh centuries.

Sporadic examples of Hindu art dating from the last centuries B.C. have been found, but we know of no great monuments before the fourth century A.D. At that time the Hindus began to emulate the Buddhist cave temples, at first by carving out monumental icons in shallow niches. One such is the *Boar Avatar of Vishnu* (FIG. 18-13)[1] at Udaygiri near Sanchi. Here, a twelve-foot figure of Varaha, a manlike creature with a boar's head, is shown raising the earth goddess from the ocean—an act symbolic of the rescuing of the earth from destruction. The powerful form of Varaha, first formulated by the Kushans, served as a model for innumerable later sculptures of this popular theme. Within a few decades, other, more developed caves at the same site acquired sculptural doorways, interior columns, and central icons.

To the south during the sixth century, in the rock hillsides at Badami, the Chalukyans carved out rectangular temples that had pillars, walls, and ceilings ornamented with figures of their favorite deities. Porches and interiors were defined by the embellished columns, which were so ordered as to focus attention on the shrine in the center of the rear wall. In a temple dedicated to Śiva—one of the two chief divinities of the Hindu pantheon—the god is shown in his cosmic dance, with numerous arms spread fanlike around his body (FIG. 18-14). Some of the god's hands hold objects while others are represented in prescribed gestures (*mudrā*), each object and each *mudrā* signifying a specific power of the deity. The arrangement of the limbs is so skillful and logical that it is hard to realize that the sculptor conceived of the figure as a symbol and not as an image of a many-armed being.

[1] An Avatar is a manifestation of a deity in which he performs a necessary function on earth; the number varies, Vishnu usually having 10, sometimes 29.

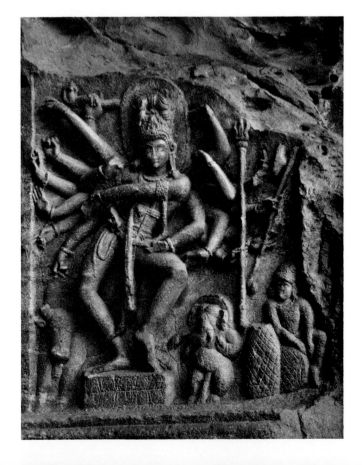

18-14 Dancing Śiva, relief from cave temple, Badami, sixth century A.D.

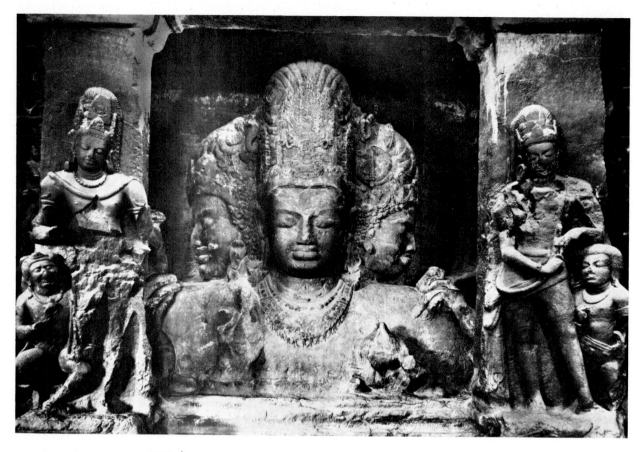

18-15 Śiva as Mahādeva in rock-cut temple, Elephanta, eighth century A.D.

Perhaps the supreme achievement of Hindu art is at Elephanta, where, in the sixth century, craftsmen excavated a hilltop and carved out a huge pillared hall almost a hundred feet square. On entering this sanctuary, the visitor peers through rows of heavy columns, until, adjusting to the dark, he sees, emerging from the end wall, the gigantic forms of three heads (FIG. 18-15). These represent Śiva as Mahādeva, Lord of Lords and incarnation of the forces of creation, preservation, and destruction. The concept of power is immediately transmitted by the sheer size of the heads, which, rising nearly fourteen feet from the floor, dwarf the onlooker. Each of the three faces expresses a different aspect of the eternal. The center one, neither harsh nor compassionate, looks beyond humanity in the supreme indifference of eternal meditation. The other two faces,

one soft and gentle, one angry and fearsome, speak of the sequence of birth and destruction that can be ended only in union with the godhead. The assurance of the period is manifest in the guardians of the shrine, who stand tall and relaxed in the certainty of their power. On the surrounding walls, deeply cut panels illustrating the legends of Śiva, carry on the robust and sensuous traditions of both Harappa and Karli.

During the fourth to sixth centuries Buddhims in turn borrowed heavily from Hindu doctrine. Elaborate rituals and incantations, inspired by similar Hindu practices, replaced the simple activities the Buddha had prescribed. Esoteric sects sprouted, and the popular Hindu worship of Śakti, the female power of the deity, was adapted for Buddhist usage. A sixth-century relief

in a Buddhist cave temple at Aurangabad depicts worship of the Buddha through music and dance (FIG. 18-16) in a scene that might have been taken from a Hindu temple, for the volatile and rapturous figures of the musicians and dancer represent an Indian, rather than Buddhist, way of life. With little to distinguish it from Hinduism, Buddhism and its art gradually withered and, within a few centuries, virtually disappeared.

In the same burst of creativity that produced the cave temples, other innovative Hindu architects were building the first stone structural temples. One of the earliest that remains is the Vishnu temple built in the early sixth century — during the Gupta period (320–c. 600) — at Deogarh in north central India (FIG. 18-17). All later developments of the Hindu temple were no more than elaborations upon the principles embodied in Deogarh.

The Hindu temple is not a hall for congregational worship; it is the residence of the god. The basic requirement is a cubicle for the cult image or symbol. This most holy of places, called the *garbha griha*, or womb chamber, has thick walls and a heavy ceiling to detain and protect the deity. A doorway through which the devotee may enter is the only other architectural necessity. As with the stupa, the temple has other meanings, for it is also the symbol of the *purusa*, or primordial man. In addition, in its plan it is a *mandala*, or magic diagram of the cosmos, and its proportions are based on modules that have magical reference. Thus the temple itself is a symbol to be observed from the exterior. Contemporary Western theories of architecture as dealing with space-enclosing form within which man carries on his activities do not apply to the Hindu temple, which is to be appreciated as sculpture rather than as architecture.

In early temples such as Deogarh, decoration is limited and restrained and the form is a simple cube, which originally was surmounted by a tower (*śikara*). All the walls, save that of the entrance, are solid but include sculptured panels like false doorways framed in the walls. On these panels are scenes from Hindu mythology, with relaxed and supple figures that carry on the Indian tradition of ease and poise.

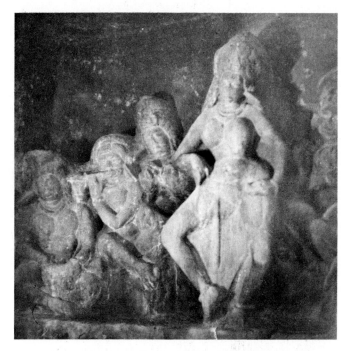

18-16 Relief with dancers and musicians, Aurangabad, seventh century A.D.

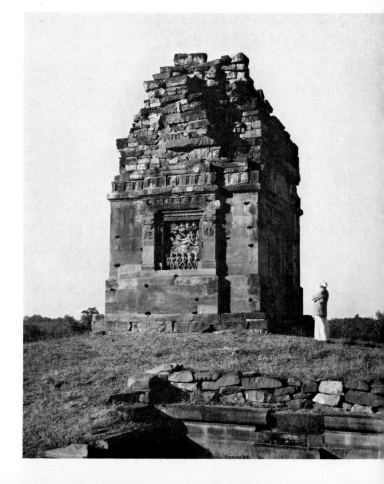

18-17 Vishnu temple, Deogarh, side view, fifth century A.D.

In striking contrast to the robust plasticity of northern sculpture are the carvings on the Buddhist monuments situated at the mouth of the Krishna River on the Bay of Bengal. The major sites, in chronological order (roughly from the second century B.C. to the third A.D.), are Jaggayyapeta, Amarāvatī, and Nāgārjunakonda. Little remains from the first, but many reliefs from the other two are extant. These are elaborately ornamented and filled with hosts of figures that, particularly in the later Amarāvatī scenes (FIG. 18-18), are slender, attenuated, and in graceful movement—stone rendered almost as if by brush.

The record of Indian art farther to the south begins with a cave temple at Maṇḍagapattu (early seventh century) that was commissioned by the first great ruler of the Pallavas, Mahēndravarman I, and dedicated to the Hindu trinity. He was soon surpassed by his immediate successors at Mahabalipuram, on the coast not far from the city of Madras. Here, near a miscellany of monuments—including cave shrines, carved cliffsides, and a masonry temple—is a unique group of five small, free-standing temples (known as *rathas*) that were sculptured, perhaps as architectural models, from some of the huge boulders

18-18 Relief from stupa, Amarāvatī, first to third centuries A.D. Musée Guimet, Paris.

18-19 Rock-cut temples, Mahabalipuram, seventh century A.D.

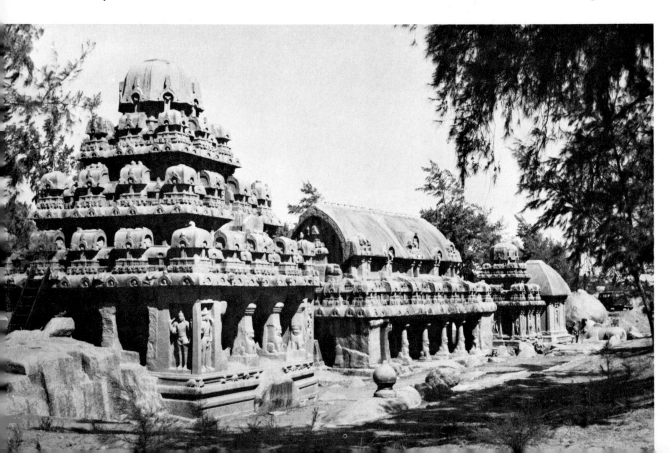

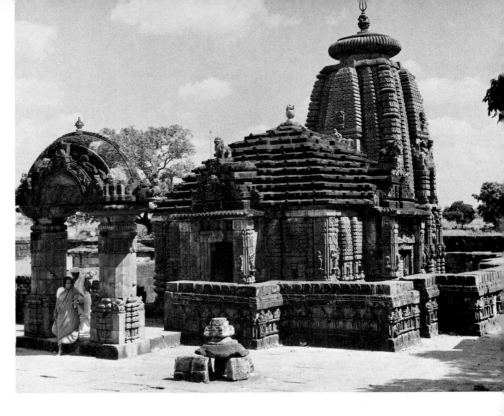

18-20 Mukteśvar Temple, Bhuvaneśvar, Orissa, *c.* A.D. 950.

that litter the area (FIG. 18-19). One of the temples is apsidal, another has a long vaulted shape with a barrel roof, the ends of which reproduce the bent-wood curves of the ancient chaitya halls. The smallest is a square shrine with a pyramidal roof that mimics in stone the thatch of primitive shrines as they appear in reliefs on the rails of early stupas. The Dharmaraja, largest of the rathas, has a simple cubic cella, as at Deogarh. But the *vimana* (composed of the garbha griha and the śikara) ascends, in typical southern style, in pronounced tiers of cornices decorated with miniature shrines. Spaced along the walls are niches containing figures of the major deities; these niches were to become a regular feature of the southern temple.

The south Indian temple was further developed at the beginning of the eighth century in nearby Kanchipuram and imitated by the artists of the Chalukya dynasty in the Virūpāksha Temple (*c.* 740) at Pattadakal near Badami. The vimana here is a more complex version of the Dharmaraja ratha, but porches and an assembly hall (*mandapa*) have been added in front of the garbha griha. The interior of this shrine consists of a dimly lighted ambulatory surrounding the cella, which is entered through a large columned assembly hall and two subsidiary shrines. Light

entering the mandapa through narrow windows and two projecting porches plays over elaborate relief carvings on the columns and walls. The devotee, who entered through an open porch, walked from the blazing light through a cool, softly lighted, and spacious area until he reached in darkness the enigma of the garbha griha itself. There, in the austere chamber, he came face to face with the barely visible symbol of his deity. The sense of mystery offered the worshiper in such a setting was as satisfactory to the Hindu as was the soaring exultation of the Gothic cathedral to the Christian.

The exterior of the Virūpāksha Temple was not as successfully organized as the interior, mainly because the śikara is awkward in direct profile. It was a century or two before the architects in the north—at Bhuvaneśvar and Khajuraho—combined the exterior and interior into a visual unity. The problem of creating a unified exterior was solved in separate stages. The first step, adding height to the mandapa to mitigate the disparity between the vertical vimana and the horizontal mandapa, was taken by the architects of the immense Kailaśa Temple (*c.* 750), the extraordinary rock-cut monument at Ellora. A second step is exemplified by the lovely Mukteśvar Temple at Bhuvaneśvar, Orissa (FIG. 18-20),

where a high pyramidal superstructure over the mandapa brought what had been disproportionately horizontal into complete harmony with the tall śikara. This evolution culminated during the tenth to eleventh centuries at Khajuraho (FIG. 18-21) in north central India. There the temples, numbering over twenty, became larger, more elaborate, and, by virtue of their high plinths, even more prominent. Two and sometimes three mandapa were put before the cella. The greatest esthetic advance was made in the roofs of the mandapa and their pyramidal eaves, which unite with the śikara to create a rapid and torrential sequence of cascading forms. The lower sections of the building, bound by a series of horizontal registers, are laden with sculptured deities, legends, and erotic scenes. It is in the figures that the weakening of a tradition can be detected. Their beauty lies in their mannered, attenuated forms and in the way in which they are contorted and often locked together in a sinuous mass. But the warm humanity of earlier sculptures, so well expressed in the Aurangabad

musicians, is no longer present; it has been lost in the mannerisms.

In the year 1000 the first of a series of Moslem invasions sounded the knell of Hindu architecture in northern India. But in the south—first under the Chola kingdom (846–1173) and later under the Hoyśala (1022–1342), the Vijayanagar (1336–1565), and Nayak (1420–1736) dynasties—sculpture and architecture continued to flourish.

Of particular beauty are the small early Chola temples scattered throughout Tamilnadu. Many of these are incomparable in the quality of their architectonic order, sensitive detail, and sculpture. A trend toward larger buildings, reflecting the imperial grandeur of the Chola, led to the great Brihadeśvara Temple (c. A.D. 1000), at Thanjavur, which is 160 feet high and replete with architectural elements and figures. On its walls are many deities although there are fewer than at Khajuraho and most are confined to niches spaced with restraint at ordered intervals.

Bronze images were made to grace the shrines and to be carried in processions during important

18-21 Temple, Khajuraho, tenth to eleventh centuries.

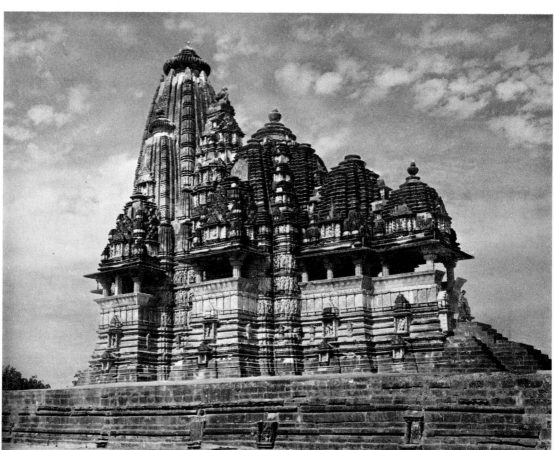

ceremonies. Some of the world's most superb bronzes were produced in the Chola kingdom, the figures of Śiva as Naṭarāja, Lord of the Dance, reaching their high point by the tenth century. The Naṭarāja (*c.* 1000) at the Naltunai Iśvaram Temple at Punjai (FIG. 18-22) shows the god, represented in an ideal human form, dancing vigorously within a flaming nimbus, one foot on the Demon of Ignorance. His flying locks terminate in rearing cobra heads, and at one side they support a tiny figure of the river goddess, Ganga. One of his four hands sounds a drum, while from another a flame flashes. Dancing thus, Śiva periodically destroys the universe so that it may be reborn again. Exquisitely balanced, yet full of movement, this bronze is a triumph of three-dimensional sculpture and the art of bronze casting.

Enormous temple compounds grew around the nucleus of earlier temples. The Mīnākshi temple at Madura and the Śrīrangām temple at Tiruchirapalli eventually covered acres of ground. "Thousand-pillared" halls were built almost one beside the other, acquiring the aspect of a continuous structure interrupted only by courtyards and sacred water tanks for ritual bathing. Elaborate monolithic columns, carved with high- and low-relief figures, evoke a solemn mood, the stone sculpture giving the effect of iron castings. The original walled enclosure came to be surrounded by other walls as the temple expanded and the gateways (*gopuram*) at each of the four cardinal points grew progressively higher with each additional wall. The fully developed gopuram are multi-storied and crowded with sculpture; with many over 150 feet high, they dominate the landscape of south India.

The spread of Moslem domination gradually sapped the Indian tradition, even in the south. By the seventeenth century the harmonious proportions of earlier figures were lost, and even the metal castings had become inferior.

Painting

The art of painting was probably as great in India as the art of sculpture but, unfortunately, less of it survives. The earliest traces are a few fragments

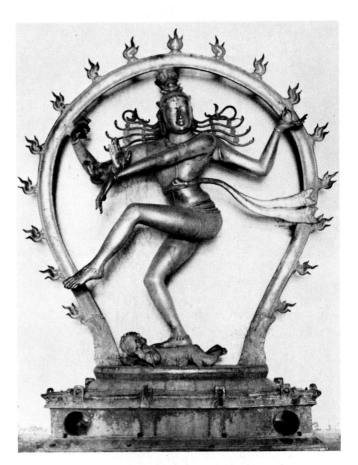

18-22 Śiva as Naṭarāja, Lord of the Dance, Naltunai Iśvaram Temple, Punjai, Tamilnadu, *c.* A.D. 1000. Bronze.

in Cave X at Ajanta that date from approximately the first century B.C. Like the ornamentation on the toranas at Sanchi (above), to which they are related in style, they illustrate scenes from the past lives of the Buddha.

At Ajanta, again, in Caves I and XVII, are found the next and most magnificent examples of Indian painting. These murals, from the fifth and sixth centuries A.D., embody all the clarity, dignity, and serenity of Gupta art; they must rank among the great paintings of the world. The *Great Bodhisattva* in Cave I moves with the subtle grace of the Deogarh sculptures, while the glow of color imparts an even more spiritual presence (PLATE 18-1). The Ajanta paintings, however, are more than the manifestations of Buddhist devotion. Their genrelike scenes and worldly figures, although illustrating Buddhist texts, reflect a sophisticated and courtly art.

The Ajanta painting tradition, in all its colorful vitality, was continued under the Chola rule, as witnessed by the paintings in the Great Temple at Thanjavur. The dancing figures in these murals—though drawn in the vivacious postures familiar in the Chola bronzes—are modeled in the soft tonality of the Gupta style.

The Moslem conquests inhibited the evolution of Hindu sculpture and architecture in northern India after the thirteenth century, but they revitalized the art of painting. In the sixteenth century, especially under the reign of Akbar, who tried to unite Hinduism with Islam, traditional Indian painters were exposed to the delicate and conventionalized miniatures of the great Persian artists. During the seventeenth and eighteenth centuries, painting responded vigorously to what was an interplay between foreign modes at the imperial capital and autochthonous idioms at isolated feudal courts. Many delightful hybrids and innovations resulted—some delicate and lyrical, as at Bundi and Kishangarh (Rajasthan); some stark and bold, as at Basoli in the Himalayan foothills. Among others, the hill schools in Guler and Kangra developed their own idiom, emphasizing such subjects as elegant figures in serene landscapes, portraits of rulers, *ragamalas* (interpretations of musical modes), and religious themes. The joyous exuberance of these new styles was particularly well suited to newer Hindu cults, which were dedicated to the worship of Krishna, an avatar of Vishnu whose praises were sung in the erotic poetry of the *Gita-Govinda*. The love of the lush and the sensuous, which the earliest sculptures had expressed, thus found an entirely new medium in exquisitely colored, often tender paintings (PLATE 18-2).

THE SPREAD OF INDIAN ART

The vigorous culture that generated the great achievements of art in India overflowed its borders. The great tide of Buddhism in the early centuries of the Christian era carried Mahāyāna beliefs and the art of Gandhāra-Mathura through Afghanistan, across the desert trade routes of Turkestan into China, and eventually into Japan.

The path of Hīnayāna Buddhism (pages 804 and 809), opened in the third century B.C. by the son of the Emperor Aśoka, led in another direction—southward from Amarāvatī to Sri Lanka (Ceylon) across the narrow straits. From that time on Sri Lanka became a little India, its arts influenced first by Amarāvatī, then successively by the Guptas, the Pallavas, and the Cholas. The largest concentration of art was at two royal centers: Anuradhapura (virtually an extension of Amarāvatī), where most of what remains is from the second and third centuries A.D., and Polonnaruwa (eleventh to twelfth century), best known for the colossal 46-foot-long sculpture of the expiring Buddha (FIG. 18-23). Here also are many famous stupas that basically adhere to the Amarāvatī tradition but are simpler; an innovation is the carvings of guardian figures on stelae placed at stupa entrances. While there are some paintings at Polonnaruwa, the earliest (fifth century) and most exquisite are the heavenly maidens on the escarpment of the fortress at Sigiriya.

By the fifth century, a series of emigrations from India was bringing the impact of Indian culture to Burma, Thailand, Cambodia, Sumatra, and Java. There, Buddhism and Hinduism continued their struggle for supremacy, with each introducing and fostering its arts. While Buddhism was under siege in India, one of its greatest monuments was rising at Barabudur in Java (FIG. 18-24). There, around 800 A.D., a huge stupa, basically rectangular and over 400 feet across the base, was built of stone in nine terraced levels, with a central stairway in each of the four sides. The base and the first four tiers are rectilinear and signify the terrestrial world of sensation; the upper four are circular and symbolize the heavens.

On the base, mostly covered by earth, 160 reliefs depict people trapped in the karmic cycle of life, death, and rebirth. Abundantly decorating the walls along the corriders of the next four tiers are over 1000 cautionary scenes from the *jātakas* and different *sūtras*. But above, on the circular terraces, no narratives intrude. Here, ringing the pathways in solitary dignity, are latticed stupas, in each of which, barely visible, is a seated Buddha of gentle beauty. (Originally there were 73.) Rising at the pinnacle is a single larger stupa,

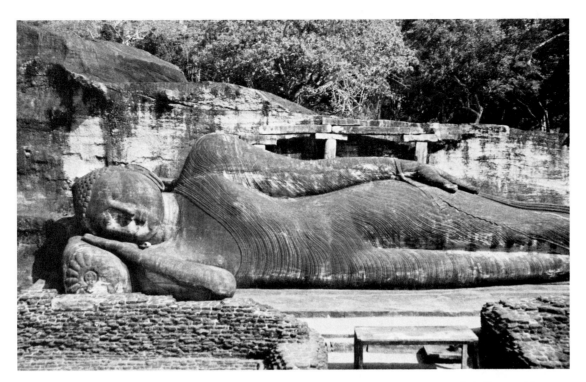

18-23 Parinirvana of the Buddha, Polonnaruwa, eleventh to twelfth centuries A.D. Stone, whole figure 46' long.

18-24 Stupa, Barabudur, Java, eighth century.

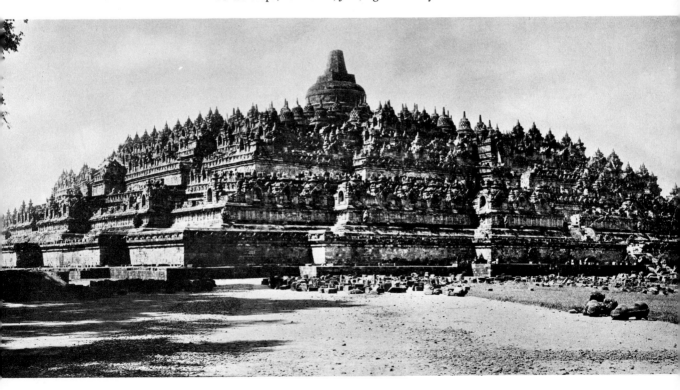

which may have enclosed a single Buddha, symbol of the ultimate.

This architectural orchestration of sculptures is a mandala, a cosmic diagram representing the three spheres of Buddhist cosmology—the Human Sphere of Desire (didactic narratives crowded with figures and foliage), the Bodhisattva Sphere of Form, and the Buddha Sphere of Formlessness, where the simplicity and isolation of the individual stupas effect a serene release. The scheme uses 505 Buddha figures. In all, it is an eloquent statement of proto-Esoteric Buddhism as developed from Mahāyāna in Java.

The Buddhists in Java also erected *chandis* (temples). Two such that are near the stupa of Barabudur and of the same date are Chandi Mendut and Chandi Pawon. Their dark sanctuaries, containing colossal Buddhist images, have the same awesome impact as the shrines of the Buddhist cave temples in northwest India. Indeed, those caves as well as other sacred sites throughout India were well known to Indonesian pilgrims, whose exposure to Indian monuments and texts influenced their island culture.

The Hindus were also active in Java. On the Dieng Plateau they erected single-celled Śiva temples based on south Indian Pallava models. At Prambanan in central Java, where structures and motifs were rapidly Javanized, the Śiva temple of Laradjhonggrang (ninth to tenth century), tall and narrow, is characteristically a studied aggregate of piled-up stones, terraced peaks, and sanctuaries, the whole a symbol of Mahameru, axis of the universe and mountain home of the gods. Reliefs on the temple balustrade illustrate the *Rāmāyana*, the great Hindu epic. Naturalistic yet decorative, these dramatic narratives are a harmony of Indian forms and Javanese physical types (FIG. 18-25).

The mainland, in contact with India by the third century A.D., also reacted to the stimuli of Indian culture. In Thailand, the softly modeled figures of bronze and stucco that were produced during the Dvāravatī period (sixth to tenth century) were inspired by the Gupta style. During the Pre-Angkor or Early Khmer period (fifth to ninth century), the Cambodians, too, borrowed the flowing planes and sensitive surfaces of Gupta.

18-25 Rāmāyana scene, Śiva temple, Laradjhonggrang, Java, ninth to tenth centuries.

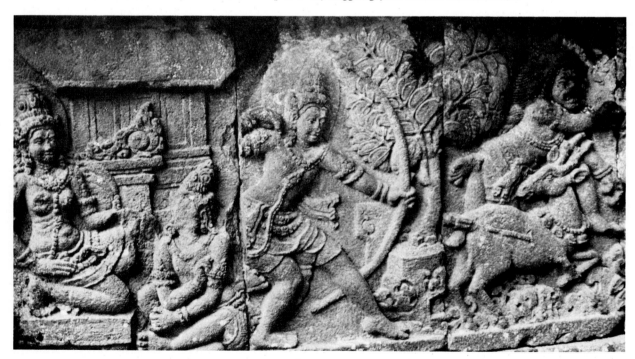

320						600				750
			Seated Buddha, Sarnath		Badami cave temples					
		C H A L U K Y A		P E R I O D						
G U P T A	P E R I O D									
	P A L L A V A		P E R I O D				to c. 900			

Around the seventh century, they also worked in the manner of the south Indian Pallavas, as we can see in the figure of Harihara (a combined form of Śiva and Vishnu) from Prasat Andet (FIG. 18-26). The elegance of the Pallava prototypes at Mahabalipuram has been modified only slightly by the addition of a taut almost spring-like tension. Tall, broad-shouldered, full-bodied, and slender-legged, this is an idealized figure, more godly than human. We shall see how the classical configuration of the Pre-Angkor gods was gradually transformed into a distinctly more squat Cambodian type with a broad face composed of full lips (doubly outlined), continuous eyebrows, and flat nose.

The temple in Cambodia was directly related to the Angkorian concept of kingship. Whereas in India the ideal king was the Universal Lord (*chakravartin*) who ruled through goodness, and in Java, the earthly manifestation of God, in Cambodia he was the God-King (*devarāja*) in life and after death. The temple the king built was dedicated to himself as the god. As the kings grew more powerful and ambitious, so grew the size of their temples and the multiplication of architectural and decorative elements.

A prime example of the colossal agglomerations typifying the fully developed Angkorean style is Angkor Wat (1100–75). A moat two and a half miles long surrounds this monument; one of its many courtyards contains half a mile of sculptured reliefs; and the foundations of the central shrine alone are more than three thousand feet on each side. The temples comprising this great complex are set at the corners of two concentric walls that gird the central shrine. Each of the eight temple towers repeats the form of the main spire, which rises in the center from a raised platform like the apex of a pyramid. The towers themselves resemble in outline the śikara of north Indian temples.

Angkor Wat was dedicated to Vishnu, and reliefs on the galleries illustrate the *Rāmāyana* and the ten incarnations of the god. These carvings express the Cambodian predilection for rhythmic design, the juxtaposition of two, three, or more identical figures, and the repetition of undulating contours. These graceful but stylized forms, thus locked together, move in a harmonious rhythm like their counterparts in Cambodian dance (FIG. 18-27).

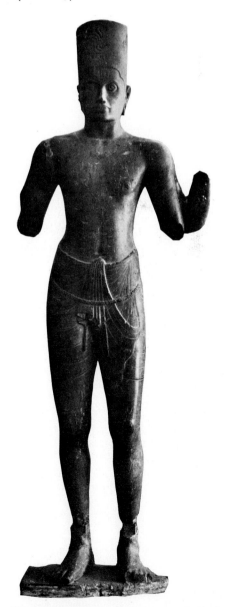

18-26 *Harihara*, Prasat Andet, eighth century. Musée Albert Sarraut, Pnompenh.

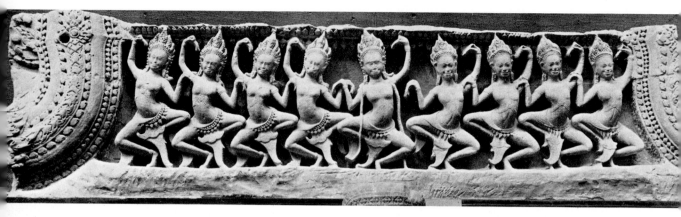

18-27 Dance relief, Angkor Wat, twelfth to thirteenth centuries. Musée Guimet, Paris.

18-28 *Bayon*, Angkor Thom, thirteenth century.

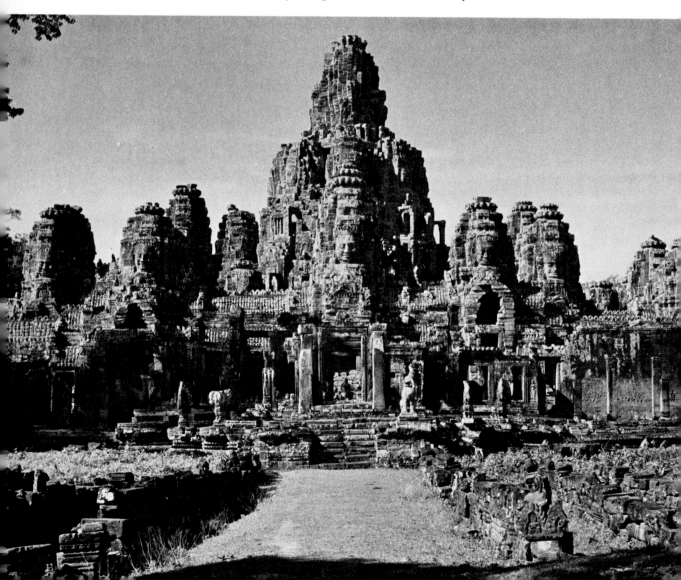

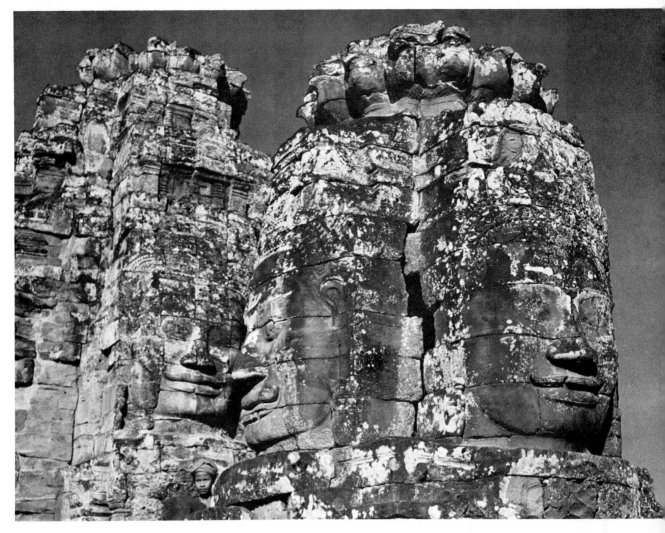

18-29 Tower of *Bayon*, Angkor Thom, thirteenth century.

The Bayon at Angkor Thom (FIG. 18-28) twelfth and thirteenth centuries, is in many ways the culmination of the Indian temple, particularly in its complete integration of sculpture and architecture. It also illustrates the syncretic relationship of Hinduism and Buddhism. The long impressive approach to the Bayon, a Buddhist temple, is lined with giant gods and demons holding onto the body of the serpent Vāsuki, in enactment of a Hindu legend, the Churning of the Sea of Milk. But the uniqueness of the Bayon lies in the size and disposition of the colossal heads, one on each side of the square towers (FIG. 18-29). These faces, their Cambodian features now fully stylized, smile enigmatically from a lofty height. They are the faces of the Bodhisattva Lokeśvara, god form of the reigning king, symbol of the infinite powers of the devarāja-Bodhisattva, which extend to all points of the compass. The Bayon was conceived as the world mountain. On it and around it a tropical luxuriance of decorative and narrative carvings intensify its magic. The creative force that had been India left its last great record abroad in these compassionate faces of Lokeśvara surveying from eternity the legendary history carved on the temple walls below.

The Art of China

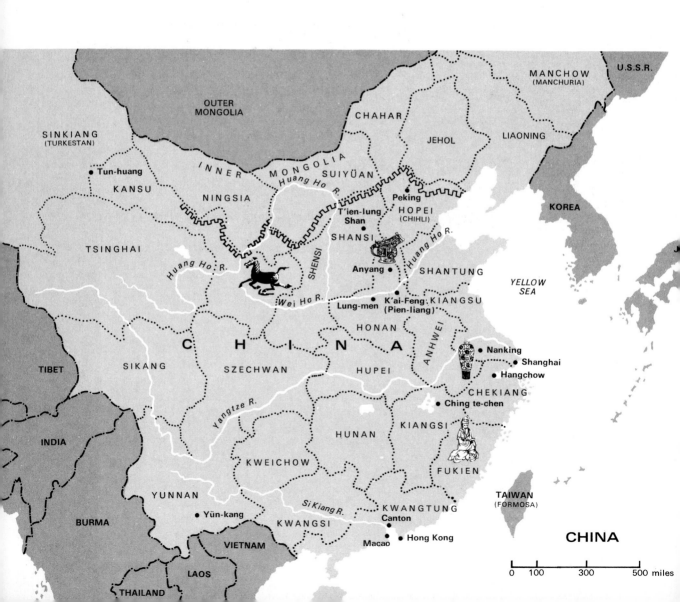

OF THE GREAT non-Western civilizations, that of China was the first known and appreciated in Europe. But it is only in the past half-century or so that the achievements of Chinese art and culture have been progressively revealed and studied systematically. Still, many in the West who now realize the extent and continuity of Chinese civilization and who recognize the striking beauty of its art are not fully aware of the complexity of either. Our task here is to identify the spirit of Chinese art and to trace, at least in outline, its major developments and styles.

China is a vast and topographically varied country about the size of the United States. Its political and cultural boundaries have spread at times to double that area, encompassing Tibet, Chinese Turkestan (Sinkiang), Mongolia, Manchuria, and parts of Korea. The country includes great stretches of sandy plains, mighty rivers, towering mountains, and fertile farmlands. North China, centering around Peking, has a dry and moderate-to-cold climate, whereas south China is moist and tropical.

While the spoken language of China varies so much as to be unrecognizable in different areas, the written language has remained uniform and intelligible in all parts of the country, permitting

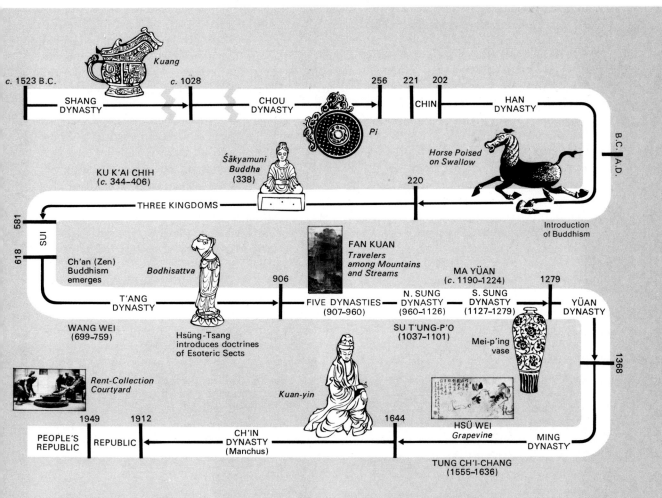

literary, philosophic, and religious traditions to be shared by people thousands of miles apart.

A similar uniformity is observable in the modes of artistic expression, for there are only slight variations in the art forms from different parts of China in any epoch other than the prehistoric.

The primarily expressive function of Chinese painting during the last millennium has been gradually made more comprehensible to the Western mind, partly by developments in the modern art of the West. We have become more aware of fundamental differences between Chinese secular art and the traditional, premodern art of the West, differences determined by those between the philosophies of nature and man of the two cultures. For the Chinese, man is not dominant in nature; he is a part of it, responding like all living creatures to its rhythms. To be happy is to live in accord with nature; to be a painter is to be the instrument through which nature reveals itself. The painter's work is an expression of his immersion in the flow of life and of his attunement to all that changes and grows and, in so being, is also the expression of a personal character refined by the contemplation of nature. Moreover, because nature is not measured and classified according to space and time, the Chinese painter does not frame it off in perspective boxes with colors scaled in light and shade. He does not attempt by such means to duplicate and fix natural appearances. The asymmetry of growing things, the ceaseless and random movements of nature, the infinity of cosmic happenings—these forbid all enframements, rigid regularities, beginnings and ends. Appearance is always transformed by the artist's passage through it. He becomes part of the total expression of his art as his art is the total expression of his experience of nature.

This philosophical attitude of the Chinese toward secular painting can be seen even in the artist's almost ritualistic preparation of his medium, his materials. The best ink, for instance, was derived from soot or lampblack mixed with animal glue and pulverized clay, oyster shells or powdered jade, and various fragrances. From these ingredients, each of which had symbolic as well as physical properties, an ink stick (often carved) was formed that was treasured by the artist.

SHANG

A series of Neolithic cultures characterized by a variety of painted wares date back to the fourth millennium B.C. According to traditional Chinese history this would have been the period of the Hsia. While the Hsia state is still a matter of legend, the remains of a considerable kingdom discovered within the last fifty years have confirmed the existence of the Shang dynasty. As late as 1929 many scholars doubted the existence of the Shang dynasty, but in that year excavations at Anyang in northern China brought to light not only one of the last capitals of the Shang but also evidence of their earlier development. Among the astounding discoveries were large numbers of inscribed bones, once used for divination, which tell us much about the Shang people. Their script was basically pictographic but sufficiently developed to express abstract ideas. These fragmentary records, together with other finds from the excavations, reveal an advanced if barbaric civilization. They indicate that the king was a feudal ruler and that some of his wives were also his vassals, living in different cities. Warfare with neighboring states was frequent, and cities were protected by surrounding walls of pounded earth. Royal tombs were extensive, and the beheaded bodies of servants or captives accompanied the deceased rulers to the grave. Chariots, trappings of horses buried alive, weapons, and ritual objects found in these graves help us to describe the art of this period.

Although sculpture in marble and small carvings in bone and jade exist, the great art of the Shang was that of ritual bronze vessels, many of which have come down to us in imperial collections. These bronzes were made in piece molds. They show a casting technique as advanced as any ever used in the East or West, which indicates that this art must have been practiced for many centuries before the Shang. The bronze vessels were intended to hold wine, water, grain, and meat used in sacrificial rites. The major elements of decoration are zoomorphic, but usually the background and sometimes the animals themselves are covered with round or squared spirals, believed to symbolize clouds, rain, or water—all fertilizing aspects of nature. Such conventions, which obviously evolved over a long period,

rigidly governed the stylistic representation of animals, so that images or symbols are often involved and difficult to decipher. A major zoomorphic motif is that of an animal divided in half and arranged symmetrically on the body of a vessel. Such an animal is shown in FIG. 19-1, a covered libation vessel, or *kuang*. In this complex design, the representation (on the vessel's side) is probably of eyes of a tiger and horns of a ram. (On other such Shang vessels the eyes may be of a sheep, the horns, of a bull, water buffalo, or deer.) The front of the lid is formed of a horned animal; the rear, of a horned head with a bird's beak in its mouth. Another horned head is on the handle. Fish, birds, elephants, rabbits, and more abstract, composite creatures swarm over the surface against a background of spirals. Specific combinations of such animal motifs evidently define certain concepts; for example, the animal or bird in the mouth of another animal probably signifies generation. The multiple designs and their enigmatic fields of spirals are so closely integrated with the form of the vessel that they are not merely an external embellishment but an integral part of the sculptural whole. The tense outline of the bronze compactly encloses the forces symbolized on its surface. These vessels not only were ritual containers but also, in their very form and decoration, a kind of sculptural icon or visualization of the early Chinese attitude toward the powers of nature.

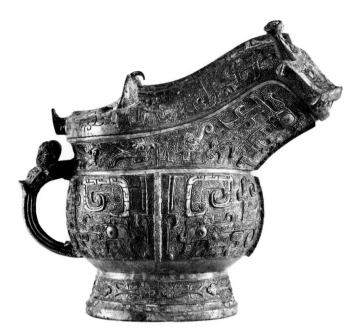

19-1 *Kuang*, Shang dynasty, twelfth century B.C. Bronze, 6½″ high. Smithsonian Institution, Freer Gallery of Art, Washington, D.C.

19-2 *Yu*, Early Chou dynasty, tenth to seventh centuries B.C. Bronze. Smithsonian Institution, Freer Gallery of Art, Washington, D.C.

CHOU

About 1027 B.C. the Shangs were overthrown by the Chous, whose dynasty endured until 256 B.C. Although the Chous were a more primitive people from the west, their culture apparently resembled that of the Shangs.

The very earliest Chou bronzes are indistinguishable from those of the Shangs. Indeed, they were probably made by the same craftsmen. But within a generation the new and bolder spirit of the conquerors was unmistakably imprinted on the ritual vessels. Where the Shang silhouette had been suave and compact, the Chou was explosive and dynamic (FIG. 19-2). Gradually this vitality diminished, and in a hundred years the shapes

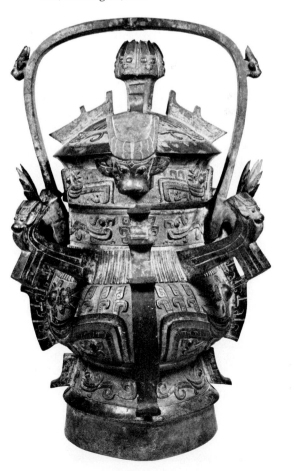

became more utilitarian and the zoomorphic shapes more ornamental. The animal forms were distorted and twisted into interlaces until, by the beginning of the Late Chou period (600–256 B.C.), almost all evidence of the original awesome motifs was lost in an exuberance of playful rhythms over the surface of the bronzes. What had once expressed the power of magic and religion was transformed into a secular display of technical skill and fantasy.

During the sixth century B.C. the Chou empire began to dissolve into a number of warring feudal states. As old values were forgotten, Confucius and other philosophers strove to analyze the troubles of their day. While Confucius urged intelligent and moral action upon his followers, his famous contemporary, Lao-tzu, favored meditation, inaction, and withdrawal from society. Neither philosophy, however, was to affect the arts for several centuries.

The art of the Late Chou, whether in bronze, jade (FIG. 19-3), or lacquer, was produced to satisfy elaborate demands of ostentatious feudal courts that vied with each other in lavish display. Popular at this time were bronzes inlaid with gold and silver and mirrors highly polished on one side and decorated with current motifs on the other. About the fourth century B.C. ritual bronzes were embellished with an entirely new system of narrative designs. Scenes of hunting, religious rites, and magic practices, although small, nevertheless reveal subjects and compositions probably reflective of paintings lost but mentioned in literature of the period.

In the Late Chou, carvings of jade, a stone regarded with special reverence by the Chinese and found in neolithic tombs, reached a peak of technical perfection in jewelry and ritual objects entombed with the dead (FIGS. 19-3 and 19-6). At this time Confucius extolled the virtues of jade in which, he said, superior men in ancient times "found the likeness of all excellent qualities": It was soft, smooth, and glossy (when polished), like benevolence; fine, compact, and strong, like intelligence; angular, but not sharp and cutting, like righteousness; and (when struck) like music. Like loyalty its flaws did not conceal its beauty nor its beauty its flaws and, like virtue, it was conspicuous in the symbols of rank.[1]

The culture that had produced the great bronzes and jades of the Shang and Chou was being transformed. The political turbulence of the late Chou period, sometimes called the period of the Warring States, was accompanied by an intellectual and artistic upheaval that coincided with the rise of conflicting schools of philosophy and, in art, a new iconography and style combined with vestigial elements from the Shang and early Chou periods. During the next four hundred years, a radically different art developed.

CH'IN AND HAN

The political chaos of the last few hundred years of the Chou dynasty was temporarily halted by Shih Huang Ti, ruler of the state of Ch'in. In the third century B.C., in an attempt to eradicate old traditions, he ordered the burning of all historical books and established totalitarian control over most of China. At his death the people revolted, and in 206 B.C. a new dynasty, the Han, was founded. A powerful centralized government ex-

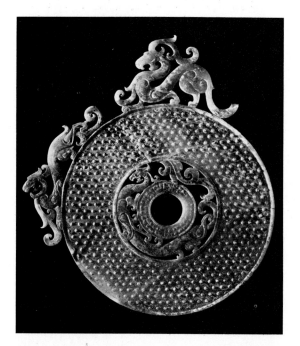

[1] From the *Li Chi* attributed to Confucius, translated by James Legge, *The Sacred Books of the East* (1968), vol. 28, p. 464.

19-3 *Pi*, Late Chou dynasty, fifth to third centuries B.C. Jade. Nelson Gallery–Atkins Museum, Kansas City, Missouri (Nelson Fund).

tended the southern and western boundaries of China. Chinese armies penetrated far into Turkestan, and indirect trade was maintained with distant Rome. Confucianists struggled with Taoists (followers of the mystic philosophy of Laotzu) for control of governmental powers. The Confucianists eventually won, though the formalized Confucianism that triumphed was far removed from the teachings of the master. The Confucian legends of filial piety and the folklore of Taoism together provided most of the subject matter of Han art.

The Han pictorial style is known from a few extant paintings and many stone reliefs as well as stamped pottery tiles. In some paintings the outlines of figures are rendered in the characteristic Chinese line, whose calligraphic elasticity conveys not only outline but depth and mass as well. Overlapping of arms and drapery further emphasizes the third dimension, while flat colors applied within contours accent the rhythmic relationship between figures. There is no background or any other indication of environment.

Numerous stone reliefs in the Wu tombs in Shantung (c. A.D. 150) also reflect modes of Han pictorial representation. A whole history of the world, from the time of creation to the burial of the deceased, is depicted on these slabs. The story unfolds in images of flat polished stone against an equally flat though roughly striated ground (FIG. 19-4). The massive figures are related by the linear rhythms of their contours. In addition, buildings and trees now indicate a milieu. Space, though, is conceptual, as in Egyptian painting; and distance is suggested by the superposition of figures although, curiously enough, chariot wheels overlap. Individuals of importance are shown hieratically in larger size than their subordinates. Most interesting are the trees, which are highly stylized as masses of intertwined branches bearing isolated, overlarge leaves. Yet within this schematic form some accidental variation in a twisted branch or broken bough shows how the designer's generalization derived from observation of specific trees and how a detail of the particular could individualize the general. It is this subtle relationship between the specific and the abstract that became one of the most important esthetic attributes of later Chinese painting.

A group of reliefs from Szechwan, while similar to those of the Wu tombs and probably of the

19-4 Mythological scenes, Wu Tomb, Shantung, Late Han dynasty, A.D. 147–168. Rubbing of stone relief, approx. 5' long.

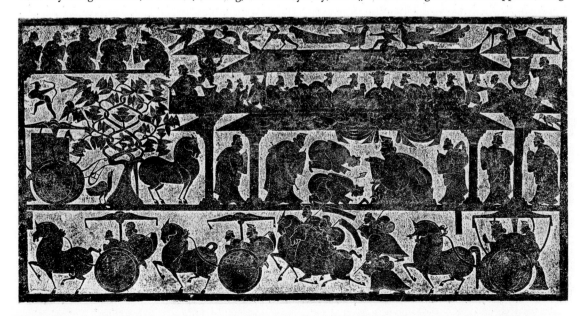

19-5 Flying horse poised on one leg on a swallow, Wu-wei, Kansu, Eastern Han dynasty, second century A.D. Bronze, 13½″ high, 17¾″ long. The exhibition of archeological finds of the People's Republic of China.

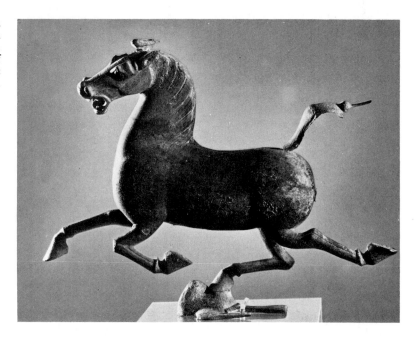

same date, are further advanced. Rhythms are more rapid, and space and the environment are more fully stated. Some subjects concern everyday life, in contrast to the earlier preoccupation with mythological or historical themes. There is also a figure of the Buddha, probably the earliest in China and therefore the first reference to the religion that was to dominate Chinese thought for the next thousand years.

A superb example of Han bronze craft in the tradition of Chinese mastery of that metal since Shang times is a recently discovered (1969) figure of a horse from a tomb (FIG. 19-5) in Hopei. Though its action is certainly that of a quick trot, it seems to be flying, one hoof lightly poised on the figure of a swallow whose wings are extended. The horse, because it was revered for its power and majesty, has a prominence in Chinese art tantamount to that of the lion or bull in the art of the Near East.

A second-century B.C. Han tomb unearthed in 1968 appears to confirm our knowledge of the use of jade. As noted above with respect to the Late Chou *Pi* (FIG. 19-3), jade was believed to have

19-6 Funeral suit of the Princess Tau Wan, Man-ch'eng, Hopei, Western Han dynasty, late second century B.C. Jade tablets sewn with gold wire; suit is 68″ long. The exhibition of archeological finds of the People's Republic of China.

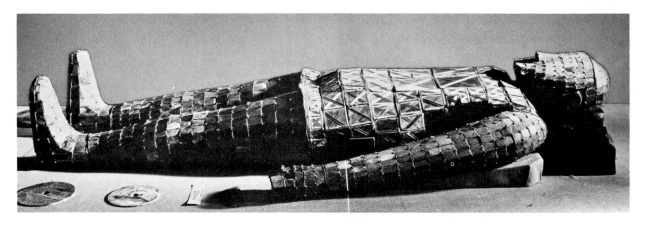

magical properties protective of the dead. The tomb (in Hopei) contained the remains of a Prince and Princess, each of whom had originally been masked and completely outfitted in suits (FIG. 19-6) composed of over 2000 jade tablets expertly cut, fitted, and sewn together with gold wire—an extraordinary technical feat.

THREE KINGDOMS THROUGH SUI

Buddhism (p. 803), whose spirit was one profoundly different from the ancient and native philosophies of China, was introduced by the first century of the Christian era. During the last hundred years of Han rule and the succeeding period of the Three Kingdoms, China, splintered by strife, grasped eagerly at a new ideal by which to live. The Confucian system of ethics had proved unable to adapt itself to the anarchy of the times, and Taoism, having degenerated into magic and superstition, no longer appealed to the philosophic mind. Buddhism offered the Chinese masses the promise of hope beyond the troubles of this world. In addition, it attracted the intellectuals by its fully developed logical system, whose refinements surpassed those of any previous Chinese system of thought. Buddhist missionaries from India, working at first with the ruling families, spread their gospel so successfully that their teachings ran like wildfire through China.

The arts flourished in the service of the imported religion. A new esthetic was developed in imitation of Indian or central Asian models, in harmony with the prescribed formalism of Buddhist doctrine. The earliest important Buddhist image, a gilt-bronze statuette of Śākyamuni Buddha, dated by inscription in the year 338 (FIG. 19-7), is clearly related, in both style and iconography, to the prototype that had been conceived and developed at Gandhāra (p. 809).[2]

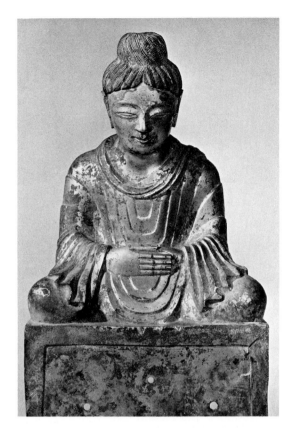

19-7 *Śākyamuni Buddha*, Six Dynasties, A.D. 338. Gilt bronze. Asian Art Museum of San Francisco, The Avery Brundage Collection.

The heavy concentric folds of the robe, the *ushnisha* on the head, and the cross-legged position all derived ultimately from the Indian prototype, examples of which had been brought to China by pilgrims and priests who had made the hazardous journey along the desert trade routes of central Asia.

The Chinese artist transformed the basic Indian pattern during the following century or so. These changes may be observed in a series of great cave temples that were carved into the hillsides after the fashion of the early Buddhists in India. At Tun-huang, westernmost gateway to China, over three hundred sanctuaries were cut into the loess cliffs, the walls decorated with paintings, and the chambers adorned with images of clay. This site was dedicated in 366, but the earliest extant caves are from the late fifth century. About the same time, in 460, sculptors at Yün-kang, near Ta-t'ung

[2] Yet so new was the icon and its meaning that the Chinese craftsman, although endeavoring to make an image faithful to prescription, nevertheless erred in representing the canonical *mudrā* of meditation: the Buddha's hands are clasped across his stomach, whereas they should be turned palms upward, with thumbs barely touching.

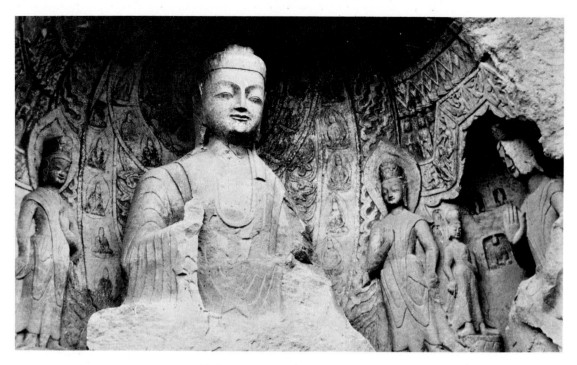

19-8 *Maitreya*, Yun-kang caves, *c.* 460.

in northern China, were carving temples in cliffs of sandstone. Although the materials are different, both sites have an archaic style similar to the sculpture of the sixth century B.C. in Greece and of the early twelfth century in France. Like their Western counterparts, the cave figures have faces carved in sharp planes and drapery conventionalized into angular patterns, and, as a whole, they too express the intense and noble dignity of a deeply felt religion (FIG. 19-8). The Buddhist concept of divinity in its most perfect form may be seen in the caves of Yün-kang, where the image of the Buddha, a blend of conventional restraint and religious fervor, became human enough for popular recognition while remaining sufficiently idealized to carry the worshiper beyond the image to the abstraction it symbolized.

In 494 the Wei Tatars, staunch Buddhists who had supported the colossal program at Yün-kang, moved their court southward to Lo-yang in Honan. Near there, in the limestone cliffs of Lung-men, another series of caves was started where work continued until the first part of the sixth century. The new carvings, despite their

undeniable charm, were mannered reworkings of the Yün-kang formula. The religious ardor reflected in the earlier caves was softened by sophistication. The elegance of the Lung-men figures, as compared with the austerity of those at Yün-kang, may be seen in the attenuation of the bodies and in the tightened drapery folds which resemble the facile line of the painter's brush.

While the Lung-men caves were being worked on, the people's imagination was captured by a new form of Buddhism, promoted by various "Paradise Sects," that gave promise of rebirth in a Buddhist paradise rich in the material pleasures that are denied to most in this world. As an idyllic existence in this paradise could be gained merely by faith in the word of the Buddha, many who might have failed to appreciate the goal of nirvana and the ultimate extinction of personality were won over to Buddhism by the more tangible and attractive goal of the Paradise Sects. Glories beyond those even of the imperial court were thus offered to every man who put his trust in the Buddha. The pleasant aspirations of these Bud-

dhists were reflected in the greater naturalism of their arts, particularly in the humanization of the deity. Thus, it is no wonder that, when the Paradise Sects reached their peak in the Sui dynasty, the Buddha was gradually transformed from an archaic image of divine perfection into a gentle and human saviour. The transition is reflected in the gilt-bronze shrine shown in PLATE 19-1. Prabhutaratna, Buddha of the remote past, listens to the sermon by Śākyamuni, the most recent Buddha. Seated within flamelike aureoles, their graceful, slender figures are almost absorbed into the rhythmic fall and flow of linear drapery beginning to acquire the character of cloth. The humanization is manifest in the gentle, suave beauty of attitude and gesture; the faces retain the characteristics of archaic formulae.

A comparable development of Buddhist images can be observed in the richly painted walls of the Tun-huang sanctuaries, which were calculated to inspire the worshiper with the splendor of Buddhism and (like Medieval paintings) to instruct the illiterate. Hieratic Buddhas were surrounded by illustrations of stories about their past lives (jātaka). The formalized patterns of the individual Buddhas are like those of the sculptured images at Yün-kang and Lung-men. But the narrative scenes carried on the traditions of Han painting, especially in the cell-like composition, in the leaping rhythms, and in the disproportionate relationship of figures to diminutive, conventionalized settings.

By 539 most traces of central Asian influence had disappeared. Like sculpture of the time, Buddhist painting responded to the happy credo of the Paradise Sects with increasing naturalism and grace. Although the Buddha groups retained the strict frontality and rigid balance of ritualistic art, the jātaka tales expanded haphazardly over the temple walls, and their figures, now slim, elegant, and emancipated from their compartmental designs, move freely over the plane surface. By the end of the century the abstract environment of the painted figures began to be three-dimensional. Overlapping was used to create depth, and a sense of reality was further heightened by the surrounding of the celestial groups with such earthly phenomena as trees, pavilions, lotus ponds, and bridges.

T'ANG

The short-lived Sui dynasty (581–618) was followed by the T'ang empire, under which China entered a period of unequaled magnificence. Chinese armies marched to the ends of central Asia, opening a path for the flow of wealth, ideas, and foreign peoples. Arab traders, Nestorian Christians, and other travelers journeyed to the cosmopolitan capital of the T'ang, and the Chinese in turn adventured westward. During the middle of the seventh century, Hsüan-tsang, a Chinese monk, visited India, as had some earlier devotees, and returned from the mother country of Buddhism with revolutionizing doctrines of the recently developed Esoteric Sects. It was a critical moment for Buddhism, which was being brought into disrepute by a lax court and a corrupt clergy. Under the notorious Empress Wu, who had usurped the throne, the religion was used as an instrument for political power and as a cloak for personal excesses. The material rewards promised in heaven by the Paradise Sects offered no effective antidote to the troubles of the time. But the elaborate and mysterious rituals of the new Esoteric Sects attracted worshipers by giving them in their daily life many of the sensory pleasures that the Paradise Sects had promised in heaven. As the new cult spread, the Chinese craftsman again looked to India, where he found appropriate models in the sculpture of the time.

The fluid style of art developed during the Gupta dynasty in India (p. 813, Chapter 18) had already affected Chinese sculpture during the late sixth century, and by the end of the next century Buddhist sculpture in China had lost much of its own character in its borrowing from the sensuous carvings of India. Fleshiness increased even more, and drapery was made to cling as if wet against the bodies. The new wave of influence from India brought not only stylistic changes but also the iconography of the Esoteric Sects, which we see in figures with multiple arms and heads, symbolizing various aspects of the deities as described in the new gospels.

The early T'ang style under Indian influence is admirably exemplified by the *Bodhisattva* in FIG. 19-9. The sinuous beauty of this figure has been accented by the hipshot pose and revealing dra-

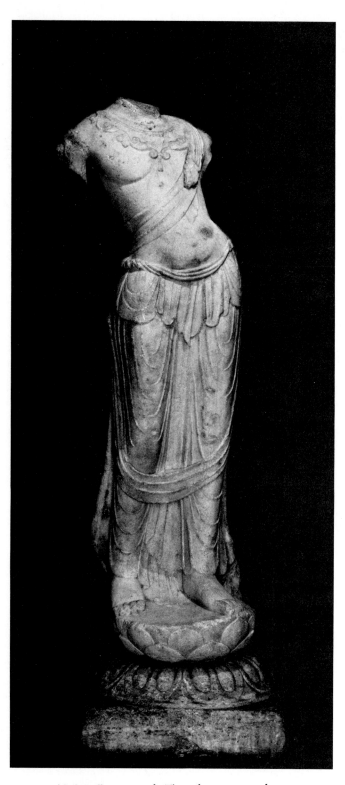

19-9 *Bodhisattva*, early T'ang dynasty, seventh to eighth centuries. Marble. Private collection, New York.

pery, as in Gupta sculpture (Chapter 18). Executed at almost the same time as the bodhisattva—around 700—were carvings in the caves of T'ien-lung Shan, which anticipated the style of later T'ang. These cave figures might seem gross were it not for the graceful postures and the soft drapery that falls in rhythmic patterns over the plump bodies.

Esoteric Buddhism, with its emphasis on detailed and complicated ritual, placed the deity in a formal relationship to the worshiper. The followers of Amitābha Buddha—one of the most important Buddhas of the Paradise Sects—in stressing salvation by faith, had visualized a warm and human deity, but by the ninth century the arduous discipline of the Esoteric Sects had inspired an austere, heavy-set, almost repellent icon. At times fleshiness was exaggerated almost to the point of obesity, and yet sufficient restraint lent the figures a somber dignity.[3]

The westward expansion of the T'ang empire increased the importance of Tun-huang. Here the desert routes converged and the cave temples profited from the growing prosperity of the people. By the eighth century wealthy donors were demanding larger and more elaborately decorated caves. The comparatively simple Buddha group in paintings of the previous century was enlarged to include crowds of attendant figures, lavish architectural settings, and minor deities who worshiped the resplendent Buddha with music and dance. The opulence of the T'ang was reflected in the detailed richness of the brilliantly colored *Paradise Paintings* (FIG. 19-10). Vignettes flanking the Buddha group illustrate incidents from specific *sūtras*. These little scenes, like the jātaka tales in earlier caves, are usually set in landscapes painted in an altogether different style from that of the hieratic groups. Mountains, for example, are stacked one behind the other and painted in graded washes to give the impression of distance. (Yet, although each mountain is related to the adjacent peak through this

[3] Few sculptures survived the terrible persecutions of Buddhism during a revival of Confucianism in 845. Many wooden temples were destroyed by fire and their bronze images melted down. Fortunately, we are able to reconstruct the style of the period from Buddhist art in Japan, which was then under direct Chinese influence (cf. pp. 850–52).

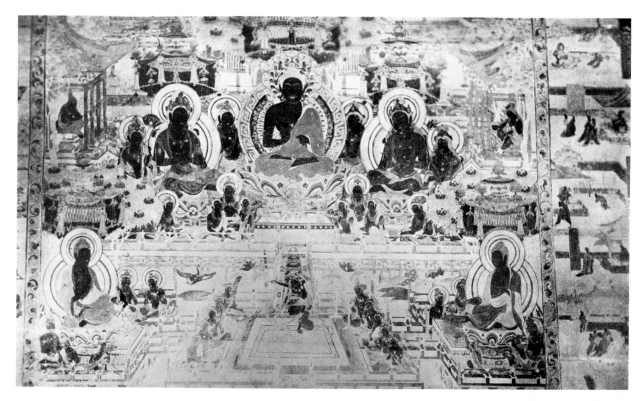

19-10 *Paradise of Amitābha*, Cave 139A, Tun-huang, T'ang dynasty, ninth century.

device of atmospheric perspective, there is still no continuous perspective to give a sense of recession into the distance.)

The persecutions of 845 did not affect Tun-huang, which was then under Tibetan rule. Numerous paintings—murals and scrolls—were produced, but in this region, isolated from the mainstream of Chinese culture, they remained static in style from the middle of the ninth to the beginning of the eleventh century. Meanwhile, in the main centers of China, the landscape scroll, one of China's unique contributions, evolved from a secular painting tradition. The early development of these scrolls remains an unsolved mystery, because the silk and paper on which they were painted have not survived. It is difficult to reconcile the glowing early accounts of such an art with the fact that similar forms do not appear in other media, such as relief sculpture. Wang Wei, for instance, wrote in the fifth century:

I unroll a picture and examine the inscription, and meditate upon mountains and water which are foreign to me. Verdant forests raise the wind; foaming waters stir the torrent of the streams. Wonderful indeed![4]

Statements such as this lead to the conclusion that fully developed landscape painting existed as early as the fifth century. Yet, as late as 600 in the murals at Tun-huang, nature was expressed only in the most rudimentary terms.

Landscape painting, we have learned from history, appears when man begins to question his place within the natural order of the world. Conversely, it is either absent or of little importance when man's thoughts are directed primarily toward the relationship of man to man or of man to God. In China the pantheistic love of nature that the Taoists professed permeated Chinese thought during the fourth century so that conditions favorable to a landscape art existed at this early date.

From the writings of KU K'AI-CHIH (*c.* 344–*c.* 406), an essayist and a painter, and from later

[4] For this and other excerpts from essays on painting which are quoted below, see Shio Sakanishi, *The Spirit of the Brush* (London: Murray, 1948).

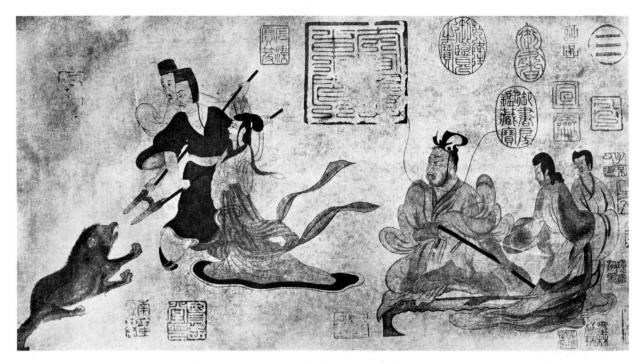

19-11 KU K'AI-CHIH, *Lady Feng and the Bear*, detail of the *Admonitions of the Instructress*, copy from the late fourth or early fifth century A.D. Horizontal scroll, ink and color on silk. British Museum, London.

paintings believed to be imitations or even copies of Ku's original designs, we learn something about such late fourth-century art. Ku wrote of "tawny rocks, wrinkled with fissures as if torn by the lightning" and of crags that were "fang-like and tapering." Painting for him transcended reality, and landscapes, while existing in material substance, soared "into the realm of the spirit."[5] "Human eyes," Wang Wei declared a few decades later, "are limited in their scope. Hence they are not able to perceive all that is to be seen; yet with one small brush I can draw the vast universe."

A horizontal scroll—an early copy, though perhaps partly original—may give some clue to Ku K'ai-chih's style. *Admonitions of the Instructress to the Young Ladies of the Palace*, a watercolor on silk, is composed of a sequence of unconnected scenes, each illustrating a different maxim. One

of these depicts a well-known act of heroism in which the Lady Feng saved the life of her emperor by placing herself between him and a ferocious bear (FIG. 19-11). The figures move in an undefined space and are delicately drawn in slender lines enclosing washes of color.

Scrolls such as this have continuity and were intended to be viewed slowly in sections of about eighteen inches at a time. As in many early Tun-huang narrative scenes, there is a series of cell-like units bounded by trees or mountains. The different parts—trees, mountains, and figures—have no relationship in scale. Yet, as in all Chinese art, there is a harmony between abstract design and the image of nature achieved by the lyric rendering of carefully observed details.

It is questionable, though, whether Ku or any other pre-T'ang artist ever painted the magnificent panoramas he so eloquently described in writing. More than a century after Ku's lifetime, around 525, even the most advanced landscape we know of still falls short of his descriptions.

During the following two centuries landscape paintings, called by the Chinese "mountain water pictures" and regarded by them as their supreme

[5] Chinese critics have always insisted that a painting be more than an image of nature. About 500 A.D. Hsieh Ho formulated his famous "Six Principles" of painting, which have guided Chinese artists ever since. The first principle required that a picture be imbued with its own life.

artistic achievement, reached full stature. Indeed, Chinese historians regard the T'ang dynasty of the eighth and ninth centuries as their golden age of painting. Glowing accounts by poets and critics and a few remaining examples of the paintings themselves permit us to understand this enthusiasm.

In perfect accord with descriptions of the robust T'ang style are the unrestored portions of *Portraits of the Emperors*, masterfully drawn with colored washes by YEN LI-PEN, celebrated painter and statesman of the seventh century. Each emperor is represented as standing in undefined space, his eminence clearly indicated by his great size relative to that of his attendants. Yen Li-pen also made designs for a series of monumental and spirited stone horses that once flanked the approach to the tomb of the T'ang emperor T'ai-tsung.

The horse in Chinese art reflected the importance the emperors placed on the quality of their stables. Even in Han times emperors had sent missions westward to Bactria for blooded stock. Paintings of the finest among his 40,000 steeds were commissioned by the emperor Ming Huang (713–756), and one of these may be the picture of a tethered horse attributed to Han Kan, Ming Huang's favorite painter of horses. The fiery stallion (FIG. 19-12) evokes the dynamic "inner vitality" so stressed by Chinese critics.

Two of the most famous artists of the T'ang period were WANG WEI (699–759), who is not to be confused with Wang Wei of the fifth century, and WU TAO-TZU (active *c.* 725–*c.* 750), both of whom are now almost legendary figures although none of their paintings has survived. Wang was not only a painter; like so many Chinese artists he was also a poet and a critic. His poems are mellow and lyrical, as his paintings are said to have been. Although none of his painting survives, numerous imitations have the peaceful lyricism of his poems. Many of these copies are of snow scenes, a favorite subject of Chinese artists, probably because of its adaptability to monochrome painting, an art of infinite variation and contrast in black and white. Wu's work, according to reports of his time, was very different. He painted with such lightning speed and "ferocious energy" and over such large surfaces that people would watch with awe the rapid appearance of vast landscapes and images that seemed frighteningly real. His bold brushwork and ex-

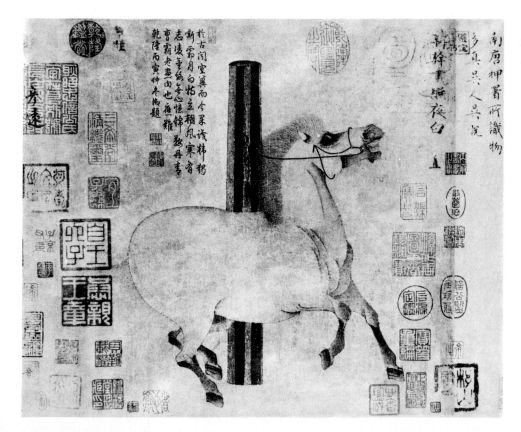

19-12 HAN KAN, *Horse*, T'ang dynasty, eighth century. Collection of Mrs. John D. Riddell.

pansive forms were frequently copied, and rubbings made from engraved replicas. Later artists looked to Wu's virtuoso brushwork and to Wang's subtle harmonies for their models.

The T'ang rulers embellished their empire with extravagant wooden structures, all of which have disappeared. Judging from records, however, they were of colossal size and colorfully

19-13 T'ang tomb figurines, seventh to ninth centuries: Left: Peddler. Portland Art Museum, Portland, Oregon. Right: Dancer. Nelson Gallery–Atkins Museum, Kansas City, Missouri. Below: Horse. Fogg Art Museum, Harvard University.

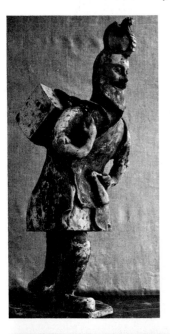
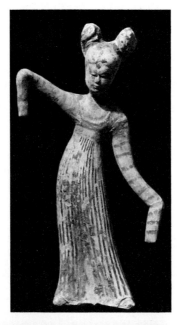
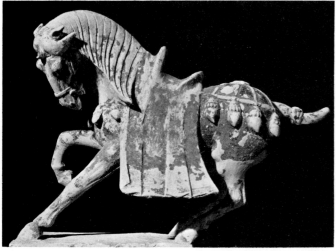

painted. Bronze mirrors with decorations in strong relief added to T'ang luxury and to the furnishings of a court already enriched by elaborate gold and silver ornaments.

The potter met the demand for display by covering his wares with colorful lead glazes and by inventing robust shapes with clearly articulated parts—base, body, and neck. Earlier potters had imitated bronze models, but the T'ang craftsman derived his directly from the character of clay. Ceramic figures of people, domesticated animals, and fantastic creatures were also made by the thousands for burial in tombs (FIG. 19-13). The extraordinarily delicate grace and flowing rhythms of these figures have a charm and vivacity seldom equaled in ceramic design. Their subject matter, which included such diverse figures as Greek acrobats and Semitic traders, is proof of the cosmopolitanism of T'ang China.

FIVE DYNASTIES AND NORTHERN SUNG

The last century of T'ang rule witnessed the gradual disintegration of the empire. When in 906 the dynasty finally fell, China was once more left to the ravages of civil war. Conflicting claims between rival states were not resolved until the country was consolidated under the early Sungs, whose court was at Pien-liang (modern K'ai-fêng in Honan). Strangely enough, during the interim of internal strife known as the Five Dynasties, painting seems to have been unaffected by the turbulence of the times.

CHING HAO, who flourished during the first half of the tenth century, left an essay in which he listed his criteria for judging paintings. Under the classification of "divine" he grouped the greatest paintings. In these, he wrote, "there appears no trace of human effort; hands spontaneously reproduce natural forms." In the lowest category he placed the "skillful" artist who "cuts out and pieces together fragments of beauty and welds them into the pretense of a masterpiece...." "This," he added, "is owing to the poverty of inner reality and to the excess of outward form." Although these ideas were not original with

Ching Hao, his restatement of them shows the continuity of thought underlying Chinese painting regardless of changing styles. The artist who painted the truth beneath surface appearances had to be imbued with *ch'i*, the "divine spirit" of the universe. The man who achieved this had done so through years of self-cultivation. Originality in the Western sense was not a necessary virtue; truth, it was believed, could be revealed in old forms. Ching Hao and his equally famous contemporary, Li Ch'êng, did little to alter T'ang formulas, but through the inherent power of their personalities they breathed life into every twig and rock they painted. Succeeding generations went to their works for inspiration—great artists to catch the spirit, lesser painters to copy tricks for drawing trees and hills.

We know enough about the art of the Five Dynasties to be able to distinguish the styles of individual masters, such as TUNG YÜAN, CHÜ-JAN, and FAN K'UAN of the late tenth century. Paintings by these artists and by KUO HSI, who lived at the beginning of the following century, express very different personalities and yet exhibit a common feeling for monumentality. A characteristic painting in this style presents vertical landscape of massive mountains rising from the middle distance (FIG. 19-14). Human figures, reduced to minute proportions, are dwarfed by overwhelming forms in nature. Numerous roads and bridges penetrate the distant heights and vanish only to reappear in such a way as to lead the spectator on a continuous journey through the landscape—a journey facilitated by shifting perspective points. No single vanishing point organizes the entire perspective, as in many Western paintings, and as a result the observer's eye moves with freedom. But in order to appreciate these paintings fully one must focus on intricate details and on the character of each line.

In this period in China the gifted amateur began to displace the professional artist. The amateur's support came either from a government sinecure or from his family, and the full development of the horizontal handscroll may be ascribed to the leisurely atmosphere that consequently surrounded such an artist and his associates. The scroll, which might measure as long as fifty feet, had to be unrolled from right to left; only a small section could be seen at a time and then, properly,

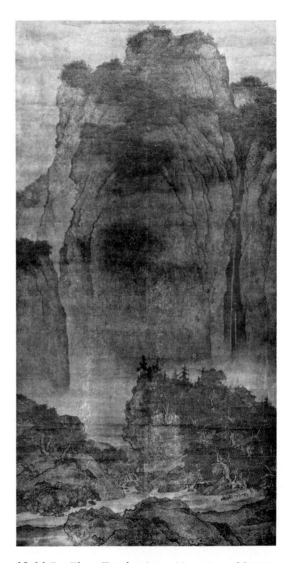

19-14 FAN K'UAN, *Travelers Among Mountains and Streams*, detail, Five Dynasties, tenth century. Hanging scroll, ink and colors on silk. Collection of the National Palace Museum, Taipei, Taiwan, Republic of China.

by only two or three persons. The organization of these paintings has been compared to the composition of a symphony because of the way in which motifs are repeated and moods are varied in the different sections. The temporal sequence of the scroll involved memory as well as vision; it was an art of contemplation and leisure. Most creative was Mi Fei, whose landscapes, an amalgam of impressionistic and architectonic elements, became the link between the strong style of early, or northern, Sung and the more delicate

style of the twelfth and early thirteenth centuries.

Among the versatile figures clustered around the court at this time was Su T'ung-p'o (Su Shih), one of China's greatest poets, a celebrated painter and statesman. Another was Li Lung-mien, who was famous for his original Buddhist compositions and for his outline drawings of horses. The emperor Hui-tsung, an avid collector and patron of art, was himself an important painter. He is known particularly for his meticulous pictures of birds in which almost every feather was carefully drawn in sharp lines. Lesser artists attached to the imperial court functioned as a sort of academy and in general followed the detailed and colorful style of the emperor. Illustrating some lines of poetry in painting often served as an examination for court office. Fans painted by master artists were treasured in albums. But while the court spent its energy on esthetic refinements, less cultured neighbors were assaulting the frontiers of China.

19-15 MA YÜAN, *Bare Willows and Distant Mountains*, Southern Sung dynasty, thirteenth century. Album leaf, ink and colors on silk, 9½″ × 9½″. Museum of Fine Arts, Boston.

SOUTHERN SUNG

In 1127, because of increasing pressure from the Tatars and Mongols in the west and north, the capital of China was moved to the south. From then until 1279 the Southern Sung court lived out its days amid the tranquil beauties of Hangchow. Neo-Confucianism, a blend of traditional Chinese thought and some Buddhist concepts, became the leading philosophy. Accordingly, orthodox Buddhism declined. Buddhist art continued to develop in the north, where a Tatar tribe had established itself as the Liao dynasty, but it stagnated in the south. Buddhist sculpture in the Southern Sung period merely added grace and elegance to the T'ang style. Ch'an (below) and secular paintings, however, reflected a new and more intimate relationship between man and nature.

A typical Southern Sung landscape is basically asymmetrical. It is composed on a diagonal and consists of three distinct parts—foreground, middle distance, and far distance—separated from each other by a field of mist. The first is marked by a rock, which, by its position in the foreground, emphasizes the distance of the other parts; the middle distance is marked by a flat cliff, and the far distance, by mountain peaks, which are usually tinted in pale blue, suggesting the infinity of space. The whole composition illustrates the manner in which the Sung artists used great voids to hold solid masses in equilibrium. The technique is one of China's unique contributions to the art of painting. To this basic composition, of which there were many variations, the artist frequently added the figure of a philosopher meditating under a gnarled pine tree and accompanied by an attendant. Such paintings were expressions of the artists' ideal of peace and pantheistic unity.

The chief painters in the Southern Sung style were MA YÜAN (c. 1190–1224) and HSIA KUEI (c. 1180–1230). Ma was a master of suggestion, as is demonstrated by a small fan-shaped album leaf —a picture of tranquility stated in a few sensitively balanced and half-seen shapes (FIG. 19-15). Hsia Kuei's misty landscapes were often so like those of Ma Yüan—though sometimes more delicate and sometimes bolder—that the Chinese refer to them and their followers as the Ma-Hsia

school. But the Ma-Hsia tradition, despite its gentle beauty, could not be maintained. It perpetuated an ephemeral, classic moment, but the serenity of its beliefs was soon threatened by political realities.

As orthodox Buddhism lost ground under the Sung, a new school of Buddhism, called Ch'an in China but better known by its Japanese name, Zen, gradually gained importance, until it was second only to Neo-Confucianism. The Zen sect traced its semilegendary origins to Bodhidharma, an Indian missionary of the sixth century A.D. By the time of the Sixth Patriarch, who lived in early T'ang, the pattern of the school was already established, and Zen remains an important religion in Japan today.

The followers of Zen repudiated texts, ritual, and charms as instruments of enlightenment. They believed, instead, that the means of salvation lay within the individual, that meditation was useful, but that direct personal experience with some ultimate reality was the necessary step to enlightenment. Zen enlightenment was conceived as a sudden, almost spontaneous act. These beliefs shaped a new art.

LIANG K'AI, a Zen painter of the thirteenth century, has left us two portraits of Hui Neng, the Sixth Patriarch. In one, the patriarch is a crouching figure chopping bamboo; in the other, he is tearing up a Buddhist sūtra (FIG. 19-16). Both are informal sketches that look as though they were caricatures of the revered figure. The brush strokes are staccato and splintery like the spontaneous process of Zen enlightenment. They probably were painted in a few minutes, but, like enlightenment, they required years of training. Their impact can be a shock, much like the shock of Zen understanding.

The spontaneity of Zen painting, with its rapid and economical brushwork, emphasizes the calligraphic, expressive quality of Chinese painting. The Chinese had always regarded calligraphy as

19-16 LIANG K'AI, *The Sixth Patriarch Tearing Up a Sūtra*, Southern Sung dynasty, thirteenth century. Hanging scroll, ink on paper. Collection Takanaru Mitsui, Tokyo.

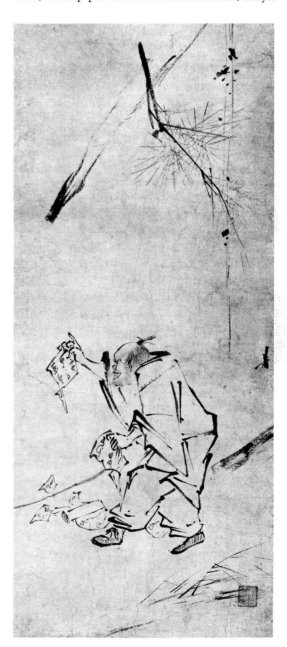

a major art, and most painters were also fine calligraphers. The quality of Chinese calligraphy depends on the dynamic relationships of strokes in a character, of character to character, and on the spacing of the characters within a given format. In addition, each stroke of the brush must have its own vitality. Up to the time of Zen, skillful brushwork had been regarded as only one of the components of a good painting. The Zen artist, however, found that bold brushwork was paramount for his succinct pictorial statements. His experiments with brush stroke so emphasized its importance that it became the dominating interest of the Chinese painter in the late Ming and Ch'ing dynasties.

Southern Sung artists also produced superb ceramics with monochrome glazes. The most famous of the single-glaze wares are known as celadon, *Yin-ching*, and *Ting*. The first is a mat gray-green, the second a subtle pale blue, and the last a fine white protoporcelain. There was also the heavier *Chün* ware, in which a blue glaze, splashed with red and purple, flowed over a stoneware body. A quite different kind of pottery, loosely classed as *Tzu-chou*, is a type of northern Chinese ceramic in which, during the Sung period, the subtle techniques of under-glaze painting and incision of the design through a colored slip were developed. The *Mei-p'ing* vase shown (FIG. 19-17) has an intricate black-white design produced by cutting through a black to a white slip. Here the tightly twining vine and petal motifs closely embrace the high-shouldered vessel in a perfect accommodation, so common in Chinese pottery in its great periods, of surface design to vase shape. These shapes were generally more suave than those of T'ang; some, however, reflecting the prevailing interest in archeology, imitated the powerful forms of Shang and Chou bronzes. Other crafts, particularly jade carving, were also subjected to the influence of archeological or antiquarian interests.

YÜAN

The artistic vitality of Southern Sung was not a reflection of the political condition. In 1260 the dynasty crumbled beneath the continued onslaughts of Kublai Khan. Yüan, the dynasty of the invaders, dominated China only until 1368, and yet it profoundly affected the culture of the country and particularly the art of painting. Many of the scholar-painters chose exile in the provinces rather than service to the barbarian usurpers in Peking. Forced by their exile to reappraise their place in the world, the artists no longer looked at a landscape as an idyllic retreat, but as part of a formidable environment. The new austerity is evident in a painting (FIG. 19-18) by one of the great masters of Yüan, HUANG KUNG-WANG (1269–1354). Here the misty atmosphere of the Sung landscapes has been replaced by clearly articulated forms. The pine that previously shaded the philosopher has become a symbol of harsh terrain and deprivation.

That the Yüan painter, perhaps again because of his need to grapple with reality, was interested

19-17 Mei-ping vase, Sung dynasty. Tzu-chou stoneware, carved black slip over white, 19½″ × 7¾″. Asian Art Museum of San Francisco, The Avery Brundage Collection.

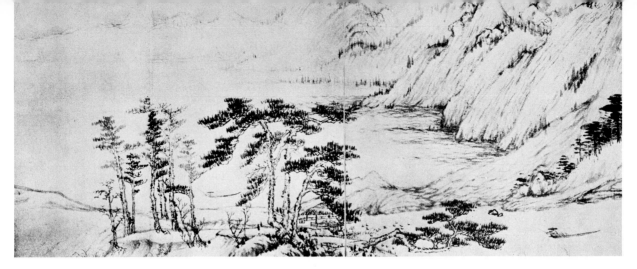

19-18 HUANG KUNG-WANG, detail of landscape, Yüan dynasty, 1347. Scroll, ink on paper. Collection, Palace Museum, Peking.

in texture, is clearly evident in a painting (FIG. 19-19) by CHAO MENG-FU (1254–1322). The artist's intention obviously was to contrast the woolly texture of the sheep with the long coarse hair of the goat, and he succeeded admirably. The quality of texture was also developed in the landscapes of such artists as Wang Meng (d. 1385). Most of these painters rejected the mellow harmonies of Southern Sung as no longer valid; for their sources they went back to the more monumental works of the tenth century. But a few, notably NI TSAN (1301–74), continued in the tranquil pattern of the previous period. The bare landscapes of Ni Tsan, however, are permeated with a new note of sadness. They contrast with paintings by WU CHEN (1280–1354), who adapted the bold brushwork of the Zen artists to conventional subjects. Paintings of bamboo, for which Wu Chen is famous (FIG. 19-20), were particularly favored at this time, for that plant is a symbol of the ideal Chinese gentleman, who in adversity bends but does not break. Moreover, the pattern of leaves, like that of calligraphic script, provided an excellent opportunity for the display of brushwork.

The Mongol regime apparently did little to disturb the Chinese potters in their increasing mastery of porcelain. A late Yüan or early Ming vase of white porcelain, discovered in 1961 (FIG. 19-21), exhibits brilliance in the use of under-glaze decoration that was so successful in the Sung period.

19-19 CHAO MENG-FU, *A Sheep and a Goat*, Yüan dynasty, thirteenth to fourteenth centuries. Horizontal scroll, ink on paper. Smithsonian Institution, Freer Gallery of Art, Washington, D.C.

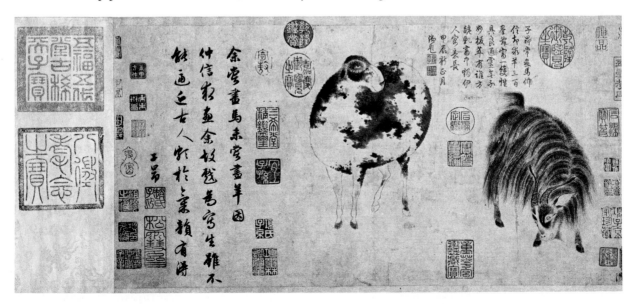

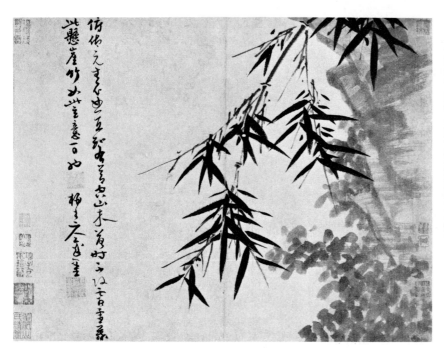

19-21 Vase and Cover, Peking, late Yüan or early Ming dynasty, late fourteenth century. White porcelain with underglaze decoration, 26½″ high. The exhibition of archeological finds of the People's Republic of China.

19-20 Wu Chen, *Bamboo*, Yüan dynasty, *c.* 1350. Album leaf, ink on paper, 16″ × 21″. Collection of the National Palace Museum, Taipei, Taiwan, Republic of China.

MING, CH'ING, AND LATER

In 1368 a popular uprising drove out the hated Mongol overlords, and from that time until 1644 China was ruled by the native Ming dynasty. Many of the fifteenth-century Ming masters, such as Wu Wei (1459–1508) and Tai Chin (active mid-fifteenth century), reverted to Sung models. The distinction between amateur and professional artists became more and more artificial. Often "amateurs" were appointed to government posts because of their painting abilities rather than for their administrative talents, and they might, therefore, more properly have been identified as artists-in-residence. Under the Ming, recognition of professional artists—those who lived on earnings from their work—was never fully granted by the elitist critics. Actually, gentlemen artist-amateurs in the Yüan period had already begun to assert their independence of the court as a means of expressing disapproval of collaboration with foreigners. Shen Chou (1427–1509), who came from a distinguished family of painters and scholars, set a new pattern by completely spurn-

ing government support in order to devote himself entirely to painting and literature.

During the sixteenth century increasing corruption in the Ming court drove some of the best minds from court circles. Tung Ch'i-ch'ang (1555–1636) and Mo Shih-lung (active *c.* 1567–82), who were among the dissidents, subsequently became the leaders of a group of artists whose standards were those of the "antique style." Actually this group, designated as the "literary" or "ink-flinging" school, experimented in both brushwork and composition; in order to show their disdain for the finicky paintings of the professionals, they consciously created pictures which, though they appear crude, required great skill. Calligraphic drawing was also developed to such a degree that the subject merged almost imperceptibly with the writing. This blending may be seen in Hsü Wei's bravura painting of a grapevine in which the tendrils seem to be characters and the characters themselves appear to be tendrils (FIG. 19-22). Other Ming artists painted long horizontal scrolls that carry the viewer on a circuitous journey through constantly

changing landscapes. This effect—which contrasts with that of the clear spatial organization of Southern Sung and Yüan paintings—was produced by use of a rapid sequence of different perspectives and an abrupt shifting of distances. The uneasy sensation created by these paintings recalls a totally different art—that of the Mannerists who were painting in Italy at the same time, and who were also disregarding established conventions. It is noteworthy that both countries were undergoing social and intellectual readjustments. Many of the extreme experiments of Chinese sixteenth-century art appear to have been perverse, but they helped to establish artistic freedom. The artists who lived into the next dynasty were the beneficiaries.

The internal decay of Ming bureaucracy permitted another group of invaders, the Manchus, to overrun the country. Established as the Ch'ing dynasty (1644–1912), the northerners quickly adapted themselves to Chinese life. The early emperors cultivated a knowledge of China's arts, but their influence seems merely to have encouraged academic work. While the Yüan style of painting continued to be fashionable among the conservatives, other artists carried the calligraphic experiments of the Ming to excess, and some, contemptuous of professional skills, painted with their fingers, while eccentrics went so far as to use their noses, or even their beards.

Two artists with intensely personal styles stand out against a mass of lesser painters. The sketchy brush and wet-ink technique of CHU TA (1626–after 1705) were derived from sixteenth-century forerunners, but his subjects—whimsical animals or petulant birds tensely balanced on an album page—demonstrated his discontent with conventional themes. Although Chu Ta's great contemporary, SHIH-T'AO (1630–1707), adapted the standard landscape to his splashy ink style, his more interesting album leaves were devoted to small segments of nature often viewed from an unusual angle.

Some twentieth-century artists, such as Ch'i Pai-shih and Chang Ta-chen, found the free brush expressive, and maintained the calligraphic tradition with vitality. Ju Peon, known for his heavily outlined pictures of horses and mules, imbued his work with social content, in keeping with China's political developments. The coming decades will reveal whether a popular art assimilates the traditions of aristocratic painting that dominated Chinese art for over a thousand years.

In ceramics the technical ingenuity of the Ming and Ch'ing potters exceeded the skill of even the Sungs. In general, porcelain was favored over pottery, with the exception of Ming stonewares, which were broadly decorated in "three-color" enamels. More delicate designs were painted in a "five-color" underglaze on fine clay. The celebrated blue-and-white porcelains (PLATE 19-2) owed their quality as much to the distinction of their painted decoration as to the purity of the imported cobalt pigments. Experiments with glazes led to the invention of the superb imperial yellow and oxblood monochromes. Craftsmen also devised a "secret," or barely visible decoration that was carved into porcelain as thin as paper.

When the Manchus came into power in 1644, they continued to support the great kilns at Ching Te-chen, where enormous quantities of excellent porcelains were made until the destruc-

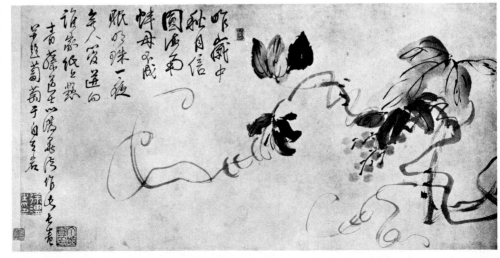

19-22 HSU WEI, *Grapevine*, detail of the *Four Seasons*, Ming dynasty, fifteenth to early sixteenth centuries. Scroll. Nationalmuseum, Ostasiatiska, Stockholm.

19-23 *Kuan-yin*, early Ch'ing dynasty, seventeenth to eighteenth centuries. Fukien ware, white porcelain, $8\frac{7}{8}'' \times 6\frac{1}{4}''$. Trustees of the Barlow Collection, University of Sussex.

for lavish court ceremonies, followed the general style of the age, becoming more intricate and at the same time more delicate.

During this long period, from mid-seventeenth to late eighteenth century, sculpture consisted primarily of charming but inconsequential porcelain bibelots and jade and ivory carvings of an almost unbelievable technical perfection. An example of this work is the white porcelain *Kuan-yin*, goddess of compassion, from the early Ch'ing dynasty (FIG. 19-23), which completes that long process of humanization of the sacred Buddhist images that began even before the T'ang. (See PLATE 19-1.) The lovely statuette, reflecting the culmination of technical achievement of Chinese ceramists, embodies the bodhisattva's quality of mercy in its softness of form. An easy play of line betrays the influence of painting upon ceramics. This "white china ware" (*blanc-de-Chine*) was widely exported to Europe in the eighteenth century, and in the West to this day fine ceramic wares, especially porcelain, are called "china."

As the eighteenth century waned, huge workshops, much like our own production-line factories, continued to provide masses of materials for imperial use. Specialists, instead of designer-craftsmen, worked on each stage of manufacture. By the middle of the nineteenth century this system had drained all vitality from the crafts.

The establishment of the People's Republic of China in 1949 has produced a social realism in art familiar to the world of the twentieth century (see pp. 743–745), breaking drastically with the

tion of the kilns during warfare in the middle of the nineteenth century. In the K'ang-hsi period (1662–1722) delicate glazes known as clair de lune (a silvery blue) and peachbloom (pink dappled with green) vied with the polychrome wares. A brief revival of Sung simplicity occurred during the reign of Yung-cheng (1723–35), but under Ch'ien-lung (1736–95) a reaction led to a style that was sometimes more elaborate than artistic.

Fine embroidered and woven textiles, created

19-24 ANONYMOUS SCULPTORS, *The Rent Collection Courtyard*, detail of a tableau, 1965. Clay-plaster, life-size.

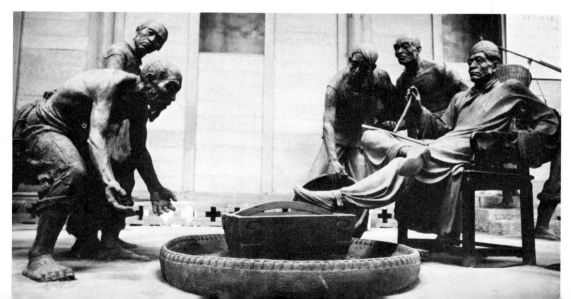

Chinese art of tradition. Though some carry on creative work based on the old traditions, for most, the purpose of art now is, as the Republic would claim, to serve the people in the struggle to liberate and elevate the masses. In the work shown in FIG. 19-24, a life-sized tableau, the old times are grimly depicted in a scene common enough before the revolution. Peasants worn and bent by toil are bringing in their taxes in produce to deposit them in the courtyard of their merciless plundering landlord. The message is clear: this kind of thing must never happen again. Significantly, the artists who depict the event are an anonymous team. The "name" artist also belongs to the past; only collective action, say its theoreticians, can bring the transformations the Republic hopes for.

ARCHITECTURE

Little has been said about Chinese architecture, partly because few early buildings exist and partly because Chinese architecture over the centuries did not display distinctive changes in style. The modern Chinese building closely resembles its prototype of a thousand years ago. Indeed, the dominating silhouette of the roof, which gives Chinese architecture much of its specific character, may go back to Chou or Shang times. Even the simple buildings depicted on Han stone carvings reveal a style and a method of construction still basic to China. The essentials consist of a rectangular hall, dominated by a pitched roof with projecting eaves supported by a bracketing system and wooden columns. Walls served no bearing function but acted only as screening elements.

Within this limited formula the Chinese architect focused his attention on the superstructure. As early as the Han dynasty, combinations of brackets, impost blocks, and columns were devised to support the weight of massive tiled roofs. The architects gave the exterior animation by varying the shapes of the brackets. From these simple beginnings later architects developed very intricate systems of support. Some brackets were placed parallel to the walls, while others reached outward to support a beam or other brackets, until the multiplication of units created a rich pattern of light and shade. The effect was intensified by decorations in red and gold lacquer. Function was often subordinated to ornament; complicated bracket systems were sometimes introduced for decoration where only minimal support was required.

On the exterior the coloristic interplay of the supports formed a pleasing contrast to the uninterrupted sweep of the pitched roof. The overhanging eaves became even wider during the T'ang period and builders began to turn up the corners. These slightly curving eaves were exaggerated in later buildings, especially in south China, where they produced a riotous fantasy of upswept lines. But in most areas the gentle curves of the roofs give an air of grace to the otherwise severe rectangular form and rigid symmetry that were imposed by the plans of the buildings and by various systems of arrangement. For centuries the orientation of buildings, even of whole cities, had been ordered on a strict north-south axis, providing a uniformity related to nature. Houses, palaces, temples, and official buildings all fell within one formal pattern. Even the seeming randomness of the varied bridges and pavilions in the informal gardens was carefully devised.

Buddhist architecture contributed a specific form, the pagoda, which to many has become a symbol of China. These towers, which dot the countryside and seem so native to the land, were derived from the Indian stupa (p. 805). Most of the wooden pagodas, with their multiplicity of winged eaves, bear little resemblance to the solid domes of Sanchi or Amarāvatī; but their origin, like that of the Chinese Buddha, is to be found in Gandhāra, where terraced and towering variants of the stupa had once impressed Chinese pilgrims with their grandeur. So quickly was the stupa structure assimilated by the Chinese that even the earliest pagodas (sixth to eighth century) show only a few traces of their Indian origin. In the Chinese wooden idiom all that remained of the Indian stupa was the *yasti* and parasols, which crowned that structure. Instead of a circular plan the Chinese preferred a four-, six-, or eight-sided one, and story was piled upon story to form towers as much as three hundred feet high. Each story was marked by its own projecting eaves, the curved lines of which soared into the sky.

The Art of Japan

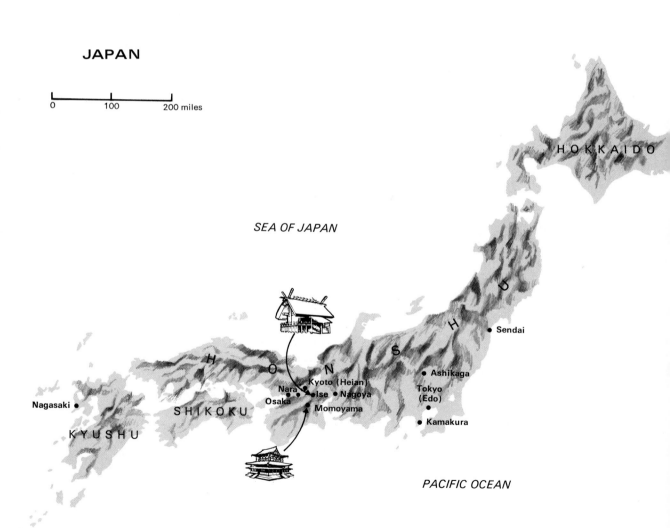

JAPAN

0 100 200 miles

HOKKAIDO

SEA OF JAPAN

HONSHU

Sendai

Ashikaga

Kyoto (Heian)
Nara
Ise Nagoya
Osaka
Momoyama

Tokyo
(Edo)

Kamakura

Nagasaki

SHIKOKU

KYUSHU

PACIFIC OCEAN

THE ARTS OF JAPAN have neither the progressive stylistic continuity of those of India nor the wide variety of those of China. A series of foreign influences sporadically affected the course of Japan's artistic evolution. Yet, no matter how overwhelming the impact of new forms and styles, the indigenous tradition invariably reasserted itself. Hence, the artistic pattern evolved in a rhythmic sequence of marked periods of borrowing, of absorption, and of return to native patterns.

Because Japan and its nearby islands are of volcanic origin, there is little stone suitable for carving or building. In architecture, this lack led to the development of wooden construction carefully devised to withstand the frequent earthquakes and tempests. In sculpture, figures were modeled in clay, which was often left unfired, cast in bronze by the *cire perdue* process familiar to many other cultures, or constructed of lacquer. Although the lacquer technique probably originated in China, Japanese artists excelled in creat-

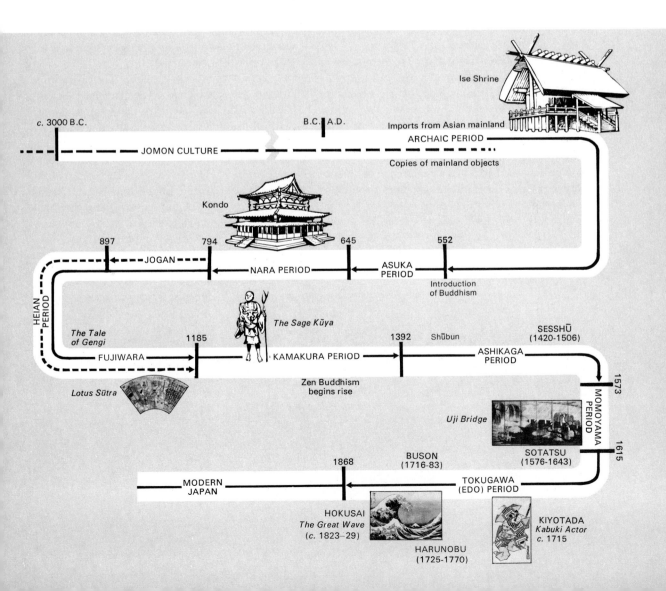

Ise Shrine

c. 3000 B.C. B.C. A.D. Imports from Asian mainland

ARCHAIC PERIOD

JOMON CULTURE

Copies of mainland objects

Kondo

897 794 645 552

JOGAN NARA PERIOD ASUKA PERIOD

Introduction of Buddhism

HEIAN PERIOD

The Tale of Gengi 1185 *The Sage Kūya* 1392 Shūbun SESSHŪ (1420-1506)

FUJIWARA KAMAKURA PERIOD ASHIKAGA PERIOD

Zen Buddhism begins rise

Lotus Sūtra

1573

MOMOYAMA PERIOD

Uji Bridge

1615

BUSON (1716-83) SOTATSU (1576-1643)

1868

MODERN JAPAN TOKUGAWA (EDO) PERIOD

HOKUSAI
The Great Wave
(c. 1823–29)

HARUNOBU
(1725-1770)

KIYOTADA
Kabuki Actor
c. 1715

ing large, hollow lacquer figures by placing hemp cloth soaked in the juice of the lacquer tree over wooden armatures. The surfaces were gradually added to and finished, but the technique remained one of modeling rather than carving. Such figures were not only light but very durable, being hard and resistant to destructive forces. Hollow lacquer was gradually superseded by sculpture carved in wood with unusual sensitivity for grain and texture.

NATIVE TRADITIONS

The first artifacts known in Japan are pottery vessels and figurines from a culture designated Jomon, which apparently flourished as early as the fourth millennium B.C. These objects are associated with Neolithic tools, although they persisted in northern Japan as late as the fourth or fifth century A.D., even while a metal culture was being fully developed in the south.

Japanese objects from about the beginning of the Christian era are of three kinds—those imported from the Asian mainland, those copied from imported articles, and those of Japanese invention. There are, for instance, bronze mirrors from Han China as well as replicas of these made in Japan. Some of the replicas are adorned with a Japanese innovation—spherical rattles attached to the perimeter. From Korea, another source of continental influence, came a gray pottery known as *yayoi*, which was soon copied, and small comma-shaped

stones (*magatama*) used in necklaces. A third area —Indo-China—was the source of motifs used on bell-shaped bronzes known as *dōtaku*. Houses and boats depicted on these bronzes are the same as those on contemporaneous drums from Annam (modern Vietnam), in Indo-China.

Within this heterogeneous culture, a specifically Japanese creativity asserted itself in the production of *haniwa*. These are sculptured tubes made of pottery and placed fencelike around burial mounds, possibly to control erosion or to protect the dead. The upper parts of the haniwa are usually modeled in human form but sometimes in the shape of a horse, a bird, or even a house (FIG. 20-1). Simple pottery cylinders were used similarly in Indo-China, but the sculptural modeling of haniwa is uniquely Japanese. The arms and legs as well as the mass of the torso in most instances recapitulate the cylindrical base of the haniwa. The tubelike character of some later monumental sculpture and even of a particular wooden doll common in Japan may derive from these remote ancestors.

Architecture was first limited to pit dwellings and simple constructions of thatched roofs on bamboo stilts, but we learn from some haniwa that wooden architecture was fully developed by the fifth century, some buildings containing such features as two stories, saddle roofs, and decorative gables. There may have been monumental constructions of wood, but nothing remains from this early period except colossal mounds, which were the tombs of rulers.

20-1 Haniwa figures, horse and peasant, fifth to sixth centuries A.D. Clay. Horse, Cleveland Museum of Art (gift of The Norweb Collection); peasant, Cleveland Museum of Art (purchase, James Parmelee Fund).

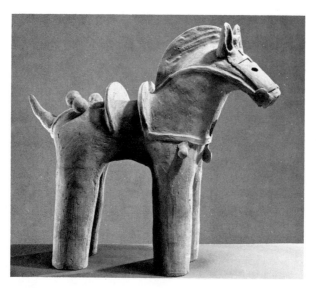
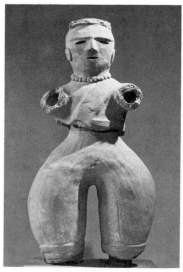

ADVENT OF BUDDHISM

The native traditions, which were established at this time, were interrupted in 552 by an event of paramount importance to Japan. In that year the ruler of Kudara (Korean: Paikche), a kingdom in Korea, sent a gilt bronze figure of the Buddha to Kimmei, emperor of Japan. With the image came the gospels. For half a century the new religion met with opposition, but at the end of that time Buddhism and its attendant arts were firmly established in Japan. Among the earliest examples of Japanese art serving the cause of Buddhism is a bronze sculpture of Shaka (Sanskrit: Śākyamuni) and attendant Bodhisattvas (FIG. 20-2) made in 623 by TORI BUSSHI, a third-generation Korean living in Japan. Tori's style is that of the mid-sixth century in China. His work proved how tenaciously the formula for a "correct" representation of the icon had been maintained since the introduction of Buddhism almost a century earlier. Yet at the same time a new influence was coming from Sui China. This may be seen in the cylindrical form and flowing draperies of the wood sculpture known as the Kudara Kannon (Chinese: Kuan-yin). The two styles were blended, and in the middle of the seventh century they coalesced in one of Japan's finest sculptures, the *Miroku* (Sanskrit: Maitreya) of the Chugu-ji nunnery at Nara (FIG. 20-3). In this figure the Japanese artist combined a gentle sweetness with formal restraint in a manner unknown in Chinese sculpture.

Within a little more than half a century, however, all the archaisms of the fused style (loosely called Suikō after the empress who reigned from 593 to 628, or Asuka after the site of the capital) were swept aside by a new influence from T'ang China. The T'ang style, which found its way to Japan at the end of the Hakuhō period (645–710), dominated Japanese art during the following periods of Late Nara (710–794) and Early Heian (794–897). Chinese models were followed not only in sculpture and painting but also in architecture, literature, and even in etiquette.

The mature style of T'ang, as seen in the Lungmen caves, appeared suddenly in Japan in the bronze *Shrine of Lady Tachibana* (FIG. 20-4). This consists of three full-round figures, the Buddha

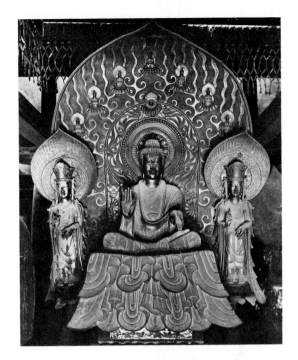

20-2 TORI BUSSHI, *Shaka Triad*, Asuka Period, 623 A.D. Bronze, 69½″ high. Horyu-ji Temple, Nara.

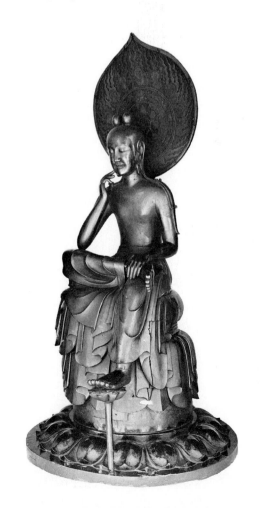

20-3 *Miroku*, Asuka period, mid-seventh century. Wood, 5′ 2″ high. Chugu-ji Nunnery, Horyu-ji, Nara.

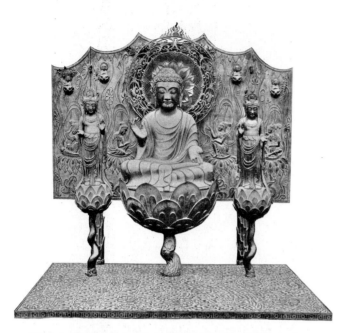

20-4 *Amida Triad*, from the *Shrine of Lady Tachibana*, Nara period, early eighth century. Gold-plated bronze; Amida, 11″ high, attendants, 10″ high. Horyu-ji temple, Nara.

20-5 *Tamamushi Shrine*, Horyu-ji, Asuka period, seventh century. Lacquer on wood, 92″ high. Horyu-ji Museum, Nara.

Amida seated on a lotus between the smaller figures of Kannon and Dai Seishi, each standing on a lotus and all three rising from a platform representing the stylized waters of the Sukhāvatī lake in the paradise of the Buddha. Behind them is a threefold screen on which are modeled in low relief the graceful forms of *apsaras* (heavenly nymphs) seated on lotuses and the tiny figures of souls newly born into heaven. The upswept scarves of the apsaras and the petals, tendrils, and pads of the lotuses create an exquisite background for the three divinities, while a detached open-work halo of delicate design frames the head of the Buddha. The ensemble gives some idea of the glorious T'ang bronzes that were melted down in China during the Buddhist persecutions of 845. It also demonstrates the remarkable adaptability of the Japanese artist, which permitted him to seize upon a new art form and make it his own.

The development of painting in Japan paralleled that of Buddhist sculpture. Among the earliest surviving examples are those on the *Tamamushi* (Beetle-Wing) *Shrine* (so-called because its base is decorated with the iridescent wings of beetles), which dates from the first half of the seventh century (FIG. 20-5). The sides and doors of the shrine, which is a wooden cabinet, are decorated with scenes from the jātaka in the style of the Tun-huang caves of a century earlier, as may be seen in the cell-like composition, the crystalline rock formations, the attenuated figures, and the free linear movement. There is also the same delight in surface pattern to the disregard of naturalism in scale and spatial relationships. The dominance of Chinese influence over Japanese culture at this time is shown also in a portrait of Shōtoku Taishi (FIG. 20-6), the prince-regent who consolidated Buddhism's position in Japan early in the seventh century. Painted about a hundred years after his death, it was closely modeled on the style of Yen Li-pen's *Portraits of the Emperors* (p. 837), the figures having the same hieratic relationship and the drapery the same treatment of colored washes over line.

The many treasured articles in the Shōsōin (storehouse for the belongings of Emperor Shōmu after his death in 756) also illustrate the dependence of eighth-century Japan on the arts of

China, although the wooden building itself is purely Japanese in style.

This Japanese dependence on China during the seventh and eighth centuries is not confined to sculpture and painting. Buddhist architecture adhered so closely to Chinese models that the lost style of the T'ang can be reconstructed from such temple complexes as the Horyu-ji or the Todai-ji, which still stand in Japan. The Kondo (Golden Hall) of the Horyu-ji (FIG. 20-7), which dates from shortly after A.D. 670, is one of the oldest wooden buildings in the world. Although periodically repaired and somewhat altered (the covered porch was added in the eighth century, the upper railing in the seventeenth), it retains the light and buoyant quality that had been characteristic of the early T'ang style in China.

For a more typically Japanese structure we must refer to the shrines of Shinto, the indigenous faith of the Japanese people.[1] These shrines were customarily destroyed every twenty years and then replaced by exact duplicates, a process that has been repeated since the third century. Thus,

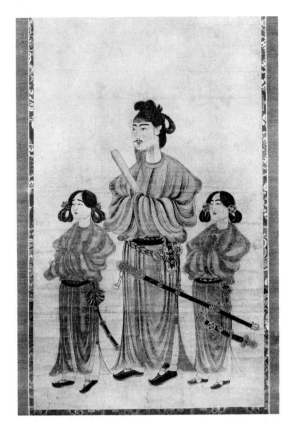

[1] Shinto or "the Way of the Gods," was based on love of nature, of the family, and, above all, of the ruling family, as direct descendents of the gods. Extremely nationalistic in character, Shinto was embodied in symbolic forms and shunned pictorial representation.

20-6 *Prince Shōtoku and His Sons*, Asuka Period, seventh century. Ink and color on paper, 50″ × 20″. Imperial Palace, Tokyo.

20-7 *Kondo (Golden Hall)*, Horyu-ji, Asuka period, seventh century.

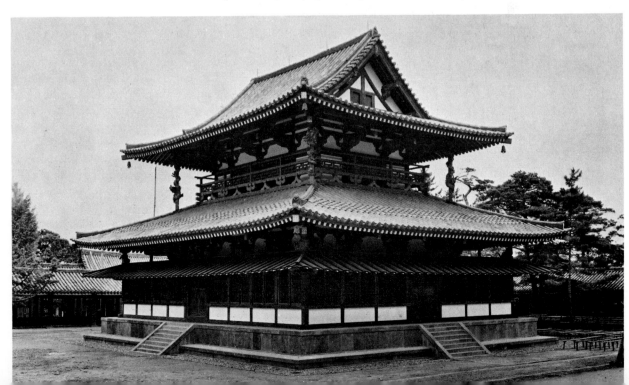

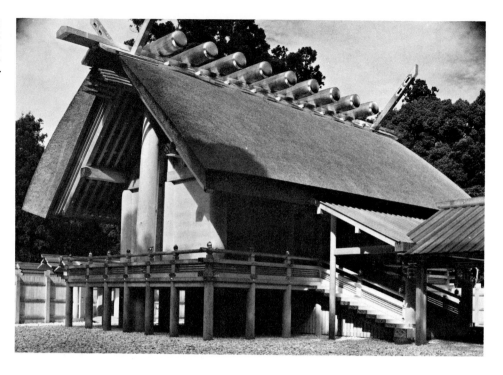

20-8 *Shōden*, main building of the Ise Shrine. Rebuilt in 1953, reproducing third-century type. © Grand Shrine of Ise.

we may assume that such a construction as the Ise shrine (FIG. 20-8) (last rebuilt in 1973), reproduces with a great measure of accuracy the original method of building. This, the greatest of all Shinto shrines, covers an area 55 by 127 yards and is enclosed by four concentric fences. The Shōden, the main building, rests on piles and has a thatched roof. Massive golden-hued columns, once the great trunks of cypress trees, and planks of the same wood are burnished to mellow surfaces, their color and texture contrasting with the white gravel that covers the ground of the sacred precinct. In the characteristic manner of the Japanese artist, the thatched roof was transformed from a simple functional element into one that established the esthetic of the entire structure. Browned by a smoking process, the thatch was sewn into bundles that were carefully laid in layers that gradually decreased in number from the eaves to the ridgepole. The entire surface was then sheared smooth, and a gently changing contour resulted. The roof line was further enhanced by decorative elements that once had been structural—the *chigi* or crosspiece at the gables, and cylindrical wooden weights placed at right angles across the ridgepole. The repeats and echoes of the various parts of the main building

and of the related structures are a quiet study in rhythmic form. The shrine, in its setting, is an expression of purity and dignity, effectively emphasized by the extreme simplicity of carefully planned proportions, textures, and architectural forms.

HEIAN PERIOD AND OTHER INDIGENOUS INNOVATIONS

A new style in representation made its way into Japan at the beginning of the ninth century. Under the influence of Esoteric Buddhism (p. 833), a heavier image with multiple arms and heads was introduced—a type which in China was then replacing the earlier classic grace of T'ang. The bloated forms of the new style, though they may be repellent, have the merit of somber dignity. In paintings these bulky figures, often cut off at the sides, give the effect of a mighty force expanding beyond the pictorial format.

From the middle of the ninth century, relations between Japan and China deteriorated so rapidly that by the end of that century almost all intercourse had ceased. No longer able to reflect

the fashions of China, the artists of Japan began to create their own forms during the Later Heian or Fujiwara period (897–1185). At this time court practices at Heian (Kyoto) were refined to the point of preciosity. A vivid and detailed picture of the period appears in Lady Murasaki's eleventh-century novel, *The Tale of Genji*, a work of superb subtlety. The picture is of a court in which etiquette overwhelmed morality, a society in which poor taste—in such matters as the color of a robe, the paper used in the endless writing of love letters, or the script itself—was considered a cardinal sin. The very essence of this court is reflected in a series of fan paintings (FIG. 20-9) illustrating, with text, the *Hokke-kyō* (the *Lotus Sūtra*). These exquisite pictures—with their everyday worldliness and their luxuriousness of color, decoration, and ornamental calligraphy—give little indication that they illustrate one of the world's great religious documents.

Paintings of this type are small—rarely more than ten by eighteen inches—and are often part of a horizontal scroll (*makimono*) on which they alternate with portions of the text that they illustrate. Continuous composition in paintings, as in contemporary China, was apparently adopted

later, toward the very end of the Fujiwara period.

TAKAYOSHI, a twelfth-century court artist, illustrated *The Tale of Genji* in a set of scrolls (PLATE 20-1) consisting of separate scenes painted in the decorative style of the *Hokke-kyō*. In these scrolls he uses a distinctly Japanese technique for representing space. The scenes are viewed as from an elevation, the ceilings removed to expose the interiors, and the ground plane sharply tilted toward a high horizon or one that is often excluded altogether. Thus the area of representation was expanded in terms of content and abruptly contracted by the resulting diminution of a sense of depth. Flat fields of unshaded color emphasize the painting's two-dimensional character, as do strong diagonal lines, which direct the eye more along the surface than into the picture space. Human figures have the appearance of being constructed of stiff layers of contrasting fabrics, and although they represent specific characters, their features are scarcely differentiated. A formula for such aristocratic faces, which produced a depersonalizing effect, called for a brush stroke for each eye and eyebrow, one for the nose, another (sometimes omitted) for the mouth. Paintings in this purely Japanese style, known as

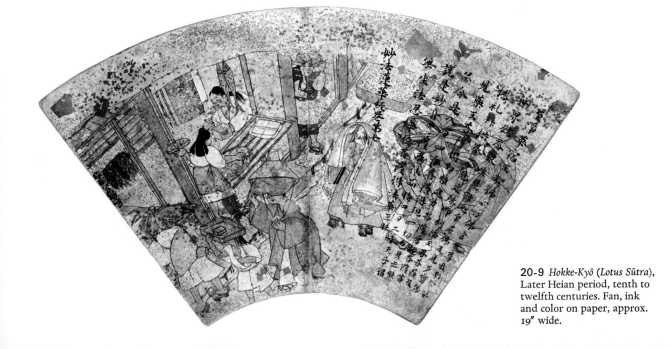

20-9 *Hokke-Kyō* (*Lotus Sūtra*), Later Heian period, tenth to twelfth centuries. Fan, ink and color on paper, approx. 19″ wide.

20-10 *The Flying Storehouse*, detail of the *Shigisan Engi*, Fujiwara period, late twelfth century. Horizontal scroll, ink and color on paper, 12½" high. Chogosonshi-ji, Nara.

Yamato-e,[2] reflect the sophisticated mannerisms of the Fujiwara nobility for whom they were created.

A different facet of Yamato-e is represented by the *Shigisan Engi* (the golden bowl of Shigisan), painted at the end of the Fujiwara period (FIG. 20-10). One of the first Japanese scrolls designed as a continuous composition, it illustrates the story of a Buddhist monk and his miraculous golden bowl. Our episode—called "The Flying Warehouse"—depicts the bowl lifting the rice-filled storehouse of a greedy merchant and carrying it off to the monk's hut in the Wakayama mountains. The gaping merchant, his attendants, and several onlookers are shown in various poses, some grimacing, others wildly gesticulating and scurrying about in frantic astonishment. The Fujiwara aristocracy felt that only the crude and ill-bred would display such feelings and that it was therefore an appropriate subject for humorous caricature. The faces—so unlike the generalized masks in the Genji scrolls—are drawn with each feature exaggerated, thus conforming to a convention of the period to distinguish the lower classes from the nobility. Cartooning of this kind

² Yamato is the area around Kyoto and Nara regarded as the cradle of Japanese culture. The suffix *-e* means, in effect, "painting of."

became an important element in Japanese pictorial art.

From the same general period (but of disputed date) are three horizontal scrolls of animal caricatures, painted in monochrome with a free calligraphic brush more typical of Chinese Zen painting than of the refined style of Yamato-e. One of these scrolls, often attributed to the Buddhist Abbot Toba (TOBA SŌJŌ), depicts a medley of frogs, monkeys, and hares in a hilarious burlesque of Buddhist practices. In one section a monkey dressed as a priest pays homage to a Buddha in the shape of a frog seated pompously on a lotus throne with a nimbus of luxuriant banana leaves (FIG. 20-11). In another, more animated, passage, the animals tumble and frolic while washing each other in a river. Throughout this whimsical satire the Japanese predilection for decoration asserts itself in charming clumps of foliage that play a delicate counterpoint to the vigorous movement of the animals.

A more conservative style of Buddhist art continued through the Later Fujiwara period, but a new subject was added. This subject, known as Raigō, portrayed the Buddha Amida descending through clouds amid a host of Bodhisattvas welcoming deceased believers to his paradise. Such paintings were products of the Paradise Sects (p. 833), which eased the rigors of

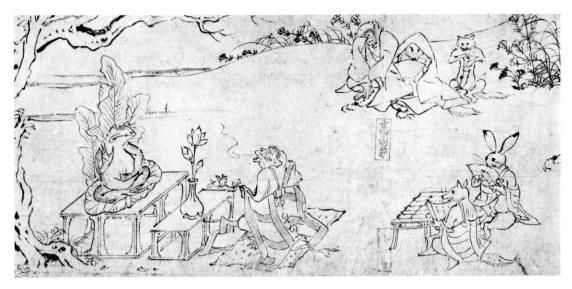

20-11 Animal caricatures, detail of a horizontal scroll attributed to Toba Sōjō, later Heian period, tenth to twelfth centuries. Ink on paper, approx. 12″ high. Kozan-ji.

religion for the luxurious courtiers in Kyoto.

Even more than Buddhist painting, Buddhist sculpture maintained its conservative character, although the refinement of the period manifested itself in the application of delicate ornament, frequently of cut gold leaf, and in the creation of forms that were more graceful and slender, if somewhat less vigorous, than those of the preceding period.

KAMAKURA REALISM

A series of civil wars led to the downfall of the decadent Fujiwara rulers, and their successful rivals established a new capital at Kamakura, the city that gave its name to the period from 1185 to about 1392. The new rulers, reacting against what they considered to be the effeteness of the Fujiwaras, supported an art emphasizing strength and realism. The style of the Nara period (710–794) was revived by Unkei (d. 1223), perhaps the greatest sculptor of Japan. Unkei and his followers went even further than the earlier realists by carefully reproducing their observations of every accidental variation in the folds of drapery and by using crystal for the eyes of their sculptures. That they were able, nonetheless, to keep a sensitive balance between the spiritual

and the realistic is shown by the superb figure of Kūya, a sage who is represented as he walked about invoking the name of Amida Buddha (FIG. 20-12). Not only is every detail meticulously rendered, but six small Buddha images issue from the saint's mouth, as if in a comic strip balloon, to represent the words Amida, Amida, Amida.... Realism was thus carried to the point at which

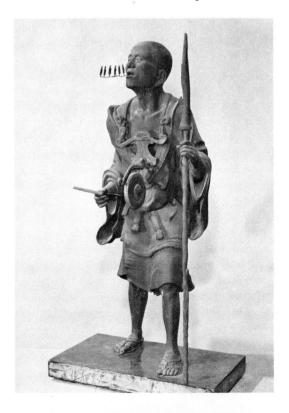

20-12 *The Sage Kūya Invoking the Amida Buddha*, Kamakura period, thirteenth century. Painted wood. Rokuharamitsu-ji Temple, Kyoto.

857

20-13 Detail of *The Burning of the Sanjo Palace*, Kamakura period, thirteenth century. Horizontal scroll, ink and color on paper, 22′ 10″ long. Fenollosa-Weld Collection, Museum of Fine Arts, Boston.

the sculptor attempted to invest his figures with speech.

Painting during the Kamakura period is most interesting for the advances made in the Yamato-e style, although all the different types of Fujiwara art were also continued. Perhaps the greatest Yamato-e of this time is a makimono, *The Burning of the Sanjo Palace*, one of a series of horizontal scrolls illustrating tales of the Heiji insurrection (*Heiji Monogatari*). Here, the artist, perfecting the symphonic composition of the Chinese landscape scroll, has added drama with swift and violent staccato brushwork and vivid flashes of color. At the beginning of the scroll (read from right to left) the eye is caught by a mass of figures rushing toward a blazing building—the crescendo of the painting—then led at a decelerated pace through swarms of soldiers, horses, and bullock carts, finally, it seems, to be arrested by a warrior on a rearing horse (FIG. 20-13). But the horse and rider are positioned to serve as a deceptive cadence (false ending), for they are a prelude to the single figure of an archer, which picks up and completes the mass movement of the soldiers and so draws the turbulent narrative to a quiet close.

ASHIKAGA: RENEWED CHINESE INFLUENCE

The power of the Kamakura rulers ceased in 1333, after which internal warfare persisted until 1392, when the Ashikaga shoguns (military dictators) imposed a brief peace. Civil war soon broke out again, though the shoguns managed to maintain control amid almost continuous insurrections, and lasted until 1573. The arts, nevertheless, flourished. New painting styles imported from China coexisted with conventional Buddhist pictures and with paintings in the Yamato-e style carried on by artists of the Tosa family. The monochrome landscape style of the thirteenth-century Sung masters Ma Yüan and Hsia Kuei was adopted by Shūbun at the beginning of the fifteenth century. Chō Densu (1352–1431) and other painters went directly to Yüan dynasty models. But the most powerful current to come from China was that which accompanied Zen Buddhism and which accounts largely for the efflorescence of art despite the troubled times of the Ashikaga period. The new philosophy appealed to the samurai, a caste of professional war-

riors composed of men who held a relatively high position in society and who were followers of the feudal nobility. They lived by rigid standards that placed high values on such virtues as loyalty, courage, and self-control. The self-reliance required of adherents (p. 840) made Zen the ideal religion for the samurai.

Because the samurai found Zen attractive, the arts that had been associated in China with it swept Japan. Sculpture, as in China under Ch'an, lost importance, and painting widely imitated the bold brush of the Sung masters of Ch'an. Early in the Ashikaga period the artist Kao worked in the style of the thirteenth-century Chinese artist Liang K'ai, while his contemporary Mokuan painted almost indistinguishably from a Chinese predecessor, Mu Ch'i. Of all the Zen artists in Japan at this time SESSHŪ (1420–1506) is the most celebrated. He had several different styles, but is best known for paintings in the Ma-Hsia manner (p. 840). He greatly admired Sung painting and, although he studied in China, he decried the work of contemporary Ming painters. Nevertheless he was affected by the Ming style, for one of his masterpieces, an ink-splash landscape in the National Museum, Tokyo (FIG. 20-14), contains elements basic to the Ming style as well as to the Sung. Although the landscape recalls the wet style of Hsia Kuei, the brushwork is more abstract and the tonal contrasts more startling, after the Ming manner.

The Tea Ceremony

The influence of Zen went considerably beyond painting. It gave rise during the Ashikaga period to the tea ceremony, a unique custom that, among other things, provided a new outlet for the products of the Japanese artist-craftsman. This ceremony soon became a major social institution of the aristocracy. Special teahouses were built in the mannered gardens of the period. The teahouse itself was small and was designed to give the appearance of refined simplicity. Even its exterior was carefully planned to blend with the calculated casualness of the garden. A flagstone path usually led past moss-covered stone

20-14 SESSHŪ, *Landscape*, Ashikaga period, fifteenth century. Hanging scroll, ink on paper, 28½″ × 10¼″. The Cleveland Museum of Art (gift of the Norweb Foundation).

lanterns to an entrance where the guests, after washing at a "natural" spring, entered through a low doorway. There the host and a group of four guests sat in an atmosphere of almost unadorned simplicity. Scaled to create a feeling of intimacy, the room was a rectangle broken only by an alcove (tokonoma), which held one painting— most appropriately one in the free monochrome style of Zen—and perhaps a stylized flower arrangement. The ritual of tea drinking in this setting imposed on all the participants a set of mannered gestures and even certain topics of conversation. Every effort was made to prevent any jarring note that might shatter a perfectly planned occasion.

Each object employed in the ceremony was selected with the utmost discrimination. The connoisseur preferred a tea bowl, a flower container, a lacquer tray or other ritual utensil—all of which had to appear to have been made without artifice. The same effect was sought in the room itself, which was constructed of unpainted wood. Although the supporting posts were fashioned so as to keep their natural appearance and thus remained rounded and knotty as tree trunks, all the surfaces were painstakingly rubbed and burnished to bring out the beauty of grains and textures. Potteries used in the ceremony were covered with heavy glazes seemingly applied in a casual manner, belying the skill that had controlled the colors and textures. Lacquers

followed the same esthetic code, avoiding the mechanical perfection of later examples. To the simplest utensil the artist brought a sense of individuality and impeccable artistry.

The Tosa and Kano Schools

The artistic understatement of the tea ceremony was counterbalanced by the continuing Yamato-e style of decorative painting. TOSA MITSUNOBU (1434–1525), the foremost exponent of the latter during the Ashikaga period, retained the coloristic patterns of his native style, but also emphasized ink outline after the fashion of Chinese painting. The new manner of painting resulting from this combination is most apparent in pictures of the Kano school. MOTONOBU (1476–1559), who was probably the grandson of the founder of the Kano school, worked so closely in the Sung tradition that some of his paintings have been mistaken for those of Hsia Kuei (p. 840). He had, however, a more personal style in which we find a new emphasis on brushed outlines and strong tonal contrasts—features that became distinctive of the Kano school. In addition Motonobu often used Tosa coloring and at times even painted in a purely Tosa manner. As a result the Tosa and Kano schools became less distinguishable after the sixteenth century.

20-15 *Uji Bridge*, Momoyama period, sixteenth to seventeenth centuries. Screen, color on paper. Tokyo National Museum.

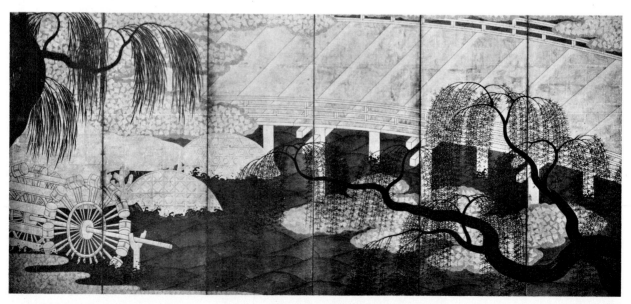

| ←— to 1392 | 1573 | 1615 | | 1715 | 1765 to 1868 —→ |

| | *Bridge at Uji* | TŌHAKU *Cryptomeria Trees* | SOTATSU *The Zen Priest Choka* | KIYOTADA *Kabuki Actor* | HARUNOBU *Evening Glow of the Ando* |
| ASHIKAGA | MOMOYAMA PERIOD | | T O K U G A W A | P E R I O D | |

MOMOYAMA AND EDO: THE DECORATIVE STYLE

In the Momoyama period (1573–1615), which followed the stormy Ashikaga, a succession of three dictators finally imposed peace on the Japanese people. Huge palaces were erected, partly as symbols of power, partly as fortresses. The grand scale of the period is typified by the Nagoya Castle, built about 1610. This castle also exemplifies how well the new style of painting suited the tastes of the Momoyama nobility. The sliding doors and large screens within the mammoth structure were covered with gold leaf on which were painted a wide range of romantic and historic subjects, even exotic portrayals of Dutch and Portuguese traders. Traditional Chinese themes were frequent, as were commonplace subjects of everyday experience. But all were transformed by an emphasis on two-dimensional design and striking color patterns (FIG. 20-15). The anecdotal or philosophical content was almost lost in a grandiose decorative display.

Not every Momoyama artist worked exclusively in the colorful style exemplified by the Nagoya paintings. HASEGAWA TŌHAKU (1539–1610), for instance, carried on the Zen manner of Mu Ch'i with brilliant success. His versatility, which was shared by most artists of the time, is evident in a brilliant monochromatic screen painting, *Cryptomeria Trees*, whose strong verticals and diagonals are distinctively Japanese (FIG. 20-16).[3]

In 1615 Ieyasu Tokugawa, last of the Momoyama rulers, consolidated his power as shogun of Edo (Tokyo) and established the Tokugawa or Edo rule, which lasted until 1857. (Print making, which emerged about this time as a popular art, is discussed on page 863.) Screen painting was continued in all its Momoyama magnificence by such artists as KANO SANRAKU (1561–1635), KOETSU (1556–1637), and TAWARAYA SOTATSU (1576–1643), whose lives spanned both periods. Koetsu and Sotatsu also composed numerous scrolls in which

[3] In Japan the decoration of screens was especially highly developed and often exemplifies the highest quality of painting.

20-16 HASEGAWA TŌHAKU, *Cryptomeria Trees*, Momoyama period, sixteenth to seventeenth centuries. Screen, ink on paper. Tokyo National Museum.

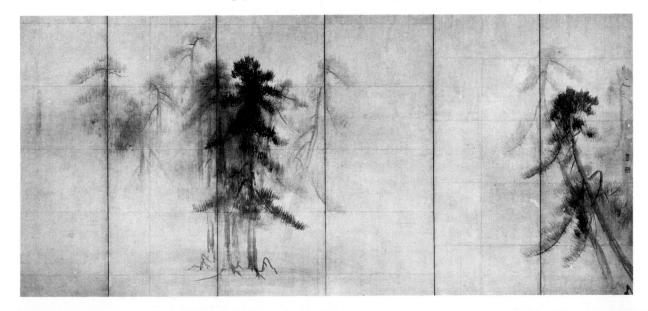

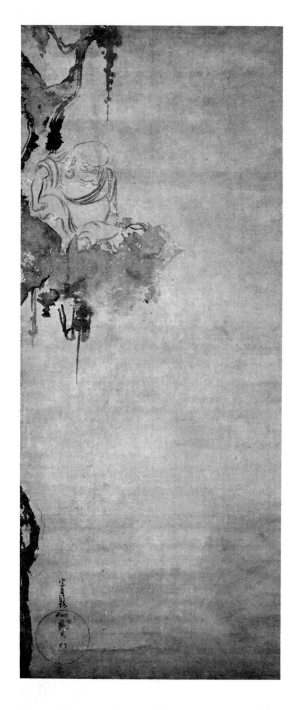

20-17 TAWARAYA SOTATSU, *Zen Priest Choka*, Tokugawa period, early seventeenth century. Hanging scroll, ink on paper, 38″ × 15¼″. Cleveland Museum of Art (Norman O. Stone and Ella A. Stone Memorial Fund).

tree to be imagined by the observer. The result is a masterpiece of understatement that closely relates the scroll to the mode of thought manifest in the studied casualness of the tea ceremony.

KŌRIN (1658–1716) and his brother KENZAN (1663–1743) carried the decorative tradition that characterized the Momoyama on into the eighteenth century. The first was primarily a decorative painter who also worked as a lacquer designer, the second a master potter, whose line of "natural" wares is still continued today by the ninth artist to take his name. Kōrin is famous largely for his dramatic renderings of rocks, tree-branches, and waves, which he combined in elegant and flowing compositions (PLATE 20-2). Both artists harmonized the decorative styles of Momoyama and early Edo with the studied simplicity required of art in the service of the tea ceremony.

Nanga and Realism

While the decorative style of the Sotatsu-Kōrin schools continued to flourish until the nineteenth century, it had to share its popularity with several other trends in later Japanese painting. One, Nanga ("southern painting"), was inspired by Chinese "ink-flinging" (p. 841) or "literary" school painting. The Nanga painters transformed the techniques of their Chinese models into one that combined virtuoso brushwork with decorative pattern and a strong sense of humor. Two outstanding early representatives of this style are IKENO TAIGA (1723–76) and YOSA BUSON (1716–83), who jointly illustrated an album entitled *The Ten Conveniences and the Ten Enjoyments of Country Life*. On one of Buson's pages (FIG. 20-18) a bulbous-nosed figure peering from a hut at richly textured summer foliage is shown with wistful humor by this master of the brush.

Another main line of later Japanese painting, which has been called realistic or naturalistic, is represented by MARUYAMA OKYO (1733–95). His

pictorial forms—those of flowers or of animals—were interlaced with strokes of a free-flowing calligraphy.

Sotatsu's hanging scroll representing the Zen priest Choka seated in a tree (FIG. 20-17) combines brilliant brushwork with a most daring asymmetrical composition that allows most of the

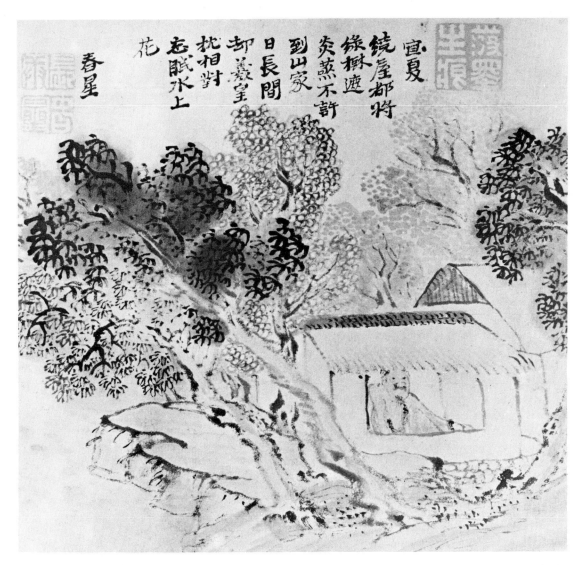

宣
夏
鏡
屋
都
將
綠
樾
遲
炎
蒸
不
許
到
山
家
日
長
間
卻
藁
室
枕
相
對
志
賦
水
上
花

春星

20-18 YOSA BUSON, *Enjoyment of Summer Scenery*, detail of *The Ten Conveniences and the Ten Enjoyments of Country Life*, Tokugawa period, 1771. Album leaves, ink and color on paper, 7″ high. Yasunari Kawabata Collection, Kanagawa.

studies of animals, insects, and plants (FIG. 20-19) combine an almost Western objectivity with an unusual handling of the brush to produce a style that follows the observed forms rather than established conventions. This kind of realism may well be due, in part, to Western influence. From the mid-sixteenth century on, Portuguese missionaries and Dutch traders visited Japan, bringing with them paintings that, despite the efforts of the Tokugawa shoguns to bar foreign influences, did not fail to have some effect on Japanese art.

Ukiyo-e and Print-Making

The Tokugawa shoguns maintained a static and stratified society and, as a result, each class developed its own distinctive culture. The center of the plebeian culture was the Yoshiwara entertainment area of Edo, where the popular idols were the talented courtesans of the tea houses and the actors of the Kabuki theater. Kabuki itself was a popular and lusty form of drama that developed in response to a demand for a more

20-19 MARUYAMA OKYO, detail of *Nature Studies*, Tokugawa period. Horizontal scroll, ink and color on paper, 12½″ high. Nishimura Collection, Kyoto.

intelligible and more easily enjoyed theater than that of the highly stylized Nō plays, the latter patronized exclusively by the nobility and a small number of the *nouveau riche*. The former provided endless subjects for a new art form, a style of genre painting, concentrated around 1600, that was to have considerable influence on Western art in the nineteenth century (page 698). This new art, known as *ukiyo-e*, or "pictures of the floating (or passing) world," was largely centered in Kyoto. Toward the end of the seventeenth century the center of production shifted to Edo, and the medium became predominantly that of the woodblock print, which reflected the tastes and pleasures of a bourgeoisie emerging in a feudal society.

The woodblock as a device for printing had been invented in China during the T'ang dynasty. The technique was introduced into Japan during the eighth century, when it was employed chiefly to reproduce inexpensive religious souvenirs or charms. In the seventeenth century, Chinese woodblock book illustrations inspired the production of low-priced illustrated guidebooks of the Yoshiwara district.

The art of block printing as it ultimately developed in the eighteenth century was a triumph

20-20 KIYOTADA, *Kabuki Actor*, Tokugawa period, c. 1715. Print, 11¼″ × 6″. Metropolitan Museum of Art, New York (Harris Brisbane Dick Fund, 1949).

of collaboration. The artist, having been selected and commissioned by a publisher, prepared his design in ink, merely adding color notations. Next, a specialist in woodcutting transferred the lines to the blocks. A third man did the printing. The quality of the finished picture depended as much on the often anonymous cutter and printer as on the painter of the original design.

MORONOBU (c. 1625–c. 1695) was probably the first to employ the woodblock print to illustrate everyday subjects in books and for individual prints, which he began to produce about 1673. The woodblock quickly evolved as a medium for cheap reproduction and wide distribution. Moronobu's woodblocks were simply in black outline against a plain white paper, as were the prints produced for the next fifty years, but often they were hand-colored by their purchasers. Moronobu's designs of large and simple forms had the exuberance of a young art. The same vitality was expressed in prints of the Torii school by such artists as KIYONOBU I (1664–1729), KIYOMASU I (1694–1716), and KIYOTADA (active in the early eighteenth century) (FIG. 20-20). These artists specialized in portraying Kabuki actors. (Kiyonobu I was an actor's son.) They worked with a broad rhythmic outline, and, for emphatic pattern, used the bold textile designs of the actors' robes.

At about the same time, members of the Kaigetsudō family were painting pictures and making designs for woodblocks of elegant courtesans. The Kaigetsudō figures had more grace but somewhat less power than those of the Torii painters. In general the print style gradually acquired more delicacy during the eighteenth century. The invention of a process of printing in color directly from blocks brought the "primitive" period of ukiyo-e printmaking to an end about 1741.

MASANOBU (1691–1768) had earlier experimented with what is called "lacquer technique" in an effort to increase the luster of the ink in his black-and-white prints. He later used a new two-color method for printing in pink and green (benizuri-e) in which the dominant pink contrasts with patches of pale green and still smaller areas of black to produce a color vibration so strong as to belie entirely the very limited palette. Coincident with the use of color printing the

20-21 HARUNOBU, *The Evening Glow of the Ando*, Tokugawa period, 1765. Print, 11¼″ × 6″. Art Institute of Chicago.

artists began to work in smaller, more delicate scale. In 1765 a device was introduced that gave more accurate register and permitted the successful use of even smaller color areas. This led to the development of the *nishiki-e* or "brocade picture," which was a true polychrome print. The new technique encouraged greater refinement and delicacy, characteristics evident in prints by the two leading print masters of the time, the incomparable HARUNOBU (1725–70) and KORYŪSAI (active 1764–88). In their work we find a new loveliness replacing the monumentality of earlier compositions. The figures are of slighter proportions, the colors more muted, the line lyric rather than dramatic (FIG. 20-21).

After the death of Harunobu, prints changed rapidly in style, shape, subject, and color. KIYONAGA (1752–1815) and UTAMARO (1753–1806) re-

20-22 Hokusai, *The Great Wave*, from *Thirty-Six Views of Mt. Fuji*, Tokugawa period. Print, 14¾″ wide. Museum of Fine Arts, Boston.

vived the taste for tall, willowy figures. Utamaro, who later concentrated on half-length figures, was fortunate in having the services of craftsmen skilled enough in woodcutting to allow him to create extraordinary nuances in color, texture, and line. BUNCHŌ (active 1766–90), working in another vein, made many striking portraits of well-known figures. Even more dramatic are the prints of SHARAKU, who, active for a brief ten months during 1794 and 1795, was a unique and enigmatic figure among print artists. About one hundred and thirty of his prints survive, all of them piercing, rather acid, psychological studies of actors, wrestlers, or managers. TOYOKUNI I (1769–1825) followed in a similar, less biting manner, but the strength of this style was dissipated in the hands of later artists.

Dozens of other artists contributed to the popular art of printmaking, but during the nineteenth century HOKUSAI (1760–1849) and HIROSHIGE (1797–1858) were outstanding. Increasing political and moral censorship, which was to contribute to the decline of this art, led Hokusai ot landscape for his ukiyo-e subjects. His brilliant and ingenious compositions, such as his *Thirty-Six Views of Mt. Fuji*, always avoided any mannerisms that might have congealed his individual style (FIG. 20-22). Nature was his primary subject, but in its setting he also included genre and anecdote as minor themes. Hiroshige, too, specialized in landscape and, like Hokusai, painted birds, flowers, and legendary scenes. In general, however, his prints did not evoke the sense of grandeur implicit in Hokusai's work.

These prints show the Japanese attitude toward nature, which regarded natural forms in their utmost simplicity as a point of departure for an interpretation of reality and which, in turn, led to abstract pictorial design.

DOMESTIC ARCHITECTURE

Until recently, the Japanese home—modest or pretentious—has been designed according to what are basically the same structural and esthetic principles as those discussed with respect to the Shinto shrine and the tea ceremony house. The Japanese dwelling almost invariably is intimately related to the land around it, and wherever pos-sible it is set in a garden closed off by a bamboo fence (a thing of beauty in itself), providing a sense of privacy and intimacy even in the most crowded environment. Uniformity and harmony of proportions are achieved by the use of the conventional mat (*tatami*) as a module for the dimensions of the rooms (FIG. 20-23).

The structure is essentially a series of posts supporting a roof. The walls, which are thus screens rather than supports, slide—to open onto the outside or from one room into another. Space is treated as continuous yet harmoniously divisi-ble—a concept that revolutionized architectural theory in the West. Adoption of the Japanese traditions of painstaking craftsmanship is more difficult for the West.

20-23 Interior of a Japanese house.

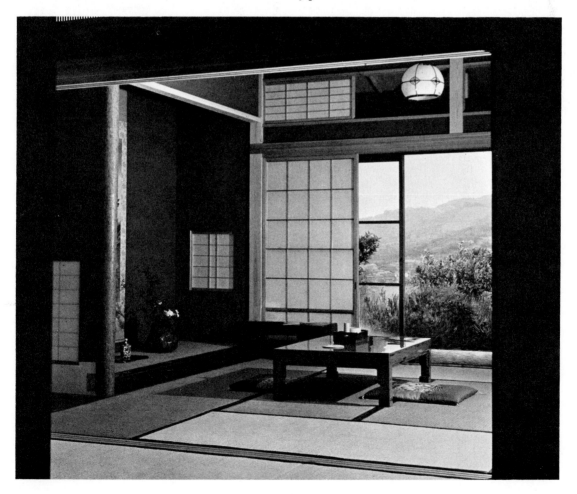

Chapter Twenty-one

Pre-Columbian Art

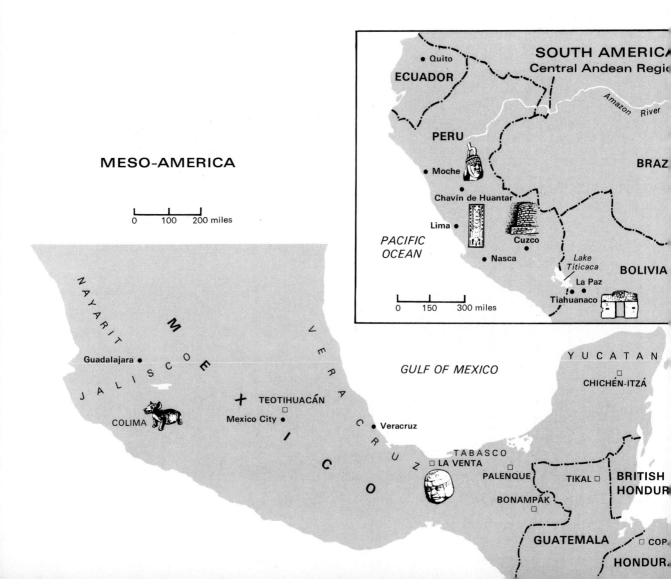

In its broadest sense, "pre-Columbian" refers to all the peoples indigenous to the New World as they existed prior to the advent of the Europeans. In practice, however, the term is used to designate the pre-European-contact cultures of Meso-America and South America. Although the Aztecs and the Incas are the two groups most commonly associated with the pre-Columbian world, in actuality they represent only a final brief flicker of a flame of cultural development that had been kindled thousands of years before the arrival of Columbus. This de-

velopment began with a series of migrations, primarily, it seems, via a land bridge from Asia at what is now the Aleutian Island chain. Perhaps as early as 4000 B.C. some of these wandering peoples had developed the food plant maize, and, with agriculture established and a constant food supply assured, these early Americans were able to turn from the time-consuming necessities of hunting and gathering to developing the complex civilizations that were marveled at by the Spanish conquistadors. As the opening map and chronology imply, these civilizations were impressive

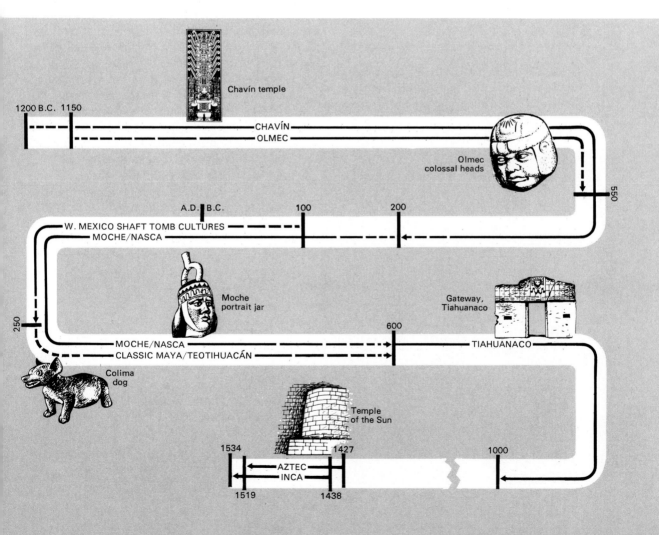

Chavín temple

1200 B.C. 1150

CHAVÍN
OLMEC

Olmec
colossal heads

550

A.D. B.C. 100 200

W. MEXICO SHAFT TOMB CULTURES
MOCHE/NASCA

Moche
portrait jar

Gateway,
Tiahuanaco

250

600

MOCHE/NASCA
CLASSIC MAYA/TEOTIHUACÁN

TIAHUANACO

Colima
dog

Temple
of the Sun

1534 1427 1000

AZTEC
INCA

1519 1438

not only in their grandeur and complexity, but as well in the vastness of time and of area in which they developed.

MESO-AMERICA

Meso-America (primarily an ethnographic term) includes most of central and southern Mexico and the northern section of Central America. Within this vast area one encounters geographic and climatic conditions (ranging from the temperate central highlands to the hot, humid southern coast of Veracruz) of a variety that is paralleled in the art styles found in it. Those discussed in this brief section are representative of four distinct periods and areas of the Meso-American realm.

Olmec

The Olmecs were the first to display a number of artistic and social features considered typical of the peoples of Meso-America. For this reason,

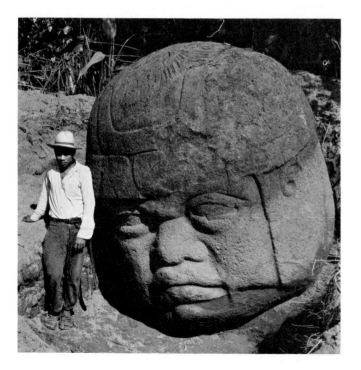

they are often referred to as the "mother culture" of that region. Although their heartland was principally in the area of La Venta and San Lorenzo (northern Tabasco and southern Veracruz) their influence was felt in many parts of Mexico. La Venta itself was a ceremonial center with earthen platforms and columns of basalt marking out two large courtyards. Facing out from the courtyard were four huge human heads of basalt (FIG. 21-1). The supple modeling of these heads reflects the Olmecs' ability to manipulate extremely hard materials such as basalt and jadeite. An equal achievement was the transportation of these huge pieces of stone, the closest known source of which is separated from La Venta by over sixty miles of swampland.

Although the colossal heads may be the best known examples of Olmec stone sculpture, this culture also produced small-scale stone carvings that frequently depicted a creature combining the features of a human infant with those of a jaguar. So numerous are these figures that it is believed that the creature was a principal figure in the Olmec pantheon.

In general, it may be seen that Olmec stone sculpture exhibits a quest for symmetry and frontality. Coupled with this is an organic quality that suggests an emergence of the work from the core of the stone as opposed to a sculpting of it. The final forms are frequently enhanced with zones of extremely fine incised line.

Although there is growing evidence that the Maya (*below*) may have had an Olmec origin, their sculpture styles cannot be confused. Mayan stone sculpture was predominantly architecture-related, while the Olmec emphasized free-standing forms modeled in the full round.

West Mexico

The pre-Columbian peoples of West Mexico produced neither massive architecture nor large-scale stone sculpture and in general did not share in the cultural achievements of the central and southern zones of Meso-America. In fact, the

21-1 Colossal head, Olmec, La Venta, 1500–800 B.C. Basalt, 8′ high and 21′ in circumference. © Courtesy National Geographic Society.

21-2 Dog effigy vessel, Colima, *c.* A.D. 250. Ceramic, 6″ high, University of California, Los Angeles, Museum of Cultural History.

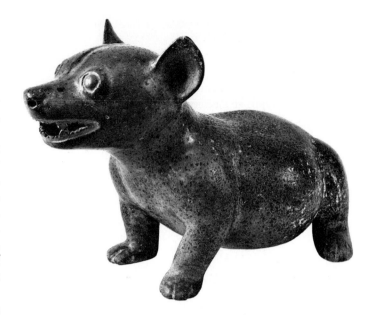

West Mexico areas of Jalisco, Nayarit, and Colima have frequently been referred to as cultural backwaters relative to the "high" cultures for which Meso-America is most famous.

Yet West Mexico had a long and rich artistic tradition, principally in the medium of clay sculpture. Effigy figures of humans, animals, and mythological creatures have been encountered in distinctive tombs consisting of shafts (as much as fifty feet deep) with chambers at their bottom end. Unfortunately, this area was long neglected by archeologists, and our limited knowledge of the tomb contents derives primarily from the operations of grave robbers.

Large, hollow ceramic effigy figures for which the area is noted exhibit—particularly in the swollen torsos and limbs of the figures—a distinct sense of volume. The Colima figures are consistently a highly burnished red-orange, in contrast with the distinctive variegated surfaces of the majority of other west coast ceramics. The area is also famed for small-scale clay scenes that include modeled houses or temples and numerous solid figurines, the latter shown in a variety of lively activities some of which have been interpreted as festivals and battles.

It has frequently been observed that the sculpture from this area exhibits a secular quality seldom encountered in the arts of Meso-America. To some degree this viewpoint may be a result of our inability to discriminate religious from nonreligious objects. A case in point are the Colima dogs (FIG. 21-2); although they were once referred to simply as genre figures, it is now known that the ancient Mexicans believed that dogs served as guides of the souls of the deceased. It seems clear now that the arts of this area, with few exceptions, were largely connected with religion and ritual.

Maya

By the early centuries of the Christian era the Maya Indians, who occupied the moist lowlands of what is now Guatemala, British Honduras, and Yucatan, had reached a stage of cultural advancement that presupposes development for many centuries. Like all Meso-American cultures, the Maya possessed only tools of stone, wood, and bone, even during their classic period (*c.* A.D. 250–600), when they erected huge limestone structures with richly carved decorations at such centers as Copán, Tikal, Uaxactún, Yaxchilán, and Palenque. Metal was not used on a large scale in Meso-America until after about A.D. 800.

Priests, astronomer-priests, and nobles are believed to have constituted a theocratic government that dominated the mass of the people, who were farmers and artisans. Agricultural activities were probably regulated by religious precept, and people traveled far to visit the ceremonial centers for festivals and markets. The intricate Maya calendar expresses the interaction of such gods as the sun god, the wind god, the maize god, and the death god in astrological combinations for purposes of prophesy and divination.

In building durable stone enclosures the Mayans used a corbeled vault structure in which the masonry courses projected inward (FIG. 21-3) until they met, producing an interior space whose upper part was triangular in section. Rooms so constructed were never more than about fifteen feet wide but might be of any length. Temples, constructed in this manner, consisted of one or more long, narrow compartments. In some buildings a pierced roof crest or decorative comb rose above the roof.

21-3 Section of a North Maya structure, Chichén Itzá, *c.* ninth century: (a) twin corbeled vaults; (b) flying façade; (c) roof comb.

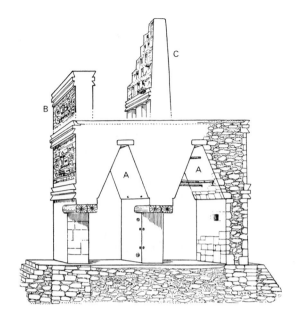

A representative temple group (FIG. 21-4) stands at Uaxactún. It was part of a larger assembly of temples and buildings on hilltops, all connected by roadways and covering many square miles. Its base consisted of a series of terraces with stairways leading up to the temple court. The massive temple roofs were surmounted by ornate and towering roof combs. Both roofs and combs were polished and painted so that their surfaces shone brilliantly.

Wealth of ornament is characteristic of Maya sculpture. This is seen in the stelae, commemorative or calendrical stone shafts five to twenty-five feet high, erected in the temple plazas. Many bear dates, often recording the day of the erection of the stone. Such stelae were carved from about the first to the seventh or eighth century A.D., so that a stylistic sequence can be accurately charted. Most are crowded with relief carvings, usually consisting of a figure in ceremonial dress surrounded by hieroglyphs and other motifs in low relief.

The huge boulder at Quiriguá (FIG. 21-5), which may have been an altar, is entirely covered with intricate carvings in both high and low relief. The most conspicuous part of the design on the north face is a human figure dressed in rich garments, wearing an enormous, elaborate headdress, and seated in the mouth of a great dragon. Such placing of a human figure in the jaws of a reptile is quite common in Maya art, and in view of the fact that serpent forms often symbolize the sky, perhaps indicates the supernatural or godlike character of the human represented.

Maya stone sculpture in the round, or in high relief, is rare, and it is usually closely associated

21-4 Temple group, Maya, Uaxactún. Reconstruction drawing by T. Proskouriakoff as of *c.* A.D. 700. Carnegie Institute, Washington, D.C.

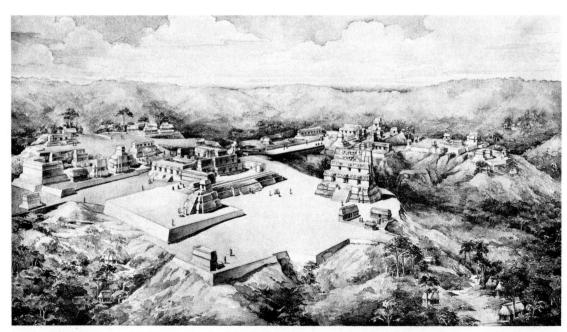

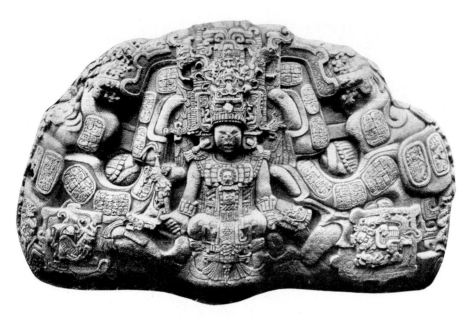

21-5 *Great Dragon*, Maya, Quiriguá, sixth century A.D. 7′ 3″ high.

with architecture, as in the case of the head and torso of the Maize God (FIG. 21-6) from Copán. Sculpture is often found on lintels, jambs, and entire façades.

The work of the Maya painter, like that of the sculptor, was closely coordinated with building and can hardly be considered separately, for most of the reliefs were colored. Most other painting occurs on the inside of temple walls. The painter

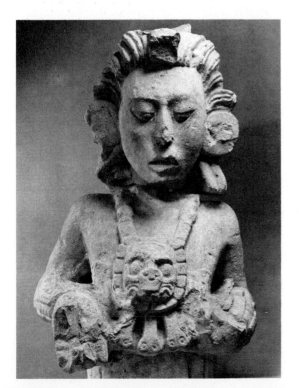

outlined his figures in red, filled them in with flat colors, and finally outlined the figures again in black.

In the temple discovered in Bonampák in 1947, narrative murals in scenes of rich color cover the walls of the three chambers. In each chamber, lower, middle, and upper registers correspond respectively to the people, to priests and nobles, and to celestial symbols. The principal scenes deal with preparations for a ritual dance, a raid on a town and capture of prisoners, the sacrifices of prisoners (FIG. 21-7), and the dance.

Teotihuacán

Contemporaneous with the period of early classic Maya art was the civilization called Teotihuacán, from the name of the great city and ritual center just north of Mexico City. The site was the largest city in the pre-contact New World with a possible population of 100,000 at its height. The builders of its temples were an agricultural people who created a distinctive art style during the first centuries of the Christian era. They worshiped many nature gods and made innumerable clay figurines of humans to place in their fields, perhaps to ensure fertility.

Teotihuacán ("place of the gods") was laid out so that all its temples were in symmetrical group-

21-6 Maize God, Maya, Copán, sixth century A.D. Limestone. American Museum of Natural History, New York.

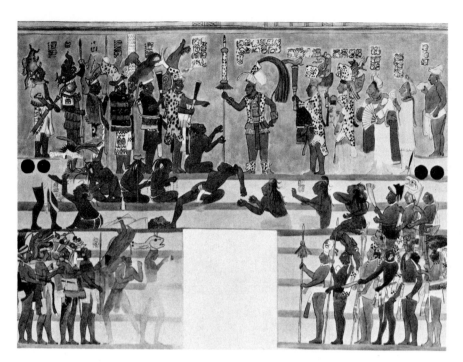

21-7 Temple mural of warriors surrounding captives on a terraced platform, Maya, Bonampák, *c.* sixth century A.D. Watercolor copy by Antonio Tejeda. Carnegie Institute, Washington, D.C.

ings flanking a broad avenue. The largest and most imposing was the so-called Pyramid of the Sun. This massive pyramidal substructure, which once supported a temple, consists of five tiers and one broad stairway, alternately single and double, leading from the ground level to the top. A smaller shrine, the Temple of Quetzalcoatl (a major hero of the Meso-American mythos), lay at the center of a great quadrangle marked by terraced mounds. Its sculptured panels, because they were covered by subsequent building, are excellently preserved. The temple (FIG. 21-8) consists of six terraces, each decorated with massive projecting heads of the feathered serpent Quetzalcoatl, which alternate with heads of the goggle-eyed rain god, Tlaloc. Linking these alternating heads are low-relief depictions of feathered serpent bodies and seashells, the latter indicating contact with the coast.

Aztec

The Aztecs, a small and warlike tribe from the north, established their capital, Tenochtitlán (now the site of Mexico City), in the Valley of Mexico about 1325. This was to become the center of an extensive empire. The Aztecs, fierce in their religious as in their military life, prac-

ticed human sacrifice, believing that since the sun god had sacrificed himself to create man, man was obliged to repay him with the nourishment of human blood. The ritual required not only a splendid temple setting, but magnificent costumes and accessories, which, like much of Aztec culture, continued customs already established by their predecessors.

Aztec sculpture is famous for its massive, monumental quality, as exemplified in the figure of Coatlicue (FIG. 21-9), mother of the gods and earth goddess. Her identifying features include a skirt composed of intertwining snakes, as well as features symbolic of sacrificial death—a necklace of human hands and hearts, and a skull pendant. The quality of overwhelming monumentality of Aztec sculpture is also present in a variety of realistic large-scale representations of organic forms, including such diverse entities as snakes, rabbits, grasshoppers, squash, and cacti.

CENTRAL ANDES

Of the three zones (jungle, highlands, and coast) that make up the Central Andean region in South America, two—the coast and the highlands

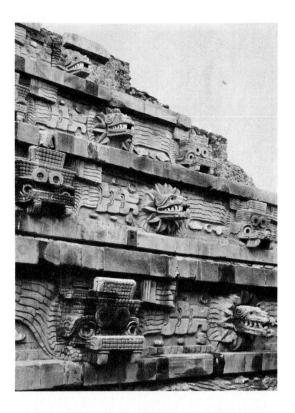

—served as homes for highly developed Andean cultures. The coastal zone is a narrow desert plain (transected by fertile valleys) whose dryness resulted in the preservation of organic burial offerings to a degree rarely encountered in the New World. The highland zone lies in the Andean Cordillera, whose massive ranges are occasionally broken by habitable high-altitude valleys.

Chavín

There is evidence that in the first millennium B.C. what may have been a religious cult began to grow, which at its height prevailed in great portions of the coast and highland areas. The cult is called Chavín after the ceremonial center Chavín de Huantar, which is located in the northern highlands and consists of a number of stone-faced pyramidal platforms penetrated by narrow passageways and small chambers and associated with a sunken court.

Chavín de Huantar is famed too for its stone sculpture. Associated with the architecture and consisting of much sunken relief on panels, lintels, and columns and some rarer instances of sculpture in the round, this sculpture has a linear quality. Free-standing sculpture is represented by an immense cult image in the center of the oldest structure as well as heads of mythological creatures that were tenoned into the exterior walls. Although at first glance the subject matter of Chavín stone carving appears to exhibit considerable variety, most consistently the emphasis is upon composite creatures that combine feline, avian, reptilian, and human features. The Raimondi stone (named after its discoverer) is representative of the late variant of Chavín stone carving (FIG. 21-10). On the lower third of the stone is a figure called the Staff God (for it is always depicted holding staffs), versions of which have been encountered from Columbia to the southern highlands of Peru, but seldom with the degree of elaboration found at Chavín. In this instance, the squat, scowling deity is depicted with his gaze directed upward. An elaborate headdress dominates the upper two-thirds of the

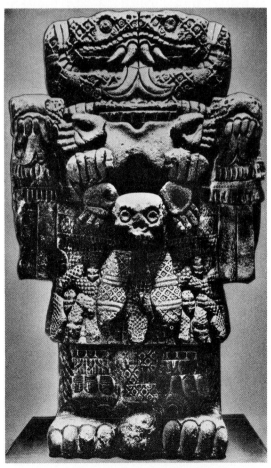

21-9 Below: Coatlicue, goddess of earth and death, Aztec, fifteenth century. Andesite, approx. 8½′ high. Museo Nacional de Antropologia, Mexico City.

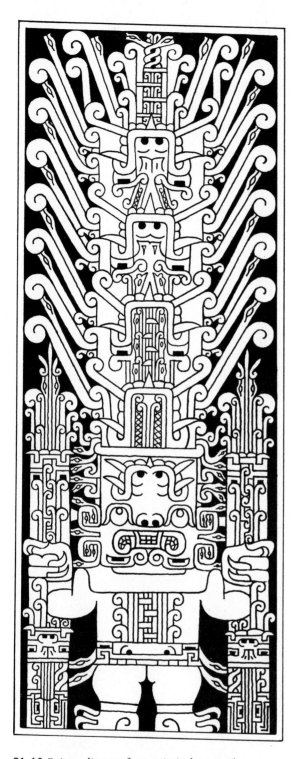

21-10 Raimondi stone, from principal pyramid, Chavín de Huantar, first millennium B.C. Incised green diorite, 6′ high.
Instituto Nacional de Cultura, Lima.

slab. Inverting the image reveals that the head-dress is composed of a series of fanged, jawless faces, each emerging from the mouth of the one above it. Snakes abound, extending from the deity's belt, forming part of the staffs, serving as whiskers and hair for the deity himself and the headdress creatures, and, finally, forming a guilloche at the apex of the composition.

The ceramic vessels of the northern Chavín area are easily identified by their massiveness of chamber, spout, and surface relief. The stirrup-spout became popular at this time and continued to be a commonly used north coast form until the advent of the Spanish.

Moche

The great variations occurring within Peruvian art styles is exemplified by two coastal traditions that developed during the period between about 200 B.C. and A.D. 600 in the cultures of the Moche on the north coast and the Nasca on the south coast.

The Moche concern with ritual is clearly reflected in their ceremonial architecture and ceramic vessels. The former consisted of immense pyramidal supporting structures for temples that, because of the scarcity of stone, were constructed of sun-dried brick or adobe. Their scale may be surmised from the remains of the so-called Temple of the Sun in the lower Trujillo Valley, which utilized millions of adobes. The temple atop it had already disappeared by the advent of the Spaniards. As a result of persistent treasure-hunting by early colonial residents, only a remnant of the original pyramid remains.

Probably the most famous art objects produced by the ancient Peruvians are the ceramic vessels of the Moche, which were predominantly flat-bottomed, stirrup-spout jars generally decorated with a bichrome slip. (Their abundance can be credited to the ancient Peruvians' practice of seeing that their dead were accompanied in the grave by many offerings.)

The ancient Peruvians produced their vessels without the aid of a potter's wheel, and by the Early Intermediate Period, were using molds for constructing vessel chambers.

The Moche potters continued to employ the

stirrup-spout, making it an elegant tube much more slender than the Chavín prototype. This may be seen in FIG. 21-11, which shows one of the famous Moche portrait bottles, believed to be either a warrior or a priest. In early bottles of this type, the sculptured form was dominant; in time, however, linear surface decoration came to be employed equally.

Nasca

Although the Nasca did not produce large-scale ceremonial architecture as was done in the north, they did create a comparable art form in their ceramic vessels, which, unlike their North-coast counterparts, had round bottoms, double spouts connected with bridges, and—most distinctive— smoothly burnished polychrome surfaces. The subject matter is of great variety, with particular emphasis on plants, animals, and mythological creatures. The initially elegant simplicity of their depiction evolved into a style exhibiting a marked complexity (FIG. 21-12).

Tiahuanaco

The bleak highland country around Lake Titicaca in southeastern Peru contrasts with the warm valleys of the coast. Isolated in these mountains, another culture, named for Tiahuanaco (on the southern shores of the lake), the principal archeological site, developed semi-independently of the coastal cultures until A.D. 1000, when the style of its art spread to the adjacent coastal area as well as to the highland areas, extending from southern Peru to northern Chile.

At Tiahuanaco an imposing center was built of massive stones, some of which were joined with copper cramps. The gateway (FIG. 21-13) is monolithic, with a sculptured frieze above the doorway. In the center of the frieze is the image of the Staff God, a deity who was part of the ancient Chavín pantheon (FIG. 21-10). During the Tiahuanaco period the Staff God is frequently associated with smaller-scale attendant figures, in this instance, sometimes rows of winged and bird-headed men. The importance of the Staff God is conveyed not only by its dominant scale, but also by its central position and its high relief,

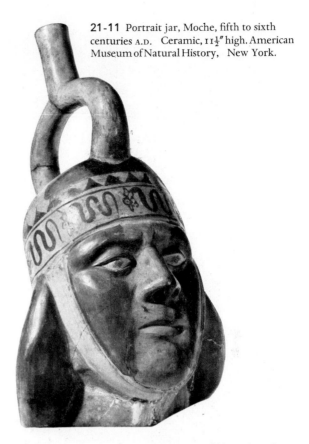

21-11 Portrait jar, Moche, fifth to sixth centuries A.D. Ceramic, 11½″ high. American Museum of Natural History, New York.

21-12 Bridge-spouted vessel, Nasca, c. fifth and sixth centuries. A.D. Ceramic with slip, 5½″ high. University of California, Los Angeles, Museum of Cultural History.

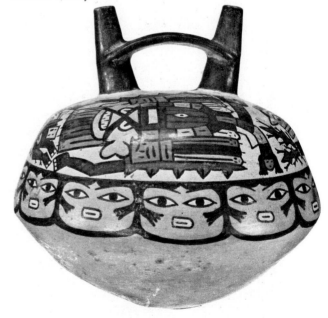

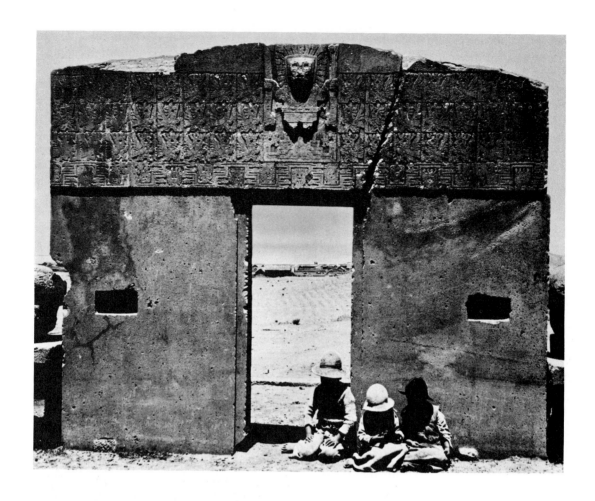

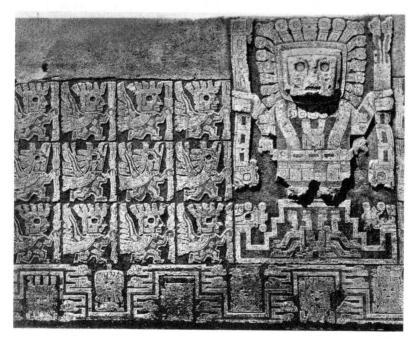

21-13 Above: Monolithic gateway, Tiahuanaco, ninth century (?). Left: Detail.

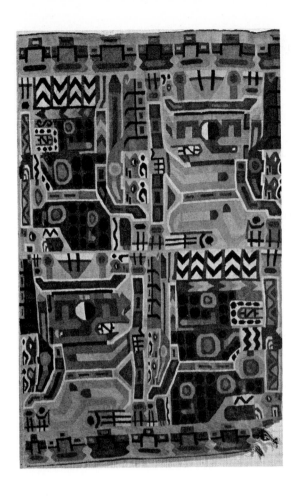

21-14 Textile, Coastal Tiahuanaco style, c. A. D. 800. Alpaca, wool, cotton, 21″ long. Museum of Primitive Art, New York.

Inca style were confined to areas that came under the power of the southern capital, Cuzco. The Inca were concerned not so much with annihilation of local traditions as with subjugation of them to those of the empire. Thus local styles, although they sometimes came to employ a few Inca features, continued to be produced in areas marginal to the centers of Inca power.

Imperial Inca architecture is famous for its dry-masonry techniques. Though stone (in the walls of temples or administrative buildings) was occasionally laid in regular horizontal courses, a dramatic polygonal pattern was more common. One of the most striking aspects of this mortarless masonry is the extreme precision with which stones were fitted together. A prime example of this precision is the Temple of the Sun (FIG. 21-15) in Cuzco, the remains of which now support the apse of a Dominican church.

21-15 Below: Temple of the Sun (now church of Santo Domingo), Inca, Cuzco, fifteenth century.

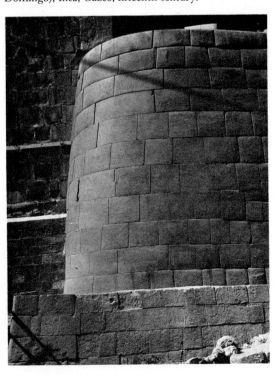

which contrasts strongly with the low-relief of the attendant figures.

Best known of the Tiahuanaco-style textiles are polychrome tapestries of extremely fine weave, in which the principal motif is frequently a single figure repeated at regular intervals but with varying details. Specific features consistent in this style include (FIG. 21-14) a bifurcated eye with one half black, the other white, N-shaped canine teeth, and limbs with sharp, squared-off ends.

Inca

The Inca, a small tribe in the southern highlands of Peru, embarked about 1438 upon a course of expansion that did not cease until the area from northern Ecuador to central Chile was under their rule.

Although the Inca aimed at imposition of their art style throughout their realm, objects of pure

North American Indian, African, and Oceanic Art

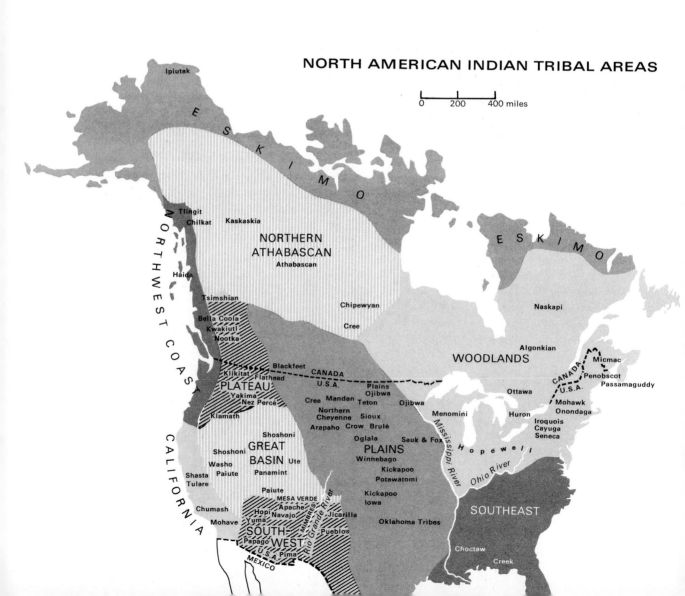

NORTH AMERICAN INDIAN TRIBAL AREAS

0 200 400 miles

AMONG THE MANY CULTURES outside the mainstream of Western history, those of the North American Indian, the Eskimo, tropical Africa, and the South Sea Islands (Oceania) have often been labeled "primitive." This designation, which, for some, still carries the connotation "inferior," originated with those who conquered, colonized, exploited, and missionized the peoples of these cultures. In the eighteenth and nineteenth centuries the art of these areas was seen as "simple," "crude," even "savage." It has taken what may be called a revolution in Western art—the changes of the late nineteenth and early twentieth centuries, themselves partially inspired by Oceanic and African art—to bring home to Western man the quality and richness of these "alien" arts.

All art is by definition sophisticated. The art forms under consideration here were once seen as "simple" because they were viewed out of context. We now regard various sculptures, paintings, and architectural works as small, if often dramatic, parts of complex spatial and temporal compositions. We also consider a work in terms of its religious, social, and political utility and try to understand its functions and meanings

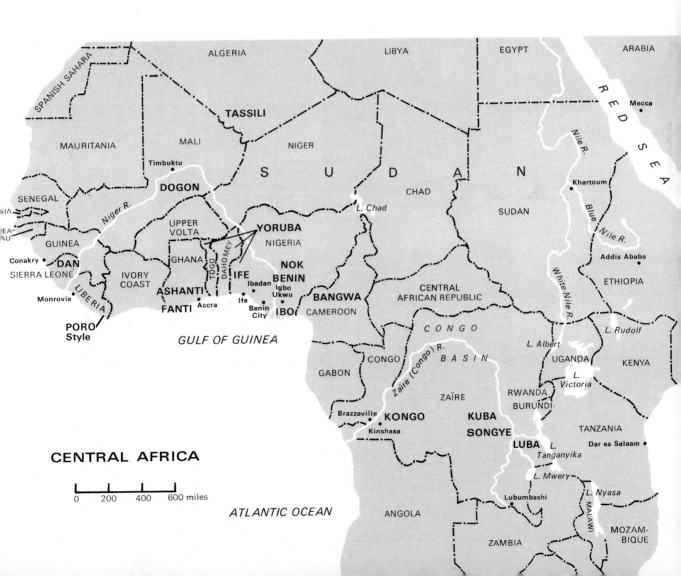

CENTRAL AFRICA

0 200 400 600 miles

GULF OF GUINEA

ATLANTIC OCEAN

in the original context. A mask, figural sculpture, or mural, seen as one of several interacting elements in a shrine, a ceremonial house, or a ritual (FIG. 22-I), emerges as anything but simple in form or meaning. Hence, we approach American Indian, African, and Oceanic arts today in the realization that, lacking a full knowledge of the cultures involved, we may not have all the perceptual tools necessary for understanding them.

When Europeans first came to these regions (in the last few centuries) there existed hundreds of relatively separate cultures (and art styles or traditions). Archeologists have unearthed evidence of hundreds more that go back several millennia. This brief survey of some of these cultures uses a conceptual approach, presenting a representative sampling of recurrent art forms such as clothing and personal decoration, figural carvings, masks, architecture, headdresses (FIG.

22-2), and other religious and political objects.

Though rich and varied (and with historical and geographical backgrounds of great diversity), the art traditions dealt with here are more like one another than they are like those of Europe or Asia or, for that matter, those of Islam or pre-Columbian America. In the cultures we examine here men live close to nature and employ many spiritual and magical acts and artifacts to ensure harmonious relations with their human and legendary forbears and with the cosmos itself. Much of this art, then, is religious, and sculpture —usually stylized human rendering—is the dominant medium. Sculptors, often capable of extremely naturalistic representation, usually choose to follow established conventions. Although there is some latitude for individual creativity, in general artists, like the public they serve, are conservative—more interested in maintain-

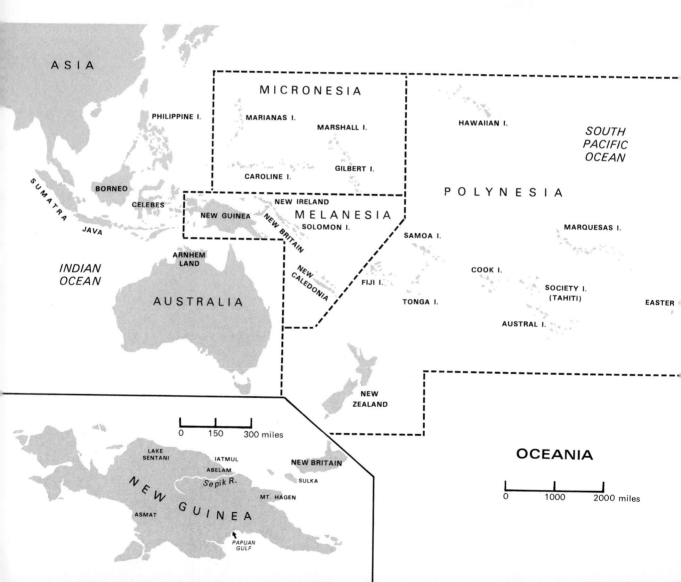

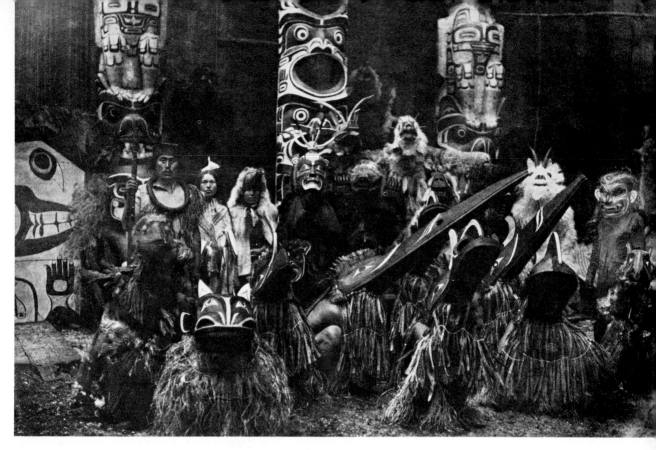

22-1 Masked dancers, Kwakiutl. Art Institute of Chicago.

ing traditions than in making virtuoso changes or inventions for their own sake. Such conservatism is present too in another important class of objects—masks, which are almost invariably symbolic representations of spirits. Through the agency of masking costumes, men transform themselves temporarily into spirits—ancestors, heroes, mythological creatures, animals, nature deities—whose intervention in human affairs is often necessary to the continuity of life itself. The entertainment value of masked dances is important too, but often secondary. Many "power images" (FIG. 22-3)—objects believed capable of healing, cursing, promoting success or failure, fertility or growth—have an artistic impact that derives from the fact that they combine magical materials from the immediate environment with carved figures, masks, or painted shields.

The cultures of Africa, Oceania, and the North American Indian give greater emphasis to transient, impermanent works of art than the cultures of Europe and Asia: the arts of personal

22-2 Helmet, Tlingit. Wood, 12″ high. American Museum of Natural History, New York.

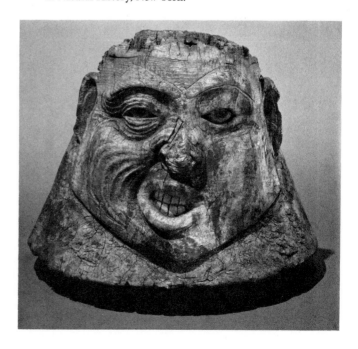

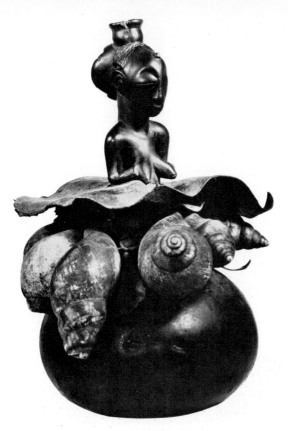

22-3 Fetish, Luba. Wood, animal hide, shells, and calabash, 1′ 3″ high. Collection Tristan Tzara, Paris.

decoration, for example, which transform individuals, and multimedia combinations, which transform whole communities for festivals (FIG. 22-1) and state occasions. At these and other times various arts are invoked to display or reinforce personal prestige and status. Still others are used for social and political control by temporal and spiritual leaders, who, as in other areas of the world, are the major patrons. Artists, sometimes celebrated, sometimes anonymous, are nearly always full members of the social or ritual community they serve and everywhere have superb control over their tools and materials. Seldom rebels or revolutionaries, they work to uphold —as their art works themselves uphold—the traditions and values of their usually conservative societies. Among all these peoples, then, art serves far more than mere "decorative" purposes; most often it is tied, as Paul Wingert has written, to the survival, security, and stability of the group. Whether social or political or spiritual in primary orientation, art in all these areas is a fundamental expression of human values.

NORTH AMERICAN INDIAN AND ESKIMO

The art styles and object types of the three artistic traditions surveyed in this chapter are quite well known for the period beginning with prolonged contact with Europeans. In the case of North American cultures, however, there is also quite extensive knowledge of much earlier forms and styles. There have been discovered in many parts of the United States and Canada "prehistoric" cultures that reach back as much as 12,000 years, although most of the finer art objects come from the last 2000 years. "Historic" cultures, designated as such beginning with the earliest date of prolonged contact with Europeans (varying from the sixteenth to the nineteenth century), have been widely and systematically recorded by anthropologists and usually reflect profound changes wrought by the impact of alien tools, materials, and values.

Scholars divide the vast and varied territory involved into a number of areas (identified on the chapter-opening map) on the basis of relative homogeneity of language and culture patterns. Both prehistoric and historic art forms from most of these culture areas are discussed briefly below.

Prehistoric Era

Eskimo sculpture, often severely economical in the handling of form, is at the same time refined, even elegant, in the placement and precision of incised designs, both geometric and representational. The carved ivory burial mask (FIG. 22-4) is from the Ipiutak culture of about A.D. 300 and is composed of nine carefully shaped parts that are interrelated so as to produce several faces, both human and animal, in the manner of a visual pun. It is a confident, subtle composition in shallow relief, a tribute to the artist's imaginative control over the materials. Over the centuries Eskimos have also carved hundreds of small figures and animals, usually in ivory, and highly imaginative "mobile" masks (ones with moving parts), used by shamans, that, because of their fanciful forms and odd juxtapositions of images and materials, were much appreciated by Surrealists in the 1920's.

Early American Indian craftsmen also excelled in working stone into a variety of utilitarian and/or ceremonial objects. The quite realistic handling of the so-called Adena pipe (1000–300 B.C.)—a figural pipe bowl (FIG. 22-5)—contrasts markedly with a spare, abstract "birdstone" (FIG. 22-6) from cultures called Hopewell, which overlapped and followed the Adena, extending from the Ohio Valley to West Virginia and Wisconsin. The standing pipe figure, although simplified, has naturalistic joint articulations and musculature, a lively flexed-leg pose, and an alert facial expression, all combining to suggest movement. In contrast, the birdstone is highly schematized, with body parts abstracted to suggestions of their actual prototypes. The birdstone was probably used as a balancing weight on a spear-throwing stick, while the pipe (if recent practices descend from those of prehistory) was used for ceremonial smoking. (Most Indians consider tobacco an offering to the gods.) The birdstone, too, may

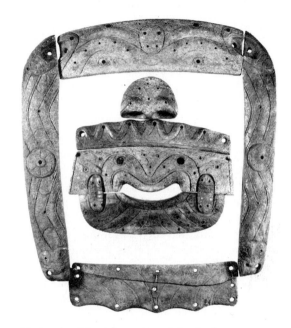

22-4 Set of burial carvings, Ipiutak. Ivory, greatest width 9½". American Museum of Natural History, New York.

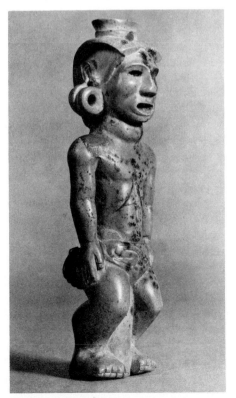

22-5 *Adena Pipe*, Adena, *c.* 1000 B.C. to A.D. 3000. Stone, 8" high. Ohio Historical Society.

22-6 Birdstone, Hopewell. Slate, 6½" long. Museum of the American Indian, Heye Foundation.

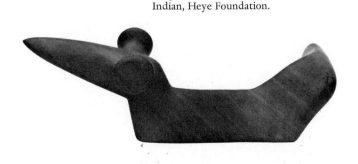

North American Indian and Eskimo 885

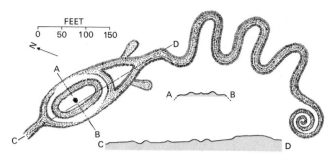

22-7 *Serpent Mound.* Approx. 1400' long. Adams County, Ohio.

have been invested with symbolic uses or meanings. Most Adena and Hopewell objects were excavated from burial mounds and are thought to have been gifts to the dead to ensure safe, prosperous arrival in the land of the spirits. Other art objects found in such contexts include fine mica and embossed-copper cut-outs of hands, bodies, snakes, birds, and other presumably symbolic forms.

One of the larger Indian creations—the Serpent Mound (FIG. 22-7) in Adams County, Ohio—is an artistic transformation of the natural environment. Undoubtedly made for spiritual purposes, this monument is a spectacular prehistoric example of the universal practice of creating visually impressive settings for ceremonial activities. The serpent, which has been restored, is about a quarter of a mile long. Other effigy mounds are known, and complex platformed temple mounds have been discovered. The latter, along with small, incised shell reliefs, show strong influence from pre-Columbian Meso-America (p. 868).

Engravings and paintings on rock are found widely distributed across North America. It is supposed that many of these are sacred sites used for communal rituals or the recording of personal spiritual experiences, which were very important in traditional American Indian religions. Rock arts vary from lively naturalistic or schematic renderings of humans and animals to complex, convoluted compositions of yet-undeciphered symbols. Both the symbolic complex in black, white, and red (FIG. 22-8) shown in its cave setting near Santa Barbara and the processions of linear, geometric, human (or spirit) figures (FIG. 22-9) picked into rock surfaces near Dinwoody, Wyoming about 1700 have overlays suggesting successive visits, probably for ritual purposes. Precise dating of rock art is often impossible, and although the examples shown were probably made prior to white contact, others depict horses and guns and have more naturalistic renderings, indicating a later date of execution.

Most Indian art forms—rock painting, pottery, architecture—span great periods. Detailed chronological sequences of pottery styles are, in fact, the historian's major tool in dating and reconstructing the cultures of the distant past, especially in the Southwest, since there were, of course, no written records. There are many fine specimens of Southwest ceramics dating from before the Christian era until the present day, but after about A.D. 1000 pottery becomes especially fine, and its decoration most impressive.

The thirteenth-century pot illustrated here (FIG. 22-10) has an animated, graphic rendering of a warrior with a shield in a composition that creates a dynamic tension between the black figuring and the white ground. Thousands of different compositions are known from Mimbres, from lively and often complex geometric patterns to fanciful, often whimsical pictures of humans and animals; almost all are imaginative creations of artists who seem to have been bent on not repeating themselves. Designs are created by linear rhythms balanced and controlled within the clearly defined border. Because the potter's wheel was unknown in the Southwest, the countless sophisticated shapes of varied size—always

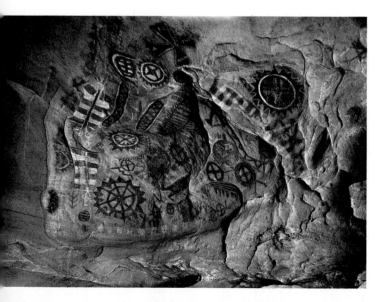

22-8 Cave Painting, probably Chumash. Santa Barbara, California.

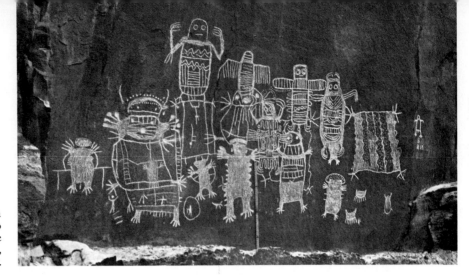

22-9 Human figures engraved on a sandstone cliff, attributed to prehistoric Shoshone, c. 1700. Size of panel, 18' × 8' 2". Dinwoody, Wyoming.

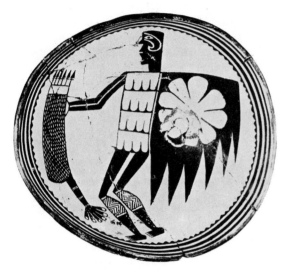

22-10 Bowl, Mimbres, thirteenth century. Ceramic, 9" in diameter. Peabody Museum, Harvard University.

characterized by technical excellence—were built by the coiling method.

In the later centuries of the prehistoric era, Indians of the Southwest constructed many architectural complexes that reflect masterful building skills and impressive talents of spatial organization. Of the many ruins of such complexes, Pueblo Bonito and the "Cliff Palace" at Mesa Verde are among the best known. The Cliff Palace (FIG. 22-11) occupies a sheltered ledge above a valley floor and has about two hundred rectangular rooms—mostly communal dwellings—in several stories of carefully laid stone or adobe and timber. Twenty larger circular underground structures, called *kivas*, were the spiritual and

ceremonial centers of Pueblo life. Pueblo Bonito (FIG. 22-12) contains similar rooms but contrasts with Mesa Verde in its siting in the open and, especially, in its superbly unified plan. The whole complex is enclosed by a wall in the shape of a giant "D." The careful planning suggests it was designed by a single architect or master builder and constructed by hundreds of workers under a firm directing hand. Modern terraced pueblos, like Taos in New Mexico, though impressive, reflect neither such unified design nor such a massive, well-organized building effort.

Historic Era

SOUTHWEST

Obviously the motivations, functions, and means of art forms from the historic period are better known than those of forms (surveyed above) from earlier eras. Thus, the complex prehistoric religious murals from the Southwest are hard to interpret, while Navajo sand painting, an art that still survives, is susceptible of detailed elucidation. These paintings, highly transient, are constructed by artist-priests to the accompaniment of prayers and chants as an essential part of ceremonies for curing disease. (In the healing ceremony the patient sits in the center of the painting so as to absorb the healing, life-giving powers of the gods and their representations.) Similar rites are used to assure success in hunting and to promote fertility in man and nature alike. The natural materials used—corn pollen, charcoal,

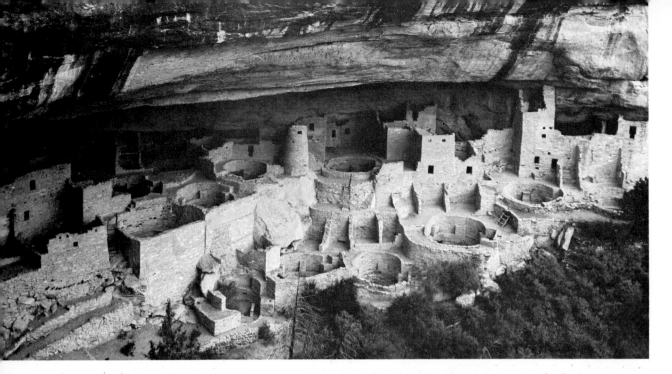

22-11 Cliff Palace, *c.* A.D. 1100. Mesa Verde National Park, Colorado.

22-12 Pueblo Bonito, *c.* A.D. 1100. New Mexico.

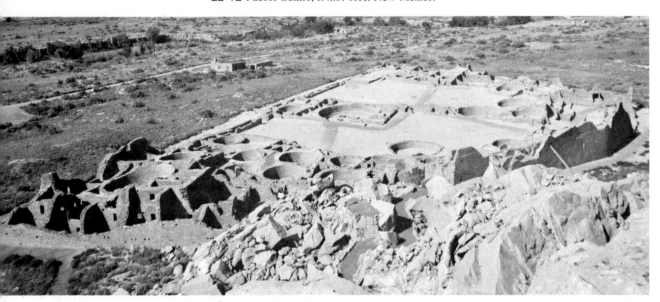

varicolored powdered stones—have a symbolic role reflecting the Southwestern Indians' preoccupation with the spirits and forces of nature. The paintings, which depict the gods and mythological heroes whose help is sought, are destroyed in the process of the ritual, so no models exist; still, the traditional prototypes, passed on from artist to artist, must be adhered to as closely as possible, since mistakes can render the ceremony ineffective. Navajo dry-painting style is rigid, composed of simple curves, straight lines, and serial repetition, despite the potential freedom of free-hand drawing (PLATE 22-1). Navajo weaving and silver jewelry-making are later developments and, until very recently, have been made to high technical and artistic standards.

North American Indian, African, and Oceanic Art

Another art form from the Southwest, the Kachina doll, is a carved and painted miniature representation of the masked spirit dancers who still perform their elaborate ceremonies aimed at bringing man and nature into harmony.

NORTHWEST COAST

Working in a highly formalized, subtle style, the Indians of the Northwest Coast have produced a wide variety of art objects—totem poles, masks, rattles, chests, bowls, clothing, charms, and decorated houses and canoes. Masks were carved for use by shamans in their healing rites and by others in public reenactments of "spirit quests." The animals and mythological creatures encountered on such quests were in turn represented in masks and a host of other carvings. The mask shown in FIG. 22-13, from the Kwakiutl people, owes its dramatic character to the exaggeration of facial parts and to the deeply undercut curvilinear depressions, which give strong shadows. It is a refined yet forceful carving typical of the more expressionistic styles of the area. Others are more subdued, and some, like the Tlingit headdress cited earlier, are exceedingly naturalistic (FIG. 22-2), probably actual portraits, almost as if the artist were proving that he could represent whatever he chose to. Inherited motifs and styles were usually preferred, however, above radical new departures. Although Northwest Coast arts have a spiritual dimension, they are more important as expressions of social status, in that the art form one uses and, indeed, the things one may depict, are functions of that status. Elaborate festivals

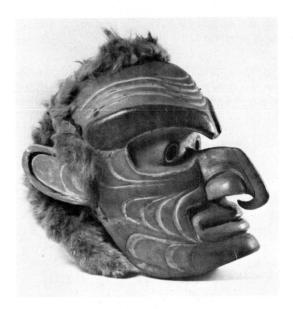

22-13 Mask, Kwakiutl, c. 1920. Approx. 13¼" high. Denver Art Museum.

(FIG. 22-1), which can themselves be considered works of art, were the formal occasions for the display and validation of such social status.

Another characteristic Northwest Coast art form is the Chilcat blanket (FIG. 22-14), the designs for which were provided by male artists in the form of pattern boards from which the female weaver worked. These blankets, which became widespread prestige items of ceremonial dress during the nineteenth century, display several recurrent characteristics of Northwest Coast style: symmetry and rhythmic repetition, schematic abstraction of animal motifs (in the

22-14 Blanket with bear design, Chilkat. Wild goat's wool and cedar bark in bright colors. American Museum of Natural History, New York.

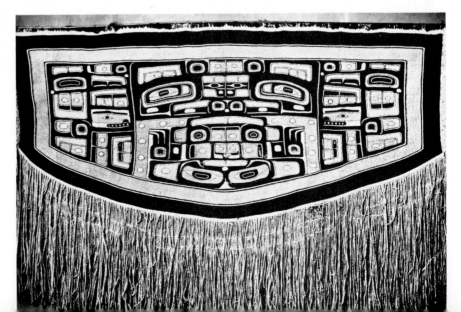

blanket illustrated, a bear), eye designs, a regularly swelling and thinning line, and a tendency to round off corners.

Elegant, precise, and highly accomplished technically, the art of the Northwest Coast is held by many to be one of the sophisticated high points of North American Indian artistic accomplishment.

GREAT PLAINS

Indians of the Great Plains worked in materials and styles quite different from those of the Northwest Coast. Much artistic energy went into decoration of leather garments, first with compactly sewn quill designs and later with beadwork patterns. Tipis, tipi linings, and buffalo-skin robes were painted with geometric and stiff figural designs prior to about 1830; after that there was a more or less gradual introduction of naturalistic scenes, often of war exploits, in styles adapted from those of visiting white artists. The tipi lining illustrated (FIG. 22-15) is of that later style, when realistic action and proportions, careful detailing, and a variety of colors were employed. An example of the earlier type of Plains art is a finely quilled buckskin shirt (FIG. 22-16), which belonged to the Dakota chief, Spotted Tail. With attached hair locks and six red and yellow bull's eye patterns connected by parallel lines, such a garment, especially in motion, would have a dramatic impact.

Since, at least in later periods, most Plains peoples were nomadic, their esthetic attention was focused largely on their clothing and bodies and on other portable objects such as shields, clubs, pipes, tomahawks, and various containers. Transient but important Plains art forms can sometimes be found in the paintings and drawings of visiting white artists. The Swiss Karl Bodmer, for example, accurately portrayed the personal decoration (PLATE 22-2) of Chief Four Bears, a Mandan warrior and chief. His body paintings and feather decorations, all symbolic of his affiliations and military accomplishments, may be said to be his biography—a composite artistic statement in several media—which could be easily "read" by other Indians. Plains men also made shields and shield covers that were at once art works and "power images." Shield paintings often derive from religious visions; their symbolism, the pigments themselves, and added materials—such as feathers—provided their owners with magical protection and supernatural power. The Arapaho example illustrated in FIG. 22-17 has a central, schematic view of a turtle whose legs, head, and tail radiate outward. This and two smaller motifs are encircled by an undulating line that repeats but varies the round format. The drawing is rough but vigorous.

22-15 Tipi lining with pictograph of war scenes, Crow, late nineteenth century. Painted muslin, 7' 1" × 2' 11". Smithsonian Institution, Washington, D.C.

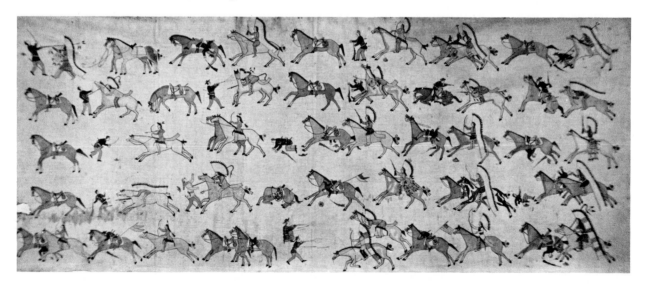

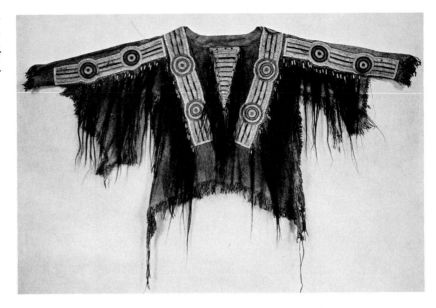

22-16 Right: Shirt, Brulé, early nineteenth century. Buckskin with quillwork, beads, and hair locks, 4′ 10″ arm spread. Museum of the American Indian, Heye Foundation.

22-17 Below: Shield, Arapaho. Buffalo hide, deerskin, black and green paint, feathers, and bells. Museum of the American Indian, Heye Foundation.

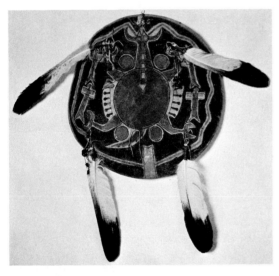

distortion and exaggeration of facial features for their strong effects. Like others used in Africa and Oceania, these masks must be hidden when not in use lest their power inadvertently cause injury.

Whether secular and merely decorative or spiritual and highly symbolic, the diverse styles and forms of North American Indian art testify to the ancient and continuing artistic sensibility of the native Americans. Their creative use of local materials and pigments constitutes an artistic reshaping of nature that in many cases reflects the Indians' reliance on and reverence toward the environment that they considered it their privilege to inhabit.

EASTERN WOODLANDS

Artists of the Eastern Woodlands made quilled and beaded objects and items of clothing often decorated with curvilinear floral motifs. Iroquois peoples also carved compelling, expressionistic masks for use by the False Face Society, whose ceremonies healed physical and psychological sickness and cleansed whole communities of destructive impurities (FIG. 22-18). The spirit "faces" portray legendary supernaturals whose exploits are recounted in mythology. Bold in conception, these masks rely on a dramatizing

22-18 ELON WEBSTER, False Face mask, Iroquois, 1937. Wood. (The artist was an Onandaga of Tonawanda Reservation.) Courtesy of Cranbrook Institute of Science, Bloomfield Hills, Michigan.

engravings, considerably more recent than the Paleolithic works found in Spain and Southern France, are equally accomplished renderings of humans, animals, and a host of nonrepresentational patterns thought to be symbolic. One very sensitively executed human figure (FIG. 22-19) is a "dancing" woman from Inaouanrhat in the Tassili region. She is actively posed and has varied types of body decoration done in several colors and with delicate precision.

The dancing figure dates from roughly 3000 B.C., but here, as with many rock paintings, dating is somewhat speculative. From a number of archeological sites collectively labeled Nok, however, we have more precise radiocarbon dating (c. 500 B.C.–A.D. 200). Here is found the earliest African evidence of sculpture in the round. Because they are so confidently handled, Nok terra-cotta heads of humans (FIG. 22-20) and

AFRICA

The huge continent of Africa has a population of millions that is subdivided into several racial and linguistic groups. Though nearly all African peoples produced artists—dancers, musicians, storytellers, rock painters, architects, and adepts at personal decoration—only those peoples dwelling in the vast areas drained by the great Niger and Congo rivers—essentially, tropical Africa—produced the great numbers of sculptures, primarily in wood, that have become deservedly famous as "African art." It is this area that will be surveyed below.

Africa is as widely varied artistically as it is sociopolitically, geographically, ecologically, linguistically, and racially. Divine rulers head great kingdoms, and groups of elders govern small tribal groups; forest regions along the coast give way inland to grassy savannas and highlands and in turn to semi-arid lands south of the Sahara.

Like North America, Africa has hundreds of Neolithic rock painting sites that contain the earliest examples of its art. These paintings and

22-20 Head, Nok, fifth century B.C. to second century A.D. Terracotta, 9″ high. Jos Museum.

animals suggest wooden or other clay prototypes, now lost. No "formative" prototypes are known. Volumes are full and surfaces smoothly modeled in these terra-cotta sculptures, which some authorities believe to be direct ancestors of Ife terra-cottas and bronzes found 150 miles southwest of the Nok area and dated from A.D. 1000 to 1200.

By about the ninth century A.D., at Igbo Ukwu in tropical Africa, sophisticated lost-wax casting techniques had evolved, and, by the twelfth century, the most naturalistic style known for any tropical African era had appeared. Woodcarvings were certainly made in the latter period too, but no examples have survived. The bronze figure illustrated here (FIG. 22-21) is undoubtedly an ancient divine king of Ife, the city in western Nigeria that is still the spiritual capital of the numerous Yoruba peoples. The king figure, unlike most African wood sculpture, shows realistic, fleshlike modeling that attempts a realistic rendering of the human form. The idealized naturalism of the flesh and head in this figure approaches portraiture, although its proportions, which exaggerate the head, are not lifelike. The casting is fine, although somewhat weathered, and accurately records precise details of costume and jewelry worn by ancient Ife kings.

There are numerous historical and ritual ties between the divine kings of Ife and those who presided over the kingdom of Benin, ascendant from the fifteenth to the eighteenth century. Many finely cast, complex bronzes, as well as ivory, wood, terra-cotta, and wrought-iron sculptures, are known from Benin, where bronze casting and ivory carving were royal prerogatives carried out by guilds of highly trained professionals. Most are rendered in a distinctive style of simplified, somewhat rigid naturalism, far more conventionalized than Ife works. Much Benin art, like the gilded objects of the Ashanti further west and the altarpiece illustrated (FIG. 22-22), glorifies the office and trappings of the divine king, who is central and most prominent in this casting, as in many others. As in the Ife figure (FIG. 22-21), the head is greatly exaggerated, reflecting the view, prevalent in many parts of Africa, that it is the center of being and the source of power and intelligence. This distortion as well as the hieratic arrangement of the group indicate

22-21 Left: Ife king figure, Yoruba, tenth to twelfth centuries A.D. Bronze, 1′ 6½″ high. Ife Museum.

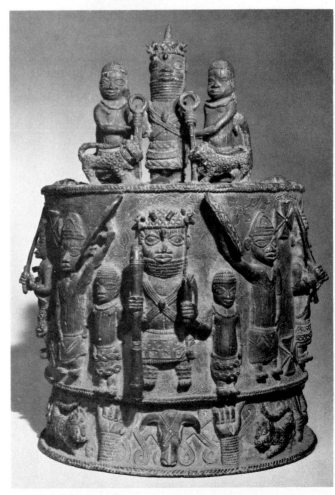

22-22 Altar of the Hand, Benin. Bronze, 1′ 5½″ high. British Museum, London.

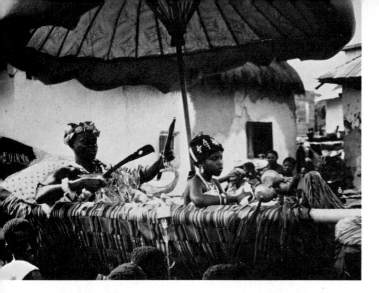

22-23 King riding in state palanquin, Ashanti.

22-24 AREOGUN, door from palace at Ikerre, Yoruba. Wood, approx. 6' high. Trustees of the British Museum, London.

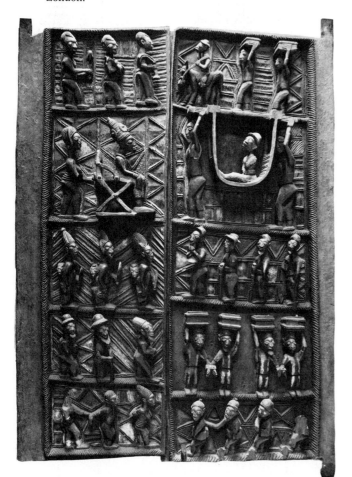

that symbolism has greater importance to the artist than photographic realism.

The sumptuous image of an Ashanti king riding in state (FIG. 22-23) can be realistically called a great work of art. Made dynamic by the movement of procession, these art complexes achieve their impact chiefly by the combination of rich, colorful cloth with cast-gold jewelry and gold-plated implements that the monarch holds in his hand.

In understanding the range and quality of African art, customary definitions must be broadened to include more than monuments, more than objects that can be displayed in museums. This is especially true of the art of masquerade, which depends on music, dance, and costuming for its real vitality. Many of the wooden masks used in such performances are dramatic carvings in their own right but should be seen as single important elements in a complex of interacting artistic media that occupy time as well as space.

The Yoruba *Gelede* masquerader (PLATE 22-3), photographed in full costume and caught in motion, is a case in point. Gelede is a cult devoted to the propitiation and entertainment of powerful senior women and deities associated with witchcraft in Yoruba communities. The masqueraders perform in pairs, their rich appliqué-panel costumes activated by vigorous dance movements. Theater and ritual combine in the dance, and the masked characters present a bewildering array of traditional and modern types: a motorcyclist, cloth-seller, hunter, leopard, king, white man, prostitute, policeman. Performances involve much social criticism of the community at large expressed in song and gesture as well as dance, and in the masks themselves.

The Yoruba, Africa's most prolific artists, created an abundance of art forms other than masks: cult figures in wood, bronze, terra-cotta, and iron, beaded objects and garments, as well as palace houseposts and doors designed to enhance the dignity and prestige of leaders. One such door (FIG. 22-24), which stood at the king's palace at Ikerre, was carved by the master sculptor Areogun of Osi. It records the historic visit of an early British colonial as well as genre scenes and anecdotes of Yoruba life. Like many African artists, Areogun had a clearly recognizable per-

sonal style—figures are elongated and rather expressionistic—and many other artists were locally famous, although individuality and personal, idiosyncratic style are of less concern here than, for example, in the modern West.

As the multimedia art of masquerade suggests, dance may be the artistic medium most important and expressive to native Africans. Many sculptures are used in dance contexts, and many others depict people dancing. The vital, energetic figures (FIG. 22-25) from the Bangwa kingdom of the Cameroon Grasslands express the vigor of dance in several complementary ways: by active, asymmetrical posing, a thrust-back head with open mouth, constrictions at the joints, which rhythmically energize the figure, and by the use of rough textures—surfaces faceted with tool marks. The female figure is believed to portray a priestess and finder of witches. Both stood among dozens of royal carvings depicting ancestors, chiefs, and priests—those, whether living or dead, who were responsible for the continuity of life itself. Such figures were gathered for rituals, given food and drink, and at the same time served to display the wealth, power, and taste of the ruler who presided over them. The importance of artistic display to Cameroon leaders made them major patrons of the arts and critics as well.

Ibo *mbari* houses, like the Yoruba door discussed above, are complex works of art. Groupings of clay sculptures (often with more than a hundred pieces in one mbari) and paintings in a specially designed architectural setting, these elaborate, unified complexes were built to honor principal community deities, often the goddess of the earth. In the illustration (PLATE 22-4) the goddess is seated with dignity in the center of the front side, her children close by, her servants, in high relief, standing guard behind. The sculptor has enlarged and extended her torso, neck, and head to express her aloofness and power. She is the apex of a formalized, hieratic composition balanced on either side by seated couples. More informally posed figures and groups are found on the other sides of the house—beautiful, amusing, or frightening figures of animals, humans, and gods taken from history, mythology, and everyday life. The complex, secret mbari con-

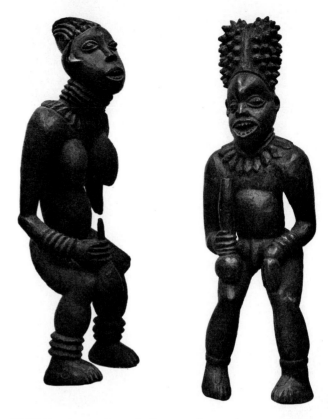

22-25 Dancing royal couple, Bangwa, nineteenth century. Wood, female 2′ 9½″ high, male 2′ 10½″ high. Collection of Mr. and Mrs. Harry A. Franklin, on loan to the Los Angeles County Museum of Art.

struction rituals, as well as the sculptural program, suggest that each house is in fact a cosmic symbol and the building process itself a stylized world-renewal ritual. Ceremonies of opening the house to public view indicate that the god has accepted the offering (of the house) and for a time, at least, will be benevolent. The mbari is never repaired; instead it is allowed to disintegrate and return to the earth from which it was made and to which it often was dedicated. The mbari, then, is a relatively transient art form, as are the arts of masquerade, personal ornamentation, and festivals. (The last three are best seen on film, which preserves the movement inherent in their design.)

Ancestral or power images from Zaïre (formerly Belgian Congo), such as the two shown in FIGS. 22-26 and 22-27, are more conventional sculptural forms that were often carefully pre-

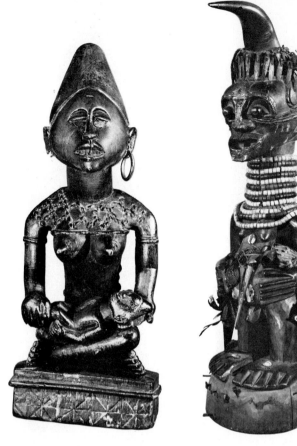

22-26 Left: Ancestral figures, Kongo. Wood and brass, 1′ 4″ high. Musée Royal de l'Afrique Centrale, Tervuren, Belgium.

22-27 Right: Fetish, Songye. Wood, iron, copper, horn, fibers, cowrie shells, feathers, and glass beads, 2′ 11″ high. Musée Royal de l'Afrique Centrale, Tervuren, Belgium.

served by their owners for generations. The commemorative ancestral mother-and-child carving from the Kongo peoples has a smooth, refined delicacy, while the composite power figure from the Songye, a people living several hundred miles east, deals with the human form more abstractly, in abrupt and forceful carving. The functions of the two are comparable, both being visible manifestations of ancestral power, which can so materially affect men's lives. The Kongo piece, probably a symbolic repository of the soul of a deceased noblewoman, received prayers invoking her continuing care and beneficence, while the Songye fetish directed (for the benefit of the community) specific ancestral

powers that were activated by (and to some extent contained in) various "medicines" placed inside and on the figure. Of the purposes of such power figures, protection in warfare, promotion of human and crop fertility, curing disease, and ending drought were among the most common.

The dramatic contrast between the style of the Songye image and that of the Kongo mother and child suggests the wide range and variety of carving conventions present in Africa. Indeed, tendencies toward realism or toward abstraction are not easily charted on the African map; deviations sometimes occur between neighboring tribes, within a tribe, and occasionally in the work of a single artist. This latter is the case among the Dan and related peoples of Liberia, Sierra Leone, and the Ivory Coast. Like many African peoples the Dan have evolved a great variety of masks representing judges, policemen, priests, and a host of other people, both harmful and helpful. In many cases the role conferred by the mask was functionally real. A person wearing a judge or executioner mask, for example, actually judged cases or executed criminals. Members of the men's masking society, usually called Poro, armed with the spirit power of the gods overseeing Poro and clothed in anonymous masking costumes, regulated the behavior of the community. The society also held masked entertainments, impersonating secular personages whose behavior was held up for public scrutiny, or performing spectacular acrobatic and stilt dances.

Dan woodcarvers, required to make representations of these varied spiritual and secular types, became skilled in several contrasting styles. The same man could carve a refined, polished mask depicting a beautiful woman, such as that shown in FIG. 22-28, and a rougher, highly abstracted mask called *Kagle* (FIG. 22-29). In fashioning the female mask the carver has simplified facial planes and brought their smooth surfaces to a high polish, while retaining naturalistic shapes and the placement of features. The carver of *Kagle*, on the other hand, simplifies and abstracts, creating a series of forceful thrusting and receding positive and negative shapes with great dramatic impact.

The royal Kuba sculptors of the central Congo (Zaïre) created an entirely different type of mask

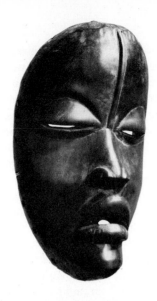

22-28 Left: Mask, Dan. Wood, 8½″ high. Museum of Primitive Art, New York.

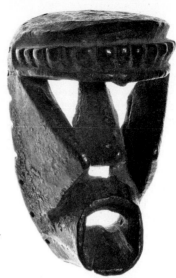

22-29 Right: *Kagle* (Poro mask), Dan. Wood, 9″ high. Yale University Art Gallery, gift of Mr. and Mrs. James M. Osborn for the Linton Collection of African Art.

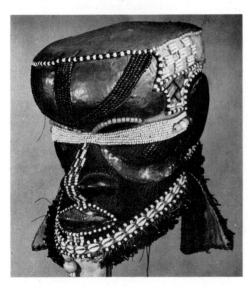

22-30 Above: Mboom helmet mask, Kuba. Wood, brass, cowrie shells, beads, seeds, 13″ high. Musée Royal de l'Afrique Centrale, Tervuren, Belgium.

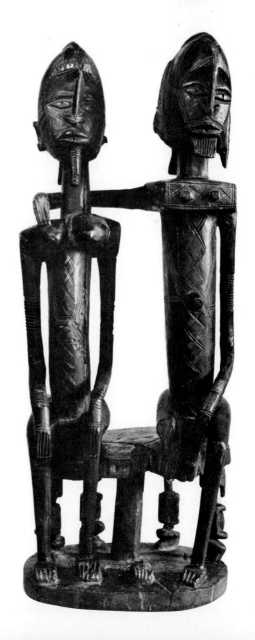

to represent a primordial ancestor who helps to oversee the ritual passage of boys into adulthood. (Many other African peoples have masks used in analogous ceremonies.) Several of these, like the Mboom mask illustrated here (FIG. 22-30), employ a rich combination of beads, feathers, copper, fur, and raffia—all attached to a carved wooden helmet. Thus a strong basic head shape with a bulging forehead is overlaid with visually complex textural effects that are symbols of royalty.

22-31 Couple, Dogon. Wood, 2′ 6″ high. Photograph Copyright 1975 by The Barnes Foundation.

The seated male and female sculpture shown in FIG. 22-31 is an example of another well-known African style, that of the Dogon people of Mali. Depicting mythical ancestors of the human race, this group is a masterfully integrated composition of vertical forms enclosed by tubular shapes, with geometric incised decorations on the surfaces of both. Rejecting naturalistic rendering in this instance (though he was capable of it) the Dogon sculptor seems here to have dismantled the human body, straightening, simplifying, and distorting its parts before reassembling them. Body parts are present but often sharpened, attenuated, or reduced to suggestions. Perhaps it was this primordial couple's remoteness from life that prompted the artist to work in such a schematic style. In any case, the group remains one of the great monuments of African creative genius, a strong and complex statement about human values—indeed, about the very origins of the human race itself.

African arts also include beautifully decorated utilitarian objects such as stools, chairs, pipes, spoons; a host of sculptural as well as decorated buildings; body painting and scarification; miniature objects such as the well-known Ashanti gold weights; finely crafted textiles and leatherwork and countless forms of pottery and basketry. Subdivision of the arts into "fine," "decorative," and "crafts" is in fact a barrier to the understanding of African artistic sensibilities; for African arts often play a role in everyday affairs, as well as in the life-crisis rituals such as initiations, funerals, and the countless other events that punctuate human existence.

OCEANIA

There is little historical depth to the arts of Oceania even though archeologists, linguists, and others have gone far in sorting out migration routes, language and racial distributions, and early aspects of stone age technology and social organization. The thousands of islands that make up Oceania are conventionally divided into three culture areas—Polynesia, Melanesia, and Micronesia.

Polynesia was the last area in the world to be settled. Its inhabitants seem to have brought complex sociopolitical and religious institutions with them, and there is a general homogeneity of style (lacking in Melanesia) despite the relative isolation of various island groups during the several centuries prior to European exploration. Polynesian societies are typically aristocratic, with ritual specialists and elaborate political organizations headed by chiefs. Polynesian art forms often served as one of the means of upholding spiritual power, *mana*, which was vested in the nobility and channeled by ancestral and state cults.

Melanesia was certainly settled early, and its art forms seem to suggest varied overlays of style and symbolism brought with a series of migrations. Art styles are both numerous and extremely varied. Typical Melanesian societies are more democratic than the Polynesian and relatively unstratified. Their cults and art forms address a host of nature and legendary ancestral spirits. Masks, absent in Polynesia, are central in many Melanesian spirit cults, and elaborate festivals, in which masks and other art forms are displayed, occur with some frequency.

Micronesia, in contrast to the other two areas, is poor in visual material and will not be discussed. The rich arts of Australia, though quite distinct from those of other areas, are often included in discussions of Oceanic art and will be mentioned briefly here.

Polynesia

Polynesian artists excelled in carving figural sculptures in wood, stone, and ivory in sizes ranging from the gigantic fabled stone images of Easter Island to tiny ivory Marquesan ear plugs an inch long. These sculptures were generally full-volumed, monochromatic human figures, often dynamic in pose. Polynesians were also adept in making decorative bark cloth, called *tapa*, and the art of tattoo was highly developed.

Polynesian carving at its most dramatic is represented by the Hawaiian figure of the war god, Kukailimoku (FIG. 22-32). Huge wooden images of this deity were erected on stone temple plat-

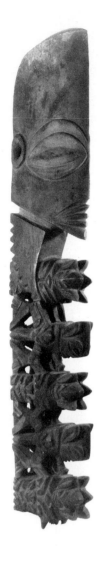

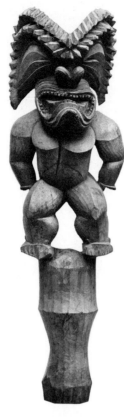

enough from one another to allow the development of distinct regional styles within a recognizable general Polynesian style. Thus, the arts of central Polynesia, represented here by the contrasting art forms of a wooden district god (FIG. 22-33) and a tattooed Marquesan warrior (FIG. 22-34), are quite different from the Hawaiian figures. The highly polished district god from Rarotonga in the Cook Islands has a blade-shaped head and schematized features. Instead of a body there appear numerous tiny abstracted figures—the god's progeny—carved in the same geometric, angular style as the head above. Such carvings probably represented clan ancestors revered for

22-32 Kukailimoku, Hawaii. Wood, 2′ 6″ high. British Museum, London.

22-33 Left: District God, Harvey Islands. Wood. Peabody Museum, Harvard University.

22-34 Tattooed Marquesan warrior. (Nineteenth-century engraving.)

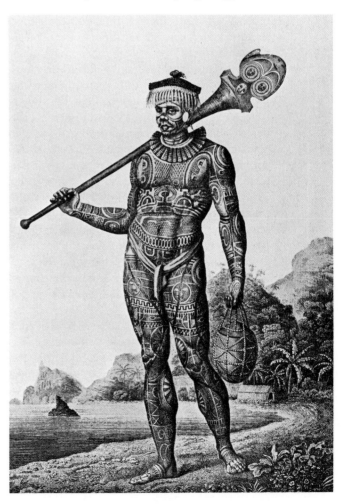

forms that, in varied forms, were part of the apparatus of all Polynesian state religions. Although relatively small, the figure illustrated here is majestic in scale and forcefully carved to convey vigorous tensions—in short, the ferocity attributed to the deity. Flexed limbs and faceted, conventionalized muscles combine with the aggressive, flaring mouth and serrated headdress to achieve a tense dynamism seldom rivaled in any art. This is the work of a master sculptor supremely confident of his materials and technique—a work that speaks forcefully across cultural barriers.

Even though Polynesians were skillful navigators, various island groups remained isolated

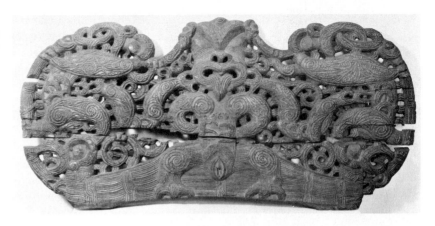

22-35 Door lintel, Maori. Wood, 3′ 9″ × 1′ 7″. Peabody Museum of Salem, Massachussetts.

their protective and procreative powers. Analogous images are known (from Mangaia in the Cook Islands and Rurutu in the Austral Islands) that also have multiple figures attached to their bodies. All such images refer ultimately to creator deities revered for their central role in human fertility.

Polynesians developed the painful but prestigious art of tattoo more fully than other Oceanic peoples. Nobles and warriors, especially, were concerned with increasing their status, mana, and personal beauty by accumulating such patterns over the years. An early nineteenth-century engraving (FIG. 22-34) shows Marquesan tattoo patterns covering most of the body with divided and subdivided geometric motifs. Such a multiplication of small, repetitive abstract forms—also seen in the "children" on the abovementioned Raratongan figure—is in fact one major tendency in much Polynesian art. The other main tendency —toward bold, full-volume, large-scale figural sculptures—is manifest in the Hawaiian war god figure (FIG. 22-32).

The highly distinctive arts of the Maori peoples of New Zealand merge these two stylistic currents in images that are at once dynamic and intricate, bold in major forms but with surfaces covered and interconnected by minute curvilinear detailing. The door lintel shown in FIG. 22-35 comes from a council house generously decorated, inside and out, with technically refined, complex imagery. The subjects are real and mythological ancestors whose advice and protection were sought for the political, war-making,

and ritual deliberations that took place in their midst. Countless prestige items and weapons of the Maori nobility displayed this unique style, as did the tattooing on their faces and bodies.

Melanesia

Despite the aggressive poses of the figural art of Hawaii and the lively surface convolutions of New Zealand, Polynesian art is generally characterized by compactness, solidity, and restraint, as exemplified in the Cook Island district god shown in FIG. 22-33. Melanesian art, on the other hand, has an insubstantial, colorful, flamboyant aspect epitomized in wood carving of New Ireland (PLATE 22-1). Called *malanggan* and used in display ceremonies of the same name, New Ireland masks and figures have a bewildering intricacy that stems from generous use of openwork and sliverlike projections and from overpainting in minute geometric patterns that further subdivide the image. The result is a "splintered" or fragmented and airy effect. This style is the more remarkable in view of the fact that most of these forms are carved from a single block of wood, a characteristic of all woodcarving considered in this chapter. In the scene shown in PLATE 22-1 several malanggan showpieces were set up in a special house dramatically opened to the public; the associated rituals served both to commemorate ancestors and initiate youths into adulthood. A variety of intricate masks was also danced during these rites.

22-36 Ceremonial Men's House, Abelam.

The Melanesian penchant for color and drama in art is reflected too in the New Guinea Abelam cult sculptures and paintings found on and inside the monumental Men's Houses (FIG. 22-36). The gable paintings on these buildings show row upon row of mythological creatures intricately painted in contrasting bright colors. This kind of repetition and almost compulsive space-filling—a *horror vacuui*—is common to many art areas considered in this chapter and can be seen in the bark-cloth banner from Lake Sentani, near the North Coast of New Guinea (FIG. 22-37). These banners, display cloths for funeral and other ritual occasions, are painted in a lively and, to us, somewhat whimsical style displaying a variety of aquatic creatures and symbols that may well refer to myths. In general, however, the making and decoration of bark cloth is less developed in Melanesia than in Polynesia.

In other Melanesian art forms, from the

22-37 Banner, Lake Sentani. Bark cloth, tapa, black and red paint, 4′ 4″ long. Collection of Paul Wingert, New York.

Papuan Gulf and Asmat areas of New Guinea's South Coast, the artists distort human forms according to local preferences, which here, as elsewhere, are not attuned to realistic proportions or modeling. The fact that remote spirits (Papuan Gulf—FIG. 22-38) and ancestors (Asmat—FIG. 22-39) are portrayed accounts partially for the lack of naturalism, as do the long traditions of repeating and renewing such spiritual images—a repetition that seems to give rise in conservative societies to highly conventionalized styles. The Papuan Gulf figure is a Melanesian version of the power image whose in-dwelling spirit is invoked to protect and otherwise benefit its owner, while the Asmat pole is erected in ceremonies that prepare the participants to avenge the death of a community member in war. Such poles represent ancestors; the openwork "flags" are called

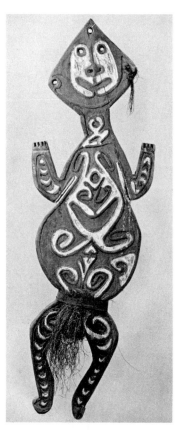

22-38 Above: Ancestral figure, Papuan Gulf. Wood, fibers, bark, red and white paint, 4′ 3″ long. Tropenmuseum, Amsterdam.

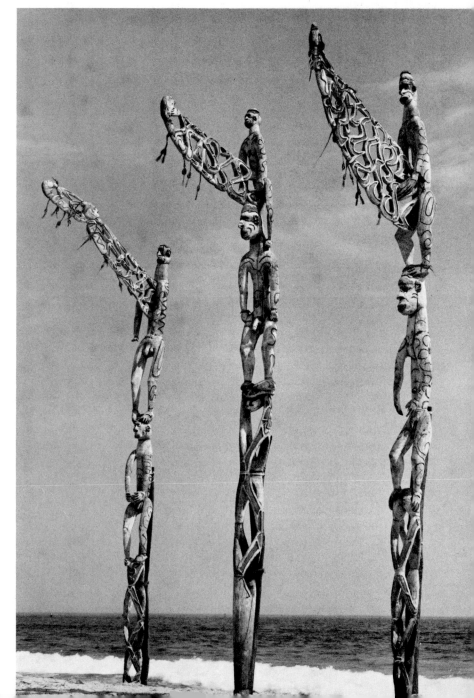

22-39 Ancestral poles, Asmat. Wood, paint, sago palm leaves, 17′ to 18′ high. Museum of Primitive Art, New York.

penises by the Asmat in a reference to aggressive male roles in sex and headhunting.

These and many other Oceanic peoples were headhunters until early in the twentieth century, and many of their art forms were created for rituals concerned with headhunting and attendant beliefs about the loss and gain of life-force. In several cultures, as among the Iatmul of the Sepik River, artists cleaned actual human skulls and reworked them into art objects (FIG. 22-40) by modeling over the skull with a claylike paste and painting the result with the kinds of flowing facial decoration worn in life, particularly on ritual occasions. These graphic images were held to contain the life-force or power men sought to increase by headhunting; they were displayed in ceremonies preparing for war or celebrating its success, and at funerals.

Face and body decoration are still important art forms in several parts of New Guinea. Although of course extremely transient, such embellishments were often highly complex, colorful, multimedia assemblages of pigments, feathers, fur, leaves, shells, and other materials, which gain both in symbolic significance and artistic impact from their combination. Both men and women decorated themselves in this fashion to display their idealized beauty and to compete with rivals similarly embellished.

Varied types and styles of masks were worn in Iatmul ceremonies as well as those of the peoples of New Ireland, Abelam, the Papuan Gulf, Asmat, and other areas. As in Africa and America, such masks were used in ceremonies to materialize spirits whom man felt the need to entertain and propitiate. Elaborate festivals sometimes included over a hundred such "spirit impersonators," who danced to entertain the human community and at the same time to remind men of their obligations to supernatural ancestors and culture-bringers. Many of the same masked spirits played an important role in initiating and educating youths to be fully socialized, productive members of the group. Especially in the design of the heads and bodies of spirits, Melanesian artists seem to have given free rein to their creativity and imagination. A bizarre, flamboyant Sulka mask (FIG. 22-41), but one example, is of a

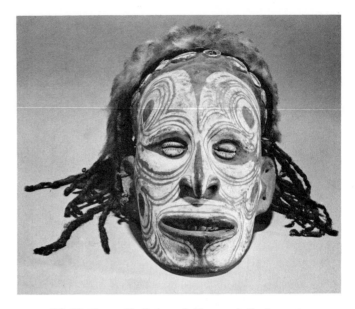

22-40 Above: Skull, Iatmul. Human skull, clay, paint, human hair, cuscus fur, 10″ high. Gift of Mr. and Mrs. John J. Klijman, Museum of Primitive Art, New York.

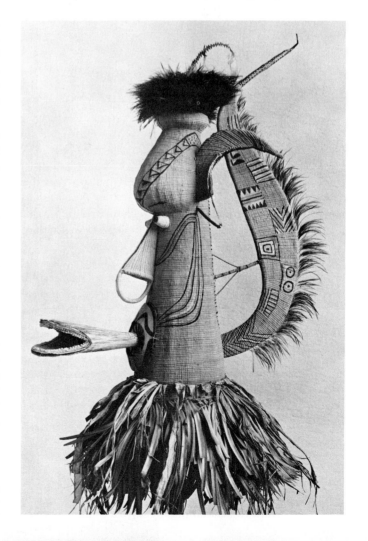

22-41 Mask, Sulka, 1900–10. Fiber structure covered with pitch, feathers, and pieces of wood, 2′ 3″ high, without leaf skirt. Übersee-Museum, Bremen.

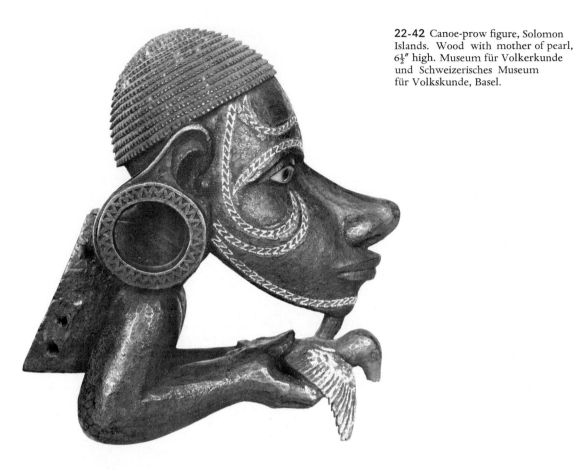

kind made by stretching and sewing vegetable fibers over a light framework. These and other Melanesian masks were thus quite perishable; indeed, in some areas the masks were ritually destroyed at the end of a ceremony, an act that banished the spirits until their next "invitation" to intervene in human affairs.

Some Melanesian styles, like that of the Solomon Islands, are more restrained than those discussed above. In the protective canoe-prow carving shown (FIG. 22-42) the emphasis is on strong modeling, the enlarging of facial features, and very precise inlay patterns of seashell fragments that contrast with the solid dark color of the head itself. In several Melanesian areas there are styles that combine high-contrast, intricate surface patterns with bold sculpture, and in some, masks are not used, which suggests that these cultures may be transitional between those in which the wilder, less restrained Melanesian style prevails and those of the Polynesian, with its more solid, full-volumed sculpture.

Australia has a number of varied styles, as well as object types, that bear little relationship to the arts of neighboring New Guinea. Most objects are ceremonial aids in projecting the people into the legendary past—called "Dream Time"—when their world, its creatures, and its institutions were created. For the native Australian, the fertility of nature and man and the continuity of life itself depended on reenactment of the primordial events of Dream Time. Cosmogonic myths were recited in concert with songs and dances, and many art forms—body painting, decorated stones, carved figures, rock and bark paintings—were essential props in these dramatic re-creations. A bark painting entitled *The Djanggawul Sisters* (FIG. 22-43) describes in schematic

form the birth of the human race along with other mythical episodes from Dream Time. Symbolic motifs include trees and pole emblems, the rising and setting sun, a Djanggawul brother, and, on the right, the artist himself. Its intricate style is representative of the main features of Australian art: rhythmic repetition, subdivision into crowded panels, fine detailing, and lack of a ground line, perspective, or modeling. Australian art is well-known, too, for its "X-ray" style, which simultaneously depicts the insides (backbone, heart, and other organs) as well as the outsides of human beings and animals.

The traditional arts of North America, Africa, and Oceania, surveyed above, are not now being practiced, for they no longer have critical roles in cultural continuity and survival. Ironically, it is only now that we are coming to acknowledge the variety and richness of earlier art traditions—at a time when most of them may no longer be accessible for study and preservation.

Although each area still produces artifacts of various sorts, some of high quality, the advent of modern mechanized life—bringing schools, missions, inexpensive clothing, plastic utensils—has changed artistic motivations and needs. Today one finds "tourist" arts, poor copies of earlier works, and some frankly modern works that draw inspiration from current European styles.

In earlier times, artistic energies were released on countless occasions and for hundreds of reasons, all bearing on the social and spiritual well-being of men and women. Some artifacts took their places in the daily rhythms of existence; others emerged only at climactic individual or community events—initiations, funerals, festivals, for example—when they often served as symbols of higher, guiding powers. In nearly all cases, the wealth and prestige of the people were involved, and art works were a focus of spiritual energy, activated in performance and display. As in all times and all places, art served to dramatize and intensify life itself, and life without art was virtually unknown.

22-43 MUNGARAWAI, *The Djanggawul Sisters*, Yirrkala. Bark and paint. Art Gallery of New South Wales, Australia.

GLOSSARY

Italicized terms are themselves defined in the glossary.

abacus (ab'a·kus) The uppermost portion of the *capital* of a *column*, usually a thin slab.

abstract In painting and sculpture, emphasizing a derived essential character having little visual reference to objects in nature.

academy A place of study, derived from the name of the grove where Plato held his philosophical seminars. Giorgio Vasari founded the first academy of fine arts, properly speaking, with his Accademia di Disegno in Florence in 1563.

Achaean (a·kee'an) Of or pertaining to *Achaia.*

Achaia (a·ka'ya) An ancient section of the northern Peloponnesos; loosely, Greece in general.

addorsed Set back-to-back, especially as in heraldic design.

adobe (a·do'bee) The clay used to make a kind of sun-dried brick of the same name, or a building made of such brick.

aerial perspective See *perspective.*

agora (ag'e·ra) An open square or space used for public meetings or business in ancient Greek cities.

alabaster A variety of gypsum or calcite of dense, fine texture, usually white, but also red, yellow, gray, and sometimes banded.

alla prima (a'la pree'ma) A painting technique in which pigments are laid on in one application, with little or no drawing or underpainting.

altarpiece A panel, painted or sculptured, above and behind an altar.

ambulatory A covered walkway, outdoors (as in a *cloister*) or indoors, especially the passageway around the *apse* and *choir* of a church.

amphora (am'fe·ra) A two-handled, egg-shaped jar used for general storage purposes.

apadana (ap·a·dan'a) The great hall in ancient Persian palaces.

apse (aps) A recess, usually singular and semicircular, in the wall at the east end of a Roman *basilica* or Christian church.

arabesque Literally, Arabian-like. A flowing, intricate pattern derived from stylized organic motifs, usually floral, often arranged in symmetrical *palmette* designs; generally an Islamic decorative motif.

arcade A series of *arches* supported by *piers* or *columns.*

arch A curved structural member that spans an opening and is generally composed of wedge-shaped blocks (*voussoirs*) that transmit the downward pressure laterally. See also *thrust.*

architectonic Having structural or architectural qualities (usually as elements of a nonarchitectural object).

architrave (ark'i·trayv) The *lintel* or lowest division of the *entablature*, sometimes called the *epistyle*.

archivolt (ark'i·volt) One of a series of concentric *moldings* on a Romanesque or Gothic arch.

armature In sculpture, a skeletonlike framework to support material being modeled.

aspara In India, a nymph of the sky or air; in Chinese Buddhism, a heavenly maiden.

atlantes (at·lan'teez) (pl. of atlas) Male figures that function as supporting columns. See *caryatid*.

atmospheric perspective See *perspective*.

atrium (ay'tree·um) The court of a Roman house, near the entrance and partly open to the sky. Also, the open colonnaded court in front of and attached to a Christian *basilica*.

Aurignacian (o'rig·nay'shun) Of or pertaining to the first epoch of Upper *Paleolithic* culture, remains of which were found at Aurignac (Haute-Garonne), France.

avant-garde (a·vahn·gard') Artists whose work is in (or work that reflects) the latest stylistic direction.

avatar (ah'vuh·tar) In Hinduism, an incarnation of a god.

axial plan See *plan*.

axis An imaginary line, or lines, about which a work, a group of works, or part of a work is visually or structurally organized, often symmetrically.

baldacchino (bal·da·kee'no) A canopy on columns, frequently built over an altar.

barrel vault See *vault*.

bas (bah) relief See *relief*.

basilica (ba·sil'i·ka) In Roman architecture, a public building for assemblies (especially tribunals), rectangular in plan and having an entrance on a long side. In Christian architecture, an early church somewhat resembling the Roman basilica, usually entered from one end and with an *apse* at the other, creating an *axial plan*.

batter To slope inward, often almost imperceptibly, or such an inward slope of a wall.

bay A subdivision of the interior space of a building. In Romanesque and Gothic churches the transverse *arches* and *piers* of the *arcade* divide the building into bays.

beehive tomb A beehive-shaped type of subterranean tomb constructed as a *corbeled vault* and found on prehistoric Greek sites.

ben-ben A pyramidal stone; a *fetish* of the Egyptian god Re.

blind arcade (wall arcade) An *arcade* having no actual openings, applied as decoration to a wall surface.

bodhisattva (bo·dee·sot'vuh) In Buddhism, a person who is a potential *buddha*.

bottega (but·tay'ga) A shop; the studio-shop of an Italian artist.

broken color A painting technique using short, thick strokes laid over a ground color to create rich textures and vibrant effects of light.

broken pediment A *pediment* in which the *cornice* is discontinuous at the apex or the base.

buddha One who is an embodiment of divine wisdom and virtue.

burin (byoor'in) A pointed steel tool for *engraving* or *incising*.

buttress An exterior masonry structure that opposes the lateral thrust of an *arch* or *vault*. A pier buttress is a solid mass of masonry; a flying buttress consists typically of an inclined member carried on an arch or series of arches and a solid buttress to which it transmits lateral *thrust*.

calligraphy Handwriting or penmanship, especially elegant or "beautiful" writing as a decorative art.

campanile (kam·pa·neel'eh) A bell tower, usually free-standing.

capital The upper member of a *column*; it serves as a transition from the *shaft* to the *lintel*.

cardo The north-south road in Etruscan and Roman towns, intersecting the *decumanus* at right angles.

cartoon In painting, a full-size drawing from which a painting is made. Cartoons were usually worked out in complete detail and the design then transferred to the working surface by coating the back with chalk and going over the lines with a stylus, or by pricking the lines and "pouncing" charcoal dust through the resulting holes.

cartouche (kar·toosh') A scroll-like design or medallion, purely decorative or containing an inscription or heraldic device; also, in ancient Egypt, an oval device containing such elements as *hieroglyphic* names of Egyptian kings.

caryatid (kar'ee·at'id) A female figure that functions as a supporting *column*. See also *atlantes*.

casting In sculpture, duplication of a clay original in plaster or metal by use of a mold.

cella (sel'a) An enclosed chamber, the essential feature of a Classical temple, in which the cult statue usually stood.

centering A wooden framework to support an *arch* or *vault* during its construction.

central plan See *plan*.

ceramics The art of making objects such as pottery of clay; also, the objects themselves.

chaitya (chight'yuh) A Buddhist assembly hall having a votive *stupa* at one end.

chalice A cup or goblet, especially that used in the sacraments of the Christian Church.

chamfer The surface formed by cutting off a corner of a board or post; a bevel.

champlevé (shahn·le·vay') A process of enameling in which a design is cut into a metal plate in such

a way as to leave thin raised lines that create compartments to hold the enamel.

chandi A Javanese temple.

chevet (sheh·vay') The eastern end of a Romanesque church, including *choir*, *ambulatory*, and radiating chapels.

chevron A zigzag or V-shaped motif of decoration.

chiaroscuro (kee·ar'eh·skoor'o) In painting or drawing, the treatment and use of light and dark, especially the gradations of light that produce the effect of modeling.

chinoiserie (shee·nwaz·eh·ree') Chinese motifs used as decorations for furniture, in wallpaper, etc., applied largely to eighteenth-century Rococo style.

chiton (kite'en) A Greek tunic, the essential (and often only) garment of both men and women, the other being the mantle (*himation*).

choir The space reserved for the clergy in the church, usually east of the *transept*, but in some instances extending into the *nave*.

ciborium (sih·bor'ee·um) A canopy, usually freestanding and supported by four columns, erected over an altar; also, a covered cup used in the sacraments of the Christian Church. See *baldacchino*.

cinquecento (cheenk·way·chain'toh) The sixteenth century in Italian art.

cire-perdue (seer-pair-dew') The "lost-wax" process. A bronze-casting method in which a figure is modeled in wax and covered with clay. When the clay dries, the wax is melted away and the resulting mold is filled with molten metal.

clerestory (kleer'sto·ry) The part of a building that rises above the roofs of the other parts and whose walls contain openings for light.

cloison (klwa·zohn') Literally, a partition. A cell made of metal wire or a narrow metal strip, usually gold, soldered end-down to a metal base to hold enamel or other decorative materials.

cloisonné (klwa·zoh·nay') A process of enameling employing *cloisons*.

cloister A court, usually with covered walks or *ambulatories* along its sides.

closed form A form, especially in painting, whose contour is not broken or blurred.

clustered pier See *compound pier*.

codex (*pl.* codices) A manuscript in the form of a volume with pages bound together between hard covers.

coffer A sunken ornamental panel in a *soffit*, *vault*, or ceiling.

coin type The pattern or design used to decorate a coin.

collage (kul·lahzh') A composition made by pasting together on a flat surface various materials such as newspaper, wallpaper, printed text and illustrations, photographs, and cloth. See *montage*.

colonnade A series or row of *columns*, usually spanned by *lintels*.

colonnette A small *column*.

color See *hue*, *saturation*, and *value*.

color solid A conceptual device in which the principal variables of *color* are visualized as having a three-dimensional relationship in the form of two cones base-to-base. The vertical *axis* is *value*, the *hues* are arranged around the axis, and *saturation* is the distance from the surface of the solid to the axis.

column A vertical, weight-carrying architectural member, circular in cross section, and consisting of a base (sometimes omitted), a *shaft*, and a *capital*.

complementary after-image The image, in a *complementary color*, that is retained briefly by the eye after the stimulus is removed.

complementary colors Those pairs of colors, such as red and green, that together embrace the entire spectrum. Thus the complement of one of the three *primary colors* is a mixture of the other two. In pigments they produce a neutral, or gray, when mixed in the right proportions.

compound or clustered pier A pier composed of a group or cluster of members, especially characteristic of Gothic architecture.

connoisseur (kon·nuh·ser') An expert on works of art and the individual styles of artists.

contour A visible border of a *mass* in space; a *line* that creates the illusion of *mass* and *volume* in space.

contrapposto (kon·tra·poh'stoh) The disposition of the human figure in which one part is turned in a direction opposite that of the other (usually hips and legs one way, shoulders and chest another)—thus, a counter-positioning of the body about its central *axis*. Sometimes called "weight-shift," since the weight of the body tends to be thrown to one foot, creating tension on one side and relaxation on the other.

cool color Blue, green, or violet. Psychologically, cool colors are calming, unemphatic, depressive; optically they generally appear to recede. See *warm color*.

corbel (kor'bel) A projecting wall member used as a support for some element in the superstructure. Also, courses of stone or brick in which each course projects beyond the one beneath it. Two such structures, meeting at the topmost course, create an archlike form.

cornice The projecting, crowning member of the *entablature*; also, any crowning projection.

cosmati (koz·ma'tee) Cut-stone *mosaic* inlay decoration in geometric patterns.

cramp A device, usually metal, to hold together blocks of stone of the same course. See *dowel*.

crenelated Notched or indented, usually with respect to tops of walls, as in battlements.

crocket A projecting foliate ornament of a *capital*, *pinnacle*, *gable*, *buttress*, or *spire*.

Cro-Magnon (kro·mag'non) Of or pertaining to the *homo sapiens* whose remains, dating from the *Aurignacian* period, were found in the Cro-Magnon cave of Dordogne, France.

cromlech (krom'lek) A circle of monoliths.

crossing The space in a cruciform church formed by the intersection of the *nave* and *transept*.

crown The topmost part of an *arch*, including the *keystone*; also, an open *finial* of a tower.

crypt A *vaulted* space under part of a building, wholly or partly underground; in Medieval churches, normally the portion under an *apse* or *chevet*.

cuneiform (kyoo·nee'ih·form) Literally, wedge-shaped; thus a system of writing used in Babylonia-Assyria, the characters of which were wedge-shaped.

cyclopean (sike·lo·pee'an) Gigantic; vast and rough; massive. Cyclopean architecture is a style of stone construction using large irregular blocks without mortar.

dado (day'doh) A horizontal band, often decorated, at the base or lower part of a wall or pedestal.

decumanus (dek·yoo·man'us) The east-west road in an Etruscan or Roman town, intersecting the *cardo* at right angles.

diptych (dip'tik) A two-paneled *altarpiece*; also, an ancient Roman and Early Christian two-hinged writing tablet, or ivory memorial panels.

dolmen (dohl'men) Several large stones capped with a covering slab, erected in prehistoric times.

dome A hemispherical *vault*; theoretically, an *arch* rotated on its vertical *axis*.

donjon (don'jun) A massive tower forming the stronghold of a Medieval castle.

dowel In ancient architecture, wooden or metal pins placed between stones of different courses to prevent shifting. See *cramp*.

dromos The passage to a *beehive tomb*.

drum The circular wall that supports a dome; also, one of the cylindrical stones of which a non-monolithic *shaft* is made.

dry point An *engraving* in a soft metal such as copper in which the burr raised by the *burin* is retained to produce a soft, richly black effect in the print. See *etching, intaglio*.

duecento (doo·ay·chain'toh) The thirteenth century in Italian art.

earth colors Pigments, such as yellow ochre and umber, that are obtained by mining; they are usually compounds of metals.

echinus (eh·kee'nus) In architecture, the convex element of a *capital* directly below the *abacus*.

eclecticism (eh·klek'ti·sism) The practice of selecting from various sources, usually in order to form a new system or style.

écorché (ay·kor·shay') A flayed figure painted or sculptured to show the muscles of the body.

elevation In drawing and architecture, a geometric projection of a building on a plane perpendicular to the horizon; a vertical projection.

embrasure A flared frame around a doorway or window.

enamel A vitreous, colored paste that solidifies when fired. See *champlevé, cloisonné*.

encaustic An ancient method of painting with colored molten wax in which the wax is fused with the surface by application of hot irons.

engaged column A columnlike, nonfunctional form projecting from a wall and articulating it visually.

engobe (en·gohb') A slip of finely sifted clay used by Greek potters; applied to a pot it would form a black *glaze* in firing.

engraving The process of *incising* a design in hard material, often a metal plate, usually copper; also, the print or impression made from such a plate. See *burin, dry point, etching, intaglio*.

entablature The part of a building, usually the *façade*, between the *capitals* of *columns* and the roof or upper story.

entasis (en·tay'sis) An almost imperceptible convex tapering (an apparent swelling) in the *shaft* of a *column*.

epistyle See *architrave*.

esthetic The distinctive vocabulary of a given style.

etching A kind of *engraving* in which the design is *incised* in a layer of wax or varnish on a copper plate. The parts of the plate left exposed are then etched, or slightly eaten away, by acid in which the plate is immersed after incising. Because wax and varnish are relatively soft materials, the etcher is freed from the restrictions imposed upon the woodcutter and engraver by their media. Etching is thus one of the most facile of the graphic arts and the one most capable of subtleties of line and tone. See *dry point, engraving,* and *intaglio*.

extrados (eks·trah'dohs) The upper or outer surface of an *arch*.

façade Usually, the front of a building; also, the other sides when they are emphasized architecturally.

faïence (feye·ahnce') Pottery (except porcelain) glazed with compounds of tin; also, any glazed earthenware.

fan vault See *vault*.

fenestration The arrangement of the windows of a building; by extension, the arrangement of all openings (windows, doors, *arcades*).

ferroconcrete See *reinforced concrete*.

fête galante (fet ga·lahnt') An elegant and graceful celebration; applied to the works of Antoine Watteau and other Rococo painters.

fetish An object believed to possess magical powers, especially one capable of bringing to fruition its owner's plans; sometimes regarded as the abode of a supernatural power or spirit.

figure-ground The visual unity, yet separability, of

a form and its background; usually with "relationship."

finial A knoblike ornament, usually with a foliate design, in which a vertical member such as a *pinnacle* terminates.

flamboyant Flamelike, flaming; applied to aspects of a late Gothic style, especially architectural tracery.

flute or **fluting** Vertical channeling, roughly semicircular in cross section and used principally on *columns* and *pilasters*.

flying buttress See *buttress*.

foreshortening Seeming visual contraction of an object viewed as extended in a plane not perpendicular to the line of sight; also, the representation of this phenomenon.

form In its widest sense, total organic structure; a synthesis of all the elements of that structure and of the manner in which they are united to create its distinctive character. The form of a work is what enables us to apprehend it. See *closed form* and *open form*.

formalism Strict adherence to, or dependence on, prescribed forms of execution and traditional rules of composition.

fresco Painting on plaster, either dry (dry fresco) or wet (wet or true fresco). In the latter method the pigments are mixed with water and become chemically bound to the plaster. Also, a painting executed in either method.

fret or **meander** An ornament, usually in bands but also covering broad surfaces, consisting of interlocking geometric motifs.

frieze (freez) The part of the *entablature* between the *architrave* and *cornice*; also, any sculptured or ornamented band in a building, on furniture, etc.

gargoyle In architecture, a waterspout, usually carved, often in the form of a *grotesque*.

genre (zhahn'reh) A style or category of art; also, a kind of painting realistically depicting scenes from everyday life.

gesso (jess'oh) Plaster mixed with a binding material and used for *reliefs* and as a *ground* for painting.

glaze A vitreous coating applied to pottery to seal the surface and as decoration; it may be colored, transparent or opaque, and glossy or *matte*. In oil painting, a thin, transparent or semitransparent layer put over a color to alter it slightly.

golden mean or **golden section** A proportional relationship obtained by dividing a line so that the shorter part is to the longer as the longer is to the whole. These proportions have an esthetic appeal that has led artists of varying periods and cultures to employ them in determining basic dimensions.

gopuram (go'pur·om) The massive, ornamented entrance structure of East Indian temples.

gouache (goo·ahsh') *Watercolor* rendered opaque by the addition of a filler such as zinc white. It has more body and dries more slowly than the transparent watercolor and lends itself to bright color effects and meticulous detail. Also, a picture painted in this medium.

granulation In jewelry, a method of ornamenting in which small grains of metal, usually gold, are soldered to a flat surface.

graphic arts Those visual arts that are linear in character (such as drawing and *engraving*); also, generally, those that involve impression (printing and printmaking).

graver A cutting tool used by engravers and sculptors.

Greek cross A cross in which all the arms are the same length.

grisaille (greez·eye') A monochrome painting done mainly in neutral grays to simulate sculpture.

groin The edge formed by the intersection of two *vaults*.

groin vault See *vault*.

grotesque In art, a kind of ornament—sometimes called (imprecisely) *arabesque*—used in antiquity and consisting of representations of medallions, sphinxes, foliage, and imaginary creatures.

ground A coating applied to a canvas or other surface to prepare that suface for painting; also, background.

guilloche (gi·lush') An ornament consisting of interlaced curving bands.

hallenkirche (holl'en·keer·kheh) A hall church. In this variety of Gothic church, especially popular in Germany, the aisles are almost as high as the *nave*.

hammer-beam ceiling An English Gothic open-timber ceiling whose support elements resemble the claws of a hammer.

hatching A technique used in drawing, engraving, etc., in which fine lines are cut or drawn close together to achieve an effect of shading.

haunch The part of an *arch* (roughly midway between the *springing* and the *crown*) where the lateral *thrust* is strongest.

herringbone perspective See *perspective*.

hieroglyphic A system of writing using symbols or pictures; also, one of the symbols.

himation (him·mat'ee·on) A Greek mantle worn by men and women over the tunic and draped in various ways.

historiated Ornamented with representations—such as plants, animals, or human figures—that have a narrative, as distinct from a purely decorative, function. Historiated initial letters were a popular form of manuscript decoration in the Middle Ages.

hue The name of a color. The *primary colors* (blue, red, and yellow) together with the *secondary colors* (green, orange, and violet) form the chief colors of the spectrum. See also *complementary colors*, *cool color*, *saturation*, *value*, *warm color*.

hydria An ancient Greek three-handled water jar.

hypostyle hall A hall whose roof is supported by columns; applied to the colonnaded hall of the Egyptian *pylon* temple.

icon (eye′con) A portrait or image, especially, in the Greek church, a panel with a painting of sacred personages that are objects of veneration. In the visual arts, a painting, a piece of sculpture, or even a building regarded as an object of veneration.

iconography (eye·con·og′ra·fee) The study dealing with the symbolic, often religious, meaning of objects, persons, or events depicted in works of art.

iconostasis (eye·con·os′ta·sis) In eastern Christian churches, a screen or partition, with doors and many tiers of *icons*, that separates the sanctuary from the main body of the church.

idealization The representation of things according to a preconception of ideal *form* or type; a kind of esthetic distortion to produce idealized forms. See *Realism*.

illumination Decoration with drawings, usually in gold, silver, and bright colors, especially the initial letters of a manuscript.

imam One who leads worshipers in prayer in Moslem services.

impasto (im·pah′stoh) A style of painting in which the pigment is applied thickly or in heavy lumps, as in many of Rembrandt's paintings.

impost block A stone with the shape of a truncated, inverted pyramid, placed between a *capital* and the *arch* that springs from it.

Impressionism A type of *Realism* whose aim is to render the immediate sense impression of the artist. It had its origins in nineteenth-century France with the work of Édouard Manet and was developed and altered by Claude Monet and others. A main concern of the Impressionists was the study and representation of light.

incising Cutting into a surface with a sharp instrument; also, a method of decoration, especially on metal and pottery.

intaglio (in·tal′yoh) A category of graphic technique in which the design is *incised*, so that the impression made is in *relief*. Used especially on gems, seals, and dies for coins, but also in the kinds of printing or printmaking in which the ink-bearing surface is depressed. Also, an object so decorated. See *dry point, engraving, etching*.

intarsia (in·tahr′sya) Inlay work, primarily in wood and sometimes in mother-of-pearl, marble, etc.

intercolumniation The space or the system of spacing between *columns* in a *colonnade*.

intrados (in·trah′dohs) The underside of an *arch* or *vault*.

isocephaly Arrangement of figures so that the heads are at the same height.

jātaka (jah′tuh·kuh) Tales of the lives of the Buddha.

jube (joo′bee) A *choir* screen treated as an architectural ornament.

ka (kah) In ancient Egypt, immortal human substance, the concept approximating the Western idea of soul.

kakemono A Japanese hanging or scroll.

karma (kar′muh) In Buddhist and Hindu belief, the ethical consequences of a person's life, determinant of his or her fate.

keystone The central, uppermost *voussoir* in an *arch*.

khutbah (koot′buh) In Moslem worship, a sermon and a declaration of allegiance to a community's leader.

kiln A large stove or oven in which pottery is fired.

krater (or crater) (kray′ter) An ancient Greek wide-mouthed bowl for mixing wine and water.

kuang A Chinese covered libation vessel.

kylix (or cylix) (kye′liks) An ancient Greek drinking cup, shallow and having two handles and a stem.

lacquer A resinous spirit varnish such as shellac, often colored.

lantern In architecture, a small, often decorative structure with openings for lighting that crowns a *dome*, turret, or roof.

lapis lazuli (la′pis la′zyoo·lye) A rich ultramarine semiprecious stone used for carving and as a source of *pigment*.

Latin cross A cross in which the vertical member is longer than the horizontal member, through whose midpoint it passes.

lierné (lyair·nay′) A short *rib* that runs from one main rib of a *vault* to another.

line The mark made by a moving point and having psychological impact according to its direction and weight. In art it defines space and may create a silhouette or define a *contour*, creating the illusion of *mass* and *volume*.

linear perspective See *perspective*.

lintel A beam of any material used to span an opening.

lithography In graphic arts, a printmaking process in which the printing surface is a polished stone (or metal plate) on which the design is drawn with a greasy material. Greasy ink, applied to the moistened stone, is repelled by all surfaces but the lines of the drawing. The process permits linear and tonal values of great range and subtlety.

local color In painting, the actual color of an object.

loggia (luh′jee·uh) A gallery that has an open *arcade* or *colonnade* on a side or sides.

lunette A semicircular opening, with the flat side down, in a wall over a door, niche, or window.

luster A thin *glaze*, usually metallic, sometimes used on pottery to produce a rich, often iridescent color. Used particularly in Persian pottery and in *majolica*.

madrasah (muh·dros'uh) A combined Moslem school and *mosque*.

Magdalenian (mag·de·lee'nee·an) Of or pertaining to the climactic cultural stage of the Upper *Paleolithic* and named after archeological findings at La Madeleine (Dordogne), France.

majolica (ma·jah'lik·uh) A kind of Italian Renaissance pottery coated with a whitish tin-compound enamel, brilliantly painted and often *lustered*.

makimono A Japanese horizontal scroll.

malanggan Intricately carved Melanesian ceremonial masks.

mandala (man'duh·luh) In Hinduism and Buddhism, a magical geometric symbol of the cosmos.

mandapa (man·dop'uh) A Hindu assembly hall, part of a temple.

mandorla An almond-shaped nimbus, or glory, surrounding the figure of Christ.

mass The effect and degree of bulk, density, and weight of matter in space. As opposed to plane and area it describes *form* in three-dimensional space. See also *volume*.

mastaba (mah'sta·buh) A bench-shaped ancient Egyptian tomb.

matte (mat) In painting, pottery, and photography, a dull finish.

mbari Ceremonial houses filled with clay sculptures, honoring community deities of the Ibo tribe in Africa.

meander See *fret*.

medium The substance or agency in which an artist works; also, in painting, the vehicle, usually liquid, that carries the pigment.

megaron (meh'ga·ron) A large rectangular living hall, fronted by an open two-columned porch, traditional in Greece since Mycenaean times.

menhir (men'heer) A prehistoric monolith, uncuts or roughly cut, standing singly or with other in rows or circles.

Mesolithic (Middle Stone Age) Of or pertaining to the period between the *Paleolithic* and *Neolithic*, characterized by food-gathering and incipient agriculture.

metope (met'a·pee) The space between *triglyphs* in a Doric *frieze*.

mihrab (mee'rob) In the wall of a *mosque*, the niche that indicates the direction of Mecca.

minbar (meen'bar) The pulpit in a *mosque*.

miniature A small picture illustrating a manuscript; also, any small portrait, often on ivory or porcelain.

modeling The shaping of three-dimensional forms in a soft material such as clay; also, the gradations of light and shade reflected from the surfaces of matter in space, or the illusion of such gradations produced by alterations of *value* in a drawing or painting.

module (mod'yool) A basic unit of which the dimensions of the major parts of a work are multiples. The principle is used in sculpture and other art forms, but it is most often employed in architecture, where the module may be the dimensions of an important part of a building, such as a column, or simply some commonly accepted unit of measurement such as the centimeter or the inch, or, as with Le Corbusier, the average dimensions of the human figure.

molding In architecture, a continuous narrow surface, either projecting or recessed, plain or ornamented, whose purpose is to break up a surface, to accent, or to decorate by means of the light and shade it produces.

monochrome A painting in one color; also, the technique of making such a painting.

montage (mohn'tahzh) A composition made by fitting together pictures or parts of pictures; also, motion-picture effects produced by superimposing images or showing them in rapid sequence. See *collage*.

monumental In art criticism, any work of art of unpretentious grandeur and simplicity, regardless of its size.

mosaic Patterns or pictures made by embedding small pieces of stone or glass (*tesserae*) in cement on surfaces such as walls and floors; also, the technique of making such works.

mosque A Moslem place of worship.

mudra (muh·drah') A stylized gesture of mystical significance, usually in representations of Hindu deities.

mullion A vertical member that divides a window or separates one window from another.

mural A painting on a wall; a *fresco* is a type of mural.

narthex A porch or vestibule of a church, generally colonnaded or arcaded and preceding the *nave*.

Naturalism The doctrine that art should adhere as closely as possible to the appearance of the natural world. Naturalism, with varying degrees of fidelity to appearance, recurs in the history of Western art.

nave The part of a church between the chief entrance and the *choir*, demarcated from aisles by *piers* or *columns*.

Neanderthal (nee·an'der·tal) A species of *Paleolithic* man.

necking A groove at the bottom of the Greek Doric capital between the *echinus* and the *flutes* that masks the junction of *capital* and *shaft*.

necropolis (neh·krop'o·liss) A large burial area; literally, a city of the dead.

Neolithic (New Stone Age) Of or pertaining to the period that saw the first elements of a farming economy and fixed settlements.

niello (nee·el'o) Inlay in a metal of an alloy of sulfur and such metals as gold or silver. Also, a work made by this process, or the alloy itself.

nirvana (neer·vah'nuh) In Buddhism and Hinduism,

a blissful state brought about by absorption of the individual soul or consciousness into the supreme spirit.

obverse On coins or medals, the side that bears the principal type or inscription. See *reverse.*

odalisque (oh'de·lisk) An Oriental slave girl or concubine, a favorite subject of artists such as Ingres and Matisse.

oenochoe (eh·nuk'oh·ee) An ancient Greek wine pitcher.

oeuvre (uh'vreh) The whole of an artist's output; literally, his "work."

ogee (oh'jee) A *molding* having in profile a double, or S-shaped, curve. Also, an *arch* of this form.

oil color *Pigment* ground with oil.

open form A *mass* penetrated or treated in such a way that space acts as its environment rather than as its limit. See *closed form.*

order In Classical architecture, a style represented by a characteristic design of the *column* and its *entablature.* See also *superimposed order.*

Paleolithic (Old Stone Age) Of or pertaining to the period preceding the *Mesolithic* and characterized by stone implements and cave painting. Lower Paleolithic man (to 32,000 B.C.) was a nomadic hunter, while Upper Paleolithic man (32,000–8000 B.C.) was a specialized hunter.

palette (pal'it) A thin board with a thumb hole at one end upon which an artist lays and mixes his colors; any surface so used. Also, the colors or kinds of colors characteristically used by an artist.

palmette A conventional decorative ornament of ancient origin composed of radiating petals springing from a calyxlike base.

Panathenaea (pan'a·then·ee'a) The most ancient and important festival of Athens, held in honor of the goddess Athena.

Pantheon All the gods of a people, or a temple dedicated to all such gods; especially, the Pantheon in Rome (though it is not certain that this was its function).

papyrus A plant native to Egypt and adjacent lands used to make a paperlike writing material; also, any writing on papyrus.

passage grave A burial chamber entered through a long tunnel-like passage.

pastel Finely ground *pigments* compressed into chalklike sticks. Also, work done in this *medium,* or its characteristic paleness.

patina (pa·teen'a) The green oxidized layer that forms on bronze and copper.

pediment In Classical architecture, the triangular space (gable) at the end of a building, formed by the ends of the sloping roof and the *cornice;* also, an ornamental feature having this shape.

pendentive (pen·den'tiv) A concave, triangular piece of masonry (a triangular section of a hemisphere), four of which support a *dome* erected over a square.

peripteral (per·ip'ter·al) A style of building in which the main structure is surrounded by a *colonnade.*

peristyle A *colonnade* surrounding a building or a court.

perspective A scheme or formula for projecting an illusion of the three-dimensional world on a two-dimensional surface. In linear perspective, the most common type, all parallel lines or lines of projection seem to converge on a single point on the horizon, known as the *vanishing point,* and associated objects are rendered smaller the further from the viewer they are intended to seem. Atmospheric or aerial perspective creates the illusion of distance by the greater diminution of color intensity, shift in color toward an almost neutral blue, and blurring of contours as the intended distance between eye and object increases. In herringbone perspective the lines of projection converge not on a vanishing point, but on a vertical *axis* at the center of the picture.

pi (pee) The Chinese symbol of heaven, a jade disk.

piano nobile (peea'no no'bee·lay) The principal story, usually the second, in Renaissance buildings.

pictograph A picture, usually stylized, that represents an idea; also, writing using such means. See *hieroglyphic.*

picture plane The surface of a picture.

pier A vertical, unattached masonry support.

Pietà (peeay·ta') A work of art depicting the Virgin mourning over the body of Christ.

pigment Finely powdered coloring matter mixed or ground with various vehicles to form paint, crayon, etc.

pilaster (pi·las'ter) A flat, rectangular, vertical member projecting from a wall of which it forms a part. It usually has a base and a *capital* and is often *fluted.*

pillar Usually a weight-carrying member such as a *pier* or a *column;* sometimes an isolated free-standing structure used for commemorative purposes.

pinnacle A tower, primarily ornamental, but functioning in Gothic architecture to give additional weight to a *buttress* or *pier.* See *finial.*

pithos (pith'oss) (*pl.* pithoi) A large clay storage vessel frequently set into the earth, and, therefore, possessing no flat base.

plan The horizontal arrangement of the parts of a building, or a drawing or diagram showing such arrangement as a horizontal *section.* An axial plan is one in which the parts of a building are organized longitudinally, or along a given *axis;* a central plan is one in which the parts radiate from a central point.

plasticity In art, the three-dimensionality of an object.

plinth The lowest member of a base; also, a block serving as a base for a statue.

polychrome Done in several colors.

polyptych (pol′ip·tik) An *altarpiece* made up of more than three sections.

porcelain Translucent, impervious, and resonant *pottery* made in a base of kaolin, a fine white clay; sometimes any pottery that is translucent, whether or not made of kaolin.

portico A porch with a roof supported by *columns* and usually having an *entablature* and a *pediment*.

pottery Objects, usually vessels, made of clay and hardened by firing.

predella The narrow ledge on which an *altarpiece* rests at the back of an altar.

primary colors The *hues* red, yellow, and blue. From these three, with the addition of white, it is theoretically possible to mix the full color spectrum. The primary colors cannot be produced by mixing others.

program The architect's formulation of a design problem with respect to considerations of site, function, materials, and aims (of the client); also, in painting and sculpture, the conceptual basis of a work.

pronaos (pro·nay′os) The enclosed space in front of the *cella* of a Greek temple.

provenance Origin, source.

psalter A book containing the Psalms of the Bible.

putto (*pl.* putti) A young child, a favorite subject in Italian painting and sculpture.

pylon (pie′lon) The *monumental* entrance of an Egyptian temple.

qibla (keeb′lah) The direction (toward Mecca) in which Moslems face in prayer. (Often *kibla*.)

quatrefoil (kat′re·foyl) An architectural ornament having four lobes or foils. See *trefoil*.

quattrocento (kwat′tro·chain′toh) The fifteenth century in Italian art.

quoin (koin) Large, sometimes *rusticated*, usually slightly projecting stone or stones that often form the corners of the exterior walls of masonry buildings.

raking cornice The *cornice* on the sloping sides of a *pediment*.

Rāmāyana A Sanskrit epic telling of Rama, an incarnation of the Hindu god Vishnu.

Realism The doctrine that art should represent nature without *idealization*.

reinforced concrete (ferroconcrete) Concrete whose tensile strength is increased by iron or steel mesh or bars embedded in it.

relief In sculpture, figures projecting from a background of which they are part. The degree of relief is designated high, low (or bas), or sunken (or hollow). In the last, the backgrounds are not cut back and the points in highest relief are level with the original surface of the material being carved. A kind of low relief that is hardly more than a scratching of the surface was originated by Donatello and is termed **stiacciata** or **sciacciata**. See *repoussé*.

reliquary A small receptacle for a sacred relic, usually of a richly decorated precious material.

repoussé (ruh·poo·say′) Formed in relief by beating a metal plate from the back, leaving the impression on the face. The metal is hammered into a hollow mold of wood or some other pliable material and finished with a *graver*. See *relief*.

respond An engaged *column*, *pilaster*, or similar structure, either projecting from a *compound pier* or other supporting device, or bonded to a wall and carrying one end of an *arch*, often at the end of an *arcade*. A nave arcade, for example, may have nine pillars and two responds.

retable (ruh·tay′bl) An architectural screen or wall above and behind an altar, usually containing painting, sculpture, carving, or other decorations.

reverse On coins or medals, the side opposite the *obverse*.

rhyton (right′on) An ancient Greek ceremonial drinking vessel whose base is usually in the form of the head of an animal, woman, or mythological creature.

rib A relatively slender molded masonry *arch* that projects from the surface. In Gothic architecture the ribs form the framework of the *vaulting*.

ribbed vault See *vault*.

rinceau (ran·so′) An ornamental design composed of undulating foliate vine motifs.

rose or **wheel window** The large circular window with *tracery* and stained glass frequently used in the *façades* of Gothic churches.

rusticate To bevel or rabbet the edges of stone blocks in order to emphasize the joints between them. The technique was popular during the Renaissance, especially for stone courses at the ground-floor level.

samsāra (som·sah′ruh) In Hindu belief, rebirth of the soul into a succession of lives.

sarcophagus A stone coffin.

saturation The purity of a *hue*; the higher the saturation, the purer the hue. *Value* and saturation are not constantly related: For example, high-saturation yellow tends to have a high value, while high-saturation violet tends to have a low value.

satyr (sat′er) In Greek mythology, a kind of demigod or deity, a follower of Dionysos, wanton and lascivious and often represented with goatlike ears and legs and a short tail.

scale The dimensions of the parts or totality of a building or object in relation to its use or function. In architectural *plans*, the relation of the actual size of a structure to the size of its representation.

sculpture in the round Free-standing figures, carved or modeled in three dimensions.

secondary colors The colors (green, orange, purple) that result from mixture of pairs of the *primary colors*.

section In architecture, a diagram or representa-

tion of a part of a structure or building along an imaginary plane passing through it vertically.

seicento (say·chain'toh) The seventeenth century in Italian art.

serdab A small concealed chamber in a pyramid for the statue of the deceased.

sfumato (sfoo·ma'toh) A smokelike haziness that subtly softens outlines in painting, particularly applied to the painting of Leonardo.

sgraffito (zgra·fee'toh) Decoration produced by scratching through a surface layer of plaster, glazing, etc., to reveal a different-colored ground; also, pottery or other ware so decorated.

shaft The part of a *column* between the *capital* and base.

shaft grave A grave in the form of a deep pit, the actual burial spot being at the base of the shaft or in a niche at the base.

sikara (shih'kuh·ruh) In Hindu temples of Vishnu, the tower above the shrine.

silver point A drawing technique involving use of a silver-tipped "pencil" on a paper with a white *matte* coating; also, the delicate drawings so made.

sinopia Reddish-brown earth color; also, the *cartoon* or underpainting for a *fresco*; often spelled sinopie.

sistrum An instrument of metal rods loosely held in a metal frame, which jingle when shaken. Peculiarly Egyptian, it was used especially in the worship of Isis and is still used in Nubia.

slip Potter's clay dispersed in a liquid and used for *casting*, decoration, and to attach parts of clay vessels such as handles.

socle (soh'kel) A molded projection at the bottom of a wall or *pier*, or beneath a pedestal or *column* base.

soffit The underside of an architectural member such as an *arch*, *lintel*, *cornice*, or stairway. See *intrados*.

Solutrean Of or pertaining to a period of the Upper *Paleolithic*. Named after the site of Solutré, France, the culture appears to have been intrusive between the *Aurignacian* and *Magdalenian*.

spandrel The roughly triangular space enclosed by the curves of adjacent arches and a horizontal member connecting their vertexes; also, the space enclosed by the curve of an arch and an enclosing right angle.

splay A large bevel or *chamfer*.

splayed opening An opening (as in a wall) that is cut away diagonally so that the outer edges are farther apart than the inner. See also *embrasure*.

springing The lowest stone of an *arch*, resting on the *impost block*.

square schematism A church plan in which the crossing square is used as the *module* for all parts of the design.

squinch An architectural device used to make a

transition from a square to a polygonal base for a *dome*. It may be composed of *lintels*, *corbels*, or *arches*.

stele (stee'lee) A carved stone slab or pillar used especially by the ancient Greeks for grave or site markers and similar purposes.

still life A painting representing inanimate objects such as flowers and household articles.

stoa In ancient Greek architecture, an open building whose roof is supported by a row of columns parallel to the back wall.

stringcourse A horizontal *molding* or band in masonry, ornamental but usually reflecting interior structure.

stucco Fine plaster or cement used as a coating for walls or for decoration.

stupa (stoo'puh) A large mound-shaped Buddhist shrine.

style A manner of treatment or execution of works of art that is characteristic of a civilization, a people, or an individual; also, a special and superior quality in a work of art.

stylobate The upper step of the base of a Greek temple, which forms a platform for the *columns*.

superimposed orders *Orders* of architecture placed one above another in an *arcaded* or *colonnaded* building, usually in the following sequence: Doric (the first story), Ionic, and Corinthian. Superimposed orders are found in Greek *stoas* and were used widely by Roman and Renaissance builders.

sūtra (soo'truh) In Buddhism, an account of a sermon by or dialogue involving the Buddha.

swag A kind of decoration for walls, furniture, etc., done in *relief* and resembling garlands and gathered drapery. It was particularly popular in the eighteenth century.

symmetry Esthetic balance, usually achieved by disposing forms about a real or imaginary *axis* so that those on one side correspond more or less with those on the other. The correspondence may be in terms of shape, color, texture, etc.

tectiforms Rooflike shapes found painted on the walls of *Paleolithic* caves.

tell In Near Eastern archeology, a hill or mound, usually ancient sites of habitation.

tempera A technique of painting using as a *medium pigment* mixed with egg yolk, glue, or casein; also, the medium itself.

Tenebrists A group of seventeenth-century European painters who used violent contrasts of light and dark.

terra-cotta Hard-baked clay used for sculpture and as a building material. It may be *glazed* or painted.

tesserae (tess'er·ee) Small pieces of glass or stone used in making *mosaics*.

tholos (thoh'los) A circular structure, generally in

Classical Greek style; also, an ancient circular tomb.

thrust The outward force exerted by an *arch* or *vault*. It must be counterbalanced by *buttresses*.

tondo A circular painting or piece of *relief* sculpture.

torana (tor'uh·nuh) Gateways in the stone fence around a *stupa*, located at the cardinal points of the compass.

torus A convex *molding* or part of a molding, usually the lowest in the base of a *column*.

totem An animal or object and its representation or image considered a symbol of a given family or clan.

trabeated Having horizontal beams or *lintels*.

tracery Branching ornamental stonework, generally in a window, where it supports the glass. It is particularly characteristic of Gothic architecture.

transept The part of a cruciform church whose *axis* crosses at right angles the axis running from the chief entrance through the *nave* to the *apse*.

trecento (tray·chain'toh) The fourteenth century in Italian art.

trefoil An architectural ornament having three lobes or foils. See *quatrefoil*.

triforium In a Gothic cathedral, the gallery between the principal *nave* arcades and the *clerestory*, and opening on the nave through an *arcade*.

triglyph A projecting grooved member of a Doric *frieze* that alternates with *metopes*.

triptych A three-paneled *altarpiece*.

trompe l'oeil (trohmp loy') A form of illusionistic painting that attempts to represent an object as though it existed in three dimensions at the surface of the painting; literally, "eye-fooling."

trumeau (troo·moh') A *pillar* in the center of a Romanesque or Gothic portal.

tympanum The space enclosed by a *lintel* and an *arch* over a doorway; also, the recessed face of a *pediment*.

ushnisha Stylized protuberance of the Buddha's forehead, emblematic of his superhuman consciousness.

value The amount of light reflected by a *hue;* the greater the amount of light, the higher the value. See also *saturation*.

vanishing point In *linear perspective*, that point on the horizon toward which parallel lines appear to converge and at which they seem to vanish.

vault A masonry roof or ceiling constructed on the *arch* principle. A **barrel vault**, semicylindrical in cross section, is in effect a deep arch or an uninter-rupted series of arches, one behind the other. A **fan vault** is a development of *lierné* vaulting characteristic of English Perpendicular Gothic, in which radiating *ribs* form a fanlike pattern. A **groin vault** is formed at the point where two barrel vaults intersect at right angles. A **ribbed vault** is one in which there is a framework of ribs or arches under the intersections of the vaulting sections.

veduta (veh·doo'ta) A painting of a view.

vignette Originally, a decorative element of vine leaves and tendrils. Hence, any rather small decorative design in a book or manuscript that has no definite boundaries or frame.

vimana (vih·mah'nuh) In Hindu and Buddhist temples, the pyramidal tower above the shrine.

volute A spiral scroll-like form characteristic of the Greek Ionic *capital*.

voussoir (voo·swahr') A wedge-shaped block used in the construction of a true *arch*. The central voussoir, which sets the arch, is the *keystone*.

wainscot A wooden facing for an interior wall, usually paneled.

wall arcade See *blind arcade*.

warm color Red, orange, or yellow. Psychologically, warm colors tend to be exciting, emphatic, and affirmative; optically they generally seem to advance or project. See *cool color*.

wash In *watercolor* painting especially, a thin, transparent film of color.

watercolor A painting technique using as a *medium*, *pigment* (usually prepared with gum) mixed with water and applied to an absorbent surface. The painting is transparent, with the white of the paper furnishing the lights. See *gouache*.

westwork A multistoried mass, including the *façade* and usually surmounted by towers, at the western end of a Medieval church.

woodcut A wood block from whose surface those parts not intended to print are cut away to a slight depth, leaving the design raised; also, the printed impression made with such a block.

yaksha (*f.* yakshi) A divinity in the Hindu and Buddhist pantheon.

yu A covered Chinese libation vessel.

ziggurat (zig'oor·at) Roughly pyramidal structures built in ancient Babylonia and Assyria and consisting of stages, each succeeding stage stepped back from the one beneath.

zoomorphism The representation of gods in the form or with the attributes of animals; the use of animal forms in art or symbolism.

BIBLIOGRAPHY

Chapter One: The Birth of Art

The standard works on prehistoric art are Paolo Graziosi, *Paleolithic Art* (1960); A. Leroi-Gourhan, *Treasures of Prehistoric Art* (1967); and Henri Breuil, *400 Centuries of Cave Art* (1952). The last-named volume contains over 500 pictures of specimens from ninety Franco-Cantabrian and two Italian sites. Less profusely illustrated, but of wider geographical range, is H. G. Bandi and Johannes Maringer, *Art of the Ice Age* (1953), which includes examples of the rock-shelter paintings of the Spanish Levant. H. G. Bandi, Henri Breuil *et al.*, *The Art of the Stone Age* (1961) contains a series of short essays by various experts on specific periods and areas, including non-European ones. A handy summary of prehistoric art down to the Roman period, including the art of the Spanish Levant and of the Megalithic culture, is Herbert Kuhn, *The Rock Pictures of Europe* (1956). Dealing only with the most famous of the French caves is Fernand Windels, *The Lascaux Cave* (1949), which, in black-and-white photographs, presents what seems to be an almost complete inventory of that cave's paintings. Somewhat less comprehensive, but visually more appealing, is Georges Bataille, *Lascaux: Prehistoric Painting* (1955), in which the author, using sixty color plates, takes the reader on a tour of the cave.

Chapter Two: The Ancient Near East

The prehistoric archeology of the Near East is lucidly interpreted by R. J. Braidwood, *The Near East and the Foundations for Civilization* (1952), and by James Mellaart, *The Earliest Civilizations of the Near East* (1966). Mellaart also gives a fascinating and readable account of the important recent Anatolian finds in *Çatal Hüyük, a Neolithic Town in Anatolia* (1967), while Kathleen Kenyon breezily reports on the Jericho excavations in *Digging up Jericho* (1957).

For the art of the historical period, the standard work is still Henri Frankfort, *Art and Architecture of the Ancient Orient* (1959). A more recent, unillustrated general introduction to the region's complex history is given by A. L. Oppenheim, *Ancient Mesopotamia* (1964). Sir Charles L. Woolley, an archeologist and one of the outstanding specialists on the region, has written popular introductions to ancient Mesopotamian art and life in *Ur of the Chaldees* (1954) and *The Middle East* (1961). Well-illustrated surveys are

Seton Lloyd, *The Art of the Ancient Near East* (1961); Giovanni Garbini, *The Ancient World* (1966); and Eva Strommenger, *Five Thousand Years of the Art of Mesopotamia* (1964); the last-named work is illustrated by Max Hirmer, probably the best of art-historical photographers. Siegfried Giedion, *The Eternal Present: The Beginnings of Architecture* (1963) deals handily with the subject.

Beautifully illustrated also are two works by André Parrot: *Sumer* (1961) and *The Arts of Assyria* (1962). In the same series as Parrot's books is Roman Ghirshman, *Persia from the Origins to Alexander the Great* (1964), which offers abundant pictures, maps, and chronologies. Also recommended are S. N. Kramer, *History Begins at Sumer* (1959) and *The Sumerians* (1963). Finally, the sources and ramifications of Persian art have been the subject of two recent studies: William Culican's *The Medes and the Persians* (1965), and Edith Porada and R. H. Dyson's *The Art of Ancient Iran* (1965).

Chapter Three: The Art of Egypt

The best general works on the civilization of ancient Egypt are J. A. Wilson, *The Burden of Egypt* (1951), and J. H. Breasted's classic *History of Egypt* (1909). Well-rounded surveys of Egyptian art are presented by two eminent Egyptologists: W. Stevenson Smith, *The Art and Architecture of Ancient Egypt* (1958), and Cyril Aldred, *The Development of Ancient Egyptian Art*, 3 vols. (1949–62). Some of the most impressive photographic coverage of Egyptian art is offered in three fairly recent publications: Kurt Lange (with Max Hirmer), *Egypt: Architecture, Sculpture and Painting in 3000 Years* (1961, 1968), and Irmgard Woldering, *The Art of Egypt* (1962) and *Gods, Men and Pharaohs* (1967).

Dealing with more specific aspects of Egyptian art, either by period or medium, are W. B. Emery, *Archaic Egypt* (1961), and E. Baldwin Smith, *Egyptian Architecture as Cultural Expression* (1938) and *Egyptian Sculpture and Painting in the Old Kingdom* (1946). Alexander Badawy, *A History of Egyptian Architecture*, 3 vols. (I, 1954; II, 1966; III, 1968) is the most comprehensive publication on the subject; the numerous plans, elevations, sections, and reconstructions with which the three volumes are illustrated will appeal particularly to the architectural student. Finally, Arpag Mekhitarian, *Egyptian Painting* (1954) is still popular for its fine color plates.

Chapter Four: The Art of the Aegean

The literature of Aegean archeology begins with the three volumes in which Heinrich Schliemann reported his findings: *Ilios* (1880), *Mycenae* (1880), and *Tiryns* (1885). After a hiatus of several decades, Sir Arthur Evans revived interest with the detailed account of his Cretan excavations, *The Palace of Minos*, 4 vols. (1921–35). The polarization of scholarly opinion into "islander" and "mainlander" theories is expressed in two works now considered classics in the field of Aegean archeology: J. D. S. Pendlebury, *Archeology of Crete* (1939, 1963), and A. J. B. Wace, *Mycenae, an Archeological History and Guide* (1949). The problems involved in the interrelationship of the two cultures are discussed (among other things) in J. W. Graham, *The Palaces of Crete* (1962), and E. T. Vermeule, *Greece in the Bronze Age* (1964). A. W. Persson examines the enigmatic subject of the *Religion of Greece in Prehistoric Times* (1942). More recent works, which stress pictorial coverage, are Pierre Demargne, *Aegean Art* (1964), and Spyridon Marinatos (with Max Hirmer), *Crete and Mycenae* (1960). Informative and nicely illustrated is Friedrich Matz, *The Art of Crete and Early Greece* (1962). Some very important recent excavations have been reported in Blegen and Marion Rawson, *The Palace of Nestor at Pylos in Western Messenia*, 2 vols. (1966).

Chapter Five: The Art of Greece

Beyond the exemplary survey by J. D. Beazley and Bernard Ashmole, *Greek Sculpture and Painting to the End of the Hellenistic Period* (1932, 1966), selections from the voluminous literature on Greek art are perhaps best grouped according to art forms. The standard works on architecture are A. W. Lawrence, *Greek Architecture* (1957); W. B. Dinsmoor, *The Architecture of Ancient Greece* (1950); and D. S. Robertson, *A Handbook of Greek and Roman Architecture* (1954). More recent publications are Robert Scranton, *Greek Architecture* (1962), and V. J. Scully's evocative and controversial *Earth, the Temple, and the Gods* (1962). An excellent pictorial survey is Helmut Berve and Gottfried Gruben (with Max Hirmer), *Greek Temples, Theatres, and Shrines* (1963).

The literature on Greek sculpture is largely dominated by Gisela Richter, whose *Sculpture and Sculptors of the Greeks* has been an invaluable aid to students since its first publication in 1929. Also recommended are her *Kouroi* (1960), *Three Critical Periods in Greek Sculpture* (1951), and the informative *Handbook of Greek Art*, 4th ed. (1965). Primarily concerned with techniques is Charles Blümel, *Greek Sculptors at Work* (1955), while Rhys Carpenter, *Greek Sculpture* (1960), studies techniques in their relationship to style. The best illustrations of Greek sculpture are provided by Max Hirmer in Reinhard Lulliès, *Greek Sculpture* (1957).

General works on Greek painting are Mary Hamilton Swindler, *Ancient Painting* (1929); Ernst Buschor, trans. by G. C. Richards, *Greek Vase Painting* (1922); and J. D. Beazley's translation of Ernst Pfuhl, *Masterpieces of Greek Drawing and Painting* (1955). Archaic vase painting receives careful

attention in two works by J. D. Beazley: *The Development of Attic Black-Figure* (1951) and *Attic Black-Figure Vase Painting* (1956). Gisela Richter deals as efficiently with vase painting as she does with sculpture in *Attic Red-Figure Vases: A Survey* (1946). Good pictorial surveys of the field are Martin Robertson, *Greek Painting* (1959), and the Hirmer-illustrated volume by Paolo Arias, *A History of 1000 Years of Greek Vase Painting* (1963). Techniques are investigated by J. D. Beazley, *Potter and Painter in Ancient Athens* (1946), and more recently by J. V. Noble, who reports the fascinating results of his years-long efforts to reproduce the forgotten methods of Greek painters in *The Technique of Painted Attic Pottery* (1965).

Chapter Six: Etruscan and Roman Art

The literature on Roman art begins with Franz Wickhoff, *Roman Art* (1900), which challenged art history's long-standing bias in favor of Greek art. Wickhoff's translator, Eugenie Strong, published her own two-volume work, *Art in Ancient Rome*, in 1928. Since then research in the field of Roman art has accelerated greatly, to produce such richly illustrated works as G. A. Mansuelli, *The Art of Etruria and Early Rome* (1965), and its thematic sequel, Heinz Kahler, *The Art of Rome and Her Empire* (1963), both liberally supplemented with maps, plans, chronological charts, and other study aids. Handsomely illustrated also is George Hanfmann, *Roman Art* (1964), a book whose rather unorthodox organization may shock, but which is filled with valuable information.

Works on Roman architecture include G. T. Rivoira, *Roman Architecture* (1925); D. S. Robertson, *A Handbook of Greek and Roman Architecture* (1954); and F. E. Brown's brief survey, *Roman Architecture* (1961). The most recent and perhaps most interesting study in the field is W. L. MacDonald, *The Architecture of the Roman Empire* (1965). Amedeo Maiuri, *Pompeii* (1957) takes the reader on a tour through that excavated site; the same author deals with a rather neglected subject in *Roman Painting* (1953), a book that is valuable primarily for its plates. Roman portrait sculpture has been the subject of several studies, among which Ludwig Goldscheider, *Roman Portraits* (1940) remains the most profusely illustrated.

Chapter Seven: Early Christian, Byzantine, and Islamic Art

Earlier general works that have been brought more or less up to date are O. M. Dalton, *Byzantine Art and Archaeology* (1961), and G. K. Hamilton, *Byzantine Architecture and Decoration* (1956). C. R. Morey's *Early Christian Art*, 2nd ed. (1953) is a very good survey, as is Ernst Kitzinger, *Early Medieval Art* (1955), which continues the account of Christian art to the twelfth century. A comprehensive anthology of articles on Byzantine history, culture, and art, written by a number of authorities and edited by N. H. Baynes and H. St. L. B. Moss, is *Byzantium* (1948). Recent general works of fundamental value are W. F. Volbach and Max Hirmer, *Early Christian Art* (1962), important for its fine plates and concise text and notes; André Grabar, *The Beginnings of Christian Art 200–395* (1967) and *The Golden Age of Justinian: From the Death of Theodosius to the Rise of Islam* (1967), large, beautifully illustrated picture books with rather brief text; and Richard Krautheimer's *Early Christian and Byzantine Architecture* (1965), a distinguished representative of the scholarly Pelican History of Art series. William MacDonald's *Early Christian and Byzantine Architecture* (1962) is a briefer yet quite dependable survey. A handsomely illustrated book is David Talbot Rice, *The Art of Byzantium* (1959), and a work of broad scope, profusely illustrated, is René Huyghe, ed., *Larousse Encyclopedia of Byzantine and Medieval Art* (1963). In the Skira series of art books, which specializes in color illustrations, the relevant work for this period is André Grabar, *Byzantine Painting* (1953).

The characteristic Early Christian and Byzantine medium, mosaic, is studied in some well-illustrated books: E. W. Anthony, *A History of Mosaics* (1935); Otto Demus, *Byzantine Mosaic Decoration* (1948); W. F. Volbach, *Early Christian Mosaics* (1948); Peter Meyer, *Byzantine Mosaics* (1952); and André Grabar and Manolis Chatzidakis, *Greece: Byzantine Mosaics* (1948). Early manuscript illumination is dealt with by Kurt Weitzmann in *Illustrations in Roll and Codex* (1947) and in *Ancient Book Illumination* (1959). Small sculpture is studied in the above-mentioned works of Morey and of Kitzinger, and in Joseph Natanson, *Early Christian Ivories* (1935).

Emerson Swift, *Hagia Sophia* (1940) is a thoroughgoing study of this most important of Byzantine buildings. E. Baldwin Smith's *The Dome* (1950) and his *Architectural Symbolism of Imperial Rome and the Middle Ages* (1956) are important and suggestive contributions to what might be called the iconography of architecture. For the iconography of Early Christian art W. S. Lowrie, *Art in the Early Church* (1947) is valuable, and Henry Bettenson, *Documents of the Christian Church* (1943) supplies in its early chapters something of the doctrinal background of Christian art. Otto von Simson's *Sacred Fortress* (1948) is an interesting investigation of Ravenna in the sixth century in terms of the iconography of its art and architecture within the context of the city's history under Theodoric and Justinian. John Beckwith makes a detailed study of *The Art of Constantinople* (1968) in the context of the history and culture of the capital of the Byzantine empire.

Many of the key works on Islamic art are written in either French or German and have not yet been translated. Still, a fair number of introductory books on Islamic art, some well illustrated, are available to the English-speaking reader. Among the more recent ones are: Ralph P. Wilson, *Islamic Art* (1957); Ernst Kuehnel, *Islamic Art and Architecture* (1966); and Katerina Otto-Dorn, *Islamische Kunst* (1964), an English edition of which was published in 1971. Oleg Grabar, *The Formation of Islamic Art* (1973) deals authoritatively with the early phases of Moslem art and the art-historical problems raised by its formation. The notion of a "classical" moment in Islamic culture is presented by Gustav von Grunebaum, *Classical Islam* (1970).

More specific aspects of Islamic art are treated by T. W. Arnold, *Painting in Islam* (1928), which contains a convenient general statement on the Islamic attitude toward the arts. More recent is Richard Ettinghausen, *Arab Painting* (1962), which probably is the best introduction to that subject. K. Archibald, C. Creswell, and Marguerite van Berchem, *Early Muslim Architecture* (1969) presents most of the significant early architectural monuments and contains an extensive bibliography. Studies on Islamic urbanism tend to stress its social and institutional aspects; an exception is Jacob Lassner, *The Topography of Baghdad in the Early Middle Ages* (1970). The fundamental introductory work on ceramics is Arthur Lane, *Early Islamic Pottery* (1947). Information on textiles may be found in Walter A. Hawley, *Oriental Rugs, Antique and Modern* (1937). Finally, among various works that deal with the art of specific regions of the Islamic world, the most ambitious and comprehensive is Arthur U. Pope and Phyllis Ackerman, *A Survey of Persian Art from Prehistoric Times to the Present*, 7 vols. (1939).

Chapter Eight: Early Medieval Art

The historical background of the period is presented, with good illustrations and maps, in Gerald Simons, *Barbarian Europe* (1968). A good general survey is John Beckwith, *Early Medieval Art* (1964), though it begins with Carolingian art, omitting the art of the Migrations and Hiberno-Saxon art. The latter area is described in Françoise Henry, *Irish Art in the Early Christian Period* (1940, 1965) and *Irish Art During the Viking Invasions* (1967). Also noteworthy are A. Kingsley Porter's seminal, stimulating study, *The Crosses and Culture of Ireland* (1931); E. T. Leeds, *Early Anglo-Saxon Art and Archaeology* (1936); and the early chapters of Bruce Arnold, *A Concise History of Irish Art* (1968). The art of the Migrations is taken up in David M. Wilson and Ole Klindt-Jensen, *Viking Art* (1966). The architecture of the period is described and interpreted in K. J. Conant,

Carolingian and Romanesque Architecture 800–1200 (1959), and a very comprehensive study of a particular architectural region is H. M. and Joan Taylor, *Anglo-Saxon Architecture*, 2 vols. (1965). For manuscript illumination a fundamental work, in two volumes of concise text and fine illustrations, is Adolf Goldschmidt, *German Illumination* (1928). Roger Hink's *Carolingian Art* (1962), a reissue, is an interpretive survey of the manuscript illumination and small sculpture of the period, and André Grabar and Carl Nordenfalk, *Early Medieval Painting* (1957) is a thorough survey illustrated in color.

Chapter Nine: Romanesque Art

General studies of the Romanesque can be found in C. R. Morey, *Medieval Art* (1942); in Joan Evans, *Art in Medieval France 987–1498* (1948); and especially in the first volume of Henri Focillon, *The Art of the West in the Middle Ages* (1962), where the renowned scholar applies his theory of the evolution of art forms to the monuments of the period. For the most part, however, the Romanesque bibliography is specialized in media and regions: Hans Decker, *Romanesque Art in Italy* (1959), and Joseph Gantner, Marcel Pobé, and Jean Roubier, *Romanesque Art in France* (1959) are handsomely illustrated examples of the almost necessarily regional approach to the study of the Romanesque. General accounts of the media have been given, however, like the monumental work of A. Kingsley Porter, *Medieval Architecture*, 2 vols. (1912), available in reprint since 1966. A much less ambitious but still useful study for the general reader is A. W. Clapham, *Romanesque Architecture in Western Europe* (1936), which has been succeeded by the already mentioned K. J. Conant, *Carolingian and Romanesque Architecture*. A more recent and briefer survey is Howard Saalman, *Medieval Architecture: European Architecture 600–1200* (1962). The regional study of Romanesque architecture first concentrated in the area of Lombardy, long thought to be the source of rib-vault construction. A. Kingsley Porter's *Lombard Architecture* (1915–17) competes in interpretation and emphasis with G. T. Rivoira, *Lombardic Architecture*, rev. ed. (1933). Other regional histories of Romanesque architecture are Bernard Bevan, *History of Spanish Architecture* (1939); A. W. Clapham, *English Romanesque Architecture after the Conquest* (1934); Corrado Ricci, *Romanesque Architecture in Italy* (1925); Geoffrey Webb, *Architecture in Britain: The Middle Ages* (1956); and Julius Baum, *Romanesque Architecture in France* (1928). A recent comprehensive treatment of Medieval art and architecture in France is Whitney Stoddard, *Monastery and Cathedral in France* (1966). A general survey of sculpture, especially bronzes, is Hanns Swarzenski, *Monuments of Romanesque Art* (1954). Sculpture is studied regionally also in Paul Deschamps, *French*

Sculpture of the Romanesque Period—Eleventh and Twelfth Century (1930); A. Kingsley Porter's monumental study of southern French sculpture, Romanesque Sculpture of the Pilgrimage Roads (1923), available in reprint since 1966; G. M. Crichton, Romanesque Sculpture in Italy (1954); and Lawrence Stone, Sculpture in Britain in the Middle Ages (1955). The bronze church portals of this period are splendidly illustrated in Hermann Leisinger, Romanesque Bronzes (1957). Carl Nordenfalk, Romanesque Painting (1958) covers the material with emphasis on manuscript illumination, and wall painting is the focus in P. H. Michel, Romanesque Wall Paintings in France (1949). Edgar Anthony gives a general treatment of the mural medium in Romanesque Frescoes (1951).

Chapter Ten: Gothic Art

The best introduction to the period is the second volume of the classic work by Henri Focillon, The Art of the West in the Middle Ages (1963). Joan Evans, Art in Medieval France (1948) is supplemented by The Flowering of the Middle Ages (1966) by the same author. Good general picture surveys appear in Marcel Aubert, The Art of the High Gothic Era (1964), and André Martindale, Gothic Art (1967). John Harvey, The Gothic World (1950) is a study primarily of the English scene. Paul Frankl, The Gothic Literary Sources and Interpretations (1960) thoroughly documents the style and its history and is especially valuable for its exposition of Medieval spiritualism, the force behind Gothic creativity. By the same author, Gothic Architecture (1962) describes Gothic analytically, and carefully follows the steps of its development. Robert Branner, Gothic Architecture (1961) covers concisely the whole European development of Gothic and provides a short general bibliography that is most valuable. George Duby, The Europe of the Cathedrals (1966) is beautifully illustrated in color. In a fascinating analogical comparison of scholastic thinking in architecture and philosophy, Erwin Panofsky, in Gothic Architecture and Scholasticism (1958), demonstrates the underlying intellectual unity of the Gothic world. Otto von Simson, The Gothic Cathedral (1956) describes the history, iconography, and philosophy of Gothic architecture. Marcel Aubert, Gothic Cathedrals of France and Their Treasures (1959), though its picture captions are in French, is a useful collection of fine plates. Whitney Stoddard, Monastery and Cathedral in France (1966) is an excellent narrative that embraces developments in France from Romanesque through late Gothic, taking in architecture, sculpture, stained glass, manuscript illumination, and the art of the church treasuries. An early but still quite adequate account of Gothic architectural structure is Clarence Ward, Medieval Church Vaulting (1915); a later study is John Fitchen, The Con-

struction of Gothic Cathedrals (1961). Chartres, perhaps the most appreciated of Medieval cathedrals, has been widely studied. Henry Adams, in Mont Saint Michel and Chartres (1904), identified it—at least to his English-speaking audience—with the Gothic spirit itself. Most recently Robert Branner, ed., Chartres Cathedral (1969) gives a brief history of the building, with documentation from Medieval texts and a selection of essays on Chartres by critics and scholars through the centuries. Chartres is included among the three great "classical" buildings of the Gothic era in Hans Jantzen, The High Gothic: The Classic Cathedrals of Chartres, Reims, and Amiens (1962). The arts that adorn the cathedral are described in Adolf Katzenellenbogen, The Sculptural Programs of Chartres Cathedral (1959), a thorough stylistic and iconographical study, and in Peter Kidson and Ursula Pariser, Sculpture at Chartres (1959); the cathedral's well-preserved stained glass is reproduced and described in J. R. Johnson, The Radiance of Chartres (1965). There are many elaborate picture books and guidebooks, of which Louis Grodecki, Chartres (1963) is a fine example. The figurative art of Chartres provides many of the illustrations in Emile Mâle's definitive study of Medieval iconography in The Gothic Image: Religious Art in France of the Thirteenth Century (1958).

Erwin Panofsky, in Abbot Suger on the Abbey Church of St. Denis and its Art Treasures (1951), has translated the document perhaps most important to the development of Gothic architecture. A description of that characteristic Gothic art, stained glass, is given in Hugh Arnold, Stained Glass of the Middle Ages in England and France (1940), and Gothic painting is discussed in Daniel Thompson, The Materials and Techniques of Medieval Painting (1956), and, with color illustrations, in Jacques Dupont and Cesare Gnudi, Gothic Painting (1954).

Chapter Eleven: The "Proto-Renaissance" in Italy

A good, complete survey of the period is John White, Art and Architecture in Italy 1250–1400 (1966), and, for sculpture alone, the same function is performed by John Pope-Hennessy, Introduction to Italian Sculpture (1955–62). The first eight chapters of E. T. De Wald, Italian Painting: 1200–1600 (1961) are a detailed survey of the painting of the Proto-Renaissance; less complete, but with fine color plates, are the first five chapters of Lionello Venturi and Rosabianca Skira-Venturi, Italian Painting: The Creators of the Renaissance, 3 vols. (1950–52). A comprehensive study of the period is found in Millard Meiss, Painting in Florence and Siena after the Black Death (1951). An encyclopedic description of Italian painting is Raimond van Marle, The Development of the Italian Schools of Painting, 19 vols. (1923–38). An

interesting recent specialized study is James Stubblebine, ed., *Giotto: The Arena Chapel Frescoes* (1969), in which a number of leading scholars examine the masterwork of the leading master of the Proto-Renaissance. A documentary supplement of backgrounds and sources is supplied. The social-economic background of the period is given in Frederick Antal, *Florentine Painting and Its Social Background* (1948). A most important document surviving from the period is Cennino Cennini's handbook for the craftsman-artist, translated by Daniel Thompson, *Cennino Cennini, Il libro, dell' arte* (1933).

Chapter Twelve: Fifteenth-Century Italian Art

Though necessarily requiring revision and updating, there are two nineteenth-century classics that still serve as effective introductions to the Renaissance: the broad study by Jacob Burckhardt, *The Civilization of the Renaissance in Italy* (1860 and numerous later editions), and the much more detailed John Addington Symonds, *The Renaissance in Italy* (1875–86 and later editions). More recently there have been collections of essays on the Renaissance that are valuable for obtaining a good general view of it: Wallace Ferguson *et al.*, *The Renaissance* (1962); Wallace Ferguson *et al.*, *Facets of the Renaissance* (1963); and Tinsley Helton, ed., *The Renaissance: A Reconsideration of the Theories and Interpretations of the Age* (1964). The last contains an especially important essay by Earl Rosenthal, "Changing Interpretations of the Renaissance in the History of Art." All three books are in essence revisions of earlier views of the period. Ferdinand Schevill, *The Medici* (1960), is a good concise study of the family that endowed the Renaissance. There have been a number of general treatments of the art of the period; especially useful is René Huyghe, ed., *The Larousse Encyclopedia of Renaissance and Baroque Art* (1960). Heinrich Wölfflin, whose stylistic polarity of Renaissance-Baroque was enormously influential, gives an introductory survey in *Classic Art* (1953). The concept of the phenomenon "renaissance" is analyzed historically in Erwin Panofsky, *Renaissance and Renascences in Western Art* (1960). André Chastel, *The Age of Humanism* (1963) considers Humanism as a Europe-wide phenomenon. Peter and Linda Murray, *The Art of the Renaissance* (1963) is a concise survey and, considering its ambitious scope, so is Heinrich Decker, *The Renaissance in Italy: Architecture, Sculpture, Frescoes* (1969). Bates Lowry, *Renaissance Architecture* (1965) is a sound survey, as is Peter Murray, *Architecture of the Italian Renaissance* (1963). Rudolf Wittkower, *Architectural Principles in the Age of Humanism* (1952) is a learned and fascinating explication of Renaissance theories of architectural proportion and their relation to

harmonic ratios in music. An invaluable document of the time, Alberti's *De re aedificatoria* is edited by Joseph Rykwert as *Ten Books on Architecture* (1955).

For sculpture there is John Pope-Hennessy's survey cited in the chapter above, and the comprehensive study by Charles Seymour, *Sculpture in Italy, 1400–1500* (1966); and for painting, De Wald and Van Marle, also mentioned in the previous chapter. Bernard Berenson, *Italian Pictures of the Renaissance* (1957) and *The Drawings of the Florentine Painters* (1938) are surveys by the renowned connoisseur. Eve Borsook, *The Mural Painters of Tuscany* (1960) presents the foremost masters of the leading schools of paintings in the fifteenth century; and F. M. Godfrey, *Early Italian Painting: 1250–1500* is another broad survey of Proto-Renaissance and Early Renaissance painting. A fundamental document of the Renaissance, still a valuable reference, is Giorgio Vasari, *The Lives of the Most Eminent Painters, Sculptors and Architects* (1550, 1568 ... 1959). There is much valuable documentary material from the fifteenth century in E. G. Holt, ed., *A Documentary History of Art*, Vol. I (1957).

Chapter Thirteen: Sixteenth-Century Italian Art

Since there is overlapping of the periods of the Renaissance and their divisions are somewhat arbitrarily defined, titles listed for Chapters Eleven and Twelve will in many cases have application to this one. The early years of the sixteenth century are surveyed in Linda Murray, *The High Renaissance* (1967), in John Pope-Hennessy, *Italian High Renaissance and Baroque Sculpture* (1963), and in Sydney J. Freedberg, *Painting of the High Renaissance in Rome and Florence* (1961). Lionello Venturi, *The Sixteenth Century: From Leonardo da Vinci to El Greco* (1956) is the second volume of a work cited earlier. James S. Ackerman, *The Architecture of Michelangelo* (1961) and *Palladio: The Architect and Society* (1967) taken together give a kind of overview of the main trends in the middle and late years of the century. An invaluable guide to artistic theory in Italy from Alberti to the Mannerists is Sir Anthony Blunt, *Artistic Theory in Italy 1450–1600* (1956). Linda Murray, *The Late Renaissance and Mannerism* (1967) is a recent example of the growing bibliography on Mannerism represented also by John Shearman, *Mannerism* (1967), a particularly fine, scholarly yet concise work; Giuliano Briganti, *Italian Mannerism* (1962); Franzsepp Würtenberger, *Mannerism* (1963), an elaborately illustrated work that considers the European phenomenon; and *Renaissance and Mannerism, Studies in Western Art*, the published Acts of the Twentieth International Congress of the History of Art, Vol. II (1963), a collection of scholarly essays in pursuit of agreement on the meaning of

"Mannerism." A seminal work, written years ago but now in a fairly recent edition, is Walter Friedlaender, *Mannerism and Anti-Mannerism in Italian Painting* (1957). There are many documents surviving from the age itself, principally Benvenuto Cellini's autobiography, the letters and poems of Michelangelo, and *The Courtier* of Baldassare Castiglione, all of which are available in popular editions. E. G. Holt, *A Documentary History of Art*, Vol. II (1957) has much appropriate material, as does the recent Robert Klein and Henry Zerner, *Sources and Documents in Italian Art: 1500–1600* (1964).

Chapter Fourteen: The Renaissance in Northern Europe

The classic work that gives the mood of the fifteenth century in the North is still Johan Huizinga, *The Waning of the Middle Ages* (1956). The first twelve chapters of F. J. Mather, *Western European Painting of the Renaissance* (1939), reissued in 1967, are still a readable and entertaining introduction to the period. Otto Benesch, *Art of the Renaissance in Northern Europe* (1945, 1967) is an excellent survey and at the same time a study of the intellectual-historical background of Northern art. Most recently there has been the comprehensive and lavishly illustrated survey by C. P. Cuttler, *Northern Painting from Pucelle to Brueghel* (1968). Of the regions of Northern Europe, Flanders has been favored in English publications. Surveys of Flemish art include W. M. Conway, *The Van Eycks and Their Followers* (1921); M. J. Friedlaender, *From Van Eyck to Bruegel* (1956) and *Early Netherlandish Painting* (1966); Leo van Puyvelde, *The Flemish Primitives* (1958); Erwin Panofsky, *Early Netherlandish Painting* (1953); and Jacques Lassaigne and Robert Delevoy, *Flemish Painting* (1956). R. H. Wilenski, *Flemish Painters* (1960) in one part places the artists within their historical setting and in a second makes a dictionary of them. For French art there is the comprehensive survey by Sir Anthony Blunt, *Art and Architecture in France 1500–1700* (1953). Earlier French art is studied by Louis Réau, *French Painting in the XIV, XV, and XVI Centuries* (1939), and Millard Meiss, *French Painting in the Time of the Duc de Berry* (1967) and *The Boucicaut Master* (1968). German art is considered in Wilhelm Waetzold, *Dürer and His Time* (1950); Erwin Panofsky, *The Life and Art of Albrecht Dürer* (1955); Otto Benesch, *German Painting, Dürer to Holbein* (1967); Francis Russell, *The World of Dürer 1471–1528* (1967); and T. Mueller, *Sculpture in the Netherlands, Germany, France and Spain* (1966). The history of the graphic arts, the popular Northern medium, is given in two works by A. M. Hind, *A History of Engraving and Etching* (1923, 1963) and *An Introduction to a History of Woodcut* (1963). Wolfgang Stechow, ed., *Northern Renaissance Art 1400–1600* (1966)

is a very valuable collection of sources and documents for the period.

Chapter Fifteen: Baroque Art

The picturesque and colorful Baroque style lends itself to elaborate illustration, and there have been a number of general books on it that make full use of the advances in reproduction techniques of the last decade: Germain Bazin, *Baroque and Rococo Art* (1964); Michael Kitson, *The Age of Baroque* (1966); James Lees-Milne, *Baroque Europe* (1962); Victor L. Tapié, *The Age of Grandeur: Baroque Art and Architecture* (1966); Harold Busch, *Baroque Europe* (1962); and Nicolas Powell, *From Baroque to Rococo* (1959). Though prior to what might be called the classical age of the colored print, Fiske Kimball, *The Creation of the Rococo* (1943), revised in paperback in 1964, is still a fine fundamental study of French design in the early eighteenth century. Henry A. Millon, *Baroque and Rococo Architecture* (1961) is a good brief introduction to the subject; and a scholarly and comprehensive treatment of a region is Rudolf Wittkower, *Art and Architecture in Italy 1600–1750* (1958). In the same series of regional studies are Horst Gerson and E. H. ter Kuile, trans. by Olive Renier, *Art and Architecture in Belgium 1600–1800* (1960); Jakob Rosenberg, Seymour Slive, and E. H. ter Kuile, *Dutch Art and Architecture 1600–1800* (1966); George Kubler and Martin Soria, *Baroque Art and Architecture in Spain and Latin America* (1959); Eberhard Hempel, *Baroque Art and Architecture in Central Europe* (1965); and Margaret Whinney and Oliver Millar, *English Art 1625–1714* (1957). For architecture by region there is T. H. Fokker, *Roman Baroque Art: The History of a Style* (1938), a thorough study that stresses architecture while dealing also with sculpture and painting. The work of that most Baroque of architects, Borromini, is brilliantly studied in the context of the city of Rome in the seventeenth century in Paolo Portoghesi, *The Rome of Borromini* (1968). The consummate matter of Baroque sculpture in Italy is studied in Rudolf Wittkower, *Gian Lorenzo Bernini, the Sculptor of the Roman Baroque* (1955), and Howard Hibbard, *Bernini* (1966). E. K. Waterhouse surveys the subject in *Italian Baroque Painting* (1962), expanding and updating A. K. McComb, *The Baroque Painters of Italy* (1934). Special accounts of the influential art of Caravaggio are presented in R. P. Hinks, *Michelangelo Merisi da Caravaggio* (1953), and in Walter Friedlaender, *Caravaggio Studies* (1955). Sir Anthony Blunt, *Art and Architecture in France—1500–1700* (1953) stops short of Rococo, but thoroughly describes the Renaissance-Baroque continuum. A continuous narrative of French painting is given in two books by Albert Châtelet and Jacques Thuillier: *French Painting from Fouquet to Poussin* (1962) and *French Painting from Le Nain to Fragonard* (1964). Sculpture and painting in Great Britain are

surveyed in Margaret Whinney, *Sculpture in Britain 1530–1830* (1967), and in E. K. Waterhouse, *Painting in Britain 1530–1790* (1966). John Summerson, *Architecture in Britain 1530–1830* (1963) completes the survey of British art and architecture in the Pelican History of Art. The bibliographies of these more or less general studies of the regions of Baroque art and architecture can furnish the titles of numerous special studies and monographs. A recent title reviewing in detail the rich production of the Dutch School of landscape painting is Wolfgang Stechow. *Dutch Landscape of the Seventeenth Century* (1968), Valuable accounts of the artistic theory of the age can be found in Denis Mahon, *Studies in Seicento Art and Theory* (1947), and in E. G. Holt, *A Documentary History of Art*, Vol. II (1957). Heinrich Wölfflin, *Principles of Art History* (1932), now reprinted in a Dover edition, offers the classic comparison of the Renaissance and Baroque styles.

Chapter Sixteen: The Nineteenth Century

A fundamental detailed narrative of modern architecture is Henry-Russell Hitchcock, *Architecture—Nineteenth and Twentieth Centuries* (1958), and, by the same author, *The Architecture of H. H. Richardson and His Times* (1936) is a study of the American architectural environment at the time that the modern style was being generated. Kenneth Clarke, *The Gothic Revival* (1950) gives a full account of this branch of Romantic eclecticism in architecture. Carl W. Condit, *The Rise of the Skyscraper* (1952); Hugh Morrison, *Louis Sullivan* (1958); and Louis Sullivan, *Kindergarten Chats and Other Writings* (1947) present a portrait of the times and the career of the influential architect and his contemporaries. Nikolaus Pevsner, *Pioneers of Modern Design* (1964) relates the story of the revolution in taste and design in architecture, arts and crafts, and painting from William Morris to Walter Gropius. Modern sculpture is presented in a series of well-selected monuments, handsomely illustrated, in Fred Licht, *Sculpture—Nineteenth and Twentieth Centuries* (1967); and Fritz Novotny, in a detailed encyclopedic study that includes the central European and Russian schools, describes nineteenth-century art in *Painting and Sculpture in Europe 1780–1880* (1960). Alan Cowans surveys an even broader span in *The Restless Art: A History of Painters and Paintings 1760–1960* (1966). John Canaday, *Mainstreams of Modern Art* (1959) is a reliable text for nineteenth-century art, giving much valuable information on the often-neglected phenomena of the academy and the salon. E. G. Holt, *From the Classicists to the Impressionists* (1966) is a most valuable documentary anthology of nineteenth-century art theory and criticism, as are Linda Nochlin, *Impressionism and Post-Impressionism 1874–1904* (1966), and, by the same author, *Realism and Tradition in Art 1848–1900* (1966). Werner Hofmann, *The Earthly Paradise: Art in the Nineteenth Century* (1961) is an interesting survey that stresses little-known and often bizarre works, and Jean Leymarie, *French Painting in the Nineteenth Century* (1962) describes that school with the help of a series of fine plates. Geraldine Pelles, in an interesting study of painting in England and France from 1750 to 1850 called *Art, Artists and Society: Origins of a Modern Dilemma* (1963), examines the ambiguous relation between early modern artists and their publics.

The Romantic period has been presented in a number of well-illustrated volumes, among which are Marcel Brion, *Art of the Romantic Era: Romanticism, Classicism, Realism* (1966); Pierre Courthion, *Romanticism* (1961); Henry Hawley, *Neo-Classicism, Style and Motif* (1964); and Eric Newton, *The Romantic Rebellion* (1963), which attempts to characterize the nature of the general phenomenon of Romanticism. Walter Friedlaender, *From David to Delacroix* (1952) is a fundamental text for the period. J. S. Sloane, *French Painting Between the Past and the Present* (1951) gives a very interesting account of the role of the critics, who were so often hostile to artistic innovation. Indispensable to the "feel" of the period is the brilliant criticism of Baudelaire in *The Mirror of Art* (1955), and *The Journals of Eugène Delacroix* (1948), wherein the great master reveals himself, his ideals, and his methods. John Rewald, *The History of Impressionism* (1962) is the indispensable historical guide through that rich period, as is his *Post-Impressionism from Van Gogh to Gauguin* (1956) for the *fin de siècle*. An important book that analyzes the esthetics of nineteenth-century French art as it is documented by the painters themselves and in relation to contemporary philosophy and science is Charles Gauss, *Aesthetic Theories of French Artists* (1949). Wylie Syphers' interesting synthesis of the arts unifies a large period in *Rococo to Cubism in Art and Literature* (1960).

Chapter Seventeen: The Twentieth Century

The art of our own times has been, and contineus to be, much written about. In the last fifteen years lavishly produced studies, both general and specialized, have recorded the artistic events of the period almost as soon as they have happened. One of the most recent and impressive treatments of the period as a whole is H. H. Arnason, *History of Modern Art: Architecture, Sculpture and Painting* (1968), with more than 1100 black-and-white reproductions, more than 200 in color, and with a very extensive bibliography. A very general background is provided by Norbert Lynton, *The Modern*

World (1965), and an introduction by J. A. Morris, *On the Enjoyment of Modern Art* (1968). Other useful general works are M. Oto Bihalji, *Adventures in Modern Art* (1966), which compares modern with primitive images; William Gaunt, *The Observer's Book of Modern Art* (1964); Gaston Diehl, *The Moderns* (1961), a treasury of worldwide modern painting; E. B. Hanning, *Fifty Years of Modern Art* (1966); Gyorgy Kepes, *The Visual Arts Today* (1966); Gregory Battock, ed., *The New Art: A Critical Anthology* (1968); Jean Cassou, Emile Langui, and Nikolaus Pevsner, *Gateway to the Twentieth Century* (1962); and Charles McCurdy, *Modern Art: A Pictorial Anthology* (1958), which has numerous small illustrations, short historical essays, and an excellent annotated bibliography. Norman Schlenoff, *Art in the Modern World* (1965) is a short, handy history. John Canaday, *Mainstreams of Modern Art* was noted in the bibliography for Chapter Sixteen, as was Henry-Russell Hitchcock, *Architecture—Nineteenth and Twentieth Centuries.*

An excellent and brief introduction to architecture is Vincent Scully, *Modern Architecture* (1962), and some other recent introductions and surveys are Reyner Banham, *Guide to Modern Architecture* (1963); Georges and Rosamond Bernier, *The Best in Twentieth-Century Architecture* (1963); John Jacobus, *Twentieth-Century Architecture: The Middle Years 1940–1964* (1966); and Peter Blake, *The Master Builder* (1960), which studies particularly Le Corbusier, Mies van der Rohe, and Frank Lloyd Wright. Peter Collins, *Changing Ideals in Modern Architecture 1750– 1950* (1965) is a study of both the history and the meaning of the great changes taking place in two centuries. Reyner Banham, *Theory and Design in the First Machine Age* (1967) is an analysis of what might be called the philosophy of modern architecture. One of the most influential of all books on modern architecture is Siegfried Giedion, *Space, Time and Architecture* (1954), which traces the development of the new architectural tradition. Talbot Hamlin, ed., *The Forms and Functions of Twentieth-Century Architecture*, 4 vols. (1952) is a monumental reference work on the elements, principles, and building types of modern structures. Arnold Whittick, *European Architecture in the Twentieth Century* (1950) is a detailed survey, and can be supplemented by G. E. K. Smith, *The New Architecture of Europe* (1961). Paul Heyer, *Architects on Architecture* (1966) presents the views of the builders themselves; and John Fleming, Hugh Honour, and Nikolaus Pevsner, *Penguin Dictionary of Architecture* (1966) is an indispensable reference work. G. H. Hamilton, *Painting and Sculpture in Europe 1880–1940* (1967) surveys the "classic" phase of modern art up to World War II. A good short survey of American developments is Sam Hunter, *Modern American Painting and Sculpture* (1959), as is Barbara Rose, *Readings in American Art Since 1900* (1968). A. C. Ritchie, *Abstract Painting and Sculpture in America* (1951), and Sidney Janis, *Abstract and Surrealist Art in America* (1944), cover the reception of abstract art and its naturalization and independent development here. For sculpture, a very good introductory survey is Herbert Read, *A Concise History of Modern Sculpture* (1964), and treating the most recent developments are Udo Kultermann, *The New Sculpture* (1968); John Baldwin, *Contemporary Sculpture Techniques* (1967); and Jack Burnham, *Beyond Modern Sculpture* (1968), an interesting account of the effect of science and technology on modern sculpture. Fred Licht, *Sculpture of the Nineteenth and Twentieth Centuries* was noted in the previous chapter. For painting there are the large, three-volume works edited by Maurice Raynal, *History of Modern Painting* (1949– 50), and Werner Haftmann, *Painting in the Twentieth Century: A Pictorial Survey* (1965), a comprehensive survey with more than a thousand illustrations. A shorter survey is Herbert Read, *A Concise History of Modern Painting* (1956). Sam Hunter, *Modern French Painting* (1967) is a brief survey from Manet to Picasso. The first school of abstract art is studied in Robert Rosenblum, *Cubism and Twentieth-Century Art* (1961), and in John Golding, *Cubism* (1967). Christopher Gray, *Cubist Aesthetic Theories* (1953) reviews the intellectual and literary world in which the art movement developed. Peter Selz, *German Expressionist Painting* (1957) thoroughly surveys the art and artists of Expressionism. Marianne W. Martin, *Futurist Art and Theory* (1968) gives an enlightening account of the development of Futurism between 1909 and 1915. Robert Motherwell, *The Dada Painters and Poets* (1951) is an anthology documented with essays and poetry as well as illustrations, and W. S. Rubin, *Dada, Surrealism and Their Heritage* (1968) reviews their development and the strong influence they exert today. Recent developments are surveyed in Mario Amaya, *Pop Art and After* (1966); L. Lippard, *Pop Art* (1966); Allan Kaprow, *Assemblage, Environments and Happenings* (1966); Michael Kirby, ed., *Happenings: An Illustrated Anthology* (1965); and Maurice Tuchman, *American Sculpture of the Sixties* (1967). Valuable references are Wolfgang Pehnt, *Encyclopedia of Modern Art* (1964); Carlton Lake and Roger Maillard, eds., *Dictionary of Modern Painting* (1964); and Paul Cummings, *Dictionary of Contemporary American Artists* (1966). R. L. Herbert, *Modern Artists on Art* (1964) presents theoretical essays written by the artist-pioneers of the modern movement. A treasury of documentation is the Wittenborn series, *Documents of Modern Art* (1970), edited by Jurg Spiller. Some of the important works of the modern movement are by its leaders: Guillaume Apollinaire, *The Cubist Painters* (1949); Piet Mondrian, *Plastic Art and Pure Plastic Art* (1947); László Moholy-Nagy, *The New Vision* (1949); Vasily Kandinsky, *Concerning the Spiritual in Art* (1947); Hans Arp, *On My Way* (1948); Max

Ernst, *Beyond Painting* (1948); D. H. Kahnweiler, *The Rise of Cubism* (1949); Marcel Raymond, *From Baudelaire to Surrealism* (1950); Georges Duthuit, *The Fauvist Painters* (1950); Carola Giedion-Welcker, *Contemporary Sculpture* (1955). Another very important source, descriptive and documentary, is the list of publications of the Museum of Modern Art in New York, beginning in 1930 and current today.

Chapter Eighteen: The Art of India

The continuous reassessment of the chronology of Indian monuments requires that many dates be regarded as tentative. This is no less the case in Ananda K. Coomaraswamy, *History of Indian and Indonesian Art* (1927, 1965) and Benjamin Rowland, *Art and Architecture of India* (1953, 1959), which are recommended as excellent surveys of art in India and its extension in Southeast Asia. Stella Kramrisch, *The Art of India* (1955) provides a sensitive appreciation and fine illustrations. The best book for illustrations is Heinrich Zimmer, *The Art of Indian Asia*, 2 vols. (1955). Bachhofer, *Early Indian Sculpture* (1972) has many fine illustrations; it should be used with care in reference to dates. Two concise surveys of architecture are Krishna Deva, *Temples of North India* (1969) and K. R. Srinivasan, *Temples of South India* (1972). More specialized are Vidya Dehijia, *Early Buddhist Rock Temples* (1972) and John Rosenfield, *Dynastic Arts of the Kushans* (1967). South Indian architecture is carefully discussed in S. R. Balasubrahmanyan, *Early Chola Art*, Part I (1966) and *Early Chola Temples* (1971). Related bronzes are analyzed in Douglas Barrett, *Early Cola Bronzes* (1965) and C. Sivaramamurti, *South Indian Bronzes* (1963). Indian painting traditions can be traced in Douglas Barrett and Basil Gray, *Painting in India* and A. Ghosh, ed., *Ajanta Murals* (1967), which has good illustrations of early Indian painting. Sivaramurti's *South Indian Paintings* (1968) illustrates some lesser-known examples from that area. Miniature painting is discussed generally in W. C. Archer, *Indian Miniatures* (1960) and specifically in his *Indian Paintings from the Punjab Hills*, 2 vols. (1973).

The major iconographical studies are the pioneering T. A. Gopinatha Rao, *Elements of Hindu Iconography*, 4 vols. (1968) and J. N. Banerjea, *The Development of Hindu Iconography* (1956). Ananda K. Coomaraswamy, *Yaksas* (1971) is a brilliant, stimulating study that goes well beyond simple identification of a limited theme. Historical and cultural background are given succinctly in A. L. Basham, *The Wonder that Was India* (1954), while the complicated aspects of Hinduism are clarified in P. Banerjee, *Early Indian Religion* (1973) and in S. Bhattacharji, *The Indian Theogony* (1970). Another aspect of the relationship between architecture and religion is explored in Stella Kramrisch, *The Hindu Temple*, 2 vols. (1946), a monumental work.

A handy survey is Philip Rawson, *The Art of Southeast Asia* (1967). The classic A. J. Bernet Kempers, *Ancient Indonesian Art* (1959) is a more detailed study of the more limited area. Paul Mus, *Barabudur*, 2 vols. (1935) is a masterly work with implications beyond the monument discussed. Outstanding of the many books on Cambodia is Pierre Dupont, *La Statuaire Préankorienne* (1955). Other good studies are G. Groslier, *La Sculpture Khmère Ancienne* (1925); H. Parmentier, *L'Art Khmer Classique* (1939); and Sherman E. Lee, *Ancient Cambodian Sculpture* (1968). There are few introductory studies of Sri Lanka (Ceylon) and Thailand; T. Bowie, ed., *The Art of Thailand* (1960) is useful.

Periodicals include *Artibus Asiae*, *Arts Asiatiques*, *Oriental Art*, *Marg*, and *Lalit Kala*, as well as others essential for current information. The Archaeological Survey of India has issued various series that are indispensable, including *Memoirs*, *Annual Reports*, *Ancient India*, and *Indian Archaeology*.

Chapter Nineteen: The Art of China

Lawrence Sickman and Alexander Soper, *The Art and Architecture of China* (1956) is recommended as a sound, comprehensive view of the subject. Michael Sullivan, *A Short History of Chinese Art* (1970) is a useful summary, and H. G. Creel, *The Birth of China* (1936, 1954) remains a worthwhile classic. Three solid works by Cheng Te-k'un are *Prehistoric China* (1958), *Shang China* (1960), and *Chou China* (1966). Max Loehr, *Ritual Vessels of Bronze Age China* (1968) is a systematic chronology, while Charles D. Weber, *Chinese Pictorial Bronze Vessels of the Late Chou Period* (1968) provides a thorough study of the last great ritual bronzes. S. Mizuno, *Bronzes and Jades of Ancient China* (1959) is a beautiful, well-illustrated Japanese text with a good English summary. Osvald Sirèn, *Chinese Sculpture from the Fifth to the Fourteenth Centuries*, 4 vols. (1925) is an indispensable resource. For specific sites and areas the following are recommended: Richard Rudolph, *Han Tomb Art of West China* (1951); Michael Sullivan and Dominique Darbois, *The Cave Temples of Maichishan* (1969); and S. Mizuno and T. Nagahiro, *Unko Sekkutsu: Yunkang, The Buddhist Cave Temples of the Fifth Century A.D. in North China*, 16 vols. (1951–56) and *A Study of the Buddhist Cave Temples at Lung-men, Honan* (1940). The latter two are in Japanese with English summaries.

Osvald Sirèn, *Chinese Painting, Leading Masters and Principles* (1956–58) is a monumental survey, thoroughly illustrated. More recent research is incorporated in James Cahill, *Chinese Painting* (1960), Sherman E. Lee, *Chinese Landscape Painting* (1971), and Michael Sullivan, *The Birth of Landscape Painting in China* (1961). New information about one of China's greatest sites is furnished in Basil Gray and John B. Vincent, *Buddhist Cave Paintings at Tun-huang*

(1959). A rich source of references useful in research is Alexander Soper, *Literary Evidence for Early Buddhist Art in China* (1959). J. LeRoy Davidson, *The Lotus Sutra in Chinese Art* (1954) is a study of the pragmatic relationships between the arts and cultural attitudes, as expressed in illustrations from religious texts. An adequate starting point in the voluminous literature on ceramics is W. B. Honey, *The Ceramic Art of China and other Countries of the Far East* (1945). A work incorporating more recent research is John Ayers, *The Seligman Collection of Oriental Art: Vol. II, Chinese and Korean Pottery and Porcelain* (1964). Exciting new archeological finds in China are well illustrated in *Historical Relics Unearthed in New China* (1972), published in Peking. Periodicals recommended are *Artibus Asiae; Arts Asiatiques; Oriental Art; Archives of Asian Art; New China*.

Chapter Twenty: The Art of Japan

Recommended as introductory texts are Robert T. Paine and Alexander Soper, *The Art and Architecture of Japan* (1955) and the Japanese sections of Sherman E. Lee, *A History of Far Eastern Art* (1973). Although prepared as an exhibition catalog, John M. Rosenfield and Shojiro Shimada, *Traditions of Japanese Art* (1970) has not only superb illustrations but a commentary that serves as an excellent history of Japanese culture. J. Edward Kidder, *Early Japanese Art* (1964) and *The Birth of Japanese Art* (1965) are comprehensive studies of archeological material but must be supplemented by reports of later discoveries, which appear chiefly in Japanese periodicals. The pictorial traditions are concisely and brilliantly treated in T. Akiyama, *Japanese Painting* (1961). J. Edward Kidder, *Japanese Temples: Sculpture, Painting and Architecture* (1965) is particularly useful in its sculpture sections. Specialized studies include John M. Rosenfield, *Japanese Art of the Heian Period, 749–1185* (1967) and Sherman E. Lee, *Japanese Decorative Style* (1961). J. Fontein and M. C. Hickman, *Zen Painting and Calligraphy* (1970) and James F. Cahill, *Scholar Painters of Japan: the Nanga School* (1972) are excellent introductions to their subjects. Arthur Drexler, *The Architecture of Japan* (1955) is a perceptive analysis by a specialist in Western architecture. One of many good books on ukiyo-e, C. Hirano's monograph *Kiyonaga* (1939) also contains an excellent discussion of the Japanese woodblock print in general. Comprehensive and well illustrated are Harold P. Stern, *Master Prints of Japan, Ukiyo-E Hanga* (1969) and *Ceramic Art of Japan* (1972), issued by The Seattle Art Museum, with a text by Henry Trubner; both have extensive, up-to-date bibliographies. Among other periodicals on Asian Art, *Bijutsu Kenkyu* is recommended specifically for its coverage of Japanese art.

Chapter Twenty-one: Pre-Columbian Art

The most comprehensive general work on pre-Columbian art is still George Kubler, *The Art and Architecture of Ancient America* (1962). Excellent general texts providing cultural background material for Meso-America and the Andes are Frederick Peterson, *Ancient Mexico* (1962) and J. Alden Mason, *The Ancient Civilizations of Peru* (1969). Intensive coverage of individual periods, areas, and mediums may be found in the following: Michael D. Coe, *The Jaguar's Children: Pre-Classic Central Mexico* (1965); Merle Greene, Robert Rands, and John Graham, *Maya Sculpture* (1972); Tatiana Proskouriakoff, *A Study of Classic Maya Sculpture*, Carnegie Institute of Washington, D. C. publication no. 593 (1950); William Coe, *Tikal, a Handbook of the Ancient Maya Ruins* (1967); John Paddock, ed., *Ancient Oaxaca* (1966); Donald Robertson, *Pre-Columbian Architecture* (1963); John H. Rowe, *Chavín Art: An Inquiry into its Form and Meaning* (1962); Wendell C. Bennett, *Ancient Arts of the Andes* (1954); André Emmerich, *Sweat of the Sun and Tears of the Moon, Gold and Silver in Pre-Columbian Art* (1965); and Junius B. Bird and Louisa Bellinger, *Paracas Fabrics and Nazca Needlework* (1954). Key handbooks are J. Eric Thompson, *Maya History and Religion* (1970); George C. Vaillant, *Artists and Craftsmen in Ancient Central America* (1973); Sylvanus G. Morley, *The Ancient Maya* (1956); Julian H. Steward, ed., *Handbook of the South American Indians*, 7 vols. (1956); and Robert Wauchope, ed., *Handbook of Middle American Indians*, 16 vols. (1969).

Recent exhibition catalogs have reached new levels of excellence. Of particular value are the Guggenheim Museum's *Mastercraftsmen of Ancient Peru* (1968); the Metropolitan Museum of Art's *Before Cortez, Sculpture of Middle America* (1970); the Los Angeles County Museum of Art's *Sculpture of Ancient West Mexico, The Proctor Stafford Collection* (1970); and the Los Angeles County Museum of Natural History's *Ancient Art of Veracruz* (1971).

Chapter Twenty-two: North American Indian, African, and Oceanic Art

A few general books survey the arts of North America, Africa, and Oceania, each from a different perspective. Paul Wingert, *Primitive Art: Its Traditions and Styles* (1962) employs the "style area" method, whereas Douglas Fraser, *Primitive Art* (1962) employs a theoretical, diffusionist, historical approach. A third, more recent work, still more broadly inclusive, is L. Pericot-Garcia, J. Galloway, and A. Lömmel, *Prehistoric and Primitive Art* (1967). Earlier approaches, now less popular, are found in F. Boas, *Primitive Art* (1927) and L. Adam, *Primitive*

Art (1945). Various methods are surveyed in D. Fraser, ed., *The Many Faces of Primitive Art* (1966).

It is best, perhaps, to consult works on the individual areas. General introductions to Indian arts, all very well illustrated, include: Norman Feder, *Art of the American Indian* (1971); Frederick Dockstader, *Indian Art in America* (1961) and, a new version that treats the entire continent, *Indian Art of the Americas* (1973); A. H. Whiteford, *North American Indian Arts* (1970) and two exhibition catalogues—Norman Feder, *Two Hundred Years of North American Art*, Whitney Museum of American Art (1971), and *American Indian Art: Form and Tradition*, Walker Art Center and Minneapolis Institute of Arts (1972), which contains thirteen essays by specialists on subareas. Another fine, scholarly catalog, this one devoted to Northwest Coast and Eskimo traditions, is H. B. Collins *et al.*, *The Far North*. A wealth of data on arts is contained in E. S. Curtis, *The North American Indian*, 30 vols. (1903–1930), and for bibliography one can consult A. Harding and P. Boling, *Bibliography of Articles and Papers on North American Indian Arts* (1938), as well as the later but more general G. P. Murdock, *Ethnographic Bibliography of North America* (1960). More specific studies include C. Grant, *Rock Art of the American Indian* (1967); V. Scully, *Pueblo Architecture of the Southwest: A Photographic Essay* (1971); J. C. Ewers, *Plains Indian Painting* (1939, out of print); E. Gunther, *Art in the Life of the Northwest Coast Indians* (1966); and, on the Eskimo, D. J. Ray, *Artists of the Tundra and the Sea* (1961).

General surveys of African arts, primarily sculpture, are Frank Willett, *African Art, An Introduction* (1971) and W. R. Bascom, *African Art in Cultural Perspective* (1973), both in paperback; M. Lieris and J. Delange, *African Art* (1968); R. S. Wassing, *African Art, Its Background and Traditions* (1968); J. Laude, *The Arts of Black Africa* (1966); E. Elisofon and W. B. Fagg, *The Sculpture of Africa* (1958, out of print); and M. Trowell, *Classical African Sculpture* (1964). More specific studies include F. Willett, *Ife in the History of West African Sculpture* (1967); W. Forman and P. Dark, *Benin Art* (1960); J. Cornet, *Art of Africa; Treasures from the Congo* (1971); Walker Art Center, *Art of the Congo*; R. Goldwater, *Bambara Sculpture from the Western Sudan* (1960) and *Senufo Sculpture from West Africa* (1964); W. B. Fagg, *Nigerian Images* (1963); B. Brentjes, *African Rock Art* (1969); and R. F. Thompson, *Black Gods and Kings, Yoruba Art at U.C.L.A.* (1971). Specific themes are developed in two anthologies of essays by specialists, W. d'Azevedo, ed., *The Traditional Artist in African Societies* (1973) and D. Fraser and H. M. Cole, eds., *African Art and Leadership* (1972). Useful for bibliography is L. J. P. Gaskin, *A Bibliography of African Art;* and, for articles on traditional as well as modern African Arts, the quarterly periodical *African Arts*, published by the University of California, Los Angeles is good.

An early but still valuable overview of Oceania is R. Linton and Paul Wingert, *Arts of the South Seas* (1946). Finer illustrations, many in color, are found in J. Guiart, *Arts of the South Pacific* (1963) and C. A. Schmitz, *Oceanic Art* (1954). General works on Polynesia are T. Barrow, *Art and Life in Polynesia* (1973) and E Dodd, *Polynesian Art* (1967). Specific Polynesian studies include P. H. Buck, *Arts and Crafts of Hawaii* (1957) and T. Barrow, *Maori Wood Sculpture of New Zealand* (1969). General New Guinea studies are R. Firth, *Art and Life in New Guinea* (1936) and D. Newton, *New Guinea Art in the Collection of the Museum of Primitive Art* (1967). A few good studies on single areas are D. Newton, *Art Styles of the Papuan Gulf* (1961) and *Crocodile and Cassowary* (1971), which deals with the Upper Sepik River area; M. C. Rockefeller, *The Asmat of New Guinea* (1967); S. Kooijman, *The Art of Lake Sentani* (1959); and R. M. Berndt *et al.*, *Australian Aboriginal Art* (1964). For bibliography: C. J. R. Taylor, *A Pacific Bibliography* (1951).

PLAN AND SECTION CONVENTIONS

The plans and sections (see Introduction, pp. 13–14) in this book use the following conventions: *In plans* masses are generally solid black. (Reconstructions are shown shaded.) Elements such as steps and sills or other structures that do not extend from floor (plan) level to roof or ceiling are shown in line. Structures above or below floor level and not integral with it are shown in dashed line. Section lines, indicating the plane along which a section is drawn, are shown by a dash-dot line. *In sections* structures are generally shown as in a simple line drawing, with masses that are cut by the plane of the drawing shown in gray. The section plane is the foremost; the first surface beyond is untinted, and surfaces beyond that are shown in light grays. Labeled specimen plans and a section are shown below.

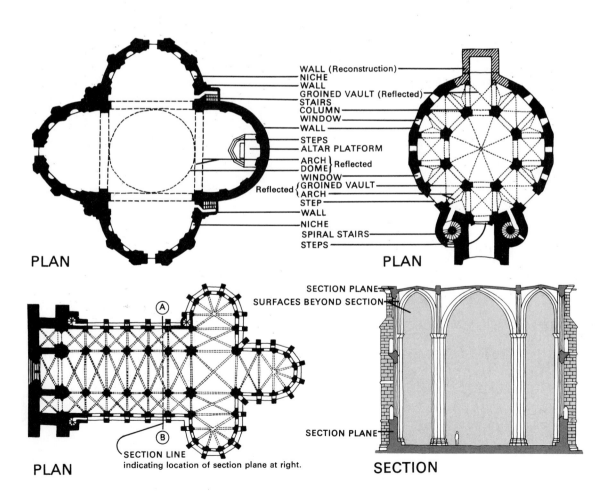

WALL (Reconstruction)
NICHE
WALL
GROINED VAULT (Reflected)
STAIRS
COLUMN
WINDOW
WALL
STEPS
ALTAR PLATFORM
ARCH } Reflected
DOME
WINDOW
GROINED VAULT
Reflected { ARCH
STEP
WALL
NICHE
SPIRAL STAIRS
STEPS

PLAN

PLAN

A

B

SECTION LINE
indicating location of section plane at right.

PLAN

SECTION PLANE
SURFACES BEYOND SECTION

SECTION PLANE

SECTION

INDEX

Wingert, Paul, 884

Witz, Conrad: *The Miraculous Draught of Fish*, 554, *555*

Wölfflin, Heinrich, 387, 480

Woman Combing Her Hair (Archipenko), 749, *749*

Woman Combing Her Hair (Gonzalez), 751, *751*

Woman I (De Kooning), 773–74, *774*

Woman of the Velcha Family, from Tomb of Orcus (Hades), Tarquinia, 189, *Plate 6-2*

Woodcuts: of Dürer, 561–62; German Expressionist, 725–26; Japanese, 864–67

Wren, Christopher, 630–31; St. Paul's Cathedral, London, 578, 630–31, *631*

Wright, Frank Lloyd, 758, 759–60, 764, 789; Kaufmann House ("Falling Water"), 717, 764, *765*; Robie House, Chicago, 760, *761*; Solomon R. Guggenheim Museum, New York, 789, *791*

Wu Chen, 843; *Bamboo*, 843, *844*

Wu Tao-tzu, 837–38

Wu Tomb, mythological scenes from, Shantung, 829, *829*

Wyeth, Andrew, 774; *Christina's World*, 716, 774–75, *775*

X

X (Bladen), 779, *779*

Y

Yamato-e style, 855–56, 858

Yayoi, 850

Yen Li-pen: *Portraits of the Emperors*, 837

Yoruba art, 894–95

Young Woman with a Water Jug (Vermeer), 614–17, *616*, *Plate 15-8*

Yu, Early Chou dynasty, 827, *827*

Yüan dynasty, 842–43

Yün-kang caves, 831–32, *832*

Z

Zaïre, art of, 895–96

Zen Buddhism, influence of, 858–60

Zen painting, 841–42, 859

Zen Priest, Choka (Sotatsu), 862, *862*

Zeus, Temple of, pediment sculpture from, *149*, 149–50, *150*

Zeus and Athena, Altar of, Pergamum, 123, *173*, 173–74

Ziggurat(s), 48–50; at Ur, *48*, 49–50, *49*

Zoser, King, Stepped Pyramid of, 79, *80*

"Zuccone" (prophet figure) (Donatello), 432, *432*–33

Zurbarán, Francisco de, 599–600; *St. Francis in Meditation*, 579, 599–600, *600*

PICTURE CREDITS

The authors and publisher are grateful to the proprietors and custodians of various works of art for photographs of these works and permission to reproduce them in this book. Sources not included in the captions are listed below.

KEY TO ABBREVIATIONS

ACL Copyright A.C.L., Brussels
Al Fratelli Alinari
AMNH American Museum of Natural History, New York
An D. Anderson
ARB Art Reference Bureau
Bg Giacomo Brogi
Br F. Bruckmann K G Verlag
Bulloz J. E. Bulloz, Paris
DAI Deutschen Archäologisches Institut
Fototeca Fototeca Unione, Rome
Gab Gabinetto Fotografico Nazionale, Rome

Gir Giraudon
Gun L. Gundermann Photo-Verlag
Hir Hirmer Fotoarchiv, Munich
Mansell The Mansell Collection, London
Mar Bildarchiv Foto Marburg
Mas Ampliaciones Y Reproducciones MAS, Barcelona
Met Metropolitan Museum of Art, New York
NYPL New York Public Library
OI Oriental Institute, University of Chicago
PRI Photo Researchers, Inc., New York
RGP Rapho-Guillumette Pictures
Scala Scala Fine Art Publishers, Ind., New York

Introduction Josef Albers: FIGS. 6, 7; Al-ARB: FIGS. 9a, 10; Bibliothèque Nationale: FIG. 13; Dr. Thomas Brachert, Courtesy of *Art Bulletin*, Dec. 1971, LIII, 4: FIG. 4; Bg-ARB: FIG. 9b; Fogg Art Museum, Harvard University, Bequest of Paul J. Sachs: FIG. 3; Hir: FIG. 12; Walter Steinkopf: FIG. 14; Wilhelm-Lehmbruck-Museum: FIG. 1.

Chapter 1 Aerofilms Ltd., London: FIG. 13; AMNH: FIGS. 7, 8, 11; Caisse Nationale: FIGS. 5, 6; Colorphoto

Hinz, Basle: FIGS. 2, 4; PLATES 1, 2; Mas: FIG. 12; Edwin Smith: FIG. 14; Studio Laborie, Bergerac: FIGS. 3, 10.

Chapter 2 Al-ARB: FIG. 34; British Museum: FIG. 8; Hir: FIGS. 10, 16, 17, 18, 19, 20, 23, 27; Jericho Excavation Fund: FIGS. 1, 2; Mansell: FIGS. 24, 25; Arlette Mellaart: FIGS. 5, 6, 7; James Mellaart: PLATE 1; Musées Nationaux, Paris: FIGS. 28, 31; OI: FIGS. 12, 29, 32, 33.

Chapter 3 Harvey Barad, PRI: FIG. 6; Egyptian Expedition, Met: FIGS. 16, 18, 30; Eliot Elisofon: FIGS. 22, 25; George Gerster, RGP: FIG. 7; Hir: FIGS. 2, 3, 10, 11, 12, 13, 14, 15, 21, 28, 32; from *L'Art et l'Homme*, Larousse: FIG. 1; Mar-ARB: FIGS. 23, 24, 34; Met: FIGS. 16, 18; Musées Nationaux, Paris: FIG. 35; OI: FIG. 19.

Chapter 4 Courtauld Institute Galleries, London Univ.: FIG. 22; Alison Frantz: FIG. 20; Hir: FIGS. 4, 5, 7, 8, 9, 10, 11, 12, 13, 14, 15, 16, 19, 24, 25; PLATES 1, 2; TAP Service: FIG. 23; from Christian Zervos, *L'Art de la Crète*, Editions Cahiers d'Art, Paris: FIG. 3; from Christian Zervos, *L'Art des Cyclades*, Editions Cahiers d'Art, Paris: FIGS. 1, 2.

Chapter 5 Al-ARB: FIGS. 14, 24, 53, 57, 58, 60, 64, 73; Herschel Levit: FIG. 22; Frederick Ayer III, PRI: FIG. 75; DAI, Athens: FIG. 12; Felbermeyer: FIGS. 68, 69; Alison Frantz: FIGS. 35, 36, 46, 47; Walter Hege: FIG. 40; Hir: FIGS. 2, 4, 6, 7, 8, 10, 17, 18, 21, 27, 30, 31, 32, 33, 37, 39, 42, 43, 44, 45, 48, 50, 51, 52, 55, 56, 59, 63, 70, 74, PLATES 1, 2; Mar-ARB: FIGS. 61, 62; Musées Nationaux, Paris: FIGS. 9, 54; Leonard von Matt, RGP: FIG. 67; Rev. Raymond V. Schoder, S.J.: PLATE 3; Dr. Franz Stoedtner: FIG. 26; TAP Service: FIG. 16.

Chapter 6 Al-ARB: FIGS. 4, 8, 9, 15, 23, 26, 28, 29, 30, 32, 33, 48, 51, 52, 53, 54, 55, 58, 64, 72, 73; An-ARB: FIG. 49; DAI, Rome: FIGS. 6, 12, 31, 57, 59, 71; Walter Drayer: FIGS. 2, 7, 10; Fototeca: FIGS. 5, 13, 14, 16, 17, 18, 19, 44, 47; Gab: FIGS. 3, 60; André Held: PLATE 4; Hir: FIG. 69; John Johnston: FIG. 70; G. E. Kidder Smith: FIG. 67; Foto KLM: FIG. 37; Herschel Levit: FIG. 50; Mar-ARB: FIG. 65; Leonard von Matt, RGP: FIG. 61; from Amedeo Maiuri, *Roman Painting*, Editions d'Art Albert Skira: FIGS. 24, 27; H. Roger-Viollet: FIG. 34; Charles Rotkin, PFI: FIG. 36; Scala: FIGS. 21, 40; PLATES 2, 3, 5, 6; Rev. Raymond V. Schoder, S.J.: PLATE 1.

Chapter 7 Al-ARB: FIGS. 13, 24, 29, 30, 31, 42; An-ARB: FIGS. 16, 20, 23, 45, 52; Arts et Metiers Graphiques, Paris (from G. Marçais, *L'Architecture Musulmane d'Occident*): FIG. 51; Bibliothèque Nationale: FIG. 5; Byzantine Institute, Inc.: FIG. 46; Clarendon Press: FIG. 57; from K. A. C. Creswell, *Early Muslim Architecture*, Clarendon Press: FIGS. 50, 55; Fotocielo: FIG. 40; Alison Frantz: FIGS. 37, 39; Hir: FIGS. 7, 8, 9, 17, 18, 19, 22, 25, 26, 28, 32; Iraq Mission to the United Nations: FIGS. 49, 56; G. E. Kidder Smith: FIGS. 34, 62, 63; Linares, Yale Photo Collection: FIG. 59; Mar-ARB: FIG. 48; Mas: FIGS. 53, 54, 60; Leonard von Matt, RGP: FIG. 2; OI: FIG. 21; Pontificia Commissione Centrale per l'Arte Sacra in Italia: FIG. 3; Josephine Powell: FIG. 44; Prestel Verlag, Munich: FIG. 33; Rev. Fabrica di San Pietro in Vaticano: FIG. 12; Scala: PLATES 1, 2, 3, 4, 5, 6; Staatliche Museen, Berlin: FIG. 58; Tass, Sovfoto: FIG. 43; Tiers, Monkmeyer Press Photo Service, N.Y.: FIG. 64.

Chapter 8 Dr. Harald Busch: FIG. 9; Hir: FIG. 20; PLATE 3; Mar-ARB: FIG. 18; J. Gudiol, Archives Photographiques, Paris: opening illus., Part 2; Hermann Wehmeyer: FIGS. 14, 16, 17.

Chapter 9 Al-ARB: FIGS. 8, 10, 17, 19; Bulloz: FIGS. 22, 26; Caisse Nationale: FIGS. 22, 23; Jean Dieuzaide: FIG 21; Willie Fix: FIG. 6; Fotocielo: FIG. 16; Gir: FIGS. 27, 28; J. Gudiol Archives Photographiques, Paris: FIG. 24;

Evelyn Hofer: FIG. 18; A. F. Kersting: FIG. 14; Mansell: FIG. 30; Studio Remy: FIG. 29; Yan, Reportage Photographique, Toulouse: FIG. 1; H. Roger-Viollet: FIG. 12; Jean Roubier: FIGS. 3, 11, 20; Scala: PLATE 1; Thames & Hudson Archive: FIG. 25.

Chapter 10 Aero-Photo, Paris: FIG. 15; Al-ARB: FIGS. 30, 48, 49, 50; An-ARB: FIG. 47; Belzeaux, RGP: FIG. 31; PLATE 2; P. Berger, Photo Researchers, Inc.: FIG. 8; Dr. Harald Busch: FIG. 40; Pierre Devinoy: FIGS. 1, 3; Theo Felten: FIG. 44; Gir: FIGS. 26, 28; George Holton, PRI: FIGS. 45, 51; A. F. Kersting: FIG. 36; Herschel Levit: FIG. 19; Mar-ARB: FIGS. 25, 27, 38, 42; National Monuments Record, London: FIGS. 34, 35; Revue Française de l'Electricité: PLATE 1; Rheinisches Bilderarchiv, Cologne: FIG. 43; H. Roger-Viollet: FIGS. 13, 23, 24; Jean Roubier: FIGS. 9, 12, 14; Helga Schmidt-Glassner: FIG. 41; Edwin Smith: FIG. 32; W. S. Stoddard: FIGS. 7, 10, 17; Clarence Ward: FIGS. 21, 22.

Chapter 11 Al-ARB: FIGS. 2, 4, 5, 6, 8, 9, 12, 13, 14, 15, 16, 17, 19; An-ARB: FIGS. 1, 7, 10, 20, 21, 22, 23; Bg-ARB: FIGS. 3, 18; Gab: FIG. 11; Leonard von Matt, RGP: opening illus., Part 3; Scala: PLATES 1, 2.

Chapter 12 Al-ARB: FIGS. 4, 5, 6, 8, 9, 10, 13, 14, 15, 16, 17, 20, 26, 27, 28, 32, 33, 34, 35, 36, 40, 43, 45, 46, 47, 52, 55, 56, 57, 58, 59, 60, 61; An-ARB: FIGS. 18, 22, 25, 29, 30, 31, 37, 39, 50; An-Gir: FIG. 51; Marcello Bertoni: FIGS. 1, 2; Bg-ARB: FIGS. 3, 11, 12, 24, 49; Farbenfotografie: PLATE 7; Rollie McKenna, PRI: FIGS. 38, 42; La Photothèque: PLATE 5; Scala: PLATES 1, 2, 3, 6.

Chapter 13 Al-ARB: FIGS. 1, 3, 10, 12, 13, 14, 15, 16, 17, 18, 21, 22, 24, 25, 32, 33, 37, 38, 40, 41, 49, 50, 51, 52, 53, 55, 56, 57; An-ARB: FIGS. 4, 6, 23, 28, 34, 35; Harvey Barad, PRI: FIG. 19; Fototeca: FIGS. 27, 30; Gir: FIG. 20; Rollie McKenna: FIG. 43; Phyllis Dearborn Massar: FIGS. 45, 47, 48; Met: FIG. 31; Charles Rotkin, PFI: FIG. 26; Scala PLATES 2, 3, 4, 7, 8, 9; Edwin Smith: FIG. 44.

Chapter 14 ACL: FIGS. 6, 7, 8, 13, 15, 16; Al-ARB: FIGS. 14, 37, 44; Caisse Nationale: FIGS. 1, 39; Jean Arland: FIG. 20; Br-ARB: FIG. 25; Bulloz: FIG. 43; Meyer Erwin Photo: PLATE 10; Gir: FIGS. 4, 38, 42; PLATES 2, 7, 8; Lauras-Giraudon: FIG. 2; Gun-ARB: FIG. 21; Musées Nationaux: PLATE 7; Studio Remy: FIG. 3; Rheinisches Bilderarchiv, Cologne: FIG. 19; Charles Rotkin, PFI: FIG. 40; Scala: PLATE 5; Walter Steinkopf: FIGS. 18, 30.

Chapter 15 Aero-Photo, Paris: FIG. 52a; AGRACI-ARB: FIG. 45; Al-ARB: FIGS. 9, 10, 13, 15, 22, 23, 24, 25, 33, 34, 38, 54, 56, 60, 61, 66, 68; An-ARB: FIGS. 4, 7, 12, 21, 26, 28, 29; Wayne Andrews: FIG. 62; Avery Library, Columbia Univ.: FIG. 1; Br-ARB: FIG. 30; British Crown Copyright, Reproduced with permission of the Controller of Her Britannic Majesty's Stationery Office: FIG. 58; Bulloz-ARB: FIG. 71; J. Allan Cash, RGP: FIG. 72; Editorial Photocolor Archives, Inc.: FIG. 18; Gab: FIG. 20; Gir: FIGS. 48, 57, 69; Gene Heil, PRI: FIG. 53a; Photo Henrot: FIG. 55; A. F. Kersting: FIGS. 5, 51; G. E. Kidder Smith: FIGS. 17, 19; Frank Lerner: PLATE 8; Mansell: FIGS. 46, 47; Ministry of Public Buildings and Works, London: FIG. 58; Erich Müller: FIG. 63; National Monuments Record, London: FIG. 59; NYPL: FIGS. 8, 52b; Charles Rotkin, PFI: FIG. 3; Scala: PLATES 1, 2, 11; Helga Schmidt-Glassner:

FIGS. 50, 64; Walter Steinkopf: FIGS. 35, 44; Yan, RGP: PLATE 3.

Chapter 16 ACL: FIGS. 22, 59; AGRACI-ARB: FIGS. 28, 49; Al-ARB: FIGS. 11, 14, 24, 30, 32, 33, 35, 37, 63; An-ARB: FIGS. 17, 20; Wayne Andrews: FIG. 66; British Crown Copyright, repro. with permission of the Controller of Her Britannic Majesty's Stationery Office: FIG. 1; John R. Brownlie, PRI: FIG. 8; Bulloz: FIGS. 13, 43; Bulloz-ARB: FIG. 34; J. Camponogara: FIG. 27; Chicago Architectural Photographing Co.: FIG. 65; Deutsche Fotothek, Dresden: FIG. 47; H. B. Fleming & Co.: PLATE 1; Gir: FIGS. 15, 21, 25, 26, 48; PLATE 6; Hedrich-Blessing: FIG. 67; A. F. Kersting: FIGS. 2, 6, 9; Studio MADEC: FIG. 38; Mar-ARB: FIG. 62; Ministry of Public Buildings and Works, London: FIG. 1; NYPL: FIGS. 19, 31; Musées Nationaux: FIG. 23; PLATES 3, 6; H. Roger-Viollet: FIG. 10; Oscar Savio: opening illus., Part 4; Scala: PLATE 7; O. Vaering: FIG. 60; Virginia Chamber of Commerce: FIG. 7.

Chapter 17 Leo Castelli Gallery: FIGS. 74, 76; Chicago Architectural Photographing Co.: FIGS. 48, 49; Geoffrey Clements: FIGS. 62, 77; Colorphoto Hinz, Basle: PLATES 5, 10; David Gahr: FIG. 72; Galerie Welz: PLATE 1; Gianfranco Gorgoni: FIGS. 69, 70; The Solomon R. Guggenheim Museum: FIGS. 84, 85; Hedrich-Blessing: FIG. 9; Lucien Hervé: FIGS. 50, 52, 82, 83; Institut für Leichte Flachentragwerke: FIG. 87a; Ralph Kleinhempel: PLATE 6; Jim Knipe: FIG. 90; William Lescaze Associates: FIG. 56; Marlborough Gallery, Inc.: FIG. 67; Mas: FIG. 47; Pierre Matisse Gallery: FIG. 60; Museum of Modern Art: FIGS. 51, 54, 57, PLATES 13, 14; Office du Film du Québec: FIG. 89a; Robert Phillips, Fortune Magazine: FIG. 88: H. Roger-Viollet: FIG. 81; *Beyond Habitat* © Moshe Safdie, MIT Press in the U.S., Tundra Books in Canada: FIG. 89b; Oscar Savio: FIG. 86; Sidney Janis Gallery, New York: PLATE 15; Dr. Franz Stoedtner: FIG. 55; Ezra Stoller, copyright ESTO: FIG. 58; Walter Thiem: FIG. 87b; Tiofoto, Stockholm: FIG. 37.

Chapter 18 Black Star: FIG. 28; J. LeRoy Davidson: FIGS. 13, 16, 18, 19, 22, 23, 25, PLATE 2; Eliot Elisofon, TIME/LIFE Books, Time, Inc.: FIG. 26; Government of India, Archaeological Survey of India: FIGS. 1, 2, 3, 4, 5, 6, 7, 9, 11, 12, 14, 15, 17, 20; India Tourist Office: FIG. 21; Elizabeth Lyons: FIG. 29; Josiah Martin, Auckland Institute & Museum Library: opening illus., Part 5; I. Job Thomas: PLATE 1.

Chapter 19 Chavannes: FIG. 4; Gir: PLATE 2; Robert Harding Associates, London: FIG. 21; Magnum: FIGS. 5, 6; Musées Nationaux, Paris: PLATE 1; National Commission for Protection of Cultural Properties of Japan: FIG. 16; Audrey R. Topping: FIG. 24; Charles Uht: FIG. 9; Courtesy Estate of Langdon Warner: FIG. 10.

Chapter 20 Japan Tourist Association: FIG. 23; National Commission for Protection of Cultural Properties of Japan: FIGS. 3, 4, 9, 11, 12; Sakamoto Photo Research Lab, Tokyo: FIG. 5, PLATE 1; Yoshio Watanabe: FIG. 8; Zauho Press: PLATE 2.

Chapter 21 Archaeological Institute of America, Reprinted from *Art and Archaeology*, IV, 6, copyright 1916:

FIG. 5; Archive of Hispanic Culture, Library of Congress: FIG. 13a; Chicago Natural History Museum: FIG. 13b; Susan Einstein, Museum of Cultural History, University of California, Los Angeles: FIGS. 2, 12; Field Museum of Natural History, Chicago: FIG. 3; Abraham Guillen M.: FIG. 15; Smithsonian Institution, Washington, D.C.: FIG. 1.

Chapter 22 *The American Anthropologist*, 1919: FIG. 7; H. M. Cole: FIG. 23, PLATE 4; Eliot Elisofon, TIME/LIFE Books, Time, Inc.: FIG. 3; David Gebhard, The Art Galleries, University of California, Santa Barbara: FIG. 9; from Campbell Grant, *Rock Art of the American Indian*: FIG. 8; Dr. George Kennedy, University of California, Los Angeles: FIG. 36; from J. D. Lajoux, *The Rock Paintings of Tassili*: FIG. 19; Museum of Navaho Ceremonial Art, Sante Fe: PLATE 1; National Park Service, Department of the Interior, Washington, D.C.: FIGS. 11, 12; from Karl von den Steinen, *Die Marquesaner und ihre Kunst*, I: FIG. 34; Frank Willett, Northwestern University: FIGS. 20, 21, PLATE 3.

Permission S.P.A.D.E.M. 1974 by French Reproduction Rights, Inc., for the following: FIGS. 16-52, 54, 55; 17-1, 5, 6, 7, 8, 9, 10, 13, 16, 20, 24, 29, 30, 42, 52, 62, 63, 64, 81, 82; PLATES: 16-5, 6; 17-3, 4, 5, 8, 11.

Permission A.D.A.G.P. 1975 by French Reproduction Rights, Inc., for the following: FIGS. 17-19, 35, 40, 43, 45, 60; PLATES 17-2, 7, 9.

Illustration Credits

FIG. 3-4: Adapted from the "Later Canon" of Egyptian Art, figure 1 in Erwin Panofsky, *Meaning in the Visual Arts*. Copyright © 1955 by Erwin Panofsky. Used by permission of Doubleday and Company, Inc.

FIGS. 3-17, 26; 5-25; 6-22, 38, 39, 41, 45; 7-41; 10-46; 13-11: From Sir Banister Fletcher, *A History of Architecture on the Comparative Method*, 17th ed., rev. by R. A. Cordingly, 1961. Used by permission of the Athlone Press of the University of London.

FIGS. 4-6; 7-1, 27: Hirmer Fotoarchiv, Munich.

FIG. 6-66: From Fiske Kimball, M. Arch, and G. H. Edgell, *A History of Architecture*, 1918. Used by permission of Harper & Row, Inc., publishers.

FIGS. 7-6, 10, 11: From Kenneth J. Conant, *Early Medieval Church Architecture*. Used by permission of The Johns Hopkins Press.

FIGS. 10-4, 5: From Ernst Gall, *Gotische Kathedralen*, 1925. Used by permission of Klinkhardt & Biermann, publishers.

FIG. 10-18: Used by permission of Umschau Verlag, Frankfort.

FIG. 12-41: From Nikolaus Pevsner, *An Outline of European Architecture*, 6th ed., 1960, Penguin Books, Ltd., © Nikolaus Pevsner, 1943, 1960, 1963.

FIG. 18-8: From Benjamin Rowland, *The Art and Architectural India*, 1953, Penguin Books.